The Century of Tung Ch'i-ch'ang 1555-1636

The Century of

安府庫而

充實而

Tung Ch'i-ch'ang
1555-1636

VOLUME II

WAI-KAM HO, EDITOR
JUDITH G. SMITH, COORDINATING EDITOR

With essays by: Wai-kam Ho and Dawn Ho Delbanco, Wen C. Fong, James Cahill, Kohara Hironobu, Xu Bangda, Wang Qingzheng, Celia Carrington Riely, and Wang Shiqing

With contributions to the catalogue by: Ai Zhigao, Richard M. Barnhart, Joseph Chang, Hui-liang J. Chu, Richard Edwards, Shi-yee Liu Fiedler, Marilyn Wong Gleysteen, John Hay, Maxwell K. Hearn, Wai-kam Ho, Jason Kuo, Chu-tsing Li, Pan Shenliang, Celia Carrington Riely, David A. Sensabaugh, Shan Guolin, Richard Vinograd, Roderick Whitfield, and Yang Chenbin

PUBLISHED BY THE NELSON-ATKINS MUSEUM OF ART
in association with
THE UNIVERSITY OF WASHINGTON PRESS, SEATTLE AND LONDON

Publication of this book was made possible in part by a generous grant from the
E. Rhodes and Leona B. Carpenter Foundation.

This exhibition was made possible in part by a grant from the National Endowment
for the Humanities, a federal agency.

This book accompanies an exhibition organized by The Nelson-Atkins Museum of Art,
Kansas City, Missouri, under the auspices of the China Cultural Relics Promotion Center,
and in collaboration with the Beijing Palace Museum and the Shanghai Museum of Art.

The Nelson-Atkins Museum of Art April 19–June 14, 1992

Los Angeles County Museum of Art July 19–September 20, 1992

The Metropolitan Museum of Art, New York October 23, 1992–January 10, 1993

Designed by Bruce Campbell

Type set by U. S. Lithograph, typographers, New York; ASCO, Hong Kong

Printed by Amilcare Pizzi, Milan

LIBRARY OF CONGRESS CATALOGING-IN-PUBLICATION DATA

The Century of Tung Ch'i-ch'ang/Wai-kam Ho, editor; contributors to
 the catalogue, Wai-kam Ho . . . [et al.].
 p. cm.
 Catalogue of exhibition organized by The Nelson-Atkins Museum of Art,
 Kansas City, Mo.
 Includes bibliographical references and indexes.
 ISBN 0-295-97157-6
I. Tung, Ch'i-ch'ang, 1555–1636—Exhibitions. I. Ho, Wai-kam.
 II. Nelson-Atkins Museum of Art.

N7349.T86A4 1992 91-25759
759.951—dc20 CIP

ISBN 0-295-97157-6 (clothbound set); ISBN 0-295-97137-1 (Vol. I clothbound); ISBN 0-295-97139-8 (Vol. II clothbound)

ISBN 0-295-97158-4 (paperback set); ISBN 0-295-97138-x (Vol. I paperback); ISBN 0-295-97140-1 (Vol. II paperback)

Jacket/Cover: (Volume I front) detail of Plate 42-2; (Volume I back) detail of Plate 63
(Volume II front) detail of Plate 22; (Volume II back) Plate 155-12
Frontispiece: (Volume I) detail of Plate 42-8; (Volume II) detail of Plate 20

Contents

* in Chinese

定人也天發殺機龍
人發殺機天地反覆天
萬化定基性有巧拙可
九竅之邪在乎三要可
火生于木禍發必剋奸

List of Illustrations

Plates refer to illustrations of works in the exhibiton not reproduced in Volume I.

Dynastic Chronology

Shang	ca. 1600–ca. 1100 B.C.
Chou	ca. 1100–256 B.C.
Ch'in	221–207 B.C.
Han	206 B.C.–A.D. 220
Western Han	*206 B.C.–A.D. 8*
Hsin	*9–23*
Liu Hsüan	*23–25*
Eastern Han	*25–220*
Three Kingdoms	220–265
(Wu not absorbed by Chin until 280)	
Wei	*220–265*
Shu	*221–263*
Wu	*222–280*
Chin	265–420
Western Chin	*265–316*
Eastern Chin	*317–420*
Northern and Southern Dynasties	420–589
Northern Dynasties	386–581
Northern Wei	*386–534*
Eastern Wei	*534–550*
Western Wei	*535–557*
Northern Ch'i	*550–577*
Northern Chou	*557–581*
Southern Dynasties	420–589
Sung	*420–479*
Ch'i	*479–502*
Liang	*502–557*
Ch'en	*557–589*
Sui	581–618
T'ang	618–907
Five Dynasties	907–960

Sung	960–1279
Northern Sung	*960–1127*
Southern Sung	*1127–1279*
Liao	916–1125
Chin	1115–1234
Yüan	1271–1368
Ming	1368–1644
Hung-wu	*1368–1398*
Chien-wen	*1399–1402*
Yung-le	*1403–1424*
Hung-hsi	*1425*
Hsüan-te	*1426–1435*
Cheng-t'ung	*1436–1449*
Ching-t'ai	*1450–1456*
T'ien-shun	*1457–1464*
Ch'eng-hua	*1465–1487*
Hung-chih	*1488–1505*
Cheng-te	*1506–1521*
Chia-ching	*1522–1566*
Lung-ch'ing	*1567–1572*
Wan-li	*1573–1620*
T'ai-ch'ang	*1620*
T'ien-ch'i	*1621–1627*
Ch'ung-chen	*1628–1644*
Ch'ing	1644–1911
Shun-chih	*1644–1661*
K'ang-hsi	*1662–1722*
Yung-cheng	*1723–1735*
Ch'ien-lung	*1736–1795*
Chia-ch'ing	*1796–1820*
Tao-kuang	*1821–1850*
Hsien-feng	*1851–1861*
T'ung-chih	*1862–1874*
Kuang-hsü	*1875–1908*
Hsüan-t'ung	*1909–1911*

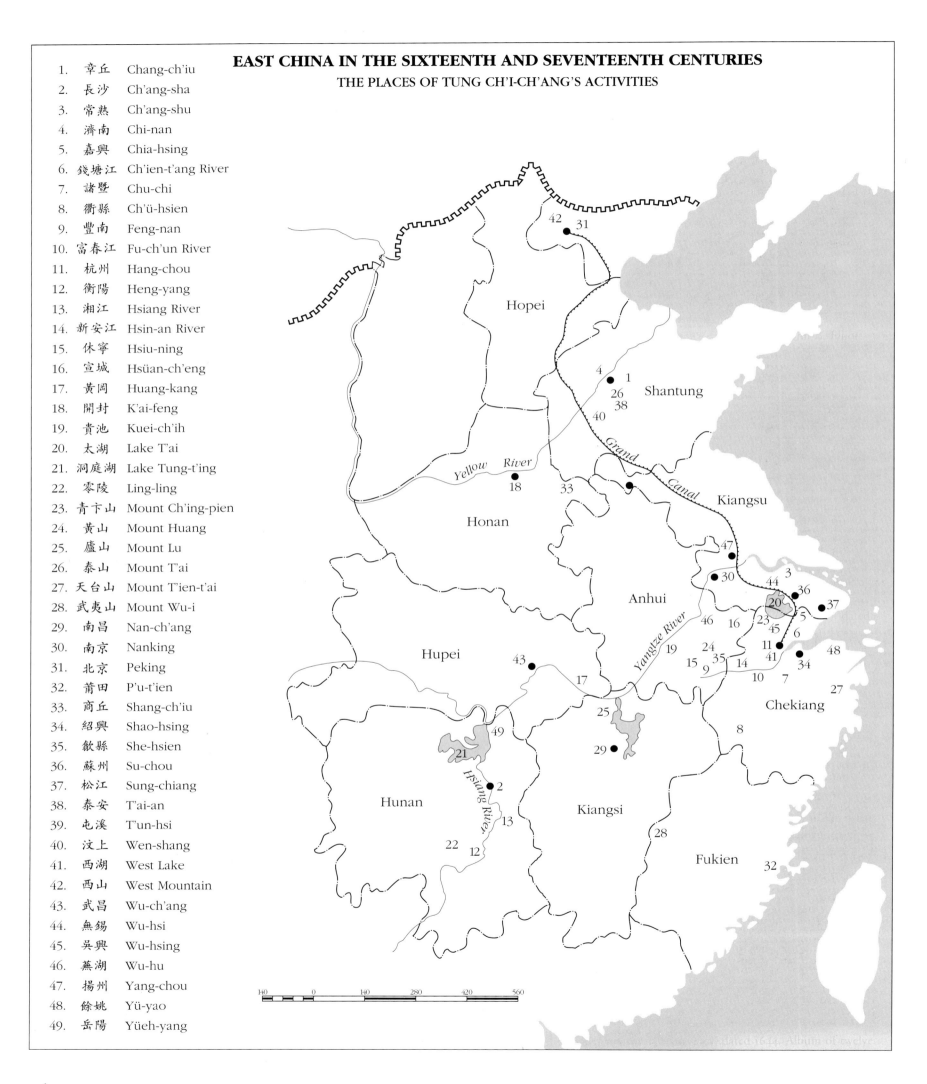

EAST CHINA IN THE SIXTEENTH AND SEVENTEENTH CENTURIES
THE PLACES OF TUNG CH'I-CH'ANG'S ACTIVITIES

1.	章丘	Chang-ch'iu
2.	長沙	Ch'ang-sha
3.	常熟	Ch'ang-shu
4.	濟南	Chi-nan
5.	嘉興	Chia-hsing
6.	錢塘江	Ch'ien-t'ang River
7.	諸暨	Chu-chi
8.	衢縣	Ch'ü-hsien
9.	豐南	Feng-nan
10.	富春江	Fu-ch'un River
11.	杭州	Hang-chou
12.	衡陽	Heng-yang
13.	湘江	Hsiang River
14.	新安江	Hsin-an River
15.	休寧	Hsiu-ning
16.	宣城	Hsüan-ch'eng
17.	黃岡	Huang-kang
18.	開封	K'ai-feng
19.	貴池	Kuei-ch'ih
20.	太湖	Lake T'ai
21.	洞庭湖	Lake Tung-t'ing
22.	零陵	Ling-ling
23.	青卞山	Mount Ch'ing-pien
24.	黃山	Mount Huang
25.	廬山	Mount Lu
26.	泰山	Mount T'ai
27.	天台山	Mount T'ien-t'ai
28.	武夷山	Mount Wu-i
29.	南昌	Nan-ch'ang
30.	南京	Nanking
31.	北京	Peking
32.	莆田	P'u-t'ien
33.	商丘	Shang-ch'iu
34.	紹興	Shao-hsing
35.	歙縣	She-hsien
36.	蘇州	Su-chou
37.	松江	Sung-chiang
38.	泰安	T'ai-an
39.	屯溪	T'un-hsi
40.	汶上	Wen-shang
41.	西湖	West Lake
42.	西山	West Mountain
43.	武昌	Wu-ch'ang
44.	無錫	Wu-hsi
45.	吳興	Wu-hsing
46.	蕪湖	Wu-hu
47.	揚州	Yang-chou
48.	餘姚	Yü-yao
49.	岳陽	Yüeh-yang

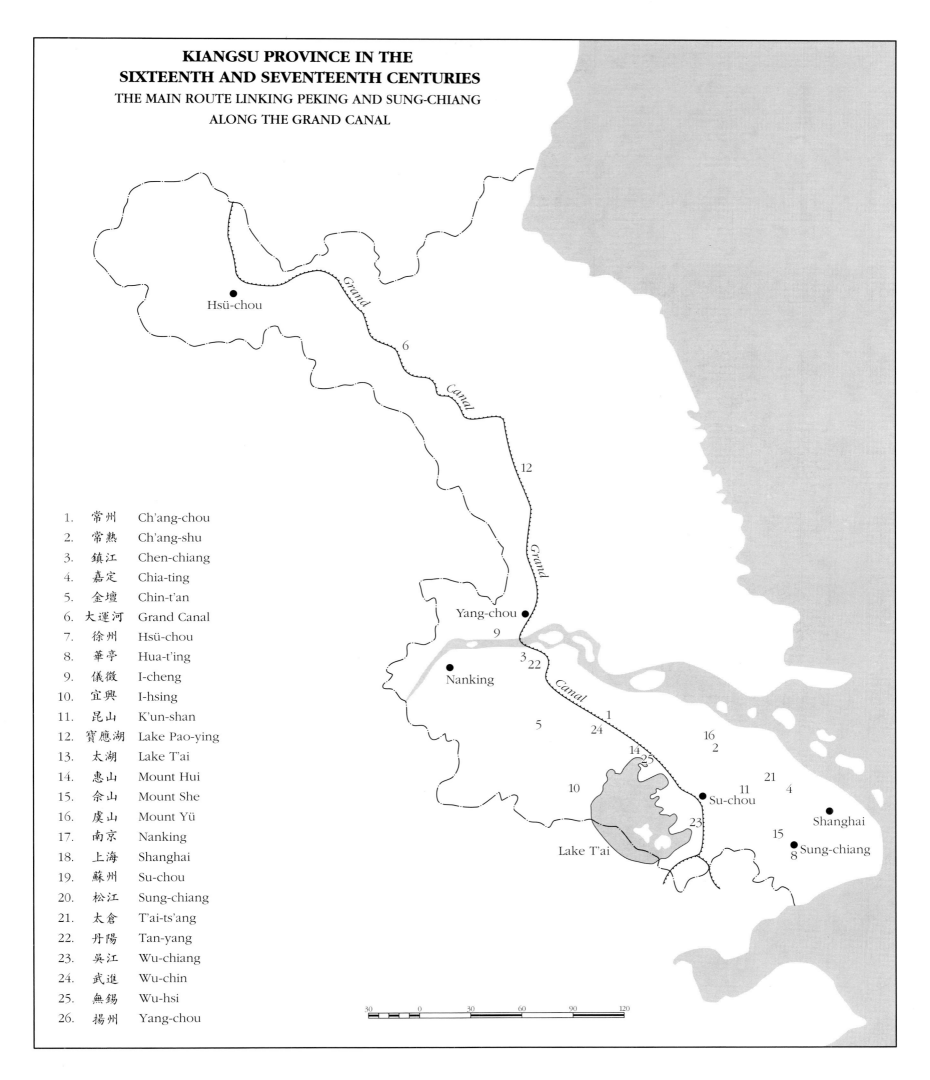

KIANGSU PROVINCE IN THE
SIXTEENTH AND SEVENTEENTH CENTURIES
THE MAIN ROUTE LINKING PEKING AND SUNG-CHIANG
ALONG THE GRAND CANAL

Hsü-chou

Grand
Canal

6

12

Grand

Yang-chou

9

3 22

Nanking

Canal

1

5

24

16

2

14

25

10

11

21

4

Su-chou

Shanghai

15

23

Sung-chiang

8

Lake T'ai

1.	常州	Ch'ang-chou
2.	常熟	Ch'ang-shu
3.	鎮江	Chen-chiang
4.	嘉定	Chia-ting
5.	金壇	Chin-t'an
6.	大運河	Grand Canal
7.	徐州	Hsü-chou
8.	華亭	Hua-t'ing
9.	儀徵	I-cheng
10.	宜興	I-hsing
11.	昆山	K'un-shan
12.	寶應湖	Lake Pao-ying
13.	太湖	Lake T'ai
14.	惠山	Mount Hui
15.	佘山	Mount She
16.	虞山	Mount Yü
17.	南京	Nanking
18.	上海	Shanghai
19.	蘇州	Su-chou
20.	松江	Sung-chiang
21.	太倉	T'ai-ts'ang
22.	丹陽	Tan-yang
23.	吳江	Wu-chiang
24.	武進	Wu-chin
25.	無錫	Wu-hsi
26.	揚州	Yang-chou

30 0 30 60 90 120

Catalogue

Notes to the Reader

Catalogue entries are followed by the initials of the authors:

RMB Richard M. Barnhart 班宗華

HLJC Hui-liang J. Chu 朱惠良

RE Richard Edwards 艾瑞慈

MWG Marilyn Wong Gleysteen 王妙蓮

JH John Hay 韓莊

MKH Maxwell K. Hearn 何慕文

JK Jason Kuo 郭繼生

CTL Chu-tsing Li 李鑄晉

DAS David A. Sensabaugh 江文葦

RV Richard Vinograd 文以誠

RW Roderick Whitfield 韋陀

DOCUMENTATION. Documentation for the works in the exhibition, including the transcription of inscriptions and colophons, the decipherment of the legends of the artists' seals, and the identification of colophon writers and collectors, was compiled by Shan Guolin (Shanghai Museum); Yang Chenbin, Pan Shenliang, and Ai Zhigao (Beijing Palace Museum); and Joseph Chang (The Nelson-Atkins Museum of Art). Documentation for paintings from non-Chinese collections is largely based on earlier publications.

ARTIST'S SEALS. In the catalogue entries for works by or attributed to Tung Ch'i-ch'ang, the romanization of the legend of each seal identified as Tung's is followed by a number in boldface which corresponds to the seal number in the illustrated list of Tung's seals, "Tung Ch'i-ch'ang's Seals on Works in *The Century of Tung Ch'i-ch'ang*," in vol. 2 of this catalogue.

ARTISTS' BIOGRAPHIES. For the biography of Tung Ch'i-ch'ang, see Celia Carrington Riely, "Tung Ch'i-ch'ang's Life," in vol. 2 of this catalogue. A brief biography of each of the other artists represented in the exhibition precedes the catalogue entries for works by the artist. The biographies of K'un-ts'an, Mei Ch'ing, Shih-t'ao, and Wu Pin were written by Maxwell K. Hearn. All other biographies were written by Ankeney Weitz.

TEXT REFERENCES, EXHIBITIONS, AND LITERATURE. Full references for sources cited in the remarks and in the exhibition and literature sections at the end of each entry appear in the Selected Bibliography in vol. 2 of this catalogue. The collected works of Tung Ch'i-ch'ang referred to in the entries—the *Hua-ch'an shih sui-pi*, *Hua-shuo*, *Hua-yen*, *Jung-t'ai pieh-chi*, *Jung-t'ai wen-chi*, and *Jung-t'ai shih-chi*—are listed in the bibliography under "Tung Ch'i-ch'ang."

1 *Theories on Calligraphy and Painting,* running script
Hsing-shu lun shu-hua fa
董其昌　行書論書畫法

Dated 1592

Handscroll, ink on Korean paper
Two sections: 26.3 x 86 cm (10⅛ x 33⅞ in.); 25 x 93.5 cm (9¹³⁄₁₆ x 36¹³⁄₁₆ in.)

Beijing Palace Museum

vol. 1, pl. 1 (detail); vol 2, pl. 1

ARTIST´S INSCRIPTIONS (section 1):
1. 1 line in small running script in the center of the text, following the twenty-second line:
Written on the eighteenth day of the fourth month of the *jen-ch'en* year [April 29, 1592] at Ts'ui-chen [Shantung] on the Yellow River with a head-wind.
壬辰孟夏，阻風黃河崔鎮書，十八日。

2. 1 line in small running script at the end of the text, following the thirty-eighth line:
On the same day [April 29, 1592] [Tung] wrote this again.
是日重書。

ARTIST´S COLOPHON (section 2; 20 lines in medium running script):
In the *hsin-mao* year [1591] I asked for formal leave [from my position as a Han-lin Bachelor] in order to accompany the funerary casket of my former Han-lin teacher T'ien [I-chün, d. 1591] for burial [in his hometown, Ta-t'ien, Fukien]. At the time Professor Han [Shih-neng, 1528–1598], who had been Ambassador to Korea, gave me a length of yellow Korean paper. In the spring of the *jen-ch'en* year [1592] when I returned to the court, the paper had been backed, and, as I had leisure time on the boat, I wrote some random comments on the art of painting and calligraphy. The paper had been folded and kept in a box, so I didn't realize that a servant or someone in the household had had it mounted as a handscroll. Thus, it has been circulating among friends for the past twenty years! Today when I was examining some old calligraphy, my good friend Wu T'ing [ca. 1555–after 1626] suddenly brought out this scroll. It was like seeing an old friend. Even though it was written nonchalantly at the time, I can now say it bears some resemblance to [the calligraphy of the Sung master] Ts'ai Chün-mo [Ts'ai Hsiang, 1012–1067]. I've never studied Ts'ai's calligraphy, but serendipitously I seem to have captured something here. I have also done some painting sketches on the paper, but unfortunately they are now lost. Written on the seventh day of the ninth month of the *keng-hsü* year [September 23, 1610] on a stopover while on the Hsin-an River [Anhui]. Tung Ch'i-ch'ang.
辛卯余以送館師田公之喪，請告還。時韓館師曾使朝鮮，有高麗黃箋一番贈余行。壬辰春還朝，紙已裝潢，舟中多暇，隨意拈筆大都論書畫法。委棄篋中，不知奴子輩何從復拆作橫卷。流傳人間且二十載矣！今日撿舊時書，忽友人吳太學出以相質，如見故吾。爾時雖率意點染，頗似蔡君謨書。余未嘗學蔡書，偶相合耳。此紙亦有畫粉本，惜亦散落。庚戌九月七日新安江舟次書，董其昌。

ARTIST´S SEALS:
Tung Ch'i-ch'ang yin 董其昌印 (*pai-wen*, square) 1
T'ai-shih shih 太史氏 (*chu-wen*, square; colophon) 35
Tung Hsüan-tsai 董玄宰 (*pai-wen*, square; colophon) 36

COLLECTORS´ SEALS: Ch'eng Mao 程茂, 1; Ch'eng K'ai 程塏, 2; Ch'eng Ts'ung-lung 程從龍, 4; Ch'ing Kao-tsung 清高宗 (r. 1736–95), 8; Ch'ing Jen-tsung 清仁宗 (r. 1796–1820), 1

Written on the Korean paper given to him by Han Shih-neng, Tung Ch'i-ch'ang's teacher in the Han-lin Academy, his mentor in the arts, and a perspicacious collector of ancient calligraphy and painting, these comments cover a host of topics on the making and appreciation of art. Within the realm of calligraphy, they are technical, theoretical, critical, and art-historical in content. They document what was in Tung's mind in 1592 and help reconstruct the formation of his overall theoretical work. They properly set the stage for the more extensive ruminations on specific paintings and works of calligraphy he would examine and collect in the next several decades, which appear subsequently as colophons on the scrolls and in printed form in his collected literary works, the *Hua-ch'an shih sui-pi* and the *Jung-t'ai chi.*

Notes such as these reveal how immersed Tung had become in the study of ancient works, making the aesthetic goals of the ancients his own and involving himself totally in the practice of brushwriting even before he had embarked on his official career (which in good part enabled him to gain access to great works of art) and before he was able to acquire a single notable work on his own. They forecast the preoccupation in his creative life with the great masters of calligraphy and their aesthetic achievements, in particular the Two Wangs—Wang Hsi-chih (303–379) and his son Hsien-chih (344–388)—as well as the Sung Masters Mi Fu (1051–1107) and Su Shih (1036–1101). In this attention, he is already aligning himself with and reinforcing a specific tradition of orthodoxy, one that essentially emphasizes the *t'ieh* 帖, or brush-written "model," approach to calligraphy.

This handscroll is the earliest dated work in the present exhibition and among the earliest dated extant works of Tung Ch'i-ch'ang (see vol. 1, fig. 51, for a work dated 1591). As stated in his attached colophon, dated 1610, Tung wrote the scroll en route back to the capital after a brief leave. In 1592, Tung was thirty-eight *sui* (thirty-seven years old) and had received his *chin-shih* degree only three years previously. As we know from his own description, he had begun the serious study of calligraphy twenty years earlier at age seventeen, after, due to his poor calligraphy, he failed to place first in the first of three examinations which eventually won him his coveted degree and appointment to the Han-lin Academy as a Bachelor in 1589. (See Xu Bangda, "Tung Ch'i-ch'ang's Calligraphy," in vol. 1 of this catalogue, p. 107, and Celia Carrington Riely, "Tung Ch'i-ch'ang's Life," part 2, in vol. 2, for Tung's statement on his study of calligraphy.) The technical nature of these comments, essentially "tips" or reminders to himself on how to achieve his aim in the creative process, stress the amount of mental and physical effort Tung applied in the development of his calligraphic art. For Tung there was no "sudden enlightenment" in calligraphy—though the natural and the spontaneous were among his highest goals—but only the "gradual accumulation" of artistic insight through constant practice and the nourishment of one's "eye" through the study of ancient art. In this respect, Tung's theory of the Northern and Southern schools as parallel modes of enlightenment in painting was not transferable to his personal experience in calligraphy.

In the following year, 1593, Tung was to acquire one of his first paintings, a work by Tung Yüan (fl. ca. 945–ca. 960) from the collector Wu T'ing, whom he had met for the first time in 1590 and mentions in his colophon of 1610 on this handscroll. During the 1590s Tung was able to examine the outstanding works in Han Shih-neng's collection; earlier, in the 1570s and 1580s, he also had had the opportu-

nity to study the ancient scrolls in the hands of the greatest Ming collector, Hsiang Yüan-pien (1525–1590). These works included some of the most outstanding examples from the Wei-Chin, T'ang, and Sung periods.

Tung's comments are written in a freehand running script with a few entries in small regular script. The ink tonality varies slightly from entry to entry, indicating pauses to collect one's thoughts and to recharge the brush with fresh ink. There are twelve entries. The date follows the ninth entry. Tung then wrote three more entries, signing in small characters at the end of the text, "On the same day [Tung] wrote this again." Then, for unity, he impressed the same seal (*Tung Ch'i-ch'ang yin*) after each date. All twelve entries appear, though in a different order, sequence, and combination, in the first two sections of his *Hua-ch'an shih sui-pi*: "On the Use of the Brush" and "Critical Comments on Calligraphy." The editor of the *Hua-ch'an shih*, Yang Pu (1598–1657), apparently collected numerous other comments and took the liberty of mixing and arranging them (with no apparent consideration given to date) according to their content.

A translation of the twelve entries and a brief commentary follow.

1. One of the secrets of calligraphy is to be able to release and retract [one's brush energy in the very act of writing]. If in executing each character one loses these two modes, then it is like having only day or only night—it's a complete loss of calligraphic principle! (*Hua-ch'an shih sui-pi, ch.* 1, p. 1)

作書之訣，在能放縱，又能攢促。每一字中失此兩竅，便如晝夜獨行，全是魔道矣！

2. The most odious thing in calligraphy is to have the strokes [in characters] arranged so evenly that each structure looks like the other. Within each character there should be tight and loose places, with the internal energy of the strokes responding to each other. Wang Ta-ling's [Wang Hsien-chih] calligraphy never shows characters with the left and right sides having the same height. Yu-chün's [Wang Hsi-chih] calligraphy was like a phoenix soaring and gliding—it appeared off-balance, but was in fact steady; it looked peculiar, but was in fact quite orthodox (*ssu ch'i, fan-cheng*). Mi Yüan-chang [Mi Fu] observed that the *Thousand Character Classic* in [Chao] Ta-nien's [Chao Ling-jang, d. after 1100] collection had characters with "configurations leaning to one side, as if departing from the Two Wangs." These observations all show that the spacing in a character ought not to be even and that characters ought to vary in size, shape, and density in a complementary way. (*Hua-ch'an shih sui-pi, ch.* 1, p. 1)

作書所最忌者，位置等勻，且如一字中須有收有放，有精神相挽處。王大令之書，從無左右並頭者。右軍如鳳翥鸞翔，似奇反正。米元章謂大年《千文》，"觀其有偏側之勢，出二王外。"此皆言布置不當平勻，當長短錯綜、疏密相間也。

The central issue in both these passages concerns Tung's perception of what constitutes life energy or vital force in individual characters, as well as in a complete work of art. He extends Mi Fu's critical observations on calligraphy even further when he emphasizes his admiration for the subtle asymmetry of the Two Wangs, and, indirectly, is critical of the strict rigidity of the stele writing of certain T'ang masters. As seen below, he praises the variety of the natural and abhors the mechanically repetitive. The breathing spaces which allow parts of the character or painting to respond to each other he would refer to elsewhere, using phrases such as *fen-ho* 分合 (divisions and gatherings) to describe how to obtain the desired dynamism in a painting, and

the concept of *shih* 勢 (momentum, or dynamic force) to refer to the thrust or potential movement in the structure of individual characters of calligraphy or in the composition of a painting.

3. The art of calligraphy lies in achieving subtlety and ingenuity (*ch'iao-miao*). Clumsiness (*cho*) and straightforwardness (*chih-shuai*) cannot lead to transformation at the highest level. (*Hua-ch'an shih sui-pi, ch.* 1, p. 2)

書道只在巧妙二字。拙則直率而無化境矣。

By "transformation," Tung meant a level of achievement resulting from the study and absorption of ancient models as a basis for personal stylistic change. "Subtlety and ingenuity" and "clumsiness and straightforwardness" are polar concepts which describe not only a technical level but also specific attributes in brushwork: in the former, manipulation of the brush by fine movements of the fingers, hand, and arm to produce nuances of ink and brushline embodying a history of form recognizable, like musical references, to the cognizant eye (and ear); in the latter, the lack of nuance, the directness of brush attack on the paper which, consciously or unconsciously, makes no reference to past models and lacks subtlety. These concepts are analogous to two others he used elsewhere: *sheng* 生 (raw) and *shou* 熟 (ripe or cooked). While Tung abhorred clumsy writing, he also criticized the calligraphy of his nemesis, the Yüan dynasty calligrapher and painter Chao Meng-fu (1254–1322), for being "overripe," by which he meant too technically perfect and so well practiced that it became *su* 俗, or "vulgar." (See Xu Bangda, "Tung Ch'i-chang's Calligraphy," pp. 115–16.) Yet what did Tung mean by "raw"? We will discuss this further below.

4. When using ink, one should strive for an effect of moistness, rather than dryness. Even so, one should also avoid using too much ink, which can be ugly. (*Hua-ch'an shih sui-pi, ch.* 1, p. 3)

用墨須使有潤，不可使其枯燥。尤忌濃肥，濃肥則大惡道矣。

Tung's concept of "moistness" (*jun* 潤) is related to a description of his calligraphy in which he contrasts himself with Chao Meng-fu: "Because Chao's calligraphy is so technically perfect or 'overripe,' it has a vulgar appeal. Because my calligraphy is less technically perfect and therefore slightly 'raw,' it has an elegant beauty" (see Xu Bangda, "Tung Ch'i-chang's Calligraphy," p. 115). "Moistness" is thus related to "elegance" (*hsiu-se* 秀色) and, in turn, to "rawness" (*sheng*). Tung does not mention this latter term in the present entries (it appears to date from works of the 1600s), but rawness is undoubtedly one of those admirable qualities, along with "naturalness," "plainness," and "spontaneity," that he held in the highest esteem.

5. The calligrapher should have firm control of the brush from the very beginning [of each stroke], and not let himself be controlled by the brush (*pu k'o hsin pi*). If he allows this, his writing will lack strength. When manipulating the brush, the calligrapher must have total control in the turns and releases (*chuan-shu*). The secret of calligraphy lies in mastery of these turns and releases. Nowadays people let the brush control them; they do not know how to control it. (*Hua-ch'an shih sui-pi, ch.* 1, p. 3)

作書須提得筆起，不可信筆。蓋信筆則其波畫皆無力。提得筆起，則一轉一束處皆有主宰。轉束二字，書家妙訣也。今人只是筆作主，未嘗運筆。

6. It is important in calligraphy to obliterate one's traces and not leave the individual strokes sitting on the surface of the paper or silk as if they were

carved out separately. Tung-p'o [Su Shih] once said in a poem on calligraphy: "Naturalness and spontaneity are my teachers." This statement captures the rare essence [of his art]. (*Hua-ch'an shih sui-pi*, ch. 1, p. 2)

作書最要泯沒稜痕，不使筆筆在紙素成板刻樣。東坡詩論書法云：「天真爛漫是吾師。」此一句丹髓也。

Su Shih's "naturalness and spontaneity are my teachers" was one of Tung's most hallowed precepts and was quoted by him in a number of different contexts. This was the ideal that Tung found most difficult to achieve, not only because it was inconsistent with his technical goals, which included the seeking of total control, but also because it was the ultimate state of enlightenment after a long process of spiritual and artistic struggle. As artistic ideals, "the natural and the spontaneous" belong in the same category as "the plain and the natural" (*p'ing-tan t'ien-chen* 平淡天真): Tung pursued these elusive qualities until the end of his life, and on rare occasions—a few instances in his middle years and then more frequently in his old age—he was able to reach this state of aesthetic transformation. The struggle entailed Tung's ability to overcome an ingrained vigilance and possibly a natural inclination to overcontrol. His artistic temperament was not the unfettered simplicity and childlike openness that Su Shih implies in his statement and appears to have achieved effortlessly.

7. In composing characters, the Chin and T'ang masters designed each character individually, often making them irregular. This is important to note. (*Hua-ch'an shih sui-pi*, ch. 1, pp. 4–5)

晉、唐人結字，須一一錄出，時常參取，此最關要。

In this and subsequent writings, Tung's artistic goal focused on the dynamic configuration of each character (and, by extension, the composition of a painting), thus picking up a feature that Mi Fu emphasized in his comments on the Two Wangs. Elsewhere, Tung would say, "The ancient masters purposely did not write balanced characters. For them, asymmetry was a form of balance" (*Hua-ch'an shih sui-pi*, ch. 1, p. 2). The notion of asymmetry—the deft arrangement of the inner spaces and components of a single configuration to achieve a subtle visual tension—was a key aesthetic principle in both Tung's calligraphy and painting and one that he unequivocally derived from his study of ancient calligraphy, particularly the Wei-Chin masters.

8. My fellow townsman Lu Yen-shan [Lu Shen, 1477–1544] often executed calligraphy in haste to meet a social obligation, yet he never did it carelessly. He once said, "Even if it is for social reasons, one still ought to respect the act of writing." I have taken these words to heart and believe that any aspiring calligrapher would do the same. When I am at leisure and am enjoying [my calligraphy practice] before an open window, I invariably do so with good spirits and concentration. However, if I have to respond to a social obligation with some calligraphy, then I tend to do it rather carelessly and in a hurry to be finished. This is a terrible fault. Now I am in a better position to reflect on these matters. The ancients never executed one brushstroke which could not be scrutinized for generations afterwards. For this reason, they achieved fame. If their grounding was not genuine, the results would be twisted and vague, lacking in the spirit and energy necessary to be transmitted over time. Fortunately, this enabled [their writings] never to perish. (*Hua-ch'an shih sui-pi*, ch. 1, pp. 4–5)

吾鄉陸儼山先生作書，雖率爾應酬，皆不苟且，嘗曰：「即此便是寫字時，須用敬也。」吾每服膺斯言。而作書不能不揀擇，或閒窗游戲，都有着精神處。惟應酬作答，皆率意苟完。此最是

病。今後遇筆硯，便當起矜莊想，古人無一筆不怕千載後人指摘。故能成名。因地不真，果招紆曲，未有精神不在傳遠，而徒能不朽者也。

9. Taking up the brush to write requires immediate control. Without it, one flails about recklessly. This is not calligraphy! Brush control gives one the expectation that one can write in a given master's style and remain faithful to that method. (*Hua-ch'an shih sui-pi*, ch. 1, p. 1)

提筆時須定宗旨。若泛泛塗抹，書道不成。形像用筆，使人望而知其爲某書，不嫌說定法也。

10. In the midst of writing a stroke, [the brush attack] ought to be direct [and the brush held upright], otherwise [the stroke] will be too light, too flat, and soft-looking [i.e. lacking inner structure]. (*Hua-ch'an shih sui-pi*, ch. 1, p. 1)

筆畫中須直，不得輕易偏軟。

11. I once inscribed a colophon on the *Thousand Character Classic* of Master [Chih-]yung [fl. late 6th century] with the words: "When writing one should have total control of the brush from the beginning to the end [i.e. from the moment one places brush to paper to the moment one lifts the brush from the paper]. One cannot trust the brush by letting it take over." Nowadays there are those who write by letting the brush do the writing. These problems can be overcome by writing with a wrist raised [above the desk] and with the brush in an upright position [keeping the tip always in the center of the stroke.] Tung-p'o [Su Shih] wrote with a rather heavy brush touch which Mi Hsiang-yang [Mi Fu] described as being like "painting characters." This comment sounds as if there was some loss of control there. (*Hua-ch'an shih sui-pi*, ch. 1, p. 1)

余嘗題永師《千文》後曰：「作書須提得筆起，自爲起，自爲結，不可信筆。」後代人作書，皆信筆耳。信筆二字，最當玩味。其所云須懸腕，須正鋒者，皆爲破信筆之病也。東坡書筆俱重落，米襄陽謂之「畫字，」此言有信筆處耳。

12. The ancient masters considered *chang-fa* [compositional arrangement of characters within each line or column of text and of lines within an entire composition] as the most important element in a single work. This is also referred to as the spatial density between lines. I once saw the "crazy" Mi's [Fu] *Elegant Gathering in the Western Garden* written in small regular script on a round fan. The columns were as taut as strings [on a zither], and there were no boundary lines drawn [for guidance]. He could do this because he was constantly vigilant about his overall compositional arrangement. The finest example of compositional arrangement is Yu-chün's [Wang Hsi-chih] *Orchid Pavilion Preface*. No matter what their size, the characters in that work flow in a natural rhythm, each responding to and complementing the other. They seem to be written effortlessly, and yet they follow certain principles. This is why it is an inspired work of the highest spiritual order! (*Hua-ch'an shih sui-pi*, ch. 1, p. 4)

古人論書，以章法爲一大事。蓋所謂行間茂密是也。余見米痴小楷作《西園雅會圖序》，是紈扇。其直如弦，此必非有界道，乃平日留意章法耳。右軍《蘭亭叙》章法爲古今第一，其字皆映帶而生，或小或大，隨手所如，皆入法界。所以爲神品也。

It is to be noted that Tung corrected himself on the first line of this entry by replacing the two characters *chieh-kou* 結構 (a term that refers to the composition of each individual character) with *chang-fa*: he did this by indicating his error with two dots, and then writing the two correct characters (in very small script) in the intercolumnar space. Such a correction bears out the extemporaneous quality of the scroll.

This final entry, in combination with the others, reinforces what in the history of calligraphy may be called the "orthodox lineage" for Tung Ch'i-ch'ang and therefore goes beyond what might first appear as "name dropping." For Tung, the Two Wangs, their sixth-generation descendant Chih-yung, and the Four Great Masters of the T'ang, along with Liu Kung-ch'üan (778–865), Li Yung (675–747), and the Four Great Masters of the Sung, all formed the apex of cultural achievement and were those most worthy of emulation. While admiring certain of Chao Meng-fu's works, Tung was generally disdainful of him; and he could not tolerate the achievement of recent masters such as Wen Cheng-ming (1470–1559) and Chu Yün-ming (1461–1527). Thus, in his late thirties Tung had already set himself apart from recent history and declared his engagement with high antiquity, much as Chao Meng-fu sought to do in the Yüan period. As in his many copies of ancient works of calligraphy, Tung in these commentaries confirms their unequivocal primacy.

From the time of this scroll, Tung would embark on an intense search for the works that would validate his key aesthetic notions, continuing a process begun during the previous decade and one that would reach fruition by the first decade of the 1600s, when he was in his late forties and early fifties.

MWG

Literature: *Hua-ch'an shih sui-pi*, sections 1 and 2, pp. 1–5; *Shih-ch'ü pao-chi hsü-pien*, completed 1793, facsim. of ms. copy 1971, pp. 439–41; Xu Bangda, *Pien-nien-piao*, 1963, p. 95; *Chung-kuo ku-tai shu-hua mu-lu*, vol. 2, 1985, *Ching* 1–2145; Ren Daobin, *Hsi-nien*, 1988, pp. 30–31, 112–13; Zheng Wei, *Nien-p'u*, 1989, pp. 24, 76–77.

2 *Eight Views of Yen and Wu*
Yen Wu pa-ching
董其昌　燕吳八景

Dated 1596

Album of eight paintings, ink and ink and color on silk
26.1 x 24.8 cm (10¼ x 9¾ in.)

Shanghai Museum

vol. 1, pl. 2 (leaves 1–8); vol. 2, pl. 2 (colophon)

Artist's inscriptions and signatures:
Leaf 1, 7 lines in running-regular script:
"Awaiting the Moon in the Boat Studio"

《舫齋候月》

When I lived in Ch'ang-an [Peking] I had a small studio shaped like a boat. T'ang Yüan-cheng [T'ang Wen-hsien, 1549–1605] named it the "Boat Studio." Very often I would go to the studio with Yen-lü [Yang Chi-li, 1553–1604] to contemplate the changing colors in the morning and at dusk over the West Mountains. We also enjoyed drinking and composing poetry together. Late at night I lit another candle and recorded this in a painting. Tung Hsüan-tsai.

余旅長安有小齋似舫子，唐元微題爲"舫齋。"時同彥履過齋中，望西山朝暮之色，亦復對酒賦詩，夜闌更燭，因圖以記之。董玄宰。

Leaf 2, 1 line in regular script:
"The Evening Mist of the West Mountains"

《西山暮靄》

Leaf 3, 4 lines in regular script:
"The Lotus Society at West Lake"

《西湖蓮社》

West Lake is located on the way to the West Mountains. [The dike in the lake] closely resembles the Su Tung-p'o Causeway [in the West Lake] in Wu-lin [Hang-chou]. That is how it acquired its name.

西湖在西山道中，絕類武林蘇公堤，故名。

Leaf 4, 1 line in regular script:
"The Autumn Colors of the West Mountains"

《西山秋色》

Leaf 5, 1 line in regular script:
"Clearing after Snow on the West Mountains"

《西山雪霽》

In the manner of Chang Seng-yu [fl. early 6th century].
倣張僧繇。

Leaf 6, 4 lines in running-regular script:
"Invitation to Reclusion from Nine Peaks"

《九峰招隱》

Ch'en Tao-ch'un [Ch'en Chi-ju, 1558–1639] lives deep in the Nine Peaks. He continues the noble and refined [mode of life] of the Lofty Three [*Wu-chung san-kao*; the Three Lofty Recluses of Wu]. Upon his return, Yen-lü should go visit him [Ch'en]. This painting will serve as a reminder. Tung Hsüan-tsai.

陳道醇居九峰深處，續三高之勝韻。彥履歸當訪之，此圖所以志也。董玄宰。

Leaf 7, 4 lines in running-regular script:
"Old Neighborhood South of Town"

《城南舊社》

The garden at Lung-men [li] where Yen-lü lives is separated from Feng Hsien-fu's [Feng Ta-shou, *chin-shih* 1526] "three paths" [old homestead for retirement] by just a stretch of water. Hsüan-tsai.

彥履所居龍門園，與馮咸甫三徑只隔一水。玄宰。

Leaf 8, 5 lines in running-regular script:
"Misty Sails under the Red Cliff"

《赤壁雲帆》

[The site that bears this name] at Mount Heng-yün [in Sung-chiang] is known as the Small Red Cliff. To the right are the *Eight Views of Yen and Wu*, painted in the brush manner of Sung masters as a send-off for Yang Yen-lü. The fourth month, summer, of the *ping-shen* year [April 27–May 26, 1596]. Tung Hsüan-tsai.

在橫雲山爲小赤壁。右《燕吳八景》倣宋人筆意，送楊彥履。歲在丙申夏四月。董玄宰。

Artist's seals:
Tung Ch'i-ch'ang yin 董其昌印 (*pai-wen*, square; leaves 1, 2, 4, 5) **2**
T'ai-shih shih 太史氏 (*chu-wen*, rectangle; leaves 3, 7, colophon) **3**
Hua-ch'an 畫禪 (*chu-wen*, rectangle; leaf 6) **4**

Tung Ch'i-ch'ang yin 董其昌印 (*chu-wen*, square; leaf 6) 5
Tung Ch'i-ch'ang yin 董其昌印 (*pai-wen*, square; leaf 8) 6
□-□ *t'ang* □□堂 (*pai-wen*, half-seal; colophon) 7
Tung Ch'i-ch'ang yin 董其昌印 (*chu-wen*, square; colophon) 8

ARTIST´S COLOPHON (29 lines in running-cursive script):
As I have often said, a painter holds two critical keys to his art: he must learn first from the ancient masters, then from nature. Wang Wei [701–761], the two Lis [Li Ssu-hsün, fl. ca. 705–20, and Li Chao-tao, fl. mid-8th century], Ching [Hao, ca. 870–80–ca. 935–40], Kuan [T'ung, fl. ca. 907–23], Tung [Yüan, fl. ca. 945–ca. 960], Chü[-jan, fl. ca. 960–ca. 986], Ying-ch'iu [Li Ch'eng, 916–967], and Lung-mien [Li Kung-lin, ca. 1049–1106] all possessed these two qualities, and their works became the supreme masterpieces of all time. If a painter, through constant copying and imitation, has achieved perfection in skill, yet failed to fully comprehend the wonders of nature, then his work shall remain "the writing of a slave-scribe," unworthy to be handed down to posterity. When we say one should learn from the ancients [or should imitate the ancients], it implies that one has not surpassed the ancients and that one is less than an equal of the ancients. Those whose insight equals that of their teacher can at best claim one-half the achievements of their teacher. Only those whose insight surpasses that of their teacher are worthy students for receiving instruction. And since to learn from Nature is the only way to surpass the ancients, it is the way that may be called the *true* learning from the ancients. I have always had an obsession with painting. In recent years, on seeing the works of old masters like Ching [Hao] and Kuan [T'ung], I have always taken pains to imitate them, but felt that I hardly succeeded in anything beyond superficial similitude. Now, with mist and clouds in possession of my dreams, while time is slipping away from my fingers, I have decided that it is time to renew my pledge to [retirement at] my old homestead and devote myself to the joy of literature and art. I shall visit famous mountains as often as I please, and, alternatively, make myself at ease and comfortable at home. From time to time I shall have a pageboy follow me with a gourd of wine and a few painting brushes, and we shall lose ourselves in the constant changes of morning mists and evening clouds among the sunny peaks and shady valleys. Whenever I see something that strikes a harmonious chord in my heart, I shall make sketches of it. The idea is to conceptualize [the image] without any pretension for realistic form-likeness. If I practice this long enough, I should be able to subject all phenomena in nature to my will and to completely fuse and integrate [Hsieh Ho's, fl. 500–535] Six Laws [of painting]. This album was painted for Yang Yen-lü in the third month of the *ping-shen* year [March 29–April 26, 1596] and is now in the possession of Mr. Kuo Hsi-so. On re-examining it, I cannot help feeling that I have never outpaced the footsteps of the old masters. Someday when I become accomplished in the art of painting, I shall make a few pictures in exchange for this album as a token of my remorse. For even I dare not admit that this is the end of my ability. Tung Ch'i-ch'ang wrote in the Mo-ch'an Studio in Ch'ang-an [Peking].
(Translation of inscriptions and colophon by Wai-kam Ho.)

予嘗論畫家有二關竅：始當以古人爲師；後當以造物爲師。王維、二李、荊、關、董、巨、營丘、龍眠皆具此二美，遂爲千古絕調。若臨撫不輟，工力無餘恨，而造物不完，但如奴書，何足齒，減師半德；見過於師，方堪傳授。惟以造物爲師，才能過古人，謂之"真師古"不虛耳。予素有畫癖，年來見荊、關諸家之跡，多苦心倣之，自覺所得僅在形骸之外。煙霞結夢，歲月不居，已有故園之盟，頗鍾翰秋之趣，將飽參名嶽，偃息家山。時令奚奴以一瓢酒，數枝筆，相從於朝嵐夕靄，晴峯陰壑之變。有會心處，一一描寫，但以意取，不問真似。如此久之，可以驅役萬象，鎔冶六法矣！此冊爲予丙申三月所贈楊彥履者，今歸希所

郭先生。重一展之，總不脫前人蹊逕。俟異時畫道成，當作數圖易去，以當懺悔，即予亦未敢自謂技窮此耳。董其昌書于長安墨禪室中。

COLLECTORS´ SEALS: Miao Yüeh-tsao 繆日藻 (1682–1761), 3; unidentified, 2

RECENT PROVENANCE: Hong Yilan

LITERATURE: *Chung-kuo ku-tai shu-hua mu-lu*, vol. 3, 1987, *Hu* 1–1338; Zheng Wei, *Nien-p'u*, 1989, pp. 28–29; *Chung-kuo ku-tai shu-hua t'u-mu*, vol. 3, 1990, *Hu* 1–1338.

3 *Wan-luan Thatched Hall*

Wan-luan ts'ao-t'ang t'u
董其昌　婉孌草堂圖

Dated 1597

Hanging scroll, ink on paper
111.3 x 36.8 cm (43¹³⁄₁₆ x 14½ in.)

Private Collection

vol. 1, pl. 3

ARTIST´S INSCRIPTIONS AND SIGNATURES:
1. 4 lines in running script:
Wan-luan Thatched Hall. In the tenth month of the *ting-yu* year [November 9–December 8, 1597], when I came back from west of the river [i.e. Kiangsi], I visited Chung-ch'un [Ch'en Chi-ju, 1558–1639] in his study at K'un-shan and painted this for him as a farewell gift. Tung Ch'i-ch'ang.

《婉孌草堂圖》。丁酉十月，余自江右還，訪仲醇於崑山讀書臺，寫此爲別。董其昌。

2. 5 lines in running script:
On the day of winter solstice of this year [1597], Chung-ch'un brought [this painting] to my studio to ask me to add some color. I had just acquired Li Ying-ch'iu's [Li Ch'eng, 919–967] blue and green [landscape] *Buddhist Temple in Misty Mountain Peaks* and Kuo He-yang's [Kuo Hsi, ca. 1020–ca. 1100] handscroll *Streams and Mountains on a Clearing Autumn Day*. We mutually cried out and sighed in admiration [of these paintings] until the end of the day. Ch'i-ch'ang inscribed.

是歲長至日，仲醇携過齋頭設色。適得李營丘青綠《煙巒蕭寺圖》及郭河陽《谿山秋霽》卷。互相咄咄，歎賞永日。其昌記。

3. 3 lines in regular script:
Because of looking at the paintings by Li [Ch'eng] and Kuo [Hsi], I had no leisure to apply color to my painting. Mi Yüan-chang [Mi Fu, 1051–1107] said that facing T'ang Wen-huang's [Emperor T'ai-tsung; r. 627–49] surviving work takes one's breath away—an excellent thought! Hsüan-tsai again inscribed this.

以觀李、郭畫，不復眼設色。米元章云，對唐文皇跡，令人氣奪，良然。玄宰又記。

NO ARTIST´S SEALS

INSCRIPTIONS: Ch'ing Kao-tsung 清高宗 (r. 1736–95), 14 dated 1754, 1755, 1758, 1760, 1763 (2), 1764, 1766, 1770, 1772, 1774, 1789, 1791, 1794–95, 2 undated; 26 seals

COLOPHONS: Ch'ing Kao-tsung, 6 dated 1769, 1775, 1782, 1785, 1787, 1797; 12 seals

COLLECTORS' SEALS: Wang Hung-hsü 王鴻緒 (1645–1723), 1; Ch'ing Kao-tsung, 11; Ch'ing Jen-tsung 清仁宗 (r. 1796–1820), 3; unidentified, 1

RECENT PROVENANCE: Wang Han-hang

As one of a handful of surviving paintings by Tung Ch'i-ch'ang dating to the late 1590s, the *Wan-luan Thatched Hall* is a key document for understanding Tung's approaches to painting at the beginning of his career. The uncompromisingly harsh and seemingly arbitrary treatment of forms and arrangement of motifs is immediately striking, an effect only exaggerated by the later, heavy-handed encroachments of the Ch'ien-lung emperor's multiple inscriptions. Even with those textual additions disregarded, the sudden cessation of the cliff at upper right, the subversions of surface continuity through effects of erasure by reserve areas of cloud, bank, and highlight, and a broad unconcern with consistent ground planes all convey an air of willful invention. The oddness of such devices of denial is increased by their juxtaposition with signs of emphatic presence: deeply shaded ridges enlivened by heavy concentrations of texturing dots and strokes, and the nearly sculptured press of furrowed and folded forms. The visual contradictions are paralleled in the air of irresolution surrounding the project, as recorded in Tung Ch'i-chang's inscriptions: a parting gift painted for Ch'en Chi-ju is later returned to the artist for modification, but the requested changes are never made because of a distracting encounter with early landscape paintings of Li Ch'eng and Kuo Hsi.

It is tempting to attribute the visual and structural peculiarities of the *Wan-luan Thatched Hall* to an emulation of early paintings, but the evidence points in a number of directions. The deep shading of repeated rounded forms, ropy texture strokes, and heavy dotting in the *Wan-luan Thatched Hall* suggest the tenth-century painter Tung Yüan (fl. ca. 945–ca. 960) as a likely source, and the fact that Tung Ch'i-ch'ang had a few months earlier acquired and inscribed the *Hsiao and Hsiang Rivers* (*Hsiao-Hsiang t'u*; vol. 1, fig. 2) handscroll attributed to Tung Yüan makes such a connection even more plausible. Specific compositional links between the two paintings are not strongly evident, however. The possibility that the works attributed to Li Ch'eng and Kuo Hsi that so excited Tung's interest may have shaped alterations to the *Wan-luan Thatched Hall* should not be discounted, since the painting manifests a certain air of additive construction. Although Tung Ch'i-ch'ang's album *Eight Views of Yen and Wu* (vol. 1, pl. 2) from the previous year seems in general a much more straightforward rendering of Sung styles, several leaves, including the leaf entitled "The Autumn Colors of the West Mountains" and the dedicated and dated leaf (vol. 1, pls. 2–4, 2–8), manifest the deep shading and steeply piled, willfully shaped forms seen in the *Wan-luan Thatched Hall*. The stark erasure of the cliffs at upper right by clouds foreshadows a prominent device in the handscroll *Misty River and Piled Peaks* (*Yen-chiang tieh-chang t'u*; vol. 1, fig. 26) of circa 1604–5, after the late Northern Sung painter Wang Shen (1036–after 1099), while such forms as the composite rounded bluff and surmounting flat-topped butte are strikingly similar to those found in a leaf of the *Landscapes in the Manner of Old Masters* of 1621–24 (vol. 1, pl. 42–10) that follows Lu Hung (fl. first half of the 8th century) and Li Kung-lin (ca. 1049–1106).

Rather than searching for a specific motivating source, then, it may be more relevant to consider the *Wan-luan Thatched Hall* as a diagram of Tung Ch'i-ch'ang's personal and pictorial encounters, reflecting a strenuous and dynamic process of scanning old paintings for indications of early structures. That process was liable to interruption—again both personal and pictorial—as is amply documented in this work, which in some important ways is a record of erasure and refusal: failure to add the requested color; distraction by newly acquired old paintings; contact followed by absence, as the artist met and left both friends and paintings. Those underlying conditions of impermanence may have fundamentally shaped Tung's activities as art-historical theorist and painter at this time—activities that are marked by qualities of willful exaggeration and overstatement as Tung sought to fix structural relationships in memorable form, however arbitrary they might appear. In cases such as this, it is evident that painting does not represent a viewing of nature, but rather the nature of reconstructive viewing.

RV

LITERATURE: Ku Fu, *P'ing-sheng ch'uang-kuan*, pref. 1692, repr. 1962, vol. 4, p. 115; An Ch'i, *Mo-yüan hui-kuan*, pref. dated 1742, repr. 1909, vol. 3, pp. 88–89; Hu Ching, *Hsi-ch'ing cha-chi*, 1816, vol. 1, p. 8; Li Pao-hsün, *Wu-i-yu-i chai lun-hua shih*, 1909, vol. 2, p. 12; Sirén, *Leading Masters and Principles*, 1956–58, vol. 5, p. 7, vol. 7, p. 246; Wu, "Apathy in Government and Fervor in Art," 1962, pl. 1; *Shih-ch'ü pao-chi san-pien*, completed 1816, repr. 1969, pp. 2067–70; Wu, "The Evolution of Tung Ch'i-ch'ang's Landscape Style," 1972, pp. 4–5, pl. 5; Fu, "A Study of the Authorship of the 'Hua-shuo,'" 1972, pp. 93–94, fig. 6; Kohara, Wu, et al., *Jo I, To Kisho*, 1978, pl. 37, pp. 67, 169–70; Kohara, *To Kisho no shoga*, 1981, pp. 232–34, pl. 1; *Tung Ch'i-ch'ang hua-chi*, 1989, app. pl. 66.

4 *Landscape after Kuo Chung-shu*
Lin Kuo Shu-hsien shan-shui
董其昌　臨郭恕先山水

Undated (ca. 1598–99; inscription dated 1603)

Handscroll, ink on silk
24.5 x 140.4 cm (9⅝ x 55¼ in.)

Östasiatiska Museet, Stockholm NMOK 539

vol. 1, pl. 4; vol. 2, pl. 4

ARTIST'S INSCRIPTIONS AND SIGNATURES:
1. 4 lines in running-regular script:
This is a copy of a Kuo Shu-hsien [Kuo Chung-shu, d. 977] study-sketch, done when I was at the Yüan-hsi Thatched Hall in Ch'ang-an [Peking]. I regret not having applied color and dotted together the small trees, but the arrangement is very similar to that of the original work. In the spring of the *kuei-mao* year [1603]. Hsüan-tsai.

此余在長安苑西草堂，所臨郭恕先畫粉本也。恨未設色與點綴小樹，然布置與真本相似。癸卯春，玄宰。

2. 7 lines in running-regular script:
In the autumn of this year I took my son with me to Pai-men [Nanking] on examination business. On the boat on the Great River, I thereupon

picked up the brush and consequently was able to finish this. But because the genuine work wasn't on the boat, I fear I wasn't able to achieve a likeness. On the second day of the ninth month [October 6, 1603], Hsüan-tsai again inscribed.

是歲秋攜兒子以試事至白門。大江舟中旋屬拈筆，遂能竟之。以真本不在舟中，恐未能肖似耳。九月二日，玄宰重題。

ARTIST'S TRANSCRIPTION AND INSCRIPTION (A passage from the *Shu-p'u* by Sun Kuo-t'ing [fl. late 7th century], and inscription; 23 lines in running script, following the painting):

When [Wang Hsi-chih, 303–379] wrote *The Eulogy of Yüeh I*, his feelings were melancholy; when he penned *The Poem Praising [Tung-fang Shuo's] Portrait*, his mind was dwelling on unusual matters; in *The Yellow Court Classic*, he reveled in vacuity; in *The Exhortations of the Imperial Tutor*, he twisted and turned with the conflicting views; in writing about the happy gathering at Lan-t'ing, his thoughts roamed and his spirit soared; in *The Official Notification*, his feelings were sad. This is what is meant by "When dealing with pleasure one laughs, when writing of sorrow one sighs." He need not (like Po Ya) rest his thoughts to create the slow rhythm of flowing waves; he need not (like Ts'ao P'i) let his spirit glide over colorful streams to think up colorful writing. Though he could clarify a matter at first glance, still his mind sometimes went astray and he made mistakes. Everybody assigns different names to the different styles [of writing], and people force labels on different schools. They do not know that as emotions stir so words are shaped—that is how one can understand *The Classic of Songs* and *The Songs of Ch'u*; they do not know that the associations of brightness with joy and of darkness with sorrow are rooted in the basic nature of Heaven and Earth.

The above is from Sun Ch'ien-li's [Sun Kuo-t'ing] *Shu-p'u*. (Translation by Hans H. Frankel and Chang Ch'ung-ho.)

寫《樂毅》則情多怫鬱；書《畫讚》則意涉瓌奇；《黃庭經》則怡懌虛無；《太師箴》則又縱橫曲折。蘭亭興集，思逸神超。私門告誓，情拘意慘。所謂"涉樂方笑，言哀已歎。"豈惟注想流波，將貽嘽嗳之奏，馳神渙，方思藻繪之文。雖其目擊道存，尚或心迷議舛。莫不強名爲體，共習分區。豈知情動形言，取會《風》《騷》之意。陽舒陰慘，本乎天地之心。

右孫虔禮《書譜》。

Master Tung-p'o [Su Shih, 1036–1101] studied the *Lan-t'ing* calligraphy in his youth. Therefore the bearing of his writing was seductive. It's similar to Hsü Chi-hai [Hsü Hao, 703–782]. When intoxicated with drink, he seemed to forget [the distinctions between] skill and clumsiness, and his characters maintained a lean vigor. And [it is] like Liu Ch'eng-hsüan [Liu Kung-ch'üan, 778–865]. His brush became round and of superior resonance, embracing the greatest wonders of literary accomplishment beneath heaven and the moral power of loyalty and righteousness that outshines the sun and moon. Tung Ch'i-ch'ang wrote this at the Pao-ting Studio.

東坡先生少日學《蘭亭》。故其書姿媚，似徐季海。至酒酣，意忘工拙，字特瘦勁。乃似柳誠懸，筆圓而韻勝。挾以文章妙天下，忠義冠日月之氣。董其昌書于寶鼎齋。

ARTIST'S SEALS:
Hsüan-shang chai 玄賞齋 (*pai-wen*, tall rectangle) **22**
Tung Ch'i-ch'ang yin 董其昌印 (*pai-wen*, square) **43**
T'ai-shih shih 太史氏 (*pai-wen*, square) **44**

NO COLOPHONS OR COLLECTORS' SEALS

Landscape after Kuo Chung-shu is one of the prime surviving documents of Tung Ch'i-ch'ang's early painting style and art-historical

interests. The handscroll was begun during Tung's early period of activity in Peking, and therefore not later than 1599, and inscribed after some alterations in 1603. Tung began painting as early as 1577, but of his major surviving works, only the *Eight Views of Yen and Wu* of 1596 (vol. I, pl. 2) and the *Wan-luan Thatched Hall* of 1597 (vol. I, pl. 3) are known to be earlier works.

The Stockholm handscroll maintains for much of its length a consistency in scale and in ground-plane relationships along deep river views into the distance, and the brushwork overall is careful and unassertive, as if reflecting a respectful attitude toward the model. Like the earlier and somewhat tentative *Eight Views of Yen and Wu*, the Stockholm scroll strives to capture the visual and spatial qualities of early paintings, while at the same time embracing oddities of form and organization that are turned to productive effect and foreshadow some of the most distinctive formulations of Tung Ch'i-ch'ang's later painting career. These include the tilted jutting of plateaus and composite boulder-and-plateau forms just after the opening of the scroll, and the dynamic rightward flowing momentum of the serial ridges that pulse from foreground into middle distance at several points. The molding of boulders and bluffs by internal surges, so that they seem folded back upon themselves, and the abrupt surrounding of forms with contrasting light bands, in a kind of reverse shading seen notably in the dark rectangular series of bluffs toward the end of the scroll, are other devices that become nearly signature passages in Tung's later works. Many of these devices can be seen in the two versions of *Misty River and Piled Peaks* (ca. 1604–5, vol. I, fig. 26; 1605, vol., I, pl. 7) but in an outspokenly diagrammatic and thereby more striking treatment.

The circumstances surrounding the creation of the Stockholm scroll suggest that it might be viewed as a filter or template for the work that lay behind it, as well as, perhaps, a still earlier work that was the source for its model. The subject of the *fen-pen* (study-sketch) by the tenth-century master Kuo Chung-shu that Tung copied is not specified in his inscription, but in a text dated 1595 Tung linked Kuo Chung-shu with a *fen-pen* version of the *Wang-ch'uan Villa* composition of Wang Wei (701–761), and on two occasions around 1596 he saw a Kuo Chung-shu copy of the *Wang-ch'uan Villa* (Zheng Wei, *Nien-p'u*, 1989, pp. 27, 29; see also vol. I, fig. 36). At the time, Tung was preoccupied with reconstructing Wang Wei's style through a variety of attributions and copies, and he expressed doubts about the adequacy of such material for verifying the T'ang master's painting methods. It is therefore not surprising that the Stockholm scroll conveys few of the qualities that we can hypothetically reconstruct of the Wang Wei pictorial tradition; Tung's model, nonetheless, may have signified something of Wang Wei to him, a filter that he scanned eagerly for traces of the ancestral homeland of literati painting and to which he added elements of his earlier investigations and reconstructions. Indeed the compressed recessions along diagonal ridges, the thin, sinuous brushlines, and the rhythmic shell-like folding of rocks in the Stockholm scroll recall qualities of various works attributed to Wang Wei that were known to Tung Ch'i-ch'ang; and the sudden upward shift in ground plane after the opening passage also recalls the abrupt transitions found in painted and engraved designs attributed to the T'ang period (cf. Cahill, *Distant Mountains*, 1982, pls. 36, 37). Other elements in the scroll, such as the white-banded rectangular bluffs, are similar to passages in Chao Meng-fu's (1254–1322) *Misty*

River and Piled Peaks handscroll inscribed by Tung's older friend Mo Shih-lung (1537–1587) in 1577, through which Tung may have glimpsed the Northern Sung style of Wang Shen (1036–after 1099), the identified model for his own later renderings of the subject (Suzuki, *Chugoku kaigashi*, 1981, vol. 1, pt. 2, pl. 122).

It is tempting for modern viewers of the *Landscape after Kuo Chung-shu* to try to duplicate Tung's archaeological process of scanning old paintings for traces of their multiple sources, but in so doing it is easy to look past or through the extant painting. We should also consider the implications of the process of formation for the conceptual status of the Stockholm scroll. The painting was an outgrowth of Tung's pursuit of an ancient style, approached through an intermediary work, and the product of a mixed process of direct copying and memory-image reconstruction and modification over a span of several years. We could read those complex conditions as the result of a more or less accidental and unique circumstance of access to old paintings, but they are largely repeated in many of Tung's most important works (cf. vol. 1, pl. 42). These implicated conditions of Tung's artistic production suggest an underlying status of painting as a hybrid field of pictorial encounter and historical-conceptual discourse.

RV

LITERATURE: Sirén, *Leading Masters and Principles*, 1956–58, vol. 5, p. 6, vol. 6, pl. 262; Wu, "Apathy in Government and Fervor in Art," 1962, pl. 2; Fu, "A Study of the Authorship of the 'Hua-shuo,'" 1972, p. 102, fig. 5 (detail); Wu, "The Evolution of Tung Ch'i-ch'ang's Landscape Style," 1972, pp. 18–22, 26–28, pl. 4; Kohara, Wu, et al., *Jo I, To Ki-sho*, 1978, pp. 166–67, pl. 19; Kohara, *To Kisho no shoga*, 1981, pp. 236–37, pl. 5; Cahill, *Distant Mountains*, 1982, pp. 91–92, pl. 35; Suzuki, *Comprehensive Illustrated Catalogue*, 1982–83, vol. 2, E20–074; *Tung Ch'i-ch'ang hua-chi*, 1989, app. pl. 126.

5 *Calligraphy in Running and Cursive Scripts*

Hsing-ts'ao-shu

董其昌　行草書

Dated 1603

Handscroll, ink on paper

31.1 x 631.3 cm (12¼ x 248⁹⁄₁₆ in.)

Tokyo National Museum TB-1397

vol. 1, pl. 5 (detail); vol. 2, pl. 5

ARTIST'S TITLES:

1. 1 line in running script, preceding two poems, one of 4 lines and one of 5 lines:
"Ode to Lohan"

《羅漢贊》

2. 1 line in running script, preceding a poem of 5 lines:
"Ode to the Founding Patriarchs"

《初祖贊》

3. 1 line in running script, preceding a poem of 5 lines in five-character regulated meter:

"Seeing off a Monk Traveling to Mount Wu-t'ai"

《送僧遊五臺》

4. 1 line in running script, preceding a poem of 6 lines:
"Seeing off a Monk to Ox Mountain and Chicken's Foot"

《送僧之牛山鷄足》

ARTIST'S TRANSCRIPTION (five prose sections on Ch'an Buddhism and calligraphy, in running script):

1. "The living are narrow-minded and inferior . . ." (*Chung-sheng hsia-lueh*) in 6 lines.

2. "I once experienced a state of perfect contemplation . . ." (*Wu ch'ang ju-ting*) in 15 lines.

3. "Composing the mind . . ." (*San mei chieh-tso*) in 8 lines.

4. "Undergoing hardship . . ." (*K'u hsing wei-chih hsiu-fu*) in 11 lines.

5. "What the ancients regard as an inspired work . . ." (*Ku-jen suo-wei shen-p'in*) in 8 lines:

What the ancients regard as an inspired work refers to a spirit which in our generation we say works in divine harmony with the universe. The precepts found in *On Preserving One's Vital Energy and Spirit* by the [Han adept] Liu An [ca. 178–122 B.C.; in his classic, the *Huai-nan-tzu*] discuss this. Tung-p'o [Su Shih, 1036–1101] and Chao Wu-hsing [Chao Meng-fu, 1254–1322] had calligraphy carved in stone which, when buried, emitted a supernatural glow. The calligraphy of those two gentlemen was not that lofty, but they were still able to accomplish that. The divine element in their art cannot be destroyed.

古人所謂神品，此神即吾輩之神，與天地轉運。劉安《精神訓》具之矣。東坡、趙吳興有書石，埋處皆放光。二公書不甚高，所以能爾者，其神用處，不可磨也。

ARTIST'S INSCRIPTIONS AND SIGNATURE:

1. 6 lines in small running script, inserted after the preceding prose sections:
Han Tsung-po [Han Shih-neng, 1528–1598] once told me that when Chao Wu-hsing's stele of calligraphy was placed several feet underground and then removed, the supernatural glow disappeared [from the location]. There was also the stone carving of the *Pao-mu* [epitaph] of Tung-p'o in Wang Hsing-fu's collection: they were able to find its location [in the ground] because of the light it emitted. In the T'ang dynasty Hsü Hao's [703–782] calligraphy emitted such a glow, and the event entered the [literary anthology *T'ang*] *Wen-ts'ui*. Actually, Hao's calligraphy was slightly inferior to Yü's [Shih-nan, 558–638] and Ch'u's [Sui-liang, 596–658].

韓宗伯曾爲余言，趙吳興一石，入地數尺，取之，遂不見光。又王行甫有東坡《保母》石刻，每放光，因跡而出之。唐人有徐浩書放光，事見《文粹》。浩書比虞、褚小劣，猶爾。

2. 22 lines in large "wild" cursive script:
In the third month of the *kuei-mao* year [April 11–May 10, 1603], I was in Su-chou at the Cloud Shadow Mountain Studio. Outside my window it was raining and I had nothing to do. My friends Fan Erh-fu, Wang Po-ming, and Chao Man-sheng dropped by to visit. We sampled some Tiger Hill tea and ground [some fresh] Korean ink. Then I tried out a new brush, writing with abandon and all quite at random. Tung Ch'i-ch'ang.

癸卯參月，在蘇之雲隱山房，雨窗無事。范爾孚、王伯明、趙滿生同過訪。試虎丘茶，磨高麗墨，並試筆亂書，都無倫次。董其昌。

ARTIST'S SEALS:

Hsüan-shang chai 玄賞齋 (*pai-wen*, rectangle) 9

Chih chih-kao jih-chiang kuan 知制語日講官 (*pai-wen*, rectangle) 10

Tung-shih Hsüan-tsai 董氏玄宰 (*pai-wen*, square) 11

No colophons

Collector's seals: Takashima Kikujiro 高島菊次郎 (20th century), 2

Recent provenance: Takashima Kikujiro

Congenial company combined with rainy weather, a sampling of Tiger Hill tea, some fresh Korean ink, and a new brush set the stage for a work which, with its early date of 1603, is a testament to Tung Ch'i-ch'ang's stature as a calligrapher and artist. The first half of the scroll is written in a modest but elegant running script of the type associated with Tung's personal style and which he used often in his inscriptions to paintings. The ink appears rich and moist, the arrangement of the columns spacious, the structure of individual characters poised and tilting to the right—all features that Tung consciously advocated (see cat. no. 1). Six lines inserted at the end of this section comprise an afterthought—a discussion of the power of certain old stelae "to emit a supernatural light"—and add an interesting compositional variation to the even columnar spacing, forming an appropriate and spontaneous postscript.

In the second half of the scroll, however, with the artist's inscription beginning with the cyclical date *kuei-mao*, something quite remarkable happens: it is as if everything about the moment coalesced to invigorate Tung with a liberating force. He literally breaks out of the daily script to which we are accustomed and treats us to an extraordinary display of *k'uang-ts'ao* 狂草, the "wild," or free, cursive associated with eighth-century masters. Generally, an artist's inscription contains mundane facts of the date, place, and personages surrounding the work at hand. Here, Tung has used it as a vehicle for pure artistic expression. The pitch of supreme artistic pleasure which this portion of the scroll embodies can be read immediately in the abrupt change of script size and type—instead of the smaller script with even-sized characters trooping down nine or ten to a vertical column, exuberant oversized forms take over in the most abbreviated of the scripts. Tung attacks the paper decisively, his brush tip perfectly centered to create the dots or horizontals that begin each character in a column. Then, the brush swoops down or soars upward, sideways, or in circles to complete the form. The ink dynamics emphasize the rhythmic pulse Tung sets up when he recharges his brush at the opening of each line and lets it run dry naturally down the course of the column, only to re-ink it again.

The insistent pulse of the first half of the scroll gives way to open rhythms of two or three characters per column, with the tension reaching a climax in four places where only one character occupies the full height of the scroll: *shih* 事, *mo* 磨, *luan* 亂, *tz'u* 次. This scroll is one of Tung Ch'i-ch'ang's earliest performances in *k'uang-ts'ao*: it places him on a par with the great cursive masters of the past and leaves the viewer breathless.

A closer analysis of the cursive section shows that Tung began to connect characters by the second, third, and fourth lines (*san-yüeh* 参月, *Su chih* 蘇之, *yün-yin* 雲隱). In the fifth line, he writes the word "studio" (*fang* 房) with a bold angularity that suggests a Calder sculpture. (It might be added that the grammatical punctuation of the inscription has little or no bearing on how the lines break.) Tung ends his first thought ("rainy window, nothing to do" *yü-ch'uang wu-shih* 雨窗無事; lines five through seven) by leaving one highly abbre-

viated character, *shih*, all to itself in one columnar space (line seven). He then picks up the momentum with the names of his three friends, each with three characters occupying one column, and then, by the eleventh line, breaks loose again to connect three characters (*t'ung kuo fang* 同過訪 "dropped by to visit"). In the meantime, the characters have become progressively larger and freer, the entire effect of the inscription lighter and more airborne, so that by lines twelve and thirteen ("sample some Tiger Hill tea" *shih Hu-ch'iu ch'a* 試虎丘茶), there are but two characters to a line. The momentum expands outward from the center of each character, giving the forms a tangled look but without the strokes ever touching.

With the phrase "grind Korean ink" (*mo Kao-li mo* 磨高麗墨; lines fourteen through sixteen), the scroll reaches its first climax: to write the character "to grind" (*mo*), Tung re-inks his brush (as he has done at the beginning of each line), and with one substantive backslanting dot, he draws a broad, wide horizontal across the paper—the increasing pitch registering in the ever paler and ever drier ink, linking all the remaining fifteen strokes of the character together in one fell swoop of verticals and horizontals. With the following two characters, *Kao-li* (Korean), the same dot and horizontal pattern begins the next line, but he has decided to link the two characters following *mo* (ink) in the next line, so that the forms echo the preceding large one in a slightly more complex pattern. After *mo*, in the same line sixteen, Tung begins a new phrase with *ping* 并; therefore, he leaves a space, as if taking a breath before the next four characters, which form another phrase: *shih-pi luan-shu* 試筆亂書. The two characters *shih-pi* ("try out a new brush," line seventeen) are again linked together. Then, after once again recharging the brush, he attacks the paper with two opposing dots leading into the highly abbreviated form for *luan* ("with abandon," line eighteen), letting the one character again fill the entire columnar space in a few sweeping lines to reveal the texture of the paper, before completing the phrase with *shu* (writing) in the next line. The size and energy of *luan* charges the character with additional meaning and gives the total composition the impact of another crescendo. The final phrase, "all quite at random" (*tou wu lun-tz'u* 都無倫次; lines nineteen through twenty-one), commences again with a breathing space after the preceding *shu* and links the following two characters, *wu lun*, but leaves the last character, *tz'u*, to itself: it commences with a downward facing dot connected to a hairline ligature, with the brush barely lifted as it swoops upward only to descend with a graceful slight pulsation before Tung lifts it completely. Finally, he re-inks the brush for the last time and adds his full signature in three characters.

An actual shorthand and early form of simplified script which eliminates strokes and dots, *ts'ao-shu* 草書, from which *k'uang-ts'ao* is derived, is not readily legible except to those who have learned it as a kind of code. Historically, cursive script dates back to the second and third centuries, when it was called *chang-ts'ao* 章草 (draft cursive). In *chang-ts'ao*, the forms were abbreviated and strokes eliminated, but each character stood separate without linkages between them. In addition, the brushwork consisted of brief wavelike strokes with a tapering "head" (or opening) and "tail" (or closing) movement. This script evolved at the same time as *li-shu* 隸書 (clerical or chancery script), in the early Han period, and the two scripts shared a number of technical features, in particular, a brief twisting movement of the wrist

which produced a wavelike brushstroke. The depth of Tung Ch'i-ch'ang's study of ancient works can be measured by the fact that one of his earliest dated works is a copy in *chang-ts'ao* of a work by Wang Hsien-chih (344–388), dated 1591 (vol. 1, fig. 51).

In this 1603 scroll Tung employs the cursive script developed in the T'ang period by Chang Hsü (fl. second half of the 8th century), who is credited with the ability to use the script to express a spectrum of emotions—hence the nomenclature *k'uang-ts'ao*, "wild" or "delirious" cursive. Tung's true inspiration, however, is Chang's pupil Huai-su (fl. late 8th century) and his *Tzu-hsü t'ieh* (*Autobiography*; vol. 1, fig. 56), a scroll dated 777, which Tung had the chance to study when it was in the collection of Hsiang Yüan-pien (1525–1590). In this work, several outstanding features may be noted: (1) Huai-su's composition (*chang-fa* 章法) displays characters of open form and varied size which break out of the columnar space and create a tangled effect; (2) the brushwork is relatively even in thickness, drawn predominantly with a brush held upright and with a strongly centered tip, which permits the calligrapher to create linear strokes with a rounded, almost three-dimensional effect; only occasionally does the brush bear down to make broad, flat, sometimes textured strokes, showing the paper beneath for a "flying white" effect (*fei-pai* 飛白); (3) the brush moves in a circular rhythm, seen also in the ligatures between characters; several large graphs, especially toward the end, suggest an almost explosive power.

Huai-su's scroll had been an inspiration to other great calligraphers before Tung, and aside from the question of its absolute authorship (see Xu Bangda, "Tung Ch'i-ch'ang's Calligraphy," in vol. 1 of this catalogue, pp. 128–31), it was a major force in Tung's aesthetic theory. In an inscription to one of his copies of the work, Tung paid homage to it:

> Twenty years ago I viewed the original manuscript [of Huai-su's *Tzu-hsü t'ieh*]. In recent years I also had ample opportunity to view other of his works; nevertheless, this work is still the best. . . . The fact that Chang Hsü had a pupil like Huai-su is like Tung Yüan [fl. ca. 945–ca. 960] having [a pupil like] Chü-jan [fl. ca. 960–ca. 986]: both followers handed down the true nature of their teachers' art. The principle of their art is a simple, unadorned, naturally accomplished quality. People often regarded them as unrestrained, but in fact they were very much under control. (*Hua-ch'an shih sui-pi*, ch. 1, p. 11)

Artistically, the cursive section is a tour de force, functioning in the structure of the entire scroll as a musical cadenza would in a concerto: it allows the composer (and performer) the freedom to improvise beyond the initial form or script type selected at the onset and to be totally expressive in terms of line, shape, and rhythm. In this case, its appearance at the end of the scroll, almost like an afterthought which then steals the show, has an analogy in painting to the final passage of Huang Kung-wang's *Dwelling in the Fu-ch'un Mountains* (*Fu-ch'un shan-chü*; vol. 1, fig. 17), a work dated 1350 and known intimately to Tung. In fact, in 1596 Tung's early spate of collecting mania peaked when he acquired the scroll and proudly inscribed it (Kohara, *To Kisho no shoga*, 1981, vol. 2, pl. 33; *Ku-kung ming-hua san-pai-chung*, 1959, vol. 4, pl. 161).

Tung's allusion to Huai-su in this 1603 scroll appears in his use of the brush—the distinctly upright manner with centered tip and a raised wrist, techniques he advocated a decade earlier (see cat. no. 1).

His rhythmic pulse is less circular, his brushlines less rounded than Huai-su; he prefers the broader movements and zigzag ligatures which create ribbonlike forms to offset the variety and dynamic configuration of the individual character structures. Aesthetically, Tung's results are plain but elegant—and infinitely exciting. It is because of Tung's mastery of the totally centered brush tip and his raised wrist that he has achieved the soaring airborne quality.

This work can be compared to Tung's *Poem by Wang Wei* in The Metropolitan Museum of Art (vols. 1 and 2, pl. 65), a hanging scroll datable to 1632. With so few examples of Tung's cursive writing extant, it is not possible to postulate much of a development. (See Tung's *Eulogy of Ni K'uan* [vols. 1 and 2, pl. 22], with a similar inscription in cursive script; the *Abbreviated Version of Su Shih's "First Excursion to Red Cliff"* [vols. 1 and 2, pl. 34]; and *"Singing Aloud"* [vols. 1 and 2, pl. 63]; see also two undated handscrolls in Kohara, *To Kisho no shoga*, vol. 1: no. 93, a work after Chang Hsü, in the Detroit Institute of Art; and no. 95, Tung's copy of the Huai-su scroll, for which he wrote the colophon cited above.) It is evident, however, that while the present handscroll makes clear references to the Huai-su scroll of 777, particularly as they are in the same format, the *Poem by Wang Wei* shows more of an interest in the archaic *chang-ts'ao*. The brushwork is rounder, fuller, weightier (perhaps a softer, older brush was used); the cursive characters are separate (only two characters are linked, *ch'un-ts'ao* 春草, "spring grass," in the middle of the center line of the hanging scroll), so that there is less emphasis on the verticality and flow of a single column or the connecting strokes and ligatures (which is a distinct feature in the 1603 work). One of the prime qualities of the Metropolitan Museum scroll is its apparent lack of emphasis on brushwork. Because of the inherent technical simplicity of the script type, attention is focused on the dynamics of each character and the gently pulsating rhythms, which are Tung's interpretation of the wavelike stroke of the *chang-ts'ao* script. These are seen especially in the briefer vertical and horizontal strokes, which are written with a swaying movement of the wrist. In both scrolls, despite the almost thirty-year lapse and the difference in cursive type, Tung has somehow managed to achieve his artistic goal: *p'ing-tan t'ien-chen* 平淡天真, the expression of the plain, the unadorned, and, particularly in the *Poem by Wang Wei*, the spontaneous and the natural.

The predominant Buddhist content of the poems and comments of the 1603 scroll underlines the importance that Ch'an had for Tung in the previous two decades. From the 1580s he had developed an interest in Ch'an, and had met the master Ta-kuan (1543–1604) while the latter was visiting in Hua-t'ing. In 1585 Tung experienced what he described as a moment of enlightenment while traveling by boat and contemplating one of the Ch'an stories posed to monks to facilitate their awakening. Moreover, the fifty-two sections devoted to Ch'an thought in his collected works testify to the important role that Buddhism played in his intellectual growth at this time (see Celia Carrington Riely, "Tung Ch'i-ch'ang's Life," part 2, in vol. 2 of this catalogue; and Kohara, *To Kisho no shoga*, vol. 2, p. 259).

MWG

LITERATURE: Ku Fu, *P'ing-sheng chuang-kuan*, pref. 1692, repr. 1962, *ch.* 5, vol. 2, p. 56; *Shodo zenshu*, 1961, vol. 21, pp. 13–15, 146, figs. 19, 20, pls. 6–9; *Min To Kisho: Gyosho shikan*, 1962, vol. 77; Takeshima, *Kaiankyo rakuji*, 1964, cat. 171; *Shodo geijutsu*, 1973, vol. 8, pls. 103–11; *Illustrated Catalogues*

of the Tokyo National Museum, 1980, cat. no. 103, p. 70; Kohara, *To Kisho no shoga*, 1981, vol. 2, no. 41, pp. 258–59; Ren Daobin, *Hsi-nien*, 1988, p. 79; Zheng Wei, *Nien-p'u*, 1989, p. 49.

6 *Stream and Hills before Rain* (by attribution)
Hsi-shan yü-i
董其昌　谿山雨意

Dated 1604

Hanging scroll, ink on paper
140.2 x 53.7 cm (55⅞₆ x 21⅛ in.)

Shanghai Museum

vol. 1, pl. 6

ARTIST'S INSCRIPTION AND SIGNATURE (4 lines in running-regular script):
Stream and Hills before Rain, painted two days after the fifteenth of the fourth month of the *chia-ch'en* year [May 15, 1604]. Hsüan-tsai.
《谿山雨意》甲辰四月望後二日，玄宰。

ARTIST'S SEAL:
Tung Ch'i-ch'ang yin 董其昌印 (*pai-wen*, square) 27

COLOPHON: Ch'en Chi-ju 陳繼儒 (1558–1639), undated, 2 seals

COLLECTORS' SEALS: Po Ch'eng-liang 柏成樑, 2; Ho Kuan-wu 何冠五 (20th century), 2

7 *Misty River and Piled Peaks*
Yen-chiang tieh-chang t'u
董其昌　煙江疊嶂圖

Dated 1605

Handscroll, ink on silk
30.5 x 156.4 cm (12 x 61⅝₆ in.)

Shanghai Museum

vol. 1, pl. 7

ARTIST'S INSCRIPTION AND SIGNATURE (7 lines in running script, excluding poem):
Poem Written for *Misty River and Piled Peaks* in Wang Ting-kuo's [Wang Kung, fl. late 11th century] Collection
書王定國所藏《煙江疊嶂圖》

To the right is the poem by Mr. Tung-po [Su Shih, 1036–1101] written for Wang Chin-ch'ing's [Wang Shen, 1036–after 1099] painting. Chin-ch'ing has responded in a poem, the language of which is strikingly beautiful; and this poem in turn received a poetic response from Tung-po [using the same rhyme as the original poem]. I assume that Chin-ch'ing must have made two or three versions of the painting, in addition to the one in Wang Ting-kuo's collection. None [of these works] has survived, and there is not even a copy known in the world. Even in his inscription on the painting

Misty River in his own collection, Wang Yüan-mei [Wang Shih-chen, 1526–1590] admits that the painting has nothing to do with the meaning of [Su Shih's] poem; thus it is clear that the painting is not a genuine work [by Wang Shen]. I once saw Chin-ch'ing's painting *Ying-shan t'u* [*The Isles of the Immortals*] at the [home of the] Hsiang family in Chia-ho [Chia-hsing, Chekiang]. Its brushwork resembles that of Li Ying-ch'iu [Li Ch'eng, 919–967], and its color scheme that of Li Ssu-hsün [fl. ca. 705–20]. Both are free from the mannerisms of the professional painters. Unfortunately, this painting in the Hsiang family was not saved from a fire and has been lost forever. Chin-ch'ing's work thus shared the fate of *Kuang-ling san* [the lost masterpiece of lute music by Hsi K'ang of the Chin dynasty]. Visualizing what Wang Shen had in mind, I did this *Misty River and Piled Peaks*. It was autumn, so I made it an autumn landscape, paying no attention to lines in the poem such as "Spring wind sways the stream under the boundless sky." This handscroll and the above inscription were done unsigned and undated. Inscribed again in the twelfth month of the *chia-yin* year [December 31, 1614–January 28, 1615] after ten years. Ch'i-ch'ang. (Translation by Wai-kam Ho.)

右東坡先生題王晉卿畫，晉卿亦有和歌，語特奇麗，東坡爲再和
之。意當時晉卿必自畫二、三本，不獨爲王定國藏也。今皆不
傳，亦無復撫本在人間。雖王元美所自題家藏《煙江圖》，亦自
以爲與詩意無取，知非真矣。余從嘉禾項氏見晉卿《瀛山圖》，
筆法似李營丘，而設色似李思訓，脫去畫史習氣。惜項氏本不戒
於火，已歸天上。晉卿跡遂同《廣陵散》矣。今爲想像其意，作
《煙江疊嶂圖》，於時秋也，輒從秋景，於所謂"春風搖江天
漠漠"等語，存而弗論矣。甲寅臘月重
題，蓋十年事矣。其昌。

ARTIST'S SEAL:
Ch'i/Ch'ang 其昌 (*pai-wen*, double seal) 59

COLOPHON: Shen Shu-yung 沈樹鏞 (1832–1873)

COLLECTORS' SEALS: P'an I-chün 潘奕雋 (1740–1830), 1; Chao Chih-ch'ien 趙之謙 (1829–1884), 1; Shen Shu-yung, 2; Li Yü-fen 李玉棻 (19th century), 1; P'ang Yüan-chi 龐元濟 (1864–1948), 5; unidentified, 1

RECENT PROVENANCE: Shanghai Municipal Administration of Cultural Relics

LITERATURE: Xu Bangda, *Pien-nien-piao*, 1963, p. 95; *Chung-kuo ku-tai shu-hua mu-lu*, vol. 3, 1987, Hu 1–1347; Zheng Wei, *Nien-p'u*, 1989, p. 99; *Chung-kuo ku-tai shu-hua t'u-mu*, vol. 3, 1990, Hu 1–1347.

8 *"Eulogy on the Dynastic Revival of the Great T'ang Dynasty,"* running script
Hsing-shu "Ta T'ang chung-hsing sung"
董其昌　行書《大唐中興頌》

Undated (ca. 1605–10)

Handscroll, ink on paper
29.7 x 613.5 cm (11¹¹⁄₁₆ x 241⅝₆ in.)

Hsü-pai Chai—Low Chuck Tiew Collection

vol. 1, pl. 8 (detail); vol. 2, pl. 8

Section 1:
ARTIST'S TITLE (1 line in running script, preceding a transcription in 56

lines of the original essay by Yen Chen-ch'ing [709–785] dated 761):
Dynastic Revival of the Great T'ang [dynasty] with preface

《大唐中興頌有序》

ARTIST'S INSCRIPTION (11 lines in running-cursive script, following the transcription):
The preceding is [the text of] the *Stele of Dynastic Revival* in Wu-hsi [Ch'i-yang hsien, Hunan] and is in the Honorable Yen Lu-kung's [Yen Chen-ch'ing] regular script. I have used running script to record it as well as the dates of the composition [761] and of the carving [771]. In the *i-ssu* year [1605] I went to Heng-yang for an examination and the Prefect of Yung-chou brought [a rubbing from] the carving to me. I regretted that Ch'i-yang [where the original stele was located] was too far and that I couldn't go there to read the stele. But in my suitcase, I happened to have Chao Wu-hsing's [Chao Meng-fu, 1254–1322] painting entitled *Shan-ku* [Huang T'ing-chien, 1045–1105] *Reading the Stele at Wu-hsi*, so I composed the following poem and gave it to the Prefect to have it carved.

右浯溪《中興頌碑》，顏魯公真書。余以行體錄之，仍存其刻撰歲月。乙巳校士衡陽，永州守以碑刻至，念祈陽猶遠，不能往讀碑。而篋中有趙吳興畫《山谷浯溪讀碑圖》，因作歌屬守鐫之。

Section 2:
ARTIST'S TITLE (1 line in running script, preceding a poem in 26 lines in five- and seven-character regulated meter):
Inscribing the *Picture of Reading the Stele at Wu-hsi*

題《浯溪讀碑圖》

ARTIST'S SIGNATURE (1 line in running script, following the poem):
Written by Tung Ch'i-ch'ang.

董其昌書。

ARTIST'S INSCRIPTION and SIGNATURE (a discussion of the meaning of "the three perfections" [*san-chüeh*]; 25 lines in running script, following the poem).

ARTIST'S SEALS:
Hsüan-shang chai 玄賞齋 (*pai-wen*, tall rectangle) **21**
Hsüan-tsai 玄宰 (*chu-wen*, square) **48**
Tung Hsüan-tsai 董玄宰 (*pai-wen*, square) **42**

LABEL STRIP: Chao Shih-kang 趙時棢 (1874–1945), dated 1934

COLOPHONS: Kao Shih-ch'i 高士奇 (1645–1704), 1 dated 1698, 1 undated; Yeh Te-hui 葉德輝 (d. 1927), dated 1921

COLLECTORS' SEALS: Cha Ying 查瑩 (18th century), 3; Huang Yüeh 黃鉞 (1750–1841), 4; P'an Cheng-wei 潘正煒 (19th century), 2; Chou Hsiang-yün 周湘雲 (20th century), 2; Low Chuck Tiew 劉作籌 (20th century), 2; unidentified, 2

The custom of "reading the stele" (*tu-pei* 讀碑) was among the more pleasurable pastimes that a government official such as Tung, or his Northern Sung predecessor Huang T'ing-chien, might partake of while on duty in the provinces. Such stelae—especially those from the T'ang period of the seventh to ninth centuries—were public monuments and written in the most formal script, *k'ai* 楷 (standard), *chen* 真 (block), or *cheng shu* 正書 (regular). They were the vital source for the rubbings of ancient models from which officials practiced their calligraphy for the examinations. While it had become the custom since the Northern Sung to also practice from model copybooks, or *t'ieh* 帖,

these, for the most part, were reproductions in carved form of brushwriting meant for private circulation—such as correspondence, more intimate in format and written in the informal scripts, *hsing* 行 (running) or *ts'ao-shu* 草書 (cursive).

A calligrapher and statesman of the stature of Yen Chen-ch'ing, whose reputation only grew with time, would have produced writings in both public and private formats. However, it is his regular script written for monumental stelae that had the most widespread cultural impact. Strictly speaking, Yen's original writing (see *Shodo zenshu*, 1966, vol. 10, pls. 44–45) belongs in the category of *mo-yai* 摩崖 (stone or cliff carvings), where the brushwriting is made permanent by carving into the living rock. Yen's text celebrates the restoration of the T'ang after the disastrous An Lu-shan rebellion, which in 756 almost felled the empire. According to accounts, the original site of the carving in the Ch'i-yang district of Hunan was near headwaters and was not only difficult to get to, but several times in its history was exposed to potential danger. The writing consisted of twenty-one columns, twenty characters per column, with each character measuring almost one foot in height. This is the kind of large writing that Yen himself called, in another context, *p'i-wo* 擘窠, big "fist-sized" structures.

Yen Chen-ch'ing's regular script was basic to Tung's early training in calligraphy. By his own statement (see Xu Bangda, "Tung Ch'i-ch'ang's Calligraphy," in vol. 1 of this catalogue, p. 107, and Celia Carrington Riely, "Tung Ch'i-ch'ang's Life," part 1, in vol. 2), Tung began with an early Yen work, the *To-pao t'a* dated 752 (see *Shodo zenshu*, 1966, vol. 10, pl. 12). The character size was smaller in scale, with a tight inner structure and with each graph fitted into a grid, no matter its complexity. Tung also imitated other works by Yen, in particular the *Tzu-shu kao-shen* dated 780 (see *Shodo zenshu*, 1966, vol. 10, pl. 60), extant in its original brushwritten form and displaying the supple, sensuous forms and noble bearing not as readily apparent in Yen's stelae carvings.

Tung was inspired here not by the size or majesty of the original cliff writing but by the prospect of being so close to the site itself. So he left his impressions in a typical manner in his comfortable running-regular script, composing inscriptions to record the event and poems to eulogize not only the idea, but also a painting by the Yüan master Chao Meng-fu, which depicted the visit to the cliff of an eminent predecessor, Huang T'ing-chien. The serendipity of having such a painting along in his suitcase may be specious, but Tung's desire to join such illustrious ancients in the entire sequence of events was very genuine. It is a graphic example of how Tung placed himself in the mainstream of the aesthetic and cultural tradition to which he was to contribute so magnificently in the next three decades.

MWG

LITERATURE: *Jung-t'ai shih-chi*, ch. 1, p. 11; Kao Shih-ch'i, *Chiang-ts'un shu-hua mu*, repr. 1924; *Kyohakusai zoshoga sen*, 1983, cat. no. 110; *I-yüan to-ying* 31 (1986): 44.

9 *Calligraphy and Painting Based on Han Yü's "Preface to Farewell to Li Yüan"*

"Sung Li Yüan kuei P'an-ku hsü" shu-hua

董其昌　《送李愿歸盤谷序》書畫

Undated (ca. 1606–10)

Handscroll, ink and color on silk
40.6 x 677.3 cm (16 x 266⅝ in.)

Osaka Municipal Museum of Art

vol. 1, pl. 9

ARTIST´S INSCRIPTION AND SIGNATURE (10 lines in running-regular
script):
Han Ch'ang-li [Han Yü, 768–824] in his "P'an-ku Preface" wrote: "Spend
the day sitting under a luxuriant tree and clean oneself bathing in the lim-
pid spring." Chao Wu-hsing [Chao Meng-fu, 1254–1322] once added a de-
piction of it. [But] the "joy of the great personage who achieves his
ambition"—no one has depicted it. I wrote out Ch'ang-li's entire preface,
and accordingly made a landscape in order to serve as a heading for it, but
only imitated Wu-hsing's pictorial imagery. Tung Hsüan-tsai.

韓昌黎《盤谷序》有云：「坐茂樹以終日，濯清泉以自潔。」趙
吳興嘗補圖。所謂「大丈夫得志之樂」未有圖之者。余寫昌黎全
序，因爲山水以弁之。僅模吳興畫境耳。董玄宰。

ARTIST´S TRANSCRIPTION (Han Yü's "Preface to Farewell to Li Yüan
upon his Return to P'an-ku"; 76 lines in running-cursive script):
To the south of the T'ai-hang Mountains there is the Meander Valley
(P'an-ku), where in the spring water is sweet and the soil fertile. Meadows
and groves abound and thrive, but the inhabitants are few. Some say the
valley is named Meander because it coils between the two mountain
ranges. Others say, being secluded and sequestered, the valley is a place
where recluses meander. My friend Li Yüan lives there.

This is what Yüan says: "What people call a great personage, I know
what he is like. He is one who bestows benefits on people, and whose re-
nown dazzles his time. When he presides over the court, he summons and
dismisses the hundred officials, and assists the emperor in issuing ordi-
nances. When he is on tour, flags and banners are carried high, and bows
and arrows are flaunted in array, armed men march bawling in front and
the retinue follows filling the streets, while the attendants, each bearing
his assigned article, gallop at full speed down both sides of the road. When
pleased, he metes out rewards; when angered, he metes out punishment.
Talented and handsome men pack in his presence, discoursing about the
past and the present and pointing up his illustrious virtue; and his ears are
not impatient of listening. The women—with arched eyebrows and plump
cheeks, clear voices and attractive figures, elegant appearance and kindly
disposition, with their weightless gowns fluttering and their long sleeves
used for a veil, with their faces powdered fair and [eyebrows] painted
dark—live idly in their lodgings arranged in rows, each jealous of the oth-
ers for favors and proud of her special position, and each competing with
her charm in order to win the Lord's attention. This is how the great per-
sonage behaves when he ingratiates himself in the favor of his emperor
and is in a position to wield his power over the empire. It is not that I
abhor this way of life and have fled it. Actually, such happenings are mat-
ters of fate, and one cannot come by them by sheer luck.

[When a great personage is not visited by good fortune], he is disposed
to live in indigence and reside in the countryside and to ascend the high
hills and gaze into the distance, to spend the day sitting under a luxuriant
tree and to clean himself bathing in the limpid spring, to pick the moun-
tain fruits and berries so pleasing to the palate, and to catch fish by the

water so fresh and edible. He will have no regular hours of rising and reti-
ring, but will do as he pleases. How much better it is to suffer no condem-
nation later than to receive all the compliments at the outset, and how
much better to have no worries at heart than to enjoy the pleasures of the
body. Unencumbered by carriages and robes and untouched by knives and
axes, unaware of order and chaos, and uninformed about promotions and
demotions—this is how a great personage lives when good fortune does
not come his way. I will do the same. What a contrast between this way
of life and the way of those who wait at the gates of the dignitaries and
scurry along the road of posts and power, who falter before they proceed
and stammer before they speak, who live in filth and feel no shame and
who run afoul of the law and are accorded capital punishment. Even if
such people should be lucky enough to die of old age, how evident is the
contrast between the ways of life of the worthy and the unworthy!"

Han Yü of Ch'ang-li heard the speech of Li Yüan and was emboldened.
Offering him a toast, he sang this song for him:
 In the Meander Valley your palace stands.
 The Meander soil is good for tilling.
 The Meander spring is good for bathing and strolling.
 The Meander seclusion bars any contention for your abode.
 Recessed and withdrawn, what expanse it embraces;
 Coiling and winding, the roads lead hither and thither.
 Ah! The pleasure of the Meander, a pleasure pure and carefree.
 Tigers and leopards keep their tracks at a distance,
 Reptiles and dragons skulk and hide.
 Spirits and gods are ever on the watch,
 To ward off wicked things.
 Eating and drinking, one lives in health and long.
 With nothing lacking, what more is there to want?
 Grease my carriage, feed my horse,
 Let me join you in the Meander, to spend my life in indolent idleness.
(Translation by Diana Yu-shih Chen Mei, *Han Yü as a Ku-wen Stylist*,
1967, pp. 138–41.)

ARTIST´S INSCRIPTION AND SIGNATURE (6 lines in running-regular
script, following the transcription):
The "P'an-ku Preface" emerged from the *Ch'u-sao* tradition; exhausting his
force to pattern descriptions, like Sung Yü's [ca. 290–223 B.C.] *Summons
of the Soul*. Hui-weng [Chu Hsi, 1130–1200] once said: "Ch'ang-li had a
very substantial taste for worldly pleasures: at times he spoke of wealth
and nobility, unconsciously driveling." Lord Han [Yü] himself said: "Pov-
erty and melancholy can easily be accomplished in their expression, while
pleasure and contentment are hard to excel in their representation." He
just wanted to use his strong points on the difficult places. Following the
calligraphy and painting, I continued with this. Tung Ch'i-ch'ang.
(Translation by Wai-kam Ho and Richard Vinograd.)

《盤谷序》自《楚騷》發竅，儘力模寫，如宋玉《招魂》。晦翁
乃謂：「昌黎世味實重，有時說富貴，不覺流涎。」韓公自云：
「窮愁易工；而歡愉難好。」正欲于難處用長耳，因書圖後及
之。董其昌。

ARTIST´S SEALS:
Tung Ch'i-ch'ang yin 董其昌印 (*pai-wen*, square) 45
T'ai-shih shih 太史氏 (*pai-wen*, square) 46
Tung Ch'i-ch'ang yin 董其昌印 (*pai-wen*, square) 47

COLOPHON: Ch'eng Yao-t'ien 程瑤田 (1725–1814), dated 1800:
When Liang Wu [Emperor Wu of the Liang, r. 502–49] commented on
Yu-chün's [Wang Hsi-chih, 303–379] calligraphy, he said it was like "dra-
gons leaping at the Heavenly Gates, tigers crouching at the Phoenix Pavil-
ion." He was probably describing its transformations as unpredictable and

its spirit as extraordinary. It is not something that can be compared to a phoenix at rest or a crane standing still. I say of Tung Wen-min's [Tung Ch'i-ch'ang] calligraphy that there is not one stroke that doesn't completely utilize his force; but at the same time, so graceful and elegant with dancing rhythm, looking like the immortals, it derives completely from the embryo of Yu-chün. Looking at this handscroll will startle even a ghost or spirit. As for the so-called dragons leaping and tigers crouching, is this it, or not? Mi Nan-kung [Mi Fu, 1051–1107] of the Sung also had this spirit daring. Wen-min's study of calligraphy began with P'ing-yüan [Yen Chen-ch'ing, 709–785]. Li Yung [675–747] and Yang Ning-shih [873–954] were those whom his mind imitated and his hand followed; Elder Mi [Fu] was one whom he prized. He inscribed the copy he made of the *Kuan-nu t'ieh*: "To gradually cultivate and suddenly confirm is not a matter of one morning and evening." This is his self-confession of sweetness and bitterness; how could so-called outsiders get to know of it?" This handscroll completely reveals the places where he was most successful in his whole career. But what is beneath [these successes] is unfathomable, and indeed not easy to penetrate or measure. As for taking the "P'an-ku Preface" as a remarkable essay, I say this handscroll is truly remarkable calligraphy. In using it to accompany Ch'ang-li's text, there are times he surpasses the text, and in no instance does he not reach its level. I have seen many examples of Wen-min's calligraphy, but this is probably the pinnacle. Among Ming dynasty calligraphy, it is appropriate that we recognize the supremacy of Wen-min's over all others. At the new moon of the eighth month of the *keng-shen* year of the Chia-ch'ing era [September 19, 1800], Ch'eng Yao-t'ien wrote this at the age of seventy-six *sui*. (Translation by Wai-kam Ho and Richard Vinograd.)

梁武評右軍書，謂如"龍跳天門，虎臥鳳閣。"蓋狀其變化莫測，氣概非常。非驚停鶴立之觀所可彷彿者也。余謂董文敏書，無一筆不使盡氣力，而蹁躚綽約，望若神仙，全由胚胎右軍來。今觀此卷，驚猶鬼神。倘所謂"龍跳、""虎臥"者，是耶？非耶？宋米南宮，乃有此神勇。文敏學書，從平原入手。李邕、楊凝式，皆其心慕手追者；米老尤所服膺。其自跋《臨官奴帖》云："漸修頓証，非一朝一夕。"此甘苦自道，所謂外人那得知者也。其生平得力處，此卷盡露。然底蘊無窮，實亦未易窺測。至以《盤谷序》爲奇文，余謂此卷真奇字。用配昌黎文，有過之，無不及。文敏書余見多矣；至是乃歎觀止。明代書品，以文敏函蓋諸家宜哉！嘉慶庚申八月之朔，程瑤田書時年七十有六。

COLLECTORS' SEALS: Lu Hsin-yüan 陸心源 (1834–1894), 2; Lu Shu-sheng 陸樹聲 (fl. ca. late 19th century), 1; Ch'eng Yao-t'ien, 4; Pao Yüeh-t'ing 鮑約亭, 1; Ts'ai Lu-shan 蔡魯山, 1; unidentified, 8

Although Tung Ch'i-ch'ang's inscriptions on the Osaka handscroll are undated, the seals he used at the end of this scroll suggest a period of execution between 1607 and 1610 (see Celia Carrington Riely, "Tung Ch'i-ch'ang's Seals," group VI, in vol. 2 of this catalogue). These years were part of a period of retirement that was to last until 1621, and it is difficult not to read Tung's quotation of Han Yü's text on the virtues of retirement as a comment on Tung's own circumstances at the time. The pointed critique of the anxieties and corruptions of life at the center of power that is embodied in Han Yü's text was certainly applicable to the Wan-li emperor's court, from which Tung had withdrawn. Although the painting lacks a dedication, it is possible that both the painting and its texts were intended for a friend or an associate as congratulations or encouragement for choosing a path of retirement.

Tung Ch'i-chang's illustration of Han Yü's "P'an-ku Preface" would thus seem to belong to a relatively functional category within his oeu-

vre, including paintings designed as social communications of ideological messages more or less distinct from his strongly art-historical or formal explorations. The Osaka scroll is strongly dominated by text, not only in the subject of the illustration, but also in the sheer amount of Tung's calligraphy and in the allusions to poetry in his inscriptions bracketing the Han Yü text. The painting is relatively placid and unadventurous, a conscious attempt, perhaps, to reflect the bucolic tone of the illustrated text. The softly modeled forms of the low river landscape with a fisherman are enlivened only by touches of muted green and by the introduction of one of Tung's upwardly tilted, flat-topped plateau forms near the end of the scroll. Otherwise, the heavy and relatively uncomplicated tree contours, the soft-edged, almost crumbly treatment of rocks, and the atmospheric treatment of hills, such as those overlaid with loose patches of colored wash near the end of the composition, seem as close to the styles of Tung Ch'i-ch'ang's substitute painters Chao Tso (ca. 1570–after 1633) and Shen Shih-ch'ung (fl. ca. 1607–40) as to Tung's own developed manner. It is not inconceivable that a functional painting such as this might have been a collaborative effort—with Tung contributing the prestigious message and calligraphy—but some of the distinctive pictorial qualities might also owe to the effects of the silk medium and the tone of the illustrative project.

In addition to the textual and functional components of this work, one art-historical reference clearly links the painting to Tung Ch'i-ch'ang's pictorial interests and practices. Tung acknowledges his indebtedness to Chao Meng-fu in his first inscription on the scroll, and his particular model is most likely Chao's *Village by the Water* (*Shui-ts'un t'u*) of 1302 (Li, *Autumn Colors*, 1965, p. 54, n. 130, and fig. 8), which Tung Ch'i-ch'ang at one time owned and which he mentions in inscriptions on two albums, the *Eight Views of Autumn Moods* (vols. 1 and 2, pl. 38) of 1620 and *Landscapes in the Manner of Old Masters* (vol. 1, pl. 42) of 1621–24. The schematic three-part river landscape in Chao's *Village by the Water*—with a stand of trees on a hillock at the right, a low stretch with houses and boats, and a final passage with conical hills at the left—is reiterated in Tung's Osaka handscroll with only mild additions at either end, notably the arched, bisected rocks and flat plateau reminiscent of the Huang Kung-wang (1269–1354) manner in the last section.

RV

EXHIBITIONS: Tokyo National Museum, 1964: *Min Shin no kaiga*, cat. no. 58, p. 22; Center of Asian Art and Culture, San Francisco, 1970: *Osaka Exchange Exhibition: Paintings from the Abe Collection and Other Masterpieces of Chinese Art*, pp. 64–65, cat no. 26.

LITERATURE: Lu Hsin-yüan, *Jang-li kuan kuo-yen lu*, 1892, repr. 1975, *ch.* 24, pp. 13–14; *Soraikan kinsho*, 1930–39, pt. 2, vol. 3, no. 60, exp. text pp. 96–98; Yonezawa, *Painting in the Ming*, 1956, pl. 18 (section); *Sekai bijutsu zenshu (Shimban)*, 1953, vol. 20, fig. 29; *Kokka* 592 (March 1940): 81, pl. 1–3; *Toyo bijutsu, kaiga*, 1968, vol. 2, pl. 14; Osaka Municipal Museum of Art, *Chinese Paintings*, 1975, vol. 1, pl. 108, vol. 2, pp. 43–44; Kohara, Wu, et al., *Jo I, To Kisho*, 1978, pp. 170–71, color pl. 43; Suzuki, *Comprehensive Illustrated Catalogue*, 1982–83, vol. 3, JM3–171.

10 *Running Script in the Manner of the Four Sung Masters*

Hsing-shu lin Su Huang Mi Ts'ai t'ieh

董其昌　行書臨蘇黃米蔡帖

Dated 1607

Handscroll, ink on silk
29.3 x 258.7 cm (11⁹⁄₁₆ x 101⁷⁄₈ in.)

Beijing Palace Museum

vol. 1, pl. 10 (detail); vol. 2, pl. 10

ARTIST'S TITLE (1 line in small regular script):
The Precious Tripod Studio [i.e. Tung Ch'i-ch'ang's calligraphy] in the Manner of the Sung Masters Su, Huang, Mi, and Ts'ai.

寶鼎齋臨宋蘇、黃、米、蔡帖

ARTIST'S INSCRIPTIONS AND SIGNATURE:

1. 6 lines in small running script, following a transcription in running script (*Shen Nung yüeh . . .*, in 16 lines) in the manner of Su Shih (1036–1101):
Tung P'o's [Su Shih] study of calligraphy included Wang Seng-ch'ien [426–485], Hsü Hao [703–782], and Yen P'ing-yüan [Yen Chen-ch'ing, 709–785]. His writings astonished the world and his loyalty and righteousness crowned the sun and the moon with their aura. For that reason he is ranked as the greatest of the Sung Masters. I write here Su's transcription of "On Nourishing Life" by the [Eastern] Chin poet Chi Shu-yeh [Chi K'ang, 223–262]. It is a pairing [of talents] made in heaven. I have already had [the original] carved in the twelfth *chüan* of my anthology of calligraphy, the [*Hsi-*]*hung t'ang t'ieh*.

東坡書學王僧虔、徐浩、顏平原。挾以文章妙天下，忠義冠日月之氣。故屬宋名家第一。其所書晉嵇叔夜《養生論》，尤合作者。已刻《鴻堂帖》第十二卷。

2. 7 lines in small running script, following a transcription in running script of two seven-character quatrains (*Chiu mai huang-ch'en . . .*, in 3 lines; *T'ao li wu-yen . . .*, in 3 lines) and a personal letter (*Chia-chou . . .*, in 7 lines, including the original signature) in the manner of Huang T'ing-chien (1045–1105):
Shan-ku's [Huang T'ing-chien] study of calligraphy included Yen P'ing-yüan's "Controversy over Seating Protocol" and also [works by] Yang Ning-shih [873–954]. For large writing, he took the "Memorial to a Crane" [dated 541] as his model, and for "wild" cursive, he grasped the secrets of Huai-su [fl. late 8th century] of Ch'ang-sha. [Huang's calligraphy] had an ancient elegance and refinement, with a matching straightforwardness that "exposed the bone" [structure in his brushwork]. It's as if someone uncommonly attractive was offered up to govern the rabble, much like giving someone who ate pork a taste of olives—once was not enough to wash away the fat accumulated in his intestines.

山谷書學顏平原《坐位帖》，間出楊凝式。大字以《鶴銘》為師，狂草得長沙懷素三昧。古雅有餘，稍伉直露骨耳。若姿態妍媚者，亦藉之以攻俗。如食豬肉人嘗橄欖，一洗肥濃腸胃。未為不可也。

3. 9 lines in small running script, following a transcription in larger running script of an essay on ethical behavior (*T'ien-ti chih-chien . . .*, in 13 lines, including Mi Fu's [1051–1107] original signature), and two seven-character poems in regulated meter in large running script (*Yang fan tsai yüeh . . .*, in 12 lines; *Shan ch'ing ch'i shuang . . .*, in 11 lines) in the manner of Mi Fu:
Mi Nan-kung's [Mi Fu] study of calligraphy included Ou-yang Shuai-keng [Ou-yang Hsün, 557–641], Ch'u Teng-shan [Ch'u Sui-liang, 596–658], Yen P'ing-yüan, and Junior Imperial Preceptor Yang [Yang Ning-shih], all of whose styles he transformed to achieve a personal style of his own. The most important element in [Mi's calligraphy] was a dynamic poise, broad and overflowing, with a weighty spontaneity. Among the Sung Masters, he ought to stand alone, but deferred his position to Tzu-chan [Su Shih]. Actually, his achievement as a calligrapher is superior to Su's, with the bulk of his efforts concentrated in imitating [ancient works], something that P'o-kung [Su Shih] had no time to undertake, depending only on [the study of] a few masters to grasp their outstanding features.

米南宮書學歐陽率更、褚登善、顏平原、楊少師，已復自成一家。以勢屬主，姿態橫溢，沈著痛快。宋時名家，自當獨步。小讓子瞻，人地使然耳。其書品出蘇上，以功力之到，全在臨摹，意坡公無此多暇，只偏師取奇也。

4. 7 lines in small running script, following a transcription in large running-cursive script of a personal letter (*Hsiang ch'i ch'iu-shu . . .*, in 9 lines) in the manner of Ts'ai Hsiang (1012–1067):
Ts'ai Chün-mo [Ts'ai Hsiang] was older than Su [Shih] or Huang [T'ing-chien], but nowadays they are referred to collectively as "Su, Huang, Mi, and Ts'ai." If that is the case, [then the Ts'ai in question] ought to be Ts'ai Ching [1047–1126]. However, because he and his father committed nefarious deeds, his calligraphy has been ignored. Actually, Ching's writing was included in the search for famous calligraphers' work in the compilation of the *Ta-kuan t'ieh* [of Sung emperor Hui-tsung, r. 1101–25]. [Ching's calligraphy] is pure and sharp with an antique feeling. Mi Yüan-chang [Mi Fu] criticized Ts'ai Ching as not having [mastered] the brush, and Ts'ai Pien [Ching's younger brother; 1058–1117] as having mastered the brush. Pien's style resembled Mi's. Ni Yün-lin [Ni Tsan, 1301–1374] once criticized Mi for such talk and disagreed with him. Tung Ch'i-ch'ang wrote this on the eighth day of the sixth month of the *ting-wei* year [July 1, 1607].

蔡君謨在蘇、黃前，今世稱"蘇、黃、米、蔡，"蓋蔡京耳。以其父子亂國政，并沒其書。京書即《大觀帖》摽各家名姓是也。清峭有古意。米元章謂蔡京不得筆，蔡下得筆。下書乃似米。倪雲林嘗訶元章此語，以為阿米顛，當不至此。董其昌書。丁未六月八日也。

ARTIST'S SEALS:
Hsüan-shang chai 玄賞齋 (*pai-wen*, tall rectangle) 12
Chih chih-kao jih-chiang kuan 知制誥日講官 (*pai-wen*, rectangle) 13
Tung Ch'i-ch'ang yin 董其昌印 (*pai-wen*, square) 14

NO COLOPHONS

COLLECTOR'S SEALS: Wang Yang-tu 王養度 (19th century), 4

Dating from Tung's early maturity, when he was fifty-three *sui* (fifty-two years old), this scroll of 1607 is one of the earliest to include references to all four of the Sung Masters. Tung's reverence for Su Shih can be seen from the early dated references to him (see cat. no. 1). He held Su's total spontaneity and naturalness (*t'ien-chen lan-man* 天真爛漫) in highest esteem. Indeed, the work that Tung regarded as Su's masterpiece was the "Cold Meal Festival Poems Written at Huang-chou" ("Huang-chou han-shih shih chüan"; *Ku-kung fa-shu*, 1965, vol. 9B). An outpouring of the despair Su felt after three bitter winters in

exile in Huang-chou, Hupei, in 1082, the scroll is at once an original manuscript composed at the height of emotion as well as a record in poetic form of the disciplined literary life of a superior man of letters in traditional China. The scroll as it is extant today also bears, serendipitously, the colophon of Su's pupil and the second Sung master, Huang T'ing-chien, written in his distinctive large running script. Tung's colophon, undated and written in two lines of respectfully small regular script, follows this: he comments that he has seen "more than thirty examples of Su Shih's calligraphy, and that this ranks at the top"; and he notes that he has already entered it into his anthology, the *Hsi-hung t'ang t'ieh* (compiled between 1603 and 1607). At the time, Su's scroll was probably in his teacher Han Shih-neng's (1528–1598) collection, as the scroll bears Han's seals.

The two poems after Huang T'ing-chien were dedicated to Sun Chüeh (1028–1090), the father-in-law of Huang T'ing-chien, and are taken from a large group of poems and correspondence of the Sung poet dedicated to Chao Ching-tao (see *Ku-kung fa-shu*, vol. 10; Chao was apparently the older brother of Chao Ling-chih [d. 1134], the good friend of Su Shih). These letters and poems had been in Hsiang Yüan-pien's (1525–1590) collection, and, like the Mi Fu scroll and other works of Su Shih, were the originals on which Tung based his early years of connoisseurship.

In comparing Tung's version with the original Huang T'ing-chien poems, one can see that unlike the first section of the scroll, which is not immediately recognizable as being written in Su Shih's style, this section does resemble the original in the structure of individual characters and brushwork. Huang T'ing-chien wrote a most superb and elegant small running script, displaying features such as an axial tilt to the upper right, elongated horizontal and vertical strokes, and a pronounced asymmetrical balance to each structure. In the original, Huang wrote the twenty-eight characters in two columns, whereas Tung writes them in three, enlarging and making them easier to execute. He elongates not only the horizontals and vertical strokes but often the entire structure. Tung's grasp of the asymmetrical balance of Huang's original is especially eloquent in the character *shui* 水 (water) at the top of the second column. However, Tung's energy is pitched at a level much lower than Huang's.

Tung Ch'i-ch'ang's admiration for Mi Fu was such that he was willing to settle for what he knew was a copy of a famous scroll by Mi and have it carved for entry in his calligraphy anthology, the *Hsi-hung t'ang t'ieh*. But in the fifth month of 1604, Tung's friend Wu T'ing (ca. 1555–after 1626) brought the original work to Tung, who was at West Lake, and, gathering together "a group of works by well-known masters," Tung exchanged them for Mi's original. The scroll in question was Mi Fu's *Calligraphy Written on Szechuan Silk* (*Shu-su t'ieh*; see *Ku-kung fa-shu*, vol. 12), dated 1088 and one of the masterworks of calligraphic art. Tung described the original calligraphy as "like a lion grappling with an elephant—using his entire strength to subdue it. It is the most perfect performance of Mi's career" (for an illustration of Tung's colophon, see Kohara, *To Kisho no shoga*, 1981, vol. 2, pl. 84).

In this work of 1607 two long poems in large running script (comprising the third section of the scroll) are taken directly from Mi Fu's scroll. Tung had three years in which to feast on the original, presumably after he also had studied the copy in order to produce this work. Or perhaps he had seen the scroll in the 1570s or 1580s, when it was

in Hsiang Yüan-pien's collection (see Celia Carrington Riely, "Tung Ch'i-ch'ang's Life," part 2, and Wang Shiqing, "Tung Ch'i-ch'ang's Circle," part 3, in vol. 2 of this catalogue).

For Tung, Su Shih's style may have been an unattainable ideal due to the many differences between the two men, most notably those of character, temperament, and artistic discipline. But with Mi Fu, Tung had a model whose artistic goals and visual energy he could presumably match. Tung's comparison of Mi's calligraphy on Szechuan silk to "a lion grappling with an elephant" reveals how vivid that model was for him. It comes as no surprise, then, that it is Mi's style that Tung's comes closest to "resembling." In general, the history of Tung's study of calligraphy overlaps with that of Mi, in that they both started with the T'ang masters, in particular Yen Chen-ch'ing, and then proceeded to reach back to the Wei-Chin period and the Two Wangs.

In comparing Tung's version with the Mi Fu original, one sees first the liberties Tung took in excerpting the two poems from the original work (which takes its name from the unusual silk twill woven in 1044 with fine black lines, according to a colophon on the scroll). Instead of eight or nine characters to a line, Tung enlarges the writing to four or five to a line, thereby emphasizing the composition and brushwork of individual components. While Mi's columnar rhythms are quite steady, the central axis of each character shifts subtly from side to side within the column, and, along with the brushwork, enlivens the characters with a vibrating energy. In contrast, Tung's large characters are unrelentingly perpendicular, as if they could be pierced with a single imaginary skewer.

As to brushwork, Mi Fu once characterized the methods of his contemporaries saying, "Ts'ai Hsiang writes by engraving his characters, . . . Huang T'ing-chien writes by designing his characters, Su Shih writes by painting his characters." When asked about his own method, Mi replied, "I write by sweeping my characters" (Mi Fu, *Hai-yüeh ming-yen*, repr. 1962, vol. 2, p. 4). Among the numerous modes that could be quoted to account for the extraordinary vitality in Mi's calligraphy, suffice it to say that he conceived of each character as a three-dimensional form, so that in striving to embody that form, his brush exhibited rotational action (or contortions). Thus within the rather tight internal structure derived from his study of Ou-yang Hsün, combined with the full-bodied brushwork of Yen Chen-ch'ing, the spontaneous freedom of Yang Ning-shih, and the rhythmic asymmetry of the Two Wangs, Mi's calligraphy packed an exhilarating if mysterious expressive power. This vibrancy was accentuated by the rich black ink he and the other Sung Masters preferred.

In comparing the structure of individual characters by Mi and Tung—for example, the character *yang* 揚 in Mi's opening poem—one sees how Mi organizes the right-hand element. Its feathery strokes converge, like spokes of a wheel with the fulcrum outside to the far right end of the horizontal, thereby giving the character a rotational poise. The central axis of Mi's character lies two-thirds to the right, where the diagonals converge, whereas the axis of Tung's character lies in the space between the two parts of the character. The result is a more balanced, static form, even though Tung clearly attempted a "Mi effect" by altering his brushwork.

In his final inscription on the work, Tung takes issue with the traditional identification of Ts'ai as Ts'ai Hsiang, preferring to defend Ts'ai Ching as one of the Four Sung Masters. Indeed, as Prime Minister

under the Sung emperor Hui-tsung, Ts'ai Ching was in a unique position to enjoy the emperor's favor and to fan his artistic interests. Proof of the special relation Ts'ai held with Hui-tsung can be seen in the placement of his inscription in tandem with the emperor's on the latter's painting, *A Literary Gathering* (National Palace Museum, Taipei; *Chinese Art Treasures*, 1961, cat. 31), and on other works by the emperor. (See *Shodo zenshu*, 1966, vol. 10, pp. 11–12, 38, 185, pl. 117, and figs. 51, 52; for Ts'ai Pien, see p. 185, pls. 118–19.) However, despite Ts'ai Ching's political power and hold on the emperor, it was still Ts'ai Hsiang who was the more highly regarded calligrapher. Hsiang is praised as superior to Ching and "the best in the empire" by the editors of Hui-tsung's own catalogue of calligraphy, the *Hsüan-ho shu-p'u* (repr. 1962, vol. 1, *ch.* 6, pp. 150–52, *ch.* 12, pp. 269–74). Thus Tung's future prominence as a critic and arbiter of taste could not weigh in Ching's favor, and Ts'ai Hsiang won out.

It might be noted that in 1592 Tung mentioned that he had never studied Ts'ai Hsiang's calligraphy (see cat. no. 1); thus his absorption of the Sung Masters as a group might be seen as a product of his maturity, and not of his initial period of study. It comes as no surprise, then, that the final section of Tung's scroll is a rather cursory reading of Hsiang's manner. The Sung master's extant correspondence reveals a wide range of formal and highly informal scripts (see *Ku-kung fa-shu*, vol. 8), all ennobled by an elegant, restrained poise and extraordinary control of the upright brush tip, which in his running or cursive manners produced extremely fine and agile ligatures. Combined with his preference for rich black ink, Ts'ai Hsiang's brushwork exhibited a penetrating and palpably tensile strength on the paper or silk. Again Tung strives for none of these qualities; rather, the brush is swift, the ink tonalities varied, even thin, and the nature of the brushline flat and noncommittal. Tung fancied that he understood Ts'ai Hsiang even before he studied him, and the results are rather too obvious. Perhaps only Tung's pronouncement that the T'ang masters excelled in "methods" (*fa* 法) and the Sung Masters in "ideas" (*i* 意) could be called up in his defense in this rendering (*Jung-t'ai pieh-chi, ch.* 4).

This work after the Four Sung Masters serves to open the discussion as to what Tung meant when he used the terms *lin* 臨 and *fang* 倣, literally, "to make a copy after" and "to imitate." The former term indicates having an original at one's side for intimate viewing, the latter the making of a free or creative copy. For Tung, these terms assumed new meanings. He openly scoffed at the idea of consciously seeking a resemblance to one's model: "I seek resemblance through nonresemblance," he wrote (see Xu Bangda, "Tung Ch'i-ch'ang's Calligraphy," in vol. 1 of this catalogue, pp. 117–18). Tung was of course long past the stage where he made close copies of works to conquer their formal style or to master any brush technicalities.

The idea of having an original at one's elbow and purposely seeking *not* to resemble it may strike one as an arrogant if not futile act. But for Tung it was the *process* (as much as the final product) and the discipline obtained in training one's mind, eye, and hand while in the presence of the original that counted. What mattered also in Tung's practice was the formal act of validating the orthodox lineage of calligraphy into which he squarely placed himself. Thus, Tung's writings "in the manner of" Su, Huang, Mi, or Ts'ai might or might not bear any resemblance to their recognized visual style.

MWG

LITERATURE: *Chung-kuo ku-tai shu-hua mu-lu*, vol. 2, 1985, *Ching* 1–2149; Zheng Wei, *Nien-p'u*, 1989, p. 67.

11 *Drawing Water in the Morning*

Hsi-yen hsiao-chi

董其昌　西巖曉汲

Dated 1607

Hanging scroll, ink and color on silk

117 x 46 cm (46⅟₁₆ x 18⅛ in.)

Beijing Palace Museum

vol. 1, pl. 11

ARTIST'S INSCRIPTIONS AND SIGNATURES:

1. 3 lines in running script:
This painting has been accomplished using a loaded brush dipped in ink; it is a variation on splashed ink (*p'o-mo*). Autumn, two days before Seventh Eve of the *ting-wei* year [August 26, 1607]. Hsüan-tsai painted and inscribed.

以水筆醮墨成畫，亦潑墨之小變。丁未秋，七夕前二日。玄宰畫題。

2. 5 lines in regular script:
The old fisherman moors at night by western cliffs,
At dawn, draws water from the clear Hsiang, burns bamboo from Ch'u.
Mists melt away, the sun appears, but not a man is seen—
Only the plash of oars is heard in the green of the hills and waters.
Look back, the horizon seems to fall into the stream,
And clouds pursue each other aimlessly over the cliffs.
　Tung Hsüan-tsai.
(Translation after Jan Walls, in Nienhauser et al., *Liu Tsung-yüan*, 1973, p. 104.)

漁翁夜向西巖宿
曉汲清湘燃楚竹
煙消日出不見人
欸乃一聲山水綠
回看天際下中流
巖上無心雲相逐
　　董玄宰。

3. 6 lines in running-regular script:
Elder brother Shih-i [Ho San-wei, 1550–1624] often thinks it regrettable that he does not obtain more of my pictures. This painting is kept by my son [Tsu]-ho. Lu Chün-ts'e [Lu Wan-yen] greatly appreciates it and wants to seize it. I say one ought to take from the many and supply the few, therefore I will allow Shih-i to obtain it so that he can brag to Chün-ts'e. Chün-ts'e himself is skilled at painting and is without affairs; this is for his comment. The second day of the first month of the *hsin-hai* year [February 14, 1611]. Tung Hsüan-tsai.

士抑兄時以不多得余畫爲恨。此圖爲兒子和所藏。陸君策殊賞鑒，欲奪。予謂當衰多益寡，且使士抑得以夸君策。君策自工畫，又無事。此希教也。辛亥春正二日，董玄宰。

ARTIST´S SEALS:

Hua-ch'an 畫禪 (*chu-wen*, rectangle) 28
Tung Ch'i-ch'ang yin 董其昌印 (*pai-wen*, square) 29
T'ai-shih shih 太史氏 (*chu-wen*, square) 30
Tung Ch'i-ch'ang 董其昌 (*chu-wen*, square) 31

NO COLOPHONS

COLLECTORS´ SEALS: Hung I-men 洪易門, 1; unidentified, 2; illegible, 1

Tall trees in full foliage stand on the foreground bank of *Drawing Water in the Morning*. Beneath them is a reedy bank and a moored boat, half seen. Beyond the trees is an overhanging cliff which also becomes part of a middle ground receding to the right. In a further shift of scale and viewpoint this middle distance is capped by a clump of trees that is in turn surmounted by another overhanging cliff, the face of which is undercut and dotted with foliage. This image is remarkable on several counts.

In executing the painting Tung Ch'i-ch'ang used little texturing. The lack of texturing is particularly evident in the foreground rocks. Although the rocks in the middle and far distances are contoured, Tung again creates the surface through wash and long wet strokes that follow the contours, giving the forms a certain instability. In his first inscription, dated 1607, Tung Ch'i-ch'ang speaks to this technical aspect: he calls his use of wash a variation on splashed ink and describes it as a saturated brush dipped in ink. This, along with his use of color, is quite different from his concern with texturing seen in the Stockholm handscroll *Landscape after Kuo Chung-shu* (vol. 1, pl. 4). The two paintings share similar forms and strangely organic shapes; both exhibit a strong thrusting movement, but the reliance in *Drawing Water in the Morning* is on wash rather than on insistently parallel texture strokes to create this effect.

The composition is another remarkable feature of this painting. Tung seldom juxtaposes solid forms along one edge of a painting against an unpainted area. In organizing these landscape forms in *Drawing Water in the Morning*, Tung has clearly set them out in a structured relationship of three major divisions: the foreground with reedy bank, boat, and trees; the middle ground with trees of one scale suddenly surmounted by trees of another scale; and then the thrusting far distance leading to its pointed peak. These divisions of the landscape are the unitings and dividings that characterize most of his paintings, but here Tung employs a composition that is associated with the professional masters of the middle Ming period rather than with his scholarly predecessors Shen Chou (1427–1509) and Wen Cheng-ming (1470–1559).

The painting is further remarkable because Tung rarely linked paintings to poems. His transcription of Liu Tsung-yüan's (773–819) "The Fisherman" written in the upper left, though undated, seems too close to the imagery of the painting to have been added at a later date. (In writing out Liu's poem, Tung seems to have misremembered the last line and added a character to it.) Tung's paintings lack figures and usually lack any kind of narrative element: here the moored boat serves as the human figure might in paintings by other artists. Directly on axis, the boat provides the narrative detail that links the painting and the poem. In 1607 Tung, after resigning the education intendentship of Hu-kuang the year before, remained in retirement. Perhaps he chose the poem for its eremitic connotations, which could also have had per-

sonal meaning in 1611 for Lu Wan-yen, who had hoped to obtain the painting, since he was likewise out of office.

Finally, in his second dated inscription, Tung leads us into the world of his close friends (see Wang Shiqing, "Tung Ch'i-ch'ang's Circle," part 1, section 2, in vol. 2 of this catalogue). Shih-i was the cognomen of Ho San-wei and Chün-ts'e that of Lu Wan-yen. Both men were old friends of Tung; they had all been members of a poetry club when young. In another inscription for Ho San-wei, Tung wrote, "Every time Shih-i visits me I am unable to do a painting and the paintings that he has obtained are forgeries," providing a cautionary note for modern connoisseurs. In this instance Tung ended up sending Ho a picture that he had done previously (*Hua-ch'an shih sui-pi, ch.* 2, pp. 37–38).

DAS

LITERATURE: Xu Bangda, *Pien-nien-piao*, 1963, p. 95; *Chung-kuo ku-tai shu-hua mu-lu*, vol. 2, 1985, *Ching* 1–2151; *Tung Ch'i-ch'ang hua-chi*, 1989, pl. 10; Zheng Wei, *Nien-p'u*, 1989, p. 67.

12 *In the Shade of Fine Trees*
Chia-shu ch'ui-yin
董其昌　嘉樹垂陰

Dated 1608

Hanging scroll, ink on silk
97.8 x 41.9 cm (38½ x 16½ in.)

Shanghai Museum

vol. 1, pl. 12

ARTIST´S INSCRIPTIONS AND SIGNATURES:
1. 6 lines in running script:
Dense tips of a hundred fine trees,
With noon comes cool shade under a canopy of vines.
Just because I was collating texts of the *Biographies of Eminent Monks*,
At a window under the pines, I allowed an illusion of the crane's dream to stretch on.
　Tung Hsüan-tsai painted and inscribed on the fifteenth day of the sixth month of the *wu-shen* year [July 26, 1608].

嘉樹森梢一百章
藤陰蒙翳午生涼
祇因校勘高僧傳
却誤松窗鶴夢長
　董玄宰畫并題，戊申六月之望。

2. 4 lines in running-cursive script:
Hsüan-yin [Yang Hsüan-yin] of the Ministry of Justice has several times through my son asked me for a painting and I send this to him as an offering. Though perhaps unsuccessful, it does come from my hand. Perhaps Hsüan-yin could use this as a yardstick in measuring the authenticity [of work attributed to me]. Tung Ch'i-ch'ang inscribed again.

玄蔭比部數從兒子請余畫，以此奉寄。雖不得工，乃出余手。玄蔭持此，心稱量真贋何如。董玄宰又題。

ARTIST'S SEALS:
Hua-ch'an 畫禪 (*chu-wen*, rectangle) **32**
T'ai-shih shih 太史氏 (*chu-wen*, square) **33**
Tung Ch'i-ch'ang 董其昌 (*chu-wen*, square) **34**

INSCRIPTION: Ho Yüan-yü 何瑗玉 (19th century), dated 1887, 1 seal:
In the eighth month of the *ting-hai* year [September 17–October 16,
1887], Ch'ü-an sending this to the great connoisseur Yü-fu for his pure
pleasure.

丁亥八月蓮盦寄贈玉甫大鑒家清玩。

LABEL STRIP: Hsi Kang 奚岡 (1746–1803), 1 seal.

COLOPHONS: Ho Yüan-yü, 2 undated, 2 dated 1881 and 1884, 4 seals

COLLECTORS' SEALS: Ho Yüan-yü, 2; Ch'ien Ching-t'ang 錢鏡塘 (20th
century), 2; unidentified, 3

RECENT PROVENANCE: Yan Zhongwan, Yan Zhongshen

This composition of an empty pavilion under a foreground grove of
trees separated by a large central area of enclosed water from a line of
hills, a valley village and a low central mountain athwart the distance,
is a handsome representative of Tung Ch'i-ch'ang's large, formal work
in the period 1600–10. The poem Tung inscribed on this painting,
presented in the second inscription to Hsüan-yin, is found in Tung's
collected poetry (*Jung-t'ai shih-chi, ch.* 4, p. 35), where Hsüan-yin is
named Yang Hsüan-yin, an Administrative Vice Commissioner in the
provincial government. This suggests that the painting and its poem
were intended for Yang from the beginning, even though the first,
dated inscription makes no mention of him. Nine years later, in 1617,
Yang was the recipient of one of the finest works of Tung's maturity
(vol. 1, pl. 33). At this point, in 1608, Tung's slightly irritable tone sug-
gests that he felt himself under a suspicion by Yang that the request
would be brushed off by a ghostpainter. Whether it was self-interest
or respect that caused Tung to take Yang's patronage so seriously is
unclear.

Despite Tung's conventional disclaimer, the painting is a serious
and careful work. The effusive pronouncements of the nineteenth-
century collector Ho Yüan-yü in his colophons refer resoundingly to
Tung Ch'i-ch'ang's own chosen patriarch Tung Yüan (fl. ca. 945–ca.
960) and in particular to his well-known though sometimes mysteri-
ous "half-scroll" masterpiece, *Travelers among Streams and Mountains*
(*Hsi-shan hsing-lü*), which, as Ho doubtless knew, was owned by Tung
Ch'i-ch'ang. There is little in this painting that might nowadays be
linked to the "half-scroll," although the balance of continuous and
fragmentary cliff structures with the associated heavy contrasting of
light and dark, the adaption of hemp-fiber texturing, the large fore-
ground trees, and the references to extensive population in the middle-
far ground are all appropriate to the "Tung Yüan" category. The
question is, What kind of category is involved? Ho is addressing my-
thology rather than history, and in this he reads Tung Ch'i-ch'ang cor-
rectly. In an inscription on the "half-scroll," Tung characterizes the
painting as "a sheet of Chiang-nan" (*Jung-t'ai pieh-chi, ch.* 6, p. 13).
This phrase, taken from the eleventh-century critic Mi Fu (1051–1107),
came to stand for a complex synthesis of cultural values embedded in
the historical and political geography of the Chiang-nan region and
cyclically rejuvenated and reinvested by the sequence of painters so
famously validated by Tung Ch'i-ch'ang himself.

With its nearby banks and trees, central waters, and soft distant
hills, this landscape represents Tung's most classical formulation of the
multivalent Chiang-nan ideal. Its bilateral symmetry imparts a stabili-
ty that Tung frequently eschewed. Here it is complicated but not
undermined. The breadth of the landscape and the forms of the hills
conjure those of Tung Yüan through the textures of Huang Kung-
wang (1269–1354). The clear typology of trees does the same, with
assistance from Ni Tsan (1301–1374). The empty pavilion is a charac-
teristic reworking of a Huang Kung-wang motif, still retaining a bal-
ance between a single and clustered dwellings, into an expanded
Ni-Tsanesque personality. The relationship between foreground and
background in Tung's paintings may perhaps be seen as an aspect of
his quasi-historical discourse. The extended foreground and the
stretching of motifs up the sides to link with the distance show the
influence of intervening Ming artists, especially Shen Chou (1427–
1509) and Wen Cheng-ming (1470–1559), of whom Tung would some-
times approve and who were both influenced by works of Tung Yüan
such as the "half-scroll." The small, compactly foliaged tree bending
over the pavilion seems almost a personalized reference to Wen Cheng-
ming.

In the Shade of Fine Trees is strongly reminiscent of *Viewing
Antiquities at Feng-ching* (*Feng-ching fang-ku*; vol. 1, fig. 29), Tung's
masterpiece of 1602. Its motifs, composition, and technique are, how-
ever, somewhat softer and more relaxed in comparison to that more
excited work. What links the two especially is their play with a physi-
cally occupiable space: the foreground is a space that invites one to
walk in, while the extremely assertive shoreline crossing the composi-
tion above the tall trees marks a denial to engagement at this level.
Tung could paint such narrative spaces, but generally it was only in
this decade that he chose to do so, to very calculated ends. His pur-
pose, through a trail that is often deliberately obfuscated, may have
been a greater rather than a lesser intensity of engagement with the
humanity of art.

The painting is a good example of the way in which Tung incorpo-
rates descriptive references in poems into paintings that on the surface
may seem quite unrelated. The poem's groves of "fine trees" are
exemplified in the foreground and generalized in the distance. There
are no vines, but the entire foreground grove is quite clearly treated as
a canopy, or screen. The texture of the painting is fairly moist. This is
in part necessitated by the use of silk, rather than paper, a choice that
conveys a certain formality in Tung's response to Vice Commissioner
Yang and an associated evocation of the solidity of Sung mountains
and waters in distinction to the more psychologically flavored pro-
cesses of the Yüan. Whereas paper makes possible a texture of extraor-
dinary depth and complexity, silk promotes more laterally distributed
but much richer tonal contrasts. The handling of tree foliage in the
lower left corner is an excellent example. But this moistness also en-
tails the lushness of late summer foliage and the depth of its shade.
The painting was done in late July. On another painting, Tung wrote:
"When under a pavilion there is nothing coarse, this is called 'trees of
seclusion.' Nothing gross. When foliage turns red and yellow after
frost, this is called 'in perfect flower.' Ch'ang-li [Han Yü, 768–824]
said, 'To [be able to] sit among dense trees until the end of the day,
the trees must be fine [lit. auspicious].' Everything is appropriate to a
season" (recorded in *Jung-t'ai pieh-chi, ch.* 6, pp. 23–24). Yang Hsüan-

yin's cultivated presence is obviously invited by the empty pavilion in such an auspiciously refined environment. It might even be suggested that the syncretism of the painting extends to a collective seasonality. The "dream of the crane" is the dream of a recluse and the suggestion in the last two lines in Tung's quatrain may perhaps be clarified through two lines from a Southern Sung poet, Hsü Chao, "The sleeping crane should have no dream, the talking monks must awake to the void." A long and leisurely self-cultivation should eventually lead to enlightenment beyond practice. The artist is perhaps implying that neither he nor the recipient have yet achieved it. In summary, this comparatively well-mannered work exemplifies an extremely important cultural distinction that Tung often demonstrated much more aggressively. Aspects such as formal structure (and its complementary analysis) that the West has usually placed in opposition to content were inseparable from meaning in a cultural commitment to structure rather than to abstraction.

JH

LITERATURE: Zheng Wei, *Nien-p'u*, 1989, p. 69.

13 *Paintings and Calligraphy on Round Fans*
Shu-hua t'uan-shan hsiao-ching
董其昌　書畫圖扇小景

Dated 1610

Album of ten paintings, ink on gold paper, with ten leaves of calligraphy, ink on paper
39.5 x 32 cm (15⁹⁄₁₆ x 12⅝ in.)

Hsü-pai Chai—Low Chuck Tiew Collection

vol. 1, pl. 13 (leaves 1, 3, 4–6, 8–10); vol. 2, pl. 13 (leaves 2, 7, colophon)

ARTIST'S INSCRIPTIONS AND SIGNATURES:
Leaf 1, 2 lines in running script:
"In the brush manner of Shan-ch'iao [Wang Meng, 1308–1385]." Hsüan-tsai.

《山樵筆意》玄宰。

Leaf 1a, 5 lines in running-cursive script:
In my household there is Wang Shu-ming's [Wang Meng] *Reading Books in Autumn Mountains*. It probably follows Chü-jan's (fl. ca. 960–ca. 986) *Wind in the Pines during Eighty-one Days of Summer*. This painting also aims at imitating their intent. Ch'i-ch'ang.

余家有王叔明《秋山讀書圖》。蓋師巨然《九夏松風》也。此亦欲倣其意。其昌。

Leaf 2, 2 lines in running script:
"Pines by a mountain torrent." Hsüan-tsai.

《澗松圖》玄宰。

Leaf 2a, 5 lines in running script:
"Dense and lush at the base of the mountain torrent; luxuriantly clustered, sprouting atop the mountain." This is Tso T'ai-ch'ung's [Tso Ssu,

d. ca. 306] poem; it appears in a calligraphy rubbing book of Wang Tzu-ching [Wang Hsien-chih, 344–388]. Ch'i-ch'ang.

《鬱鬱澗底松；離離山上苗。》左太沖詩；王子敬帖中有之。其昌。

Leaf 3, 2 lines in running script:
"Mist and rain at Yen Ford." Hsüan-tsai.

《延津煙雨》玄宰。

Leaf 3a, 4 lines in running-cursive script:
I have a *tz'u*-style poem in the tune of *Man-t'ing-fang* that records thoughts during rain at Yen Ford. I further made this, as if a *tz'u* poem within the painting. Ch'i-ch'ang.

余有《滿庭芳》詞，記延津雨思。又爲此，畫中詞也。其昌。

Leaf 4, 2 lines in running script:
"Overhanging precipice and cut-off cliffs." Hsüan-tsai.

《懸崖絕壁》玄宰。

Leaf 4a, 5 lines in running script:
That which is transmitted as Wang Yu-ch'eng's [Wang Wei, 701–761] *Wang-ch'uan t'u*, Mi Yüan-hui [Mi Yu-jen, 1074–1151] called "painting as if engraving." Nowadays in Wu-lin [Hang-chou] there is Kuo Shu-hsien's [Kuo Chung-shu, d. 977] direct copy of it. And after all, it is just like Hu-erh's [Mi Yu-jen] words. Ch'i-ch'ang.

王右丞所傳《輞川圖》，米元暉謂之"畫如刻畫。"今武林有郭恕先臨本。果如虎兒語。其昌。

Leaf 5, 2 lines in running script:
"Distant sky, isolated trees, and a high plateau." Hsüan-tsai.

《天邊獨樹高原》玄宰。

Leaf 5a, 6 lines in running script:
T'ang Tzu-wei's [T'ang Yin, 1470–1523] poem says:
Red trees on autumn mountains, disordered clouds flying;
Beneath the white thatched eaves shines the slanting light of day.
Amidst this there is much for leisurely enjoyment,
What is hard to describe to you, I paint for you.
　This picture is similar to the poem, but doesn't follow Tzu-wei's or Li T'ang's [ca. 1049–ca. 1130] painting. Ch'i-ch'ang.

唐子畏詩云：
　　紅樹秋山飛亂雲
　　白芧簷底屆斜曛
　　此中大有逍遙處
　　難說於君畫與君
此圖似之，然非學子畏、李唐畫也。其昌。

Leaf 6, 2 lines in running script:
"Ancient tree and lofty gentleman." Hsüan-tsai.

《古木高士》玄宰。

Leaf 6a, 4 lines in running script:
A man in the mountains, fragrant russet pear; like drinking from a stony stream, shaded by pines and cedars. Tung Ch'i-ch'ang.

山中人兮芳杜若；飲石泉兮蔭松柏。董其昌。

Leaf 7, 1 line in running script:
Painted by Tung Hsüan-tsai.

董玄宰畫。

Leaf 7a, 4 lines in running script:
"Autumn mountains enter the window screen, dripping green." This is old Tu's [Tu Fu, 712–770] poem; it rather possesses a painting's intent. Ch'i-ch'ang.

《秋山入簾翠滴滴》老杜詩也，顏有畫意。其昌。

Note: The line attributed to Tu Fu should be attributed instead to Chang Chih-ho (fl. ca. 780).

Leaf 8, 2 lines in running script:
"Beneath the mountain, isolated mists and a distant village." Hsüan-tsai.

《山下孤烟遠村》玄宰。

Leaf 8a, 4 lines in running script:
Landscape painters' use of luxuriant twigs on upright trees originated with Tung Pei-yüan [Tung Yüan, fl. ca. 945–ca. 960]. That is an example of what old Tu [Fu] called "requesting the gentleman to unloose his brush to paint straight tree trunks." Ch'i-ch'ang.

山水家森梢直樹，起於董北苑。老杜所謂："請君放筆爲直幹"者是已。其昌。

Note: The poetry quotation is from the last line of a poem by Tu Fu entitled "A Song Playfully Written for a *Picture of Twin Pines*, by Wei Yen [fl. late 7th–early 8th century]."

Leaf 9, 2 lines in running script:
"Valley stream and mountain pavilion." Hsüan-tsai.

《谿山亭子》玄宰。

Leaf 9a, 4 lines in running script:
In the Yüan dynasty Wang Shu-ming [Wang Meng], Ni Yüan-chen [Ni Tsan, 1301–1374], and Hsü Yu-wen [Hsü Pen, 1335–1380] all painted versions of *Valley Stream and Mountain Pavilion*. Tung Ch'i-ch'ang.

《谿山亭子》元時王叔明、倪元鎮、徐幼文皆有之。董其昌。

Leaf 10, 2 lines in running script:
"Mount Chiang-lang." Hsüan-tsai.

《江郎山圖》玄宰。

Leaf 10a, 6 lines in running script:
From Mount Lan-k'o eastward ascending, the tallow trees [*Saplum sebiforum*] form groves. Passing through frost, red and yellow are mutually inlaid together with the mountains' radiance bright and shining. There are distant mountain peaks, rising abruptly in front of the horse's head—this is Mount Chiang-lang. Having traveled and wandered amid the famous mountains within the seas, I have not yet seen these kind of strangely elegant triple peaks. Ch'i-ch'ang.

自爛柯山東上，烏白成林。經霜紅黃相錯，與山光映照。有遠巒兀突馬首，是江郎山。行遊海內名山，未見此奇秀三峰也。其昌。

ARTIST'S COLOPHON AND SIGNATURE (8 lines in running script):
In the new autumn, while escaping the summerlike heat, I unrolled Chiang Kuan-tao's [Chiang Shen, ca. 1090–1138] *Dwelling by the River* and Chao Ta-nien's [Chao Ling-jang, d. after 1100] *Lakeside Village*. All at once, I was aroused by the pure exhilaration of brush and ink. Consequently I completed ten leaves of small scenery. Ch'i-ch'ang. Written on the third day after the new moon in the seventh month of the *keng-hsü* year [September 5, 1610].

新秋暑退，展江貫道《江居圖》、趙大年《湖莊圖》。輒動筆墨清興，遂成小景十幅。其昌。庚戌七月望後三日識。

ARTIST'S SEALS:
Tung Ch'i-ch'ang 董其昌 (*chu-wen*, square; leaves 1–10) **39**
Tung-shih Hsüan-tsai 董氏玄宰 (*pai-wen*, square; leaves 1a, 3a–10a) **49**
T'ai-shih shih 太史氏 (*pai-wen*, square; 1a, 3a–10a) **37**
Tung Hsüan-tsai 董玄宰 (*pai-wen*, square; leaf 2a) **40**
T'ai-shih shih 太史氏 (*chu-wen*, square; leaf 2a) **38**
Hsüan-shang chai 玄賞齋 (*chu-wen*, tall rectangle; colophon leaf) **15**
Chih chih-kao jih-chiang kuan 知制誥日講官 (*pai-wen*, rectangle; colophon leaf) **16**
Tung Ch'i-ch'ang yin 董其昌印 (*pai-wen*, rectangle; colophon leaf) **17**

COLLECTORS' SEALS: Li Wen-t'ung 李文通 (Ch'ing dynasty), 1; Han Jung-kuang 韓榮光 (fl. ca. 1825–51), 1; Hu Chen 胡震 (Hu Pi-shan 胡鼻山, 1822–1867), 1; Huang Shao-hsien 黃紹憲 (fl. ca. 1891), 1; Low Chuck Tiew 劉作籌 (20th century), 17

This previously unpublished album, dated 1610, is an important document of Tung Ch'i-ch'ang's early middle period of activity, which also saw the production of the *Invitation to Reclusion at Ching-hsi* of 1611 (vol. 1, pl. 18), in The Metropolitan Museum of Art, and the dramatic *Landscape* of 1612 (vol. 1, fig. 30), in the National Palace Museum, Taipei. The fan-shaped album leaves are painted on gold paper, a relatively unusual medium for Tung. One of the few other examples of Tung's painting on gold paper is an undated album *Landscapes in the Manner of Old Masters* in the Shanghai Museum (*Tung Ch'i-ch'ang hua-chi*, 1989, pl. 22/1-8). Like the Shanghai album, the inscriptions in the *Album of Round Fans* similarly identify a variety of allusions to old styles.

The compositions in the *Album of Round Fans* are relatively unadventurous. The album concentrates instead on more intimate qualities: rich and subtle variations of foliage textures and exquisitely calculated arrangements of trees. Many features reveal connections with others of Tung's works. Tung seems to have used this and other albums as an opportunity to explore devices and themes that might appear, reconfigured, in other paintings. The stimulus for the project, according to the artist's colophon, was Tung's review during a period of late summer idleness of two Sung dynasty scrolls in his collection. The painters Chiang Shen and Chao Ling-jang are not otherwise mentioned in the inscriptions to individual leaves; thus it appears that the old paintings served as generalized stimuli to emulation or competition, rather than as specific sources. The *Ch'ing-ho shu-hua fang* records Tung Ch'i-ch'ang's purchase of a Chiang Shen handscroll entitled *Rivers and Mountains without End* (*Chiang-shan pu-chin*); and the handscroll *River Village on a Cool Summer Day* (*Chiang-hsiang ch'ing-hsia*) by Chao Ling-jang, in the Museum of Fine Arts, Boston, bears Tung's colophons and may well be the specific work cited in his account of his painting of the *Album of Round Fans*.

Among the painted leaves of special interest, "Valley Stream and Mountain Pavilion" (vol. 1, pl. 13–9) makes use of a narrow vertical ridge with steep, infolded fissures angling rightward at the right edge of the leaf, a form that strikingly foreshadows the dramatic central ridge of the 1612 *Landscape* in Taipei. In the fan-shaped leaf the rightward movement is answered by the leftward projections of folded rocks above. The title and theme of the leaf recurs in the Bei Shan

Tang album *Landscapes in the Manner of Old Masters* (vol. 1, pl. 14–6), where the subject is associated with Ni Tsan. Here the emphasis on broad movements of dynamically shaped forms suggests Huang Kung-wang (1269–1354) as a likely model.

The leaf "In the Brush Manner of Wang Meng" (vol. 1, pl. 13–1) is also of special interest, because it seems to be one of Tung Ch'i-ch'ang's earliest explicit explorations of a manner that would yield some of his most powerful designs, such as the Cleveland *Ch'ing-pien Mountain* of 1617 (vol. 1, pl. 32) and a leaf in the Nelson-Atkins *Landscapes in the Manner of Old Masters* of 1621–24 (vol. 1, pl. 42–2). The Wang Meng image-source utilized here is that seen in Wang's hanging scroll *Forest Dwellings at Chü-ch'ü* (*Chü-ch'ü lin-wu*; Cahill, *Chinese Painting*, 1960, p. 114), a painting packed with densely textured, deeply fissured and folded vertical ridges that seem to have been molded by powerful pressures and that, in turn, exert powerful and barely constrained outward forces. Tung Ch'i-ch'ang wrote two colophons for Wang Meng's *Forest Dwellings at Chü-ch'ü*, so his model can be identified with some confidence. The dynamically scalloped, inverted anvil-shaped hollow at the center of Tung's composition is echoed in the positive upright form of the spreading ridge to the upper left; the entire composition builds in a cascading flow of rock toward the upper left, where the interruption of the border cuts off the dynamic movement without fully resolving its forces.

Although his paintings most often reference earlier pictorial formulations, Tung Ch'i-ch'ang alludes to specific places and the experiences he had of them with some frequency in his inscriptions. In many cases the specificity of experience was mediated in some way: either the scene reminded Tung of a painting he knew, and thereby in that sense became "picturesque" in his rendering, or the perceptual experience of the site was made secondary to the events, meetings, or viewings that took place there, and the landscape became a stage for cultural activities. The leaf illustrating Mount Chiang-lang in the *Album of Round Fans* (vol. 1, pl. 13–10) conveys both in picture and in text a relatively unusual sense of Tung's captivation by the dramatic topography of the place. Tung was probably familiar with the site, and Wai-kam Ho has noted that the distinctive peaks of Mount Chiang-lang are located in Ch'ü hsien, the native place of Chiang Shen, whose painting was one of the sources of inspiration for the album. A saddle-shaped ridge and leftward thrusting bluff in the center of the composition presumably depict the distinctive peaks mentioned in his inscription. The ascending, heavily shaded stepped cliffs at the upper left are hardly less dramatic, and have the additional interest of foreshadowing the shape and treatment of the Wang Meng–style landscape in the Nelson-Atkins album of 1621–24 (vol. 1, pl. 42–2).

Some other references in the *Album of Round Fans* carry resonances with works from other phases of Tung Ch'i-ch'ang's career. The statement in one of the calligraphy leaves (vol. 1, pl. 13–8a) that the manner of using luxuriant twigs on upright trees originated with Tung Yüan is of interest because it reflects the part of Tung Ch'i-ch'ang's writings and sketches concerned with analysis of technique. In fact, the concern with variations of tree textures is one of the paramount themes of the *Album of Round Fans*. Treatments range from thin sheets of wash to meticulously positioned horizontal dots—whose vibrancy recalls one of Tung's sources in the Chao Ling-jang landscape which may have inspired him to paint the album—and to a notable

device of floating, dark spreading wash dots over paler stippled dots that has an unusual, indeterminate visual effect and seems particularly suited to the slick surface of gold paper. As Wai-kam Ho has pointed out, the subtle tonal variations on the extremely difficult surface of gold paper show an absolute mastery of ink and brush technique. No artist before or after Tung Ch'i-ch'ang was able to match this accomplishment. Another of Tung's inscriptions in the present album (vol. 1, pl. 13–4a) refers to Kuo Chung-shu's copy of Wang Wei's *Wang-ch'uan Villa* composition, one of the sources for Tung's earlier *Landscape after Kuo Chung-shu* in the Östasiatiska Museet, Stockholm (vol. 1, pl. 4).

RV

14 *Landscapes in the Manner of Old Masters (tai-pi)*
Fang-ku shan-shui
董其昌　倣古山水

Undated (ca. 1610–12)

Album of eight paintings, ink and color on silk
27.8 x 24.4 cm (10¹⁵/₁₆ x 9⅝ in.)

Bei Shan Tang Collection

vol. 1, pl. 14; vol. 2, pl. 14 (colophon)

ARTIST'S INSCRIPTIONS AND SIGNATURES:
Leaf 1, 4 lines in running script:
"Cold Grove." This imitates the brush intent of Li Ying-ch'iu [Li Ch'eng, 919–967]. Hsüan-tsai.

《寒林圖》此倣李營丘筆意。玄宰。

Leaf 2, 2 lines in running script:
Imitating the brush method of Pei-yüan [Tung Yüan, fl. ca. 945–ca. 960]. Hsüan-tsai.

擬北苑畫法。玄宰。

Leaf 3, 3 lines in running script:
Heaven sends down timely rain;
Mountains and streams produce clouds.
　Hsüan-tsai painted this.

天降時雨
山川出雲
　玄宰畫。

Leaf 4, 3 lines in running script:
Mountain peaks of Ch'u—a thousand ridges jade-green;
On the Hsiang River—a single yellow leaf.
　Painted by Hsüan-tsai.

楚岫千峰碧
湘潭一葉黃
　玄宰畫。

Leaf 5, 2 lines in running script:
Imitating Tzu-chiu's [Huang Kung-wang, 1269–1354] brush. Tung Hsüan-tsai.

倣子久筆。董玄宰。

Leaf 6, 3 lines in running script:
Imitating Yün-lin's [Ni Tsan, 1301–1374] *Valley Stream and Mountain Pavilion.* Hsüan-tsai.

倣雲林《谿山亭子》。玄宰。

Leaf 7, 3 lines in running script:
This is a study of the lofty Ni's [Ni Tsan] brush. I did this from imagination. Hsüan-tsai.

此學倪高士筆也。余以意倣之。玄宰。

Leaf 8, 5 lines in running script:
The stony stream's flowing is already disordered;
A mossy byway enters, gradually becomes tiny.
The sun sets below the eastern grove;
The mountain monk returns alone.
　Painted by Hsüan-tsai.

石谿流已亂
苔徑入漸微
日暮東林下
山僧還獨歸
　玄宰畫。

ARTIST'S SEAL:
Tung Ch'i-ch'ang yin 董其昌印 (*pai-wen*, square; leaves 1–8) 52

COLOPHON: T'ang Ch'ou 唐醻 (late Ming dynasty), undated, 3 seals:
This album was done by Wen-min kung [Tung Ch'i-ch'ang] while visiting Mr. Feng at Tai-tsung [Mount T'ai, Shantung] and before assuming his official robes. Looking at the album's mobile spirit and moving intent, [one knows that] it is completely a fine and delicate achievement of the brush from his youth. Subsequently, when he entered the Han-lin Academy, there were times when [his works] also had skillful and delicate passages, refined beyond comparison and without the least bit of carelessness. Then, in his late years, if one covered up his inscriptions and signatures [on such works, even if] the gentleman [Tung Ch'i-ch'ang] himself reviewed them, he wouldn't recognize them! Forgeries found in the present-day world only make use of a broad summary to achieve superficial resemblance. Most laymen believe that Tung Ch'i-ch'ang's art is limited to those [works similar to the forgeries]. Seeing a finely painted work, on the other hand, they shout out that it is not his. They are probably those who have "seen only the spots and not the entire leopard" [i.e. people of narrow and partial views]. In the *wu-yin* year of the Ch'ung-chen era [1638], I stayed as a guest with [Feng's] grandson. Because I loved looking at [this album], my host presented it to me. Accordingly I have obtained this treasure, and also understood its history which I record at the end [of the album]. This [I do] so that when later men look at it, there will be those who know that the paintings of the gentleman's youthful years were like the budding plant's first life, or the stream's first flowing—possessing an uncheckable momentum. One cannot take the rough and hasty brushwork of his late life and speak of it on the same day! T'ang Ch'ou of Nan-p'u inscribed this at the Horse-track Hall.
(Translation by Richard Vinograd and Wai-kam Ho.)

此册乃文敏公釋褐以前遊於岱宗馮氏家作。觀其行神運意，俱少年精到之筆。嗣後，入院時，亦嘗有工緻處，精妙絕倫，無纖毫苟且。迫晚年，掩其欵識，公自閱之，亦不知矣。今世之賞者，僅以大略肖其皮毛耳。目習俗遂謂公作止於是。見有入細畫，反譁之以爲非。此蓋"未窺全豹"者也。崇禎戊寅，余客于岱宗之孫。主人以好見投。因獲此珍，并曉其顛末，記之于尾。使後人觀之，有以知公少年時畫，如萌之始生，泉之始流，有不可遏之勢。未可以末路粗率之筆同日而語也。南浦唐醻題于馬跡堂。

COLLECTOR'S SEALS: T'ang Ch'ou, 2

This album in the Bei Shan Tang Collection is strikingly similar to an album of six paintings on silk entitled *Dream Journeys to the Five Mountains*, in the Tokyo National Museum (Kohara, Wu, et al., *Jo I, To Kisho*, 1978, pls. 73–76). The poetic inscription on the third leaf of the Bei Shan Tang album is also found on one of the Tokyo leaves, and several of the compositions have close counterparts. Above all, the broad brushwork and loose, atmospheric quality of the two albums indicate a common derivation. It seems likely that both works belong to the category of *tai-pi* (works of substitute brushes or ghostpainters), and there are compelling reasons to doubt that the two albums were contemporaneous with Tung Ch'i-ch'ang. Both works betray the qualities of late Ming Sung-chiang School painting associated with Sung Hsü (1525–after 1605) and Chao Tso (ca. 1570–after 1633), the latter known to have produced works for Tung Ch'i-ch'ang's signature. Celia Riely has noted that the seal on the Bei Shan Tang album appears on other works attributed to Tung Ch'i-ch'ang dated to the period 1610–12, suggesting an estimated range for the date of the present album. Thus the colophon by T'ang Ch'ou, which mentions his having received the album in 1638, only two years after Tung's death, may well be genuine, only betraying in its effusive praise of the album as an early work of Tung's in a fine and delicate style (a style in some respects untypical of his best-known manner) a hint of contemporary doubts about the album's authenticity.

The qualities that raise doubts about the Bei Shan Tang and Tokyo albums are worth remarking because they may be symptomatic of a larger class of substitute paintings or, more generally, of imitations attributed to Tung Ch'i-ch'ang. Both albums are strongly atmospheric, with evocations of mist and visual blurring, soft textures and deep space, in a manner that seems to have seldom concerned Tung himself, at least in such straightforward and nonidiosyncratic formulations. Neither work conveys much of the structural ambiguities, dynamic tension of momentum, or analytical treatment that characterizes so many of Tung's fully realized works in all phases of his career. In its inscriptions, the Bei Shan Tang album in particular evokes the theme of imitations of the styles of old masters, principally the Yüan painters Ni Tsan and Huang Kung-wang and the tenth-century patriarchs Li Ch'eng and Tung Yüan, but in none of the paintings is there a sense of the competitive, often anxiety-ridden, engagement with the styles of the past that shapes, or deforms, Tung's characteristic works. Both albums are thus more attractive in a straightforward way and more representationally oriented than most of Tung's works. The leaves in the manner of Tung Yüan and Huang Kung-wang (vol. 1, pls. 14–2, 14–5), as well as the final leaf (vol. 1, pl. 14–8), convey something of the fracturing of forms and the tension of momentum that we associate with Tung, thereby placing the album within his

orbit of influence, but the treatment throughout is so soft and concili-
atory of ambiguities and tensions that nothing much comes of these
ventures in formal manipulation.

RV

LITERATURE: Suzuki, *Comprehensive Illustrated Catalogue*, 1982–83, vol. 2,
s7–044; *Tung Ch'i-ch'ang hua-chi*, 1989, app. pl. 148.

15 *Water Village and Mountain Colors (tai-pi)*
Shui-hsiang shan-se
董其昌　水鄉山色

Undated (ca. 1610–15)

Hanging scroll, ink and color on silk
151 x 49.5 cm (59⁷⁄₁₆ x 19½ in.)

Shanghai Museum

vol. 1, pl. 15

ARTIST'S SIGNATURE (1 line in running script):
Tung Hsüan-tsai painted.
董玄宰畫。

ARTIST'S SEALS:
T'ai-shih shih 太史氏 (*pai-wen*, square) **25**
Tung Ch'i-ch'ang yin 董其昌印 (*pai-wen*, square) **26**

INSCRIPTION: Ch'ien Hsiang-k'un 錢象坤 (1569–1640), undated, 1 seal

NO COLOPHONS

COLLECTORS' SEALS: unidentified, 2

LITERATURE: *Chung-kuo ku-tai shu-hua mu-lu*, vol. 3, 1987, *Hu* 1–1393;
Chung-kuo ku-tai shu-hua t'u-mu, vol. 3, 1990, *Hu* 1–1393.

16 *Blue and Green Landscape in the Manner of Chao Meng-fu* (by attribution)
Fang Chao Tzu-ang hua
董其昌　倣趙子昂畫

Undated (ca. 1610–15)

Hanging scroll, ink and color on silk
179.7 x 99.9 cm (70¼ x 39⁵⁄₁₆ in.)

Beijing Palace Museum

vol. 1, pl. 16

ARTIST'S INSCRIPTION AND SIGNATURE (2 lines in running script):
Tung Hsüan-tsai imitated Chao Tzu-ang's [Chao Meng-fu, 1254–1322]
painting.
董玄宰倣趙子昂畫。

ARTIST'S SEALS:
Hsüan-shang chai 玄賞齋 (*pai-wen*, tall rectangle) **23**
Tung Ch'i-ch'ang yin 董其昌印 (*pai-wen*, square) **24**

NO COLOPHONS

COLLECTORS' SEALS: unidentified, 2

LITERATURE: *Chung-kuo ku-tai shu-hua mu-lu*, vol. 2, 1985, *Ching*
1–2231.

17 *Landscapes in the Manner of Old Masters*
Fang-ku shan-shui
董其昌　倣古山水

Dated 1611

Album of seven paintings, ink on silk
30.8 x 28.5 cm (12⅛ x 11¼ in.)

Beijing Palace Museum

vol. 1, pl. 17

ARTIST'S INSCRIPTIONS AND SIGNATURES:
Leaf 1, 3 lines in running script:
Hsüan-tsai painted for [my] fellow club member Ching-t'ao [Chu Kuo-
sheng]. On the day of the spring lustration of the *hsin-hai* year [1611].
玄宰畫爲敬韜社兄，辛亥春，禊日。

Leaf 2, 2 lines in running script:
After Mi Yüan-hui [Mi Yu-jen, 1074–1151]. Hsüan-tsai.
倣米元暉。玄宰。

Leaf 3, 2 lines in running script:
After Huang Tzu-chiu [Huang Kung-wang, 1269–1354]. Hsüan-tsai.
倣黃子久。玄宰。

Leaf 4, 2 lines in running script:
After Huang-ho-shan-ch'iao [Wang Meng, 1308–1385]. Hsüan-tsai.
倣黃鶴山樵。玄宰。

Leaf 5, 1 line in running script:
Hsüan-tsai ink-play.
玄宰墨戲。

Leaf 6, 1 line in running script:
Hsüan-tsai painted.
玄宰畫。

Leaf 7
1. 2 lines in running script:
In the *hsin-hai* year [1611], on the day of the spring lustration, [I] painted
eight leaves of small scenes. Tung Hsüan-tsai.
歲在辛亥禊日，寫小景八幅。董玄宰。

2. 5 lines in running script:
My brushwork of the *hsin-hai* year now suddenly turns up at the admin-

istrative branch office on Lake P'i-she. Ching-t'ao has brought it out to show me [and ask] for another inscription. Ch'i-ch'ang, on the nineteenth day of the second month of the *jen-hsü* year [March 30, 1622].

辛亥筆，今日至覽社湖分司署中，敬韜出以見示，重題。其昌，時壬戌二月十九日。

NO ARTIST'S SEALS, COLOPHONS, OR COLLECTOR'S SEALS

The artist's first inscription on the last leaf of this album refers to eight leaves. Nothing is known of the missing leaf. Ching-t'ao, for whom the album was painted in 1611 and reinscribed eleven years later, in 1622, was Chu Kuo-sheng. He had an eminent official career, rising to be Minister of Works, but his life remains otherwise obscure. His family was from Tung's own hometown, Hua-t'ing, and Tung evidently knew them (see *Jung-t'ai shih-chi, ch.* 3, p. 7; *ch.* 4, pp. 14–15). Lake P'i-she is located north of Kao-yu, approximately midway between Yang-chou near the Yangtze and Ch'ing-ho on the Yellow River, by the canal and connecting them. In 1622 Tung returned to the capital as an editor of the Veritable Records of the previous reign. The records were presented in the eighth month. Tung may have been traveling north during the second month.

By "the day of the spring lustration," Tung may be referring specifically to the third day of the third month or, probably, more loosely to the beginning of the month. This was the time when, in the year 353, Wang Hsi-chih's friends had gathered at the Orchid Pavilion. Any meeting of friends at this season had at least a distant resonance with this most famous of all literary gatherings.

Tung's inscriptions might imply that all the leaves were painted on the same day. The amount of work embodied in the album, however, suggests a slightly more leisurely pace. Nevertheless, there is a high level of continuity running through the surviving seven leaves. The abbreviated and very consistent inscriptions, and the complete lack of seals, also indicate a common circumstance and purpose. Whether, peculiarly, Tung was without his seals at this moment or whether their absence was due, for example, to an exceptionally informal attitude, is difficult to say. The lack of seals on another album (vols. 1 and 2, pl. 59) was said by a later collector to have been due to the work's being purely a family affair. Whereas the inscriptions here exhibit a somewhat casual attitude, the paintings themselves are no idle work. The paintings are on silk, which in itself bestows a certain formality. Perhaps Chu Kuo-sheng had provided the material. The variations in the inscriptions, between references to particular artists and generalized comments such as "ink-play," though they may seem trivial, raise perennially interesting questions about how meanings were negotiated in this concluding phase of a performance.

It might be too explicit an interpretation to say that Tung's pictorial variations here are analogous to the poetic variations of the Orchid Pavilion assembly but, at some level, the functions are comparable. There is a compositional schema—a row of foreground trees across a lateral screen of distant mountains—that runs through a set of structural and executive variations. Leaves 2, 3, and 4 are referred to Mi Yu-jen, Huang Kung-wang, and Wang Meng respectively. Leaf 7, which must originally have been the eighth and last, is unmistakably a reference to Ni Tsan (1301–1374). Mi Yu-jen is, so to speak, a reversion from Kao K'o-kung (1248–1310), and these four Yüan artists were those to whom Tung felt most personally and profoundly at-

tached. Leaf 5, in which Tung "plays," might be read as one of Tung's many comments on Chao Meng-fu's (1254–1322) *Village by the Water* (*Shui-ts'un t'u*; Cahill, *Hills Beyond a River*, 1976, pl. 13). Leaf 6 seems like a gesture to Shen Chou (1427–1509) and Wen Cheng-ming (1470–1559), while the first leaf is perhaps an almost subconscious opening bow to Tung Yüan (fl. ca. 945–ca. 960). These modes of execution, and even that of Tung Yüan by this later time, were generally associated with paper. The artist's knowing adaption of them to the greater clarity and weight of a silk-brushed technique imparts a very distinctive flavor.

These are all scenes of Tung Ch'i-ch'ang's Chiang-nan mythology. Some of them, such as leaves 1, 5, and 7, at first glance seem not far removed from the widespread pictorial conventions that Tung was trying so persistently to remythologize. But the superficiality is misleading. In the first leaf, for instance, the long caterpillar of white that crawls along the contour of the central hill, the carefully disjunct ground lines, and the ponderous dance of the trees, each like a character out of some Ming mummenschanz, are all symptoms of the change that has already matured. The bands of clouds that writhe their way, like intestinal ghosts, across the Mi-Kao mountains in leaf 2 are a comfortably relaxed revisitation of the climactic disturbance in the *Misty River and Piled Peaks* (vol. 1, pl. 7) handscroll of 1605. Chao Meng-fu's *Village by the Water*, a probable source in leaf 5, was in Tung's collection. Huang Kung-wang's *Dwelling in the Fu-ch'un Mountains* (*Fu-ch'un shan-chü*; vol. 1, fig. 17), the certain source of leaf 3, he acquired in 1596. Leaf 4, an especially inspired passage of invention, could have been provoked by several works by Wang Meng, although there are specific hints of Wang's *Ch'ing-pien Mountain*, which Tung had seen (Cahill, *Hills Beyond a River*, pl. 53). The twisted and swirling cliff mass on the right, out of which a monstrous face threatens to emerge, would be worthy of Ch'en Hung-shou (1598–1652) at his most outrageous. The aggressively linear technique in this leaf, though readily associated with Wang Meng, is an unusual and almost "camp" indulgence for Tung himself.

Tung subjects all these visualizations to his own vision, not only in personality but also in presence. The trees in the first leaf appear to have been worked through and even inserted after the composition was laid out. In the following leaves, they seem to have established their presence earlier in the structural process, as though Tung had discovered his theme for the album while working on the opening leaf. Trees, though formally derived from Yüan conventions, exert a peculiarly psychological force in many of Tung's works. In this album, he asserts this most distinctively in the Huang and Wang leaves. The source images here are sufficiently clear in their lack of such foreground trees for their intrusive stance to be seen as a very willful intervention. In the Huang Kung-wang leaf, Tung seems to have planted a quotation from the eleventh-century painter Kuo Hsi (ca. 1020–ca. 1100) in front of Huang's very nose, as though to remind him both of an unorthodox origin and an equally unorthodox outcome. The schema prominent in these leaves, which Tung had been developing over several years, continues to inspire some of his finest paintings for more than a decade.

JH

LITERATURE: *Chung-kuo ku-tai shu-hua mu-lu*, vol. 2, 1985, *Ching* 1–2153.

18 *Invitation to Reclusion at Ching-hsi*

Ching-hsi chao-yin t'u

董其昌　荊谿招隱圖

Dated 1611

Handscroll, ink on paper
28.4 x 120 cm (11⅛ x 47¼ in.)

The Metropolitan Museum of Art, New York
Gift of Mr. and Mrs. Wan-go H.C. Weng, 1990 (1990.318)

vol. 1, pl. 18; vol. 2, pl. 18 (colophons)

ARTIST'S INSCRIPTION AND SIGNATURE (3 lines in running script):
"Invitation to Reclusion at Ching-hsi," written [painted] by Tung Hsüan-tsai on the Day for Mankind [seventh day of the first month] in the *hsin-hai* year [February 19, 1611] at the Precious Cauldron Studio.

《荊谿招隱圖》，辛亥人日董玄宰寫于寶鼎齋。

ARTIST'S COLOPHON AND SIGNATURE (mounted after the painting; 20 lines in running script):
I did this [painting] for Ch'e-ju [Wu Cheng-chih, d. ca. 1619], Assistant Minister of the Court of Imperial Entertainments, in the *hsin-hai* year [1611]. This year I was summoned from the countryside [where I was living in retirement] for official service at the same time as Ch'e-ju. I have already vowed in front of my ancestors' tombs not to go, and it is Ch'e-ju's idea also to remain remote and withdrawn; so I am taking a poem that I once presented to a friend and am inscribing it on this scroll:

> I am like clouds returning to the mountain
> You are like the rising sun.
> To go forth [and serve] or abide at home, either is appropriate,
> Why must one [live in isolation like] a crane or gibbon?
> Only those who shun this world,
> Can live out their days in the Peach Blossom Spring [an idyllic community of hermits celebrated in poetry by T'ao Ch'ien, 365–427; see Hightower, *The Poetry of T'ao Ch'ien*, 1970, pp. 254–56].

Let Ch'e-ju take this [painting] with him when he travels to Chiang-men [Kiangsi, where Wu had recently been reassigned; see Celia Carrington Riely, "Tung Ch'i-ch'ang's Life," part 4, in vol. 2 of this catalogue] [so that] when he peruses it he will know that I am not behaving like K'ung Chih-kuei [447–501, a famous recluse who rebuked a friend who accepted an official appointment after professing his intention to retire; see Riely, "Tung Ch'i-ch'ang's Life," part 4]. Three days after the mid-autumn [festival] in the eighth month of the *kuei-ch'ou* year [October 1, 1613], the *nien-ti* [*chin-shih* graduate of the same year], Tung Ch'i-ch'ang of Hua-t'ing wrote this in a skiff near Wu-ch'ang.

此余辛亥歲爲澂如光祿作也。今年予自田間被徵，與澂如同一啓事。予既已誓墓不出，而澂如亦意在鴻冥；余舉贈友人詩題此卷曰：
　　我如還山雲
　　君如朝日暾
　　出處各有宜
　　何必鶴與猿
　　惟容避世者
　　終老桃花源
澂如攜此遊江門，時以展之，知余不作孔稚圭舉止也。癸丑八月中秋後三日，華亭年弟董其昌，書於吳昌舟次。

ARTIST'S SEALS:
Tung Ch'i-ch'ang yin 董其昌印 (*pai-wen*, square) **51**
Hsüan-shang chai 玄賞齋 (*pai-wen*, tall rectangle; colophon) **18**
Chih chih-kao jih-chiang kuan 知制誥日講官 (*pai-wen*, square; colophon) **19**

Tung Ch'i-ch'ang yin 董其昌印 (*pai-wen*, square; colophon) **20**

LABEL STRIP: unidentified, undated, 1 seal

COLOPHONS: Wu Cheng-chih 吳正志, dated 1617, 2 seals; Weng T'ung-ho 翁同龢 (1830–1904), dated 1877, 1 seal

Colophon by Wu Cheng-chih:
I have known Hsüan-tsai [Tung Ch'i-ch'ang] since before we passed the [*chin-shih*] examination. At that time, Hsüan-tsai's talent was already well known. Later, we were selected at the same time [1589] to be "presented scholars" (*chin-shih*). A great many of our generation competed to be chosen by the examination officials for high honors, but among the successful Han-lin candidates, even Hsüan-tsai, who was at the top, was almost bested by the most able ones. I humbly withdrew and didn't take the examination; furthermore, on account of some "wild remarks" [I made; see Riely, "Tung Ch'i-ch'ang's Life," part 4], I was ordered to a remote post. Because of this, Hsüan-tsai began to regard me as a friend. Barely ten years later [i.e. 1599], he was also transferred from his position as historian [at court] to a provincial post. From Mao-hu [a lake in Sung-chiang, Kiangsu] to Ching-hsi [a stream near I-hsing, Kiangsu] it is almost 600 *li* [200 miles], but we traveled to and fro [to visit one another], and continued to stay in touch without interruption.

I once asked [Tung] for a painting and although in his heart he wanted to respond, he never did. In the *wu-shen* year [1608], because of my naïve rectitude, the powerful and influential Ch'en Chih-tse had me removed as Assistant Minister of the Court of Imperial Entertainments, where I had been for only a brief time, and had me demoted to an administrative post in Hu-chou [Wu-hsing, Chekiang]. Because Hsüan-tsai was also disliked by this man, he shared the same "affliction" and so we sympathized with each other's plight. When he came to visit me at my Hall of Rising Clouds (Yün-ch'i lou), he presented me with two scrolls and a painting. Since each time he was sent to an official post there were those who were jealous of him, he was not permitted to come out of retirement. Although I am just a small blade of grass, I also had the deep feeling that I should follow the example of P'eng-li [i.e. T'ao Ch'ien, who retired from office in P'eng-li after only eighty days], so I shook off my [official] garb and returned home. Thus, this picture became an omen. Now, [dwelling in retirement] in the mountains, time is abundant so we white-haired brothers can sit in our calligraphy and painting boat [like Mi Fu, 1051–1107] and discuss scholarly matters back and forth. Since we have sworn not to be caught [again] by the hunters, why should we wait for an invitation to become recluses? On the summer solstice of the *ting-ssu* year [June 21, 1617], the long-hibernating idle fellow, Wu Cheng-chih wrote this.

余識玄宰在未第前，時玄宰才名謙甚。後同舉進士，群輩競爲考館逐鹿，即玄宰臚唱第一，幾屬捷足所先。余遜不就試，又以狂言謫塞外，玄宰由此見知。不十年，玄宰亦以史官外補。自泖上至荊谿，幾六百里，扁舟過從，音問不絕。曾乞畫，玄宰雖心諾而未踐也。戊申復以慧直爲權門要人陳治則所逐，光祿之席未煖，黜爲湖州司李。玄宰故見惡斯人者，不覺同病相憐，訪余雲起樓頭，貽以二卷一畫。既各移藩臬，忌玄宰者，未容出山。余雖爲小草，亦望望然從彭蠡拂衣而歸，此圖遂成先識矣。今而後，山中日月正長，白首兄弟載書畫船，問字往還，誓不爲弋者所慕，又豈待招而後隱哉？丁巳夏至日，長蟄散人吳正志識。

COLLECTORS' SEALS: Weng T'ung-ho, 5; Weng Wan-ko 翁萬戈 (Wan-go Weng, b. 1918), 2

RECENT PROVENANCE: Weng T'ung-ho, Wan-go Weng

Invitation to Reclusion at Ching-hsi, painted in 1611 when Tung Ch'i-ch'ang was fifty-seven *sui* (fifty-six years old), is an important experi-

mental work of the artist's formative years. In it, we see Tung exploring the relationship between abstraction and naturalistic description. In the right half of the scroll, interlocking wedge-shaped masses create the illusion of a logical spatial recession. In the second half, logic is abandoned: ground planes shift, changes in scale are capricious, frequent contrasts between light and dark ink deny the blurring effects of atmosphere, and the illusion of recession is confounded by flat patterns of brushwork and patches of blank paper that continually assert the two-dimensionality of the picture surface. Following his dictum that "if one considers the wonders of brush and ink, real landscape can never equal painting," Tung has rejected the imitation of nature in favor of animating his picture with energetic brushwork and unstable landscape forms whose tilting, leaning, and bulging shapes create dynamic compositional movements.

As the painting's title suggests, the scroll invites the viewer on a journey that leads not only from illusionism to abstraction, but from the external world of appearances to the inner world of the recluse's mind. In so doing, it visualizes the disparate worlds between which both the artist and the scroll's recipient, Tung's longtime friend Wu Cheng-chih, must choose. In 1611, the year of the painting's execution, Tung had been living in retirement for twelve years while Wu continued to endure the vicissitudes of official service. Shortly after both men earned their *chin-shih* degrees in 1589, Wu had narrowly avoided being flogged for his idealistic defense of the reformer Chao Nan-hsing (1550–1627; see Goodrich and Fang, *Dictionary of Ming Biography*, 1976, pp. 128–32). Wu was demoted and promoted several times in subsequent years, rising to the rank of Assistant Minister of the Court of Imperial Entertainments in 1607 only to be demoted again in 1608 to the post of Prefectural Judge in Hu-chou, Chekiang. It was at this low point in Wu's career that Tung presented him with this painting, beckoning him to become a recluse. Though Wu may have expressed an inclination to retire, in 1612 he accepted the directorship of a bureau in the Ministry of Justice in Nanking. The very next year he was again reassigned to a provincial post in Kiangsi (see Riely, "Tung Ch'i-ch'ang's Life," part 4). It was at this moment that Tung added his long colophon, asserting that he would not rebuke his friend for preferring government service over retirement. Shortly thereafter, however, Wu did resign, declaring in his colophon of 1617 that Tung's painting was like an omen that presaged his renunciation of officialdom in favor of reclusion. Ching-hsi, Wu's place of retirement, is a stream located just south of his hometown of I-hsing, Kiangsu.

MKH

A copy of this scroll, which transcribes Tung's colophon but lacks those of Wu Cheng-chih and Weng T'ung-ho, is also known (Ch'en Jen-t'ao, *Chin-kuei ts'ang hua chi*, 1956, pl. 33).

EXHIBITION: University Art Museum, Berkeley, 1971: Cahill, *Restless Landscape*, no. 34.

LITERATURE: Sirén, *Leading Masters and Principles*, 1956–58, vol. 5, p. 8, vol. 7 (lists), p. 247; Wu, "Apathy in Government and Fervor in Art," 1962, pl. 3; Suzuki, *Chinese Art in Western Collections*, 1973, vol. 2, no. 23; Kohara, Wu, et al., *Jo I, To Kisho*, 1978, vol. 5, pl. 18; Kohara, *To Kisho no shoga*, 1981, pls. 7, 47, pp. 237–38, 262–63; Suzuki, *Comprehensive Illustrated Catalogue*, 1982–83, vol. 1, A13–055; Cahill, *Distant Mountains*, 1982, pp. 96–97, pl. 39; *I-yüan to-ying* 34 (1987): 22.

19 *Sketches of Traditional Tree and Rock Types*
Chi ku shu-shih hua-kao
董其昌　集古樹石畫稿

Undated (ca. 1611)

Handscroll, ink on silk
30.1 x 527.7 cm (11⅞ x 207¾ in.)

Beijing Palace Museum

vol. 1, pl. 19

ARTIST'S INSCRIPTION (7 lines in running script):
The painting *Golden Palace amid Myriad of Pines* by Chao Hsi-yüan [Chao Po-su, 1123–1182] was executed in horizontal and vertical dots alone. Ink was not used extensively, but reinforced with green color washes. This shows that even Mi Fu [1051–1107] had learned from Wang Wei [701–761]. The *ma-ya* [horse-tooth] texturing technique was not used at all.

《萬松金闕》趙希遠畫。全用橫點、豎點，不甚用墨，以綠汁助之，乃知米畫亦是學王維也。都不作馬牙鉤。

Dots have to be spread out spaciously.

點要開闊。

ARTIST'S SEAL:
T'ai-shih shih 太史氏 (*pai-wen*, square) 53

FRONTISPIECE: Chou Pao-shan 周保珊 (20th century), dated 1926, 3 seals

COLOPHON: Ch'en Chi-ju 陳繼儒 (1558–1639), undated:
This is Hsüan-tsai's [Tung Ch'i-ch'ang] sketch of the trees and rocks by various old masters. Whenever he made a large composition, he copied from these sketches. After his house was burned down, I chanced to acquire [this scroll] from a professional mounter. It must not be shown to [Tung] lest it provoke his anxiety. Remarks by Mei-kung.

此玄宰集古樹石。每作大幅，出摹之。焚劫之後，偶得於裝潢家。勿復示之，恐動其胸中火宅也。眉公記。

COLLECTORS' SEALS: Lu Shu-sheng 陸樹聲 (19th century), 2; unidentified, 3

LITERATURE: Lu Hsin-yüan, *Jang-li kuan kuo-yen lu*, 1892, repr. 1975, ch. 24, p. 8; *Chung-kuo ku-tai shu-hua mu-lu*, vol. 2, 1985, *Ching* 1–2215.

20 *After Mi Fu's "Rhyme-prose on the Celestial Horse,"* large running script
Hsing-shu ta-tzu lin Mi Hai-yüeh "T'ien-ma fu"
董其昌　行書大字臨米海岳《天馬賦》

Dated 1612

Handscroll, ink on silk
41.9 x 1,831.2 cm (16½ x 720¹⁵⁄₁₆ in.)

Shanghai Museum

vol. 1, pl. 20 (detail); vol. 2, pl. 20

ARTIST´S TITLE (2 lines in large running script):
"Rhyme-prose on the Celestial Horse"
《天馬賦》

ARTIST´S INSCRIPTION AND SIGNATURE (16 lines in large running script, following a transcription in 118 lines of Mi Fu's [1051–1107] "Rhyme-prose on the Celestial Horse"):
On the twenty-third day of the ninth month of the *jen-tzu* year [October 17, 1612], as I was passing in my boat below Feng-men, [the east] gate of the city [in Wu-hsien, Kiangsu], I was imitating Mi Hai-yüeh's [Mi Fu] "Rhyme-prose on the Celestial Horse." Viewing the calligraphy with me was Kao Chung-chü of Wei-yang, Chang Chung-wen of Hua-t'ing, Lei Ch'en-fu of Ch'ing-p'u, and my grandnephew [Tung] Yen-ching [Tung Kao, fl. 17th century]. Tung Ch'i-ch'ang records this.

壬子九月廿三日，舟行葑門城下，臨米海岳《天馬賦》。同看書者，維揚高仲舉、華亭張仲文、青浦雷宸甫、家姪孫彥京。董其昌識。

ARTIST´S SEALS:
T'ai-shih shih 太史氏 (*chu-wen*, square) 54
Tung Hsüan-tsai 董玄宰 (*pai-wen*, square) 55

COLOPHON: Lü Ching-jui 呂景瑞 (20th century), dated 1908

COLLECTORS´ SEALS: Weng Ting-ch'en 翁鼎臣, 3; Weng Yü-fu 翁玉甫, 2

RECENT PROVENANCE: Li Wenzhen, Wang Zhenxiang, and Wang Ximing

"Like a star leaping out and with a sound like thunder!"— wrote the Yüan dynasty painter Huang Kung-wang (1269–1354) when he first viewed Mi Fu's calligraphy, "Rhyme-prose on the Celestial Horse." Tung Ch'i-ch'ang's scroll after Mi Fu realizes its own aural and dynamic level as sensed by the Yüan painter in the Sung original. The characters are six to seven inches (15 to 18 cm) in height and seem to leap off the silk with a roar, simulating the almost supernatural and mythic characteristics of the T'ang steeds described in the poem and referred to adoringly as "celestial horses" by the Chinese. As a poetic genre, the rhyme-prose is a lengthy semidescriptive dramatic form employing verbal virtuosity and hyperbole to glittering effect. It was the perfect form for the subject, and Mi Fu, as poet, set up a cadence of alternately rhyming lines (of six to seven characters each) in balanced parallel phrases to create a pulsating rhythm like galloping hoofbeats. Moreover, the length itself—308 characters, for a total of 134 lines in Tung Ch'i-ch'ang's copy—becomes a metaphor for the marathon distance the horse can run.

In his lifetime, Tung Ch'i-ch'ang saw four different versions of Mi Fu's "Rhyme-prose on the Celestial Horse," and he regarded all four as genuine. It is of interest to list the four versions as he describes them in the *Hua-ch'an shih sui-pi* (p. 10):

1. "Large 'fist-sized' characters (*p'i-wo ta-tzu* 擘窠大字) with Mi's inscription at the end and written for Master P'ing-hai, in Huang Lü-ch'ang's collection of Chia-ho"; Tung described the work as being "virile and heroic."
2. "Written in the manner of Yen Chen-ch'ing's [709–785] 'Controversy over Seating Protocol,' in the collection of Wang Lü-t'ai"; presumably in running script, as was the original work by Yen.
3. "Carved in the *Hsi-hung t'ang t'ieh*," Tung's collection of ancient model calligraphies, with the original in the collection of Sung Ts'an-cheng of Hua-t'ing.
4. "With colophon by Huang Kung-wang and other Yüan masters"; Huang's comment about this work is noted above. This version was in Wu T'ing's (ca. 1555–after 1626) collection and was written, Tung observed, "with lots of dry brushstrokes, so that it represented another kind of Mi calligraphy."

This latter observation was written by Tung as a colophon to one of his many copies of Mi Fu's *T'ien-ma fu*; a preliminary survey of the recorded pieces produces a count of at least half a dozen other versions by Tung—all of them on paper—with at least two in album form and four in handscroll format (see Shi-yee Liu Fiedler, "Chronology," under Mi Fu, in vol. 2 of this catalogue). As the present version is on silk, it appears not to have been otherwise recorded. However, Tung's colophon suggests that the work by Mi Fu that he probably had on hand when he wrote this version was the first version with the "large fist-sized characters" written for Master P'ing-hai.

Tung's inscription of 1612 on the present scroll is important not only for its date, but also because he mentions having the original as direct inspiration. This was not an exercise in writing "from memory" (*pei-lin* 背臨), as he often did, but rather it can be regarded as a "close copy" (*lin-pen* 臨本), because at the end of the scroll (lines 110–18), Tung not only includes Mi Fu's original inscription, but also his signature: "Mi Fu of Hsiang-yang."

One's impression upon viewing this scroll is that it is, as Tung would have it, "virile and heroic"—a genuine tour de force. The original challenged Tung in a way that compelled him to muster his utmost physical and mental resources. From the opening title, *T'ien-ma*, the huge characters break the silence of the silk and one begins to read the scroll with the multiple levels of form and content possible in a compelling work: the eye picks up the associations of form as the ear registers the musical notes of the poem. Using rich black ink, with few of the tonal variations he generally preferred in his own writing, Tung draws the brush down deliberately in a flat wedge-shaped form, reaching to the upper right for the first stroke of *t'ien* (celestial), beginning and completing the stroke with the reversed "head" and "tail" motions advocated by Mi. Then the brush picks up speed with the second longer horizontal, parallel in position, but open in form, with the left and right edges linking it to the previous stroke as well as to the following left-diagonal in one continuous motion. Finally, the right-diagonal proceeds from dead center of the horizontal, extending to the far right like two splayed legs of a tripod to balance the upward tilting form. Without hesitation, Tung's brush then proceeds downward to write the character *ma* (horse): first a quick curved vertical, then three brief horizontals all linked to the large right-curved hook, which swings to the right and downward, leaving the pattern of drying ink as a "flying white" (*fei-pai* 飛白) effect. This hook is followed directly by a decisive horizontal, representing four linked dots.

Thus the rhythm of the line begins slowly and deliberately, then picks up speed to a final flourish, before the recharged brush starts the last, complex character of the title, *fu* (rhyme-prose). More so than the previous two characters, this graph contains a typical Mi Fu configuration: the tall triangular shape, with the long right-diagonal reaching upward to form the apex and then descending far below the whole form to end, blunt and clublike, with tightly meshed interior

strokes. Further down, other typical configurations strike the eye as being particularly successful in capturing Mi's inimitable style, as in the next few lines with the words *mu* 牧 (to breed, line 4), with its tall narrow shape and contrast of thick and thin strokes; and *t'ien-ku* 天骨 (celestial bones, lines 5 and 6), *t'ien* being lexically the same graph as the title, but looking much more like Mi's with its wavelike strokes contrasting thick and thin, and *ku*, a tall, top-heavy configuration, following in the next line.

It should be noted that a number of the same lexically identical graphs appear throughout the scroll, but they are never identical in form or brush execution (for example, *fang* 方, lines 3 and 10; *i* 以, lines 10, 13, 15, 18, 23, 31, 42, 44; *t'ien* 天, lines 1, 5, 95, 124). Not all the graphs carry a typical "Mi look"; but, for example, in the detail featured (vol. 1, pl. 20), the characters *shui* 水, *pai* 白, *tse* 澤, *tsai* 宰, and *chüeh* 覺 all carry Mi's slightly disjointed structure and asymmetrical balance, combined with flattened, often blunt or abrupt, brush endings.

In the absence of any of the four original Sung versions of the *T'ien-ma*, one might turn for possible comparison to two works by Mi in large "fist-sized" running script: the account of his calligraphic history given in the *Ch'ün-yü t'ang t'ieh*, extant in rubbing form (Tokyo National Museum); and his handscroll of poetry, *Hung-hsien shih* (*Illustrated Catalogues of the Tokyo National Museum*, 1980, no. 16). The latter work contains two poems: the first quatrain, with its large graphs, two per column; and a longer poem, with three or four graphs per column. Unlike Tung's scroll, this work revels in tonal variations of ink, the rhythmic sequences of moist and very dry brushwork of the first poem contrasting with the predominantly dark ink of the second. The difference in total effect is one of aural dynamics—with dark ink representing a *forte*, and pale dry ink *piano* or *diminuendo*. Thus, Tung's version of the "Celestial Horse," its length notwithstanding, presents the equivalent of an entire symphony performed at the level of *forte* and *fortissimo*, a prospect that one might consider somewhat daunting. The *ch'i* 氣, or vital energy, required of such a performance must have left Tung both exhilarated and exhausted.

Having the Sung scroll before him must have been a constant goad if not an inspiration to his abilities. At the age of fifty-eight *sui* (fifty-seven years old), he was still in a position to undertake several such tasks, but it is of interest to note how few such large scrolls he would write. Would it not have been irritating for Tung to be reminded that his earlier rival, the Ming dynasty poet, calligrapher, and painter Wen Cheng-ming (1470–1559), regularly wrote large characters to the end of his life?

<div align="right">MWG</div>

LITERATURE: *Chung-kuo ku-tai shu-hua mu-lu*, vol. 3, 1987, *Hu* 1–1346; Zheng Wei, *Nien-p'u*, 1989, p. 84; *Chung-kuo ku-tai shu-hua t'u-mu*, vol. 3, 1990, *Hu* 1–1346.

21 *River Pavilion on a Clear Autumn Day* (by attribution)

Hsi-t'ing ch'iu-chi
董其昌　谿亭秋霽

Undated (ca. 1612–15)

Hanging scroll, ink on silk
132.2 x 54.6 cm (52 x 21½ in.)

Shanghai Museum

vol. 1, pl. 21

ARTIST'S INSCRIPTION AND SIGNATURE (2 lines in running script): "River Pavilion on a Clear Autumn Day." Tung Hsüan-tsai painted.
《谿亭秋霽》。董玄宰畫。

ARTIST'S SEALS:
Tung Ch'i-ch'ang yin 董其昌印 (*chu-wen*, square) **113**
Tsung-po hsüeh-shih 宗伯學士 (*pai-wen*, square) **114**

INSCRIPTION: Ch'en Chi-ju 陳繼儒 (1558–1639), 1 seal: Among the paintings by Shih-t'ien [Shen Chou, 1427–1509] that have been in Hsüan-tsai's collection, only *River Pavilion on a Clear Autumn Day* is first rate. This scroll is its rebirth. Mei-kung.

玄宰藏石田畫，獨《谿亭秋霽》爲第一，此幅其化身也。眉公。

NO COLOPHONS

COLLECTORS' SEALS: Ch'in Tsu-yung 秦祖永 (1825–1884), 1; Kao Shou-t'ing 高壽亭, 1

The style of this painting places it approximately between 1612 and 1615. Its spare and cool severity is the psychological aspect of a reductive structuralism that was one of Tung's most powerful strategies. It has close connections with the Cleveland handscroll *River and Mountains on a Clear Autumn Day* (vol. 1, pl. 53) after Huang Kung-wang (1269–1354), which, even more reductive in both execution and motif and more strong-armed in its spatial manipulation, is probably slightly later. The substructure of banks and trees slanting forward and downward across the lower right presages the handscroll. Its subversive nature is already clearly, if quietly, revealed in the channel of white snaking along its diagonal contour. This same serpentine flow of energy winds throughout the painting, predominantly up the central ridge, from the crest of which it twists back through one of Tung's intestinal clouds, before submerging into the infrastructure. At the same time, this flow is congealing, becoming quiescent though not enfeebled. This structurally dynamic quality was, of course, a function of seasonal transformation in autumn, and Tung seems to have consciously exploited this in a manner founded in the inseparability of structure and content. Clarity, and especially a clarity of ambiguity, is essential to works such as this. Its seasonal manifestation is characteristically invested by Tung in a material stratum. The silk medium in this painting, an idiosyncratic choice, is exploited for its clarity rather than its potential lushness. The heavily sized paper of the Cleveland scroll is exploited for the same effect. Here, it also enables Tung to bring critical passages throughout the painting up into startlingly dark sharpness. This was a favored device for articulating dynamic structure.

The visionary intensity of paintings such as this is matched by

the complexity with which they are tied into their immediate past. The composition, in its overall layout and its spiraling distribution of larger expansion and fragmentary conglomeration, for instance, reverts very closely to works of Tung's former teacher Mo Shih-lung (1537–1587). Mo's landscape after Huang Kung-wang, dated 1581 and now in The Metropolitan Museum of Art, might even have been a specific source—a thought reinforced by the fact that it also bears an inscription by Ch'en Chi-ju, saying in part: "Mo Shih-lung's calligraphy and painting brought about a renaissance [of those arts] in our district. Even Tung Ch'i-ch'ang was one of those who followed him" (Cahill, *Distant Mountains*, 1982, p. 85). And as James Cahill wrote in connection with Mo's painting, "The transition . . . to [a landscape] in which large forms interact with each other and with intervening spaces is basic to the growth of the Hua-t'ing school" (Cahill, *Distant Mountains*, p. 85). There even seems to be a visual reminiscence in both style and place between the inscriptions by Mo and Ch'en on the earlier painting and those by Tung and Ch'en on the later.

The reference by Ch'en Chi-ju to a Shen Chou original in Tung's collection, given the extremely close relationship between the two men, may probably be read back into Tung's own thinking. It seems to be a characteristic move in making rigidified conventions ambiguous and opening subsidiary levels of meaning. The painting, within the repertoire of Tung, would normally be taken as an almost unadulterated engagement with Huang Kung-wang, who also provided Mo Shih-lung's main frame of reference. While Tung always realized his connectedness with predecessors such as Shen Chou, he never succeeded in coming fully to terms with those connections. Shen Chou's position here partakes of that characteristic ambiguity. It is possible that Shen's own copy of Huang Kung-wang's *Great Peak of Fu-ch'un* (*Fu-ch'un ta-ling*) is playing a role more specific than that of the work Ch'en mentions. It is tempting, however, to find Shen in the hut at the lower left. Its rendering would be more at home with Chao Tso (ca. 1570–after 1633) than Tung, still retaining some of the ambulatory space with which Tung had earlier experimented. In association with the disruptively assertive brushwork in the fence and trees, it introduces a presence that can hardly be unintended, whether it is that of Shen Chou or some other[s].

JH

22 *Eulogy of Ni K'uan*, running-regular script
Hsing-k'ai-shu Ni K'uan chuan tsan
董其昌　行楷書倪寬傳贊

Undated (ca. 1612–16)

Handscroll, ink on silk
36.8 x 1,588 cm (14½ x 625⁹⁄₁₆ in.)

Beijing Palace Museum

vol. 1, pl. 22 (detail); vol. 2, pl. 22

ARTIST'S TITLE (1 line in large regular script, preceding a transcription in 114 lines in large regular script):
"Eulogy [following] the Biography"

《傳贊》

ARTIST'S INSCRIPTION AND SIGNATURE (15 lines in large cursive script, following the transcription):
Ch'u Sui-liang [596–658] wrote [a version of] this text which had some elements of clerical script in it. I am using Yen P'ing-yüan's [Yen Chench'ing, 709–785] [style] to write it. This is what Shan-ku [Huang T'ingchien, 1045–1105] meant when he said that [Yen's] *Sung [Ts'ai] Ming-yüan hsü* was neither running nor clerical script, just bent and curved and extraordinarily mysterious. Maybe, out of a hundred [percent], I have gotten one. Tung Ch'i-ch'ang.

褚遂良有此帖，頗類八分。余以顏平原法爲之；山谷所謂《送明遠序》非行非隸，屈曲瓌奇。差得百一耳。董其昌。

ARTIST'S SEALS:
Tung Hsüan-tsai 董玄宰 (*pai-wen*, square) 56
Tung Ch'i-ch'ang yin 董其昌印 (*chu-wen*, square) 57

NO COLOPHONS

COLLECTORS' SEALS: Sung Chün-yeh 宋駿業 (d. 1713), 1; Ch'ing Kao-tsung 清高宗 (r. 1736–95), 6; Ch'ing Jen-tsung 清仁宗 (r. 1796–1820), 1; Ch'ing Hsüan-t'ung 清宣統皇帝 (r. 1909–11), 2

The original inspiration for this handscroll, the *Ni K'uan chuan tsan* attributed to Ch'u Sui-liang (*Shodo zenshu*, 1966, vol. 8, fig. 16) was, even in Tung Ch'i-ch'ang's time, a work of almost legendary reputation, on a par with the eighth-century *Ts'ai Ming-yüan hsü* (*Shodo zenshu*, 1966, vol. 10, pls. 66–67), mentioned in Tung's inscription and in other of his colophons. Extant as an ink original, it is the only example attributed to Ch'u Sui-liang beyond his corpus of stelae inscriptions (the most celebrated of which is his inscription of 653 commemorating the Great Goose Pagoda in Hsi-an, the *Yen-t'a sheng-chiao hsü*).

As would become a typical occurrence, however, instead of merely presenting a close copy, or even an imitation "in the manner of" Ch'u's famous composition, Tung Ch'i-ch'ang performs a calligraphic sleight of hand: he presents the text of the original (committed to memory) in the style of another T'ang master, Yen Chen-ch'ing. That the master Tung chose was Yen Chen-ch'ing should come as no surprise, since, as noted earlier in his own account of his study of calligraphy (see cat. no. 8), Tung commenced his efforts with the earliest of Yen's works in strict regular script, the *To-pao t'a*, dated 752 (*Shodo zenshu*, 1966, vol. 10, pl. 12). As his study progressed, he not only turned to other masters of the T'ang as well as the Wei-Chin periods, but to other works by Yen. In particular, Tung was influenced by Yen's *Cheng tso-wei t'ieh* (vol. 1, fig. 53), written in running-cursive script and datable to 764; and Yen's official document of 780 written in formal regular script, the *Tzu-shu kao-shen t'ieh*, a transcription of the imperial patent conferring on him the honorific title *Kuang-lu tai-fu*, and extant as an ink original (*Shodo zenshu*, 1966, vol. 10, pl. 60).

The work by Yen mentioned in Tung's inscription, the *Ts'ai Ming-yüan hsü*, dated 772, is also an ink original, a mixture of archaic regular, running, and cursive scripts. Like the *Ni K'uan chuan tsan* of Ch'u Sui-liang, the question of the absolute authenticity of this work remains to be answered; however, the interesting mixture of script types and its overall vitality has captured the imagination of calligraphers through the ages, in particular, the Sung Masters. Tung cites Yen's work to justify his choice of scripts—large regular script with running elements followed by a flourish of cursive as a postscript.

Surely Yen Chen-ch'ing and Huang T'ing-chien would have been pleased to be so invoked.

Tung's writing is vigorous and forthright, and when compared to a dated example in similarly large script, the *Rhyme-prose on the Celestial Horse* (vols. 1 and 2, pl. 20), *Eulogy* impresses one as being less forced and strident. The difference in script type may be the answer. In regular script, the structures present an inherent dignity and formality, yet may still bear features of the individual practitioner and his times, as well as any internalized formal references to past masters. With three characters per column, each about four inches in height, Tung has chosen a consistency of visual size, regardless of the number of strokes per graph; it is as if an invisible grid, sized to contain three characters per column, had been drawn on the silk into which Tung fitted each form as he wrote. In the enlarged detail showing six characters (vol. 1, pl. 22) and throughout the transcription, the pressure and pace of Tung's brush remains relatively even, largely avoiding exaggerated thick or thin strokes. Only in the opening character of the title, *chuan*, in the first two strokes—a diagonal and a vertical which break the emptiness of the white surface—did Tung's brush come down with any appreciable heaviness. In coming down so broadly, he presumably sought to contrast these two strokes of the "man radical" with the more complex form necessitated by the nine strokes of the right-hand phonetic element. In the succeeding character, *tsan*, Tung seems to have found the right brush weight and gotten a better feeling for the interaction of ink with silk, for he completes the *tsan* neatly and crisply, setting the spacing and tone for the remainder of the essay.

A comparison of this work with the *To-pao t'a* cited above shows Yen's influence in the following: the compact perpendicular structures of each graph, suggesting a geometric matrix; the fitting of simple and complex characters into the imaginary grid to present a uniform overall appearance and sense of spacing; the emphasis on broad vertical and diagonal strokes against thin horizontals; the crisp articulation of the brushstrokes, stressing angular points of entry and squared-off or knobby shoulder and corner turns, as well as perfectly tapered diagonal and hook closures. As one of Yen's earliest dated works, the *To-pao t'a* does not bear the overt mannerisms such as the split "swallowtail" diagonals or knuckle-shaped hooks often found in later examples. Thus, Tung's homage to Yen is predominantly of this early disciplined variety.

In comparing this work with the *Ts'ai Ming-yüan hsü* mentioned by Tung in his inscription, one senses that the mixture of scripts fascinated him, so that Tung's references appear in terms of elements of running script and ligatures connecting the strokes between characters, rather than any specific form. To identify Tung's calligraphy as an example of a Ming interpretation of classic T'ang regular script, one would have to cite the generally frontal brush attack and flattened appearance of the structures, as well as the customary absence of fully articulated turns, hooks, and diagonals (a characteristic which, conversely, would be exaggerated in later generations among Ch'ing interpreters of Yen's style). The Sung dynasty interpreters of Yen Chen-ch'ing—namely the Four Masters—would still present rounded, gracefully articulated forms, as seen in Ts'ai Hsiang's (1012–1067) elegant colophon to Yen's *Tzu-shu kao-shen t'ieh*. Their forms were, by virtue of their elegance, less weighty; they were stately, but less imposing. By the Southern Sung, Chin, and Yüan dynasties, when Yen's style became almost synonymous with large regular script, one observes the

brushwork becoming increasingly flatter, the stroke articulation less precise, with few of the overt mannerisms that were criticized earlier, for example, by Mi Fu (1051–1107; see Marilyn Wong Gleysteen, "Calligraphy and Painting: Some Sung and Post-Sung Parallels," 1991, pp. 152–68). While Yüan masters did turn to genuine T'ang writings for models, their studies were more appreciative than imitative; and by the Ming dynasty, calligraphers preferred the fluent and elegant Sung interpretations of T'ang regular script. This is the legacy that Tung Ch'i-ch'ang inherited in his interpretations of Yen's style; yet he would differ from earlier Ming interpreters not only in locating and obtaining T'ang originals, but also in immersing himself fully in their study. Of the *Ts'ai Ming-yüan hsü*, Tung himself stated that only after he had copied it five hundred times did he feel a responsive chord in himself (*Hua-ch'an shih sui-pi*, p. 15). Even if the figure was exaggerated, it implies concentrated study and daily practice of that work for over a year's time.

In the history of calligraphy, the development of regular script was a truly epoch-making event. As a type, it evolved as early as the first through third centuries, during the late Han, when the major brush-written script types were reaching formulation. It was not until the sixth through eighth centuries, during the Sui and especially the T'ang dynasties, that regular script achieved aesthetic maturity and dominated the other scripts. As developed by the Four T'ang Masters—Yü Shih-nan (558–638), Ou-yang Hsün (557–641), Ch'u Sui-liang, and Yen Chen-ch'ing—regular script came to represent the integrity of the empire as embodied in the personal and official accomplishments of these four exemplary statesmen. But aside from the moral and symbolic connotations which this script could convey, its formal structure was the most complex of all the scripts, its execution the most demanding, and its subtlety of form limitless. Not only the overall structure of each individual graph—its balance, its spatial arrangement, and its total configuration—was of visual interest, but when dissected, each of the component strokes had extraordinary beauty. And yet, when composed to form the ideograph as we know it, the whole was always more than the sum of its parts.

Thus, given its technical difficulty, regular script, known as *chen* 真, *k'ai* 楷, or *cheng-shu* 正書, was a form to be mastered in one's early training, as well as the one that could pose a formidable challenge even to a calligrapher in his mature years. It was and still is to many practitioners today the script that has the greatest potential for formal beauty; at the same time, it is the script least appreciated by otherwise sensitive art lovers who are noncalligraphers. Thus, while the *Rhyme-prose on the Celestial Horse* is long and impressive, its individual structures are less likely to hold up to analysis than would those in this *Eulogy*.

It is also appropriate that Tung chose to write this essay in Yen's style (after all, Yen was Ch'u Sui-liang's follower in calligraphy) because of the nature of the eulogy as a genre form. The *tsan*, or eulogy, was the text that appeared at the end of the official biography in the dynastic history. Ni K'uan was an historical personage of the Former Han dynasty, living in a time when the art of historical biography was in its early stages of formulation. The *Han shu* (*History of the Former Han*) is regarded as the earliest full-fledged history based largely on fact rather than creative fictional accounts, such as found in the earlier *Shih-chi* (*Historical Records*) by the great Ssu-ma Ch'ien (145–86 B.C.).

The Former Han was also the period when the basic tenor of Chinese history as "praise or blame" (*pao pien* 褒貶) was being formulated, and when the custom of authorship by an illustrious committee of scholars from the succeeding dynasty was instituted. The basic tenets of Confucian thought were being absorbed into society and functioning as a state orthodoxy. In addition, literary and historical writing carried judgments about character, personal integrity, and talent. For example, the text of this eulogy tells of the glories of the Han and names a number of the most accomplished gentlemen of the time in their various fields of expertise. The subject of the biography, Ni K'uan, is cited as being a "refined Confucian," along with the philosophers Tung Chung-shu (179?–104? B.C.) and Kung-sun Hung (2nd century B.C.). The passage concludes by saying that "all these men served in so meritorious a way as to have an account of their virtue passed on to later generations. All were notable gentlemen, so they are listed here."

One final word ought to be said about Tung's inscription in large cursive script (see vol. 1, pl. 22). Like the 1603 handscroll in the Tokyo National Museum (vols. 1 and 2, pl. 5), which also concludes with a breathtaking cursive section, this colophon celebrates Tung's sense of accomplishment in completing the essay to his satisfaction, despite his words to the contrary. The inscription bursts forth with a liberating energy, contrasting all the more with the strict formality of the preceding section. One senses that Tung is speaking to Huang T'ing-chien in the language of Huang's own extraordinary cursive, calling to him for a word of approval.

<div align="right">MWG</div>

LITERATURE: *Shih-ch'ü pao-chi*, completed 1745, repr. 1918, *ch.* 30, p. 49; *Chung-kuo ku-tai shu-hua mu-lu*, vol. 2, 1985, *Ching* 1–2223.

23 *Lin Pu's Poetic Idea*
Lin Ho-ching shih-i
董其昌　林和靖詩意

Dated 1614

Hanging scroll, ink on paper
84 x 38.7 cm (33¹/₁₆ x 15¼ in.)

Beijing Palace Museum

vol. 1, pl. 23

ARTIST'S INSCRIPTIONS AND SIGNATURES:
1. 5 lines in running script:
Not yet so deep among mountains and waters,
 here fish and birds are few,
In this life I still expect to move once more.
I should find a place by the stream at Mount T'ien-chu,
[And there,] with a single log to bridge the stream, build a small
 thatched hut.
 Writing the idea of a poem by Ho-ching [Lin Pu, 967–1028]. Hsüan-tsai.
On the twenty-second day of the second month of the *chia-yin* year
[March 31, 1614], recorded at a rainy window.

山水未深魚鳥少
此生還擬重移居
祇應三竺溪流上
獨木爲橋小結廬
　　寫和靖詩意，玄宰，甲寅二月廿二，雨窗識。

2. 5 lines in running script:
In Yüan times, Ni Yün-lin [Ni Tsan, 1301–1374] and Wang Shu-ming [Wang Meng, 1308–1385] both added [a painter's vision] to this poem. But I have not seen a version by Huang Tzu-chiu [Huang Kung-wang, 1269–1354], so I made this in his manner. Hsüan-tsai inscribed again. The third month of the *hsin-yu* year [April 22–May 20, 1621].

元時，倪雲林、王叔明皆補此詩意，惟黃子久未之見，余以黃法
爲此。玄宰重題，辛酉三月。

ARTIST'S SEALS:
Tung Ch'i-ch'ang yin 董其昌印 (*pai-wen*, square) 58
Tung Ch'i-ch'ang yin 董其昌印 (*chu-wen*, square) 93

NO COLOPHONS

COLLECTORS' SEALS: Kao Shih-ch'i 高士奇 (1645–1704), 3; Chang Chao 張照 (1691–1745), 1; Juan Yüan 阮元 (1764–1849), 1; Wang Feng-ch'en 王逢辰 (1802–1870), 1; Wang Tsu-hsi 王祖錫 (1858–1908), 1; Hsü Ch'uan-ching 徐傳經, 2; P'an Ch'eng-mou 潘承謀, 1

Lin Pu was a poet who lived in reclusion on the West Lake in Hang-chou, treating plum blossoms as his wife and cranes as his children. The technique of the painting is closely comparable to other works in the Huang Kung-wang manner that preoccupied Tung at this time. The painting remains, however, very distinctive.

Lin Pu's Poetic Idea, like so many of Tung Ch'i-ch'ang's works, establishes the artist's characteristic presence in a tree-crowned hummock in the central foreground, around which other visual, structural, and semiotic concerns are elaborated. As a compositional schema, of course, it comes directly from Yüan painters, especially Ni Tsan. But Tung made it both leitmotiv and key. A study of his seemingly endless variations in this performance practice would be of considerable help in understanding this most ostentatious yet secretive of painters. In the opening of this painting, starting with a white boulder at the base line, he takes a small but abrupt step to the left; steadies himself in three expanding and perfectly vertical rises; moves sweepingly to the right; rebounds to the left and slightly upwards; then slows his remaining distribution of steps to the left and right, gently cresting in a perfectly central and symmetrical point.

From the contours of these concluding foregrounded movements, a cluster of five trees fans out in a display of brush movements and ink textures that is quietly spectacular across a very wide spectrum. It appears that he started with four of these trees rising up the central axis but, finding them too tame, then forced upon them the outrageous interloper on the right, whose precarious attitude is matched by a prickly, even provocative manner.

Around such a confident presence, the rest of the picture may at first glance seem scattered, even incoherent, tied together by little more than the consistency of its reference to the work of Huang Kung-wang. But this is precisely wherein lies the attraction that is so evident in the extensive record of its later ownership. The looseness of the composition can be related to the structural breakdown in late Ming

painting that Tung himself sought to repair. But it was also, in itself, a theme in Chinese painting. Here, Tung transforms it into an open invitation to those both sensitive and knowing, an unfettered surface through which the longing exemplified in Lin Pu's poem may find its own quiet satisfaction.

It is typical of Tung's approach that he extends this discourse into Huang Kung-wang's estate across the years. The perennial conventions of dwelling found a fresh voice from time to time. The poetry of Lin Pu and the painting of Huang Kung-wang, especially the latter's *Dwelling in the Fu-ch'un Mountains* (*Fu-ch'un shan-chü*; vol. 1, fig. 17) handscroll, both being closely associated with the region of Hang-chou, were such moments.

JH

EXHIBITION: *Mei-chan t'e-k'an*, 1929

LITERATURE: *Hsiang-kuan chai*, 1782, ch. 6; *T'ien-hui ko*, 1930, vol. 1; Xu Bangda, *Pien-nien-piao*, 1963, p. 97; *Chung-kuo ku-tai shu-hua mu-lu*, vol. 2, 1985, *Ching* 1–2159; *Tung Ch'i-ch'ang hua-chi*, 1989, pl. 71; Zheng Wei, *Nien-p'u*, 1989, p. 95.

24 *Panoramic View of a Lake*

Hu-t'ien k'ung-k'uo

董其昌　湖天空闊

Dated 1615

Handscroll, ink on paper
30 x 111.8 cm (11¹³⁄₁₆ x 44 in.)

L. and C. Rosshandler Collection

vol. 1, pl. 24

ARTIST'S INSCRIPTION AND SIGNATURE (4 lines in running script): From the north side of Mount Chung-chia, to gaze at the villages in the level distance has the force of lake and sky meeting in an empty and vast expanse of water. I urgently grasped the brush and made this picture of it. It interacts with the styles of the [two Buddhist] monks Hui-ch'ung [ca. 965–1017] and Chü-jan [fl. ca. 960–ca. 986]. I will take it to my fellow devotees [of the two master monks] and wait for their criticism. Written on the nineteenth day of the fourth month of the *i-mao* year [April 16, 1615]. Ch'i-ch'ang.

鍾貫山陰望平原邨，有湖天空闊之勢。亟拈筆爲此圖。出入惠崇、巨然兩秃師法門。以俟同參者評之。乙卯四月十九日。其昌。

ARTIST'S SEAL:
Tung Hsüan-tsai 董玄宰 (*pai-chu wen*, square) **60**

NO COLOPHONS

COLLECTORS' SEALS: Chang Shan-tzu 張善孖 (1882–1940), 1; Chang Ta-ch'ien 張大千 (1899–1983), 7; unidentified, 1

An unresolved issue concerning this scroll involves the record of a Tung Ch'i-ch'ang handscroll with an identical inscription but different signature and documentation, entitled *From the North Side of Mount Chung-chia, Gazing at the Level Distance Village Scenery* (*Chung-chia shan yin wang P'ing-yüan ts'un ching*), in the imperial catalogue *Shih-ch'ü pao-chi hsü-pien* of 1793. The title is drawn directly from the opening text of the recorded inscription, which duplicates that of the Rosshandler handscroll exhibited here but lacks a date and is signed "Hsüan-tsai" rather than "Ch'i-ch'ang." Three artist's seals different from the single seal on this painting are also recorded in the imperial catalogue, along with eight imperial seals and two collectors' seals that do not appear here. The brief account of the scroll in the imperial catalogue describes an ink painting of mountain groves and a village, with a distant shore and long bridge.

The painting recorded in the *Shih-ch'ü pao-chi hsü-pien* is thus certainly not the present scroll, and the specificity of the occasion for the painting noted in the inscription makes it seem unlikely that Tung would have painted two versions of the work. While the problems raised by the two versions of the subject cannot be resolved in the absence of the recorded one, it is worth noting that the opening passage of the Rosshandler scroll, which begins with a pine-strewn slope set back in the distance, seems unusual among Tung Ch'i-ch'ang's horizontal scroll compositions, and might be an indication that the work is missing an original opening passage. The extant works in horizontal formats that most closely parallel *Panoramic View of a Lake* all open with foreground or combined foreground and middle-distance passages. These include two paintings from about the same time— *Invitation to Reclusion at Ching-hsi* of 1611 (vol. 1, pl. 18), in The Metropolitan Museum of Art, and *Dwelling in Mountain Seclusion* of 1613 (*Tung Ch'i-ch'ang hua-chi*, 1989, pl. 63), in the Wuxi Municipal Museum—as well as the early *Landscape* of 1599 in the Nanjing Museum (vol. 1, fig. 25). All four handscrolls make use of similar compositional rhythms, with crowded central sections and rising closing movements, and all are outspokenly more concerned with the dynamics of brush and ink than with formal coherence. The middle passage of *Panoramic View of a Lake*, with its loosely raveled surfaces, diagonally splayed trees, and abundant pentimenti, seems an especially direct and not entirely resolved record of Tung's working method in which experimentations with shapes and placements are held in rough order by persistent compositional habits and rhythms, as seen in the related horizontal scrolls cited above.

It might be postulated that *Panoramic View of a Lake* is a fragment of one of Tung's works to which a recorded inscription has been added, although the notably sketchy and spontaneous quality of the painting accords quite well with the account of its genesis as the urgent notation of some striking scenery. The middle and closing passages in particular convey an air of improvisatory haste, with contour lines sometimes partial or doubled, and an uneasy fit between the reedy boat passage at the end and the rest of the landscape in terms of underlying ground plane. The tension between scenic and pictorial qualities in Tung Ch'i-ch'ang's painting discourse was usually resolved in favor of the pictorial, however; and in this case the distant historical styles of Hui-ch'ung and Chü-jan are introduced as well. This reference to the past could be read as an indication either that what Tung Ch'i-ch'ang found notable in the panorama was its congruity with the tenth-century picturesque or that Tung was unable to evade the capture of his perceptual experience by identifiable stylistic catego-

ries. Paintings of this kind functioned as mixed notations of cultural-pictorial as well as perceptual experience. Tung's technique did not enable him to realize the potential of visual notation, but he could certainly diagram the dynamics of a scene, as seems to have been the case here.

RV

LITERATURE: *Shih-ch'ü pao-chi hsü-pien*, completed 1793, repr. 1948, *Yü-shu-fang* section, vol. 21, p. 54.

25 *Boneless Landscape after Yang Sheng* (by attribution)
Ni Yang Sheng mo-ku shan
董其昌　擬楊昇沒骨山

Dated 1615

Hanging scroll, color on silk
77.1 x 34.1 cm (30⅛ x 13⁷⁄₁₆ in.)

The Nelson-Atkins Museum of Art 58–46

vol. 1, pl. 25

ARTIST'S INSCRIPTION AND SIGNATURE (5 lines in running script):
I once saw a genuine work by Yang Sheng [fl. first half of the 8th century] with mountains done in colored wash without outline (*mo-ku*). From this, one realizes the striking impact of the ancients' spontaneous brush, which, like the fleeting glow of vermilion clouds, is something rarely seen in this world. This is an imitation of it. Inscribed by Tung Ch'i-ch'ang in the spring of the *i-mao* year [1615].
(Translation after K. S. Wong, in Ho et al., *Eight Dynasties*, 1980, p. 243.)

余曾見楊昇真蹟沒骨山。乃見古人戲筆奇突，雲霞滅沒，世所罕
觀者。此亦擬之。乙卯春，董玄宰識。

ARTIST'S SEALS:
Hua-ch'an 畫禪 (*chu-wen*, rectangle) **82**
Tung Ch'i-ch'ang 董其昌 (*chu-wen*, square) **83**

NO COLOPHONS

COLLECTOR'S SEALS: An Ch'i 安岐 (1683–ca. 1746), 3

RECENT PROVENANCE: P'ang Yüan-chi, Teijiro Yamamoto, Ch'eng Ch'i, Mayuyama and Co.

In many respects an anomaly in Tung Ch'i-ch'ang's oeuvre, the Nelson-Atkins *Boneless Landscape after Yang Sheng* has an extant counterpart in the *White Clouds and Red Trees after Chang Seng-yu (Fang Chang Seng-yu pai-yün hung-shu)*, now in the National Palace Museum, Taipei (Kohara, Wu, et al., *Jo I, To Kisho*, 1978, pl. 42). Tung's second inscription on the Taipei handscroll, dated 1628, mentions several earlier imitations by him of the "boneless" manner; and the Ch'ing collector An Ch'i, whose seals appear on the Nelson-Atkins painting, recorded another version of a boneless landscape after Yang Sheng attributed to Tung Ch'i-ch'ang and included a corroborating account of having seen five other works by Tung in that manner (An Ch'i, *Mo-yüan hui-kuan*, repr. 1909, vol. 3, p. 91).

Although Tung often used restrained color schematically for structural purposes in works after 1620, and sometimes bolder color for dra-

matic design effects (cf. vol. 1, pls. 41, 42), the strong decorative appeal of the two "boneless-style" landscapes after early masters seems to demand some explanation. The association of the decorative/visual and art-historical/textual aspects of these landscapes may be due to more than the accidents of Tung's viewing discoveries. Rather, the linkage would seem to have been required by Tung Ch'i-ch'ang's theoretical discourse, since his association of skill and decoration with the Northern School lineage demanded some compensatory invocation of deep historical structure to legitimize his practice. Tung's virtual reinvention of the "boneless" style of colored landscape, based on the slenderest historical precedents, is implied in An Ch'i's account, cited above.

In accounting for the motivations for this style, we might discern the catholic connoisseurial appetites of an artist who pursued the past in whatever form he found it, even if seemingly uncongenial to his core theoretical and visual interests in structurally adventurous brush-and-ink performances. Tung Ch'i-ch'ang indeed seems to have been less programmatic in his appreciation of old painting than a bare outline of his theories might imply.

Another kind of accounting for the *Boneless Landscape after Yang Sheng* would begin by noting in it qualities not easily reconciled with Tung's standard practices: effects of atmospheric spaciousness; smooth applications of brilliantly decorative colors at the expense of effects of solidity or dynamism of forms; supple brushwork, sometimes forming pointed joints in the tree contours; a free use of floating patches of ink and color; and relatively solid-looking, spatially consistent architectural motifs. Though there is no reason to doubt the authenticity of Tung's bold and supple inscription on the painting, a substitute painter's hand for the landscape is not out of the question. The well-documented status of Shen Shih-ch'ung (fl. ca. 1607–40) as a ghostpainter for Tung comes easily to mind, since the anomalous stylistic features of the painting are in many respects the visual hallmarks of Shen's own style. In this example, the principal stimulus for the formation of the work would most likely have been the demands of a recipient whose taste ran to qualities Tung was ill-equipped to supply. What Tung could provide was the imprimatur of scholarly historicism, as well as the more direct imprint of his prominent and graceful script above, with its assurances of a respectable historical pedigree for the lovely but otherwise unadventurous landscape below. If this were the case, the strategy anticipates that of Yün Shou-p'ing (1633–1690) several generations later, who endowed his colorful and graceful flower paintings with largely fabricated distant historical antecedents as a means of saving his works from critical and scholarly disregard.

RV

EXHIBITIONS: Tokyo Imperial Museum, 1928: *To-So-Gen-Min meiga taikan*, 1930, vol. 2, pl. 356; Nelson Gallery-Atkins Museum and The Cleveland Museum of Art, 1980–81: Ho et al., *Eight Dynasties*, pp. 243–44, no. 190.

LITERATURE: P'ang Yüan-chi, *Hsü-chai ming-hua lu*, 1909, ch. 8, pp. 48–49; *Shina nanga taisei*, 1935–37, vol. 9, pl. 171; *Shodo zenshu*, 1954–68, vol. 21, p. 17, fig. 23; Kawakami, "To Kisho," 1955, pp. 36–38, pl. 1; Kawakami, "Min Shin ga no shiryo," 1963, p. 33, pl. 3; *Mei-shu* 36 (July, 1969): cover illus.; Kohara, Wu, et al., *Jo I, To Kisho*, 1978, p. 168, color pl. 24; Loehr, *Great Painters*, 1980, pp. 289, 291, color pl. 10; Kohara, *To Kisho no shoga*, 1981, pp. 238–39, pl. 9; Suzuki, *Comprehensive Illustrated Catalogue*, 1982–83, vol. 1, 1–324, A28–054; *Tung Ch'i-ch'ang hua-chi*, 1989, app. pl. 72.

26 *Landscape*
Shan-shui
董其昌　山水

Undated (ca. 1615)

Hanging scroll, ink and color on gold-flecked paper
122.9 x 56.6 cm (48⅛ x 22⅕⁄₁₆ in.)

Shanghai Museum

vol. 1, pl. 26

ARTIST'S INSCRIPTIONS AND SIGNATURES:
1. 3 lines in running script:
For years writing books behind closed doors;
The pines planted before have all grown "old-dragon scales" on their trunks.
　Hsüan-tsai.

閉戶著書多歲月
種松皆作老龍鱗
　玄宰。

2. 9 lines in running script:
A painter should study the old masters, and above all, nature. That is why it is said that the ten thousand horses in the imperial stable can all serve as a painter's models. Huang Tzu-chiu [Huang Kung-wang, 1269–1354] always carried a brush with him while roaming among streams and mountains, and made sketches whenever he saw some unusual trees. Wang An-tao [Wang Lü, 1322–after 1383], traveled to Mount Hua and made forty sketches of the landscape. They look ordinary until they are shown to those who have traveled to Mount Hua, [who then] feel as if they are faced with the actual scenery. Now confined in a small room, not being able to see anything stirring to the heart and spectacular to the eyes, how can I compete with the ancients? Inscribed again by Hsüan-tsai.

畫家當以古人爲師，尤當以天地爲師，故有天閑萬馬皆粉本之論。黃子久每袖筆山川，見奇樹即寫之。王安道遊華山，臨圖四十幅，初視之平平耳，及與曾游華山者一寓目，恍如當境。今困坐斗室中，無驚心洞目之觀，安能與古人抗行也。玄宰又題。

ARTIST'S SEALS:
Hua-ch'an 畫禪 (*chu-wen*, rectangle) **61**
Tung Ch'i-ch'ang yin 董其昌印 (*pai-wen*, square) **62**
Tung Ch'i-ch'ang 董其昌 (*chu-wen*, square) **63**

NO COLOPHONS

COLLECTORS' SEALS: Ch'ien Ching-t'ang 錢鏡塘 (20th century), 1; unidentified, 4

27 *The Long and Winding Stone Steps*
Shih-teng p'an-yü
董其昌　石磴盤紆

Dated 1616

Hanging scroll, ink on paper
94 x 44.5 cm (37 x 17½ in.)

Shanghai Museum

vol. 1, pl. 27

ARTIST'S INSCRIPTIONS AND SIGNATURES:
1. 5 lines in running script:
The cliff path winds round, mountain trees are dense,
With groves and streams like this, such is pure seclusion.
But if I could wear magic sandals and fly beyond the thousand peaks,
I would settle my retreat even higher, on the very summit.
　Hsüan-tsai painted. Inscribed in the *ping-yin* year [1626].

石磴盤紆山木稠
林泉如此足清幽
若爲飛屐千峰外
卜築誅茆最上頭
　玄宰畫，丙寅題。

2. 3 lines in running script:
This is a work of the *ping-ch'en* year [1616], autumn, brushed in the region of Shanghai. It has been eleven years. Summer, the fifth month of the *ping-yin* year [May 25–June 23, 1626]. Hsüan-tsai.

此丙辰秋在海上筆，十一年矣。丙寅夏五，玄宰。

ARTIST'S SEALS:
Tung Ch'i-ch'ang yin 董其昌印 (*pai-wen*, square) **126**
Ta tsung-po chang 大宗伯章 (*pai-wen*, square) **127**
Tung Ch'i-ch'ang 董其昌 (*chu-wen*, square) **128**

COLLECTORS' SEALS: Pi Lung 畢瀧 (late 18th century), 1; P'ang Yüan-chi 龐元濟 (1864–1948), 1; P'an Chiao-p'o 潘荶坡, 2; unidentified, 2

NO COLOPHONS

RECENT PROVENANCE: Shanghai Municipal Administration of Cultural Relics

This is a somewhat curious and very interesting work. It seems to look both forward and backward through the artist's oeuvre, yet lacks the usual powerful sense of its own stylistic moment. Its mountainous contortions are reminiscent of such works as the Stockholm hand-scroll *Landscape after Kuo Chung-shu* of circa 1598–99 (vol. 1, pl. 4) and the handscroll after Wang Shen (1036–after 1099) of 1605, in the National Palace Museum, Taipei. In its mountains and trees, it also implies later works that pick up on those earlier interests, such as the *Landscape Inspired by a Wang Wei Poem* of 1621 (vol. 1, pl. 40). The textures are unusually rich, even warm.

It seems, beneath the surface, to draw inspiration from Kuo Hsi's (ca. 1020–ca. 1100) famous *Early Spring* (*Tsao-ch'un t'u*; vol. 1, fig. 12) of 1072. Tung did not let an interest in Kuo Hsi's painting go entirely unacknowledged, but it nevertheless appears to have been an influence both powerful and problematic. The painting also draws into this engagement Huang Kuang-wang (1269–1354), especially at both sides, and Wang Meng (1308–1385), especially in the trees and the center. The centrally contorted cliffs and the rhythms of the foreground trees seem to predict Tung's famous version of Wang Meng's *Ch'ing-pien Mountain* of 1617 (vol. 1, pl. 32), and indeed the entire composition might be seen as a still rather tame preparation for that explosive work.

The painting reflects the poem very effectively. The composition turns on an unusually powerfully stated central axis, reminiscent of Kuo Hsi, but the symmetrical spiraling is asymmetrically pulled to the right. The central mountain, and the spaces surrounding it to the left and below, do indeed curl around the dwellings buried in the forested valley in the upper right, as lines of force around the pole in a mag-

netic field. As with many other Chinese mountain-and-water paintings, spatial illogicalities become perfectly coherent when read this way. This aspect of the work is somewhat conventional. But the poem, of course, was added ten years later, a circumstance that merely emphasizes the inherent complexity and elusiveness of relationships between text and image in Chinese painting. The dividing line between them is highly permeable, and in this case one might well say there was already "a poem in the painting." Tung used this same poem elsewhere, including an album he painted for Wang Shih-min (1592–1680) in 1617 (Zheng Wei, *Nien-p'u*, 1989, pp. 110–11).

We may be particularly curious about the nature of this painting, of course, because it was done some four to six months after the destruction of Tung's estate, presumably while he was still in flight on the rivers and lakes around his lost home. One might speculate, cautiously, that Tung's unusually direct reference here to the comfortingly protective structure of a reclusive site, so different from the open poetry in his rendering of Lin Pu two years before (vol. 1, pl. 23), was an overt pictorialization of a passionate desire. That the painting originally bore neither signature nor seal might here signify the pain of too much significance and too little hope. The inscriptions are ten years later, eleven by Chinese count but psychologically cyclical since the year begins with the same *t'ien-kan*. Despite their resolutely enigmatic character, the poem itself nevertheless refers to Tung's arduous escape and profound longing for security. Such speculation must be made in the context of unabated artistic activity at this time, while he was continually on the move, traveling by boat and, presumably, visiting friends. Interpretation of this circumstance, of course, can go in more than one direction.

JH

LITERATURE: P'ang Yüan-chi, *Hsü-chai ming-hua lu*, 1909, *ch.* 8, p. 47; Xu Bangda, *Pien-nien-piao*, 1963, p. 97; Ren Daobin, *Hsi-nien*, 1988, p. 147; *Tung Ch'i-ch'ang hua-chi*, 1989, pl. 73; Zheng Wei, *Nien-p'u*, 1989, p. 109.

28 *Stately Trees Offering Midday Shade*

Ch'iao-mu chou-yin

董其昌　喬木晝陰

Undated (ca. 1616–20)

Hanging scroll, ink on paper
90.3 x 28.3 cm (35 9/16 x 11 1/8 in.)

Museum of Fine Arts, Boston 55.86

vol. 1, pl. 28

ARTIST'S INSCRIPTION AND SIGNATURE (3 lines in running script):
Stately trees shade the day;
In the old ravine cold water rushes, singing.
The village below the mountain is wrapped in low clouds;
Now thunder rolls on and on.
　Hsüan-tsai painted and inscribed.

喬木生畫陰
古澗鳴寒溜
前村杳靄中
大有雷霆鬪
　　玄宰畫并題。

ARTIST'S SEALS:
T'ai-shih shih 太史氏 (*pai-wen*, square) 80
Tung Ch'i-ch'ang 董其昌 (*chu-wen*, square) 81

INSCRIPTION: Ch'ing Kao-tsung 清高宗 (r. 1736–95), dated 1766, 2 seals:
The rain has passed; from the trees hang pearls;
The old huts' eaves drip raindrops.
The lofty peak strives to lift its head;
But loathsome clouds hinder.
　Inscribed by the Emperor in the summer of the *ping-hsü* year [1766]. (Translations of inscriptions by Tomita and Tseng, in *Portfolio of Chinese Paintings*, 1961, p. 14.)

雨過樹垂珠
古屋滴簷溜
嶢峰欲出頭
膩雲與之鬪
　　丙戌夏御題。

NO COLOPHONS

COLLECTORS' SEALS: Sung Lo 宋犖 (1634–1713), 1; Ch'ing Kao-tsung, 7; Ch'ing Jen-tsung 清仁宗 (r. 1796–1820), 1; Chang Ta-ch'ien 張大千 (1899–1983), 3

Stately Trees Offering Midday Shade is one of a number of Tung Ch'i-ch'ang paintings in the Mi-family manner, emphasizing broad patches of horizontal wash or dots that collectively fabricate loose, conically structured mountains riddled with clouds and mist. Here the rather regimented alignment of horizontal dots along ridge lines in the mountains suggests the Mi-family derived style of the Yüan painter Kao K'o-kung (1248–1310) as the most likely immediate reference.

Stately Trees is one of the most satisfying of Tung's efforts in a manner that was not especially congenial to the more innovative side of his practice, since it was based on the broad effects of ink wash rather than the intricate dynamics of forms shaped with linear brushwork. In *Stately Trees* Tung approaches the underlying problem of enlivening the composition in reverse: the dynamic aspect of his mountains here is found in the patterns of reserve clouds which tie an intricate knot around and through the base of the peaks, creating spatial ambiguities of relative distance in the trees and slopes on either side of the ribbon-like mist. The contrast with the foreground section of the composition, where the three-dimensional volumes of rounded knolls are powerfully and simply asserted, is striking and suggests a deliberate thematization of effects of flat design and three-dimensional rendering. In this respect and in the erosion of the distant mountains by reserve clouds, the scroll recalls Tung's *Ch'ing-pien Mountain* of 1617 (vol. 1, pl. 32). Though a much less ambitious work, *Stately Trees* may have been painted around the same time, since according to Celia Riely the evidence of seals indicates a likely date of circa 1616–20.

RV

EXHIBITION: Tokyo Imperial Museum, 1928: *To-So-Gen-Min meiga taikan*, 1930, p. 355.

LITERATURE: *Shih-ch'u pao-chi*, completed 1745, repr. 1918, *ch.* 38, p. 75; Yamamoto, *Chokaido shoga mokuroku*, 1932, kan 4, pp. 11–12; *So-Gen irai meiga sho-shu*, 1947, no. 38; Sirén, *Leading Masters and Principles*, 1956–58, vol. 5, p. 9, vol. 6, pl. 261b; Tomita and Tseng, *Portfolio of Chinese Paintings*, 1961, p. 14, pl. 66; Kohara, *To Kisho no shoga*, 1981, p. 252, pl. 28; *Tung Ch'i-ch'ang hua-chi*, 1989, app. pl. 117.

29 *Concealing Clouds and Scattering Rain*

Yün-ts'ang yü-san

董其昌　雲藏雨散

Undated (ca. 1616–20)

Hanging scroll, ink on silk

101.8 x 41.2 cm (40⅛ x 16¼ in.)

Hsü-pai Chai—Low Chuck Tiew Collection

vol. 1, pl. 29

ARTIST'S INSCRIPTION AND SIGNATURE (3 lines in running script):
Clouds conceal the divine-woman's temple;
Rain scatters around the palace of the King of Ch'u.
　Written by Hsüan-tsai.

雲藏神女觀
雨散楚王宮
　玄宰寫。

ARTIST'S SEALS:

Tung Ch'i-ch'ang 董其昌 (*chu-wen*, square) **85**
T'ai-shih shih 太史氏 (*pai-wen*, square) **86**

COLOPHON: Liang Chang-chü 梁章鉅 (1775–1849), dated 1836, 2 seals:
I have seen Hsiang-kuang's [Tung Ch'i-ch'ang] paintings in the past; most were pure and refined, incomparable in quality, but often I objected to the fault of their being somewhat weak. Now, gazing at this work, the old brush very antique; the redness of the sky passes through the door. It truly links together the strong points of Wu [Tao-tzu, fl. ca. 700–ca. 750] and Hsiang [Jung] in a way that even Mi Hu-erh [Mi Yu-jen, 1074–1151] couldn't achieve. This is truly the most excellent masterpiece of Hsiang-kuang's entire life; one honestly can make of it something viewed as a divine work from the Sung or Yüan dynasties. Inscribed by Liang Chang-chü of Fu-chou in the winter of the *ping-shen* year of the Tao-kuang era, the last ten days of the tenth month [November 28–December 7, 1836].

嘗見香光畫，多清秀絕倫之品，而往往嫌病於嫩。今觀此作，老筆沉古；紅光貫戶。實兼吳、項之長，米虎兒所不及也。此真香光平生第一傑製，直可作宋、元神迹觀之矣。道光丙申冬，十月下浣，福州梁章鉅題。

COLLECTOR'S SEALS: Low Chuck Tiew 劉作籌 (20th century), 3

The Mi-family style cloudy mountainscape depicted here is seemingly uncongenial to Tung Ch'i-ch'ang's talents for structural deformation and reformation, but it occupied him at numerous times in his artistic career. Examples include the 1627 handscroll *After the Mi-family Cloudy Mountains* in the Liaoning Provincial Museum (*Tung Ch'i-ch'ang hua-chi*, 1989, pl. 64) and an undated hanging scroll *After the Mi-family Landscape Style* in the collection of Ch'eng Shih-fa (*Tung Ch'i-ch'ang hua-chi*, pl. 41). One of the most successful examples is the hanging scroll entitled *Strange Peaks and White Clouds* (*Ch'i-feng pai-yün*; Kohara, Wu, et al., *Jo I, To Kisho*, 1978, pl. 30) in the National Palace Museum, Taipei, which avoids the ink-wash seductions of the Mi-family manner in favor of a more awkward, astringent, and diagrammatic formulation that is still within the recognizable parameters of the Mi-family manner.

The present painting is more wholeheartedly given up to patches of ink wash for the foliage, long stringy contours for the banks, and an overall preoccupation with deep tonal effects. The scroll seems a fairly routine effort; and the artist's generic poetic inscription, without date or dedication, suggests a kind of prefabricated performance. The same poetic couplet appears on a leaf painted in the manner of Kao K'o-kung (1248–1310) in an undated album *Landscapes after Old Masters*, now in the Shanghai Museum (*Tung Ch'i-ch'ang hua-chi*, pl. 22/6). In its level serenity and rich ink washes, *Concealing Clouds and Scattering Rain* is so unmarked by any of Tung Ch'i-ch'ang's characteristic dynamism that it may be appropriate to refer to Richard Wollheim's category of the "extra-stylistic": genuine works that fall outside the limits of an artist's identifying style, whether for reasons of patronage demands or of divergent experimentation (Wollheim, *Painting as an Art*, 1987, pp. 28–35).

RV

LITERATURE: *Kyohakusai zoshoga sen*, 1983, p. 364, cat. no. 21; *Tung Ch'i-ch'ang hua-chi*, 1989, pl. 6.

30 *Poetic Ideas from T'ang and Sung*

T'ang Sung shih-i

董其昌　唐宋詩意

Dated 1617

Album of sixteen paintings, ink on paper

26 x 25.3 cm (10¼ x 9⁹⁄₁₆ in.)

Shanghai Museum

vol. 1, pl. 30

ARTIST'S INSCRIPTIONS AND SIGNATURES:
Leaf 1, 3 lines in running script:
Behind closed doors I have been writing books for years.
The pine trees I planted have now grown with trunks like old dragons' scales.
　Hsüan-tsai.

閉戶著書經歲月
種松皆作老龍鱗
　玄宰。

Leaf 2, 4 lines in running script:
In the mountains, what do I own?
Only the white clouds on the top of the hills.
They are only for my own enjoyment,
Not sufficient as gifts for you.
 Hsüan-tsai.

山中何所有
嶺上多白雲
只可自怡悦
不堪持贈君
 玄宰。

Leaf 3, 2 lines in running script:
Near the steps outside my bedroom, I have placed the fishing rod.
[This is] an illustration of the poetic idea of Pai Hsiang-shan [Pai Chü-i,
772–846]. Hsüan-tsai.

卧房階下插漁竿。補白香山詩。玄宰。

Leaf 4, 3 lines in running script:
Below the mountain, lonely mist and distant village.
On the edge of heaven, a lone tree on the high plains.
 Hsüan-tsai.

山下孤烟遠村
天邊獨樹高原
 玄宰。

Leaf 5, 4 lines in running script:
At sunset, at the ferry, the blue mountains come into view.
Who knows how much leisure there is?
You were a woodcutter north of the Northern Mountains.
Carrying an axe, you came to this world to sell firewood.
 Hsüan-tsai.

夕陽渡口見青山
誰識其中有許閒
君本爲樵北山北
賣薪持斧到人間
 玄宰。

Leaf 6, 4 lines in running script:
Leisurely clouds come in all seasons,
Permeating this deep valley.
Fortunately no rain has appeared.
Why not enjoy this quiet solitude.
 Hsüan-tsai.

閒雲無四時
散漫此深谷
幸乏霖雨姿
何妨媚幽獨
 玄宰。

Leaf 7, 5 lines in running script:
When the geese return, water touches heaven.
Low-lying hills and old trees are surrounded by blue mists.
I borrow your spare land to anchor my fishing boat,
And, drifting into sleep, listen to the rain near the western window.
 [I] painted this to illustrate the poetic idea of Ts'ai T'ien-ch'i.
Hsüan-tsai.

鴻雁歸時水拍天
平岡古木尚蒼烟
借君餘地安漁艇
著我西窗聽雨眠
 蔡天啓詩意。玄宰畫。

Leaf 8, 6 lines in running script:
With abundant clouds, it doesn't matter how deep or shallow the
 mountains.
This place is deserted, without people coming and going.
Don't be surprised that I begin to compose poems as soon as I look at
 the painting,
For I have long kept my wooden doors open to the blue mountains.
 Hsüan-tsai painted.

雲多不計山深淺
地僻絶無人往來
莫訝披圖便成句
柴門曾對翠峰開
 玄宰畫。

Leaf 9, 2 lines in running script:
"A Hermit Dwelling among Cliffs." Hsüan-tsai painted.

《巖居高士圖》。玄宰畫。

Leaf 10, 2 lines in running script:
"Pavilion among Streams and Mountains." Hsüan-tsai painted.

《溪山亭子》。玄宰畫。

Leaf 11, 2 lines in running script:
In the style of Yün-lin [Ni Tsan, 1301–1374]. Hsüan-tsai.

倣雲林筆意。玄宰。

Leaf 12, 2 lines in running script:
In the style of the lofty Ni [Ni Tsan]. Hsüan-tsai.

倣倪高士。玄宰。

Leaf 13, 1 line in running script:
Hsüan-tsai painted.

玄宰畫。

Leaf 14, 1 line in running script:
Hsüan-tsai painted.

玄宰畫。

Leaf 15, 1 line in running script:
Hsüan-tsai painted.

玄宰畫。

Leaf 16
1. 4 lines in running script:
The stone paths circle around the mountains lush with trees.
With this kind of forest and streams, it is quiet and remote enough.
But if I could fly on my wooden sandals beyond one thousand peaks,
I would cut grass and build my thatched hut on top of the mountains.
 Hsüan-tsai.

石徑盤紆山木稠
林泉如此足清幽
若爲飛屩千峰外

卜築誅茆最上頭
　玄宰。

2. 4 lines in running script:
In the second month of the *ting-ssu* year [March 7–April 5, 1617], I painted these sixteen leaves for [my] family friend Hsün-chih [Wang Shih-min, 1592–1680]. Tung Ch'i-ch'ang.

丁巳二月寫此十六幅似遜之世丈覽教。董其昌。

ARTIST'S SEAL:
Tung Ch'i-ch'ang 董其昌 (*chu-wen*, square; leaves 1–16) 77

POEMS OPPOSITE EACH PAINTING: Ch'en Wan-ch'üan 陳萬全, Wen Ju-kua 溫汝适

COLOPHONS: Yang Lung-yu 楊龍猶 (20th century), dated 1915; Shen Chien-chih 沈劍知 (20th century), dated 1953

COLLECTORS' SEALS: Wang Shan 王掞 (1645–1728), 16; Ch'ing Hsüan-tsung 清宣宗 (r. 1821–50), 13; Yang Lung-yu, 3; Chang Heng 張珩 (1915–1963), 1; Chiang Tsu-i 蔣祖詒 (20th century), 1; Sun Yü-feng 孫煜峰 (20th century), 3; unidentified, 3

Tung Ch'i-ch'ang's *Poetic Ideas from T'ang and Sung* was painted for his student Wang Shih-min, who was the grandson of the former Grand Secretary Wang Hsi-chüeh (1534–1610) and later achieved recognition as one of the Four Wangs of the Orthodox School. Tung had known Wang Shih-min since his childhood and developed a close relationship with him. Another of Tung's works in this exhibition, the Shanghai landscape album of 1625 (vol. 1, pl. 54), was also painted for Wang Shih-min. The present album was once in the collection of Wang Shih-min's son Wang Shan, whose seals appear on many of the leaves.

Poetic Ideas from T'ang and Sung demonstrates that by 1617 Tung Ch'i-ch'ang had already established most of the stylistic concepts that the Four Wangs would later develop in their paintings: the building up of whole compositions from small units; the interest in *shih* 勢, or "momentum," in the composition expressed in the principles of *lung-mo* 龍脈 (dragon vein) and *k'ai-ho* 開合 (opening and closing); and the blending of dry and wet brushstrokes in building up basic units of form. Some leaves are ostensibly after earlier masters, such as the Yüan painter Ni Tsan, while others are based on T'ang and Sung poems. In each case, however, Tung Ch'i-ch'ang is more interested in his own re-creation or interpretation than in the slavish imitation of earlier paintings or the literal illustration of poems.

Tung was fully aware of the problem of creating paintings based on poetry. His pupil Ch'eng Cheng-k'uei (1604–1676) recorded: "'West of the Tung-t'ing Lake, the moon is bright. North of the Hsiao and Hsiang Rivers, geese fly in the morning.' Hua-t'ing [Tung Ch'i-ch'ang] liked to recite this couplet, and said, 'Even though one can recite this, it would be difficult to make a painting out of it.' To this I replied, 'It is possible to do it, but the results would not be poetry.' He laughed approvingly" (Ch'ien Chung-shu, *Chiu-wen ssu-p'ien*, 1979, p. 31).

JK

LITERATURE: Cheng Chen-to, *Yün-hui chai*, 1948, pl. 94 (leaf 1), pl. 95 (leaf 16); *Chung-kuo ku-tai shu-hua mu-lu*, vol. 3, 1987, *Hu* 1–1350; Zheng Wei, *Nien-p'u*, 1989, p. 110; *Chung-kuo ku-tai shu-hua t'u-mu*, vol. 3, 1990, *Hu* 1–1350.

31 *Lofty Recluse*
Kao-i t'u
董其昌　高逸圖

Dated 1617

Hanging scroll, ink on paper
89.5 x 51.6 cm (35¼ x 20⁹⁄₁₆ in.)

Beijing Palace Museum

vol. 1, pl. 31

ARTIST'S INSCRIPTIONS AND SIGNATURES:
1. 7 lines in running-regular script:
Serpentine misty mountains and woven paths,
The newly built thatched hut, cramped but fine.
Pine and cypress, planted by one's own hand, all now grown tall,
For a whole year not having walked the street in front of the county magistrate's office.
　A picture of "Lofty Recluse," presenting it to elder Chiang Tao-shu. The third month of the *ting-ssu* year [April 6–May 4, 1617]. Tung Ch'i-ch'ang.

煙嵐屈曲徑交加
新作茆堂窄亦佳
手種松杉皆老大
經年不踏縣門街
　《高逸圖》贈蔣道樞丈，丁巳三月，董其昌。

2. 4 lines in running-regular script:
Tao-shu filled a large jar with pine wine and came boating on the Ching River with me. On board, I wrote this to record our exhilaration. Hsüan-tsai inscribed again.

道樞載松醪一斛，與余同汎荊溪，舟中寫此紀興。玄宰又題。

ARTIST'S SEALS:
T'ai-shih shih 太史氏 (*pai-wen*, square) 72
Tung Ch'i-ch'ang yin 董其昌印 (*pai-wen*, square) 73

COLOPHONS:
Ch'en Chi-ju 陳繼儒 (1558–1639), undated, 2 seals:
Chang Hao was of towering stature,
Beard and eyebrows have long been shining white.
In service, the teacher of emperors and princes,
In retirement, an old man lost in a desolate valley.
Bowing his head to hoe his own field,
For ten years without a companion.
[Now] his precious sword broken to make a sickle,
And cutting the frost-caught scallions full of grief and frustration.
　Hsüan-tsai has written the picture "Lofty Recluse" to give to Mr. [Chiang] Tao-shu, so [I] have inscribed a few words in presentation. Such limitless melancholy! Ch'en Chi-ju.

張鎬九尺餘
鬢眉皓然久
用之帝王師
不用窮谷叟
低頭事躬耕
十載無其耦
寶劍折作鎌
悲畏刈霜韭
　玄宰寫《高逸圖》贈道樞先生，因題數言贈之。無限感慨矣！陳繼儒。

Wang Chih-tao 王志道 (17th century), undated, 2 seals:
He has been the magistrate of Lien-hu,
Visiting several times the city of A-meng [Su-chou].
[Here] within, dwells a recluse,
Opening a path like Yüan-ch'ing.
Why sweep away the fallen blossoms,
Carriages of the wealthy stop because of them.
His wall is like that of Tsung Ping [375–443, who painted on the walls
 of his studio landscapes he had visited when younger],
So much inexhaustible inspiration from his collection of history books
 and paintings!
Who could represent one such as this?
Ni yü [Ni Tsan, 1301–1374] and Shu-ming [Wang Meng, 1308–1385].
Who have a close bond built on [a common interest in] connoisseurship?
The two gentlemen of the San-mao lakes [Tung Ch'i-ch'ang and Ch'en Chi-ju].
Moved by such Yen-chou righteousness,
They publish the fame of this lofty gentleman.

曾爲練湖長
幾度阿蒙城
中有幽人居
開徑似元卿
落花何用掃
軒車爲之停
壁是少文壁
圖史百餘清
誰能圖此者
倪迂與叔明
賞鑒最來往
三泖兩先生
因感延州義
遂標高士名

Chiang Shou-chih 蔣守止, undated, 2 seals:
There have always been empty claims,
But could there, in the end, be empty fame?
A lofty gentleman, in the world of his brush and ink,
Smiles at having his immortality there secured.

空業未能無
空名竟何有
高人楮墨間
哂以托不朽

COLLECTORS' SEALS: Po Ch'eng-liang 柏成樑, 2; unidentified, 2

Chiang Tao-shu has not been identified. He evidently lived in retreat at Lake Lien, between Tan-yang and Lake T'ai. This is mentioned in Wang Chih-tao's poem, the many obscure allusions of which have not here been deciphered. These allusions, taken with those in Ch'en Chi-ju's poem, indicate that Chiang had been a local official, presumably the Magistrate of Lien-hu, perhaps later becoming an army officer. Having achieved a reputation, even if a minor one, he had evidently settled down to a literary retirement through choice or perhaps force of circumstance. There is some hint of a rather lively past. Tung Ch'i-ch'ang apparently enjoyed his freewheeling company, although Tung's inscription is typically somewhat staid. He used the same poem, with the difference of a single character, on a painting for Ch'en Chi-ju

himself (recorded in *Jung-t'ai shih-chi*, ch. 4, p. 33). Judging by the lack of seals after the first inscription and the continuity in the writing, the second inscription was written at the same time as the first. The painting must have been done after returning from the outing and Chiang may have asked Tung to be a little more expansive in his inscription. Whatever the case, Chiang acquired a magnificent painting.

Lofty Recluse was painted about one year after disaster had struck Tung and his family, and also just as Tung was entering on an extraordinary period of creative ambition and energy. Superficially, such a painting would support both the hard-nosed economic explanations of this development—Chiang may well have had the money to pay for a handsome picture—and also more psychologically oriented interpretations. The quality and the originality of this and comparable works suggest, on the other hand, that the destruction of Tung's estate, the damage to his reputation, and perhaps especially the loss of his collection, had miraculously released him from an overwhelming burden of cultural debt.

Among the shifts that occur is that away from Huang Kung-wang (1269–1354) toward Ni Tsan and Wang Meng, as though, having absorbed the constructive strengths of Huang, he could now investigate other functions, some of them more immediately psychological. As should be expected of an artist of Tung's intelligence, his assessment of others, such as the Four Yüan Masters, depended on the context. Whereas, at times, he crowned Huang as supreme, he also said of Huang, contrasting him with Ni Tsan, "The ubiquitous consciousness of practice was something that Huang could never break" (*Jung-t'ai pieh-chi, ch.* 6, pp. 8–9).

For comparisons in what Tung was achieving in this painting, the *Landscape* (vol. 1, pl. 33) and the *Ch'ing-pien Mountain* (vol. 1, pl. 32) of the same year are very close. However, among different kinds of comparisons that could be made for this painting, which so clearly invokes a Ni Tsan born of Huang Kung-wang, one with the more univocally Huang *Lin Pu's Poetic Idea* of three years earlier (vol. 1, pl. 23) is particularly instructive. They share the same polarized composition, with a tree-crowned bank in the foreground on the vertical axis, and an upper section centered on a hermit's dwelling, on the verge between water and hills that stretches back on a diagonal from left to right. The opening hummock of the 1617 painting is constructed along a zigzag path that more or less duplicates the movements of the earlier work. But the tightly controlled boundaries of the 1614 work are now lightened, opened, and made ambiguous, so that the space flows throughout the depth of surface in the entire painting. The subtle modulations of shape and texture in the trees implicate this same flow. The perfectly judged construction of this painting is exemplified in the small but deeply significant dwelling. Its alignment and interior angles are exactly calculated to turn the entire composition on this moment. If Tung had been converted by one of the Catholic missionaries active at this time, he might have agreed that God dwells in the details. The point can still be made, however, for it nests on the crown of the great pine stretching up toward the building, and the demonstrative presence in the trees is absorbed into the reclusive inhabitation of the dwelling. As other works of this period amply show, and as the facts of his life might lead us to suspect, Tung's engagement here is not only with the art of painting, but more impor-

tantly with the cultural, psychological, and structural functions of dwelling itself, as one of the greatest of all themes in literati art and literature. One can only speculate on the depth of significance to be granted to Tung's converse with Chiang in this regard.

JH

LITERATURE: Xu Bangda, *Pien-nien-piao*, 1963, p. 97; Contag, *Seventeenth Century Masters*, 1969, pl. 5b; Xu Bangda, *T'u-lu*, 1984, vol. 2, pl. 405; Xu Bangda, *Kao-pien*, 1984, text, vol. 2, p. 157, illustrations, vol. 2, pls. 33–23; *Chung-kuo ku-tai shu-hua mu-lu*, vol. 2, 1985, *Ching* 1–2164; Ren Daobin, *Hsi-nien*, 1988, pp. 152–53.

32 *The Ch'ing-pien Mountain in the Manner of Tung Yüan*

Ch'ing-pien t'u fang Pei-yüan pi

董其昌　青弁圖倣北苑筆

Dated 1617

Hanging scroll, ink on paper
224.5 x 67.3 cm (88⅛ x 26½ in.)

The Cleveland Museum of Art 80.10

vol. 1, pl. 32

ARTIST'S INSCRIPTIONS AND SIGNATURES:
1. 3 lines in running script:
A painting of the Ch'ing-pien Mountain in the manner of Pei-yüan [Tung Yüan, fl. ca. 945–ca. 960]. In the summer of the *ting-ssu* year, on the last day of the fifth month [July 2, 1617], [I] send this to my elder, Chang Shen-ch'i. Tung Hsüan-tsai.

青弁圖倣北苑筆。丁巳夏五晦日，寄張慎其世丈。董玄宰。

2. 5 lines in running script:
Piling irons for ten thousand feet guard the purple sky;
Where puppies are seen on top of clouds, villages and marketplaces lie.
In the splendor of autumn, where is the most worthy spot to spend the
 day?
Amid the rustling sounds of mountain streams, with a volume in hand,
 meditating on the Way (Tao).
 Inscribed by Ch'i-ch'ang.
(Translation by Wai-kam Ho and Ling-yün Shih Liu, in Ho et al., *Eight Dynasties*, 1980, p. 246.)

積鐵千尋亘紫虛
雲端稚犬見邨墟
秋光何處堪消日
流澗聲中把道書
　　其昌題。

ARTIST'S SEALS:
Chih chih-kao jih-chiang kuan 知制誥日講官 (*pai-wen*, rectangle) **64**
Tung Ch'i-ch'ang yin 董其昌印 (*pai-wen*, square) **65**

NO COLOPHONS

COLLECTORS' SEALS: Li En-ch'ing 李恩慶 (*chin-shih* 1833), 3; Weng Wan-ko 翁萬戈 (Wan-go Weng, b. 1918), 1

One of the largest of Tung Ch'i-ch'ang's surviving works, the *Ch'ing-pien Mountain* embodies a level of sustained formal complexity perhaps unmatched elsewhere in his art. Painted in 1617, the year after the attack on Tung's family estates and the looting of his art collection, this work—along with the *Landscape* (vol. 1, pl. 33) of a few months later—seems to manifest a deliberate measuring against the ancients in both structural and visual terms that may have served as a symbolic restoration of losses both psychic and artistic. The model invoked by Tung in his first inscription is the tenth-century master Tung Yüan, but the more important source—though unacknowledged by Tung Ch'i-ch'ang and relatively neglected by modern scholars as well—would seem to be the similarly titled painting by Wang Meng (1308–1385), *Dwelling in Reclusion in the Ch'ing-pien Mountain* (*Ch'ing-pien yin chü*), dated 1366 (Cahill, *Hills Beyond a River*, 1976, pls. 53–55). Tung Ch'i-ch'ang wrote two colophons for Wang Meng's painting, one of which proclaimed it "the supreme Wang Shu-ming [Wang Meng] painting in the world." Although the dated colophon was not written until 1620, after Tung painted his own version of the subject, the Wang Meng painting had been in the collection of the renowned connoisseur Hsiang Yüan-pien (1525–1590), which was well known to Tung in his youth in Hua-t'ing. There are also parallelisms in design and treatment between Tung Ch'i-ch'ang's and Wang Meng's versions of the *Ch'ing-pien* subject, though characteristically transposed and reformulated in Tung's work. These include the narrow, crowded proportions; the use of dynamically varied rows of trees, angled upward toward the right in the foreground; the upwardly surging rhythms of the complex landscape formations in the middle distance; the appearance of spatially ambiguous formations in the center of the composition; and even the placement of the cottages behind diagonal ridges at the left-center edge of the painting. The relationships are in the form of structural transpositions rather than specific emulations, though more specific transpositions may be discerned in the transference of forms like the round-topped, rightward-leaning buttes from the top of Wang Meng's composition to a place just above the tall trees in the near middle distance of Tung Ch'i-ch'ang's design. Tung's composition culminates in misty distant peaks quite unlike Wang Meng's somber crowded summits. Thus the reference to Tung Yüan may point to scattered passages in the painting, or possibly represent a projection of Tung Ch'i-ch'ang's historical speculations regarding the sources of the Wang Meng scroll onto his own work.

Tung Ch'i-ch'ang's *Ch'ing-pien Mountain* makes use of two prominent organizing devices: rows of dark conifers that accent horizontal sections, as in the regular rise and fall across the width of the scroll in the near middle distance, and reserve bands of unpainted paper that surround solid forms and create an irregular grid of intervals within the larger landscape. These organizing devices seem ultimately spurious, because coherence is broadly denied, notably in the unresolvable juxtaposition of powerfully plastic forms with flat patterns in the middle-distance ridges and in the insecure linkage of the upper misty mountains with the formations below. Ultimately the viewer is unable to resolve the discordant passages, and the effect is of an uninterrupted cycle of dynamic circulation around the contradictory passages of the painting, in a manner that holds something in common with diagrammatic optical illusions or the ambiguous readings of cubist spaces, as James Cahill has noted (Cahill, *Distant Mountains*, 1982,

p. 101). Rather than pure formalism, however, Tung's devices might equally reflect his working methods, in which reformulations of various remembered passages from older paintings were juxtaposed in conscious disregard of an overall coherence.

RV

EXHIBITIONS: Haus der Kunst, Munich, 1959: *Tausend Jahre Chinesische Malerei*, cat. no. 63; Asia House Gallery, 1967: Cahill, *Fantastics and Eccentrics*, p. 19, cat. no. 1; Fogg Art Museum, Cambridge, Mass., 1979; Nelson Gallery-Atkins Museum and The Cleveland Museum of Art, 1980–81: Ho et al., *Eight Dynasties*, cat. no. 192.

LITERATURE: Sirén, *Leading Masters and Principles*, 1956–58, vol. 5, pp. 7–8, vol. 7, p. 247; Lee, *Chinese Landscape Painting*, 1962, no. 67; Wu, "Apathy in Government and Fervor in Art," 1962, pl. 4; Goepper, *The Essence of Chinese Painting*, 1963, pls. 61–63; Lee, *Far Eastern Art*, 1973, p. 438, fig. 581; Cahill, "Chugoku kaiga ni okeru kiso to genso," pt. 1, 1975, color pl. 2 (detail); Kohara, Wu, et al., *Jo I, To Kisho*, 1978, p. 170, pl. 38 (color), pl. 39 (detail), p. 157 (seals); Sullivan, *Symbols of Eternity*, 1979, p. 134, pl. 80; Kohara, *To Kisho no shoga*, 1981, p. 239, pl. 10; Cahill, *Compelling Image*, 1982, pp. 39–43, fig. 2.2; Cahill, *Distant Mountains*, 1982, pls. 44–45; Suzuki, *Comprehensive Illustrated Catalogue*, 1982–83, vol. 1, A13–029; *Tung Ch'i-ch'ang hua-chi*, 1989, app. pl. 75.

33 *Landscape*
Shan-shui
董其昌　山水

Dated 1617

Hanging scroll, ink on paper
167.6 x 52.9 cm (66 x 20¹³⁄₁₆ in.)

National Gallery of Victoria, Melbourne

vol. 1, pl. 33

ARTIST'S INSCRIPTION AND SIGNATURE (3 lines in running script): On the full moon of the ninth month of the *ting-ssu* year [October 14, 1617] I sketched this to give to the honorable Hsüan-yin. At the time, I was in Wu-lin [Hang-chou] at the Le-chih Garden. Written by Tung Hsüan-tsai.

歲在丁巳九月之望，寫贈玄蔭使君。時在武林之樂志園。董玄宰識。

ARTIST'S SEALS:
Hua-ch'an 畫禪 (chu-wen, rectangle) 74
T'ai-shih shih 太史氏 (pai-wen, square) 75
Tung Ch'i-ch'ang 董其昌 (chu-wen, square) 76

NO COLOPHONS

COLLECTORS' SEALS: Weng Sung-nien 翁嵩年 (1647–1728), 2; Ho Yüan-yü 何瑗玉 (fl. late 19th century), 3; Wang Chi-ch'ien 王季遷 (b. 1907), 1; unidentified, 2

RECENT PROVENANCE: Wang Chi-ch'ien

Following the Cleveland *Ch'ing-pien Mountain* (vol. 1, pl. 32) by three months, the Melbourne *Landscape* stands with that painting as one of Tung Ch'i-ch'ang's most fully realized and powerful creations. The work combines the interest of dynamic forms, brush and ink, and scenic complexity in a manner rarely equaled elsewhere in Tung's oeuvre. Both landscapes of 1617 followed the destruction and looting of Tung's family estates in the previous year. Whatever stimulus they may have provided to increased production of painting and calligraphy, these destructive events seem in these cases to have encouraged Tung to attempt a re-creation of not only the structural and diagrammatic qualities of some earlier sources, but a large measure of their visual impact, as if in compensation for the visual qualities of the paintings he had lost.

The Melbourne *Landscape* is unusually spacious and consistently scaled, with larger trees and houses giving way to progressively smaller ones in episodes that lead from foreground banks, around great bluffs, and back into distant misty valleys. A scattering of small trees with horizontal foliage dots among the larger and more differentiated trees in the foreground is the only obtrusive element of scale ambiguity in an otherwise convincingly monumental composition. The V-shaped space formed by the silhouettes of the foreground trees is answered in a cluster of rocks directly in front of the largest houses, and the rhythm is then subtly inverted in the ranked hills above, but there is otherwise little of Tung's often heavy-handed manipulation of forms into repeated patterns.

The scroll is notable for the rich use of wash in the distant hills at upper right and the tonal range of the mountains in general, which convey an effect of rounded masses and deep shaded furrows. Those qualities, and the conformation of the upper peaks, suggest a derivation from the Tung Yüan–Chü-jan manner, seen in the short, fibrous texture strokes, repeated curves, and lumpy boulders of the upper peaks. The arrangement of the composition as a three-part river landscape indicates Yüan dynasty prototypes, and there are elements of the Huang Kung-wang style in the schematic boulders and level plateaus in the middle section. The most important source, however, may again have been Wang Meng (1308–1385), as in the *Ch'ing-pien Mountain* scroll of a few months earlier. Some of Wang Meng's monumental landscapes of the mid-1360s, such as the *Lofty Recluses in Summer Mountains* (*Hsia-shan kao-yin*) of 1365, contain massive segmented bluffs and darkly modeled, heavily textured cliffs in the manner of the present scroll (*Chung-kuo li-tai hui-hua*, 1983, vol. 4, pp. 69–71). Wang Meng's landscapes in general most fully embody the qualities seen here: a three-part composition of rivers and mountains of monumental scale, deep spaces complexly filled and articulated, and forms heavily textured and modeled with dark tonalities to create volume. There is a record of Tung Ch'i-ch'ang's having seen and imitated a Wang Meng painting entitled *Le-chih lun* six months before he painted the Melbourne *Landscape*. The characters in the title to the Wang Meng painting are the same as the name of the garden mentioned in the dedication to the *Landscape*; and the coincidence of names might have suggested an appropriate model for the painting. Whatever the model or models for the 1617 *Landscape*, Tung Ch'i-ch'ang's expressive manipulations of forms—including the powerful friction of leaning cliffs pressed up against the peak at upper left and the way the earthy bluffs directly below the upper peaks seem to be infolded upon themselves—stamp the work as unmistakably his own.

RV

EXHIBITION: University Art Museum, Berkeley, 1971: Cahill, *Restless Landscape*, cat. no. 35, pp. 91–92, 96.

LITERATURE: Sirén, *Leading Masters and Principles*, 1956–58, vol. 6, pl. 263; Pang, "Tung Ch'i-ch'ang and His Circle," 1971, pp. 91–92, cat. no. 35; Kohara, Wu, et al., *Jo I, To Kisho*, 1978, p. 169, pl. 31; Kohara, *To Kisho no shoga*, 1981, pp. 239–40, pl. 11; Cahill, *Distant Mountains*, 1982, pp. 99–100, pls. 42–43; Pang, *Album of Chinese Art*, 1983, pp. 137–38; *Tung Ch'i-ch'ang hua-chi*, 1989, app. pl. 76.

34 *Abbreviated Version of Su Shih's "The First Excursion to Red Cliff," running script*

Hsing-shu yin-k'uo "Ch'ien Ch'ih-pi" shih

董其昌　行書檃括《前赤壁》詩

Undated (datable to 1617–18)

Album of fifteen leaves, ink on satin

26.3 x 15.6 cm (10⅜ x 6⅛ in.)

Beijing Palace Museum

vol. 1, pl. 34 (detail); vol. 2, pl. 34

ARTIST'S TITLE (2 lines in running-cursive script, preceding an abbreviated version in *tz'u*, or lyric, form of irregular meter based on Su Shih's [1036–1101] essay, "The First Excursion to Red Cliff"): Abbreviated Version of "The First Excursion to Red Cliff"

檃括《前赤壁》

ARTIST'S SIGNATURE (1 line in running-cursive script, following the poem in 27 lines): Written by Ch'i-ch'ang.

其昌書。

ARTIST'S SEALS:

Hsüan-shang chai 玄賞齋 (*pai-wen*, tall rectangle) **66**
Chih chih-kao jih-chiang kuan 知制誥日講官 (*pai-wen*, rectangle) **67**
Tung Ch'i-ch'ang yin 董其昌印 (*pai-wen*, square) **68**

NO COLOPHONS

COLLECTORS' SEALS: unidentified, 2

The "First and Second Excursions to Red Cliff" (*Ch'ien hou Ch'ih-pi fu*) by the Sung dynasty poet, humanist, calligrapher, and sometime painter Su Shih are among the essays most cherished by the Chinese-reading public. Written during his period of exile in Huang-chou, Hupei, Su described two outings in 1082 to the Red Cliff, on the Yangtze River, which he believed to be the original site of a historic battle in 208 that led to the downfall of the military dictator Ts'ao Ts'ao (155–208). In this prose poem, Su managed in an utterly simple yet magical language combining poetry and prose to capture the awesome spirit of nature and history, infinite beauty and sadness, so that one is left with the palpable sense of having been with the poet and his friend and partaken of their wine, relived the battle at the site,

and experienced the mystery of nature and fate which inhabits humanity. (For a translation of the text, see Watson, *Su Tung-p'o*, 1965, pp. 87–93.)

Thus, "Red Cliff" is almost a mnemonic device for a host of associations that accompany any reading of Su's original composition, and it has functioned as a source of inspiration to calligraphers, painters, and poets alike. Even though Su's writing was proscribed for a time, as early as the succeeding Chin dynasty, poets paid homage to Su's memory and his genius by composing poems "in response to" or with similar words, phrases, or rhymes as the original composition. (The Chin poet and calligrapher Chao Ping-wen [1159–1232] wrote an exceptional colophon in *tz'u* form, dated 1232, which is attached to a depiction of the Red Cliff excursion by Wu Yüan-chih [fl. late 12th century], one of the earliest paintings of the subject; see *Chinese Art Treasures*, 1961, no. 46, and Murck and Fong, *Words and Images*, 1991, fig. 71.) This, in fact, is what Tung Ch'i-ch'ang chose to do here in this "abbreviated version" of the Red Cliff prose poem. While his original draft has disappeared, Su did make a copy for a friend (*Ku-kung fa-shu*, 1965, vol. 9B), which Tung Ch'i-ch'ang had the good fortune to see a number of times. It is known that as early as 1596, on his way to Ch'ang-sha, Hunan, Tung traveled down the Yangtze, and, presumably passing one of the sites that had since been identified as the Red Cliff, was asked to write some calligraphy in large characters after Su's prose poem (*Hua-ch'an shih sui-pi*, pp. 11–12). Later, in 1601, Tung saw Su's original version and inscribed it with a colophon:

> As rhyme-prose, Tung-p'o's is one transformation of the *Ch'u* [*tz'u*, "Songs of the South"] and [*Li*] *sao* ["Encountering Sorrow," of the poet Ch'ü Yüan, 343–277 B.C.; a classic of its genre]. As calligraphy, it is one transformation of the *Orchid Pavilion* [*Preface*, of Wang Hsi-chih, 303–379; also a classic]. The people of the Sung regarded this composition as the ultimate of its type, and even though in all I have seen quite a number of famous and genuine works [by Su] in collections, there is nothing that can surpass this one. (*Ku-kung fa-shu*, vol. 9B)

Su's handscroll bears Hsiang Yüan-pien's (1525–1590) seals, so it is likely that Tung saw and studied the work earlier, in the 1570s and 1580s, when he was a friend of one of the Hsiang sons. In another colophon, Tung mentions that he had seen three examples of Su's "Red Cliff" calligraphy in three different collections, one version having Su's inscription at the end; however, they were all of the "First Excursion." Tung wrote out several versions of the "Second Excursion," but these were based only on a carved version owned by Chao Meng-fu (1254–1322). (Tung wrote a colophon to one of his own versions in 1604; there are also recorded versions by him dating to 1608 and 1613. See *Hua-ch'an shih sui-pi*, p. 13; Kohara, *To Kisho no shoga*, 1981, pp. 186–93.)

Tung's version of "The First Excursion to Red Cliff" can be regarded as yet another transformation in the history of this classic: he selects a luxurious surface—satin; a free and expressive mode—cursive script; and a convenient form—a truncated text. There is no dedication and no commentary about the circumstances (something Tung did like to do; possibly they were lost in the interim), so one can speculate on its recipient and on Tung's mood and motivation. Tung must have been both exhilarated and content, because the brush reveals the calligrapher at his elegant best. Tung chooses to serve up his "Red Cliff" in the guise of two of his most esteemed models of cursive

script: Huai-su (fl. late 8th century) of the T'ang (see vol. 1, fig. 56) and Huang T'ing-chien (1045–1105) of the Sung. The influence of the latter is especially recognizable by the circular and flying-brush movements (see leaves 5 and 6, as well as 8–10 and 12–15), while Huai-su's influence can be detected in the thinner brushlines, slightly drier ink, and use of the brush tip (as in the two characters *ch'ih-pi* of the title, leaf 1, and leaves 10 and 14). At the same time, the viewer is treated to a luscious sampling of Tung's personal seasoning of rich moist ink and crisp, pungent brushwork. Although there is no overt reference to a third master of running-cursive, Mi Fu (1051–1107), Tung pays homage to him in the way in which he has spontaneously manipulated his brush like a rotational device, sensuously caressing the silken surface and allowing the brush to fall relatively easily into the shape of each graph. Mi's more tactile brush touch differed from the struggling brush of Huang T'ing-chien, yet Tung has somehow managed to incorporate the divergent features of these two masters into his personal manner (see vol. 1, pl. 34).

Some of the ligatures, especially toward the end, seem heavy and labored, but Tung rescues himself in the last leaf. In the final, picturesque phrases of his lyric, where "the dew falls on the cassia oars of the boat / in the mountain valley glows the white moon," Tung lets the ink run pale and almost dry in the brush, and, dragging the brush slowly and fondly, brings the excursion to a close. In combining Su's poem with references to T'ang and Sung masters of cursive, Tung has achieved a level of aesthetic synthesis (*chi ta-ch'eng* 集大成) that could certainly rival his achievement in painting.

MWG

Literature: *Chung-kuo ku-tai shu-hua mu-lu*, vol. 2, 1985, *Ching* 1–2206.

35 *Calligraphy and Painting*
Shu-hua
董其昌　書畫

Dated 1618

Album of eight paintings with eight leaves of calligraphy, ink on paper
21.1 x 13.5 cm (8⅛₆ x 5⅜₆ in.)

Shanghai Museum

vol. 1, pl. 35 (leaves 1, 2, 4, 7); vol. 2, pl. 35 (leaves 3, 5, 6, 8)

Artist's inscriptions and signatures (and transcriptions of poems by Ni Tsan [1301–1374]; the location of the poems in Ni's collected poetry is given in brackets):
Leaf 1, 3 lines in running script:
Hsüan-tsai painted. The fourth month of the *wu-wu* year
[April 25–May 23, 1618]. Writing several styles.

玄宰畫。戊午四月寫各體。

Leaf 1a, 4 lines in running script:
Blue river waters, on all sides,
Dwelling as if in a painting.

If the host wishes to engrave the record of "all mountains,"
He should get hold of the drunken old man from Ch'u-yang
[i.e. Ou-yang Hsiu, 1007–1072]!
[*Ch'ing-pi ko ch'üan-chi*, ch. 7, p. 11]
Hsüan-tsai.

一色青江四面同
樓居如在畫圖中
主人欲刻皆山記
須得滁陽老醉翁
　玄宰。

Leaf 2, 2 lines in running script:
Hsüan-tsai after Chao Ch'ien-li [Chao Po-chü, ca. 1120–ca. 1170].

玄宰倣趙千里。

Leaf 2a, 4 lines in running script:
After snow in gardens and groves, plum already blossoming,
Breeze rising in the west, a line of geese.
Streams and mountains silent, no sign of people,
A good moment to call on the hermit home of Lin Pu [967–1028].
[*Ch'ing-pi ko ch'üan-chi*, ch. 8, p. 1]
Hsüan-tsai.

雪後園林梅巳花
西風吹起雁行斜
溪山寂寂無人迹
好問林逋處士家
　玄宰。

Leaf 3, 2 lines in running script:
Hsüan-tsai after Ni Yüan-chen [Ni Tsan].

玄宰倣倪元鎮。

Leaf 3a, 4 lines in running script:
Such an eccentric indulged by dwelling in solitude, always getting up late,
Reaching the stream, thoughts still blurred.
A hut among trees, in morning light and stretching space,
Eyeing a departing sail, westwards across the water.
[*Ch'ing-pi ko ch'üan-chi*, ch. 7, p. 21]
Hsüan-tsai.

性癖居幽每起遲
一來溪口意凄迷
林亭曉色蒼茫裏
目送風帆過水西
　玄宰。

Leaf 4, 1 line in running script:
Hsüan-tsai painted.

玄宰畫。

Leaf 4a, 4 lines in running script:
The hall in old Tu's [Tu Fu, 712–770] garden is hard against the foot
 of a cliff,
The Jang River flows west from East Village.
Autumn rain fills the courtyard, green with moss,
Getting up to raise the blind, draining the verdant cup.
[*Ch'ing-pi ko ch'üan-chi*, ch. 7, p. 20]
Hsüan-tsai.

杜老茆堂倚石根
往來西漢與東屯
一庭秋雨青苔色
自起鉤簾畫綠尊
　　玄宰。

Leaf 5, 1 line in running script:
Hsüan-tsai painted.

玄宰畫。

Leaf 5a, 4 lines in running script:
In the slanting sun, a westerly breeze blows hair back from my brow,
Opening a painting, playing with a brush, just like childish pleasure.
The [rustic] fishing rod brushes the [elegant] coral tree—
My teacher in inscribing poetry is Chang Yu (d. ca. 853).
[*Ch'ing-pi ko ch'üan-chi*, ch. 7, p. 20]
　　Hsüan-tsai.

斜日西風吹鬢絲
披圖弄翰學兒嬉
釣竿拂著珊瑚樹
張祐題詩是我師
　　玄宰。

Leaf 6, 1 line in running script:
Hsüan-tsai painted.

玄宰畫。

Leaf 6a, 4 lines in running script:
Pavilions here and there, gauze mists parting,
Mountain peaks one beyond the other, watercourses winding again
　　and again.
Under the drooping willows the bridge's crimson balustrade,
Strolling under the moon, blowing panpipes, approaching here.
[*Ch'ing-pi ko ch'üan-chi*, ch. 7, p. 19]
　　Hsüan-tsai.

樓閣參差霞綺開
峰巒重複水縈迴
赤欄橋外垂楊下
步月吹笙向此來
　　玄宰。

Leaf 7, 1 line in running script:
Hsüan-tsai painted.

玄宰畫。

Leaf 7a, 4 lines in running script:
The waters of Wu-sung look like the Ching River—
Except that there are no mountains to be reflected in my cup of wine.
Ancient trees and remote bamboo thickets, endlessly full of thoughts,
A westerly breeze blowing hairs from my brow, streaks of shadow.
[*Ch'ing-pi ko ch'üan-chi*, ch. 8, p. 6]
　　Hsüan-tsai.

吳松江水似荊溪
只欠山光落酒卮
古木幽篁無限思
西風吹鬢影絲絲
　　玄宰。

Leaf 8, 1 line in running script:
Hsüan-tsai painted.

玄宰畫。

Leaf 8a, 5 lines in running-regular script:
Pale shapes of distant mountains, softly piled hair,
Ripples on the autumn water, the silent sparkle of maidens' glances.
Wind-filled sails to north and west, the river way goes on forever,
One streak of cloud refuses to drift across, becoming attached.
[*Ch'ing-pi ko ch'üan-chi*, ch. 8, p. 23]
　　Happening to write quatrains by Ni Yüan-chen. They don't have to be appropriate to the painting! On the fifteenth day of the second month of the *chi-wei* year [March 10, 1618]. On the way to K'un-shan. Hsüan-tsai. (Translations by John Hay and Wai-kam Ho.)

脉脉遠山螺翠橫
盈盈秋水眼波明
西北風帆江路永
片雲不度若為情
　　偶書倪元鎮絕句，不必與畫有當也。己未二月望日，崑山
道中，玄宰。

ARTIST'S SEALS:
Hsüan-tsai 玄宰 (*chu-wen*, square; leaves 1, 1a, 4, 7) **88**
Ch'i-ch'ang 其昌 (*chu-wen*, square; leaves 2, 3, 5, 6) **89**
Tung Ch'i-ch'ang yin 董其昌印 (*pai-wen*, square; leaves 2a–5a, 7a, 8, 8a) **91**
Tung Ch'i-ch'ang yin 董其昌印 (*pai-wen*, square; leaf 6a) **90**

COLOPHONS: Ku Wen-pin 顧文彬 (1811–1889), dated 1873, 2 seals; Weng T'ung-ho 翁同龢 (1830–1904), dated 1903, 1 seal; Wu Hu-fan 吳湖帆 (1894–1968), dated 1941, 1 seal

COLLECTORS' SEALS: Ch'en Ting-shan 陳定山 (1897–1989), 1; Chang Heng 張珩 (1915–1963), 3; unidentified, 5

These leaves of painting and calligraphy have great consistency and are clearly the product of a single effort, presumably while on a leisurely trip to K'un-shan, northwest of Hua-t'ing. There are variations in the choice of seals, indicating either a degree of whimsy in the final gesture or different occasions. As Tung writes on the last leaf, the accompanying texts (here drawn from Ni Tsan's literary oeuvre; leaves 4a–7a originally written for paintings) are not strictly obliged to match the painting. This mild protest might be taken as a warning for interpretation in general. Nevertheless, the habits of associative thinking were so deeply ingrained that complete disengagement is probably rare. Here, for instance, the "drunken old man from Ch'u-yang" in the first pair of leaves refers to Ou-yang Hsiu, while the painting turns to Mi Fu (1051–1107). Ou-yang Hsiu wrote the poem "Pavilion of the Drunken Old Man" about a site in Anhui province where he was Prefect. Ou-yang Hsiu was not a painter, but was a leading elder in the most famous group of Northern Sung literati critics who were best represented in painting a generation later by Mi Fu. Mi himself was intimately associated with the cultural representation of the southeastern landscapes. Such indirections add to the richness of association. On a simpler level, in the fourth pair, the painting of which reflects on Wu Chen (1280–1354), the dwelling is indeed hard against a cliff. In the sixth pair, there is certainly no sign of pavilions either here or there, but the crisp and silvery tonality glows as

though in moonlight. In the last pair, where Tung mentions the source of his texts, the painting is a fascinatingly macho transformation of Ni Tsan. All the leaves seem to explore ways of introducing substance into various conventional manners. Although so informal in this context, Tung is nevertheless taking himself very seriously. These works are in no sense slight, and their seriousness of purpose was as important to Tung Ch'i-ch'ang himself as it has proved elusive to many later critics, especially Western ones. The calligraphy is a fine, relaxed performance in his characteristic *hsing-shu* style derived from the Chin and T'ang masters.

JH

LITERATURE: Cheng Chen-to, *Yün-hui chai*, 1948, pl. 96 (leaf 8); Contag, *Seventeenth Century Masters*, 1969, pl. 51 (leaf 1); *Chung-kuo ku-tai shu-hua mu-lu*, vol. 3, 1987, *Hu* 1–1353; *Tung Ch'i-ch'ang hua-chi*, 1989, pl. 138; Zheng Wei, *Nien-p'u*, 1989, pp. 117, 121–22; *Chung-kuo ku-tai shu-hua t'u-mu*, vol. 3, 1990, *Hu* 1–1353.

36 *Landscape in the Manner of Ni Tsan*
Fang Yün-lin shan-shui
董其昌　倣雲林山水

Undated (ca. 1618–20)

Hanging scroll, ink on paper
77.4 x 39.5 cm (30½ x 15⁹⁄₁₆ in.)

Shanghai Museum

vol. 1, pl. 36

ARTIST'S INSCRIPTION AND SIGNATURE (4 lines in running script):
Rushing rapids over the shoal chime with the rain,
To the north and the south of the cottage, spring waters brim.
Walking with a staff, I make my way through the flowers.
Over the wind-blown waves of the Five Lakes are light-winged white
 gulls.
[Ni] Tsan.
Hsüan-tsai imitating Yün-lin's [Ni Tsan, 1301–1374] brushwork.

灘聲嘈嘈雜雨聲
舍北舍南春水平
拄杖穿花出門去
五湖風浪白鷗輕
　瓚。
　玄宰倣雲林筆。

ARTIST'S SEALS:
Hua-ch'an 畫禪 (*chu-wen*, rectangle) **78**
Tung Ch'i-ch'ang 董其昌 (*chu-wen*, square) **79**

NO COLOPHONS

COLLECTORS' SEALS: Kao Shih-ch'i 高士奇 (1645–1704), 1;
unidentified, 1

LITERATURE: *Hua-yüan*, 1955, vol. 1, pl. 44; *Tung Ch'i-ch'ang hua-chi*, 1989, pl. 13.

37 *After Ni Tsan's "Lofty Scholar in Autumn Mountains"* (by attribution)
Fang Ni Yün-lin "Ch'iu-shan kao-shih" t'u
董其昌　倣倪雲林《秋山高士》圖

Undated (ca. 1620)

Hanging scroll, ink and color on silk
137.2 x 65.4 cm (54 x 25¼ in.)

Shanghai Museum

vol. 1, pl. 37

ARTIST'S INSCRIPTIONS AND SIGNATURES:
1. 2 lines in running script:
Lofty Scholar in Autumn Mountains, Hsüan-tsai [painted].

《秋山高士圖》，玄宰。

2. 7 lines in running script:
The leftover streams and mountains were fine places to live.
The only sad thing is the Academy style that survived the shrunken
 dynasty.
Who can understand the simple and far-reaching mind of the lofty scholar,
Each stroke of his brush is saturated with the wisdom of a hundred
 volumes of books.
 A poem on Yün-lin's [Ni Tsan, 1301–1374] painting, transcribed here
on my imitation of his work for Hu-ch'en. Hsüan-tsai.

剩水殘山好卜居
差憐院體過江餘
誰知簡遠高人意
一一豪端百卷書
　　題雲林畫，因倣倪畫書此。玄宰爲虎臣丈。

ARTIST'S SEALS:
Hua-ch'an 畫禪 (*chu-wen*, rectangle) **84**
T'ai-shih shih 太史氏 (*pai-wen*, square) **87**
Tung Ch'i-ch'ang yin 董其昌印 (*pai-wen*, square) **71**
Chih chih-kao jih-chiang kuan 知制誥日講官 (*pai-wen*, rectangle) **70**

COLOPHON: Ch'en Chi-ju 陳繼儒 (1558–1639), dated 1620, 2 seals

COLLECTORS' SEALS: Ch'ien Ching-t'ang 錢鏡塘 (20th century), 1; Han Hsi 韓熙, 1; unidentified, 1

LITERATURE: *Chung-kuo ku-tai shu-hua mu-lu*, vol. 3, 1987, *Hu* 1–1396; *Tung Ch'i-ch'ang hua-chi*, 1989, p. 29; *Chung-kuo ku-tai shu-hua t'u-mu*, vol. 3, 1990, *Hu* 1–1396.

38 *Eight Views of Autumn Moods*
Ch'iu-hsing pa-ching
董其昌　秋興八景

Dated 1620

Album of eight paintings, ink and color on paper
53.8 x 31.7 cm (21³⁄₁₆ x 12½ in.)

Shanghai Museum

vol. 1, pl. 38 (leaves 1, 4, 5, 7); vol. 2, pl. 38 (leaves 2, 3, 6, 8)

ARTIST'S INSCRIPTIONS AND SIGNATURES:

Leaf 1, 9 lines in running-regular script:
I used to have in my collection Chao Wen-min's [Chao Meng-fu, 1254–1322] handscrolls *Autumn Colors on the Ch'iao and Hua Mountains* and the *Water Village*, two hanging scrolls of *Paired Mountains at Tung-t'ing*, the huge hanging scroll inscribed with the couplet "In myriad valleys echo the whispering pines; over the hundreds of sandbanks run the autumn waters," and the colored landscape *High Mountains and Flowing Water*. I exchanged all of them with friends; only *Whispering Pines in the Eighty-one Days of Summer*, a large hanging scroll modeled after Chü-jan [fl. ca. 960–ca. 986], remains. Today I imitated Wen-min's brushwork and made these remarks. The day before the first day of the eighth month of the *keng-shen* year [August 27, 1620], Hsüan-tsai.

余家所藏趙文敏畫有《鵲華秋色》卷、《水村圖》卷、《洞庭兩山》二軸、《萬壑響松風；百灘渡秋水》巨軸，及設色《高山流水圖》。今皆爲友人易去，僅存巨軸學巨然《九夏松風》者。今日倣文敏筆并記。庚申八月朔前一日，玄宰。

Leaf 2, 8 lines in running-regular script:
Autumn light fades away in the hibiscus garden.
On the doorway the jackfrost looks as neat as if it were cut out with scissors.
In the west tower we sit close with wine cups full;
The wind presses on the embroidered curtain, fragrant and unrolled.
The jadelike hands idly adjust the geese [line of pegs] on the silver zither.
The red sleeves are often warm with the golden duck [hand-warmer].
In only one evening, the flower of a year gives way to the west wind;
Only the faces of the inebriated retain the red hue of spring.

I happened to write the *tz'u* by Shao-yu [Ch'in Kuan, 1049–1101]. In the eighth month of the *keng-shen* year (August 28–September 25, 1620), while boating in favorable wind on the Kua-pu River, I sat at ease and happened to feel like writing something. Inscribed by Hsüan-tsai.

秋光老盡芙蓉院
堂上霜花勻似剪
西樓促坐酒杯深
風壓繡簾香不捲
玉纖慵整銀箏雁
紅袖時籠金鴨煖
歲華一夕委西風
獨有春紅留醉臉。
　　偶書少游詞。庚申八月，舟行瓜步江中，乘風晏坐，有偶然欲書之意。玄宰識。

Leaf 3, 9 lines in running-regular script:
The river clouds after rain accentuate the mountain green,
Flower petals mixed with the sand add fragrance to the water.
Someone stops rowing to fish at the spring cove,
Clear dewdrops falling on the boat wet his clothes.
　　Hsüan-tsai.

Reeds stretch afar on the calm river,
Clear frost half melts, revealing shallow traces of sand.
Misty trees are blurry toward the evening,
A lone wild goose descends in the sunset.

On the fifteenth day of the eighth month of the *keng-shen* year [September 11, 1620], painted aboard boat at Wu-men [Su-chou].

溪雲過雨添山翠
花片粘沙作水香
有客停橈釣春渚
滿船清露濕衣裳
　　　玄宰。

平波不盡兼葭遠
清霜半落沙痕淺
煙樹晚微茫
孤鴻下夕陽
　　玄宰。庚申中秋，吳門舟中畫。

Leaf 4, 10 lines in running-regular script:
White duckweed is thick at the crossing, the riverbank is bordered with
　yellow reeds;
Green willows shade the dike with red smartweed beach.
Although I do not have a friend who will die for me,
I have plenty of friends who are without a single scheme on their minds,
Like those white egrets and seagulls flying over the autumn river.
I am proud of myself even in front of the great noblemen;
An illiterate fisherman am I on the misty waves.

While sailing on the great river near Kua-pu on the twenty-fifth day of the eighth month of the *keng-shen* year [September 21, 1620] I painted this and wrote a poem (*tz'u*) composed by a Yüan poet. One may take the poem as a description of the painting or the painting as an illustration of the poem. Hsüan-tsai.

黃蘆岸白蘋渡口
綠楊堤紅蓼灘頭
雖無列鼎交
頗有忘機友
點秋江白鷺沙鷗
傲殺人間萬戶侯
我是不識字煙波釣叟
　　庚申八月廿五日，舟行瓜步大江中，寫此并書元人詞，亦似題畫，亦似補圖。玄宰。

Leaf 5, 6 lines in running-regular script:
Stations near and far,
Parting sorrow of today, parting sorrow of yesterday never change.
A halo is growing behind the cool moon outside,
Mountains look cleaner after the rain.
Evening clouds are lying flat;
Evening mountains stretch across [the horizon].
The autumn sound of falling leaves mingles with the sound of wild geese;
Travelers cannot bear to listen.

Hsüan-tsai painted on the first day of the ninth month of the *keng-shen* year [September 26, 1620] on a boat off Ching-k'ou [Chen-chiang, Kiangsu].

短長亭
古今情
樓外涼蟾一暈生
雨餘山更清
暮雲平
暮山橫
幾葉秋聲和雁聲
行人不要聽
　　玄宰。庚申九月朔，京口舟中寫。

Leaf 6, 9 lines in running script:
The vermilion clouds fade, while the twilight moon still shines.
On the sparse trees hang the lingering stars.
On the mountain path people are few;
Deep in the greenery,
A few chirrups of birds.
The chill of frost penetrates the light garments.
My heart, like the horseshoes, is light.

Ten miles of green mountains,
A stream of flowing water,
All stir up much emotion.

 Hsüan-tsai, on the fifth day of the ninth month of the *keng-shen* year [September 30, 1620].

霽霞散曉月猶明
疎木掛殘星
山逕人稀
翠蘿深處
啼鳥兩三聲
霜華重逾雲裘冷
心共馬蹄輕
十里青山
一溪流水
都做許多情
 玄宰。庚申九月五日。

Leaf 7, 4 lines in running-regular script:
A friend in Wu-men [Su-chou] showed me Mi Hai-yüeh's [Mi Fu, 1051–1107] *Dawn in the Ch'u Mountains*. I, therefore, made this copy. On the seventh day of the ninth month of the *keng-shen* year [October 2, 1620], Hsüan-tsai.

吳門友人以米海岳《楚山清曉圖》見視，因臨此幅。庚申九月七日，玄宰。

Leaf 8, 11 lines in running-regular script:
From past to present how many vicissitudes has China gone through?
Mansions became hills.
With a pigweed staff I stroll on a fragrant isle.
The ownerless peach blossoms bloom and fade,
Only to evoke sorrow.
On the waves boats come and go.
Everything seems to pass indifferently.
The spring breeze has seen visitors of the past.
Only the water under the stone bridge
Still runs eastward.

 Written on the day before the ninth day of the ninth month of the *keng-shen* year [October 4, 1620]. I painted eight small landscapes in color in this month, which can be compared to [Tu Fu's, 712–770] eight poems on autumn moods. Hsüan-tsai.

今古幾齊州
華屋山丘
杖黎徐步立芳洲
無主桃花開又落
空使人愁
波上往來舟
萬事悠悠
春風曾見昔人游
只有石橋橋下水
依舊東流
 庚申九月重九前一日書。是月寫設色小景八幅，可當秋興八首。玄宰。

No artist's seals

Colophons: Hsieh Hsi-tseng 謝希曾 (18th century), 2 dated 1808, 1810, 5 seals; Wu Jung-kuang 吳榮光 (1773–1843), 6 dated 1841, 2 undated, 9 seals; K'ung Kuang-t'ao 孔廣陶 (19th century), 1 dated 1860, 1 undated; 1 unidentified, undated

Collectors' seals: Tung Tsu-yüan 董祖源 (17th century), 1; Sung Lo 宋犖 (1634–1713), 1; Sung Chün-yeh 宋駿業 (d. 1713), 1; Hsieh Hsi-

tseng, 10; P'an Cheng-wei 潘正煒 (19th century), 7; Wu Jung-kuang, 15; Wu Yüan-hui 伍元蕙 (19th century), 5; P'ang Yüan-chi 龐元濟 (1864–1948), 9; Ho Kuan-wu 何冠五 (20th century), 1; unidentified, 10

Recent Provenance: Liu Jingji

Literature: *Tung Hua-t'ing shu-hua lu*, repr. 1962, p. 44; Wu Jung-kuang, *Hsin-ch'ou*, 1841, *ch.* 5, p. 70; P'an Cheng-wei, *T'ing-fan lou*, 1843, *ch.* 2; K'ung Kuang-t'ao, *Yüeh-hsüeh lou*, 1861, *ch.* 4, p. 47; P'ang Yüan-ch'i, *Hsü-chai ming-hua hsü-lu*, 1924, *ch.* 2, p. 62; Cheng Chen-to, *Wei-ta*, 1951–54, vol. 2, no. 10, pl. 4 (leaf 6); Xu Bangda, *Pien-nien-piao*, 1963, p. 98; Li Jingyan, "Ch'iu-hsing," 1982, pp. 266–74; *Chung-kuo ku-tai shu-hua mu-lu*, vol. 3, 1987, *Hu* 1–1358; Ren Daobin, *Hsi-nien*, 1988, pp. 175–76; *Tung Ch'i-ch'ang hua-chi*, 1989, pl. 27; Zheng Wei, *Nien-p'u*, 1989, p. 129; *Chung-kuo ku-tai shu-hua t'u-mu*, vol. 3, 1990, *Hu* 1–1358.

39 *Landscapes*
Shan-shui
董其昌　山水

Dated 1621

Album of seven paintings, ink on paper
27.3 x 19.5 cm (10¾ x 7¹¹⁄₁₆ in.)

Beijing Palace Museum

vol. 1, pl. 39; vol. 2, pl. 39 (colophon)

Artist's inscriptions and signatures:
Leaves 1–5, 1 line in running script:
Hsüan-tsai painted.

玄宰畫。

Leaf 6, 2 lines in running script:
Hsüan-tsai painted Mi's [i.e. Mi Fu, 1051–1107, and Mi Yu-jen, 1074–1151] mountain.

玄宰畫米家山。

Leaf 7, 2 lines in running script:
Hsüan-tsai painted in the autumn of the *hsin-yu* year [1621].

辛酉秋，玄宰畫。

Artist's seals:
Tung-shih Hsüan-tsai 董氏玄宰 (*pai-wen*, rectangle) **94**
Tung-shih Hsüan-tsai 董氏玄宰 (*pai-wen*, square; colophon) **99**

Artist's colophon (10 lines in running script):
In my practice of painting, I have been unable to restrict myself to one field of concentration. Whenever encountering a genuine piece by an old master, I was inspired to paint an imitation, which, however, would be forgotten after a period of time. Thus I accomplished nothing. To reproduce tomorrow what I create today is simply impossible. The landscape albums I have painted number no less than a hundred; all have been dispersed, and I've never seen them again. This one is in Sheng-p'ei's collection. If I someday travel to Chin-ling and hold it again in fond appreci-

ation, it will be a great joy to have it entertain me while old memories ebb and flow. Inscribed by Tung Ch'i-ch'ang on the twenty-second day of the intercalary tenth month of the *kuei-hai* year [December 13, 1623].

余於畫道不能專詣。每見古人真蹟，觸機而動，遂爲擬之；久則
遺忘，都無所得。若欲今日爲之，明日復然，不能也。冊葉小景
不下百本，不知散何處，不曾相值。此冊爲聖斐所藏，異時舟次
晉陵，過從把玩，吾與我周旋，如忘忽憶，亦一快事。癸亥閏十
月廿二日，董其昌題。

COLOPHON: Ch'en Chi-ju 陳繼儒 (1558–1639), undated, 2 seals (5 lines in running script):
The painting of the literati lies not in the rendering of the scene, but in the brushwork. The reason why Li Ying-ch'iu [Li Ch'eng, 919–967] begrudged ink as if it were gold is that he insisted on the subtle flavor in brushwork, as did the Four Yüan Masters. This album by Hsüan-tsai, in my view, testifies to the saying that quality supercedes quantity. Those who attempt to forge his work will reach the edge of the cliff and have to return. Inscribed by Mei-kung.

文人之畫不在蹊徑，而在筆墨。李營丘惜墨如金，正爲下筆時要
有味耳。元四大家皆然。吾觀玄宰此冊，所謂一真許勝人多多
許。彼借名贋行者，望崖而反矣。眉公題。

COLLECTORS' SEALS: Pien Yung-yü 卞永譽 (1645–1702), 3; Ch'ing Kao-tsung 清高宗 (r. 1736–95), 1

LITERATURE: Chin Liang, *Sheng-ching*, 1913, vol. 6, p. 23; *Nei-wu-pu ku-wu*, 1925, ch. 4, p. 7; *Chung-kuo ku-tai shu-hua mu-lu*, vol. 2, 1985, *Ching* 1–2170; Kao Mayching, *Paintings of the Ming Dynasty*, 1988, cat. no. 60; *Tung Ch'i-ch'ang hua-chi*, 1989, pl. 33.

40 *Landscape Inspired by a Wang Wei Poem*
Hsieh Wang Wei shih-i
董其昌　寫王維詩意

Dated 1621

Hanging scroll, ink on paper
109 x 49 cm (42¹⁵⁄₁₆ x 19⁹⁄₁₆ in.)

C. C. Wang Family Collection

vol. 1, pl. 40

ARTIST'S INSCRIPTION AND SIGNATURE (and transcription of Wang Wei's [701–761] poem "Written after Long Rains at My Villa by Wang Stream"; 5 lines in regular script):
Long rains in deserted forests, smoking fires
 burn slowly.
Steaming greens, boiling millet, the men take their meals
 on the eastern acreage.
Over the mists of watery fields a white
 egret flies.
In the shade of a summer wood, a yellow
 oriole warbling.
Here in the mountains practice stillness, watch flowers
 that bloom for a day,

Beneath the pines fast in purity and harvest
 dewy mallows.
An old man of wilderness long ago ceased squabbling
 for a mat,
So why should the seagulls ever suspect him
 any more?
(Translation by Stephen Owen, *The Great Age of Chinese Poetry*, 1980, p. 45.)
 Written on the sixteenth day of the first month of the *jen-hsü* year [February 25, 1622]; painted in the *hsin-yu* year [1621]. Hsüan-tsai.

積雨空林煙火遲
蒸梨炊黍餉東菑
漠漠水田飛白鷺
陰陰夏木囀黃鸝
山中習靜觀朝槿
松下清齋折露葵
野老與人爭席罷
海鷗何事更相疑
　　壬戌元正十六日書；辛酉畫。玄宰。

NO ARTIST'S SEALS

COLOPHONS: Hsieh Hsi-tseng 謝希曾 (18th century), 1 undated, 1 dated 1755, 4 seals:
This picture describes Yu-ch'eng's [Wang Wei] poetic intent, and the painting also comes out of Yu-ch'eng with transformations; scraping the skin to manifest the bone—its ancient harmonies are hoary. Hsi-tseng.

此圖寫右丞詩意，畫亦從右丞。變化出之；削膚見骨，古韻蒼
然。希曾。

Using the brush like a needle and sparing of ink as if it were gold, he traced back to painting's beginnings and opened up the study of his lonely exploration. It can truly be said that Ssu-weng [Tung Ch'i-ch'ang] was one who didn't yield to the ancients. Written after seeing this again, in the winter of the *i-hai* year [1755].

用筆如針，惜墨如金；推原畫之始，而開獨闢之學。思翁真可謂
不讓者矣。乙亥冬，重觀書。

COLLECTORS' SEALS: Chu Chih-ch'ih 朱之赤 (fl. mid-17th century), 2; Hsieh Hsi-tseng, 2; Yen Yen-chün 燕延駿, 3; Chang Ta-ch'ien 張大千 (1899–1983), 8; Wang Chi-ch'ien 王季遷 (b. 1907), 2; unidentified, 3

The Wang Wei poem, which Tung Ch'i-ch'ang inscribed on the painting the year after its production, alludes to stories in the Taoist text *Lieh-tzu* (see Owen, *The Great Age of Chinese Poetry*, 1980). The first story recounts Lao-tzu's rebuke to Yang Chu for allowing himself to appear so grand that others paid him deference. Yang Chu mended his ways, and when he returned to the inn where he had been staying, the innkeeper and guests, who had previously shown him respect, ignored him and even squabbled to take possession of the mat he had been sitting on. The second story concerns a boy who was fond of seagulls, which approached him without fear. The boy's father urged him to trap the gulls by taking advantage of their trust, but when he returned to the shore to try to do so, the gulls, sensing his motive, would not come near him.
 The painting at first glance appears to be an exercise in a purified style imitative of the Yüan poet-painter Ni Tsan (1301–1374), but on closer analysis reveals unexpected levels of complexity that are cata-

logued here as a case study of Tung Ch'i-ch'ang's recastings of past sources. Painted in the same year as the hanging scroll *Pine Pavilions and Autumn Colors in the Manner of Ni Tsan* (Wan-go Weng Collection; Kohara, *To Kisho no shoga*, 1981, pl. 12) and the first leaf of the album *Landscapes in the Manner of Old Masters* in the Nelson-Atkins Museum (vol. 1, pl. 42), this scroll shows clear affinities to each of those works. The foreground trees and distant mountains are stretched tautly apart in the *Landscape Inspired by a Wang Wei Poem*, in a manner that exaggerates the spareness of a Ni Tsan composition into a bifurcated pictorial space. Tung's acknowledged imitations of Ni Tsan—including the 1621 *Pine Pavilions and Autumn Colors*, a leaf dated 1623 in the Nelson-Atkins album (vol. 1, pl. 42–3), an undated hanging scroll *Sparse Trees and Distant Mountains* in the Shanghai Museum, and an undated hanging scroll *Landscape in the Manner of Ni Tsan* in the Guangzhou Fine Arts Museum (*Tung Ch'i-ch'ang hua-chi*, 1989, pls. 13, 34)—all convey much more of the piled volumes characteristic of Yüan amateur painting than the *Landscape Inspired by a Wang Wei Poem*.

These comparisons also indicate that the distant mountains in the present scroll are more likely indebted to later Ming mediated interpretations of Ni Tsan than to the Yüan master proper. Lu Chih's (1496–1576) *Landscape* hanging scroll in the Suzhou Museum, Chü Chieh's (fl. ca. 1559–83) *Spring in Chiang-nan* of 1531 or later (Cahill, *Parting at the Shore*, 1978, pls. 122, 135), and even Ku Cheng-i's (fl. 1575–97) *Brisk Autumn Weather over Streams and Mountains* of 1575 (Cahill, *Distant Mountains*, 1982, pl. 33) all provide precedents for the crystalline foldings of Tung Ch'i-ch'ang's mountains in the *Landscape Inspired by a Wang Wei Poem*. This second group of comparative works also illuminates what is distinctive about Tung Ch'i-ch'ang's formulation here: the surging rightward lift in the mountains and the marshaled architectonic arching of forms that would become the structural keystone of the undated, but probably later, *River and Mountains on a Clear Autumn Day* (vol. 1, pl. 53). In fact, the present landscape (however tenuous its foundations) is more monumental in scale and construction than Ni Tsan's work as we know it from surviving paintings. The ridges behind the houses at upper left are piled up to a considerable, stable height, while the arching cliffs at upper right convey a kind of perilous instability at odds with the usual flavor of Ni Tsan's landscapes. Some connection with the Nelson-Atkins album *Landscapes in the Manner of Old Masters* can be seen in the use of heavy foliage dots clustered at the topmost peak-line at upper left, also found (in color) in the album leaf after a poem by the eighth-century poet Tu Fu (vol. 1, pl. 42–1).

There is no necessary connection between the style of the 1621 landscape and the inscription added a year later, but the poetic allusion to Wang Wei and the flinty quality of the mountains is reminiscent of Tung Ch'i-ch'ang's quotation in an album dated 1610 (vol. 1, pl. 13–4a) of Mi Yu-jen's (1074–1151) appraisal of Wang Wei's *Wang-ch'uan Villa* picture. Mi termed it "painting as if engraving," a characterization confirmed by Tung in his experience of Kuo Chung-shu's (d. 977) copy of the Wang Wei design. Stone-engraved versions of the *Wang-ch'uan Villa* composition (cf. vol. 1, fig. 36, and Cahill, *Distant Mountains*, pl. 37) indeed convey something of the choppy angularity of Tung's cliffs; and the linear suspension of undercut cliffs in the *Clearing after Snowfall in Hills by a River* attributed to Wang Wei

(Ogawa Collection; cf. Cahill, *Distant Mountains*, pl. 36) may indicate another source for Tung's painting.

The *Landscape Inspired by a Wang Wei Poem* holds in a kind of tense suspension compositional references to Ni Tsan, reformulations of later Ming linearized versions of the Ni manner, allusions to earlier imitations of designs associated with Wang Wei, as well as some of Tung's own experiments in dynamic construction and graphic devices. Ironically, these complex elements appear under the rubric of an illustration of Wang Wei's poetic rumination on the extinction of calculated purpose.

RV

LITERATURE: Chang Ta-ch'ien, *Ta-feng-t'ang ming-chi*, 1956, vol. 4, pl. 31; Kohara, Wu, et al., *Jo I, To Kisho*, 1978, pl. 20, pp. 44, 167; Kohara, *To Kisho no shoga*, 1981, p. 240, pl. 13; *Tung Ch'i-ch'ang hua-chi*, 1989, app. pl. 81.

41 *Reminiscence of Chien River*
Chien-hsi chiu-yu
董其昌　建溪舊遊

Undated (ca. 1621)

Hanging scroll, ink and color on paper
126 x 47.8 cm (49⅝ x 18¹³⁄₁₆ in.)

Yale University Art Gallery 1982.19.2

vol. 1, pl. 41

ARTIST'S INSCRIPTION AND SIGNATURE (6 lines in running script):
On six pieces of raw silk, a painting of the Chien River;
Beneath the blossoms of the *tz'u-t'ung* tree,
　　the path rises and falls.
Clearly I remember having traveled to this place;
All that is missing are monkeys' cries and birds' songs.
　　Hsüan-tsai painted this at Wan-hsien lu.

六幅生綃畫建溪
刺桐花下路高低
分明記得曾游處
只欠猿聲與鳥啼
　　玄宰寫於頑仙廬。

ARTIST'S SEALS:
Hua-ch'an 畫禪 (*chu-wen*, rectangle) **95**
T'ai-shih shih 太史氏 (*pai-wen*, square) **96**
Tung Ch'i-ch'ang 董其昌 (*chu-wen*, square) **97**

INSCRIPTION: Li Liu-fang 李流芳 (1575–1629), undated, 1 seal:
The mountains and rivers are not deep, fish and birds few.
In this life I still intend to move to another place.
Going directly to T'ien-chu, at the stream's edge,
With a single plank for a bridge, I will build
　　a small thatched hut.
　　Vice Minister Tung painted this poetic idea. The brushwork of this scroll is derived from Tzu-chiu [Huang Kung-wang, 1269–1354] and its compo-

sition esteemed as if it were a soundless poem by Pu-sou [Lin Pu, 967–1028]. Li Liu-fang.
(Translation by Mary Gardner Neill, "The Integration of Color and Ink," 1987, p. 40.)

山水未深魚鳥少
此生還擬別移居
直過天竺溪流上
獨木爲橋小結廬

　　董侍郎曾畫此詩意。此幀筆法出自子久，而位置俯仰亦是遺叟無聲之詩也。李流芳。

No colophons

Collectors' seals: Wu Yüan-hui 伍元蕙 (fl. early 19th century), 1; Hsin Yü-ch'ing 辛聿頃, 1; unidentified, 3

The Yale landscape is constructed around an unusually centralized axial movement, as the twisted evergreen that dominates the foreground finishes with a vertical thrust continued immediately in the conical hills above. The vertical theme is completed in the slender peaks at upper right, but finds a powerful counterforce in the pronounced descending leftward slope of the level banks, trees, dwellings, and hills at upper left. This orchestration of dynamic forces—vertical against diagonal, straight against twisted—is continued throughout the composition, and seems to reflect, here as elsewhere in Tung Ch'i-ch'ang's later works, a long-standing involvement with a constructivist approach to landscape derived most fully from the Yüan master Huang Kung-wang (see Neill, "The Integration of Color and Ink," 1987).

The *Reminiscence of Chien River* is also notable for its abundant color, less dramatic and rich than in Tung's "boneless" style colored landscapes or the Nelson-Atkins album leaves (vol. 1, pls. 25, 42), but enlivening the entire work with yellow and green foliage patches, and touches of warm ochre and cool blue in the slopes and ridges. The color is used constructively, emphasizing separated planes and reinforcing contrasting patterns. In both its use of color and the amplitude of its forms, the Yale landscape seems related to a landscape on silk in the Asian Art Museum of San Francisco (Kohara, Wu, et al., *Jo I, To Kisho*, 1978, pl. 35).

The foreground trees in the Yale scroll provide virtually a demonstration of Tung's theoretical injunctions to create effects of twisting and turning and four-sidedness in rendering trees by avoiding straight lines, as noted by Neill. The reduction of the foreground trees to a few dynamically twisting, dramatic shapes is reminiscent of the hanging scroll *Returning Home from an Homage to the Imperial Tombs*, dated 1624, in the Rietberg Museum (vol. 1, pl. 50); some of the smaller, leaning conifers in the left middle distance of both works are also closely related. There are some similarities between the Yale landscape and one of the colored leaves in the Nelson-Atkins album *Landscapes in the Manner of Old Masters* (vol. 1, pl. 42–8), including the arrangement and elaborate twisting and folding of tree trunks, and the leftward downsloping of distant hills and clouds. These comparisons indicate a likely date of around 1621–24 for the production of the *Reminiscence of Chien River*. In any case, the painting could not have been executed after 1629, the year in which Tung's follower Li Liu-fang, who inscribed the work, died.

RV

Literature: Neill, "The Integration of Color and Ink," 1987, pp. 40–46; Kohara, Wu, et al., *Jo I, To Kisho*, 1978, p. 170, color pl. 41; Kohara, *To Kisho no shoga*, 1981, p. 252, pl. 26; *Tung Ch'i-ch'ang hua-chi*, 1989, app. pl. 114.

42 *Landscapes in the Manner of Old Masters*
Fang-ku shan-shui
董其昌　倣古山水

Dated 1621–24

Album of ten paintings, ink and ink and color on paper
56.2 x 35.6 cm (22⅛ x 14 in.)

The Nelson-Atkins Museum of Art 86–3/1–10

vol. 1, pl. 42

Artist's inscriptions and signatures:
Leaf 1, 5 lines in regular script:
By the stone cliff the passing clouds open like brocade embroidery;
Scattered pines, separated by water, as if playing music on panpipes and
　reeds.
　　In the ninth month of the *hsin-yu* year [October 15–November 13, 1621] on the road to Mount Hui I described what I saw and added a picture of it. I decreed it as "Poetic Intent of Tu Ling [Tu Fu, 712–770]." Hsüan-tsai.

石壁過雲開錦繡
陳松隔水奏笙簧
　　辛酉九月惠山道中寫所見，因補圖命之曰：「杜陵詩意。」玄宰。

Note: The quoted couplet is a variation on a Tu Fu poem, "On the first day of the seventh month, two verses inscribed at the Chung-ming fu-shui Storied Pavilion."

Leaf 2, 2 lines in regular script:
In the fourth month of the *kuei-hai year* [April 29–May 28, 1623] I imitated Huang-ho shan-ch'iao's [Wang Meng, 1308–1385] brush. Hsüan-tsai.

癸亥四月倣黃鶴山樵筆。玄宰。

Leaf 3, 6 lines in regular script:
By the river islets the evening tides begin to ebb;
In the wind-swept grove, frosty leaves are jumbled and scattered.
Leaning on a staff in my humble brushwood cottage, lonely and quiet,
Remembering someone; mountain colors are fading into the distance.
　[Ni] Tsan.
　　Hsüan-tsai imitates Yün-lin's [Ni Tsan, 1301–1374] brush, inscribing it on the twenty-second day of the seventh month of the *kuei-hai* year [August 17, 1623].

江渚暮潮初落
風林霜葉渾稀
倚杖柴門闃寂
懷人山色依微
　　瓚。
　　玄宰倣雲林筆，癸亥七月廿二日識。

Leaf 4, 9 lines in regular script:
"Hermitage under the Cliff"
General Wan Pang-fu, who is stationed at the P'ien-t'ou Pass, has in his household collection Li Ying-ch'iu's [Li Ch'eng, 919–967] silk scroll depicting a level distance view; it has the same brush method as the large vertical scroll in the Duke of Ch'eng's house. Mi Yüan-chang [Mi Fu, 1051–1107] said: "Genuine Li Ch'eng's—I've seen only two." This one is nearly close to it. Accordingly I imitate it as a [painting of] small scenery. Only the places where the layered ink washes circulate are not what Kuo Hsi [ca. 1020–ca. 1100] or Hsü Tao-ning [ca. 970–ca. 1052] could attain. Inscribed on the twenty-ninth day of the seventh month of the *chia-tzu* year [September 11, 1624]. Hsüan-tsai.

《巖居高士圖》
偏頭關萬金吾邦孚家藏李營丘平遠小絹幅，與成國家巨軸同一筆法。米元章云：「真李成見二本。」此殆近之。因做為小景。唯水墨渲運處，非郭熙、許道寧所能及耳。甲子七月廿九日。玄宰。

Leaf 5, 6 lines in regular script:
"Poetic Intent of Hsiang-shan [Pai Chü-i, 772–846]"
I hear you have gone to live among the village mounds;
By the lonely gate where the bamboo groves abound.
I have come now only to beg you;
Lend me your south garden that I may look at the hills.
("Visiting the Hermit Cheng," by Pai Chü-i; translation by Ching Ti, in Payne, *The White Pony*, 1960, p. 214.)
 On the thirteenth day of the eighth month of the *chia-tzu* year [September 25, 1624]. Hsüan-tsai.

《香山詩意》
聞道移居村塢間
竹林多處獨開關
故來不為緣他事
暫上南亭望遠山
 甲子八月十三日，玄宰。

Leaf 6, 7 lines in regular script:
Every time Chao Ta-nien [Chao Ling-jang, d. after 1100] painted a good landscape scroll, people jokingly asked whether he had just returned from a visit to the Imperial Mausolea. That is because during the Sung dynasty members of the royal clan were not permitted to travel far. This painting was done on the day after I visited the Imperial Mausolea, and I recorded it here. In the *chia-tzu* year, three days after the Double Ninth [ninth day of the ninth month; October 23, 1624]. Hsüan-tsai. (Translation by Chu-tsing Li, *A Thousand Peaks and Myriad Ravines*, 1974, vol. 1, p. 109.)

趙大年每作佳山水卷，人輒謂是上陵回耶。宋時宗室有遠游之禁故也。余此圖在上陵回日，因識之。甲子重九後三日。玄宰。

Leaf 7, 5 lines in running script:
My household had Academician Chao's [Chao Meng-fu, 1254–1322] *Village by the Water* as well as Han-lin Compiler Wen's [Wen Cheng-ming, 1470–1559] direct copy of it. Both derive their brush technique from the *Wang-ch'uan Villa* painting. Both handscrolls were lost long ago; they were more or less like this. Recorded on the last day of the moon in the ninth month of the *chia-tzu* year [November 10, 1624]. Hsüan-tsai.

吾家有趙集賢《水村圖》及文太史臨本。皆從《輞川》得筆。二卷久已失之，彷彿為此。甲子九月晦記。玄宰。

Leaf 8, 12 lines in running script:
Clearing rain, a remnant band of rainbow;
The declining sun's slanting beam, one smear of red.
Atop the storied pavilion, the painted horn has just finished playing three stanzas.
In the eastern grove the evening bell;
In the southern sky dawn's wild geese.
In the yellow dusk a new moon's crescent first drawn like a bow,
Gazing toward the long emptiness, opening the bosom of my gown, who will be together with me?
For ten thousand miles, only the windy terraces of Ch'u.
 Yang Yung-hsiu's [Yang Shen, 1488–1559] "Song Composed to Dispel Sorrow during Rain." Hsüan-tsai wrote this in order to inscribe it on the painting; but the song doesn't necessarily harmonize with the painting.

霽雨帶殘紅
映斜陽一抹紅
樓頭畫角收三弄
東林晚鐘
南天曉鴻
黃昏新月弦初控
望長空披襟誰共
萬里楚臺風
 楊用脩「雨中遣懷曲。」玄宰書以題畫，不必與畫有合。

Leaf 9, 3 lines in regular script:
This also imitates Yen Wen-kuei's [fl. ca. 988–ca. 1010] brush. It's close to the spirit resonance of Yüan painters. Ni Yüan-chen [Ni Tsan] seemed to have only a limited view of Yen's style, and Wang Shu-ming [Wang Meng] is distant [from it]. Hsüan-tsai.

此亦擬燕文貴筆也。與元人氣韻相近。倪元鎮似窺其一斑，王叔明遠矣。玄宰。

Leaf 10, 5 lines in regular script:
"Brocade Clouds and Sound of Flowing Water"
The [*Ten Views from a*] *Thatched Hall* by Lu Hung [fl. first half of the 8th century] in the form of direct copies by Li Lung-mien [Li Kung-lin, ca. 1049–1106] are now at Chang Ch'iu-yü's [Chang Chin-ch'en] household in Ching-k'ou. I was able to examine them several times, and here imitate [the picture in the series called] "Brocade Clouds and Sound of Flowing Water." Hsüan-tsai.

《雲錦淙》
盧鴻《草堂圖》李龍眠臨本今在京口張秋羽家。余數得寓目，因做《雲錦淙》一幅于此。玄宰。

NO ARTIST'S SEALS OR COLOPHONS

COLLECTORS' SEALS: Wang Hung-hsü 王鴻緒 (1645–1723), 2; An Ch'i 安岐 (1683–ca. 1746), 1; Ch'ing Kao-tsung 清高宗 (r. 1736–95), 5; Tai Ch'üan 戴銓 (d. 1854), 2; P'ang Yüan-chi 龐元濟 (1864–1949), 10; T'an Ching 譚敬 (early 20th century), 5; Wang Chi-ch'ien 王季遷 (b. 1907), 6

RECENT PROVENANCE: Wang Chi-ch'ien

The Nelson-Atkins *Landscapes in the Manner of Old Masters* records a sustained exploration of the experience of art and the act of painting that qualifies the album as one of Tung Ch'i-ch'ang's masterworks. Painted over the three-year period from 1621 to 1624, during the late years of Tung's retirement and immediately after his return to Peking in the spring of 1622, the album belongs to a key period in the artist's

life and represents a summation of his identity as a painter through the period of his maturity. The paintings are unusually large, and several manifest an outspoken colorism rarely found in Tung's oeuvre. These factors, along with the sustained level of inventiveness circulating around themes of encounter with ancient art, suggest that Tung may have consciously viewed this work as his magnum opus in the album format.

The Nelson-Atkins album was preceded in 1620 by the *Eight Views of Autumn Moods* album in the Shanghai Museum (vols. 1 and 2, pl. 38), which foreshadows many of the later work's qualities: an unusually large physical format, prominent color, and bold surface-oriented designs based on a few large compositional episodes. Although the Nelson-Atkins album is more thoroughly organized around art-historical themes, two of the Shanghai leaves are based on ancient paintings and one refers to the same Chao Meng-fu painting mentioned in Tung's inscription in the Nelson-Atkins album. There is thus a strong element of retrospection running through the two album projects, but in both cases the earlier materials are thoroughly restated. The Nelson-Atkins album in particular displays an unusual visual intensity, in elements of vibrant colorism, a dynamic friction of forms, and even hints of a sculpturesque chiaroscuro. There is an element of poignancy in these displays of perceptually oriented painting modes, which are left in suspension as if in acknowledgment of Tung's usual strenuous avoidance of their seductiveness; and this poignancy is matched in Tung's harboring of styles and experiences of painting accumulated over several decades. An emotional, rather than intellectual, aspect of these projects appears in the powerful moldings of space and form, which might be interpreted in the context of a deep psychological need to revise and reshape the past.

There are strong elements of stylistic and thematic reprise in the Nelson-Atkins album. The leaf after Lu Hung (vol. 1, pl. 42–10) recalls Tung's engagement with and virtual resuscitation of T'ang landscape painting, while in some formal aspects the leaf also recalls the *Wan-luan Thatched Hall* from the beginning of Tung's career (vol. 1, pl. 3). Similarly, features of the leaf in the Wang Meng manner (vol. 1, pl. 42–2) recall the *Ch'ing-pien Mountain* of a few years before (vol. 1, pl. 32); and the Ni Tsan-style leaf (vol. 1, pl. 42–3) is reminiscent of the 1621 *Landscape Inspired by a Wang Wei Poem* (vol. 1, pl. 40). The leaf after Chao Meng-fu (vol. 1, pl. 42–7) surveys Tung's long-term involvement with the image and surviving corpus of that artist, reaching back to the *Calligraphy and Painting Based on Han Yü's "Preface to Farewell to Li Yüan"* (vol. 1, pl. 9), in which Tung followed the design of Chao's *Village by the Water* (*Shui-ts'un t'u*) of 1302. By this time, the theme of personal restatement and reformulation had become as large as that of imitation of the nonpersonal past.

The "Lu Hung" leaf in the Nelson-Atkins album was derived at the outset from an earlier restatement, in the form of copies of the T'ang painter's *Ten Views from a Thatched Hall* (*Ts'ao-t'ang shih-chih*) by Li Kung-lin of the late Northern Sung. The collector mentioned in Tung's inscription, Chang Ch'iu-yü, is probably Chang Hsiu-yü (Chang Chin-ch'en) from Ching-k'ou, whom Tung had known as early as 1577 and whose versions of Lu Hung's *Thatched Hall* pictures Tung had seen in 1617. In this leaf we can glimpse some of the emotional satisfaction that repeated derivation and reworking held for Tung Ch'i-ch'ang. Tung's restatements operate in several dimensions,

rescuing them from any imputations of sterile repetition. He refers to not only Li Kung-lin and, through him, Lu Hung, but also his own earlier works: the upward sloping, tree-bearing plateaus of *Viewing Antiquities at Feng-ching* of 1602 (vol. 1, fig. 29) and the odd, composite rounded hills and flat-topped buttes of the *Wan-luan Thatched Hall* of 1597 (vol. 1, pl. 3) reappear at the upper left and center of the Nelson-Atkins "Lu Hung" leaf. The composition of the leaf is oddly bifurcated, with the lower passage of cottages and trees in markedly smaller scale and seemingly lying at a greater distance than the slopes above. A less dramatic bifurcation appears horizontally in the upper section, where the grassy banks at the right seem to lie in a different plane than the curling waves at the left. There are a number of instances of pentimenti, mostly contour lines of rocks and banks that are seen to pass through the trunks of trees, and these only add to the montagelike effect. The conception of painting that is at work here involves a simultaneous holding in visual suspension of experiences from different times and of different orders: experiences of viewing old paintings, imaginative reconstructions of the sources of those paintings, and Tung's earlier pictorial reformulations of both. The result is less a unified representation than a montage of references and experiences, in which partial passages serve as visual counterparts of the textual rhetoric of the inscription.

Tung's inscription on the "Lu Hung" leaf records an additional dimension of the painting as a notation of a work seen in another's collection. This function of painting as documentation or *aide-mémoire* for absent images recurs in the leaf after Chao Meng-fu's *Village by the Water* (vol. 1, pl. 42–7). The Chao Meng-fu painting had at one time been in Tung's collection, along with a copy by Wen Cheng-ming. According to Tung's inscription on the *Eight Views of Autumn Moods* album of 1620 (vol. 1, pl. 38–1), the Chao Meng-fu painting was one of several that had been sold to a friend, possibly as a consequence of the pillaging of the Tung family estates in 1616. Tung's commemoration on the "Chao Meng-fu" leaf is again typically complex: it involves not only Chao Meng-fu's original handscroll and Wen Cheng-ming's copy of the painting, but also the style of Wang Wei's *Wang-ch'uan Villa* composition, which, in Tung's view, informed the later works. Moreover, the album image seems to be not only an art-historical reconstruction but also a symbolic reparation for loss. Tung had produced a more straightforward rendering of the *Village by the Water* composition in his illustration of Han Yü's "Preface" of some years earlier (vol. 1, pl. 9). The Nelson-Atkins album leaf seems much more independent of its purported sources—not unexpectedly, given the complex associations it was made to bear. The level placidity of Chao Meng-fu's original painting and of Tung's illustration of Han Yü's "Preface" is almost literally wrenched into a dynamic disequilibrium by the sudden upslope of cottages and hillocks at center right. The reserve clouds that sweep across the hills in this area serve as a kind of direct erasure of hill forms derived from Chao Meng-fu, which give way to Tung Ch'i-ch'ang's characteristically harsher and more abrupt rock forms below.

In contrast to the elusive, intellectualized complexities of the two leaves discussed above, Tung Ch'i-ch'ang's leaf in the manner of Wang Meng (vol. 1, pl. 42–2) presents an almost dizzying visual impact of folded forms and intense color. The most striking device—the juxtaposed flat vertical ribbons of fissured rocks and volumetrically piled

overlapping ridges in the central cliff—reiterates a key feature of Tung's *Ch'ing-pien Mountain* vertical scroll of six years earlier (vol. 1, pl. 32). Rather than a historical rumination on the Wang Meng manner, however, the album leaf represents if anything a visual competition with one of Tung's own earlier masterworks. The album painting does not fare badly in the competition: even the large format is scarcely adequate to contain the pulsing dynamic of forms. The nearly vertical ascent of the reserve stream at the far left is a daring device, while the fluent curve of the stream descending diagonally from upper right across the center of the composition is striking mostly for its rarity among Tung's usually harsh and ungainly forms. Each undulation of the diagonal stream is accompanied by a diminutive tree tucked into the intervals between cliff and hillocks below. A tense interval is maintained throughout an intricate medley of textures and foliage types, until, at upper right, the separation gives way to a visceral friction of forms where the cliff rubs up against a sloping plateau. Such passages pull the viewer away from structural and historical references to the act and moment of painting.

The most brilliantly colored leaf in the Nelson-Atkins album (vol. 1, pl. 42–1) is described by Tung as a depiction of the scenery he saw on the road to Mount Hui, and thematizes the pull of perception. The rhythmic jostling of points of color in the cliff tops is at once decidedly schematic and vividly direct. The device references possibilities of perceptual transcription that are kept at a certain remove. The inscription points also to a process of literal acculturation of experience, in which the theme of an illustration of a Tu Fu poem is superimposed on the landscape.

The "Landscape after a Song by Yang Shen" (vol. 1, pl. 42–8) acknowledges the arbitrariness of text-image relationships in an even more forthright way: "The song," Tung writes, "doesn't necessarily harmonize with the painting." The painting is an exercise in formal pattern and massing. The trees at upper right seem to march heedlessly across the chasm between a diagonal slope and winding hollow across the stream, and ink-washed trees elsewhere form regular chevrons on the slopes in persistent graphic formations. Tung's use of color here is especially effective: the ladderlike zigzag path under the overhang in the center of the composition is rendered in green, and a bright spot of vermilion alludes to autumn foliage. The leaf in the manner of Li Ch'eng (vol. 1, pl. 42–4) raises some parallel issues of perceptual transcription and stylization within a monochrome format. The sculpturesque modeling of foreground boulders and tree trunks with strongly contrasted zones of light and shadow suggests a kind of chiaroscuro and an effort at illusionistic rendering. Tung's inscription, characteristically, resuscitates those issues in the historical arena of a reconstruction of the tenth-century manner of Li Ch'eng.

The inscription on the landscape leaf in the manner of Chao Ling-jang (vol. 1, pl. 42–6) alludes to a point of experiential parallelism between Tung, writing in 1624 upon his return from the Ming imperial tombs, and Chao Ling-jang, whose travels were said to have been limited to visits to the Sung imperial tombs. The visual reference to that Northern Sung aristocrat-painter appears to be confined to the wispy trees with horizontal foliage dots that decorate the rocks and slopes. The mountainscape behind is notably harsh and ungainly, with protruding slabs and jutting boulders that recall the more sculptural dynamic of tenth-century monumental landscape. Thus even while searching for experiential affinities with his models, Tung asserts a basis for competition with or improvement on them based on his broader pictorial experience.

RV

LITERATURE: An Ch'i, *Mo-yüan hui-kuan*, pref. dated 1742, repr. 1909, vol. 3, pp. 91–93; P'ang Yüan-chi, *Hsü-chai ming-hua hsü-lu*, 1924, ch. 2, pp. 55–58; *Tung Hsiang-kuang shan-shui ts'e*, 1922 and 1936; Sirén, *Leading Masters and Principles*, 1956–58, vol. 5, pp. 6–7; Wu, "Apathy in Government and Fervor in Art," 1962, pl. VI; Fu, "A Study of the Authorship of the 'Hua-shuo,'" 1972, pp. 102–3, fig. 18 (leaf 5); Kohara, Wu, et al., *Jo I, To Kisho*, 1978, p. 171, color pls. 44–45, pls. 46–47, frontispiece (color); Kohara, *To Kisho no shoga*, 1981, pp. 242–43, pl. 17; Cahill, *Compelling Image*, 1982, pp. 47–57, figs. 2.13, 2.16, 2.28, color pl. 4; Cahill, *Distant Mountains*, 1982, pp. 116–17, 125–26, pls. 57–58, color pl. 8; *Tung Ch'i-ch'ang hua-chi*, 1989, app. pl. 139.

43 *Returning Home from a Field at Northern Hill*
Pei-shan ho-ch'u
董其昌　北山荷鋤

Undated (ca. 1621–26)

Hanging scroll, ink on satin
117.7 x 56.3 cm (46⁹⁄₁₆ x 23³⁄₁₆ in.)

Shanghai Museum

vol. 1, pl. 43

ARTIST'S INSCRIPTION AND SIGNATURE (4 lines in running-cursive script):
Blue mountains seen across the river crossing in the evening sun,
Who recognizes how much leisure is to be found there?
You used to cut wood from the north of Northern Hill,
Carrying hoe and ax, just arrived in our world.
　Hsüan-tsai.

夕陽渡口見青山
誰識其中有許閒
君本爲樵北山北
荷鋤持斧到人間
　玄宰。

ARTIST'S SEAL:
Tung Hsüan-tsai 董玄宰 (*pai-wen*, square) 133

COLOPHON: Wu Hu-fan 吳湖帆 (1894–1968), dated 1950, 2 seals:
Ssu-weng's [Tung Ch'i-ch'ang] inspired brush. Truly, it matches Ch'ih [Huang Kung-wang, 1269–1354] and Yü [Ni Tsan, 1301–1374]. This picture flows with invention, vigorous yet refined. Ni and Huang may even have to retreat before it! This is not the sort of work that could be achieved by a casual brush seeking the commonplace. Judging by the force of the brush, it must have been done before the artist's seventieth year; of this there is no doubt. In the summer of the *keng-yin* year [1950], Wu Hu-fan authenticated.

思翁神來之筆。直逼癡、迂。此圖天機流暢，剛健婀娜。恐起倪、黃亦當退避！非尋常隨筆可及。審其筆勢，在七十歲以前所作；無疑義。庚寅夏，吳湖帆鑒識。

COLLECTOR'S SEAL: Wu Hu-fan, 1

No colophons

Recent provenance: Yang Tieh-mien

As Wu Hu-fan opines, the most likely date for this painting is circa 1624–25 (Tung's seventieth and seventy-first years), judging by its similarity to works such as the *Landscape in the Manner of Tung Yüan* of 1625 (vol. 1, pl. 52). The highly controlled dynamic balance between massive substance and volumetric spaces, and the vertical axiality of the powerfully structured composition are characteristics of this period. Also characteristic is the dominance of an outermost contour to the mountain mass and the tight construction of its internal subdivisions, emphasized by very straight modeling strokes, an approach also conceptually articulated by Tung. In these respects, the painting is a classic instance of Tung Ch'i-ch'ang's Tung Yüan–Huang Kung-wang reconstruction. A dating in the early 1620s is confirmed by the peculiarity of the calligraphy, which seems to have been drawn into the reconstructive enterprise of the painting. Its exaggerated angularities and precarious balance are similar to the calligraphy on a painting of 1624, *Returning Home from an Homage to the Imperial Tombs* (vol. 1, pl. 50).

It is curious that such an impressive picture persisted in such obscurity, with no sign of documentation until its authentication by one of the greatest twentieth-century connoisseurs, Wu Hu-fan. It is also a pity that Wu gave no hint of its history, for surely he must have known something. Celia Riely has pointed out that no other impression of this seal is known on any other work by Tung, and she suggests that since the seal appears to be an inexpert copy of a genuine seal that occurs in Tung's works in the late 1620s and early 1630s, it was probably added to the painting by an enterprising dealer or collector. The painting's lack of a dedication and seal may have contributed to a problematic status. Tung's poem, on the other hand, may imply a recipient, and it is possible that the final cause of the painting evaporated just before completion and that the work was put aside without being turned to another purpose. Certainly, if anyone had been sufficiently expert to produce a forgery of such quality, it would have been a comparatively simple matter for them to provide it with false documentation.

JH

Literature: *Chung-kuo ku-tai shu-hua mu-lu*, vol. 3, 1987, Hu 1–1391; *Chung-kuo ku-tai shu-hua t'u-mu*, vol. 3, 1990, Hu 1, 1391.

44 *After Huang Kung-wang's "Warm and Green Layered Hills"*

Fang Huang Tzu-chiu "Ts'eng-luan nuan-ts'ui" t'u

董其昌　倣黃子久《層巒暖翠》圖

Dated 1622

Hanging scroll, ink and color on paper
234.5 x 101.2 cm (92⁵⁄₁₆ x 39³⁄₁₆ in.)

Shanghai Museum

vol. 1, pl. 44

Artist's inscription and signature (7 lines in running script): Huang Tzu-chiu [Huang Kung-wang, 1269–1354] has his *Warm and Green Layered Hills*. Although it has a wonderful quality, its scenery is too fussy. This is because he was not able to bring about the full configuration of its energy. I think that nothing can better fill a room with powerful color than the heroic strength of Pei-yüan [Tung Yüan, fl. ca. 945–ca. 960]. In the eighth month, autumn, of the *jen-hsü* year [September 5–October 4, 1622], Hsüan-tsai.

黃子久有《層巒煖翠圖》。雖精妙而景太繁，此未能取勢也。余謂滿堂動色不若北苑雄壯耳。壬戌秋八月，玄宰。

Artist's seals:
Tung-shih Hsüan-tsai 董氏玄宰 (*pai-wen*, square) III
Tung Ch'i-ch'ang yin 董其昌印 (*pai-chu wen*, square) 123

No colophons

Collectors' seals: Chang Jo-ai 張若靄 (1713–1746), 2; unidentified, 1

This painting exhibits Tung Ch'i-ch'ang at his most confrontational. One would dearly like to hear him commenting on his own performance here. It is a work in which he plays with the peculiar way in which ugliness and beauty come full circle. He was just embarking on his task of editing the Veritable Records of the Wan-li era and may well have had a rising sense of power from this intellectually, emotionally, and physically challenging work, at which he was very good.

Tung works through the confrontations of attraction and repulsion in several dimensions, between Tung Yüan and Huang Kung-wang, silk and paper, color and ink, for example. It is interesting that he chooses to do so in the context of criticism of a famous composition by Huang Kung-wang that was certainly admired by him as well as by others. This opinion became a minor cause célèbre of the critical tradition and the choice here is symptomatic of a deliberately contradictory rhetoric in the painting. One of the copies in the album *The Great Revealed in the Small* (*Hsiao-chung hsien-ta*; National Palace Museum, Taipei), which has been attributed by Howard Rogers to Ch'en Lien (fl. first half of the 17th century), a student of Tung's and associate of Wang Shih-min (1592–1680), can be taken as representing the source of what became a generic composition for the Yün-chien group of painters. Wang Shih-min is quoted, presumably as having written on the now lost original of the *Fou-lan nuan-ts'ui* (*Floating Mists, Warm Greenery*): "This is the very finest of the colored landscapes by Ta-ch'ih [Huang Kung-wang] . . ." (Ku Fu, *P'ing-sheng chuang-kuan*, repr. 1962, *ch.* 9, pp. 32–33). Tung wrote opposite the copy, as he must have earlier on the original, "There are two scrolls by Huang Kung-wang copying Tung Yüan. One is the *Fou-lan nuan-ts'ui* in the home of Mr. Hsiang Hsüan-tu [Hsiang Te-hung] of Chia-ho. The other is the *Hsia-shan t'u* (*Summer Mountains*), which is this one. Tzu-chiu [Huang Kung-wang], in studying Tung Yüan, finds himself. One can say that he combines the finest art of Sung and Yüan. The saying 'ice is colder than water' is not empty" (*Ku-kung shu-hua lu*, 1965, vol. 4, p. 73). The *Fou-lan nuan-ts'ui* is probably the same as the *Ts'eng-luan nuan-ts'ui*. On another occasion, Tung wrote, "I have seen at least thirty paintings by Huang Tzu-chiu. The *Fou-luan nuan-ts'ui* is the best. Unfortunately the scenery [silk?] is fragmentary." Ch'en Chi-ju (1558–1639) also made, or reflected, the same judgment. And the irony of this judgment was noted in the *Shu-hua-fang* (recorded in

Pien Yung-yü, *Shih-ku t'ang shu-hua hui-k'ao*, repr. 1958, *ch.* 4, p. 210). It is, however, the *Summer Mountains* that appears to have been compositionally closer to the present work. It is probably not only impossible but even inappropriate to disentangle what painting is referred to by which, and not because Tung might have become confused by the thirty attributions. As our own saying goes, "the map is not the territory." In constructing a mythology rather than a history, it was connections that mattered rather than identities, the power of multiple meanings rather than the clarity of decisive difference.

Here Tung Ch'i-ch'ang once again subjects the weighty mountain complex to the foregrounding of his own presence. The buildings have an unusual degree of narrative detail, even showing books on a table. This may be an invocation of Northern Sung. The houses beyond are entirely pressed into the service of other formations. Incorporated into the construction of the painting at every level is the presence of both Huang and Tung, the latter perhaps through the exceptional structural clarity of *Wintry Groves and Layered Banks* (*Han-lin ch'ung-t'ing*), which Tung Ch'i-ch'ang owned. The execution is one of the clearest exemplifications of Tung's concept of "straight texture strokes." Yet the artist has also managed to work in the fragmentary excitement of an archaism that would have been associated with T'ang painting. The startling color scheme evokes at once a paradisical desirability, not entirely denied elsewhere in the painting, and a paradoxical monstrosity of commercialized art. Typically, also, a sense of aloof intellection is embodied in an in-your-face physicality. Whereas earlier in his career Tung had tended, perversely, to translate paper styles into a silk medium, here he does the opposite. It is enough to make one feel ill and to exult at the same time.

The phrasing of Tung Ch'i-ch'ang's peculiar critique of Huang Kuang-wang in his own inscription on this painting offers one focus for discussion among these complexities, for it encapsulates some of his most readily visible concerns. The phrase translated as "not able to bring about the full configuration of its energy" turns on the term *ch'ü-shih* 取勢 (to get hold of the *shih*). This term is central in a well-known remark by Tung: "First settle the contours of a mountain. Only then texture it. People nowadays start from fragmentary places, then pile up large mountains. This is an extremely serious weakness. Ancient [masters], when working on a large hanging scroll, would set out its compositional structure through only three or four major divisions. Although there would be many subsidiary sections of fragmentary detail, the overall configuring of energy (*ch'ü-shih*) would be dominant. I have some writing by a Yüan author about the painting of mountains by Mi [Fu, 1051–1107] and Kao [K'o-kung, 1248–1310]. Truly, they got the idea before I did" (*Jung-t'ai pieh-chi, ch.* 6, p. 9).

Shih is one of the most persistently and distinctively important terms in all of Chinese ontology, for which all phenomena were transient, specific configurations out of a generalized state of energy. A specific *shih*, bringing some phenomenon from potentiality into actuality, inevitably implicates the coherence and therefore the identity of the phenomena it is configuring. In contrast to the outer shell of a completely configured shape, which is a much more limited aspect of identity, the *shih* always sustains its connectedness with both the transformative processes of existence in the permanence of flux and the impermanence of stasis. Mountains were exemplars of *shih* on a grand scale, having an almost iconic status. Paintings of mountains therefore

embodied this same critical interaction of energy and structure. The *shih* is most characteristically seen in serpentine formations unifying the entire structure. Painters of mountain-and-water pictures, of course, could use their subject for many different purposes, variously making more explicit a specific mountainscape, associated human activity, or the ontological processes therein exemplified—or a calculated balance of these various and always related frames of reference. Tung Ch'i-ch'ang was deeply interested in how the three ontological frames of nature, man, and art could be shuffled, superimposed, interchanged, merged, and identified. In these concerns, the configurations of *shih* were particularly important, implicated by definition not only in the subject matter but most immediately in the development of the painting as a painting, as the artist figured it forth from a potential state. Both the excitement and the discomfort that Tung's paintings often generate stem to a considerable degree from the intensity of his engagement with *shih* at several levels, as in this work.

There is one coincidence of style and subject matter that may be worth attention. Two years later, in 1624, Tung painted a work with a distinctively similar composition, although in ink alone (vol. 1, pl. 50). Its inscription refers to "returning from an homage to the imperial tombs, . . . painting what I saw." Chu-tsing Li notes that this was probably the Wan-li mausoleum (*A Thousand Peaks and Myriad Ravines*, 1974, vol. 1, p. 109). It is possible that the composition functions as an empty shell, so to speak, with no direct connection other than convenience to its hermit-crab content. It is also possible that painting on an occasion connected with Wan-li's mausoleum, in 1624, recalled a composition previously associated simply by its date with his work pursuant on the Wan-li emperor's passing, perhaps even subconsciously. But it is also possible that the connections run much deeper and that they are of a kind for which our analyses are at present inadequate.

JH

LITERATURE: d'Argencé, *Treasures*, 1983, color plate 25, cat. no. 106; *Tung Ch'i-ch'ang hua-chi*, 1989, pl. 44; Rogers and Lee, *Ming and Qing Painting*, 1988, p. 156.

45 *Poems after the Rhyme of Yeh, the Junior Imperial Preceptor,* running script

Hsing-shu yü Yeh Shao-shih ch'ang-ho-shih
董其昌　行書與葉少師倡和詩

Dated 1622

Handscroll, ink on paper
24.3 x 220.6 cm (9⁹⁄₁₆ x 86⁷⁄₈ in.)

Beijing Palace Museum

vol. 1, pl. 45 (detail); vol. 2, pl. 45

ARTIST'S TITLE (2 lines in running script, preceding a transcription of four poems in seven-character regulated meter [*Tung-ch'ao lien-shih. . .*, in 6 lines; *Su-i tuan-ho. . .*, in 6 lines; *Shen-lun pu-chieh. . .*, in 7 lines; *Ch'ü-chü wan-luo. . .*, in 6 lines]):

Four Poems presented to the Honorable Yeh [Hsiang-kao, 1559–1627], of Fu-t'ang [Fu-ch'ing, Fukien], the Junior Imperial Preceptor, upon my departure, in response to his rhymes.

福唐葉少師有贈行之什，次韻訓四首。

ARTIST'S INSCRIPTIONS AND SIGNATURE:
1. 1 line in small running script, following the four poems and preceding the transcription of Yeh's poem:
Appended is the Imperial Preceptor's original poem.

附少師原作。

2. 2 lines in small running script, preceding the fifth poem (*Hsieh-t'ing yü-shu...*, in 6 lines):
Mao-ts'ai Yeh Chün-hsi [Yeh Hsiang-kao] presented a poem [to me] as a farewell present. I again take this chance to thank him with one of my own.

葉君錫茂才以詩贈行，復次前韻訓之。

3. 2 lines in small running script, preceding two poems (*Yeh-lang fen-chin...*, in 6 lines; and *Hsiu-i ch'ih-fu...*, in 6 lines):
Presented to Censor Hou Liu-chen, who was sent to subdue [the rebels] in Kueichou, where there are border problems, and where he was also ordered to oversee the generals.

送候六真侍御按黔，時黔有兵事，侍御兼視師之命。

4. 2 lines in small running script, preceding the final poem (*Chiu-liu ch'ing-chien...*, in 6 lines):
Bestowed on Chang P'eng-hsüan, the Vice Censor-in-chief. Chang departed from the Ministry of Personnel to subdue Shang-ku.

贈張蓬玄中丞。張自吏部郎出撫上谷。

5. 2 lines in small running script and 1 line in running script:
At the time he [Chang P'eng-hsüan] had just pacified a rebellion in Ching-chou.

時公方平荆州之亂。

Written by Ssu-weng [Tung Ch'i-ch'ang] in the tenth month of the *jen-hsü* year [November 1622].

思翁壬戌十月書。

ARTIST'S SEAL:
Tung Ch'i-ch'ang yin 董其昌印 (*pai-wen*, square) 98

NO COLOPHONS

COLLECTORS' SEALS: Chu Chih-ch'ih 朱之赤 (17th century), 3; Tung I-ch'ing 董貽清, 1; unidentified, 1

Unlike a number of works in this exhibition whose appeal lies in their visual impact, this scroll may be likened to a manuscript, valuable for its content and the offhand information it reveals. Unpretentiously written in a small-sized running script, the work is in fact a thank-you note in response to a farewell present given to Tung on his departure from Peking south to Nanking. In all, they are nine poems in like rhyme recording the literary talents of men serving the emperor in high office in the late Ming. It is also one of the few scrolls in the exhibition, and possibly in Tung Ch'i-ch'ang's large oeuvre, which regis-

ters some of the political background of the 1620s: border troubles and incipient rebellion in the empire.

Yeh Hsiang-kao, to whom the scroll is dedicated and who wrote the original poem to Tung, was a gentleman of scruples. Yeh served the emperor as Minister of Personnel and twice as Grand Secretary in difficult times when the integrity of office and the power of the imperial seat was being threatened by factional struggles and insidious forces, notably the actions of the infamous eunuch Wei Chung-hsien (ca. 1568–1627). In his long political career, Tung managed to steer a course safe of truly devastating political intrigue, to retire in 1625, and to outlive both Yeh and Wei. (See Celia Carrington Riely, "Tung Ch'i-ch'ang's Life," and Wang Shiqing, "Tung Ch'i-ch'ang's Circle," part 4, in vol. 2 of this catalogue.) Even though Yeh was younger, he received his *chin-shih* degree in 1583, six years prior to Tung, and also was appointed to higher offices at a younger age, as early as 1607, as both Grand Secretary and Minister of Rites. From 1621 to his retirement in 1624, Yeh served as Minister of Personnel and senior Grand Secretary, his power equal to the vulnerability of his position vis-à-vis Wei Chung-hsien. One of Yeh's early recommendations was the promotion of Tung Ch'i-ch'ang to the office of Vice Minister of the Court of Imperial Sacrifices.

In 1620, both Yeh and Tung were on the emperor's favored list of former tutors, and they both participated in the compilation of the *Veritable Records of the Emperor Kuang-tsung*, Yeh as one of the Directors and Tung as a Compiler. This scroll was written in the tenth month at a farewell gathering, after the project was completed. When Tung finally reached Nanking, he remembered Yeh's birthday with presents and a painting. In reply, Yeh wrote a letter of thanks to Tung. The letter contains seldom-revealed feelings of a loyal minister and comments on the roles of Yeh and Tung in the historical enterprise in which the two men were players (see Riely, "Tung Ch'i-ch'ang's Life," and Wang Shiqing, "Tung Ch'i-ch'ang's Circle").

MWG

LITERATURE: *Jung-t'ai shih-chi*, *ch*. 3, pp. 9–10, 44, *ch*. 4, pp. 4–6; *Chung-kuo ku-tai shu-hua mu-lu*, vol. 2, 1985, *Ching* 1–2173; Zheng Wei, *Nien-p'u*, 1989, pp. 146–47.

46 *The Transmission of Examination Papers*
Mo-chüan ch'uan-i
董其昌　墨卷傳衣

Dated 1623

Hanging scroll, ink on paper
101 x 39.2 cm (39¾ x 15⁷⁄₁₆ in.)

Beijing Palace Museum

vol. 1, pl. 46

ARTIST'S INSCRIPTION AND SIGNATURE (7 lines in running script):
Five volumes of my *chin-shih* examination papers that I wrote at the Ministry of Rites in the *chi-ch'ou* year [1589] were in the hands of a collector. The Buddhist monk Te-an brought them to show me. They were

written in a hurry under the wind-blown eaves and the calligraphy was quite mediocre. Why has someone bothered to keep them in the gauze cases for thirty-five years? Since my grandson T'ing wants to collect them, [the examination papers] may as well be regarded as the "robe of transmission" that I'm handing down to him. I did this painting in exchange for them. On the twenty-first day of the third month of the *kuei-hai* year [April 20, 1623]. Hsüan-tsai.

已丑南宮墨卷五策爲好事者所藏。得岸上人袖以示予。風簷倉卒，書道殊劣。何煩碧紗籠襲之三十五年也？自予孫庭收之，則不當傳衣矣！以此畫易之。癸亥三月念一日。玄宰。

ARTIST´S SEAL:

Tung Ch'i-ch'ang yin 董其昌印 (*pai-wen*, square) 116

NO COLOPHONS

COLLECTORS´ SEALS: Tung T'ing 董庭 (17th century), 3; unidentified, 1

The year 1589 was important in Tung Ch'i-ch'ang's career: he obtained his *chin-shih* degree and was appointed to the prestigious Han-lin Academy.

Tung was ever conscientious about his progress as a calligrapher. After his humiliation at the age of thirteen *sui* (twelve years old) in placing second in the prefectural examination because the examiner judged his calligraphy inferior, Tung began a lifelong search for his own calligraphic style. By 1601, when he was forty-seven *sui*, Tung was confident enough to claim that after thirty years' practice he had achieved transformation of the ancients; and ten years later, in 1611, he declared that his calligraphy was superior to that of the Yüan master Chao Meng-fu (1254–1322). Despite these comments, he still felt uncertain (or perhaps modest) about his calligraphy, for in 1620, at the age of sixty-six *sui*, he remarked that forty years' effort in improving his calligraphy had been in vain. In his inscription to *The Transmission of Examination Papers*, Tung Ch'i-ch'ang refers to his early calligraphy written on the occasion of his *chin-shih* examination in 1589, and seems surprised to find that the product of his brush had become a collector's item.

The Transmission of Examination Papers, painted in exchange for his calligraphy, is a work from the most productive and creative period of Tung Ch'i-ch'ang's artistic career. In this diagonal composition, Tung synthesizes the styles of many of the ancient masters he admired, such as Tung Yüan (fl. ca. 945–ca. 960), Mi Fu (1051–1107), Huang Kung-wang (1269–1354), and Ni Tsan (1301–1374). The tilted horizon, bold contrast of light and dark, and positive use of void in the distant mountains, however, are characteristic of Tung Ch'i-ch'ang's mature style.

JK

LITERATURE: Wu Sheng, *Ta-kuan-lu*, preface dated 1713, *ch.* 19, p. 35; Xu Bangda, *Pien-nien-piao*, 1963, p. 100; *Chung-kuo ku-tai shu-hua mu-lu*, vol. 2, 1985, *Ching* 1–2176; Ren Daobin, *Hsi-nien*, 1988, pp. 200–201; Zheng Wei, *Nien-p'u*, 1989, p. 147.

47 *Yen-ling Village*
Yen-ling ts'un t'u

董其昌　延陵村圖

Dated 1623

Hanging scroll, ink and color on silk
78.5 x 30.2 cm (30⅞ x 11⅞ in.)

Beijing Palace Museum

vol. 1, pl. 47

ARTIST´S INSCRIPTION AND SIGNATURE (13 lines in regular script):

Yen-ling Village lies east of Mao Mountain. There stands a stele [written by] Chang Ts'ung-shen. Ts'ung-shen was a man of the T'ang dynasty who held office in the Ta-li era [766–79]. Chao Tzu-ku [Chao Meng-chien, 1199–1264] praised his calligraphy as being better than that of Li Pei-hai [Li Yung, 675–747]. The "Priest Hsüan-ching stele" and this stele commemorating Master Chi [Cha] of Yen-ling are both in Hua-yang. The brush method is the same as that in the stele for Master of the Dharma San-tsang by Hsü Hao [703–782]. The [text of the] Yen-ling stele was composed by Hsiao Ting [8th century]. It says, in summary: "By listening to their music one can distinguish between principalities that are flourishing and those that are declining, and by the number of worthy men, one may tell whether a clan will survive or disappear. Hanging up a sword demonstrates an unspoken promise. Fleeing the state protects uprightness in an absence of personal desire. One may imagine his transcendental Way, and his great virtue is herein preserved." Beside the stele is a shrine to Four Sages—Tung Yung [later Han dynasty], Wei Chao [204–273], Wang Su [418–471], and Master Chi. In the second month of the *kuei-hai* year [March 1–30, 1623]. Painted on board a boat at Tan-yang. So I titled it *Picture of Yen-ling Village* and wrote this. Tung Hsüan-tsai.

延陵村在茅山之東，有張從申碑。從申唐大曆時司直，趙子固稱其書品在李北海之右。《玄靖天師碑》與延陵季子此碑皆在華陽，筆法類徐浩三藏法師碑。延陵碑，蕭定作也。略曰："聽樂辯列國之興亡，審賢知世數之存沒，掛劍示不言之信，避國保無欲之貞。玄風可想，至德如存云。"旁有四賢以祠董永、韋昭、王素與季子而四。癸亥二月畫于丹陽舟中，因命之《延陵村圖》，并書此，董玄宰。

ARTIST´S SEAL:

Tung Ch'i-ch'ang 董其昌 (*chu-wen*, square) 115

NO COLOPHONS

COLLECTORS´ SEALS: Liu Shu 劉恕 (1759–1816), 4; unidentified, 2

Yen-ling was in the vicinity of modern Ch'ang-chou and Tung Ch'i-ch'ang was traveling toward modern Chen-chiang. The painting is not one of his best, being somewhat stiff and uncoordinated in both composition and execution. The inscription is in small square *k'ai-shu* (regular script), which is unusual for Tung and perhaps was intended to reflect the stele inscription itself. The journey, possibly, was not a comfortable one. On the other hand, Tung Ch'i-ch'ang on occasions used *k'ai-shu* in inscribing a painting to which he attached particular importance. A degree of artistic shortcoming does not necessarily signify that this work lacked significance for Tung. Indeed, the care taken in transcribing the inscription and the attention to matters of

ethics and history suggest that Tung was deeply exercised over the meaning that this site held for him at a time when his review of the previous reign must have made the incipient chaos of the present one seem even more unpleasant. One might even wonder whether it was such psychological discomfort that affected this painting.

The distinctively narrative content of Tung's own inscription is carried through in the structure of the painting. A series of diagonal slopes across the lower left corner draws the visitor into the valley and its village. One imagines that the further pair of buildings represents the shrine. The inscription was included in Tung's collected works edited by Ch'en Chi-ju (1558–1639), with the presumably clerical error of "Chu-yang" 朱楊 for "Tan-yang" 丹陽.

Master Chi, or Chi Cha, a man famed for his virtue, was enfeoffed at Yen-ling during the Spring and Autumn period (770–476 B.C.). Hearing the music of Chou, he was able to foretell the fate of the dynasty. On his way to the Chou capital, he passed through a principality whose lord silently coveted his sword. Chi Cha sensed his desire but traveled on. Returning the same way and finding that the lord had died, he left his sword hanging on the grave.

JH

LITERATURE: *Jung-t'ai pieh-chi*, ch. 6, pp. 21–22; *Tung Hua-t'ing shu-hua lu*, repr. 1962, p. 15; *Chung-kuo ku-tai shu-hua mu-lu*, vol. 2, 1985, *Ching* 1–2175; Zheng Wei, *Nien-p'u*, 1989, p. 147.

48 *Casual Writings by a Window*, running script
Hsing-shu hsien-ch'uang man-pi
董其昌　行書閑窓漫筆

Dated 1623

Album of fourteen leaves mounted as a handscroll, ink on paper
27.5 x 32.7 cm (10¹³⁄₁₆ x 12⅞ in.)

Beijing Palace Museum

vol. 1, pl. 48 (detail); vol. 2, pl. 48

ARTIST'S TITLE (1 line in running script):
"Casual Writings by a Window"

《閑窓漫筆》

Section 1:
1. A discussion in 18 lines of the content of *Yün-yen kuo-yen lu*, a catalogue by the Southern Sung calligrapher, collector, and connoisseur Chou Mi (1232–1298), comparing its contents with the collections of contemporaries such as Han Shih-neng (1528–1598) and Hsiang Yüan-pien (1525–1590), and lamenting the lack of availability of great works of art, all of which cannot be compared with Mi Fu (1051–1107) and his record of works, the *Pao-chang tai-fang lu*.

2. A discussion in 10 lines of the rarity of Sung and Yüan dynasty works and their monetary value, and the decline of connoisseurship when compared to that of a collector such as Mi Fu.

3. A discussion in 10 lines of the calligraphy of Chu Hsi (1130–1200), the Neo-Confucian thinker, and his comments on calligraphy.

4. A record in 9 lines of a quatrain Tung Ch'i-ch'ang inscribed on a painting for the collector Wang Po-ts'an.

5. A discussion in 15 lines of the theory of large and small characters as postulated by Su Shih (1036–1101) and Mi Fu and some examples of large writing on plaques by Mi and Wu Chü (fl. 1150–1200) of the Northern Sung which were better than Chao Meng-fu's (1254–1322) of the Yüan.

ARTIST'S INSCRIPTION AND SIGNATURE (2 lines in running script, following the five prose sections):
Written while it was raining, on the twenty-second day of the third month of the *kuei-hai* year [April 22, 1623]. Ch'i-ch'ang.

癸亥三月廿二日雨中書。其昌。

Section 2:
ARTIST'S INSCRIPTION AND SIGNATURE (3 lines in small running-regular script, following a transcription in 20 lines in running-regular script of the Sung original):
On the right is Mi Yüan-chang's [Mi Fu] writing in "ant-head" script, carved in his calligraphy anthology, *Pao-Chin chai t'ieh*. It bears a resemblance to the brush ideas in Ch'u Ho-nan's [Ch'u Sui-liang, 596–658] *Ai-ts'e*. People have called Mi crazy, but if one reads his commentaries on calligraphy, they are certainly not crazy. Ch'i-ch'ang.

右米元章𥂁子蠅頭書，刻《寶晉齋帖》。似褚河南《哀册》筆意。人謂米狂，觀其論事，乃不狂也。其昌。

Section 3:
Transcription in medium running-cursive script of three passages from the *Kuan [Ch'un-hua k'o] t'ieh*, the Northern Sung anthology of model calligraphy: *Te Yüan Chia-hsing shu*. . . (in 5 lines); *Tsu-hsia shang-t'ing shu-jih*. . . (in 6 lines); *Hsiang-li-jen ts'ai-chu*. . . (in 6 lines).

ARTIST'S INSCRIPTION AND SIGNATURE (2 lines in small running-cursive script, following the preceding transcription):
A guest happened to come by with a set of Sung rubbings of the *Kuan-t'ieh*. I examined them carefully and then transcribed these several passages. Ch'i-ch'ang.

偶有客持宋搨《官帖》見視。臨此數則。其昌。

ARTIST'S SEALS:
Tung Hsüan-tsai 董玄宰 (*pai-wen*, square) 117
Tung Ch'i-ch'ang yin 董其昌印 (*pai-wen*, square) 118
Tsuan-hsiu liang-ch'ao shih-lu 篹修兩朝實錄 (*pai-wen*, rectangle) 119
Tung Ch'i-ch'ang 董其昌 (*pai-wen*, square) 120

NO COLOPHONS

COLLECTORS' SEALS: Wang Shih-min 王時敏 (1592–1680), 3; Chang Chih-wan 張之萬 (1811–1897), 4; unidentified, 3

"Today I was examining Chou Mi's *Yün-yen kuo-yen lu* (*A Record of [Painting and Calligraphy] which Passed before my Eyes*), and in it he mentions the small regular script of T'ao the Hermit [T'ao Hung-ching, 456–540] in his *Huang-t'ing wai-ching ching* (*Yellow Court Sutra*) and his *Ta-tung ching* (*Great Cavern Sutra*). As there are no rubbings extant of these two [Taoist] scriptures, how could we even speak of the genuine article? Also Yang Ning-shih's [873–954] *Thousand Character Classic* is no longer extant. I think that is because at the end of the Yüan and the beginning of our dynasty, calligraphy suffered massive losses during the political change. Nowadays in the

southeast area, we have only the T'ang family of Chin-ling, the Han family of Su-chou, and the Hsiang family of Hsiu-shui who have any collections to speak of, with an occasional object in the hands of an art lover. Other than that, there is not much. I have traveled the earth back and forth for thousands of miles before coming upon one scroll or album that is worth looking at. How difficult it would be to match those recorded by Old Mi [Fu] in his *Pao-chang tai-fang lu*."

Such are the opening comments of Tung Ch'i-ch'ang in this scroll, which can be considered a form of the "reading notes" he made on a daily basis, whenever he had some leisure to spare. This accounts for the random nature of the nine passages, followed by his three explanatory inscriptions. Indeed, the date, April 22, 1623, indicates that these passages were written not long after he executed the painting *Yen-ling Village* (vol. 1, pl. 47), testimony to a productive period resulting from disciplined daily habits. One can imagine Tung's desk cleared of official documents near the light of an open window overlooking the garden, his brushes ready, fresh ink ground, and paper spread before him, ready to receive his thoughts.

Thus the contents of this scroll encapsulate the artistic issues that concerned Tung for most of his life: the searching out and finding of exemplary painting and calligraphy of ancient origin, and the confirmation of their value for the present generation; comments on painting and calligraphy by past critics of like mind, such as Chou Mi (see Marilyn Wong Gleysteen, "Hsien-yü Shu's Calligraphy," 1983, pp. 36–50), Mi Fu, and Chu Hsi (see Gleysteen, "Calligraphy and Painting," 1991, pp. 150–61); and the copying of passages from model calligraphy anthologies.

Unlike a number of other scrolls in the exhibition that demonstrate Tung's calligraphic prowess in a formal or full-scale presentation, whether "in the manner of" old masters or in large cursive, standard, or running script, this one shows the artist at ease, his calligraphy presented in various sizes and levels of formality. One might liken it to the difference between an actor's stage performance of a classic work from the past, with its declamation and given text, versus his natural but melodious speech in conversation with a friend. This scroll is analogous to the latter; it is not "for show," therefore not forced or stylized, and as such, reveals the artist's natural charm. In particular, Tung's mention in the fifth passage of the large plaques of Mi Fu and a later, lesser-known contemporary, Wu Chü (see Gleysteen, "Calligraphy and Painting," pp. 152–61), led Tung to write the marvelous phrase "The Finest Rivers and Mountains under Heaven!" (*tien-hsia ti-i chiang shan*).

<div align="right">MWG</div>

LITERATURE: *Chung-kuo ku-tai shu-hua mu-lu*, vol. 2, 1985, *Ching* 1–2177; Zheng Wei, *Nien-p'u*, 1989, p. 154.

49 *"Yin-fu ching,"* regular script

K'ai-shu "Yin-fu ching"

董其昌　楷書《陰符經》

Dated 1624

Handscroll, ink on paper

25.1 x 143.4 cm (9⅞ x 56⁷⁄₁₆ in.)

Shanghai Museum

vol. 1, pl. 49 (detail); vol. 2, pl. 49

Section 1:

ARTIST'S TITLE (1 line in small regular script, preceding a transcription of the text in 27 lines):

"Scripture on Esoteric Credentials"

《陰符經》

ARTIST'S INSCRIPTION (3 lines in small regular script, following the transcription of the text):

Because I recently saw Yen Lu-kung's [Yen Chen-ch'ing, 709–785] stele, the *To-pao t'a*, I wrote out this *Yin-fu ching*, using [as a model] Mi Yüan-chang's [Mi Fu, 1051–1107] version, which is missing some twenty characters, including *pa-kua* and *chia-tzu*.

因觀顏魯公《多寶塔碑》書此《陰符經》。用米元章課本，少"八卦甲子"等二十餘字。

Section 2:

ARTIST'S TITLE (1 line in small regular script, preceding a transcription of the text in 9 lines):

Hsü Hao's [703–782] transcription of his deceased father's stele.

徐浩書府君碑。

ARTIST'S INSCRIPTION AND SIGNATURE (9 lines in running script, following the transcription of the text):

Li Pei-hai [Li Yung, 675–747] composed the text and [Hsü] Hao wrote the calligraphy for the stele. There was also Councilor Wang Chao's [8th century] regimentary style of writing, which is rather rare among steles. Hsü Hao and his father Hsü Ch'iao-chih were both able calligraphers of the T'ang, just as were [Wang] Hsi[-chih, 303–379] and his son Hsien [-chih, 344–388] of the Chin and Ou-yang Hsün [557–641] and his son Ou-yang T'ung. But T'ung was slightly inferior to his father. Written in the fourth month of the *chia-tzu* year [May 17–June 15, 1624] at the Western Garden ambulatory hall. Ch'i-ch'ang.

李北海爲文，浩自書碑，又有朝議郎王釗排文。排文，諸碑所罕見。徐嶠之、徐浩父子擅臨池之能，故是唐之義、獻。歐陽詢亦有歐陽通，類徐氏。然通小劣於率更耳。甲子四月，范西行館書。其昌。

NO ARTIST'S SEALS

COLOPHON: Weng T'ung-ho 翁同龢 (1830–1904), undated

COLLECTORS' SEALS: Wang Hung-hsü 王鴻緒 (1645–1723), 4; Yin Hsiang 胤祥 (1686–1730), 1; Yin Li 胤禮 (1697–1738), 1; Hung-hsiao 弘曉 (d. 1778), 1; Ch'ing Kao-tsung 清高宗 (r. 1736–95), 2; Han T'ai-hua 韓泰華 (19th century), 1; Weng T'ung-ho, 3

To sing the praises of regular script and of Tung Ch'i-ch'ang's in particular is to recognize what was for Tung himself one of the most challenging aspects of the calligraphic enterprise in which he was engaged.

While regular script of medium or large size was of sufficient difficulty, it was the execution of small-sized regular script that actually commanded Tung's greatest respect and of which he was most proud. Thus, this work dated 1624, when Tung was well into his old age, deserves particular notice.

Tung seldom went out of his way to laud any post–Sung dynasty master, let alone any recent masters, such as Wen Cheng-ming (1470–1559) and Chu Yün-ming (1461–1527). Chao Meng-fu (1254–1322) was a different matter, possibly because he stood at the juncture between the more recent and ancient past; possibly because of his mastery of the triple arts of poetry, painting, and calligraphy, as well as the full range of calligraphic expression in all the scripts; and possibly because of his imperial heritage from the Sung and attainment of high rank in the Mongol government. In his writings, Tung consistently denigrated Chao's calligraphy as being vulgar, or "too technically perfect" (see Xu Bangda, "Tung Ch'i-ch'ang's Calligraphy," in vol. 1 of this catalogue, p. 115). In 1628, however, he had the opportunity to view an example of Chao's small-sized regular script, saying that it resembled the style of Yang Hsi (330–387), the Six Dynasties calligrapher who carried the place of honor in Tung's collection of rubbings, the *Hsi-hung t'ang t'ieh*. Tung described Chao's version of the "Yellow Court Sutra" as an outstanding piece and regretted not having seen it earlier. Tung's sense of himself and of his place in history was such that this can be regarded as a rare expression of regret and of praise.

Examples of Tung's small regular script are rare; this scroll, dated four years before he saw Chao's work, reveals why Tung regarded Chao as a suitable rival. The control and polish that are evident in every stroke and dot ring out in pure and precise tones. Small writing of this type, in which the graphs measure a half-inch or less, demands tremendous powers of mental and physical concentration because it requires the focusing of the brush tip in a confined area of paper over the sustained length of the text. Su Shih (1036–1101) made one of the classic pronouncements about small and large calligraphy: "In writing large characters, the difficulty lies in making them compact and tight without any [dead] spaces. In writing small characters, the difficulty lies in making them spacious and monumental with an expansive feeling" (*Tung-p'o t'i-pa*, 1974, ch. 4, p. 86). While the scripture transcribed here is not inordinately long, what is remarkable is that Tung was able to sustain this level of perfection from the beginning to the end as well as in his colophon and in the second essay after Hsü Hao. Technically, one should note in particular the left and right diagonal strokes (*p'ieh* 撇 and *na* 捺), the verticals (*shu* 束), hooks (*kou* 鈎), the opening and closing "heads" and "tails," as well as the sense of compactness in the composition of individual graphs (*chieh-kou* 結構) and in the plumbline verticality of the columns (*hang-ch'i* 行氣). Should anyone question Tung's ability to repeat such an exercise, they need only consult an album by Tung imitating Ou-yang Hsün's *Thousand Character Classic* (National Palace Museum, Taipei; Kohara, *To Kisho no shoga*, 1981, vol. 2, cat. 61) dated 1628, when Tung was seventy-four *sui* (seventy-three years old).

Although they are rare, other works by Tung in this script size do exist, including some early examples. There are also a number of dated and undated colophons to well-known works, often in a more informal running-regular script (usually a sign of respect). (See, for example, Kohara, *To Kisho no shoga*, vol. 2, pls. 32, 33, 40–42, 44–46,

63, 79, 80, 86.) Occasionally, too, Tung selects small regular script to grace his own works. Two early scrolls in the present exhibition (vol. 1, pl. 4, inscription dated 1603; and vol. 1, pl. 7, dated 1605) should be noted. Any judgments of authenticity must take into account the quality of the calligraphy in these inscriptions.

It is also interesting to compare examples of Tung's small regular script with two by Chao Meng-fu himself. In lieu of the "Yellow Court Sutra," which is no longer extant, there is the fine early example of Chao's small regular script written on silk around 1292, the "Daoist Sutra of Constant Purity and Tranquility" (Freer Gallery of Art; Fu Shen et al., *From Concept to Context*, 1986, cat. 6, pp. 30–31), as well as a later example, the "Biography of Chi An of the Han Dynasty," written in 1320, when Chao was sixty-seven *sui* (*Shodo geijutsu*, 1970, vol. 7, pls. 85–93). One can of course consult Tung's original inspiration, Yen Chen-ch'ing's *To-pao t'a* (*Shodo zenshu*, 1966, vol. 10, pl. 12), which is in a medium-sized regular script. Tung also mentions Mi Fu's version of the text in his colophon. In lieu of that example, which is also not extant, one might turn to Mi's funerary lyric presented to the throne on the death of the empress Shen-tsung and dated 1101 (*Shodo zenshu*, 1967, vol. 15, pls. 107, 108). This work demonstrates how this most admired of Tung's models preserved the characteristic appearance and essential nature of his larger writing style when writing in smaller script on a vastly reduced scale. Tung is nonetheless still closer to Chao (and even to Wen Cheng-ming, who was also a virtuoso master of small regular script) than to Mi in his sublimation of formal personal traits to brush precision.

The "Scripture on Esoteric Credentials," which Tung transcribes in the first section of this scroll, is a Taoist text on alchemy of uncertain origins; the present version was said to have inspired commentaries by six early personages, including Chu-ko Liang (181–234), as well as later figures such as Chu Hsi (1130–1200). Early transcriptions of the text by T'ang masters, including Ch'u Sui-liang (596–658), are extant in rubbing form, indicating that the text was also associated with the T'ang emperor T'ai-tsung (r. 627–49), who was known to sponsor such projects (see Ecke, *Chinese Calligraphy*, 1971, cat. 10H). In their inception, Taoist and Buddhist scriptures were executed to accrue merit and were written in the most respectful of scripts, small regular, in prescribed formats, such as a grid with a certain number of graphs per column. Such scriptures were produced in large numbers especially from the third to sixth centuries, though few such early examples are extant in brushwritten form. Occasionally these texts were associated with certain master calligraphers, but on the whole they were produced by anonymous scribes of varying calligraphic aspirations. The "Scripture on Esoteric Credentials" was not associated with any master but with the small regular script of the Six Dynasties period in general, when Taoism was of special interest to the educated elite.

Here Tung Ch'i-ch'ang is not so much invoking the Taoist content of the text, but the tradition of sutra-copying, which had become almost synonymous with the practice of small regular script. Tung's models are clearly not the anonymous scribes of history, but, rather, two of his most esteemed calligraphic muses, Yen and Mi. Thus in this work he is not only performing a quiet calligraphic tour de force, but further reinforcing the Grand Tradition of orthodoxy.

MWG

63

Catalogue

LITERATURE: Han T'ai-hua, *Yü-yü t'ang*, 1851, repr. 1963, *ch.* 3; Xu Bangda, *Pien-nien-piao*, 1963, p. 100; *Chung-kuo ku-tai shu-hua mu-lu*, vol. 3, 1987, *Hu* 1–1365; Zheng Wei, *Nien-p'u*, 1989, p. 156; *Chung-kuo ku-tai shu-hua t'u-mu*, vol. 3, 1990, *Hu* 1–1365.

50 *Returning Home from an Homage to the Imperial Tombs*

Shang-ling so-chien
董其昌　上陵所見

Dated 1624

Hanging scroll, ink on paper
123 x 46 cm (48⁷⁄₁₆ x 18⅛ in.)

Museum Rietberg, Zürich

vol. 1, pl. 50

ARTIST'S INSCRIPTION AND SIGNATURE (3 lines in running script): After my return from a pilgrimage to the imperial tombs in the ninth month, I have painted what I saw. Done by Hsüan-tsai, in the autumn of the *chia-tzu* year [1624] as a farewell gift for Mr. Tseng-pei.

九月上陵還，寫所見。甲子秋，玄宰爲繪北丈贈行。

ARTIST'S SEALS:
Tsung-po hsüeh-shih 宗伯學士 (*pai-wen*, square) 100
Tung-shih Hsüan-tsai 董氏玄宰 (*pai-wen*, square) 101

COLLECTORS' SEALS: P'ang Yüan-chi 龐元濟 (1864–1949), 1; Chin Wang-ch'iao 金望喬 (Ch'ing dynasty), 2

NO COLOPHONS

RECENT PROVENANCE: P'ang Yüan-chi

As noted by Chu-tsing Li (*A Thousand Peaks and Myriad Ravines*, 1974, vol. 1, p. 109), the Rietberg landscape was produced at almost precisely the same time as leaf 6 of the Nelson-Atkins album *Landscapes in the Manner of Old Masters* (vol. 1, pl. 42–6)—the ninth month of 1624, following Tung Ch'i-ch'ang's return from a visit to the imperial tombs. At the time, Tung was in his second period of government service in Peking; by the following year, he had managed once again to distance himself from the purges carried out by the powerful eunuch Wei Chung-hsien (ca. 1568–1627) by accepting an honorary position in Nanking. Tung's inscription on the Nelson-Atkins album leaf refers to the late Northern Sung aristocrat-painter Chao Ling-jang (d. after 1100), and the painting explores complexly folded and segmented cliff forms in its upper passages. The Rietberg landscape includes some related passages, especially the jaggedly undercut flat-topped plateau in the upper middle distance, but its forms are generally broader and looser in treatment. It belongs to a distinctive series of large-scale mountainscapes from the mid-1620s organized around broad movements and simplified, though still dynamic, forms, as in the scalloped profile of the peak at upper left or the few large, complexly edged trees in the foreground. These works abstract elements of

dynamic silhouette and structure which are confidently recombined in somewhat summary arrangements. Unlike works from Tung's earliest period, their diagrammatic qualities seem to derive less from old paintings than from Tung's own formulations. The summariness of many such landscapes reflects both a confident experience and, very probably, the pressures of frequent demands for paintings from an artist whose brush efforts conveyed a high cultural and official prestige. The unusually prominent pentimenti in the middle-distance group of trees and horizontal shoals may represent one effect of rapid production.

RV

LITERATURE: P'ang Yüan-chi, *Hsü-chai, ming-hua hsü-lu*, 1924, vol. 2, p. 52; Sickman and Soper, *Art and Architecture of China*, 1968, pl. 141b; *Weltkunst aus Privatbesitz*, 1968, C12; Contag, *Seventeenth Century Masters*, 1969, pl. 55; Li, *A Thousand Peaks and Myriad Ravines*, 1974, vol. 1, pp. 108–10, vol. 2, p. 33, fig. 23, p. 108, fig. 23 (seals); Kohara, Wu, et al., *Jo I, To Kisho*, 1978, p. 269, pl. 32; Kohara, *To Kisho no shoga*, 1981, p. 242, pl. 16; Suzuki, *Comprehensive Illustrated Catalogue*, 1982–83, vol. 2, E7–024; *Tung Ch'i-ch'ang hua-chi*, 1989, app. pl. 85.

51 *Cloudy Mountain Ink-play*

Yün-shan mo-hsi
董其昌　雲山墨戲

Undated (ca. 1624–26)

Hanging scroll, ink and color on paper
101.1 x 27.4 cm (39¹³⁄₁₆ x 10¹³⁄₁₆ in.)

Shanghai Museum

vol. 1, pl. 51

ARTIST'S INSCRIPTION AND SIGNATURE (3 lines in running script): Ch'en Tao-fu [Ch'en Ch'un, 1483–1544] uses cursive script (*ts'ao-shu*) to make pictures; in this he has the intention of Mi Yüan-hui [Mi Yu-jen, 1074–1151]. I too do this to stand for a cloudy mountain [ink-]play. Ch'i-ch'ang.

陳道復草書作畫，有米元暉意。余亦以此代雲山之戲。其昌。

ARTIST'S SEAL:
Tung Ch'i-ch'ang yin 董其昌印 (*pai-chu wen*, square) 122

COLOPHON: Wu Hu-fan 吳湖帆 (1894–1968), dated 1951

COLLECTORS' SEALS: Tai Chih 戴植 (19th century), 2; Wu Hu-fan, 2; Xu Bangda 徐邦達 (b. 1911), 1; Ch'ien Ching-t'ang 錢鏡塘 (20th century), 2; Lien Ch'üan 廉泉 and Wu Chih-ying 吳之瑛, 3; unidentified, 3

"Cloudy mountains" (*yün-shan* 雲山) and "ink-play" (*mo-hsi* 墨戲) were closely tied to the tradition of scholar painting (*shih-jen-hua* 士人畫) from Sung times on and particularly to the painting of the men of culture (*wen-jen-hua* 文人畫) as defined by Tung Ch'i-ch'ang. The two terms were linked integrally with Mi Fu (1051–1107) and his son Mi Yu-jen. On a painting entitled *Misty River and Piled Peaks* (*Yen-chiang tieh-chang*) Tung wrote: "Cloudy mountains did not begin

64

with Mi Yüan-chang [Mi Fu], for from T'ang times Wang Ch'ia's (d. 805) splashed ink (*p'o-mo* 澄墨) already had this idea. Tung Pei-yüan [Tung Yüan, fl. ca. 945–ca. 960] liked to execute misty scenery; as to the transformations of mist and cloud, this is [to be found only in] Mi's painting. I was awakened to the secrets (*san-mei* 三昧) of ink-play by Mi Fu's *White Clouds over the Hsiao and Hsiang* (*Hsiao-Hsiang pai-yün*). Therefore I employed them in writing the mountains of Ch'u" (*Hua-ch'an shih sui-pi*, ch. 2, pp. 30–31). In another passage, Tung wrote that an artist's abilities were to be seen in the depiction of the transformations of mist and cloud. He quoted Mi Yu-jen as saying that most of Wang Wei's (701–761) paintings were detailed and not worth studying, and only his cloudy mountains could be taken as ink-play (*Hua-shuo*, paragraph 2). Tung was thus able to link cloudy mountains and ink-play not only to Wang Ch'ia but also to the great T'ang poet and painter Wang Wei, whom he saw as the founder of his Southern School. In yet another passage Tung stated that Mi Fu was able to correct the errors of painters and that in doing so the Mi family brought about a transformation of the methods of painting (*Hua-yen*, p. 31).

From the Sung period the ink-play of Mi Fu and Mi Yu-jen was transmitted to Kao K'o-kung (1248–1310) in the early Yüan and to Ch'en Ch'un in the mid-Ming. Tung Ch'i-ch'ang had particular praise for Kao as the inheritor of this tradition and on at least one occasion inscribed a Ch'en Ch'un handscroll (*Mountains in Clouds*, dated 1535, in the Freer Gallery of Art). Ch'en had a particular affinity for Mi Yu-jen. On *Cloudy Mountain Ink-play* Tung linked Ch'en's execution to calligraphy: Ch'en painted as though writing cursive script and in doing this understood the direction that Mi Yu-jen had been taking. Tung's own painting would then be a further move in the same direction.

Perhaps for this reason the picture is unlike Tung's other Mi-style paintings. His various studies of Mi-style mountains and brushwork as seen in the album in the Museum of Fine Arts, Boston (Kohara, Wu, et al., *Jo I, To Kisho*, 1978, pl. 60), or in the album of landscapes executed for Wang Shih-min in 1625 (vol. 1, pl. 54) show a central cone-shaped mountain built up of horizontal dots surmounting a foreground copse. This particular shape of mountain and the dotting technique accord well with the standard image of Mi Fu, Mi Yu-jen, and Kao K'o-kung. A similar type of mountain girdled by clouds is also seen in the hanging scroll *Stately Trees Offering Midday Shade* (vol. 1, pl. 28) and in the sixth leaf of the *Eight Landscapes* album dated 1630 (vol. 2, pl. 62–6). In *Cloudy Mountain Ink-play* Tung has achieved a transcendence of the motifs of the Mi mode; few of these now remain. Awakened to Mi Yu-jen's intent through Ch'en Ch'un's use of cursive script in painting, Tung has instead re-created what he perceived Mi's intention to be.

Tung Ch'i-ch'ang's concern with form relationships, evident in *Cloudy Mountain Ink-play*, is that of *River and Mountains on a Clear Autumn Day* (vol. 1, pl. 53) and of the two paintings from the Museum Rietberg, Zürich, dated to 1624 and 1625 (vol. 1, pls. 50, 52). In all three paintings Tung is concerned with the interlocking of landscape elements and has arrived at different solutions for combining his distances. In *Cloudy Mountain Ink-play* Tung has not been as stark in his divisions, but there is a similar sense of tension in the combination of parts and in the creation of a precarious stability. These com-

parisons indicate a probable dating to around 1625 when Tung was seventy-one *sui* (seventy years old), as is suggested by Wu Hu-fan in his colophon on the mounting.

DAS

52 *Landscape in the Manner of Tung Yüan*
Fang Pei-yüan shan-shui
董其昌　倣北苑山水

Dated 1625

Hanging scroll, ink on paper

107.1 x 43.1 cm (42³⁄₁₆ x 16¹⁵⁄₁₆ in.)

Museum Rietberg, Zürich

vol. 1, pl. 52

ARTIST'S INSCRIPTIONS AND SIGNATURES:

1. 6 lines in running script:
Green trees grow in thick profusion;
Tall pines surge above the trees.
In a place like this, the paths of Mr. Chiang
Are beautiful even without bamboo.
 Some years ago, I wrote this poem for a painting. Today, as a strong wind has forced our boat to moor at P'ing-wang [on the west bank of the Grand Canal south of Su-chou] I have painted the present picture, which is inspired by the feeling of the poem, and used the poem as an inscription. Hsüan-tsai, on the twenty-second day of the fourth month of the *i-ch'ou* year [May 27, 1625].

青林鬱蒙茸
長松出林杪
所以蔣生徑
無竹亦自好
　舊有此題畫一絕。今日阻風平望寫此小景，頗合詩意，因以題之。玄宰，乙丑四月廿二日識。

2. 3 lines in running script:
Recently, on the official boat of Mr. Chu Ching-t'ao [Chu Kuo-sheng], the political councilor, I was shown a painting by Pei-yüan [Tung Yüan, fl. ca. 945–ca. 960], in whose style I have painted this picture. Further noted by Hsüan-tsai.
(Translations after Chu-tsing Li, *A Thousand Peaks and Myriad Ravines*, 1974, vol. 1, p. 111.)

近於朱參知敬韜官舫觀北苑畫，倣此。玄宰重題。

ARTIST'S SEALS:
Tsung-po hsüeh-shih 宗伯學士 (*pai-wen*, square) 102
Tung Ch'i-ch'ang yin 董其昌印 (*pai-chu wen*, square) 121

NO COLOPHONS OR COLLECTORS' SEALS

RECENT PROVENANCE: Walter Hochstadter

Chu-tsing Li notes that the reference to Mr. Chiang in Tung Ch'i-ch'ang's first inscription is probably an allusion to Chiang Hsü of the

Han dynasty, who withdrew from his official career when Wang Mang usurped the throne in the year A.D. 9 (*A Thousand Peaks and Myriad Ravines*, vol. I, p. III). Chiang spent the remainder of his life in retirement enjoying the company of old friends and the pleasure of his garden, renowned for its paths among the bamboos. Li also notes the parallelism with Tung's own circumstances under the oppressive regime of the eunuch Wei Chung-hsien (ca. 1568–1627).

The phenomenon of a painting with a double inscription, or, in effect, a rededication of the painting, occurs frequently in Tung Ch'i-ch'ang's oeuvre and is of considerable interest, since some of the artist's most notable works fall into that category. In this case, the genesis of the painting seems to have been doubly belated. The poem was composed first and the painting then conceived and executed as an accompaniment to the poem. The painting was then rededicated, and possibly completed or altered, to commemorate a double encounter—with an acquaintance and with a Tung Yüan painting. If the painting had already been completed before the second inscription was added, we might not expect to see any traces of the tenth-century master in the work. As it happens, the conical distant mountains heavily eroded by reserve clouds are fully in keeping with Tung Ch'i-ch'ang's conception of the Tung Yüan manner, as manifested in the similar treatment in the *Ch'ing-pien Mountain* scroll of 1617 (vol. I, pl. 32). The splayed arrangement of foreground trees and low, nearly symmetrical hillocks in the Rietberg painting also appear in Tung Ch'i-ch'ang landscapes in the Tung Yüan style dated 1607 and 1622 (see *Tung Ch'i-ch'ang hua-chi*, 1989, pl. 9; and the Shanghai scroll in the present exhibition, vol. I, pl. 44). This raises the possibility that the Rietberg painting was one of a number kept on hand by Tung Ch'i-ch'ang, and deemed suitable to commemorate a viewing of an antique Tung Yüan scroll. The official status of the dedicatee as a political councilor makes some such effort on his behalf plausible. Such circumstances would also not be out of keeping with Tung Ch'i-ch'ang's conception of *shen-hui* 神會, or "spiritual communion," in which Tung Yüan, represented by his surrogate brush traces, ought to be happy to encounter Tung Ch'i-ch'ang's creative reformulation of his manner.

Whatever the motivations for its production, Tung Ch'i-ch'ang's painting was not in any way a perfunctory effort. Although composed around broad movements, like other works of this period, it maintains the interest of a broad tonal range, as well as the structural tension created by the ambiguous spatial placement of reserve passages of water, clouds, and plateaus, and the powerful juxtaposition of conical peaks with rectilinear, sculpted cliffs in the distance.

RV

EXHIBITION: Haus der Kunst, Munich, 1959: *Tausend Jahre Chinesische Malerei*, cat. no. 66.

LITERATURE: Sirén, *Leading Masters and Principles*, 1956–58, vol. 5, p. 8, vol. 6, pl. 265b; Goepper, *Chinesische Malerei*, 1967, pl. 5; Li, "Chinese Paintings in the Drenowatz Collection," 1967, pl. 6; *Weltkunst aus Privatbesitz*, 1968, pl. C13; Li, *A Thousand Peaks and Myriad Ravines*, 1974, vol. I, pp. III–13, vol. 2, p. 33, fig. 24, p. 34, fig. 24 (detail), p. 108, fig. 24 (seals); Kohara, Wu, et al., *Jo I, To Kisho*, 1978, p. 169, pl. 33; Kohara, *To Kisho no shoga*, 1981, p. 242, pl. 18; Suzuki, *Comprehensive Illustrated Catalogue*, 1982–83, vol. 2, E7–025; *Tung Ch'i-ch'ang hua-chi*, 1989, app. pl. 88.

53 *River and Mountains on a Clear Autumn Day*
Chiang-shan ch'iu-chi
董其昌　江山秋霽

Undated (ca. 1624–27)

Handscroll, ink on Korean paper
37.8 x 136.4 cm (14⅞ x 53¹¹/₁₆ in.)

The Cleveland Museum of Art 59.46

vol. I, pl. 53; vol. 2, pl. 53 (colophons)

ARTIST'S INSCRIPTION AND SIGNATURE (3 lines in running script): Huang Tzu-chiu's [Huang Kung-wang, 1269–1354] *River and Mountains on a Clear Autumn Day* is like this. It is indeed regrettable that the old masters cannot see my painting. Ssu-weng.

黃子久《江山秋霽》似此。當恨古人不見我也。思翁。

NO ARTIST'S SEALS

COLOPHONS:
Kao Shih-ch'i 高士奇 (1645–1704), dated 1690, 2 seals:
Whenever Tung Wen-min [Tung Ch'i-ch'ang] came across any Korean paper with its mirror-smooth surface, his calligraphy and painting would become particularly inspired. This handscroll was originally a paper used for memorializing the emperor [Wan-li, r. 1573–1620]. The traces of characters are still visible, as is the seal of the Korean [king]. His [Tung's] brushstrokes are rounded and elegant, developed directly out of Ni [Tsan, 1301–1374] and Huang [Kung-wang]. How could Shen [Chou, 1427–1509] and Wen [Cheng-ming, 1470–1559] be compared with him. On the day after the mid-autumn festival [the sixteenth day of the eighth month] in the *keng-wu* year of the K'ang-hsi era [September 18, 1690], the weather is clear. The remounting has just been finished. I inscribe the colophon at P'ing-lu. Pao-weng weng, Kao Shih-ch'i.

董文敏每遇高麗鏡面箋，書畫尤爲入神。此卷改表紙用之。字蹟隱然，兼有朝鮮之印。至於筆法圓秀，直接倪、黃。豈文、沈所可同日而語也。康熙庚午中秋後一日，天氣澄爽。重裝初畢。跋於瓶廬。抱瓮翁高士奇。

Kao Shih-ch'i, dated 1694, 2 seals:
On the twenty-third day of the ninth month of the *chia-hsü* year of the K'ang-hsi era [November 10, 1694], I packed my bags to head north. When my boat passed Wu-ch'ang [Su-chou] Mr. Man-t'ang [Sung Lo] brought wine to bid me farewell so that we could share our thoughts on our separation in the last few years. I showed him the paintings and calligraphy that I collected and asked his opinions. Since Mr. Man-t'ang does not own any handscrolls by Wen-min, I leave this one for him in commemoration of our parting; thus the painting will have a worthy owner and our meeting will become a beautiful story in the future. It is the fourth day after the beginning of winter, with the sky clear and sober. Trees under frost have turned red and yellow, seemingly echoing the brush and ink in the painting. I also ask Mr. Man-t'ang to inscribe a poem to commemorate our meeting so that it will survive forever. Chiang-ts'un, Kao Shih-ch'i.

康熙甲戌九月廿三日，趣裝北上。舟過吳閶，漫堂先生載酒相餞，得話數年別緒。因以平日所藏書畫請爲鑒定。漫堂先生未有文敏畫卷，遂留此志別；茲卷得有所歸，可成他日佳話。時立冬已四日，天宇清肅，霜樹紅黃，與卷中筆墨互相暎帶。并乞漫堂先生一詩紀之，附以不朽。江村高士奇。

Sung Lo 宋犖 (1634–1713), dated 1694, 3 seals:

Who is the foremost art connoisseur of our dynasty?

T'ang-ts'un [Liang Ch'ing-piao, 1620–1691] is dead, so the title passes
 to Chiang-ts'un [Kao Shih-ch'i].

Leaving office, you retired for five years in the Lake Tang region.

Fondling handscrolls and hanging scrolls from morning to evening.

You sent me your collection catalogue *Hsiao-hsia lu* last year;

It is indeed the true equal of [Chou Mi's, 1232–1298] *Yün-yen kuo-yen.*

This year you returned to the capital by imperial order;

Your boat with calligraphy and paintings anchored at the riverbank in
 Su-chou.

When we met each other you did not waste any time for conversation
 but poured out immediately

From your coral net extraordinary treasures.

You produced incomparable scrolls, with gold-inscribed labels and jade
 rollers.

Pouring out from bags and trunks, they were spread in disarray.

Without a word, I rolled and unrolled until my fingers were numbed,

We sat straight, facing each other quietly, and never felt tired.

For three days we forgot about sleep and food.

And at times we shouted our joy out loud, forgetting who is host or
 guest.

Your *Dwelling in the Fu-ch'un Mountains* and the *Yüan-sheng* manuscript,

These peerless works I myself examined with delight.

As an added pleasure to the farewell dinner under the Maple Bridge,

You allowed me to hold again this handscroll by Tung Ch'i-ch'ang.

The *Misty River and Piled Peaks* [by Chao Meng-fu, 1254–1322] and this
 Clear Autumn Day are two extraordinary masterpieces.

In showing such life and spirit with *ch'i-yün*, the artists were truly men of
 heaven.

The *Clear Autumn Day* is not even three feet long,

Painted on tributary Korean paper, it shines like silver.

Every building up and every turn of the mountains imitates nature,

Every tree and every rock is removed from the commonplace.

From the beginning, the theory of poetry is the theory of painting,

Like the lotus and the morning sunshine, they complement and refresh
 each other.

The artist's inscription regrets that "the old masters cannot see my painting,"

Huang Kung-wang would have agreed in his grave.

The vermilion of the seals glitters and dazzles the eyes,

These added accessories are as valuable as jade.

You are very kind to give it to me,

The feelings expressed in your inscription are so sincere.

Wanting to refuse, but unable, I accept it to respect your wish,

And taking off my gown and cap I wrapped it with care.

You asked me to write a long poem in commemoration of this beautiful
 occasion,

I am too ashamed that my effort in response is so poor and inadequate.

Returning home, I unrolled it under candlelight, trying to write the
 colophon,

The light of the waning moon shines at the foot of the mossy wall.

Earnestly humming and brows knit in deep thought, I try to compose;

The verses are not outstanding, but the facts are real.

With this poem recorded at the end of the scroll, I mail it to you for
 approval,

This poem and this painting shall outlast a thousand springs.

 The old man herding ducks at the Western Mountain slope, Sung Lo.

(Translations of the inscription and colophons after Ling-yün Shih Liu,
Henry Kleinhenz, and Wai-kam Ho, in Ho et al., *Eight Dynasties*, 1980,
pp. 244–46.)

昭代鑒賞誰第一
棠邨已歿推江邨
五年當湖暫休沐
摩抄卷軸窮朝昏
昨歲寄我銷夏錄
雲煙過眼實弟昆
今年奉召北赴闕
書畫船泊胥江濱
相見不暇作絮語
珊瑚之網出異珍
金題玉躞得未有
傾囊倒篋縱橫陳
卷舒寧亂胝我手
聳肩靜對不欠伸
三日眠食爲之廢
有時大叫忘主賓
富春山圖袁生帖
無上妙迹欣相親
楓橋祖席興不極
華亭畫卷許更捫
煙江秋霽兩奇絕
氣韻生動真天人
秋霽長不滿三尺
高麗表紙光如銀
一重一掩師造化
一樹一石絕點塵
從來詩理即畫理
芙蓉朝日相鮮新
跋云古人不我見
大癡心折定九原
朱印燦燦色奪目
點綴更足重璵璠
先生好我舉相贈
題識數語情彌敦
欲辭不得拜命辱
包裹脫我衣與巾
要我長歌記勝事
報辭良愧薄且貧
歸來重展燭屢跋
缺月光射苺牆根
苦吟攢眉作山字
句雖不警事則真
錄入卷尾更寄似
此詩此畫爭千春
　　西陂放鴨翁，宋犖。

Shao Ch'ang-heng 邵長蘅 (1637–1704), undated, 2 seals:

Both the Yüan and Ming dynasties had men titled Wen-min;

The later man was Minister of Rites [Tung Ch'i-ch'ang], the earlier man
 princely descendant [Chao Meng-fu].

The princely descendant alone captured the elegance of the T'iao-sha
 River region;

His calligraphy's refinement and painting wonders were startling in
 surpassing the common dust.

The Minister of Rites followed him by three hundred years;

In his elegant manner and literary taste; how [could he not be] a
 reincarnation [of Chao Meng-fu]?

Obstructions and obstacles already oppressive; literary felicitations pour out.

His texture wrinkles and washes, how much more do they bow to Ni
 [Tsan] and Huang [Kung-wang] as relatives.

On this handscroll [Tung] himself inscribed it as imitating Tzu-chiu
[Huang Kung-wang];
River and Mountains on a Clear Autumn Day, scenery pure, fresh, and new.
On three feet of Korean mirror-surface paper;
Vast and boundless level distances open without limits.
Among sands and grasses obscure and indistinct, one recognizes a narrow
 path;
Clear waterways and shallow sandbars, a visitor to the desolate river;
By the cut-off banks, none leads or silently follows.
Separated cliffs seem to conceal a misty village.
Clouds and mountain mists graceful and moist; by the precipice trees are
 moving.
Brush and ink swept completely, without leaving the minutest traces.
I am unable to paint, but I know the principles of painting;
By the bright window's vastness, harmonize mind and spirit.
Who sighs over this precious treasure but Kao *chan-shih* [Kao Shih-ch'i]?
Serving in the imperial court as a connoisseur beyond compare.
Mr. Man-t'ang [Sung Lo] just recently acquired this.
A treasure to compare with rare jades.
Showing it to the guest—he feared dirtying it with greasy hands.
Wrapping it carefully, why begrudge the white cotton cloth?
Recently [Mr. Sung's] poetic brush has the strength to lift a tripod,
His poem will compete with the painting to outlast a thousand
 springtimes.
That these words are not boastful I can completely approve,
Indeed surely this poem and this painting will outlast a thousand
 springtimes.
 Shao Ch'ang-heng from P'i-ling offered this to harmonize with the
others.

元明兩代兩文敏
後有宗伯前王孫
王孫獨攬苕雪秀
書精畫妙驚軼塵
宗伯去之三百載
風流文采宣後身
波折已壓文祝倒
皴染況揖倪黃親
此卷自題仿子久
江山霽景澄鮮新
高麗鏡面祇三尺
漠漠平遠開無垠
沙草微茫認細迤
清沱淺渚荒江濱
斷岸無人帶略彴
隔崦髣髴藏烟邨
雲嵐秀潤巖樹活
筆墨掃盡無纖痕
我不能畫識畫理
明窗礧磈融心神
誰歎琭者高詹事
大內鑒賞精絕倫
漫堂先生乍得之
珍比珣玗琪瑤琨
示客怕汙寒具油
裏將郉惜白氎巾
邇來吟筆健扛鼎
便欲與畫爭千春
斯語非謾吾許
果然此詩此畫爭千春
　　毘陵邵長蘅奉和。

COLLECTORS' SEALS: Kao Shih-ch'i, 5; Sung Lo, 1; Ch'ing Kao-tsung
清高宗 (r.1736–95), 14; Ch'ing Jen-tsung 清仁宗 (r. 1796–1820), 1;
Hsüan-t'ung emperor 宣統皇帝 (r. 1909–11), 3; Wang Chi-ch'ien 王季遷
(b. 1907), 1; unidentified, 1

RECENT PROVENANCE: Wang Chi-ch'ien

Tung Ch'i-ch'ang's regret, expressed in his inscription, that "the old
masters cannot see my painting" was in keeping with a lifelong high
self-estimation, but it also seems to have reflected a sense of accom-
plishment specific to his later years of artistic maturity, when he could
confidently offer innovative formulations for the inspection of his
imaginary interlocutors from the past. Tung's statement implies a re-
versal of the customary chronology of likeness, in which Huang Kung-
wang's older painting could find similarity with Tung Ch'i-ch'ang's
later production, rather than the other way around. This view was in
some respects a reasonable corollary of Tung's construction of a visual
and theoretical discourse with his correspondents, the old masters.
Tung formulated a revision of painting history in which the works
of the old masters came to resemble his versions of them, so that the
earlier masters could in essence comprehend his elaborations and
innovations of their pictorial ideas. Tung's statement carries a certain
poignant implication that he had passed beyond competition and com-
munion with his contemporaries, and a regret that the dialogue be-
tween the surviving old masterworks and his contemporary
reformulations could not extend to their authors.

River and Mountains on a Clear Autumn Day manifests a radical
structural compression and reorganization of pictorial components
which, along with the confident and summary tone of the inscription,
recall some of the leaves of the 1621–24 album *Landscapes in the Man-
ner of Old Masters* (vol. 1, pl. 42) and suggest a date of production
around 1624–27, in the years immediately following that album.
Tung's choice of Huang Kung-wang as model was in keeping with the
pictorial and formal interests of his later career, when Ni Tsan and
Huang Kung-wang became especially prominent sources. Both Huang
and Ni served as pretexts for an analytical approach to pictorial struc-
ture, a noticeable concern in the present work, and in the (presum-
ably) late *Album of Sketches* (*Hua-kao ts'e*; Kohara, Wu, et al., *Jo I, To
Kisho*, 1978, pls. 56–58) in the Museum of Fine Arts, Boston, and in
the *Eight Landscapes* album of 1630 in The Metropolitan Museum of
Art (vols. 1 and 2, pl. 62). The collapsing of historical distance that
Tung calls for in his inscription—the wish that the ancients could see
his work—has a counterpart in the reordering of coherent scale and
distance relationships announced in the foreground of the painting.
The Cleveland handscroll embodies fundamental discontinuities of or-
ganization, with the foreground slopes carrying trees in a seemingly
wide array of scale, intermingled and juxtaposed, as if to announce a
disregard of scenic plausibility. The rising ridge in the middle distance
harbors discontinuities of its own, as massive ledges and bunched
knucklelike ridges at the left give way to smooth linear textures at
upper right. Most of the middle- and far-distance rocks thrust upward
toward the right, counteracting the steep leftward flow of the com-
position as a whole. Tung's discovery of a means of developing the
Huang Kung-wang manner seems to have emphasized structure at the
expense of tone and texture, and a principled unconcern with
compositional continuity.

 RV

EXHIBITIONS: Haus der Kunst, Munich, 1959: *Tausend Jahre Chinesische Malerei*, cat. no. 64; The Cleveland Museum of Art, 1960; Smith College Museum of Art, Northampton, Mass., 1964; The Asia Society, New York, 1967: Cahill, *Fantastics and Eccentrics*, cat. no. 2; The Asia Society, New York, 1974: Lee, *Colors of Ink*, cat. no. 32; Fogg Art Museum, Cambridge, Mass., 1979; Nelson Gallery-Atkins Museum, Kansas City, and The Cleveland Museum of Art, 1980–81: Ho et al., *Eight Dynasties*, cat. no. 191.

LITERATURE: *Shih-ch'ü pao-chi hsü-pien*, completed 1793, repr. 1948, *Yü-shu-fang* section, ch. 38, pp. 53–54; Juan Yüan, *Shih-ch'ü sui-pi*, repr. 1854, ch. 6, p. 2; Ch'en Jen-t'ao, *Ku-kung i-i shu hua mu chiao-chu*, 1956, p. 24; Lee, *Chinese Landscape Painting*, 1962, pp. 86, 87, no. 66; Fong, "The Orthodox Master," 1967, p. 135; Fong, "Tung Ch'i-ch'ang and the Orthodox Theory of Painting," 1968, pl. 5; Fong, "Wang Hui chih chi ta-ch'eng," 1968, pl. 1; Fong, "Towards a Structural Analysis of Chinese Landscape Painting," 1969, p. 7, pl. 8–b; Contag, *Seventeenth Century Masters*, 1969, p. 16, pl. 15; Lee, "The Water and the Moon in Chinese and Modern Painting," 1970, p. 50, fig. 8; Lee, *Far Eastern Art*, 1973, p. 439, fig. 580; Sullivan, *Three Perfections*, 1974, p. 39, figs. 21 (detail), 22; Cahill, "Chugoku kaiga ni okeru kiso to genso," pt. 1, 1975, fig. 2; Kohara, Wu, et al., *Jo I, To Kisho*, 1978, pp. 167, 168, pl. 23, seal p. 157; Capon, *Chinese Painting*, 1979, p. 44; Kohara, *To Kisho no shoga*, 1981, pp. 250–51, pl. 24; Suzuki, *Comprehensive Illustrated Catalogue*, 1982–83, vol. 1, A22–079; Cahill, *Compelling Image*, 1982, pp. 49, 53, fig. 2.21; Cahill, *Distant Mountains*, 1982, pp. 102, 115, pl. 46; Fong et al., *Images of the Mind*, 1984, pp. 171–72, figs. 143, 143 a–b (details); *Tung Ch'i-ch'ang hua-chi*, 1989, app. pl. 135.

54 *Landscapes Painted for Wang Shih-min*

Wei Hsün-chih tso shan-shui

董其昌　爲遜之作山水

Dated 1625

Album of eight paintings, ink and ink and color on paper

29.5 x 22.8 cm (11⅝ x 9 in.)

Shanghai Museum

vol. 1, pl. 54

ARTIST'S INSCRIPTIONS AND SIGNATURES:

Leaf 1, 2 lines in running script:
Hsüan-tsai after Yen Wen-kuei's [fl. ca. 988–ca. 1010] brush.

玄宰倣燕文貴筆。

Leaf 2, 1 line in running script:
Hsüan-tsai.

玄宰。

Leaf 3, 1 line in running script:
Hsüan-tsai.

玄宰。

Leaf 4, 2 lines in running script:
"Pine pavilion, autumn colors." Hsüan-tsai.

《松亭秋色》玄宰。

Leaf 5, 2 lines in running script:
"Autumn mountains, yellow leaves." Writing what I have seen. Hsüan-tsai.

《秋山黃葉》寫所見，玄宰。

Leaf 6, 1 line in running script:
Hsüan-tsai.

玄宰。

Leaf 7, 3 lines in running script:
In the tenth month of the *keng-shen* year [October 25–November 23, 1620], written but not finished. In the ninth month of the *i-ch'ou* year [October 1625], completed. Hsüan-tsai.

庚申十月寫，未竟。乙丑九月續成之。玄宰。

Leaf 8

4 lines in running script:
In the ninth month of the *i-ch'ou* year [October 30, 1625], returning from my estate at Mount Pao-hua, I wrote eight small scenes on the boat. Giving them to my old in-law Hsün-chih [Wang Shih-min, 1592–1680], for his correction. Hsüan-tsai.

乙丑九月自寶華山莊還，舟中寫小景八幅，似遜之老親家請正。玄宰。

5 lines in running script:
At the time I picked up a brush, I was planning my dwelling in
　　Wang-k'ou,
But knew in my heart that I could never escape from my old hobby [of
　　painting].
Do not take the humble routines of a mountain dweller
For treasures to be kept in your basket of Taoist scriptures.
　　This is an old work. Moved by recent events, I inscribe it again.
Hsüan-tsai.
(Translation by Wai-kam Ho and John Hay.)

拈筆時營輞口居
心知習氣未能除
莫將枕漱閒家具
又入中山篋裏書
　　此舊作也，感近事重書。玄宰。

ARTIST'S SEALS:
Tung Ch'i-ch'ang 董其昌 (chu-wen, square; leaves 1–8) **124**
Tung Ch'i-ch'ang yin 董其昌印 (pai-wen, square; leaf 8) **125**

COLOPHONS: Wang Ju-huai 王汝槐 (19th century), 2 dated 1830 and 1849, 3 seals; Huang Yen-lan 黃言蘭 (19th century), dated 1831, 1 seal

COLLECTORS' SEALS: Wang Shih-min, 王時敏 4; Cha Ying 查瑩 (18th century), 3; Li Chien 黎簡 (1747–1799), 1; Wang Ju-huai, 2; P'ang Yüan-chi 龐元濟 (1864–1948), 4; Chang Chen-tsung 張振宗, 1; unidentified, 1

RECENT PROVENANCE: Shanghai Municipal Administration of Cultural Relics

The artist's inscriptions tell us that these leaves were done over at least five years. Nevertheless, their concerns are consistent. Each leaf is signed "Hsüan-tsai" and given the same seal. Only the seal of the added inscription on leaf 8 is different. It is possible that as little as one partial sketch preceded the main body of work. Some aspects of the album are comparable to the *Album of Six Small Scenes from Pao-hua Villa* (*Kuei-hai Pao-hua shan-chuang chi-hsing liu-ching ts'e*) of

1623, now in the National Palace Museum, Taipei, and of which Nelson Wu has written so elegantly ("The Evolution of Tung Ch'i-ch'ang's Landscape Style," 1972, pls. 12–23, pp. 41–43). Leaves 1, 6, and 7 in the present album are clearly similar to leaves 2, 1, and 6, respectively, of the Taipei album. The inscription on the final leaf here was written while Tung was returning from his estate at Mount Pao-hua, and the relationship between the two albums is probably complexly mediated, through people, localities, and paintings. The Taipei album was evidently done as a very personal pleasure, and its firm, rich execution is extremely consistent. That of the Shanghai album is centered in these same qualities, but is more variegated in stroke, texture, and even color. Its compositions, likewise, are more explicit in their references to other painters, beginning with Yen Wen-kuei and ending with Kao K'o-kung (1248–1310). They are all powerfully constructed and executed. There are also other albums from this period, such as the Nelson-Atkins *Landscapes in the Manner of Old Masters* of 1621–24 (vol. 1, pl. 42), with even more formally developed historical, technical, and structural concerns. These different albums represent a wide variety of purposes, and it is evident that Tung found album leaves a particularly effective format for his experimenting at this time. Whether this was due to purely artistic reasons or also to practical reasons is hard to say. The sudden activity in his official career suggests the latter but the former may well have been significant.

The album was given to—and perhaps painted for—Tung Ch'i-ch'ang's most distinguished student, Wang Shih-min. Tung's mode of address, *lao ch'in-chia* 老親家, makes Wang, a relative by marriage, seem like a close family member. Tung had begun teaching Wang twenty years earlier, but it was just at this time, with renewed contact between the two, that Wang began seriously to both paint and collect. This album is surely an encouragement in that choice. An assumption that Tung had Wang in mind even as he was painting is speculative but significant, for it implies a particular kind of purpose in the style. The degree of personal presence and structural formality, intermediate between the other *Pao-hua shan-chuang* album in Taipei and the Nelson-Atkins album, seems exactly analogous to Tung's complex relationship with Wang. Various of the ancient masters so important to both of them may be found throughout the album, but dispersed and merged. Leaf 4, for example, seems to incorporate all four of the Great Masters of the Yüan.

The first leaf might seem oddly associated with the early Northern Sung painter Yen Wen-kuei, but it does specifically invoke the type of composition still linked with Yen, in which a range of mountains rises to the left and curls forward at the summit, embracing a perfect dwelling site below the right-hand slope, while paths wind along rivers and over bridges in the foreground. There is even a degree of reference in the fibrous texture strokes. Recorded inscriptions show that Tung, below the level of his schematic history, was interested in Yen Wen-kuei. He described Yen's *Rain Storm over Streams and Mountains* as being "between Hui-ch'ung and Chü-jan" (*Jung-t'ai pieh-chi, ch.* 6, p. 13). His purpose here is probably to establish a powerful sense of both distance and residence appropriate to the Mount Pao-hua estate. The leaves following move the dwelling at close quarters through various cultural values invested in painting. Leaf 4, perhaps the most complex, seems to grab the landscape by its lapels and pull it right into our senses. The album concludes with a monumental reflection on the

Mi Fu–Kao K'o-kung lineage (cf. vol. 1, pl. 17–2) which by now had become an almost obsessive interest of Tung's. Here the album withdraws into the distanced but enriched landscape of the two friends' experience.

It is remarkable to read, in the later undated inscription, Tung referring to this work of his seventy-first year as "an old work." The reference in this inscription to "recent events" is intriguing. The same poem (with the third character altered) occurs in his writings (*Jung-t'ai shih-chi, ch.* 4, pp. 41–42), as inscribed on his painting *After Li Ch'eng's "Winter Mountains"* and preceded by a lengthy introduction in which Tung ruminates on his life as a landscape painter. It turns into a diatribe against the "vulgarity of this dynasty's great gentlemen," the "court dignitaries in whose bellies there is neither antiquity nor modernity," and those "slanderers whose entire lives are given to evil business, [so that] there's no difference between a phoenix and a vulture if their words are equally vile." Tung concludes by asking, "Why should I mind them?" But it is obvious that he minded all too deeply. This seems to have been provoked by court officials remarking that Tung was besmirching the dignity of the court by his creative activities, an accusation that the emperor evidently heard. Perhaps in response to some imperial communication, Tung reverently prepared himself and spent an entire night painting the scroll, with its clearly symbolic references of Li Ch'eng (919–967) and the winter landscape.

This was presumably the event invoked by Tung's choice of the same poem and described as "recent" in the Shanghai album inscription, which must be later than 1625. It appears on the surface to involve the ancient conflict between civil service and professional craft, of which the classic exemplar was Yen Li-pen (fl. ca. 626–73). Since Wang Shih-min had also risen to eminence at court, such a reference would have been doubly appropriate. However, this may also have occurred during the eunuch Wei Chung-hsien's (ca. 1568–1627) infamous purge of Chiang-nan intellectuals, which ended in 1628. It is not impossible that the "event" was also brushed by the convoluted tentacles of that horror, and that very personal affections invested in this album provoked the later rumination. The poem's third line refers specifically to Wang Wei (701–761), the distinguished poet and amateur painter, who built his Wang-ch'uan estate at Wang-k'ou and immortalized it in both poetry and painting. This reference, of course, is conventionally suitable for any work referring to a country estate, such as the Pao-hua shan-chuang. Beyond that, however, Wang Wei was the most exemplary fulcrum of the scholar-official-craftsman rhetoric, and this reference would be complexly and equally appropriate to both the scroll and this album.

JH

LITERATURE: *Jung-t'ai shih-chi, ch.* 4, pp. 41–42; Pang Yüan-ch'i, *Hsü-chai ming-hua lu,* 1909, *ch.* 13, p. 1; Wu, "The Evolution of Tung Ch'i-ch'ang's Landscape Style," 1972, pls. 12–23, pp. 41–43; Xu Bangda, *Pien-nien-piao,* 1963, p. 101; *Chung-kuo ku-tai shu-hua mu-lu,* vol. 3, 1987, *Hu* 1–1359; *Chung-kuo mei-shu ch'üan-chi,* 1988, Painting vol. 8, pl. 12; Ren Daobin, *Hsi-nien,* 1988, pp. 225–26; *Tung Ch'i-ch'ang hua-chi,* 1989, pl. 38; Zheng Wei, *Nien-p'u,* 1989, p. 168; *Chung-kuo ku-tai shu-hua t'u-mu,* vol. 3, 1990, *Hu* 1–1359.

55 *"Record of the Grand Tutor Hsü Kuo's Tomb Shrine,"* running script

Hsing-shu "T'ai-fu Hsü Wen-mu-kung mu-tz'u chi"

董其昌　行書《太傅許文穆公墓祠記》

Undated (datable to 1625–26)

Handscroll, ink on paper
26.4 x 301.5 cm (10⅜ x 118¹¹⁄₁₆ in.)

Beijing Palace Museum
vol. 1, pl. 55 (detail); vol. 2, pl. 55

ARTIST'S TITLE (2 lines in running-regular script, preceding the transcription in 54 lines):
"Record of the Shrine of the Grand Tutor, the Honorable Hsü Wen-mu [Hsü Kuo, 1527–1596]"

《太傅許文穆公墓祠記》

ARTIST'S INSCRIPTION AND SIGNATURE (7 lines in running-regular script, following the transcription):
Presented by Metropolitan Graduate and Grand Master for Assisting toward Good Governance, Left Vice Minister of Rites in Nanking, and concurrently Han-lin Academician Reader-in-waiting, Vice Director-general [in the Historiography Institute] for compilation of the True Records, Lecturer in the Classics Colloquium and Disciple, Tung Ch'i-ch'ang, who composed and transcribed [this record].

賜進士出身，資政大夫，南京禮部尚書，前禮部左侍郎兼翰林院侍讀學士，經筵講官，門生董其昌撰并書。

ARTIST'S SEALS:
Tsung-po hsüeh-shih 宗伯學士 (*pai-wen,* square) 105
Tung-shih Hsüan-tsai 董氏玄宰 (*pai-wen,* square) 106

FRONTISPIECE: Wang Fu-tseng 王福曾 (19th century)

COLOPHONS: Wang Wen-chih 王文治 (1730–1802), dated 1791, 2 seals: The Honorable Hsü Wen-mu and Tung Wen-min [Tung Ch'i-ch'ang] were especially close as student and teacher. This account commemorates the shrine of Wen-mu's tomb, and in it we see expressed an exchange of life and death matters of the heart. The calligraphy is totally appropriate to the spirit of the text and can be compared to the way Yen Lu-kuo [Yen Chen-ch'ing, 709–785] and Junior Imperial Preceptor Yang [Yang Ning-shih, 873–954] complemented each other. . . .

許文穆公與董文敏公師生最爲契合。此爲文穆作墓祠記，生死交情具見於此。宜其書法亦真氣鬱勃，直與顏魯國、楊少師相俯仰也。⋯

Li Hsi-yüan 李西園 (19th century), dated 1870, 1 seal; Wang Fu-tseng, dated 1883, 2 seals

COLLECTORS' SEALS: Ch'en Tou-ch'üan 陳斗泉 (18th century), 1; Wang Fu-tseng, 6; unidentified, 1

As the Chief Examiner in the examinations in which Tung Ch'i-ch'ang ultimately won his *chin-shih* degree in 1589, Hsü Kuo, the subject of this posthumous record by Tung commemorating the establishment of his tomb shrine, can be considered to have launched Tung's career. In this record written about a decade after Hsü's death, Tung refers to Hsü as "my teacher." He then introduces the three top candidates in that notable exam—T'ao Wang-ling (1562–1608) of K'uai-chi, Liu Yüeh-ning of Nan-ch'ang, and himself—before proceeding to list the

topics on which each based their success. That Tung did not place first in the examination seems to have been more a blow to his pride than an actual setback, considering the subsequent upward turns in his career and his political skill in steering a safe course until his retirement in 1626 (see Celia Carrington Riely, "Tung Ch'i-ch'ang's Life," part 2, in vol. 2 of this catalogue).

Tung's indebtedness to Hsü Kuo, who was serving as a Grand Secretary when Tung first knew him, was genuine, and the occasion of this record allowed him to consider the history of his relationship with this very powerful figure. The probable date of this scroll (ca. 1625–26) is based on the list of official titles given in Tung's inscription. He was in his early seventies and had reached a position of sufficient eminence in the government, presumably safe from the machinations of Wei Chung-hsien (ca. 1568–1627) and his clique, to enjoy the fruits of his two decades of public service.

The text is written in running-regular script, slightly larger and more formal than that of the handscroll of poems composed a few years earlier, in 1622, for Yeh Hsiang-kao (1559–1627; see vol. 1, pl. 45), also a Grand Secretary and powerful figure who managed to survive Wei Chung-hsien's tenure. The formality is in part out of respect for the subject as well as the function of the text, and it did not prevent Tung from engaging in what a later colophon writer, Wang Wenchih, admiringly called "an exchange of life and death matters of the heart." Tung's personal style reveals a naturalness and ease not evident in his more conscious modes "in the manner of" a particular master. Yet it does evince the discipline of his years of training and the vestiges of his immersion in Yen Chen-ch'ing's regular and running styles and those of the Sung masters, particularly Mi Fu (1051–1107). Those influences have been completely integrated here, becoming a part of Tung's personal calligraphic "image," much the way the Ming master Wen Cheng-ming's (1470–1559) personal running script bore the imprint of his years of study of the T'ang dynasty compilation of Wang Hsi-chih's (303–379) writing, the *Sheng-chiao hsü.*

Naturalness and ease were among the qualities Tung sought assiduously in his earlier years (see cat. no. 1) and upheld in his theories on calligraphy as among the highest aesthetic goals. In the calligraphic works from the last decade of his life, in particular this scroll and the *Epitaph of Hsiang Yüan-pien* (vols. 1 and 2, pl. 69), Tung achieved those goals.

MWG

LITERATURE: *Jung-t'ai wen-chi,* ch. 4, p. 48; *Chung-kuo ku-tai shu-hua mu-lu,* vol. 2, 1985, *Ching* 1–2224.

56 *Poetic Feeling at the Ch'i-hsia Monastery*

Ch'i-hsia ssu shih-i

董其昌　棲霞寺詩意

Dated 1626

Hanging scroll, ink on paper
133.1 x 52.5 cm (52⅜ x 20¹¹⁄₁₆ in.)

Shanghai Museum

vol. 1, pl. 56

ARTIST'S INSCRIPTION AND SIGNATURE (7 lines in running-regular script):
A path winds to its end here,
Where a mountain monk washes in the white clouds.
After chanting idly, settling [my spirit], what remains now?
Pine needles scattered on the rock—wind must often blow.

Ch'üan Te-yü's [759–818] poem on the wall at Ch'i-hsia Temple, a painting in a poem. In the sixth month of the *ping-yin* year [June 24–July 22, 1626], in the Hsiao-hsien kuan, I wrote the painting. Inscribed in the fifth month of the *ting-mao* year [June 27, 1627], Hsüan-tsai.

一徑縈紆至此窮
山僧盥漱白雲中
閒吟定後更何事
石上松枝常有風
　　權德輿棲霞寺壁詩，詩中畫也。丙寅六月寫於蕭閒館，丁卯五月望題。玄宰。

No artist's seals or colophons

COLLECTORS' SEALS: Ch'eng Chen-i 程楨義 (19th century), 1; Chin Wang-ch'iao 金望喬 (19th century), 2; unidentified, 1

The Ch'i-hsia monastery is in a valley on the slopes of Mount She, which rises above the Yangtze River some fifteen miles northeast of Nanking. Since the fifth century, it had been one of the most scenically admired and culturally favoured sites in the Nanking area. Tung Ch'i-ch'ang could not have failed to visit it, especially while he was Minister of Rites in Nanking in 1625. The Hsiao-hsien lodge may have been in Nanking. As a studio name, however, this had also been chosen by Ni Tsan (1301–1374), as Tung would have known. Why he neither signed this picture at the time of painting nor sealed it at the time of inscription is one of those puzzles that are not uncommon with this artist.

Famous though the scenery of Mount She is, it has little directly to do with Tung's painting. In this case, there is an appropriate contrast in a painting by Chang Hung (1577–ca. 1652), as discussed at length by James Cahill (*Compelling Image*, 1982, pp. 1–35). This is not to say that the knowledgeable would not have readily identified the temple, high in its valley of densely growing pines, the cliff of the Western Peak to the right and the summit of the Highest Peak above; and Tung probably had the complex and sometimes heroic history of this region in mind as he painted. But these connections are drawn into a pictorial engagement of more internal grandeur. Several aspects of the composition are surprisingly reminiscent of *The Long and Winding Stone Steps* of 1616 (vol. 1, pl. 27). But if that picture is characterized by a sense of nervous withdrawal, this work represents the achievement of security at the end of a long, complex, and (in its own way) heroic journey.

The painting opens with the tree-crowned, rounded hillocks that Tung had forged so persistently out of his understanding of Sung and Yüan masters, especially Tung Yüan (fl. ca. 945–ca. 960) and Huang Kung-wang (1269–1354). From here, it moves to a reductive residence across the water, perhaps functioning as the Hsiao-hsien kuan. Its open structure invites the visitor into a quiet clearing in the surface. Once entered, an experience of epic proportions is in store. Around this initial emptiness, slopes rise in suddenly agitated texture strokes, and piles of rocks jostle in a clustering ascent that continues upward in pulses of articulated energy, until finally settling around the High-

est Peak. Meanwhile, the rich, smooth textures of trees and straight slopes have risen in their own more placid climb up the right-hand border. The parallel ascents are integrated and coordinated by the impeccable control of opening and closing dynamics that Tung had by now perfected. From initial opening to final closing, a remarkable tension between the nearby residence and the remote temple is masterfully orchestrated.

One is tempted, as is often the case with Tung Ch'i-ch'ang, to see the interaction of several works in this painting, especially some associated with Tung Yüan, Huang Kung-wang, and Wang Meng (1308–1385). But one aspect must be emphasized, and this is the vertical monument that Tung had explored in his earliest handscrolls and that kept reappearing in these towering and crystalline formations. This painting eventually turns on such a form as its principal support. The possible reference to Ni Tsan in the Hsiao-hsien kuan may conceivably be at work. Tung admired Ni, among the other Yüan masters, for his solitary inspiration in the angular, rock-hard structure of early Northern Sung painters such as Ching Hao (ca. 870–80–ca. 935–40) and Kuan T'ung (fl. ca. 907–23) (see *Jung-t'ai pieh-chi*, ch. 6, p. 14). The powerful album leaf "After Wang Meng," dated 1623 (vol. 1, pl. 42–2), which uses this motif in a Wang-Mengesque idiom, may be seen as a compressed predecessor of this monumental hanging scroll.

JH

LITERATURE: Cahill, *Compelling Image*, 1982, chap. 1; *Chung-kuo ku-tai shu-hua mu-lu*, vol. 3, 1987, Hu 1–1367; *Tung Ch'i-ch'ang hua-chi*, 1989, pl. 90; Zheng Wei, *Nien-p'u*, 1989, p. 174; *Chung-kuo ku-tai shu-hua t'u mu*, vol. 3, 1990, Hu 1–1367.

57 *After Tung Yüan's "Shaded Dwellings among Streams and Mountains"*
Fang Tung Pei-yüan "Hsi-shan yüeh-kuan" t'u
董其昌　倣董北苑《溪山樾館》圖

Undated (ca. 1622–26)

Hanging scroll, ink on paper
158.6 x 72 cm (62⁷/₁₆ x 28⅛ in.)

The Metropolitan Museum of Art, New York
Gift of Douglas Dillon, 1979 (1979.75.2)

vol. 1, pl. 57

ARTIST'S INSCRIPTION AND SIGNATURE (6 lines in running script):
I once saw Tung Pei-yüan's [Tung Yüan, fl. ca. 945–ca. 960] painting *Shaded Dwellings among Streams and Mountains* at the eunuch Chu's place at Pei-fei. I made a sketch copy for my satchel and have just now completed this [painting]. It does have some resemblance. Hsüan-tsai.

董北苑《溪山樾館圖》，往在北扉得觀朱黃門所，因臨粉本篋中。今始成此，頗有肖似。玄宰。

ARTIST'S SEALS:
Tsung-po hsüeh-shih 宗伯學士 (*pai-wen*, square) **132**
Tung Hsüan-tsai 董玄宰 (*pai-wen*, square) **131**

No colophons

Collectors' seals: Chang Ching 張經 (before 1861), 2; K'ung Kuang-t'ao 孔廣陶 (19th century), 2; K'ung Kuang-yung 孔廣鏞 (19th century), 1; Li Yao-han 李耀漢 (fl. ca. 1900–after 1939), 2; Huang Wen 黃雯 (fl. mid-20th century), 1; Earl Morse 穆思 (1908–1988), 1

Recent provenance: Wang Chi-ch'ien, Earl Morse

This bold mountainscape, built up of alternating blocks of ink and blank paper, follows a tripartite compositional schema in which large-scale foreground elements are separated from the monolithic distant mountain by a middle-ground stretch of water. Northern Sung artists used this device to enhance the illusion of recession; Tung's landscape, however, is virtually impenetrable. A narrow defile that leads into the painting from the lower left-hand corner, the overlapping trees and hillocks, the mist-encircled peak, and the rounded earthen forms modeled with graded ink tones all convey the illusion of three-dimensional forms in space, but these effects are relentlessly contradicted by the patternized brushwork and stark juxtapositions of ink wash with blank paper. Similarly, the translucent, silvery gray ink washes soften and blur forms, at times giving a surprisingly vivid impression of atmosphere until stark white paper or an occasional jet black highlight reasserts the primacy of flat abstract pattern. This tension between illusion and abstraction is fundamental to the visual liveliness of the picture.

In place of the consistent description of illusionistic spatial recession, the composition is unified by a series of diagonal lines that zig-zag simultaneously across the picture surface and back into the picture space, beginning with the rightward diagonal of the foreground hillock, continuing with the leftward receding echelon of foreground trees and the rightward thrust of the distant slope, and culminating with the twisting serpentine form of the summit. These linear vectors of kinetic force or compositional movement (*shih* 勢) are complemented by the countervailing push and pull of light and dark landscape elements that alternately appear as voids or solids (*hsü* 虛, *shih* 實) which recede or leap forward. Above this pulsating landscape the artist's equally bold running script reiterates the rhythmic contrasts of dark and light and angular versus curvilinear that animate the painting.

Tung's inscription credits a work by the tenth-century master Tung Yüan as the source of his inspiration, but in formal terms, the painting simply presents a new permutation of the artist's oft-repeated tripartite compositional schema. What is different here is that instead of the separation of foreground and distant landscape elements being accentuated through the use of a wide expanse of water (see vol. 1, pl. 46), foreground and distant forms overlap and fuse together into a single unified compositional movement which later artists identified as a "dragon vein" (*lung-mo* 龍脈). *The Ch'ing-pien Mountain* (vol. 1, pl. 32) of 1617 may be seen as an early example of this compositional type in which foreground trees lead directly into a towering wall of writhing tectonic shapes. In *Shaded Dwellings*, however, Tung's calculated division (*fen* 分) and massing (*ho* 合) of landscape forms has resulted in larger, simpler, less convoluted shapes that are unified within an overriding compositional pattern.

A similar compositional design integrates the monumental hanging scroll *In the Shade of Summer Trees*, an undated work in the National Palace Museum, Taipei (*Chinese Art Treasures*, 1961, cat. no. 104),

which was inspired by a Tung Yüan that Tung Ch'i-ch'ang saw in Peking at the residence of the Academician Wu (*Ku-kung shu-hua lu*, 1965, vol. 3, pp. 460–61). In date, the Metropolitan and Taipei scrolls must be very close. Both bear the artist's seal with the legend *Tsung-po hsüeh-shih*, a title Tung held from 1622 to 1625. Both are also large-scale works that would have been appropriate decorations for the grand residences of powerful courtiers. It seems likely, therefore, that Tung produced the paintings as "gifts" for the high officials whose Tung Yüans had "inspired him"—during one of his two brief stays in the capital, either in 1622 or 1624–25 (Hummel, *Eminent Chinese*, 1943, p. 788).

MKH

Exhibition: The Art Museum, Princeton University, 1969: Whitfield, *In Pursuit of Antiquity*, cat. no. 9.

Literature: K'ung Kuang-t'ao, *Yüeh-hsüeh lou*, 1861, *ch.* 4, p. 89; Fong, "Tung Ch'i-ch'ang and the Orthodox Theory of Painting," 1968, p. 10, pl. 5; Kohara, Wu, et al., *Jo I, To Kisho*, 1978, vol. 5, pl. 36; Loehr, *Great Painters*, 1980, pp. 290–91, fig. 158.

58 *Landscape after Wang Ch'ia and Li Ch'eng*
Fang Wang Ch'ia yü Li Ch'eng shan-shui
董其昌　倣王洽與李成山水

Undated (ca. 1626–30)

Hanging scroll, ink on paper
225.7 x 75.4 cm (88⅞ x 29¹¹/₁₆ in.)

Shanghai Museum

vol. 1, pl. 58

Artist's inscription and signature (6 lines in running script): Wang Ch'ia [d. 805] splashed ink; Li Ch'eng [919–967] spared ink. To bring the two together is to achieve the secret of painting. Hsüan-tsai painted and inscribed.

王洽潑墨，李成惜墨。兩家合之，乃成畫訣。玄宰畫并題。

Artist's seals:
Tung Hsüan-tsai 董玄宰 (*pai-wen*, square) 129
Tsung-po hsüeh-shih 宗伯學士 (*pai-wen*, square) 130

No colophons

Collectors' seals: Feng Ch'ao-jan 馮超然 (1882–1954), 1; Ti Hsüeh-keng 狄學耕, 2; Yüan An-p'u 袁安圃, 1; Wang Hsien 王賢, 1; Li Hung-hsün 李鴻勛, 1

This is one of a number of paintings that shift so radically toward a polarity of ink that they draw suspicion. Tung Ch'i-ch'ang, however, was capable of such extreme gestures, and the technical and compositional control of this work confirms his authorship. The trees, with their powerfully three-dimensional brushwork and variegations of tonality and texture, are in themselves sufficient to convince. But the painting as a whole also does so.

In contemporary parlance, Tung might be called a "theory-driven" painter, except that this would give a misleading idea about the nature of theory in seventeenth-century China. It would be better to call him rhetorically obsessed, so long as this is not taken to exclude content. The Shanghai painting is indeed rhetoric on a very grand scale, being one of his largest works. This scale is carried systematically through the composition, the technique, and the inscription, and it is very impressive to see Tung performing so capably at this level. The style of the inscription is clearly adapted to the purpose, but one may ask what this purpose is. Its view of both the past of painting and the present of the painter is consistent with Tung's ideas, although it is more usual to cite Wu Tao-tzu (fl. ca. 700–ca. 750) and Hsiang Jung (late 8th–early 9th century) in connection with both ink and brush (*Jung-t'ai pieh-chi, ch.* 6, p. 7). The unusual aspect is to see Tung writing of ink alone. It is nevertheless clear that ink was of enormous importance to him, a fact associated with his growing fascination with clouds and mists during the 1620s (cf. inscription on vol. 1, pl. 59–2a). Here he seems to equate density of ink with the "closing" dynamics of composition, and sparseness with its "opening." In the foreground trees he characteristically elaborates his rhetoric in a self-sufficient and critical subsection. Whom he wished to address with this grand gesture remains an unanswered although important question. It conveys almost the sense of an imperial proclamation in the court of art. Certainly it required a setting on an equally grand scale. In all the above respects, the most likely period for Tung to have produced such a work would have been around 1624–25, probably in Peking. But a chronological discrepancy in the seals would then remain unexplained (see Celia Carrington Riely, "Tung Ch'i-ch'ang's Seals," entry XXXII, in vol. 2 of this catalogue).

JH

LITERATURE: Zhong Yinlan, "Shui-mo ch'ing-lü, 1962, p. 8, pl. 1; *Tung Ch'i-ch'ang hua-chi*, 1989, pl. 47.

59 *Landscapes*
Shan-shui
董其昌　山水

Undated (ca. 1626–30)

Album of nine paintings, ink and ink and color on paper

26.1 x 16 cm (10¼ x 6⁵⁄₁₆ in.)

Beijing Palace Museum

vol. 1, pl. 59 (leaves 1, 2, 4–6, 9); vol. 2, pl. 59 (leaves 3, 7, 8, colophons)

NO ARTIST'S INSCRIPTIONS, SIGNATURES, OR SEALS

COLOPHONS:

Shen Ch'üan 沈荃 (1624–1684), preceding the paintings, dated 1678, 3 seals:

The brush and ink of Mr. Wen-min [Tung Ch'i-ch'ang] is a wonder under heaven. He has penetrated to the essential and obtained the mar-

row of the six principles, and ascended directly into the chamber of Pei-yüan [Tung Yüan, fl. ca. 945–ca. 960]. The Four Great Masters of the Yüan would look on him as their superior. This album was in the collection of my colleague Yüeh-chih, Wen[-min's] grandson. Its use of ink is free and vigorous beyond conventional practice. He does not simply hold rigidly to imitating antiquity and yet, really, there is not a single stroke that is not in harmony with it. When others try this, they become sweet and vulgar, or coarse and thin; if not immature then confused. Yüeh-chih carried this in his trunk, unwilling to leave it for even a moment. So it must have traveled to all the famous sites and places at least once—no different from Tzu-ku [Chao Meng-chien, 1199–1264] and his [version of] the *Lan-t'ing* manuscript. Although I love it truly, could I dare ever to covet it? On the first day of the new year, the *wu-wu* year [January 23, 1678], Shen Ch'üan leisurely inscribed.

文敏先生筆墨妙天下。其於六法，更洞精抉髓，直登北苑之室；元人四大家，以衙官眡之耳。此冊爲文孫約之兄所藏。觀其澄墨淋漓，超脫畦徑，不拘拘彷古，而實無一筆不合於古。他人學之便甜俗粗踈，非稚即雜矣。約之攜之行笈，頃刻不忍離，名區勝地，涉歷幾遍，不啻子固之於《蘭亭》。余雖篤好，寧敢萌朵頤之心耶？戊午元正，沈荃漫識。

Kao Shih-ch'i 高士奇 (1645–1704), 1 colophon opposite each painting, 15 seals (the sources of Tung Ch'i-ch'ang's comments quoted by Kao are noted in brackets):

Leaf 1a:

Chü-jan [fl. ca. 960–ca. 986] studied Pei-yüan [Tung Yüan]. Yüan-chang [Mi Fu, 1051–1107] studied Pei-yüan. Ni yü [Ni Tsan, 1301–1374] studied Pei-yüan. One Pei-yüan and yet each unlike the other. That is why they are famous masters. Wen-min's [Tung Ch'i-ch'ang] approach to the ancients is precisely [such], able to emerge from an established pattern with fresh ideas. Shih-ch'i. [*Jung-t'ai pieh-chi, ch.* 6, p. 6]

巨然學北苑；元章學北苑；黃子久學北苑；倪迂學北苑，一北苑而各各不相似，所以能名家。文敏之臨古，正能出新意於法度之中。士奇。

Leaf 2a:

Cloudy mountains did not begin with Mi Yüan-chang. The idea already existed in the splashed ink of Wang Ch'ia [d. 805]. Tung Pei-yüan loved to do misty scenes. The shifting changefulness of mists and clouds [in Tung Yüan's painting] is no different from Mi Fu's painting. Wen-min himself said that he was awoken to the mysteries of ink-play by Mi Fu's *White Clouds over the Hsiao and Hsiang*. Chu-ch'uang Shih-ch'i. [*Jung-t'ai pieh-chi, ch.* 6, p. 15]

雲山不始於米元章。蓋自王洽澄墨，已有其意。董北苑好作烟景，煙雲變沒，即米畫也。文敏自云於米芾《瀟湘白雲圖》悟墨戲三昧。竹窗士奇。

Leaf 3a:

When Academician Mi [Yu-jen, 1074–1151] was living in Ching-k'ou, he said that the mountain ranges of Mount Pei-ku wind all the way to the mouth of the river [on the coast]. He chose this idea in painting his *White Clouds over the Hsiao and Hsiang* which shows absolutely no conscious trace of brush and ink. I have also seen his *Mist and Rain over Five Islets*, a scroll only three inches high, which writes out the five islets on the river and is truly wonderful scenery. It is now in the home of our provincial governor. This painting by Tsung-po [Tung Ch'i-ch'ang] is only a few inches high but its creative agency is fully present. How could it be matched by a professional painter? Pao-weng-weng Shih-ch'i. [*Jung-t'ai pieh-chi, ch.* 6, p. 3]

米敷文居京口，謂北固諸山與海門連亘，取其意作《瀟湘白雲圖》，絕無筆墨蹊徑。又余見《五洲烟雨》，高僅三寸，寫江上五洲，真屬妙境。今在令之撫軍處。宗伯此幅不盈呎，而神理具備，豈畫工所可骩髊耶？抱甕翁士奇。

Leaf 4a:

Tzu-ang [Chao Meng-fu, 1254–1322] inscribed Academician Mi's [Mi Yu-jen] *Mountains of Ch'u in a Clear Dawn*: "In the brush old trees are born; under the brush strange rocks emerge." Truly, with this painting Ssu-weng [Tung Ch'i-ch'ang] holds the cosmos in his hands. This is not to be lightly passed off as an ordinary work. Chu-ch'uang. [source not located]

子昂題米敷文《楚山清曉圖》云：「老樹筆間生；奇石筆下出。」思翁此幅，真有宇宙在乎手者，莫作尋常看過。竹窗。

Leaf 5a:

Minister Kao Yen-ching's [Kao K'o-kung, 1248–1310] *Ta-yao Village* [owned by Tung Ch'i-ch'ang] is awash with pale mists. Its structural harmony is entirely extraordinary, beyond anything that Tzu-chiu [Huang Kung-wang, 1269–1354] or Shan-ch'iao [Wang Meng, 1308–1385] could reach. This leaf by Ssu-pai [Tung Ch'i-ch'ang] possesses these qualities to a high degree. Ts'ang-yung lao-jen Ch'i. [*Jung-t'ai pieh-chi, ch.* 6, pp. 17–18]

高彥敬尚書《大姚村圖》，烟雲淡蕩，格韻俱超，非子久、山樵所及。思白此幀殊有風味。藏用老人奇。

Leaf 6a:

The *Fu-ch'un Mountains* by Huang Ta-ch'ih [Huang Kung-wang] has a cool clarity that is different from all his other paintings [end of quotation]. This painting by Wen-min has a profound grasp of its inner force. Shih-lai-i-jen Shih-ch'i. [source not located]

黃大癡《富春山圖》，蕭遠踈秀，與其諸畫不同。文敏此幅深得神髓。侍萊衣人士奇。

Leaf 7a:

Whenever Wen-min said that Yün-lin's [Ni Tsan] trees are like Ying-ch'iu's [Li Ch'eng, 919–967], his wintry groves and mountains and rocks were in the lineage of Kuan T'ung [fl. ca. 907–23], and his texturing strokes like Pei-yüan [Tung Yüan], [he would note that] in each respect there was a transformation. If, in studying the ancients, one is unable to transform them, then [what you get] is no more than refuse to be chucked over a wall. Shih-ch'i. [source not located]

文敏每言，雲林樹木似營丘；寒林、山石宗關全；皴似北苑，而各有變局。學古人不能變，便是籬堵間物。士奇。

Leaf 8a:

The painting of Shen Shih-t'ien [Shen Chou, 1427–1509] and Wen Heng-shan [Wen Cheng-ming, 1470–1559] is certainly very fine. But if one is thinking in terms of the inception of modern painting and the heir to the robe and bowl of the Yüan masters, then beside Ssu-weng, I would not lightly admit anyone else into this category. Tu-tan-weng Shih-ch'i. [cf. *Jung-t'ai pieh-chi, ch.* 6, p. 4]

沈石田、文衡山畫固精妙；然究開近代之法，直接元人衣鉢者，思翁外，吾未肯輕許人。獨旦翁士奇。

Leaf 9a:

Painting and calligraphy each have their separate gateway and courtyard. Calligraphy can be raw, painting cannot be overdone. [In practicing] calligraphy, [one's work] should first be ripe and only then raw. Painting

should be ripe [first] and only then well done. Could one discuss [these arts] with anyone who does not truly understand these principles? Wen-min drew his strength from such profound understanding. Chu-ch'uang Shih-ch'i. [*Jung-t'ai pieh-chi, ch.* 6, p. 2]

畫與字各有門庭，字可生，畫不可熟；字須熟後生，畫須熟後熟。非直知此理者，豈足與道？文敏深得力於此。竹窗士奇。

Kao Shih-ch'i, 2 colophons following the paintings, dated 1698 and 1700, 2 seals:

Wen-min painted this and gave it to his son, so he didn't sign it. His grandson [i.e. Tung Yüeh-chih] took it to the capital, where Shen Wen-k'o [Shen Ch'üan] wrote his colophon. I don't know how it came to be floating around there. Chou Mao-ch'ing bought it and gave it to me. At first, I didn't value it so highly. Returning to Che[-hu], I had it remounted and kept it in my traveling trunk. Over more than ten years I have seen several hundred paintings by Wen-min. There are not so many that achieve a nobility in ink and brushwork in harmony with the energy and resonance of Yüan painters. So I now know that he must have considered these nine leaves as among his most successful and given them to his sons and grandsons to keep. Unexpectedly, it has come to me. At this moment, I am taking care of my parents and living in idleness. The spring rain is soft and fine. The door is closed and incense is burning. So I have written a few words on each leaf for the pleasure of elderly eyes. Fearing that later people may not realize how greatly I value this work, I have added an inscription after the album. On the fourth day of the third month of the *wu-yin* year, the K'ang-hsi era [April 14, 1698], I finished writing. The rain has continued for several days, crab-apple blossoms scattered in profusion. Sitting in the Chien-ching Studio, and sipping [the finest] Lung-ching tea picked before Ch'ing-ming. Chiang-ts'un Kao Shih-ch'i.

文敏畫此與乃郎者，故未書款。其文孫携之京師，沈文恪復跋之，不知何以流落燕市？周茂卿得而贈余。初未甚珍惜，歸拓上重裝，留之行笈。十餘年來，所見文敏畫不止數百本。求其筆墨矜貴，合元人之氣韻蓋鮮。因知此九幀乃當年得意之作，故與賢子孫收藏，卒而歸余。項養親閒居，春雨綿密，杜門焚香，各記數語以娛老眼，恐後人不知貴重，再書於後。康熙戊寅上巳後一日書畢。連日陰雨，海棠狼藉，坐簡靜齋，焚香啜龍井火前茶。江邨高士奇。

The spring and summer of the *chi-mao* year [1699] have fled and [I] have been running around north and south. At the end of summer and in the beginning of autumn I was sick from the heat and full of lassitude. In autumn and winter, because my eldest son was involved in the examinations and traveling on official business, our lives were plunged into confusion from dawn to dusk. At the winter solstice [first day of the eleventh month; December 21] I was sending off my son at the Maple Bridge. After we had parted, snow continued right until the close of the year. On New Year's eve [February 18, 1700] it rained. On the second day of the first month of the *keng-ch'en* year [February 20, 1700] it began to clear and the spring turned cold. I wrote out the *Healing Buddha Sutra* and, when finished, opened this album. This, then, is the first pure pleasure of the new year. Chu-ch'uang Shih-ch'i.

己卯春夏，馳驅南北；夏末秋初，病暑懶德；秋冬以大兒入闈，及公車諸事，晨夕冗襍；長至送大兒於楓橋。別後，雨雪直至歲暮，除夕又雨，庚辰正月二日始晴，而春寒書《藥師經》畢展此，乃今年第一清適也。竹窗士奇。

COLLECTORS′ SEALS: Kao Shih-ch'i, 5; Ku Wen-pin 顧文彬 (1811–1889), 1; Chang Yen-ch'iao 張研樵, 1; unidentified, 3

Kao Shih-ch'i's view that the lack of seals and signatures on this album signifies its utterly personal origin may be correct. It presents a remarkable contrast to albums such as the *Intimate Landscapes Done in the Ting-mao Year* of 1627 (vol. 1, pl. 60). But the intimacy, modesty, and relaxed confidence of each leaf indicate a very mature work of the same period, in the last three or four years of the 1620s. The manipulation of structure here is not so muscular or extended as in the dated album, but the sense of engagement is very similar. Whereas the *Ting-mao* album moves far toward the polarity of brush, this work shifts back toward that of ink. But even where ink is nominally dominant, such as in the "Mi" and "Kao" leaves (leaves 2, 3, and 5), the texture is complex and dryness still governs its internal structure. The compositions, like the technique, seem at first glance rather straightforward; and without giving anything away at a deeper level, Tung seems on the surface to be communicating with other painters of his time as well as with himself, more than is usually the case. There is, however, an underlying complexity that comes to the surface in leaves such as that after Huang Kung-wang (leaf 6).

The album has a distinctive warmth, contrasting with the coolness of the *Ting-mao* work. Kao Shih-ch'i's inscription on the last leaf is appropriate. In comparing these two albums, one might well characterize this one as having a "well-done" richness discovered beyond a full ripeness of technique. The presence of calligraphic "rawness" constantly subverts the threat of overindulgence and keeps the execution alive as a constantly interactive process.

In its route toward Kao Shih-ch'i, via Tung's descendants, this album may not have been alone (cf. vol. 1, pl. 68). Shen Ch'üan, who obtained the work from Tung's grandson, was, like Tung, a native of Sung-chiang, and rose to be Supervisor of Education in the imperial palace. In the highly coded language of collecting, it is obscurely clear that there was some peculiarity in the passage of the album both from Tung Yüeh-chih to Shen, and from Shen to Kao. By 1698, when according to his own account Kao finally came around to examining this album, he was deeply involved with Tung's painting. At the beginning of 1700 he seems to have spent much of his time browsing among the works he owned, such as this album and the *Album of Painting Studies* (*Hua-kao ts'e*) now in the Museum of Fine Arts, Boston (Kohara, *To Kisho no shoga*, 1981, vol. 1, pp. 247–50, vol. 2, pp. 54–61).

Kao Shih-ch'i's activity, an especially well focused exemplar of the fundamentally semiotic and often deconstructive practices of Chinese painting, would be well worth close study. Enclosing himself in a densely textured private world, in which even the weather seems like a reflective envelope, Kao was writing the text of his own personal Tung Ch'i-ch'ang. One assumes that his frequent quotations were drawn from both original inscriptions and collected writings. Albums such as this, as yet unarticulated by the original author, must have appeared as a golden gift. Kao published his record of calligraphies and paintings in 1693, well before his inscriptions here. But even then he was promising, in the last sentence of his introduction, to publish a separate study because his authentic works were "more numerous than those of any modern artist" (*Chiang-ts'un hsiao-hsia lu, fan-li*, p. 2).

JH

LITERATURE: Ku Wen-pin, *Kuo-yün lou*, 1883, ch. 5, p. 11; *Chung-kuo ku-tai shu-hua mu-lu*, vol. 2, 1985, Ching 1–2199.

60 *Intimate Landscapes Done in the Ting-mao Year*
Ting-mao hsiao-ching
董其昌　丁卯小景

Dated 1627

Album of eight paintings, ink on paper, with eight leaves of calligraphy, ink on gold-flecked paper
23.6 x 14.7 cm (9⁹/₁₆ x 5¹³/₁₆ in.)

Shanghai Museum

vol. 1, pl. 60

ARTIST'S INSCRIPTIONS AND SIGNATURES:
Leaf 1a, 3 lines in running script:
"Rivers, mountains, Buddhist temple." My family owns a short scroll by Chü-jan [fl. ca. 960–ca. 986]. Hsüan-tsai did this after it.

《江山蕭寺圖》，家藏巨然短幅。玄宰做作。

Leaf 2a, 4 lines in running script:
The stone cliff was Li T'ang's [ca. 1049–ca. 1130] specialty. I do not usually look at paintings in the Sung academy style, but I have done it here with the brush intention of Ching [Hao, ca. 870–80–ca. 935–40] and Kuan [T'ung, fl. ca. 907–23]. Hsüan-tsai.

石壁乃李唐擅場。予素不觀南宋院體畫，但以荆、關筆意爲之。玄宰。

Leaf 3a, 2 lines in running script:
This is Kao Yen-ching [Kao K'o-kung, 1248–1310] writing Mi-family mountains. Hsüan-tsai.

此亦高彥敬寫米家山也。玄宰。

Leaf 4a, 3 lines in running script:
Once, on a stream, I saw Huang Tzu-chiu's [Huang Kung-wang, 1269–1354] *Clearing after Snow at Nine Peaks*. Its painting method was like this. Hsüan-tsai.

昔於溪上見黃子久《九峰雪圖》，畫法如此。玄宰。

Leaf 5a, 4 lines in running script:
A small scene inscribed by Yün-lin [Ni Tsan, 1301–1374], "Willows weeping in mist wrap the southern bank." In autumn of the *ping-yin* year [1626], this came to me at [the home of] the Scholar of the National University Wu Ch'ien-chih in Hui-shan. Hsüan-tsai.

雲林小景所題“垂垂煙柳籠南岸”者，丙寅秋得之惠山吳太學千之。玄宰。

Leaf 6a, 2 lines in running script:
Wang Shu-ming's [Wang Meng, 1308–1385] *Pine Peaks*. Hsüan-tsai copied.

王叔明《松岫圖》。玄宰臨。

Leaf 7a, 2 lines in running script:
While traveling around Yü-shan, I saw the terrace of the Brushing-water Pavilion. On returning home, I wrote this. Hsüan-tsai.

游虞山，見拂水亭臺。歸而寫此。玄宰。

Leaf 8a, 4 lines in running script:
"Stream-side pavilion, clear autumn weather." Hsüan-tsai painted.

《谿閣秋晴》。玄宰畫。

In the *ting-mao* year [1627], moored at Nan-hsü [Tan-t'u], I wrote this. On the way home we had great difficulty with contrary winds, and I finished it to dispel my ennui. I could call it "small scenes of *ting-mao*," like the *Ting-mao chi* [*Ting-mao Anthology*] of Hsü Hun [*chin-shih* 832, who lived by the Ting-mao Bridge at Tan-t'u]. Hsüan-tsai inscribed again.

丁卯舟泊南徐寫此。歸途爲石尤所困，排悶終之。可命曰《丁卯小景》，如許渾之《丁卯集》也。玄宰再題。

ARTIST'S SEALS:
Tung Ch'i-ch'ang 董其昌 (*chu-wen*, square; leaves 1a–8a) **134**
T'ai-shih shih 太史氏 (*pai-wen*, square; leaves 1a–8a) **135**

NO COLOPHONS

COLLECTORS' SEALS: Wang Wen-chih 王文治 (1730–1802), 3; Chu Jung-chüeh 朱榮爵 (20th century), 6; Wu Hu-fan 吳湖帆 (1894–1968), 1; unidentified, 2

This is surely one of Tung Ch'i-ch'ang's most peculiarly beguiling albums. It accommodates no one, except the artist himself in the power of his brush. Its spare and rather blunt execution foretells a particular obsession of several artists of the following three decades, but here it has, rather, the complex dryness of a classic vintage. It reappears, although in a much more calculating and mollified form, in albums such as the *Eight Landscapes* of 1630 in The Metropolitan Museum of Art (vols. 1 and 2, pl. 62). It is entirely unpretentious, yet every gesture of the brush, every passage of ink, and every movement in the composition is deeply invested with some fifty years of intense study and practice in calligraphy and painting. It gives the impression of being entirely self-reflexive, bearing no one else in mind. But it does not have the sense of location found, for instance, in Tung's album *Landscapes Painted for Wang Shih-min* (vol. 1, pl. 54). The leaves roam at ease through the breadth of "ten thousand miles and ten thousand books," and the album is centered, instead, on Tung Ch'i-ch'ang himself. Each leaf is monumentally endowed with the strength of Tung's extraordinary engagement between mind and material. Thus, despite the achievement of freedom, there is an accompanying sense of specificity. Each leaf is Tung painting, at that time and in that place. The connections, too, can be quite specific. Huang Kung-wang's monumental original (now in the Beijing Palace Museum; see Xu Bangda, *T'u-lu*, 1984, vol. 1, pl. 206) is at once recognizable in the powerful structure of the fourth leaf.

According to the inscriptions, the leaves were done both while staying with acquaintances and while traveling by boat. The Wu-hsi canal joins the Yangtze at Nan-hsü (modern Tan-t'u), just downstream from Chen-chiang. The calligraphy on the facing leaves of gold-flecked paper was probably done at the same time. The seals repeated on each leaf follow the "added" inscription on the last leaf. Tung Ch'i-ch'ang's own choice of a title for this album suggests that he himself saw it as having an unusual consistency of both time and place. The collocation of coincidences, noted with a hint of dry humor, clearly appealed to his sense of cultural identity. The collected poetry of the T'ang poet Hsü Hun, titled after the Ting-mao Bridge that Tung was passing in the *ting-mao* year, provided a coincidence of cultural ideals on the axes of both space and time, a coordination that appealed deeply. Hsü Hun was a poet and local prefect, known for his austerity. Frequently

sick, he would retire to a rural retreat at Tan-t'u when afflicted. Tung Ch'i-ch'ang may have had some particular interest in him.

JH

LITERATURE: Kuan Mien-chün, *San-ch'iu-ko*, 1928, vol. 1, *ch. shang*, p. 61; *Ku-kung-shu-hua-lu*, 1965, vol. 3, *ch.* 6, p. 71; Xu Bangda, "*Huang Kung-wang te liang-fu hsüeh-ching shan-shui-hua*," 1981, p. 69; *Chung-kuo ku-tai shu-hua mu-lu*, vol. 3, 1987, *Hu* 1–1371; *Chung-kuo ku-tai shu-hua t'u-mu*, vol. 3, 1990, *Hu* 1–1371.

61 *Mountain Forms and River Colors*
Lan-jung ch'uan-se
董其昌　嵐容川色

Dated 1628

Hanging scroll, ink on paper
139 x 53.2 cm (54¾ x 20⅞⁄₁₆ in.)

Beijing Palace Museum

vol. 1, pl. 61

ARTIST'S INSCRIPTIONS AND SIGNATURES:
1. 6 lines in running-regular script:
Mountain Forms and River Colors

《嵐容川色》

The family of the Censor Wu, of Liang-hsi, has passed down this picture by Shen Ch'i-nan (Shen Chou, 1427–1509). It can be put against the Four Masters of the Yüan period. As soon as I had set eyes on it, it was bought by some meddler. So I did this in trying to recall it. In mid-autumn of the *wu-ch'en* year [September 12, 1628], Hsüan-tsai inscribed.

梁谿吳黃門家傳沈啓南此圖，與元季四家對壘。一嘗寓目，遂爲好事者購去，追想其意爲此。戊辰中秋題，玄宰。

2. 2 lines in running-regular script:
In mid-spring of the *chi-ssu* year [1629], offering this to Yüan-lin, Elder Wang. Hsüan-tsai inscribed again.

己巳仲春，贈元霖汪丈。玄宰重題。

ARTIST'S SEALS:
Ta tsung-po chang 大宗伯章 (*chu-wen*, square) **136**
Tung Ch'i-ch'ang yin 董其昌印 (*pai-wen*, square) **137**

NO COLOPHONS

COLLECTORS' SEALS: Ku Lin-shih 顧麟士 (1865–1930), 1; Chin Lan-p'o 金蘭坡, 1

No painting of this title by Shen Chou has been identified, nor, given the obvious variables, is it really possible to hypothesize one. Neither is it impossible for there to have been one. The circumstance to which Tung refers, of a valued painting being spirited away by some obsessed ingenuity, could certainly have occurred in a culture in which collecting was an obsessive activity. On the other hand, it is

also part of the mythology of literati culture. Tung's inscription betrays some irritation, which makes it difficult to know what he was up to. The painting itself also has a certain quality of irritability, which keeps it from attaining the highest standard of the artist's work. The foreground trees fall below Tung's usual level of attention and tend to remain in two dimensions. The empty space behind the middle ground also fails to impart the life and substance customary in such a passage in this artist's work. The agitated and somewhat conflicting dynamics of the masses and the variation of texture are nonetheless in accord with Tung's interests at this time. He was very active in this period, a circumstance that could account for either a work lacking in commitment or the contribution of a substitute hand.

JH

LITERATURE: Ku Wen-pin, *Kuo-yün lou*, 1883, repr. 1970, *ch.* 5, p. 13; Xu Bangda, *Pien-nien-piao*, 1963, p. 102; Xu Bangda, *Kai-lun*, 1981, pl. 57; Weng and Yang, *Palace Museum: Peking*, 1982, pl. 107; *Chung-kuo ku-tai shu-hua mu-lu*, vol. 2, 1985, *Ching* 1–2180; Ren Daobin, *Hsi-nien*, 1988, p. 253; Zheng Wei, *Nien-p'u*, 1989, p. 187.

62 *Eight Landscapes*

Pa-ching shan-shui

董其昌　八景山水

Dated 1630

Album of eight paintings with two leaves of calligraphy, ink on paper
24.5 x 16 cm (9⅝ x 6⁵⁄₁₆ in.)

The Metropolitan Museum of Art, New York
The Edward Elliott Family Collection, Gift of Douglas Dillon, 1986
(1986.266.5)

vol. 1, pl. 62 (leaves 4, 5, 7, 8); vol. 2, pl. 62 (leaves 1–3, 6, 8a)

ARTIST'S INSCRIPTIONS AND SIGNATURES:
Leaf 2a, 3 lines in running script:
These two leaves follow the essential painting [styles] of Ni Yüan-chen [Ni Tsan, 1301–1374]. Brushed while residing in Ku-su [Su-chou] in the sixth month of the *keng-wu* year [July 10–August 7, 1630].

此二幅乃倪元鎮畫髓也。庚午六月，姑蘇寓筆。

Leaf 4, 3 lines in regular script:
"Buddhist Temple amid Rivers and Mountains" after the brush style of Chü-jan [fl. ca. 960–ca. 986]. Hsüan-tsai.

《江山蕭寺》倣巨然筆，玄宰。

Leaf 5, 2 lines in regular script:
"Lofty scholar dwelling in the mountains." Hsüan-tsai.

《巖居高士圖》，玄宰。

Leaf 7, 5 lines in regular script:
Chimney smoke mingled with evening mist,
Hidden in the distance is a pavilion under pine trees;

In the pavilion is a quiet recluse,
In solitude he recites a sutra.
　Hsüan-tsai.

炊煙連宿靄
隱隱見松亭
亭中有靜者
單讀淨名經
　玄宰。

Leaf 8, 2 lines in regular script:
On the ninth day of the ninth month of the *keng-wu* year [October 14, 1630] I [finished] painting these eight scenes. The old man of seventy-six *sui*.

庚午九月九日寫此八景，七十六翁。

Leaf 8a, 5 lines in running script:
From the fourth month of the *ting-ch'ou* year [April 1577], when I started studying how to paint, until now, the *keng-wu* year [1630], fifty-two years have passed. Although the true style of my painting is not yet established, still the time I have spent is longer than any other painter. In ancient times the Lord Buddha, after preaching for forty-nine years, still had not turned the Wheel of the Law. Am I not like Buddha? If so, some later critic may indeed argue [as Mi Fu did about Li Ch'eng] that, after a lifetime of study, there is no true Tung Ch'i-ch'ang. Hsüan-tsai. (Translation after Fong et al., *Images of the Mind*, 1984, p. 174.)

余自丁丑四月始學畫，至庚午，五十二年矣。畫品即未定，畫臘已久在諸畫史之上。昔世尊四十九年說法，猶謂未轉法輪，吾得無似之耶？果爾，當有作無董論者。玄宰。

NO ARTIST'S SEALS

LABEL STRIPS: Fei Nien-tz'u 費念慈 (1855–1905), mounted on wooden cover, dated 1892, 1 seal; Wang Wen-chih 王文治 (1730–1802), remounted on a blank page of the album, undated, 1 seal

COLOPHONS: Wang Wen-chih, undated, 1 seal; Lu Kung 陸恭 (1741–1818), dated 1796, 2 seals

COLLECTORS' SEALS: Tung Tsu-yüan 董祖源 (17th century), 1; unidentified, 6

RECENT PROVENANCE: Wu P'u-hsin

In this album, done when he was seventy-six *sui* (seventy-five years old), Tung Ch'i-ch'ang demonstrates how he interprets the whole spectrum of Sung and Yüan styles in a set of contrasting brushstroke methods. Tung takes as his point of departure the works of the Yüan master Ni Tsan, whose paintings Tung regarded as calligraphic abstractions of earlier Sung styles. In the first two leaves, Tung contrasts Ni Tsan's early "earthen" landscape style, which follows the round, parallel, "hemp-fiber" (*p'i-ma ts'un* 披麻皴) brushstrokes of the tenth-century master Tung Yüan (fl. ca. 945–ca. 960; cf. *Enjoying the Wilderness in an Autumn Grove* of 1339; Sickman, *Chinese Calligraphy and Painting*, 1962, no. 48, pl. 31), with Ni's late "rocky" landscape style, which emphasizes the angular, oblique "folded-ribbon" (*che-tai* 折帶) brushstrokes that Ni associated with Kuan T'ung (fl. 907–23; cf. *The Jung-hsi Studio* of 1372; Chang Kuang-pin, *Yüan ssu-ta-chia*, 1975, no. 314).

In succeeding leaves, Tung continues to juxtapose "earthen" and "rocky" landscape manners. The angular, folded-ribbon textures of the

distant cliff in the third leaf contrast with the consistent application of straight, hemp-fiber texture strokes in the manner of Chü-jan in the fourth leaf. The flinty, dry-brush stippling of the rock face in leaf 5 boldly contrasts with the wet dots and softly rubbed textures of the Mi-style cloudy mountains of leaf 6.

In the final two leaves, Tung returns to Ni Tsan's angular and round idioms to create a final pair of images—one simple, the other complex—that reveal his understanding of Ni Tsan's personality as well as his stylistic development. The simple composition of leaf 7 recalls Ni Tsan's late style in its harmonious integration of angular contours and dry, rubbed texturing. In Ni Tsan's late paintings, figures are omitted, but the artist's reclusive spirit pervades his imagery. Except for a path leading up the mountain, Tung's painting shows no trace of human habitation, but as Tung observes in his poem, the recluse's hidden dwelling is like a trace of smoke mingled with evening mist: to the trained eye his presence is pervasive and unmistakable. In his final leaf, Tung Ch'i-ch'ang illustrates how Ni Tsan's early style, like his own, is derived from the study of Tung Yüan and his fourteenth-century interpreter Chao Meng-fu (1254–1322). Having mastered Ni Tsan's two styles, this was the one with which Tung was most comfortable. His crowded composition, dotted with thatched buildings and bridges, reveals that, ultimately, Tung was more engaged in worldly affairs than Ni Tsan, the "noble recluse."

MKH

EXHIBITION: University Art Museum, Berkeley, 1971: Cahill, *Restless Landscape*, no. 36.

LITERATURE: Suzuki, *Chinese Art in Western Collections*, 1973, vol. 2, no. 24; Riely, "Tung Ch'i-ch'ang's Ownership of Huang Kung-wang's *Dwelling in the Fu-ch'un Mountains*, 1974–75, n. 3, p. 66; Kohara, Wu, et al., *Jo I, To Kisho*, 1978, vol. 5, pls. 65–72; Kohara, *To Kisho no shoga*, 1981, pl. 21, pp. 245–46, figs. 53, 54; Fong and Hearn, "Silent Poetry," 1981–82, pp. 55–58, figs. 43, 44; Suzuki, *Comprehensive Illustrated Catalogue*, 1982–83, vol. 1, A17–115; Cahill, *Compelling Image*, 1982, pp. 47, 51, fig. 2.17; Cahill, *Distant Mountains*, 1982, pp. 117–18, pls. 47–49; Fong et al., *Images of the Mind*, 1984, pp. 174–76, fig. 145a–d.

63 *"Singing Aloud,"* cursive script
Ts'ao-shu "Fang-ko hsing"
董其昌　草書《放歌行》

Undated (ca. 1630)

Handscroll, ink on silk
32 x 645.2 cm (12⅛ x 254 in.)

Shanghai Museum
vol. 1, pl. 63 (detail); vol. 2, pl. 63

ARTIST'S TITLES:
1. 1 line in cursive script, preceding a song in seven-character meter in 42 lines:
"A Song for Singing Aloud"

《放歌行》

2. 1 line in cursive script, preceding a song in five-character meter in 17 lines:
"A Song of Wild Fields and Yellow Sparrows"

《野田黄雀行》

ARTIST'S INSCRIPTION AND SIGNATURE (4 lines in cursive script, following a quatrain in seven-character meter quoted from Huai-su [fl. late 8th century] in 9 lines):
Aiming at the fresh and original without strict rules,
Old and lean, drop by drop, half out of ink:
When drunk, he trusts his hand to two or three lines;
When sobered up, he tries to write and can't do it.
　As I was writing in [Huai-]su's style, I thought to take this poem from [his] *Autobiography* to make a further connection. Tung Ch'i-ch'ang.

意在新奇無定則
古瘦灘灘半無墨
醉來信手兩三行
醒後邻書書不得
　　因作素書，以《自叙帖》詩系之。董其昌。

ARTIST'S SEALS:
Tung Ch'i-ch'ang yin 董其昌印 (*pai-wen*, square) **138**
Ssu-po 思白 (*chu-wen*, square) **139**

No colophons

COLLECTOR'S SEAL: Weng Ting-ch'en 翁鼎臣, 1

The T'ang calligrapher Huai-su and his *k'uang-ts'ao* 狂草 ("mad" cursive script) are recurrent themes in Tung Ch'i-ch'ang's art. From one of the earliest dated works in the present exhibition, the Tokyo National Museum scroll dated 1603 (vols. 1 and 2, pl. 5), to this scroll, datable to around 1630, Tung's indebtedness to this early master of cursive script as a source of artistic inspiration is constant. Indeed, in more than one instance Tung has chosen some form of cursive either as the sole vehicle to convey the substance and feeling of a poem or as a contrasting element to a presentation of text in a different script type: in the Tokyo scroll of 1603; in a colophon of around 1612–16 to a handscroll in formal regular script (vols. 1 and 2, pl. 22); in an album of poems after Su Shih (1036–1101), written around 1617–18 (vols. 1 and 2, pl. 34); and in a rare hanging scroll of a Wang Wei (701–761) poem, datable to 1632 (vols. 1 and 2, pl. 65). In each case, it is the spirit of Huai-su that informs Tung's art, and it is primarily in this guise that Tung seems able to throw off the mantle of sobriety and free himself from the decades of the slow accumulation of artistic insight through study of the ancients, a practice that was his hallmark and claim to art-historical fame.

Between Tung and Huai-su there was the important figure of Huang T'ing-chien (1045–1105), the key interpreter of Huai-su and foremost practitioner of *k'uang-ts'ao*. When Tung, who so often spoke of total control over the brush in the art of writing (see cat. no. 1), chose to "let himself go," he did so most often by invoking the names of Huai-su and Huang T'ing-chien.

The title of this work, *"Fang-ko hsing"*—literally "to let go of song poem"—proudly announces its expressive level. In this work, cast in a form of ballad with twenty-four verse lines and a strong rhythmic pulse of repeated end rhymes, Tung sings a song of himself, a kind of

autobiographical account of the period from his youth onward. Essentially, one might say he is mimicking Huai-su himself and his famous *Tzu-hsü t'ieh* (vol. 1, fig. 56), an essay dated 777 whose title has been variously translated as *Autobiography*, *Account of My Calligraphy*, and *Account of Myself*. Tung even quotes Huai-su's self-mocking quatrain in his inscription, thereby paying homage to the T'ang master in both form and content.

As noted in the discussion of the 1603 Tokyo scroll (see cat. no. 5), Huai-su's calligraphy is distinguished by a number of formal features: graphs that break out of the column to create a tangled effect in the composition, brushlines with a rounded and occasionally flat effect achieved by a brush held upright, and an overall circular brush rhythm. Huang T'ing-chien not only absorbed these features but infused into them his own precisely articulated approach to brushwriting. In his "Biographies of Lien P'o and Lin Hsiang-ju" (The Metropolitan Museum of Art), Huang's concern with the primacy of the individual brushstroke and the composition of each character restored the integrity of each graph in a column and gave renewed interest to the vertical movement of linear forms within the column itself. Thus Huang shifted the emphasis of Huai-su's "tangled effect" from the overall composition to the characters themselves and infused the technique of the upright brush with a renewed intensity. The individual brushstrokes—their shape, weight, and direction—create character forms of unfailing interest, without the brush ever losing the momentum of the vertical column or the entire composition.

In Tung Ch'i-ch'ang's work, one senses immediately his respect for the intercolumnar space. He varies the upright-brush technique by using occasional flat splayed strokes with unmodulated heads—a practice derived from the Sung master Mi Fu (1051–1107)—and employs zigzag diagonal rhythms as much as circular ones. Tung is least interested in the "tangled effect," and when he is, his interest is manifested in the compressed internal linking of strokes within a single character or group, a trait possibly derived from his study of Ou-yang Hsün (557–641). Instead of Huai-su's headlong rush of arabesques, or the high-pitched and struggling intensity of Huang T'ing-chien, Tung's performance combines not only the major influences of Huai and Huang, but also those of his own training—Mi Fu, Yen Chen-ch'ing (709–785), Ou-yang Hsün, and even *chang-ts'ao* 章草 (draft cursive) as interpreted by Wang Hsien-chih (344–388). Again, Tung is unable to escape from his very literate calligraphic training, and it is this complex integration of influences that emerges as the distinctive airborne cursive identifiable as uniquely his.

<div align="right">MWG</div>

LITERATURE: *Chung-kuo ku-tai shu-hua mu-lu*, vol. 3, 1987, *Hu* 1–1420; *Chung-kuo ku-tai shu-hua t'u-mu*, vol. 3, 1990, *Hu* 1–1420.

64 *Running Script in the Manner of the Four Sung Masters*

Hsing-shu lin Su Huang Mi Ts'ai t'ieh

董其昌　行書臨蘇黃米蔡帖

Undated (ca. 1632)

Handscroll, ink on satin
28.6 x 422.2 cm (11¼ x 166¼ in.)

Beijing Palace Museum
vol. 1, pl. 64 (detail); vol. 2, pl. 64

ARTIST'S TITLE (1 line in large running script):
Su Huang Mi Ts'ai

蘇黃米蔡

ARTIST'S TRANSCRIPTION (ten quatrains in seven-character meter in running script):
1. *T'ien-chi wu-yün* . . . , in 4 lines, after Su Shih (1036–1101); poem by Ts'ai Hsiang (1012–1067).
2. *Ch'o-yüeh hsin-ch'ou* . . . , in 4 lines, after Su Shih.
3. *Lung-shang ch'ao-k'ung* . . . , in 4 lines, after Su Shih.
4. *Pi-she hu-chung* . . . , in 4 lines, after Huang T'ing-chien (1045–1105).
5. *T'ao-li wu-yen* . . . , in 4 lines, after Huang T'ing-chien.
6. *Chu-hsi sang-che* . . . , in 4 lines, after Mi Fu (1051–1107).
7. *Fan-fan wu-hu* . . . , in 5 lines, after Mi Fu.
8. *Tuan-yün i-p'ien* . . . , in 5 lines, after Mi Fu.
9. *Yü-hsün lan-chien* . . . , in 5 lines, after Ts'ai Hsiang.
10. *Hua wei ch'üan-k'ai* . . . , in 4 lines, after Ts'ai Hsiang.

ARTIST'S INSCRIPTION AND SIGNATURE (3 lines in running script, following the ten poems):
Of the Four [Sung] Masters' calligraphy, I am most familiar with Su [Shih] and Mi [Fu]. [Although] Huang [T'ing-chien] and Ts'ai [Hsiang] are masters I have practiced the least, I think I have gotten close enough here. Ssu-weng [Tung Ch'i-ch'ang] presents this calligraphy to his grandson, [Tung] Kuang.

四家書以蘇、米爲熟境。黃、蔡非串習者，想當近似耳。思翁書付孫廣。

ARTIST'S SEAL:
Tung Ch'i-ch'ang yin 董其昌印 (*pai-wen*, square) **69**

COLOPHONS: Tung Tsu-ho 董祖和 (late 16th–early 17th century), dated 1657, 1 seal:
In the third month of the *ting-yu* year [April 14–May 12, 1657], I humbly bestow [this scroll] on the Grand Preceptor. Tung Tsu-ho of Yünchien [Kiangsu].

丁酉三月，奉寄大相師。雲間年晚董祖和。

Hsü Liang 徐良 (1704–1774), dated 1769, 2 seals; Liang Yen 梁巘 (18th century), dated 1776, 2 seals

COLLECTORS' SEALS: Tung Tsu-ho, 2; Mei I 梅钺, 6; Kao Yung 高邕 (1850–1921), 1; Li Kuo-sung 李國松 (20th century), 4; unidentified, 2

As both poets and calligraphers, the Four Sung Masters stand as giants in Chinese cultural history. Although they are discussed as a group, each attained such a high degree of individuality in his art that he conjures up a visual image distinct from the others. Their aesthetic values

and approaches to the fine arts, in particular to that of writing, enriched the concept of the "personal style" in Chinese art history with a humanistic dimension. Differences in character, temperament, and political and artistic involvement were fully embodied in their brushwriting and belied the fact that all four derived their art from Yen Chen-ch'ing (709–785), and, in varying degrees of intensity, from Wang Hsi-chih (303–379) and his son Wang Hsien-chih (344–388).

Wide appreciation of the works of the Four Sung Masters—beyond their circle of immediate admirers—as objects to be collected began as early as the Yüan period, when such calligrapher-connoisseurs as Hsien-yü Shu (1257–1302) and Chao Meng-fu (1254–1322) collected and discussed their writings; however, although study and imitation was part of their aesthetic interest, Hsien-yü and Chao did not themselves produce work "in the manner of" these masters. Not until the Ming period did artists such as Yao Shou (1423–1495) and Shen Chou (1427–1509) pattern their calligraphy after a particular master, in both cases, Huang T'ing-chien. Other scholars, such as Wu K'uan (1435–1504), wrote exclusively in one mode, that of Su Shih. (See Fu et al., *Traces of the Brush*, 1977, cat. nos. 28, 29, 31.) Wen Cheng-ming (1470–1559), poet, calligrapher, and painter, was probably the first artist of stature to tackle three of the four Sung masters: Su, Huang, and Mi. It is not known whether he ever combined the three in one work, but in a handscroll, now in The Metropolitan Museum of Art, he writes in the manner of Su, Huang, and the T'ang master Huai-su (fl. late 8th century); a rare scroll in the Mi style by Wen is also extant (in the collection of Mr. and Mrs. Hans Frankel; see Fu et al., *Traces of the Brush*, cat. nos. 50, 51). It should be noted that this interest in the Sung was part of a larger revival movement taking place in the arts during the late Ming, in the sixteenth and seventeenth centuries. In literature, "imitating the ancients" (*ni ku* 擬古) included taking the Han, Wei, and Chin classics as models, with the T'ang for verse and the Sung for prose (Fu et al., *Traces of the Brush*, pp. 130–34).

Tung Ch'i-ch'ang's entrance into this literary and artistic arena enabled him to reap the full benefits of this revival of the antique. While Mi and Tung pursued remarkably similar courses of studies in calligraphy, it remained for Tung to spearhead the Ming revival of antiquity into an artistic movement of coherence including both painting and calligraphy. That Tung's interest in the past as a source of artistic renewal came initially in calligraphy is well documented by his activities in the 1580s and 1590s, when he sought out, studied, and imitated examples of ancient calligraphy, particularly those in the collections of his three artistic mentors, Hsiang Yüan-pien (1525–1590), Han Shih-neng (1528–1598), and Wu T'ing (ca. 1555–after 1626). According to Xu Bangda, Tung's album dated 1591 (his earliest extant calligraphic work) included not only his imitations of Eastern Chin and T'ang masters (well known to him from his early study of the *Ch'un-hua ko t'ieh*, the Sung compilation of model calligraphies), but also imitations of Su Shih and Mi Fu, striking in their resemblance to the models (see Xu Bangda, "Tung Ch'i-ch'ang's Calligraphy," in vol. 1 of this catalogue, pp. 109–10).

In Tung's extant dated works from the 1590s and early 1600s, one finds scattered references to two Sung masters in particular, Su Shih and Mi Fu (see Shi-yee Liu Fiedler, "Chronology," in vol. 2 of this catalogue; and Kohara, *To Kisho no shoga*, 1981, pp. 177 ff.). From this

evidence, one is led to the conclusion that Tung's scroll after the Four Sung Masters dated 1607 (vols. 1 and 2, pl. 10) is possibly the first and earliest work from the Ming period in which Su, Huang, Mi, and Ts'ai are combined as an artistic group yet with their individual styles respected. Moreover, Tung also includes their poems, correspondence, or prose. In the present work, datable to around 1632, some twenty-five years hence, Tung selects an even more consistent presentation of the Sung Masters' poems in the same *chüeh-chü* 絕句 (quatrain) form, thus preserving both their literary and calligraphic styles.

The first two poems after Su Shih are from a well-known group in the Tianjin Museum (see *Su Shih "T'ien-chi wu-yün" t'ieh chen-chi*, 1988). In his original colophon to the first quatrain Su writes: "This was a poem of Ts'ai Hsiang's that came to me in a dream. I had stopped off at Hang-chou, where Mr. Ch'en invited me in for a drink. In the front hall, there hung on the wall of a small room a scroll of calligraphy bearing this quatrain. It was a genuine work by Ts'ai Hsiang."

The original Su Shih scroll bears the collector's seals of Hsiang Yüan-pien, so it is likely that Tung knew that work from the period of the 1570s and 1580s. Tung Ch'i-ch'ang's versions of the two poems contain character variants, which suggests that he transcribed them from memory. What Tung does stylistically with the work is almost subliminal in that he is seeking an evocation of Su Shih resulting from a period of some forty years of study and assimilation of the Sung master's work. The squat, flattened tilt to the upper right of the opening character, *t'ien* 天, and the generous saturation of ink (almost to the point of blotting) whenever the brush is reloaded are "codes" that distinctly evoke Su's art. In the Sung original, the ink appears almost uniformly black, Su's brush moving with a weighty intensity of measured rhythmic pulse. In contrast, Tung's feeling for ink is variable and very much his own, with a brush pace that is lighter and quicker, beginning slowly, as if in homage, and then picking up speed.

The two quatrains after Huang T'ing-chien were also familiar to Tung, as the original group of poems was also in Hsiang Yüan-pien's extraordinary collection. In these poems excerpted from a set written by Huang for his father-in-law, Sun Chüeh (1028–1090; see *Ku-kung fa-shu*, 1965, vol. 10), Tung performs what amounts to a quick-change act: he pares down Huang's forms to their skeletal essence, elongating their overall shape and using ink sparingly. Tung does not evoke any of the more obvious Huang Ting-chien mannerisms—such as wavering horizontals or verticals, which are often associated with him and exaggerated by copyists to suggest a likeness. Rather, by virtue of the contrast and juxtaposition with the heavier forms of the previous poems "in the manner of Su Shih," Tung attempts to convey a more intuitive character of Huang's style, one that might at first glance appear to be somewhat weak, but that on further study and comparison with the original stands up rather admirably, considering its improvisational nature.

In the third section, in the manner of Mi Fu, Tung again draws on a work from Hsiang Yüan-pien's collection, the Sung master's illustrious work of 1088 written on Szechuan silk (*Ku-kung fa-shu*, vol. 12). In the two quatrains taken from the 1088 scroll (nos. 7 and 8), Tung loosens up, allowing his brush, fully loaded with rich ink, to caress the lustrous satin to create contrasts of character size and brush rhythms. Tung's "codes" for the Mi style are the strongly arched

vertical and hook strokes, the flattened splaying of the brush in the "water" and "silk" radicals, the slightly disjointed structures of the characters, and the rich spectrum of ink tonalities and weight in the brushline, all of which simulate the vibrant pulsating energies of the original.

In Tung's evocation of the fourth master, Ts'ai Hsiang, one senses immediately an attempt at a more regulated pace, a slightly more spacious formality in the script, and an evenness of ink tone and rhythms, which for Tung represent the stately conclusion to this exercise. (For an example of Ts'ai Hsiang's calligraphy, see *Ku-kung fa-shu*, vol. 8.)

Little is known about Tung Ch'i-ch'ang's progeny other than their help in the printing of his collected writings, the *Jung-t'ai chi*, in 1630, and their mention in occasional references in colophons to his works, such as this handscroll (see Celia Carrington Riely, "Tung Ch'i-ch'ang's Life," part 6, in vol. 2 of this catalogue). Indeed, the reference to this scroll as a gift to his grandson Kuang is a rare occurrence and also an indication of the scroll's probable late date (another grandson, Tung T'ing, is better known). Tung Kuang did not keep the scroll, but let Tsu-ho, his father (or uncle), present it to a fellow examination holder (the term *nien-wan* 年晚 in the colophon) who was his senior (an unidentified official). Tsu-ho's writing in small-sized regular script is properly respectful, placed as it is in the lower left corner, but disappointingly timid, as it is also squeezed on the left edge, presumably because it was written after the scroll had been mounted for presentation.

As for the calligraphy by the intimidating father, Ch'i-ch'ang, it can be compared with the earlier work dated 1607 (vols. 1 and 2, pl. 10), also after the Four Sung Masters, written when Tung was fifty-three *sui* (fifty-two years old). As in the earlier work, the poems here were derived from originals long familiar to him. In his inscription, Tung mentions that he practiced the styles of Huang T'ing-chien and Ts'ai Hsiang less than those of Su Shih and Mi Fu, and seems pleased, if not surprised, that he captured a likeness. This kind of talk is not exactly what one would expect from a master who professed not to aim for likeness after his model. However, it shows that, after several decades, Tung was still engaged in an active dialogue with the great masters of the past and could summon up his total experience in a most formidable way.

<div align="right">MWG</div>

LITERATURE: *Chung-kuo ku-tai shu-hua mu-lu*, vol. 2, 1985, Ching 1–2227.

65 *Poem by Wang Wei,* cursive script

Ts'ao-shu Wang Wei shih

董其昌　草書王維詩

Undated (datable to 1632)

Hanging scroll, ink on paper
189.9 x 74.4 cm (74¼ x 29⁹⁄₁₆ in.)

The Metropolitan Museum of Art, New York
Bequest of John M. Crawford, Jr., 1988 (1989.363.100)

vol. 1, pl. 65 (detail); vol. 2, pl. 65

ARTIST'S TRANSCRIPTION OF POEM AND SIGNATURE (3 lines in cursive script):
Among the mountains we bid each other farewell;
The sun sets as I close my bramble gate.
Spring grass every year is green;
But will the young prince ever return?
　Ch'i-ch'ang.

山中相送罷
日暮掩荆扉
青草年年綠
王孫歸不歸
　其昌。

ARTIST'S SEALS:
Hsüan-shang chai 玄賞齋 (*chu-wen*, tall rectangle) 140
Tsung-po chih chang 宗伯之章 (*pai-wen*, square) 141
Tung Ch'i-ch'ang yin 董其昌印 (*pai-wen*, square) 142

NO COLOPHONS

COLLECTORS' SEALS: Chu Hsing-chai 朱省齋 (20th century), 3; Alice Boney (1901–1988), 1; John M. Crawford, Jr. (1913–1988), 2; unidentified, 1

RECENT PROVENANCE: Alice Boney

As in painting, Tung Ch'i-ch'ang drew inspiration for his calligraphy from the ancient masters. Aiming to capture the spirit rather than the physical likeness of his models, his writing style remained distinctively his own. In contrast to the brusque, coarse power displayed by other late Ming calligraphers, Tung's fluid lines, alternately wet and dry from his constant twisting of the brush tip, possess tremendous grace.

This monumental writing is one of the largest known examples of Tung's cursive script extant, with individual characters measuring as large as thirty centimeters in height (Kohara, *To Kisho no shoga*, 1981, p. 280). The relatively loose structure of the calligraphy suggests that it is a late work, done in the final decade of Tung's life. Written in a fully cursive manner, Tung's abbreviated, curvilinear forms are quite distinct from his running script style and reflect his knowledge of Huai-su's (fl. late 8th century) *Autobiography* (*Tzu-hsü t'ieh*; vol. 1, fig. 56; *Chinese Art Treasures*, 1961, cat. no. 114), dated 777, which he could have seen in the collection of Hsiang Yüan-pien (1525–1590). Compared to Huai-su's writing, however, Tung's cursive script is rounder and fleshier with less variation in line thickness and almost no connecting ligatures between characters: each ideograph stands by itself with an independent, almost sculptural, identity. Tung's writing is also more calculated than Huai-su's. In spite of an appearance of spontaneous fluid movement, the artist's consummate control is evident in his manipulation of ink tonalities. Whereas the ink tonality in Huai-su's writing varies according to how much ink is left in the brush, Tung's alternates at will between dry and wet, dark and light. By overlapping dry, transparent brushstrokes that appear to recede with opaque dark lines that appear to project forward or lie on top of the paler lines, Tung gives his characters a dynamic three-dimensional quality, making them appear as if they were abstract sculptures suspended in space.

The poem Tung chose to transcribe seems particularly appropriate to his circumstances. The quatrain was composed by the T'ang poet-painter Wang Wei (701–761), whom Tung revered both as the founder

of the Southern School of painting and as the epitome of the scholar-amateur living in retirement at his country estate, the Wang-ch'uan Villa. Wang Wei's poem is a bittersweet contemplation of the passage of time and the pain of separating from a friend; it may also contain a veiled reference to the friend's becoming a recluse. Robinson points out that the second couplet of this quatrain is based on lines from "Summons for a Gentleman Who Became a Recluse" ("Chao-yin shih") from the *Ch'u tz'u* (Robinson, *Wang Wei: Poems*, 1973, p. 47):

A prince went wandering
And did not return
In spring the grass grows
Lush and green

In transcribing this poem the aged artist reveals both his awareness of life's brevity and his ambivalent feelings toward an official career which he alternately pursued and shunned all his life.

MKH

EXHIBITIONS: China Institute in America, New York, 1966: Katz, *Selections of Chinese Art*, no. 68; Philadelphia Museum of Art, 1971: Ecke, *Chinese Calligraphy*, no. 60; Lowe Art Museum, University of Miami, 1973: *Ancient Chinese Painting*, no. 32.

LITERATURE: Weng, *Chinese Painting and Calligraphy*, 1978, no. 43; Kohara, *To Kisho no shoga*, 1981, p. 280, pl. 94; Shih Shou-ch'ien et al., *The John M. Crawford, Jr., Collection*, 1984, no. 108.

66 *Landscape in the Manner of Ni Tsan*

Fang Ni yü shan-shui

董其昌　倣倪迁山水

Dated 1634

Hanging scroll, ink on paper
100.4 x 26.4 cm (39½ x 10⅜ in.)

Lent by Wen C. and Constance Tang Fong L.1991.2

vol. 1, pl. 66

ARTIST'S INSCRIPTION AND SIGNATURE (5 lines in regular script):
Mount Hsi in Wu-hsi is [the same as Mount] Wu-ping;
How strange that Ni yü [Ni Tsan, 1301–1374] doesn't come to life again!
There are only the mist and rosy clouds filling in like bones' marrow;
You ought to know that my method and yours are the same.
　Written on the full moon of the second month of the *chia-hsü* year [March 14, 1634], in my eightieth year. Hsüan-tsai.

錫山無錫是無兵
惟得倪迁不再生
但有煙霞填骨髓
須知我法本同卿
　甲戌二月望寫，時年八十歲。玄宰。

ARTIST'S SEAL:
Ch'ang 昌 (*chu-wen*, square) **143**

NO COLOPHONS

COLLECTORS' SEALS: Chang Ta-ch'ien 張大千 (1899–1983), 4; unidentified, 1

Landscape in the Manner of Ni Tsan is of great interest for its documentation of Tung Ch'i-ch'ang's late style of painting after 1630. One structurally related work, though dramatically more monumental and complex, is the *Landscape* hanging scroll dated 1633 in the Beijing Palace Museum (*Tung Ch'i-ch'ang hua-chi*, 1989, pl. 65). Both compositions are organized as tall, narrow river-scapes, with strongly shaped negative spaces formed by angularly arched surrounding ridges. Tung Ch'i-ch'ang's inscription on the Beijing landscape calls it a synthesis of Tung Yüan (fl. ca. 945–ca. 960) and Fan K'uan (d. after 1023), in a conscious exploration of Northern Sung qualities based on his experiences of collections in Peking, and to that degree a turning away from qualities of the Yüan dynasty masters, whose paintings were well represented in southern collections. The principal reference in the present 1634 landscape is clearly to the Yüan painter Ni Tsan, since he is mentioned in the inscription and Wu-hsi was his hometown. The arched momentum of the foreground rocks recalls the closely related treatment of the undated Cleveland handscroll *River and Mountains on a Clear Autumn Day* (vol. 1, pl. 53), modeled after another Yüan master, Huang Kung-wang (1269–1354). Nevertheless, the repeated rectilinear shapes and tightly interlocked passages in the 1634 landscape convey a Sung-like aura of monumentality, which involves an emphasis on total design rather than additive, piecemeal construction. In this context, it is worth recalling the inscription on one of the leaves in the Nelson-Atkins album *Landscapes in the Manner of Old Masters* of 1621–24 (vol. 1, pl. 42–9), where Tung proposed affinities between the styles of Ni Tsan and the Northern Sung master Yen Wen-kuei (fl. ca. 988–ca. 1010).

RV

LITERATURE: Wang Shih-chieh et al., *I-yüan i-chen*, 1967, vol. 3; Suzuki, *Comprehensive Illustrated Catalogue*, 1982–83, vol. 1, A18–005, vol. 2, s8–021.

67 *Poem for Mao Hsiang*, running script

Wei Pi-chiang tso hsing-shu

董其昌　爲辟疆作行書

Undated (ca. 1634)

Hanging scroll, ink on gold-flecked paper
117.5 x 45 cm (46¼ x 17¹¹⁄₁₆ in.)

Lent by Wen C. and Constance Tang Fong L.1991.3

vol. 1, pl. 67 (detail); vol. 2, pl. 67

ARTIST'S INSCRIPTION AND SIGNATURE (2 lines in small running-cursive script, following a poem in seven-character regulated meter in 4 lines):
In the realm of arts and letters, the great divisions were made
By [Ssu-ma] Hsiang-ju [ca. 179–117 B.C.] in rhyme-prose, and
　Ch'iu [Tso Ch'iu-ming, ca. 6th century B.C.] in history;

So with the theoretical and profound, one can forget mundane
responsibilities,
Whatever has come or gone, one waits for the empty boat [with a
sage's equanimity].
Lately at the Golden Horse [Gate of the Han-lin Academy], we have
rarely seen each other;
For a thousand years the Dragon in Clouds will continue his
memorable journey.
In the snow the official's plum tree blossoms along the path of the
Eastern Hall,
One by one, like heavenly flowers scattering, we sadly depart.

　　Originally I composed this poem for the Companion to the Heir
Apparent, Li T'ai-hsü, and here present it to Pi-chiang [Mao Hsiang,
1611–1693], my brother in poetry, to correct. Tung Ch'i-ch'ang.

直從秋苑割鴻溝
賦是相如史是丘
遂以空玄忘俗駕
無論去住等虛舟
衰年金馬稀良覿
千載雲龍續勝游
雪裏官梅東閣路
天花點點散離憂
　　元日訓李宮允太虛作，似壁疆詞兄正。董其昌。

Artist's seals:
Tsung-po hsüeh-shih 宗伯學士 (*pai-wen*, square) **109**
Tung-shih Hsüan-tsai 董氏玄宰 (*pai-wen*, square) **110**

No colophons

Collectors' seals: Chang Ta-ch'ien 張大千 (1899–1983), 1;
unidentified, 2

The relationship between an aging scholar and a talented student has
often served spiritually to rejuvenate the elder and artistically to nur-
ture the younger. Mao Hsiang, to whom Tung Ch'i-ch'ang presented
this scroll, was one of the more colorful literary figures of the late
Ming whose political activity and romantic interests captured the pop-
ular imagination. In politics, his reformist bent led him to join the po-
litico-literary Restoration Society, known as the Fu-she; he and three
other members, Ch'en Chen-hui (1604–1656), Hou Fang-yü (1618–
1655), and Fang I-chih (1611–1672), were known as the Four Scions
of the late Ming (*Ssu-kung-tzu* 四公子) and immortalized in K'ung
Shang-jen's (1648–1708) drama "Peach Blossom Fan" ("T'ao-hua-
shan"), completed in 1699. With the fall of the Ming dynasty, Mao
refused to serve in the new Manchu government, thereby joining the
ranks of other illustrious Ming loyalists, or *i-min*. In society, Mao asso-
ciated with actors, entertainers, and beautiful talented women; his con-
cubines Tung Pai (1625–1651), Ts'ai Han (1647–1686), and Chin Yüeh
(fl. 1660–90) were all accomplished painters, and Mao's colophons in-
variably grace their works (see Marsha Weidener et al., *Views from
Jade Terrace*, 1988, nos. 22, 33–35, pp. 98–99, 112–115, 177, 179, 180).
Mao recounted his liaison with the short-lived Tung Pai in his "Rem-
iniscences of the Retreat of Shadowy Plum Blossoms" ("Ying-mei an i-
yü"). In poetry, Mao was known as a prodigy who, at fourteen *sui*
(thirteen years old), had published a collection of his verses. In calligra-
phy, fewer than a dozen works survive to document Mao's talent, but
a major handscroll, *Waiting for the Moon at Six Bridges* (*Bulletin of the*

Allen Memorial Art Museum, Oberlin College, 36, no. 2, 1978–79),
testifies to his scintillating abilities, which fully impressed others,
such as Tung Ch'i-ch'ang, Ch'en Chi-ju (1558–1639), and the critic-
poet Wang Shih-chen (1634–1711).

　　In his recent study of the Oberlin handscroll and Mao Hsiang's
life, Chou Ju-hsi writes: "When they first met, Tung Ch'i-ch'ang was
already a venerable septuagenarian and Mao Hsiang, a mere teen. The
two appeared to have struck up a friendship at once, and in the ensu-
ing ten years, they enjoyed, in lieu of the usual teacher-pupil relation-
ship, what Tung characterized as *wang-nien-chia* (friendship in spite of
age difference)." (Chou Ju-hsi, "From Mao Hsiang's Oberlin Scroll to
His Relationship with Tung Ch'i-ch'ang," *Bulletin of the Allen Memo-
rial Art Museum*, Oberlin College, 36, no. 2, p. 156.)

　　Mao had presented Tung with his collection of verses and requested
a preface from the elder statesman. Tung consented, and in Mao's
Hsiang-li yüan Ou-ts'un, Tung pays Mao the generous compliment of
comparing him to a young Wang Wei (701–761), the great T'ang
poet. Their subsequent friendship is preserved in a series of nine let-
ters recorded in Mao's *T'ung-jen chi* of 1673, a collection of the prose
and verse dedicated to him in his earlier years. Tung's recognition of
Mao's gifts took the form of favors and mementos, with an special eye
to guidance in his calligraphic studies. A colophon written by Tung in
1634, two years before his death, suggests the artistic direction he gave
to Mao:

Mao Hsiang in "eight methods" has fathomed the brush-idea of Yen Chen-
ch'ing. He had frequently beseeched me for calligraphies in *hsing* and *ts'ao*
styles, to which I responded with several works [in the manner of] ancient
masters. [This time] my boat passed through Yang-chou, and I had the op-
portunity of discussing calligraphy with him and found indeed a harmony
of spirit. I once again wrote Tu Fu's modern-style verses in imitation of
Yen Chen-ch'ing's *k'ai* script and gave him as a gift . . . (Translation by
Chou Ju-hsi, "From Mao Hsiang's Oberlin Scroll to His Relationship with
Tung Ch'i-ch'ang," p. 157.)

　　In 1635 Mao expressed his admiration for Tung by having the callig-
raphy Tung presented to him reproduced in carved form as the *Han-
pi lou t'ieh* (roughly the equivalent of Tung's own *Hsi-hung t'ang t'ieh*)
to be used as a model for calligraphic study. Moved by such an
honor, Tung described their friendship as engraved "on metal and
stone" and able to endure "a thousand antiquities." Tung completed a
painting for Mao as late as the autumn of 1636. Upon Tung's death,
Mao eulogized his friend and teacher, writing that "a lofty mountain
has collapsed from high; and humanity has lost its mirror." (Chou Ju-
hsi, "From Mao Hsiang's Oberlin Scroll to His Relationship with
Tung Ch'i-ch'ang," pp. 156–57.)

　　This hanging scroll, datable by Tung's seals and calligraphy style to
1634, close to the time of the colophon quoted above, is an example
of the kind of work Tung presented to his younger friend. The poem,
though composed for another, contains intimations of mortality and
the future parting of the two men. It is a tribute to Tung that at this
stage in his career he felt no necessity to impress his younger constitu-
ent with bold or consciously presented handwriting. The calligraphy is
Tung's most natural running-cursive, written with an offhand reserve
that belies its authority. By contrast, Mao's scroll, which, according to
Chou Ju-hsi's research, was possibly written in his final years, evinces
a conscious aestheticism: where Tung's writing registers a steady pulse

of zigzag rhythms in the ligatures and an urgency in the vertical pull of the columns, the very size of Mao's characters (about four inches in height) invites the leisurely, sensuous brush movements seen in Tung's large-sized scrolls, especially those after the Sung master Mi Fu (for example, see vols. 1 and 2, pls. 20, 34, 63).

In Tung's works from the 1620s and 1630s, one observes a gradual but unmistakable trend toward reduction of form and movement, consonant with his taste for the "bland and unadorned" (*p'ing-tan t'ien-chen* 平淡天真) as well as the "raw" (*sheng* 生), qualities pronounced early in his artistic writings (see cat. no. 1). In form and technique, this entailed a rejection of sharp contrasts: thin and thick, brushtip and "belly," fluency and perfectly formed strokes. These contrasting features were of great interest to Mao Hsiang, especially in the outstanding Oberlin work. Where in the hanging scroll Tung preferred a used brush with a slightly worn-out tip, Mao selected one that registered every crisp, nuanced, and agile maneuver.

This juxtaposition of the late works of both teacher and pupil reveals the degree to which Tung's formal aesthetic changed, with the pupil choosing to emulate an earlier, more forcefully expressive image of his predecessor. Tung's hanging scroll signifies his very special personal relationship with Mao on several levels, while Mao's handscroll embodies the stylistic phenomenon of Tung's influence some five or six decades hence, when his calligraphy style had gained currency by virtue of Ch'ing imperial patronage.

MGW

LITERATURE: Suzuki, *Comprehensive Illustrated Catalogue*, 1982–83, vol. 1, A18–049.

68 *Clearing after Snow on Mountain Passes*
Kuan-shan hsüeh-chi t'u
董其昌　關山雪霽圖

Dated 1635

Handscroll, ink on paper

13 x 143 cm (5⅛ x 56⁹⁄₁₆ in.)

Beijing Palace Museum

vol. 1, pl. 68; vol. 2, pl. 68 (colophons)

ARTIST'S INSCRIPTION AND SIGNATURE (6 lines in running-regular script): Kuan T'ung's [fl. ca. 907–23] *Clearing after Snow on Mountain Passes* is in my family [collection, but] I have not unrolled it to look for over twelve years. Today this length of small-sized (*ts'e-li*) paper happened to be on the table and I have adapted all the scenery in that picture to make this small scroll. For the entire day no vulgar faces have interrupted me, so I have managed to complete it. In the fifth month, summer, of the *i-hai* year [June 15–July 13, 1635]. Hsüan-tsai.

關全《關山雪霽圖》在余家，一紀餘未嘗展觀。今日案頭偶有此小側理，以圖中諸景改爲小卷。永日無俗子面目，遂成之。乙亥夏五，玄宰。

ARTIST'S SEAL:
Tung [*Ch'i-ch'ang*] *yin* 董印 (*pai-wen*, half-seal) **144**

COLOPHONS:

Ku Ta-shen 顧大申 (*chin-shih* 1652), dated 1663, 1 seal:
Wen-min's [Tung Ch'i-ch'ang] ink wonders are a class unto themselves. His creative skills working in accord with his own intentions, he never wholly modeled himself on the ancients. So this scroll, after Kuan T'ung, contains within a few inches the configurations of wide-stretching, cloud-filled mountains. Such lofty purity, glowing like jade, has never been easy to attain. The painting is now owned by Provincial Administrative Vice Commissioner Hsiang Hsi-shui. A divine work finds its home. In the ninth month of the *kuei-mao* year [October 1–30, 1663], Ku Ta-shen of Hua-t'ing was able to see this.

文敏墨妙自成一家，適意匠心，不全摹古。此卷倣關全，紙不盈尺而有雲山浩蕩之勢，清襟玉暎，未易到也。今歸項大參犀水，神物得所矣。癸卯九月，華亭顧大申獲觀。

Tai Pen-hsiao 戴本孝 (1621–1693), dated 1664, 2 seals:
Surviving works of Master Kuan [T'ung] are rarely seen today. Wen-min, in his customarily idiosyncratic approach to copying calligraphies of the Chin and T'ang, was always able to grasp their inner force. The forms of brush energy in this scroll are sharp and vigorous, unalloyed by ink wash. The force goes straight through the back of the paper. This is a direct adaption of the calligraphic method into the painting method. [Hsiang] Hsi-shui loves antiquity and has a passion for the extraordinary. He has brought this out from his pillow box and we have looked at it together. He says that Wen-min's grandson gave it to him. One may say that it is now a treasure for all. May it be valued as such. In the third month of the *chia-ch'en* year [March 27–April 25, 1664]. Ying-o shan-ch'iao, Tai Pen-hsiao, inscribed in a boat at Chiu-li. [Chia-hsing].

關氏遺墨近代希覯。文敏素擅臨摹，如撫晉、唐諸帖，莫不得其神髓。此卷筆勢遒逸，不假渲染，力透紙背，直以書法爲畫法耳。犀水公好古嗜奇，於枕函中出示同觀，云屬文敏孫所貽。可謂能共家珍矣。寶之！寶之！甲辰三月，鷹阿山樵戴本孝識于就李舟次。

Shen Ch'üan 沈荃 (1624–1684), dated 1667, 3 seals:
Tung Tsung-po's [Tung Ch'i-ch'ang] calligraphy and painting was supreme in its generation. His finest landscapes are even harder to find than his calligraphies. This is a small scroll after Kuan T'ung. Every movement of the brush and the composition have the ancient freshness of the natural world. It has a unique sense of its own creation. No other hand could exactly duplicate this. Two gentlemen, Ku [Ta-shen] and Tai [Pen-hsiao], are both deeply experienced in this Way and both are so attached to this painting! Its authenticity cannot be doubted. [Hsiang] Hsi-shui carried it in his luggage, morning and evening opening it to look. Just as when brushing the strings of a musical instrument, one may suddenly be taken by a magical meeting of the spirit. In the intercalary [fifth] month of the *ting-wei* year [May 23–June 20, 1667]. Shen Ch'üan of Yün-chien wrote in the guesthouse at Yen-shan [near Peking].

董宗伯書畫擅絕一代，而山水佳作較八法尤爲難遘。茲摹關全小卷，布勢運筆無不蒼秀，而自有一種天然之趣，非它手所能髣髴也。顧、戴二子深研此道，乃心折若此，其爲真蹟，夫復何疑？犀水攜之行笈，朝夕展觀，拊絃動操，殆神與之遇矣。丁未閏夏，雲間沈荃書於燕山客舍。

Mao Hsiang 冒襄 (1611–1693), dated 1690, 3 seals:
Kuan T'ung studied the painting of Hung-ku-tzu [Ching Hao, ca. 870–80–ca. 935–40] so diligently that he neglected to sleep

and eat in the endeavor to surpass his model. His paintings, compositionally sparse yet eminent in their suggestion of spatial vastness, were all created in a single burst of inspiration. The precipitous perspective of towering peaks and deep valleys evoked a sense of awe beyond description. He did mostly hanging scrolls depicting mountain passes. Such were the remarks in *A Supplement to the Record of Famous Paintings of the Five Dynasties* (*Wu-tai ming-hua pu-i*), as I recall. The paintings were known at the time as "Kuan's landscapes." My mentor Tung Wen-min [Tung Ch'i-ch'ang] once owned the painting *Autumn Forests and Evening Mists* by Kuan T'ung. Although the silk was peeling off, my master greatly admired the painting's spirited vigor, which anticipated the styles of generations of Sung masters. In painting, my mentor modeled himself after Pei-yüan [Tung Yüan, fl. ca. 945–ca. 960] and sometimes followed Mo-chieh [Wang Wei, 701–761], Chin-ch'ing [Wang Shen, 1036–after 1099], the two Mis [Mi Fu, 1051–1107, and Mi Yu-jen, 1074–1151], Fang-shan [Kao K'o-kung, 1248–1310], and the Four Yüan Masters. In all of his paintings that he gave to me or were collected by others, mists and clouds flowed in and out; the brushwork derived from nature. They attest to the saying, "Spiritual resonance is something inborn. It transcends the divine and enters the untrammeled." Nowadays everyone loves his works, though they may not fully understand them. In the late spring of the *keng-wu* year [1690] I reached the age of eighty. Tai Wu-chan [Tai Pen-hsiao, 1621–1693] from Li-yang, son of a *t'ung-nien* of mine, reached seventy. He came across the river from a thousand miles away to make a toast to me in celebration. His painting, lively yet elegant with an archaic flavor, derived from Ching [Hao] and Kuan [T'ung]. From his luggage he took out a small handscroll by my mentor, the imitation of the *Clearing after Snow on Mountain Passes*. It was given to him after he made an oath to heaven, as was Mi Fu-wen's [Mi Yu-jen] small handscroll in color, the *Hsiao-Hsiang t'u*, forcedly taken from its owner by Chai Po-shou [fl. early 12th century]. The painting, precipitous in perspective, eminent and vast in vision, corresponds to what I remembered of the remarks [on Kuan T'ung]. It was self-inscribed in the fifth month of the *i-hai* year [June 15–July 13, 1635], just a little over a year before my mentor died in the eighth month of the *ping-tzu* year [August 30–September 28, 1636]. This must be his last work. When I was fourteen, as I recall, my mentor praised my poems among friends and compared me to [the prodigy] Wang Tzu-an [Wang Po, 647–675]. For eleven years I was able to attend to him for his guidance; that was sixty or seventy years ago. It has also been almost fifty years since Mr. Tai Ho-ts'un [Tai Chung, 1602–1646] and I became *t'ung-hsüeh* and *t'ung-nien*. At that time Wu-chan was in attendance. It was so kind of him, thirty years ago, to frequent my Shui-hui Garden, together with Ch'en Ch'i-nien [Ch'en Wei-sung, 1626–1686] from Yang-hsien [I-hsing] to guide my two sons in their studies for several years. Ch'i-nien died long ago, and the Shui-hui Garden has become ruins among the weeds, yet [Tai Pen-hsiao and I] still live on calligraphy and painting. In our inscriptions and authentications of works of art, we are still able to transmit the knowledge of our mentor and friends and do honor to the masters of earlier times. I recorded this at the end of the scroll so that the descendants of both our families and all those who love antiques and learning who die after us may know that the bonds of our friendship and our common rapport with the classics never degenerate or fail to survive the test of time just because of poverty or old age. Chih-kao, Ch'ao-min lao-jen, Mao Hsiang wrote this colophon under lamplight.
(Translation by Shi-yee Liu Fiedler and Wai-kam Ho.)

關全畫師洪谷子，至廢寢食，思欲過之。其畫辣攉杳漠，皆能一筆湧出。上突巍峰下瞰窮谷，峭拔不可名狀，又多作關山掛幅。余臆記《五代名畫補遺》所載如此，當時稱爲"關家山水。"吾師董文敏公曾藏全《秋林暮靄圖》，雖絹素剝落，師極贊其風骨

猶能掩映宋代名手數輩。吾師畫師北苑，間出摩詰、晉卿、大小米、房山、元人四家。其與余畫，并見之他藏者，皆煙雲變沒，筆師造化，所謂"氣韻生知，超神入逸。"今人無不極好之，未必盡知之也。庚午晚春，馬齒正八十，歷陽年世友戴務旃亦年七十，涉江千里爲余舉觴。其畫之蒼古挺秀，則荊、關後身也。行笈中出吾師所臨《關山積雪圖》小卷，如米敷文著色袖珍《瀟湘圖》，爲翟伯壽豪奪，盟於天而與之者。其畫之上突下瞰，峭拔杳漠，正如余昔臆記所稱。計題畫爲乙亥五月間臨，去丙子八月吾師仙遊，不過年餘，乃絕筆也。思昔余年十四，吾師即叙其詩以傳，比之王子安，得侍教十有一年，即今皆六、七十年事。余與戴河村先生爲同學、同年友，亦將五十年，時務旃在侍。三十年前，務旃无恙兄弟，與陽羨陳其年俱相依水繪，偕兩兒讀書，經年屢歲。今其年久逝，水繪化爲孤墟蔓草。我兩人向以書畫覓食，品題鑒定，猶能緒述師友見聞，表章異代，特書卷尾，留視兩家子孫及海內好古讀書後死者，知我輩道義風雅，未嘗以貧賤夭朽一日不長留天地間也。雉臯巢民老人冒襄，燈下跋并書。

Ch'ing Kao-tsung 清高宗 (r. 1736–95), dated 1746

The enthusiasm of the colophons after this painting is entirely justified. The artist, in his eighty-first year and some fourteen months before his death, painted a work of astonishingly concentrated power. Twelve hundred years after Tsung Ping's (375–443) classic formulation of how "a horizontal stretch of several feet will form a distance of a hundred miles," Tung shows that the original meaning and its subsequent metaphorical truth can still be reinvested with undiminished force. Such is authentic originality in Chinese painting.

The scroll opens with an almost entirely blank edge that is immediately transformed into its polar opposite, a wall of opening spaces and closing brushwork. Borders and transitions became extremely critical in Chinese painting and no one understood this better than Tung. This confrontation is equally suddenly articulated into a classic categorization of near ground (with dwellings and trees), middle-ground hills, and remote mountains. An intervening space stretches disruptively downward from the central horizontal axis, and then the whole structure abruptly jumps into the upper border. This movement is concentrated and thematically restated in an upward sweeping configuration forming the dynamic axis around which turns the entire composition. It is followed by its negative expansion, in a powerfully arced space that plunges into the mass of mountains like the bow of a boat into a huge wave. This brings about a cataclysmic revisitation of the earlier bottom-to-top slope that initiated the mountains. The result is an explosive fragmentation of the structure into blocks of compressed space and shards of brushwork, threatening to lift the entire substance of the painting beyond the upper border. Unexpectedly, in what one might call a *deus ex pictura*, the rocks are suddenly restored to the softly rounded territory of Tung Yüan (fl. ca. 945–ca. 960), out of which roll the intestinal clouds in which Tung Ch'i-ch'ang so often found his fortitude. Here, in the recovered surface of his beloved painting, Tung inscribes himself.

Clearing after Snow on Mountain Passes could be analyzed again and again, always in different ways. The composition opens with the textures of Ni Tsan (1301–1374), breaks outrageously into the exotic realm of Ching Hao (ca. 870–80–ca. 935–40) and Kuan T'ung, col-

lects itself in time to revisit the source in Tung Yüan, and eventuates in the irresistible clouds of Mi Fu (1051–1107) and Kao K'o-kung (1248–1310). The play of textures throughout the painting, a marvelously adventurous exploitation of the riches of paper and brush, is masterful. The spatial manipulation through the horizontal composition is highly characteristic of this period, but its powerful structure is not. Tung has learnt most from Huang Kung-wang's (1269–1354) *Dwelling in the Fu-ch'un Mountains* (*Fu-ch'un shan-chü*; vol. 1, fig. 17), and it is tempting to suppose that he may have studied another masterwork closer in subject matter and title, Wen Cheng-ming's (1470–1559) *Snow Piling in Mountain Passes* (*Kuan-shan chi-hsüeh*; National Palace Museum, Taipei) finished in 1532. From the Northern Sung onward, painters exploited the hard-edged clarity of winter mountains to explore the multiple levels of structure in a landscape. Tung Ch'i-ch'ang's work presents another exemplary moment in that tradition. His achievement here also demonstrates the fact that, in general, only painters of the so-called Orthodox School had sufficient structural technology to compose long handscrolls of this quality.

Tung's inscription suggests that he may not have seen the "Kuan T'ung" for over a decade, and what it might have been like seems hardly to matter, although at some level it must have. He had certainly admired Kuan's work on occasion. Of another scroll by that artist in his collection, *Autumn Forests and Evening Mists*, he wrote, "The silk is much damaged, only the wind and bones remain, but it is still sufficient to surprise several generations of famous Sung artists. In the Yüan period, only Ni yü [Ni Tsan] understood his intention . . . " (*Jung-t'ai pieh-chi*, ch. 6, pp. 14–15). Mao Hsiang, in his colophon to the present scroll, refers to Tung's opinion of this other attribution. The "bones" and the "wind" were the most essential functions in the transmission of cultural lineage and one might indeed see them as paramount in Tung's painting here, even though this was presumably not the Kuan T'ung scroll in question. The intensity of this work perhaps reflects on the fact that it remained initially in his family. Hsiang Hsi-shui, who obtained the painting from Tung's grandson, may have been a descendant of Tung's early mentor Hsiang Yüan-pien (1525–1590). Ku Ta-shen was himself a painter who followed Tung closely. Tai Pen-hsiao was a fine but still rather obscure painter from Anhui, who was instrumental in introducing some of Tung Ch'i-ch'ang's influence into that region. He evidently saw the painting on a boat while Hsiang was carrying it about with him. Shen Ch'üan, a native of Sung-chiang and an exponent of Tung's calligraphic style, also seems to have seen the painting while it was still in Hsiang's hands, under similar circumstances. Mao Hsiang, one of the most romantic figures in seventeenth-century literati society, had been a literary protégé of Tung Ch'i-ch'ang and also published a collection of Tung's calligraphy. As noted in Howard Rogers's very helpful catalogue entry on this painting, the painting was much admired by An Ch'i before it passed into imperial hands, from which it later escaped at an unknown date (Rogers and Lee, *Ming and Qing Painting*, 1988, p. 147).

JH

EXHIBITIONS: Honolulu Academy of Arts, Hawaii, 1989: Rogers and Lee, *Ming and Qing Painting*, 1988, cat. no. 28.

LITERATURE: An Ch'i, *Mo-yüan, hui-kuan*, pref. dated 1742, ch. 5, p. 29; Xu Bangda, *Pien-nien-piao*, 1963, p. 104; Xu Bangda, *T'u-lu*, vol. 2, 1984, pl. 407; Xu Bangda, "Pien-wei," 1984, p. 208; Xu Bangda, *K'ao-pien*, 1984, vol. 4, pp. 157–328; *Chung-kuo ku-tai shu-hua mu-lu*, vol. 2, 1985, *Ching* 1–2190; Ren Daobin, *Hsi-nien*, 1988, p. 293; *Tung Ch'i-ch'ang hua-chi*, 1989, pl. 61; Zheng Wei, *Nien-p'u*, 1989, p. 223.

69 *Epitaph of Hsiang Yüan-pien,* running-regular script
Ming ku Mo-lin Hsiang-kung mu-chih-ming
董其昌　明故墨林項公墓誌銘

Dated 1635

Handscroll, ink on paper
27 x 543 cm (10⅝ x 213¾ in.)

Tokyo National Museum TB–1238

vol. 1, pl. 69 (detail); vol. 2, pl. 69

ARTIST'S TITLE (1 line in running-regular script, preceding the text in 99 lines):
"Epitaph of the Honorable deceased Hsiang Mo-lin [Hsiang Yüan-pien, 1525–1590] of the Ming"
《明故墨林項公墓誌銘》

ARTIST'S INSCRIPTION AND SIGNATURE (5 lines in running script, following the text):
The refined scholar Mo-lin's [Hsiang Yüan-pien] fame filled the Wu and Yüeh regions [Kiangsu and Chekiang provinces]. This epitaph of mine was written to give substance to the glory of his spirit. His second grandson [Hsiang Miao-mo] paid me a visit and invited me to transcribe it for him to have carved in stone [after I had composed it upon the invitation of Hsiang's second son, Hsiang Te-ch'eng]. This is a custom of the descendants of the noble families of old, like the Wangs and the Hsiehs. Written in the eighth year of the Ch'ung-chen era, the *tzu* month of the *i-hai* year [October 1635] and inscribed by Tung Ch'i-ch'ang.

墨林雅士名滿吳越間。余此誌亦具其神照。次孫相訪請余書，且以鎸石。亦王謝子弟家風也。書此應之。崇禎八年，乙亥子月，董其昌題。

ARTIST'S SEALS:
Tsung-po hsüeh-shih 宗伯學士 (*pai-wen*, square) **103**
Tung-shih Hsüan-tsai 董氏玄宰 (*pai-wen*, square) **104**

COLOPHONS:
Ch'en Chi-ju 陳繼儒 (1558–1639), undated, 1 seal:
. . .This handscroll by Ssu-weng [Tung Ch'i-ch'ang] is written in the manner of Junior Imperial Preceptor Yang's [Yang Ning-shih, 873–954] *Chiu-hua t'ieh* ["Thank-you for a Gift of Leeks"]. Tung wrote this when he was eighty-one. What a wonder! What a wonder!
⋯思翁此卷學楊少師《韭花帖》。八十一書此。大奇！大奇！

Fan Yün-lin 范允臨 (1558–1641), undated, 2 seals; Wang T'ing-tsai 王廷宰 (17th century), dated 1645, 3 seals; Kao Meng-ch'ao 高孟超 (17th century), dated 1645, 3 seals; Chang T'ing-chi 張廷濟 (1768–1848), dated 1834 and 1837, 3 seals; Chin Sen 金森 (19th century), dated 1835; Chin Jung-ching 金蓉鏡 (1856–1928), dated 1928, 2 seals; Ch'u Te-i 褚德彝 (1871–1942), dated 1928; Huang Pao-wu 黃葆戊 (20th century), undated, 1 seal.

COLLECTORS' SEALS: Hsiang Yü-k'uei 項禹揆 (17th century), 11; Hsiang Hui-mo 項徽謨 (1605–1686), 1; Hsiang K'uei 項奎 (17th century), 3; Kao Shih-ch'i 高士奇 (1645–1704), 6; Chang T'ing-chi, 5; Ch'en Hsi-lien 陳希濂 (18th century), 2; Hu Chung 胡重 (19th century?), 1; Lu Hsin-yüan 陸心源 (1834–1894), 6; Lu Shu-sheng 陸樹聲 (19th century), 2; Fei Nien-tz'u 費念慈 (1855–1905), 1; P'ei Ching-fu 斐景福 (1854–1926), 12; Li Shu-t'ung 李叔同 (1880–1942), 2; Lin Hsiung-kuang 林熊光 (d. 1971), 1; Takashima Kikujiro 高島菊次郎 (20th century), 1; unidentified, 16

RECENT PROVENANCE: Takashima Kikujiro

Of the formative events in Tung Ch'i-ch'ang's life, his exposure to Hsiang Yüan-pien's collection of ancient painting and calligraphy must surely be considered among the most significant. A friend and fellow student of the eldest of the six Hsiang sons, Hsiang Mu (*tzu* Te-ch'un, b. 1551), Tung entered the collector's household as a *chu-sheng* in the 1570s, and, according to his own account in the text of this epitaph, was, on a daily basis, able to rub shoulders with Hsiang's knowledgeable friends and feast his eyes on numerous paintings and calligraphies of venerable antiquity, which left an indelible imprint on him. While it is certainly true that in his subsequent career Tung encountered other notable collections and befriended other esteemed collectors—such as Han Shih-neng (1528–1598) and Wu T'ing (ca. 1555–after 1626)—this early experience of close and repeated dialogue with the objects from the Hsiang collection molded his artistic taste and kindled in him a love for the antique. The opportunity to view ancient works of such peerless quality and inestimable quantity would play a paramount role in the formation of his intellectual and artistic growth.

According to Tung, it was only after viewing in the Hsiang household the genuine scrolls of the Wei-Chin, T'ang, and Sung periods, rather than the carved versions he had previously known, that he was able to intuit the secrets of using brush and ink. Considered in the light of his vivid pronouncement on art and nature concerning the superiority of brush and ink to the natural landscape, one cannot take the substance of this intuition lightly, for it formed the matrix of his aesthetic approach to both painting and calligraphy. Moreover, being exposed to numerous ancient works from several dynasties gave Tung the opportunity to compare and contrast, to formulate a notion of historical sequence, and to characterize what was important about particular artists or dynasties. In calligraphy, for example, he stated that the Eastern Chin masters excelled in *yün* 韻 (resonance or lyric grace), the T'ang masters in *fa* 法 (methods or principles), and the Sung masters in *i* 意 (ideas or concepts). This centuries-old characterization provides intellectual fodder for even the contemporary historian.

In composing this epitaph, which he did sometime before 1622 at the invitation of Hsiang's second son, Tung had the chance to reflect on the senior Hsiang's importance for him. He compares Hsiang to the two learned connoisseur-collectors of the Northern Sung, Li Kung-lin (ca. 1049–1106) and Mi Fu (1051–1107), both of whom helped define the levels of taste and the parameters of collecting antiquities as integral to a certain way of life. In addition to artistic activities, Tung describes how Hsiang's philanthropic efforts helped offset the effects of a great famine in 1588 and how he raised his six sons to be models of filial loyalty. Tung describes how Hsiang loved to paint landscapes

after the Yüan masters Huang Kung-wang (1269–1354) and Ni Tsan (1301–1374), but says that he was especially "intoxicated" with Ni; Tung praises Hsiang as having grasped Ni's "outstanding flavor." Hsiang's calligraphy was modeled on that of Chih-yung—the late sixth century descendant of Wang Hsi-chih (303–379)—and Chao Meng-fu (1254–1322), and was avidly sought after by collectors.

While Tung's acknowledgment of the importance of Hsiang Yüan-pien and his collection is a point well taken, the reverse is also true—that Tung's formulation of the Northern and Southern schools theory and its ramifications also validated and rendered more significant the contents of Hsiang's collection (as well as others), especially when it resulted in the placing of Tung's imprimatur, in the form of colophons and inscriptions, on the works. As for the influence of such ancient art on Tung, one need only review the works dating to the four decades of his mature artistic development to see that he returned time and again to the masterpieces that had originally nurtured his aesthetic sensibilities. This is especially true of the calligraphy from the Four Sung Masters (see cat. nos. 10, 34, 64) from Hsiang's collection. (A similar survey could be done of the paintings in Hsiang's collection.)

This epitaph is a superb example of the creative process Tung himself described: "With old age comes familiarity, and, eventually, the birth of simplicity and ease" (*Hua-ch'an shih sui-pi*, ch. 1, p. 15). This quality of simplicity and ease, or plainness and naturalness, was one Tung had sought since his earliest theoretical musings (see cat. no. 1), and one that, except for occasional flashes of insight when inspired by Huai-su (fl. late 8th century) or Tung Yüan (fl. ca. 945–ca. 960) and Ni Tsan, effectively eluded him until the last decade of his life. In a work such as this epitaph, however, the use of an old worn-out writing implement, the direct brush attack, the absence of extraneous and flamboyant maneuvers, and the steady measured pulse of the characters within each column all point to the weighty artistic powers still within Tung's grasp.

Tung transcribed his *Epitaph of Hsiang Yüan-pien* in the autumn of 1635, the year before his death. While there are later dated works in this exhibition and in other collections, this handscroll is remarkable for the concatenation of personages and events, both historical and art historical, that it summarizes. Its handsome pedigree of collectors' seals and colophons also testifies to the esteem in which it has been held from Tung's death to recent times.

MWG

LITERATURE: *Jung-t'ai wen-chi*, ch. 8, p. 30; Kao Shih-ch'i, *Chiang-ts'un shu-hua mu*, repr. 1968; Lu Hsin-yüan, *Jang-li-kuan kuo-yen-lu, hsü*, 1892, repr. 1975, *ch.* 8, p. 14; Xu Bangda, *Pien-nien-piao*, 1963, p. 104; Takashima, *Kaiankyo rakuji*, 1964, cat. no. 169; *Illustrated Catalogues of the Tokyo National Museum*, 1980, cat. no. 105; Kohara, *To Kisho no shoga*, 1981, vol. 1, pp. 269–70; vol. 2, pl. 69; Ren Daobin, *Hsi-nien*, 1988, p. 298; Zheng Wei, *Nien-p'u*, 1989, pp. 226–27.

70 *Detailed and Complex Landscape in the Sung Manner*

Hsi-so Sung-fa shan-shui

董其昌　細瑣宋法山水

Dated 1636

Handscroll, ink on paper

25.3 x 111.4 cm (9¹⁵⁄₁₆ x 43⅞ in.)

Shanghai Museum

vol. 1, pl. 70

ARTIST'S INSCRIPTION AND SIGNATURE (6 lines in running script): Until now I have painted few handscrolls. After turning eighty-one *sui*, I have been painting handscrolls more often to test my eyesight. I once saw Shen Ch'i-nan's [Shen Chou, 1427–1509] handscroll in the manner of Mei-hua tao-jen [Wu Chen, 1280–1354], painted when Shen was eighty-one *sui*. At that time I was seventy-nine and worried that after turning eighty I would no longer be able [to paint handscrolls]. Today I nonetheless painted this detailed and complex work in the Sung manner for my son Tsu-ching to keep so that he may know the signs of growing old. Two days before the Double Ninth [ninth day] of the ninth month of the *ping-tzu* year (October 5, 1636). Ssu-weng. (Translation by Joseph Chang and Ankeney Weitz.)

山水卷不多作，自八十一歲後時復爲之，以試眼力。曾觀沈啓南八十一歲做梅花道人卷，彼時吾年七十九，恐八十後無復能事。今乃益作細瑣宋法與兒祖京收藏，以知吾老去盛衰之候。丙子九月重九前二日，思翁。

NO ARTIST'S SEALS

FRONTISPIECE: Li Shih-mei 李式郿, dated 1802, 2 seals

COLOPHON: Huang Hsi-shuang 黃西爽

COLLECTORS' SEALS: Ch'ien Ching-t'ang 錢鏡塘 (20th century), 2; Wang T'ung-wen 王彤文, 1; unidentified, 2

LITERATURE: Zheng Wei, *Nien-p'u*, 1989, p. 232; *Chung-kuo shu-hua t'u-mu*, vol. 3, 1990, *Hu* 1–1381.

71 *Self-transcribed Imperial Decree of Appointments, regular script*

K'ai-shu tzu-shu ch'ih-kao

董其昌　楷書自書勅誥

Dated 1636

Album of sixteen leaves, ink on paper

29.9 x 30.8 cm (11¾ x 12⅛ in.)

Shanghai Museum

vol. 1, pl. 71 (detail); vol. 2, pl. 71

ARTIST'S TRANSCRIPTION (126 lines in regular script of an imperial decree conferring upon him the prestige title Grand Master for Splendid Happiness [*Kuang-lu tai-fu*]. Translated excerpts appear below):

Leaf 10:
. . . When the Honorable Yen Lu-kung [Yen Chen-ch'ing, 709–785] served at court, he not only transcribed patents but also wrote his imperial decree conferring his official patent [in 780]. The original is in the collection of Han Tsung-po [Han Shih-neng, 1528–1598] of Kiangsu. Ts'ai Chün-mo [Ts'ai Hsiang, 1012–1067] wrote a colophon [dated 1055] saying, "This is Lu-kung's own transcription of his patent. Ts'ai Hsiang of Fu-yang [Fukien] fasted and abstained before viewing." Such was [Ts'ai's] loyalty, filiality, and great purity to be remembered generations after, not only for his calligraphy alone. . . .

…顏魯公嘗爲朝士書官告，亦復自書告身。真蹟藏吳門韓宗伯家。蔡君謨跋云：「此魯公自書告身。莆陽蔡襄齋戒以觀。」其忠孝大節，不獨書法足傳耳。…

ARTIST'S INSCRIPTIONS AND SIGNATURE (2 lines in regular script):
Leaf 14:
Written on the fifteenth day of the third month of the *ping-tzu* year, the ninth year of the Ch'ung-chen era [March 21, 1636], by servitor Tung Ch'i-ch'ang.

崇禎九年，歲在丙子三月望，臣董其昌書。

Leaves 15–16:
Recording the names of witnesses to the patent: Wang T'u (1557–1627), Junior Compiler and Examining Editor in the Han-lin Academy; Lai Tsung-tao (*chin-shih* 1604), Vice Minister in the Court of Imperial Sacrifices and Academician Reader-in-waiting, as well as Right Vice Minister of Rites; Lo Yü-i (*chin-shih* 1613), Right Vice Minister of Rites and Advisor in the Household Administration of the Heir Apparent; and Hsü Shih-jou (1587–1642), Grand Master for Splendid Happiness, Grand Guardian of the Heir Apparent and Minister of Rites, as well as Han-lin Academician in Charge of the Household Administration of the Heir Apparent in addition to Right Secretariat and Right Mentor of the Household of the Heir Apparent.

NO ARTIST'S SEALS OR COLOPHONS

COLLECTORS' SEALS: Chin Wang-ch'iao 金望喬 (19th century), 4; Shen Chien-chih 沈劍知 (20th century), 1

RECENT PROVENANCE: Sun Yü-feng

Like the modern-day diplomas, certificates, and awards that might line the office walls of a distinguished physician or lawyer, imperial decrees and official patents in traditional China would be displayed in ancestral halls for the proper instruction and admiration of succeeding generations. Such was the function of a document like this one: the imperial decree conferring the highest honorific title in officialdom to the artist and statesman Tung Ch'i-ch'ang, transcribed by his own hand in the final year of his life.

It is not a work done for artistic purposes, but rather sums up in correctly splendiferous terms Tung's engagement with his professional career, as it notes virtually all of his official titles, including Minister of Rites (*Li-pu shang-shu*, rank 2b), Han-lin Academician in Charge of Household Administration of the Heir Apparent (*Han-lin yüan hsüeh-shih chang Chan-shih fu shih*, rank 3a–4b), and his highest title, Grand Guardian of the Heir Apparent (*T'ai-tzu t'ai-pao*, rank 1b). Written in a small regular script with running elements and neatly scored with a grid, this document represents an act of diligent concentration and a lifetime of discipline. Tung apparently had copied out

more than one of his own patents; another, dated to 1624, is in the Beijing Palace Museum (see Celia Carrington Riely, "Tung Ch'i-ch'ang's Life," part 6, in vol. 2 of this catalogue).

The history of the patent (*kao* 告, *kao-shen* 告身, or *kao-ming* 誥命) dates to the seventh and eighth centuries, during the T'ang dynasty. As Tung's text relates, one of the most celebrated examples from the period was that of the great Yen Chen-ch'ing, who transcribed the proclamation of his patent in 780, which conferred the same title Tung received in this one, Grand Master for Splendid Happiness (see *Shodo zenshu*, 1966, vol. 10, pl. 60). Having written a colophon to it and copied it a number of times, Tung knew the work well when it was in his teacher Han Shih-neng's collection; one such copy is extant in hanging scroll form in the National Palace Museum, Taipei (Kohara, *To Kisho no shoga*, 1981, vol. 2, no. 75). Tung copied a number of other formal official documents from the T'ang, such as one in regular script by Chang Hsü (fl. second half of the 8th century; Kohara, *To Kisho no shoga*, vol. 2, no. 76). In his colophon to the original Yen Chen-ch'ing patent, Tung mentions that he regards such disciplined writing as the foundation of the "wild cursive" script associated with Chang Hsü (Kohara, *To Kisho no shoga*, vol. 1, p. 272). This statement reveals how much Tung respected regular script, understood its history, and regarded its serious practice as the basis for artistic expression in other scripts. From this, one can also see how the present document, so resplendent with official titles but so unassuming artistically, actually embodies the kernel of Tung's most cherished artistic ideas.

MWG

LITERATURE: *Chung-kuo ku-tai shu-hua mu-lu*, vol. 3, 1987, *Hu* 1–1379; Zheng Wei, *Nien-p'u*, 1989, p. 229; *Chung-kuo ku-tai shu-hua t'u-mu*, vol. 3, 1990, *Hu* 1–1379.

72 *Four Letters and Copies of the Two Ink Rubbings "Huan-shih" and "Hsüan-shih" T'ieh*

Ch'ih-tu ssu-t'ung chi lin "Huan-shih" yü "Hsüan-shih" erh-t'ieh
董其昌　尺牘四通及臨《還示》與《宣示》二帖

Dated 1636

Album of twelve leaves, ink on paper
Average 22.3 x 9.4cm (8¾ x 3¹¹⁄₁₆ in.)

Shanghai Museum
vol. 1, pl. 72 (detail); vol. 2, pl. 72

Part 1:
Four letters, three on ruled paper (leaves 1–6), in regular script

ARTIST'S SIGNATURE (1 line in running script, on the fourth letter, leaf 8):
Ch'i-ch'ang
其昌

Part 2:
ARTIST'S TITLE (1 line in small regular script, preceding a transcription in 6 lines of a text by Chung Yu [d. 230], leaves 9–10):
"Huan-shih t'ieh" [Reply] of the Grand Mentor Chung [Yu]

鍾太傅《還示帖》

ARTIST'S TITLE (1 line in small regular script, preceding a transcription in running-regular script of Chung Yu's text, leaves 11–12):
"Hsüan-shih t'ieh" [Proclamation]

《宣示帖》

ARTIST'S SIGNATURE (1 line in running script, following the transcription of the text, leaf 12):
The old man of eighty-two *sui*, Ch'i-ch'ang, wrote from memory.

八十二翁，其昌背臨。

ARTIST'S SEALS:
[*Tung*] *Ch'i-ch'ang* [*yin?*] 其昌 (*chu-wen*, half seal) 145
Hsüan-tsai 玄宰 (*pai-wen*, square) 146

COLOPHON: (unidentified), dated 1636:
In the *ping-tzu* year, the ninth year of the Ch'ung-chen era [1636], Hsiang-kuang [Tung Ch'i-ch'ang] was eighty-two *sui*. The Honorable Gentleman died in that year, and he also copied [these two works] by the Grand Mentor Chung [Yu].

崇禎九年丙子，香光年八十有二。公即卒於是年，此臨鍾太傅。

COLLECTOR'S SEAL: unidentified, 1

Works dated in the final year of a master's life assume a particular poignancy when viewed in light of an entire artistic career. In reviewing the extant and recorded works Tung Ch'i-ch'ang completed in the last several years of his life, one is struck by the wide range of interests he maintained up to the very end. There is no particular emphasis on any master or dynasty. Perhaps in calligraphy one might have expected a renewed interest in the favorite masters of earlier decades, such as Yen Chen-ch'ing (709–785) or Huai-su (fl. late 8th century) of the T'ang, or possibly the Sung masters Su Shih (1036–1101) or Mi Fu (1051–1107). In fact, one finds Tung continuing the same steady pattern of engagement with all the masters from the Wei-Chin period up through the T'ang and Sung.

One calligrapher found infrequently in the copies of Tung's earlier years is Chung Yu, who was known for his small-regular script. While it is true that, in his statements about his early study of calligraphy, Tung mentions Chung Yu's name in the same breath as that of Wang Hsi-chih (303–379), few of Tung's copies after this early master are extant. It might not be of little importance that the works known to Tung were available only in the form of rubbings taken from carved examples reproduced in the *Ch'un-hua ko t'ieh* compilation, dating from the tenth century. The *t'ieh* 帖, or model writing, from this collection formed the basis for his knowledge of calligraphy in the earliest stages of his practice in the 1570s until he had the opportunity to study the original works of calligraphy in the collection of Hsiang Yüan-pien (1525–1590) and others, such as his teacher Han Shih-neng (1528–1598) and friend Wu T'ing (ca. 1555–after 1626), and until he began his successful climb up the political ladder, which gained him access to the other masterworks upon which he would base his connoisseurship. The carvings in the *Ch'un-hua ko t'ieh* register the revival of interest in Chung Yu's calligraphy as the principal model of small-sized regular script in the Sung period. While interest in Chung Yu suffered a slight decline in the next period, during the Yüan (due primarily to the overarching interest of Yüan masters in the Two Wangs

and the "Orchid Pavilion Preface," and in brushwritten originals), the Ming period witnessed a revival of interest in Chung as part of the general predilection of scholars for printed books, collections of carved reproductions, and a host of scholarly *objets de vertu*. (See Li and Watt, *The Chinese Scholar's Studio*, 1987, chaps. 1, 6.)

Tung Ch'i-ch'ang's however, was no mere antiquarian taste, but rather part of a total program to master the entire carved and brushwritten tradition of masterworks in the history of calligraphic art. Here, in his copy of two of the most familiar works associated with Chung Yu, one can see the success of his program. The significant phrase appears in Tung's signature, "the eighty-two-year-old man, Ch'i-ch'ang, wrote from memory." Despite his age, Tung could muster formidable resources garnered over a lifetime of disciplined study. Thus in the present work one glimpses almost the entire history of Tung's intensive study of antiquity: there is of course no obvious "resemblance" to the third-century master except as a mnemonic device for the text of the two essays, in the respectful formality of the title, and in the choice of script. Beyond that, one can identify individual components from the spectrum of Tung's study of the past, from Wang Hsi-chih (the *chih* 之 ideograph and the feeling of rhythmic poise in the succession of characters down each column); to the T'ang masters Ou-yang Hsün (557–641; the "tight" and slightly elongated internal structure of some forms), Ch'u Sui-liang (596–658; the "openness" of other forms), and Yen Chen-ch'ing (the heavier brushwork in some characters and the overall regularity and disciplined "look" of the composition); to the Sung master Mi Fu (the sense of elegant refinement and fluency, in spite of the worn-out brush Tung preferred in his old age). These influences inform the characters in no obvious way but have been thoroughly internalized to become second nature, a process that is released in the act of writing from memory or by heart.

MWG

LITERATURE: *Chung-kuo ku-tai shu-hua mu-lu*, vol. 3, 1987, *Hu* 1–1382.

73 *Landscape in the Manner of Huang Kung-wang (tai-pi)*

Fang Huang Tzu-chiu pi-i shan-shui
董其昌　倣黃子久筆意山水

Undated

Hanging scroll, ink on silk
113 x 52.1 cm (44½ x 20½ in.)

Shanghai Museum

vol. 1, pl. 73

ARTIST'S INSCRIPTION AND SIGNATURE (2 lines in running script): Imitating Huang Tzu-chiu's [Huang Kung-wang, 1269–1354] brush manner. Hsüan-tsai.

倣黃子久筆意。玄宰。

ARTIST'S SEAL:
Tung-shih Hsüan-tsai 董氏玄宰 (*pai-wen*, square) 112

COLOPHON: Wu Hu-fan 吳湖帆 (1894–1968), undated, 1 seal

NO COLLECTORS' SEALS

LITERATURE: *Tung Ch'i-ch'ang hua-chi*, 1989, pl. 102.

74 *Manuscript*

Ts'ao-kao
董其昌　草稿

Undated

Handscroll, ink on paper
25.9 x 367.8 cm (10³⁄₁₆ x 144¹³⁄₁₆ in.)

Lent by John B. Elliott L.1970.298

vol. 1, pl. 74 (detail); vol. 2, pl. 74

NO ARTIST'S INSCRIPTION, SIGNATURE, OR SEALS

LABEL STRIP: Kuei Fu 桂馥 (1735–1805), undated, 1 seal:
Manuscript by Tung Hua-t'ing [Tung Ch'i-ch'ang]

董華亭草稿

COLOPHONS: Wu Yu-sung 吳友松 (18th century) and four others, dated 1792, 1 seal; Kuei Fu, dated 1793, 1 seal; Weng Fang-kang 翁方綱 (1733–1818), dated 1793, 1 seal; Sung Ssu-wen 宋思文 (18th century) and three others, dated 1793; Juan Yüan 阮元 (1764–1849), dated 1793, 1 seal; Fang Fu 方輔 (18th century), dated 1797, 2 seals; Ch'en Yü-chung 陳豫鐘 (1762–1806), dated 1800, 1 seal; Ch'eng Yao-t'ien 程瑤田 (1725–1814), dated 1802, 3 seals; Fang Fang-p'ei 方芳佩 (19th century), dated 1803, 1 seal; Hung Fan 洪範 (19th century), dated 1806, 2 seals; Chi Erh-ch'ing 季爾慶 (19th century), undated, 4 seals

Colophon by Juan Yüan:
A Genuine Manuscript by Tung Tsung-po [Tung Ch'i-ch'ang]. Authenticated by Juan Yüan in the *kuei-ch'ou* year [1793] of the Ch'ien-lung era.

董宗伯草篆真蹟。乾隆癸丑，阮元審定。

COLLECTORS' SEALS: Chu Chün-shan 朱君山, 1; unidentified, 2

This unusual work represents a rough draft or the makings of an essay on a number of different subjects, including some aspect of the sixteenth-century Wu School of painting; the names Shen Chou (1427–1509) and Wen Cheng-ming (1470–1559) appear in the text. Double and triple emendations abound. Entire lines have been deleted with a single vertical stroke, whereas other passages have been emphasized with a series of repeated dots. Restored characters or passages have been marked by a series of circles next to the deleted text. In some cases, as in those phrases that appear to be biographical notes, the circles in the main column follow text and represent passages to be filled in after research was completed.

Artistically, such a manuscript helps one appreciate the author's more polished writing and makes one aware of the degree of formality

present in his other works. It also underscores the importance of the script type selected for each work and its relationship to the named text, whether an essay, poem, or memorial. The manuscript shows the author in his least self-conscious, possibly most natural mode, as there is no intention of presentation. The brushwork and character forms, the layout of the columns and the manner of emendation, and even the type of worn-out brush favored all reveal the author's level of scholarly training and refinement.

Judgments of authorship and authenticity in such a manuscript might appear difficult, but this work has been confidently authenticated by two renowned scholars, Weng Fang-kang and Juan Yüan. Both were active in the epigraphical movement that had its beginnings as early as the tenth and eleventh centuries, during the Northern Sung, but that became most influential from the late seventeenth to the early twentieth centuries, when it was referred to as the study of bronze and stone inscriptions (*chin-shih-hsüeh* 金石學). Weng Fang-kang, one of the most senior of the colophon writers, signed his comments on yellow T'ang dynasty sutra paper and noted that he had seen other manuscripts of this type by Tung; he compares this work to that of the T'ang master Yen Chen-ch'ing (709–785) and the Five Dynasties calligrapher Yang Ning-shih (873–954), adding that only Tung Ch'i-ch'ang could match them. Yen's "Memorial on the Death of his Nephew, Chi-ming," dated 758 (National Palace Museum, Taipei), is one of the rare brushwritten masterpieces extant from the T'ang period; it reveals the calligrapher at a profound period of grief over the barbaric sacrifice of several family members during the tragic An Lu-shan rebellion. The brushwritten examples of Yang Ning-shih's calligraphy are equally rare, but less well-known; Weng Fang-kang may be referring to the spontaneous colophon dated 947 and found at the end of Lu Hung's (fl. first half of the 8th century) *Ten Views from a Thatched Cottage* (*Ts'ao-t'ang shih-chih*), now in the National Palace Museum, Taipei (see Fu et al., *Traces of the Brush*, 1977, p. 181, fig. 71).

The authentication by Juan Yüan carries particular authority because this formidable scholar, author, antiquarian, and bibliographer counted among his many achievements the co-editorship of the second installment of the Ch'ing emperor Kao-tsung's (r. 1736–95) imperial catalogue of painting and calligraphy, the *Shih-ch'ü pao-chi hsü-pien* (1793), which included the responsibility of selecting and authenticating the emperor's vast holdings.

MWG

LITERATURE: Suzuki, *Comprehensive Illustrated Catalogue*, 1982–83, vol. 1, A17–102.

Mo Ju-chung (1509–1589) 莫如忠

tzu Tzu-liang 子良, *hao* Chung-chiang 中江

A native of Hua-t'ing in Sung-chiang prefecture (in modern Kiangsu province), Mo Ju-chung was among the first to recognize the talent and promise of Tung Ch'i-ch'ang. Mo, who invited Tung to attend the Mo family school in 1571 or thereabouts, was to have a decisive influence on the intellectual and artistic development of his young pupil and protégé.

Beginning in 1538, the year he obtained his *chin-shih* degree, Mo advanced steadily in his official career, rising ultimately to the position of Chekiang Provincial Administration Right Commissioner in 1570. During his long career, Mo achieved a reputation as a connoisseur of paintings and an accomplished poet and calligrapher. He associated with many distinguished officials and scholars, including Ho Liang-chün (1506–1573), Lu Shu-sheng (1509–1605), and Wang Shih-chen (1634–1711), and with his son Shih-lung (1537–1587) participated in some of the most exclusive literary gatherings in the Chiang-nan region.

75 *Poems,* running script
Hsing-shu shih
Mo Ju-chung and Mo Shih-lung
莫如忠　莫是龍　行書詩

Dated 1578

Handscroll, ink on paper
Three sections: (1) 19.6 x 41.6 cm (7¹¹⁄₁₆ x 16⅜ in.); (2) 18.8 x 176.3 cm (7⅜ x 69⁷⁄₁₆ in.); (3) 18.8 x 108.1 cm (7⅜ x 42⁹⁄₁₆ in.)

Beijing Palace Museum

vol. 1, pl. 75

Section 1:
ARTIST'S INSCRIPTION AND SIGNATURE (2 lines in running script, following a prose passage in 7 lines in running script describing an outing with friends to visit a cousin, and two poems in five-character regulated meter in 6 and 5 lines, respectively, written to remember the event): Chung-chiang, Mo Ju-chung bows his head to present this manuscript. 中江莫如忠頓首稿。

ARTIST'S SEAL:
Mo-shih Tzu-liang 莫氏子良 (*pai-wen*, square)

Section 2:
ARTIST'S TITLES (in running script, preceding four poems in five-character regulated meter): "An evening gathering with the Junior Compiler Shen Mao-jen" (in 2 lines; poem in 9 lines); "In response to a poem sent by Sung Tzu-ch'eng" (in 2 lines; poem in 8 lines); "Crossing Chin Mountain" (in 1 line; poem in 9 lines); and "To Ch'ien Ch'iu-p'u" (in 1 line; poem in 8 lines).

ARTIST'S SIGNATURE (following the four poems):
Yün-ch'ing [Mo Shih-lung]
雲卿

ARTIST'S SEALS:

Chʻiao-feng tiao-ku 樵峰釣谷 (*pai-wen*, rectangle)
Mo-shih Tʻing-han 莫氏廷韓 (*pai-wen*, square)
Mo Yün-chʻing yin 莫雲卿印 (*pai-wen*, square)

Section 3:

ARTIST'S INSCRIPTION (4 lines in running script, preceding a poem in seven-character regulated meter in 15 lines):

Writing a poem with Po-lung using the [twelve characters] from the phrase, "Chang Yü-ju lü-chʻiung-shu hua-hsia-chʻi teng-chʻien-yü" [to begin each line].

用 "張玉如侶瓊樹花下期燈前遇" 排首字聯句，與伯龍同賦。

ARTIST'S INSCRIPTION AND SIGNATURE (10 lines in running script, following the poem):

I wrote this poem in late spring of the *ping-tzu* year [1576]. Now when I think about it, the lady Yü-ju is so vague, like a thousand miles distant. I came across this draft and, happily, feel the rhymes to be fresh and the expression not too awkward. Remembering our wanderings together, I record this casually at the Listening to the Jade Hall and leave it as the subject for local gossip. In late autumn of the *wu-yin* year [1578], Mo Yün-chʻing, Tʻing-han [Mo Shih-lung] records.

余作此詩於丙子暮春。今所稱玉如生者，已渺然千里之外矣！偶撿舊稿，喜其格新而語不甚窘，興懷舊游。漫錄於聽玉館中，留作談柄云耳。時戊寅晚秋也。莫雲卿，廷韓甫記。

ARTIST'S SEALS:

Yün-chʻing 雲卿 (*pai-wen*, rectangle)
Tʻing-han shih 廷韓氏 (*pai-wen*, square)

NO COLOPHONS

COLLECTORS' SEALS: Han Te-shou 韓德壽, 2; Wen Yün-hsin 溫雲心, 2; unidentified, 6

Mo Ju-chung was Tung Chʻi-chʻang's teacher in the early 1570s, when Tung came to study at the Mo family school. Ju-chung's son Shih-lung, who was eighteen years older than Tung, was a prodigy in his own right. (For information on Tung's relationship with the two Mos, see Celia Carrington Riely, "Tung Chʻi-chʻang's Life," part 1, and Wang Shiqing, "Tung Chʻi-chʻang's Circle," part 1, in vol. 2 of this catalogue.) Tung's assessment of his teacher is duly respectful and tells us what he considered important about the senior Mo:

In my district, the Provincial Administration Commissioner Mo Chung-chiang [Mo Ju-chung] studied the calligraphy of Yu-chün [Wang Hsi-chih, 303–379], which he said he mastered through the [model rubbing] *Sheng-chiao hsü* [672; compiled by the Tʻang dynasty monk Huai-su]. But his calligraphy still differs somewhat from that work, and is deeply imbued with ancient brushwork. He is one of the illustrious gentlemen of the present, and really cannot be surpassed by anyone. Whenever I question him about his sources, he is too modest and refuses to say. In 1579, however, when I was in the [old] capital [Nanking] for an examination, I chanced to see the original of the *Kuan-nu tʻieh* of Wang Yu-chün. How it resembled my teacher's writing! From then on I began to understand how deeply he had grasped the art of the Two Wangs. His son, Yün-chʻing [Mo Shih-lung], also excelled in calligraphy. (*Hua-chʻan shih sui-pi*, ch. 1, pp. 5–6)

Tung Chʻi-chʻang's study of the *Kuan-nu tʻieh* (see vol. 1, fig. 48) also formed a turning point in his understanding of Wang Hsi-chih and

his son Wang Hsien-chih (344–388) during the period of Tung's early study of calligraphy, in the 1570s and 1580s, when he became acquainted with the ancient works in the collection of Hsiang Yüan-pien (1525–1590). Recent studies of Mo Ju-chung and Mo Shih-lung point to the Two Wangs and Mi Fu (1051–1107) as the prime sources for their calligraphy. However, the extent to which Ju-chung and Shih-lung studied originals and whether they did so with the same discerning eye as Tung remains undetermined.

A preliminary survey of the extant calligraphy of the two Mos produces a list of about a dozen works: letters and poems (Tokyo National Museum and Museum of Calligraphy, Tokyo) and hanging scrolls (e.g. Shanghai Museum; *Chung-kuo mei-shu chʻüan-chi*, 1989, vol. 5, pl. 89), all in medium or large running script, and one handscroll in large cursive script (Tokyo National Museum; *Illustrated Catalogues of the Tokyo National Museum*, 1980, no. 15). A comparison of the present Beijing handscroll with this corpus shows a predictable consistency in the style of writing, possibly because so little of the work of these two calligraphers is extant.

The Tokyo handscroll by Mo Shih-lung, however, is the anomaly which, fortunately, substantiates the biographical evidence about his early, though ultimately unfulfilled, promise as a calligrapher. Undated, it was presumably written before the sequence of unsuccessful attempts to obtain the *chin-shih* degree had completely sapped Shih-lung of all his resources. Aesthetically, the exhilarating cursive script is exactly the type of calligraphy that would have made the young Tung Chʻi-chʻang take notice and wish to emulate. In the present Beijing scroll, the third section of Mo's poems is dated 1578, when he was forty-two *sui* (forty-one years old) and four years after his first attempt at the metropolitan examinations. Although a more modest undertaking than the undated Tokyo scroll, this work also displays some of the same powers that earned him praise as a youth: the supple brushwork, the rhythmic contrast of rounded turning strokes with square or angular entering strokes, corners, and diagonals, as well as the disciplined compositional arrangement, columnar spacing, and consistency of script type.

Mo Ju-chung's writing, while smaller and with reduced columnar spacing, presents character structures similar to Shih-lung's: relatively tall and narrow with constricted "waists" and the same mixture of square plus round (or centered) brush tip strokes. Ju-chung's narrower spacing between columns of characters shows an affinity to the Yüan masters, as does his mixture of angular and rounded brushwork. This is also true of the overall flavor of Shih-lung's writing. The works of Yüan calligraphers such as Teng Wen-yüan (1259–1328), Chang Yü (1283–1350), Yang Wei-chen (1296–1370), who studied Chin and Tʻang masters but were somewhat independent of Chao Meng-fu's (1254–1322) over-arching influence, come to mind, especially their colophons and correspondence written in small-size script. Perhaps it is in this respect that Tung felt that his teacher's writing contained "ancient brushwork," but as reinterpreted by Yüan intermediaries. One might draw parallels in painting with the pioneering efforts of the two Mos and others of their generation to extricate the art of painting from the "sweet vulgarity" of contemporary influences and look to the past—especially the Yüan dynasty—for artistic redirection.

Later critics identified Mi Fu as another of the calligraphic influences on Mo Ju-chung and Mo Shih-lung. An important work

available for study in the Sung-chiang area at the time was Mi's hand-scroll *Three Letters*, bearing Hsiang Yüan-pien's seals and now in the Tokyo National Museum (*Illustrated Catalogues of the Tokyo National Museum*, 1980, no. 15; see also vol. 1, fig. 58, for another letter by Mi with Hsiang's seals). While the letters vary in script type, size, and total expression, they contain a number of characteristic features present in the works of Ju-chung and Shih-lung, as well as in Tung Ch'i-ch'ang's own writings. First, the wide spacing between columns (*hang-ch'i* 行氣), also found in the works of Shih-lung and Tung, is generally consistent in all of Mi Fu's letters, regardless of the character size and the formality or freedom of the script. Ultimately, as Tung recognized (see cat. no. 1), this spacious composition traced back to the *Orchid Pavilion Preface* (*Lan-t'ing hsü*) of Wang Hsi-chih and other works by the Two Wangs. Second, the tall constricted shape of the individual graphs (*chieh-kou* 結構) is evident particularly in the first and third of Mi's letters, and reflects his study of Ou-yang Hsün (557–641). In Mi's graphs, the constriction led to a kind of dynamic torsion (*shih* 勢) that propelled his characters; in the Ming masters, the movement gives way to a more static frontal presentation. Third, the combination of square and rounded brushwork is actually a reduction of Mi Fu's extraordinary concept of a character "having eight sides" (*Hai-yüeh ming-yen*, p. 1) or of his using the "four sides of the brush" while others use just one (*Hsüan-ho shu-p'u*, *ch.* 12, p. 283). While the concept was fully realized by Mi, it was not within reach of either the Yüan calligraphers or the Ming masters, who further simplified it to square and rounded maneuvers or to predominantly slanted and centered strokes. Still, such a concept—even in its simplified or "reduced" form—enriched the brushwork of such middle and late Ming practitioners as the two Mos and Tung Ch'i-ch'ang to a degree not apparent in the calligraphy of earlier Ming masters like Wen Cheng-ming (1470–1559) or Chu Yün-ming (1461–1527).

<div align="right">MWG</div>

LITERATURE: *Chung-kuo ku-tai shu-hua mu-lu*, vol. 2, 1985, *Ching* 1–1768.

Mo Shih-lung (1537–1587) 莫是龍

tzu T'ing-han 廷韓, Yün-ch'ing 雲卿, *hao* Ch'iu-shui 秋水, *chai* Shih-hsiu chai 石秀齋

An active participant in literary and artistic circles in his native Hua-t'ing and an early friend of Tung Ch'i-ch'ang, Mo Shih-lung played a notable role in the development of the new aesthetic ideals that were to propel his hometown into prominence during the seventeenth century. Tung Ch'i-ch'ang came to live in the Mo household around 1571, where he studied with the father, Ju-chung (1509–1589), and became friendly with the son, Shih-lung. Tung admired the brilliance of his older friend; however, the true extent of Mo Shih-lung's influence on Tung as a painter and calligrapher is difficult to ascertain.

Mo Ju-chung appears to have been a major influence on his son's intellectual, artistic, and social life; and contemporary records of poetry society meetings and pleasure outings often list both father and son in attendance. Among their friends, those closest to Shih-lung included Wang Shih-chen (1526–1590), Lu Shu-sheng (1509–1605), Ku Cheng-i (fl. 1575–97), Sun K'o-hung (1533–1611), and Ch'en Chi-ju (1558–1639). Praised as one of the most promising scholars of his generation, Mo Shih-lung performed only marginally in the official examinations. He passed the prefectural examination, qualifying as a *sheng-yüan* (Government Student), at the age of fourteen *sui* (thirteen years old), but failed to pass the *chin-shih* (Metropolitan Graduate) examination on three attempts. He served briefly in the minor position of editing clerk in Nanking in 1573.

In spite of his repeated failures in the examinations and the resulting strain on the family's financial resources, Mo Shih-lung continued to participate in poetry gatherings and sightseeing trips. In 1586, on the last of his four visits to Peking, Mo stayed at the home of the collector and connoisseur Chan Ching-feng (1533–ca. 1602), who introduced him to other collectors in the capital. Mo returned home to Hua-t'ing in late 1586 or early 1587, and died shortly thereafter at the early age of fifty-one *sui*.

76 *Landscape*
Shan-shui
莫是龍　山水

Dated 1581

Hanging scroll, ink and color on paper
119 x 41 cm (46⅞ x 16⅛ in.)

The Metropolitan Museum of Art, New York
Gift of Ernest Erickson Foundation, 1985 (1985.214.148)

vol. 1, pl. 76

ARTIST'S INSCRIPTION AND SIGNATURE (3 lines in running script): On an autumn day in the *hsin-ssu* year [1581], painted in the Shih-hsiu Studio. Yün-ch'ing.

辛巳秋日，寫於石秀齋中，雲卿。

ARTIST'S SEALS:
Yün-ch'ing 雲卿 (*chu-wen*, round)
Mo-shih T'ing-han 莫氏廷韓 (*pai-wen*, square)

INSCRIPTION: Ch'en Chi-ju 陳繼儒 (1558–1639), 4 lines in running script, undated, 1 seal:
Mo T'ing-han's [Mo Shih-lung] calligraphy and painting brought about a revival [of those arts] in our district. Even Hsüan-tsai [Tung Ch'i-ch'ang] was one of those who followed him. Although this painting follows Ta-ch'ih [Huang Kung-wang, 1269–1354], its layered peaks and piled-up cliffs display vigorous brush and ink. Today we drifters meet; seeing this [painting] is like hearing the [sad melodies] of the Yang Mountain flute. Inscribed by Ch'en Chi-ju.

莫廷韓書畫實屬吾郡中興，即玄宰亦步武者也。此幅雖倣大癡，而層巒疊嶂筆墨遒勁。今流落人間，見之如聞山陽笛也。陳繼儒題。

LABEL STRIP: Lu Hui 陸恢 (1851–1920), undated, 1 seal

NO COLOPHONS OR COLLECTORS' SEALS

This hanging scroll shows Mo Shih-lung striving to achieve a strong sense of three-dimensional form in his painting. Piling up hummock and plateau motifs of the Yüan master Huang Kung-wang into a few, interlocking units, Mo builds a mountain ridgeline that stands solidly within the picture frame. Compared to his earlier landscape of around 1575 (Li, *A Thousand Peaks and Myriad Ravines*, 1974, no. 22), forms here are rounder and more substantial with a clearer delineation of foreground, middle-ground, and far-distant components. But this composition is still rather busy. In his landscape of 1586 (*Shina Nanga Taisei*, 1937, vol. 9, pl. 164) Mo carries this simplification further, but he has not achieved the clarity of form or dynamic compositional movement found in the works of Tung Ch'i-ch'ang. In the present painting the somewhat cluttered composition, uniformly pale ink tones tinged with red, and numerous narrative details all hark back to the work of such Wu School artists as Wen Chia (1501–1583) and Hou Mao-kung (fl. ca. 1540–80).

Although Mo Shih-lung's development as an artist was cut short by his early death, the inscription by Ch'en Chi-ju makes it clear how deeply Mo's vision impressed his contemporaries. In taking Huang Kung-wang as his model, Mo led the way for a creative revival of Yüan styles in preference to the more recent styles of the Wu School, but his scholarly reconstruction of Huang's style falls short of establishing a new, personalized synthesis. Mo's brushwork is still tentative, showing neither the rich variety of his model nor the robust use of ink and bold compositional simplifications that Tung Ch'i-ch'ang was to introduce. While pointing out a new direction, Mo Shih-lung's art lacks the conviction or imagination to transform past models into a vigorous new style.

MKH

EXHIBITION: University Art Museum, Berkeley, 1971: Cahill, *Restless Landscape*, no. 32.

LITERATURE: Cahill, *Distant Mountains*, 1982, pp. 85–86, pl. 34; Hearn, *Ancient Chinese Art*, 1987, no. 134.

Ku Cheng-i (fl. 1575–97) 顧正誼

tzu Chung-fang 仲方, *hao* T'ing-lin 亭林

The son of a minor Sung-chiang official, Ku Cheng-i attended the National University in Peking and around 1575 became a Drafter in the Central Drafting Office. His official duties apparently afforded him the leisure time in which to paint, since his reputation as an artist began during his stay in the capital. After his retirement to his hometown of Hua-t'ing, Ku Cheng-i became acquainted with several local painters, among them Sung Hsü (1525–after 1605) and Sun K'o-hung (1533–1611).

Ku, who is often credited with the founding of the Hua-t'ing School of painting, specialized in the styles of the Four Late Yüan Masters, principally Huang Kung-wang (1269–1354). In advocating the emulation of the late Yüan style, Ku Cheng-i had a profound impact on the aesthetic sensibilities of his students Mo Shih-lung (1537–1587), Ting Yün-peng (1547–after 1621), and Tung Ch'i-ch'ang.

77 *Landscapes*

Shan-shui

顧正誼　山水

Undated

Album of ten paintings, ink and ink color on paper
33.6 x 23.8 cm (13¼ x 9⅜ in.)

Beijing Palace Museum

vol. 1, pl. 77 (leaves 1, 3, 8, 9); vol. 2, pl. 77 (leaves 2, 4–7, 10)

ARTIST'S SIGNATURES (1 line in running-regular script):
Leaf 1: T'ing-lin. 亭林。
Leaf 2: Chung-fang painted. 仲方寫。
Leaf 3: Ku Cheng-i. 顧正誼。
Leaf 4: Cheng-i painted. 正誼寫。
Leaf 5: Ku Cheng-i painted. 顧正誼寫。
Leaf 6: Chung-fang painted. 仲方寫。
Leaf 7: T'ing-lin-sheng. 亭林生。
Leaf 8: T'ing-lin painted. 亭林寫。
Leaf 9: T'ing-lin, I painted. 亭林，誼寫。
Leaf 10: Chung-fang, I painted. 仲方，誼寫。

ARTIST'S SEALS:
Cheng-i 正誼 (*pai-wen*, square; leaves 1, 8–10)
Ku Cheng-i yin 顧正誼印 (*pai-wen*, square; leaf 2)
Chung-fang 仲方 (*pai-wen*, rectangle; leaves 3, 4)
Chung-fang shih 仲方氏 (*pai-wen*, square; leaf 5)
T'ing-lin-sheng 亭林生 (*pai-wen*, rectangle; leaf 6)
Cheng-i 正誼 (*pai-wen*, rectangle; leaf 7)

FRONTISPIECE: Chang Hsiung 張熊 (1803–1886), dated 1880, 1 seal

COLOPHONS: Chang Hsiung, dated 1880, 1 seal; Shen Tseng-chih 沈曾植 (1852–1922)

COLLECTORS' SEALS: Ch'u T'ing-kuan 褚庭琯 (17th century), 3; Ch'en Chi-te 陳驥德 (19th century), 3; Chu Jung-chüeh 朱榮爵 (20th century), 3; Chiang Tsu-i 蔣祖詒 (20th century), 1

As one of Tung Ch'i-ch'ang's teachers, Ku Cheng-i played an important role in the formation of the artist's painting style. In an inscription on a landscape hanging scroll now in the National Palace Museum, Taipei, Ku Cheng-i wrote: "I have recently studied genuine paintings by various Sung and Yüan masters and have been able to capture their essence. Ssu-pai [Tung Ch'i-ch'ang] received my instruction but the pupil has now surpassed his teacher" (*Ku-kung shu-hua lu*, 1965, vol. 3, *ch.* 5, p. 435; Fu, "A Study of the Authorship of the 'Hua-shuo,'" 1970, fig. 24). Using an analogy from Ch'an Buddhism, Tung Ch'i-ch'ang maintained that Ku Cheng-i followed the

gradualist approach in the careful study of earlier masters. Indeed, Ku Cheng-i had a good collection of masterpieces by Huang Kung-wang (1269–1354), most of which were later acquired by Tung Ch'i-ch'ang (Wu Yin-ming, "Tung Ch'i-ch'ang yen-chiu," 1959, pp. 348–49; Nelson Wu, "Tung Ch'i-ch'ang," 1990, pp. 21–30).

This album of landscapes demonstrates Ku Cheng-i's eclecticism; the stylistic features are derived from several Yüan masters, such as Wu Chen (1280–1354; leaves 1 and 2), Huang Kung-wang (leaves 3 and 4), Ni Tsan (1301–1374; leaves 7 and 8), and Wang Meng (1308–1385; leaves 9 and 10). On the other hand, his adaptations of these masters seem to have been dominated by the style of Huang Kung-wang in their generally broad and relaxed brushwork and the large geometric units used to build up the compositions. It seems likely that Tung Ch'i-ch'ang was simply echoing Ku Cheng-i's teaching when he asserted the following principle: "The form of the mountain should first be outlined and then texture strokes applied. People nowadays pile up small bits to make up a large mountain. This is one of the worst mistakes. When an ancient master worked on a large scroll, he made only three or four large 'proportionings' and 'unitings' (*fen* 分 and *ho* 合), and in that manner accomplished the whole composition. Although within the composition there are many small parts, the principal aim is to grasp the momentum [or force, *shih* 勢] of the forms" (Tung Ch'i-ch'ang, *Hua-chih*, in Yü An-lan, *Hua-lun ts'ung-k'an*, 1960, p. 71; translation by Mae Anna Pang, in Cahill, *Restless Landscape*, 1971, p. 91).

JK

LITERATURE: *Chung-kuo ku-tai shu-hua mu-lu*, vol. 2, 1985, *Ching* 1–2513.

Sung Mao-chin (ca. 1559–after 1622) 宋懋晉

tzu Ming-chih 明之

Literary records provide few clues for tracing the life of the Sung-chiang painter Sung Mao-chin. Although his family had produced several *chin-shih* graduates, Sung Mao-chin early on abandoned any hope of taking the examinations or pursuing an official career. The *Sung-chiang fu-chih* records that after he gave up studying the classics, he spent all his time copying ancient masterworks. He became a student of Sung Hsü (1525–after 1605; a leading member of what came to be known as the Yün-chien School of painting), joining ranks with Sung Hsü's other pupil, Chao Tso (ca. 1570–after 1633). The painting styles of these two temperamentally incompatible students were often compared: it was said that "Sung waves [his brush] and splashes [his ink] for spontaneous effects, while Chao spares his ink and organizes his thoughts, not engaging himself lightly with the brush" (Cahill, *Distant Mountains*, 1982, p. 68). Sung Mao-chin received the backing of several prominent Sung-chiang figures, including Tung Ch'i-ch'ang, and succeeded in establishing a place for himself in the eclectic artistic scene of the late Ming period.

78 *Journey to Mount Kan-chiang*
Yu Kan-chiang shan
宋懋晉　游干將山

Dated 1589

Hanging scroll, ink on paper
92.8 x 23.3 cm (36⁹⁄₁₆ x 9⁹⁄₁₆ in.)

Beijing Palace Museum

vol. 1, pl. 78

ARTIST'S INSCRIPTION AND SIGNATURE (2 lines in regular script): On the fifteenth day of the third month, spring, of the *chi-ch'ou* year [April 29, 1589], I painted this while traveling in Mount Kan-chiang. Sung Mao-chin.

己丑春三月望日，游干將山作。宋懋晉。

ARTIST'S SEAL:
Sung Mao-chin yin 宋懋晉印 (*pai-wen*, square)

NO COLOPHONS

COLLECTORS' SEALS: unidentified, 2

EXHIBITION: The Art Gallery, Chinese University of Hong Kong, 1988: Kao Mayching, *Paintings of the Ming Dynasty*, cat. no. 66.

LITERATURE: *Chung-kuo ku-tai shu-hua mu-lu*, vol. 2, 1985, *Ching* 1–1943; Kao Mayching, "Sung Mao-chin," 1988, pp. 22–24.

Ting Yün-p'eng (1547–after 1621) 丁雲鵬

tzu Nan-yü 南羽, *hao* Sheng-hua chü-shih 聖華居士

Ting Yün-p'eng, a native of Hsiu-ning, Anhui, is best known for his figure paintings of Buddhist and Taoist subjects, but he also painted landscapes, produced designs for woodblock prints, and wrote poetry. Ting's father was a prominent member of the gentry in the rapidly expanding economy of Anhui; his father's wealth probably enabled Ting to receive a classical education, but he chose not to pursue an official career. By 1577, Ting had moved to Sung-chiang, where he took up residence at the Ma-shih Temple. In Sung-chiang he became acquainted with Tung Ch'i-ch'ang and Ku Cheng-i (fl. 1575–97), with whom he later studied, and soon expanded his circle of acquaintances to include Mo Shih-lung (1537–1587) and Chan Ching-feng (1533–ca. 1602), who is also sometimes cited as Ting's teacher.

Although the record is unclear, Ting probably remained in Sung-chiang until the mid-1580s, when he returned to Hsiu-ning to mourn the death of his father. For several years thereafter, Ting lived with his mother in what appear to have been greatly reduced circumstances; and it has been suggested that because of these financial constraints he began to sell his art to book publishers in Anhui. Several of his designs appeared in the well-known woodblock print compendia of ink-cake

designs, the *Fang-shih mo-p'u* of circa 1588, produced by Fang Yü-lu (fl. 1570–1619), and the *Ch'eng-shih mo-yüan* of 1606, published by Ch'eng Ta-yüeh (1541–ca. 1616).

In the early 1600s, Ting traveled widely in the Chiang-nan region, often taking up temporary residence at Buddhist temples. Ting transcended the school-oriented divisiveness of the late Ming by incorporating into his work diverse influences from the artistic schools centered in the three regions where he lived for extended periods—Sung-chiang, Anhui, and Su-chou.

79 *Waterfall at the Wintry Cliff*

Han-yen fei-p'u

丁雲鵬　寒巖飛瀑

Dated 1578

Hanging scroll, ink and color on paper
133.4 x 31.2 cm (52½ x 12⁹⁄₁₆ in.)

Beijing Palace Museum

vol. 1, pl. 79

ARTIST'S INSCRIPTION AND SIGNATURE (2 lines in seal script):
Painted on a spring day in the *wu-yin* year [1578] of the Wan-li era for Mr. Yü-hua's correction. Ting Yün-p'eng.

萬曆戊寅春日寫似玉華先生教正。丁雲鵬。

ARTIST'S SEALS:
Ting Yün-p'eng yin 丁雲鵬印 (*pai-wen*, square)
Nan-yü 南羽 (*chu-wen*, square)
Yün-p'eng 雲鵬 (*pai-wen*, square)

NO COLOPHONS

COLLECTORS' SEALS: Ku Hsüan-yen 顧玄言, 1; unidentified, 1

Painted by Ting Yün-p'eng at the early age of thirty-two *sui* (thirty-one years old), this winter landscape in tall narrow format is typical of late sixteenth century painting, with many elements carefully fitted in. The precise and tightly convoluted forms of the foreground trees, particularly the lofty foreground pine, are the forebears of those intricately painted by Hsiang Sheng-mo (1597–1658); and the cliffs that overhang them, leading one into the dark valley and its waterfall, approach the daring inventions of Wu Pin (fl. ca. 1591–1626). Nowhere, however, is the space between these forms opened up to increase their grandeur: Tung Ch'i-ch'ang, who was nearly ten years younger than Ting Yün-p'eng and had at this time still to produce his first extant dated work, would be the first to make the artists of his time aware of the importance of movement in the composition and of space between and around the landscape elements. Nevertheless, Tung himself would never match Ting Yün-p'eng in painterly skill, and in fact held the highest opinion of him, saying that "for three centuries there has not been his equal"—a span of time perhaps not to be taken entirely literally but certainly according Ting Yün-p'eng singular importance in the Ming dynasty.

RW

EXHIBITION: The Art Gallery, Chinese University of Hong Kong, 1988: Kao Mayching, *Paintings of the Ming Dynasty*, cat. no. 58.

LITERATURE: *Chung-kuo ku-tai shu-hua mu-lu*, vol. 2, 1985, *Ching* 1–2070.

80 *Landscape*

Shan-shui

丁雲鵬　山水

Dated 1583

Hanging scroll, ink and color on paper
77.5 x 30.2 cm (30½ x 11⅞ in.)

Hsü-pai Chai—Low Chuck Tiew Collection

vol. 1, pl. 80

ARTIST'S INSCRIPTION AND SIGNATURE (3 lines in regular script):
On a spring day in the *kuei-wei* year [1583], written for the appreciation of Mr. Huai-ch'in. Ting Yün-p'eng.

癸未春日，寫上懷琴先生賜覽。丁雲鵬。

ARTIST'S SEALS:
Ting Yün-p'eng yin 丁雲鵬印 (*pai-wen*, square)
Nan-yü 南羽 (*chu-wen*, square)
Chia-shu-lin 嘉樹林 (*pai-wen*, square)

LABEL STRIP: Chang Hsiang-ning 張祥凝 (20th century), 1 seal

COLOPHONS: Ts'ao I 曹懌 (18th century), dated 1782, 1 seal

COLLECTORS' SEALS: Ts'ao I, 1; Yang Shih-ts'ung 楊士驄 (20th century), 1; Ma Chi-tso 馬積祚 (20th century), 2; Chang Hsiang-ning, 4

As with the 1578 Beijing scroll *Waterfall at the Wintry Cliff* (vol. 1, pl. 79), this painting exhibits Ting Yün-p'eng's skill in combining a host of smaller elements into a large composition. The theme of the lonely fisherman out on a vast lake against a backdrop of impenetrable mountains would seem to show an affinity with the works of Yüan masters such as Wu Chen (1280–1354), but the finely detailed manner of Ting's brushwork recalls that of Wen Cheng-ming (1470–1559) and is not clearly identified with any earlier master, as would become the case with the pupils and followers of Tung Ch'i-ch'ang in the following century.

RW

LITERATURE: *Kyohokusai zoshoga sen*, 1983, pp. 76, 367.

Wu Pin (fl. ca. 1591–1626) 吳彬

tzu Wen-chung 文仲, *hao* Chih-an fa-seng 枝菴髮僧, Chih-yin 枝隱

Wu Pin was one of the most original and technically accomplished artists of the late Ming, yet the details surrounding the beginning and end of his life remain vague. Born in the coastal city of P'u-t'ien, Fukien, he spent most of his career in the Ming secondary capital of Nanking, to which he had moved in the 1580s. In Nanking Wu practiced two very different types of painting. A devotee of Buddhism, he made a specialty of depicting Buddhist figures, notably Lohans. He also served as a court artist, in which capacity he created both narratives and landscapes. His circle of friends included the high official Mi Wan-chung (fl. 1595–1628), who is said to have studied painting with Wu "morning and night" (Cahill, *Distant Mountains*, 1982, p. 167). Like Mi, in the early 1620s Wu ran afoul of the powerful eunuch Wei Chung-hsien (ca. 1568–1627) and was imprisoned. Although it is not certain that he died in jail, no extant painting is dated later than 1621 and there is no record of his continued activity after Wei's downfall in 1627.

MKH

81 *A Thousand Peaks and Myriad Valleys*
Ch'ien-yen wan-huo
吳彬　千巖萬壑

Dated 1617

Hanging scroll, ink on silk
120.4 x 40.1 cm (47⅜ x 15¹³⁄₁₆ in.)

Collection of Henry and Lee Harrison

vol. 1, pl. 81

ARTIST'S INSCRIPTION AND SIGNATURE (3 lines in running script):
From a thousand cliffs, cascades scatter and fall.
In a myriad ravines, the trees twine and twist.
(Translation by James Cahill, *Fantastics and Eccentrics*, 1967, p. 113.)
　On the lantern festival in the *ting-ssu* year of the Wan-li era [February 20, 1617] for the literary master Heng-ch'ang's learned improvements. [The single] branch recluse, Wu Pin.

千巖泉灑落
萬壑樹縈迴
　萬曆丁巳燈朝寫似亨長詞丈博雅。枝隱，吳彬。

ARTIST'S SEALS:
Wu Pin tzu yüeh Wen-chung 吳彬字曰文仲 (*pai-wen*, square)
I-chih-ch'i 一枝栖 (*chu-pai wen*, square)

NO COLOPHONS OR COLLECTORS' SEALS

RECENT PROVENANCE: Ching Yüan Chai Collection

In his landscape art, Wu Pin championed a revival of the Northern Sung monumental style. While contemporary scholar-official amateurs

such as Wang To (1592–1652), Tai Ming-yüeh (d. ca. 1660), and fellow Fukienese Chang Jui-t'u (1570?–1641) all advocated a return to the richly detailed Sung mode in preference to the spare, minimalist paintings created by imitators of Ni Tsan (1301–1374), only Wu Pin possessed both the interest and the requisite technical skill to re-create the meticulous descriptive manner of Sung models. As early as 1603 (see Cahill, *Distant Mountains*, 1982, pl. 22), Wu began to experiment with large-scale compositions in the Sung mode, but it was during the last decade of his career, beginning around 1615 (see Cahill, *Distant Mountains*, pl. 29), that he achieved the unique integration of convincingly substantial forms and impossibly fantastic scenery that is his hallmark.

Wu Pin's late landscape paintings stand at the opposite extreme from the rarefied paintings of contemporary amateurs in which definition of surfaces with texture strokes and washes was avoided. In contrast to this dematerialized approach, Wu exploited his command over the conservative representational techniques utilized by professional painters of the day to create richly detailed images. Like his younger contemporary, Ch'en Hung-shou (1598–1652), however, Wu energized his archaistic compositions with extravagant exaggerations and distortions, perhaps, in part, to distinguish them from the hack imitations of Sung art that must have been a prevalent part of the contemporary art market (Cahill, *Fantastics and Eccentrics*, 1967, pp. 35–36). Whatever Wu's motives, his late landscapes, some ranging over ten feet in height, not only achieve a "fantastic grandeur," they represent a sophisticated transformation of past traditions into a uniquely expressive and personal style.

A Thousand Peaks and Myriad Valleys, one of Wu's smallest compositions in his monumental landscape mode, is also one of his most beguiling because it maintains a precarious balance between descriptive realism and fantasy. The bottom quarter of the composition is entirely believable. There, mountain streams flow out of the misty background and cascade into a lake from between densely forested rock outcrops. Pavilions raised on stilts over one of the cataracts are dwarfed by overarching rocks and trees, emphasizing the diminutive scale of man's presence in this world. The landscape's visual coherence begins to disintegrate, however, as one's gaze travels above the rising mist into the middle distance. To the left, a palatial complex stands on the brink of a high escarpment; on the right, another storied hall with encircling veranda is precariously perched on a rock overhang that juts ominously into the void. These implausible building sites appear comfortingly secure, however, when compared with the impossible form of the intervening mountain. High above the pavilions a ridgeline extends leftward into an unstable projecting rock mass. The column of rock which ostensibly buttresses this dangling cliff is itself impossibly long and only tenuously supported from below. The unreality of these contorted shapes is compounded by the even more unsettling optical illusions engendered by Wu Pin's manner of depiction, which often makes it difficult to interpret whether landscape elements project or recede, describe masses or voids. The top of the rock column appears tenuously linked to the adjacent mountainside at only two points, for example, while the area below the column may be read as either an undercut valley or a swollen appendage. Above this anomalous geologic formation the painting reverts again to a plausible description of sheer pinnacles clustered around a towering central peak, undermining

our conviction that something is terribly amiss. But every effort to rationalize the irrational is in the end thwarted. Tracing the flow of water through the composition, one finds no discernible relationship between the various waterfalls in the picture. The nearly identical scale of the pavilion in the foreground and that on the rock overhang also defies logic. In spite of the plausibility of Wu Pin's rock textures and unifying atmosphere, the landscape remains disturbingly illogical and enigmatic.

Wu's richly particularized trees and rocks show a sophisticated awareness of earlier stylistic traditions. His foreground trees recall similar species found in works attributed to Chü-jan (fl. ca. 960–ca. 986), while the angular and scalloped rock texturing are derived from works in the manner of Yen Wen-kuei (fl. ca. 988–ca. 1010) and Li T'ang (ca. 1049–ca. 1130). Whether or not Wu was aware of Tung Ch'i-ch'ang's theoretical categorization of Northern and Southern schools, this conscious blending of Chü, Yen, and Li idioms shows that Wu was well aware of the distinctive stylistic traits of "Southern" and "Northern" artists. By integrating these disparate models, Wu Pin transformed them and made them serve new expressive ends.

<div align="right">MKH</div>

EXHIBITIONS: Smith College, Northhampton, Mass., 1962: *Chinese Art*, no. 22; The Asia Society, New York, 1967: Cahill, *Fantastics and Eccentrics*, no. 6.

LITERATURE: Cahill, "Yüan Chiang and His School," 1963, fig. 16 (detail); Levenson, *Modern China and Its Confucian Past*, 1964, pl. 6 (detail); Cahill, "Wu Pin and his Landscape Paintings," 1972, pp. 637–85, pl. 31; Suzuki, *Comprehensive Illustrated Catalogue*, 1982–83, vol. 1, A31–124.

Chao Tso (ca. 1570–after 1633) 趙左

tzu Wen-tu 文度

Although Chao Tso was active in Sung-chiang literati and artistic circles, materials documenting his life are scarce. He was born in Hua-t'ing sometime around 1570, a date extrapolated from his earliest known dated painting of 1603. In a brief biography of the artist, the early seventeenth century writer Hsü Shih-chün states that in his youth Chao traveled to Peking, where he made a name for himself as a poet. None of Chao's literary works survive except for the few inscriptions on his paintings; and, despite his presumed reputation as a poet in the north, Chao was never commended for his poetry after his return home.

Upon his return to Hua-t'ing from the capital, Chao met Ku Cheng-i (fl. 1575–97), an older friend of Tung Ch'i-ch'ang's who directed the young Chao toward the careful study of the old masters, particularly those of the Yüan dynasty. Chao Tso, along with Sung Mao-chin (ca. 1559–after 1622), studied painting with the Yün-chien School master Sung Hsü (1525–after 1605). Under his teacher's direction, Chao

developed the highly atmospheric, architectonic landscape style that was to become the hallmark of the Yün-chien School.

Sometime before 1611 Chao moved to Hang-chou and established a residence on the shores of the West Lake. Since most of his dated works fall after 1610, it would appear that he began to paint in earnest after this relocation. As his reputation grew, Chao attracted the attention of many artists and collectors, including Tung Ch'i-ch'ang, who befriended him and for whom Chao may have served as a ghostpainter. The Nanking collector Chou Liang-kung (1612–1672) praised Chao, claiming that "his contemporaries could not reach his level of accomplishment." Chao Tso's many students included Shen Shih-ch'ung (fl. ca. 1607–40), Ch'en Lien (fl. first half of the 17th century), and Li Chao-heng (ca. 1592–ca. 1662). The latest known dated work by Chao Tso was executed in 1633.

82 *After Chao Meng-fu's "High Mountains and Flowing Water"*
Mo Sung-hsüeh-weng "Kao-shan liu-shui"
趙左　摹松雪翁《高山流水》

Dated 1611

Hanging scroll, ink and color on paper
121.3 x 39.5 cm (47¼ x 15⁹⁄₁₆ in.)

Shanghai Museum

vol. 1, pl. 82

ARTIST'S INSCRIPTION AND SIGNATURE (2 lines in regular script):
On the twentieth day of the ninth month, autumn, of the *hsin-hai* year of the Wan-li era [October 25, 1611], Chao Tso imitated Sung-hsüeh-weng's [Chao Meng-fu, 1254–1322] *High Mountains and Flowing Water*.

萬曆辛亥秋九月廿日，趙左摹松雪翁《高山流水》。

ARTIST'S SEALS:
Chao Tso chih yin 趙左之印 (*pai-wen*, square)
Wen-tu 文度 (*pai-wen*, square)

INSCRIPTION: Tung Ch'i-ch'ang 董其昌, undated, 1 seal (*Tung-shih Hsüan-tsai*; *pai-wen*, square, 50)
This painting by Chao Wu-hsing [Chao Meng-fu] in my collection is modeled after Lu [Lu Hung, fl. first half of the 8th century], who turned down the summons to serve as an official. Wen-tu [Chao Tso] used to recline under it for three days and nights. Ch'i-ch'ang.

趙吳興此圖在余家，乃學盧徵君，文度常坐臥其下三日夕。其昌。

NO COLOPHONS OR COLLECTORS' SEALS

LITERATURE: T'ao Liang, *Hung-tou-shu kuan*, 1882, *ch.* 8, p. 49; Li Tso-hsien, *Shu-hua chien-ying*, 1871, *ch.* 22, p. 9; Chu Hui-liang, *Chao Tso*, 1979, p. 80; *Chung-kuo ku-tai shu-hua mu-lu*, vol. 3, 1987, *Hu* 1–1588; *Chung-kuo ku-tai shu-hua t'u-mu*, vol. 4, 1990, *Hu* 1–1588.

83 *Lofty Recluse among Streams and Mountains*

Hsi-shan kao-yin t'u

趙左　谿山高隱圖

Dated 1609–10

Handscroll, ink on paper

31.2 x 454.7 cm (12⅕/16 x 179 in.)

Ching Yüan Chai Collection

vol. 1, pl. 83

Artist's inscription and signature (3 lines in regular script): "Lofty Recluse among Streams and Mountains." In the ninth month of the *chi-yu* year [September 28–October 27, 1609], I first applied the brush; on the fifteenth day of the first month of the *keng-hsü* year [February 8, 1610], I finished it. Chao Tso of Hua-t'ing. (Translation in Cahill, *Restless Landscape*, 1971, no. 28.)

《谿山高隱圖》。己酉秋九月著筆，庚戌正月望日足成之。華亭趙左。

Artist's seals:

Tso 左 (*chu-wen*, square)

Wen-tu 文度 (*pai-wen*, square)

Chao Tso chih yin 趙左之印 (*pai-wen*, square)

No colophons

Frontispiece: Li Jui-ch'ing 李瑞清 (1867–1920), dated 1918, 4 seals

Label strip: Nagao Uzan 長尾雨山 (20th century)

Collectors' seals: Tung Ch'i-ch'ang 董其昌, 1 (*Tung Ch'i-ch'ang*; *chu-wen*, square, 41) Sung Pao-ch'un 宋葆淳 (b. 1748), 1; unidentified, 2

Exhibitions: University Art Museum, Berkeley, 1971: Cahill, *Restless Landscape*, no. 28; Vancouver Art Gallery, 1985: Caswell, *Single Brushstroke*, cat. no. 33.

Literature: Lu Hsin-yüan, *Jang-li kuan kuo-yen lu*, 1892, repr. 1975, ch. 24, p. 3; Chu Hui-liang, *Chao Tso*, 1979, pl. 5; Cahill, *Distant Mountains*, 1982, pls. 26, 27; Cahill, *Compelling Image*, 1982, fig. 3.16; Suzuki, *Comprehensive Illustrated Catalogue*, 1982–83, vol. 1, A31–046; *I-yüan to-ying* 41 (1990): 23.

84 *Streams and Mountains without End*

Hsi-shan wu chin

趙左　谿山無盡

Dated 1613

Handscroll, ink on paper

26.7 x 454.3 cm (10½ x 178⅞ in.)

Beijing Palace Museum

vol. 1, pl. 84

Artist's inscription and signature (5 lines in regular script): "Streams and Mountains without End." Painted on the fifteenth day of the twelfth month of the *jen-tzu* year [February 4, 1613], the fortieth year of the Wan-li era, as a gift for Mr. Wu-lu's returning to the court. Hua-t'ing Chao Tso.

《谿山無盡》。萬曆四十年，歲在壬子臘月之望，寫贈五鹿先生還朝。華亭趙左。

Artist's seals:

Chao Tso chih yin 趙左之印 (*pai-wen*, square)

Wen-tu shih 文度氏 (*pai-wen*, square)

Colophons: Yen Shih-ch'ing 顏世清 (1873–1929), dated 1916, 1 seal

Collectors' seals: Li Chih-kai 李芷陔 (19th century), 1; illegible on photograph, 2

Chao Tso is generally regarded as the founder of the Su-Sung School, which emerged in the late Ming period and combined certain stylistic elements derived from the Su-chou and Sung-chiang painters. Chao Tso's dates are unknown; however, since his earliest recorded painting is dated 1603 and his latest 1633, we may presume that he was probably born around 1570 and died sometime after 1633. Chao studied painting under Sung Hsü (1525–after 1605), who followed Shen Chou's (1427–1509) style and studied extensively the styles of such Northern Sung masters as Li Ch'eng (919–967), Kuan T'ung (fl. ca. 907–23), and Fan K'uan (d. after 1023).

Chao Tso spent most of his life in Sung-chiang, where he became well acquainted with Tung Ch'i-ch'ang and Ch'en Chi-ju (1558–1639). He often visited Tung's residence, and made copies of the masterpieces in Tung's collection. Chao Tso was unrestrained and carefree in temperament. He had never intended to advance in government, and led a poor but tranquil life in a thatched house in the western suburbs of Sung-chiang. Tung Ch'i-ch'ang greatly admired Chao's lofty personality, often addressing him as "my respectful friend." In his later years Chao Tso moved to T'ang-ch'i, a small town north of Hang-chou. He named his home Ta-yü an (Cottage of the Great Fool), and had a new seal carved with those three characters. The earliest work impressed with this seal is dated 1611, evidence that Chao Tso's move to T'ang-ch'i occurred no later than that year. After settling down at T'ang-ch'i, Chao Tso began to concentrate on painting and finally reached his highest achievements in that form.

The stylistic development of Chao Tso's painting can be divided into three stages. Before 1615, his works are strongly influenced by the Wu School and incline toward archaism. Most works of the period bear an inscription by Chao indicating that he was imitating a certain ancient master's style. His calligraphic style is neat, the characters square in structure, and the brushwork round and gentle. In the second period, from 1615 to 1620, Chao's individual moist and atmospheric style gradually developed. At the same time, however, Tung Ch'i-ch'ang's influence can also be detected in his work of that time. His calligraphy is more rectangular in shape, and his brushwork more forceful. Works done after 1620 exhibit a natural and carefree quality that was highly praised by his contemporaries such as Ch'en Chi-ju, Sung Mao-chin (ca. 1559–after 1622), and Chu Mou-yen (fl. early 17th century). Chao Tso's painting style was very close to that of Tung Ch'i-ch'ang, and he was often asked to be Tung's ghostpainter when Tung wearied of the endless requests for his paintings from admirers.

Though he was not a theorist, Chao Tso did write a brief essay on his accumulated experience in the art of painting. The essay, entitled "Lun-hua" ("Discussion on Painting"), is primarily devoted to the discussion of *shih* 勢 (dynamic force or momentum) and *li* 理 (natural

order) in landscape painting. Chao lucidly explains that one can capture the dynamic force if one understands the natural order; thus dynamic force is virtually equivalent to natural order. Chao's emphasis on both *shih* and *li* was in fact a reaction to the shortcomings of the brushwork-oriented Sung-chiang School and the overpiled composition of the Wu School. Chao efficiently put his theory into practice and created a unique style of his own. Many younger painters of the Sung-chiang region, such as Shen Shih-ch'ung (fl. ca. 1607–40), Li Chao-heng (ca. 1592–ca. 1662), Ch'en Lien (fl. first half of the 17th century), and Chu Hsüan (1620–1690), followed his style, and a new painting school was thus formed.

Streams and Mountains without End was done in 1613, when Chao Tso was still under the influence of the Wu School and imitating the styles of old masters. In this painting Chao artfully integrates the styles of Mi Fu (1051–1107), Chao Ling-jang (d. after 1100), and Huang Kung-wang (1269–1354) into one harmonious picture plane. High mountains and valleys appear in the beginning and at the end of the scroll. In these two segments Chao combines the hemp-fiber texture strokes of Huang Kung-wang with the horizontal moss dots and cloud patterns of Mi Fu. In the middle section of the scroll, the water village scenery and the brush treatment allude to the style of Chao Ling-jang. Although each part reveals features of a different artistic tradition, Chao Tso unifies them with his unique wet-ink brushwork and his formal repertory, most notably the triangular-shaped distant mountains and sparsely scattered pine tree motif. The moist and atmospheric tone, which would later become the distinctive feature of his work, takes its general shape in this scroll. Nevertheless, the brushwork here is fairly neat and skillful. The natural and carefree quality characteristic of his later brushwork has not yet fully developed.

HLJC

LITERATURE: Cahill, *Restless Landscape*, 1971, pp. 77–78; Sirén, *Later Chinese Painting*, repr. 1978, vol. 1, pp. 187–191; Chu Hui-liang, *Chao Tso yen-chiu*, 1979; Cahill, *Distant Mountains*, 1982, pp. 68–82; Xu Bangda, *T'u-lu*, 1984, vol. 2, pp. 647–649; Xu Bangda, *K'ao-pien*, 1984, text, vol. 2, p. 158; *Chung-kuo ku-tai shu-hua mu-lu*, vol. 2, 1985, p. 75.

Shen Shih-ch'ung (fl. ca. 1607–40) 沈士充

tzu Tzu-chü 子居

Shen Shih-ch'ung was born in Sung-chiang sometime in the last quarter of the sixteenth century. He studied painting with Sung Mao-chin (ca. 1559–after 1622) and Chao Tso (ca. 1570–after 1633), both of whom were pupils of the Yün-chien School master Sung Hsü (1525–after 1605). Like his two mentors, Shen Shih-ch'ung painted architectonic landscapes in the softly modulated ink tonalities of the Yün-chien School style.

Shen's painting career was spent exclusively in Sung-chiang, and he was well acquainted with many of the region's artists and connoisseurs, including Tung Ch'i-ch'ang, Ch'en Chi-ju (1558–1639), and Wang Shih-min (1592–1680). Wang invited Shen to paint an album of landscapes of his garden, the Chiao yüan, in 1625. That this work (and many others by Shen) may have been a professional commission is suggested by a letter reportedly written by Ch'en Chi-ju to Shen offering him payment for a large hanging scroll:

My old friend, I am sending you a piece of white paper together with a brush fee of three-tenths of a tael of silver. May I trouble you to paint a large-size landscape? I need it by tomorrow. Don't sign it—I will get Tung Ch'i-ch'ang to put his name on it (recorded in Wang Hsiu, *Lun-hua chüeh-chü mei-shu ts'ung-shu*, vol. 16, p. 219; translation by Cahill, *Distant Mountains*, 1982, p. 82).

Although the authenticity of the letter cannot be verified, several paintings attributed to Tung Ch'i-ch'ang bear the unmistakable mark of Shen Shih-ch'ung's brush. It is likely, therefore, that Shen on occasion acted as a ghostpainter for Tung Ch'i-ch'ang.

85 *Peach Blossom Spring*

T'ao-yüan t'u
沈士充　桃源圖

Dated 1610

Handscroll, ink and color on silk
29.5 x 805.2 cm (11⅝ x 317 in.)

Beijing Palace Museum

vol. 1, pl. 85

ARTIST'S INSCRIPTION AND SIGNATURE (2 lines in running-regular script):
In the tenth month of the *keng-hsü* year [November 15–December 14, 1610] Shen Shih-ch'ung painted this at the Ju-shui Studio in Yen-kuan [southwest of Hai-ming county, Chekiang].

庚戌小春，沈士充寫于鹽官之如水齋。

ARTIST'S SEAL:
Shih-ch'ung 士充 (*chu-wen*, rectangle)

FRONTISPIECE: Shu-yü 叔玉, undated

COLOPHONS:

Tung Ch'i-ch'ang 董其昌, undated, 1 seal (*Tung Ch'i-ch'ang yin*; *pai-wen*, square, 92):
I saw the *Peach Blossom Spring*, an authentic work by Chao Po-chü [ca. 1120–ca. 1170], in the collection of Mr. Wu in Hsi-nan [Anhui]. I have acquired the same artist's depiction of Su's [Su Shih, 1036–1101] "Second Rhyme-prose on the Red Cliff," the refined and precise brushwork of which compares closely with that of the *Peach Blossom Spring*. In this painting, Tzu-chü [Shen Shih-ch'ung] captured Chao's idea and was able to transcend his model. Treasure it. Treasure it. Ch'i-ch'ang.

趙伯駒《桃源圖》真跡，余見之溪南吳氏；已得其所作蘇公《後赤壁賦圖》，與《桃源》筆法精工絕類。子居以意爲之，有出藍之能。珍重！珍重！其昌。

Ch'en Chi-ju 陳繼儒 (1558–1639), undated, 1 seal:
The practice of painting in our Sung[-chiang] area during the last two hundred years was just like an academic's practice of Ch'an—merely for fun. In painting the *Peach Blossom Spring* for Ch'iao Ku-hou [Ch'iao Kung-pi], Shen Tzu-chü deviated from the traditions of Lung-mien [Li Kung-lin, ca. 1049–1106] and Ch'ien-li [Chao Po-chü] with the spirit and grace of brushwork as refreshing as springtime. It seems to have combined the arts of Hsüan-lü-shih [Priest Tao-hsüan, Master of Monastic Discipline] and the untrammeled immortals to conform to the orthodoxy of painting. It is regrettable that masters like Ch'ien-li could not see it, not to mention Mr. Ch'iu [Ch'iu Ying, ca. 1494–ca. 1552]. Inscribed by Ch'en Chi-ju.

吾松二百年畫道，如書生學禪，僅游戲耳。沈子居爲喬穀侯寫《桃源》，一變龍眠、千里舊習，神韻姿態如春撲筆端，真如宣律師兼帶散聖，此畫之正宗也。恨千里諸君不見之，無論仇氏矣。陳繼儒題。

Chao Tso 趙左 (ca. 1570–after 1633), undated, 2 seals:
The illustration to the "Peach Blossom Spring" originated from the two Lis [Li Ssu-hsün, fl. ca. 705–20, and Li Chao-tao, fl. mid-8th century], flourished first in the hands of [Chao] Po-chü, and was further developed by Ch'iu Shih-fu [Ch'iu Ying] of our dynasty. Shih-fu and others, however, made meticulously detailed versions of this subject for circulation and thus perpetuated their mediocrity. Shen Tzu-chü attempted to shake off this bad habit by tracing back to the origin. He modeled himself after the two Lis and Po-chü and combined the methods of Pei-yüan [Tung Yüan, fl. ca. 945–ca. 960] and Wu-hsing [Chao Meng-fu, 1254–1322]. Accomplished in the use of both brush and ink, he became famous. Treasure it, Magistrate Ch'iao. Inscribed by Chao Tso.

《桃源圖》派自二李，暢於伯駒，再暢於我朝仇實甫。而實甫諸郎刻畫粉本流布人間濫以哉！沈子居欲洗其習而窮其源，規模二李、伯駒之徑，出入北苑、吳興之法，筆墨兼得，遂成名家，明府其寶之。趙左題。

Sung Mao-chin 宋懋晉 (ca. 1559–after 1622), undated, 2 seals:
After the popularization of the "Story of the Peach Blossom Spring," its representations by T'ang and Sung painters numbered in the hundreds. Only the handscroll by [Chao] Po-chü was handed down as a treasure. Despite the hundreds of thousands of copies, this handscroll by Tzu-chü alone succeeds in capturing its idea. One-tenth of his method was derived from Chao, nine-tenths from the Yüan masters. It is a wonderful embodiment of the Six Principles, indeed worthy of pairing with that of Po-chü. Inscribed by Sung Mao-chin.

自《桃源記》出，而唐宋諸畫家爲圖者，無慮數百，獨伯駒一卷爲傳世寶。其後摹臨之者，又不知幾千萬億。獨子居此卷師其意，用其法者十一，用元人法者十九，六法臻妙，當與伯駒並驅。宋懋晉題。

Lu Ying-yang 陸應陽 (17th century), dated 1611, 2 seals; Lu Wan-yen 陸萬言 (*chü-jen* 1576), undated, 2 seals; Chang Kung-ting 章公鼎 (17th century), undated, 1 seal; Teng Hsi-chi 鄧希稷 (17th century), undated, 2 seals

COLLECTORS' SEALS: Ch'ing Kao-tsung 清高宗 (r. 1736–95), 9; Ch'ing Jen-tsung 清仁宗 (r. 1796–1820), 1; I Hsin 奕訢 (1833–1898), 2; P'u Ju 溥儒 (1896–1963), 4; unidentified, 4

EXHIBITION: The Art Gallery, Chinese University of Hong Kong, 1988: Kao Mayching, *Paintings of the Ming Dynasty*, cat. no. 70.

LITERATURE: *Shih ch'ü pao-chi hsü-pien*, completed 1793, repr. 1948, vol. 29; Xu Bangda, *K'ao-pien*, 1984, illustrations, vol. 2, p. 330; *Chung-kuo ku-tai shu-hua mu-lu*, vol. 2, 1985, Ching 1–2390.

86 *Thatched Hall in a Pine Grove*

Sung-lin ts'ao-t'ang

沈士充　松林草堂

Dated 1626

Handscroll, ink and color on paper
26.2 x 312.3 cm (10⁵⁄₁₆ x 122¹⁵⁄₁₆ in.)

Shanghai Museum

vol. 1, pl. 86

ARTIST'S INSCRIPTION AND SIGNATURE (2 lines in regular script):
Painted in the spring of the *ping-yin* year [1626] at the Red Banana Hall. Shen Shih-ch'ung.

丙寅春日寫于紅蕉館。沈士充。

ARTIST'S SEALS:
Shih-ch'ung 士充 (*chu-wen*, square)
Tzu-chü 子居 (*pai-wen*, square)

NO COLOPHONS

COLLECTOR'S SEALS: Chin Wang-ch'iao 金望喬 (19th century), 2

Shen Shih-ch'ung was the leading master of the Sung-chiang School after the generation of Tung Ch'i-ch'ang and Chao Tso (ca. 1570–after 1633). He developed a painting style that is praised for its "fluid treatment of ink" and "loose yet elegant brushwork." Tung Ch'i-ch'ang once declared that many painters supported his revival of the styles of Tung Yüan (fl. ca. 945–ca. 960) and Chü-jan (fl. ca. 960–ca. 986); among them, Chao Tso and Shen Shih-ch'ung were the most outstanding. The late Ming literati painter Yang Wen-ts'ung (1596–1646) compared Tung Ch'i-ch'ang, Chao Tso, and Shen Shih-ch'ung to Tung Yüan, Huang Kung-wang (1269–1354), and Wang Meng (1308–1385), an indication that during his lifetime Shen Shih-ch'ung had already earned the respect and admiration of his contemporaries.

Like his teacher Chao Tso, Shen Shih-ch'ung is reported to have ghostpainted for Tung Ch'i-ch'ang. An anecdote recorded by the collector Wu Hsiu (1765–1827) is often quoted as evidence of this. Wu wrote that he discovered a letter written by Ch'en Chi-ju (1558–1639) to Shen Shih-ch'ung requesting Shen to paint a large landscape painting without signature so that Tung Ch'i-ch'ang could inscribe his name on it. This kind of request reveals that Shen Shih-ch'ung not only followed Chao Tso, but also was capable of imitating Tung Ch'i-ch'ang's style.

Most of the few extant works by Shen Shih-ch'ung are dated in the 1610s and 1620s. While the paintings reveal Chao Tso's influence in their emphasis on the moist and atmospheric quality of nature, Shen was inclined to use softer and lighter brushwork, which makes his painting more delicate and peaceful. *Thatched Hall in a Pine Grove* was painted in 1626. In composition and individual motifs, it closely resembles Chao Tso's handscroll *Streams and Mountains without End* of 1612, now in The Metropolitan Museum of Art. Both scrolls are composed in a solid-void-solid structure. A large landmass appears in the opening section, with streams winding through the valleys, villages nestled in the woods, and figures leisurely strolling along the riverbank or on a bridge. At the end of the first solid mass, tall pine trees,

towering in the foreground above gradually receding slopes, introduce the second section of open space. A vast expanse of water occupies this space, which presents a tranquil void. Following this void, solid cliffs rising in the foreground lead the way to a splashing cascade and draw the whole landscape to an end. Although many of the motifs in the two scrolls—such as the triangular-shaped mountains, pine trees, long-robed figures, and cascades—are strikingly similar, they are differentiated by their individual brushwork. Shen Shih-ch'ung uses drier and softer strokes blurred with ink wash, which conceals their linear quality, whereas Chao Tso prefers well-defined strokes of different lengths and movement to enrich the expression of lines. Shen Shih-ch'ung's more painterly brushwork enhances the lyrical feeling of his painting. This stylistic tendency was carried further by followers of the Sung-chiang School, resulting in milder modes of painting that eventually led to the school's decline.

HLJC

LITERATURE: Cahill, *Restless Landscape*, 1971, p. 78; Sirén, *Later Chinese Painting*, repr. 1978, vol. 1, pp. 191–92; Cahill, *Distant Mountains*, 1982, pp. 82–86; *Chung-kuo ku-tai shu-hua mu-lu*, vol. 3, 1987, *Hu* 1–1559; *Chung-kuo ku-tai shu-hua t'u-mu*, vol. 3, 1990, p. 41.

87 *Floating Mist over Wintry Grove*
Han-lin fu-ai

沈士充　寒林浮靄

Dated 1633

Hanging scroll, ink on silk
149 x 39 cm (58¹¹⁄₁₆ x 15⅛ in.)

Beijing Palace Museum

vol. 1, pl. 87

ARTIST'S INSCRIPTION AND SIGNATURE (1 line in seal script and 1 line in running script):
Floating Mist over Wintry Grove. One summer day in the *kuei-yu* year [1633] Shen Shih-ch'ung painted.

《寒林浮靄》。癸酉夏日沈士充寫。

ARTIST'S SEALS:
Shen Shih-ch'ung yin 沈士充印 (*pai-wen*, square)
Tzu-chü 子居 (*pai-wen*, square)

NO COLOPHONS

COLLECTORS' SEALS: unidentified, 2

EXHIBITION: The Art Gallery, Chinese University of Hong Kong, 1988: Kao Mayching, *Paintings of the Ming Dynasty*, cat. no. 69.

LITERATURE: *Chung-kuo ku-tai shu-hua mu-lu*, vol. 2, 1985, *Ching* 1–2399.

Wu Chen (fl. early 17th century) 吳振

tzu Chen-chih 振之, Yüan-chen 元振, *hao* Chu-yü 竹嶼

Born in Hua-t'ing, Wu Chen was affiliated with the regional Yün-chien School of painting under the leadership of Chao Tso (ca. 1570–after 1633) and Shen Shih-ch'ung (fl. ca. 1607–40). Tung Ch'i-ch'ang admired Wu Chen's paintings and, according to some sources, engaged Wu to ghostpaint for him. There is no firm evidence to support this assertion; the most revealing account of the relationship between the two artists states only that Wu assisted Tung when he painted on moist silk or with special materials (see poem by Ku Ta-shen, *Ch'ing hua-chia shih-shih*, repr. 1983, *ch.* 1, p. 13). Described in contemporaneous sources as "unconventional," Wu Chen's paintings were prized for their marvelous depictions of withered trees.

88 *Streams and Mountains without End*
Hsi-shan wu chin
吳振　溪山無盡

Dated 1632

Handscroll, ink on paper
34.2 x 1382.3 cm (13⁷⁄₁₆ x 544³⁄₁₆ in.)

Tokyo National Museum TA–171

vol. 1, pl. 88

ARTIST'S INSCRIPTION AND SIGNATURE (2 lines in regular script):
Painted on an autumn day in the *jen-shen* year [1632] by Wu Chen.

壬申秋日畫。吳振。

ARTIST'S SEAL:
Wu Chen 吳振 (*pai-wen*, square)

LABEL STRIPS: Sun Ch'eng-tse 孫承澤 (1592–1676), undated; Wang Wen-chih 王文治 (1730–1802), undated

FRONTISPIECE: Ch'ien Ta-hsin 錢大昕 (1728–1804), undated; Pi Lung 畢瀧 (19th century), undated

COLOPHONS: Sun Ch'eng-tse, undated, 2 seals; Wang Ch'ung-chien 王崇簡 (1602–1678), dated 1670, 2 seals; Hsü Ch'ien-hsüeh 徐乾學 (1631–1694), dated 1676, 4 seals; Hsü Ping-i 徐秉義 (1633–1711), undated, 2 seals; Hsü Yüan-wen 徐元文 (1634–1691), dated 1676, 3 seals; Li Chien 黎簡 (1747–1799), dated 1798, 3 seals; Wang Wen-chih, dated 1800, 3 seals; Ch'ien Ta-hsin, dated 1801, 1 seal; Ch'ien Po-chiung 錢伯坰 (1738–1812), dated 1802, 2 seals; Hsieh Lan-sheng 謝蘭生 (1760–1831), 2 dated 1803 and 1813, 3 seals; I Ping-shou 伊秉綬 (1754–1815), dated 1805, 2 seals; Li Fu-ch'ing 李符清 (19th century), dated 1805, 2 seals; Huang Ch'i-ch'in 黃其勤 (b. 1747), dated 1806, 2 seals; Wan Shang-lin 萬上遴 (1739–1813), dated 1808, 2 seals; Sha Mu 沙木 (19th century), dated 1808, 3 seals; Chang Ju-chih 張如芝 (d. 1824), dated 1814, 2 seals; T'ang I-fen 湯貽汾 (1778–1853), dated 1816, 3 seals; Chang Wei-p'ing 張維屏 (1780–1859), dated 1816, 1 seal; Namekawa To'oru, 滑川達 dated 1930, 2 seals

COLLECTOR'S SEAL: unidentified, 1

Wu Chen, like Chao Tso (ca. 1570–after 1633), is said to have been one of Tung Ch'i-ch'ang's ghostpainters. Wu and Chao indeed shared many stylistic affinities (Chu, *Chao Tso yen-chiu*, 1979, pp. 56, 60). In this painting, Wu Chen combines the styles of the Yüan masters Huang Kung-wang (1269–1354), Wu Chen (1280–1354), and Wang Meng (1308–1385). The Y- and V-shaped faces of the rocks in the last section of the scroll, for instance, appear to have been derived from Huang Kung-wang. The overall style is characterized by patternistic and formal construction. Although lingering influences from the Su-chou followers of Wen Cheng-ming (1470–1559) can be detected in this painting, the positive use of void, the repetitive use of dots as organizing elements, and the restless horizon in the latter third of the scroll are stylistic features also found in the works of Tung Ch'i-ch'ang.

JK

LITERATURE: Kuan Mien-chün, *San-ch'iu-ko*, 1928, *ch. shang*, p. 66; *Illustrated Catalogues of the Tokyo National Museum*, 1979, no. 97; Suzuki, *Comprehensive Illustrated Catalogue*, 1982-83, vol. 3, JM 1–132.

89 *Autumn Waterfall on Mount Lu*
K'uang-lu ch'iu-p'u
吳振　匡廬秋瀑

Dated 1631

Hanging scroll, ink and color on paper
211 x 61.1 cm (83¹¹⁄₁₆ x 24¹⁄₁₆ in.)

Beijing Palace Museum

vol. 1, pl. 89

ARTIST'S INSCRIPTION AND SIGNATURE (2 lines in running script):
After the fifteenth day of the sixth month, summer, of the *hsin-wei* year of the Ch'ung-chen era [July 13, 1631], while suffering from the scorching heat, I casually painted *Autumn Waterfall on Mount Lu* for Chih-hsiu as an offering of coolness. Wu Chen from Hua-t'ing.

崇禎辛未夏，六月既望，酷暑困人，漫興寫《匡廬秋瀑》，似稚脩詞兄，以當清涼供。華亭吳振。

ARTIST'S SEALS:
Wu Chen yin 吳振印 (*pai-wen*, square)
Yüan-chen shih 元振氏 (*pai-wen*, square)
Wu Chen 吳振 (*pai-wen*, square)

NO COLOPHONS

COLLECTORS' SEALS: unidentified, 2

LITERATURE: Xu Bangda, *T'u-lu*, vol. 2, 1984, pl. 410; *Chung-kuo ku-tai shu-hua mu-lu*, vol. 2, 1985, *Ching* 1–2716.

Li Liu-fang (1575–1629)　李流芳

tzu Ch'ang-heng 長蘅, *hao* T'an-yüan 檀園; *chai* Yüan-shuai chai 緣率齋

One of the Four Masters of Chia-ting and the Nine Friends of Painting, Li Liu-fang was widely admired for his poetry, painting, and calligraphy. A descendant of an Anhui family that had recently moved to Chia-ting, Kiangsu, Li grew up with the expectation that he would succeed in the examinations and pursue an official career, thereby advancing his family's social and economic position. Although he attained the *chü-jen* degree in 1606 (in the same class with his lifelong friend Ch'ien Ch'ien-i, 1582–1664), Li's repeated attempts in the *chin-shih* examinations were unsuccessful. His failure to advance in an official career may have been due to his growing interest in Pure Land Buddhism, which diverted his attention from his studies. Christina Chu (*Li Liu-fang*, 1990) suggests that Li Liu-fang had already made contacts with devotees of the Pure Land sect in the late 1590s and that by 1605, the year before he became a *chü-jen*, he had entered the Pure Land laity under the guidance of the monk Chu-hung (1535–1615).

After his last unsuccessful attempt in the metropolitan examinations in 1622, Li moved to Nan-hsiang, near Chia-ting, where he built his Sandalwood Garden (T'an yüan). There he spent his days painting, writing poetry, tutoring students, and entertaining friends, including his two closest companions, Ch'ien Ch'ien-i and Ch'eng Chia-sui (1565–1644).

In addition to tutoring for a living, Li Liu-fang also admitted to selling his writings in order to support his extensive travels. As the years passed, he lamented having to sell his belongings to care for his aging mother. Financial difficulties and the hopelessness of the late Ming political scene weighed heavily on the artist, and he turned to drinking to relieve the pressures of his life. In the epitaph he composed for his close friend, Ch'ien Ch'ien-i linked Li Liu-fang's excessive drinking to the onset of the severe illness that eventually caused his death.

90 *Landscape*
Shan-shui
李流芳　山水

Dated 1626

Hanging scroll, ink on satin
130.3 x 42 cm (51⁵⁄₁₆ x 16⁹⁄₁₆ in.)

Östasiatiska Museet, Stockholm ÖM 25/62

vol. 1, pl. 90

ARTIST'S INSCRIPTION AND SIGNATURE (2 lines in running script):
Two days after the fifteenth day of the fifth month of the *ping-yin* year in the T'ien-ch'i era [June 10, 1626], Li Liu-fang painted for Elder Shu-chai's comments.

天啓丙寅五月望後二日，曙齋老人正。李流芳。

ARTIST'S SEAL:
Ch'ang-heng 長蘅 (*chu-wen*, square)

No colophons

Collector's seal: unidentified, 1

Literature: Suzuki, *Comprehensive Illustrated Catalogue*, 1982–83, vol. 2, E20–037.

Wang Shih-min (1592–1680), and was intimately acquainted with Li Liu-fang (1575–1629) and his brothers. As one of the Nine Friends of Painting, Ch'eng was closely affiliated with Tung Ch'i-ch'ang and his circle.

Ch'eng Chia-sui's small paintings in album and fan form, executed in a loose, spare manner, were sought after by collectors even during his own lifetime. Ch'ien Ch'ien-i writes of being asked to authenticate a forged album bearing Ch'eng's name (this statement was previously ascribed to Tung Ch'i-ch'ang, but that attribution is now known to have been the result of an alteration during the literary inquisition of the Ch'ien-lung period; Kim, *Chou Liang-kung*, 1985, vol. 2, pp. ix, 67). Although Ch'eng himself probably did not openly sell his paintings, this story is indicative of the high prices his works could bring. Ch'eng died in early 1644, only a few months before the fall of the Ming dynasty.

91 *Ink-play of the Sandalwood Garden*
T'an-yüan mo-hsi

李流芳　檀園墨戲

Dated 1627

Hanging scroll, ink on satin
129 x 57.3 cm (50¹³/₁₆ x 22⁹/₁₆ in.)

Beijing Palace Museum

vol. 1, pl. 91

Artist's inscription and signature (3 lines in running script):
On an autumn day of the *ting-mao* year [1627], Li Liu-fang painted in the Yüan-shuai Studio in the Sandalwood Garden.

丁卯秋日，畫於檀園之緣率齋。李流芳。

Artist's seals:
Li Liu-fang yin 李流芳印 (*pai-wen*, square)
Ch'ang-heng shih 長蘅氏 (*pai-wen*, square)

Colophon: Wu Wei-yeh 吳偉業 (1609–1672), dated 1636, 2 seals:
Ch'ang-heng [Li Liu-fang] learned from Mei tao-jen's [Wu Chen, 1280–1354] [painting]. The ink [in Li's landscape] is so dripping wet as to evoke the feeling of the approaching rain and the moist green in the mountain. This is indeed Li's successful work. In the *ping-tzu* year [1636], Wu Wei-yeh viewed in the Plum Blossom Retreat.

長蘅學梅道人，墨瀋淋漓，如山雨欲來，蒼翠若滴。此其得意合作也。丙子觀於梅花庵中。吳偉業。

Collectors' seals: unidentified, 2

Literature: *Chung-kuo ku-tai shu-hua mu-lu*, vol. 2, 1985, Ching 1–2579.

92 *Landscape*
Shan-shui

程嘉燧　山水

Dated 1617

Hanging scroll, ink and color on paper
76.5 x 31.5 cm (30⅛ x 12⅜ in.)

Shanghai Museum

vol. 1, pl. 92

Artist's inscription and signature (1 line in running script):
In the summer of the *ting-ssu* year [1617], Sung-yüan tao-jen painted.

丁巳夏，松圓道人筆。

Artist's seal:
Meng-yang 孟陽 (*chu-wen*, rectangle)

No colophons or collectors' seals

Ch'eng Chia-sui (1565–1644) 程嘉燧

tzu Meng-yang 孟陽, *hao* Sung-yüan tao-jen 松圓道人, Chieh-an 偈庵

Ch'eng Chia-sui, a native of Hsiu-ning, Anhui, spent most of his life in Chia-ting, Kiangsu, where he participated in the literati culture of the Sung-chiang region. Early in his career he failed to pass the official examinations, and he eventually opted for the more carefree life of a poet and painter. Ch'eng had a wide circle of friends including Wang Shih-chen (1526–1590), Sun K'o-hung (1533–1611), Ch'en Chi-ju (1558–1639), Ch'ien Ch'ien-i (1582–1664), and Wang Heng (1561–1609), the father of

Li Chao-heng (ca. 1592–ca. 1662) 李肇亨

Buddhist name Ch'ang-ying 常瑩, *tzu* Hui-chia 會嘉, *hao* K'o-hsüeh 珂雪, Tsui-ou 醉鷗

Li Chao-heng was the son of the well-known literatus Li Jih-hua (1565–1635). As a young man Li Chao-heng chose not to engage in the examination competition but instead pursued a life of cultured refinement in his hometown of Chia-hsing, Kiangsu. Chao-heng made many friends among his father's elite circle of acquaintances; and he was particularly close to his contemporary Hsiang Sheng-mo (1597–1658), the grandson of the preeminent collector Hsiang Yüan-pien (1525–1590). During the Manchu conquest of 1644–45, Li Chao-heng lost most of his inheritance. Shortly thereafter he entered the Ch'an monastery of the Ch'ao-

kuo Temple in Hua-t'ing and took the Buddhist name Ch'ang-ying, by which he is widely known.

Li Chao-heng was recognized for his landscapes in the style of Sung and Yüan masters, and he also excelled as a calligrapher.

93 *Clear Stream and Sparse Trees*
Ch'üan-shu ch'ing-shu
李肇亨　泉樹清踈

Undated

Hanging scroll, ink on paper
95 x 41.2 cm (37⅜ x 16¼ in.)

Beijing Palace Museum

vol. 1, pl. 93

ARTIST´S SIGNATURE (1 line in running script):
Ch'ang-ying
常瑩

ARTIST´S SEALS:
Shih Ch'ang-ying yin 釋常瑩印 (*pai-wen*, square)
K'o-hsüeh 珂雪 (*pai-wen*, square)

COLOPHONS: Huang P'ei-fang 黃培芳 (1779–1859), dated 1853, 2 seals; Tseng Chao 曾釗 (d. 1854), dated 1853, 2 seals; Hsiung Ching-hsing 熊景星 (19th century), dated 1853, 1 seal; Ch'en Li 陳澧 (1810–1882), dated 1853, 1 seal; Chang Wei-p'ing 張維屏 (1780–1859), dated 1853, 2 seals

COLLECTORS´ SEALS: unidentified, 2

LITERATURE: *Chung-kuo ku-tai shu-hua mu-lu*, vol. 2, 1985, *Ching* 1-2674.

Ch'en Chi-ju (1558–1639) 陳繼儒

tzu Chung-ch'un 仲醇, *hao* Mei-kung 眉公, Po-shih-ch'iao 白石樵, Mi-kung 糜公

The life of Tung Ch'i-ch'ang's close friend Ch'en Chi-ju has often been contrasted with Tung's own life. Both men came from relatively humble family origins, and both achieved recognition for their talents, but they each secured fame through entirely different means. Unlike Tung, Ch'en Chi-ju abandoned his ambition to advance in politics after obtaining the *hsiu-ts'ai* degree at the age of twenty-nine *sui* (twenty-eight years old), and chose to pursue the lifestyle of a reclusive literatus. He built a small mountain retreat in the She-shan region of his native Hua-t'ing, whence he sold the products—encomiums, epitaphs, and birth-day greetings—of his elegant brush. Ch'en's long-standing intimate friendship with Tung Ch'i-ch'ang resulted in the elevation of his own name in official and scholarly circles. His fame was further spread by the publication of several works which bear his name as editor or author, including the well-known compilation *Pao-yen-t'ang pi-chi* and the *Sung-chiang fu-chih*.

That the trade of free-lance writer could be quite lucrative in late Ming China is attested by the size and quality of Ch'en Chi-ju's collection of paintings and objects and by the simple but elegant style of his semireclusive life. Ch'en took delight in cultivated aesthetic activities, and his notebooks offer the modern reader a guide to the ideal, refined life of the upper echelon of Chinese society.

94 *Dewdrops in Early Autumn*
Lu-ti hsin-ch'iu t'u
陳繼儒　露滴新秋圖

Undated

Hanging scroll, ink and color on paper
121 x 29.6 cm (47⅝ x 11⅝ in.)

Shanghai Museum

vol. 1, pl. 94

ARTIST´S INSCRIPTION AND SIGNATURE (3 lines in running script): The painting *Dewdrops in Early Autumn* is in the manner of Tzu-chiu [Huang Kung-wang, 1269–1354] by Mei-kung, Ju.

《露滴新秋圖》，倣子久筆。眉公，儒。

ARTIST´S SEALS:
Mei-kung 眉公 (*chu-wen*, square)
Po-shih ch'iao 白石樵 (*pai-wen*, square)

NO COLOPHONS OR COLLECTORS´ SEALS

EXHIBITION: The Asia Society, New York, 1987: Li and Watt, *Chinese Scholar's Studio*, cat. no. 13.

Yang Wen-ts'ung (1596–1646) 楊文驄

tzu Lung-yu 龍友

Yang Wen-ts'ung, a native of Kuei-yang, Kueichou, attained his *chü-jen* degree in 1618, whereupon he was appointed Director of Studies in Hua-t'ing. During his tenure in this post he took painting lessons with Tung Ch'i-ch'ang, and became one of the Nine Friends of Painting; several contemporary sources even claim that Yang surpassed his teacher in painting skill.

Yang Wen-ts'ung became entangled in the political intrigues of the late Ming period to an extent that was rare among his fellow painters, who tended to avoid the dangers attendant on the rapidly shifting factional disputes. His early allegiances were with the Fu-she (Restoration Society), a literary group devoted to political reform; and he was an intimate friend of Hsia Yün-i (1597–1645), the founder of a branch of the Fu-she called the Chi-she. Yang's true political motives became apparent when in 1644 he obtained the position of Magistrate of Nanking at the recommendation of his brother-in-law Ma Shih-ying (d. 1645), a powerful opponent of the Fu-she. Yang was dismissed from office on charges of corruption but with the influence of Ma was able to secure another position in 1645, this time as a secretary in the Board of War in the Southern Ming court. He was placed in charge of troops in the Yangtze River area and subsequently rose to the position of Assistant Military-intendant in Kiangsu province.

In the spring of 1645 the Manchu forces took Nanking and defeated the Ming army. Yang fled south and managed to evade capture until the autumn of 1646, when the Manchus overtook him in P'u-ch'eng, Fukien. He was executed for refusing to transfer his loyalty to the Ch'ing, and was hailed as a martyr for the Ming cause. Yang Wen-ts'ung's shifting political loyalties are recounted in K'ung Shang-jen's (1648–1708) "The Peach Blossom Fan" ("T'ao-hua-shan"), a dramatic exposé of the corruption at the Southern Ming court written in the late seventeenth century.

95 *Landscape*
Shan-shui
楊文驄　山水

Dated 1628

Handscroll, ink on gold-flecked paper
31 x 577 cm (12³⁄₁₆ x 227³⁄₁₆ in.)

Tokyo National Museum TA–188

vol. 1, pl. 95

ARTIST'S INSCRIPTION AND SIGNATURE (4 lines in running-cursive script):
In the summer of the *wu-ch'en* year of the Ch'ung-chen era [1628], I painted this for Shih-t'ien during my sojourn to the capital when I was about to travel to the south. Unrolling the scroll, he should feel as if he were seeing me. Your junior, Yang Wen-ts'ung.

崇禎戊辰夏日，爲石田仁兄畫於長安客舍，時余將南行，石田展卷如見楊生也。友弟楊文驄。

ARTIST'S SEALS:
Lung-yu shih 龍友氏 (*chu-wen*, square)
Yang Wen-ts'ung yin 楊文驄印 (*pai-wen*, square)
I-tao 意到 (*chu-wen*, square)
Hu wo i ma 呼我以馬 (*pai-wen*, square)

FRONTISPIECE: Lo Chen-yü 羅振玉 (1866–1940)

COLOPHON: Wu Ch'ang-shuo 吳昌碩 (1844–1927), dated 1917, 2 seals

COLLECTORS' SEALS: Juan Yüan 阮元 (1764–1849), 5; Takashima Kikujiro 高島菊次郎 (20th century), 1

LITERATURE: Takashima, *Kaiankyo*, 1964, p. 23; *Illustrated Catalogues of the Tokyo National Museum*, 1979, no. 96; Suzuki, *Comprehensive Illustrated Catalogue*, 1982–83, vol. 3, JM1–234; *Yang Lung-yu*, 1988, p. 305.

Shao Mi (ca. 1592–1642) 邵彌

tzu Seng-mi 僧彌, *hao* Kua-ch'ou 瓜疇, Kuan-yüan-sou 灌園叟

Shao Mi was born in Su-chou, where as a youth he learned to paint in the Wu School style. The son of a physician, Shao received a classical education, but his weak constitution—the result of a childhood illness—prevented him from sitting for the grueling three-day examinations. Despite this impediment, Shao soon attracted considerable attention for his mastery of the triple arts of poetry, calligraphy, and painting. Although his early contacts were with Su-chou artists and intellectuals, in mid-life Shao became acquainted with Tung Ch'i-ch'ang's circle in Sung-chiang and was later counted among the Nine Friends of Painting. In his colophon to an album of landscapes painted by the artist in 1634, Tung claimed that Shao Mi's work was equal to that of the Four Great Masters of the Yüan, praise that testifies to their close friendship (Cahill, *Distant Mountains*, 1982, p. 60, n. 25).

Other acquaintances remarked on Shao's frailty and compulsive cleanliness. In his epitaph of the artist, Wu Wei-yeh (1609–1671) noted that Shao was "as thin as a yellow crane and as free as a seagull." In middle age Shao contracted a lung disease, and failing to find a doctor who could cure him, he pored through medical texts in search of an ever-elusive remedy. Shao's family resources were eventually depleted by his many illnesses and his fondness for collecting art, and he died in poverty before reaching his fiftieth birthday.

96 *Landscapes*
Shan-shui
邵彌　山水

Dated 1638

Album of ten paintings, ink and color on paper
28.9 x 43.2 cm (11³⁄₈ x 17 in.)

Seattle Art Museum, Eugene Fuller Memorial Collection 70.18

vol. 1, pl. 96 (leaves 1, 4–7, 10); vol. 2, pl. 96 (leaves 2, 3, 8, 9, colophon)

ARTIST'S INSCRIPTION AND SIGNATURE:
Leaf 10, 2 lines in regular script:
The realm of the spirit is where the immortals hide themselves.

In my dream I have often traveled here.

In the fourth month of the *wu-yin* year of the Ch'ung-chen era [May 14–June 11, 1638]. Shao Mi.

靈境仙所閟

夢曾來此頻

　　崇禎戊寅四月。邵彌。

ARTIST'S COLOPHON AND SIGNATURE (11 lines in regular script):
To take the old masters as one's teachers is certainly good, but in order to make further progress it is necessary to take Heaven and Earth as one's teachers [quotation from Tung Ch'i-ch'ang]. I often returned to the mountains and observed the changing forms of the clouds and mists in the mornings, and also the unusual shapes of trees and the springs. I have recorded all I have seen on the plain silk. I sometimes feel my paintings are better than those by my contemporaries and sometimes worse; such are the pleasant diversions of hermits. I painted this album after drinking wine by lamplight; it is not worth examining by critical eyes. In the fourth month, summer, of the *wu-yin* year of the Ch'ung-chen era [May 14–June 11, 1638], recorded in the Ch'ang-shui Studio. Kua-ch'ou, Shao Mi.
(Translation after Sirén, *Leading Masters and Principles,* 1956–58, vol. 5, p. 33.)

畫以古人爲師已是上乘，進此當以天地爲師。往常憩息山中，晨
起看雲煙變幻，林泉駭異。悉收之生絹。覺與今人時有進退，亦
幽人弗快中一樂事也。是冊迺酒後燈下所及，不堪供醒眼人披攬
也。崇禎戊寅夏四月，記於長水龕。瓜疇，邵彌。

ARTIST'S SEALS:
Shao Mi chih yin 邵彌之印 (*pai-chu wen,* square; leaf 10)
Seng-mi 僧彌 (*chu-wen,* square; leaf 10)
Shao Mi ssu-yin 邵彌私印 (*chu-wen,* square; leaves 1, 3–9, colophon)
Kua-ch'ou 瓜疇 (*chu-wen,* oval; colophon)
Tzu Seng-mi 字僧彌 (*pai-wen,* square; colophon)

COLOPHON: Tsai-e 在峩, undated, 8 seals

NO COLLECTORS' SEALS

Shao Mi was called by the poet Wu Wei-yeh (1609–1672) one of the Nine Friends in Painting, a group that also included Tung Ch'i-ch'ang, Ch'eng Chia-sui (1565–1644), Li Liu-fang (1575–1629), Pien Wen-yü (ca. 1576–1655), Yang Wen-ts'ung (1596–1646), Wang Shih-min (1592–1680), Wang Chien (1598–1677), and Chang Hsüeh-tseng (fl. ca. 1634–57). Although he apparently came under the influence of Tung Ch'i-ch'ang and the Sung-chiang School, Shao Mi also appropriated the styles of Wu School artists such as Wen Cheng-ming (1470–1559) and T'ang Yin (1470–1523). Thus we find in Shao Mi's work both an interest in the narration of human activities derived from his familiarity with the Wu School (leaves 1 and 2) and a tendency toward fantastic and even unreal or dreamlike spatial treatment inspired by the circle of Tung Ch'i-ch'ang (leaves 7, 8, and 9). In leaf 2 of this album, for instance, a hermit is waiting for a visitor who is approaching the open pavilion across a bridge above a pond. The foreground is filled with a row of pine trees that form a screen through which the narrative is seen. The viewpoint of the whole painting, however, is quite unstable, for it tilts upward toward the right and downward on the lower left. Although the manner in which the forms are depicted and the color scheme (pale blue-green and yellow-brown) are reminiscent of the Wu School, the distorted space seems to be more in keeping with the work of Tung Ch'i-ch'ang's circle.

The upward-leaning mountain peaks suspended in midair in leaf 7 are also typical of Shao Mi's exploration of the restless and the dramatic. Like Tung Ch'i-ch'ang and Chao Tso (ca. 1570–after 1633), Shao Mi used narrow blank strips of surface as schematic devices to set off forms from their surroundings (cf. leaf 8). The result is a dynamic landscape that is both real and open to fantasy (Cahill, *Distant Mountains,* 1982, pp. 59–62; Cahill, *Restless Landscape,* 1971, pp. 57–63).

JK

EXHIBITIONS: University Art Museum, Berkeley, 1971: Cahill, *Restless Landscape,* cat. no. 19; Krannert Art Museum, University of Illinois, 1990: Munakata, *Sacred Mountains,* cat. no. 71.

LITERATURE: Sirén, *Leading Masters and Principles,* 1956–58, vol. 5, p. 33, vol. 6, pl. 284; *Asiatic Art,* 1973, cat. no. 152; Cahill, *Distant Mountains,* 1982, pp. 61–62, color pl. 5, pl. 18; Cahill, *Compelling Image,* 1982, pls. 3.9, 3.10, 3.11; *Hai-wai i-chen,* Painting II, 1988, pl. 92.

Ch'en Hung-shou (1598–1652) 陳洪綬

tzu Chang-hou 章侯, *hao* Lao-lien 老蓮, Fu-ch'ih 弗遲, Yün-men-seng 雲門僧, Hui-seng 悔僧, Hui-ch'ih 悔遲, Lao-ch'ih 老遲; *chai* Ch'ing-t'eng shu-wu 青藤書屋

Ch'en Hung-shou, renowned for his eccentric lifestyle and unique painting style, was born into a scholar-gentry family in Chu-chi, Chekiang. His early education was directed toward success in the official examinations, but his father's premature death in 1605 left him under the tutelage of his granduncle, who introduced the young Ch'en Hung-shou to the pleasures of wine, poetry, and painting. In this environment, Ch'en's artistic talent was rapidly discovered, and at the age of ten *sui* (nine years old) he was already a student in Lan Ying's (1585–ca. 1664) Hang-chou atelier. His artistic endeavors notwithstanding, Ch'en passed the *hsiu-ts'ai* examination in 1618 and then advanced to the metropolitan examinations, which he failed on both attempts in 1623 and 1638. Ch'en's reputation as a painter increased during this period; by the time of his second trip to Peking he was lauded as the southern counterpart of the northern figure painter Ts'ui Tzu-chung (ca. 1595–1644).

Ch'en was summoned to the Ming court to serve as a Painter-in-attendance (*Tai-chao*), an offer he rejected with disdain. Later, he also declined to join the Southern Ming court as a Han-lin Academician. Despite his refusal to serve at the court, Ch'en Hung-shou became a dedicated partisan of the Ming after its demise at the hands of the Manchu conquerors, often lamenting that he had not taken his own life in 1644.

In 1646 Ch'en Hung-shou entered a monastery near Shao-hsing prefecture, Chekiang. The Buddhist names he assumed at this time reveal his overwhelming remorse for the loss of the Ming: Hui-seng (Repentant Monk), Hui-ch'ih (Belated Repentance), and Lao-ch'ih (Old and

Too Late). Unable to reconcile his Confucian sense of filial piety and familial responsibility with the rigors of monastic life, Ch'en abandoned the monkhood and returned to secular life. He worked as a professional painter in Shao-hsing until his death in 1652.

97 *Landscape and Figures*
Shan-shui jen-wu

陳洪綬　山水人物

Undated

Hanging scroll, ink and color on silk
171.8 x 48.5 cm (67⅝ x 19⅛ in.)

Beijing Palace Museum

vol. 1, pl. 97

ARTIST'S INSCRIPTION AND SIGNATURE (1 line in running script):
Hung-shou painted [this] at the Blue Wisteria Study.

洪綬畫於青藤書屋。

ARTIST'S SEALS:
Ch'en Hung-shou yin 陳洪綬印 (*pai-wen*, square)
Chang-hou shih 章侯氏 (*pai-wen*, square)

NO COLOPHONS

COLLECTOR'S SEALS: unidentified, 1

Ch'en Hung-shou did not have a direct relationship to Tung Ch'i-ch'ang as did Ting Yün-p'eng (1547–after 1621) and Ts'ui Tzu-chung (ca. 1595–1644). Rather, Ch'en is linked to Tung through their shared objectives. His interpretation and re-creation of the past may be seen as being in the spirit of Tung's ideas; he presents a different approach to the return to the mind of antiquity, *fu-ku* 復古. Ch'en wrote, "If one can enliven the rigidity of Sung with the charm of T'ang and apply the Yüan style within the Sung rationality, this indeed will be the Great Synthesis" (Huang Yung-ch'üan, *Ch'en Hung-shou nien-p'u*, 1960, p. 117). *Landscape and Figures* shows his revivalism under very specific historical circumstances.

Judging from his signature, Ch'en Hung-shou painted *Landscape and Figures* in the years just after the Manchu conquest as the Manchus were consolidating their rule over south China. Sometime during the spring or summer of 1644, Ch'en, who greatly admired the sixteenth-century painter Hsü Wei (1521–1593), moved into Hsü's old residence, the Blue Wisteria Study (Ch'ing-t'eng shu-she) at Shan-yin in Shao-hsing prefecture (Huang Yung-ch'üan, *Ch'en Hung-shou nien-p'u*, pp. 78–79). He was there in 1645 through the collapse of the Southern Ming in Nanking and the flight of the court to the south and seems to have stayed there through the middle of 1645 before fleeing to Hang-chou. In 1647, after an interval in the mountains with his family, Ch'en returned again to Shao-hsing; there is a recorded inscription for a painting at the Blue Wisteria Study for that year (Huang Yung-ch'üan, *Ch'en Hung-shou nien-p'u*, p. 104). It was probably during his 1644–45 stay at the Blue Wisteria Study that he painted *Land-*

scape and Figures. It has been suggested that immediately following the fall of the Ming while living more or less in seclusion Ch'en felt the necessity of working out his own identity as an *i-min*, a leftover subject of the Ming, in order to be able to present himself to the world after the suicide of so many of his friends (Kohara, "An Introductory Study of Chen Hongshou, part 1," 1986–87, pp. 398–410). *Landscape and Figures* helped him establish that image.

Ch'en Hung-shou made multiple allusions to the past in creating *Landscape and Figures*. He placed a single seated figure, probably meant to be himself, inside a thatched hut set deep within the landscape. The figure is surrounded by scholarly accoutrements and the hut by trees and foraminate garden rocks. The reclusive precinct is closed off by a wall with a brushwood gate. In the foreground a boy carrying a zither approaches across a bridge, and tall mountains appear above clouds in the far distance. The division of the composition serves to isolate the retreat, while at the same time the converging perspective of the hut focuses the viewer's attention on the building and its occupant. Through these means Ch'en draws on the tradition of thatched hut pictures (*ts'ao-t'ang t'u* 草堂圖), particularly as such images of the place of reclusion evolved from the fourteenth century onward (see Sensabaugh, "The Recluse Dwells Deep within a Thatched Hut," 1990, pp. 169–218). The perspective scheme of the hut goes back even further, however, to the beginning of the tradition as it was known from Lu Hung's (fl. first half of the 8th century) *Ten Views from a Thatched Hut* (*Ts'ao-t'ang shih-chih*, in the National Palace Museum, Taipei; *Three Hundred Masterpieces*, 1959, vol. 1, pls. 5–14). It echoes the opening section of the *Ten Views*, which shows Lu seated in his cottage cut off from the surrounding world. Recensions of Lu Hung's painting were known in fifteenth- and sixteenth-century Su-chou; T'ang Yin (1470–1523) and Hsieh Shih-ch'en (1487–ca. 1560) both executed versions after Lu Hung (Li Zhongyuan, *Shen-yang ku-kung po-wu yüan*, 1989, no. 9). Other Su-chou painters such as Ch'iu Ying (ca. 1494–ca. 1552) and Wen Cheng-ming (1470–1559) may have provided immediate sources for Ch'en's treatment of the subject as well. Ch'iu's *Relaxing in a Forest Pavilion* (*Lin-t'ing chia-ch'ü*, in the National Palace Museum, Taipei; Chiang Chao-shen, *Wu-p'ai hua chiu-shih nien chan*, 1975, no. 93) is remarkably similar in its central placement of a scholar in a pavilion and in its division of the composition. There are also similarities to Wen Cheng-ming's *Living Aloft* (*Lou-chü t'u*; Cahill, *Parting at the Shore*, 1978, color pl. 13) in the wall and the isolation of the hut. The startlingly tall tree that seems to dwarf all else in the painting probably has its source in a Wang Meng (1308–1385) picture of the Single Wu-t'ung Study now known only through sixteenth- and seventeenth-century copies (see Whitfield, *In Pursuit of Antiquity*, 1969, no. 8, for a version attributed to Wen Po-jen).

A final reference should perhaps also be made to Sheng Mou (ca. 1310–ca. 1350). Ch'en Hung-shou's rock forms are executed in the tradition of Li Ch'eng (919–967) and Kuo Hsi (ca. 1020–ca. 1100), and similar rocks are seen in Sheng Mou's *Whiling Away the Summer in a Mountain Pavilion* (*Shan-chü na liang*) in the Nelson-Atkins Museum (Ho et al, *Eight Dynasties*, 1980, no. 107). Sheng's picture similarly combines a theme of scholarly seclusion with a tripartite composition and thus may be yet another allusion within Ch'en's *Landscape and Figures*.

All of these references to past traditions of depicting the place of re-clusion, from T'ang through Ming, helped Ch'en Hung-shou establish the image of himself as an *i-min* recluse. It was in this way that Ch'en made the transition into the new world of Ch'ing China. It was in this way too that he created his own Great Synthesis.

DAS

LITERATURE: *Chung-kuo ku-tai shu-hua mu-lu*, vol. 2, 1985, *Ching* 1–2981, p. 70.

Hsiang Sheng-mo (1597–1658) 項聖謨

tzu K'ung-chang 孔彰, *hao* I-an 易庵, Hsü-shan-ch'iao 胥山樵, Lien-t'ang chü-shih 蓮塘居士; *chai* I-yü chai 疑雨齋

Hsiang Sheng-mo was a scion of one of the most renowned artistic families in the Chiang-nan region. His grandfather Hsiang Yüan-pien (1525–1590) amassed a vast collection of ancient paintings that formed the training ground for a whole generation of painters, including, among others, Tung Ch'i-ch'ang. As one of the heirs to this collection, as well as to the family library and wealth, Sheng-mo had from birth the finest educational and cultural resources at his disposal.

Although his early training prepared him for the official examinations, Hsiang Sheng-mo did not excel in these scholarly competitions and from a young age he expressed a desire for a leisured and reclusive life. These inclinations were lodged in his painting, especially in the series of handscrolls on the theme of reclusion entitled *Calling the Hermit*, the first of which he completed in 1626, at the age of thirty *sui* (twenty-nine years old). The painting bears congratulatory colophons by three of the most eminent scholars of the day—Tung Ch'i-ch'ang, Li Jih-hua (1565–1635), and Ch'en Chi-ju (1558–1639). Hsiang was particularly close to Li Jih-hua, to whom he was related by marriage. In 1628 Hsiang was with Li in Peking, and it was apparently through Li's introduction that he secured an appointment as a designer in the imperial wardrobe. During this time, Hsiang began his second *Calling the Hermit* scroll, explicitly declaring his desire to escape to the countryside despite his active engagement in governmental affairs.

Hsiang returned to his native Chia-hsing in 1629, where he remained in refined seclusion, studying and painting until the dramatic events of 1644–45 brought the Ming dynasty to an end. During the fighting between Ming loyalists and the Ch'ing Manchu army, Hsiang's home was destroyed and much of his family collection lost. After the fall of the Ming, Hsiang often incorporated nostalgic allusions to the former dynasty in his poems and paintings. A self-portrait of 1644 (in a private collection in Taipei) employs the unusual device of a red sky, a subtle reference to the surname of the Ming royal family, Chu 朱, which also means "vermilion." Hsiang spent his remaining years mourning the loss of the Ming.

98 *Invitation to Reclusion*
Chao-yin t'u
項聖謨　招隱圖

Dated 1625–26

Handscroll, ink on paper
29.2 x 762 cm (11½ x 300 in.)

Los Angeles County Museum of Art, Los Angeles County Funds
60.29.2

vol. 1, pl. 98; vol. 2, pl. 98 (colophons)

ARTIST'S INSCRIPTION AND SIGNATURE (1 line in seal script and regular script):
"Invitation to Reclusion," painted by Hsiang Sheng-mo.
《招隱圖》項聖謨畫。

ARTIST'S SEAL:
Hsiang-shih k'ung-chang 項氏孔彰 (*chu-wen*, square)

ARTIST'S COLOPHON, dated 1626:
I painted this scroll because in the autumn of the *i-ch'ou* year [1625], when my boat was reaching Wu-chiang [about twenty-five miles north of Chia-hsing], I, being quite free, found this set of paper in a total of six lengths and made it into a long handscroll to start to paint. Since then, sailing from Wu[-chiang] by way of Sung-chiang for almost a month, I completed less than a foot of this painting. Somehow some talkative people had already reported this to Mr. Tung Hsüan-tsai [Tung Ch'i-ch'ang]. When I went to visit Mr. Tung, he kept pressing me to show him this painting. I returned to the boat and moored at the White Dragon Lake, and then completed the first length of the scroll. Putting it inside my sleeve, I went to see Mr. Tung again. When he looked at it, he kept nodding his head without saying a word for a while. Then he said: "The mountains are high; the valleys are beautiful. The forests are green and the breezes touch our clothes. The man does not look back but seems to have the air of being out of this world. What is this painting about?" I said: "I was very much inspired after reading the poems on the invitation to reclusion by Lu Chi [261–303] and Tso Ssu [d. ca. 306], and painted this piece." It was already evening and he invited me for dinner. Having drunk a lot of wine, we talked and talked and discussed the many famous calligraphic works and paintings in my grandfather's collection. When midnight came, I got up and bade farewell to him, bringing the scroll back with me. In the tenth month of that year I was together with Mr. Hsüan-tsai again at Wu-chiang. Impatiently he asked: "Since I saw your scroll last time, how many mountains and valleys and mists and clouds have you added?" I then replied: "Since I have not found a mountain companion, I have not yet finished it. Now I want to bring my inkstone and live like a hermit. I shall express what is in my bosom and try to attain my ideal, as a way to achieve fulfillment in my life. Many people at the point of making a decision to leave the world behind find that they are unable to cut off their ties because they cannot leave worldly things behind. When you heard about this, you smiled. This means that you understood what I said quite well, for you have the same ideal." Having said this, I thanked him and left. Returning home, I worked with my brush and ink so hard that I seem not to have noticed the passing of months and years. When this scroll was finally completed, it had taken nine months, during which I was both sick and sad. Every time I got up from my sickbed and stretched out my painting, I was often prevented from working on it by worldly matters and sometimes had to spend my time meeting requests from various people. All these

made me so confused and worried that I could not work on it except perfunctorily. Only after the sun was down was I able to clean my ink-stone and light my lamp. I abstained absolutely from drinking and ate only pine-flower cakes and tea-leaf soup. Then I ordered the servant to burn incense and grind the inkstick. I worked until I got very tired before putting down the brush. Then I held the candle to look at the flowers or rolled up the curtain to look at the moon. If I felt refreshed, then I picked up my brush again. I usually worked until midnight before I went to bed. If the time is added up, it amounted to a period of somewhat less than two months. Now when I look at it, I can see that the forests and hills are bright and smiling, grasses and trees are happy and growing, the air is lively and the spirit is pleasant, all being far from vulgarity. I then gave it the title *Invitation to Reclusion*, and composed twenty poems of five-character lines with the same rhymes and wrote them down at the end of the scroll. I fully realize that many people in the world are not hermits, and that they want to be hermits but are not able to. Alas! There must have been some people who have become hermits before me. I say: Please call me for reclusion. I say: I shall call myself to reclusion. I can just say: It is all right for me to call myself for reclusion. I want to be a hermit in the cities, but cannot. I want to retreat into mountains and rivers, but cannot. I want to retreat into my poems and paintings, but they have been scattered around in the world, making it impossible for me to collect the names of those who own them. Thus I must keep this in my arms and store it well, in order to wait for those who share my ideal. On the sixteenth day of the sixth month of the *ping-yin* year of the T'ien-ch'i reign [1626], the Hermit of the Lotus Pond, Hsiang Sheng-mo, wrote this.
(Translation by Chu-tsing Li.)

余畫此卷，因乙丑秋涉吳江，舟次無事，檢得此紙，計共六幅，接爲長軸，始落墨也。自吳放流，遠至松江，將匝月矣，未及盈尺。有好事者已聞得董玄宰先生。及見先生，索觀甚急，乃退而辟舟，泊白龍潭，先了前一紙袖見。先生點頭不語，久許而問之曰：「山高谿秀，林翠撲衣，人不回顧，甚有超逸之風。此何圖也？」曰：「因讀陸機、左思招隱詩，有興于懷，將補是圖。」薄暮留之，豪飲劇談。因論及先王大父所藏法書名畫，夜半方起，索之而歸。是歲十月，復會玄宰先生於吳江。急謂余曰：「前觀此卷之後，又開得幾層丘壑，耕得幾頃烟雲？」余曰：「因未得尋山侶，志未竟也。今將借硯田以隱焉。抒懷適志，亦足了生平。蓋世人於出處之際，不能割裂，以世念未銷耳。先生聞之解頤，蓋亦有心人也。」言畢，謝退。歸事筆墨，若忘歲月。此卷計成，雖九易朔晦，病愁相半。及病起展閱，日未免爲塵鞅所妨，兼應酬徵索者命，煩亂不敢草草。每至落日，滌硯挑燈，絕不飲酒，所食者松花餅茗葉湯。命侍兒焚香研墨，神將倦，遂攔筆；或秉燭看花，或捲簾對月，爽則援毫，越子丑而方寢焉。累其功不二月也，因自展閱。林巒映發，草木欣向，氣爽神怡，流風絕俗，遂題曰《招隱圖》，并賦五言二十韻，書於卷末。我固知世人皆非隱者也，皆思隱而未肯者也。噫嘻哉！其必有先我而隱之者矣。曰招我隱可也；曰自我招隱可也；即曰自招亦無不可也。我將隱朝市，而不得；隱陵藪，而不得；將隱於詩畫，而詩畫已散落人間，又不得收拾姓字矣。亟懷此而善藏，以俟夫同志者。天啓丙寅六月既望，蓮塘居士項聖謨并記。

FRONTISPIECE: Tung Ch'i-ch'ang 董其昌, undated, 2 seals (*Tsung-po hsüeh-shih; pai-wen*, square, **107**; and *Tung Ch'i-ch'ang yin; pai-wen* square, **108**):
The picture and chant for *Invitation to Reclusion*. K'ung-chang [Hsiang Sheng-mo] used his poems on the calling of the reclusive life as the theme to paint this long handscroll of landscape—therefore, it became a twofold beauty. I wrote this as a foreword.

《招隱》圖詠。孔彰以所作招隱詩，繪爲山水長卷，遂成雙美。書此弁之。

COLOPHONS:
Tung Ch'i-ch'ang, undated, 2 seals (see frontispiece above):
Wang Mo-chieh [Wang Wei, 701–761] wrote his "Peach Blossom Poems" at the age of nineteen, and P'an An-jen [P'an Yüeh, 247–300] composed his "Poems on Leisure" when he was thirty-one. Now K'ung-chang wrote his "Invitation to Reclusion" at the age of thirty, with his ideal set at the forests and springs and his sounds being strong and firm. The subject of his poems comes from [*Wen-*]*hsüan* [a book of early Chinese poetry and essays compiled under the auspices of Prince Hsiao T'ung in the early sixth century], and the form from T'ang poems. Thus his poems have combined the best features of both Mo-chieh and An-jen and created the feeling of living in the Wang-ch'uan Villa [of Wang Wei] and the Ho-yang Retreat [of P'an Yüeh] for the rest of his life, without the distraction of the cities. Even though he is at the age of thirty, his lines, "Hoary head is what everybody will eventually become; there is no completely secure earthly net," show that he was already well aware of the rugged perils one might have to face late in life, such as those that befell Mo-chieh and An-jen. However, although the characters of the poets are different, the practices of the painters are the same. Hsiang's long landscape handscroll, while having some ideas from Yu-ch'eng [Wang Wei], also derives from Ching [Hao, ca. 870–80–ca. 935–40] and Kuan [T'ung, fl. ca. 907–23] and is modeled after Tung [Yüan, fl. ca. 945–ca. 960] and Chü[-jan, fl. ca. 960–ca. 986]. It is meticulous but does not hurt its bone structure; it is free but does not harm its spirit resonance. Thus it does not seem to take the Wang-ch'uan as its ultimate goal, but goes far beyond. In the future, when he reaches full maturity like Wei Su-chou [Wei Ying-wu, 737–ca. 792] and Li Hsi-ku [Li T'ang, ca. 1049–ca. 1130], how will his poetry and painting be? On the basis of this youthful work we can look forward with great expectations. Inscribed by Tung Ch'i-ch'ang.
(Translation by Chu-tsing Li.)

王摩詰十九賦《桃源行》，潘安仁三十一作《閒居賦》。孔彰今年三十賦《招隱詩》，志在林泉，聲出金石。其詩則取材於《選》，程格於唐。淹有摩詰、安仁之長，而若置身於輞川莊、河陽別業以終老，無朝市慕者。雖年三十，而摩詰、安仁晚歲踦驅涉世，賦「白首同所歸，安得舍塵網」之句，蚤分悟矣。惟是詞客之品雖懸，畫師之習猶在。其山水長卷，不免乞靈於右丞，然又出入荊、關，規模董、巨。細密而不傷骨，奔放而不傷韻。似未以輞川爲竟者。他時如韋蘇州、李晞古之大年，詩畫更當何若。以此爲少年之筆，爲券可也。董其昌題。

Ch'en Chi-ju 陳繼儒 (1558–1639), undated, 1 seal:
K'ung-chang's "Invitation to Reclusion" in both poetry and painting combines four lengths of Sung paper to form a long handscroll. The road leads into winding paths, sharp turns, high peaks, thatched huts, and deep caves, all so clean that no dust can be found. Also there are vegetables and mushrooms in the valley that taste pure and desirable. When the scroll is unrolled, all desire for fame and profit has been drained away. Among the famous paintings in the collection of Mr. Tzu-ching [Hsiang Yüan-pien, 1525–1590], Lu Hung's [fl. first half of the 8th century] *Thatched Hut* ranked the very first. K'ung-chang's handling of the brush has captured the strange and precarious compositions of this T'ang painter. There is no need for him to compete with the masters of the last dynasty. Inscribed by Ch'en Chi-ju.
(Translation by Chu-tsing Li.)

孔彰《招隱》詩圖，宋紙四番，遂成長卷。路入迂詰，勢轉嶺
欹。縐茆穴土，鮮潔無塵。飡谷茹芝，清淡有味。一展卷間，名
利之心，泏除盡矣。子京先生家藏盧鴻《草堂圖》，為名畫第
一。孔彰落筆，極得其奇險位置處，不願與勝國之賢摩壘相角
也。陳繼儒題。

Li Jih-hua 李日華 (1565–1635), dated 1628, 2 seals:

The masters of the last dynasty, strongly inspired by Tung [Yüan] and
Chü[-jan], always achieved spirit resonance in their paintings; even their
brushwork was seemingly casual and free. Only in composition did they
seldom originate their own. Huang [Kung-wang, 1269–1354] and Wang
[Meng, 1308–1385] were a little more innovative in this respect; their
works of this kind, however, are still quite rare. This is due to the fact
that the importance of composition to painting is similar to that of *fu* [a
literary form emphasizing the descriptive function of literature] to essay
writing. For painting is an art that requires the cultivation of a broad
mind and wide learning, embracing all elements of nature with the skill-
ful hands of the celestial Weaving Maid, who is the master of beautiful
fabrics. Nowadays the art of painting in the world is getting worse every
day because it has fallen into a state of fantastic, bizarre emptiness. So
bad has it become that trees are done without order and depth and rocks
are shown without front and back. People try to hide their shortcomings
behind the so-called Yüan style by saying, "I do this to preserve the
spirit of the untrammeled." Since this kind of excuse passes on from
teacher to pupil as acceptable behavior, there is no way to stop it. My
friend Hsiang K'ung-chang [Hsiang Sheng-mo], who is a youthful scion
of a famous family, has devoted himself to this art in his spare time
from his studies. One day he showed me this scroll. It is beautifully and
skillfully done, powerful and dramatic in expression, with the forms and
feelings of the mountains and waters constantly changing from section
to section, in a length of about thirty to forty feet. Its brushwork is mod-
eled after Hung-i's [Lu Hung] *Thatched Hut*, Mo-chieh's [Wang Wei]
Wang-ch'uan, Kuan T'ung's *Snowy Cliff-walks*, and Ying-ch'iu's [Li
Ch'eng, 919–967] *Wintry Forests*. There is not one single stroke that fol-
lows the narrow path of the Southern Sung painters. Nonetheless, there
is no lack of vividness and vitality. It represents the mainstream of paint-
ing. K'ung-chang's grandfather, Mr. Tzu-ching [Hsiang Yüan-pien], was
a great collector and a discerning connoisseur. His collection of great
masterpieces from the past and present was unexcelled in the world. I
once saw his own paintings *Kuo Wu Practicing Alchemy on Mount Chiao*
and *Wu Tso-ch'ing Sailing in the Peach Blossom River*, both more than
two feet long. Now this scroll, so monumental and splendid, is about
three times as long. Truly the Wu-wa [in present-day Kansu] horses are
justly famed for their dragon seeds. During this decline of the art of
painting, the ground has been defiled by the devil's saliva, which spreads
out like a spider web, entrapping any painter who tries to escape. K'ung-
chang alone seems to have been able to overcome such pitfalls with his
forceful ideas and intuitive understanding. Can we not recognize him as
a rising star? As we are natives of the same hometown and our families
have known each other for generations, I feel that my praise and admira-
tion for his work should count double that of Tung and Ch'en. The first
day of the last month of winter of the *ting-mao* year of the T'ien-ch'i era
[January 7–February 4, 1628], a friend from Pai-chu, Li Jih-hua.
(Translation by Wai-kam Ho.)

勝國諸公繪事，得董、巨心印，縱橫塗抹，皆有神韻。獨於作
圖，不輕自任。唯黃、王有之，亦不多見。蓋繪之有圖，猶文之
有賦，非胸次淹宏，苞茹山海，吐吞日月，而又出以天孫七襄組
麗之手，未易為也。今天下畫習日繆，率多荒穢空疏，�幻慌
惚。乃至作樹無復行次，寫石不分背面，動以元格自掩。曰：

"我存逸氣耳。"相師成風，不復可挽。吾友項孔彰，以妙年
名裔，讀書之餘，篤意此道。一日出示此卷，精工美麗，雄渾岑
崿。山態水情，段段轉換。長幾三四丈。其筆法一本鴻乙《草
堂》、摩詰《輞口》、關同《雪棧》、營丘《寒林》諸蹟，無一
毫入南渡蹊徑。而生動之趣，未嘗不在，此繪林正脈也。孔彰大
父子京先生，博雅精鑒，所蓄古今名蹟甲天下。余嘗見先生所作
《郭五遊焦山煉丹圖》、《鄔佐卿桃花放棹圖》，皆盈二尺有
奇。而此卷巨麗，實三倍之，信渥渥之多龍種也。當此畫道凋
落，魔涎灑地，布網粘綴，無一得脫之時，而英思神悟，超然獨
得如孔彰，可不謂崛起之豪歟。余忝同里世交，其嘆服稱快，又
倍於陳、董二先生也。天啟丁卯季冬朔日白学友人李日華識。

Yü Yen 俞彥 (17th century), dated 1628, 2 seals; Fei Nien-tz'u 費念慈
(1855–1905), dated 1889, 1 seal

COLLECTORS' SEALS: Yang Yin-pei 楊蔭北 (20th century), 3; Chou
Hsiang-yün 周湘雲 (20th century), 3; Wang Chi-ch'ien 王季遷
(b. 1907), 1; unidentified, 2

LITERATURE: Li, "Hsiang Sheng-mo," 1976, pp. 535–39, pl. 2; Yang Xin,
Hsiang Sheng-mo, 1982, pls. 14–17.

99 *Untrammeled Immortal amid Soughing Pines*
Sung-t'ao san-hsien t'u
項聖謨　松濤散仙圖

Dated 1628–29

Handscroll, ink on paper
28.3 x 689.2 cm (11⅛ x 271⁵⁄₁₆ in.)

Museum of Fine Arts, Boston
Frederick L. Jack Fund 55.928

vol. 1, pl. 99

ARTIST'S INSCRIPTION AND SIGNATURE (5 lines in regular script):
"Untrammeled Immortal amid Soughing Pines." Its execution began in
the seventh month of the *wu-ch'en* year in the Ch'ung-chen era [July 31–
August 28, 1628], when the reign title was changed. It was completed in
the second month of the following year [February 23–March 24, 1629].
This inscription is written at the I-yü Studio on the day of *hsin-mao*.
Hsiang Sheng-mo.

《松濤散仙圖》。崇禎改元戊辰七月援筆，至明年二月始成，是
日辛卯，識于疑雨齋。項聖謨。

ARTIST'S SEALS:
Sheng-mo 聖謨 (*chu-wen*, rectangle)
K'ung-chang fu 孔彰父 (*pai-wen*, square)
Lien-t'ang chü-shih 蓮塘居士 (*pai-wen*, square)
Feng-sung 鳳松 (*chu-wen*, rectangle)
Hsiang Sheng-mo shih hua 項聖謨詩畫 (*pai-wen*, square)
Hsiang Sheng-mo yin 項聖謨印 (*chu-wen*, square)
K'ung-chang 孔彰 (*pai-wen*, square)
Kao-wu hsiu-chu jen-chia 高梧脩竹人家 (*pai-wen*, square)
Sung-t'ao san-hsien 松濤散仙 (*pai-wen*, square)
Tsui feng shih hua 醉風詩畫 (*pai-wen*, square)

Hsiang Po-tzu liao i tzu-yü 項伯子聊以自娛 (*chu-wen*, square)
Ta-yu shan-fang so ts'ang t'u-shu yin 大酉山房所藏圖書印 (*chu-wen*, square)

ARTIST'S COLOPHON, dated 1629, 5 seals:

When I was still a boy I already loved to play with the brushes, but my late father reprimanded me and forbade my doing it in the daytime, because I had to study for the civil examination. So every night I sketched insects, grasses and trees, birds, flowers, and bamboos under lamplight. Only when I produced a semblance did I stop. One night I suddenly dreamed of my brush standing like a pillar straight up to the sky. On it was a stairway like a ladder, the length probably ten or even twenty feet. As I climbed to the tip of the brush, I clapped my hands, talked, and laughed to myself. Since then, whenever I have followed the footsteps of the old masters my wishes have always been fulfilled. I have always wanted to have a rustic hut among mountains and streams with which I could commune, but I was disappointed in not being able to find an ideal spot. To this day, for more than twenty years, my writings and paintings have never departed from this wish. In the sixth month of the *ping-yin* year [June 24–July 22, 1626], I completed the *Invitation to Reclusion*. Next I painted this scroll and entitled it *Untrammeled Immortal amid Soughing Pines*, after my mountain villa built on a slope formed by a pile of stones on which grew numerous ancient pines, studded also with flowers and bamboos. One summer day when I sat beneath the pines and enjoyed the cool breeze, suddenly I composed a poem:

Here am I, a retired scholar resting among waving pines;
Napping in the daytime and hanging my cap on the wall.
Bamboos grow before the window, shielding me from the mundane;
For nearly ten years I have not visited the capital city.

In the *wu-ch'en* year [1628], I passed through the states of Ch'i and Lu [Shantung province] and went beyond the Great Wall, traveling over Mount Yen and the River Kuei [Shansi province]. I then returned to the capital [Peking]. The trip took me about nine months. In Peking I lived in a lodging-place and was at leisure. During this time I closed the door and painted this picture. One day, when the painting was just about half done, I went out and, feeling tired, I turned my horse homeward. As the horse ran like a flying bird, I was suddenly thrown off, injuring my right arm, which made me incapable of using it. This was due neither to the horse, nor to my lack of skill in horsemanship. It might have been the will of Heaven. Some people who saw my injury said: "You have incurred Heaven's [the Creator's] jealousy." Some people encouraged and comforted me, saying: "Your arm is protected by the spirit of God and you will soon recover." I felt the same way. Day after day I drank several pints of wine. After I became drunk I yelled and asked: "Is it true that I have been punished by Heaven? Would it be the end of Master Hsiang?" Sometimes I lifted up my voice and sang to the moon. On rainy days I slept and in my dreams wandered around the heavens. After ten days there was a slight improvement in my arm. So I took out the calligraphy and paintings which I had at hand for my enjoyment. As I went through them, I found this scroll. When I saw it, I was even more grieved and sad. Not long afterward my arm was fully mended. I was delighted, and immediately told my servant-boy to prepare the baggage for my return to the south. We arrived at home on the first moon of the following year. My mountain retreat was beautiful, surrounded by luxuriant verdant pines. Then I suddenly became excited and, taking out this scroll, without delay completed the last half. Can it be true that there was a ghost in my arm? Is Master Hsiang a real untrammeled immortal? More likely, I was inspired by the old masters' brushworks, which I cherished and which united in guiding my hand to paint, for suddenly I had recovered the power of my arm. When the scroll was unrolled, I was overjoyed and was beside myself. Disregarding my unworthiness, I wrote this account, preceded by eight poems in five-character lines. In the month of clear weather [the fourth month] of the *chi-ssu* year, the second year of the Ch'ung-chen era [April 23–May 22, 1629]. Inscribed at Lang-yün t'ang. K'ung-chang, Hsiang Sheng-mo of Hsiu-chou. (Translations of inscription and colophon after Tomita and Tseng, *Portfolio of Chinese Paintings*, 1961, pp. 14–15.)

余髫年便喜弄柔翰。先君子責以制舉之業，日無暇刻，夜必篝燈着意摹寫。昆蟲、草木、翎毛、花竹，無物不備，必至肖形而止。忽一夕，夢筆立如柱，直干雲漢，上有層級如梯，長可一二丈許。余登而據其毫端，鼓掌談笑。嗣後師法古人，往往自得。每欲別置草堂于山水之間，以寄我神情，恨未能得一勝處。迄今二十餘年，孳孳筆墨，未嘗離之。自丙寅六月畫成《招隱圖》後，此第二卷也。命曰《松濤散仙圖》。蓋爲余山齋壘石作坡，多種古松，綴以花竹，嘗夏日箕踞其下，以追涼風，偶有自咏詩曰：「偃息松濤一散仙，葛巾掛壁自閒眠。窗前有竹聊醫俗，不到長安已十年。」適戊辰歲，經齊、魯，出長城，歷燕山，遊嬀川，又入長安，凡九閱月。邸中無事。唯捬扉作此圖。將半卷，一日出，既倦，乘馬歸，而馬疾如飛鳥，忽爾墜地，傷右肱不能展舒。夫馬非不良也，御亦非不善也，意者其天乎。見之者莫不爲項子太息，曰：「君爲造物忌。」又有次相慰示者，曰：「此腕當有神護，諒無恙也。」余亦自忖爾爾。日飲酒數升，盡醉狂叫，果爲造物忌邪？抑欲窮項子邪？對月則長嘯浩歌，聽雨則卧遊天表。將旬日，稍有起色，乃出平昔所自玩書畫，遍覽一番。此卷在內，見之更自嗟悼不已。未幾，臂果無恙，遂欣然命童僕治裝南還。迨明年之正月穀日抵家，見山齋松色蒼秀森蔚，率爾神動，急出此卷以續其半，豈真腕中有鬼邪？項子其真散仙邪？不然，豈古人筆墨精華欲一發洩，倩余手作合聚會，一時而惠及我臂邪？展卷間，不覺躍然，題此不自知其妄也。并前五言八韻書之。崇禎二年歲在己巳清和月，識於朗雲堂。秀州孔彰項聖謨。

LABEL STRIP: Ch'ing Kao-tsung 清高宗 (r. 1736–95), 2 seals

INSCRIPTION: Ch'ing Kao-tsung, undated, 1 seal

COLLECTORS' SEALS: Hsiang Yü-k'uei 項禹揆 (17th century), 9; An Ch'i 安岐 (1683–ca. 1746), 5; Ch'ing Kao-tsung, 16; Yang Shou-shu 楊壽樞 (20th century), 1; Yang Yin-pei 楊蔭北 (20th century), 3; Chou Hsiang-yün 周湘雲 (20th century), 4; T'an Ching 譚敬 (20th century), 5; unidentified, 1

RECENT PROVENANCE: C. C. Wang

LITERATURE: *Shih-ch'ü pao-chi hsü-pien*, completed 1793, repr. 1948, vol. 33, p. 136; Juan Yüan, *Shih-ch'ü sui-pi*, repr. 1854, *ch.* 6, pp. 14–15; An Ch'i, *Mo-yüan hui-kuan*, pref. 1742, repr. 1900, *ch.* 4, pp. 26–29; Tomita and Tseng, *Portfolio of Chinese Paintings*, 1961, cat. no. 72; Li, "Hsiang Sheng-mo," 1976, pp. 539–40, fig. 3; Yang Xin, *Hsiang Sheng-mo*, 1982, pls. 10–13.

Chang Hung (1577–ca. 1652) 張宏

tzu Chün-tu 君度, *hao* Ho-chien 鶴間

Details concerning the life of the highly innovative painter Chang Hung are scarce. According to his inscription on his painting *Mount Chü-ch'ü* of 1650 (Museum of Fine Arts, Boston), Chang Hung was born in Su-chou in 1577. Although information about his family is not available, we may conjecture that he was from a commoner house-hold—perhaps even a family of professional painters since he appears to have had little contact with literati painters or scholars in the Chiang-nan region. His painting style relies on highly coloristic effects to achieve an illusion of space, atmosphere, and texture that is unprece-dented in Chinese painting. Nonetheless, allusions to previous masters do not go undetected in his works. The broad range of styles and sub-jects depicted in his paintings suggests that Chang Hung was one of the many late Wu School artists who, as professional painters, flooded the marketplace with their works during the first half of the seventeenth century.

100 *Landscapes in the Manner of Sung and Yüan Masters*

Fang Sung Yüan shan-shui
張宏　倣宋元山水

Dated 1636

Album of eleven paintings, ink and color on silk
42.5 x 26.7 cm (16¾ x 10½ in.)

Ching Yüan Chai Collection

vol. 1, pl. 100 (leaves 1–3, 10); vol. 2, pl. 100 (leaves 4–9, 11)

ARTIST'S INSCRIPTIONS AND SIGNATURE:
Leaf 1, 1 line in running-regular script:
Imitating Li Ch'eng [919–967]

倣李成

Leaf 2, 1 line in running-regular script:
Imitating Pei-yüan [Tung Yüan, fl. ca. 945–ca. 960]

倣北苑

Leaf 3, 1 line in running-regular script:
Imitating Fan K'uan [d. after 1023]

倣范寬

Leaf 4, 1 line in running-regular script:
Imitating Kuo Hsi [ca. 1020–ca. 1100]

倣郭熙

Leaf 5, 1 line in running-regular script:
Imitating Nan-kung [Mi Fu, 1051–1107]

倣南宮

Leaf 6, 1 line in running-regular script:
Imitating Hsia Kuei [fl. ca. 1220–ca. 1250]

倣夏珪

Leaf 7, 1 line in running-regular script:
Imitating Ta-ch'ih [Huang Kung-wang, 1269–1354]

倣大痴

Leaf 8, 1 line in running-regular script:
Imitating Yün-hsi [Ts'ao Chih-po, 1272–1355]

倣雲栖

Leaf 9, 1 line in running-regular script:
Imitating Chung-kuei [Wu Chen, 1280–1354]

倣仲珪

Leaf 10, 1 line in running-regular script:
Imitating Yün-lin [Ni Tsan, 1301–1374]

倣雲林

Leaf 11, 7 lines in running-regular script:
Imitating Shu-ming [Wang Meng, 1308–1385]

倣叔明

In the summer of the *ping-tzu* year during the Ch'ung-chen era [1636], Jen-weng asked me to paint twelve album leaves. However, the everlast-ing spirit of the old masters was not easy to capture. I tried my best to emulate it, which was highly audacious in itself! I feel ashamed that they do not bear the slightest resemblance, but are only good for a laugh. Chang Hung from Wu-men [Su-chou].

崇禎丙子夏，訂翁命筆十二葉。然諸先輩千古精神亦不易得。余盡追之，事亦莽極矣！愧不能似其毫末，聊供一咲云爾。吳門張宏。

ARTIST'S SEAL:
Chang Hung, Chün-tu 張宏　君度 (*pai-wen*, rectangle)

NO COLOPHONS

NO COLLECTORS' SEALS

EXHIBITIONS: University Art Museum, Berkeley, 1971: Cahill, *Restless Landscape*, cat. no. 17; Vancouver Art Gallery, 1985: *The Single Brushstroke*, cat. no. 43.

LITERATURE: Cahill, *Distant Mountains*, 1982, pls. 53, 56; Cahill, *Compelling Image*, 1982, p. 60; Suzuki, *Comprehensive Illustrated Catalogue*, 1982–83, vol. 1, A31–057; *I-yüan to-ying* 41 (1990): 25.

101 *Landscapes in the Manner of Old Masters*
Fang-ku shan-shui
張宏　倣古山水

Dated 1636

Album of ten paintings, ink and ink and color on silk, with colophons by Ch'en Chi-ju (1558–1639)
31 x 22.5 cm (12¾₁₆ x 8⅞ in.)

Beijing Palace Museum

vol. 1, pl. 101 (leaves 1–4, 6, 7, 9, 10); vol. 2, pl. 101 (leaves 5, 8)

ARTIST'S INSCRIPTIONS AND SIGNATURE:
Leaf 1, 1 line in running-regular script:
The implication of [Ku] K'ai-chih [344–405]
愷之意

Leaf 2, 1 line in running-regular script:
The typical manner of Hu-t'ou [Ku K'ai-chih]
虎頭法墨

Leaf 3, 1 line in running-regular script:
Imitating [Chang] Seng-yu [fl. early 6th century]
倣僧繇

Leaf 4, 1 line in running-regular script:
After Li Ch'eng [919–967]
學李成

Leaf 5, 1 line in running-regular script:
The typical manner of Fan K'uan [d. after 1023]
范寬法墨

Leaf 6, 1 line in running-regular script:
Imitating the Mis [Mi Fu, 1051–1107, and Mi Yu-jen, 1074–1151]
倣米

Leaf 7, 1 line in running-regular script:
In the manner of Li T'ang [ca. 1049–ca. 1130]
李唐法

Leaf 8, 1 line in running-regular script:
In the brush manner of Ta-ch'ih [Huang Kung-wang, 1269–1354]
大癡筆意

Leaf 9, 1 line in running-regular script:
The implication of Chung-kuei [Wu Chen, 1280–1354]
仲珪意

Leaf 10, 4 lines in running-regular script:
In the brush manner of Yün-lin [Ni Tsan, 1301–1374]
雲林筆法

In the winter of the *ping-tzu* year of the Ch'ung-chen era [1636], I am staying at the Ch'u-ch'u Studio of the Ts'ao family in P'i-ling [Wu-chin county, Kiangsu]. Myriad trees shiver in bare branches, while pines and cedars are laden with greens. As if deep within the mountains, I feel par-ticularly peaceful. Picking up the brush, I paint as my heart pleases. Inscribed by Chang Hung.

崇禎丙子冬日，寓毘陵曹氏楚楚閣。萬木蕭踈，松杉積翠，儼若深山中，殊覺適情，隨興捉筆。張宏識。

ARTIST'S SEAL:
Chang Hung, Chün-tu 張宏　君度 (*pai-wen*, rectangle)

COLOPHONS: Ch'en Chi-ju 陳繼儒, undated, 2 seals (following the poems on each facing leaf); Hsü Tsung-hao 徐宗浩 (1880–1957), 2 dated 1943, 1950, 2 undated, 6 seals

COLLECTORS' SEALS: Hsü Tsung-hao, 3; unidentified, 4

LITERATURE: *Chung-kuo ku-tai shu-hua mu-lu*, vol. 2, 1985, *Ching* 1–2612.

102 *Twelve Views of Su-chou*
Su-t'ai shih-erh ching
張宏　蘇臺十二景

Dated 1638

Album of twelve paintings, ink and ink and color on silk
30.5 x 24 cm (12 x 9⁷₁₆ in.)

Beijing Palace Museum

vol. 1, pl. 102 (leaves 1, 3, 5, 6, 8, 9, 11, 12); vol. 2, pl. 102 (leaves 2, 4, 7, 10)

ARTIST'S INSCRIPTIONS AND SIGNATURE:
Leaf 1, 1 line in clerical script:
"The Evening Green of Mount Chih-hsing"
《支硎晚翠》

Leaf 2, 1 line in clerical script:
"Enjoying the Cool Breeze on Lotus Pond"
《荷蕩納凉》

Leaf 3, 1 line in clerical script:
"Stone Cliff by the Pond of Heaven"
《天池石壁》

Leaf 4, 1 line in clerical script:
"Wintry Mist on Mount Ling-yen"
《靈巘冬靄》

Leaf 5, 1 line in clerical script:
"Ten Thousand Peaks Reaching the Sky"
《萬笏朝天》

Leaf 6, 1 line in clerical script:
"A Breezy Spring Morning on Fan-li"
《蘩綺春曉》

Leaf 7, 1 line in clerical script:
"Evening Anchorage by the Maple Bridge"

《楓橋夜泊》

Leaf 8, 1 line in clerical script:
"Autumn Colors on Tiger Hill"

《虎山秋色》

Leaf 9, 1 line in clerical script:
"Night Moon over Tiger Hill"

《虎丘夜月》

Leaf 10, 1 line in clerical script:
"Mist and Rain on Stone Lake"

《石湖烟雨》

Leaf 11, 1 line in clerical script:
"Evening Ferry on the Hsü River"

《胥江晚渡》

Leaf 12, 5 lines in clerical and regular script:
"Snow on Yao Peak"

《堯峰積雪》

In the autumn of the *wu-yin* year [1638] while staying at the Chuang family studio in P'i-ling [Wu-chin county, Kiangsu], Chang Hung casually painted twelve leaves of Su-chou to ease the heat, feeling embarrassed [that my depictions] do not resemble [the actual locations].

戊寅秋日，寓毘陵莊氏之齋頭，漫圖蘇臺十二葉以消暑，愧不能似。張宏。

ARTIST'S SEAL:
Chang Hung, Chün-tu 張宏　君度 (*pai-wen*, rectangle)

NO COLOPHONS

COLLECTORS' SEALS: Chuang Ch'i-yüan 莊起元 (17th century), 1; Chou Ch'i-chiu 周郊九, 1

EXHIBITION: Beijing Palace Museum, 1990: *Wu-men*, cat. no. 95.

LITERATURE: *Chung-kuo ku-tai shu-hua mu-lu*, vol. 2, 1985, *Ching* 1–2618.

103 *The Chih Garden*
Chih-yüan
張宏　止園

Undated

Album of eight paintings, ink and color on paper
32.1 x 34.3 cm (12⅝ x 13½ in.)

Museum für Ostasiatische Kunst, Berlin

vol. 1, pl. 103

ARTIST'S INSCRIPTION AND SIGNATURE:
Leaf 1, 2 lines in running-regular script:
Overall View of the Chih Garden. Chang Hung from Wu-men [Su-chou] painted.

止園全景。吳門張宏寫。

ARTIST'S SEAL:
Chang Hung, Chün-tu 張宏　君度 (*pai-wen*, rectangle)

NO COLOPHONS OR COLLECTORS' SEALS

RECENT PROVENANCE: Franco Vannotti Collection

EXHIBITION: University Art Museum, Berkeley, 1971: Cahill, *Restless Landscape*, cat. no. 16.

LITERATURE: Cahill, *Distant Mountains*, 1982, color pl. 4, pl. 12.

104 *Clearing after Snow on the Ling-yen Hills*
Ling-yen chi-hsüeh
張宏　靈巖霽雪

Dated 1643

Hanging scroll, ink and color on paper
128.9 x 44.7 cm (50¾ x 17⅝ in.)

Museum Rietberg, Zürich, C. A. Drenowatz Collection

vol. 1, pl. 104

ARTIST'S INSCRIPTION AND SIGNATURE (2 lines in running-regular script):
"Clearing after Snow on the Ling-yen Hills." Chang Hung painted in the beginning of winter in the *kuei-wei* year [1643].

《靈巖霽雪》。癸未立冬日，張宏寫。

ARTIST'S SEALS:
Chang Hung 張宏 (*pai-wen*, square)
Chün-tu shih 君度氏 (*pai-wen*, square)

NO COLOPHONS OR COLLECTORS' SEALS

RECENT PROVENANCE: Charles A. Drenowatz Collection

EXHIBITIONS: Haus der Kunst, München, 1959: *Tausend Jahre Chinesische Malerei*, cat. no. 74; Kunsthalle, Köln, 1968: *Weltkunst aus Privabesitz*, cat. no. C14.

LITERATURE: Li, *A Thousand Peaks and Myriad Ravines*, 1974, no. 16; *Hai-wai i-chen*, 1988, Paintings II, pl. 86.

Wang To (1592–1652) 王鐸

tzu Chüeh-ssu 覺斯, *hao* Shih-chin 十津

A highly esteemed calligrapher, scholar, and painter, Wang To achieved almost unparalleled political success under both the Ming and the Ch'ing dynasties. From the time he received his *chin-shih* degree in 1622 until his death in 1652 (except for a short period of mourning for a parent in 1641–44), he served continuously as a high-level government official. In the top ranks of his class, Wang To received a coveted appointment as a Bachelor in the Han-lin Academy, which soon led to a series of promotions. In the 1630s and early 1640s, Wang's career advanced steadily, culminating in 1644 with his appointment as Minister of Rites in Peking. Before Wang arrived at his new post, the rebel leader Li Tzu-ch'eng had already taken the capital and the last Ming emperor had hung himself at Coal Hill. Upon receiving this disheartening news, Wang rushed back to Nanking to join the Southern Ming court.

Wang played a prominent role in the exiled court as Minister of Rites and Grand Secretary. Despite his long-standing devotion and service to the Ming government, he decided to join Ch'ien Ch'ien-i (1582–1664), Ch'eng Cheng-k'uei (1604–1676), Chou Liang-kung (1612–1672), and other high-ranking Ming officials in welcoming the Manchu forces at the Nanking city gates in the fifth month of 1645. For his part in this surrender, Wang To received an offer from the Manchus to continue in his position as Minister of Rites in Peking. As a former high official of the Ming, Wang To's co-optation into the new government mostly amounted to a propaganda ploy for the Manchus; and like most of the co-opted officials, Wang enjoyed light official duties, with ample leisure time in which to pursue artistic activities.

Wang's interest in the arts began during his youth in his native Honan. Later, during his residence in Peking and Nanking, he came in contact with many painters, calligraphers, collectors, and art dealers. In addition to gaining a reputation as a painter and calligrapher, Wang To also amassed a sizable collection of ancient masterworks.

105 *Landscape*

Shan-shui
王鐸　山水

Dated 1651

Hanging scroll, ink on satin
188.5 x 53 cm (74³⁄₁₆ x 20⅞ in.)

Beijing Palace Museum

vol. 1, pl. 105

ARTIST'S INSCRIPTION AND SIGNATURE (2 lines in regular script): Second month, second day of the *hsin-mao* year [February 21, 1651], written for the prominent poet, my in-law Fu Meng-chen. Wang To.
辛卯二月初二日，寫爲夢禎傳老親家詞壇。王鐸。

ARTIST'S SEAL:
To 鐸 (*chu-wen*, square)

NO COLOPHONS

COLLECTORS' SEALS: Wang Hung-hsü 王鴻緒 (1645–1723), 1; Wang Yang-tu 王養度 (19th century), 3; Liu Ch'un-hsi 劉春禧, 1; unidentified, 2

In the history of calligraphy Wang To is ranked along with Tung Ch'i-ch'ang as one of the great masters of the seventeenth century. Although his paintings did not garner equal praise, Wang, like Tung, was engaged in the re-creation of the past. Rather than emphasizing the Yüan masters as Tung had done, Wang looked to the painters of the tenth and eleventh centuries. In a letter to his friend Tai Ming-yüeh (d. ca. 1660) he wrote: "In regard to paintings that are bland and without feelings, such as the works of Ni Tsan [1301–1374], although such compositions are suffused with calm, they cannot avoid being dry and weak, like a sick man gasping for breath. Although they are called atmospheric and elegant, they are extremely insipid and limp. Great masters do not paint this way" (Chang Keng, *Kuo-ch'ao hua cheng lu*, repr. 1963, pp. 20–21; translation by Whitbeck, "Calligrapher-Painter-Bureaucrats in the Late Ming," 1971, p. 118, and Cahill, *Distant Mountains*, 1982, p. 166). Wang is said to have taken Ching Hao (ca. 870–80–ca. 935–40) and Kuan T'ung (fl. ca. 907–23) as his "great masters," and several paintings that later passed into the Ch'ing imperial collection as early landscapes bear his inscriptions. One is a hanging scroll attributed to Kuan T'ung entitled *Autumn Mountains at Dusk* (*Ch'iu-shan wan ts'ui*) in the National Palace Museum, Taipei. Wang wrote: "This is a genuine work of Kuan T'ung. . . . It is finely detailed but richly mature in style, with a feeling of great expansiveness that goes beyond brush and ink. The works of a great master are substantial in this way. Artists of the lineage of Ni Tsan, on the other hand, compete over who can be thinnest and most mannered. When they have produced two trees, one stone, and a sandy bank, they acclaim it as 'A landscape, a landscape!' Ching [Hao], Kuan [T'ung], Li [Ch'eng, 919–967], and Fan [K'uan, d. after 1023] were the ones who opened the gate" (*Ku-kung shu-hua lu*, 1965, *ch.* 5, p. 16; translation by Whitbeck and Cahill).

Wang To's *Landscape* in the Beijing Palace Museum has the substantiality of which he speaks. There are sandy banks and sparse trees in the foreground, but rising beyond is a developed middle ground and far distance. Unlike Tung Ch'i-ch'ang, Wang eschews clear divisions into three or four parts, as well as openings and closings, solids and voids. The middle ground to far distance is one massive section built up along the right through the repeated shapes of flat projections of land to enclose a valley with a temple. The whole is capped by the farther mountains. The composition, with its sharp break between the foreground banks and the distance, resembles the type of Kuan T'ung represented by *Waiting for the Ferry* (*Tai-tu t'u*), formerly in the Saito Collection (Sirén, *Leading Masters and Principles*, 1956–58, vol. 3, pl. 146). Although Wang To in this way refers to paintings that were thought to be by Kuan T'ung and thus geographically northern, the distant mountains in the Beijing *Landscape* are soft and rounded with earthy hummocks near the crest in what is a clear reference to the geographically southern tradition of Tung Yüan (fl. ca. 945–ca. 960) and Chü-jan (fl. ca. 960–ca. 986). The banks in the foreground, although not covered with reeds, may also be seen as a reference to this southern tradition.

Wang To was well familiar with the Tung Yüan–Chü-jan tradition: the hanging scroll *Cave Heaven Mountain Hall* (*Tung-t'ien shan t'ang*) now in the National Palace Museum, Taipei, is attributed to Tung Yüan on Wang's authority; he inscribed the *Hsiao and Hsiang Rivers* (*Hsiao-Hsiang t'u*) handscroll, so much appreciated by Tung Ch'i-ch'ang and now in the Beijing Palace Museum; and in 1643 he inscribed *Layered Cliffs and Dense Trees* (*Ts'eng-yen ts'ung-shu*) attributed to Chü-jan by Tung Ch'i-ch'ang, in the National Palace Museum, Taipei. Wang, then, incorporated various elements into *Landscape* through his direct knowledge of paintings attributed to early periods. This painting shows him to have been as important in the revival of Tung Yüan and Chü-jan as in the return to Ching Hao and Kuan T'ung. Although he did not adopt Tung Ch'i-ch'ang's style per se, Wang To was inspired by the possibilities that had been opened up by Tung.

DAS

LITERATURE: *Chung-kuo ku-tai shu-hua mu-lu*, vol. 2, 1985, *Ching* 1–3462. *Chung-kuo mei-shu ch'üan chi, hui-hua pien*, vol. 9, 1988, *ch'ing-tai hui-hua, shang*, pl. 2, p. 3; Xu Bangda, *Pien-nien-piao*, 1963, p. 360.

Chang Hsüeh-tseng (fl. ca. 1634–57) 張學曾

tzu Erh-wei 爾唯, *hao* Yüeh-an 約菴

Though he was well regarded in his own time as a painter, collector, poet, and government official, only a few paintings and some meager textual materials remain to document Chang Hsüeh-tseng's life and artistic accomplishments. Born in Shan-yin, Chekiang, Chang resided temporarily in the Sung-chiang region, where he associated with Tung Ch'i-ch'ang and his circle, resulting in his later designation as a member of the Nine Friends of Painting.

In 1651, when he was serving in the central government in Peking, Chang met the collector Chou Liang-kung (1612–1672) and painted several scrolls for him. One of these paintings, done in the manner of the Sung painter Chiang Shen (ca. 1090–1138), was praised by Ch'eng Cheng-k'uei (1604–1676), another disciple of Tung Ch'i-ch'ang, who in his colophon to the scroll not only refers to Chang as "my friend," but also claims that he was the only person who understood painting well enough to carry on a conversation on the subject (Kim, *Chou Liang-kung*, 1985, vol. 2, p. 110).

Ch'eng's respect for the artist may also have been bolstered by Chang Hsüeh-tseng's fine collection of ancient paintings, which included a highly coveted scroll by Chiang Shen. In his *Ch'i-sung t'ang chih hsiao-lu*, the scholar-official Liu T'i-jen (*chin-shih* 1655) records that when Chang was preparing to leave Peking in 1654 to take up a new post as Prefect of Su-chou, a group of collectors gathered to compare their treasures and admire the Chiang Shen painting in Cheng's collection (Liu

T'i-jen, *Ch'i-sung t'ang chih hsiao-lu*, 1720, pp. 10–11). At the time of this gathering, Chang Hsüeh-tseng was already an old man, and he must have died only several years after assuming his post in Su-chou.

106 *Landscape in the Manner of Wu Chen*
Fang Wu Chung-kuei shan-shui
張學曾　倣吳仲圭山水

Dated 1654

Hanging scroll, ink on satin
190 x 51.6 cm (74¹³⁄₁₆ x 20⁵⁄₁₆ in.)

Beijing Palace Museum

vol. 1, pl. 106

ARTIST'S INSCRIPTION AND SIGNATURE (3 lines in running-regular script):
Painted in the Mid-Autumn Festival [the fifteenth day of the eighth month] in the *chia-wu* year [September 25, 1654] in the manner of Wu Chung-kuei [Wu Chen, 1280–1354] for the amusement of elder Hsün-weng, an accomplished man of letters. Chang Hsüeh-tseng.

甲午中秋畫倣吳仲圭，似巽翁老先生詞宗一笑。張學曾。

ARTIST'S SEALS:
Chang Hsüeh-tseng yin 張學曾印 (*pai-wen*, square)
Erh-wei 爾唯 (*pai-wen*, square)

NO COLOPHONS

COLLECTORS' SEALS: Li I-mang 李一氓 (20th century), 1; unidentified, 5

RECENT PROVENANCE: Li I-mang

LITERATURE: *Chung-kuo ku-tai shu-hua mu-lu*, vol. 2, 1985, *Ching* 1–3843.

Chang Feng (d. 1662) 張風

tzu Ta-feng 大風, *hao* Sheng-chou tao-shih 昇州道士, Shang-yüan lao-jen 上元老人

Chang Feng was born in Nanking in the early part of the seventeenth century. His father, Chang K'o-ta (d. 1631), was a military official and was able to provide a substantial education for his two sons, I (1608–1695) and Feng. Chang Feng earned his *hsiu-ts'ai* degree sometime during the Ch'ung-chen period (1628–44), and after the fall of the Ming in 1644 he and his older brother I demonstrated their loyalty to the Ming

by living in reclusion, mainly in Buddhist and Taoist temples. Chang I made his home at Kao-tso Temple but maintained close social ties with many artists and intellectuals in Nanking, including Chou Liang-kung (1612–1672), with whom he forged a close friendship. Chang Feng shared many of his brother's friends and moved in most of the same circles.

After Nanking was taken by the Manchus in the spring of 1645, Chang Feng traveled to the north, where he visited temples in and around Peking. While in the capital he was feted by many officials, whose hospitality he repaid by painting for them. Chang returned to Nanking around 1647, and though he lived in greatly reduced circumstances (in various Buddhist temples and later in a small residence) he continued to paint and socialize with other artists and collectors in the area. Chou Liang-kung's compilation of contemporary correspondence, the *Ch'ih-tu hsin-ch'ao,* includes several letters from Chang Feng to collectors in which he discusses his ideas on painting.

In 1662 Chou Liang-kung invited Chang Feng to visit him at the Kao-tso Temple. According to Chou's record of the visit in his *Tu-hua lu,* during the five or six nights they spent together Chang painted several album leaves for Chou and gave him an album that he had completed earlier. Chou goes on to lament that several months later Chang Feng died (*Tu-hua lu,* preface dated 1673, *ch.* 3, p. 35).

107 *Landscapes*
Shan-shui
張風　山水

Dated 1644

Album of twelve paintings, ink and color on paper
15.5 x 23 cm (6⅛ x 9¹⁄₁₆ in.)

The Metropolitan Museum of Art, New York
The Edward Elliott Family Collection, Gift of Douglas Dillon, 1987
(1987.408.2)

vol. 1, pl. 107 (leaves 1–3, 5, 11, 12); vol. 2, pl. 107 (leaves 4, 6–10)

ARTIST'S INSCRIPTIONS AND SIGNATURES:
Leaf 1, 4 lines in regular script:
The mouth of this stream resembles the Peach Blossom Spring, but it isn't. Ta-feng.

水口略類桃源而非也。大風。

Leaf 2, 1 line in regular script:
Imitating Ni [Tsan, 1301–1374].

仿倪。

Leaf 3, 6 lines in regular script:
The red dust [of worldly affairs] does not pollute my doorstep;
Green trees lean over, crowding together above my house;
Blue mountains just fill the breach atop my wall.
These lines are from a lyric poem (*tz'u*) by a Yüan dynasty poet [Ma Chih-yüan, ca. 1260–1324]. It seems that I should use the water-and-trees method to achieve success, then I would probably have a skillful

result. I am put to shame by [the poet] Chang Kou-ch'ü's [Chang Yü, 1283–1350] words, "beating the side of a drum." [Written on] an evening in the seventh month of the *chia-shen* year [August 1644].

紅塵不向門前惹
綠樹偏宜屋角遮
青山正補墻頭缺
　　元人填詞也，似宜作水樹法爲得，而大概亦夯工處處，媿張句曲"擊鼓邊"一語。甲申七夕。

Leaf 4, 1 line in regular script:
Chimes in the clouds and sails in the wind.

雲磬風帆。

Leaf 5, 5 lines in regular script:
The subject of a painting is not predestined. When in a place you may be inspired, for example, by hearing the sound of a mountain torrent or thinking of [the couplet by Wang Wei, 701–761]: "The bright moon shines through the pines; The clear stream flows across the rocks." Elder brother Pei-chin must believe that I follow this path and also use contemporary literary methods. Ha! On the last day of the sixth month [August 1].

画無命題，在處移似聽澗響耳。若以爲"明月松間照，清泉石上流"亦可。北觀兄必以爲大風於此道亦用時文法也，一笑。六月晦日。

Leaf 7, 6 lines in regular script:
I don't seem to be able to achieve lightness (*tan*). After trying with all my might, this is what I have done. In the end, the brushwork is still cumbersome. [Done] while it was raining on the tenth day of the seventh month [August 11]. Ta-feng.

余苦不能淡至此，其亟力摹擬，然終是筆繁。七月十日雨中，大風。

Leaf 11, 1 line in regular script:
Evening sun on the mountains.

夕陽在山。

Leaf 12, 9 lines in regular script:
Elder brother Pei-chin gave me this album as something to be presented. I happened to be reading Yüan Chung-lang's [Yüan Hung-tao, 1568–1610] collected writings. I liked this couplet:
　　At the bottom of a waterfall, someone emerged from a cave.
　　The sound of a pebble tossed from the mountain is heard
　　　　in the next village.
So I made a painting of it. Because it is rather vague, I suspect I only got eighty or ninety percent. Younger brother Chang Feng uninhibitedly inscribed this at the Ju-ya Studio.

北觀兄以冊子見投。偶讀袁中郎集，因喜：
　　澗底有人穿洞出
　　山間投礫隔村聞
之句，輒爲圖，似恍恍疑得八九。小弟張風漫識於乳鴉軒。

ARTIST'S SEALS:
Feng 風 (*chu-wen,* oval; leaves 1–4, 6, 9–12)
Chang Feng 張風 (*chu-wen,* oval; leaves 5, 8)
Chang Feng 張風 (*pai-wen,* square; leaf 7)

FRONTISPIECE: Chang Ta-ch'ien 張大千 (1899–1983), dated, by seal, to 1968, 4 seals

COLOPHONS: An Chih-yüan 安致遠 (fl. early 18th century), undated, ca. 1725, 1 seal; Yu Yin 尤蔭 (1732–1812), dated 1781, 1 seal

COLLECTORS' SEALS: Ho Kuan-wu 何冠五 (20th century), 3; Chang Shan-tzu 張善孖 (1882–1940), 1; Chang Ta-ch'ien, 12

RECENT PROVENANCE: Chang Ta-ch'ien

In this album we see Chang Feng working in the manner of a miniaturist with controlled ink washes, delicate brushwork, and exquisitely small regular script inscriptions. The detailed style and intimate format of this work stands in marked contrast to the bravura manner of his later years.

Following the fall of Peking to the bandit-rebel Li Tzu-ch'eng in April 1644, and its subsequent occupation by the Manchus, the "southern capital" of Nanking endured a chaotic year of factional infighting before the city surrendered to Manchu forces in June 1645. Chang Feng, a native of Nanking, painted this album in August 1644, just as the Ming dynasty was crumbling.

Chang's album makes no overt reference to the chaos into which his world had been plunged, but his decision to withdraw from the "dusty world" of politics into the realm of the recluse-artist is already apparent. The album opens with a pointed reference to the eremitic utopia described in T'ao Ch'ien's (365–427) poem "Peach Blossom Spring" (Hightower, *The Poetry of T'ao Ch'ien*, 1970, pp. 254–56). The painting shows a lone fishing skiff moored on a secluded stream, but this vision of a peaceful haven, like that conjured up by T'ao's poem, is illusory and unattainable: Chang tersely notes that while his image resembles the Peach Blossom Spring, it isn't.

Throughout the album Chang utilizes the pale, dry ink style of the Yüan recluse Ni Tsan to create idyllic images evocative of lofty seclusion, but the gossamer lightness of Chang's touch adds a new lyrical charm to Ni's austere manner. In leaf 2, where he acknowledges Ni as his source, Chang softens his spare image of rocks and trees through the addition of pale reddish-brown color. The same device is applied in leaf 9 where the desolate emptiness of Chang's mountainscape is tempered by faint touches of umber and blue in his foliage dots and distant mountains.

The third leaf exemplifies Chang's state of mind at this time. It illustrates a verse of poetry by the Yüan poet Ma Chih-yüan (*Yüan Ming Ch'ing ch'ü hsüan*, 1953, vol. 1, p. 28), the middle three lines of which Chang has inscribed on his painting:

[I have] finished with fame and fortune;
Separated [myself] from right and wrong.
The red dust [of worldly affairs] does not pollute my
 doorstep;
Green trees lean over, crowding together above my
 house;
Blue mountains just fill the breach atop my
 wall;
A bamboo fence and thatch hut [is enough].

To translate this poetic image into painting, Chang Feng switches to the colorful idiom of Ni Tsan's close contemporary Wang Meng (1308–1385). Evoking his poetic and pictorial sources without trying to be too literal, Chang concentrates on telling details: unwanted visitors will find the compound's front door closed, but close friends know that the back gate stands open.

Chang also draws inspiration from actual scenery. To illustrate the poetic line "Chimes in the clouds and sails in the wind," leaf 4 depicts the Hung-chi Temple, which overlooks the Yangtze River just northeast of Nanking. Precariously perched above the river on long stilts, the temple conveys a special sense of remoteness and inaccessibility, particularly in Chang's image which juxtaposes the temple with an empty expanse of river and sky that merge seamlessly together like the sound of a temple bell reverberating through the mist. Images of isolation are a recurring motif in the album: leaf 6 portrays a bare tree whose solitude is reinforced by the chorus of circling blackbirds; leaf 8 depicts a secluded dwelling nestled under the shadow of a formidable cliff; and leaf 10 presents fishermen on a wintry river.

Chang's keen interest in stimulating all the senses through an expressive interplay of visual and poetic imagery constantly enriches his melancholy visions with dramatic and surprising effects. In leaf 5, a lone stroller tilts his head as if to concentrate on the sound of the nearby stream; in the distance, the pale form of a mountain appears bathed in moonlight. Chang points out in his inscription that his painting could have been inspired either by the actual experience of a mountain stream or by the imagery of a Wang Wei couplet. Leaf 11 presents a rare image of a sunset. It is not the sun or evening sky that interests Chang, however, but the evanescent afterglow that lingers on the tallest mountain after the sun has set. The surname of the Ming emperors, *chu* 朱, also means "red"; thus this image of a fleeting moment before the crimson light is swallowed up by the growing darkness held an ominous and tragic message for Chang and his contemporaries.

An equally haunting image, this time an evocation of sound through Chang's "wordless poetry," comes in the final leaf of the album. There, the rhythmic repetition of ovoid shapes in his landscape uncannily evokes the echoing reverberations of a stone tossed into a deserted valley. The aggregation of ovoid forms in this leaf also points up Tung Ch'i-ch'ang's influence on Chang Feng's art. In spite of his predilection for descriptive detail, Chang's calculated repetition of similar shapes and the contrasts in light and dark tonalities in this leaf cause his mountains to vibrate with abstract energy. By building his landscape forms into dynamic agglomerations, Chang successfully channels this kinetic energy, animating his composition in much the same way as Tung, although with a totally new and different end in mind.

MKH

EXHIBITION: Nanking, 1943: Republic of China Ministry of Education, *Famous Chinese Painting and Calligraphy*, no. 282.

LITERATURE: Sirén, *Leading Masters and Principles*, 1956–58, vol. 7 (lists), p. 286; Murray, "Chang Feng's 1644 Album of Landscapes," 1976; Jao Tsung-i, "Chang Ta-feng chi ch'i chia-shih," 1976, p. 67, pls. 4–10; Suzuki, *Comprehensive Illustrated Catalogue*, 1982–83, vol. 1, A17–107.

108 *Listening to the Waterfall by a Rocky Cliff*
Shih-yai t'ing-ch'üan
張風　石崖聽泉

Undated

Hanging scroll, ink on paper
94.3 x 40.9 cm (37⅛ x 16⅛ in.)

The Art Museum, Princeton University
Gift of Mrs. Edward L. Elliott (y1984–53)

ARTIST'S INSCRIPTION AND SIGNATURE (2 lines in regular script):
Looking up I see rocky cliffs;
Bending down I hear rushing water.
The mountain trees are firm and upright;
The valley flowers burst forth in a riot of brightness.
The call of a yellow-plumed bird
[Pierces] ten thousand layers of gray mist.
Those with tranquil hearts walk through the scenery,
Forever enjoying it.
　Chang Feng from Shang-yüan [Nanking] painted his ideas and inscribed this to amuse Mr. Shih-ch'ing.
(Translation by Ch'en Pao-chen, in Fong et al., *Images of the Mind*, 1984, p. 405.)

仰觀石壁
俯聽流泉
山木挺秀
澗花吐鮮
一聲黃鳥
萬叠蒼煙
靜者邁往
樂茲永年
　　上元張風寫意并題，屬士慶先生清玩。

ARTIST'S SEAL:
Shang-yüan lao-jen 上元老人 (*chu-wen*, square)

NO COLOPHONS

COLLECTOR'S SEALS: Ma Chi-tso 馬積祚 (20th century), 3

RECENT PROVENANCE: Ch'en Jen-t'ao

EXHIBITION: The Art Museum, Princeton University, 1984: Fong et al., *Images of the Mind*, cat. no. 36.

LITERATURE: *Shina nanga taisei*, 1936, pt. 9, pl. 241; Ch'en Jen-t'ao, *Chin-kuei ts'ang-hua chi*, 1956, vol. 1, pl. 42; Ch'en Jen-t'ao, *Chin-kuei ts'ang-hua p'ing-shih*, 1956, vol. 2, pp. 190–92; Jao Tsung-i, "Chang Ta-feng chi ch'i chia-shih," 1976, p. 68, pl. 12; Suzuki, *Comprehensive Illustrated Catalogue*, 1982–83, vol. 1, pl. A17–009.

Hsiao Yün-ts'ung (1596–1673) 蕭雲從

tzu Ch'ih-mu 尺木, *hao* Wu-men tao-jen 無悶道人,
Chung-shan lao-jen 鍾山老人

A native of Wu-hu, Anhui, Hsiao Yün-ts'ung was encouraged from an early age to pursue training in both the classics and painting. Like his two brothers, Hsiao sat for the official examinations, but he was unsuccessful, failing the first-level examinations in 1639 and again in 1642. At this time Hsiao lived with his younger brother in Nanking, where in 1638 they participated in the annual meeting of the Fu-she (Restoration Society).

　Hsiao Yün-ts'ung returned home to Wu-hu after his second failed attempt in the examinations, only to flee from the advancing Manchu forces as they tore through central Anhui in the late spring of 1645. He took refuge in Kao-shun, Anhui, a center of anti-Manchu activity. Although Hsiao's poems from this period express strong anti-Manchu sentiments, the actual extent of his involvement in the resistance movement remains unknown.

　In 1647 Hsiao set about repairing his house, which had been almost completely demolished by the Manchu army. Giving up all hope of pursuing a career in government service, he turned to painting and teaching for his livelihood. He received several commissions to illustrate woodblock-printed books, the first of which was for an edition, printed in 1645, of the *Li sao*, the famous poetic lament of Ch'ü Yüan (343–277 B.C.). This poem by the loyalist minister of Ch'u clearly functioned as a metaphor for the anguish felt by Hsiao and his patrons at the fall of the Ming, as well as a symbol of their abiding loyalty to the former dynasty. In his late years, Hsiao spent most of his time in Anhui, traveling on occasion to the Nanking and Yang-chou regions, where he met many painters and poets. His closest friend in Anhui was the painter Sun I (fl. mid-17th century), with whom he is often paired.

109 *Landscape*
Shan-shui
蕭雲從　山水

Dated 1644

Hanging scroll, ink and color on paper
88.2 x 33.4 cm (34¾ x 13⅛ in.)

Beijing Palace Museum

vol. 1, pl. 109

ARTIST'S INSCRIPTION AND SIGNATURE (10 lines in regular script):
In spring, beautiful trees grow all over the island;
Groves of orchids exude subtle fragrance in secret.
The Immortals have come to reside here;
In the tent of clouds, they dine in the house of fungi.
Ancient pines spread out their green draperies;
Entwining pearls grow long strings of their offspring.

Half the cliff opens into a picture;
Morning mists surround rattan beds.
Steep pavilions are away from the sounds of bells;
The dragons return, bringing cool rains.
The hibiscuses cast their shadows on rocks;
Tasty wine fills shell-shaped goblets.
[I wish] to get drunk and sleep along the bank of Peach Blossom,
As heavily as thousand-day-old wine.

On the eighth day of the first month of the *chia-shen* year of the Ch'ung-chen era [February 15, 1644], after having a few drinks at the Shou-shu Studio, I selected this paper to paint the green mountains. Grieving over the separation of family and friends during the turmoil, I put down my thoughts in these remarks so people might know of my longing for the Peach Blossom Spring of Wu-ling. Inscribed by Shih-jen, Hsiao Yün-ts'ung.

春島榮琪樹
蘭蓀祕細香
仙人來卜宅
雲幄飯芝房
翠禎松羅古
縈珠結子長
畫圖開半壁
晚霧繞藤床
峻閣鐘鍼遠
龍歸帶雨飆
芙蓉留石影
美醞盈螺椿
醉卧桃花隝
如沈千日釀

　　崇禎甲申穀日，坐授書堂小酌，拾此素紙，圖厭青山。因感念亂離，致數語紀願，知我有志於武陵源矣。石人，蕭雲從識。

ARTIST'S SEAL:
Hsiao Yün-ts'ung 蕭雲從 (*pai-wen*, square)

NO COLOPHONS

COLLECTORS' SEALS: Miao Yüeh-tsao 繆日藻 (1682–1761), 2; Liang Chang-chü 梁章鉅 (1775–1849), 1

Hsiao Yün-ts'ung lived through one of the most turbulent periods in Chinese history, one that witnessed the gradual decline and eventual demise of the Ming dynasty. In April 1644, several months after Hsiao painted this scroll, the Ming general Li Tzu-ch'eng seized Peking and the Ming emperor committed suicide. The turmoil was to last for more than ten years as the conquering Manchus continued to hunt down Ming loyalists and pretenders to the throne.

Hsiao Yün-ts'ung's inscription makes it clear that the theme of this landscape painting is the Peach Blossom Spring, the utopian world immortalized in the essay by the Six Dynasties poet T'ao Ch'ien (365–427). With its white clouds and vermilion pavilions, its feeling of peace and quietude, the painting is also related stylistically to the blue and green tradition. From 1644 to 1645, around the time that he executed this scroll, Hsiao prepared a series of illustrations for a woodblock print edition of the *Li sao*, a group of poems composed by Ch'ü Yüan (343–277 B.C.), the nobleman of the state of Ch'u who committed suicide after being dismissed by his prince (Wang Shicheng, *Hsiao Yün-ts'ung*, 1979, pls. 18–24). These two subjects, the Peach Blossom

Spring and the *Li sao*, were poignant vehicles for Hsiao Yün-ts'ung's self-expression in the final years of the Ming.

The scroll is similar in style to an album dated 1653 and now in the Anhui Provincial Museum (*Anhui ming-jen hua-hsüan*, 1961, pls. 10–13). It is apparently the earliest dated extant painting by Hsiao (Xu Bangda, *Pien-nien-piao*, 1963, p. 125; Kuo Wei-ch'ü, *Nien-piao*, 1962, p. 137). Hsiao's interest in the archaistic blue and green tradition can be seen in his colophon, dated 1639, to a blue and green handscroll *Greeting the New Year* (*Sui-chao t'u*) by the early Ming artist Shih Jui (fl. ca. 1426–70), now in The Cleveland Museum of Art (Ho et al., *Eight Dynasties*, 1980, no. 136).

In 1647 Hsiao Yün-ts'ung painted an album leaf for a certain Ch'en Ying-ch'i who, like Hsiao, was from Wu-hu, Anhui. Other leaves were later added by Anhui artists, including Wang Chih-jui (fl. mid-17th century) in 1649, Hung-jen (1610–1664) around 1652, and Cha Shih-piao (1615–1698) in 1653 (reproduced in *Hsin-an ming-hua chi-chin ts'e*, 1920). Since Ch'en was addressed as a "society comrade" (*she-meng* 社盟) by the artists, it is likely that they all were members of a politico-literary organization such as the Fu-she (Restoration Society), to which Hsiao once belonged.

Although a pupil-teacher relationship between Hung-jen and Hsiao Yün-ts'ung has been suggested by some writers, there seems to be no evidence to indicate that Hung-jen ever studied with Hsiao (Kuo, *Austere Landscape*, 1990, pp. 52–53). However, Hsiao's 1648 hanging scroll *Walking with a Staff in a Sparse Forest* (*Shu-lin ts'e-chang*), now in the Tianjin Art Museum, does contain features such as the dry and sparse brushwork and sense of restlessness on the pictorial surface that suggest a strong stylistic affinity with Hung-jen. Hsiao Yün-ts'ung's contacts with Hung-jen might also have led to the gradual relaxation of brushwork and broader, simpler rock forms, as seen, for example, in the 1664 handscroll *Pure Tones among Hills and Waters* (*Shan-shui ch'ing-yin*) and the 1668 *Album of Seasonal Landscapes*, both in Cleveland (Ho et al., *Eight Dynasties*, nos. 223, 224).

Through his contacts with fellow artists such as Wang Chih-jui, Hsiao might have been aware of Tung Ch'i-ch'ang's ideas. For example, Hsiao's 1647 hanging scroll *Landscape with Man Crossing a Bridge*, in the Ching Yüan Chai Collection, exhibits a stylistic affinity with Tung Ch'i-ch'ang in that its composition sets a foreground enveloped in space against a background enveloping space (Cahill, *Shadows of Mt. Huang*, 1981, no. 15).

JK

LITERATURE: *Chung-kuo ku-tai shu-hua mu-lu*, vol. 2, 1985, *Ching* 1–3522.

Ch'eng Cheng-k'uei (1604–1676) 程正揆

tzu Tuan-po 端伯, *hao* Chü-ling 鞠陵, Ch'ing-hsi tao-jen 青溪道人

Ch'eng Cheng-k'uei, a native of Hsiao-kan, Hupei, descended from a scholar-gentry family. He was awarded the *chin-shih* degree in 1631 and shortly thereafter was appointed Compiler in the Han-lin Academy. His tenure in this position did not last long, for his disenchantment with the political infighting at the court soon led him to resign.

In 1632 Ch'eng Cheng-k'uei met Tung Ch'i-ch'ang, perhaps through the introduction of the Senior Grand Secretary Chou Yen-ju (1588–1643), who had been Ch'eng's mentor and examiner in the *chin-shih* examination (see *Ku-kung shu-hua lu*, 1956, *ch.* 4, p. 43). Tung Ch'i-ch'ang took an immediate liking to Ch'eng, and while others clamored in vain to get a glimpse of Tung's collection, Ch'eng was treated to entire days of leisurely contemplation of the finest works that Tung had acquired. These visits with the seventy-seven-year-old master must have been a heady experience, one that would have a profound influence on Ch'eng's later artistic development.

Ch'eng left Peking with his father in late 1634 to return to the south; and after a short period of detention as hostages of a band of rebel peasants, they managed to escape and complete their journey home. The following year, Ch'eng moved to Nanking, where he settled near the Ch'ing River. Ch'eng was recalled to Peking in 1642 to serve as Chief Minister of the Seals Office. In March 1644, hearing of the rebel leader Li Tzu-ch'eng's march on the capital, he attempted to flee the city but was caught and surrendered to the rebels. After Li Tzu-ch'eng's flight from Peking several months later, Ch'eng escaped to Nanking where he served in the beleaguered Southern Ming court. In the fifth month of 1645, Ch'eng was among the group of Ming officials who gathered to greet the Manchu forces as they approached the city gates of Nanking. For deserting the Ming cause, he was rewarded with a position in the Ch'ing bureaucracy, and rapidly advanced to Vice Minister of the Board of Works. Like most co-opted former Ming officials, Ch'eng filled a largely honorary post that afforded him the leisure to pursue his own interests. It was while he was in Peking that Ch'eng began his series of *Dream Journey* landscapes.

In 1657 an official brought an impeachment charge against Ch'eng, accusing him of currying favor by giving his paintings to other officials. Denying these trumped-up charges, Ch'eng returned to the south and took up the reclusive life-style of many painters. After his retirement, Ch'eng befriended several *i-min* (leftover subject) painters in Nanking, notably K'un-ts'an (1612–1673) and Kung Hsien (1619–1689). He continued to paint, producing more than three hundred *Dream Journey* handscrolls before his death in 1676.

110 *Dream Journey among Rivers and Mountains, Number 25*

Chiang-shan wo-yu t'u ch'i erh-shih-wu

程正揆　江山臥遊圖其二十五

Dated 1652

Handscroll, ink and color on paper
26 x 305.1 cm (10¼ x 120⅛ in.)

Beijing Palace Museum

vol. 1, pl. 110

ARTIST'S INSCRIPTION AND SIGNATURE (4 lines in running-regular script): "Dream Journey among Rivers and Mountains." Painted in the sixth month of the *jen-ch'en* year [July 6–August 3, 1652]. Ch'ing-hsi tao-jen. Number 25.

《江山臥遊圖》壬辰六月畫，青溪道人。其二十五。

ARTIST'S SEALS:
Cheng-k'uei yin 正揆印 (*chu-wen*, square)
Tuan-po 端伯 (*pai-wen*, square)
Ch'eng 程 (*chu-wen*, round)

FRONTISPIECE: Li Shen 李慎 (19th century), dated 1876, 2 seals

COLOPHON: Chi Huai 吉懷 (18th century), dated 1739, 2 seals

COLLECTOR'S SEALS: Li Po-sun 李伯孫 2

Ch'eng Cheng-k'uei was a pupil of Tung Ch'i-ch'ang's from 1632 to 1634. Inspired by his teacher, Ch'eng studied the Yüan masters, particularly the work of Huang Kung-wang (1269–1354) as exemplified in the well-known masterpiece *Dwelling in the Fu-ch'un Mountains* (*Fu-ch'un shan-chü*; vol. 1, fig. 17), a painting that, in Ch'eng's words, he had "digested in his mind for more than ten years" (Yang Xin, *Ch'eng Cheng-k'uei*, 1982, pp. 27–28).

Ch'eng Cheng-k'uei knew many of the leading painters of his time. He was a close friend of K'un-ts'an's (1612–1673) and was well regarded by Kung Hsien (1619–1689) and Shih-t'ao (1642–1707). Ch'eng and K'un-ts'an often painted and studied paintings together (Ho Ch'uan-hsing, "Pi-mo chih-chi," 1985). In a long colophon to the *Collected Landscape Album by Famous Painters* (*Chi ming-chia shan-shui ts'e*) assembled by Chou Liang-kung (1612–1672) and now in the National Palace Museum, Taipei, Kung Hsien ranked Ch'eng among the "untrammeled," the highest class in Chinese art: "[Speaking of] the painters of today, we can say that Chiang-nan has the greatest abundance and that of the fourteen prefectures of Chiang-nan, the one of the capital [Nanking] is the richest. In this prefecture there are more than a score who have made their names famous, yet we have well over a thousand who know how to lick their brush! . . . Among the painters of Chin-ling [Nanking] the 'capable' ones are the most numerous, yet of the 'inspired' and 'untrammeled' categories there also are a few for each. As for the 'untrammeled' ones, in the first place [I want to] point out two: Shih-hsi [K'un-ts'an] and Ch'ing-hsi [Ch'eng Cheng-k'uei]. . . The painting of Deputy Ch'eng has flesh of ice and bones of jade, like the calligraphy of Hua-t'ing [Tung Ch'i-ch'ang]. . . In this album, I particularly like the two leaves by Ch'eng Cheng-k'uei" (*Ku-kung shu-hua lu*, 1965, vol. 4, *ch.* 6, pp. 277–78; also

quoted in Yang Xin, *Ch'eng Cheng-k'uei*, p. 31; translation after Lippe, "Kung Hsien," 1958, pp. 159–60). Shih-t'ao also ranked Ch'eng Cheng-k'uei among the best painters of his day. In an inscription on a leaf from his *Album of Landscapes* in the Los Angeles County Museum of Art, Shih-t'ao remarks, "Those who enter through the ordinary gate to reach the *Tao* of painting are nothing special. . . But to achieve resounding fame in a given age—isn't that difficult to accomplish? For example, the lofty antiquity of K'un-ts'an, Ch'eng Cheng-k'uei, and Ch'en Shu; the pure elusiveness of Cha Shih-piao [1615–1698] and Hung-jen [1610–1664]; the parched leanness of Ch'eng Sui [1602–after 1690]; the drenched moistness and rare antiquity of Pa-ta shan-jen [1626–1705], . . . Of a generation these were all the ones who understood" (translation after Shen Fu and Marilyn Fu, *Studies in Connoisseurship*, 1973, pp. 52–53; reproduced in Edwards, *The Painting of Tao-chi*, 1967, p. 108).

The Beijing handscroll is one of Ch'eng Cheng-k'uei's early attempts to produce hundreds of pictures of the "dream journey." Its style is characterized by a strong formal interplay of pushes and pulls of shapes that run through the horizontal scroll. At the end, the viewer's attention is brought back to the foreground and to the paper itself. After all, it is an image of the mind and the creation of the artist's brush and ink, nothing less and nothing more. In responding to a friend's criticism that his handscrolls of dream journeys did not look natural, Ch'eng Cheng-k'uei said: "Seas, hills, and valleys are like blue dogs and white clouds; a thousand years are like a blink of a moment. How do you know that someday rivers and mountains may not move into my paintings?" (Yang Xin, *Ch'eng Cheng-k'uei*, p. 26; translation after Hongnam Kim, "The Dream Journey," 1990, p. 23). Ch'eng Cheng-k'uei's reliance on an artist's power of creation is an echo from his mentor Tung Ch'i-ch'ang, who maintained: "For the rare wonders of scenery, painting is no equal to mountains and water; but mountains and water are no equal to painting for the sheer marvels of brush and ink" (quoted in Kim, "The Dream Journey," p. 28).

<div style="text-align:right">JK</div>

EXHIBITION: Honolulu Academy of Arts, Hawaii, 1989: Rogers and Lee, *Ming and Qing Painting*, 1988, cat. no. 37.

LITERATURE: Yang Xin, *Cheng Cheng-k'uei*, 1982, pl. 5; *Chung-kuo ku-tai shu-hua mu-lu*, vol. 2, 1985, Ching 1–3706; *Chung-kuo mei-shu ch'üan-chi*, 1988, Painting, vol. 9, pl. 79; Kim, "The Dream Journey," 1990, fig. 25.

III *Dream Journey among Rivers and Mountains, Number 90*

Chiang-shan wo-yu t'u ch'i chiu-shih

程正揆　江山臥遊圖其九十

Dated 1658

Handscroll, ink and color on paper
26 x 344.2 cm (10¼ x 135½ in.)

The Cleveland Museum of Art 60.182

vol. 1, pl. III

ARTIST'S INSCRIPTION AND SIGNATURE (3 lines in regular script): "Dream Journey among Rivers and Mountains," Number 90. Ch'ing-hsi tao-jen. In the fifth month, summer, of the *wu-hsü* year [June 1–30, 1658].

《江山臥遊圖》，其九十。青溪道人。戊戌夏五。

ARTIST'S SEAL:
Ch'eng Cheng-k'uei 程正揆 (*pai-wen*, square)

FRONTISPIECE: Huang I 黃易 (1744–1801), dated 1793, 3 seals

COLOPHON: Yen Shih-ch'ing 顏世清 (1873–1929), dated 1914, 3 seals

COLLECTORS' SEALS: Tai Chih 戴植 (19th century), 2; Wang Nan-p'ing 王南屏 (20th century), 3

RECENT PROVENANCE: Walter Hochstadter

Ch'eng Cheng-k'uei began a series of *Dream Journey* pictures in 1649 after he had made the decision to serve the new Manchu government in Peking. Inscribing the picture that he numbered as seven in 1652, he expressed the intention of painting a hundred such "dream journeys" (Yang Xin, "Ch'eng Cheng-k'uei chi ch'i *Chiang-shan wo-yu t'u*," 1981, p. 79). The pace of his production seems to have increased after his impeachment and return to Nanking in 1657; the handscroll in The Cleveland Museum of Art, dated 1658, is numbered ninety in the sequence.

Dream Journey Number 90 is a view of rivers and mountains seen from a high vantage point. The composition is carefully constructed of solids and voids, and the mountains are composed of repeated units emphasized by strong contour lines. The unit shapes are derived from the Yüan master Huang Kung-wang (1269–1354), while the brushwork and color allude to the Ming painter Shen Chou (1427–1509). Ch'eng Cheng-k'uei's knowledge of Huang Kung-wang came from direct experience with Huang's paintings. In 1645 he saw and copied Huang's *Scenic View of Rivers and Mountains* (*Chiang-shan sheng-lan*). In his colophon to this copy, his earliest dated painting, Ch'eng mentions that he owned works by each of the Four Masters of the Yüan and that the *Scenic View of Rivers and Mountains* along with *Dwelling in the Fu-ch'un Mountains* (*Fu-ch'un shan-chü*; vol. 1, fig. 17) were the two paintings by Huang that remained beyond his grasp. They had, he says, been wandering back and forth in his mind for ten years or more since he had first seen them. In 1657 in Nanking he was able to see *Dwelling in the Fu-ch'un Mountains* again, but only after the opening section had been lost. He executed a picture after it at that time and stated that he had heard that there was a complete copy in existence; in a second colophon dated 1669, he recorded a later encounter with the scroll and its opening section (Xu Bangda, *Pien-nien-piao*, 1963, p. 357; Yang Xin quotes from *Shih-pai chai shu-hua lu*, in *Ch'eng Cheng-k'uei*, 1982, pp. 27–28; *Shih-ch'ü pao-chi*, completed 1745, *ch.* 6, pp. 83–84). Ch'eng Cheng-k'uei's knowledge of Shen Chou is not so specifically recorded.

In studying both the Four Yüan Masters and the Ming dynasty Wu School painters, Ch'eng Cheng-k'uei comes close to the ideas of Tung Ch'i-ch'ang. According to Chiang Shao-shu's *History of Soundless Poetry* (*Wu-sheng-shih shih*, postface dated 1720, repr. 1963), Ch'eng received instruction from Tung directly, probably just after Ch'eng had passed his *chin-shih* degree and entered the Han-lin Academy. "At

that time Minister Tung Ssu-pai [Tung Ch'i-ch'ang] was a refined teacher, and Ch'eng strove to serve him with an empty heart asking to be filled. Master Tung for his part was very fond of Ch'eng and wholeheartedly taught him in all the secrets of calligraphy and principles of painting, like [a Ch'an master] transmitting the robe and bowl [to his disciple]" (*Wu-sheng-shih shih, ch.* 4, p. 73). In a colophon on a painting attributed to Wang Wei (701–761), Ch'eng further records his experiences with Tung Ch'i-ch'ang: When Tung's ministerial status was restored to him and he was made Grand Guardian of the Heir Apparent, ". . . he carried this picture [Wang Wei's *Clearing after Snow over Riverbanks*] to the capital. Connoisseurs all sought to get a look at it but none succeeded. Only when I came he always brought it out for us to look at together, and enjoying it would invariably take the whole day. Moreover he would point out and instruct me in the key passages of brush and ink, saying 'Ching [Hao], Kuan [T'ung], Tung [Yüan], and Chü[-jan] all come from this. If in painting one does not see the true face of Mo-chieh [Wang Wei], it is like traveling north without seeing the Dipper [for guidance]'" (Yang Xin, *Ch'eng Cheng-k'uei*, p. 18). In his approach to the past, then, Ch'eng Cheng-k'uei followed Tung Ch'i-ch'ang closely. He even echoed Tung in saying that only after one's feet had exhausted the famous mountains of the world and one's eyes had exhausted the divine works of the ancients could one begin to paint. His results, however, as seen in the handscroll *Dream Journey among Rivers and Mountains, Number 90*, do not resemble Tung's brushwork, as noted by later Ch'ing period critics. Chang Keng (1685–1760), for example, remarked: "At first he studied Tung Hua-t'ing [Tung Ch'i-ch'ang], obtaining his direct instruction; later, however, he put forth his own 'springs and pivot,' with much use of a worn brush that was dry and strong and simple and mature and with application of color that was rich and moist" (Chang Keng, *Kuo-ch'ao hua cheng lu*, repr. 1963, *shang*, p. 19). However much his brushwork may not have resembled Tung's, his friend the painter Kung Hsien (1619–1689) gave him the ultimate praise by comparing his painting to Tung's calligraphy: "Vice Minister Ch'eng's [painting is like a man] of icy flesh and jade bones, thus it is like Tung Hua-t'ing's calligraphy" (Yang Xin, *Ch'eng Cheng-k'uei*, p. 31; see also Sirén, *Leading Masters and Principles*, 1956–58, vol. 5, p. 112).

<div align="right">DAS</div>

EXHIBITIONS: Haus der Kunst, Munich, 1959: *Tausend Jahre Chinesische Malerei, cat. no. 88;* Nelson Gallery-Atkins Museum and The Cleveland Museum of Art, 1980–81: Ho et al., *Eight Dynasties*, cat. no. 231; Tokyo National Museum, 1982: *Special Exhibition*, cat. no. 230.

LITERATURE: Sirén, *Leading Masters and Principles*, 1956–1958, vol. 5, p. 112, vol. 7, (lists), p. 302 (erroneously dated 1674); Lee, *Chinese Landscape Painting*, 1962, p. 90, no. 71; Lee, *Far Eastern Art*, 1964, p. 441, fig. 584; Lee, "The Water and the Moon in Chinese and Modern Painting," 1970, p. 55, fig. 26; Fu, "Ming Ch'ing chih chi te k'e-pi kou-le feng-shang yü Shih-t'ao te tsao-ch'i tso-p'in," 1976, p. 594, fig. 15 (section); Suzuki, *Comprehensive Illustrated Catalogue*, 1982–83, vol. 1, A22–075; Kim, "The Dream Journey," 1990, fig. 2.

112 *Dream Journey among Rivers and Mountains, Number 150*

Chiang-shan wo-yu t'u ch'i i-pai-wu-shih

程正揆　江山臥遊圖其一百五十

Dated 1662

Handscroll, ink and color on paper
35.9 x 534 cm (14⅛ x 210¼ in.)

Los Angeles County Museum of Art M.75.25

vol. 1, pl. 112

ARTIST'S INSCRIPTION AND SIGNATURE (8 lines in regular script): "Dream Journey among Rivers and Mountains," Number 150. This picture was executed in the eleventh month of the *hsin-ch'ou* year [December 21, 1661–January 19, 1662] [when] I was in a boat returning to Huan from Chin-ling [Nanking] and followed my brush. On the sixteenth day of the twelfth month [February 4, 1662] I reached home and due to human affairs put it [aside] in a pavilion. On New Year's Eve I was sorting and found that it actually comprised four sheets of paper, about one foot six inches in length. Ch'ing-hsi tao-jen.

《江山臥遊圖》，其一百五十。此圖作于辛丑十一月，予自金陵歸澴，舟中隨筆。十二月十六日抵家，以人事置閣。至除夕撿點始竟，計紙四幅，約長一丈六尺。青溪道人。

ARTIST'S SEALS:
Ch'eng Cheng-k'uei 程正揆 (*pai-wen*, square)
Tuan-po 端伯 (*chu-wen*, square)
Ch'en Cheng-k'uei 臣正揆 (*chu-pai wen*, square)
Ch'eng 程 (*chu-wen*, round)

NO COLOPHONS

COLLECTORS' SEALS: Wang Nan-p'ing 王南屏 (20th century), 3; Ch'eng Chih-hua 程芷華, 1; unidentified, 1

In 1649 Ch'eng Cheng-k'uei painted a picture simply entitled *Dream Journey* (*Wo-yu t'u*) (Lu Hsin-yüan, *Jang-li kuan kuo-yen lu*, repr. 1975, pp. 1669–70). Sometime later he adopted the generic title *Dream Journey among Rivers and Mountains* and began to number the paintings. Such a practice was unprecedented—his friend Chang I (1608–1695) commented on just how unusual such numbering was (Yang Xin, "Ch'eng Cheng-k'uei chi ch'i *Chiang-shan wo-yu t'u*," 1981, p. 78)— and in this respect Ch'eng remains unique in the history of Chinese painting before the twentieth century. In 1652, in an inscription at the end of the scroll that he numbered seven in his sequence, he gave some indication as to why he was painting the series: "Those who live in Ch'ang-an [Peking] have three hardships: there are no mountains and waters that can be enjoyed; there is no calligraphy and painting that can be purchased; and there are no collectors from whom one can borrow. I therefore want to make a hundred *Dream Journey among Rivers and Mountains* scrolls to put into circulation in the world in order to alleviate the suffering of those on horseback [in the service of the government]. I have completed thirty or more scrolls and all of them have been taken away by knowledgeable persons. This one happened to be preserved in a desk, therefore I inscribed and sent it to Wu-kung." (Yang Xin, "Ch'eng Cheng-k'uei chi ch'i *Chiang-shan wo-yu t'u*," p. 79. The painting is in the Beijing Palace Museum. See

also Kim, "The Dream Journey," 1990, p. 23.) In substituting painting for real landscape, Ch'eng Cheng-k'uei went back through Kuo Hsi (ca. 1020–ca. 1100) to Tsung Ping (375–443) and to the very origins of the term *wo-yu*, or "dream journey." Such a term implied imaginary traveling while reclining and had been used in a famous essay by Tsung Ping. The idea was later extended by Kuo Hsi, who wrote that one of the purposes of painting was to provide escape for the busy bureaucrat who did not have time to travel in the mountains (Kim, "The Dream Journey," passim).

Many of Ch'eng's *Dream Journey* paintings from about the time of his 1652 inscription show idyllic views of landscape. Later, however, after Ch'eng's dismissal and return to Nanking, his intentions seemed to have changed. In Nanking his closest friends were among the Ming *i-min*, the leftover subjects of the Ming dynasty, and he seems to have taken on their view that the rivers and mountains of China were now under Manchu occupation, that past and present reality were different. In the summer of 1659 he inscribed on one of his *Dream Journey* pictures: ". . . Kung-yüan said to me that my river scenery did not resemble [the real landscape]. I said, 'Since the creative energy of the universe is in my hand, I ought to be able to open a fresh face for the world. Why should I be dependent on the leftover water and disheveled mountains? Moreover the seas, hills, and valleys are like blue dogs and white clouds [the ephemeral world], a thousand years are like a blink. Who knows, someday rivers and mountains may move into my painting. Kung-yüan laughed and acknowledged that it was possible" (Yang Xin, "Ch'eng Cheng-k'uei chi ch'i *Chiang-shan wo-yu t'u*," p. 79; Yang Xin, *Ch'eng Cheng-k'uei*, 1982, p. 26; Kim, "The Dream Journey," p. 23). Here Ch'eng's sense of loss is more than just the lost opportunity to enjoy the scenery; it is the loss of the nation and the verities found in the dream journey that are indicated. Perhaps this helps explain something of the vision seen in *Dream Journey among Rivers and Mountains, Number 150*: suddenly among the hills after the opening section a strange foraminate rock formation appears, and spatial ambiguities become more apparent as the scroll unfolds.

It is unclear exactly how many *Dream Journey* pictures Ch'eng Cheng-k'uei finished and how he chose to number them. Like the painting in Los Angeles, he did not always inscribe his pictures immediately upon completion; and judging from recorded and surviving paintings, his numbering seems arbitrary. The paintings do not seem to have been numbered consecutively nor do they follow chronologically within a given year. In the fall of 1652 Ch'eng had recorded his intention to paint a series of one hundred pictures. According to Chou Liang-kung (1612–1672), by the early 1660s Ch'eng intended to paint five hundred scrolls and had already completed three hundred (Chou Liang-kung, *Tu-hua lu*, repr. 1963, p. 22). A painting (now in the collection of the Beijing Palace Museum) dated 1674, two years before his death, is numbered four hundred and thirty-five, suggesting that he continued his project until near the end of his life.

DAS

LITERATURE: Los Angeles County Museum of Art, *Handbook*, 1977, p. 42; Louise Yuhas, "Imaginary Journeys," 1989, fig. 5, pp. 82–83; Kim, "The Dream Journey," 1990, fig. 4, pp. 20–21.

113 *Landscape*
Shan-shui
程正揆　山水

Undated

Handscroll, ink and color on paper
22.4 x 205.2 cm (8¹³⁄₁₆ x 80¹⁵⁄₁₆ in.)

Museum für Ostasiatische Kunst, Berlin

vol. 1, pl. 113

ARTIST'S INSCRIPTION AND SIGNATURE (2 lines in running script): Ch'ing-hsi tao-jen painted this in Wu-ch'ang [Hupei].

青溪道人畫。武昌。

ARTIST'S SEAL:
Cheng-k'uei 正揆 (*chu-wen*, rectangle)

COLOPHON: Wang Lo-nien 汪洛年 (1870–1925), dated 1918, 2 seals

COLLECTOR'S SEAL: unidentified, 1

Hung-jen (1610–1664) 弘仁

Original name Chiang T'ao 江韜, *tzu* Liu-ch'i 六奇, Ou-meng 鷗盟, Wu-chih 無智, *hao* Chien-chiang 漸江

Hung-jen, who is considered to be the foremost monk-painter in the Anhui School, achieved recognition as an important artist in his own lifetime. Chou Liang-Kung's (1612–1672) assertion that a family's social status and aesthetic taste could be measured by the possession of a Hung-jen scroll indicates the esteem the artist commanded from his contemporaries.

As a child, Hung-jen studied the classics in preparation for the official examinations, eventually attaining the *hsiu-ts'ai* degree. In his early twenties he began to paint and socialize with other painters. Among his earliest extant works is a collaborative piece, *Picture of High Mounds (Kan-ling t'u)*, dated 1639 and now in the Shanghai Museum. One of the contributors to the scroll was Liu Shang-yen (fl. first half of the 17th century), a follower of and alleged ghostpainter for Tung Ch'i-ch'ang (Shan Guolin, "Chien-chiang tsao-nien hsing-i chi ch'i feng-t'an," 1987, p. 119). This early association with members of Tung Ch'i-ch'ang's artistic circle suggests that Hung-jen was possibly influenced by Tung's art and theories.

In 1645, following the Manchu conquest of the Ming, Hung-jen, accompanied by his teacher Wang Wu-ya, fled to Fukien, where members of the exiled Ming court had also taken refuge. Whether Hung-jen went to Fukien to lend his support to the Ming cause or to escape the political upheaval is not known, but whatever his original motive may have been, he ultimately decided to renounce the secular world. In 1647, at Mount Wu-i in Fukien, he took the tonsure under the teacher

Tao-chou ku-hang (1585–1655) and adopted the Buddhist name Hung-jen. In 1651 Hung-jen returned to She-hsien. He lived in temples there and at his beloved Mount Huang, and traveled widely in the Chiang-nan area. During his later years, he became acquainted with the Anhui painters Mei Ch'ing (1623–1697), Tai Pen-hsiao (1621–1693), and Ch'eng Sui (1602–after 1690), and the Nanking artist Kung Hsien (1619–1689). Hung-jen was the leading figure among the Four Great Masters of Hsin-an. The group, known as the Hsin-an School in Chinese art-historical literature and as the Anhui School in the West, included Sun I (fl. mid-17th century), Cha Shih-piao (1615–1698), and Wang Chih-jui (fl. mid-17th century).

In this painting, Hung-jen combines the *p'i-ma* 披麻, or "hemp-fiber," texture strokes derived from Tung Yüan (fl. ca. 945–ca. 960) with the *che-tai* 折帶, or "bent-sash," texture strokes characteristic of Ni Tsan. The five willow trees may be an allusion to T'ao Ch'ien (365–427), the well-known poet of the Eastern Chin period and a paragon of Chinese hermits. In its delicate depiction of the willow trees, the painting is reminiscent of the late work of Wen Cheng-ming (1470–1559) and his followers, to whom Hung-jen was stylistically indebted. The construction of formal elements in the mountain mass in the background and the pushes and pulls of the rocks in the middle ground, however, suggest the influence of Tung Ch'i-ch'ang.

JK

LITERATURE: Zhu Jiajin, *Kuo-pao*, 1983, ca. no. 48; Wang Shiqing and Wang Cong, *Chien-chiang tzu-liao chi*, 1984, pp. 73–74; Kuo, *Austere Landscape*, 1990.

114 *T'ao's Retreat*

T'ao-an t'u

弘仁　陶菴圖

Dated 1660

Hanging scroll, ink on paper

109 x 58.4 cm (42¹⁵⁄₁₆ x 23 in.)

Beijing Palace Museum

vol. 1, pl. 114

ARTIST'S INSCRIPTION AND SIGNATURE (4 lines in regular script and seal script):

Chien-chiang hsüeh-che painted "T'ao's Retreat" for Tzu-weng chü-shih.

漸江學者爲子翁居士作《陶庵圖》。

In the *keng-tzu* year [1660].

庚子。

ARTIST'S SEALS:
Hung-jen 弘仁 (*chu-wen*, round)
Chien-chiang seng 漸江僧 (*pai-wen*, square)

COLOPHON: Lo I 羅逸 (late 17th century), undated

COLLECTORS' SEALS: unidentified, 2

The year 1660 was one of Hung-jen's most productive years. In addition to the Beijing scroll, *T'ao's Retreat*, he produced several other important paintings, including the majestic hanging scroll *Heavenly Citadel Peak [at Mount Huang]* (*T'ien-tu feng*) in the Nanjing Museum (Kuo, *Austere Landscape*, 1990, pl. 181) and the equally impressive hanging scroll *Pines and Rocks at Mount Huang* (*Huang-hai sung-shih*) in the Shanghai Museum (Kuo, *Austere Landscape*, pls. 183–87). Like these paintings, *T'ao's Retreat* exemplifies Hung-jen's unique style, in particular his transformation of the Ni Tsan (1301–1374) tradition. In the foreground on the left, seen through five willow trees and beyond a stone bridge over a stream, are a house and a pavilion; these must be what the artist called "T'ao's Retreat" in his inscription. Behind the retreat is a series of mountain ranges and to the right a pond in which protruding rocks can be seen. On the face of the mountain at the far right, the artist wrote the date *keng-tzu* (1660) in seal script.

115 *Views of Mount Huang*

Huang-shan t'u

弘仁　黃山圖

Undated

Album of ten paintings, from a set of seven albums, ink and color on paper

21.5 x 18.3 cm (8⁷⁄₁₆ x 7³⁄₁₆ in.)

Beijing Palace Museum

vol. 1, pl. 115 (leaves 1–3, 5–8, 10); vol. 2, pl. 115 (leaves 4, 9)

ARTIST'S INSCRIPTIONS (each leaf with 1 line in clerical script):
Leaf 1. "Harboring Clouds Cave"

《藏雲洞》

Leaf 2. "Hide-thatched Hut"

《皮蓬》

Leaf 3. "Alchemist Platform"

《煉丹臺》

Leaf 4. "White Dragon Pool"

《白龍潭》

Leaf 5. "Stone Gate"

《石門》

Leaf 6. "Lotus Flower Monastery"

《蓮華庵》

Leaf 7. "Pine Valley Nunnery"

《松谷庵》

Leaf 8. "Immortal's Lamp Cave"

《仙鐙洞》

Leaf 9. "Radiant Brightness Summit"

《 光明頂 》

Leaf 10. "Kuan-yin Grotto"

《 觀音岩 》

ARTIST'S SEAL:
Hung-jen 弘仁 (*chu-wen*, round; leaves 1–10)

NO COLOPHONS OR COLLECTOR'S SEALS

The ten leaves exhibited here comprise one of seven albums, including sixty paintings, and colophons, on the theme of scenic spots at Huang-shan (Yellow Mountains) in southeastern Anhui.

The larger project of which this album forms a part is a fascinatingly diverse example of the rising interest in topographical painting, and specifically the local scenery of the Yellow Mountains, which was a hallmark of the emerging Anhui School of painting in the seventeenth century. Feelings of regional pride, the rise of patronage along with the increasing commercial prosperity of the region, the interplay of paintings with woodblock illustrations, and a widespread growth in the informational aspect of pictures were all contributing elements to this movement. The monk-painter Hung-jen, a central figure in the Anhui School, was an enthusiastic and frequent participant in these developments. A large majority of his paintings with identifiable subjects depict notable scenes of the Yellow Mountains, near the artist's home, and much of the remainder of his oeuvre bears the characteristics of the Huang-shan style associated with seventeenth-century Anhui School painters: flinty, sharply faceted peaks, pines growing at odd angles from cliffsides, and an aura of remoteness, sparseness, and solitude.

Despite the spirit of isolation that pervades such works, illustrations of the scenery of the Yellow Mountains engaged a whole community of artists in the seventeenth century, who responded to the demands of a new market stimulated in part by the opening up of the region as a travel site. Paintings and woodblock prints of the notable scenic spots most likely served as memorabilia for visitors, as well as visual surrogates for those unable to complete the full circuit or to make the journey to the mountains.

The inscriptions identifying the sites depicted in the album often intrude over the painted motifs, reflecting an affinity of the project with map-making, where such graphic intrusions were the norm. The refreshing variety of compositions and motifs owes to the extent of the illustrative project and the richness of the actual scenery. Thus within the polar discourse of "brush-and-ink" versus "scenery" formulated by Tung Ch'i-ch'ang, the present work is solidly entrenched in the scenic camp.

The attribution of the albums to Hung-jen, which is supported by the circular seal with the characters *Hung-jen*, impressed on each of the unsigned leaves, has recently been challenged by James Cahill, who has proposed Hung-jen's older contemporary Hsiao Yün-ts'ung (1596–1673, who wrote a colophon for the albums dated 1665) as the likely author of the albums (Cahill, "Lun Hung-jen *Huang-shan t'u ts'e te kuei-shu*," 1985). Cahill's argument is based on the unique "Hung-jen" seal, not found elsewhere in the artist's work, and on certain anomalous stylistic features: the abundant use of color, the frequent appearance of simple, often faceless, human figures, and a general looseness and flatness of treatment of the mountain landscapes. Among the present leaves, we might note the use of square patches of ink-wash shading, the patternization of interior contours, and the use of split-brush exterior contours frequently interrupted by sharp points in the third leaf, "Alchemist Platform," as stylistic features suggestive of Hsiao Yün-ts'ung's authorship. The allusion to the dot-and-wash manner of the Mi family in the sixth leaf, "Lotus Flower Monastery," is also uncharacteristic of Hung-jen.

While questions of authorship cannot be finally resolved here, the albums remain of interest. The large scale of the project testifies to the popularity of topographical painting in the seventeenth century and to the potential of such an approach as a source for varied and inventive compositions. Among the exhibited leaves, the "Harboring Clouds Cave" (leaf 1) and "Radiant Brightness Summit" (leaf 9) are especially severe and dramatic, while the cavern scenes with meditating monks—"Immortal's Lamp Cave" (leaf 8) and "Kuan-yin Grotto" (leaf 10)—reveal a sense of anecdotal interest within complex formations. Most of the leaves convey an effect of density of detail and of actual scenery, and the designs differ dramatically from one another based on the identifying features of caverns, cliffs, and summits. The physical isolation of the sites, conveyed by truncated compositions that provide only glimpses of summits, caverns, or pathways, is somewhat at odds with the frequent evocation of human activity in figures climbing pathways, crossing bridges, and meditating in caverns. As portrayed here, this is a decidedly populated remoteness.

RV

LITERATURE: *Shina nanga taisei*, 1935–37, vol. 13; Su Tsung-jen, *Huang-shan ts'ung-k'an*, 1937, vol. 2; Cheng Hsi-chen, *Hung-jen, K'un-ts'an*, 1979, figs. 8–9; Kuo, "The Paintings of Hung-jen," 1980, pp. 112, 143–46, pls. 65–124; DeBevoise and Jang, "Topography and the Anhui School," 1981, pp. 43–50, fig. 10; Cahill, "Lun Hung-jen *Huang-shan t'u ts'e* te kuei-shu," 1985, pp. 108–24; Xu Bangda, "*Huang-shan t'u ts'e* tso-che k'ao-pien," 1985, pp. 125–29; Shi Gufeng, "Kuan-yü Chien-chiang *Huang-shan t'u ts'e* chih wo chien," 1985, pp. 130–36; Kuo, *Austere Landscape*, 1990, pp. 62–63, pls. 65–114.

116 *Snowy Pines on Western Peak*
Hsi-yen sung-hsüeh
弘仁　西巖松雪

Dated 1661

Hanging scroll, ink on paper
192.8 x 104.8 cm (75⅞ x 41¼ in.)

Beijing Palace Museum

vol. 1, pl. 116

ARTIST'S INSCRIPTION AND SIGNATURE (4 lines in regular script):
"Snowy Pines on Western Peak"

《 西巖松雪 》

During the spring of the *hsin-ch'ou* year [1611], painted for the lay Buddhist devotee, Hsiang-yeh, by Hung-jen.

辛丑春，爲象也居士圖，弘仁。

ARTIST'S SEAL:
Chien-chiang seng 漸江僧 (*pai-wen*, square)

NO COLOPHONS OR COLLECTORS' SEALS

EXHIBITION: Honolulu Academy of Arts, Hawaii, 1989: Rogers and Lee, *Ming and Qing Painting*, 1988, cat. no. 40.

LITERATURE: Wang Shiqing and Wang Cong, *Chien-chiang tzu-liao chi*, 1984, p. 75; *Chung-kuo ku-tai shu-hua mu-lu*, vol. 2, 1985, *Ching* 1–3812.

117 *Washing the Inkstone in a Shallow Stream*

Shu-ch'üan hsi-yen t'u

弘仁　疏泉洗硯圖

Dated 1663

Handscroll, ink and color on paper
19.7 x 69.7 cm (7¾ x 27⁷⁄₁₆ in.)

Shanghai Museum

vol. 1, pl. 117

ARTIST'S INSCRIPTION AND SIGNATURE (2 lines in regular script): "Washing the Inkstone in a Shallow Stream." In the spring of the *kuei-mao* year [1663], painted by Hung-jen.

《疏泉洗硯圖》。癸卯春。弘仁作。

ARTIST'S SEAL:
Chien-chiang seng 漸江僧 (*pai-wen*, square)

INSCRIPTION: T'ang Yen-sheng 湯燕生 (1616–1692), undated

NO COLOPHONS

COLLECTORS' SEALS: Wu Yüan-hui 伍元蕙 (19th century), 2; Xu Bangda 徐邦達 (b. 1911), 1

RECENT PROVENANCE: Xu Bangda

The inscription in the upper left-hand corner of the handscroll was written by T'ang Yen-sheng, one of Hung-jen's close friends. According to T'ang, the painting was done for a certain Mr. Pai-yü. It is possible to identify the dedicatee as Hsü Ch'u (1605–1676), another of Hung-jen's friends. Hsü Ch'u was a member of the Fu-she (Restoration Society), an important politico-scholarly society established by Hsü's mentor Chang P'u (1602–1641). After the fall of the Ming dynasty in 1644, many members of the Fu-she either committed suicide or were executed by the Manchus for their resistance activities. In 1647 Hsü Ch'u himself was jailed for his involvement in anti-Manchu activities but was soon released. Much of what we know today about Hung-jen comes from Hsü's writings. Hung-jen was a member of the Pai-yü she (White Elm Society), which was reestablished by Hsü and originally counted among its members Chou T'ien-ch'iu (1514–1595) from Su-chou and Mo Shih-lung (1537–1587) from Sung-chiang.

To escape from the social and political turbulence after 1644, Hsü Ch'u moved from T'an-tu in She-hsien to Mount Kao-miao, where he built a studio called "Stone Rain" (Shih-yü). He owned an inkstone named "Blue Cliff" (Ch'ing-yen), which he had acquired in Nanking in 1627, more than thirty years before Hung-jen painted this scroll in 1663. The painting depicts a life-style typical of late Ming scholars, in which objects from the scholar's studio acquired aesthetic status and even symbolic value (Li and Watt, *Chinese Scholar's Studio*, 1987, pp. 1–13, pls. 73–74).

Although Hung-jen apparently had no direct contacts with Tung Ch'i-ch'ang, many of his older contemporaries did. In 1639, when he was still a layman and using his secular name Chiang T'ao, Hung-jen painted a collaborative handscroll (now in the Shanghai Museum) with Liu Shang-yen, Li Yung-ch'ang, and two other artists. Both the sections by Liu and Li suggest stylistic influences from Tung Ch'i-ch'ang. According to the eighteenth-century writer Huang Yüeh (1751–1841), Liu Shang-yen's calligraphy and painting were so close in style to Tung Ch'i-ch'ang's that he sometimes ghostpainted for Tung. Many collectors in Hui-chou, where Hung-jen lived and worked, were on good terms with Tung Ch'i-ch'ang and his circle. For example, the prominent collector Wu T'ing (ca. 1555–after 1626) was intimately acquainted with Tung Ch'i-ch'ang, and Tung often visited Wu to view his collection of calligraphy and paintings. Another Hui-chou collector, Wu Chen (fl. ca. 1621–27), also invited Tung to stay at his home and discuss his collection of calligraphy and paintings. Thus it is likely that through his associations with local painters and collectors Hung-jen came into contact with Tung Ch'i-ch'ang's artistic ideas and practices (Kuo, *Austere Landscape*, 1990, pp. 19–20, pl. 23).

JK

LITERATURE: Zhong Yinlan, "Hung-jen," 1982, pp. 255–57; *I-yuan to-ying* 36 (Sept. 1987): 47; *Chung-kuo mei-shu ch'üan-chi*, 1988, Painting, vol. 9, pl. 42; *Chung-kuo ku-tai shu hua mu-lu*, vol. 3, 1987, *Hu* 1–2445; Kuo, *Austere Landscape*, 1990; *Chung-kuo ku-tai shu-hua t'u-mu*, vol. 4, 1990, *Hu* 1–2445; *Ssu-kao-seng hua-chi*, 1990, pl. 8.

K'un-ts'an (1612–1673) 髡殘

Original surname Liu 劉, *tzu* Shih-hsi 石谿, Chieh-ch'iu 介丘, *hao* Pai-t'u 白禿, Ts'an tao-jen 殘道人

One of the Four Great Monk Painters of the early Ch'ing dynasty, K'un-ts'an, or Shih-hsi (Stone Stream), spent his youth diligently studying the Confucian classics until a local Confucian scholar who was also a specialist in Ch'an (Zen) Buddhism inspired him to become a Buddhist monk. In 1638 he shaved his head, traveled to Nanking, and began studying with a disciple of Chu-hung's (1535–1615) who preached a syncretic creed that synthesized Buddhist, Confucian, and Taoist doctrines.

Living in Hunan at the time of the Manchu invasion of southern China in 1644–45, K'un-ts'an wandered for three months in the wilderness, during which time he endured great hardships, but also experienced a profound closeness to nature.

Returning to Nanking in 1654, he took up residence at the Pao-en Temple where he became a well-known figure among the poet-painters of the Nanking area, many of whom considered themselves loyal *i-min* (leftover subjects) of the vanquished Ming dynasty. One of his closest friends was Ch'eng Cheng-k'uei (1604–1676), who had studied painting with Tung Ch'i-ch'ang. Ch'eng had retired as Vice Minister of the Board of Works in 1657, about the same time that K'un-ts'an took up painting. The two men often visited one another and Ch'eng made his collection of paintings available for K'un-ts'an to study.

In 1658 or 1659, K'un-ts'an became the abbot of the Yu-ch'i Temple just outside Nanking, living there for the rest of his life except for a yearlong sojourn which he made in 1659 to Mount Huang in Anhui, where he was joined, at least for part of his stay, by Ch'eng Cheng-k'uei. Inspired by the mountain's dramatic scenery, K'un-ts'an returned to Nanking in 1660 and immediately entered into a period of intense creative activity that lasted until 1663. In his later years, K'un-ts'an often complained of poor health and his painting output diminished.

MKH

118 *Journey to Mount Huang*
Huang-shan chi-hsing
髡殘　黃山紀行

Dated 1660

Hanging scroll, ink and color on paper
158 x 69.5 cm (62⅟₁₆ x 27⅛ in.)

Shanghai Museum

vol. 1, pl. 118

ARTIST'S INSCRIPTION AND SIGNATURE (12 lines in running-cursive script):

I have climbed more than one hundred *li* in the mountains,
Yet I have not exhausted the peaks and ravines.
Although it is now the warmest time of summer,
Above these peaks it is as cool as the end of autumn.
Straightening my robes I climb the Heavenly Peak.
All the mountains seem to come and welcome me.
Outside the deep caves arise pines like reclining dragons,
Solemnly I am filled with affection and awe.
Suddenly I turn and it is another world.
All the precipices are high and strong,
Stone steps are connected by precarious ladders,
And quietude can be found near dangerous cliffs.
I used to be an explorer of strange sceneries,
But, in composing this, I become distressed and anxious.
Reluctantly I leave the creation of Heaven,

And descend through paths of pine trees.
The panorama opens up.
The Benevolent Light Temple (Tz'u-kuang ssu) embodies the highest vehicle [of Mahayana Buddhism].
It lets me stay in its hut of water and cloud.
When the bells sound before midnight, I stop meditating.
I wish the sun were still here,
Together we could set a date to meet again with water and mountain.

In the eighth month of the *keng-tzu* year [September 5–October 3, 1660], I returned from Mount Huang. I remember its myriad of sceneries; they are indeed inexhaustible. Meditating in the Pavilion of Containing Void at Mount Heavenly Gate [T'ien-ch'üeh shan], and recalling the sceneries I have seen, I have just painted this painting and composed the poem to accompany it. Shih-hsi, Ts'an tao-che.

山行百餘里
冥搜全未竟
雖歷伏火中
峰高已秋盡
振衣上天嶺
群峰悉趨迎
閟洞起臥龍
肅然生愛敬
忽轉別一天
插石皆峭勁
虛磴接危梯
崩崖倚幽寂
我本探奇人
寫茲憂虞併
黽勉敲天工
下山達松徑
廓然眼界寬
慈光演上乘
假我水雲寮
鐘鳴定出定
安得日在茲
山水共幽訂

　　庚子秋八月，來自黃山。道經風物森森，真如山陰道上，應接不暇也。靜坐天關之含虛閣，擬其所歷之景以屬圖，并系其作。石溪，殘道者。

ARTIST'S SEALS:
Chieh-ch'iu 介丘 (*chu-wen*, double oval)
Shih-hsi 石谿 (*pai-wen*, square)
Ts'an tao-che 殘道者 (*pai-wen*, square)

NO COLOPHONS

COLLECTOR'S SEAL: unidentified, 1

This painting from the autumn of 1660 was done at Mount Heavenly Gate (T'ien-ch'üeh shan), also known as Mount Ox Head (Niu-shou shan), located south of the city of Nanking, where K'un-ts'an lived from 1654 until his death in 1673.

Although the earliest dated paintings by K'un-ts'an are from 1657, most of his works date from 1660 to 1670, particularly the years 1660, 1661, 1663, and 1666. K'un-ts'an was a close friend of Ch'eng Cheng-k'uei's (1604–1676); they wrote colophons on each other's paintings and also painted for each other. Because Ch'eng Cheng-k'uei studied with Tung Ch'i-ch'ang, it is particularly important when Ch'eng writes, in a colophon on a painting by K'un-ts'an, that K'un-ts'an's

style achieved the essence of Tung Ch'i-ch'ang (see Yang Xin, "Shih-hsi tsu-nien tsai-k'ao," 1988, pp. 36–41).

In its vigorous brushwork and dynamic and complex composition, *Journey to Mount Huang* is unmistakably indebted to Tung Ch'i-ch'ang. The twisted foreground trees are also influenced by Tung, who said, "When a gentleman paints, he should use the methods of cursive (*ts'ao*) and clerical (*li*) script; trees are like bent iron rods, mountains like traces [of sharp tools] on sand." K'un-ts'an's paintings also reflect the influence of the Yüan master Wang Meng (1308–1385), as Ch'eng Cheng-k'uei once pointed out. Indeed, the visual drama and strong sense of growth and vitality in this painting reminds one of Wang Meng's masterpiece *Dwelling at Mount Ch'ing-pien*, now in the Shanghai Museum, a work that also inspired Tung Ch'i-ch'ang's 1617 hanging scroll, *The Ch'ing-pien Mountain in the Manner of Tung Yüan*, in the Cleveland Museum (vol. 1, pl. 32). K'un-ts'an himself wrote in the inscription on his 1667 painting *Pavilions on Pine Cliffs* (*Sung-yen lou-ko*; in the Nanjing Museum), "Tung Ch'i-ch'ang said that both painting and Ch'an Buddhism have the same essence; they should rely on sudden enlightenment, not just skills" (*Chung-kuo mei-shu ch'üan-chi*, 1988, Painting, vol. 9, pl. 55).

JK

LITERATURE: *Chugoku meigashu*, 1945, vol. 7; Chang, "K'un-ts'an te Huang-shan chih lü," 1987, p. 362; Fu, "Shan-kao shui-ch'ang," 1987, p. 64; *Chung-kuo mei-shu ch'üan-chi*, 1988, Painting, vol. 9; Huang-weng, "K'un-ts'an," 1988, p. III.

119 *Landscape in Color*

She-se shan-shui

髡殘　設色山水

Dated 1660

Hanging scroll, ink and color on paper
95.5 x 58.4 cm (37⅝ x 23 in.)

Beijing Palace Museum

vol. 1, pl. 119

ARTIST'S INSCRIPTION AND SIGNATURE (16 lines in running-cursive script):

Last night the sound of the waterfall shook the mountains and valleys;
This morning I see layers of cascades emerging from the forests and
　trees.
I look down and see the mist and light rain as if from the ancient past;
The shade of pine trees falls in layers on the thatched hut.
Waterfalls and cascades scatter without order;
Clouds along the river and snow in the wind chase one another.
A monk meditates on the straw mat;
The cold sound through the windows disturbs listening and seeing.
The dragons gobble up the cold sky;
Competing to fly, they almost break the mountains.
In front of the hut, a crane cries and takes off to the sky.
The bright moon renders the pond snow-white.
Having traveled ten thousand miles, who can be so narrow-eyed?
Having returned in leisure, I wear my hermit's clothes.

I remember last time I strode on the cloud;
I did not have the leisure to wear two sandals.
This year I sit under the sun at Mount Heavenly Gate (T'ien-ch'üeh
　shan).
Taking a break from Buddhist sutras, I study painting.
Painting has been in my heart for half of my life.
To paint landscapes, I simply let my brush go as it wishes.
My paintings lack complete scenes and are hard to penetrate.
My poetry likewise comes casually and does not have a definite style.

One day before the fifteenth day of the eleventh month, winter, of the *keng-tzu* year [December 15, 1660], I painted this hermit's dwelling at Mount Ox Head (Niu-shou shan). Yu-ch'i, Tien-chu, Shih-hsi, Ts'an tao-jen.

瀑聲昨夜搖山谷
曉見重泉沸林木
下望溟濛太古初
松陰疊疊歷茆屋
瀑流澗流無序次
溪雲峰雪相逐至
宵然殘衲坐蒲團
寒響一驄紛聽視
玉龍群向寒空咽
競势爭飛山嶽裂
屋前一鶴唳凌霄
皎皎如來一潭雪
足下萬里誰目窄
歸來閒暇披蘿薜
我聞前度跨雲去
不有閒心到雙屧
今年曝背天關山
偶然經暇講六法
六法在心已半生
隨筆所止寫丘壑
畫妙會境無可入
詩亦偶成無體格

　　庚子冬十一月望前一日，於牛首山房作此。幽棲，電住，石溪，殘道人。

ARTIST'S SEALS:
Chieh-ch'iu 介丘 (*chu-wen*, double oval)
Shih-hsi 石豁 (*chu-wen*, square)
Ts'an tao-che 殘道者 (*pai-wen*, square)

NO COLOPHONS

COLLECTORS' SEALS: unidentified, 4

This painting depicts a monk meditating on a straw mat in the rustic hut in the lower left-hand corner. Outside the hut and beside a stream, a crane turns its head toward the monk. Beyond the promontory on the right, a temple can be seen in the mist. Wet brushwork is used to depict twisted trees, cliffs, and mountains. Light and dark ink washes and light, brownish washes give the painting a sense of profuse growth. Dark accent dots complement animated and vigorous brushstrokes.

Like K'un-ts'an's *Journey to Mount Huang* (vol. 1, pl. 118), this painting is indebted to both Wang Meng (1308–1385) and Tung Ch'i-ch'ang. The visual effects of the calligraphy in the inscription are very likely inspired by Tung Ch'i-ch'ang in the way K'un-ts'an begins with dark ink, continues to write until the ink becomes light, and then

uses dark ink again, thus achieving a sense of dynamic visual drama through the interplay of light and dark, and echoing the composition below the inscription.

JK

LITERATURE: Yang Xin, "Lüeh-lun Shih-hsi te i-shu," 1983, p. 44.

120 *Autumn Mood among Streams and Mountains*
Hsi-shan ch'iu-i
髡殘　溪山秋意

Dated 1663

Hanging scroll, ink and color on paper
108.8 x 48.5 cm (42⅞ x 19⅛ in.)

The Nelson-Atkins Museum of Art (acquired through the 40th Anniversary Memorial Acquisition Fund) F75–41

vol. 1, pl. 120

ARTIST'S INSCRIPTION AND SIGNATURE (11 lines in running-cursive script):

An expanse of mountain peaks, six times six,
Soaring heaven high, since the start of time.
In the cool autumn, clear without a cloud,
Jostling they come, serried round my desk.
Temple banners, suspended against the sky;
The colors of trees, splendid in the open air.
A waterfall plunges myriads of meters in the air,
Unbroken by the puffing of winds high aloft.
Suddenly, spewing forth mist and fog,
Mountain peaks lose their place near and far.
Swelling like great waves upon a sea,
A boundless expanse, with limits unfixed.
In a while, mountain vapors thin;
Delicate ranges shimmer like mallow flowers.
Hard it is to paint ridges and high clefts,
Where monkeys and birds call back and forth.
I recall the masterful hands of Tung [Yüan, fl. ca. 945–ca. 960] and
　　Chü[-jan, fl. ca. 960–ca. 986],
Whose brush and ink show no trace of the dusty commonplace.
Alas for those men of the ordinary world;
For who can change their plebeian air?
Conversely, I envy the man in the house,
With writings spread out beside mists and clouds.
A woodcutter returns home on a bridge of boards;
And they converse about ancient days of Fu-hsi's time.
　Done on an autumn day in the *kuei-mao* year [1663] beneath the eaves of white clouds on Ox Head [Hill]. Shih-hsi, Ts'an tao-jen.
(Translation by Marc F. Wilson and Kuan S. Wong, in Ho et al., *Eight Dynasties*, 1980, p. 314.)

六六峯之間
振古凌霄漢
清秋淨無雲
爭來列几案
寺幢天際懸

樹色空中燦
飛瀑幾萬尋
高風吹不斷
俄然吐霧烟
近遠山峰亂
渾如大海濤
浩淼靡涯岸
少焉嵐氣收
秀嶺芙蓉爛
巒岫畫難工
猨鳥聲相喚
我憶董巨手
筆墨絕塵俗
嗟嗟世上人
俗氣疇能換
翻羨屋中人
攤書烟雲畔
板橋樵子歸
共語義皇上
　　癸卯秋日，作於牛首之白雲檐下，石溪殘道人。

ARTIST'S SEALS:
Chieh-ch'iu 介丘 (*chu-wen*, oval)
Shih-hsi 石谿 (*pai-wen*, square)
Pai-t'u 白禿 (*chu-wen*, square)

NO COLOPHONS OR COLLECTORS' SEALS

RECENT PROVENANCE: Victoria Contag von Winterfeldt

EXHIBITIONS: Kunstsammlungen der Stadt Düsseldorf, 1950: Speiser and Contag, *Austellung*, cat. no. 98, pp. 29, 50, pl. 12; Nelson Gallery-Atkins Museum and The Cleveland Museum of Art, 1980–81: Ho et al., *Eight Dynasties*, cat. no. 232; Tokyo National Museum, 1982: *Special Exhibition*, cat. no. 231.

LITERATURE: Contag, *Zwei Meister*, 1955, pp. 89, 90, pl. 26; Contag, *Seventeenth Century Masters*, 1969, pp. 26, 27, 49, pls. 34, 34a; Chang, "K'un-ts'an te Huang-shan chih lü," 1987, p. 365.

121 *Autumn Dusk in the Mountains*
Ch'ün-luan ch'iu-shuang
髡殘　群巒秋爽

Dated 1666

Hanging scroll, ink and color on paper
124.4 x 60 cm (49 x 23⅝ in.)

The Metropolitan Museum of Art, New York
Bequest of John M. Crawford, Jr., 1988 (1989.363.129)

vol. 1, pl. 121

ARTIST'S INSCRIPTION AND SIGNATURE (12 lines in running-cursive script):
Rising beyond the charms of hills and valleys
The moon hangs cold above the precipice.
Crisp weather, but with steamy mountain mists—
I will not try for the Hung-men confrontation[?].

Startled by twilight, I walk on with my staff,
Leaping along, engaged in idle dreams,
[illegible] . . . an old monkey calls.
I rise and stare into the fading light.
All day I've traveled, no one for companion,
Excited by hidden and perilous places.
Distant peaks and nearby mountaintops,
Behind, in front, in orderly relations.
A strange sense pervades the firmament
As flying green [leaves] hit against my face.
The sun descends, as though approaching man;
Combed mists engender utmost loveliness.
As I walk on, they clear before me;
But my legs are seized suddenly with cramps.
I hold a stone, bony as if pared,
Regard a pine, its green moss looking dyed.
I sit myself down, like a small bird,
And the crowd of peaks falls suddenly into place.
Having climbed high, now at the brink of depths,
Holding fast, I ponder my pettiness.
The road ends; I plant myself firmly there.
Where a spring issues, I set up shelter beneath the cliff.
All this suffices for nourishing my eyes,
Suffices also just to rest my feet.
With one large piece of rattan paper from [Yen-]ch'i,
I draw this, and the *ch'i* infuses it.
(Translation by James Cahill, "K'un-ts'an and His Inscriptions," 1991,
pp. 513–14.)

In the first ten days of the eighth month, autumn of the *ping-wu* year
[August 30–September 8, 1666], at the time when my poet friend Tung-
t'ien [Hsü Yen-wu, fl. ca. 1666–78], riding a sedan chair in the rain,
passed my Double Tree Studio (Shuang-shu hsüan). From his sleeve he
took some paper and asked for a painting; I did this in response to his
request. Yu-ch'i-tien-chu, Shih-hsi, Ts'an tao-jen recorded this.

凝出丘壑姿
巖額懸月□
爽氣與蒸嵐
不將洞門掩
驚昏忽策杖
跳躑成夢想
□□老獱啼
起視光瞇瞇
鎮日□經行
發興在幽險
遙巒與近巘
後先□天儼
魂情出天表
飛翠撲人臉
日脚欲近人
梳雲生絕艷
吾欲即往之
決股廢拘過
撿石骨如削
有松髮如染
身坐如小鳥
群峰忽然歛
登高而臨深
拳拳齊諫貶
路窮剛置我

源開輒與唇
既足供□目
又言息吾肝
一幅溪藤紙
寫此氣冉冉
　丙午秋，八月上浣，值東田詞盟雨中乘輿過余雙樹軒，袖
□楮索畫，聊應此。幽栖電住石溪殘道人記事。

ARTIST'S SEALS:
Chieh-ch'iu 介丘 (*chu-wen*, two semi-circles)
Shih-hsi 石谿 (*pai-wen*, square)
Pai-t'u 白秃 (*chu-wen*, square)

NO COLOPHONS

COLLECTORS' SEALS: John M. Crawford, Jr. 顧洛阜 (1913–1988), 3;
Chao Wei-lao 趙魏老, 1; unidentified, 1

Autumn Dusk in the Mountains is one of several major works that
K'un-ts'an created in the autumn of 1666 (see also Ho et al., *Eight Dynasties*, 1980, no. 233). Both the painting and the inscription describe
not merely an excursion in the mountains, but a spiritual passage.
K'un-ts'an's poem relates how, traveling alone all day, he is startled by
the rising mist and fading light of evening. Gazing with awe across
the expanse of peaks bathed in the light of the setting sun, he is suddenly stricken with a leg cramp that reminds him of his physical limitations; perched like a small bird on the edge of a cliff, he contemplates
his insignificance in the midst of the mountain's grandeur. Then, just
as the road ends, he comes upon a sheltering cliff where a spring issues forth. This geomantically potent spot at the heart of the landscape offers K'un-ts'an both protection and nourishment, a place
where he can find physical and spiritual renewal as both he and his
painting are filled with vital energy or *ch'i*.

The painting does not illustrate the poem, but offers a parallel experience. Beginning with the figure of a traveler with a carry pole and
staff, the viewer moves in stages from a placid stream at the bottom of
the composition up a well-marked path to a temple. No trail leads beyond the temple; a Ch'an-like intuitive leap is required to reach the
other side of the mist-filled chasm. There, under a natural rock arch,
a small figure sits on his prayer mat beside a gushing spring. The
image of a solitary man seated in a grottolike cavity beside a water
source appears in several of K'un-ts'an's paintings, but the peculiar geologic feature introduced here recalls the famous rock bridge spanning
a waterfall at Mount T'ien-t'ai. Legend has it that this sacred Buddhist peak is crowned with "beautiful and exquisite buildings inhabited by those who have attained the Way (*Tao*). Although there is a
rock bridge across the deep ravine, the bridge is blocked by a huge
stone which stops all travelers" (Fong, "The Lohans and a Bridge to
Heaven," 1958, p. 15; see also pl. 1). In K'un-ts'an's depiction, one side
of the rock bridge is blocked by an enormous boulder while the other
connects to a slope surmounted by a Ni Tsan–like pavilion; in the distance, an elegant tower appears beneath the sheltering overhang of the
main peak. While this heavenly hall may represent the ultimate goal
of the pilgrim, K'un-ts'an's painting suggests that one may attain a
measure of contentment and even enlightenment in this world.

Significantly, K'un-ts'an situates his refuge in the midst of a complex and richly embellished landscape that embodies the shifting ap-

pearances and varied phenomena of nature: rushing cascades, rising mist, towering trees with clinging roots and vine-draped boughs, a profusion of lush vegetation, and boldly articulated mountains bathed in the rosy hues of sunset, reminders that the cosmos is in a constant state of creative flux. Clearly, K'un-ts'an was deeply affected by the natural world, which appealed to his reclusive instincts far more meaningfully than did human affairs.

To create this image, K'un-ts'an has drawn inspiration from the densely textured brush style and colorful palette of the Yüan recluse Wang Meng (1308–1385) without seeking to make a literal evocation of the earlier master's style as "Orthodox School" followers of Tung Ch'i-ch'ang might have done. Indeed, while he would have been acquainted with the theories and art of Tung Ch'i-ch'ang through Ch'eng Cheng-k'uei (1604–1676), his sensitive and sympathetic description of the natural world betrays little interest in Tung's intellectualized view of landscape painting as a vehicle for "the wonders of brush and ink." K'un-ts'an's painting is not about ancient masters, compositional abstraction, or expressive brushwork as ends in themselves. Rather, his encounter with the landscape was deeply spiritual, and it is his wonder at the richly varied and harmonious workings of creation that he conveys through his art.

MKH

A copy of this painting exists in the Museum of Eastern Art, Oxford. According to Aschwin Lippe's entry in Sickman, *Chinese Calligraphy and Painting*, 1962, no. 71, the copyist transcribed K'un-ts'an's cyclical date as *ping-tzu* (1696).

EXHIBITIONS: Pierpont Morgan Library, New York, 1962: Sickman, *Chinese Calligraphy and Painting*, no. 71; Victoria and Albert Museum, London, 1965: Arts Council of Great Britain, *Chinese Painting and Calligraphy*, no. 58; Musée Cernuschi, Paris, 1966: *Dix Siècles de Peinture Chinoise*, no. 60; Bell Gallery, List Art Center, Brown University, 1980: *The Individualists*, no. 7.

LITERATURE: Chang and Hu, *Shih-hsi hua-chi*, 1969, pl. 13; Weng, *Chinese Painting and Calligraphy*, 1978, pl. 51; Sullivan, *Symbols of Eternity*, 1979, pl. 89; Suzuki, *Comprehensive Illustrated Catalogue*, 1982–83, vol. 1, A15–004; Shih Shou-ch'ien et al., *The John M. Crawford, Jr., Collection*, 1984, no. 137; Cahill, "K'un-ts'an and His Inscriptions," 1991, pp. 513–34.

Wang Shih-min (1592–1680) 王時敏

tzu Hsün-chih 遜之, *hao* Yen-k'o 煙客, Hsi-lu lao-jen 西廬老人, Hsi-t'ien chu-jen 西田主人

As the scion of the wealthy and influential Wang clan of T'ai-ts'ang, Kiangsu, Wang Shih-min inherited a prominent position in the cultural and intellectual milieu of the early seventeenth century, a position he employed as a platform for promoting the artistic ideals of his teacher Tung Ch'i-ch'ang. After the premature death of his father Wang Heng in 1609, Wang Shih-min was educated by his grandfather Wang Hsi-

chüeh (1534–1610), a former Grand Secretary and a patron of Tung Ch'i-ch'ang. It was through his grandfather's encouragement that Wang Shih-min began his painting studies with Tung Ch'i-ch'ang in 1605.

Wang Shih-min never sat for the *chin-shih* examinations, but he was awarded official appointments through hereditary privilege, eventually rising to the position of Vice Minister in the Court of Imperial Sacrifices. He retired to his native T'ai-ts'ang in 1639, probably as a result of the political instability of the late Ming, and remained active in intellectual and cultural circles throughout the rest of his long life.

Of the Nine Friends of Painting, Wang became the foremost advocate of Tung Ch'i-ch'ang's antiquarianism. His enthusiasm for the paintings of the Sung and Yüan masters led him to expand his family's already sizable collection. In fact, many works from Tung Ch'i-ch'ang's own collection eventually ended up in Wang's hands, and formed the main inspiration for his painting style and theory. In his emphasis on emulating ancient painting styles, Wang often spoke of transmitting the spirit rather than the formal qualities of the old masters' works; his own paintings, however, were composed of codified forms and standard compositional structures that could easily be identified with the style of a particular master. Hence his principal contribution to the history of later Chinese painting was the development of a typology of Chinese painting, a system that ultimately achieved the status of orthodoxy in the hands of his conservative followers.

122 *Landscape in the Manner of Huang Kung-wang*
Fang Ta-ch'ih pi-i
王時敏　倣大癡筆意

Dated 1664

Hanging scroll, ink on paper
95.5 x 54 cm (37⅝ x 21¼ in.)

Shanghai Museum

vol. 1, pl. 122

ARTIST'S INSCRIPTION AND SIGNATURE (3 lines in running script):
In the *tzu* [eleventh] month of the *chia-ch'en* year [December 17, 1664–January 15, 1665], following the brush ideas of Ta-ch'ih [Huang Kung-wang, 1269–1354]. Wang Shih-min.

甲辰子月，倣大癡筆意。王時敏。

ARTIST'S SEALS:
Wang Shih-min yin 王時敏印 (*pai-wen*, square)
Yen-k'o 煙客 (*chu-wen*, square)

NO COLOPHONS

COLLECTORS' SEALS: Chou Hsiang-yün 周湘雲 (20th century), 2; unidentified, 1

Wang Shih-min's landscape appears relaxed and inviting to the viewer. The reference to the "brush ideas of Ta-ch'ih" (Huang Kung-wang's self-styled sobriquet, literally meaning "the great idiot") is hardly nec-

essary, so close is the painting in feeling to the Yüan artist's master-piece *Dwelling in the Fu-ch'un Mountains (Fu-ch'un shan-chü*; vol. 1, fig. 17) of 1350, in the National Palace Museum, Taipei, but it under-lines the lack of pretension in the soft brushwork and the fairly lim-ited range of tree and rock forms. Wang Shih-min's paintings generally show a marked preference for Huang Kung-wang's style over those of the other late Yüan masters, whereas Wang Chien (1598–1677) and especially Wang Hui (1632–1717) are more eclectic. Never-theless, it was Wang Shih-min who first, doubtless with the encour-agement and example of Tung Ch'i-ch'ang, produced a volume of reduced-size versions of the Sung and Yüan masterpieces in his own collection, entitled *Hsiao-chung hsien-ta* (now in the National Palace Museum, Taipei), to be later followed by Ch'en Lien (fl. first half of the 17th century), Wang Chien, and Wang Hui. These albums, two of which are shown in the present exhibition (vols. 1 and 2, pls. 125, 164), are discussed below (cat. no. 164).

RW

LITERATURE: *Chung-kuo ku-tai shu-hua mu-lu*, vol. 3, 1987, Hu 1–2224; *Chung-kuo ku-tai shu-hua t'u-mu*, vol. 4, 1990, Hu 1–2224.

123 *Landscape Album by Six Masters*
Liu ta-chia shan-shui
王時敏　王鑑　吳歷　惲壽平　王翬　王原祁　六大家山水

Dated 1651–1711

Album of twelve paintings, ink and ink and color on paper
Average: 21.5 x 19.3 cm (8⁷⁄₁₆ x 7⅝ in.)

Beijing Palace Museum

vol. 1, pl. 123 (leaves 1–4, 7, 8, 10, 11); vol. 2, pl. 123 (leaves 5, 6, 9, 12)

Leaf 1, Wang Shih-min (1592–1680)
ARTIST'S INSCRIPTION AND SIGNATURE (3 lines in running script):
In the winter of the *hsin-mao* year [1651], painted for my literary elder Tzu-chieh. Wang Shih-min.

辛卯冬，爲子介詞兄畫。王時敏。

ARTIST'S SEAL:
Wang Shih-min yin 王時敏印 (*pai-wen*, square)

Leaf 2, Wang Chien (1598–1677)
ARTIST'S INSCRIPTION AND SIGNATURE (3 lines in running script):
Painted in the summer of the *wu-hsü* year [1658] for my literary elder in literature Sung-huan's birthday. Wang Chien.

戊戌夏畫爲松寰詞兄壽。王鑑。

ARTIST'S SEAL:
Chien 鑑 (*chu-wen*, square)

INSCRIPTION: unidentified, 1 seal

Leaf 3, Wang Chien
ARTIST'S INSCRIPTION (1 line in running script):
After Ying-ch'iu [Li Ch'eng, 919–967]

倣營丘

ARTIST'S SEAL:
Chien 鑑 (*chu-wen*, square)

Leaf 4, Wang Chien
ARTIST'S INSCRIPTION AND SIGNATURE (4 lines in running script):
Deserted paths of mist through the wilderness;
Deep in the mountains the ancient trees flourish.
 Hsiang-pi.

野戍荒煙斷
深山古木豐
　　湘碧。

ARTIST'S SEAL:
Wang Chien chih yin 王鑑之印 (*pai-wen*, square)

Leaf 5, Wu Li (1632–1718)
ARTIST'S INSCRIPTION AND SIGNATURE (6 lines in running-regular script):
A fine dotting of white flowers, [the water] still, no waves;
Tender leaves just opening, all soft corners.
Just a murmur from the wind in the fading sunset;
Whose family can tune to Gathering Water-chestnuts?
 On a day with clear sky after spring snow, inscribed for Jo-han, my respected senior. Wu Li. The *chia-yin* year, the day after *shang-yüan* [the sixteenth day of the first month; February 21, 1674].

白花細點靜無波
嫩葉初藏軟角多
風拂一聲殘照裏
誰家新調採菱歌
　　春雪初晴，題爲若韓道兄。吳歷。歲甲寅，上元後一日。

ARTIST'S SEALS:
Wu Li 吳歷 (*chu-wen*, square)
Mo-ching 墨井 (*chu-wen*, square)

Leaf 6, Wu Li
ARTIST'S INSCRIPTION AND SIGNATURE (7 lines in running script):
My friend, whither are you trudging on the bright grass?
How many drunken bamboo hats in the spring wind?
I think all this rain has made the moss paths slippery.
How can we brew tea and enjoy ourselves?
 The day before *shang-ssu* [the third day of the third month], inscribed and sent to brother Ts'ang-yü. Yü-shan-tzu, Wu Li.

故人何處踏晴莎
笠帽春風醉幾多
料得雨深苔逕滑
豈能煮茗共婆娑
　　上巳前一日題寄滄漁有道兄。漁山子，吳歷。

ARTIST'S SEALS:
Wu Li 吳歷 (*chu-wen*, square)
Yen-ling 延陵 (*chu-wen*, rectangle)
Mo-ching 墨井 (*chu-wen*, square)

Leaf 7, Yün Shou-p'ing (1633–1690)
ARTIST'S INSCRIPTION AND SIGNATURE (3 lines in running script):
Crossing the bridge to the southern bank, seeking the spring;
Treading everywhere on the plum blossoms we return with the moon.
 The *ting-ssu* year [1677], summer, painted for fun. Shou-p'ing.

過橋南岸尋春去
踏遍梅花帶月歸
　　丁巳夏戲圖。壽平。

ARTIST´S SEALS:
Yün, Cheng-shu 惲　正叔 (*pai-chu wen*, rectangle)
Nan-t'ien ts'ao-i 南田草衣 (*pai-wen*, square)

Leaf 8, Yün Shou-p'ing
ARTIST´S INSCRIPTION AND SIGNATURE (2 lines in running script):
After Old Ch'ih [Huang Kung-wang, 1269–1354]. Yüan-k'o, Shou.

傲癡翁。園客，壽。

ARTIST´S SEAL:
Shou-p'ing, Cheng-shu 壽平　正叔 (*pai-chu wen*, rectangle)

Leaf 9, Wang Hui (1632–1717)
ARTIST´S INSCRIPTION AND SIGNATURE (3 lines in running-regular script):
In the *keng-wu* year [1690] on the day of establishing winter, at the Lan-hsüeh t'ang I was able to see Shu-ming's [Wang Meng, 1308–1385] *Dwelling in the Mountains on a Summer Day*, so I followed his general ideas. Shih-ku-tzu.

庚午立冬日，蘭雪堂得觀叔明《夏日山居圖》真蹟，因傲大意。石谷子。

ARTIST´S SEALS:
Shih-ku-tzu 石谷子 (*chu-wen*, square)
Wang Hui chih yin 王翬之印 (*pai-wen*, square)

Leaf 10, Wang Hui
ARTIST´S INSCRIPTION AND SIGNATURE (2 lines in running-regular script):
The aged rustic is thinking of the herd-boy,
Leaning on his staff, he waits by the thorn hedge.

野老念牧童
倚杖候荊扉

ARTIST´S SEALS:
Shih-ku-tzu 石谷子 (*chu-wen*, square)
Wang Hui chih yin 王翬之印 (*pai-wen*, square)

Leaf 11, Wang Yüan-ch'i (1642–1715)
ARTIST´S INSCRIPTION AND SIGNATURE (5 lines in running script):
In the long summer of the *hsin-mao* year [1711], imitating Chao Sung-hsüeh's (Chao Meng-fu, 1254–1322) *Summer Mountains*. "The mountains are as tranquil as in high antiquity, the days are long as in my boyhood years"—these two phrases come close to it. [These well-known phrases are the opening couplet of a poem on the pleasures of solitary living by the Sung dynasty poet T'ang Keng.] Wang Yüan-ch'i.

辛卯長夏傲趙松雪《夏山》。"山靜似太古；日長如小年，"二語近之。王原祁。

ARTIST´S SEALS:
San-mei 三昧 (*chu-wen*, gourd shape)
Yüan-ch'i 原祁 (*pai-wen*, square)
Mao-ching 茂京 (*chu-wen*, square)

Leaf 12, Wang Yüan-ch'i
ARTIST´S SIGNATURE (1 line in running script):
Lu-t'ai

麓臺

ARTIST´S SEAL:
Wang Yüan-ch'i yin 王原祁印 (*chu-wen*, square)

COLOPHON: unidentified, 1 seal

COLLECTOR´S SEALS: P'ang Yüan-chi (1862–1948), 5

Perhaps the most interesting aspect of this collection of small landscapes from a period of sixty years (1651 to 1711) is the choice of works used to represent the Orthodox masters, beginning with the Wang Shih-min in a dry version of Huang Kung-wang's style and ending with a composition by Wang Yüan-ch'i that shows his fully developed personal style. The latter is very close to Wang Yüan-ch'i's great interpretation of the *Wang-ch'uan Villa* in The Metropolitan Museum of Art (vol. 1, pl. 169), but strongly reminiscent also of Wang Meng's sky-line and densely textured compositions, as indeed is leaf 9 by Wang Hui, which likewise takes a small section of a large landscape to make a new composition. These leaves thus represent a stage beyond the "copies on a reduced scale" seen in leaves 3 and 4 by Wang Chien after Li Ch'eng and (we might hazard a guess) Chao Ling-jang (d. after 1100) respectively; an artist such as Kung Hsien (1619–1689) uncircumscribed by the Orthodox tradition, was able to go still further and abstract the trees and ink dots entirely from the Yüan context by the omission of human elements, as in the album of tree sketches (vols. 1 and 2, pl. 133).

In the present album, Wu Li and Yün Shou-p'ing, like Wang Yüan-ch'i, are able to appear most clearly in their own character: the former with two contrasting landscapes, one of rhythmic strokes of a dry brush, the other of broad color washes; and the latter with delicacy and lightness of touch, leaf 8 being clearly inspired by the last rounded peak of Huang Kung-wang's *Dwelling in the Fu-ch'un Mountains* (*Fu-ch'un shan-chü*; vol. 1, fig. 17) of 1350, in the National Palace Museum, Taipei.

RW

LITERATURE: P'ang Yüan-chi, *Hsü-chai ming-hua lu*, 1909, *ch.* 15, p. 1; *Chung-kuo ku-tai shu-hua mu-lu*, vol. 2, 1985, *Ching* 1–3422.

Ch'en Lien (fl. first half of the 17th century) 陳廉

tzu Ming-ch'ing 明卿, *hao* Wu-chiao 無嬌, Chan-liu 湛六

Though the details of his life are obscure, Ch'en Lien appears to have been well acquainted with late Ming artistic circles in his native Sung-chiang (in modern Kiangsu province). Most of the material concerning his life survives in a series of colophons on his paintings by Wang Shih-min (1592–1680) and Wang Chien (1598–1677). According to these sources, Ch'en first studied painting under the guidance of Chao Tso (ca. 1570–after 1633). Later, Wang Shih-min recognized his talent and asked Ch'en to copy into a small album the Sung and Yüan master-

pieces in the Wang family collection, an experience that, according to Wang Shih-min, resulted in Ch'en's adopting the orthodox painting manner of his patron. Ch'en Lien died while still in his fifties, sometime before 1663.

124 *Landscape Dedicated to Wang Shih-min*
Wei Yen-k'o tso shan-shui
陳廉　爲煙客作山水

Dated 1624

Handscroll, ink on paper
22.4 x 375.8 cm (8¹¹⁄₁₆ x 147¹⁵⁄₁₆ in.)

Beijing Palace Museum

vol. 1, pl. 124

ARTIST'S INSCRIPTION AND SIGNATURE (2 lines in running-regular script):
The *chia-tzu* year, in the first ten days of the first month [February 19–28, 1624], for Mr. Yen-k'o's [Wang Shih-min, 1592–1680] correction. Ch'en Lien.

甲子正月上瀚，煙客先生教正。陳廉。

ARTIST'S SEAL:
Ch'en Lien chih yin 陳廉之印 (*pai-wen*, square)

NO COLOPHONS

COLLECTOR'S SEAL: Ch'ing Jen-tsung 清仁宗 (r. 1796–1820), 1

Although at first glance this handscroll appears to be an endless panorama of ink-washed hills and clouds—leading to comparisons with Mi Fu (1051–1107) and Mi Yu-jen (1074–1151)—there are in fact cottages and hamlets scattered throughout its length, with connecting paths and footbridges, and an inviting summerhouse near the largest group of trees. The painting, which bears a seal of the Chia-ch'ing emperor, was very respectfully dedicated by the artist to Wang Shih-min. According to Wang Chien (1598–1677), in the colophon appended to his own album (vol. 2, pl. 125), Wang Shih-min had asked Ch'en Lien to make scaled-down copies of the paintings in his collection, and kept these by him always.

RW

LITERATURE: Xu Bangda, *K'ao-pien*, 1984, text, vol. 2, p. 155.

Wang Chien (1598–1677) 王鑑

tzu Yüan-chao 圓照, *hao* Hsiang-pi 湘碧, Jan-hsiang an-chu 染香庵主

Like his older contemporary and close friend Wang Shih-min (1592–1680), Wang Chien was a descendant of a prominent family in T'ai-ts'ang, Kiangsu. His great-grandfather was Wang Shih-chen (1526–1590), a literary and political luminary of the late Ming period who advocated the emulation of ancient literary styles. The inspiration for Tung Ch'i-ch'ang's aesthetic theories derived in large part from the thought of Wang Shih-chen, and thus it is no coincidence that Shih-chen's great-grandson Wang Chien sought painting instruction from Tung during the early 1630s.

Wang Chien's brief political career spanned eight years, culminating in his appointment as Prefect of Lien-chou (modern Ho-p'u hsien), in Kuangtung, from 1639 to 1641. After his retirement from public office he returned to his family estate in T'ai-ts'ang and devoted himself to literature and art, eventually amassing a large collection of ancient masterworks.

Wang's collection provided a source of inspiration for his large circle of friends and students. His "discovery" of Wang Hui (1632–1717) in 1651 and his continued patronage of the young artist were of major significance in the development of seventeenth-century Chinese painting. The enthusiastic promotion of Wang Hui by Wang Chien and his friend Wang Shih-min ultimately led to the establishment and perpetuation of the Wangs' artistic orthodoxy at the Ch'ing imperial court under the leadership of their most talented protégé.

125 *Copies of a Sung and Yüan Landscape Album in the Family Collection of Wang Shih-min*
Lin Wang Shih-min chia-ts'ang Sung Yüan shan-shui
王鑑　臨王時敏家藏宋元山水

Dated 1663

Album of twelve paintings, ink and color on paper
55.2 x 35.2 cm (21¾ x 13⅞ in.)

Shanghai Museum

vol. 1, pl. 125 (leaves 1–12); vol. 2, pl. 125 (colophon)

ARTIST'S INSCRIPTIONS:
Leaf 1, 1 line in running-regular script:
After Pei-yüan [Tung Yüan, fl. ca. 945–ca. 960]

倣北苑筆

Leaf 2, 1 line in running-regular script:
After Chü-jan [fl. ca. 960–ca. 986]

倣巨然

Leaf 3, 1 line in running-regular script:
After Chao Ch'ien-li [Chao Po-chü, ca. 1120–ca. 1170]

倣趙千里

Leaf 4, 1 line in running-regular script:
After Chao Wen-min [Chao Meng-fu, 1254–1322]

倣趙文敏

Leaf 5, 1 line in running-regular script:
After Tzu-chiu's [Huang Kung-wang, 1269–1354] *Autumn Mountains*

臨子久《秋山圖》

Leaf 6, 1 line in running-regular script:
Copying Ta-ch'ih's [Huang Kung-wang] brush

摹大癡筆

Leaf 7, 1 line in running-regular script:
After Mei tao-jen's [Wu Chen, 1280–1354] brush

倣梅道人筆

Leaf 8, 1 line in running-regular script:
Learning from Mei-hua an-chu [Wu Chen]

學梅花菴主

Leaf 9, 2 lines in running-regular script:
After lofty Ni's [Ni Tsan, 1301–1374] *Scenery with Streamside Pavilion*
(*Hsi-t'ing shan-se*)

倣倪高士《溪亭山色》

Leaf 10, 1 line in running-regular script:
After Huang-ho shan-ch'iao [Wang Meng, 1308–1385]

倣黃鶴山樵

Leaf 11, 2 lines in running-regular script:
After Hsiang-kuang chü-shih [Wang Meng]

倣香光居士

Leaf 12, 1 line in running-regular script:
After Ch'en Wei-yün [Ch'en Ju-yen, ca. 1331–before 1371]

倣陳惟允

ARTIST'S COLOPHON AND SIGNATURE (11 lines in running script):
Tung Wen-min [Tung Ch'i-ch'ang] used to say that collectors of calligraphy and painting are different from connoisseurs, for collectors are those who have the financial means and who enjoy making a name for themselves: they do not distinguish between the genuine and the imitation, but will pay a high price for their acquisitions, placing them in lofty halls and not looking at them for years, letting the dust pile up an inch thick; whereas connoisseurs who obtain a sheet of paper or a few characters, treat it like a jade from heaven and depend upon it for their very life. In the past the scholars and officials of Chiang-nan considered that the possession or lack of calligraphy and painting was a mark of refinement or vulgarity, and when they swept the floor and burnt incense to receive friends, they would never fail to talk about brush and ink. This refined tradition of former generations has all but disappeared; only Mr. Yen-k'o [Wang Shih-min, 1592–1680] of T'ai-yüan from our district of Lou [T'ai-ts'ang], like the towering Ling-kuang Palace of the state of Lu, still stands as the last paradigm of the old tradition. There are ink treasures still preserved in his Ch'ing-pi ko, but unless he comes across persons that are knowledgeable, he will not casually display them. He did ask my old friend Ch'en Ming-ch'ing of Hua-t'ing [Ch'en Lien, fl. first half of the 17th century] to make a reduced-size portfolio of the Sung and Yüan paintings in his collection, and coming and going keeps

it with him, for enjoying at leisure. Now this year I am in Nan-hsiang, and have met my fraternal elder Wen-shu [Tai Tzu-lai, a contemporary of Ch'eng Chia-sui, 1565–1644], whose spirit is extraordinary, excelling in the art of painting, and grasping fully the secrets of the ancients, and so I have made another copy of Ch'en's version to give to him. The secrets of the pillow I do not dare to enjoy alone. May Wen-shu kindly forgive the album's shortcomings and accept it for what it is, and please do not follow the example of Huan Hsüan-wu and Liu *ssu-k'ung* to declare that nothing is right about it. Three days before the fifteenth of the *chia-p'ing* [twelfth] month of the *jen-yin* year [January 20, 1663], Wang Chien, junior member of the Lou-tung fraternity.

董文敏嘗謂書畫收藏家與賞鑒不同，收藏乃有力好名者，不分真贗，概以重值得之，置之高閣，經年不觀，塵埃積寸；賞鑒家得片紙隻字，如天球供璧，性命倚之。往時江南士大夫以書畫有無為雅俗，無不掃地焚香相對，未有不及筆墨者。前輩風流零落欲盡，惟吾婁太原烟客先生，魯靈光巍然獨存。其清秘閣中尚存墨寶，然不遇知者，亦不輕示。曾見所藏宋元大家真蹟，屬華亭故友陳明卿縮成一冊，出入携帶，以當卧遊。予今歲偶來南翔，諦交文庶社長，見其豐神超邁，雅善丹青，深得古人三昧，余因復臨陳本贈之。枕中之秘不敢獨擅，文庶幸遺其陋而取其形，勿謂此冊如桓宣武，似劉司空，無所不恨耳。壬寅嘉平月望前三日，婁東社弟王鑑畫并識。

ARTIST'S SEALS:
Chien 鑑 (*chu-wen*, square; leaves 1–12)
Pao-chih lou 寶鞮樓 (*chu-wen*, oval; colophon)
Yüan-chao 員照 (*chu-wen*, round; colophon)
Jan-hsiang an-chu 染香菴主 (*pai-wen*, square; colophon)

COLOPHON: Yang Lung-yu 楊龍猶 (early 20th century), dated 1917

COLLECTORS' SEALS: Pi Lung 畢瀧 (18th century), 2; Yang Lung-yu, 1

From Wang Chien's colophon, it would appear that Ch'en Lien (see cat. no. 124) was one of the first to make an album of reduced-size copies from the paintings in Wang Shih-min's collection, although, as discussed below in the context of a similar album by Wang Hui (1632–1717; see cat. no. 164), Ch'en's album does not seem to have survived. Wang Chien's own paintings in this album, carefully precise, bear the hallmarks of an exercise or careful study of the models, each labeled for identification. In contrast to the set of hanging scrolls of 1670 (vol. 1, pl. 127), only two of the twelve leaves (5 and 9) in the album bear a title; the rest, only the name of the Sung or Yüan master whose style the artist followed. Of the identifications that differ from Tung Ch'i-ch'ang's attributions in Wang Shih-min's album in the National Palace Museum, Taipei, the most helpful may be leaf 5, there unattributed and here identified as after Huang Kung-wang's *Autumn Mountains*. For the rest, Tung's choices may perhaps be more reliable than Wang's: Tung Yüan/Chü-jan; Huang Kung-wang after Tung Yüan/Chao Meng-fu; Wang Shen/Wu Chen; Chao Meng-fu/Wang Meng; Huang Kung-wang/Ch'en Ju-yen. These discrepancies, and the uniform appearance of the identifying labels, suggest that they were written after the album was completed.

RW

LITERATURE: Xu Bangda, *K'ao-pien*, 1984, text, vol. 2, pp. 154–55; *Chung-kuo ku-tai shu-hua mu-lu*, vol. 3, 1987, *Hu* 1–2304; Zheng Wei, "Wang Chien," 1989, p. 103; *Chung-kuo ku-tai shu-hua t'u-mu*, vol. 4, 1990, *Hu* 1–2304.

126 *Landscapes in the Manner of Old Masters*
Fang-ku shan-shui
王鑑　倣古山水

Dated 1664

Album of ten paintings with ten leaves of calligraphy, ink and ink and color on paper
28 x 19.8 cm (11 x 7¹³⁄₁₆ in.)

Shanghai Museum

vol. 1, pl. 126 (leaves 3, 5, 6, 10); vol. 2, pl. 126 (leaves 1, 2, 4, 7–9)

ARTIST'S INSCRIPTIONS:
Leaf 1a, 2 lines in running script:
This is a passage from Hui-ch'ung's [ca. 965–1017] handscroll, *Spring in Chiang-nan.* I have imitated it.

惠崇《江南春》卷中有此一段景。遂仿之。

Leaf 2a, 2 lines in running script:
The river flows beyond Heaven and Earth;
The mountains now appear and now vanish from view.

江流天地外
山色有無中

Leaf 3a, 3 lines in running script:
A host of clouds are no sign of how deep the hills;
The place is remote and no one comes or goes.
Since the painting is an instant creation of a poetical image, I made a verse:
"The brushwood door opens on the verdant peaks."

雲多不計山深淺
地僻絕無人往來
莫怪披圖便成句
柴門曾向翠峰開

Leaf 4a, 3 lines in running script:
I once saw Chao Wen-min's [Chao Meng-fu, 1254–1322] painting after Pei-yüan [Tung Yüan, fl. ca. 945–ca. 960], in the collection of Tung Ssu-weng [Tung Ch'i-ch'ang] and have cherished it within my breast for thirty years. Visiting now and so idle and restless, I have loosely imitated its method.

余見董思翁所藏趙文敏倣北苑畫，懷於腦中者幾三十年，客窗無聊，漫擬其法。

Leaf 5a, 4 lines in running script:
Tzu-chiu's [Huang Kung-wang, 1269–1354] *Steep Valleys and Thick Woods* is one of his masterworks, now in the collection of Master T'ai-yüan (Wang Shih-min, 1592–1680). I was able to look at it at leisure from time to time, and made this brush idea, but I don't know if it remotely resembles it.

子久《陡壑密林》乃其生平得意作，今為太原公所珍藏。余時得縱觀，即此筆意，不識能彷彿萬一否。

Leaf 6a, 3 lines in running script:
Crossing the water toward the mountains and seeking the steep cliff,
Where the white clouds fly there opens the cave of heaven.
The recluses leave no tracks as they come and go,
And the emerald moss grows thick on the path to the gate in spring.

渡水望山尋絕壁
白雲飛處洞天開
幽人來往無踪跡
門徑春深長綠苔

Leaf 7a, 2 lines in running script:
Mei tao-jen [Wu Chen, 1280–1354] has a painting, *Streams and Mountains without End*, in which he has followed only Chü-jan [fl. ca. 960–ca. 986]. This painting imitates it.

梅道人《溪山無盡圖》純師巨然；此幅擬之。

Leaf 8a, 2 lines in running script:
Chung-kuei [Wu Chen] has a painting of "mountains as tranquil as in high antiquity, days as long as in boyhood years." This picture is done after it.

仲圭有"山靜似太古；日長如小年"畫。此圖似之。

Leaf 9a, 3 lines in running script:
Over river and islets eventide is just falling;
In the maple woods the frosty leaves are thinning.
Leaning on my staff at the brushwood gate I fall silent,
Longing for someone, in the fading colors of the distant mountains.

江渚暮潮初落
楓林霜葉渾稀
倚杖柴門閒寂
懷人山色依微

Leaf 10a, 2 lines in running-regular script:
Imitating Huang-ho shan-ch'iao's [Wang Meng, 1308–1385] *Studying at Nine Peaks.*

倣黃鶴山樵《九峯讀書圖》。

ARTIST'S COLOPHON AND SIGNATURE (6 lines in running script):
In the art of painting, after Wen [Cheng-ming, 1470–1559] and Shen [Chou, 1427–1509], and Tung Tsung-po [Tung Ch'i-ch'ang], there has been no one to carry on the tradition. In recent years learning to paint has become popular in the Chia-ting T'ai-ch'ang area, but the models [for these aspiring artists] have been limited to a few such as Mr. Li [Liu-fang, 1575–1629] and Ch'eng [Chia-sui, 1565–1644]. In this album I have followed the masters of Sung and Yüan, and though it may not be quite like meeting the ancients in a dream, I have at least tried to choose superior models. There is only my clumsy brush to leave behind, a bit like the "stone from Yen" [a worthless stone mistaken as precious and valuable] with the real treasures in the shop of a Persian jeweler. It is merely for the laugh of those who know. Thinking of this I drop my brush down in sadness. On the fifteenth day of the tenth month of the *chia-ch'en* year [December 2, 1664], Wang Chien. (Translation by Wai-kam Ho and Roderick Whitfield.)

畫道自文、沈、董宗伯後，幾作廣陵散矣。近時學者獨盛於婁，然所師不過李、程兩先生耳。余此冊倣宋、元諸家，雖未能夢見古人，聊用取法乎上之意。但拙筆留於此地，如以燕石充斯胡肆中，徒為識者捧腹，擲筆為之憫然。甲辰小春望日王鑑。

ARTIST'S SEALS:
Chien 鑑 (*chu-wen*, square; leaves 1–10)
Yüan-chao 員照 (*chu-wen*, round; leaves 1a, 6a, colophon)
Jan-hsiang an-chu 染香菴主 (*chu-wen*, square; leaves 2a, 5a, 7a)
Wang Chien chih yin 王鑑之印 (*pai-wen*, square; leaves 3a, 9a)
Wang Chien chih yin 王鑑之印 (*pai-wen*, square; leaf 4a)

Hsiang-pi shih 湘碧氏 (*chu-wen*, square; leaves 8a, 10a)
Yü-hsin chai 雨新齋 (*chu-wen*, square; colophon)
Jan-hsiang an-chu 染香菴主 (*pai-wen*, square; colophon)

Collectors' seals: Xu Bangda 徐邦達 (b. 1911), 2; Ch'ü Pao-chün 屈保鈞, 1; Sun Yü-feng 孫煜峰 (20th century), 2

Recent provenance: Sun Yü-feng

It would seem that in these leaves the delicate balance between verse and image is weighted in favor of the former. The visual correspondence with a model by some ancient master is less important than the sentiments aroused by the poetic phrase, and particularly the associations of the mountain as a realm of the immortals, as suggested by phrases referring to the "cave of heaven" and the trackless moss-grown paths.

RW

Literature: *Chung-kuo ku-tai shu-hua mu-lu*, vol. 3, 1987, *Hu* 1–2308; Zheng Wei, "Wang Chien," 1989, p. 105; *Chung-kuo ku-tai shu-hua t'u mu*, vol. 4, 1990, *Hu* 1–2308.

127 *Landscapes in the Manner of Old Masters*
Fang-ku shan-shui
王鑑　倣古山水

Dated 1670

Four hanging scrolls from a set of twelve, ink and color on silk
200.4 x 56.5 cm (78⅞ x 22¼ in.)

Shanghai Museum

vol. 1, pl. 127

Artist's inscriptions and signatures:
1. 4 lines in running-regular script:
River and Sky Clearing after Snow after Li Ch'eng [919–967]. The chrysanthemum [ninth] month of the *keng-hsü* year [October 14–November 12, 1670]. Painted for the venerable Hsiao-weng by his disciple Wang Chien.

《江天雪霽》倣李成。庚戌菊月，爲孝翁老父臺大詞宗畫，治弟王鑑。

2. 2 lines in running-regular script:
Travelers among Streams and Mountains after Fan K'uan [d. after 1023].

《溪山行旅》倣范寬。

3. 2 lines in running-regular script:
Streams and Mountains without End after Pei-yüan [Tung Yüan, fl. ca. 945–ca. 960].

《溪山無盡》倣北苑。

4. 2 lines in running-regular script:
After Chü-jan's [fl. ca. 960–ca. 986] *Lofty Recluse in Summer Mountains*.

《夏山高逸》擬巨然。

Artist's seals:
Lai-yün kuan 來雲館 (*chu-wen*, rectangle)
Wang Chien chih yin 王鑑之印 (*pai-wen*, square)
Hsiang-pi 湘碧 (*chu-wen*, square)

No colophons or collectors' seals

These four scrolls, dated with the remaining eight in the set to 1670, show Wang Chien manipulating the compositions of the masterpieces in Wang Shih-min's (1592–1680) collection to produce new versions of his own—full-sized but all twelve uniform in dimensions. Wang Chien's meticulous attention to detail means that the different styles appear much closer to each other, though the four here still are faithful enough to the ancient masterworks to be instantly recognizable. Two of them—Fan K'uan's *Travelers* (see vol. 1, fig. 8) and the *Snow Landscape* attributed to Chü-jan by Tung Ch'i-ch'ang in the Taipei album *The Great Revealed in the Small* (*Hsiao-chung hsien-ta*) but here ascribed to Li Ch'eng—are preserved in the National Palace Museum, Taipei. (*The Snow Landscape* has been reattributed to Feng Chin of the late Northern Sung by Richard Barnhart; see Barnhart, "The Snow Landscape Attributed to Chü-jan," 1970–71.) Wang Hui's album of 1672 (vol. 1, pl. 164), keeping to the more modest format pioneered by his teacher Wang Shih-min, manages to convey more effectively the distinctions between the ancient masters.

Nonetheless, it is fascinating to watch the transformations that take place through Wang Chien's brush. In the landscape after Fan K'uan, the travelers of the title descend the mountain path and are dwarfed by the trees behind them, much as in Fan K'uan's own work, but the whole painting has become an explosion of autumn colors. The middle ground is expanded upward, affording a vista of the principal falls of water, while the stream entering from the right also attains greater prominence. Fan K'uan's compact tree-covered cliff in the middle distance bursts forth in three directions, with a huge growth rising and almost completely concealing the silver thread of the high falls; the main peak stands no longer vertical but shoots out at a pronounced angle. Such a landscape appears to throb and pulse with the fevered energy of the *lung-mo* 龍脈 (dragon arteries) within the landscape forms, compared to the sober massiveness of Fan K'uan's own work, which seems to have been the feature that most struck Wang Shih-min in his version of the composition—one that is broader in the beam than Fan K'uan's just where Wang Chien's proportions are narrower.

Similar considerations apply to the other three scrolls shown here: immaculate brushwork and immense skill in adjusting the composition to the space available. The third and fourth scrolls are ascribed to Tung Yüan and Chü-jan respectively, whereas the corresponding leaves in the Taipei *Hsiao-chung hsien-ta* album by Wang Shih-min are captioned by Tung Ch'i-ch'ang as Wu Chen (1280–1354) following Chü-jan, and as Tung Yüan. Indeed, Wang Chien seems to contradict himself with the title of the third scroll, *Streams and Mountains without End* after Tung Yüan; in his album *Landscapes in the Manner of Old Masters* of 1664, he agrees with Tung Ch'i-ch'ang in ascribing the same composition to Wu Chen (vol. 1, pl. 126–7). Thus we find that the personal identities of the great masters, especially ones at once so distant in time and so close to each other in style as Tung Yüan and Chü-jan, mattered less than the concept of ascribing a classical compo-

sition to one or another of them, once the original painting had been lost sight of. As for Li Ch'eng, Tung Ch'i-ch'ang's inscription on the first leaf of the Taipei album takes issue with Mi Fu's (1051–1107) theory that none of his paintings survived, ascribing the composition to Li because of its combination of qualities drawn from both Wang Wei (701–761) and Chü-jan: such was the shortage of proven works to match with the recorded names of the classical masters.

RW

LITERATURE: *Chung kuo ku-tai shu-hua mu-lu*, vol. 3, 1987, *Hu 1–2328*; Zheng Wei, "Wang Chien," 1989, p. 109; *Chung-kuo ku-tai shu-hua t'u mu*, vol. 4, 1990, *Hu 1–2328*.

128 *Landscape in the Blue and Green Manner*
Ch'ing-lü shan-shui
王鑑　青綠山水

Dated 1675

Hanging scroll, ink and color on paper
175.1 x 87.7 cm (68¹⁵/₁₆ x 34½ in.)

Shanghai Museum

vol. 1, pl. 128

ARTIST'S INSCRIPTION AND SIGNATURE (3 lines in running-regular script):
In the fifth month, summer, of the *i-mao* year [May 25–June 22, 1675], Venerable Fu ordered me to paint, so I present this to the venerable gentleman on the occasion of his sixtieth birthday. Wang Chien.

乙卯夏五月，孚翁囑筆，奉祝宸老年翁六褭初度。王鑑。

ARTIST'S SEALS:
Wang Chien chih yin 王鑑之印　(*pai-wen*, square)
Yüan-chao 員照 (*chu-wen*, square)

NO COLOPHONS

COLLECTORS' SEALS: Liang Chang-chü 梁章鉅 (1775–1849), 1; Ch'ien Ching-t'ang 錢鏡塘 (20th century), 1

For a conventional purpose such as the celebration of the all-important sixtieth birthday of a respected man, the blue and green manner was the most appropriate, refined in appearance and carefully worked. At the same time, the stately composition of this scroll reflects the whole tradition of the classical masters as studied in the late Ming and early Ch'ing dynasties.

RW

LITERATURE: d'Argencé, *Treasures*, 1983, cat. no. 123; *Chung-kuo ku-tai shu-hua mu-lu*, vol. 3, 1987, *Hu 1–2342*; Zheng Wei, "Wang Chien," 1989, p. 113.

129 *Eighteen Landscapes in the Manner of Old Masters*
Mo-ku shih-pa fan
王鑑　摹古十八番

Undated

Album of eighteen paintings, ink and color on paper
40.6 x 35.5 cm (16 x 14 in.)

The Metropolitan Museum of Art, New York
The Edward Elliott Family Collection, Gift of Douglas Dillon, 1989
(1989.235.2)

vol. 1, pl. 129 (leaves 4, 7–9, 12, 18); vol. 2, pl. 129 (leaves 1–3, 5, 6, 10, 11, 13–17)

ARTIST'S INSCRIPTION AND SIGNATURE:
Leaf 18, 1 line in regular-running script:
Evocations of eighteen fragrances from the past. Wang Chien.

摹古十八番。王鑑。

ARTIST'S SEAL:
Chien 鑑 (*chu-wen*, square)

FRONTISPIECE: Yang Chi-chen 楊繼振 (b. 1831), undated, 2 seals

COLOPHONS: Yang Chi-chen, 3 dated 1857, 1 undated, 14 seals

COLLECTORS' SEALS: Yin Shu-po 殷樹柏 (1769–1847), 3; Huang Ch'ü-ch'en 黃去塵 (19th century?), 1; Yang Chi-chen, 7; unidentified, 4

RECENT PROVENANCE: Chang Ting-ch'en

Wang Chien, the teacher of Wang Hui (1632–1717) and close friend of Wang Shih-min (1592–1680), stands at the center of the group of scholar-artists that endeavored to establish a new orthodoxy in painting through the vigorous study of past masters. Wang Chien's paintings exemplify the vision of a man steeped in tradition. A member of the educated elite, Wang enjoyed access to numerous private collections as well as inheriting a rich assemblage of old master-works from his great-grandfather Wang Shih-chen (1526–1590). This firsthand knowledge of past masterpieces inspired Wang to follow Tung Ch'i-ch'ang's example of seeking a personal artistic synthesis through the diligent study of "orthodox" models.

This album displays Wang Chien's command over his tradition. Each leaf recalls a specific past master, yet each presents a new solution in which the model is transformed by the smaller, album format as well as by Wang's own distinctive brush mannerisms. Because his objective was not imitation but a creative reinterpretation that captured the spirit rather than the exact appearance of his models, Wang did not find it necessary to identify his sources. While his references may have been clear to members of his immediate circle, therefore, the originality of his interpretations makes it far from obvious today which masters he is invoking.

The album is unusual among Wang's oeuvre for its spacious, open compositions and its homogeneous appearance. In contrast to his dated albums from the 1660s where tall, densely textured mountain forms fill the picture frame, many of these leaves exhibit panoramic vistas across broad river valleys that extend deep into the distance. The repeated use of a low horizon line with an open expanse of sky,

frequently softened by evocations of mist or red sunset glow, recalls the Western-influenced perspectives of Yeh Hsin (fl. ca. 1650–70) or Fan Ch'i (1616–after 1697). Mountains are described with a wide variety of texture strokes, but overlays of pale wash, often tinged with orange or blue, diminish the contrasts in style that are the main objective in other re-creations of ancient styles. Wang's interest here appears more focused on narrative detail: all but one leaf—which shows an old tree and rock (vol. 2, pl. 129–17)—feature a thatched hut, fisherman, or solitary scholar seated in a rustic studio, making the album a virtual catalogue of the pleasures of retirement.

MKH

LITERATURE: Suzuki, *Chinese Art in Western Collections*, 1973, vol. 2, no. 42; Suzuki, *Comprehensive Illustrated Catalogue*, 1982–83, vol. 1, A18–034.

Kung Hsien (1619–1689) 龔賢

tzu Pan-ch'ien 半千, Yeh-i 野遺, *hao* Ch'ai-chang-jen 柴丈人, Chung-shan yeh-lao 鍾山野老

Born in K'un-shan, near Su-chou, Kung Hsien moved with his family to Nanking in his childhood. Nothing of his family background is known, but the intellectual habits of his adult life—his voracious reading and elegant writing—betray an upbringing in a family of some means. In 1634, when he was fourteen *sui* (thirteen years old), Kung Hsien attended a gathering of scholars and artists with Yang Wen-ts'ung (1596–1646) in Yang-chou at which Tung Ch'i-ch'ang was present (Chang, "Kung Hsien yü K'un-ts'an," 1990, p. 225). This meeting with the doyen of painting undoubtedly had a profound effect on the young artist, and traces of Tung's painting style and theory can be detected in much of his later work.

Kung Hsien, like K'un-ts'an (1612–1673), was a disciple of the Buddhist monk Chüeh-lang tao-sheng (1592–1659), whose arrest and imprisonment by the Manchus in 1647 may have contributed to Kung's decision to flee Nanking in that year (Chang, "Kung Hsien yü K'un-ts'an," pp. 225, 227). After serving as a tutor in a private household in the remote town of Hai-an-chen, in 1651 he moved to Yang-chou, where he lived mainly in seclusion until his return to Nanking in the autumn of 1664.

In Nanking Kung Hsien purchased some land in the Mount Ch'ing-liang area, where he built a retreat named the Half-Acre Garden (Pan-mou yüan). The collector and connoisseur Chou Liang-kung (1612–1672) became Kung's close friend, patron, and liaison with other intellectuals and painters in the city. During this period Kung also spent time in the company of K'un-ts'an and Ch'eng Cheng-k'uei (1604–1676).

In 1687 Kung Hsien made a return visit to Yang-chou to attend a meeting of the Spring River Poetry Society (Ch'un-chiang shih-she), a group of distinguished poets and painters centered on the scholar-

official K'ung Shang-jen (1648–1708). Finding the atmosphere in his former home congenial, Kung Hsien remained there for two years under the patronage of K'ung, with whom he had formed a close friendship. Forced by an illness to return to Nanking in early 1689, Kung fell prey to the demands of an overzealous admirer who hoped to obtain a poem by the ailing artist. K'ung Shang-jen blamed Kung Hsien's untimely death in the autumn of 1689 on the unrelenting and offensive pressure of the unwanted solicitation (K'ung Shang-jen, *Hu-hai-chi*, repr. 1957, *ch*. 7, p. 151).

130 *Landscape for the Artist's Own Collection*
Tzu-ts'ang shan-shui
龔賢　自藏山水

Dated 1656

Hanging scroll, ink on paper
102.7 x 51.5 cm (40⁷⁄₁₆ x 20¼ in.)

Beijing Palace Museum

vol. 1, pl. 130

ARTIST'S INSCRIPTIONS AND SIGNATURES:
1. 1 line in running script:
During the second month of the *ping-shen* year [February 25–March 25, 1656] Kung Hsien painted this for his own collection.

丙申春仲，龔賢自藏畫。

2. 18 lines in running script:
In painting, spiritual resonance is the most essential element; brushwork comes next, and then the rendering of the scene. Brush and ink, when complementing each other, create spiritual resonance; when properly applied, [they] complete the scenery. People nowadays, however, occupy themselves with the rendering of the scene at the expense of brushwork. In spite of thousands of peaks of sheer beauty and a myriad of ravines with contending streams, if they are executed in ink like burnt ashes and with brushwork like decayed cotton, the painting is nothing. Having some leisure today, I cleaned a fine inkstone, took out the brushes and some old paper that I collected, together with the precious inkstick given to me by a friend from T'ien-tu [Mount Huang], and felt both my mind and eyes opening up. As no visitor came, I painted this at will and realized that it was no easy task. Inadequate brushwork, as well as an impure mind and unquiet surroundings, precludes the creation of art. Once the mind is carefree and the surroundings congenial, and the brushwork attains proficiency, apply the latter to the service of the former. Isn't this difficult to explain to others? For brush, there is brush method; for ink, ink aura. The proper execution of one stroke leads to the proper execution of all strokes; the improper execution of one stroke results in the appearance of decayed cotton. It is comparable to the way the Buddhist disciples discuss their creed. I hope all those who are learning to paint will, like me, spend thirty years familiarizing themselves with the art. Inscribed again by Yeh-i [Kung Hsien].
(Translation by Shi-yee Liu Fiedler.)

畫以氣韻為上，筆墨次之，丘壑又次之。筆墨相得則氣韻生；筆墨無過則丘壑具。奈何今人舍筆墨而事丘壑。吾即見其千巖競

秀，萬壑爭流，其中墨如橋灰，筆如敗絮，亦無謂也。今日人事
稍暇，偶滌佳硯，出我藏毫故楮，并有天都友人所贈珍墨。覺心
目俱開，門外又無客至，隨意作此，然後知此道甚不易易也。夫
筆墨不具，與心不清，境不靜，皆未可從事。心閒境適，筆墨具
措，能事以濟事其先。蓋有未易語人者耶？筆有筆法，墨有墨
氣，一筆得則俱得；一筆不是則滿紙敗絮，譬若釋子談宗。然吾
願同學者，各須三十年涉獵。野遺又紀。

ARTIST´S SEALS:
Ch'en Hsien 臣賢 (*chu-pai wen*, square)
Pan-ch'ien 半千 (*pai-chu wen*, square)
Hsien chü 賢居 (*chu-wen*, square)

NO COLOPHONS

COLLECTORS´ SEALS: unidentified, 2

LITERATURE: Kong Chen, "Kung Hsien," 1984, p. 31; *Chung-kuo ku-tai shu-hua mu-lu*, vol. 2, 1985, *Ching* 1–4046; Xiao Ping and Liu Yujia, *Kung Hsien*, 1989, vol. 2, pl. 7.

131 *Cloudy Peaks*
Yün-feng t'u
龔賢　雲峰圖

Dated 1674

Handscroll, ink on paper
17 x 570.2 cm (6¹¹⁄₁₆ x 224¼ in.)

The Nelson-Atkins Museum of Art (Nelson Fund) 68–29

vol. 1, pl. 131

ARTIST´S COLOPHON (27 lines in running script):
Tung Yüan [fl. ca. 945–ca. 960] is called the founding father of
 landscape.
Fan K'uan [d. after 1023] and the monk Chü-jan [fl. ca. 960–ca. 986]
 followed in his footsteps.
Yet again, there were Ying-ch'iu [Li Ch'eng, 919–967] and Kuo Hsi
 [ca. 1020–ca. 1100].
Different branches and schools came up with new stylistic types.
But Mi Fu [1051–1107] of Hsiang-yang was unique,
His [heroic] vitality [*ch'i*] could consume an ox, his power was like that
 of a tiger.
[Mi] Yu-jen [1074–1151] passed his methods on to Minister Kao
 [K'o-kung, 1248–1310],
But in the end the three were of different approaches.
Later on, only Ni [Tsan, 1301–1374], Huang [Kung-wang, 1269–1354],
 and Wang [Meng, 1308–1385] [stand out] among the many;
And Meng-tuan [Wang Fu, 1362–1416] and Shih-t'ien [Shen Chou,
 1427–1509] can hold their own against anyone past or present.
Then came the Wen family, father and sons, and the top candidate of
 the provincial examination T'ang [Yin, 1470–1523].
Their genuine works are few, and the spurious many; so do not treat
 them lightly or ridicule them.
In my lifetime, I have had the good fortune of meeting with Tung
 Hua-t'ing [Tung Ch'i-ch'ang].

The two Lis, Yün, and Tsou are men I especially approve of.
In my later years I have become exceedingly fond of the two Kueichou
 [painters].
The sound of the brush and the posture of the ink can sing and dance.
Yet, I still know little of this Tao [of painting].
For forty years I have striven bitterly [with the hardships of this art].
A friend now asks me to paint a scene of cloudy peaks;
Like lotuses that have not yet opened, they vie with one another in
 shooting forth.
Whatever I have received from the heritage of the masters, I dare not
 forget.
And so, one by one, I have recorded these illustrious greats.
 In the fourth month of the *chia-yin* year [May 6–June 6, 1674] Kung
Hsien of the Half-Acre painted this and inscribed it.
(Adapted from a translation by Marc F. Wilson, in Ho et al., *Eight Dynasties*, 1980, p. 282.)

山水董源稱鼻祖
范寬僧巨繩其式
復有營丘與郭熙
支分派別翻新譜
襄陽米芾更不然
氣可食牛力如虎
友仁傳法高尚書
畢竟三人異門户
後來獨數倪黄王
孟端石田抗今古
文家父子唐解元
少真多贗休輕侮
吾生及見董華亭
二李惲鄒尤所許
晚年酷愛兩貴州
筆聲墨態能歌舞
我於此道無所知
四十春秋茹茶苦
友人索畫雲峰圖
菡萏蓮花相競吐
凡有師承不敢忘
因之一一書名甫
　　甲寅清和月，半畝龔賢畫并題。

ARTIST´S SEALS:
Kung Hsien 龔賢 (*chu-wen*, square)
Chung-shan yeh-lao 鍾山野老 (*pai-wen*, square)

NO COLOPHONS

LABEL STRIP: Chao Chih-shen 趙之琛 (1781–1860), 1 seal

COLLECTORS´ SEALS: P'an P'ei-shang 潘佩裳, 1; unidentified, 1

RECENT PROVENANCE: Lawrence Chan

EXHIBITIONS: Nelson Gallery-Atkins Museum, 1969: Wilson, "Kung Hsien," cat. no. 9, pp. 30, 31, centerfold pl.; Nelson Gallery-Atkins Museum and The Cleveland Museum of Art, 1980–81: Ho et al., *Eight Dynasties*, cat. no. 215; Tokyo National Museum, 1982: *Special Exhibition*, cat. no. 214.

LITERATURE: Akiyama et al., *Chugoku bijutsu*, 1973, vol. 2, pp. 233–36, pls. 44, 45; *Nelson Gallery-Atkins Museum Handbook*, 1973, vol. 2, p. 70; Wilson, "Vision," 1973, no. 11, pp. 237, 238; Chang, "Kung Hsien," 1990, pp. 223–25.

132 *Landscape Triptych for Hsi-weng*
Wei Hsi-weng tso shan-shui
龔賢　爲錫翁作山水

Dated 1674

Panel of three hanging scrolls, ink on silk
One scroll: 277.7 x 78.5 cm (109⁹⁄₁₆ x 30⅞ in.); two scrolls: 277.7 x 72.5 cm (109⁹⁄₁₆ x 28⁹⁄₁₆ in.)

Beijing Palace Museum

vol. 1, pl. 132

ARTIST'S INSCRIPTION AND SIGNATURE (3 lines in running script):
In the winter of the *chia-yin* year [1674], painted for Hsi-weng by Pan-mu, Kung Hsien.

甲寅冬爲錫翁先生，半畝龔賢。

ARTIST'S SEALS:
Kung Hsien 龔賢 (*chu-wen*, square)
Chung-shan yeh-lao 鐘山野老 (*pai-wen*, square)

NO COLOPHONS

COLLECTORS' SEALS: unidentified, 2

LITERATURE: Kong Chen, "Kung Hsien," 1984, p. 31; *Chung-kuo ku-tai shu-hua mu-lu*, vol. 2, 1985, Ching 1–4049; Xiao Ping and Liu Yujia, *Kung Hsien*, 1989, vol. 2, pl. 82.

133 *Landscapes and Trees*
Shan-shui ts'ung-shu
龔賢　山水叢樹

Undated (ca. 1679)

Album of twelve paintings with twelve leaves of calligraphy, ink on paper
15.9 x 19.5 cm (6¼ x 7¹¹⁄₁₆ in.)

The Metropolitan Museum of Art, New York
From the P. Y. and Kinmay W. Tang Family Collection, Gift of Wen and Constance Fong in honor of Mr. and Mrs. Douglas Dillon, 1979 (1979.499)

vol. 1, pl. 133 (leaves 3, 5, 6, 10); vol. 2, pl. 133 (leaves 1, 2, 4, 7–9, 11, 12)

ARTIST'S INSCRIPTIONS:
Leaf 1a, 2 lines in running script:
When you are afraid of producing too much painting, you will make a good painting.

惟恐有畫，是謂能畫。

Leaf 2a, 6 lines in running script:
In [painting] wild willows, I frankly followed Li Ch'ang-heng [Li Liu-fang, 1575–1629], but lately whenever I see Ch'ang-heng's willows I feel rather dissatisfied. Is it possible that I have surpassed him? I must keep looking for a painting of willows by Ch'ang-heng and compare again.

余荒柳實師李長蘅，然後來所見長蘅荒柳，皆不滿意，豈余反過之耶？今而後，仍欲痛索長蘅荒柳圖一見。

Leaf 3a, 5 lines in running script:
Cheng Ch'ien [fl. mid-8th century] of the T'ang dynasty made a painting called *Ancient Trees* in which the brushwork was round and the spirit deep. Not one artist of the Five Dynasties era could match him, much less painters of a later age. I am trying to imitate him.

唐鄭虔有《老樹圖》，筆圓氣厚，非五代人可及，況其後乎？因摹之。

Leaf 4a, 5 lines in running script:
With Mi [Fu, 1051–1107] calligraphy stressed the sideways movement, and painting also developed a new direction. But Mi carried his own style to its limits. Thereafter, Ni [Tsan, 1301–1374] and Huang [Kung-wang, 1269–1354] arose and new styles were opened up. How could it have been otherwise?

書法至米而橫，畫至米而益橫，然蔑以加矣。是後遂有倪黃輩出，風氣所開，不得不爾。

Leaf 5a, 5 lines in running script:
A monk asked his guest: "What do you do so that there are mountains, rivers, and the great earth in your painting?" The answer was: "Indeed, what do you do so that there will be mountains, rivers, and the great earth in your painting?" A painter who understands this will never be lacking in mountains and valleys.

一僧問古德："何以忽有山河大地？" 答云："何以忽有山河大地？" 畫家能悟到此，則丘壑不窮。

Leaf 6a, 5 lines in running script:
Nowadays when people paint they only do what appeals to the common eye; I alone do not seek to please the present. I note this with a laugh.

今人畫，竟從俗眼爲轉移。余獨不求媚於當世，紀此一咲。

Leaf 7a, 6 lines in running script:
Landscape painting flourished during the Northern Sung dynasty and, continuing throughout the Southern Sung, it remained strong during the Yüan. As for Yün-lin's [Ni Tsan] landscapes, they have a hoary substantiality. Later imitators have never understood this. Since they have never seen authentic works by the ancients, how can they imitate them?

畫家山水盛於北宋，至南宋入元，亦自不衰，即雲林生猶有蒼厚之氣，後之摹者，則不可言矣。不見古人真蹟，可妄擬乎？

Leaf 8a, 5 lines in running script:
Little by little is better than more and more; this is the advanced stage of a painter. Likewise, the [short] five-word quatrain of the old poets is more difficult than any other form of poetry.

少少許勝多多許，畫家之進境也。故詩家五言截句難於諸體。

Leaf 9a, 3 lines in running script:
Being clever is not as good as being dull. The uses of cleverness can be grasped at a glance, while apparent dullness may embody limitless flavor.

用巧不如用拙，用巧一目了了，用拙味玩不窮。

Leaf 10a, 6 lines in running script:
Among those who talk about hills and valleys today, one out of a hundred may speak of brush and ink, and one out of ten thousand may know about "breath-movement" (*chi-yün*). Breath-movement is not simply a matter of using ink wash; the density or sparseness of ink wash is still a matter of brush and ink.

今之言丘壑者一一，言筆墨者百一，言氣運者萬一。氣運非染也，若渲染深厚，仍是筆墨邊事。

Leaf 11a, 6 lines in running script:
In painting one need not follow any ancient masters. Among recent artists the brush and ink of Tung Hua-t'ing [Tung Ch'i-ch'ang] is lofty and untrammeled and is quite likable. Finishing this work, it looks like Lung-yu's [Yang Wen-ts'ung, 1596–1646]. This is because in our youth Lung-yu and I both followed Hua-t'ing.

畫不必遠師古人，近日如董華亭，筆墨高逸，亦自可愛。此作成反似龍友，以余少時與龍友同師華亭故也。

Leaf 12a, 5 lines in running script:
In the abbreviated style of painting the most hateful is that of the Northern School. Today, if a collector has even one Northern School scroll in his collection then all of his other paintings are diminished. This must be recognized. Most important, there is no Northern School painter in the greater Wu [Su-chou] area.

減筆畫最忌北派。今收藏家篋中有北派一軸，則群畫皆爲之落色。此不可不辨，要之，三吳無北派。

ARTIST'S SEALS:
Pan-ch'ien 半千 (*chu-wen*, rectangle; leaf 1)
Kung Hsien chih yin 龔賢之印 (*pai-wen*, square; leaf 1a)
Pan-ch'ien 半千 (*chu-wen*, square; leaf 2)
Hsien 賢 (*pai-wen*, rectangle; leaf 2a)
Ta-pu-i 大布衣 (*pai-wen*, square; leaf 3)
Pan-ch'ien 半千 (*chu-wen*, square; leaf 3a)
An chieh 安節 (*pai-wen*, rectangle; leaf 4)
Kung Hsien yin 龔賢印 (*pai-wen*, square; leaf 4a)
Hsien 賢 (*pai-wen*, square, with flanking dragons; leaf 5)
Ch'i-hsien 豈賢 (*chu-wen*, rectangle; leaf 5a)
P'eng-hao-jen 蓬蒿人 (*pai-wen*, rectangle; leaf 6)
Kung Hsien 龔賢 (*chu-wen*, square; leaf 6a)
Yeh-i 野遺 (*pai-wen*, rectangle; leaf 7)
Pan-ch'ien 半千 (*pai-wen/chu-wen*, square; leaf 7a)
Yeh-i 野遺 (*pai-wen*, rectangle; leaf 8)
Kung Pan-ch'ien 龔半千 (*chu-wen*, square; leaf 8a)
Yeh-i 野遺 (*pai-wen*, square; leaf 9)
Pan-shan yeh-jen 半山野人 (*chu-wen*, square: leaf 9a)
Ch'ai-chang 柴丈 (*pai-wen/chu-wen*, square; leaf 10)
Ch'en Hsien 臣賢 (*pai-wen*, rectangle; leaf 10a)
Ch'ai-chang 柴丈 (*chu-wen*, rectangle; leaf 11)
Chung-shan yeh-lao 鐘山野老 (*pai-wen*, square; leaf 11a)
P'eng-hao-jen 蓬蒿人 (*pai-wen*, square; leaf 12)
Yeh-i 野遺 (*pai-wen*, square; leaf 12a)

LABEL STRIP: Hsiung Kuang 熊光 (20th century), undated, 1 seal

NO COLOPHONS

COLLECTORS' SEALS: unidentified, 3

RECENT PROVENANCE: Ch'eng Ch'i

By the mid-1670s Kung Hsien's self-confidence as a painter had taught him to avoid an overly skillful or popular style. He writes (on leaf 6a): "Nowadays when people paint they only do what appeals to the common eye; I alone do not seek to please the present." In this album, executed around 1679, both paintings and inscriptions attest to Kung's striving after a spiritual communion with earlier masters while creating a pictorial vocabulary all his own. Departing from his densely-textured, monumental landscape style of the 1660s, Kung moves toward a sparser manner in which each brushstroke is made to function calligraphically as well as descriptively—embodying both expressive and representational meaning.

The album's format—paintings accompanied by art-historical comments—serves as a reminder that Kung Hsien taught painting for a living. In contrast to the *Mustard Seed Garden Painting Manual* (*Chieh-tzu-yüan hua-chuan*), published in 1679 by his student Wang Kai (fl. 1677–1700), Kung's album is not an instruction manual. His paintings are evocative rather than directly didactic. In the first painting, for example, Kung responds to his accompanying admonition not to put too much into one's painting by producing a spare, dry-brush landscape in the manner of Ni Tsan. His second leaf is even more restrained; it shows a cluster of wintry willow trees with their leafless whips brushed so lightly that they almost fade into the paper.

In the third leaf, a cluster of ancient trees is depicted with hardly any use of ink wash; the image is composed primarily of dots and lines which are, nevertheless, remarkably effective in evoking the appearance of gnarled trunks and shattered branches. The short, jerky outline strokes give a sense of the rough bark and the three-dimensional twisting shapes. By breaking the contours, the artist avoids flat silhouettes while suggesting shifting planes and foreshortened forms in space. In the accompanying inscription, Kung Hsien identifies his model as a work by the T'ang dynasty painter Cheng Ch'ien. By selecting a lost masterpiece as a precedent, Kung frees himself to create a highly personal image.

Kung reverts to the lush ink tonalities of his 1670s manner in the fourth leaf, creating a densely dotted "Mi-style" landscape to accompany his comments on the painting style of Mi Fu. His fifth painting continues this style and demonstrates Kung's own transformation of Mi's "cloudy mountains" theme. The leaf shows a single cottage set adrift in a vaporous world of densely foliaged hills that seem to emerge or recede as in a dream. On the facing page, Kung offers a Ch'an (Zen) Buddhist parable by way of explanation.

The yin-yang interplay of dark and light, mass and void, line and dot, constitutes one of Kung Hsien's basic means for energizing his paintings. In leaf 6, the previous image of a house suspended amid lush foliage is transformed into a dwelling outlined in stark relief against the blank background of a river, the white tree trunks are replaced by the dark contours of a massive outcrop, and diffuse ink dots are supplanted by an assertive use of line. This uncompromisingly severe image illustrates Kung's deep appreciation for Tung Ch'i-ch'ang's principles of compositional construction in which simplified landscape elements are clustered together to form a powerful, abstract mountain mass animated by kinetic shapes and energized brushwork.

Leaf 7 emphasizes Kung's highly personal understanding of the ancient masters. Asserting in his inscription that Ni Tsan's paintings have a hoary substantiality, Kung creates an iconoclastic interpretation in which the picture space is completely filled with densely textured boulders and trees. A more Ni-like image follows in leaf 8 where an empty pavilion is set among a sparse grove of trees. But here, too, Kung's imagery is ultimately his own. Ni Tsan would have set his pavilion against the blank expanse of a wide river; Kung places his pavilion in the middle of a mountain valley. As a metaphor, the painting

is an apt reflection of Kung's circumscribed world. Lacking Ni Tsan's expansive vistas—Kung made his home in the middle of the city of Nanking—the blank, unpainted interior of his hut symbolizes the pure "empty heart" of a recluse living in the marketplace.

The last four leaves all show trees in landscape settings. By varying ink tonalities and dotting techniques, however, each is made distinctive and interesting. In the texts accompanying the final two paintings, Kung Hsien makes clear his debt to Tung Ch'i-ch'ang. In leaf 11 he pointedly praises Tung's "lofty and untrammeled" quality and notes that in his youth he studied Tung's style; in leaf 12 he excoriates the "abbreviated style of painting" of the Northern School, which for Tung represented painters working outside his orthodox lineage of Southern School artists. From Kung's comments it is clear that by his time "Northern School" had already become a pejorative label for slick commercial artisans.

An ardent Ming loyalist who suffered the loss of many family members during the Manchu conquest, Kung expressed his continued loyalty to the fallen Ming and his sense of himself as a hermit living outside of society through the legends of some of the seals impressed on this album: "Leftover subject dwelling in the wilderness" (*Yeh-i*); "Wild old man of Mount Chung [where the first Ming emperor's mausoleum is located]" (*Chung-shan yeh-lao*); "Overgrown with thickets" (*P'eng-hao-jen*); "How could I be 'worthy' ['Hsien,' the artist's name]?" (*Ch'i-hsien*). Yet by the late 1670s, his primary focus was clearly painting, not politics. Kung was renowned as a poet before he became known as a painter; and the visionary intensity of his landscapes and his extreme economy of means reveal a poet's sensibility. Both paintings and inscriptions in this album attest to Kung Hsien's striving after a direct and unencumbered form of expression that was as personal as it was intensely evocative.

MKH

EXHIBITIONS: Nelson Gallery-Atkins Museum of Art, 1969: Wilson, "Kung Hsien," pp. 31–32; Philadelphia Museum of Art, 1971: Ecke, *Chinese Calligraphy*, p. 15, fig. 15, no. 80; China Institute in America, New York, 1972: Barnhart, *Wintry Forests, Old Trees*, pp. 60–61, no. 20.

LITERATURE: William Wu, *Kung Hsien*, 1979, pp. 165–68; Suzuki, *Comprehensive Illustrated Catalogue*, 1982–83, vol. 1, A18–061.

134 *A Thousand Peaks and Myriad Valleys*

Ch'ien-yen wan-huo

龔賢　千巖萬壑

Undated

Handscroll, ink on paper
62.4 x 100.3 cm (24⁹/₁₆ x 39½ in.)

Museum Rietberg, Zürich

vol. 1, pl. 134

ARTIST'S SIGNATURE, 1 line in running script:
Yeh-i-sheng Kung Hsien tso

野遺生龔賢作

ARTIST'S SEAL:
Kung Hsien yin 龔賢印 (*pai-wen,* square)

COLOPHON: Lo T'ien-ch'ih 羅天池 (1805–after 1860), undated, 1 seal: In painting landscapes, Kung Ch'i-hsien [Kung Hsien] used the method of ancient masters to express a new spirit. His lonely and self-reliant character made it difficult for him to associate with people. That is why his style differs entirely from that of other painters, for he wanted to be a painter without equal before or after. . . . In the present painting, the thick mist, the surging clouds, and the precipitous waterfalls enliven every part of the mountains, throbbing with vitality. He has achieved a school of his own. This is Kung Hsien's masterpiece which hardly has its equal in the world. . . . In his *Hua-chüeh*, he says: "When a talented hand starts to paint, even the first sketches are already interesting. A few years' exercise will improve his works. But what is the criterion for a good painting? The most obvious one is the manner of painting wrinkles (*ts'un*)"

龔宣賢先生作山水師古法而新意特出。其品性孤介，與人落落難合。故其畫法亦一洗畫家谿徑，其立意欲前無古人，後無來者。⋯此作烟幻深沈，雲氣湧鬱，瀑布懸空，能使山氣脉絡栩栩欲動，遂自成家。乃先生生平第一傑製，而世罕匹者也。⋯先生《画訣》云：「初畫高手亦自可觀。畫至數年後，其好處在何處分別？其顯而易見者，皴法也。⋯」

No collectors' seals

RECENT PROVENANCE: Walter Hochstadter, Charles A. Drenowatz

A Thousand Peaks and Myriad Valleys is unique among the works of Kung Hsien for a number of reasons. First, it is the only work, aside from some of his small albums, that resembles a Western format. Second, it is the darkest, and thus the gloomiest, work of the artist. Third, it seems to embody all the major characteristics of Kung Hsien's art in one single composition. Finally, it can be called the best-known painting of Kung Hsien, since it has been extensively reproduced and published.

This handscroll has often been discussed as a work with possible Western influence. Its format, the strong light and dark contrasts, the cluttered shapes of mountains and rocks, and the broad stretch of landscape that reaches beyond the upper limits of the painting all seem, as suggested by Michael Sullivan and James Cahill, to point to illustrations in *Teatrum Orbis Terrarum*, a copy of which was presented to the Wan-li emperor (r. 1573–1620) in 1601 by the Jesuit priest Matteo Ricci (Sullivan, "Some Possible Sources of European Influence on Late Ming and Early Ch'ing Painting," 1972, pp. 605–6; Cahill, *Compelling Image*, 1982, pp. 178–80). There is no documentary proof of a relationship between Kung Hsien's painting and those illustrations, but a visual comparison makes a convincing argument for such a relationship.

Although he was only eighteen *sui* (seventeen years old) when Tung Ch'i-ch'ang died in 1636, there is evidence that Kung Hsien regarded Tung as his teacher in painting. In an inscription on the album *Landscapes and Trees* in The Metropolitan Museum of Art (vol. 2, pl. 133–11a), Kung writes:

In painting there is no need to take distant ancient masters as teachers. In recent times someone like Tung Hua-t'ing [Tung Ch'i-ch'ang] is known for the high, untrammeled expression of his brush and ink, which is to be treasured. This piece that I have done looks like the

work of Lung-yu [Yang Wen-ts'ung, 1596–1646], because when I was young I studied his work under Tung Hua-t'ing.

Kung does not say in his inscription when he studied under Tung, but in view of the age difference between the two men, the only period when this relationship would have been possible is the last years of Tung's life. In his "Kung Hsien nien-p'u" (1990, p. 50), Lin Shu-chung indicates that this probably occurred between the years 1632 and 1634, but during this period Tung was in Peking, not Nanking. It is recorded that Kung attended a literary gathering in Yang-chou in 1634, along with such artists as Yang Wen-ts'ung and Ch'eng Cheng-k'uei (1604–1676), and that Tung Ch'i-ch'ang made an appearance at this gathering, perhaps en route to Sung-chiang from Peking. Although during the last two years of his life Tung did make occasional trips to the Chiang-nan area, he did not stay long in either Yang-chou or Nanking, where Kung is known to have lived at that time. In this context, the master-pupil relationship that Kung refers to in his inscription could only have been a short and casual one. However, because of Tung's prestige and influence, Kung was only too happy to acknowledge the relationship.

Whatever the extent and nature of their relationship, it was important for the development of Kung's art, since in his last years Tung Ch'i-ch'ang must have had definite ideas about his theories. At that time Kung Hsien's work was still done in his light manner, with an emphasis on brushwork and without the dark, moody expression of his later years. In the development of his personal style, Kung must have drawn upon the ideas of Tung Ch'i-ch'ang, though such influence is difficult to discern in the present painting. Still, the bold, arbitrary handling of the forms of mountains, rocks, waterfalls, and trees, the extensive use of dots, and the overall abstract patterns in the composition show that Kung Hsien, unlike the Four Wangs, never directly imitated Tung's work, but instead transformed a number of Tung's ideas into his own without showing clear traces of them.

Though it is not dated, *A Thousand Peaks and Myriad Valleys* must have been done around 1670, after Kung took up residence at Ch'ing-liang Hill in Nanking. After settling in Nanking, he became more reclusive and his paintings took on a much darker tone. Indeed, the present painting seems to embody all that Kung Hsien wanted to express in that period, a poetic realization of his grieving for the fall of the Ming and his own lonely life.

CTL

EXHIBITIONS: The Metropolitan Museum of Art, New York, 1956; Asia Society, New York, 1967; Cahill, *Fantastics and Eccentrics*; Kunsthalle, Köln, 1968: *Weltkunst aus Privatbesitz*.

LITERATURE: Lippe, "Kung Hsien and the Nanking School," 1958; Sickman and Soper, *Art and Architecture*, 1956, pp. 195–96, 199; Contag, *Seventeenth Century Masters*, 1969, pp. 36–38; Li, *A Thousand Peaks and Myriad Ravines*, 1974, pp. 206–11; Cahill, *Compelling Image*, 1982, pp. 146–83.

Fan Ch'i (1616–after 1697) 樊圻

tzu Hui-kung 會公, *hao* Hsia-kung 冶公

Fan Ch'i and his older brother Fan I (b. before 1616) spent their entire lives in their native Nanking, painting and socializing with the many artists and collectors who gathered in this late Ming cultural center. Usually numbered among the Eight Nanking Masters, Fan Ch'i associated most closely with Kung Hsien (1619–1689) and Kung's student Wang Kai (fl. 1677–1700).

Fan Ch'i must have attained renown as a painter at a relatively early age, for K'ung Shang-jen in his *Hu-hai-chi* implies that Fan's paintings from the period 1621–43 were so highly coveted by collectors that many of the works had already found their way into the imperial collection (*Hu-hai-chi*, repr. 1957, *ch.* 7, p. 150). According to K'ung, Fan Ch'i painted for a living, which perhaps accounts for the artist's wide-ranging subject matter and detailed style.

135 *Landscape*
Shan-shui
樊圻　山水

Undated

Handscroll, ink and color on silk
31 x 207 cm (12³⁄₁₆ x 81½ in.)

Museum für Ostasiatische Kunst, Berlin

vol. 1, pl. 135

NO ARTIST'S INSCRIPTION OR SIGNATURE

ARTIST'S SEALS:
Fan Ch'i yin 樊圻印 (*chu-wen*, square)
Hui-kung shih 會公氏 (*pai-wen*, square)

NO COLOPHONS

COLLECTORS' SEALS: Wu Ch'ing-po, 吳晴波, 1; unidentified, 1; illegible on photograph, 2

This handscroll probably depicts scenes along the Yangtze River. It is filled with pronounced three-dimensional forms of rocks and hills and imbued with an equally strong sense of distance and perspective, particularly in the juxtaposition of the foreground trees and the distant boats. The purple hue of the river complements the blue of the remote peaks.

Although, as Cahill has suggested, Fan Ch'i might have been influenced by European treatment of space, particularly in the sharply drawn horizons above bodies of water and the use of horizontal hatching to shade the water below, it is highly likely that his art also exemplifies the revival of interest during the seventeenth century in the realistic tradition of the late Sung artists of the twelfth and thirteenth centuries (see Cahill, "Wu Pin and His Landscape Paintings,"

1972, p. 652, fig. 14; Edwards, *The World around the Chinese Artist*, 1987, pp. 13–54).

Fan Ch'i's stylistic affinity to the Sung tradition was clearly pointed out by the contemporary calligrapher, painter, and connoisseur Wang To (1592–1652) in a colophon on an album by Fan Ch'i written in 1650 and recorded by Chou Liang-kung (1612–1672) in his *Tu-hua lu*: "This picture is entirely in the manner of Chao Sung-hsüeh [Chao Meng-fu, 1254–1322] and Chao Ta-nien [Chao Ling-jang, d. after 1100], quiet and peaceful; it is like rich virtue overflowing with learning, like great wealth steeped in accomplishment, without error and without meanness . . . This is [like] the brush of an ancient; it is not of the contemporary school" (see Lippe, "Kung Hsien," 1958, pp. 164–65). Fan Ch'i's extant paintings demonstrate that he also painted figures and bird and flower paintings in the stylistic modes of Huang Ch'üan (10th century) and Liu Sung-nien (late 12th–early 13th century) (*Chung-kuo mei-shu ch'üan-chi*, 1988, Painting, vol. 9, pls. 115–119).

The style of the Berlin handscroll is quite close to a landscape handscroll dated 1691 in a private collection in Taipei (*Ming Ch'ing chih chi ming-hua t'e-chan*, 1970, pl. 16); we can therefore date the Berlin scroll to about the same time in Fan Ch'i's late years.

<div align="right">JK</div>

LITERATURE: Sirén, *Later Chinese Painting*, 1938, vol. 2, pl. 185; Sirén, *Leading Masters and Principles*, 1956–58, vol. 6, pl. 359; Lippe, "Kung Hsien," 1958, p. 165, fig. 6; *Ostasiatische Kunst*, 1970, no. 42; Cahill, "Wu Pin and His Landscape Paintings," 1972, pp. 635–720, fig. 14; Suzuki, *Comprehensive Illustrated Catalogue*, 1982–83, vol. 2, E18–0400; Miyagawa, *Chinese Painting*, 1983, pl. 95, pp. 201–2.

Kao Ts'en (fl. 1650–79) 高岑

tzu Wei-sheng 蔚生, Shan-ch'ang 善長

Kao Ts'en, a native of Hang-chou, lived most of his adult life in Nanking. He began preparing for the official examinations as a child, but soon gave up the rigors of his studies, turning instead to poetry and painting. His early training as a painter took place in Hang-chou under the direction of Chu Jui-wu, known as the monk Ch'i-ch'u ho-shang.

Kao Ts'en's older brother, Kao Fu, pursued his classical studies and eventually attained renown for his dedication to scholarship. Chou Liang-kung (1612–1672) counted Kao Fu among his closest friends but did not meet Kao Ts'en until perhaps around 1644–45 (Kim, *Chou Liang-kung*, 1985, vol. 2, p. 143). Upon his move to Nanking, Kao Ts'en apparently relied on his brother's numerous contacts to establish himself in artistic circles there.

Kao Ts'en shared his teacher's interest in the doctrines of Buddhism; his Buddhist instructor was Chu Jui-wu's close friend, the monk-painter

Tao-hsin (Ch'en Tan-chung, *chin-shih* 1643). In his *Tu-hua lu*, Chou Liang-kung describes Kao Ts'en and Tao-hsin discussing painting until late in the night. Whenever Kao Ts'en felt inspired, he would hastily paint out the gist of the conversation, and Tao-hsin would then take up his brush and add own his ideas—a collaboration that (as Chou tells it) resulted in a marvelous painting.

136 *Landscapes*

Shan-shui

高岑　山水

Dated 1672

Album of eleven paintings, ink and ink and color on paper

15.1 x 18.1 cm (5¹⁵/₁₆ x 7⅛ in.)

Museum für Ostasiatische Kunst, Berlin

vol. 1, pl. 136 (leaves 1–3, 5, 6, 8, 10, 11); vol. 2, pl. 136 (leaves 4, 7, 9)

ARTIST'S INSCRIPTION AND SIGNATURE:
Leaf 11, 9 lines in running-regular script:
In imitation of the ink methods of twelve Sung and Yüan masters at the Pi-lo ts'ao-t'ang. In the second month, spring, of the *jen-tzu* year [February 28–March 28, 1672]. Shih-ch'eng, Kao Ts'en.

臨宋、元十二家墨法於薜蘿草堂。時壬子春二月。石城，高岑。

ARTIST'S SEALS:
Kao Ts'en 高岑 (*pai-wen*, rectangle; leaf 11)
Kao Ts'en 高岑 (*chu-wen*, rectangle; leaves 1, 2, 5)
Kao Ts'en 高岑 (*pai-wen*, rectangle; leaves 1, 6–10)

NO COLOPHONS OR COLLECTORS' SEALS

Kao Ts'en is regarded as one of the Eight Masters of the Nanking School of painting. As pointed out by Chang Keng (1685–1760), "In the Chin-ling [Nanking] School, there were two divisions, one resembling the Che and another resembling the Sung-chiang School [founded by Tung Ch'i-ch'ang and Chao Tso]" (Chang Keng, *P'u-shan lun-hua*, in Yü Chien-hua, *Chung-kuo hua-lun lei-pien*, 1957, p. 223). This stylistic eclecticism is evident in the present album, which originally contained twelve leaves according to the artist's inscription, in which he refers to twelve Sung and Yüan masters. Leaf 2 is reminiscent of the Southern Sung academic style of Ma Yüan (fl. ca. 1190–ca. 1225) and Hsia Kuei (fl. ca. 1220–ca. 1250) in its emphasis on mist and in the juxtaposition of foreground and background. It also exemplifies the renewed interest in the seventeenth century in Sung realism. Leaf 11 is probably based on the one-corner compositional scheme typical of the late Sung academic painters, but the brushwork seems more calligraphic, suggesting the influences of the Yüan literati painters as transmitted through the Ming dynasty.

Several leaves suggest that Kao Ts'en was influenced by the Wu School, as well as by his contemporaries in Nanking. For example, leaves 5 and 8 share stylistic affinities with the broad and undulating but strong brushwork of Shen Chou (1427–1509) and Wen Cheng-

ming (1470–1559); similar affinities with the Wu School can be seen in the work of Kao Ts'en's Nanking contemporary Wu Hung (fl. 1653–79), for example in his 1672 hanging scroll in the Nanjing Museum (*Chung-kuo mei-shu ch'üan-chi*, 1988, Painting, vol. 9, pl. 137). Leaf 1 is similar to a hanging scroll by the Nanking artist Tsou Che (fl. ca. 1647-79) entitled *Conversing with a Monk in a Pine Forest*, dated 1647 and now in the Shanghai Museum, particularly in its tall, dark pine trees, spread out at the top like an umbrella and silhouetted against the mountain and the houses (Capon and Pang, *Chinese Paintings*, 1981, cat. no. 52). Leaves 3 and 4 are very close to Kung Hsien (1619–1689) in their use of dark ink contrasted with mist to create a strong sense of remoteness and desolation in the landscape (cf. Kung Hsien's 1671 *Landscape Album* and undated handscroll *Landscape in the Manner of Tung Yüan* [*Fang Pei-yüan shan-shui*], both in the Nelson-Atkins Museum; Ho et al., *Eight Dynasties*, 1980, nos. 214, 217).

Like many of his Nanking contemporaries, Kao Ts'en seemed to move freely between emulating ancient masters, as seen in this album, and observing and recording sceneries near Nanking, as seen in an album dated 1666 and now in the University of Michigan Museum of Art (Suzuki, *Comprehensive Illustrated Catalogue*, 1982–83, vol. 1, A5–30). In a letter to Chou Liang-kung (1612–1672), which was later published in the *Lai-ku-t'ang ch'ih-tu hsin-ch'ao*, Kao Ts'en referred to the usefulness of the theoretical and art-historical writings of Tung Ch'i-ch'ang and his circle but concluded that, despite what one learned from past masters, real scenery still posed challenges to the artist as he began to paint (quoted in Ho Ch'uan-hsing, "Ming Ch'ing chih chi te Nan-ching hua-t'an," 1987, p. 351).

<div align="right">JK</div>

LITERATURE: Sirén, *Later Chinese Painting*, 1938, vol. 2, pl. 187; Sirén, *Leading Masters and Principles*, 1956–58, vol. 6, pl. 362; *Ostasiatische Kunst*, 1970, cat. no. 43; Suzuki, *Comprehensive Illustrated Catalogue*, 1982–83, vol. 2, E18-027.

Tai Pen-hsiao (1621–1693) 戴本孝

tzu Wu-chan 務旃, *hao* Ying-a shan-ch'iao 鷹阿山樵

Born in Ho-chou, Anhui, Tai Pen-hsiao grew up in a family of scholar-officials. Tai's later life as a staunch Ming loyalist was heavily shaped by his father's dedicated resistance to the invading Manchu army. In 1632 his father, Tai Chung, foreseeing the civil unrest that bands of rebel peasants from nearby regions would soon bring to Ho-chou, moved the family to Nanking, where they lived in relative security for five years. As the situation in southern China degenerated into chaos, the Tai family was forced to move from place to place in the Chiang-nan region in search of sources of income and safe living conditions.

After the fall of Peking in 1644, Tai Chung obtained a position in the Southern Ming court, but before he reached his assigned post in

Lien-chou, Kuangtung, he received news of the capture of Nanking by the Manchus. Arriving in Ho-chou, he helped organize a small army of two thousand men to defend the region against the advancing Manchu forces. In the ensuing battle in the autumn of 1645, Tai Chung was seriously injured; soon thereafter he starved himself to death at the family home.

After the martyrdom of his father, Tai Pen-hsiao resolved to remain loyal to the Ming; and in order to support himself and his family, he relied upon the sale of his paintings. Tai lived mostly in his native Ho-chou until around 1660, when he began to wander from place to place, a life-style reminiscent of his early years. This time, however, his destinations were famous mountains—Huang, T'ai, Lu, and Hua—where he sought artistic inspiration rather than temporary asylum. Tai also sojourned in She-hsien, Peking, and Nanking, and became widely known in literary and painting circles in those cities. His friends and acquaintances included Wang Shih-chen (1634–1711), Mao Hsiang (1611–1693), Fu Shan (1605–1690), Kung Hsien (1619–1689), K'ung Shang-jen (1648–1708), Hung-jen (1610–1664), and Shih-t'ao (1642–1707).

137 *The Wen-shu Monastic Retreat*
Wen-shu yüan
戴本孝 文殊院

Undated

Hanging scroll, ink and color on silk
188 x 54 cm (74 x 21¼ in.)

Chien-lu Collection, Ann Arbor

vol. 1, pl. 137

ARTIST'S INSCRIPTION AND SIGNATURE (7 lines in running script):
"Wen-shu yüan "

《文殊院》

In front of a hanging cliff are stones suggestive of seated Buddhas. They are attended by ranks of assembled peaks and the soughing of the reed-pipe fluting pines. Mi-yün lao-jen has inscribed the legend: "To be here is to be enlightened." How deep was his understanding. On the very top of the mountain is a moon-cave revealing in its light and shadow the semblance of a branch over a mountain stream. Not to perceive this is to be ignorant of what truly divides the immortal from the commonplace. Ying-a.

懸崖前，有石上趺跏之跡。群峰列侍，松籟流音。密雲老人署曰：「到者方知，」可謂深得其義矣。絕巘上有月窟，中現光影，儼若山河枝也。不觀此，不知果有仙凡之隔。鷹阿。

ARTIST'S SEALS:
Ying-a shan-ch'iao 鷹阿山樵 (*pai-wen*, rectangle)
Pen-hsiao 本孝 (*chu-wen*, square)
Shui-hsia 蛻俠 (*chu-wen*, rectangle)
Shih-hua shih-li keng □詩畫食力耕□ (*chu-wen*, rectangle; damaged, of the period and possibly an informal seal of the artist)

Catalogue

No colophons

Collectors' seals: Wang Yang-tu 王養度 (19th century), 2; unidentified, 1

Even at first glance, one is struck by the artist's bold handling of an interlocking, towering structure of contending mountain forms: cliff, peak, spare plateau, irregularly shaped rocks, and—as one's gaze moves upward, aided by brief suggestions of increasingly tilted paths— the presence of threatening overhanging mountain masses. These are penetrated in the upper left by the echoing circles of a mysterious cave. At the upper right, there is release into far peaks that recede horizontally across a deeper distance shadowed by precise bands of an ink-washed sky. The sky is partially screened by the artist's inscription, with title, signature, and three of his seals.

The painter Tai Pen-hsiao takes his place in history as a master from Anhui, a province where a special type of painting was founded in the seventeenth century, an art more often than not rooted in a personal sparseness of definition. In their attempts to condense the essence of nature, Anhui painters recorded subtleties that captured renewed visions of it—both the reserve of quiet openness and the passion of majesty and power. Nowhere did this approach find more inspiration than in the warm, weathered granite peaks of the soaring mountain complex of Mount Huang (Yellow Mountain). The Wen-shu Monastic Retreat, established in 1613 by the monk P'u-men, was a famous site at Mount Huang, a resting place for the traveler. Today, a modern structure, robbed of early architectural excellence, still offers overnight hospitality. The site is familiar to the modern tourist as Yü-p'ing (Jade Screen). Approached by a steep path, its welcome plateau rests between the prominent summits of Lotus Peak and Heavenly Citadel, whose pines and competing heights were once described by Tai Pen-hsiao as displaying a unique "air" or "energy" (feng 風) (Cahill, Shadows of Mt. Huang, 1981, no. 55, p. 143). Tai Pen-hsiao traveled extensively, visiting many of China's most famous mountains, but he apparently retained a special connection with the peaks of Mount Huang in his native Anhui. He was a friend of both Hung-jen (1610–1644) and Shih-t'ao (1642–1707), who were also intimately connected with that mountain complex.

The Anhui style owed a great deal to sixteenth-century Su-chou painters, beginning with Shen Chou (1427–1509) and extending through Wen Cheng-ming (1470–1559) and his followers. But behind these Su-chou masters lay the spare style of the great Yüan painter Ni Tsan (1301–1374). Although Tung Ch'i-ch'ang was well acquainted with Anhui, especially through his contacts with collectors in the region (Kuo, Austere Landscape, 1990, p. 19ff.), his direct influence on painters there is more difficult to assess. In the case of Tai Pen-hsiao, such influence was most likely of a general rather than specific nature. Tung Ch'i-ch'ang seldom turned toward the objectivity of specific scenery, and when he did he paid little attention to recognizability (cf. vol. 1, pls. 50, 56). In this scroll Tai Pen-hsiao presents an identifiable scene, which places him far closer to the mainstream of Anhui painting than to that of Hua-t'ing. Although this initially separates him from Tung, both theoretical and formal aspects of the earlier master are found in Tai's work.

The Wen-shu Monastic Retreat resonates with what Tung Ch'i-ch'ang articulated in his theory. Tai floats his scene on the indeterminate emptiness of cloud-mist, a significant disembodying detail that suggests a scene of visionary detachment. Within this we seem to be entering the phrases of Tung's formal idea-world:

> If one considers the wonderful excellence of brush and ink, the real landscape can never equal painting.

> The transmission of the spirit depends on the form. It is better to be obscure (an 暗) than obvious (ming 明) . . . To be obscure is to hide behind clouds and mist.

> In painting, mountains must have concave and convex forms. Outline first the general shapes.

> The principal thing is to grasp the shih 勢 (force or momentum) of the design.

> (Translations by Wen Fong, "Tung Ch'i-ch'ang and the Orthodox Theory of Painting," 1968, pp. 6, 11, 15.)

Consistent with such ideas, what Tai Pen-hsiao has created can be seen as a magnificent construct of bold, irregularly shaped forms. They rely on prominent outlines presented with the artist's characteristic thick, dry brush and are only briefly touched with interior modeling. There are no distracting minutiae. The freely outlined architecture is empty, even ghostly in appearance. The squat accents of pines and the lower deciduous trees are sparingly introduced, and human detail is reduced to a single faceless profile, a seeker with basket and spade, symbol of a search for the herbs of immortality. The painting is thus open to much that is "convex" and "concave." Further, the interlocking of these basic forms, their variety in shape and irregularity of size and placement are completely at home in the framework of Tung's theoretical and painterly insistence on the force and momentum he designated as shih. If a form leans, there is a counter-thrust. A stable vertical (cliff, peak) or horizontal (plateau) is destabilized by angled juxtapositioning. Somehow the massive cliff-rock above the monastery threatens all below it, but never crashes. The leaning cliff-peak at upper left is in turn buttressed by this same rock, its solidity questioned by the circular "moon-cave" that bores into it. Even the smooth, frugally textured rocks that by virtue of their dark edges emerge as weatherworn primeval shapes question that perception in their simplicity of surface. Are they solid, or are they void? The conclusion must be a dynamic one: density within sparseness, void within solid.

Tai Pen-hsiao, speaking through such forms, had a more tangible purpose—the personal vision that probed the meaning of a specific place known to him and countless others. It is possible that this painting was one of several companion views of Mount Huang. In the Shanghai Museum are five similar landscapes, four of which are mounted as a screen. The general style, surface of silk, measurements, and use of title and inscriptions all correspond to The Wen-shu Monastic Retreat. Awaiting further confirmation, the present scroll could well be combined with them (Chung-kuo ku-tai shu-hua t'u-mu, vol. 4, 1990, Hu 1-2645, 1-2646).

The off-center focus of this painting is directed to a Buddhist monastery, one dedicated to Wen-shu, the Indian Manjusri or Bodhisattva of Wisdom. Nishigami Minoru, who places the painting late in Tai Pen-hsiao's life (ca. 1690), has suggested that the scroll represents a deep-seated approach to Buddhism through nature and anchors it in

the Six Dynasties vision of Tsung Ping (375–443), who is mentioned elsewhere in Tai's writings (Nishigami, "Tai Banko ni tsuite," 1981, p. 330; "Tai Pen-hsiao yen-chiu," 1987, p. 157). In his Buddhist treatise, the *Ming-fo lun*, Tsung Ping writes:

"If we travel through wild nature and climb to the top of the peak, we can view the great span of the marvelous landscape, the expansion of Cosmic space which is clear and pure, and the miracles of the sun and moon which illuminate the darkness. How could we fail to find in them the nobility and dignity of the sages and the powerful sacred spirits . . . This is a matter of contemplating infinity and thus being open to the thought of the divine karmic Way." (Translation by Kiyohiko Munakata, "Concepts," 1983, p. 120.)

It is Buddhism, too, that may be seen to rest at the heart of the significance of the mysterious branch in the moon-cave. No less a painter than Shih-t'ao brushed the same Lotus Peak. In two surviving versions—one in the present exhibition (vol. 2, pl. 158-15) and the other in the Sumitomo Collection in Kyoto (*Bunjinga Suihen*, 1976, vol. 8, figs. 41–48)—the familiar circle and branch haunts the upper reaches of the mountain. In the Sumitomo version, Shih-t'ao notes in his inscription that there is "a rock as large as the circle of the moon within which is a horizontal pine commonly called 'the *sal* tree within the moon.'" As with the "lotus" of the mountain itself, the *sal* tree had a close association with Buddhism, most specifically as the setting for Nirvana. Without discounting other "spirit" possibilities in the painting—such as the Taoist search for mushrooms of immortality—here, surrounding the temple of the Bodhisattva of Wisdom, connotations must be centered on Buddhism, a Buddhism revealed through nature, not as a generality but as the concrete embodiment of a particular place: "To be here is to be enlightened."

RE

EXHIBITION: University Art Museum, Berkeley, 1981: Cahill, *Shadows of Mt. Huang*, cat. no. 54.

LITERATURE: Nishigami, "Tai Banko ni tsuite," 1981, p. 328ff.; Suzuki, *Comprehensive Illustrated Catalogue*, 1982–83, vol. 1, A6–003; Nishigami, "Tai Penhsiao yen-chiu," 1987, p. 155ff., pl. 23.

Ch'eng Sui (1602–after 1690) 程邃

tzu Mu-ch'ien 穆倩, *hao* Kou-ch'ü 垢區, Kou tao-jen 垢道人, Huang-hai lao-jen 黄海老人

Born into a distinguished scholar-official family from She-hsien, Anhui, Ch'eng Sui benefited from all the advantages of wealth and privilege. He received a classical education at the clan school, enjoyed the fine collection of antiquities and paintings amassed by his forebears, and drew on a network of family connections that included officials, painters, poets, and collectors.

In his early thirties, Ch'eng Sui moved to Yang-chou, where through introductions by his uncle Cheng Yüan-hsün (1598–1645) he became acquainted with the community of artists, writers, and intellectuals active in the local branches of the Fu-she (Restoration Society). He was a close follower of the former Tung-lin reformer Huang Tao-chou (1585–1646), to whom he may have been introduced in Peking around 1624–25 (Rogers and Lee, *Ming and Qing Painting*, 1988, p. 161). By the mid-1630s Ch'eng had apparently given up all hope of pursuing a government career, and instead devoted his time to socializing, painting, composing poetry, and seal-carving. His renowned skills as a seal carver were cultivated through his studies of inscriptions on ancient bronze vessels in his family's collection. He carved seals for many friends and acquaintances, including the collector Chou Liang-kung (1612–1672) and the artists Pa-ta shan-jen (1626–1705), Cha Shih-piao (1615–1698), and Fa Jo-chen (1613–1696).

After the fall of the Ming dynasty, Ch'eng Sui was active in *i-min* (leftover subject) circles in Nanking. His strong feelings of loyalty to the former dynasty led him to decline the tempting invitation to sit for the *po-hsüeh hung-tz'u*, the prestigious national examination held in Peking in 1679 that was intended to attract outstanding Chinese scholars to serve at the Ch'ing court. Instead of pursuing this path to wealth and fame, Ch'eng preferred to spend his days drinking wine and chanting poetry in the company of friends.

138 *Poetic Mood under Wintry Grove*
Han-lin shih-hsing
程邃　寒林詩興

Dated 1676

Hanging scroll, ink on paper
78.8 x 42.5 cm (31 x 16¾ in.)

Beijing Palace Museum

vol. 1, pl. 138

ARTIST'S INSCRIPTION AND SIGNATURE (5 lines in running script):
The rain over the three Hsiang rivers was driven away by the fresh wind,
The clear sky reveals a thousand cloudy peaks.
Walking to the end of the water, comes one's poetic moods.
Who recalls the elegant style of Adjutant Pao [Pao Chao]?
On the fifth day of the fifth month of the *ping-ch'en* year [June 15, 1676], painted by the old man from Yellow Sea [Mount Huang], Ch'eng Sui.

清風急捲三湘雨
霽色橫開千嶂雲
行到水窮詩興發
風流誰識鮑參軍
　　丙辰五月五景，黄海老人，程邃。

ARTIST'S SEALS:
Ch'eng Sui 程邃 (*pai-wen*, rectangle)
Mu-ch'ien 穆倩 (*chu-wen*, rectangle)

An-p'in pa-shih nien tzu-hsin ju i-jih 安貧八十年自信如一日 (*pai-wen*, square)

Chiang-tung pu-i 江東布衣 (*pai-wen*, square)

NO COLOPHONS

COLLECTORS' SEALS: Shih Shou-yü 師守玉, I; unidentified, I

EXHIBITION: Honolulu Academy of Arts, Hawaii, 1989: Rogers and Lee, *Ming and Qing Painting*, 1988, cat. no. 38.

LITERATURE: *Chung-kuo ku-tai shu-hua mu-lu*, vol. 2, 1985, *Ching* I–3787.

Cha Shih-piao (1615–1698) 查士標

tzu Erh-chan 二瞻, *hao* Mei-huo 梅壑, Lan-piao 懶標, Hou i-mao sheng 後乙卯生

This versatile and well-liked artist was born in Hsiu-ning, Anhui. The family's wealth (probably derived from the lucrative Anhui salt trade) enabled them to amass a fine collection of ancient bronzes and Sung and Yüan paintings, which provided the foundation for Cha Shih-piao's early artistic training. Cha's literary education prepared him for the official examinations, but he advanced only to the *hsiu-ts'ai* degree. With the Manchu conquest of the Ming in 1644, Cha gave up all ambitions for a government career and never again sat for an official examination.

In the late 1660s or early 1670s, Cha Shih-piao settled in Yang-chou. A crossroads of economic and cultural activity in the Chiang-nan region, Yang-chou attracted many artists, merchants, poets, and scholars in the first century of Ch'ing rule. In Yang-chou, and on his frequent trips to nearby Nanking and Chen-chiang, Cha became acquainted with a large circle of scholars and painters, including Ta Chung-kuang (1623–1692), Wang Hui (1632–1717), Shih-t'ao (1642–1707), Sung Lo (1634–1713), and K'ung Shang-jen (1648–1708). In 1687 he attended the meeting of the Spring River Poetry Society (Ch'un-chiang shih-she) in Yang-chou.

Though he grew up in a prosperous family, Cha Shih-piao was unable to maintain his inherited wealth after the Manchu conquest and was thus forced to sell his paintings for a living. Late in life he referred to himself as one who had "plowed with his inkstone for seventy years" (i.e. marketed the products of his brush as a farmer markets his produce). Cha's most prominent patron was Sung Lo, a distinguished scholar and official who served as governor of Kiangsu province from 1692 to 1705. Cha once presented Sung Lo with an imitation of Tung Ch'i-ch'ang's calligraphy. Sung, fooled into believing the work to be genuine, discovered belatedly the true author of the piece. This duplicity only added to Sung's admiration for Cha's cleverness. After Cha Shih-piao's death, Sung showed his great esteem for the artist by writing a preface for his collected poetry and composing his epitaph.

139 *Landscape*

Shan-shui

查士標　山水

Dated 1671

Hanging scroll, ink and color on paper
121.9 x 54.6 cm (48 x 21½ in.)

Collection of Henry and Lee Harrison

vol. 1, pl. 139

ARTIST'S INSCRIPTION AND SIGNATURE (4 lines in running script):
A small bridge spans [the stream], distant
　　mountains are blue,
Along wilderness paths where clouds are deep,
　　I always walk alone.
I remember in years past, seeking the dwelling-
　　place of a crane;
The pines were soughing in the wind, the water
　　was murmuring.
　　Painted by Shih-piao in the second month of the *hsin-hai* year
　　[March 11 - April 8, 1671].

小橋橫接遠山青
野徑雲深每獨行
記得當年尋鶴處
風松認認水泠泠
　　辛亥二月，士標畫。

ARTIST'S SEAL:
Shih-piao ssu-yin 士標私印 (*pai-wen*, square)

LABEL STRIP: unidentified, I seal

NO COLOPHONS

COLLECTORS' SEALS: unidentified, 2

RECENT PROVENANCE: Nicholas Conran, Esq.

Cha's earliest extant paintings date to the 1650s and show him working in a manner influenced by Hung-jen (1610–1664), with whom he was personally acquainted, and Hung-jen's principal model, the fourteenth-century master Ni Tsan (1301–1374). After establishing himself in Yang-chou, Cha came into contact with a wider spectrum of artists, including Wang Hui (1632–1717) and Yün Shou-p'ing (1633–1690), and his stylistic sources broadened. In his later years, Cha's works often exhibit loose brushwork and a slapdash quality that may have resulted from his increased output and a local preference for "untrammeled" paintings executed in a swift and spontaneous manner.

This important dated work from the early years of Cha Shih-piao's residency in Yang-chou is notable for its departure from the spare, angular compositions of Hung-jen. The painting presents a densely filled picture space organized around the emphatic diagonal recession of a stark, white stream—virtually the only unpainted surface in the picture. Almost nothing is allowed to intrude upon this diagonal; instead, the leaning and curving forms of the mountains and trees reinforce it, channeling the viewer's attention into the distance toward Cha's inscription, which holds the key to the picture's imagery. When one considers the scroll in light of Cha's poem, the prominent stream,

bridge, pines, and strolling scholar gazing into the misty distance all may be seen to fulfill a specific narrative function.

Cha's modulated brushwork, rich ink washes, and use of color show him moving away from the sparsely inked, dry-brush manner of his earlier, Hung-jen–inspired style. Rounded landscape forms are modeled in sensuous shades of blue and red wash with alternating colors employed to reinforce the painting's spatial structure (pinkish hues indicate flat surfaces while blue tints suggest shaded vertical cliff faces). The combination of soft colors, pale washes, and rhythmic contour lines evoke a dreamy, atmospheric quality that differs markedly from the crystalline clarity of Hung-jen's granitic peaks.

Stylistically, Cha's contours in dilute ink, dragged texture strokes, schematic trees with conventionalized foliage patterns, and looming, unstable landscape forms all suggest the influence of Tung Ch'i-ch'ang. Like Tung, Cha exploits the tension between representationally believable forms and abstraction. Here, richly descriptive brushwork, atmospheric effects, and narrative content are contradicted by the abstract push and pull of shifting ground planes and receding and protruding mountain forms. Yet Cha's sensuous use of ink and color washes sets his work apart from the stark, monochromatic ink tones and layered hemp-fiber texture strokes typical of Tung Ch'i-ch'ang. While maintaining something of his identity as an Anhui artist—through his still restrained use of ink, preference for large, lightly textured rock faces, and pale, red-blue color scheme—Cha has succeeded in developing a new stylistic direction of his own.

MKH

EXHIBITION: University Art Museum, Berkeley, 1981: Cahill, *Shadows of Mount Huang*, no. 44.

LITERATURE: Cahill, manuscript on seventeenth-century painting, 1986, pp. 64–65, pl. 20.

140 *Small Pavilion by the Water*
Hsiao-t'ing lin-shui
查士標　小亭臨水

Undated

Hanging scroll, ink on paper
130 x 62.4 cm (51¹⁄₁₆ x 24⁹⁄₁₆ in.)

Shanghai Museum

vol. 1, pl. 140

ARTIST'S INSCRIPTION AND SIGNATURE (3 lines in running script):
A small pavilion reposes by the water,
All day long playing with the seagulls.
What is he searching for—the Emperor's friend dressed in lambskin?
Solitary is the journey beyond the mundane.
 Shih-piao.

小亭臨水憩
長日狎沙鷗
何事羊求侶
蕭然物外游
　　士標。

ARTIST'S SEALS:
Lan-lao 爛老 (*chu-wen*, rectangle)
Cha-shih Erh-chan 查氏二瞻 (*chu-wen*, square)
Lan-lao 爛老 (*chu-wen*, oval)

NO COLOPHONS

COLLECTORS' SEALS: unidentified, 2

LITERATURE: *Chung-kuo ku-tai shu-hua mu-lu*, vol. 3, 1987, *Hu* 1-2532; *Chung-kuo ku-tai shu-hua t'u-mu*, vol. 4, 1990, *Hu* 1-2532.

141 *Calligraphy,* running script
Hsing-shu
查士標　行書

Undated

Hanging scroll, ink on paper
124 x 49.7 cm (48¹³⁄₁₆ x 19⁹⁄₁₆ in.)

The Nelson-Atkins Museum of Art
Gift of Mr. and Mrs. Robert Stanton Everitt in memory of Mr. Everitt's brother, Leslie G. Everitt F74-31

vol. 1, pl. 141

ARTIST'S INSCRIPTION AND SIGNATURE (4 lines in running script):
A famous garden in the southern suburb is only in the next county,
I shall plant some flowers and bamboo to enjoy my moments of peace.
Return while I am still young and the crude wooden carriage is still waiting,
We shall make a date to search for the spring, even a hundred *li* away.
 Written for elder Ch'ih-ch'eng by Cha Shih-piao.

南郭名園纔隔縣
好添花竹及清時
歸來未老柴車在
百里尋春定可期
　　書似赤城道翁，查士標。

ARTIST'S SEALS:
Mei-huo 梅壑 (*chu-wen*, rectangle)
Shih-piao chih yin 士標之印 (*pai-wen*, square)
Erh-chan 二瞻 (*pai-wen*, square)

NO COLOPHONS OR COLLECTORS' SEALS

RECENT PROVENANCE: Mr. and Mrs. Robert Stanton Everitt

Kao Chien (1634–1707) 高簡

tzu Tan-yu 澹游, *hao* Lü-yün shan-jen 旅雲山人

Kao Chien was born in Su-chou in 1634, ten years before the fall of the Ming dynasty. Kao's birthdate is confirmed in his inscription, dated 1707, on a landscape hanging scroll in the Taitsu Hashimoto Collection, in which he gives his age as seventy-four *sui* (seventy-three years old). Little else is known about Kao's life. His biographer Chang Keng (1685–1760) states that he was well-educated and that his erudition found expression in his painting (Chang Keng, *Kuo-ch'ao hua-cheng lu*, repr. 1963, *ch.* 2, p. 36). Kao Chien is best known for his small format works; Chang Keng, in fact, asserts that the artist lacked the ability to execute large-scale paintings. Kao's ink drawings of plum blossoms have been the most highly treasured by Chinese collectors and connoisseurs.

142 *Landscape in the Manner of Ts'ao Chih-po*
Fang Ts'ao Yün-hsi pi-fa
高簡　仿曹雲西筆法

Dated 1670

Hanging scroll, ink on paper
90.5 x 32.3 cm (35⅛ x 12¹¹⁄₁₆ in.)

Beijing Palace Museum

vol. 1, pl. 142

ARTIST'S INSCRIPTION AND SIGNATURE (1 line in running-regular script):
In autumn, the ninth month of the *keng-hsü* year [October 14–November 12, 1670], I imitated the brushwork of Ts'ao Yün-hsi [Ts'ao Chih-po, 1272–1355]. Kao Chien.

庚戌九秋，仿曹雲西筆法。高簡。

ARTIST'S SEAL:
Wu-hsia Kao Chien yin-hsin 吳下高簡印信 (*chu-wen*, rectangle)

NO COLOPHONS

COLLECTOR'S SEAL: unidentified, 1

LITERATURE: *Chung-kuo ku-tai shu-hua mu-lu*, vol. 2, 1985, *Ching* 1–4640.

Yün Shou-p'ing (1633–1690) 惲壽平

tzu Cheng-shu 正叔, *hao* Nan-t'ien 南田, Yün-hsi wai-shih 雲溪外史, Po-yün wai-shih 白雲外史, Tung-yüan ts'ao-i 東園草衣

Yün Shou-p'ing, a descendant of a Ming official-gentry family in Wu-chin, Kiangsu, remained loyal to the fallen Ming dynasty even though he was only a child at the time of its demise. The reason for his staunch partisanship may lie in the dramatic events of his teenage years, when he followed his father, Yün Jih-ch'u (1601–1678), into the anti-Manchu resistance. Among the last defenders of the dynasty, the father and son were separated during a battle at Chien-ning, Fukien, in 1648, and Shou-p'ing was captured by the Manchu forces. While in detention, Shou-p'ing's refined demeanor and artistic talent attracted the attention of the wife of the Manchu general Ch'en Chin (d. 1652), who adopted the young boy as her son. In the meantime, Yün Jih-ch'u, searching constantly for his son, returned to Chekiang. One day he by chance saw Madame Ch'en and her entourage at a monastery on West Lake in Hang-chou and immediately recognized his son in the group. With the help of the temple's abbot, father and son were soon reunited.

After returning to Kiangsu with his father, Yün Shou-p'ing dedicated himself to poetry and painting. His small circle of intimate friends included Wang Hui (1632–1717) and Ta Chung-kuang (1623–1692), both of whom introduced him to influential collectors and painters, among them Wang Shih-min (1592–1680), whom he met shortly before the artist's death in 1680. Yün specialized in landscape and bird and flower paintings, which he sold to support himself and his aging father.

143 *Imitating Chü-jan's "Streams and Mountains without End"*
Fu Chü-kung "Hsi-shan wu chin" t'u
惲壽平　撫巨公《溪山無盡》圖

Dated 1677

Hanging scroll, ink and color on paper
136.7 x 60 cm (53¹³⁄₁₆ x 23⅝ in.)

Shanghai Museum

vol. 1, pl. 143

ARTIST'S INSCRIPTION AND SIGNATURE (6 lines in running-regular script):
Chü-jan's [fl. ca. 960–ca. 986] brush runs like a dragon, as though thunder rolled and lightning shone within a [square] foot of the painting. His movement is constantly changing and unpredictable, as if he had simply flung his brush straight down from the sky; this is truly to transform creation, and sojourn in heaven: something not even to be dreamt of by contemporary painters. In the sixth month of the *ting-ssu* year [June 30–July 29, 1677], kept indoors in my north chamber by the heat of summer, I copied Master Chü's *Streams and Mountains without End*. Nan-t'ien, Yün Shou-p'ing.

巨然行筆如龍，若于尺幅中雷轟電激。其勢變幻不可知；直從半空擲筆而下；正是潛移造化，而與天游。非時史所能夢見也。丁巳六月，北堂銷暑，橅巨公《溪山無盡圖》。南田，惲壽平。

Artist's seals:
Chi yüeh yün 寄岳雲 (*chu-wen*, rectangle)
Cheng-shu 正叔 (*chu-wen*, square)
Shou-p'ing chih yin 壽平之印 (*pai-wen*, square)

No colophons

Collector's seals: Wu Hu-fan 吳湖帆 (1894–1968), 5

Yün Shou-p'ing's inscription makes it clear that he is concerned above all with brushwork and the dynamics of form. Though there is reference to Chü-jan and his *Streams and Mountains without End*, a somewhat closer parallel for the composition of this painting, with the sweeping curve of the lake shore, might be the *Thatched Hut in Autumn Mountains* by Wang Meng (1308–1385), now in the National Palace Museum, Taipei.

RW

Literature: Cheng Ming-shih, *Yün Shou-p'ing*, 1987, p. 211.

Mei Ch'ing (1623–1697) 梅清

tzu Yüan-kung 淵公, *hao* Ch'ü-hsien 瞿仙

Mei Ch'ing was born into a family of prominent local gentry living in the southeastern Anhui city of Hsüan-ch'eng. The Mei clan had established itself in Hsüan-ch'eng in T'ang times and thereafter produced a succession of high officials and renowned scholars including the Sung poet Mei Yao-ch'en (1002–1060) and the Ming dramatist and bibliophile Mei Ting-tso (1549–1618), who was Mei Ch'ing's great-grandfather. Mei Ch'ing followed the family tradition of scholarship. In 1654 he was awarded the *chü-jen* degree and traveled to the capital to sit for the *chin-shih* examination, which he tried and failed four times before finally giving up in 1667. After returning home, Mei remained involved in local scholarly pursuits: he was an active member in a poetry and painting society to which Shih-t'ao (1642–1707) also belonged; he published several volumes of his poetry as well as the *Mei-shih shih-lüeh*, an anthology of one hundred and eight poets of the T'ang through the Ming; and beginning in 1673 he participated in the compilation of a series of local histories (Yang Chenbin, "Mei Ch'ing sheng-p'ing," 1985, pp. 50–54).

Mei Ch'ing's interest in painting may be seen as a natural outgrowth of his passion for poetry and his lifelong exposure to natural scenery. Though Mei grew up in Hsüan-ch'eng, he must have had occasion to visit the family's old residence some twenty miles south of the city near Mount Po-chien. In 1642, when he was twenty *sui* (nineteen years old),

the family moved about a mile out of town, probably to avoid civil unrest, and in 1649, it moved again, settling southeast of the city in Hsin-t'ien, a scenic area situated between Mount Po-chien and Mount Hua-yang. Mei Ch'ing's earliest extant painting, a landscape fan in the style of Li Ch'eng (*Semmen taikan*, 1915, vol. 3), dates to this year. In addition to his intimate knowledge of his home region, Mei's travels included four trips to Peking between 1654 and 1667, sojourns to Nanking, Hang-chou, and K'un-shan in the 1670s, a journey to Mount T'ai in 1670, and excursions to Mount Huang in 1671 and 1690. His visits to Mount Huang were particularly influential on his painting; throughout his career, he drew inspiration from its dramatic rock formations and distinctive pines. Favoring the album format, he repeatedly illustrated the mountain, returning again and again to a familiar set of compositional types.

MKH

144 *Ten Views of Wan-ling*
Wan-ling shih-ching
梅清　宛陵十景

Dated 1657
Album of ten paintings with one leaf of calligraphy, ink and color on satin
Average: 25.7 x 21.5 cm (10⅛ x 8⁷⁄₁₆ in.)

The Art Museum, Princeton University, Lent by the Kinmay W. Tang Family Collection L.1984.50

vol. 1, pl. 144 (leaves 2, 7, 8, 9); vol. 2, pl. 144 (leaves 1, 3, 4, 5, 6, 10, 10a)

Artist's inscriptions:
Leaf 1, 1 line in regular-clerical script:
"[Mount] Hsia-shih"
《硤石》

Leaf 2, 1 line in regular-clerical script:
"Old [Mount] Ching-t'ing"
《古敬亭》

Leaf 3, 1 line in regular-clerical script:
"Wan Stream"
《宛溪》

Leaf 4, 1 line in regular-clerical script:
"Mount Hua-yang"
《華陽山》

Leaf 5, 1 line in regular-clerical script:
"Echo Hill Pond"
《響山潭》

Leaf 6, 1 line in regular-clerical script:
"Descending Geese on South Lake"
《南湖落雁》

Leaf 7, 1 line in regular-clerical script:
"Flying Bridge on Old Mount Po-chien"

《古柏梘山飛橋》

Leaf 8, 1 line in regular-clerical script:
"Paired Bridges"

《雙橋》

Leaf 9, 1 line in regular-clerical script:
"Piled-up Peaks Tower"

《疊嶂樓》

Leaf 10, 1 line in regular-clerical script:
"K'ai-yüan Water Pavilion"

《開元水閣》

ARTIST'S COLOPHON AND SIGNATURE (leaf 10a; 7 lines in running script):
Since olden times many copybook versions of the "Ten Views of Wan-ling" [have been made]. Painters mired down by these established models may achieve the outward appearance [of these views] but will lack "brush and ink." By my window on a wintry day with nothing to do, I casually painted these leaves to ask for instruction from Venerable P'ei, my respected fellow townsman and literary master. Someday [this album] will find a place where they will know that the paintings of Ch'ü-hsing's son [i.e. Mei Ch'ing; "Ch'ü-hsing" refers to an Eastern Chin hermit who lived at Mount Po-chien] not only go beyond copybook versions, but go beyond "brush and ink." Done with the idea of requesting instruction. On the day after the full moon in the eleventh month of the *ting-yu* year [December 20, 1657], Ch'ü-hsing, your junior, Mei Ch'ing, composed this.

"宛陵十景"舊多粉本。畫家泥於成蹟，有形似無筆墨矣。寒窗無事，偶圖數幅請教培翁老祖臺大辭宗博覽。他日過存之處，應知瞿硎之子之畫，不獨在粉本之外，並在筆墨之外。是則請教之意也。丁酉十一月望後，瞿硎治晚，梅清識。

ARTIST'S SEALS:
Chin chih Ch'ü-hsien 今之瞿儇 (*chu-wen*, rectangle; leaf 1)
Mei Ch'ing chih yin 梅清之印 (*pai-wen*, square; leaves 2, 10)
Ch'ü-hsing Yüan 瞿硎淵 (*chu-wen*, oval; leaf 3)
Chiang-tung Ch'ü shih 江東瞿史 (*chu-wen*, oval; leaf 4)
Yüan-kung shih 淵公氏 (*chu-wen*, square; leaves 5, 10a)
Ch'ü-hsing-tzu 瞿硎子 (*chu-wen*, oval; leaves 6, 9)
Po-chien shan chung jen 柏梘山中人 (*chu-wen*, rectangle; leaf 7)
Ch'en Ch'ing 臣清 (*chu-pai wen*, square; leaves 8, 9)
Yüan-kung 淵公 (*chu-wen*, square; leaf 10)
Yü-shih nan-t'ien 玉史南天 (*chu-wen*, oval; leaf 10a)
Po-chien shan chung jen 柏梘山中人 (*pai-wen*, rectangle; leaf 10a)
Mei Ch'ing chih yin 梅清之印 (*pai-wen*, rectangle; leaf 10a)

LABEL STRIP: unidentified

NO COLOPHONS

COLLECTORS' SEALS: unidentified, 3

Ten Views of Wan-ling, one of Mei Ch'ing's earliest extant works, is a key monument for understanding his early development, preserving invaluable evidence of the artist's regional stylistic beginnings before he met Shih-t'ao (1642–1707) in the late 1660s. The album's ten small paintings depict scenic spots around Mei's hometown of Hsüan-ch'eng, which in Han times was known as Wan-ling. Twenty-three years later, in 1680, he produced a twenty-four leaf album illustrating many of the same views (vols. 1 and 2, pl. 145). These later paintings are accompanied by Mei's commentaries on these sites, providing a firsthand account of their local significance.

The first leaf in the 1657 album depicts Mount Hsia-shih, a branch of Mount Ching-t'ing located seven miles north of the city where the local river flows past precipitous cliffs into a deep clear pool (*Ning-kuo fu chih*, 1919, *ch.* 10, p. 8). Mei's painting contrasts convincingly described landscape forms with the blank surface of the bottom quarter of the composition. The tension between flat picture plane and illusionistically rendered masses is sustained by the two principal interlocking landscape elements, the solidly three-dimensional ridgeline that recedes into the distance, and the flat silhouette of a boulder where Mei has placed his title and seal.

Mount Ching-t'ing, the subject of leaf 2, is located three miles north of Hsüan-ch'eng and was the site of the Kuang-chiao Ch'an Monastery where Shih-t'ao resided between 1666 and 1680. Mei's panoramic view, done in a wet, ink-wash manner that recalls the Mi-style paintings of Ch'en Ch'un (1483–1544), shows the mountain dotted with temple halls as well as two stone pagodas—all that remained of the original temple built by the mid-ninth century Ch'an master Huang-po hsi-yün (d. ca. 856), founder of the sect that bears his name (Obaku in Japanese; see vol. 2, pls. 145–5, 145–12; Li, *A Thousand Peaks and Myriad Ravines*, 1974, p. 192).

Leaf 3 illustrates the Wan Stream, which flows along the eastern city wall and joins the Chü River northeast of Hsüan-ch'eng (*Ning-kuo fu chih*, 1919, *ch.* 11, p. 16). In his 1680 album Mei describes it as follows: "The Wan Chin [Wan River Ford] and the Chü-shui [Chü River] have long been famous. At the ford are a bridge and a temple. The scenery, with its misty willows, is reminiscent of Ch'ang-kan" (vol. 1, pl. 145–13; the Ch'ang-kan [Pao-en] Monastery was situated just outside the southwest corner of the Nanking city wall). In this depiction, the stream, flowing out of the lower left corner of the composition, is overshadowed by the looming form of Hsüan-ch'eng's city wall, which appears to float upon a bank of mist. Mei's pale ink tones, accented with touches of red and blue, add to the ethereal, dreamlike quality of the image.

Leaf 4 presents a startling view of Mount Hua-yang which, in his 1680 album, Mei describes as having the shape of a flatiron (vol. 1, pl. 145–8). The painting, which anticipates the dramatic exaggerations of form and shifts in scale that characterize Mei's mature style, contrasts the leftward thrust of the main promontory with the vertical spikes of the distant peaks. The leaf's wavy contour lines and pointed dots become important expressive features in later works by both Mei Ch'ing and Shih-t'ao.

Another leftward projecting mass animates the composition of leaf 5 where the cliff face of Echo Hill (Hsiang-shan) seems to hang unsupported above the blank surface of the water. Washed with a pale red tint that sets it apart from the blue foreground shoreline and distant mountain, the rock looms precariously above the near-ground boat and trees. Echo Hill rises above Wan Stream less than a mile south of the city. In his 1680 album Mei notes: "Echo Hill, also known as Echo Pond, is the place where [the immortal] Tou Tzu-

ming went fishing for the white dragon. Below is a limpid pond; above is a pavilion wrapped in mist. Travelers on the river like this place most of all" (vol. 1, 145–6).

"Descending Geese on South Lake," the subject of leaf 6, draws upon the imagery of the Hsiao and Hsiang Rivers, particularly the scene identified by the poetic phrase, "Wild geese descending to a sandbar." In his 1680 album Mei adds the comment: "The misty waves extend into the distance; ducks and geese fly in rows to the clouds" (vol. 2, pl. 145–22). Here, the lone pavilion beside a grove of trees, windblown water reeds, and the wide expanse of water separating foreground and distant shores recall the imagery of Ni Tsan (1301–1374), the favorite model of later Anhui School painters.

Leaf 7 features the "Flying Bridge" on Mount Po-chien, which was first built by a member of the Mei clan during the Ch'un-hsi era (1174–89; *Ning-kuo fu chih*, 1919, *ch.* 12, p. 16). Po-chien Mountain, which lies close to Mei's ancestral home, is depicted twice in the 1680 album, where Mei remarks on its high and craggy peaks, waterfalls like white rainbows, and awesome bridges built "halfway to the sky." He writes: "At the Mountain Pass there is a high-arching bridge. The Prefect Lo Chin-hsi [1515–1588] inscribed the words 'Arching Rainbow' here, thus making the spot even more famous" (vol. 1, pl. 145–7). In his 1657 image, washes of blue and red on the bridge give it a rainbowlike appearance, as if it might be an illusion of the sunlight shining through the rising mist, but Mei evokes neither the towering height nor the rugged inaccessibility that he conveys in his later album. The bridge is buttressed on either side by massive promontories, but one of these rests on a foreground ledge, greatly diminishing the sense of the mountain's scale. Angled rock faces frame the waterfall, pool, and a lone figure within a sheltered space that is isolated from the houses clustered in the valley beyond. The feathery contour lines and delicately delineated trees add to the painting's sense of intimacy and complete Mei's transformation of this monumental mountain into a private world of seclusion.

Abandoning descriptive logic, Mei's "Paired Bridges" in leaf 8 do not link together any apparent pathways; in fact, one of the bridges is barely visible at all. The prominent foreground structure, which joins a rock face to a grove of trees, is topped by a roof that makes it appear like two bridges standing side by side. This ambiguity is only resolved when one discovers a second bridge extending from a middle-ground promontory to a shoreline that lies out of sight beyond the left-hand margin of the composition. In contrast to his dry, linear brushwork in the preceding painting, Mei's main interest here is the rich washes, which he employs both to define the winding course of the stream and to throw into bold relief the foreground tree trunks and rock faces.

Piled-up Peaks Tower, the subject of leaf 9, is the name given to one of the three summits of Ling-yang Hill, which rises in front of the Hsüan-ch'eng government offices (*Ning-kuo fu chih*, 1919, *ch.* 10, p. 1). Mei's illustration vividly conveys the feeling of the site's location in the midst of the city: the hill, topped by a multistoried hall, is nested between flanking outcrops and taller peaks while overlooking an expanse of densely crowded roofs.

The final painting in the album illustrates the K'ai-yüan Water Pavilion, a spacious hall supported on pilings above a stream. Mei notes in his 1680 album that the pavilion, "built during the K'ai-yüan pe-

riod [713–56], served as a lecture hall for the Prefect Lo Chin-hsi" and was also a place where Tu Mu (803–852) once composed poems (vol. 2, pl. 145–3). In Mei's image, the unadorned rectilinear structure of the pavilion contrasts with the rounded, ink-wash forms of the landscape, particularly the overhanging boughs of several large willows whose upper branches echo and merge with the silhouettes of the distant mountains.

Opposite each painting of this album is an identical facing leaf of satin, but only the final facing page bears an inscription. This artist's colophon, like the titles inscribed on each painting, shows the calligraphic influence of the early master Chung Yu (d. 230), whose archaic writing style was favored by such later scholar-recluses as Li Kung-lin (ca. 1049–1106) and Ni Tsan.

It is more difficult to identify the stylistic sources of Mei Ch'ing's paintings. Executed on satin, a surface much favored in late Ming times, Mei exploits the absorbent qualities of his medium, painting in a wet manner that plays up the contrast between inked forms and unpainted ground, light and dark ink tones, and areas of wash versus lines and dots. Mei's limited palette of pale red and blue color washes corresponds to the color scheme favored by other Anhui artists, but his wet style contrasts markedly with the dry-brush manner—exemplified by the works of Hung-jen (1610–1664)—that was to become the hallmark of the Anhui School. One explanation for this difference is that Mei Ch'ing was not exposed to artists from the She-hsien (Hsin-an) region around Mount Huang until later in his career. Living in southeastern Anhui not far from Hsiao Yün-ts'ung's (1596–1673) hometown of Wu-hu, Mei must have looked for inspiration to Nanking and Su-chou artists—Yeh Hsin (fl. ca. 1650–70), Chang Feng (d. 1662), and Shao Mi (ca. 1592–1642)—whose atmospheric, lyrical painting styles may lie behind the paintings in this album. Most likely, the thirty-four-year-old Mei Ch'ing had not seen a great many important paintings, relying instead on provincial works and woodblock prints for his models.

Mei's subject matter, like his style, derived from local sources. Topographic depiction of scenic spots was a popular genre among seventeenth-century artists as well as a common feature of local gazetteers and illustrated guidebooks, and Mei complains in his colophon that Hsüan-ch'eng's scenery had been illustrated repeatedly in copybooks. Just the previous year, Hsiao Yün-ts'ung depicted Wan-ling's sights in a long handscroll which was based, in turn, on a composition by a local monk (see Li, *A Thousand Peaks and Myriad Ravines*, no. 43). What sets Mei's work apart from such paintings was his avowed intention not to create a literal record of Hsüan-ch'eng's scenery, but to use this subject matter as a vehicle for his "casual" explorations of "brush and ink."

As one of Mei's earliest surviving works, the 1657 album sheds important light on the question of how much Mei Ch'ing may have influenced Shih-t'ao, who arrived in the Hsüan-ch'eng area around 1666. This album shows that Mei had already developed an appreciation for rich ink washes, bold tonal contrasts, and the dramatic exploitation of spatial ambiguities—elements that were to remain important in his mature style. But Mei's relatively limited repertoire of brushstrokes and simple compositional types reveal little that could have inspired Shih-t'ao. Judging from Mei Ch'ing's unabashed praise of Shih-t'ao's early masterpiece, the *Sixteen Lohans* of 1667 (vol. 1,

pl. 153), it seems likely that it was Shih-t'ao who provided the artistic leadership, introducing Mei to a rich variety of new landscape and foliage forms and inspiring him to vigorously exploit the artistic potential which is already apparent in this work.

MKH

LITERATURE: Suzuki, *Comprehensive Illustrated Catalogue*, 1982–83, vol. 1, AI8–073; Cahill, manuscript on seventeenth-century painting, 1986, p. 97.

145 *Famous Views of Hsüan-ch'eng*
Hsüan-ch'eng sheng lan
梅清　宣城勝覽

Dated 1680

Album of twenty-four paintings, ink and ink and color on paper
27.1 x 54.6 cm (10¹¹⁄₁₆ x 21½ in.)

Museum Rietberg, Zürich

vol. 1, pl. 145 (leaves 1, 4, 6–8, 10, 13, 15, 17, 18, 21, 23); vol. 2, pl. 145 (leaves 2, 3, 5, 9, 11, 12, 14, 16, 19, 20, 22, 24, colophons)

ARTIST'S INSCRIPTIONS AND SIGNATURES:
Leaf 1, 10 lines in running-regular script:
Lung-hsi [Dragon River] was the old name of Shui-yang Village [about 70 *li* north of Hsüan-ch'eng]. Here the homes stand along the waterfront, and merchant ships from all over drop anchor. The clouds that float above the river seem friendly, and fishermen's songs can be heard echoing back and forth. The place seems to be another, far-off world. I have painted this picture of the village in the manner of Hsü Hsi. Looking at it is like living on a houseboat.

龍溪，水陽之舊名也。煙市連江，旅商轉泊。而雲水親人，漁歌響答，悠然具物外之賞，圖以徐熙之法。宛置身於浮舟泛宅間矣。

Leaf 2, 6 lines in running script:
Shan-k'ou [Mountain Pass] is the pass through Mount Po-chien, 80 *li* to the south of the city [Hsüan-ch'eng]. I once went there and wrote a poem called "Song of the Mountain Pass." The following lines are from the poem:
The peaks of Mount Po-chien are high and craggy,
Twisting and turning through the clouds.
Waterfalls like white rainbows come thundering down—
Frightened travelers stand still in their wooden sandals.
How did they build these bridges here, halfway to the sky?
The path winds in and out, following a stream.
This mountain occupies a strategic position—
Its central peak is higher than the Big Dipper,
And the surrounding peaks stand like sentinels.
Looking down from here, we see ramparts on all sides.
　From this, one can get a general idea of what the place is like. Po-chien shan-k'ou jen.

山口，柏梘山之口也，去城南八十里。余游柏梘曾作《山口行》，中有：
柏梘之峰何崔嵬
十折九折雲嵐開
白虹奔瀑聲如雷

同游屐齒驚徘徊
飛梁天半胡來哉
磴道交關九十九
蟠龍踞虎爲樞紐
中峰文脊爲南斗
纏奎絡璧群巒守
俯凌四疊如蒼狗
　即此數語，可以識其大概矣。柏梘山口人。

Leaf 3, 6 lines in running-regular script:
K'ai-yüan shui-ko [Waterside Pavilion] of the K'ai-yüan period [713–56] served as a lecture hall for the Prefect Lo Chin-hsi [1515–1588]. It is the place where Tu Tzu-wei [Tu Mu, 803–852] of the T'ang dynasty once wrote poems. In one of these poems, Tu wrote:
A late autumn rain is falling on a thousand curtained homes,
The sun sets over the pavilion—a flute sounds in the wind.
　I have painted here what I saw of the place during my visit there. I cannot hope to show what it looked like in the old days. Ch'ü-shan, Ch'ing.

開元水閣舊爲羅近溪太守講學之所。即唐時杜紫薇留詠之處也。
杜詩云：
深秋簾幌千家雨
落日樓臺一笛風
　今姑據所見而圖之，不能盡如舊觀矣。瞿山清。

Leaf 4, 3 lines in regular script:
Huang-ch'ih [Yellow Pond], also known as Jade Stream [located about 200 *li* to the northwest of Hsüan-ch'eng], borders on Ku-shu [present-day Tang-t'u], and is truly a large village. The smoke from the homes and the moon over the river make the place picturesque both in the morning and in the evening. I often traveled by boat to this spot, enjoying the sights and charming poems. I found it difficult to leave. This picture of Yellow Pond is based on the painting *Misty Willows on the River at Evening*, by Kuo Ho-yang [Kuo Hsi, ca. 1020–ca. 1100].

黃池，一名玉溪，與姑孰鄰壤，實大鎮也。市烟江月，映帶朝昏。余嘗游泛其間，往往流連嗟眺，不能即去。用郭河陽《晚江煙柳圖》圖之。

Leaf 5, 6 lines in running script:
Mount Ching-t'ing is famous because of the First Peak in the west. On this peak there is a temple where the sutra hall, the meditation bench, and the tea garden and flowering plants are all beautiful. The visitor finds it hard to believe that the place is near an important thoroughfare. I have painted this picture in the style of Tai Ch'ien-t'ang [Tai Chin, 1388–1462], making Mount Ching-t'ing seem to occupy an impregnable position.

敬亭西之第一峰。即以一峰得名，中有庵，其經樓禪榻與茗圃花林相映帶。遊者不知其在孔道也。以戴錢塘法寫之，使敬亭得藉以爲襟帶者。

Leaf 6, 7 lines in regular script:
Hsiang-shan [Echo Hill, also known as Echo Pond] is the place where Tou Tzu-ming went fishing for the white dragon. Below is a limpid pond; above is a pavilion wrapped in mist. Travelers on the river like this place most of all. When I went there, the weather was fine, and many people had come to see the sights. Thus the poems written then were particularly numerous.

響山，一名響潭，仙人竇子明釣白龍處也。下瞰澄潭；上籠煙郭。舟泛者唯此稱最。良時勝景，客遊多集於此。故于題詠尤多。

Leaf 7, 5 lines in running-regular script:
In Mount Po-chien, a thousand cliffs twist and turn, with two streams flowing among them. At the Mountain Pass there is a high-arching bridge. The Prefect Lo Chin-hsi inscribed the words "Arching Rainbow" here, thus making the spot even more famous. I have painted this picture in the style of *The Roads of Shu* by Wen Yü-k'o [Wen T'ung, 1019–1049], hoping to reproduce their craggy appearance. Po-chien shan chu-jen.

柏梘山，千巖迴合，中貫雙流。山口有飛橋。郡守羅近溪先生題曰"引虹，"尤稱勝境。圖以文與可《蜀道》筆法，其奇險之致，差可髣髴。柏梘山主人。

Leaf 8, 8 lines in running script:
Huang-ku k'eng [Yellow Valley] is the lowest spot in the Hua-yang Mountains. The peak above is shaped like a flatiron. In troubled times, people used to take refuge in this valley. Once I visited here as a youth, and wrote the following brief poem:
This may not be the Wu-ling road,
But it still seems to be another world.
The mountains all surge above the pavilion;
A waterfall splashes right in front of my bed!
Morning rains darken a thousand cliffs;
Spring clouds form layers in the sky.
This is a place where one may stop
Without borrowing money to buy mountain land.
 Written for Yellow Valley Pavilion. Lao-ch'ü, Ch'ing.

黃谷坑，華陽最深處。其高嶺爲熨斗坪。昔人嘗避亂於此。余少時游此，曾留短句：
未識武陵路
真疑別有天
山都在樓上
瀑竟到床前
曉雨千巖暝
春雲一榻懸
此中聊可托
不藉買山錢
 題黃谷坑草閣。老瞿，清。

Leaf 9, 7 lines in running script:
Kao Feng [High Peak] is in the southern part of the Hua-yang Mountains, and surges higher than the clouds. The old monks who live here share the peak with monkeys. Below can be seen a pagoda and a spring. The peak is over ten *li* high, and when one looks down from the top, the other mountains seem to be its sons and grandsons. A fragrant tea is produced on the Kuan-yin Cliff at the summit. There is no finer tea in Wan-ling. Ch'ing.

高峰，踞華之南，迫出雲表，峰頭老僧多與猿猱雜處。其下有塔泉。凌空而上計十里餘，俯視諸峰，皆兒孫也。峰頂觀音巖產香茗。宛陵之茶，未有出其右者。清。

Leaf 10, 4 lines in running script:
South of the city, below Mount Shuang-yang, there is a path
Where plum blossoms shade an old pavilion.
But the pavilion is deserted—no one uses it.
Across the stream stands a green peak.
 On the Plum Viewing Pavilion. The Plum Viewing Pavilion is below Mount Shuang-yang, beside the tomb of the Auxiliary Secretary of the Ministry of Justice, who was my ancestor. It was actually built in his honor, not because of the plum blossoms. Written by Ch'ü-hsing, Mei Ch'ing.

南郭雙羊路
梅花覆古亭
亭空誰處倚
溪外一峰青
 題景梅亭。景梅亭在雙羊山下，先都官墓側。建以人，不以花也。瞿硎梅清識。

Leaf 11, 7 lines in running script:
Lu-mo River and Mount Hsin-t'ien form a belt of beautiful scenery. Between them is a plain which serves as the main thoroughfare for the Hua-yang region. And yet the expansive, secluded features of the landscape make this seem like another world. I have painted this picture of the place in the manner of Li Hsien-hsi [Li Ch'eng, 919–967]. The village, with smoke coming from the houses, takes up only a few inches, but might be mistaken for Peach Blossom Spring. Ch'ü shan-jen, Ch'ing, on the day of *Fo-la* in the *chi-wei* year [August 20, 1679].

魯墨溪，與新田山相爲映帶。中爲華陽出入孔道。而山水幽曠，迴出塵外。以李咸熙畫法表之。咫尺煙村，尚可作桃源觀也。己未佛臘，瞿山人，清。

Leaf 12, 5 lines in running script:
Formerly, the Ch'an master Huang-po [d. ca. 856; founder of the sect that bears his name] built a temple below Mount Ching-t'ing, at the request of Minister P'ei [Hsiu, mid-9th century]. The timber came from south of the ocean, and emerged from a well. The present Golden Cock Well is the one in question. The temple later burned down, except for two stone pagodas which still remain. These are commonly known as the Twin Pagodas. I have painted this in the manner of [Liu] Sung-nien [fl. late 12th–early 13th century], but I am afraid that I have only captured of the beauty of this holy spot. Ching-t'ing hua-i, Ch'ing.

始，黃檗禪師應裴丞相之請，建寺於敬亭山麓。其材木皆來自海南，而出於井。今所傳金雞井是也。寺既燬，僅存兩石幢，俗名雙塔。以松年法寫之，未能盡福地之十一也。敬亭畫逸，清。

Leaf 13, 16 lines in running script:
Wan Chin [Wan River Ford] and the Chü-shui [Chü River] have long been famous. At the ford are a bridge and a temple. The scenery, with its misty willows, is reminiscent of Ch'ang-kan [a suburb of Nanking]. Formerly T'u Wei-chen [T'u Lung, 1542–1605] visited this place and liked it very much. He got drunk, put on a dark red gown, and played the tune "Yü-yang san kuo" on a drum. From this one can imagine how beautiful the spot must have been at that time.

宛津與句水著名久矣。津有橋有庵。煙柳之勝，頗似長干。昔屠緯真泛此愛之。醉被緋袍擊鼓，作《漁陽三撾》。即此可想見其勝。

Leaf 14, 10 lines in running-regular script:
Long reeds grow on the islets;
A tributary of the river flows around the city.
It is evening—Wan-ling is covered by mist
And autumn rains fall on Mount Ching-t'ing.
The current flows faster—we are approaching the lake;
Voices from the ford are heard through the forest.
Lingering on the sand bank
Commoners and officials watch the boats come in.
 Above is the poem "Traveling by Boat below Hsia-shih Mountains," by Li Hsien-fang [1511–1594; poet and official]. I have painted this picture in the style of Ching [Hao, ca. 870–80–ca. 935–40] and Kuan [T'ung, fl. ca. 907–23]. Mount Hsia-shih is particularly beautiful at dusk, as one watches the returning boats. Ch'ü-shan.

長薄帶芳洲
支江繞郡流
潭煙宛陵夕
山雨敬亭秋
溜急知湖口
林喧指渡頭
依依沙渚上
人𠊳待行舟

 右李先芳"硤石舟中"詩。寫以荊、關法。蓋硤石之景，在晚爲望歸舟也。瞿山。

Leaf 15, 5 lines in running script:
T'ien-chu ko [The Pavilion That Holds Up the Sky] is east of Turtle Peak, and was built by Chang Chia-yen, an official of the local academy, in accordance with the recommendations of geomancers, as a school for the sons of the scholar-officials. The President of the Board of Civil Affairs, Hu, wrote this couplet on the subject:
Peach and plum trees fill every valley with spring colors;
Whenever I come here, I remember Chang K'an.

 I have painted this picture so that the pavilion, as well as Hu's thoughts about it, will become better known. Written by Ch'ü-shan, Ch'ing.

天柱閣，在鰲峰東，郡學左推官張嘉言建，從形家言，置此以課士子也，胡銓部詩：
桃李谿谿春色滿
每從去後憶張堪
 今圖之以廣見聞，亦猶胡公之所繫思云。瞿山，清識。

Leaf 16, 10 lines in running script:
Here is the poem "Ch'un kuei t'ai" ["The Terrace of Waning Spring"], by Liu Chung-kuang, a native of our city:
Autumn is drawing to a close, but it feels like spring here—
On the Terrace of Waning Spring, we get drunk in the autumn wind.
We're amazed to see the color of peach blossoms all around us,
But it's only the frosty red leaves of a thousand trees reflected in our
 wine cups.

 The terrace is in the western part of the city and is a popular place for spring outings. Written by Ch'ing.

里人劉仲光《春歸臺》詩：
秋盡行春逸興同
春歸臺上醉秋風
惟來滿座桃花色
霜葉千林入酒紅
 臺在西城內，郡人春游之所也。清述。

Leaf 17, 6 lines in running script:
Ao Feng [Turtle Peak].
Of the three peaks of Mount Ling-yang, this is the most beautiful. It was here that three Taoists refined the pill of immortality. In the [Southern] T'ang dynasty, Governor Lin Jen-chao [d. 972] had the city rebuilt in the shape of a turtle. The city is flanked by mountains and rivers, and occupies an excellent position to set off the strange form of Turtle Peak. Below the peak are White Dragon Pond and the Bridge Where Immortals Meet. Painted in the manner of Pei-yüan [Tung Yüan, fl. ca. 945–ca. 960].

鰲峰
陵陽有三峰，獨此最爲幽勝。即三真人丹成處也。唐刺史林仁肇更創城制，肖鰲形。襟山帶水，深得形勢，故因此以標其異。下有白龍潭、會仙橋。畫倣北苑。

Leaf 18, 6 lines in running script:
Ch'ü-shui t'ang [Hall of the Meandering Stream] was built by the Prefect Chao Shih-ch'ui. He led the water of the stream into a pond, and here he would float wine cups together with his guests. From this the hall takes its name. Here I have given a general feeling of the spring drinking party at the Orchid Pavilion so as to record the historic traditions of the hall. Written by Ch'ü-shan.

曲水堂，郡守趙師垂之所建也。引池注水，與客流觴。堂因以名。偶損益蘭亭褉飲，髣髴寫之，亦以備故實也。瞿山記。

Leaf 19, 9 lines in running-regular script:
Hsi Hao [West Moat] is the name of a moat to the west of [Hsüan-]ch'eng. In the past, it was the country home of the retired scholar Liu. White lotuses are planted in the moat, and for several decades people have come here to enjoy the coolness. The place has changed its appearance, but I have attempted to show it as it once was by painting this scene in the manner of Hsia Kuei [fl. ca. 1220–ca. 1250]. Ch'ü-shan.

西濠，城西之濠也。舊爲劉處士別野軒。於濠內種白蓮花，數十年來游人納涼。爲之改觀，以夏珪筆意補之。瞿山。

Leaf 20, 18 lines running-regular script:
The customs of Wan-chih are roughly the same as those of Kua-fu and Wu-yin, but its tranquil, isolated scenery is much more beautiful. In this painting, I have adopted the manner of Hai-yüeh shan-jen [Mi Fu, 1051–1107] and added a touch of Yün-lin's [Ni Tsan, 1301–1374] exalted simplicity. What a good place for playing the lute. In the tenth month of the *chi-wei* year [November 1679], Ch'ü shan-jen, Ch'ing.

灣沚風俗與瓜阜、蕪陰略相似，而山水之靜遠實勝之。用海嶽山人筆而益以雲林之高簡。或可攜琴動操。己未十月，瞿山人，清。

Leaf 21, 4 lines in regular script:
Yü-shan [Jade Mountain] is commonly called T'u-shan [Earth Mountain] by mistake. The mountain is steep and angular, overgrown with old trees. On it is Hui-chao Temple. Here my ancestors, [Mei] Sheng-yü and his uncle, studied. In the following lines, Chang Chün-ming of the Yüan dynasty refers to [Mei] Hsün [962–1041], who was Secretary to the Court:
He sits high in a silver saddle, riding in the spring wind;
He plays an iron flute, astride an ox under the moon.
 Ch'ü-shan, Mei Ch'ing.

玉山俗誤稱土山。突起拳屈，古木叢蔚。中有惠照寺。先人聖俞叔姪，皆讀書於此。元張泼明詩：
春風跨馬銀鞍穩
夜月騎牛鐵笛閒
 謂先尚書公詢也。瞿山梅清。

Leaf 22, 11 lines in regular script:
Here is the poem "Nan-hu" ["South Lake"] by Yeh Tao-ch'ing of the Yüan dynasty:
I travel by boat to South Ch'i Lake,
Setting out from North Ch'i Lake.
The sky floats darkly beyond the water;
No trees can be seen beyond the damp clouds.

 Although there are two lakes—South Ch'i and North Ch'i—the two actually constitute a single lake. The misty waves extend into the distance; ducks and geese fly in rows to the clouds. This is indeed the largest lake of the Wan[-ling] region. I have painted it here in the manner of Yang Wan-li [1127–1206, better known as a calligrapher]. Ch'ü-shan, Ch'ing.

album was Teng Hsing's request that Mei Ch'ing paint for him all the magnificent scenes of the Hsüan-ch'eng region that he had come to love so dearly. Obligingly, Mei Ch'ing not only painted these twenty-four scenes in a topographical manner, but also inscribed on each of them long descriptions of historical and literary episodes. As such, the album is a very important document in the history of Hsüan-ch'eng.

Mei Ch'ing was the leader of the Hsüan-ch'eng School of painting, one of the subgroups of the larger Anhui School that flourished in the seventeenth century. Born into a literati family in 1623, Mei came of age at the crucial juncture between the Ming and Ch'ing dynasties. Unlike many of his contemporaries, who chose to be *i-min* (leftover subjects) after the Manchus conquered the country in 1644, he took the examinations given by the Manchu government in 1654 as the first step in pursuing an official career. Although successful in the first-level examinations, he failed to pass subsequent ones. As a result, he remained in the Hsüan-ch'eng area as a member of the local gentry, as well as the leader of a literary circle. This album evinces his talent in the three arts of painting, calligraphy, and poetry. One unique feature of the album is that Mei Ch'ing used a total of more than sixty of his seals, a larger number than that found on any of his other albums and an indication of his own interest in the project. While a majority of the seals are only of his names and sobriquets, some do indicate how he thought of himself. For example, one seal reads "Po-chien ku-yün," meaning "A lonely cloud on [Mount] Po-chien"; another reads "Meng tsai t'ien-ya," meaning "My dreams are on the horizon." Two of his seals take sentences from T'ao Ch'ien's (365–427) poem "Homeward Bound" ("Kuei-ch'ü-lai tzu"): "Wu chin shih erh tso fei" ("I realize that I was wrong in the past but am on the right track now"), and "Yün wu-hsin i ch'u hsiu" ("Unwillingly, clouds rise from the precipices of the hills"). These lines seem to express his own feelings about his life in Hsüan-ch'eng.

In his later years Mei Ch'ing visited Mount Huang frequently and became known as a member of the Mount Huang School of painters. A number of his albums and hanging scrolls depict many of the beautiful sights of the famous mountain. He consequently became better known as a painter of Mount Huang than of his native town of Hsüan-ch'eng. His Mount Huang paintings are usually free in brushwork, imaginative in rock and mountain forms, and bold in composition. These characteristics are already anticipated in the present album, which shows Mei Ch'ing's interest in bringing out the poetic quality of nature and exploring the potential of brush and ink.

It was in Hsüan-ch'eng and at Mount Huang that Mei became well acquainted with the younger artist Shih-t'ao (1642–1707). Shih-t'ao was said to have spent more than ten years in Hsüan-ch'eng, mostly in the late 1660s and the 1670s, when he was still a young man. Through their association in the Hsüan-ch'eng circle, Mei Ch'ing and Shih-t'ao, despite their age difference, became close friends. As a result, their painting styles also are quite close; in his later years, Mei was strongly influenced by Shih-t'ao's style. The Hsüan-ch'eng album, painted when the artist was fifty-eight *sui* (fifty-seven years old), is an example of Mei Ch'ing's mature style and displays the two major aspects of his art. One is the direct depiction of actual scenery, which reveals the topographical interest typical of the Anhui School. Another is the frequent reference to masters of the past, also characteristic of the Anhui painters. This last characteristic is one of the major differ-

ences between Mei Ch'ing and Shih-t'ao, who seldom referred to old masters. Although he paints in his own style rather than merely imitating the old masters, in his inscriptions Mei mentions as his sources Ching Hao, Tung Yüan, Li Ch'eng, Kuo Hsi, Mi Fu, Liu Sung-nien, Hsia Kuei, Ni Tsan, and Tai Chin.

Since Mei Ch'ing spent all of his of time in Hsüan-ch'eng in his early years and was only fourteen when Tung Ch'i-ch'ang died in 1636, there was no direct contact between the two artists. However, Tung's influence was very extensive during Mei Ch'ing's mature years, and many of Tung's ideas on painting and calligraphy were undoubtedly known to the Hsüan-ch'eng circle and to Mei himself. In the present album, the frequent references to past masters, the arbitrary use of forms, and the emphasis on brush and ink are probably elements that were derived, though indirectly, from Tung Ch'i-ch'ang. On the other hand, he seems not to have been a close follower of the master. In drawing inspiration from the past, he includes artists from both the Southern and Northern schools in Tung's theory. In depicting the scenes of Hsüan-ch'eng, he is more topographical in his approach, and his compositions and brushwork show certain innovations of his own. Still he was an artist of the century in which Tung Ch'i-ch'ang was the dominant figure in artistic development.

CTL

EXHIBITION: Andrew Dickson White Museum, Cornell University, Ithaca, New York, 1965: *The Eccentric Painters of China*.

LITERATURE: Li Yü-fen, *Ou-po-lo shih shu-hua kuo-mu k'ao*, preface dated 1894, *ch.* 2, vol. 95, p. 26; Ch'en Jen-t'ao, *Chin-kuei ts'ang-hua chi*, 1956, vol. 2, p. 47; Li, *A Thousand Peaks and Myriad Ravines*, 1974, pp. 186–99; Mu Hsiao-t'ien, *Mei Ch'ing*, 1986; *Lun Huang-shan chu hua-p'ai wen-chi*, 1987, pp. 206–49.

Fa Jo-chen (1613–1696) 法若真

tzu Han-ju 漢儒, *hao* Huang-shih 黃石, Huang-shan 黃山

Unlike most of the artists represented in the present exhibition, Fa Jo-chen came from northern China. A native and resident of Ch'iao-chou, Shantung, Fa experienced firsthand the initial advances of the Manchu forces as they invaded Shantung in early 1643. He fled with his family to the mountains southwest of his home but was taken hostage by rebels. Although he was soon ransomed by his mother and wife, Fa chose to remain in the relatively safe and peaceful mountain retreat in order to continue his studies of the *Five Classics*.

Though he had obtained a minor official degree under the Ming, Fa Jo-chen, as a northerner, did not share the strong Ming loyalist sentiments of many southerners. In 1645, along with a number of other scholars from the northern provinces, Fa sat for the first provincial examinations under the newly established Ch'ing dynasty. In the follow-

ing year, he became a *chin-shih* and was appointed a Bachelor in the Han-lin Academy. After his promotion to Assistant Reader in the Palace Library, he offended one of the Grand Secretaries and was demoted to the position of Grain Intendant in Chekiang. In his subsequent role as a Circuit Intendant in Fukien, Fa fended off attacks by rebels under the command of Cheng Ch'eng-kung (1624–1662), a former general of the Ming who hoped to restore the dynasty.

Fa Jo-chen's highest ranking position was Provincial Administration Commissioner of Anhui, which he held from 1668 to 1670. Dismissed from office in 1670 on charges of corruption, he continued to hope for reinstatement. In 1679 he was recommended for the special *po-hsüeh hung-tz'u* examination, which had he passed would have led to a new official assignment. Though disappointed by his failure in the examination, Fa Jo-chen was rewarded in the same year with the news that his son Fa Yün had earned his *chin-shih* degree. Fa Jo-chen's long forced retirement until his death in 1696 afforded him the leisure time in which to concentrate on painting, his avocation since the 1640s, and poetry.

146 *Panoramic View of Mount T'ien-t'ai*

T'ien-t'ai shan t'u

法若真　天台山圖

Dated 1681

Handscroll, ink and color on paper
32.4 x 1355 cm (12¾ x 533⁷⁄₁₆ in.)

Beijing Palace Museum

vol. 1, pl. 146

ARTIST'S INSCRIPTION AND SIGNATURE (6 lines in running-regular script):

In the seventh month of the *hsin-yu* year [August 14–September 11, 1681], the twentieth year of the great Ch'ing K'ang-hsi emperor, my son Chang asked for a painting and so I created a scroll of [*Mount*] *T'ien-t'ai*. He must know that at a time of scholarly leisure devoted just to amusement, the creating of precise structure is not a matter of easy sketching. Recorded by an old father of sixty-nine *sui*. Yu-lu.

大清康熙皇爺廿年，辛酉七月，樟兒索畫，乃作《天台圖》一卷，須於讀書之閒時，細心沈玩，知經營結構之匪草草。六十九老父識，友廬。

ARTIST'S SEALS:
Shan-p'i 山癖 (*pai-wen*, square)
Hsiao-chu shan-jen 小珠山人 (*chu-wen*, square)

COLOPHONS: Yen Shih-ch'ing 顏世清 (1873–1929), 1 undated, 1 dated 1919, 4 seals

COLLECTORS' SEALS: Sung K'ai 宋曖, 5; unidentified, 1

This elegant handscroll by Fa Jo-chen was painted for his son, the poet Fa Chang. Previously unpublished and, except for a recent listing, apparently unrecorded, it takes its place with other paintings in the present exhibition as that of an identified geographical location

in south China—in this case, Mount T'ien-t'ai in the province of Chekiang, some fifty miles southwest of the city of Ning-po.

Although Fa Jo-chen was a native of Shantung in the northeast, his close connections with Anhui, perhaps from having served as Lieutenant-governor there in 1668–70, have often earned him a position in the so-called Anhui School of painters. His adoption of the courtesy name (*hao*) Huang-shan, after the famous mountain in southeastern Anhui—a name later used in the title of a collection of more than four thousand of his poems as well as the recorded title of a chronological autobiography (Hummel, *Eminent Chinese*, 1943, pp. 226–27)—can hardly be pure coincidence. Furthermore, the *Panoramic View of Mount T'ien-t'ai*, while revealing unique personal characteristics, is not unrelated to Anhui painting in its application of a fertile imagination to specific scenery, a feature characteristic of works by such contemporaries as Tai Pen-hsiao (1621–1693), Mei Ch'ing (1623–1697), and Shih-t'ao (1642–1707). Before taking up his Anhui post, Fa Jo-chen held a government position in Chekiang, from 1662 to 1664. It is possible that he visited T'ien-t'ai at that time. In any case, the Chekiang-Anhui connection was clearly established for him in the 1660s.

Mount T'ien-t'ai was, like Mount Huang, famous for its natural beauty and other-worldly connotations. As early as the fourth century the poet Sun Ch'o (ca. 300–380) likened it to the fabled isles of immortality in the Eastern Sea, "the very godly essence of mountains and precipices," a place to search for the mushrooms of immortality (*chih* 芝) and communicate with the gods. "I am going to cast off the bounds of this world and send [my spirits] to this mountain to rest," Sun wrote (Fong, *The Lohans and a Bridge to Heaven*, 1958, pp. 18, 19). Around the same time, Mount T'ien-t'ai became closely connected with Buddhism. It was known for its cult of lohans, enigmatic Buddhist sages who were designated as guardians of the Law until the coming of the future Buddha and at Mt. T'ien-t'ai closely associated with a famous natural stone bridge called the Bridge to Heaven. At the end of the sixth century the mountain was the founding center of the T'ien-t'ai School of Buddhism. There, too, was located the Kuo-ch'ing Monastery, reputedly haunted in the T'ang dynasty by the Ch'an (Zen) Buddhist poet-sage Han-shan and his companion Shih-te (see Tokiwa and Sekino, *Shina bunka shiseki*, 1939, vol. 4).

It is the generality of mountain scenery that strikes one most about Fa Jo-chen's vision of this famous site: the rise and fall, openings and closings, and cut-off peaks whose summits cannot be contained within the extended narrow format. The painting was executed in 1681, almost twenty years after Fa Jo-chen served as an official in Chekiang. Although little is known of the details of his life, both the nature of the painting and the fact that Fa's inscription makes no mention of his presence at the site suggests that the painting was anchored in memory and imagination. This was often true of an artist's experience of great mountains. Some thirty years after his close association with the mountain, Shih-t'ao was to recapture the scenery of Mount Huang in paintings from the mind.

The scroll begins abruptly, in the middle of the mountain, with pines and tumbled rocks leading to peaks against the sky. Those acquainted with Chinese painting will immediately recognize here forms indebted to the tenth-century painters Tung Yüan (fl. ca. 945–ca. 960) and Chü-jan (fl. ca. 960–ca. 986). The view then becomes more personal. For long sections the tops of cliffs are out of view, and we are

drawn into a scene that is both lightened and expanded through a softening of tone and passages of brightness that are trails of mist and water, the denial of solidity. There are patches of trees, evergreens and deciduous varieties, with and without leaves and apparently defying any identification of season. Ghostly cliffs hang suspended in this dreamlike setting. The spare spotting of contrasting deep black moss-dots strengthens our perception of what is visionary.

Shortly after midpoint the scroll opens to an even more ephemeral valley whose limits are mist-filled and by implication endless. Then our journey abruptly returns to the base of a symmetrically rising mountain whose summit we never see but whose surface is alive with the accents of tumbling streaks of countless waterfalls, apparently the source of the mist-filled passage we have just left. From here we are drawn into a more distant, tightly interlocked landscape of lesser scale until the whole is carried to an ending of disappearing horizontal lines of far land and peaks. Here the artist's brief inscription rides in the foreground, a statement reminding us that the apparent ease of brush and wash rests on the discipline of structure.

As with the painting and theory of Tung Ch'i-ch'ang, "transmission of the spirit depends on the form" (Fong, "Tung Ch'i-ch'ang and the Orthodox Theory of Painting," 1968, p. 15), and here that form is allowed to stand in the repeated rhythms and variations of rock and mountain shapes largely unhindered and unobscured by distracting detail. The groves of trees guide our passage rather than conceal the way. Only the shadowy shapes of a half dozen boats at the scroll's distant finish present a faint image of man and his works, and remind us how far removed we are from them in this mind landscape only tenuously linked to the everyday world.

The preeminence of bold form parallels that in Tai Pen-hsiao's *The Wen-shu Monastic Retreat* (vol. 1, pl. 137). Fa Jo-chen's structure differs, however, as his outlines are thin and spare and fuse readily with disembodying washes. Nor does he dwell on the specifics of place. His painting is strongly cerebral, illustrating Tung Ch'i-ch'ang's assertion that in brush and ink nature is no match for painting. Here are found no definable natural wonders such as T'ien-t'ai's soaring natural "Bridge to Heaven," no temple (Buddhist or Taoist), and no sign of Han-shan and Shih-te, only the echo of ghostly cliffs.

Although we recognize the style of this scroll as that of a seventeenth-century painter expressing his own personal vision, we cannot separate Mount T'ien-t'ai from its Buddhist background. In an age conscious of history, we must, as with Tai Pen-hsiao, at least in part join Fa Jo-chen's vision of nature to Buddhist understanding. What better than to return to the Six Dynasties, when the mountain was so significant a nature retreat, and to the way in which the consummate nature-Buddhist Tsung Ping (375–443) might have viewed such a painting. In his famous "Landscape Essay," Tsung writes: "I shall open the painting . . . There, with peaks of various shapes towering high and with cloud-covered forest mysteriously stretching afar, I will sense the sages and worthies shining through the innumerable ages and their divine thoughts clearly showing through the myriad spiritual effects [of great nature]. Then what have I to do? I will just let my soul be exalted. When one's soul is exalted, there is nothing more left to do" (translation by Kiyohiko Munakata, "Concepts," 1983, p. 121).

<div align="right">RE</div>

LITERATURE: *Chung-kuo ku-tai shu-hua mu-lu*, vol. 2, 1985, *Ching* 1–3891.

147 *Clouds and Peaks*
Ts'eng-yün tieh-chang
法若真　層雲疊嶂

Undated

Hanging scroll, ink on satin
151 x 48 cm (59⁷⁄₁₆ x 18⅞ in.)

Hsü-pai Chai—Low Chuck Tiew Collection

vol. 1, pl. 147

ARTIST'S INSCRIPTION AND SIGNATURE (2 lines in cursive script): Yün-chan, a *t'ung-nien* of mine, asked for my painting. This is to raise a hearty laugh from him. Huang-shan, Fa Jo-chen.

雲瞻年臺委畫，以當大噱。黃山弟法若真。

ARTIST'S SEALS:
Fa Jo-chen yin 法若真印 (*pai-wen*, square)
Huang-shan na 黃山衲 (*chu-wen*, square)

NO COLOPHONS

COLLECTOR'S SEALS: Low Chuck Tiew 劉作籌 (20th century), 2

LITERATURE: *Kyohokusai*, 1983, cat. no. 56.

148 *Landscape*
Shan-shui
法若真　山水

Undated

Hanging scroll, ink and color on paper
205.8 x 75.2 cm (81 x 29⅝ in.)

Östasiatiska Museet, Stockholm NMOK 50

vol. 1, pl. 148

NO ARTIST'S INSCRIPTION OR SIGNATURE

ARTIST'S SEALS:
Fa Jo-chen yin 法若真印 (*pai-wen*, square)
Huang-shih 黃石 (*pai-wen*, square)

COLOPHON: Wu Tz'u-chih 吳慈治 (19th century), dated 1855, 2 seals

NO COLLECTORS' SEALS

Too little is known about the painting career of Fa Jo-chen to carefully place this towering mountainscape within it. The painting bears no inscription, signature, or date. Two seals guide us to the artist, and the painting's high quality, special style, and unique vision affirm his hand.

This work is a very personal version of the vertical towering mountainscape which, as is true of much seventeenth-century painting, had its roots in a long tradition. The type matured in the Northern Sung in the eleventh century, was overshadowed in the Southern Sung in the twelfth and early thirteenth centuries, when more fo-

cused, intimate views prevailed, and was then revived and consciously reanimated in the Yüan, especially in the brush of Wang Meng (1308–1385). It was continued in the Ming dynasty, most notably in the art of Wen Cheng-ming (1470–1559) and his followers. Indeed, if one adds to the complexities of great towering vertical mountains in nature the complexities of human visions of them, the richness of the theme becomes apparent, its possibilities seemingly endless.

By the seventeenth century this traditional theme of the tall mountain was ready for further transformations. These cannot be restricted to Tung Ch'i-ch'ang, however unique his vision (cf. vol. 1, pl. 32). Somewhat unusual, nevertheless, is the survival of great size when an artist appears to be matching nature's heights and complexities with the physical presence of a towering format. Such paintings take us from the intimacy of the private studio to great palaces and halls, to what might best be described as portable wall-paintings. Only the rich and powerful could afford the proper architectural setting to display such works.

The present landscape, nearly seven feet in height, contrasts markedly with the quieter, more personal, and introspective vision found in Fa Jo-chen's handscroll *Panoramic View of Mount T'ien-t'ai* (vol. 1, pl. 146) dated 1681. In the present painting, the vibrant outlines of rock masses give the mountain a deliberate leftward, upward slanting movement as though charged with visible electricity; but in a more general sense the styles of the two paintings are not incompatible. The vertical scroll, like the horizontal, begins with a strong, dark statement of rocks and trees in the lower right corner and then fades into the softer, more visionary world of the mist-encircled, smoky center. Vibrant linear form reemerges above, as though this were necessary literally to climb the daunting heights that threaten to conceal a hard-pressed sky.

This peculiar overt, slanting, and mannered animation may be of some help in dating the painting. The earliest known dated appearance of this manner is found in a mountainscape of 1687, now in the Shanghai Museum (*Chung-kuo ku-tai shu-hua t'u-mu*, vol. 4, 1990, *Hu 1–2499*). It occurs, more loosely applied, in a published hanging scroll of 1692 (*So-Gen-Min-Shin meiga taikan*, 1931, p. 241). It is also an integral part of the handscroll *Snow Coloring the World White* (*Hsüeh-se chieh t'ien pai*)—although there somewhat muted by a winter scene—dated 1690 and now in the Cleveland Museum (Ho et al., *Eight Dynasties*, 1980, no. 234). The Cleveland scroll, in turn, is stylistically related to another handscroll of the same year in the Tokyo National Museum (*Illustrated Catalogues of the Tokyo National Museum*, 1979, no. 140). Thus it seems likely that the Stockholm *Landscape* was executed close to 1690, in the decade following the artist's *Panoramic View of Mount T'ien-t'ai*.

While Fa Jo-chen's ready political service to the alien Manchus of the Ch'ing dynasty denies him the stance of a Ming loyalist with its implications of individual, even eccentric, withdrawal, he nonetheless emerges as a true literatus: scholar, poet, painter, calligrapher. He was famous as a poet, and we can in part approach him from his poetry, or more correctly—since it is not clear that much of his poetry has survived—from the source of his poetry. The poet of the past he most admired was Li Ho (791–817). Li Ho was not the standard classical poet of familiar anthologies, but one of more recent critical discovery whose lines were charged with strange imagination and visions of an

ever-shifting world, in the words of A. C. Graham, with "fantasies of watching from heaven the land and sea change places over thousands of years . . . halfway across the boundary between the living and the dead . . . a ghostly or demonic genius" (Graham, *Poems*, 1965, pp. 90–91). It is not surprising that an admirer of such poetry painted as he did.

RE

EXHIBITION: The Asia Society, New York, 1967: Cahill, *Fantastics and Eccentrics*, cat. no. 22.

LITERATURE: Sirén, *Later Chinese Painting*, 1938, vol. 2, pl. 184; Sirén, *Leading Masters and Principles*, 1956–58, vol. 2, pl. 357a; *Arts of Asia* (November–December, 1981): 144; Suzuki, *Comprehensive Illustrated Catalogue*, 1982–83, vol. 2, E20–054; Chin Shishin, *Chugoku gajin ten*, 1984, pp. 100–103; *Hai-wai i-chen: Painting III*, 1990, pl. 78.

Pa-ta shan-jen (1626–1705) 八大山人

Buddhist name Ch'uan-ch'i 傳綮, *hao* Hsüeh-ko 雪个, Ko-shan 个山, Lü 驢

Pa-ta shan-jen, a descendant of the Yiyang branch of the Ming imperial family, grew up in the scholarly and artistic environment of his family's ancestral home in Nan-ch'ang, Kiangsi. He received a classical education in preparation for the civil service examinations and passed the first-level examination in the early 1640s, but any youthful ambitions he might have had for an official career were dashed by the Manchu conquest of the Ming in 1644. Shortly after the occupation of Nan-ch'ang by the Manchu forces in 1645, Pa-ta escaped to the mountains northwest of the city, where he took refuge in a Buddhist temple. In 1648 he entered the Buddhist faith and five years later, in 1653, became a disciple of Ying-hsüeh hung-min (1607–1672), a master of the Ts'ao-tung sect of Ch'an Buddhism.

During the thirty years that he lived as a monk in the remote areas of Kiangsi, Pa-ta shan-jen penetrated the complex doctrines of his sect and gained recognition among local Buddhist circles as an outstanding teacher. In 1672, upon the death of Ying-hsüeh hung-min, he was appointed abbot of the Keng-hsiang Monastery in Feng-hsin. Toward the end of the 1670s, Pa-ta began to display signs of mental and emotional instability. His erratic behavior, which may have been feigned, included intermittent and uncontrollable laughing or crying, tearing and burning his clothes, and wild dancing and singing in public places. From surviving documents, it appears that Pa-ta was grappling with some sort of personal crisis that produced debilitating doubts about his dedication to monastic life.

Pa-ta left the monkhood and returned to Nan-ch'ang around 1680. A brief marriage, symbolic of his new status, ended in failure, and during his slow recovery from this emotional crisis, the artist began to devote himself to painting and calligraphy, from which he made a meager living. Early in his life he had studied Tung Ch'i-ch'ang's calligraphy, and

his later paintings exhibit an increasing interest in the art and theory of the master.

Throughout his life, Pa-ta shan-jen remained staunchly loyal to the Ming dynasty. In 1704, long after many of his contemporaries had resigned themselves to Ch'ing rule, he nostalgically commemorated the sixtieth anniversary of the last Ming emperor's death by forgoing painting and calligraphy for an entire year. He resumed painting in the next year, but died shortly thereafter, in his eightieth year. (See Wang and Barnhart, *Master of the Lotus Garden*, 1990.)

149 *Landscape*

Shan-shui

八大山人　山水

Dated 1699

Hanging scroll, ink on paper
152.7 x 72 cm (60⅛ x 28⅜ in.)

Shanghai Museum

vol. 1, pl. 149

ARTIST'S INSCRIPTION AND SIGNATURE (3 lines in cursive script):
One day during the tenth month of the *chi-mao* year [1699] Pa-ta shan-jen painted for elder Hsü.

己卯小春日爲笈老年翁寫。八大山人。

ARTIST'S SEALS:
Pa-ta shan-jen 八大山人 (*chu-wen*, irregular)
Ho-yüan 何園 (*pai-wen*, square)

NO COLOPHONS OR COLLECTOR'S SEALS

Pa-ta shan-jen's serious interest in landscape painting appears to have been limited to the last twelve years of his life, when he was between sixty-eight and eighty *sui* (sixty-seven and seventy-nine years old). His earlier efforts at painting the subject—especially around 1681, the only earlier period for which there is any documentation—now seem isolated and abandoned, as if somehow unsatisfactory to him, and it is only much later, from about 1693 until his death in 1705, that he returns to the subject and explores it consistently and thoroughly. There were undoubtedly many reasons for this curious pattern, including some that were deeply psychological and symbolic (Wang and Barnhart, *Master of the Lotus Garden*, 1990, pp. 70, 140–44), but it is certain that Tung Ch'i-ch'ang's art and theories became the basis for Pa-ta's mature study of landscape painting. He had carefully studied and copied Tung's calligraphy early in his life, at a time when he painted mainly bird and flower subjects and his occasional landscapes were still in the tradition of Su-chou to which his family adhered. Now, toward the end of his life, he found in Tung's art and writing the direction for his own private exploration of landscape.

Among the concrete documents of Pa-ta's lifelong study of Tung Ch'i-ch'ang are the following:

The album of six leaves of landscapes copied after Tung Ch'i-ch'ang

(vol. 1, pl. 152; Wang and Barnhart, *Master of the Lotus Garden*, cat. no. 53, pp. 178–81), dated stylistically by Joseph Chang to circa 1697.

A letter to Ching Lao of around 1702 in which Pa-ta expresses an interest in buying calligraphy and paintings by Tung Ch'i-ch'ang (Wang and Barnhart, *Master of the Lotus Garden*, p. 283).

A landscape hanging scroll dated April 18, 1703, copied after a work by Tung (Wang and Barnhart, *Master of the Lotus Garden*, p. 276, no. 157).

These documents indicate that for a period of at least thirty years Pa-ta shan-jen collected, studied, and copied the calligraphy and painting of Tung Ch'i-ch'ang. Pa-ta's mature landscape painting is in fact unimaginable without the precedent of technique, style, pictorial structure, and pattern of historical allusion created by Tung Ch'i-ch'ang.

The present landscape is one of two large hanging scrolls of the subject extant that were painted by Pa-ta in the late fall and early winter of 1699 (both in the Shanghai Museum; for the other scroll, see Wang and Barnhart, *Master of the Lotus Garden*, p. 271, no. 122). One is done in the bold, wet brush manner Pa-ta associated with the progenitor of Tung's Southern School, Tung Yüan (fl. ca. 945–ca. 960), in the period from 1696 to 1699, and therefore comes at the end of a four-year sequence of such works. The other is created from the spare, dry brush manner of Ni Tsan (1301–1374), who epitomizes the austere, restrained extreme of Southern School landscape, and is among the earliest in a series of such paintings done by Pa-ta during the last years of his life (for a later example, see the Beijing album of landscapes, vols. 1 and 2, pl. 150).

The present landscape is perhaps the last of the large, strong, freely brushed, wet, and exuberant works painted by Pa-ta before he began producing the spare, dry, ethereal images that typify his last years. In this Tung Yüan style, Pa-ta uses round and curving rock and mountain forms and wet, flat, smooth brushwork. A companion to the Shanghai scroll is the great Stockholm *Landscape after Tung Yüan* of circa 1696 (Wang and Barnhart, *Master of the Lotus Garden*, p. 165, fig. 96). The two are so similar that the dating of the Stockholm picture might better be given as circa 1696–99 instead of circa 1696, a date arrived at by comparison with the landscape album leaves datable to 1696 (Wang and Barnhart, *Master of the Lotus Garden*, p. 163, fig. 95). Indeed, dating Pa-ta's undated landscapes is still difficult and uncertain, a problem for the present exhibition only with the set of four hanging scrolls from Melbourne (vol. 1, pl. 151), whose actual date of execution could vary by as much as ten years. The present Shanghai scroll of 1699 has much in common with the set of six undated album leaves after Tung Ch'i-ch'ang (vol. 1, pl. 152), especially in the shading of rock and mountain forms, which is yet another reason for dating the album leaves to the period after 1697. Clearly one of the things Pa-ta shan-jen learned from his study of Tung's landscape painting was how to create the illusion of solid rock and mountain forms through shading (*ts'un-fa* 皴法) and how to create solid compositional structures. These things became less and less interesting to Pa-ta in the end, however; and the wispy, smokelike images of his last years are like faint echoes of great events that happened long ago.

Tung Ch'i-ch'ang's Southern School of landscape painting had special meanings for Pa-ta shan-jen. For the displaced former prince of the Ming imperial family, the south was the symbolic direction of the true emperors of China—his relatives, destroyed by the Manchus

along with the dynasty itself. The south was the same object of loyalty it had been for Cheng Ssu-hsiao (1241–1318), the leftover subject (*i-min*) of the former Sung dynasty who lived on under the Mongol conquerors of China with the name So-nan (Face the South). For Pa-ta shan-jen, and perhaps for other followers of Tung Ch'i-ch'ang (both individualist and orthodox masters), the Southern School was undoubtedly symbolic of an anti-Manchu sentiment. The Manchus represented the north, a development in the north-south artistic debate intensified by Tung Ch'i-ch'ang's theories that he obviously could not have anticipated.

It is odd that the central rock shape in Pa-ta's landscape resembles both a melon and an egg, since such egglike shapes are fairly uncommon in Chinese landscape painting. Pa-ta was painting them regularly by around 1698 (in the San Francisco album of landscapes and calligraphy, for example; Wang and Barnhart, *Master of the Lotus Garden*, cat. no. 54, pp. 181–83), and they seem almost to grow directly out of his earlier preoccupation with melons. Melons were among the carefully selected symbols of himself and his life, and he painted them as virtual self-portraits in earlier years (Wang and Barnhart, *Master of the Lotus Garden*, cat. no. 8, pp. 104–6). Like melons, containing so many seeds, eggs too are symbols of ancestry and progeny—two of Pa-ta's psychological preoccupations, since he lost his ancestry and failed to create progeny. He did not directly paint eggs, as far as I know, but he endlessly painted birds, fish, chickens, and ducks—the producers of eggs—and occasionally humorously suggested eggs in his images of small birds resting on rocks or melons that resemble nesting birds (Wang Tzu-tou, *Pa-ta shan-jen shu-hua chi*, 1983, vol. 2, p. 259).

By this time in his long, dangerous, and troubled life, a village of a few houses lost in remote mountains such as that depicted here was probably Pa-ta shan-jen's dream. In fact, he lived with utmost spareness in a dark room or two in the city of Nan-ch'ang, Kiangsi, the traditional residence of the great princely family he alone survived to represent. Undoubtedly he wandered in such mountains as these, so they are probably both dream and reality shaped by the prism of Tung Ch'i-ch'ang's legacy.

RMB

EXHIBITION: The Memorial Museum of Pa-ta shan-jen, Nan-ch'ang, 1986.

LITERATURE: Wang Tzu-tou, *Pa-ta shan-jen shu-hua chi*, 1983, vol. 1, p. 89; *Chung-kuo ku-tai shu-hua mu-lu*, vol. 3, 1987, Hu 1–2735; *I-yüan to-ying* 37 (1987): frontispiece; *Chung-kuo ku-tai shu-hua t'u-mu*, vol. 4, 1990, Hu 1–2735; Wang and Barnhart, *Master of the Lotus Garden*, 1990, p. 271.

150 *Landscapes*

Shan-shui

八大山人　山水

Dated 1702

Album of ten paintings, ink on paper

26 x 41 cm (10¼ x 16⅛ in.)

Beijing Palace Museum

vol. 1, pl. 150 (leaves 1–3, 5, 7, 10); vol. 2, pl. 150 (leaves 4, 6, 8, 9)

ARTIST'S INSCRIPTIONS AND SIGNATURES:

Leaves 2, 5, 6, 8, 9, 1 line in running script:
Pa-ta shan-jen.

八大山人。

Leaf 7, 2 lines in running script:
Pa-ta shan-jen painted.

八大山人寫。

Leaf 10, 2 lines in running-cursive script:
Pa-ta shan-jen painted at Wu-ko Thatched Hall on the seventh day of the first month of the *jen-wu* year [February 3, 1702].

壬午人日寫于寤歌草堂。八大山人。

ARTIST'S SEALS:

Shih-te 拾得 (*pai-wen*, rectangle; leaves 1, 3, 4, 5, 10)
Pa-ta shan-jen 八大山人 (*chu-wen*, irregular; leaves 2, 4, 5, 6, 7, 8, 9, 10)
Chen-shang 真賞 (*chu-wen*, square; leaf 7)
Ho-yüan 何園 (*chu-wen*, square; leaf 10)

NO COLOPHONS

COLLECTORS' SEALS: Chou To-ling 周多齡, 6; Wang Wen-hsin 王文心, 7; unidentified, 4

Pa-ta shan-jen painted this album of ten landscapes at the beginning of his seventy-seventh year. In these final years of his life small albums were his favorite format for landscape, and he painted a great many of them. The most closely comparable example may be the album of eight leaves done one year later, in the third month of 1703, and now in the collection of Wang Fangyu and Sum Wai (Wang and Barnhart, *Master of the Lotus Garden*, 1990, cat. no. 69, pp. 208–9). Both represent Pa-ta's own final form of the Southern School, vaguely recalling Tung Yüan (fl. ca. 945–ca. 960), Mi Fu (1051–1107), Huang Kung-wang (1269–1354), and Ni Tsan (1301–1374)—and, of course, Tung Ch'i-ch'ang. Tung himself had been especially drawn toward the spare, remote images of Ni Tsan in his last years, and now in his own final years Pa-ta too followed Tung's precedent and turned again and again toward the Yüan master. Pa-ta hated predictable patterns and expectations, so there is no neat sequence of styles and no discernible program based upon historical themes. Over half the album is empty paper.

Working throughout with dry brush and dilute ink wash, constructing each picture slowly and deliberately, Pa-ta began with one of his odd melon and egg compositions. A tiny "Village of Three Houses" is visible in the distance. Misshapen pine trees stretch out as if in imitation of the earthen contours they reflect. Along the right edge two empty pockets appear. One is a balloon of space in which a pine tree grows from an egg, the other a pool of water in which two rocks are visible. The seal, Shih-te, after the strange T'ang Ch'an monk of the same name, is half hidden in the lower right corner. All landscape paintings of the time consist basically of rocks and trees, like these; yet these resemble no other in their combined idiosyncrasies.

Seven of the paintings are extended over the full width of the paper, but three of them, the second, third, and last, are done on only one half, as if on one leaf of a folded double page. The creases down the center of each page indicate that the original format was that of a

book of facing pages. Pa-ta's friend and fellow townsman Lo Mu (1622–1708) used the same format, and sometimes Pa-ta himself inscribed poems on such albums (see *Christie's*, December 1, 1986, no. 81). These empty pages, then, were probably left for poetic inscriptions that were never written. In fact, I know of scarcely any paintings by Pa-ta shan-jen on which contemporary inscriptions appear. It was presumably difficult, and possibly dangerous, to inscribe a painting by this eccentric former monk who was still loyal to a nonexistent dynasty. To my knowledge, the one contemporary who did write directly and dramatically on a Pa-ta painting was his royal cousin, the great artist Shih-t'ao (1642–1707; see Wang and Barnhart, *Master of the Lotus Garden*, cat. no. 45, pp. 168–69), who mistakenly believed that Pa-ta was dead when he inscribed the painting.

The second and third leaves feature rocky landscapes done with a slanted dry brush like Ni Tsan. Ni's empty pavilion is seen in the third leaf, while in the second a colossal pine echoing in wood the stone cliff behind it towers over another hidden village of six houses.

The fourth, ninth, and tenth leaves all feature grassy rolling or cone-shaped mountains in the manner of Mi Fu. It is odd to see the traditionally wet and freely splashed Mi style now desiccated and autumnal—yet, to my eyes, the unattainably remote, miniature Mi-style landscape of the penultimate leaf is like the very essence and marrow of the entire southern tradition. One sees in it the spirit of Tung Yüan and Chü-jan (fl. ca. 960–ca. 986), of Mi Fu and Mi Yu-jen (1074–1151), of the Hsiao and Hsiang rivers, of Chao Meng-fu (1254–1322), and of Ni Tsan.

The four central leaves (5, 6, 7, and 8) are all treescapes of the kind Pa-ta loved to paint in his later years. Obviously, as for so many other painters, trees were for Pa-ta a specially personal reflection and metaphor. He learned to paint them by copying Tung Ch'i-ch'ang's trees (that seems clear), but he changed them into his own. They are strikingly anthropomorphic, almost like self-images. Everything Pa-ta painted is a kind of self-image, of course; indeed everything every painter paints is a kind of self-image, but we lack the knowledge to read them as such. In Pa-ta's trees, however, is probably the essence of his physical appearance at the age of seventy-seven. His trees are awkward, graceless, misshapen, missing most of their branches, oddly bent and twisted. Seamlessly integrated with rocks, earth, and water, they join earth to heaven, and transform death and decay into life and growth. Trees must have seemed to Pa-ta shan-jen symbolic of his own strange life, and when as here he slowly drew their images with his brush he was almost certainly remembering his past while revealing his arthritic joints, his thin, bent form, his receding chin, and his thinning hair.

RMB

LITERATURE: *Chung-kuo ku-tai shu-hua mu-lu*, vol. 2, 1985, *Ching* 1–4246; Wang and Barnhart, *Master of the Lotus Garden*, 1990, p. 274, no. 144.

151 *Landscapes*
Shan-shui
八大山人　山水

Undated

Four hanging scrolls, ink and color on satin
168 x 44 cm (66⅛ x 17⁵⁄₁₆ in.)

National Gallery of Victoria, Melbourne

vol. 1, pl. 151

ARTIST'S SIGNATURE (scroll 1; 1 line in running script):
Pa-ta shan-jen
八大山人

ARTIST'S SEALS:
Pa-ta shan-jen (?) 八大山人 (*chu-wen*, square; scrolls 1, 3, 4)
Pa-ta shan-jen 八大山人 (*pai-wen*, square; scroll 1)
She-shih 涉事 (*pai-wen*, rectangle; scrolls 1, 2, 3)

NO COLOPHONS

COLLECTOR'S SEALS: Wang Chi-ch'ien 王季遷 (b. 1907), 4

RECENT PROVENANCE: Wang Chi-ch'ien

EXHIBITIONS: Poughkeepsie, New York, 1973: Giacalone, *Chu Ta*, cat. nos. 3A–3D; Yale University Art Gallery, 1991: Wang and Barnhart, *Master of the Lotus Garden*, 1990, cat. no. 31.

LITERATURE: *Bunjinga suihen*, vol. 6, *Hachidai Sanjin*, 1977, pp. 73–76; Pang, *Zhu Da, the Mad Monk Painter*, 1985, figs. 7a–d; Pang, "A Landscape Quartet by Zhu Da," 1986, pp. 24–31; Chang, "Bada Shanren," 1987, p. 145.

152 *Landscapes in the Manner of Tung Ch'i-ch'ang*
Fang Tung Ch'i-ch'ang shan-shui
八大山人　仿董其昌山水

Undated

Album of six paintings, ink on paper
31 x 24.6 cm (12³⁄₁₆ x 9¹¹⁄₁₆ in.)

Wang Fangyu and Sum Wai Collection

vol. 1, pl. 152

ARTIST'S INSCRIPTIONS AND SIGNATURES:
Leaf 1, 3 lines in running script:
Imitating the brushwork of my clan's Pei-yüan [Tung Yüan, fl. ca. 945–ca. 960].
仿吾家北苑筆意。

Leaf 2, 2 lines in running script:
The Long Shade of Summer Trees, Hsüan-tsai [Tung Ch'i-ch'ang] painted.
《夏木垂陰》玄宰畫。

Leaf 3, 2 lines in running script:
The Immortal's Residence amid Streams and Mountains, Hsüan-tsai
painted.

《溪山仙館》玄宰寫。

Leaf 4, 5 lines in running script:
Water Village, Hsüan-tsai painted.

《水邨圖》玄宰畫。

Leaf 5, 2 lines in running script:
While passing on the Lou River, I unrolled Huang Tzu-chiu's [Huang
Kung-wang, 1269–1354] painting, *The Main Range of Fu-yang*, and
picked up a brush to paint this. Hsüan-tsai.

婁江道中展黃子久《富陽大嶺圖》，拈筆寫此。玄宰。

Note: Pa-ta probably mistook the character *ch'un* 春 for *yang* 陽; the
title of the painting should be *The Main Range of Fu-ch'un*.

Leaf 6, 4 lines in running script:
Ni yü's [Ni Tsan, 1301–1374] painting is plain and natural (*p'ing-tan
t'ien-chen*), without the vulgar habits and mannerisms of ordinary paint-
ers. This album is a copy of the authentic work in the Wang family col-
lection. Hsüan-tsai.

倪迂畫平淡天真，無畫史縱橫俗狀。此冊臨王氏所藏真蹟也。玄
宰。

ARTIST'S SEALS:
Pa-ta shan-jen (?) 八大山人 (*chu-wen*, irregular; leaves 1–6)

COLOPHON: Chang Ta-ch'ien 張大千 (1899–1983), undated, 2 seals

COLLECTORS' SEALS: Wang Tzu-t'ao 汪子濤, 3; Chang Ta-ch'ien, 10;
Sum Wai 沈慧 (20th century), 1

EXHIBITION: Yale University Art Gallery, New Haven, 1991: Wang and
Barnhart, *Master of the Lotus Garden*, 1990 cat. no. 53.

LITERATURE: Chang Ta-ch'ien, *Ta-feng-t'ang ming-chi*, 1955–56, vol. 3,
pls. 14–19; Sirén, *Leading Masters and Principles*, 1956–58, vol. 6, pl. 386;
Chang Wan-li and Hu Jen-mou, *Pa-ta shan-jen shu-hua chi*, 1969, vol. 2,
pl. 39; Chou Shih-hsin, *Pa-ta shan-jen chi ch'i i-shu*, 1974, pp. 6–11;
Suzuki, *Comprehensive Illustrated Catalogue*, 1982–83, vol. 1, A19–022.

Shih-t'ao (1642–1707) 石濤

Original name Chu Jo-chi 朱若極, *tzu* Yüan-chi 原濟, *hao* K'u-kua ho-
shang 苦瓜和尚, Ta-ti-tzu 大滌子, Hsia-tsun-che 瞎尊者, Ch'ing-
hsiang lao-jen 清湘老人

Shih-t'ao, born Chu Jo-chi, a scion of one branch of the Ming imperial
family enfeoffed in Kuei-lin, Kwangsi, was orphaned in 1645 when a
rival claimant to the Ming throne imprisoned or killed the members of
his family. Rescued from death by a loyal retainer, he found refuge in
the Buddhist church where he concealed his identity by adopting the re-
ligious appellations Yüan-chi and Shih-t'ao. By the age of ten, he was
living in Wu-ch'ang, Hupei, where he began to study calligraphy and
painting. For reasons that are still unclear, Shih-t'ao was forced to leave
Wu-ch'ang in the early 1660s; after a period of wandering that took
him to monasteries on Mount Lu and in the Chiang-nan region, he be-
came a disciple of Lü-an pen-yüeh (d. 1676), a powerful Ch'an master
who had followed his teacher Mu-ch'en tao-min (1596–1674) in serving
the first Ch'ing emperor, Shih-tsu (Shun-chih, r. 1644–61) at the
Ch'ing court. After spending a period in Lü-an's entourage, at K'un-
shan, Kiangsu, in 1666 Shih-t'ao took up residence at a monastery in
Hsüan-ch'eng, Anhui, a location that offered a kindred community of
scholars and artists as well as convenient access to the commercial and
cultural center of She-hsien and the inspiring scenery of Mount Huang.
During the next fourteen years Hsüan-ch'eng served as a home base for
Shih-t'ao though he continued his peripatetic lifestyle, making extended
sojourns to Yang-chou, Sung-chiang, Nanking, She-hsien, and Mount
Huang, which he climbed in 1667, 1669, and 1676.

In 1680 Shih-t'ao transferred his residence to the Ch'ang-kan (Pao-
en) Monastery in Nanking where he practiced Ch'an austerities in his
own retreat, the I-chih-ko (Single Branch Studio). While becoming an
acknowledged Ch'an master, he also made the acquaintance of a wide
spectrum of Nanking society from Ming loyalists to Ch'ing officials. In
1684 he met the K'ang-hsi emperor (r. 1662–1722) when the Manchu
ruler visited Nanking on his first southern inspection tour. Responding
to encouragement from members of the imperial entourage, Shih-t'ao
began planning a trip to the capital. When the trip fell through, he de-
cided to settle in the commercial city of Yang-chou, to which he had
moved early in 1687. In 1690, after meeting K'ang-hsi again during the
emperor's second southern tour, Shih-t'ao was inspired to visit Peking,
but his trip brought him neither royal preferment nor advancement
within the Ch'an establishment. Disillusioned with the Buddhist church
and Ch'ing court, he returned south in late 1692, but was unable to
find either a permanent residence or peace of mind. For four years he
lived as a guest at temples or with patrons in the Nanking–Yang-chou
region, during which time he suffered from illness as well as a growing
sense of homelessness and inner turmoil. Alienated by the politicized
Buddhist clergy and regretting his own worldly ambitions, Shih-t'ao
identified increasingly with other Ming loyalists, and even began to ac-
knowledge his Ming princely heritage. Finally, in 1697, he renounced
his status as a monk, and, identifying himself with Mount Ta-ti, a Tao-
ist holy site with Sung loyalist associations, he sought to wash away his
past errors, declaring himself to be Ta-ti-tzu, the "Great Cleansed One."

The final decade of Shih-t'ao's life was one of great creative activity.
Supporting himself through his art, he produced a tremendous number
of paintings and completed a painting treatise, the *Hua-yü-lu*, in which
he set forth his theories in creativity and art. Although the text does
not mention Tung Ch'i-ch'ang, it is concerned with many of the same
core issues that interested Tung: "imitation, transformation, spiritual
correspondence, and individual style" (Fu and Fu, *Studies in Connoisseur-
ship*, 1973, p. 52). Where the two artists differ is largely a matter of em-
phasis: while Tung stresses the primacy of antique models as a source of
inspiration, Shih-t'ao emphasizes the importance of directly experienc-
ing the physical world.

MKH

153 *The Sixteen Lohans*

Shih-liu tsun-che

石濤　十六尊者

Dated 1667

Handscroll, ink on paper
46.3 x 600 cm (18¼ x 236¼ in.)

The Metropolitan Museum of Art, New York
Gift of Douglas Dillon, 1985 (1985.227.1)

vol. 1, pl. 153

ARTIST´S INSCRIPTION AND SIGNATURE (1 line in regular-clerical script):
[In the] *ting-wei* year [1667], the "grandson" of T'ien-t'ung Min [Mu-ch'en tao-min, 1596–1674], and the "son" of Shan-kuo Yüeh [Lü-an pen-yüeh, d. 1676]. Shih-t'ao, Chi.

丁未年，天童忞之孫，善果月之子，石濤濟。

ARTIST´S SEALS:
Chi shan-seng 濟山僧 (*pai-wen*, rectangle)
Ch'ing-hsiang Shih-t'ao 清湘石濤 (*pai-wen*, rectangle)

INSCRIPTION: Mei Ch'ing 梅清 (1623–1697), undated, 2 seals:
Among the inspired practitioners of monochrome drawing (*pai-miao*), the very best is Lung-mien [Li Kung-lin, ca. 1049–1106]. Most [works attributed to him] that I have seen are imitations, not authentic.

Master Shih-t'ao's *Sixteen Lohans* [possesses] exquisite detail, bravura [brush] movements, and divinely interesting composition, brushwork, and ink washes that almost exhaust [the possibilities of] creative metamorphosis. He said that this handscroll took one year from start to finish. I have set it out on my table and admired it tens of times, but I have never been able to exhaust one ten-thousandth [of its richness]. Respectfully written by Ch'ü-shan Mei Ch'ing.

白描神手首善龍眠，生平所見多贋本，非真本也。
　　石濤大士所製《十六尊者》，神采飛動，天趣縱橫，筆痕墨跡變化殆盡。自云：「此卷閱歲始成。」予嘗供之案前，展玩數十遍，終不能盡其萬一，真神物也。瞿山梅清敬識。

LABEL STRIP: Wang Lü-pen 汪律本 (1867–1930), dated 1914

FRONTISPIECE: Wang Ch'ang 王昶 (1725–1806), undated, 3 seals

COLOPHONS: Wu Jung-kuang 吳榮光 (1773–1843), dated 1836, 2 seals; Li Jui-ch'ing 李瑞清 (1867–1920), undated, 2 seals; Hsü Heng 徐衡 (fl. first half of the 20th century), dated 1939, 3 seals; Chang Ta-ch'ien 張大千 (1899–1983), dated 1952, 2 seals

COLLECTORS´ SEALS: Huang Chung-ming 黃仲明 (18th century?), 2; Wu Jung-kuang, 1; Wu Yüan-hui 伍元蕙 (fl. ca. 1820–60), 5; Chou Yu 周遊 (20th century), 1; Chu Jung-chüeh 朱榮爵 (fl. first half of the 20th century), 8; Hsü Po-chiao 徐伯郊 (contemporary), 2

RECENT PROVENANCE: Ch'eng Ling-sun, Chu Jung-chüeh, Hsü family

Shih-t'ao's early masterpiece, *The Sixteen Lohans*, completed in Hsüan-ch'eng when he was only twenty-five years of age, is striking testimony to the young monk's involvement in the Buddhist faith. The handscroll, which according to Mei Ch'ing's inscription took Shih-t'ao a year to paint, depicts the sixteen guardian lohans (in Sanskrit, *arhats*, or "saints") ordered by the Buddha to live in the mountains and protect the Buddhist Law until the coming of the future Buddha.

Figures are set within a tripartite landscape setting in which tranquil opening and closing sections resembling a scholar's garden frame a turbulent middle zone where the hidden forces of nature are made manifest. In the opening scene, seven lohans lean against a tree or sit around a stone platform while one of their number reads from a scroll. The lohans' poses and activities recall classic depictions of scholars in a garden, such as *Literary Gathering at the Liu-li Hall* (Fong and Hearn, "Silent Poetry," 1981–82, pp. 22–23, fig. 12). In place of the household servants and scholarly accoutrements found in these secular gatherings, however, the lohans burn incense, study a bundle of sutra scrolls, play with a lion cub, or are waited upon by Indian-looking attendants and one of the guardian kings of the four directions. The final section of the scroll offers a continuation of the garden imagery: two holy men seated in chairs beside a large rock pause in their conversation to welcome two more of their number escorted by a fabulous beast and two extravagantly clad retainers.

In between these gardenlike mossy plateaus with low horizon lines, powerful tectonic forms expand beyond the picture frame, drawing the viewer deep inside the mountains to a magical interior world of grotto-heavens. Only a thin wall of stone separates the garden where sutras are being read from the figure of a lohan meditating in a cavern together with his tiger: a striking image of Shih-t'ao's complementary worlds of "external" and "internal" cultivation. To the left, massive boulders and serpentine outcrops divide this cave from a cleft in the rock where three lohans and an attendant sprite look on as the "dragon-tamer" lohan releases his genielike emanation from a bottle. The dragon, emblem of the cosmic forces of creation, coils at the center of a vortex of rock and water, constantly transmuting one into the other to make new life.

Throughout his life Shih-t'ao used art to explore his own identity. How are we to interpret this painting's complex imagery, which juxtaposes serene garden settings with an untamed landscape punctuated by yawning grottoes and a maelstrom of cosmic forces? Concealing his family background behind the trappings of the Buddhist church, Shih-t'ao was no ordinary monk and his painting is hardly a typical religious icon. Living in obscurity in southern Anhui, Shih-t'ao undoubtedly identified with these reclusive holy men whose own identities could only be fulfilled with the advent of the messianic Maitreya Buddha. The scroll's references to literary gatherings are a reminder, however, that Shih-t'ao's duties as a Buddhist monk did not preclude his participation in secular pursuits such as the local "poetry and painting society" to which both he and Mei Ch'ing belonged (Wang Shi-qing, "*Ch'iu-feng wen-chi* chung yu kuan Shih-t'ao ti shih-wen," 1979, p. 46). Ultimately Shih-t'ao's image of himself as both monk and scholar is subsumed within the role of artist-creator. Deep in the mountains, in the center of his composition and at the very wellspring of creation, Shih-t'ao presents us with a powerful image of himself as the "dragon-tamer" lohan, from whose brushlike inverted bottle flow the rocks, trees, and myriad creatures of his personal universe.

Stylistically, Shih-t'ao's monochrome drawing (*pai-miao* 白描) links his work to that of the eleventh-century scholar, artist, and devout Buddhist Li Kung-lin. But Shih-t'ao must have seen Li more as a role model to emulate than as the source of a specific style he could copy. As Mei Ch'ing points out in his inscription, genuine works by Li Kung-lin were exceedingly rare; it is unlikely that a young monk

would have had access to creditable examples of his art. Instead, the immediate sources for Shih-t'ao's figures were woodblock prints and the works of such late Ming painters as Wu Pin (fl. ca. 1591–1626). Unlike Wu Pin's lohans which, by comparison, seem to be merely grotesque caricatures, Shih-t'ao's intimately observed figures possess such thoroughly human qualities as humor and curiosity. Another original feature of Shih-t'ao's treatment of this theme is his placement of his figures within a continuous landscape setting. In earlier depictions of the sixteen lohans, including one by the twelfth-century monk Fan-lung (Lawton, *Chinese Figure Painting*, 1973, no. 20) as well as one by Wu Pin (Fong and Hearn, "Silent Poetry," pp. 54–57, figs. 40–42), landscape motifs function like stage props while most figures are silhouetted against a blank ground. Shih-t'ao has integrated his lohans within a richly described environment that functions as an integral part of the narrative.

According to his biographer Li Lin (1634–1707), Shih-t'ao collected old books even before he could read (Wang Shiqing, "*Ch'iu-feng wen-chi* chung yu kuan Shih-t'ao ti shih-wen," p. 46); his indebtedness to woodblock images is evident from the linear character of his painting. Landscape forms are described using almost no textures strokes; instead, rocks and trees are built up through the repetition of concentric contour lines, occasionally filled in with wash. Basing his approach on the principle of dynamic interaction of such yin-yang complements as dark and light, dry and wet, angular and curved, or pattern and ground, Shih-t'ao animates his painting through the continuous variation of linear patterns, stroke thickness, and ink tonality. The intricate textile patterns and facial features of the lohans, drawn in fine brushstrokes that barely graze the paper, contrast with the sooty black trunks of spidery trees and the broad dry-brush outlines of the rocks. Graded washes serve less to model form than to create alternating patches of light and dark. In addition, every line is animated with graphic energy; even the strokes of wash that fill in the sky are made to work: over the heads of the lohans gazing at the dragon, the lines of gray wash radiate outward as if responding to the cyclonic currents that emanate from the dragon.

What is most remarkable about *The Sixteen Lohans*, and what amazed Mei Ch'ing, is how this young artist, working with only a limited number of stylistic sources, was able to create such vibrant figures and landscape images. One reason for Shih-t'ao's originality is that, even at this early age, he was not seeking to imitate a specific style or antique model; rather, he was already absorbed in creating images that were deeply expressive of his own world and of himself.

MKH

A later copy of this composition is also in the collection of The Metropolitan Museum of Art (13.220.37).

EXHIBITIONS: National Museum of History, Taipei, 1984: *Paintings and Calligraphy of Pa-ta and Shih-t'ao*, no. 10; North Carolina Museum of Art, Raleigh, 1992: Weidner, *Latter Days of the Law*.

LITERATURE: Edwards, *The Painting of Tao-chi*, 1967, pp. 27–28, fig. 4; Fu and Fu, *Studies in Connoisseurship*, 1973, p. 36, fig. 1; Fu et al., *Sekito, Bunjinga suihen*, vol. 8, 1976, fig. 6; Wang Shiqing, "*Ch'iu-feng wen-chi* chung yu kuan Shih-t'ao ti shih-wen," 1979, pp. 46–47; Fong and Hearn, "Silent Poetry," 1981–82, pp. 4–5, 69–75, figs. 1, 51–53; Fong et al., *Images of the Mind*, 1984, pp. 199–200, fig. 165; *The Metropolitan Museum of Art: Asia*, 1987, pp. 104–5, pl. 66.

154 *Bamboo Retreat under Fantastic Peaks*

Ch'i-feng chu-yin

石濤　奇峰竹隱

Dated 1682

Hanging scroll, ink and color on paper
200.7 x 69.2 cm (79 x 27¼ in.)

Shanghai Museum

vol. 1, pl. 154

ARTIST'S INSCRIPTION AND SIGNATURE (5 lines in running script):
Waterfall thundering down like lightning.
Fantastic peaks pile toward the sky like clouds.
Fish in the stream can be counted one by one.
Mountain flowers are sometimes seen and sometimes smelled.
If only one can lie on a rock-pillow underneath,
The fragrance will surely saturate one's clothes.
　On the first day of the twelfth month of the *hsin-yu* year [January 9, 1682], I added this inscription at the I-chih Studio for Ts'an-hsi's amusement. Shih-t'ao, Chi.

飛瀑亂分若電
奇峰疊漢如雲
谿魚歷歷可數
山花忽見忽開
但能枕石其下
自然香滿衣裙
　辛酉十二月一日，一枝室中屬粲兮先生補題。一咲。石濤，濟。

ARTIST'S SEAL:
Chi shan-seng 濟山僧 (*pai-wen*, rectangle)

NO COLOPHONS

COLLECTORS' SEALS: Chang Shan-tzu 張善孖 (1882–1940), 1; Chang Ta-ch'ien 張大千 (1899–1983), 3

LITERATURE: *Chung-kuo ku-tai shu-hua mu-lu*, vol. 3, 1987, *Hu* 1–3112; *I-yüan to-ying* 36 (1987): 6; *Ssu-kao-seng hua-chi*, 1990, pl. 26; Zheng Wei, *Shih-t'ao*, 1990, p. 26.

155 *Wonderful Conceptions of the Bitter Melon: Landscape Album for Liu Shih-t'ou*

K'u-kua miao-ti

石濤　苦瓜妙諦

Dated 1703

Album of twelve paintings, ink and ink and color on paper
48 x 31.8 cm (18⅞ x 12½ in.)

The Nelson-Atkins Museum of Art F83–50/1–12

vol. 1, pl. 155 (leaves 1–3, 6, 7, 10–12); vol. 2, pl. 155 (leaves 4, 5, 8, 9)

ARTIST'S INSCRIPTIONS AND SIGNATURES:
Leaf 1, 11 lines in regular script:
Sitting high above looking down at everything around. This is the spirit

cultivated by those who practice the art of ink and brush in their lives. Lofty and extraordinary, clear and distinct, like military armors in clouds, sometimes hidden and sometimes visible. Figures, plants, boats and carriages, cities and suburbs—everything is clearly and reasonably shown. This makes the viewers desire to go into the mountains. Ta-ti-tzu.

盤礴睥睨乃是翰墨家生平所養之氣。崢嶸奇崛，磊磊落落，如屯甲聯雲，時隱時現。人物、艸木、舟車、城郭，就事就理，令觀者生入山之想乃是。大滌子。

Leaf 2, 4 lines in clerical script:
Spring grasses are green;
Spring river has green waves;
Spring breeze lingers playfully.
Who will not sing about this?
 Ch'ing-hsiang lao-jen, A-ch'ang.

春草綠色
春水綠波
春風留戲
孰爲不歌
 清湘老人，阿長。

Leaf 3, 25 lines in running script:
In depicting tree leaves and moss colors, ancient people used dots, sometimes in light ink and sometimes in thick ink, in shapes like the characters *fen, ko, i, chieh, p'in,* and *mo,* and arranged them in threes and fives, like those in *wu-t'ung,* pine, cypress, and willows, sometimes hanging down and sometimes slanting down, to show different kinds of leaves and various types of trees, mountains, and winds. However, I am different. For dots, I have dots for rainy, snowy, windy, and clear days and for all seasons. I have negative and positive dots and yin and yang dots, complementing each other; dots with water and dots with ink, all mixed together; dots for holding budding flowers, for algae lines, fringes, and joining strings; empty, broad, dry and tasteless dots; dots with ink, without ink, flying white and smokelike; and dots burnt like lacquer, dark and transparent. There are also two other kinds of dots that I have not been willing to reveal to scholars. There are dots that show no heaven or earth but seem to cut right in front of you; there are also dots that show absolute quietude over a thousand peaks and myriad ravines. Alas, there are no definite rules; only the spirit makes them the way they are! In autumn days of the *kuei-wei* year [1703], I noted down these ideas in this painting done for Mr. Liu Shih-t'ou. Ta-ti-tzu.

古人寫樹葉、苔色，有淡墨、濃墨，成分字、个字、一字、介字、品字、厶字，已至攢三聚五，梧葉、松葉、柏葉、柳葉等，垂頭、斜頭諸葉，而行容樹木、山色、風神泰度。吾則不然。點有雨、雪、風、晴，四時得宜點。有反正陰陽襯貼點，有夾水、夾墨，一氣混襍點；有含苞、藻絲、纓絡、連牽點；有空空闊闊乾遭沒味點；有墨無墨飛白如煙點；有焦似漆邋遢透明點。更有兩點未肯向學人道破。有沒天沒地當頭劈面點；有千巖萬壑明靜無一點。噫！法無定相；氣慨成章耳！時癸未秋日，爲石頭劉先生寫畫拈出請正。大滌子。

Leaf 4, 4 lines in clerical script:
In the practice of this art, there are things that do not meet the taste of their own time but are deeply appreciated by later people; there are also things that make thundering sounds deafening people's ears in their own time but are never heard again in later periods. It is a matter of not meeting the understanding people. Ta-ti-tzu.

此道有彼時不合眾意，而後世鑒賞不已者。有彼時轟雷震耳，而後世絕不聞問者。皆不得逢解人耳。大滌子。

Leaf 5, 10 lines in running-regular script:
The Yellow River comes down from the sky to the rivers and the sea,
After ten thousand *li* pouring into my bosom.
In its midst is a sacred mountain up in the heavens,
With white clouds rolling amid layers of misty clouds.
At its gate huge valleys compete under the waterfalls.
Whose red cinnabar is on its very top?
I often stop my brush to look over it,
Much better than riding the heavenly horse in the sky.
 Ta-ti-tzu.

黃河落天走江海
萬里瀉入胸懷間
中有岳靈踞霄漢
白雲滾滾迷松關
當門巨壑爭泉下
絕頂丹砂誰人者
我時住筆還自看
猶勝飛空駕天馬
 大滌子。

Leaf 6, 11 lines in regular-clerical script:
Rosy clouds on a clear day above the water look like mosses on rocks;
Layers and layers of them open up in my painting.
The recluse loves the scene under fine autumn light;
Even in early evening he still does not want to return.
 Ch'ing-hsiang, Ta-ti-tzu.

水面晴霞石上苔
層層疊疊畫中開
幽人戀住秋光好
薄暮依然未肯回
 清湘，大滌子。

Leaf 7, 9 lines in running-cursive script:
The generative forces of Heaven and Earth are crystallizing
And gradually unfold the four seasons and morning and evening.
Through the vital principle in nature,
They will leave something wonderful for a hundred generations.
 Ch'ing-hsiang, Ta-ti-tzu, A-ch'ang.

天地氤氳秀結
四時朝暮垂垂
透過鴻濛之理
堪留百代之奇
 清湘，大滌子，阿長。

Leaf 8, 10 lines in running-regular script:
Your high reputation in calligraphy and painting is well known,
Showing you high above the superficial people.
This old man is among the superficial ones;
This inscription by my quick, colored brush is for your laugh.
 Ch'ing-hsiang, Ta-ti-tzu presenting this to Mr. Shih-t'ou for his comment.

書畫名傳品類高
先生高出眾皮毛
老夫也在皮毛類
一笑題成迅綵毫
 清湘，大滌子呈石頭先生博教。

Leaf 9, 8 lines in running-cursive script:
The rhythm of the waterfall from the autumn brook over the rock is light;
Cold arrives over morning peaks and misty trees.

There is painting in poetry among the light, frosty red leaves,
To be seen at will by your cold eyes.

 Hsia-tsun-che.

秋澗石頭泉韻細
曉峰煙樹乍生寒
殘紅霜葉詩中畫
博意任從冷眼看
 瞎尊者。

Leaf 10, 7 lines in clerical script and 1 line in regular script:
The flowing water contains the cold from the clouds;
The fisherman returns after his fishing trip.
What is it like up in the mountains?
The falling leaves are flying like birds.

 Ta-ti-tzu, A-ch'ang.

流水含雲冷
漁人罷釣歸
山中境何似
落葉如鳥飛
 大滌子，阿長。

Leaf 11, 6 lines in running-regular script:
Rapid wind sweeps over the wide lake, with waves hitting my head;
Though the boat is small, the fisherman's interest is hard to control.
Please take off your gray silk hat [of an official],
When the moon is up you can adjust the fishing line for your game.

 Ta-ti-tzu.

風急湖寬浪打頭
釣魚船小興難收
請君脫去烏紗帽
月上絲綸再整遊
 大滌子。

Leaf 12, 13 lines in running-regular script:
Mr. Shih-t'ou is pure and elegant in taste;
His heart is aimed at expression of culture.
Ten thousand *li* of great waves have washed his bosom;
Wind and snow all over the sky have sharpened his eyes.
Five thousand volumes of distinguished books are on his shelves;
Three hundred *hu* of fine wine are in his cellar.
He reads a volume and pours a cup of wine.
In purple gown, smiling, he relaxes in his house under plum blossoms.
Rapid sleet flies around without interruption.
Cold waves run down the wintry banks.
As a Ch'an monk I would like to sweep away my writing,
But find myself composing poetry for his high ideals.

 For Mr. Shih-t'ou, my senior of the same year. Ch'ing-hsiang ch'en-jen, A-ch'ang.

石頭先生耽清幽
標心取意風雅流
萬里洪濤洗胸臆
滿天冰雪眩雙眸
架上奇書五千軸
甕頭美酒三百斛
一讀一卷傾一巵
紫裘笑倚梅花屋
急霰飛飛無斷時
凍波森森滾寒涯
枯禪我欲掃文字
鄰爲高懷漫賦詩
 冬日爲石頭先生年道長并正。清湘陳人，阿長。

ARTISTS' SEALS:
Ch'ien yu Lung-mien Chi 前有龍眠濟 (*pai-wen*, rectangle; leaves 1, 2)
Ch'ing-hsiang lao-jen 清湘老人 (*chu-wen*, oval; leaf 3)
Yüan-chi, K'u-kua 元濟　苦瓜 (*pai-chu wen*, rectangle; leaf 3)
Ch'ing-hsiang Shih-t'ao 清湘石濤 (*pai-wen*, rectangle; leaves 4, 6, 9, 12)
Kao-huang-tzu Chi 膏肓子濟 (*pai-wen*, square; leaf 5)
Sou chin ch'i-feng ta ts'ao-kao 搜盡奇峰打草稿 (*pai-wen*, square; leaf 7)
Tsan chih shih-shih sun, A-ch'ang 贊之十世孫阿長 (*chu-wen*, rectangle; leaf 8)
Hsia-tsun-che 瞎尊者 (*chu-wen*, square; leaf 10)
A-ch'ang 阿長 (*pai-wen*, square; leaf 11)
Ts'ang chih ming-shan 藏之名山 (*pai-wen*, square; leaf 12)

FRONTISPIECES: Chin Ch'eng 金城 (1878–1926), dated 1926, 2 seals; Wang Jung-pao 汪榮寶 (early 20th century), undated, 1 seal

COLOPHONS: Li Jui-ch'ing 李瑞清 (1867–1920), undated, 1 seal; Chou Chao-hsiang 周肇祥 (1880–1954), undated, 2 seals; Ch'eng Ch'i 程琦 (20th century), 1 dated 1968, 1 undated, 3 seals

COLLECTORS' SEALS: Liu Hsiao-shan 劉小山 (early 18th century), 1; Ma Yüeh-kuan 馬曰琯 (1688–1755) and Ma Yüeh-lu 馬曰璐, 1; Ch'in Tsu-yung 秦祖永 (1825–1884), 1; Lu Shu-sheng 陸樹聲 (19th century), 1; Chin Ch'eng (1878–1926), 1; Chin K'ai-fan 金開藩 (1895–1946), 1; Wang Jung-pao (1878–1953), 1; Ch'eng Ch'i, 4; unidentified, 1

RECENT PROVENANCE: Ch'eng Ch'i

Of the large number of albums Shih-t'ao painted during his life, perhaps the two most important are the landscape album in the Museum of Fine Arts, Boston (Edwards, *The Painting of Tao-chi*, 1967, cat. no. 33), and this *K'u-kua miao-ti* album in The Nelson-Atkins Museum. In size, they are the largest of his albums. In composition, they are the most complex. They both reveal Shih-t'ao's range in brushwork and colors and demonstrate some of his major theories on art. They are the gems among his works—possibly the best embodiments of Shih-t'ao's art in his last years.

The two albums were painted in the same year, 1703, when Shih-t'ao was sixty-two *sui* (sixty-one years old). They passed through the same collections in the eighteenth century, for they bear seals of "Hsiao-shan" and the Ma brothers of Yang-chou. Until recently "Hsiao-shan" was identified as Wang Hsiao-shan, a contemporary of Shih-t'ao's in Yang-chou, there being a seal reading "Wang" in both albums. The Boston album is dedicated to Hsiao-shan, the Nelson-Atkins album to Liu Shih-t'ou. It is now known that the two dedicatees are the same person. Evidence for this is found in a hanging scroll by Shih-t'ao—*Orchids*, now in the Nanjing Museum—which bears three poems above the painting (*Chung-kuo ku-tai shu-hua t'u-mu*, vol. 7, 1989, *Su* 24–0658). One of the poems is by Liu Shih-t'ou; the other two are by Chu K'an-p'u, who mentions that he wrote his poems in response to his *t'ung-hsüeh* 同學 (schoolmate) Liu Hsiao-shan (Liu Shih-t'ou). This identification brings the two albums much closer to each other, since it confirms that they were done by Shih-t'ao for the same person.

Liu Hsiao-shan seems to have been a prominent figure in Yang-chou in Shih-t'ao's time, though strangely he is not mentioned in Li Tou's *Yang-chou hua-fang lu*, the standard reference on the city's cultural activities during that period. In the Nelson-Atkins album, Shih-t'ao describes him as a person of "pure and elegant" taste, who had

traveled throughout the country; he had a library of five thousand volumes of outstanding books and a cellar of good wine. In one leaf Liu is praised for his high reputation in both calligraphy and painting, and in another he is urged to take off his "gray silk hat" of an official. These comments suggest that Liu was a man of high position and wealth as well as taste and culture, and thus a patron of Shih-t'ao in his last years in Yang-chou. Still, it seems strange that Liu is not recorded in any of the sources on Yang-chou in that period.

That the Boston and Nelson-Atkins albums are the largest of Shih-t'ao's works in this format indicates that they were done as commissions for an important patron rather than for a close personal friend. In both paintings and poetry, Shih-t'ao must have striven to satisfy the taste of his patron. Apparently Liu Hsiao-shan was so pleased with the first album he received from Shih-t'ao (the Boston album was done in the second month of 1703) that he requested more paintings. This circumstance makes the later Nelson-Atkins album (done in autumn of the same year) all the more interesting and valuable.

It must have been in the same period that Shih-t'ao also wrote his famous treatise, the *Hua-yü-lu*, as a number of the ideas expressed in the inscriptions to the two albums are similar to certain sections of that work. His criticism of superficial imitation of past masters (one should follow one's heart), his discussion of the generative forces of Heaven and Earth, and his insistence on direct inspiration from nature all can be found in both the treatise and the albums. Thus both represent the culmination of Shih-t'ao's theory and art in the last years of his life. This demonstrates the important place that the present *K'u-kua miao-ti* album holds in the life of Shih-t'ao.

Shih-t'ao was born six years after the death of Tung Ch'i-ch'ang and therefore could not have known him. However, because Tung's influence was extensive during his time, Shih-t'ao must have known about Tung's ideas. Since he spent two years (1662–64) studying Ch'an Buddhism under the monk Lü-an pen-yüeh (d. 1676) in Sung-chiang, Kiangsu, Tung's hometown, Shih-t'ao must have been aware of some of Tung's works. In one respect, Shih-t'ao and Tung seem to have been at opposite ends of the spectrum: Tung was a great advocate of studying the old masters, while Shih-t'ao rejected this practice. There is no mention in any of Shih-t'ao's writings about Tung's theories of the Southern and Northern schools of painting. Moreover, Tung derives his forms from past masters, while Shih-t'ao takes his landscape elements from nature. In one major respect, however, Shih-t'ao seems to have come close to Tung: that is, the emphasis on brush and ink and the power of transformation as the basis for the artist's creation. Shih-t'ao seems to have grasped the basic spirit of Tung's essential ideas while rejecting some of the superficial aspects of them. The *K'u-kua miao-ti* album reflects this link to Tung Ch'i-ch'ang.

CTL

LITERATURE: Lu Hsin-yüan, *Jang-li-kuan kuo-yen lu*, 1892, *ch.* 36, pp. 18–21; Edwards, *The Painting of Tao-chi*, 1967; Ch'eng Ch'i, *Hsüan-hui t'ang shu-hua lu* (*hua*), 1972, pp. 145–48; Cahill, *Compelling Image*, 1982; Li, "Shih-t'ao te K'u-kua miao-ti ts'e," 1988, pp. 91–97.

156 *Large Landscape Album*
Shan-shui ta-ts'e

石濤　山水大冊

Undated

Four album leaves, ink on paper
47.5 x 31.2 cm (18¹¹⁄₁₆ x 12⁵⁄₁₆ in.)

Bei Shan Tang Collection

vol. 1, pl. 156

ARTIST'S INSCRIPTIONS AND SIGNATURES:
Leaf 1, 4 lines in running-cursive script:
Moss colors, waterfall sounds, a thousand *chang* of painting;
Plum blossoms, bamboos, a hill in my poetry.
In vain I see myself getting old in winds and dust;
Totally intoxicated, I am painting like a fool.
　　Ch'ing-hsiang, Ta-ti-tzu, Ch'ing-lien ts'ao-ko.

苔色水聲千丈畫
梅花竹子一山詩
予生徒向風塵老
爛醉揮毫有是癡
　　清湘大滌子，青蓮草閣。

Leaf 2, 9 lines in running-regular script:
With doors at home closed, life seems to be ordinary all year round;
But once outside the city into open fields I can let myself be wild.
Taking the small path I shall not meet any courteous guest;
In the open fields I rest my back to talk to poets.
It is not because of old friendship that we play the same tune;
We can be totally free to enjoy ourselves like this.
Laughing loudly I seem to be in the precious city today;
Under the red trees all over the sky I become totally intoxicated in my writings.
　　Ta-ti-tzu.

常年閉戶鄰尋常
出郭郊原忽恣狂
細路不逢多揖客
野田息背選詩郎
也非契闊因同調
如此歡娛一解裳
大咲寶城今日我
滿天紅樹醉文章
　　大滌子。

Leaf 3, 5 lines in running-regular script:
The hill looks awkward, mixing earth and rocks;
The tree looks old, being half alive and half dead.
The road looks white and grasses dry, beaten by frost;
With bird sounds around, I bid farewell to my guest with affection.
　　Ching-chiang hou-jen, A-ch'ang.

山笨夾土夾石
樹古半死半生
路白草枯霜打
鳥聲送客多情
　　靖江後人，阿長。

Leaf 4, 9 lines in running-regular script:
Painting within poetry comes from temperament in man. As such, poetry cannot be done after painting is done in imitation of either Chang

or Li [i.e. either this or that]. Poetry within painting comes from feeling for nature. As such, painting cannot be done after poetry is made by force or power. When we first come into contact with reality, like depicting images from a mirror, we cannot tolerate it. But people nowadays are bound to be rude to poetry and painting. Hsiao-ch'eng k'o, A-ch'ang.

詩中畫，性情中來者也。則畫不是可擬張擬李而後作詩。畫中詩，乃境趣時生者也。則詩不是便生吞生剝而後成畫。真識相觸，如境寫影，初何容心。今人不免唐突詩畫矣。小乘客，阿長。

ARTIST'S SEALS:

Ling-ting lao-jen 零丁老人 (*chu-wen*, square; leaf 1)
Tsan chih shih-shih sun A-ch'ang 贊之十世孫阿長 (*chu-wen*, rectangle; leaf 2)
Ch'ien yu Lung-mien Chi 前有龍眠濟 (*pai-wen*, rectangle; leaf 3)
A-ch'ang 阿長 (*pai-wen*, square; leaf 3)
Ch'ing-hsiang Shih-t'ao 清湘石濤 (*pai-wen*, square; leaf 4)
Ch'ing-hsiang ko 清湘閣 (*chu-wen*, rectangle; leaf 4)

NO COLOPHONS

COLLECTORS' SEALS: Liu Hsiao-shan 劉小山 (early 18th century), 1; Ma Yüeh-kuan 馬曰琯 (1688–1755) and Ma Yüeh-lu 馬曰璐, 1; unidentified, 3

There is no question that these four album leaves in the Bei Shan Tang Collection are related to the two leaves in Stockholm (vol. 1, pl. 157), the *K'u-kua miao-ti* album in The Nelson-Atkins Museum (vols. 1 and 2, pl. 155), and the album in the Museum of Fine Arts, Boston (Edwards, *The Painting of Tao-chi*, 1967, cat. no. 33). Although the present leaves are not dated, they are almost identical in size to those in the other three collections and bear the same set of eighteenth-century seals—those of Liu Hsiao-shan (Liu Shih-t'ou), to whom the Nelson-Atkins and Boston albums are dedicated, and the Ma brothers, who were well-known collectors in Yang-chou. In addition, the two unidentified seals in the Bei Shan Tang album, reading "Ching-hsi" and "Wang," are also found in the Nelson-Atkins and Boston albums. The brushwork and compositions in the present leaves also share the same characteristics as those in the other albums. These similarities indicate that the four leaves in the Bei Shan Tang collection and the two leaves in Stockholm probably had the same history as the Boston and Nelson-Atkins albums during the eighteenth century.

In this context, it is not difficult to assume that they were also done for Liu Hsiao-shan at about the same time, in 1703, since Liu's seal appears on all four leaves. The fact that there are only four leaves in this album raises questions about the original form of the album. Did Liu ask Shih-t'ao to paint a large number of leaves of the same size and then have them mounted in separate albums of twelve leaves each? That more than half a year separates the Nelson-Atkins *K'u-kua miao-ti* from the Boston album indicates that Shih-t'ao probably painted these leaves during the year, either as a guest at or a frequent visitor to Liu's house. Was the Ch'ing-lien ts'ao-ko (Thatched Pavilion of Green Lotus), where one of these leaves, as well as some of the leaves in the Boston album, was done, a building in Liu's garden? (The name of this pavilion actually appears in Shih-t'ao's works as early as 1700, and it has generally been taken as one of his studios

in Yang-chou.) These are interesting questions, but they cannot be answered with any certainty.

It seems likely that each of the three albums was in a standard form of twelve leaves, and that the Nelson-Atkins and Boston works remain in their original form. If this is the case, the four leaves of the Bei Shan Tang album have been separated from the other eight. This seems reasonable, as all four leaves are in ink only, whereas in the other two albums there is a mixture of leaves in ink and in color. Among the four leaves here we can find quite different calligraphic styles and compositions, and different artist's seals. The inscriptions, however, reveal a typical Shih-t'ao, always expressing his own feelings about himself, his world, and his art.

CTL

LITERATURE: Fu et al., *Sekito, Bunjinga suihen*, vol. 8, 1976; Suzuki, *Comprehensive Illustrated Catalogue*, 1982–83, vol. 2, s7-041.

157 *Large Landscape Album*
Shan-shui ta-ts'e
石濤　山水大冊

Undated

Two album leaves, ink on paper
47.9 x 32.3 cm (18⅞ x 12¹¹⁄₁₆ in.); 47.7 x 31.7 cm (18¼ x 12½ in.)

Östasiatiska Museet, Stockholm NMOK 447, NMOK 448

vol. 1, pl. 157

ARTIST'S INSCRIPTIONS AND SIGNATURES:
Leaf 1, 4 lines in regular-clerical script:
Awakened, I concentrate my mind on my sketches;
I draw lines to resemble seal and clerical scripts.
In one generation there must be one man to take hold,
To attain the supreme expression in the world.
 On a summer day, Ch'ing-hsiang, K'u-kua, Ch'ih-chüeh.

悟後運神草稿
鈎勒篆隸相形
一代一夫執掌
羝羊掛角門庭
　　夏日，清湘苦瓜，癡絕。

Leaf 2, 5 lines in running-regular script:
Among the peaks and ravines trees are old;
At the bottom of the brook things are dark.
A recluse comes to see the bamboos.
The teeth of his wooden shoes break the moss.
The wisterias across the river blossom;
I feel relaxed and content in my mind.
From the long flute comes the autumn music;
The evening sun is cutting into the shadows.
 Ta-ti-tzu, A-ch'ang.

樹老巔崟間
陰生澗底黑
幽人看竹來
屐齒破苔色

對岸藤花開
悠然心自得
長篷起秋聲
夕陽光影蝕
　　大滌子，阿長。

ARTIST'S SEALS:

Tsan chih shih-shih sun A-ch'ang 贊之十世孫阿長 (*chu-wen*, rectangle; leaf 1)

Ssu-pai feng chung jo-li-weng t'u-shu 四百峰中箬笠翁圖書 (*pai-wen*, square; leaf 1)

Ling-ting lao-jen 零丁老人 (*chu-wen*, square; leaf 2)

No colophons

COLLECTORS' SEALS: Liu Hsiao-shan 劉小山 (early 18th century), 1; Ma Yüeh-kuan 馬日琯 (1688–1755) and Ma Yüeh-lu 馬日璐, 1; Wang Chi-ch'ien 王季遷 (b. 1907), 2; unidentified, 3

RECENT PROVENANCE: Wang Chi-ch'ien

The two Stockholm leaves are slightly larger than those in the Shih-t'ao album in The Nelson-Atkins Museum (vols. 1 and 2, pl. 155) and the four album leaves in the Bei Shan Tang Collection (vol. 1, pl. 156), but the difference may be due to remounting. Indeed, these two leaves are so similar to those in the other albums that they must have come from the same group, which also includes the album of 1703 in the Museum of Fine Arts, Boston (Edwards, *The Painting of Tao-chi*, 1967, cat. no. 33). Like the Bei Shan Tang leaves, both leaves are done in ink only and are inscribed with poems by the artist. Two of the three seals of the artist are identical to those in the Bei Shan Tang album. In addition, the leaves bear the same eighteenth-century seals as those in the other three albums. Thus the relationship of the Stockholm leaves to the other three albums seems clear. They were painted for Liu Hsiao-shan (Liu Shih-t'ou), probably in the same year, 1703. Indeed, they may originally have belonged to the same album as the Bei Shan Tang leaves and later became separated from them, most likely in the twentieth century.

The link between these two leaves and those in the Bei Shan Tang Collection becomes even stronger when other collectors' seals are taken into account. The "Ching-hsi" seal, found on one of these leaves, also appears on at least two leaves in the Bei Shan Tang album as well as seven leaves in the Nelson-Atkins album and four leaves in the Boston album. Two of the seals on the Stockholm leaves belong to a "Mei-hsüeh chai" (Plum Snow Studio) of a Mr. Kuan, which correspond to one seal of the same studio in the Bei Shan Tang album.

Each of the Stockholm leaves shows Shih-t'ao's originality in composition and variety in brushwork. They support the suggestion already made in the previous two entries that in all of these albums—presumably done for the same recipient, Liu Hsiao-shan—Shih-t'ao was attempting to summarize his life's work in painting, poetry, and the theory of art. The thirty leaves in the four albums present a broad range of ideas and forms of expression, and in that sense the albums together document Shih-t'ao's lifelong artistic achievement.

CTL

158 *Landscapes of Mount Huang*
Huang-shan t'u

石濤　黃山圖

Undated

Album of twenty-one paintings, ink and ink and color on paper
30.8 x 24.1 cm (12⅛ x 9½ in.)

Beijing Palace Museum

vol. 1, pl. 158 (leaves 1, 3, 4, 6, 8, 10–12, 14, 17, 19, 21); vol. 2, pl. 158 (leaves 2, 5, 7, 9, 13, 15, 16, 18, 20)

NO ARTIST'S INSCRIPTIONS OR SIGNATURES

ARTIST'S SEALS:

Chih-yüeh 指月 (*chu-wen*, oval; leaves 2–5, 8, 9, 14, 15, 19)
Lao T'ao 老濤 (*pai-wen*, rectangle; leaves 7, 10, 12, 13, 16, 20)
Lao T'ao 老濤 (*chu-wen*, oval; leaf 11)
Chi 濟 (*pai-wen*, square; leaves 17, 18)
Chi shan-seng 濟山僧 (*pai-wen*, square; leaf 21)

NO COLOPHONS

COLLECTOR'S SEAL: unidentified, 1

This remarkable album of twenty-one views of Huang-shan (Yellow Mountain), the famous cluster of peaks in southeastern Anhui, is important not so much because of its subject—already well known as a theme for seventeenth-century painters and Shih-t'ao in particular—as for its revelation of further dimensions in the artist's approach to the great mountain. This can best be described as being in the nature of fresh and spontaneous insights in which brush and ink, ink and discrete color are marvelously blended, a series of close and intimate views both rich and restrained. There is no signature of the artist. If the paintings were once accompanied by leaves of calligraphy (an introduction, postscript, or explanatory text), that is no longer the case. We are left only with a single, usually tiny, bright red seal sensitively placed on all but one leaf and the quality of the painting itself as assurance of Shih-t'ao's authorship.

There is a marked difference between this album and the most famous of the other surviving views of Mount Huang by Shih-t'ao, the *Eight Views of Mount Huang* in the Sumitomo Collection in Kyoto. The Sumitomo album is a sophisticated, elegant construct often combining two important scenes or sites in a single leaf, with the addition of poetry and an appropriate commentary, sometimes in double inscriptions, and completed by the more self-conscious impressions of numerous artist's seals (*Bunjinga suihen*, 1976, vol. 8, figs. 41–48). The handscroll *Landscape of Mount Huang*, dated 1699 and also in the Sumitomo Collection represents a passage of some thirty years of Shih-t'ao's close association with the mountain. Although certain peaks are recognizable, the painting has the distant touch of memory confirmed by a visual remoteness through which the visitor is magically elevated above the tops of trees, foreground peaks, and clouds to survey, however compellingly, a world removed in both space and time (*Bunjinga suihen*, vol. 8, figs. 4, 5). His handscroll done the following year, in 1700 (Chih-lo Lou Collection), portraying the Beginning to Believe Peak and the Stone Bamboo-shoot Screen, presents remarkable formations in a frontal profile carefully spread across the paper's surface more in the nature of a painted woodblock print than

a subtle painting confronting us with the immediate mysteries of these extraordinary sites (*Ming i-min*, 1975, no. 20).

Viewers of the present exhibition may compare Shih-t'ao's views of Mount Huang with the approach of other seventeenth-century painters: Hung-jen (vols. 1 and 2, pl. 115), K'un-ts'an (vol. 1, pl. 118), Tai Pen-hsiao (vol. 1, pl. 137), and, for other scenery in the region, Mei Ch'ing (vols. 1 and 2, pl. 145). Of these works, the Hung-jen album, which predates Shih-t'ao's first visit to Mount Huang, is the most comparable in subject. The two albums offer contrasting styles, however. Although similarly using light color, Hung-jen presents far more purified abstractions, cut with the dry outlines of his often angular brush and therefore removed from warmer, more intimate, and even immediately earthy atmospheric effects.

Wang Shiqing has outlined Shih-t'ao's early travels that eventually led him to Mount Huang: from Mount Lu in Kiangsi and Mount Ta-ti in Chekiang to Hang-chou and thence to Hsüan-ch'eng in Anhui, where he arrived in 1666. The next year he was at Mount Huang, a visit he repeated in 1669, which resulted in an extensive album of seventy-two views, one peak depicted in each leaf, painted at the request of the Prefect Ts'ao Ting-wang (1618–1690) (Wang Shiqing, *Ch'iu-feng wen-chi* chung yu kuan Shih-t'ao ti shih-wen, 1979, pp. 46, 47). One cannot help but suspect that the twenty-one leaves presented here have some connection with this early comprehensive effort—not so much the finished result, perhaps, as a series of personal sketches leading to it.

Many of the scenes in the Beijing album can be identified by comparison with other contemporary paintings of the mountain: Hung-jen's albums of sixty views, of which ten are shown in the present exhibition (vols. 1 and 2, pl. 115); Tai Pen-hsiao's hanging scroll *The Wen-shu Monastic Retreat* (vol. 1, pl. 137); and a Mei Ch'ing album now in the Shanghai Museum (*Chung-kuo ku-tai shu-hua t'u-mu*, vol. 4, 1990, *Hu* 1–2682). The album opens with the "Gateway" in leaf 1 and is followed by the depiction of different sites, most of which, pending further study, may be initially identified as follows:

Leaf 2, Nine Dragon Pools (Chiu-lung t'an 九龍潭)
Leaf 3, Refining Cinnabar Platform (Lien-tan t'ai 煉丹台)
Leaf 4, Moon Pagoda (Yüeh-t'a 月塔)
Leaf 5, Wen-shu Monastic Retreat (Wen-shu yüan 文殊院)
Leaf 6, Reclining Dragon Pine (Wo-lung sung 臥龍松)
Leaf 7, Single Thread to Heaven (I-hsien t'ien 一綫天)
Leaf 8, Beginning to Believe Peak (Shih-hsin feng 始信峯), with a view of Cloud Sea (Yün-hai 雲海) and the top of Stone Bamboo-shoot Screen (Shih-sun chiang 石筍矼)
Leaf 11, Wine Herb Gorge (Chiu-yao hsi 酒藥谿)
Leaf 12, Round Mat Pine (P'u-t'uan sung 蒲團松)
Leaf 14, White Dragon Pool (Pai-lung t'an 白龍潭)
Leaf 15, Lotus Peak (Lien-hua feng 蓮華峯)
Leaf 17, Tz'u-kuang Temple (Tz'u-kuang ssu 慈光寺)
Leaf 18, Hot Springs (T'ang-ch'üan 湯泉)
Leaf 19, Twisted Dragon Pine (Jao-lung sung 擾龍松)
Leaf 21, Close view of Nine Dragon Pools

The other five leaves provide no specific clues about the identity of the site depicted. This is partly the result of Shih-t'ao's lively imagination, which infuses all the paintings; the presentation is not stereotyped. According to Shih-t'ao's friend and biographer Li Lin (1634–

1707), early experiences of the mountain stirred in the young artist, then only in his late twenties, a "wild joy" (k'uang-hsi 狂喜) that inspired his painting and raised it to a level in which his own expression spontaneously and without conscious attempt acquired qualities of the old masters, explicitly those of the Sung and Yüan periods (Wang Shiqing, *Ch'iu-feng wen-chi* chung yu kuan Shih-t'ao ti shih-wen, pp. 46, 47). In pointing to such easy naturalness, Li Lin implies that Shih-t'ao, following the long history of Chinese aesthetics, has reached the highest level of creativity. Reviewing these twenty-one leaves, one is hard pressed to recognize any surface debt to specific old masters, with the possible exception of leaf 10, which carries suggestions of Huang Kung-wang (1269–1354).

While exact connections to the apparently lost album of 1669 cannot be affirmed, there is little doubt that the Beijing album is early and generally fits Li Lin's critical appraisal of Shih-t'ao's paintings of Mount Huang. Each leaf has the freshness and spontaneity of a skilled young artist on first reacting to the mountain's natural wonders. Both the mystery and the ecstasy of the mountain may be summed up in leaf 8, a high, deep-distance view featuring Beginning to Believe Peak, a dizzying elevation of a layered and overhanging cliff summit, the emptiness of the cloud-sea penetrated by the far tips of Stone Bamboo-shoot Screen. Human figures, however small, offer important focus. Here two tiny, briefly sketched climbers—one rose, one blue; one huddled in contemplation, the other with arms raised in ecstatic joy—condense the psychological meaning of such a view.

In exploring the album, one is struck by its ever-shifting variety. Dominated by ink and brushline or wash, there is also restrained color, antiquarian suggestions of blue-green in rock or peak, a blue-gray roof, a red or green leaf, a blue sky, black wiry trees. Along with the vibrancy of brush there is oddity of shape; the interlocking relations of cliff, peak, and boulder that swell and rise; streams that turn and tumble; paths of ephemeral access; and swiftly sketched humans that walk, plod, sit, stand, stare, point, are sheltered or in the open, emerge and disappear. Perhaps the largest of these figures (the painter-traveler?) hovers portraitlike over Reclining Dragon Pine in leaf 6. In leaf 12 three scholars sit atop the Round Mat Pine, unperturbed by its sharp, upward pointing needles. (In 1693 Mei Ch'ing was to use the same convention; *Chung-kuo ku-tai shu-hua t'u-mu*, vol. 4, *Hu* 1–2682.) The midstream boulder that is a main focus in Wine Herb Gorge (leaf 11) appears magically suspended. Lotus Peak, its upper reaches shown at close range in leaf 15, retains the legendary moon-rock with its cave circle and visionary branch, as also depicted by Tai Pen-hsiao (vol. 1, pl. 137). The cliffside pine in leaf 13 may be drawn from the same natural source as Hung-jen's *Yellow Sea Cliff Pines* in the Shanghai Museum (*Chung-kuo ku-tai shu-hua t'u-mu*, vol. 4, *Hu* 1–2443). Shih-t'ao's pine stretches suspension to the limit, with more of the tree's roots reaching for nourishment from the air than clinging to the rock.

Such twists of form and meaning, individually unique, evince a style that fits what we know of Shih-t'ao's early manner. His hand-scroll *Sixteen Lohans* of 1667 in The Metropolitan Museum of Art (vol. 1, pl. 153) was painted at the time when the artist was first becoming acquainted with Mount Huang. While there is a contrast between a handscroll and an album leaf, between something created from the mind and forms, however imaginatively presented, disciplined by con-

crete nature, between the iconography of Buddhist sages and mountain-dwarfed humans, between no color and occasional color, the two works share in common a dynamic force that surges through the rocky setting of the lohans and the rocks painted in various leaves of the album. This is in particular the result of a "graphic energy" of line, as noted by Maxwell Hearn in his discussion of the Metropolitan Museum handscroll. But parallels can also be seen in specifics: the pointed moss-dots, leaf convention, black-limbed wiry trees, and rocks and cliffs contoured in repeated layers.

Finally, the evidence of seals helps secure an early date. Judgment must be made on published versions of the seals rather than on exact impressions, but the breakdown is instructive. *Chih-yüeh* (the oval-shaped seal used most frequently in the album), the oval *Lao T'ao* seal, and the impression of the square *Chi shan-seng* seal are not found elsewhere in Shih-t'ao's works. The small square *Chi* seal is rare but found early and no later than 1683. Only the thin rectangular seal bearing the name *Lao T'ao* has, as a type, a long life extending from the late 1650s into the early 1700s. Were these twenty-one leaves a late creation, a work of this quality would surely display seals more familiar to that time (see Edwards, *The Painting of Tao-chi*, 1967, pp. 63–70; Zheng Wei, *Shih-t'ao*, 1990, pp. 140–43).

RE

LITERATURE: *Chung-kuo ku-tai shu-hua mu-lu*, vol. 2, 1985, *Ching* 1–4724.

湖外青青大滌山
寫來寄去渾茫間
不知果是餘杭道
紙上重遊老眼閒
　　癸酉冬日，借亭先生攜此卷遊餘杭。歸來，云與大滌不異。若即印正，我得重遊，再寄博笑。清湘，苦瓜和尚，濟。

ARTIST'S SEALS:
Shih Yüan-chi yin 釋元濟印 (*pai-wen*, square)
Ch'ien yu Lung-mien Chi 前有龍眠濟 (*pai-wen*, rectangle)
Hsia-tsun-che 瞎尊者 (*chu-wen*, rectangle)

COLOPHONS: Ch'ien Tsai 錢載 (1708–1793), dated 1769, 2 seals; Kuan Lien 關廉 (18th century), dated 1770, 4 seals; Ch'ien Ta-hsin 錢大昕 (1728–1804), undated, 3 seals; Sun Yüan-hsiang 孫原湘 (1760–1829), dated 1814, 2 seals; Ch'en P'u 陳璞 (19th century), dated 1866, 1 seal; K'ang Yu-wei 康有為 (1858–1927); Shen Tseng-chih 沈曾植 (1852–1922); Tseng Hsi 曾熙 (1861–1930)

COLLECTORS' SEALS: Hsiung Ching-hsing 熊景星 (19th century), 1; unidentified, 4

LITERATURE: Chang Wan-li and Hu Jen-mou, *Shih-t'ao*, 1969, vol. 2, pl. 66; *Chung-kuo ku-tai shu-hua mu-lu*, vol. 3, 1987, *Hu* 1–3155; *I-yüan to-ying* 36 (1987): 18; *Ssu-kao-seng hua-chi*, 1990, pl. 46; Zheng Wei, *Shih-t'ao*, 1990, pp. 6–7.

159 *Viewing Mountains in Yü-hang*

Yü-hang k'an-shan t'u

石濤　餘杭看山圖

Undated

Handscroll, ink and color on paper
30.5 x 134.2 cm (12 x 52¹³⁄₁₆ in.)

Shanghai Museum

vol. 1, pl. 159

ARTIST'S INSCRIPTIONS AND SIGNATURES:
1. 5 lines in running script:
"Viewing Mountains in Yü-hang [Chekiang province]." Sketched for Shao-wen and sent over for his comments by K'u-kua ho-shang [Bitter-melon Monk], Chi.

《餘杭看山圖》。為少文先生打稿，寄請博教。苦瓜和尚，濟。

2. 6 lines in running-regular script:
Beyond the lake stands the verdant Mount Ta-ti,
Its vastness is depicted and mailed away.
I didn't realize it was indeed like the scenery of Yü-hang,
A second trip on paper blesses my idle old eyes.

　　In the winter of the *kuei-yu* year [1693], Chieh-t'ing carried this scroll with him on a trip to Yü-hang. Upon his return, he said the scenery looked the same as Mount Ta-ti. Your verification reconfirmed that [by creating this painting] I had already made a second [dream] visit to [Yü-hang]. The scroll is sent back to you [after the inscription was written] for your amusement. Ch'ing-hsiang, K'u-kua ho-shang, Chi.

160 *Landscape Album for Elder Yü*

Wei Yü lao tao-hsiung tso shan-shui ts'e

石濤　為禹老道兄作山水冊

Undated

Album of twelve paintings, ink and ink and color on paper
24 x 28 cm (9⁷⁄₁₆ x 11 in.)

C. C. Wang Family Collection

vol. 1, pl. 160 (leaves 1–3, 6, 7, 12); vol. 2, pl. 160 (leaves 4, 5, 8–11)

ARTIST'S INSCRIPTION AND SIGNATURE (5 lines in running-regular script):
These methods are no methods, which therefore become my methods. Twelve leaves sent for elder Yü's comments, K'u-kua ho-shang [Bitter-melon Monk], Chi.

是瀘非法，即成我法。十二冊寄上禹老道兄正，苦瓜和尚，濟。

ARTIST'S SEAL:
Yüan-chi, Shih-t'ao 原濟　石濤 (*pai-chu wen*, rectangle)

NO COLOPHONS

COLLECTOR'S SEAL: Wang Chi-ch'ien 王季遷 (b. 1907), 1

RECENT PROVENANCE: Nü-wa Chai Collection

EXHIBITION: The Museum of Art, University of Michigan, 1967: Edwards, *The Painting of Tao-chi*, cat. no. 19.

LITERATURE: Contag, *Die Beiden Steine*, 1950, pls. 13–16; Lee, *Chinese Landscape Painting*, 1954, pl. 91.

Wu Li (1632–1718) 吳歷

Christian name Simon Xavier, *tzu* Yü-shan 漁山, *hao* T'ao-hsi chü-shih
桃溪居士, Mo-ching tao-jen 墨井道人

Wu Li, like his friend Wang Hui (1632–1717), was born in 1632 in
Ch'ang-shu, Kiangsu, and studied painting with Wang Shih-min (1592–
1680) and Wang Chien (1598–1677). Though he produced far fewer
paintings than his fellow townsman and did not achieve the same de-
gree of fame during his lifetime, connoisseurs, including Wang Yüan-
ch'i (1642–1715), praised his art as surpassing that of Wang Hui, and he
became known, together with the Four Wangs and Yün Shou-p'ing
(1633–1690), as one of the Six Orthodox Masters of the early Ch'ing.

Wu Li appears to have been a withdrawn and introspective person
who spent much of his life in search of spiritual fulfillment, first in the
study of Confucianism, then Buddhism, and, finally, Christianity. His
father died shortly after he was born, and he was raised by his widowed
mother, whom he helped support through the sale of his paintings.
Two years after his mother's death in 1662, he developed a close friend-
ship with the Buddhist monk Mo-jung (d. 1672), but by 1676 he had
become friendly with Jesuit missionaries in Ch'ang-shu and in 1681 he
accompanied Fr. Philippe Couplet (1624?–1692) to Macao, where he en-
tered the Society of Jesus the following year. Ordained as a priest in
1688, he was sent in 1689 to do missionary work in Shanghai, where he
died in 1718 (Fong, "Wang Hui, Wang Yüan-ch'i and Wu Li," 1969,
p. 191).

In the mountains there is no need to bother with visiting dignitaries;
Just listening to the running streams will make one's guests feel at
ease.
 Early on the ninth day, Li, the recluse of peach blossom rill, again
inscribed.

水遠溪迴石路深
白雲遮屋樹重陰
山中不管鳴騶至
惟聽泉流淨客心
 九日晚窗，桃溪居士，歷又題。

ARTIST'S SEALS:
Wu Li 吳歷 (*chu-wen*, square)
Yü-shan 漁山 (*chu-wen*, square)
Wu Li 吳歷 (*chu-wen*, square)
Mo-ching ts'ao-t'ang 墨井草堂 (*pai-wen*, rectangle)

COLOPHON: Wu Hu-fan 吳湖帆 (1894–1968)

COLLECTORS' SEALS: Lu Shih-hua 陸時化 (1714–1789), 1; Ho Kuan-
wu 何冠五 (20th century), 2; Ch'ien Ching-t'ang 錢鏡塘 (20th cen-
tury), 1; T'an Ching 譚敬 (20th century), 1; unidentified, 2

In this comparatively early painting, Wu Li's ink brushwork already
shows the precision and limpid clarity by which his works may be
known. Though the style is clearly based on Huang Kung-wang, as ac-
knowledged in the inscription, the two figures seated on a ledge in the
center of the composition give it a more personal touch, reminiscent
of the Individualist painters.

RW

161 *After Huang Kung-wang's Late Style*
Hsieh I-feng lao-jen wan-nien pi-fa
吳歷　寫一峯老人晚年筆灋

Dated 1675

Hanging scroll, ink on paper
74.6 x 57 cm (29⅛ x 22⁷⁄₁₆ in.)

Shanghai Museum

vol. 1, pl. 161

ARTIST'S INSCRIPTIONS AND SIGNATURES:
1. 3 lines in running-regular script:
On the eighth day of the *ch'ing-ho* [fourth month] of the *i-mao* year
[May 2, 1675] at the Bright Moon Hall, using the brush technique of
I-feng lao-jen's [Huang Kung-wang, 1269–1354] late years. Yü-shan-tzu
of Yen-ling, Wu Li, presented [this] to his fellow scholar Feng-a.

乙卯清和八日，在明月堂寫一峰老人晚年筆灋。延陵漁山子，吳
歷，贈鳳阿同學大兄。

2. 3 lines in running-regular script:
The water meanders and the streams return, the stony path goes deep;
White clouds gather and huts and trees are shaded.

162 *Whiling Away the Summer at the Ink Well Thatched Hall*
Mo-ching ts'ao-t'ang hsiao-hsia t'u
吳歷　墨井草堂消夏圖

Dated 1679

Handscroll, ink on paper
36.4 x 268.3 cm (14⁵⁄₁₆ x 105⅝ in.)

The Metropolitan Museum of Art, New York
Purchase, Douglas Dillon Gift, 1977 (1977.81)

vol. 1, pl. 162

ARTIST'S INSCRIPTION AND SIGNATURE (4 lines in running script):
At the first clearing of the rain, [I] sat alone in the early dawn at the
Ink Well Thatched Hall; and taking an ancient master's *Whiling Away
the Summer* composition as my teacher, [I painted this] to send to Mr.
Ch'ing-yü [Hsü Tz'u-chien, *chin-shih* 1655] of P'i-ling [Wu-chin,
Kiangsu] in order to gratify my long yearnings for him. The tenth day
of the fourth month of the *chi-wei* year [May 19, 1679]. Wu Li.

梅雨初晴，晚來獨坐墨井草堂上，師古人《消夏圖》寄於毘陵青
嶼先生，以致久遠之懷。己未年四月十日，吳歷。

ARTIST'S SEALS:
Yü-shan Wu Li 漁山吳歷 (*pai-wen*, square)
Yen-ling 延陵 (*chu-wen*, square)

Li 歷 (*pai-wen*, square)
Yü-shan 漁山 (*chu-wen*, rectangle)
Wu Li 吳歷 (*pai-wen*, square)

LABEL STRIPS: Yeh Kung-ch'o 葉恭綽 (1881–1968), mounted on brocade wrapper, undated, 1 seal; Ku Wen-pin 顧文彬 (1811–1889), mounted on damask border in front of painting, undated, 1 seal

COLOPHONS: Sun Yüan-hsiang 孫原湘 (1760–1829), dated 1820, 1 seal; Ku Wen-pin, dated 1866, 2 seals; Yeh Kung-ch'o, dated 1947, 1 seal; Fei Nien-tz'u 費念慈 (1855–1905), dated 1905, 1 seal; Chang Ta-ch'ien 張大千 (1899–1983), dated 1946, 2 seals

COLLECTORS' SEALS: Hsü Hsi 徐熙 (fl. early 19th century), 1; Ku Wen-pin, 2; Wang Nan-p'ing 王南屏 (1924–1985), 1; Wang Chi-ch'ien 王季遷 (b. 1907), 3; Earl Morse 穆思 (1908–1988), 2; unidentified, 3

RECENT PROVENANCE: Wang Nan-p'ing, Wang Chi-ch'ien, Earl Morse

This painting is a depiction of Wu Li's modest estate, the Ink Well Thatched Hall, which he named after a well that had once belonged to Confucius' disciple Yen Yen (b. ca. 506 B.C.). In his inscription, Wu Li records that he painted the handscroll one clear morning after rainfall, sitting alone in his studio thinking of an absent friend. It is the beginning of the rainy season and Wu, inspired by the theme of "whiling away the summer," creates a dreamlike image of retirement in silvery gray tones that eloquently evokes the moisture-suffused atmosphere of a May morning.

The scroll opens with a view into the distance across a wide body of water and rice paddies that recede into the mist. Large willow trees line the shore, their lush foliage bent down under the weight of the night's rain. Only the flapping wings of a flock of water birds disturb the early morning stillness, causing egrets standing among the paddies to raise their heads in unison. A bridge and roadway lead the eye from this tranquil scene to a walled compound where, in spite of the early hour, members of the household are already stirring. Outside the wall, a boy dangles his fishing line from a grassy bank; inside, a youthful servant is surprised to find his master ensconced in an easy chair reading. Wu Li portrays himself in the carefree attitude of a Six Dynasties aesthete, his robes thrown open and one foot bare. The similarly informal appearance of his rustic dwelling, with its plaster walls in need of patching, cannot obscure its elegant comforts. Behind the porch where Wu Li sits overlooking a lotus pond, a covered walkway leads to a two-story library and a pavilion built over the water on stilts. Across the pond and screened from view by a wicker fence are the servants' quarters, a well, and a large kitchen where a small boy has just knelt down to build a fire in the stove. The back gate opens directly onto a wooded mountain slope where a rock outcrop forms a natural part of the compound's perimeter wall.

Wu Li might have ended his painting here, for his sheet of paper comes to an end at just this point of closure. But Wu continued his composition onto a second sheet of paper, affixing two seals across the join to deter later owners from turning his painting into two independent compositions. In this second section, Wu moves from the enclosed, sheltered world of mundane existence to a vision of boundless nature where the unfettered mind can approach the infinite. As the morning mist begins to dissolve, we see a mountain path leading through a grove of rustling bamboo and along the shoreline of a wide

expanse of water until it disappears in the distance. The painting closes with a view of distant mountains whose suggestive silhouettes resemble robed figures bowing before a single towering peak. Wu Li's jet black inscription, written in the boldly modulated style of Su Shih (1036–1101), stands in striking counterpoint to these ghostly profiles.

Wu painted this intimate self-image for his close friend Hsü Tz'u-chien, who shared Wu Li's idealistic disdain for moral relativism and also exhibited an interest in Christianity. Earning his *chin-shih* degree in 1655, Hsü rose to the rank of Attendant Censor, but was dismissed in 1665 when Yang Kuang-hsien (1597–1669), a self-appointed opponent of Western missionaries, accused him of writing a preface to a work propagating the Christian faith. Hsü was pardoned in 1669, and when he returned to Peking the following year, Wu Li accompanied him (Hummel, *Eminent Chinese*, 1943, p. 876). Ch'ang-shu at that time was one of the centers of Jesuit missionary activity and the Catholic church occupied the traditional site of Yen Yen's home. Wu Li's choice of Yen Yen's "Ink Well" as the name of his studio may well have signified his ties to the church as well as his personal integration of Confucian and Catholic doctrines. Depicting himself in his Ink Well Thatched Hall served not only to remind his friend of the pleasures of retirement, but also of his diligent study of Christian theology at that time.

Two years later, in the seventh month of 1681, Wu painted another handscroll for Hsü that also draws upon conventional imagery, this time for leave-taking, to express his feelings on the eve of his departure for Macao (*Chung-kuo mei-shu ch'üan-chi, hui-hua pien*, 1989, vol. 10, no. 24). The painting, now in the Shanghai Museum, illustrates Pai Chü-i's (772–846) "Song of the Lute" ("P'i-p'a hsing"), a ballad that describes how the poet, while seeing off a friend, hears a lute played by a woman who was once a famous performer in the capital and is reminded of his own drifting life in banishment. As in *Whiling Away the Summer*, the mist-filled atmosphere and silvery ink tones of this painting impart a dreamlike quality to the image that recalls the works of the Sung dynasty recluse-artist Chao Ling-jang (d. after 1100).

Wu Li first became familiar with Chao Ling-jang's works through his study of Sung and Yüan orthodox masters with Wang Shih-min, but in his mature style, exemplified here, it is difficult to identify his stylistic sources. Wu's moist atmosphere, willows, and intimate setting owe something to Chao Ling-jang's misty views of rustic retreats, but he has also been influenced by Wang Meng's (1308–1385) love of densely textured surfaces, the rich ink tones of Wu Chen (1280–1354), and the hemp-fiber texture strokes of Huang Kung-wang (1269–1354). But all these influences have been blended and transformed into a distinctly personal style which marries descriptive detail with abstract pattern. A close inspection of Wu's painting reveals that his vividly described landscape is actually a patchwork of lively abstract designs. Foliage, paddies, lily pads, bamboo groves, and rock surfaces are all built up through the repetition of simple dots or lines laid down in different densities and in varied ink tones to create a vibrant surface of intricate, contrasting patterns.

Clearly, Wu Li's interest in Christianity never deterred him from seeking spiritual comfort and meaning within the vocabulary of his native culture. Until his death in 1718, he continued to paint in a traditional manner. In *Whiling Away the Summer at the Ink Well Thatched*

Hall, his quest for spiritual enlightenment takes place within the traditional role of the lofty hermit-scholar, who cultivates his mind in the privacy of his own idyllic domain.

MKH

EXHIBITIONS: China Institute in America, New York, 1968: Weng, *Gardens in Chinese Art*, no. 11; The Art Museum, Princeton University, 1969: Whitfield, *In Pursuit of Antiquity*, pp. 191–94, cat. no. 32; China Institute in America, New York, 1979: Roberts, *Treasures from the Metropolitan Museum*, no. 60.

LITERATURE: Ch'en Yüan, "Wu Yü-shan," 1938, p. 146, n. 64; Cheng Chen-to, *Wei-ta ti i-shu ch'uan-t'ung*, 1954, vol. 2, fascicle 11, pl. 12; Sirén, *Leading Masters and Principles*, 1956–58, vol. 5, p. 187, n. 2, vol. 6, pls. 408–409b; vol. 7 (lists), p. 447; Shao Lo-yang, *Wu Li*, 1962, p. 21; Tam, *Six Masters*, 1986, pp. 66–69, fig. 21; *The Metropolitan Museum of Art: Asia*, 1987, pl. 61.

Wang Hui (1632–1717) 王翬

tzu Shih-ku 石谷, *hao* Keng-yen san-jen 耕煙散人, Ch'ing-hui chu-jen 清暉主人, Wu-mu shan-jen 烏目山人, Chien-men ch'iao-k'o 劍門樵客

Unlike his mentors, Wang Shih-min (1592–1680) and Wang Chien (1598–1677), Wang Hui came from a family of humble means. His early years were spent in his native Ch'ang-shu, Kiangsu, where in 1647, at the age of sixteen *sui* (fifteen years old), he began studying painting with a local painter named Chang K'o (1635–after 1717). Wang Hui soon revealed his talents as an artist and in 1651 received an invitation from Wang Chien to study painting with the master at his home in T'ai-ts'ang. Wang Hui became the cherished protégé of Wang Shih-min, the leading painter of the Orthodox School, and Wang Chien, both of whom introduced him to major collectors and painters in Kiangsu. In the following decades Wang Hui's fame increased dramatically; in his *Tu-hua lu*, the art patron and critic Chou Liang-kung (1612–1672) pronounced him the best of contemporary artists, asserting that Wang surpassed all the painters of his century. He subsequently became known as the most gifted painter of the Four Wangs.

Given this widespread adulation, it is not surprising that Wang Hui was summoned by the K'ang-hsi emperor (r. 1662–1722) in 1691 to direct the painting of twelve handscrolls documenting the emperor's 1689 inspection tour of the south. After the completion of this project, Wang Hui remained in Peking and socialized with some of the most highly regarded scholars and collectors of the day. He returned to Kiangsu in 1698, where he continued to paint until his death in 1717.

163 *Ten Li of Creek and Ponds*
Shih-li hsi-t'ang

王翬　十里谿塘

Dated 1669

Hanging scroll, ink on paper
117.5 x 61.5 cm (46¼ x 24³⁄₁₆ in.)

Shanghai Museum

vol. 1, pl. 163

ARTIST'S INSCRIPTIONS AND SIGNATURES:
1. 1 line in running-regular script:
On the sixth day of the third month of the *chi-yu* year [March 7, 1669], Shih-ku-tzu, Wang Hui of Yü-shan painted.

歲在己酉三月六日，虞山石谷子，王翬畫。

2. 2 lines in running-regular script:
On the eighth day of the ninth month of the *hsin-hai* year [September 10, 1671], receiving a visit from Mr. Shih-men in my hill studio; he stayed for some nights, and when he was about to go I brought this out to present to him. Wang Hui inscribed again.

辛亥秋，九月八日，承石門先生枉過山齋，盤桓信宿，臨行出此以贈。王翬又識。

ARTIST'S SEALS:
Wu-mu shan-ch'iao 烏目山樵 (*chu-wen*, oval)
Wang Hui chih yin 王翬之印 (*chu-pai wen*, square)
Tzu Shih-ku 字石谷 (*pai-wen*, square)
Wang Hui chih yin 王翬之印 (*pai-wen*, square)

COLOPHONS: Wang Shih-min 王時敏 (1592–1680), dated 1669, 2 seals; Wang Chien 王鑑 (1598–1677), dated 1672, 2 seals; Wu Wei-yeh 吳偉業 (1609–1672), undated, 2 seals

COLLECTORS' SEALS: P'ang Yüan-chi 龐元濟 (1862–1948), 2; Yao Shao-ying 姚少英, 2

Wang Hui's own inscriptions are brief, and the place of honor is kept for his teacher Wang Shih-min's lyrical verse in *li-shu* (clerical) calligraphy which gives the painting its title, "Water rushing along ten *li* of creek and ponds." Although neither the artist nor the writers of the colophons say so, the main inspiration for the composition must be the style of Huang Kung-wang (1269–1354), as a comparison with leaf 18 of the album *The Great Revealed in the Small* (*Hsiao-chung hsien-ta*) in the National Palace Museum, Taipei, makes clear: a similar mountain form with narrow ledges or shelving plateaus in the center, and a similar configuration of the low banks by which the viewer first approaches the painting. The fore and middle ground are not the same. Nevertheless, such a comparison shows the progress of the Orthodox School from a composition that is clearly based on a painting by or close to Huang Kung-wang to Wang Hui's version, in which the elements are rearranged so that the whole orientation of the painting is quite changed. The mountain, changed from being remote and dominant, swathed in mists and broadest at its summit, is now no longer the most distant point in the painting: we see beyond it both along a shallow valley to the left and above to the right, where the subsidiary peaks of the earlier painting have been magnified. Steps leading to pa-

vilions on the mountainside make clear its accessibility and seem to present a goal to be reached, in contrast to the modest dwelling tucked away to the side in the Taipei album leaf, which Tung Ch'i-ch'ang regarded as an important demonstration of Huang Kung-wang's "broken ink" technique of building from light to dark.

RW

LITERATURE: P'ang Yüan-chi, *Hsü-chai ming-hua lu*, 1909, *ch.* 9, p. 14; Xu Bangda, *Pien-nien-piao*, 1963, p. 156; *Chung-kuo ku-tai shu-hua mu-lu*, vol. 3, 1987, *Hu* 1–2859; *Chung-kuo ku-tai shu-hua t'u mu*, vol. 4, 1990, *Hu* 1–2859.

164 *Large Emerging from Small*

Hsiao-chung hsien-ta

王翬　小中現大

Dated 1672

Album of twenty-one paintings with two leaves of calligraphy, ink and color on paper and silk
Average: 55.5 x 34.5 cm (21⅞ x 13⁹⁄₁₆ in.)

Shanghai Museum

vol. 1, pl. 164 (leaves 1–21); vol. 2, pl. 164 (colophon)

Leaf 1, *Landscape* after Tung Yüan (fl. ca. 945–ca. 960); cf. *Hsiao-chung hsien-ta*, leaf 3, National Palace Museum, Taipei (hereafter cited as NPM).

Leaf 2, *Traveling in Autumn Mountains* after Wang Meng (1308–1385); cf. NPM leaf 10.

Leaf 3, *Snow* after Chü-jan (fl. ca. 960–ca. 986); cf. NPM leaf 5.

Leaf 4, *Travelers among Streams and Mountains* after Fan K'uan (d. after 1023); cf. NPM leaf 2.

Leaf 5, *Misty River and Piled Peaks* after Wang Shen (1036–after 1099); cf. NPM leaf 17.

Leaf 6, *River Landscape with Floating Mist* after Chao Ling-jang ? (d. after 1100)

Leaf 7, *Gathering Ling-chih* after Chao Po-chü (ca. 1120–ca. 1170)

Leaf 7a, Artist's inscription (7 lines in running-regular script):
Gathering Fungi, after a fan painting on silk by Chao Po-chü.
This painting was formerly in a Wei-yang [Yang-chou] collection, from which I borrowed it. Examining its *ts'un* and washes, it is entirely modeled on Kuan T'ung (fl. ca. 907–23); the application of color is learnt from the Senior and Junior Li [Li Ssu-hsün, fl. ca. 705–20, and Li Chao-tao, fl. mid-8th century]. The cliffs and valleys are remote, the woods clear and sparse. Though the brush is used in a most painstaking way, it reaches a pinnacle of ethereality. It completely discards the academy style and is not at all of the ordinary kind. Its beauty belongs to the tradition of Ch'ien Shun-chü [Ch'ien Hsüan, b. ca. 1235], Ting Yeh-fu [Ting Yün-p'eng, 1547–after 1621], and Ch'iu Shih-fu [Ch'iu Ying, ca. 1494–ca. 1552].

《采芝圖》拓趙伯駒紈扇本。此圖曩從維揚客館借撫，觀其皴染，全法關全，設色師大小李。嚴壑幽邃，林木清踈，用筆極工而有瀟洒之致，脫盡院體，并非平時本色。爲錢舜舉、丁野夫、仇實父諸公之祖。

Leaf 8, *Landscape* after Kao K'o-kung (1248–1310); cf. NPM leaf 7.

Leaf 9, *Playing the Ch'in* after Chao Meng-fu (1254–1322); cf. NPM leaf 4.

Leaf 10, *Dwelling in Seclusion in Summer Mountains* after Chao Meng-fu; cf. NPM leaf 6.

Leaf 10a, artist's inscription (1 line in running-regular script):
Chao Wen-min's [Chao Meng-fu] *Dwelling in Seclusion in Summer Mountains*.

趙文敏《夏山幽居》。

Leaf 11, *Landscape* after Huang Kung-wang's (1269–1354) *Summer Mountains*; cf. NPM leaf 9.

Leaf 12, *Landscape* after Huang Kung-wang; cf. NPM leaf 12.

Leaf 13, *Autumn Mountains* after Huang Kung-wang; cf. NPM leaf 16.

Leaf 14, *Ink Landscape* after Huang Kung-wang; cf. NPM leaf 18.

Leaf 15, *Landscape* after Wu Chen (1280–1354); cf. NPM leaf 11.

Leaf 16, *Mountain Passes on a Clear Autumn Day* after Wu Chen and Tung Yüan; cf. NPM leaf 15.

Leaf 17, *Lakeshore Pavilion* after Ni Tsan (1301–1374); cf. NPM leaf 21.

Leaf 18, *Ink Landscape* after Ni Tsan; cf. NPM leaf 20.

Leaf 19, *Pavilion and Rock* after Ni Tsan; cf. NPM leaf 22.

Leaf 20, *Elegant Gathering among Forests and Streams* after Wang Meng; cf. NPM leaf 14.

Leaf 21, *Spring Dawn over Mount Tan-t'ai* after Wang Meng; cf. NPM leaf 19.

ARTIST'S COLOPHON AND SIGNATURE (6 lines in running-regular script):
Among the scholar-officials who devoted themselves to brush and ink and whose literary accomplishments and elegant style illuminated the world, Vice Director of the Directorate of Imperial Sacrifice Wang [Wang Shih-min, 1592–1680] of Lou-tung [T'ai-ts'ang, Kiangsu] has been the only one since Tung Tsung-po [Tung Ch'i-ch'ang] who is able to carry on the tradition. In the art of painting, the Vice Director has almost become a peer of Wen-min [Tung Ch'i-ch'ang] in his penetrating study of the art and his outstanding achievement, which surpasses even the Sung and Yüan masters. I was fortunate enough to have been accepted by the Vice Director as a friend in spite of our age difference. I still remember in the *jen-tzu* year [1672] I was invited to his villa at Hsi-t'ien to spend the summer with him. The Vice Director showed me all the masterpieces in his collection. We discussed problems of connoisseurship and our minds were usually in accord with each other. Consequently he brought out this [blank] album and asked for my painting. As I was unable to excuse myself, I made copies of the original works one after another. I was much ashamed of this immature work of imitation. But the Vice Director was always kind enough to shower me with praise, appreciation, and such over-appraisal that my copies were even superior to the original. I know only too well that I was not up to such appraisal. But the critical acclaim of a senior scholar [such as Wang Shih-min] really arose in me a feeling of gratitude toward a true friend who understood me. It has been more than thirty years since then. When I look at this album again I feel as if I had a reunion with an old friend, as if I could hear the Vice Director's coughing and laughing just in front of me. I respectfully write down a few words in memory of a friend who is no more. On the twenty-fourth

day of the fifth month of the *kuei-wei* year [July 7, 1703], Wang Hui from Hai-yü.
(Translation by Wai-kam Ho.)

士大夫留心翰墨，文采風流照耀奕世者，董宗伯後，惟婁東王奉常先生能踵繼焉。奉常之於繪事，研精入微，軼宋超元，直與文敏并駕。余辱奉常忘年下交。憶壬子歲，邀過西田結夏，盡發所藏諸名迹，相與較論鑒別，兩心契合，因出此冊命圖，余遜謝不遑，遂次第對摹真本，殊慚學步。奉常輒嘆詫欣賞，謬加出藍之譽，自問不敢仰承。而前輩品題，實切知己之感。迄今三十餘年，展閱一過，如逢故人，不啻奉常之謦欬吾前也。謹識數語，以當山陽鄰蓬。癸未五月廿有四日，海虞王翬。

ARTIST'S SEALS:
Wang Hui 王翬 (*chu-wen*, rectangle; leaves 1–4, 10, 14, 15, 17)
Wang Hui chih yin 王翬之印 (*pai-wen*, square; leaves 5, 12, 18, 21)
Shih-ku-tzu, Wang Hui chih yin 石谷子　王翬之印 (*chu-pai wen*, rectangle; leaves 6, 7)
Wang Hui chih yin 王翬之印 (*pai-wen*, square; leaves 8, 11, 13, 16)
Wang Hui chih yin 王翬之印 (*pai-wen*, square; leaves 9, 19)
Wang Hui chih yin 王翬之印 (*chu-pai wen*, square; leaf 10a)
Wu-mu shan-jen 烏目山人 (*pai-wen*, square; leaf 10a)
Shih-ku 石谷 (*chu-wen*, square; leaf 18)
Wang Hui chih yin, tzu Shih-ku 王翬之印　字石谷 (*chu-pai wen*, rectangle; leaf 20)
Hai-yü 海虞 (*chu-wen*, round; colophon)
Lai-ch'ing ko 來青閣 (*chu-wen*, square; colophon)
Shih-ku 石谷 (*pai-wen*, square; colophon)
Li-chia sheng-huo 隸家生活 (*pai-wen*, square; colophon)
Keng-yen yeh-lao shih nien ch'i-shih yu erh 耕煙野老時年七十有二 (*chu-wen*, square; colophon)

FRONTISPIECE: Wang Shih-min 王時敏, undated, 3 seals

COLOPHONS: Yün Shou-p'ing 惲壽平 (1633–1690), undated, 2 seals; Shen Hsien-hsiu 沈賢修 (early 20th century), 1 dated 1907, 1 undated, 4 seals

Yün Shou-p'ing (leaf 10a):
In painting blue and green landscapes it is easy to be luxuriant instead of plain. It is easier to be plain but very difficult to be plain and luxuriant. Only Chao Wu-hsing [Chao Meng-fu, 1254–1322] was able to be free from the rigid manner of Sung painters, achieving a modest, charming, and elegant approach and a balance between luxuriance and delicacy, which is inspirational. This is what is called becoming natural after reaching the summit of glittering, a stage of transformation in painting. Shih-ku tzu [Wang Hui] has been exploring the methods of applying colors for more than twenty years. He always observes quietly the ever-changing atmospheric phenomenon and finally figures out the nature of Creation and the secrets [in the painting of] his predecessors. He elevates his art to a "Way" of painting. Nan-tien Shou-p'ing.
(Translation by Joseph Chang.)

青綠重色爲穠厚易，爲淺澹難；爲淺澹易，淺澹而愈見穠厚爲尤難。惟趙吳興洗脫宋人之刻畫，運以虛和，出之妍雅，穠纖得中，靈氣洞目，所謂絢爛之極仍歸自然，畫法之一變也。石谷子於傅采法，研精廿餘年，每從風雨晦明萬象舒慘之際，靜觀默會，始於造化自然之文，先匠不傳之秘，爽然心開，妙有神解。蓋藝也進於道矣。南田壽平識。

COLLECTORS' SEALS: An Ch'i 安岐 (1683–ca. 1746), 1; P'ei Ching-fu 裴景福 (1854–1926), 1; Chou Hsiang-yün 周湘雲 (20th century), 4

The title of this album, magnificently written by Wang Shih-min, is one of those splendidly simple Chinese four-character phrases that de-

fies direct translation into English. It is also the title of the album Wang Shih-min himself painted—under Tung Ch'i-ch'ang's tutelage and with the latter's inscriptions opposite each leaf—that is now in the National Palace Museum, Taipei (and that was long attributed to Tung Ch'i-ch'ang himself).

Here in Wang Hui's version, leaves 1, 3, and 4 are already familiar from the elongated transformations elaborated by Wang Chien (1598–1677) in his set of scrolls in the Shanghai Museum (vol. 1, pl. 127), but remain more faithful to their respective originals in both format and brushwork, although the reduction in scale necessarily entails a corresponding loss of majesty. An additional colophon by Wang Hui, dated 1703, just thirty-one years after he first painted the album, tells how at that time, when he was a young man of thirty-one *sui* (thirty years old), Wang Shih-min showed and discussed with him the Sung and Yüan paintings in his collection and produced the volume for him to copy them. All but two of the twenty-one leaves here, though not labeled, are in fact new renderings of the same paintings in Wang Shih-min's own *Hsiao-chung hsien-ta* album, which we can use for comparison and checking the sources. Thus, leaf 9 here corresponds with Wang Shih-min's copy of Chao Meng-fu following Tung Yüan. Indeed, in its placing of a solitary *ch'in* player among regularly spaced trees, this leaf evokes Chao Meng-fu's *Mind Landscape of Hsieh Yu-yü* (*Yu-yü ch'iu-ho*, in The Art Museum, Princeton University; see Fong et al., *Images of the Mind*, 1984, pp. 280–81); however, it is more likely to be a faithful rendering of another painting by Chao. Wang Hui's *Whispering Pines in Myriad Valleys* (vol. 1, pl. 167), painted in 1715, at the end of his long life, represents a final reworking of this composition in which Wang follows his master in invoking the name of Tung Yüan, but transforms the style into that of his own maturity.

Wang Chien's reference to a reduced-size portfolio of the Sung and Yüan paintings in Wang Shih-min's collection commissioned from Ch'en Lien (fl. first half of the 17th century; see cat. no. 125) raises the question of whether Ch'en Lien's album might be extant. Indeed it has been suggested by James Cahill elsewhere in this catalogue that the large album entitled *Hsiao-chung hsien-ta* in the National Palace Museum is by him (see vol. 1, p. 71). Such a conclusion would overturn Wen Fong's attribution of the Taipei album to Wang Shih-min himself. Fong's attribution is based on the passage in Chang Keng's (1685–1760) *Kuo-ch'ao hua-cheng lu*, which he translates as:

> [Wang Shih-min] once selected among ancient works some of the most successful in methods and in breath [*ch'i*], twenty-four in all, made reduced copies of them, and had them mounted into a giant album. He took this album with him wherever he went, to serve as his models. Thus, in his works, every compositional detail, every outline, texture and ink wash had its origin in an ancient source.

This record of Chang Keng's affords us a more specific rationale for the origin of the *Hsiao-chung hsien-ta* album than Wang Chien's inscription to his album of scaled-down copies. The Taipei album is indeed giant in size, a proper vehicle for the twenty-two extant reduced-size versions of the large originals. Its production must have taken considerable time and required an intimate knowledge of the original paintings in order to reproduce "every compositional detail, every outline, texture and ink wash" and serve as a lifetime source of inspiration for this author. Almost all the copies

also have facing inscriptions signed by Tung Ch'i-ch'ang, with his seals. The dates on these inscriptions, for the most part transcribed from his titles or colophons to the original works, range from 1598 to 1620, 1625, and 1627. It has been suggested that these are merely transcriptions, not necessarily written by Tung Ch'i-ch'ang himself. But Tung Ch'i-ch'ang did write the title for the album, and evidently played a major role in its conception. While it is possible that the author of the copies also transcribed Tung's original inscriptions, the presumption is that these too are the work of Tung himself. Manifestly, they cannot have been written by Ch'en Lien, whose hand, in the inscription to the handscroll exhibited here (vol. 1, pl. 124), does not seem to suggest a further reserve of strength. It is not in composition alone that the artist of the Taipei album has been faithful to the originals: the paintings display a wide range of styles of brushwork, and one may discern that predilection of Wang Shih-min for Huang Kung-wang that Chang Keng goes on to cite in the sentence immediately following that just quoted. Were Ch'en Lien so skilled in painting, one might have expected that more works by him would have survived (a landscape in the Nanjing City Museum, not yet published in reproduction, is all that I could turn up in a search for his paintings). The handscroll by him in the present exhibition displays a blandness that is sustained throughout the length of the composition, particularly in the slender conical forms of the mountain peaks, with concave slopes hardly to be found at all in the Taipei album. In considering the authorship of the Taipei album, we may see Wang Shih-min's hand in such items as the *Elegant Gathering among Forests and Streams* after Wang Meng, which features the close-set pines that are a hallmark of Wang Shih-min's own paintings. Wang Shih-min thus remains the strongest contender as the creator of the Taipei album.

Naturally, once the "great album" had been conceived and executed, it was no longer necessary to return to the precious original paintings in order to execute further copies. Wang Chien's album exhibited here (vol. 1, pl. 125) is a case in point: he himself presents his as "another copy" of Ch'en Lien's reduced-size portfolio. The proportions of each composition have been modified to fit the standard dimensions of the album leaves, and the landscape forms are less vigorously articulated. The identifications of the source of each painting are kept to a minimum, and indeed are sometimes at variance with those given in the Taipei album. Wang Hui's album, on the other hand, can be shown to have been copied directly from the Taipei album. Nineteen of its leaves have their counterparts in the latter, and in every case Wang Hui has preserved the original proportions almost exactly. As his tutor in painting, Wang Shih-min seems to have entered into the spirit of Wang Hui's enterprise by echoing Tung Ch'i-ch'ang's title in four large characters, choosing again the same arrangement and the same proportions, with variations in the calligraphy that appear to be a direct response to those of Tung Ch'i-ch'ang: note Wang Shih-min's outward-flung dots in the character *hsiao*, where Tung's turn inward. This exact correspondence between the two albums, each executed by the pupil for his master and then inscribed by the master, is a powerful argument for Wang Shih-min's authorship of the Taipei album and for considering that the inscriptions on the facing pages, as well as the title inscription, were written by Tung Ch'i-ch'ang himself.

The fidelity to his models displayed by Wang Hui invests leaves 6

and 7 of the album with a special interest: according to Xu Bangda, these two leaves were added later, but it would appear equally, if not indeed more probable, that they are in fact the two compositions missing today from the Taipei album out of the original total of twenty-four recorded by Chang Keng. As it happens, neither composition figures in Wang Chien's album, which has only twelve leaves in all. As Wang Chien was by his own account reproducing Ch'en Lien's version, it remains possible that Ch'en Lien himself made copies not from Wang Shih-min's own scaled-down versions in the Taipei album, but directly from a smaller number of the original paintings in Wang Shih-min's collection, and that it was he who reduced them to a common format, rather than preserving the original proportions, as did Wang Shih-min and Wang Hui.

<div align="right">RW</div>

LITERATURE: Xu Bangda, *K'ao-pien*, 1984, text vol. 2, p. 155; *Chung-kuo ku-tai shu-hua mu-lu*, vol. 3, 1987, *Hu* 1–2905; *Chung-kuo ku-tai shu hua t'u-mu*, vol. 4, 1990, *Hu* 1–2905.

165 *In Pursuit of Antiquity*
Ch'ü-ku

王翬　趙古

Dated 1673

Album of twelve paintings, ink and ink and color on paper
Average: 21.6 x 31.7 cm (8½ x 12½ in.)

The Art Museum, Princeton University. Gift of Mr. and Mrs. Earl Morse (y1973–67)

vol. 1, pl. 165 (leaves 1, 2, 6–8, 10–12); vol. 2, pl. 165 (frontispiece, leaves 3–5, 9)

ARTIST'S INSCRIPTION AND SIGNATURE (leaf 12, 4 lines in regular script):
In the ninth month, autumn, of the *kuei-ch'ou* year [October 10–November 8, 1673], visiting at the Pi-yüan of Mr. Li of Wei-yang [Yang-chou], I imitated a number of Sung and Yüan styles in small paintings to be sent to my revered master Yen-weng Feng-ch'ang [Wang Shih-min, 1592–1680] to wish him a happy life, and also to take the place of waiting on him in person. His student, Wang Hui.

癸丑九秋，客維揚李氏之祕園，雜倣宋元小品，寄呈煙翁奉常尊先生，景序融和，以當覲對。後學，王翬。

ARTIST'S SEALS:
Shih-ku-tzu 石谷子 (*chu-wen*, square; leaves 1, 2, 4, 10, 11, 12)
Wang Shih-ku 王石谷 (*chu-pai wen*, rectangle; leaves 3, 8)
Wang Hui chih yin 王翬之印 (*pai-wen*, square; leaves 6, 7)

TITLE: Pi Lung 畢瀧 (fl. Ch'ien-lung era, 1736–96), undated, 1 seal

FRONTISPIECE: Wang Shih-min 王時敏, undated, 2 seals:
Ch'ü-ku [In Pursuit of Antiquity]

趙古

COLOPHONS: Cha Shih-piao 查士標 (1615–1698), undated, 2 seals; Ch'eng Sui 程邃 (1605–after 1691), undated, 1 seal; Ta Ch'ung-kuang 笪重光 (1623–1692), 5 undated, 7 seals; Yün Shou-p'ing 惲壽平 (1633–1690), 7 undated, 2 dated 1673 and 1680, 10 seals; Juan Yü-hsüan 阮玉鉉 (fl. second half of the 17th century), undated, 1 seal; Li Tsung-k'ung 李宗孔 (fl. second half of the 17th century), 2 undated, 5 seals; Ch'en Ch'eng 陳誠 (fl. second half of the 17th century), undated, 2 seals; Yeh Jung 葉榮 (fl. second half of the 17th century), undated; Liu Yü 柳堉 (fl. K'ang-hsi era, 1662–1722), 2 undated, 3 seals; Chou Erh-yen 周而衍 (fl. K'ang-hsi era), 2 undated, 1 seal; Shen Ping-ch'eng 沈秉成 (1823–1895), undated, 1 seal

Yün Shou-p'ing (leaf 2):
Opening to this leaf, I suddenly find myself in a lonely and uninhabited world of wild cliffs and deep valleys. The trees cast somber shadows, while mountain torrents and paths wind their way around them. The scene fills less than one foot (*ch'ih*), yet one can roam in it with endless enjoyment. [A painter] must concentrate his spirit, reflect in solitude, cleanse [his mind], and emit a supernatural breath [so that] the powers of his miraculous brush may describe flavors beyond outward appearances, or he will not easily achieve such excellence. Shih-ku-tzu [Wang Hui] painted for Master Yen-weng this small scene in the style of Pei-yüan [Tung Yüan, fl. ca. 945–ca. 960]. Truly, the metamorphosis is divine and brilliant. It is a masterpiece of the first order. Shou-p'ing inscribed.

偶一展對，忽如置身荒崖邃谷，寂寞無人之境。樹影森蕭，磵路盤紆，景不盈尺，游賞無窮。自非凝神獨照，洗發靈氣，妙筆先機，通象外之趣者，未易臻此。石谷子為煙翁先生擬北苑小景，真變化神明，第一合作。壽平題。

Yün Shou-p'ing (leaf 4):
In the style of Ch'ih-weng [Huang Kung-wang, 1269–1354] the location of peaks and valleys can be learned with success, but beyond the brush and ink there is also a certain rustic and hoary feeling which cannot be successfully learned. This is why in studying Ch'ih-weng one frequently falls short of attaining excellence. Only Master Feng-ch'ang of Lou-tung [Wang Shih-min] and Master Shih-ku of Yü-shan [Wang Hui] have been able to reach this degree. Shou-p'ing respectfully records this. (For translations of remaining colophons, see Whitfield, *In Pursuit of Antiquity*, 1969, pp. 119–28.)

癡翁畫法，丘壑、位置皆可學而至，惟筆墨之外別有一種荒率蒼莽之氣，則不可學而至。故學癡翁輒不得佳。能臻斯境者，婁東奉嘗先生與虞山石谷子耳。壽平敬志。

COLLECTORS' SEALS: Ta Chin-shan 笪近山, 1; Hou Ch'üan 侯銓 (fl. K'ang-hsi era), 1; Pi Lung, 3; Chang Hsiung 張熊 (1803–1886), 1; Wang Shih-hsin 王時新 (20th century), 2; Chu Ting-fu 朱定甫, 2; unidentified, 2

RECENT PROVENANCE: M. Jean Pierre Dubosc

In this series of twelve leaves, Wang Hui presents an even wider range of styles than may be seen in his own *Hsiao-chung hsien-ta* album (vol. 1, pl. 164) or in those by Wang Shih-min, in the National Palace Museum, Taipei, and Wang Chien (1598–1677; vol. 1, pl. 125). The paintings reflect Wang Hui's diligent study under the tutelage of the older masters. Though most of the compositions are more likely to be "in the manner of" a given master rather than direct copies of surviving paintings, some may in fact be so. Some appear close to other versions of the same compositions by Wang Hui in an album executed

the previous year, in 1672, jointly with Yün Shou-p'ing (*Flowers and Landscapes*, in the National Palace Museum, Taipei). For instance, the brush manner and bright colors of leaf 8 may also be compared to a leaf in the Taipei album entitled "Scarlet Forests on a Bright Autumn Day, in the manner of Fan K'uan [d. after 1023]" ("Hung-lin ch'iu-chi yung Fan Hua-yüan fa"): though viewed from a different angle, the setting is quite similar. Leaf 9 after Kao K'o-kung (1248–1310) has a similar counterpart in the Taipei album, and the final leaf, identified on a previous occasion as in the manner of Li Ch'eng (919–967) or Kuo Hsi (ca. 1020–ca. 1100) (see Whitfield, *In Pursuit of Antiquity*, p. 127), is identified in the 1672 version as "Yu-ch'eng's [Wang Wei, 701–761] 'Snow Accumulating on the Cliffs'" ("Yu-ch'eng ts'eng-yen chi-hsüeh").

RW

EXHIBITIONS: Venice, 1954: *Arte Cinese*, p. 241; The Art Museum, Princeton University, 1969: Whitfield, *In Pursuit of Antiquity*, pp. 119–42, cat. no. 16.

LITERATURE: Suzuki, *Comprehensive Illustrated Catalogue*, 1982–83, vol. 1, no. A16–058.

166 *Landscape in the Manner of Li Ch'eng*
Fang Li Ying-ch'iu shan-shui
王翬　倣李營丘山水

Dated 1687

Hanging scroll, ink on paper
99.7 x 56.9 cm (39¼ x 22⅛ in.)

Shanghai Museum

vol. 1, pl. 166

ARTIST'S INSCRIPTION AND SIGNATURE (4 lines in running script):
The clouds part and reveal the lofty peaks;
When the leaves fall, it shows the strength of the wind.
Below the hut you will meet no person;
The evening sun weakens the autumn shadows.
　　On the twenty-fourth day of the eleventh month of the *ping-yin* year [January 7, 1687], mooring my boat at Shih-t'ou town [Nanking], I used Ying-ch'iu's [Li Ch'eng, 919–967] brush to describe Yü-weng's [Ni Tsan, 1301–1374] poetic sentiment. Wu-mu shan chung jen, Wang Hui.

雲開見山高
木落知風勁
亭下不逢人
夕陽澹秋影
　　丙寅十一月廿四日，泊舟石頭城下，用營丘筆寫迂翁詩意。烏目山中人，王翬。

ARTIST'S SEALS:
Wang Hui chih yin 王翬之印 (*pai-chu wen*, square)
Shih-ku-tzu 石谷子 (*pai-wen*, square)

NO COLOPHONS

COLLECTORS' SEALS: unidentified, 3

In this work of Wang Hui's maturity, one feels that he has so completely assimilated the heritage of the masters that the ascription of the brush manner to one of them, in this case Li Ch'eng, has very little substance. While the bare foreground trees might have some association with the Sung master, other elements, such as the piled-up boulders and the horizontal ledges of the peak, may be more recognizable as deriving from Chü-jan (fl. ca. 960–ca. 986) or Huang Kung-wang (1269–1354). Wang Hui is able to combine them effortlessly to achieve the Great Synthesis (*ta-ch'eng* 大成) that was the goal of Tung Ch'i-ch'ang's followers.

<div align="right">RW</div>

LITERATURE: Lu Shih-hua, *Wu-yüeh*, preface dated 1776, repr. 1879, *ch.* 6, p. 32; *Chung-kuo ku-tai shu-hua mu-lu*, vol. 3, 1987, *Hu* I–2881; *Chung-kuo ku-tai shu-hua t'u-mu*, vol. 4, 1990, *Hu* I–2881.

167 *Whispering Pines in Myriad Valleys*

Wan-huo sung-feng t'u

王翬　萬壑松風圖

Dated 1715

Hanging scroll, ink and color on paper
97 x 43 cm (38⅛₆ x 16¹⁵⁄₁₆ in.)

Shanghai Museum

vol. I, pl. 167

ARTIST'S INSCRIPTIONS AND SIGNATURE:
1. 3 lines in running-regular script:
"Whispering Pines in Myriad Valleys." The ninth month, autumn, of the *i-wei* year of the K'ang-hsi era [September 27–October 26, 1715], after Pei-yüan's [Tung Yüan, fl. ca. 945–ca. 960] brush, for Mr. Hsüeh-chiang to correct. Your junior from Hai-yü, Wang Hui.

《萬壑松風圖》。康熙乙未九秋，倣北苑筆，請正雪江先生。海虞弟，王翬。

2. 4 lines in running-regular script:
Tai An-tao [Tai K'uei, d. 395] said: "Where the cliffs and peaks are high, then the vapors of the covering clouds will be fresh; where the woods are deep, then the sound of the *ch'in* will be clear." The thoughts in his breast are subtle and far-reaching, truly worthy to reflect the magic of the mountains. I have selected this scene, which happens to harmonize [with his thought], and so have written as below. Keng-yen inscribed a second time.

戴安道云：「岩岫高，則雲霞之氣鮮；林藪深，則琴筑之音清。」其胸思幽曠，真堪爲山靈寫照。適余此景與符合，故錄於左。耕煙再識。

ARTIST'S SEALS:
Shang-hsia ch'ien-nien 上下千年 (*chu-wen*, round)
Wang Hui chih yin, shih-ku 王翬之印　石谷 (*pai-chu wen*, rectangle)
Chiang-tso 江左 (*chu-wen*, rectangle)
Keng-yen 耕煙 (*chu-wen*, square)
Wang Hui chih yin 王翬之印 (*chu-wen*, square)

Keng-yen san-jen shih nien pa-shih yu ssu 耕煙散人時年八十有四 (*pai-wen*, square)
Lai-ch'ing ko 來青閣 (*chu-wen*, square)

NO COLOPHONS

COLLECTOR'S SEAL: P'ang Yüan-chi 龐元濟 (1864–1948), I

RECENT PROVENANCE: Shanghai Municipal Administration of Cultural Relics

In this very late work, Wang Hui's brush cultivates an insistent rhythm that unifies the whole composition. The inscription claims inspiration from Tung Yüan, omitting to specify that its descent is actually through Chao Meng-fu (1254–1322), as comparison with leaf 4 of Wang Shih-min's (1592–1680) Taipei album *The Great Revealed in the Small* (*Hsiao-chung hsien-ta*) in the National Palace Museum, Taipei, and leaf 9 of Wang Hui's own album of 1672 in the Shanghai Museum (vol. I, pl. 164) will make clear. The pine trees, however, with densely clustered needles and thickly dotted trunks, have more in common with Wang Meng (1308–1385), or even Wen Cheng-ming (1470–1559), than the willowy rhythms of Wang Hui's own earlier version, and no longer invite comparison with Chao Meng-fu's *Mind Landscape of Hsieh Yu-yü* (*Yu-yü ch'iu-ho*, in The Art Museum, Princeton University; see Fong et al., *Images of the Mind*, 1984, pp. 280–81), with its echoes of early landscape portraiture.

<div align="right">RW</div>

LITERATURE: P'ang Yüan-chi, *Hsü-chai*, 1909, *ch.* 9, p. 25; Xu Bangda, *Pien-nien-piao*, 1963, p. 167; *Chung-kuo ku-tai shu-hua mu-lu*, vol. 3, 1987, *Hu* I–2938; *Chung-kuo ku-tai shu-hua t'u-mu*, vol. 4, 1990, *Hu* I–2938.

Wang Yüan-ch'i (1642–1715) 王原祁

tzu Mao-ching 茂京, *hou* Lu-t'ai 麓臺, Hsi-lu hou-jen 西廬後人

Wang Yüan-ch'i, the last of the Four Wangs and a grandson of Wang Shih-min (1592–1680), was born in T'ai-ts'ang, Kiangsu, in 1642. His early instruction with his grandfather initiated him into the painting styles and theories of Tung Ch'i-ch'ang and the Orthodox School. He later became a foremost practitioner and spokesman for the Orthodox style at the court of the K'ang-hsi emperor (r. 1662–1722).

Wang obtained his *chin-shih* degree in 1670, thereafter embarking on a long and prestigious official career. He climbed steadily from a position in the Board of Civil Affairs to Magistrate of Jen-hsien in Chih-li, Secretary in the Supervisorate of Imperial Instruction, and Chancellor of the Han-lin Academy. His highest ranking position was that of Senior Vice President of the Board of Revenue, which he held from 1712 until his death in 1715.

During the years he spent in Peking, Wang Yüan-ch'i became an important cultural leader both in and out of the court. In 1700 he was appointed Advisor for the K'ang-hsi emperor's art collections, and while serving in the Han-lin directed the compilation of the *P'ei-wen chai shu-hua p'u*, a collection of writings on the history and theory of painting and calligraphy in one hundred volumes, completed in 1708. Wang was also a major contributor to the *Wan-shou ch'ang-t'u* project, a pictorial and literary commemoration of the K'ang-hsi emperor's sixtieth birthday which was completed in 1716. In addition to his accomplishments as an official, Wang Yüan-ch'i was the author of a treatise on painting entitled *Yü-ch'uang man-pi* and had many private students, including the Kiangsu painter Huang Ting (1660–1730) and the Manchu official T'ang Tai (1673–1752).

168 *Landscape in Color after Tung Ch'i-ch'ang's Interpretation of Huang Kung-wang's Style*
She-se shan-shui yung Tung Hua-t'ing fang Huang Ta-ch'ih i-i
王原祁　設色山水用董華亭倣黃大癡遺意

Dated 1710

Hanging scroll, ink and color on paper
128.2 x 55.9 cm (50½ x 22 in.)

Shanghai Museum

vol. 1, pl. 168

ARTIST'S INSCRIPTION AND SIGNATURE (15 lines in running script):
The ancients' way of painting, after [mastering] its secrets, was to make their own school, not restrained or fettered by established method. Just so did Tung Hua-t'ing [Tung Ch'i-ch'ang] learn from Ta-ch'ih [Huang Kung-wang, 1269–1354], cultivating himself throughout his life, and when it came to copying, using his ideas to obtain the spirit, not seeking an exact likeness. Whether Ni [Tsan, 1301–1374] or Chao [Meng-fu, 1254–1322], he has them both, [ink that is] dark or pale, delicate or lush— there is nothing that he could not do. It is what is known as staying within the rules when coming and going, but being outside them when it comes to spiritual brightness. This spring I rested from my labors, staying at home and declining visits. Yü-p'ei has brought *ts'e-li* [paper] to ask for paintings for Yü-weng, the honorable gentleman, my relative [through marriage], and since I am in a bit of a state (lit. fearing the heat and hating the cold), I dare not hide my own ugliness, and so have done this with these ideas. Those who know will laugh (lit. splutter their rice). Inscribed when the painting was finished, on Flower Morning [the twelfth day of the second month] of the *keng-yin* year of the K'ang-hsi era [March 11, 1710]. Wang Yüan-ch'i of Lou-tung.

古人畫道，精深之後，自成一家，不屬成法羈絆。如董華亭之於大癡，本生平私倣者，及至倣摹，用意得其神，不求其形。或倪或趙，兼而有之，蒼淡秀潤，無所不可。所謂出入於規矩之中，神明於規矩之外也。余春初以積勞靜攝，扃戶謝客。玉培以側理為雨翁老親家老先生索筆，余正在畏熱惡寒中，不敢自匿其醜，因以此意作之，以博識者噴飯耳。康熙庚寅花朝畫畢後題。婁東王原祁。

ARTIST'S SEALS:
Yü shu t'u-hua liu yü jen k'an 御書圖畫留與人看 (*chu-pai wen*, oval)
Wang Yüan-ch'i yin 王原祁印 (*pai-wen*, square)
Lu-t'ai 麓臺 (*chu-wen*, square)
Hsi-lu hou-jen 西廬後人 (*chu-wen*, rectangle)

NO COLOPHONS

COLLECTORS' SEALS: Liang T'ung-shu 梁同書 (1723–1815), 1; Ch'ien Yung 錢泳 (1759–1844), 1; Yeh Ming-shen 葉名琛 (1807–1859), 1; Ting Hui-k'ang 丁惠康 and Ku An-mi 顧安宓, 1

Perhaps Wang Yüan-ch'i's dizzying landscape forms were indeed strange enough to make his more staid contemporaries choke on their rice. The asymmetry of the main peak, and the twisted ground planes of the valleys to either side of it, seem directly indebted to Tung Ch'i-ch'ang and eschew any closer connection with the Yüan masters Wang names. Nevertheless, the trees, rocks, and larger elements are all unmistakably characteristic of Wang Yüan-ch'i. It is as though he himself had written the critical commentary, not merely in the inscription, but in the very substance of his painting.

RW

LITERATURE: Lu Shih-hua, *Wu-yüeh*, preface dated 1776, repr. 1879, *ch.* 6, p. 88; Xu Bangda, *Pien-nien-piao*, 1963, p. 1861.

169 *Wang-ch'uan Villa*
Wang-ch'uan t'u
王原祁　輞川圖

Dated 1711

Handscroll, ink and color on paper
35.7 x 537.2 cm (14¹/₁₆ x 211½ in.)

The Metropolitan Museum of Art, New York
Purchase, Douglas Dillon Gift, 1977 (1977.80)

vol. 1, pl. 169

ARTIST'S TRANSCRIPTION OF POEMS AND SIGNATURE: (mounted in front of the painting, 42 lines in running script, undated):
Wang Yüan-ch'i transcribes Wang Wei's (701–761) brief preface and twenty poems composed on scenes from his *Wang-ch'uan Villa* (see Whitfield, *In Pursuit of Antiquity*, 1969, pp. 200–203, for translations of the poems).

ARTIST'S INSCRIPTION AND SIGNATURE (mounted following the painting, 21 lines in running script):
On the right is Yu-ch'eng's [Wang Wei] Wang-ch'uan Villa. Having written twenty poems of five-word regulated verse to describe the scenes, [Wang Wei] also painted this composition. In the art of the Six Principles [i.e. painting], it was Yu-ch'eng who first mastered [the secret of] "breath-movement-life-motion," capturing the true composition of the universe. Ching [Hao], Kuan [T'ung], Tung [Yüan], Chü[-jan], the two Mis [Mi Fu and Mi Yu-jen], Li [Ch'eng] and Fan [K'uan] of the Northern Sung, as well as Kao [K'o-kung], Chao [Meng-fu] and

the Four Masters [Huang Kung-wang, Wu Chen, Ni Tsan and Wang Meng] of the Yüan, all followed [Wang Wei's] ideas, each inheriting the "lamp-flame" and becoming a great master of the Orthodox tradition. Since the Southern Sung period, there have been a great many known painters competing with each other like flowers on a piece of brocade, each of them of a different stature, school and tradition. Though a student might broaden himself by using these different traditions to fill out [his education], were he to mistake this as his sole training, he would then have attained merely the dregs of the ancient tradition, and not its inner essence.

During the three hundred years of the Ming dynasty, only Tung Ssu-weng [Tung Ch'i-ch'ang] succeeded in sweeping away the web of confusion. My late grandfather Feng-ch'ang [Wang Shih-min] personally inherited the [orthodox] mantle [from Tung]. As I used to attend [my grandfather] in my youth, I have learned a few things [about painting]. In recent years, I have become acquainted with the elderly gentleman Chi-weng. When I painted for him Lu Hung's [*Ten Views from a*] *Thatched Lodge* (*Ts'ao-t'ang t'u*), about three years ago, I had promised that I would someday paint also the long handscroll composition Wang-ch'uan [by Wang Wei]. Since I had not then had access to a reliable sketch of the composition, I did not dare to tackle it from ignorance. Last autumn, I acquired a popular stone engraving [of the composition]. Using the poems found in [Wang Wei's] collected works as a reference, I made this scroll with my own ideas, so that it is different from a copy of "physical likeness" (*hsing-ssu*) by a professional painter. Nine whole months have since passed. During every leisure hour away from official duties, I have worked on it. By adding poetry to the ink engraving, I have been able to see the wonders of Yu-ch'eng's designs of *yang* and *yin*, their ever-changing forms and steps. Though some may think that my work is clumsy and inferior, I believe that it has captured some of [Wang Wei's] idea of "painting in poetry and poetry in painting." Will not the Master [Chi-weng] have a chuckle over this? (Translation by Marilyn and Shen Fu, in Whitfield, *In Pursuit of Antiquity*, pp. 203–4.)

Inscribed on the eleventh day of the sixth month of the *hsin-mao* year of the K'ang-hsi era [July 26, 1711] by Wang Yüan-ch'i of Lou-tung.

右丞輞川別業，有五言絕句二十首紀其勝，即系以圖。六法中氣運生動，得天地真文章者，自右丞始。北宋之荊、關、董、巨、二米、李、范；元之高、趙、四家俱祖述其意，一燈相續爲正宗大家。南宋以來，雖名家蝟立，如簇錦攢花，然大小不同，門戶各判，學者多聞廣識，皆可爲腹笥之助。若以爲心傳在是，恐未登古人之堂奧，徒涉古人之糟泊耳。有明三百年，董思翁一掃蠶叢，先奉常親承衣鉢。余髫齔時，承歡膝下，間亦竊聞一二。近與寄翁老先生論交已久，三年前擬盧鴻《草堂圖》，即相訂爲輞川長卷，以未見粉本，不敢妄擬。客秋偶見行世石刻，并取集中之詩參考，以我意自成，不落畫工形似，迄今已九閱月，公事之眼無時不加點染，墨刻中參以詩意，如見右丞陽施陰設、移步換形之妙。即云拙劣，亦略得詩中有畫、畫中有詩遺意。先生見之，得無捧腹一咲乎。康熙辛卯六月十一日題，婁東王原祁。

ARTIST'S SEALS:
Yüan-ch'i Mao-ching 原祁茂京 (*chu-wen*, square)
Mo-chieh hou-shen 摩詰後身 (*pai-wen*, square)
Hsing yü yen-hsia hui 興與烟霞會 (*pai-wen*, rectangle)
Shih-shih tao-jen 石師道人 (*pai-wen*, square)
Hua-t'u liu yü jen k'an 畫圖留與人看 (*chu-wen*, rectangle)
Wang Yüan-ch'i yin 王原祁印 (*pai-wen*, square)
Lu-t'ai 麓臺 (*chu-wen*, square)

LABEL STRIP: Chu I-fan 朱益藩 (19th-20th century), undated, 2 seals

COLOPHONS: Wu Hu-fan 吳湖帆 (1894–1968), on the brocade border preceding Wang Yüan-ch'i's poems and painting, undated, 2 seals; Huang I 黃易 (1744–1802), undated, 1 seal; Wu Hu-fan, dated 1944, 3 seals; Chao Shih-kang 趙時棡 (1874–1945), dated 1944; Wu Cheng 吳澂 (fl. mid-20th century), dated 1944, 1 seal; Wu Tzu-shen 吳子深 (b. 1894?), dated 1944, 3 seals; Xu Bangda 徐邦達 (b. 1910), dated 1945; T'ang Yün 唐雲 (contemporary), dated 1945; Chang Ta-ch'ien 張大千 (1899–1983), dated 1946, 2 seals; Wang Ya-ch'en 汪亞塵 (b. 1893), dated 1949; Huang Chün-pi 黃君璧 (b. 1898), dated 1966; Kao I-hung 高逸鴻 (contemporary), dated 1966; Ling Shu-hua 凌叔華 (contemporary), dated 1967
(For translations of colophons, see Marilyn and Shen Fu, in Whitfield, *In Pursuit of Antiquity*, pp. 199, 204–8.)

COLLECTORS' SEALS: Wu Hu-fan, 1; Wang Chi-ch'ien 王季遷 (b. 1907), 9; Earl Morse 穆思 (1908–1988), 3

RECENT PROVENANCE: Xu Bangda, Wang Chi-ch'ien, Earl Morse

Because of his family ties and official position, Wang Yüan-ch'i saw himself as the standard-bearer of orthodoxy in his generation. In his long inscription following this painting, Wang recites the canonical lineage of earlier masters whose styles derived from that of Wang Wei, culminating with Tung Ch'i-ch'ang and his grandfather, Wang Shih-min (1592–1680), thereby asserting his own legitimacy as the inheritor of the orthodox mantle.

No painting better illustrates Wang's role as the proper interpreter of scholar-painting than his *Wang-ch'uan Villa*, which he worked on over a nine-month period, completing it in the summer of 1711 when he was seventy *sui* (sixty-nine years old). This long handscroll depicts the country estate of the poet-painter Wang Wei, revered as the fountainhead of Tung Ch'i-ch'ang's Southern School of painting. Just as the villa epitomized the scholar's garden and way of life, Wang Wei's legendary painting of his estate, known only through later copies, was regarded as the starting point of scholar-painting.

Wang Yüan-ch'i asserts in his inscription that he drew inspiration for his painting from Wang Wei's poetic descriptions of the villa while basing his design on a recently acquired rubbing of the Wang-ch'uan composition that had been engraved into stone in 1617. In fact, Wang Yüan-ch'i's interpretation is neither a literal illustration of Wang Wei's poems nor a precise replica of the transmitted design. As Wang Yüan-ch'i proudly declares in his inscription, "I made this scroll with my own ideas, so that it is different from a copy of 'physical likeness' (*hsing-ssu* 形似) by a professional painter." Thus, as James Cahill has pointed out, the painting was not "an act of visualization or a process in which poetic insight or impressions of natural scenery played much part." Instead, Wang approached his interpretation in terms of compositional devices, brushwork, and the imitation of old masters (Cahill, *Compelling Image*, 1982, pp. 191–92). The rubbing, which preserves only a schematic likeness of the original, liberated Wang Yüan-ch'i to fill in and modify the composition according to his own ideas. Just as Shih-t'ao reinterpreted woodblock designs to create his early landscape and figural style, Wang took the engraving as a starting point which he could creatively elaborate upon and transform using the variables of brushwork, color, and dynamic compositional movements.

In his *Wang-ch'uan Villa*, Wang Yüan-ch'i has made shifts in the ground plane, added and subtracted landscape elements, and varied

the density of motifs to transform the static, maplike rubbing into a dynamic composition. Wang described this creative process in his "Yü-ch'uang man-pi" ("Scattered Notes by a Rainy Window"), as follows: "[The artist] must first decide on the *ch'i-shih* 氣勢 [dynamic movement of the vital energy, or *ch'i*], then make divisions [of the painting surface] as a framework, then lay out the sparse and dense areas, then distinguish the darker and lighter places" (Cahill, *Compelling Image*, p. 192). Rejecting the rational, quasi-illusionistic spatial organization of the engraving in favor of a formal construction in abstract space, Wang sought a strong sense of surface rhythm by linking landscape forms into large-scale compositional structures which he called "dragon veins" (*lung-mo* 龍脈). In concept, these abstract graphic structures are built up and interconnected in much the same way that characters are creatively composed and linked in a piece of cursive calligraphy. In treating landscape forms as abstract patterns, Wang Yüan-ch'i followed the lead of Tung Ch'i-ch'ang, who was the first artist to transform landscape structure in painting by means of abstract compositional movements. Inspired by the archaic convention of ringed mountain motifs in the rubbing, Wang Yüan-ch'i creates "dragon veins" through which the cosmic "vital energy" (*ch'i-shih*) vigorously flows.

Wang further energized his picture surface with calligraphic brushwork and color. Landscape forms are built up through a complex layering of thin, angular contour lines and broad, dry-brush texture strokes loosely derived from the fourteenth-century scholar-artists Huang Kung-wang (1269–1354) and Wang Meng (1308–1385). This rich skein of brushstrokes is complemented by Wang Yüan-ch'i's scintillating use of color. His rich palette pointedly recalls the blue-and-green color scheme of archaic landscapes, but he avoids the artisan's method of applying color in opaque fields of mineral pigment or in flat washes that fill in monochrome outlines. Instead, Wang's washes and dots interact and complement his monochrome brushstrokes in order to enhance and enrich the calligraphic structure of his landscape forms.

Wang Yüan-ch'i believed that he could achieve "spiritual correspondence" with Wang Wei through his personal metamorphosis of past styles. By transcending the "physical likeness" of his model through the creative application of brush conventions and compositional principles adapted from other scholar-artists in the Southern School lineage, Wang successfully integrated and transformed his sources, demonstrating his mastery over the tradition and proving himself a worthy transmitter of the orthodox "lamp flame."

MKH

EXHIBITIONS: China Institute in America, New York, 1968: Weng, *Gardens in Chinese Art*, no. 14, p. 29, figs. 3, 4, pp. 8–9; The Art Museum, Princeton University, 1969: Whitfield, *In Pursuit of Antiquity*, pp. 180–86, 199–211, cat. no. 31.

LITERATURE: Sirén, *Leading Masters and Principles*, 1956–58, vol. 7 (lists), p. 443; Moskowitz, *Great Drawings*, 1962, vol. 4, p. 905; Contag, *Seventeenth Century Masters*, 1969, p. 34, pl. 58; Murck and Fong, "A Chinese Garden Court," 1980–81, pp. 4–6, 20–22, figs. 2, 20, 33; Kuo Chi-sheng, *Wang Yüan-ch'i*, 1981, pp. 76–77, figs. 66–72; Cahill, *Compelling Image*, 1982, pp. 188–225, figs. 6.3, 6.6, 6.8, 6.22, 6.47; Silbergeld, *Chinese Painting Style*, 1982, pl. 3, fig. 18; *The Metropolitan Museum of Art: Asia*, 1987, pl. 63.

170 *Iron Cliff*

T'ieh-yai t'u

王原祁　鐵崖圖

Dated 1715

Hanging scroll, ink and color on silk
130.5 x 74.1 cm (51⅛ x 29³⁄₁₆ in.)

Shanghai Museum

vol. 1, pl. 170

ARTIST'S INSCRIPTION AND SIGNATURE (9 lines in running script): Ta-ch'ih's [Huang Kung-wang, 1269–1354] paintings were lush and luxuriant; he did not make strange crags, and in many places sand and water merge into one another. Only in his *T'ieh-yai t'u* did he use many precipitous cliffs and great boulders, to express solemn grandeur and endurance. Now that his disciple is on a tour of inspection [as a Prefect] in the province of Ch'u, I would like to use my clumsy brush to present to the venerable Mr. A. I have made a point of taking [Huang Kung-wang's] ideas, and idly daubing, but without really knowing if it even remotely resembles [Huang Kung-wang]. In mid-autumn of the *i-wei* year of the K'ang-hsi era [September 12, 1715], Wang Yüan-ch'i of Lou-tung painted and inscribed.

大癡畫華滋渾厚；不爲奇峭，沙水容與處甚多。惟《鐵崖圖》多用陡壁磐石，以見巍峨永固之意。今樹弟觀察楚中，欲以拙筆奉贈阿老先生，特取其意，漫爲塗抹，未識能彷彿萬一否。康熙乙未中秋，婁東王原祁畫并題。

ARTIST'S SEALS:

Yü shu t'u-hua liu yü jen k'an 御書圖畫留與人看 (*chu-pai wen*, oval)
Wang Yüan-ch'i yin 王原祁印 (*pai-wen*, square)
Lu-t'ai 麓臺 (*chu-wen*, square)
Hsi-lu hou-jen 西廬後人 (*chu-wen*, rectangle)

NO COLOPHONS OR COLLECTORS' SEALS

Despite the fact that Wang Yüan-ch'i identifies a specific composition by Huang Kung-wang, this painting is so imbued with his own character, both in the brushwork and in the whole composition, that one would be hard put to imagine the appearance of the original work. Wang Yüan-ch'i attains a sense of grandeur and awesomeness in the landscape not by means of surface texture, such as might have been the case in the work of Fan K'uan (d. after 1023) or Yen Wen-kuei (fl. ca. 988–ca. 1010), classical masters of the northern landscape, but through the restless energy of the rock formations, constantly changing direction but moving diagonally upward in an unbroken sequence from foreground to the mountain summit and with sharply tilted ground planes. Similarly, Wang Yüan-ch'i makes distinctive use of color and of dense patches of white cloud, achieving a complete transformation of Huang Kung-wang's style and subject into something entirely personal.

RW

LITERATURE: *Chung-kuo ku-tai shu-hua mu-lu*, vol. 3, 1987, *Hu* 1–3280.

Hsüeh-chuang (d. ca. 1718) 雪莊

Buddhist name Ch'uan-wu 傳悟, *tzu* Hsing-t'ang 惺堂, *hao* T'ieh-hsieh tao-jen 銕鞋道人, Huang-shan p'i-fa-weng 黃山披髮翁, *chai* Yün-fang 雲舫

Hsüeh-chuang, a monk-painter from Huai-an, Anhui, entered a monastery as a child and took the Buddhist name Ch'uan-wu. He became a pupil of Nan-an ta-i, a follower of the Ts'ao-tung sect of Ch'an Buddhism.

After completing his initial training in the 1670s, Hsüeh-chuang moved from temple to temple in the Chiang-nan region, finally settling in 1689 at P'i-p'eng, a remote site high in the peaks of Mount Huang in southeastern Anhui. He built a simple residence that he named Yün-fang (Cloudy Boat) where he eked out an existence on the edge of the wilderness.

Though Hsüeh-chuang remained in seclusion, his high-minded integrity and tranquil spirit soon attracted the attention of travelers to the region, some of whom made the arduous journey to Cloudy Boat to discuss with him the teachings of Ch'an Buddhism, listen to him play the *ch'in* (Chinese zither), and admire his paintings and poetry. Eventually, his reputation spread as far as the imperial palace, whence repeated summons were issued in 1693. Hsüeh-chuang twice declined the K'ang-hsi emperor's (r. 1662–1722) invitations, but the third missive from the court brought acquiescence. Arriving in the capital in the spring of 1694, he immediately regretted his decision and beseeched the emperor to allow him to return home. After several months his request was granted and in the autumn of that year he quietly returned to P'i-p'eng, where he lived out the remainder of his life.

other things. Therefore, I made this painting of the *Cloudy Boat* for his enjoyment and as a token of consolation for our mutual sadness at being separated. At the same time, I duly request his comments for improvement. One day before the Ch'ung-yang [Double Ninth] Festival in the *wu-hsü* year [October 31, 1718]. Huang-shan P'i-fa-seng, [Ch'uan-]wu, Hsüeh-chuang painted and inscribed in Ch'in-ch'uang [Studio].

《黃海雲舫圖》
蒙君訪我季春天
夏又通書寄舫邊
欲慰多情難當面
和峰飛到韻人前

今春喜我且碩先生山遊過訪。夏月又蒙遠寄書物。因作《雲舫圖》寄供清賞，聊慰懷思，兼請教正。時戊戌登高前一日。黃山披髮僧，悟，雪莊氏画并題於琴窗中。

ARTIST'S SEALS:
Yün-fang 雲舫 (*chu-wen*, rectangle)
Huang-shan p'i-fa-weng 黃山披髮翁 (*chu-wen*, square)
Hsüeh-chuang 雪莊 (*chu-wen*, square)
Ch'in-ch'uang 琴窗 (*chu-pai wen*, gourd shape)
Shou ch'ang wu-shih 壽昌五世 (*chu-wen*, rectangle)
Ch'u-chou seng Wu tzu Hsing-t'ang hao Hsüeh-chuang pieh-hao T'ieh-hsieh tao-jen 楚州僧悟字惺堂號雪莊別號銕鞋道人 (*pai-wen*, square)

NO COLOPHONS OR COLLECTORS' SEALS

RECENT PROVENANCE: Sotheby's, New York

LITERATURE: Hsüeh-chuang, *Huang-shan t'u*, preface dated 1698; *I-lin* 45 (1929): 4; Zhu Yunhui, "Hsüeh-chuang," 1980, p. 82, pl. 8; Sotheby's, catalogue, December 4, 1986, no. 87; Wang Shiqing, "Hsüeh-chuang te *Huang-hai yün-fang* t'u," 1987.

171 *Cloudy Boat in the Yellow Ocean*
Huang-hai yün-fang t'u
雪莊　黃海雲舫圖

Dated 1718

Hanging scroll, ink and color on paper
100 x 57.7 cm (39⅜ x 22¹¹⁄₁₆ in.)

The Nelson-Atkins Museum of Art (Nelson Gallery Foundation Purchase) F86–43

vol. 1, pl. 171

ARTIST'S INSCRIPTION AND SIGNATURE (12 lines in running-regular script):
Painting of the *Cloudy Boat in the Yellow Ocean.*
You visited me in late spring,
You wrote me again at Cloudy Boat in summer.
I would like to repay your affection but it will fall short of actually meeting,
With these mountains I fly to the presence of a refined man.

This spring I was happy that Mr. Ch'ieh-shih made an excursion to the mountains and visited me. During the summer he sent me books and

Supplementary Plates

PLATE I. Tung Ch'i-ch'ang. *Theories on Calligraphy and Painting*, running script, dated 1592. Beijing Palace Museum.

PLATE 2. Tung Ch'i-ch'ang. *Eight Views of Yen and Wu*, dated 1596. Album of eight paintings. Shanghai Museum. (colophon)

寫樂敦則情多怫持
書畫讚則意涉瑰奇
黃庭經則怡懌虛無
太師藏則又縱橫曲折
蘭亭興集則逸神超
社門告誓情拘意慘
所謂涉樂方笑言哀
己欲豈惟注想流波
將貼舉嗳之奏馳神
澳方里藻繪之文雅其
目擊道存荀或心遽議
牉莫不強名為體其習

玄色豈克情動形言
取會風騷之意陽舒
陰慘本乎天地之心
右孫虔禮書譜
東坡先生少日學蘭
亭亦自書姿媚似徐
季海至酒酣意忘工拙
字特疫動乃似柳誠懸
筆園而韻勝揉以文章
妙天下忠義剔日月之
棠

董其昌書于寶鼎齋

PLATE 4. Tung Ch'i-ch'ang. *Landscape after Kuo Chung-shu*, undated (ca. 1598–99; inscription dated 1603). Östasiatiska Museet, Stockholm. (colophon)

PLATE 5. Tung Ch'i-ch'ang. *Calligraphy in Running and Cursive Scripts*, dated 1603. Tokyo National Museum.

羅漢贊

名身句身如月標指情
或產眼達照鑽紙吡俗
慈者我注王子貝第一
此大藏裏許

大海号漚洀即全海
向法海中遊戲自在
攬壽虫敲珠招
恬掁入鉢盂
　　初祖贊
廓然無聖鬩抉豈
魯刹那印證據里
坐虔金錘抹曉云
家慶河著取於相
聖魏娑羅
送僧遊五臺
此語不僧寒長揚雪
敕勾清凉古人天

無盡無來無去住此
是了達三世事趣法
才便筆十力平時六解
此語不如惺時觀得受
因年一看
偈曰帝釋明珠
緇剌菴若來當
念當三生塵米飲
主分昭柔子十三參
　　鈍置人
三昧解此正里惟曰
謂正里惟此正不正扎
里不里乃心心念念相
續不乃依多言夢也
只人解作念念里
以當佛法此乃雜
當人此永寿吟前
北三昧義也
若行謂之修福此意難
眷屬精修梵川使陌天

P L A T E 8. Tung Ch'i-ch'ang. *"Eulogy on the Dynastic Revival of Great T'ang,"* running script, undated (ca. 1605–10). Hsü-pai Chai—Low Chuck Tiew Collection.

大唐中興頌

尚書水部員外
郎兼殿中侍御
史荊南節度
判官元結撰
金紫光祿大夫
前行撫州刺
史上柱國曹郡
開國公顏真卿
書
天寶十四年安祿
山陷洛陽明年
陷長安天子幸
蜀太子即位於
靈武明年皇帝

立一呼千麾萬
旟戎卒前驅我
師其東儲皇撫
戎蕩攘群凶復
復指期曾不逾
時有國無之事
有至難宗廟再
安二聖重歡地
闢天開蠲除祆
災瑞慶大來凶
徒逆儔涵濡天休死生堪羞
功勞位尊忠烈名存
澤流子孫盛德
之興山高日昇
萬福是膺能令大

君聲容沄沄
漫郎左氏癖曾
圍篆之兒千聲
遠擅場同時恰
對墨看唐九廉
隨秋烟一片中央
石不敗幾回吟
猶寶子春幾發
秀解陳迹新
遼寧為米退襟
郭杜鶴壽意
舍哭丞扣鈥黃
絹素光怡彥圍以
山修棄葉學時富
貴腴斜多異代
風流楊筆在七生
毎負柱圍藝元
右為

寶鼎齋臨宋蘇黃米蔡帖

神農曰上藥養命中
藥養性省誠知性命
之理因輔養以通也而
世人不察惟五穀是
見聲色是耽目惑言
黃耳務淫哇滛味
煎其府藏體膰貴
其腸胃香芳腐其
骨髓喜怒悖其正
氣思慮燒其精神
哀樂殊其平粹夫以
蒶尔之軀改之者非一
途易竭之身而外內受
敵身非木石其能久
乎

東坡書學王僧虔徐浩顏
平原挾以文章妙天下忠義
冠日月之氣故為宋名家革
一此甚所書晉宋間夜墨堂
論尤合作者已刻鴻堂帖第十
三卷

九陌黃塵烏帽底五湖春
水白鷗前扁舟不為鱸魚去
收取聲名四十年
桃李無言一弄風黃鸝唯見
綠愁、人言九事八為律僮
有江船吾欲東

嘉州趙肯堂頃過施州
清江而識之學問之士
而不慚為吏及問其里人
本窗寄孤立而能自奮官之暉
祿以事其父母而解官之暉
未蒙諸呂除用也
 庭堅再拜

山谷書學顏平原坐位帖間生
楊凝式大字以鶴銘為師短
羊小長沙怳素三昧古雅有
餘猷伉真意氣不署豬懃
妍媚志二藁之以攻俗此在
牲肉人意橄攬一洗肥懷
腸胃末為不而山

天地之間雜大體陽
況君子陰比小人而五行
交相為功吞有正位其
厖雜者未交豪于陰陽

之間蓋乱臣賊子之
所稟雖其自粉飾一
時瑕域聖賢明未即
察而陰謀未旋踵
則澤國之女嬖竇宬
所共信而古今不可浮
而議者中岳外史米芾帶
筋祠揭千古是幽顯之

政肅野多滯
路不拾遺知
慈、聽謳歌
遠相過佳氣
揚帆載月
秋晏資餘興
穗是時和天分

PLATE 10. Tung Ch'i-ch'ang. *Running Script in the Manner of the Four Sung Masters*, dated 1607. Beijing Palace Museum.

味向詩編　　晴獻溪山入

辰事考來情　醉峨便揮帳

獨把秋英縷　蝼其研墨絲

守風流古而傳　歲書畫蜀江

閱客今馬是謝　波

粮居前杜郎

後群賢畢至　山清氣桑九

里結言寧有　秋天黃菊紅

莫滿汉船千

米南宮書學歐陽率更
褚登善顏平原楊少師
已降自成一家以勢為主
姿態橫溢沈著痛快
宋時名家目當獨步
小遠子晚人地使然平
于書品出辞上以功力
于到全左此牽克埴
心筆山勢脈凡偏師取奇也

襄陽秋暑稍盛不審
動止佳居藥遷田
正旦蒙示書涇歲荷
之玉門中休豫者
親之下多因平望
者廷日來事務漸
閱令夏病能金樓
輕安鄉親來及一.
通書不宣

蔡君謨在蘇黃前今世稱蘇黃米蔡
蓋蔡京卒以其父云則國政并沒
其書京師大觀帖標各姓是
也清媚有古意然米元章謂蔡京不得
筆蔡卞浮華似米倪雲林
當訶元章此傳以為阿米顯當不玄
此董其昌書丁未六月八日也

13–2a

leaf 13–2

13–7a

leaf 13–7

PLATE 13. Tung Ch'i-ch'ang. *Paintings and Calligraphy on Round Fans*, dated 1610. Album of ten paintings with ten leaves of calligraphy. Hsü-pai Chai—Low Chuck Tiew Collection.

PLATE 13. colophons

PLATE 14. Tung Ch'i-ch'ang (*tai-pi*). *Landscapes in the Manner of Old Masters*, undated (ca. 1610–12). Album of eight paintings. Bei Shan Tang Collection. (colophon)

PLATE 18. Tung Ch'i-ch'ang. *Invitation to Reclusion at Ching-hsi*, dated 1611. The Metropolitan Museum of Art. (colophons by Tung Ch'i-ch'ang and Wu Cheng-chih)

PLATE 20. Tung Ch'i-ch'ang. *After Mi Fu's "Rhyme-prose on the Celestial Horse,"* large running script, dated 1612. Shanghai Museum.

天馬賦方唐牧之至盛有天骨之超俊勒四十萬

署龍顯而孤起耶鳳衒竿翠竿以雙峻建而出步闌闔下而輕

橫馳而立元領斷盛絕林以比德敢伺瞰以戟客豈肯浪逐金粟

於是鳳　灾但覽　喬岳揚
靡格頳　駛要就　四夷之
色妙才　茆鼠伏　塵轂岐
駘入伏　防猜姤　陽之獵
不動終　心雅屬　則飛黃
日如林　馴彌期　腰裊
乃得玉　諧誓倪　彌雲追
為衙　首以畢　電何所
飾繡作　並末伏　臨雨遑
安　壖以興　來夕所

賓 四 充 安 海 十 漢 傳
制 夷 實 府 內 餘 興 贊
度 未 而 庫 乂 載 六

主 枚 蒲 及 之 父 方 多
父 生 輪 始 如 武 欲 闕
而 見 迎 以 弗 求 用 上

青 賈 羊 芻 式 並 異 士 歎
奮 竪 擢 牧 拔 出 人 慕 息
于 衞 於 弘 於 卜 間 嚮 羣

PLATE 22. Tung Ch'i-ch'ang. *Eulogy of Ni K'uan*, running-regular script, undated (ca. 1612–16). Beijing Palace Museum.

儒雅則公孫弘董仲舒倪寬篤行則石建石慶質直則汲黯卜式推賢

枚皋應對則嚴助朱買臣數則唐都洛下閎協律則李延年運籌

其餘不可勝紀以興功業制度遺文後世莫及宣承統纂

奴　則　降　末　版　牛　芙　浮　是
僕　出　霧　暴　藥　之　漢　人　為
日　於　於　時　飯　朋　之　於　戚

則　國　時　則　張　章　馬　如
韓　鄭　定　趙　湯　則　遷　滑
安　當　令　禹　文　司　相　稽

則　羊　奉　張　武　則　霍　受　霍
桑　孔　使　騫　將　衛　去　遺　光
弘　僅　則　襄　帥　青　病　則　金

始以儒術進劉向王褒以文章顯將相則張安世趙充國魏相

漢嚴延年張敞之屬皆有功迹見述於後世亦其次也褚遂良

董其昌

俻洪業　亦講論　六秋招　選茂異　而蕭望　之梁丘　賀夏侯　勝韋玄　咸嚴彭

丙吉于　定國杜　延年治　民則黃　霸王成　龔遂鄭　弘趙信　臣韓延　壽日肖

有此帖　　　　孔余以　龔平　之山光　屈居为　而雨迫　明膏序

leaf 34–4 leaf 34–3 leaf 34–2 leaf 34–1

leaf 34–8 leaf 34–7 leaf 34–6 leaf 34–5

PLATE 34. Tung Ch'i-ch'ang. *Abbreviated Version of Su Shih's "The First Excursion to Red Cliff,"* running script, undated (datable to 1617–18). Album of fifteen leaves. Beijing Palace Museum.

leaf 34–12 leaf 34–11 leaf 34–10 leaf 34–9

leaf 34–15 leaf 34–14 leaf 34–13

35–3a leaf 35–3 35–5a leaf 35–5

35–6a leaf 35–6 35–8a leaf 35–8

PLATE 35. Tung Ch'i-ch'ang. *Calligraphy and Painting*, dated 1618. Album of eight paintings with eight leaves of calligraphy. Shanghai Museum.

leaf 38–2

leaf 38–3

leaf 38–6

leaf 38–8

PLATE 38. Tung Ch'i-ch'ang. *Eight Views of Autumn Moods*, dated 1620. Album of eight paintings. Shanghai Museum.

文人之畫不在錢徑而在筆墨
李營丘惜墨如金正不業時為有
此耳元四大家皆於多觀主辜
此冊而諸一共評許好
偽名顧小者崖而文矣　眉公識

金於畫尤不能爭諸長見
古人真蹟絹楮而等遂如
撒之久字悉都等所滑
美能各日暗室凌逸不能
此冊甚小暑不以百存而去
荀日毫不曾把佳此冊為
雪業而薨暑時母次晉
陸遇陪把玩吾與我聞
旋此焉身修二一帙子
癸亥三十月廿二日董其昌識次

PLATE 39. Tung Ch'i-ch'ang. *Landscapes*, dated 1621. Album of seven paintings. Beijing Palace Museum. (colophons by Tung Ch'i-ch'ang and Ch'en Chi-ju)

PLATE 45. Tung Ch'i-ch'ang. *Poems after the Rhyme of Yeh the Junior Imperial Preceptor*, running script, dated 1622. Beijing Palace Museum.

君之宗元名筆一幛百
金鑒空小詁類收贋
市而淺學之流竊學
挽筆夕已自標或曰
此學蓺冥或曰民學
董巨元章而因得紹復
無人也
宋晦翁自言書學
曹雲涇宗時學書者
臣古錢版之晦為書
自榜額之知而之每見
予得端州之友石臺
記董玄齋姓縮為
小市大考且鍾太傅
法二隆呂分轉意時
寓論多居天下字被疆
貢寫壞但負不小
金沙王伯素明府
為書浦廣之時莘然

匡謂往歲福建賊廖恩
湖南賊詹遇只是場冶流
浪惡積貫盈不死不佳放殺
人放火保依險固偷延性命
時本霄不飢百姓皆欲持
挺捕殺所以不旋踵敗獲
今蘇湖與江海連接而民饑
築賊鼓扇輕他與行小人若
因而勢不可還入江下海
為患必長其名廖恩詹遇亦
是當時郡縣當職無銷之
之術使至驚擾數郡數路
遣兵方能彈定今來兩浙
及其末有主名以術壞之禾
亦善乎余小人不知朝廷德
澤深厚曲為姑息以為飢則

PLATE 48. Tung Ch'i-ch'ang. *Casual Writings by a Window*, running script, dated 1623. Album of fourteen leaves mounted as a handscroll. Beijing Palace Museum.

閒窗漫筆

今日拾閱舊煙雲過眼
錄有陶隱居寫
小楷黃庭亦景純

與大洞經此三經為
吾石庫歸論真蹟
又曰楊凝式書千文
今皆無傳想見元末

國初法書彩為裹
中之筆今東南惟
晉陵唐民好藏珍
氏綱於項民好藏者
官之漸為好事者而
嚬此於寒之無冲余
小游天下惟之地問于

者彩如朱老之作寶
章初訪錄雜矣
當一卷一帖無入眼
玉杼畫如道丞託論素
書弓法帖為之意求

重佑收予書畫予跋
畫卷予弓弦句云石室
奉章待訪孫尺家自
弓舊青體奇閱主藏
多悵怪昌獻河為擔
儔轉伯奮予因館主
宇泰拾詞之彩子也
大字難於結密而筆冒

小字難於寬展而
餘彩無萬論著米云
而云大字如小字小字
如大字品心壽為主
山異琚之天下第一云
如來壽之寶裝第一
善乃筆法今榜書
當玉趙那若之上稍

穎尊之稚營讓序
章為力乃左作小行書
時有之結構也書云

右米元章剗子姪頭書刻寶晉齋帖
似褚河南東兩筆意人謂米往觀其
論事乃不往也 曹君

當然勁米則不為強盜
盜藏則必招所以度宣
而藏之使出小人意外乃
善

溪大熱去恆中玉

（草書數行，字難辨）

Plate 49. Tung Ch'i-ch'ang. *"Yin-fu ching,"* regular script, dated 1624. Shanghai Museum.

PLATE 53. Tung Ch'i-ch'ang. *River and Mountains on a Clear Autumn Day*, undated (ca. 1624–27). The Cleveland Museum of Art. (colophons by Kao Shih-ch'i, Sung Lo, and Shao Ch'ang-heng)

PLATE 55. Tung Ch'i-ch'ang. *"Record of the Grand Tutor Hsü Kuo's Tomb Shrine,"* running script, undated (datable to 1625–26). Beijing Palace Museum.

太傅許文穆公墓

祠記

神祖朝歲在巳丑吾

师許文穆公典南宮

試而舉會稽陶望齡

華亭其昌南昌劉日寧

三人皆以天下士相許

俊以生死交相託比公

還政歸則陶子以呪

劉子以白馬素車赴

骸大斗備祝噥之儀

執綿之會玉於先师

兆城諸子董構皆未及

見其大全也貞昌年顏

第一束問賓玉於水濱必

於樂我丘也別起福庭

則魂兮歸來仍依華

屋蕭家师倫何取焉

形華而翠華斯飛宗

玉招魂兮參蘭為橑

而桂為宇若堂封若

釜封出自森之柏迎

神曲迄神出鑴柞翼

費之廡堂惟孝子慈孫

進酺精乎有所且使門

生牧吏蓬藜而知歸

失哉曰峋地西室軒皇鑄

鼎之區東連許祖煉丹

之窟公與宣平同姓捋因

59-3a

leaf 59-3

59-7a

leaf 59-7

59-8a

leaf 59-8

PLATE 59. Tung Ch'i-ch'ang. *Landscapes*, undated (ca. 1626–30). Album of nine paintings, with colophons by Kao Shih-ch'i. Beijing Palace Museum.

colophon by Shen Ch'üan

colophon by Kao Shih-ch'i

leaf 62–1 leaf 62–2 62–2a

leaf 62–3 leaf 62–6 62–8a

PLATE 62. Tung Ch'i-ch'ang. *Eight Landscapes*, dated 1630. Album of eight paintings with two leaves of calligraphy. The Metropolitan Museum of Art.

PLATE 63. Tung Ch'i-ch'ang. *"Singing Aloud,"* cursive script, undated (ca. 1630). Shanghai Museum.

PLATE 64. Tung Ch'i-ch'ang. *Running Script in the Manner of the Four Sung Masters*, undated (ca. 1632). Beijing Palace Museum.

蘇黃米蔡

天際烏雲含雨重樓
頸紅日照山嶋蕩漾居
士今何在春睡重看人萬
里情

綽約新嬌生眠障

侵尋舊事上眉尖

閑愁別恨都多少

溶溶春潮滿滿添

隴上囊空歲月壽

須看回首自標鈉閑

羞花放雲在女長念

石且題娥娥稱窓
星

漸雲一片洞庭

帆玉破鱸魚霜

破柑好作新詩

繼染苧垂紅秋
色滿東南

欲尋闌檻倒芳

樽江上風煙雲向

晚香歡溟喚春風

吹散雨明朝卻待
入花園

花來全開月未圓看

花待月思依然明知

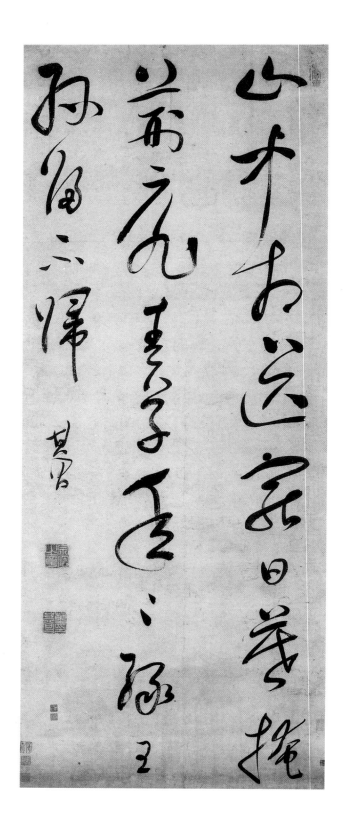

PLATE 65. Tung Ch'i-ch'ang. *Poem by Wang Wei*, cursive script, undated (datable to 1632). The Metropolitan Museum of Art.

P L A T E 67. Tung Ch'i-ch'ang. *Poem for Mao Hsiang*, running script, undated (ca. 1634). Lent by Wen C. and Constance Tang Fong.

PLATE 68. Tung Ch'i-ch'ang. *Clearing after Snow on Mountain Passes*, dated 1635. Beijing Palace Museum. (colophons by Ku Ta-shen, Tai Pen-hsiao, Shen Ch'üan, and Mao Hsiang)

文敏墨妙自成一家道
意匠心不全摹古此卷
倣關仝帝不全尺而
有雲山浩蕩之勢
清襟玉暎未易到
也今歸項太參屏
水神物得所矣
癸卯九月華亭顧大
申獲觀

關氏遺墨近代希觀文
敏素擅臨摹如撫晋唐諸
帖莫不得其神髓此卷筆
勢遒遠不假渲染力透紙
背直以書法為畫法可
犀水公好古嗜奇於枕圖

PLATE 69. Tung Ch'i-ch'ang. *Epitaph of Hsiang Yüan-pien*, running-regular script, dated 1635. Tokyo National Museum.

明故墨林項公墓誌銘
陶隱居論書曰不為無益
之事何以悦有涯之生世
無達人孰知其解其在攜李
項子京平公篤世業富貴
利達非其好也畫以收金
石遺文圖繪名蹟尺斷幀
蓬行悉翰公門雅米蒂
之書畫船李公麟之洗玉
池不啻也而世遂以元章
知公元章論書以端明
伯時目公之為人此何足以
為畫字蔡卞為得筆伯
時故游蘇門眈之羽翅臺
事起尋頁之一死一生之際

子三人長上林巫元淇次
東粵少參篤壽公其季也
少而穎敏十歲屬文不雜
究其家學已念贈公既
背養而太宜人苦節即
仲玆身主塗不遑將母
先輩風流及書法繪品
以是日習作公々每稱舉
公之長君德純寔為風學
矣憶予為諸生時游攜李
聖之誌生壙者洵稱達人
且手題押樔比於司空表

奉太宜人色養親自浣
滁終身孺慕少參公忠
孝大節公有馳馬公居
恒以儉為訓被服如寒畯
如野老婚嫁謹會諸所
族眎窮緩急非罪咸出
經費咕有常度玉柞膳
人望外日吾自為節縮正
看所用之也戊子歲大稷
饑民自今溝壑不恤扞

藉高明而甘柘橋巍秉素
易著謙吉老補儉寶瓠
狀中不隕載銘曰
娒曾玄之屬具京山先生行
辭他若生卒姐姻之詳子
不謂知公者何敢以不文
事余受交公父子間不可
圖公不朽屬余以金石之
人殘數十年而次君德成
謂相見晩也公與配錢孺
上下千載軼若列眉余永
日怠疲即公亦引為同味

也恐不生當其時一接丰儀左執
鞭弭猶右擁彖疑以居缺陷乃丰溽
宗伯所謂志銘讀之儼然如見其
人可謂三生后上蔴姻緣矣如屢
佳文向又浮名筆書之可稱興摩
國朝某諸於尾以為記於硯之附
驅使垂千秋耳

芳元賕書

此項墨林先生墓志卷向藏華亭
王氏曩余從見耐田刻清嘯閣帖
以重價購求不得因借鈎上石未卒
業耐田即去世大夫出資刻成之
壬辰三月吳中徐桐老以此卷頁售
數函伸紙如遇人即償金聯藏
曩者求之而不得今則不求而得之
真跡云董文敏書於沈雄劉蔥江
村跋不可及也此卷凡百有
五行一千餘字文敏時年已筆
有鸞翔鳳舞之致故上接魏晉
苣驅唐宋
藝林宏寶即在文敏諸跡中亦
蒼結撐架具見良工苦心洵屬
不易得惟孫君倮之所藏揚魯
源墓志及步虛詞與此相同耳
特記數語以附不朽道光乙未重
九日芸舫金森

是卷尝書萬夫之筆悟其遠操蔞若生
不善修字人手君不真失眼必將導恐不能
崇舫云他日當專刻一卷貽吳
丁酉一月廿日張廷濟母題於武林寓館

崇禎甲申眺月證日法學王廷丞栢青詩跋

項子京先生視董文敏為前輩文敏自諸年卅
數至先生夫賴閑覩觀名蹟天視見先生隱豪
作詩書滬微寫逸翔寄為心折久敬雅
天子卑出藉之精高絕肥眄京化曾小嘗無而
右此亦示甲交玄廢晚接子眈顯吐納風流鑒
我特知先士之門風于不學子昳工以文敏
書入石傳詬不朽中宏之研有道蘇子之志
梁金其文則右筆庄字睇閣石此是卷為可
寶也

PLATE 71. Tung Ch'i-ch'ang. *Self-transcribed Imperial Decree of Appointments*, regular script, dated 1636. Album of sixteen leaves. Shanghai Museum.

奉天承運

皇帝制曰朕纘緒迪題漢館
懷明發每瞻耽御究存
明德之輝既觀者英風
署哲心之益念言沒告
深注返思春鸞鳳之可
儀嘅徽音而在宇仰墨

雲之載色昭美報於在
躬爾太子太保禮部尚
書無翰林院學士掌詹
事府事董其昌道撷金
華德苪玉鉉學海滌璇
源之派與岳津梁文華
標翠嶽之林暎人綉錦
隣我

皇祖擢置芸事喉笙風
秀起鄉環之色步趨垂
範品高糊硬之宗迫
皇考紙德重輪嵒雨躬執
經講席觀德行而審諭
萬國以貢譜聖哲而陳
謨三善咸備自遣外泉

尝簪履之求不遺故舊
惟婦德克贊夫夫有友
道焉惟君恩先恒臣私
况舊芳乎並貴齋體之
禮于太保禮部尚書無翰
林院學士掌詹事府事
董其昌妻景封沖人槧

民婉嫕成性蕭穆為儀
秉鵜鳴儆戒之心勵葛
覃澣濯之德御諸縢而
攀木能遠下撫摩子而
尸鳩必均仁備其蘋藻
薦以釜錡秩然庭屏之
間蔚矣河山之度迫爾
夫升沉內外之際一付

諸風雨晦明之遭蓋惟
松有心而竹有筠一德
娘美是以玉為節而金
為和八十相莊茲用封
商為一品夫人於載錫
之寵章嘉其偕老永有
閣於彤管尚焉觀于內

皇帝召寧唐府神部尚
書入春明後以年玉誥
告几七孫不得
俞旨甲戌元日朝下告老
始蒙
恩拊准致仕又以郭霞
先朝講邃同事四臣之例
加一品秩馳

贈曾祖祖父母異毅煌煌
不不朕惡懼所可昭示子
孫者惟勇退一念知立
知止之誠而已曰書爾
後勅誥刻置祠堂之解
以存家訓云
崇禎九年歲在丙子三

leaf 72–2 leaf 72–1

PLATE 72. Tung Ch'i-ch'ang.
Four Letters and Copies of the Two
Ink Rubbings "Huan-shih" and
"Hsüan-shih" T'ieh, dated 1636.
Album of twelve leaves. Shanghai
Museum.

leaf 72–4 leaf 72–3

leaf 72–6 leaf 72–5

leaf 72–8 leaf 72–7

leaf 72–10

leaf 72–9

令日再世榮名同國休感
敢不自量竊致愚慮仍
日達晨坐以待旦
八十二翁其昌背臨

夢蔑之言可擇廊廟況
緜始以踈賤得為前恩
橫昕睨公私見異愛
同骨肉殊遇厚寵以至

leaf 72–12 leaf 72–11

PLATE 74. Tung Ch'i-ch'ang. *Manuscript*, undated. Lent by John B. Elliott.

leaf 77-2

leaf 77-4

leaf 77-5

leaf 77-6

leaf 77-7

leaf 77-10

PLATE 77. Ku Cheng-i. *Landscapes*, undated. Album of ten paintings. Beijing Palace Museum.

leaf 96–2

leaf 96–3

leaf 96–8

leaf 96–9

colophon

PLATE 96. Shao Mi. *Landscapes*, dated 1638. Album of ten paintings. Seattle Art Museum, Eugene Fuller Memorial Collection.

255

PLATE 98. Hsiang Sheng-mo. *Invitation to Reclusion*, dated 1625–26. Los Angeles County Museum of Art. (colophons by Hsiang Sheng-mo, Tung Ch'i-ch'ang, Ch'en Chi-ju, and Li Jih-hua)

leaf 100–4

leaf 100–5

leaf 100–6

leaf 100–7

PLATE 100. Chang Hung. *Landscapes in the Manner of Sung and Yüan Masters*, dated 1636. Album of eleven paintings. Ching Yüan Chai Collection.

leaf 100–8

leaf 100–9

leaf 100–11

101-5a

leaf 101-5

101-8a

leaf 101-8

PLATE 101. Chang Hung. *Landscapes in the Manner of Old Masters*, dated 1636. Album of ten paintings, with colophons by Ch'en Chi-ju. Beijing Palace Museum.

leaf 102–2

leaf 102–4

leaf 102–7

leaf 102–10

PLATE 102. Chang Hung. *Twelve Views of Su-chou*, dated 1638. Album of twelve paintings. Beijing Palace Museum.

leaf 107–4

leaf 107–6

leaf 107–7

leaf 107–8

leaf 107–9

leaf 107–10

PLATE 107. Chang Feng. *Landscapes*, dated 1644. Album of twelve paintings. The Metropolitan Museum of Art.

leaf 115–4

leaf 115–9

PLATE 115. Hung-jen. *Views of Mount Huang*, undated. Album of ten paintings, from a set of seven albums. Beijing Palace Museum.

leaf 123–5

leaf 123–6

leaf 123–9

leaf 123–12

PLATE 123. Wang Shih-min, Wang Chien, Wu Li, Yün Shou-p'ing, Wang Hui, and Wang Yüan-ch'i. *Landscape Album by Six Masters*, dated 1651–1711. Album of twelve paintings. Beijing Palace Museum.

PLATE 125. Wang Chien. *Copies of a Sung and Yüan Landscape Album in the Family Collection of Wang Shih-min*, dated 1663. Album of twelve paintings. Shanghai Museum. (colophon)

126–1a leaf 126–1 126–2a leaf 126–2

126–4a leaf 126–4 126–7a leaf 126–7

126–8a leaf 126–8 126–9a leaf 126–9

PLATE 126. Wang Chien. *Landscapes in the Manner of Old Masters*, dated 1664. Album of ten paintings with ten leaves of calligraphy. Shanghai Museum.

leaf 129–1

leaf 129–2

leaf 129–3

leaf 129–5

leaf 129–6

leaf 129–10

PLATE 129. Wang Chien. *Eighteen Landscapes in the Manner of Old Masters*, undated. Album of eighteen paintings. The Metropolitan Museum of Art.

leaf 129–11

leaf 129–13

leaf 129–14

leaf 129–15

leaf 129–16

leaf 129–17

leaf 133–1 133–1a

leaf 133–2 133–2a

leaf 133–4 133–4a

PLATE 133. Kung Hsien. *Landscapes and Trees*, undated (ca. 1679). Album of twelve paintings with twelve leaves of calligraphy. The Metropolitan Museum of Art.

leaf 133-7 133-7a

leaf 133-8 133-8a

leaf 133-9 133-9a

leaf 133-11 133-11a

leaf 133-12 133-12a

leaf 136–4

leaf 136–7

leaf 136–9

PLATE 136. Kao Ts'en. *Landscapes*, dated 1672. Album of eleven paintings. Museum für Ostasiatische Kunst, Berlin.

leaf 144–1

leaf 144–3

leaf 144–4

leaf 144–5

PLATE 144. Mei Ch'ing. *Ten Views of Wan-ling*, dated 1657. Album of ten paintings with one leaf of calligraphy. Lent by the Kinmay W. Tang Family Collection.

leaf 144–6

leaf 144–10

144–10a

leaf 145-2

leaf 145-3

leaf 145-5

leaf 145-9

leaf 145-11

leaf 145-12

leaf 145-14

leaf 145-16

PLATE 145. Mei Ch'ing. *Famous Views of Hsüan-ch'eng*, dated 1680. Album of twenty-four paintings. Museum Rietberg, Zürich.

leaf 145–19

leaf 145–20

leaf 145–22

leaf 145–24

colophons by Mei Ch'ing and Hsi-yüan chu-jen

leaf 150–4

leaf 150–6

leaf 150–8

leaf 150–9

PLATE 150. Pa-ta shan-jen. *Landscapes*, dated 1702. Album of ten paintings. Beijing Palace Museum.

leaf 155–4

leaf 155–5

leaf 155–8

leaf 155–9

PLATE 155. Shih-t'ao. *Wonderful Conceptions of the Bitter Melon: A Landscape Album for Liu Shih-t'ou*, dated 1703. Album of twelve paintings. The Nelson-Atkins Museum of Art.

leaf 158–2

leaf 158–5

leaf 158–7

leaf 158–9

leaf 158–13

leaf 158–15

PLATE 158. Shih-t'ao. *Landscapes of Mount Huang*, undated. Album of twenty-one paintings. Beijing Palace Museum.

leaf 158–16

leaf 158–18

leaf 158–20

leaf 160–4

leaf 160–5

leaf 160–8

leaf 160–9

leaf 160–10

leaf 160–11

PLATE 160. Shih-t'ao. *Landscape Album for Elder Yü*, undated. Album of twelve paintings. C. C. Wang Family Collection.

PLATE 164. Wang Hui. *Large Emerging from Small*, dated 1672. Album of twenty-one paintings with two leaves of calligraphy. Shanghai Museum. Colophon.

frontispiece leaf 165–3

PLATE 165. Wang Hui. *In Pursuit of Antiquity*, dated 1673. Album of twelve paintings. The Art Museum, Princeton University.

leaf 165–4

leaf 165–5

leaf 165–9

Tung Ch'i-ch'ang's Seals on Works in *The Century of Tung Ch'i-ch'ang*

Celia Carrington Riely 李慧聞

Tung Ch'i-ch'ang's Seals on Works in "The Century of Tung Ch'i-ch'ang"

The seals illustrated here are all reproduced from works appearing in the present exhibition, for the most part from works by or attributed to Tung, but also from works by other artists to which Tung has added an inscription or colophon and impressed one or more of his seals. Every seal in the exhibition purporting to be Tung's has been reproduced, as closely as possible to its actual size (though in some cases the size has been difficult to estimate from the photograph provided for study). The seals are arranged in forty groups, in combinations that permit the scholar either to compare impressions of the same seal as it appears on different works and at different times or to contrast seals that are similar in design but not identical. Where possible, the seals have been arranged so that all those appearing on a single work remain together, placed in a column (with the name of the work on which they appear provided below); but in some cases the seals on a work fall into different groups and are arranged accordingly. Seals that have no duplicate in the exhibition, and cannot usefully be compared with any other, appear alone (in the case of single seals) or are simply grouped with others on the same work.

Each seal has been assigned a discrete number (1 through 146), which follows in boldface the romanization of its legend in the catalogue entries at the beginning of this volume. In the presentation below, each seal is followed by a caption having a maximum of six lines, the key to which is as follows:

Line 1: the seal's assigned number;

Line 2, in square brackets: the seal numbers of any other seals belonging to Tung appearing on the same work (in the case of a single seal, this bracketed line does not appear);

Line 3: the seal's legend, in romanization;

Line 4: the word "Identical," followed by a reference to a seal or seals in one or more of the three seal catalogues (yin-p'u) cited below (this line appears only when the seal illustrated here and a seal reproduced in one of the three yin-p'u are the same seal, appearing on the same work);

Line 5: the abbreviation "Ref" for "reference," followed by a reference to a seal or seals in one or more of the yin-p'u cited below (this line appears when the seal illustrated here and a seal reproduced in the yin-p'u are different impressions of the same seal, appearing on different works);

Line 6: the date associated with this particular instance of the seal—provided that the seal is appended to a dated inscription or colophon—followed by the plate number of the work in the present catalogue on which the seal appears. If the inscription or colophon is not dated, the seal is listed as "Undated" (even if the work on which it appears has been assigned a tentative date in the catalogue). There are, however, two exceptions: if the seal follows an inscription that was probably written at the same time as another dated inscription by Tung on the same work, the seal is assigned a probable date (e.g. "Probably 1607"); and if the seal follows an inscription or colophon that either contains a date or appears on a work that is dated in another earlier inscription, that date is given as a terminus a quo (e.g. "1605 or after" or "After 1610"). Seal 105 is assigned a terminus ad quem as well as a terminus a quo (i.e. "1625–1630"), for reasons given in "Tung Ch'i-ch'ang's Life," note 100, in vol. 2 of this catalogue.

Thus a sample caption might read:

25
[26]
T'ai-shih shih
Identical: SM 73
Ref: NPM, p. 315
Undated (vol. 1, pl. 15)

Lines 1, 3, and 6 always appear in the caption; lines 2, 4, and 5 may or may not appear, depending on whether or not they apply.

Lines 4 and 5, when they do appear, refer to seals reproduced in the sections illustrating Tung's seals in one or more of the three yin-p'u listed below, whose titles are abbreviated as follows:

CW: Victoria Contag and Wang Chi-ch'ien, *Seals of Chinese Painters and Collectors of the Ming and Ch'ing Periods*, rev. ed., Hong Kong: Hong Kong University Press, 1966, pp. 417–19, 707. References are to seal number, e.g. CW 39.

NPM: *Chin T'ang i-lai shu-hua-chia chien-ts'ang-chia kuan-yin-p'u* (English title: *Signatures and Seals on Painting and Calligraphy: The Signatures and Seals of Artists, Connoisseurs, and Collectors on Painting and Calligraphy since the Tsin Dynasty*), compiled by the National Palace Museum and National Central Museum; Hong Kong: The Arts and Literature Press, 1964, vol. 2 (The Ming Dynasty), pp. 312–18. References are to page number (e.g. NPM, p. 315), since seals reproduced here are not individually numbered.

SM: *Chung-kuo shu-hua-chia yin-chien kuan-shih*, compiled by the Shanghai Museum; Peking; Wen-wu ch'u-pan she, 1987, vol. 2, pp. 1304–09. References are to seal number, e.g. SM 26.

The confines of this catalogue, generous as they are, precluded an exhaustive treatment of every seal or seal group appearing in this section. The fourteen entries that follow the seal reproductions—each entry prefaced by a roman numeral that corresponds to one of the forty seal groups presented below—are intended to illustrate the variety of seals encountered by the researcher who undertakes a study of this kind: seals of which only a single instance is known; seals that appear on a large number of works, over a period of time; seals known from only two or three works, in use for only a very short period; genuine seals that were frequently copied; and forged seals, for the most part appearing on forged works, but occasionally appearing on a work whose style and quality speak for its authenticity. Included are essays on the three most important of Tung's office seals, in which I attempt to define their period of use: *T'ai-shih shih*, in entry II; *Chih chih-kao jih-chiang kuan*, in entry III; and *Tsung-po hsüeh-shih* in entry XXV.

Throughout these entries, seal numbers coupled in angular brackets refer to seals that appear together as a pair (one following the other) at the end of an inscription or colophon; thus <19,20>, for example, refers to the pair of seals, nos. 19 and 20, following Tung's colophon on *Invitation to Reclusion at Ching-hsi* (cat. no. 18). Seal numbers separated by a slash refer to seals that are different impressions of the same seal; thus 14/17/20, for instance, means that seal 14 (which appears on *Running Script in the Manner of the Four Sung Masters*; cat. no. 10), seal 17 (on *Paintings and Calligraphy on Round Fans*; cat. no. 13), and seal 20 (on *Invitation to Reclusion at Ching-hsi*) are all impressions of the same seal, appearing on different works.

I

1
[35,36]
Tung Ch'i-ch'ang yin
1592 (vol. 2, pl. 1)

**Theories on Calligraphy and
Painting (cat. no. 1)**

I I

2
[3,4,5,6,7,8]
Tung Ch'i-ch'ang yin
1596 (vol. 1, pl. 2)

4
[2,3,5,6,7,8]
Hua-ch'an
1596 (vol. 1, pl. 2)

6
[2,3,4,5,7,8]
Tung Ch'i-ch'ang yin
1596 (vol. 1, pl. 2)

8
[2,3,4,5,6,7]
Tung Ch'i-ch'ang yin
1596 or after (vol. 2, pl. 2)

3
[2,4,5,6,7,8]
T'ai-shih shih
Ref: CW 11; NPM, p. 315;
 SM 26
1596 (vol. 1, pl. 2)

5
[2,3,4,6,7,8]
Tung Ch'i-ch'ang yin
1596 (vol. 1, pl. 2)

7
[2,3,4,5,6,8]
□ - □ -*t'ang*
1596 or after (vol. 2, pl. 2)

Eight Views of Yen and Wu (cat. no. 2)

9
[10,11]
Hsüan-shang chai
1603 (vol. 2, pl. 5)

12
[13,14]
Hsüan-shang chai
Ref: CW 39
1607 (vol. 2, pl. 10)

15
[16,17,37,38,39,40,49]
Hsüan-shang chai
Ref: NPM, p. 318
1610 (vol. 2, pl. 13)

18
[19,20,51]
Hsüan-shang chai
Ref: CW 39
1613 (vol. 2, pl. 18)

21
[42,48]
Hsüan-shang chai
Identical: CW 39
1605 or after (vol. 2, pl. 8)

10
[9,11]
Chih chih-kao jih-chiang kuan
1603 (vol. 2, pl. 5)

13
[12,14]
Chih chih-kao jih-chiang kuan
Ref: CW 21; NPM, p. 317
1607 (vol. 2, pl. 10)

16
[15,17,37,38,39,40,49]
Chih chih-kao jih-chiang kuan
Ref: CW 21; NPM, p. 317
1610 (vol. 2, pl. 13)

19
[18,20,51]
Chih chih-kao jih-chiang kuan
Ref: CW 21; NPM, p. 317
1613 (vol. 2, pl. 18)

11
[9,10]
Tung-shih Hsüan-tsai
1603 (vol. 2, pl. 5)

14
[12,13]
Tung Ch'i-ch'ang yin
Ref: NPM, p. 312 (twice)
1607 (vol. 2, pl. 10)

17
[15,16,37,38,39,40,49]
Tung Ch'i-ch'ang yin
Ref: NPM, p. 312 (twice)
1610 (vol. 2, pl. 13)

20
[18,19,51]
Tung Ch'i-ch'ang yin
Ref: NPM, p. 312 (twice)
1613 (vol. 2, pl. 18)

Calligraphy (cat. no. 5)	*Running Script in the Manner of the Four Sung Masters (cat. no. 10)*	*Paintings and Calligraphy on Round Fans (cat. no. 13)*	*Invitation to Reclusion at Ching-hsi (cat. no. 18)*	*"Eulogy on the Dynastic Revival of Great T'ang" (cat. no. 8)*

22
[43,44]
Hsüan-shang chai
Ref: cw 39
Undated (vol. 2, pl. 4)

23
[24]
Hsüan-shang chai
Undated (vol. 1, pl. 16)

25
[26]
T'ai-shih shih
Identical: sm 73
Ref: npm, p. 315
Undated (vol. 1, pl. 15)

26
[25]
Tung Ch'i-ch'ang yin
Identical: sm 80
Undated (vol. 1, pl. 15)

**Water Village and Mountain
Colors (cat. no. 15)**

24
[23]
Tung Ch'i-ch'ang yin
Undated (vol. 1, pl. 16)

**Landscape after Kuo
Chung-shu (cat. no. 4)**

**Blue and Green Landscape
in the Manner of Chao
Meng-fu (cat. no. 16)**

V

27
Tung Ch'i-ch'ang yin
1604 (vol. 1, pl. 6)

**Stream and Hills before
Rain (cat. no. 6)**

28
[29,30,31]
Hua-ch'an
1607 (vol. 1, pl. 11)

32
[33,34]
Hua-ch'an
1608 (vol. 1, pl. 12)

29
[28,30,31]
Tung Ch'i-ch'ang yin
1607 (vol. 1, pl. 11)

37
[15,16,17,38,39,40,49]
T'ai-shih shih
1610 (vol. 1, pl. 13)

30
[28,29,31]
T'ai-shih shih
Probably 1607 (vol. 1, pl. 11)

33
[32,34]
T'ai-shih shih
1608 (vol. 1, pl. 12)

35
[1,36]
T'ai-shih shih
1610 (vol. 2, pl. 1)

38
[15,16,17,37,39,40,49]
T'ai-shih shih
1610 (vol. 2, pl. 13)

31
[28,29,30]
Tung Ch'i-ch'ang
Probably 1607 (vol. 1, pl. 11)

34
[32,33]
Tung Ch'i-ch'ang
1608 (vol. 1, pl. 12)

39
[15,16,17,37,38,40,49]
Tung Ch'i-ch'ang
1610 (vol. 1, pl. 13)

41
Tung Ch'i-ch'ang
1610 or after (vol. 1, pl. 83)

36
[1,35]
Tung Hsüan-tsai
Ref: CW 12, 55; SM 21
1610 (vol. 2, pl. 1)

40
[15,16,17,37,38,39,49]
Tung Hsüan-tsai
Ref: CW 12, 55; SM 21
1610 (vol. 2, pl. 13)

Drawing Water in the **Morning** (cat. no. 11)	**In the Shade of Fine Trees** (cat. no. 12)	**Theories on Calligraphy and** **Painting** (cat. no. 1)	**Paintings and Calligraphy** **on Round Fans** (cat. no. 13)	**Seal on Chao Tso's** *Lofty* *Recluse among Streams and* *Mountains* (cat. no. 83)

45
[46,47]
Tung Ch'i-ch'ang yin
Undated (vol. 1, pl. 9)

43
[22,44]
Tung Ch'i-ch'ang yin
Undated (vol. 2, pl. 4)

44
[22,43]
T'ai-shih shih
Undated (vol. 2, pl. 4)

46
[45,47]
T'ai-shih shih
Undated (vol. 1, pl. 9)

47
[45,46]
Tung Ch'i-ch'ang yin
Undated (vol. 1, pl. 9)

42
[21,48]
Tung Hsüan-tsai
Identical: CW 12, SM 21
Ref: CW 55
1605 or after (vol. 2, pl. 8)

**"Eulogy on the Dynastic
Revival of Great T'ang"
(cat. no. 8)**

**Landscape after Kuo
Chung-shu (cat. no. 4)**

**Calligraphy and Painting
Based on Han Yü's "Preface to
Farewell to Li Yüan" (cat. no. 9)**

VII

48
[21,42]
Hsüan-tsai
Identical: CW 38
Ref: SM 99
1605 or after (vol. 2, pl. 8)

**"Eulogy on the Dynastic
Revival of Great T'ang"
(cat. no. 8)**

VIII

49
[15,16,17,37,38,39,40]
Tung-shih Hsüan-tsai
1610 (vol. 1, pl. 13)

50
Tung-shih Hsüan-tsai
1611 or after (vol. 1, pl. 82)

**Paintings and Calligraphy
on Round Fans (cat. no. 13)**

**Inscription on Chao Tso's
After Chao Meng-fu's "High
Mountains and Flowing
Water" (cat. no. 82)**

IX

51
[18,19,20]
Tung Ch'i-ch'ang yin
1611 (vol. 1, pl. 18)

52
Tung Ch'i-ch'ang yin
Undated (vol. 1, pl. 14)

*Invitation to Reclusion at
Ching-hsi (cat. no. 18)*

*Landscapes in the Manner of
Old Masters (cat. no. 14)*

XII

58
[93]
Tung Ch'i-ch'ang yin
1614 (vol. 1, pl. 23)

*Lin Pu's Poetic Idea
(cat. no. 23)*

X

53
T'ai-shih shih
Undated (vol. 1, pl. 19)

*Sketches of Traditional Tree
and Rock Types (cat. no. 19)*

XI

54
[55]
T'ai-shih shih
Ref: NPM, p. 315
1612 (vol. 2, pl. 20)

55
[54]
Tung Hsüan-tsai
1612 (vol. 2, pl. 20)

56
[57]
Tung Hsüan-tsai
Undated (vol. 2, pl. 22)

57
[56]
Tung Ch'i-chang yin
Undated (vol. 2, pl. 22)

*After Mi Fu's "Rhyme-prose
on the Celestial Horse"
(cat. no. 20)*

*Eulogy of Ni K'uan
(cat. no. 22)*

XIII

59
Ch'i / Ch'ang
1614 (vol. 1, pl. 7)

*Misty River and Piled Peaks
(cat. no. 7)*

XIV

60
Tung Hsüan-tsai
Identical: CW 57
1615 (vol. 1, pl. 24)

Panoramic View of a Lake
(cat. no. 24)

XV

61
[62,63]
Hua-ch'an
Undated (vol. 1, pl. 26)

62
[61,63]
Tung Ch'i-ch'ang yin
Undated (vol. 1, pl. 26)

63
[61,62]
Tung Ch'i-ch'ang
Undated (vol. 1, pl. 26)

Landscape (cat. no. 26)

XVI

66
[67,68]
Hsüan-shang chai
Undated (vol. 2, pl. 34)

64
[65]
Chih chih-kao jih-chiang kuan
Ref: SM 86
1617 (vol. 1, pl. 32)

67
[66,68]
Chih chih-kao jih-chiang kuan
Ref: SM 86
Undated (vol. 2, pl. 34)

70
[71,84,87]
*Chih chih-[kao] jih-chiang
[kuan]*
Undated (vol. 1, pl. 37)

65
[64]
Tung Ch'i-ch'ang yin
Identical: CW 61
Ref: CW 59; SM 79
1617 (vol. 1, pl. 32)

68
[66,67]
Tung Ch'i-ch'ang yin
Ref: CW 59, 61; SM 79
Undated (vol. 2, pl. 34)

69
Tung Ch'i-ch'ang yin
Undated (vol. 2, pl. 64)

71
[70,84,87]
Tung Ch'i-ch'ang yin
Undated (vol. 1, pl. 37)

**The Ch'ing-pien Mountain
in the Manner of Tung Yüan
(cat. no. 32)**

**Abbreviated Version of Su
Shih's "The First Excursion
to Red Cliff" (cat. no. 34)**

**Running Script in the
Manner of the Four Sung
Masters (cat. no. 64)**

**After Ni Tsan's "Lofty
Scholar in Autumn
Mountains" (cat. no. 37)**

74
[75,76]
Hua-ch'an
Ref: SM 58
1617 (vol. I, pl. 33)

78
[79]
Hua-ch'an
Identical: SM 58
Undated (vol. I, pl. 36)

72
[73]
T'ai-shih shih
Probably 1617 (vol. I, pl. 31)

75
[74,76]
T'ai-shih shih
1617 (vol. I, pl. 33)

80
[81]
T'ai-shih shih
Undated (vol. I, pl. 28)

73
[72]
Tung Ch'i-ch'ang yin
Probably 1617 (vol. I, pl. 31)

76
[74,75]
Tung Ch'i-ch'ang
Ref: CW 18; NPM, p. 312
1617 (vol. I, pl. 33)

77
Tung Ch'i-ch'ang
Ref: CW 18; NPM, p. 312
1617 (vol. I, pl. 30)

79
[78]
Tung Ch'i-ch'ang
Identical: SM 32
Undated (vol. I, pl. 36)

81
[80]
Tung Ch'i-ch'ang
Ref: NPM, p. 312 (?)
Undated (vol. I, pl. 28)

Lofty Recluse (cat. no. 31) | *Landscape (cat. no. 33)* | *Poetic Ideas from T'ang and Sung (cat. no. 30)* | *Landscape in the Manner of Ni Tsan (cat. no. 36)* | *Stately Trees Offering Midday Shade (cat. no. 28)*

XVIII

82
[83]
Hua-ch'an
1615 (vol. 1, pl. 25)

84
[70,71,87]
Hua-ch'an
Undated (vol. 1, pl. 37)

85
[86]
Tung Ch'i-ch'ang
Undated (vol. 1, pl. 29)

86
[85]
T'ai-shih shih
Undated (vol. 1, pl. 29)

87
[70,71,84]
T'ai-shih shih
Undated (vol. 1, pl. 37)

**Concealing Clouds and
Scattering Rain (cat. no. 29)**

**After Ni Tsan's "Lofty
Scholar in Autumn
Mountains" (cat. no. 37)**

83
[82]
Tung Ch'i-ch'ang
1615 (vol. 1, pl. 25)

**Boneless Landscape after
Yang Sheng (cat. no. 25)**

**After Ni Tsan's "Lofty
Scholar in Autumn
Mountains" (cat. no. 37)**

XIX

88
[89,90,91]
Hsüan-tsai
Identical: SM 12
1618 (vol. 1, pl. 35)

90
[88,89,91]
Tung Ch'i-ch'ang yin
Identical: SM 14
1618 (vol. 2, pl. 35)

89
[88,90,91]
Ch'i-ch'ang
Identical: SM 2
1618 (vol. 1, pl. 35)

91
[88,89,90]
Tung Ch'i-ch'ang yin
Identical: SM 11
1618, 1619 (vol. 1, pl. 35)

**Calligraphy and Painting
(cat. no. 35)**

XX

92
Tung Ch'i-ch'ang yin
After 1610 (vol. 1, pl. 85)

**Colophon on Shen
Shih-ch'ung's *Peach Blossom
Spring* (cat. no. 85)**

XXI

93
[58]
Tung Ch'i-ch'ang yin
1621 (vol. 1, pl. 23)

**Lin Pu's *Poetic Idea*
(cat. no. 23)**

XXII

94
[99]
Tung-shih Hsüan-tsai
1621 (vol. 1, pl. 39)

Landscapes (cat. no. 39)

XXIII

95
[96,97]
Hua-ch'an
Undated (vol. 1, pl. 41)

96
[95,97]
T'ai-shih shih
Undated (vol. 1, pl. 41)

97
[95,96]
Tung Ch'i-ch'ang
Undated (vol. 1, pl. 41)

**Reminiscence of Chien River
(cat. no. 41)**

XXIV

98
Tung Ch'i-ch'ang yin
1622 (vol. 2, pl. 45)

**Poem after the Rhyme of
Yeh the Junior Imperial
Preceptor (cat. no. 45)**

XXV

100
[101]
Tsung-po hsüeh-shih
Ref: CW 33; NPM, p. 317;
SM 84
1624 (vol. 1, pl. 50)

102
[121]
Tsung-po hsüeh-shih
Ref: CW 33; NPM, p. 317;
SM 84
1625 (vol. 1, pl. 52)

103
[104]
Tsung-po hsüeh-shih
Ref: CW 33; NPM, p. 317;
SM 84
1635 (vol. 2, pl. 69)

99
[94]
Tung-shih Hsüan-tsai
Ref: CW 35; NPM, p. 315;
SM 91
1623 (vol. 2, pl. 39)

101
[100]
Tung-shih Hsüan-tsai
Ref: CW 35; NPM, p. 315;
SM 91
1624 (vol. 1, pl. 50)

104
[103]
Tung-shih Hsüan-tsai
Ref: CW 35; NPM, p. 315;
SM 91
1635 (vol. 2, pl. 69)

Landscapes (cat. no. 39)

Returning Home from an Homage to the Imperial Tombs (cat. no. 50)

Landscape in the Manner of Tung Yüan (cat. no. 52)

Epitaph of Hsiang Yüan-pien (cat. no. 69)

105
[106]
Tsung-po hsüeh-shih
Ref: CW 33; NPM, p. 317;
SM 84
1625–1630 (vol. 2, pl. 55)

107
[108]
Tsung-po hsüeh-shih
Ref: CW 33; NPM, p. 317;
SM 84
1626 or after (vol. 2, pl. 98)

109
[110]
Tsung-po hsüeh-shih
Ref: CW 33; NPM, p. 317;
SM 84
Undated (vol. 2, pl. 67)

106
[105]
Tung-shih Hsüan-tsai
Ref: CW 35; NPM, p. 315;
SM 91
1625–1630 (vol. 2, pl. 55)

108
[107]
Tung-shih Hsüan-tsai
Ref: CW 35; NPM, p. 315;
SM 91
1626 or after (vol. 2, pl. 98)

110
[109]
Tung-shih Hsüan-tsai
Ref: CW 35; NPM, p. 315;
SM 91
Undated (vol. 2, pl. 67)

111
[123]
Tung-shih Hsüan-tsai
1622 (vol. 1, pl. 44)

"Record of the Grand Tutor Hsü Kuo's Tomb Shrine" (cat. no. 55)

Frontispiece and colophon on Hsiang Sheng-mo's Invitation to Reclusion (cat. no. 98)

Poem for Mao Hsiang (cat. no. 67)

After Huang Kung-wang's "Warm and Green Layered Hills" (cat. no. 44)

XXVI

112
Tung-shih Hsüan-tsai
Ref: SM 92 (?)
Undated (vol. 1, pl. 73)

**Landscape in the Manner of
Huang Kung-wang
(cat. no. 73)**

XXVII

113
[114]
Tung Ch'i-ch'ang yin
Undated (vol. 1, pl. 21)

114
[113]
Tsung-po hsüeh-shih
Undated (vol. 1, pl. 21)

**River Pavilion on a Clear
Autumn Day (cat. no. 21)**

XXVIII

115
Tung Ch'i-ch'ang
Ref: SM 34 (?)
1623 (vol. 1, pl. 47)

Yen-ling Village (cat. no. 47)

XXIX

117
[118,119,120]
Tung Hsüan-tsai
Ref: NPM, p. 315
1623 (vol. 2, pl. 48)

116
Tung Ch'i-ch'ang yin
1623 (vol. 1, pl. 46)

118
[117,119,120]
Tung Ch'i-ch'ang yin
1623 (vol. 2, pl. 48)

119
[117,118,120]
Tsuan-hsiu liang-ch'ao shih-lu
Ref: SM 89
1623 (vol. 2, pl. 48)

120
[117,118,119]
Tung Ch'i-ch'ang
1623 (vol. 2, pl. 48)

**The Transmission of
Examination Papers
(cat. no. 46)**

**Casual Writings by a
Window (cat. no. 48)**

XXX

121
[102]
Tung Ch'i-ch'ang yin
Identical: CW 66
Ref: SM 97
1625 (vol. I, pl. 52)

122
Tung Ch'i-ch'ang yin
Identical: SM 97
Ref: CW 66
Undated (vol. I, pl. 51)

123
[III]
Tung Ch'i-ch'ang yin
1622 (vol. I, pl. 44)

**Landscape in the Manner of
Tung Yüan** (cat. no. 52)

**Cloudy Mountain Ink-play
(cat. no. 51)**

**After Huang Kung-wang's
"Warm and Green Layered
Hills"** (cat. no. 44)

XXXI

124
[125]
Tung Ch'i-ch'ang
Identical: SM 33
1625 (vol. I, pl. 54)

125
[124]
Tung Ch'i-ch'ang yin
Identical: SM 48
Ref: CW 58
1625 or after (vol. I, pl. 54)

126
[127,128]
Tung Ch'i-ch'ang yin
Ref: CW 58; SM 48
1626 (vol. I, pl. 27)

127
[126,128]
Ta tsung-po chang
1626 (vol. I, pl. 27)

128
[126,127]
Tung Ch'i-ch'ang
1626 (vol. I, pl. 27)

**Landscapes Painted for Wang
Shih-min** (cat. no. 54)

**The Long and Winding
Stone Steps** (cat. no. 27)

XXXII

129
[130]
Tung Hsüan-tsai
Ref: CW 67; NPM, p. 315; SM 101
Undated (vol. I, pl. 58)

131
[132]
Tung Hsüan-tsai
Undated (vol. I, pl. 57)

130
[129]
Tsung-po hsüeh-shih
Identical: SM 106
Ref: CW 41; NPM, p. 316
Undated (vol. I, pl. 58)

132
[131]
Tsung-po hsüeh-shih
Undated (vol. I, pl. 57)

**Landscape after Wang Ch'ia
and Li Ch'eng** (cat. no. 58)

**After Tung Yüan's "Shaded
Dwellings among Streams
and Mountains"** (cat. no. 57)

XXXIII

133
Tung Hsüan-tsai
Undated (vol. 1, pl. 43)

**Returning Home from a
Field at Northern Hill
(cat. no. 43)**

XXXV

136
[137]
Ta tsung-po chang
1628 (vol. 1, pl. 61)

137
[136]
Tung Ch'i-ch'ang yin
1629 (vol. 1, pl. 61)

**Mountain Forms and River
Colors (cat. no. 61)**

XXXIV

134
[135]
Tung Ch'i-ch'ang
Identical: SM 23
1627 (vol. 1, pl. 60)

135
[134]
T'ai-shih shih
Identical: SM 17
1627 (vol. 1, pl. 60)

**Intimate Landscapes Done in
the Ting-mao Year
(cat. no. 60)**

XXXVI

138
[139]
Tung Ch'i-ch'ang yin
Undated (vol. 2, pl. 63)

139
[138]
Ssu-po
Undated (vol. 2, pl. 63)

"Singing Aloud" (cat. no. 63)

XXXVII

140
[141,142]
Hsüan-shang chai
Undated (vol. 2, pl. 65)

141
[140,142]
Tsung-po chih chang
Undated (vol. 2, pl. 65)

142
[140,141]
Tung Ch'i-ch'ang yin
Ref: NPM, p. 314 (?)
Undated (vol. 2, pl. 65)

**Poem by Wang Wei
(cat. no. 65)**

XXXVIII

143
Chang
Ref: CW 4 (?); NPM, p. 314
(twice, once printed
backwards) (?); SM 30 (?)
1634 (vol. 1, pl. 66)

**Landscape in the Manner of
Ni Tsan (cat. no. 66)**

XXXIX

144
Tung [Ch'i-ch'ang] yin
1635 (vol. 1, pl. 68)

**Clearing after Snow on
Mountain Passes (cat. no. 68)**

XL

145
[146]
[*Tung*] *Ch'i-ch'ang* [*yin?*]
Undated (vol. 2, pl. 72)

146
[145]
Hsüan-tsai
Ref: SM 46
1636 (vol. 2, pl. 72)

**Four Letters and Copies of
the Two Ink Rubbings
"Huan-shih" and "Hsüan-
shih" T'ieh (cat. no. 72)**

II. All seven of the seals illustrated in this group appear singly or in combination on the leaves of the album entitled *Eight Views of Yen and Wu* (vols. 1 and 2, pl. 2), which is dated the fourth month of 1596 and is thus the earliest dated of Tung's extant paintings, save for a fan now in the National Palace Museum, Taipei, that was painted by Tung in 1592 on his way north to Peking (vol. 2, fig. 39; Chang Chao et al., *Shih-ch'ü pao-chi*, completed 1745, facsim. of ms. copy, 1971, vol. 2, p. 857). The discovery of *Eight Views*, which until recently was known only to the curators of the Shanghai Museum and is now being published in the West for the first time, provides us ready-made, as it were, with a *yin-p'u* or "catalogue of seal impressions" for the seals Tung was using in 1596.

Four of these seals (nos. 4, 6, 7, 8) are not known by me to appear on any other work; but unexpectedly, in view of their early date and the scarcity of Tung's works from this period, three of the seals that appear on the leaves of this album occur elsewhere. A seal identical to no. 3 (*T'ai-shih shih*) follows Tung's inscription—dated, significantly, the same year, 1596—on the *ch'ien ko-shui* (mounting immediately preceding the painting) of Huang Kung-wang's *Dwelling in the Fu-ch'un Mountains* (*Fu-ch'un shan-chü*) in the National Palace Museum, Taipei; and the same seal is appended to two undated but unquestionably early colophons by Tung, one following a handscroll by the Yüan painter Chuang Lin, again in the National Palace Museum, the other following his inscription on the mounting of an album leaf (originally a short handscroll) entitled *Mountains in Cloud* (*Yün-shan t'u*) by the Yüan master Fang Ts'ung-i, of which apparently only a photograph survives (*Ku-kung shu-hua lu*, 1956, rev. ed. 1965, vol. 2, *ch.* 4, pp. 134, 303–4; *Wei-ta ti i-shu ch'uan-t'ung t'u-lu*, 1955, vol. 2, pl. 11). Whereas the impressions of the seal on leaves 3 and 7 of *Eight Views of Yen and Wu* and the impression that follows Tung's inscription on the *Fu-ch'un* scroll (dated the seventh day of the tenth month, 1596) show a border completely intact, the impression that follows Tung's colophon at the end of *Eight Views of Yen and Wu* (vol. 2, pl. 2), and those following his colophons on the Chuang Lin handscroll and Fang Ts'ung-i album leaf, show a small but very distinct break in the lower right-hand border just above the corner; thus we may conclude that the last three colophons were written at a slightly later date, that is to say, postdating the seventh day of the tenth month, 1596.

Seal 5 (*Tung Ch'i-ch'ang yin*) appears on two other works: one, the fan in the National Palace Museum, Taipei, dated 1592 (vol. 2, fig. 39), mentioned above; the other, also a fan, undated but clearly very early in style, now in the Honolulu Academy of Arts (Tseng Yu-ho Ecke, *Poetry on the Wind*, 1981, color pl. 4 and p. 75). Though the fan in the National Palace Museum is dated 1592 in the first of Tung's two inscriptions, the seal follows his second inscription, undated and written after the first, when Tung dedicated the fan to an unidentified friend by the name of Meng-po. We cannot be certain, therefore, that Tung was employing this seal as early as 1592.

The third of the seals to appear elsewhere, no. 2 (*Tung Ch'i-ch'ang yin*), is perhaps the most interesting, because it occurs on only one other work, a small handscroll by Tung in ink on silk, of which no reproduction has ever been published, entitled simply *Calligraphy and*

Painting, Paired Treasures (*Shu-hua ho-pi*), preserved in the National Palace Museum, Taipei (Wang Chieh et al., *Shih-ch'ü pao-chi hsü-pien*, completed 1793, facsim. of ms. copy, 1971, vol. 2, pp. 1077–78). At the beginning of the handscroll Tung has transcribed six T'ang poems, which he follows with a small painting dedicated to a friend named Chi-liang, possibly the Chou Chi-liang whose name is mentioned in colophons that Tung wrote on two different works in the tenth month of 1603 (for Tung's two colophons, see Wu Sheng, *Ta-kuan lu*, pref. 1712, facsim. of ms. copy, 1970, *ch.* 17, p. 49; and *Pei-Sung Su Shih Chi Huang Chi-tao wen, Shu-p'u ts'ung-t'ieh, Ti-san-chi* (4), *Shang-hai po-wu-kuan ts'ang*, repr. Hong Kong, n.d.). Following the painting on the handscroll, Tung has written out nine passages of his own composition, eight on the theory of calligraphy and the first describing how he came to write them down. The handscroll matches exactly an unusually descriptive entry in the *Chu Wo-an ts'ang shu-hua mu*, a list compiled by the mid-seventeenth century collector Chu Chih-ch'ih of the works in his collection (Huang Pin-hung and Teng Shih, *Mei-shu ts'ung-shu*. 1911–36, rev. ed. 1975, vol. 8, II/6, p. 111); and the handscroll is impressed as well with two of Chu's seals, rendering the identification certain. In 1975 I pointed out that the second of Tung's two seals at the end of this small handscroll appeared to be identical to the first of Tung's seals impressed at the end of his inscription on the *Fu-ch'un Mountains*, and I suggested that the handscroll was a genuine early work (Riely, "Tung Ch'i-ch'ang's Ownership of Huang Kung-wang's 'Dwelling in the Fu-ch'un Mountains,'" 1974–75, p. 62). Now that the first of the seals at the end of the handscroll proves to be identical with an otherwise unknown seal on *Eight Views of Yen and Wu*, it is time to include this small handscroll in the corpus of Tung's authentic works and to assign it a date of circa 1596.

It is worth remarking that had the impressions of seal 2 on leaves 1 and 4 appeared on different paintings rather than on leaves of the same album, one would have been hard pressed to identify them with absolute certainty as coming from the same seal—an example that underscores how difficult it may sometimes be to arrive at the conclusion that impressions on different paintings come from one and the same seal.

With the *Tai-shih shih* seal on *Eight Views of Yen and Wu*, we are introduced to the first in the series of Tung's office seals, of which Tung was eventually to adopt at least ten, more than any Chinese artist before or since. Seals with the legend *Tai-shih shih*, meaning *Shih-kuan* or "Historiographer," have in the past been identified as having been adopted by Tung sometime after 1622, when he became associated with the compilation of the *Veritable Records of the Emperor Shen-tsung* (Yonezawa Yoshiho, *Painting in the Ming Dynasty*, 1956, p. 22). The presumption that seals with this legend were adopted by Tung because of his connection with the Veritable Records is, however, mistaken; in the Ming as well as in the Ch'ing, *T'ai-shih shih* was an unofficial term generally denoting a Compiler—usually Junior Compiler (*Pien-hsiu*)—in the Han-lin Academy, the term a reference to the Compilers' principal duty "to compile the national history" (*hsiu kuo-shih*) (Charles Hucker, *A Dictionary of Official Titles in Imperial China*, 1985, no. 6212; H. S. Brunnert and V. V. Hagelstrom, *Present Day Polit-*

ical Organization of China, 1911, nos. 200B, s. 193C to 200C; and R. H. van Gulik, *Chinese Pictorial Art as Viewed by the Connoisseur*, 1958, p. 455). Of five men in addition to Tung listed in *Chin T'ang i-lai shu-hua-chia chien-ts'ang-chia kuan-yin-p'u* (vol. 2: Ming) as having used a seal with the *T'ai-shih shih* legend, all had been appointed Han-lin Compilers (either *Hsiu-chuan* or *Pien-hsiu*): Sung Lien (1310–1381), Liang Ch'ien (1366–1418), Li Tung-yang (1447–1516), Wang Heng (1561–1609), and Han Ching (*chin-shih* 1610). Having earlier served as a Bachelor or trainee in the Han-lin, Tung was appointed a Junior Compiler—his first formal official position—on the twenty-eighth day of the fifth month, 1593 (see "Tung Ch'i-ch'ang's Life," part 3 and note 169, in vol. 2 of this catalogue), which is thus the *terminus a quo* for Tung's adoption of a seal with the *T'ai-shih shih* legend. His earliest extant dated work with such a seal, however, is, as far as I know, none other than *Eight Views of Yen and Wu* in the present exhibition.

The only evidence to dispute a *terminus a quo* of 1593 for the *T'ai-shih shih* seal is to be found in the *Tung Hua-t'ing shu-hua lu*, which records a handscroll by Tung entitled *White Clouds on the Hsiao and Hsiang Rivers* (*Hsiao-Hsiang pai-yün*) (see Ch'ing-fu shan-jen, *Tung Hua-t'ing shu-hua lu*, n.d. [but no earlier than 1800], rev. ed. in ISTP, vol. 25, no. 192, pp. 7–8). The handscroll has an inscription by Tung reading, "Tradition has it that paintings of 'Mountains in Cloud' were [first] done by the Mis, father and son. No one knows that in truth it was Wang Ch'ia who was the real pioneer. As for this [particular subject]—'White Clouds on the Hsiao and Hsiang Rivers'—actually the Mis were copying Ch'ia's brush. I, too, copy it—one tradition, three [paintings]. On an autumn day, 1591, while moored on the Yellow River, I completed this and wrote the inscription. Hsüan-tsai." Impressed at the end are two seals, reading *Tung Ch'i-ch'ang* and *T'ai-shih shih*. The inscription is close in sentiment, though different in wording, to the opening lines of a short passage in the *Jung-t'ai chi*, which read, "[The motif of] mountains in cloud did not begin with Mi Yüan-chang [Mi Fu]. The idea was already present in the splashed ink [technique] of Wang Ch'ia in the T'ang" (Tung Ch'i-ch'ang, *Jung-t'ai pieh-chi*, 1635, ch. 6, p. 15).

White Clouds on the Hsiao and Hsiang Rivers is important from a biographical standpoint because of the colophon that follows. Supposedly written by Wu T'ing—the wealthy merchant and collector from She-hsien, in present-day Anhui, from whom Tung was to acquire Tung Yüan's *Travelers among Streams and Mountains* in 1593 (see "Tung Ch'i-ch'ang's Life," part 3 and note 159)—the colophon purports to document his earliest acquaintance with Tung: "In the spring of 1590 I arrived in the capital and became friends with the *T'ai-shih* Tung Hsüan-tsai. Taking advantage of a leisurely moment, I took a piece of plain silk for a horizontal scroll and begged him for a painting. But a year drifted by and he had yet to favor me [with an example]. In the autumn of 1591, when—while [serving] as a [Han-lin] Bachelor—he requested leave to return south, I followed along behind his boat; with leisure in plenty aboard his boat, he was able at last to command his brush. By the time we reached the Yellow River, he had finished this [painting of] *White Clouds on the Hsiao and Hsiang Rivers*. Inspiration drove his brush; truly [his work] in no way fell short of what Yüan-chang achieved in the past. Highly delighted, I brought back [the painting], quickly had it mounted, and recorded this at the end. Recorded by Wu T'ing, Yung-ch'ing, of Hsin-an."

Plausible as Wu's colophon seems to be at first glance, it is constructed around a serious inaccuracy. Tung, as we now know, took leave from the Han-lin and started south in the spring of 1591, on the eleventh day of the intercalary third month ("Tung Ch'i-ch'ang's Life," part 3 and note 132). Wu, on the other hand, represents Tung as setting out in autumn, hence painting the scroll on his outward journey rather than on his way back to Peking. Since Wu claims to have accompanied him as far as the Yellow River (and to have written his record of the trip almost immediately thereafter), the error cannot be excused as a lapse of memory: the only explanation is that Wu's colophon (assuming that its text was accurately transcribed) is an elaborate and rather clever fabrication, and Tung's purported inscription a reformulated version of the passage in his collected writings. (Ren Daobin, in *Tung Ch'i-ch'ang hsi-nien* [1988, p. 27], also concludes that this painting is a forgery, his reason being that since Tung left Peking toward the end of spring and did not return in 1591, he could not have painted this painting while moored on the Yellow River in the autumn of that year; actually, however, Tung did return to Peking in 1591, no later than the fifteenth day of the tenth month: see "Tung Ch'i-ch'ang's Life," part 3 and note 135.)

That Wu's colophon is a forgery verges on certainty when we discover that almost unquestionably it was inspired in part by another passage in the *Jung-t'ai chi*, which begins: "This . . . I wrote in 1591—having requested leave to return while [serving] as a [Han-lin] Bachelor—as I was moored on the Yellow River, with leisure in plenty aboard my boat . . ." (Tung Ch'i-ch'ang, *Jung-t'ai pieh-chi*, ch. 5, p. 18). Though admittedly the sentence is composed of stock phrases, the resemblance of the passage in Wu's colophon is too close to be fortuitous. The phrase "moored on the Yellow River," deleted in Wu's colophon, has simply been transferred by the forger to the end of Tung's "inscription" on the painting. Significantly, the passage in the *Jung-t'ai chi* omits the word "autumn," the mistaken insertion of which provides the clue to the forgery. We can no longer, then, rely on Wu's colophon as evidence that Tung met Wu T'ing before 1593; and we may conclude that the seal *T'ai-shih shih* following Tung's "inscription" is not evidence that Tung used the seal before 1593, but is instead additional evidence that the painting is a forgery.

Tung was to continue to use seals with a *T'ai-shih shih* legend regularly until 1622 but only rarely thereafter, since from late 1622 or 1623 onward he had begun to employ a series of new office seals, with legends referring to office titles he had more recently acquired. Proof that occasionally he used the seal late in life is provided by two colophons, both undated but datable to circa 1629, on the grounds of their other seal (dated examples of which fall all to that year): one, a colophon on Chao Ch'ang's *Butterflies Drawn from Life* (*Hsieh-sheng chia-tieh*), in the Beijing Palace Museum; the other, a colophon following a calligraphy by Chao Meng-fu entitled *Hsüan-miao kuan chung-hsiu San-men chi*, in the Tokyo National Museum (*Chung-kuo li-tai hui-hua: Ku-kung po-wu-yüan ts'ang-hua chi II*, 1981, *fu-lu*, p. 3 [colophon reproduced but without seals]; and Kohara Hironobu, *To Kisho no shoga*, 1981, vol. 2 [*Zuhan hen*], pl. 85). A *T'ai-shih shih* seal is to be found as well on Tung's album of 1627 entitled *Intimate Landscapes Done in the Ting-mao Year* in the present exhibition (vol. 1, pl. 60), though neither of the seals on this album appears to occur on any other work.

Celia Carrington Riely

Seals with the *T'ai-shih shih* legend, being the earliest adopted of Tung's office seals and the longest in use, are consequently the least interesting from the standpoint of dating Tung's undated works. To the best of my knowledge, however, there are no dated examples—either extant or recorded—of a *T'ai-shih shih* seal in the 1630s, the years including Tung's final period at court and his accession to new and even higher office.

III. Seal 11 (*Tung-shih Hsüan-tsai*), the third of Tung's seals on his *Calligraphy* of 1603 (vol. 2, pl. 5), appears as well on an unpublished calligraphy album by Tung dated 1606 in the collection of the Guangzhou Meishuguan. What may well prove to be another dated instance of the seal follows Tung's colophon dated 1602 on the handscroll attributed to Mi Yu-jen entitled *Rare Views of the Hsiao and Hsiang Rivers* (*Hsiao-Hsiang ch'i-kuan*), in the Beijing Palace Museum, though until better photographs are forthcoming, it is impossible to state unequivocally that the seal is the same (the colophon, one of three Tung wrote on the scroll, is reproduced in small size in *Chung-kuo li-tai hui-hua: Ku-kung po-wu-yüan ts'ang-hua chi III*, 1982, *fu-lu*, p. 3). Another instance of seal 11 follows Tung's signature in the first part of an undated two-part album in the National Palace Museum, Taipei (*Ku-kung li-tai fa-shu ch'üan-chi*, 1977–78, vol. 21, pp. 130–34). Since Tung's signature in this section of the album is entirely consistent with an early date, we may tentatively assign this portion of the album to a period circa 1602/3–1606. The signature on the second half of the album, however, dates at least a decade later (see entry XI), so that from the point of view of style and authenticity, the two halves of the album must be considered separately. A seal very similar to no. 11 appears on an undated double album leaf by Tung with an early signature, copying out a T'ang poem, preserved in the Liaoning Provincial Museum, but in the only available reproduction of this leaf, the seal is too blurred to make the identification certain (*Shu-fa ts'ung-k'an* 6 [1983]: 65).

On three of the five works cited above, the seal reading *Tung-shih Hsüan-tsai* appears alone; on Tung's colophon of 1602 and *Calligraphy* of 1603, however, it is coupled with a second seal, reading *Chih chih-kao jih-chiang kuan*, an office seal whose meaning is discussed at the end of this entry. By 1607 Tung had begun to use a seal with the *Chih chih-kao jih-chiang kuan* legend (no. 13) together with a seal reading *Tung Ch'i-ch'ang yin* (no. 14), and this pair <13,14> fast became his favorite: he was to use these two seals with great frequency over the next few years, almost always in tandem (in which case the office seal is invariably placed first), though occasionally the seal reading *Tung Ch'i-ch'ang yin* appears alone. The two seals are paired on three works in the present exhibition, ranging in date over a period of six years: on *Running Script in the Manner of the Four Sung Masters*, dated 1607 (<13,14>), the earliest dated work known to me on which the pair appears; on *Paintings and Calligraphy on Round Fans*, dated 1610 (<16,17>); and following his colophon of 1613 on *Invitation to Reclusion at Ching-hsi* (<19,20>). So great is the deterioration in the two seals, particularly in the seal reading *Tung Ch'i-ch'ang yin*, that the identity of the three pairs <13,14>/<16,17>/<19,20> would be difficult to establish were it not that the pair appears so often on Tung's works, in varying stages of wear. Whether no. 10—the seal reading

Chih chih-kao jih-chiang kuan on Tung's *Calligraphy* of 1603—is identical to no. 13—the seal with the same legend on his *Running Script* of 1607—is open to question, however; though very similar, there are differences enough to render their identity problematical, and there is no dated example of either seal in the intervening period.

The latest dated instance of the pair <13,14>/<16,17>/<19,20> that I have so far discovered follows an inscription by Tung dated the seventh month, 1615, on a hanging scroll by T'ang Yin entitled *Viewing an Apricot Tree* (*Kuan-hsing t'u*), now in the Suzhou Museum (*Su-chou po-wu-kuan ts'ang-hua chi*, 1963, pl. 14). Since by 1617, at the latest, Tung was to adopt another pair of seals (<64,65>, entry XVI) that seems to have been executed in conscious imitation of the pair here, it seems possible that the earlier pair was lost when Tung's house was destroyed in the third month of 1616 (see "Tung Ch'i-ch'ang's Life," part 4). Provisionally, then, the third month of 1616 may be taken as the *terminus ad quem* for the pair under discussion here.

Many of Tung's colophons or inscriptions to which he appends this pair of seals are undated, some of the more important being his inscription on the *shih-t'ang* ("poetry hall," a paper mounted above the painting on a hanging scroll to receive an inscription) of Wang Meng's *Forest Grotto at Chü-ch'ü* (*Chü-ch'ü lin-shih*); the second of his three colophons on Mi Fu's famous *Shu-su t'ieh*; his colophon on Yen Chen-ch'ing's *Liu Chung-shih t'ieh* (where he uses only the seal reading *Tung Ch'i-ch'ang yin*); and the first of his two inscriptions on Shen Chou's album after Ni Tsan (*Fang Ni Tsan pi-i*)— all four of these works being in the collection of the National Palace Museum, Taipei (*Ku-kung li-tai fa-shu ch'üan-chi*, vol. 2, p. 123; vol. 9, p. 46; *Ku-kung shu-hua lu*, rev. ed. 1965, vol. 3, ch. 5, p. 210; vol. 4, ch. 6, p. 35). Two others of interest are his colophon on a handscroll by Tai Chin entitled *Spring Clouds at Ling-ku* (*Ling-ku ch'un-yün*)—now in the Museum für Ostasiatische Kunst, Berlin—where again only the single seal appears (Suzuki Kei, *Chugoku kaiga sogo zuroku*, 1982–83, vol. 2, E18-032); and his inscription on the left-hand mounting of the hanging scroll attributed to Mi Fu—now in the Freer Gallery—that Tung named the *Yün-ch'i lou t'u* after the studio belonging to his friend Wu Cheng-chih, to whom Tung presented the painting (see "Tung Ch'i-ch'ang's Life," part 4 and note 273). On all six of these colophons or inscriptions, the seals show greater wear than does the pair <13,14> on *Running Script in the Manner of the Four Sung Masters*, dated 1607, in the present exhibition; and in every case Tung's signature is consistent with a date before 1616. Thus all six can be dated to the period 1607–15, some earlier, like his inscription on *Forest Grotto*, where the seals show relatively little wear, some later, like his colophon on the *Liu Chung-shih t'ieh*, where the single seal shows marked deterioration.

Tung's calligraphies and colophons during this period frequently exhibit a third seal—reading *Hsüan-shang chai*, the name of one his studios—impressed (as was generally the case with a studio seal) at the beginning of the calligraphy or colophon, in the upper right-hand corner. The commonest of the *Hsüan-shang chai* seals that Tung uses before 1616 (see nos. 12, 18, 21, and 22 for impressions of the same seal) appears on four works in the present exhibition: twice on undated works (vol. 2, pls. 4, 8); once on his *Running Script in the Manner of the Four Sung Masters*, dated 1607 (vol. 2, pl. 10); and once again at the beginning of his colophon dated 1613 on his own *Invitation to Reclusion at Ching-hsi* (vol. 2, pl. 18). Almost certainly it is the same seal

that appears on his *Calligraphy* of 1603 (vol. 2, pl. 5), though it is impossible to be completely sure because the seal on the 1603 calligraphy (no. 9), coming at the beginning of the scroll, has suffered considerably from abrasion.

Both the *Hsüan-shang chai* seal (12/18/21/22) and the *Chih chih-kao jih-chiang kuan* seal (13/16/19) appear on a calligraphy hanging scroll of which there is no published reproduction, entitled simply *Four-word Poem* (*Ssu-yen shih*), belonging to the National Palace Museum, Taipei, and relegated to the *Chien-mu* section of the *Ku-kung shu-hua lu* (i.e. to the list of works considered likely to be forgeries: rev. ed. 1965, vol. 4, *ch.* 8, p. 9; see also Chang Chao, *Shih-ch'ü pao-chi*, facsim. ed. 1971, vol. 2, p. 1095). The third seal on this calligraphy, reading *Tung Ch'i-ch'ang yin*, has yet to be photographed; but the overwhelming likelihood is that it is identical to seal 14/17/20 and that the calligraphy—far from being a forgery—is a genuine and relatively early work. This is but one example where a knowledge of Tung's seals necessitates a reappraisal of a previously neglected work.

On one work in the present exhibition, Tung's *Paintings and Calligraphy on Round Fans* (vol. 2, pl. 13), an entirely different seal reading *Hsüan-shang chai* appears (no. 15), impressed at the beginning of the colophon, which is dated 1610 and followed by the pair of seals <16,17> that Tung uses with such frequency in the period 1607–15. No. 15, which is very much rarer than the first *Hsüan-shang chai* seal (12/18/21/22), is so faint that matching it with other impressions is exceedingly difficult; but as best I can judge, there are two other examples of the same seal (both used, like the seal on *Round Fans*, in combination with the pair <16,17>). One is impressed at the beginning of Tung's first inscription on Shen Chou's album after Ni Tsan in the National Palace Museum, mentioned above; the other (somewhat smudged and distorted, being impressed right at the opening margin of a long piece of silk) appears on a magnificent calligraphy by Tung in very large characters (only two per line) copying out a T'ang poem in the style of Mi Fu (*Fang Mi Nan-kung shu T'ang-shih*), which is presumably still in a private collection (*I-yüan i-chen* [English title: *A Garland of Chinese Calligraphy*], 1967, vol. 2, pls. 15–1,2). Both the inscription and the calligraphy are undated; but the rarity of the *Hsüan-shang chai* seal suggests that Tung used it only for a very short period, so that both works (which already fall, on the basis of their other seals, to the period 1607–15) may be tentatively dated—on the basis of *Round Fans*—to about the year 1610.

Seals 23 and 24 on *Blue and Green Landscape in the Manner of Chao Meng-fu* (vol. 1, pl. 16) are possibly copies of seals 12/18/21/22 and 14/17/20; but in the only available photograph they are so small and indistinct that it is impossible to be more definite.

In the first month of 1598, Tung, along with three fellow members of the Han-lin Academy (Yeh Hsiang-kao, Feng Yu-ching, and Lin Yao-yü) was ordered to assume charge of the drafting of patents for civil officials; and in the eighth month of the same year, he was appointed a Lecturer (*Chiang-kuan*) to the emperor's eldest son (see "Tung Ch'i-ch'ang's Life," part 3 and notes 210 and 213). To commemorate his two appointments, Tung devised a new seal—of which he eventually used several different examples, all but one very similar in design—with the legend *Chih chih-kao jih-chiang kuan* "[Drafter] Responsible for Imperial Proclamations and Daily Lecturer." Neither half

of the seal describes entirely accurately the appointment to which it alludes. *Jih-chiang kuan* or "Daily Lecturer" was a title assigned those appointed to lecture to the emperor himself, in sessions that were similar to the Classics Colloquia but less elaborate and with a different syllabus (Chang T'ing-yü, *Ming-shih*, completed 1736, orig. ed. 1739, rev. ed. 1974, *ch.* 55, p. 1407). Tung, then, was guilty of exercising a certain literary license in choosing to use the slightly grander title "Daily Lecturer" rather than the more accurately descriptive title *Tung-kung chiang-tu kuan* (Lecturer and Reader to the Heir Apparent), which occasionally prefaces his signature in compositions of a semiofficial kind (e.g. "epitaphs," *mu-chih-ming*; "memorial tablets," *shen-tao pei*). No doubt Tung preferred the three-character phrase as a balance to *Chih chih-kao*, and reasoned, perhaps, that he was in effect a "daily lecturer" to the emperor's son, if not to the emperor himself.

The title *Chih chih-kao*—Tung's use of which is explained only by a reading of the *Ming shih-lu*, the sole source for his appointment—has a more complicated history. Adopted in the T'ang and continued under the Sung, it has been rendered by E. A. Kracke (*Civil Service in Early Sung China*, 1953, repr. 1975, p. 230) as "Special drafting official of the Secretariat," the Secretariat-Chancellery being in Sung the body in charge of civil administration for all matters other than fiscal. The documents such officials were assigned to draft included patents, but were by no means exclusively confined to them; thus Tung again allowed himself a certain latitude in borrowing a title that not only had fallen into disuse, but that also implied a wider range of responsibility than he had actually been called upon to assume. The Sung title, in fact, is sufficiently different from Tung's title as a drafter of patents (*kuan-li wen-kuan kao-ch'ih*) as to produce initial uncertainty about whether indeed Tung adopted the one to refer to the other. *Chih*, however, is the literary equivalent of *kuan-li*; and though *chih-kao* (imperial proclamations) as a term is more general in scope than *kao-ch'ih* (imperial patents), it was not infrequently used in precisely this sense by Ming and Ch'ing writers (e.g. by Ch'en Chi-ju, in the opening words of his colophon on Tung's copy of an imperial patent that was granted to Tung in 1624: see "Tung Ch'i-ch'ang's Life," part 5 and note 336).

Why did a title so obviously antique—borrowed by Tung to refer to an appointment that (unlike the lectureship) enjoyed in the Ming period no out-of-the-ordinary distinction—appeal so strongly to Tung that he chose to incorporate it in a seal? The answer must lie in its association with such monumental figures of the past as Ts'ai Hsiang (1012–1067), Sung Lien (1310–1381), and especially Chao Meng-fu (1254–1322), all of whom had succeeded as Tung hoped to succeed—as calligraphers or connoisseurs, and in varying degrees as officials—and all of whom had at one time or another signed their names using *Chih chih-kao* as one of their titles (see Ts'ai Hsiang's *Hsieh tz'u yü-shu shih piao* and Chao Meng-fu's colophon of 1318 on Wang Hsi-chih's *K'uai-hsüeh shih-ch'ing t'ieh*, in Pien Yung-yü, *Shih-ku t'ang shu-hua hui-k'ao*, pref. 1682, facsim. repr. 1921, facsim. repr. of 1921 ed., 1958, vol. 1, p. 293 [*shu-chüan* 6, p. 28], and p. 449 [*shu-chüan* 10, p. 1]; and Sung Lien's colophon of 1372 on Wang Hsi-chih's *Tung-fang Shuo hua-hsiang tsan*, in Wu T'ing, *Yü-ch'ing chai t'ieh*, 1596, supplement 1614). That he could now lay claim to the title himself was, for Tung, one confirmation that he was following in their wake.

While the eighth month of 1598—the date now established for Tung's appointment as a Lecturer—is the theoretical *terminus a quo*

for Tung's adoption of seals with the legend *Chih chih-kao jih-chiang kuan*, the earliest dated instance of the seal that has so far come to light appears only four years later, following his colophon of 1602, on Mi Yu-jen's *Rare Views of the Hsiao and Hsiang Rivers*, mentioned at the beginning of this entry. Tung was to continue using seals reading *Chih chih-kao jih-chiang kuan* (just as he was to use seals reading *T'ai-shih shih*) throughout the remainder of his twenty-three year absence from court, from 1599 through 1621 (a period that for the most part he spent in self-imposed retirement); and he seems to have employed the seal briefly even after his return to Peking in 1622. The latest extant instance of such a seal, so far as I know, on a work unquestionably by Tung, follows his colophon—dated the twenty-first day of the ninth month, 1620—on a transcription of the *Diamond Sutra* (*Chin-kang ching*) by the Sung calligrapher Chang Chi-chih, of which the original is now in The Art Museum, Princeton University, and a stone-engraved copy (which includes Tung's colophon and seals) is in the Han-shan Temple in Su-chou (for this colophon, see also entry XVI).

A still later instance of the seal, however, is recorded as impressed at the end of a colophon dated the first day of the sixth month, 1622. This colophon is the second of two colophons inscribed by Tung on one of his earliest recorded calligraphies, entitled the *Cheng-yang men Kuan-hou miao pei*, copying out a text composed by his friend and fellow *chin-shih* Chiao Hung for a stele to be erected in a temple dedicated to the God of War Kuan-ti (Chang Chao et al., *Shih-ch'ü pao-chi*, facsim. ed. 1971, vol. 2, p. 929; see also "Tung Ch'i-ch'ang's Life," part 3 and notes 147–148). Though a rubbing of the text on the stele, which is dated "a winter's day, 1591," still survives, the original calligraphy with its colophons is apparently lost; nevertheless circumstantial evidence provided in the first of Tung's two colophons argues strongly in support of the calligraphy's authenticity, since Tung signs himself there "Vice Minister of the Court of Imperial Sacrifices and Director of Studies of the Directorate of Education" (*T'ai ch'ang ssu shao-ch'ing chien Kuo-tzu chien ssu-yeh*), a title he held for a mere three months in 1622, and of which no record exists save in the *Ming shih-lu* and in Tung's copy of an imperial patent awarding him the prestige title *T'ung-i ta-fu* in 1624—sources never utilized by Tung's biographers, let alone by his forgers (see "Tung Ch'i-ch'ang's Life," part 5 and notes 312 and 336). The *Kuan-hou miao pei*, then, provides reliable evidence that Tung used the *Chih chih-kao jih-chiang kuan* seal till well into 1622, before adopting new office seals toward the end of 1622 or in 1623 (see entry XXV).

What is of key significance for the study in hand is that only two works attributed to Tung—out of some forty extant paintings, calligraphies, and colophons known at present on which the *Chih chih-kao jih-chiang kuan* seal appears—exhibit a date later than 1622. The first is an album of landscapes, each with a leaf of calligraphy opposite, which is now in the collection of the Shanghai Museum (*Chung-kuo ku-tai shu-hua t'u-mu*, vol. 3, 1990, Hu 1–1364). One of the landscapes is dated New Year's Day, 1624 (a date that clearly applies only to that painting), and the ten double leaves are followed by a colophon, purportedly by Tung, dated 1633. The *Chih chih-kao jih-chiang kuan* seal is not impressed on the leaf dated 1624, so that technically it is not associated with as late a date as this (still less with the date 1633—the date of the colophon—though it is erroneously assigned this date in the Shanghai Museum's *Chung-kuo shu-hua-chia yin-chien*

kuan-shih [SM 82, pp. 1306, 1312]); but the landscapes are so obviously all of a piece that the 1624 date cannot be ignored. The album exhibits six different seals (SM 15, 28, 70, 72, 82, and 90), not one of which is to be found on any other work, unusual in a genuine work of this date; but more significant still, the idiosyncratic style of the paintings is so different from that which we associate with Tung—in leaves 1, 3, and 5, for instance, the landscape elements are so flat that they look like cut-outs arranged on the page in the form of a collage—that the viewer is driven to conclude that the album is by another hand.

The only other extant instance of a *Chih chih-kao jih-chiang kuan* seal joined with an inscription postdating 1622 follows what purports to be a colophon by Tung, dated 1636, on a handscroll attributed to Tung Yüan entitled *Mountain Peaks after Snow* (*Chün-feng chi-hsüeh*), in the Ohara Museum of Art in Kurashiki (Suzuki Kei, *Chugoku kaiga sogo zuroku*, vol. 3, JM25–002). The text of the colophon, in which Tung identifies the handscroll as one of three Tung Yüan paintings owned by him in 1633 and describes the other two in some detail, is identical in all but a character here and there to the last of his three colophons on the celebrated *Summer Mountains* (*Hsia-shan t'u*) attributed to Tung Yüan in the Shanghai Museum (P'ang Yüan-chi, *Hsü-chai ming-hua lu*, pref. 1909, facsim. repr. 1971, vol. 1, pp. 56–57). The priority of Tung's colophon on the *Summer Mountains* (to which, incidentally, Tung affixed no seal) is established at a glance by its superior calligraphy as well as by the painting's superior pedigree; hence the Ohara colophon is immediately identifiable as a forgery, to which the forger himself unwittingly provided the clue by his addition of the seal *Chih chih-kao jih-chiang kuan*, which evidence now indicates Tung had abandoned by 1623.

I have discovered to date only three recorded works attributed to Tung that dispute this conclusion. Two—one a handscroll, the other a colophon on an anonymous Ming work—are recorded in the *Shih-ch'ü pao-chi san-pien* (to which as a rule were relegated paintings and calligraphies either late in entering the palace collection or considered by the cataloguers as less likely than others to be authentic, though it records as well many genuine works), and the other is a colophon on an album leaf attributed to the Yüan master Kao K'o-kung, recorded in the *Shih-ku t'ang shu-hua hui-k'ao* (Hu Ching, *Shih-ch'ü pao-chi san-pien*, completed 1816, facsim. of ms. copy, 1969, vol. 2, p. 575; and vol. 5, pp. 2120–21; Pien Yung-yü, *Shih-ku t'ang shu-hua hui-k'ao*, facsim. repr. 1958, vol. 3, p. 245 [*hua-chüan* 4, p. 17]; for the last, see also Ren Daobin, *Tung Ch'i-ch'ang hsi-nien*, p. 246). Since neither the two colophons nor the handscroll appears to be extant, it is not possible to identify them positively as forgeries; but for reasons too lengthy to explore in the space allotted here, both the handscroll and the colophon recorded in the *Shih-ch'ü pao-chi* are unlikely to be genuine.

Altogether, it is possible to trace at present well over one hundred and fifty paintings, calligraphies, and colophons by Tung, extant or recorded, that are both impressed with his seals and postdate 1622. Of this number, only the five mentioned above exhibit a *Chih chih-kao jih-chiang kuan* seal, and two of the five—the only two extant—can be labeled conclusively as forgeries. The evidence, then, overwhelmingly supports the conclusion that when Tung adopted new office seals in 1623 (or perhaps even as early as late 1622), he discarded his *Chih chih-kao jih-chiang kuan* seals as obsolete. The inference is that Tung's undated works with the seal *Chih chih-kao jih-chiang kuan* may

all be placed before 1623, thereby distinguishing them at a glance from the works of Tung's final years, which survive in greatest abundance.

VIII. Seal 49, reading *Tung-shih Hsüan-tsai*, follows Tung's signature on all but one of the calligraphy fans in his album of *Paintings and Calligraphy on Round Fans*, dated 1610 (vol. 1, pl. 13). Only two other instances of this seal are known to me: one (no. 50) follows his undated inscription on Chao Tso's hanging scroll of 1611 entitled *After Chao Meng-fu's "High Mountains and Flowing Water,"* in the present exhibition (vol. 1, pl. 82); the other follows the second of his two inscriptions, both undated, on Shen Chou's album after Ni Tsan (*Fang Ni Tsan pi-i*) in the National Palace Museum, Taipei, which was discussed above in entry III. The probability is that Tung used the seal only for a short period, and that his inscription on Chao Tso's hanging scroll was written very soon after it was painted—all the more likely since Tung records in his inscription that he was himself the owner of Chao Meng-fu's *High Mountains and Flowing Water*, from which Chao Tso took his inspiration.

Since all four of the seals that accompany Tung's two undated inscriptions on the Shen Chou album appear on his album of *Round Fans* (i.e. nos. 15, 16, 17, and 49; for the first three, see entry III), and since two of these (nos. 15 and 49) are rare, it is more than likely that Tung inscribed the Shen Chou album at much the same time that he completed the *Round Fans* in the autumn of 1610.

What is clearly a forgery of seal 49/50 appears on one section of a handscroll attributed to Tung on loan to the National Palace Museum, Taipei (*Lan-ch'ien-shan kuan ming-hua mu-lu*, 1987, p. 35, pl. 21).

X. Seal 53, which is only just legible as *T'ai-shih shih*, is placed at the very bottom edge of the scroll entitled *Sketches of Traditional Tree and Rock Types* (vol. 1, pl. 19), following a few brief notes on painting techniques (those in particular used by the Sung master Chao Po-su) jotted down beneath the boughs of the trees in the handscroll's opening section. The seal is too rubbed and indistinct to match it with any of Tung's known seals; what strikes one as surprising is that a seal is impressed in such an unlikely place on so informal a painting, especially since the seal is one of Tung's office seals, which elsewhere Tung never uses except in combination with a seal engraved with his name. Inevitably the suspicion arises, then, that the seal may have been affixed by another hand.

XI. The second seal, no. 55 (*Tung Hsüan-tsai*), on Tung's calligraphy *After Mi Fu's "Rhyme-prose on the Celestial Horse,"* dated 1612 (vol. 2, pl. 20), is quite obviously identical to the first seal, no. 56, on his undated *Eulogy of Ni K'uan* (vol. 2, pl. 22). There is to my knowledge only one other instance of this seal, impressed on Tung's undated copy of Pai Chü-i's *P'i-p'a hsing* in cursive script that is known from old reproductions, though whether the scroll still survives is uncertain (Kohara Hironobu, *To Kisho no shoga*, vol. 2 [*Zuhan hen*], pl. 92). The engraved lines of the seal on the *P'i-p'a hsing* are by no means so sharp and clear-cut as are those of the two impressions on the scrolls in the present exhibition; moreover, the seal on the *P'i-p'a hsing* ap-

pears to be slightly distorted, even though the *P'i-p'a hsing* was reportedly executed on paper rather than silk. These differences, however, can probably be attributed to the quality of the *yin-ni* (vermilion seal pigment), the wear on the seal, and the deficiencies of an old reproduction, and there seems no reason to doubt that the impression on the *P'i-p'a hsing* is from the same seal.

Curiously, another old reproduction of the *P'i-p'a hsing*, different from the one used to produce the plates in *To Kisho no shoga*, shows not one seal but two, placed to the left of the signature rather than underneath, the second seal identical to the one that appears in the *To Kisho no shoga* reproduction and the other identical to seal 54—in other words, the very pair <54,55> that appears here on the *Celestial Horse* of 1612 (the second reproduction was published by Shen-chou kuo-kuang she in Shanghai in 1929 as a booklet simply entitled *Tung Hsiang-kuang ts'ao-shu*; a copy is to be found in the Fung Ping Shan Library at the University of Hong Kong). The two reproductions of the *P'i-p'a hsing*, however, were clearly made from the same scroll, not from different versions of the same composition. Presumably whoever made the reproduction from which the plates in *To Kisho no shoga* were taken altered the photograph in order to accommodate the final section of the calligraphy in the space available on the page. All three works—the *P'i-p'a hsing* and the two in the present exhibition—exhibit signatures in which the shape of the character *ch'ang* is in transition from the *ch'ang* of Tung's earlier signatures (in which the upper element is taller than it is broad) to that on his later works (where the relative dimensions of this element are reversed); hence the two undated scrolls may be dated with some security to the period 1612 to 1616, when this transition was taking place.

Seal 54 (*T'ai-shih shih*) appears not only on the *P'i-p'a hsing* (in one of its reproductions) but also follows Tung's signature on the *yin-shou* (paper or silk at the beginning of a handscroll, reserved for a title or quotation) of Tung's copy of the *Yüeh-i t'ieh* in the National Palace Museum, Taipei (*Ku-kung li-tai fa-shu ch'üan-chi*, vol. 8, p. 58; for the seal, see NPM, p. 315). We are told by Tung, in an undated colophon at the end of the *Yüeh-i t'ieh*, that he copied out the text in 1602; but the colophon is later in date by at least five years: it is followed by the pair of seals discussed in entry III, exhibiting rather more wear than the earliest dated examples of these seals, <13,14>, which appear on *Running Script in the Manner of the Four Sung Masters* (vol. 2, pl. 10), dated 1607. The *yin-shou*, then, need not date as early as 1602, and may well have been inscribed, like the colophon, a year or so after 1607. Tung's signature on the *yin-shou*, however, plainly predates his signature on the *Celestial Horse* of 1612. Since the *T'ai-shih shih* seal (no. 54) accompanies both, Tung evidently made use of the seal for several years, at the very least from about 1609 to 1612. A seal that appears at first glance to be the same, SM 98, is probably a copy.

Seal 57, the second seal figuring on Tung's *Eulogy of Ni Kuan*, is not known by me to appear on any other work.

XII. Seal 58, which follows the earlier of Tung's two inscriptions, dated 1614, on his painting entitled *Lin Pu's Poetic Idea* (vol. 1, pl. 23), appears, as far as I know, on only one other work by Tung, an undated calligraphy handscroll copying out Pai Chü-i's *P'i-p'a hsing* in running-standard script, preserved in the National Palace Museum,

Taipei (*Ku-kung li-tai fa-shu ch'üan-chi*, vol. 25, pp. 6–17). At first glance, the vertical stroke through the center of the character *ch'i* in no. 58 does not seem to carry through the upper half of the character, as it does in the seal on the Palace Museum handscroll, but on enlargement it can be clearly seen that what seems a break in the stroke in no. 58 was caused by a small globule of *yin-ni* that stuck to the seal and obscured the stroke when the seal was impressed —an example of how necessary it is to employ magnification when trying to determine whether two seal impressions were made from the same seal. There can be no doubt that such is the case here: every tiny break in the outer edge of one appears in the outer edge of the other. The signature on the Palace Museum handscroll is entirely consistent with a date of circa 1614, and the handscroll can be assigned to this period without hesitation.

Interestingly enough, a second handscroll copying out the *P'i-p'a hsing* in running-standard script, very similar in appearance but lacking the robustness and freedom of the handscroll in the Palace Museum, is illustrated in Kohara Hironobu, *To Kisho no shoga*, vol. 2 (*Zuhan hen*), pl. 78. The two signatures are so similar, particularly the characters "Ch'i-ch'ang" (despite the fact that Tung signed his name using a *ch'ang* of this shape only for a short period of time: see entry XI), that it is almost impossible to believe that one piece is not a copy of the other. The priority of the Palace Museum handscroll (which in addition to Pai Chü-i's text has a comment by Tung at the end, missing on the other scroll) is confirmed when we examine the seals on the handscroll in *To Kisho no shoga*, which are clearly copies of a favorite pair <100,101> that Tung was to employ with great frequency after 1622 or 1623 (see entry XXV). The handscroll in *To Kisho no shoga* is patently a forgery.

XIII. Seal 59 is a "joined seal" or *lien-chu yin*, both halves carved on the base of the same rectangular block, so that though the impressions appear to be separate, the two halves of the seal are impressed simultaneously. It follows an inscription signed "Ch'i-ch'ang" and dated 1614 on *Misty River and Piled Peaks* (vol. 1, pl. 7), another version of which is to be found in the National Palace Museum, Taipei (vol. 1, fig. 26). Neither the seal here nor the single seal reading *Tung-shih Hsüan-tsai* that follows Tung's signature on the Palace Museum painting appears, to my knowledge, on any other work. The signature on the Palace Museum version, however, is entirely in keeping with a 1614 date (see entry XI), whereas the signature on the painting in the present exhibition resembles much more closely those on Tung's later works. What is interesting is that, as is often the case with forgeries of Tung Ch'i-ch'ang's paintings, the copyist here has made no attempt to reproduce the seal on the original, but instead devised a completely new one; in many cases, then, where two versions of a work exist, an intimate knowledge of Tung's seals allows one to identify the genuine work with relative ease.

XIV. There are a number of *pai-chu wen* seals (that is to say, seals that are half *pai-wen*, half *chu-wen*), reading *Tung Hsüan-tsai*, impressed on works by or attributed to Tung, but only one is to be found on more than one work: a seal that follows Tung's inscription on the *hou*

ko-shui (mounting immediately following the painting) of the handscroll entitled *The River Shu* (*Shu-ch'uan t'u*) attributed to Li Kung-lin, in the Freer Gallery; and that follows as well his inscription on the *ch'ien ko-shui* of the handscroll entitled *A Dream Journey along the Hsiao and Hsiang Rivers* (*Hsiao-Hsiang wo-yu*) attributed to a Sung painter known only as Master Li, in the Tokyo National Museum (Kohara Hironobu, *To Kisho no shoga*, vol. 2 [*Zuhan hen*], pls. 79–80). As Fu Shen has pointed out, the calligraphy and the signatures of these two inscriptions, which are early in style, are clearly alike (Kohara Hironobu, *To Kisho no shoga*, vol. 1 [*Kenkyu hen*], pp. 274–75). Since, in addition, the same seal accompanies both, it is reasonable to suppose that the two were written at much the same time. Neither inscription is dated; but Tung has written a later colophon on *The River Shu*, which is dated "the day of the year-end sacrifice" (i.e. the eighth day of the twelfth month), 1602; and thus his inscription on the *hou ko-shui* precedes that date. The seal in question, then, was employed by Tung as early as 1602, perhaps only for a short period.

What may be the same seal follows Tung's signature on a section of a calligraphy handscroll by Tung, entitled the *Chin-sha t'ieh* (after the place where he inscribed it), now in the Capital Museum (Shoudu Bowuguan) in Peking; but the seal is too small in reproduction to make the identification certain (*Chung-kuo ku-tai shu-hua t'u-mu*, vol. 1, 1986, *Ching* 5–227). The section of the scroll where the seal appears, however, is dated by Tung the eighth month of 1602, which agrees well with the date of Tung's second colophon on *The River Shu*, so it is not unlikely that here we have a third instance of the same seal. SM 44, which is listed as appearing on an undated calligraphy fan (*Chung-kuo shu-hua-chia yin-chien kuan-shih*, pp. 1305, 1311), may be yet another instance of this seal; but there are enough small differences to make it impossible to vouch for its authenticity, without being able to examine the seal on the work itself.

All the other seals of this type known to me—including seal 61, which appears on the handscroll entitled *Panoramic View of a Lake*, dated 1615, in the present exhibition (vol. 1, pl. 24)—are not only a decade or so later in date but also unique, in that each appears on just one work. Curiously enough, no. 61 is not the only seal of this type to be found on a work dated 1615. Two other handscrolls attributed to Tung dated 1615 have seals of this type, one, a calligraphy in the Chokaido Bunko (Kohara Hironobu, *To Kisho no shoga*, vol. 2 [*Zuhan hen*], pl. 48), the other a painting after Mi Yu-jen (*Fang Mi Wu-chou shan t'u*) in the Shanghai Museum (*Chung-kuo ku-tai shu-hua t'u-mu*, vol. 3, *Hu* 1–1348). One hopes that with the eventual publication of hitherto unknown works by Tung in Chinese collections, other works with some of these seals will someday come to hand.

XV. Neither seal 62 nor seal 63, which appear on an undated *Landscape* in the present exhibition (vol. 1, pl. 26), is to be found, as far as I know, on any other work, and their appearance does not inspire confidence. No. 62, which follows the first inscription, is particularly crude: note the unevenly carved "legs" of the character *ch'i*, and the squashed and misshapen central element of the character *tung*. Seal 63 is little better: the stroke running vertically through the lower half of the character *tung* slants to the left, so that the two lower halves of the character are decidedly uneven. That they appear on a work

whose authenticity can at best be called questionable makes it all the more likely that the seals are forgeries.

Seal 61 is so faint and indistinct in the available reproduction that comparison with other seals is impossible.

XVI. Seals 64 (*Chih chih-kao jih-chiang kuan*) and 65 (*Tung Ch'i-ch'ang yin*) appear as a pair on Tung's *Ch'ing-pien Mountain in the Manner of Tung Yüan* (vol. 1, pl. 32), following Tung's first inscription, which is dated the last day of the fifth month, 1617. Though Tung was to use this pair for only about four years, a much shorter period than he did the pair discussed in entry III—of which there are three sets of impressions on works in the exhibition (<13,14>/<16,17>/<19,20>)—nevertheless, on works from those few years, from 1617 to 1620, the prolific period in which Tung produced a disproportionate number of his finest paintings (the *Ch'ing-pien Mountain* foremost among them), it is to be found with almost equal frequency.

The two pairs, in fact, are remarkably alike; the two seals 14/17/20 and 65 even exhibit some of the same small flaws—like the small break in the character *ch'ang*, linking the right-hand edge of the upper element to the right-hand arm of the lower element extending upward beside it; and the flaw in the character *ch'i* joining the left-hand "leg" (shaped like the letter "c" in reverse) to the horizontal stroke above—so that at first glance the two seals appear to be identical, and it is only on noticing that the character *tung* is quite differently carved that it becomes evident that they are different seals. The two seals 13/16/19 and 64 are even more alike, and may possibly prove to be the same, should there eventually come to light dated examples that bridge the period from the seventh month of 1615 (the latest dated impression of no. 13/16/19) to the fifth month of 1617 (the earliest dated impression of no. 64); but for the moment it seems preferable to consider them separate seals, until such a sequence of dated examples can be found to account for a number of slight disparities between them, notably in the degree of wear apparent in the upper left-hand corner, and in the shape of the interior space of the right-hand element of the character *jih*.

It is clear, however, that sometime between 1615 and 1617 the pair <64,65> replaced the earlier pair <13,14>/<16,17>/<19,20> as Tung's favorite pair of seals, either because seal 14/17/20 had disintegrated to such a point that Tung no longer cared to use it (the impression dated 1615, which follows his inscription on T'ang Yin's *Viewing an Apricot Tree* in the Suzhou Museum, shows marked deterioration) or because it perished in the third month of 1616, when Tung's house and its contents were destroyed by fire.

The earliest dated example of seal 65 that I have so far discovered appears on a striking hanging scroll, entitled *Landscape after a Poem by Wang Wei* (*Wang Wei shih-i*), painted by Tung in the fifth month of 1616. Though belonging to the Shanghai Museum, the painting has hitherto escaped attention through being on display, for a number of years, in a little-visited historical museum far from the city's center (see "Tung Ch'i-ch'ang's Life," note 296). The seal (SM 79, in *Chung-kuo shu-hua-chia yin-chien kuan-shih*) already exhibits all the small flaws or breaks that can be seen in the impression on the *Ch'ing-pien Mountain*; and since there is no evidence to suggest that Tung began to use the seal much before it appears on his *Landscape after a Poem*

by Wang Wei in the fifth month of 1616, it is hard to avoid conjecture either that the two flaws described above were deliberately executed (unlikely as this may seem), or at least that because of them, the seal was deliberately chosen to make up the new pair, so that the new seal (no. 65)—though clearly different from the old (14/17/20)—was yet distinctly reminiscent of its predecessor, which was no longer usable (or available for use), and of which Tung had been particularly fond.

There are five other dated instances of seal 65 known to me: one, following Tung's colophon dated the nineteenth day of the third month, 1617, on Shen Chou's album entitled *Eastern Villa* (*Tung-chuang t'u*), in the Nanjing Museum (*Chung-kuo ku-tai shu-hua t'u-mu*), vol. 7, 1988, *Su* 14-0028); another, impressed at the end of a calligraphy handscroll by Tung that is dated the twelfth day of the intercalary fourth month, 1618, and entitled simply *Miscellaneous Writings* (*Tsa-shu chüan*), in the National Palace Museum, Taipei (Kohara Hironobu, *To Kisho no shoga*, vol. 2 [*Zuhan hen*], pl. 51); a third, following Tung's colophon dated "five days after the mid-autumn festival" (i.e. the twentieth day of the eighth month), 1619, on a handscroll formerly attributed to Chü-jan, entitled *Ten Thousand Li along the Yangtze* (*Ch'ang-chiang wan-li*), in the Freer Gallery (Suzuki Kei, *Chugoku kaiga sogo zuroku*, vol. 1, A21-114); a fourth, following an inscription by Tung, dated the autumn of 1619, on the left-hand mounting of a hanging scroll attributed to Huang Kung-wang, with the title *Jade Trees at Tan-yai* (*Tan-yai yü-shu*), in the Beijing Palace Museum (for the painting but not the inscription, see *I-yüan to-ying*, 1979, no. 1, p. 16); and finally, what at present appears to be the latest dated instance of this seal, impressed at the end of Tung's colophon, dated the twenty-first day of the ninth month, 1620, on a transcription of the *Diamond Sutra* (*Chin-kang ching*) by the Sung calligrapher Chang Chi-chih, in The Art Museum, Princeton University (Nakata Yujiro and Fu Shen, *O-Bei shuzo Chugoku hosho meseki shu*, 1981–83, vol. 2, pp. 80–81, pls. 97–99; for this colophon, see also entry III).

Like seal 14/17/20 before it, no. 65 deteriorated considerably over the four year period Tung employed it—so much so that in *Seals of Chinese Painters and Collectors of the Ming and Ch'ing Periods*, the impression that appears on *Ten Thousand Li along the Yangtze* (CW 59) is considered to be a different seal from the impression on the *Ch'ing-pien Mountain* (CW 61), though in fact they are the same seal, the one postdating the other by a little more than two years. It is no surprise, then, that the seal appears no more after the ninth month of 1620, when Tung appended it to his colophon on Chang Chi-chih's *Diamond Sutra*, where the edges of the seal have become so worn that it has taken on an almost trapezoidal shape.

Between 1618 and 1619 small changes took place in the appearance of seals 64 and 65, so that impressions are easily divided between those dating from 1617 and 1618 and those dating from 1619 and 1620. In seal 64 (*Chih chih-kao jih-chiang kuan*), two flaws, one larger than the other, developed midway along the seal's left-hand edge, biting well into the left-hand element (*yen-tzu-p'ang*) of the character *chiang* (for a poor but genuine impression of the seal in this state, see an undated calligraphy by Tung copying out a poem by Tu Fu, in *Chung-kuo li-tai fa-shu ming-chi ch'üan-chi*, 1978, vol. 6, pp. 74–90). In seal 65 (*Tung Ch'i-ch'ang yin*), a slight bulge outward to the left developed on the left-hand side of the upper element of the character *ch'ang*, and the right-hand vertical stroke in the topmost element (*ts'ao-tzu-*

t'ou) of the character *tung* disappeared altogether (see, for example, CW 59). It was thus an easy matter, when faced with Tung's undated *Abbreviated Version of Su Shih's "The First Excursion to Red Cliff"* (vol. 2, pl. 34), on which the identical seals occur (nos. 67 and 68), to assign it a date of 1617 to 1618, since the flaws evident in later impressions of these two seals have not yet made their appearance.

The third seal on Tung's copy of the *"Red Cliff"*—no. 66, reading *Hsüan-shang chai*—is strongly reminiscent of the earlier seal 12/18/21/22 with the same legend and design, so much so that, again, the two seals are conceivably the same, though (as is so often the case with seals coming at the beginning of a handscroll) seal 66 is so rubbed and so faint that it is impossible to reach a firm conclusion. Just as on earlier calligraphies—his *Running Script in the Manner of the Four Sung Masters*, dated 1607 (vol. 2, pl. 10), for instance, and his colophon of 1613 on *Invitation to Reclusion at Ching-hsi* (vol. 2, pl. 18)—Tung employed the earlier seal 12/18/21/22 reading *Hsüan-shang chai* in conjunction with his favorite early pair, so on the *"Red Cliff,"* Tung employs no. 66 in conjunction with the new pair <67,68>. Thus on a number of calligraphies from 1616/17 to 1619/20 (e.g. the *"Red Cliff"* and the handscroll copying out a poem by Tu Fu mentioned above), the new trio <66,67,68> replaces the old <12,13,14>/<18,19,20>, which quite obviously it was intended to resemble.

Seal 65 does not always appear as a pair with no. 64 (*Chih chih-kao jih-chiang kuan*); on occasion it appears alone (as it does following Tung's colophon of 1617 on Shen Chou's *Eastern Villa*, and again on Tung's *Miscellaneous Writings* of 1618), or coupled with another seal, reading *T'ai-shih shih* (as it does on Tung's *Landscape after a Poem by Wang Wei*, dated 1616, and again following his colophon of 1619 on *Ten Thousand Li along the Yangtze*). On one of Tung's most innovative albums, which is still in private hands, seal 65 appears three times: once in combination with seal 64 and twice with the seal *T'ai-shih shih* (for two leaves from this album—unfortunately, exhibiting seals different from those under discussion here—see vol. 1, figs. 31 and 32). The album is undated; but since seals 64 and 65 exhibit all the small changes that identify them as later impressions—the two flaws in the left-hand element of the character *chiang*, the missing vertical in the *ts'ao-tzu-t'ou* of the character *tung*, and the slight bulge outward to the left in the upper element of the character *ch'ang*—we can propose a date for the album of 1619 or 1620. That the impressions of the *T'ai-shih shih* seal on the album (which show two sizable chunks of the seal missing) match very closely the impression of the same seal (CW 62) on Tung's colophon from the eighth month of 1619 on *Ten Thousand Li along the Yangtze*, simply confirms that the album warrants a 1619/1620 date.

Seal 65, being the seal most frequently encountered on Tung's works from 1617 to 1620—the years in which Tung's powers as a painter reached full maturity—is thus one of the seals most frequently copied by forgers, though often the forger has expended little effort in trying to produce an exact copy and has contented himself with achieving a general resemblance. Two copies of no. 65 appear on works in the exhibition, one (seal 69) on the undated handscroll entitled *Running Script in the Manner of the Four Sung Masters* (vol. 2, pl. 64; for questions concerning this work, see "Tung Ch'i-ch'ang's Life," note 393), the other (seal 71) on a hanging scroll entitled *After*

Ni Tsan's *"Lofty Scholar in Autumn Mountains"* (vol. 1, pl. 37). Both copies reproduce the flaws that are among the seal's most conspicuous features—the slight break joining the upper and lower halves of the character *ch'ang*, and the flaw joining the left-hand "leg" of the character *ch'i* to the horizontal above—but both are easily distinguished from the genuine seal, no. 69 all too obviously by the shape of the character *yin*, no. 71 by the vertical strokes in the *ts'ao-tzu-t'ou* element of the character *tung* (which are set much too closely together) and by the final stroke of the same character (which grows thicker on the left rather than on the right). Whereas on every other work by (or even attributed to) Tung, the seal *Chih chih-kao jih-chiang kuan* appears as the first of a pair of seals following Tung's signature, on *"Lofty Scholar"* the seal with this legend (no. 70) is impressed on the lower right-hand edge of the painting, yet another indication (if one were needed) that the seals on this painting are forgeries.

Two much more clever imitations of seal 65—different from one another but unusual in that both are close enough so that they might almost be taken as genuine—are to be found on two calligraphies, one an album and the other a handscroll, in the National Palace Museum, Taipei, both (as it happens) calligraphies that were late in entering the imperial collection, hence with the seals of Chia-ch'ing rather than Ch'ien-lung, and recorded only in the *Shih-ch'ü pao-chi san-pien* (*Ku-kung li-tai fa-shu ch'üan-chi*, vol. 8, pp. 144–57; vol. 25, pp. 22–45). Yet another imitation of seal 65—which, despite a very poor reproduction, appears to be identical to the imitation of the seal on the calligraphy handscroll in the National Palace Museum just mentioned—is to be found on another calligraphy dated 1620, illustrated in *To Kisho no shoga* (vol. 2 [*Zuhan hen*], pl. 55). All three calligraphies are plausible enough to have been singled out recently for publication; that their seals are forgeries inevitably forces us to subject them to renewed scrutiny—a scrutiny that they might all too easily escape, if their seals did not call them into question.

XXIII. Seals 96 and 97, which appear on Tung's undated hanging scroll in the Yale University Art Gallery entitled *Reminiscence of Chien River* (vol. 1, pl. 41), are twice impressed as a pair on the undated album by Tung that is discussed at some length in entries XVI and XXIX, where I attempt to show that the album's probable date is 1619 or 1620 (for two leaves from this very interesting album, see vol. 1, figs. 31 and 32). The same pair of seals is to be found on an undated hanging scroll by Tung—painted, according to Tung's inscription, in the manner of Mi Yu-jen's *Hsiao and Hsiang Rivers*—now in the Honolulu Academy of Arts, a painting that has received very little attention, though it was published in 1965 by Gustav Ecke in his *Chinese Paintings in Hawaii* (vol. 1, pl. 6 and fig. 72). The impressions on all three works are very similar, though the upper right-hand corners of the seals on the Honolulu painting are still intact, whereas those on the album and the Yale painting are slightly rounded from wear. Judging from the appearance of its seals, the Yale painting is the latest of the three, with a date, perhaps, of circa 1620–21. At any rate, it can date no later than 1624, since there appears on the painting an inscription by Li Liu-fang in which he speaks of Tung as "Tung *Shih-lang,*" that is to say, Vice Minister (of Rites) Tung; had Li Liu-fang written

his inscription after 1624, he would have addressed Tung as "Tung *Tsung-po*"—Minister of Rites Tung—in view of Tung's promotion to that office in the first month of 1625.

The third seal on the Yale painting, no. 95, bears a resemblance to seals 74 and 78 but is not identical to them, and I know of its appearance on no other work.

XXV. Each of the two seals illustrated in this group, the first reading *Tsung-po hsüeh-shih* (100/102/103/105/107/109), the second reading *Tung-shih Hsüan-tsai* (99/101/104/106/108/110), appears on six different works in the exhibition, dating from 1623 to 1635, from which alone one could draw the conclusion—which is in fact entirely correct— that these two were the seals Tung used most frequently in his later years. In most cases the seals appear as a pair, as they do on five works here (vol. 1, pl. 50; vol. 2, pls. 55, 67, 69, 98). On one work in the exhibition (vol. 2, pl. 39), however, the seal reading *Tung-shih Hsüan-tsai* appears alone, no doubt because in writing his inscription, Tung left himself only enough space to impress one seal; and on another work, his *Landscape in the Manner of Tung Yüan* (vol. 1, pl. 52), the seal *Tsung-po hsüeh-shih* (no. 102) is coupled with a different seal (no. 121), these two seals (i.e. nos. 102 and 121) occasionally appearing as a pair on other works.

The seal reading *Tung-shih Hsüan-tsai* (of which we see here six different impressions, i.e. nos. 99/101/104/106/108/110), is easily recognized from a number of features, the most obvious being the small chip in the left-hand edge that is to be found, even in the earliest impressions of this seal, about a third of the way up from the lower left-hand corner. Others are the slight outward flare of the vertical border at the upper left; the small but perceptible dip in the border at the top, just as it crosses the space from the character *tung* to the character *hsüan*; and the beginning of a hairline crack leading from the left-hand border to the lower left-hand corner of the central element in the character *hsüan*. What is worth remarking about the two seals here is that unlike the pair discussed in entry III (<13,14>, <16,17>, <19,20>)—and, in fact, unlike most of Tung's seals that he used for a period of years—the pair here shows no variation over time: the impressions in 1635 (<103,104>) are as crisp and distinct as the impressions in 1624 (<100,101>), so that the seals were evidently carved from a very hard material. The rather worn appearance of the impressions on Tung's *Poem for Mao Hsiang* (<109,110>) is owing not to the deterioration of the seals themselves but to the abrasion of the paper's surface, and also, perhaps (though this is hard to judge in the absence of the work itself), to the quality of the *yin-ni* used and roughness of the paper's surface.

Being the seals that appear most often on Tung's later works, inevitably they were copied by forgers familiar with their appearance, though for the most part the copies are so badly executed that there is little possibility of mistaking them for genuine impressions. One such forgery, seal III, reading *Tung-shih Hsüan-tsai*, is to be found on the hanging scroll in the present exhibition, dated 1622, entitled *After Huang Kung-wang's "Warm And Green Layered Hills"* (vol. 1, pl. 44). Predictably, seal III appears in combination with a second seal—reading *Tung Ch'i-ch'ang yin* (no. 123)—that is itself another forgery, a

close though not exact imitation of a genuine seal of which two impressions appear on works in the exhibition: no. 121, on Tung's *Landscape in the Manner of Tung Yüan*, dated 1625; and no. 122, on his undated painting entitled *Cloudy Mountain Ink-play* (all three seals illustrated, for purposes of comparison, in group XXX). That both seals on *"Warm and Green Layered Hills"* can be readily identified as forgeries necessarily calls into question the authenticity of the painting, in which color has been combined with too heavy an application of ink, in an almost repellent manner completely atypical of Tung, who elsewhere, at this very period, was producing (albeit in album-leaf form) some of the most strikingly beautiful paintings in color to emanate from the Ming—an achievement, one might add, with which he has never been properly credited. Rather than accept *"Warm and Green Layered Hills"* as a genuine but peculiarly unattractive work (uniquely so in Tung's oeuvre), one might better wonder whether it is not simply a reasonably clever parody of Tung's style.

With the seal reading *Tsung-po hsüeh-shih*, we are presented with Tung's third important office seal; and though later, as he was awarded even higher office, he was to adopt seals with legends referring to his subsequent appointments, he was to continue to use seals reading *Tsung-po hsüeh-shih* for the rest of his life. The seal here (100/102/103/105/107/109) is a case in point: it follows his colophon, dated "the mid-autumn festival" (i.e. the fifteenth day of the eighth month), 1636, on the famous handscroll now in the Osaka Municipal Museum of Art, entitled the *Five Planets and Twenty-eight Constellations* (*Wu-hsing erh-shih-pa-hsiu shen-hsing*), traditionally attributed to the sixth century figure painter Chang Seng-yu, though Tung attributes it to the most celebrated figure painter of all, the T'ang master Wu Tao-tzu (Suzuki Kei, *Chugoku kaiga sogo zuroku*, vol. 3, JM3-165).

Precisely when Tung first adopted a seal with the legend *Tsung-po hsüeh-shih* poses more of a problem. Ostensibly the legend refers to the appointment he was awarded on the twenty-third day of the seventh month, 1623, as Right Vice Minister of Rites and Academician Reader-in-waiting in the Han-lin Academy assisting in the direction of the Household Administration of the Heir Apparent (*Li-pu yu-shih-lang chien Han-lin yüan shih-tu hsüeh-shih hsieh-li Chan-shih fu shih*; see "Tung Ch'i-ch'ang's Life," part 5 and note 337), *Tsung-po* being a literary reference either to the Minister of Rites (*Ta tsung-po*) or to a Vice Minister of Rites (*Shao tsung-po*), and *Hsüeh-shih* a contraction of *Han-lin yüan shih-tu hsüeh-shih*, Academician Reader-in-waiting in the Han-lin Academy. There is, however, one instance of the seal's appearing before this date: on a hanging scroll entitled *Landscape after Yen Wen-kuei* (*Fang Yen Wen-kuei pi-i*), now in the National Palace Museum, Taipei, Tung's inscription, dated the winter of 1622, is followed by the very two seals discussed at the beginning of this entry (100/102/103/105/107/109 and 99/101/104/106/108/110), the earliest dated impressions of these seals that I have so far discovered. The painting, executed in ink and light color, has—particularly in the foreground—an ungainly, almost unfinished appearance, no doubt the reason it was assigned to the second class by the cataloguers of the *Shih-ch'ü pao-chi* and discounted as a forgery by the curatorial staff of the National Palace Museum, who relegated it to the *Chien-mu* section of the *Ku-kung shu-hua lu* (rev. ed. 1965, vol. 4, *ch.* 8, p. 87) and

have yet to publish it in reproduction. But in my view the painting is definitely Tung's nonetheless, the foreground an interesting (though unsuccessful) attempt to conjure up the terrain of the Yen Wen-kuei handscroll Tung mentions in his inscription—a terrain of folded rock or bare earth (it is hard to tell which), textured with short, dry, often angular strokes and stripped of all softening vegetation, save for a few spare trees that rise from its barren and creviced surface. The painting, moreover, exhibits two seals that have hitherto escaped all notice, belonging to Tung's son Tsu-ho, impressed in the lower left-hand corner (see "Tung Ch'i-ch'ang's Life," note 393).

The painting in the National Palace Museum raises the possibility that Tung had already adopted a seal reading *Tsung-po hsüeh-shih*—in fact the very seal illustrated here (100/102/103/105/107/109)—before he was appointed Right Vice Minister of Rites in the seventh month of 1623. What office, then, might the seal have originally referred to? Almost exactly one year earlier, on the seventh day of the seventh month, 1622, Tung had been appointed Vice Minister of the Court of Imperial Sacrifices and Academician Reader-in-waiting in the Han-lin Academy (*T'ai-ch'ang ssu shao-ch'ing chien Han-lin yüan shih-tu hsüeh-shih*; see "Tung Ch'i-ch'ang's Life," part 5 and note 317). The term *Tsung-po*, in the Ch'ing period, was used to refer not only to a Minister or Vice Minister of Rites, but also to the Chief Minister of the Court of Imperial Sacrifices (Brunnert and Hagelstrom, *Present Day Political Organization of China*, no. 933; Hucker, *Dictionary of Official Titles*, no. 7147); and terms current in the Ch'ing were not infrequently already in use by the late Ming (cf. the term *kung-shih*: see "Tung Ch'i-ch'ang's Life," note 92). Admittedly, Tung was a Vice Minister of the Court of Imperial Sacrifices rather than Chief Minister (though interestingly enough, the *Ming-shih* mistakenly records that Tung was promoted to the post of Chief Minister in 1622; see "Tung Ch'i-ch'ang's Life," note 318). But Tung had a penchant for applying to himself the literary equivalent of titles he did not really quite hold: in his "Yin-nien ch'i-hsiu shu" (Memorial requesting permission to retire on account of age), Tung writes that he was promoted to Vice Minister of the Court of Imperial Sacrifices and then to *Kung-chan*—*Kung-chan* being a literary term for the Supervisor of the Household Administration of the Heir Apparent (*Chan-shih*)—though in fact he was only appointed a Junior Supervisor, to which the term *Kung-chan* did not apply (Tung Ch'i-ch'ang, *Jung-t'ai wen-chi*, 1630, *ch.* 5, p. 53; Hucker, *Dictionary of Official Titles*, no. 3391). Tung, in fact, had by 1623 apparently adopted a seal reading *Kung-chan hsüeh-shih*, though the calligraphy on which this seal appears is not known at present to be extant (Victoria Contag and Wang Chi-ch'ien, *Seals of Chinese Painters and Collectors of the Ming and Ch'ing Periods*, rev. ed. 1966, p. 419, no. 48).

That during his tenure in office in the south, from the late autumn or early winter of 1622 to the late spring of 1624, Tung was styled "*Shao tsung-po*" by his friends receives confirmation from the title of a poem by Mao Wei (1575–ca. 1640) congratulating Tung on the occasion of his seventieth birthday, hence composed early in 1624 (see Ren Daobin, *Tung Ch'i-ch'ang hsi-nien*, p. 209). The poem's title mentions Tung as promoted from "*Nan shao-tsung*" (meaning "*Shao tsung-po* in Nanking") to the post of "*ling Pei-chan*" ("directing the Household Administration of the Heir Apparent in Peking," a clear reference to the second half of Tung's appointment in 1623 "to assist in the dir-

ection of the Household Administration of the Heir Apparent"). Thus, apparently, the post Tung was holding in Nanking entitled him to be addressed as *Shao tsung-po*, even before his promotion in 1623 to Vice Minister of Rites in Peking; and as his *Landscape after Yen Wen-kuei* suggests, he might well have adopted a seal reading *Tsung-po hsüeh-shih* in the winter of 1622, soon after he arrived in the south.

There remains the possibility that the two seals following Tung's signature on his *Landscape after Yen Wen-kuei* of 1622 might have been impressed only later, sometime after he received his appointment as Right Vice Minister of Rites in the seventh month of 1623. Simple as this solution sounds, there is good reason to discard it: in every other case where an office seal appears on an extant work that predates the appointment to which the seal refers, one can demonstrate convincingly that the work and its seals are forgeries, though the demonstration is too long to be included here. With the large number of works that survive in the People's Republic of China only now being published at long last, conceivably works may come to light that decide the question of whether it was indeed in 1622 or only in 1623 that Tung adopted his earliest *Tsung-po hsüeh-shih* seal.

XXIX. It is evident at a glance that seals 116 and 118 are identical, and it is no surprise to find that they appear on works that date not only from the same year but also (in part, at least) from the same month: seal 116 follows Tung's signature on his hanging scroll entitled *The Transmission of Examination Papers* (vol. 1, pl. 46), dated the twenty-first day of the third month, 1623; and seal 118 follows an undated section of his *Casual Writings by a Window* (vol. 2, pl. 48), the opening section of which was written only a day after he painted the hanging scroll, on the twenty-second day of the same month. The same seal appears, to the best of my knowledge, on only one other work, a hanging scroll by Tung that has never been published in reproduction, entitled *After Ni and Huang's Combined Work (Fang Ni Huang ho-tso)*, in the collection of the National Palace Museum, Taipei (Hu Ching et al., *Shih-ch'ü pao-chi san-pien*, facsim. ed. 1969, vol. 5, p. 2072). The painting is no more successful than his *Landscape after Yen Wen-kuei*, discussed in entry XXV, and like the latter it has been assigned to the *Chien-mu* section of the *Ku-kung shu-hua lu* (rev. ed. 1965, vol. 4, *ch.* 8, p. 87). But though compositionally the work is a failure—with its foreground trees and rocks leaning so precariously to the left that they threaten to slip from the painting altogether—the brushwork, calligraphy, and seal, taken in combination, provide convincing evidence that the painting is Tung's. In his inscription, where he models his calligraphy on Ni Tsan, Tung writes that he painted the painting aboard boat near Tiger Hill (at Su-chou) in 1623 on "the day of the bathing of Buddha" (the eighth day of the fourth month), so that all three works—the two paintings and the calligraphy—were executed within a month of one another; and it seems likely that the seal (116/118), which appears on all three but as far as I know on nothing else, was in use, like many of Tung's seals, only for a very short period. At some point Tung presented his painting *After Ni and Huang's Combined Work* to Wang Shih-min, whose own inscription on the scroll not only records the gift, but also mentions that he later acquired the original work by Ni and Huang.

Seal 117, which follows the opening dated section of *Casual Writings*

by a Window, appears on two other works, neither of them dated: an album by Tung of eight paintings, each with a facing leaf of calligraphy, in a private collection (for two leaves from this work—one of Tung's most original and inventive albums—see vol. 1, figs. 31 and 32); and a calligraphy handscroll by Tung after the two Sung masters Su Shih and Huang T'ing-chien (*Lin Su Shih Huang T'ing-chien t'ieh*), in the National Palace Museum, Taipei (*Ku-kung li-tai fa-shu ch'üan-chi*, vol. 8, pp. 74–85). The two impressions of the seal that appear on the album (which has a colophon by Tung dated 1621) show decidedly less wear than does the impression on *Casual Writings by a Window*; and judging from its wear, the impression on his calligraphy after Su and Huang falls between them, so that probably the calligraphy after Su and Huang was executed after the album but before the third month of 1623, when Tung wrote the opening section of *Casual Writings*.

We can gain a clearer idea of the album's date by examining its other seals, most of which appear on other works in the present exhibition. Two of these are the pair illustrated in group XVI (<64,65>/ <67,68>), of which dated examples fall between the years 1617 and 1620, after which the seals seem to have been abandoned. The impressions on the album exhibit the flaws evident in impressions dated 1619 and 1620 but missing in impressions dated two years earlier, so that we can assume that the album was painted only a year or two before Tung appended his colophon in 1621. Another of the album's seals is identical to the small seal (no. 94) that Tung has impressed on each leaf of his seven-leaf album dated 1621, also in the exhibition (vol. 1, pl. 39). Impressions on the undated album exhibit slightly less wear than do those on his album of 1621, so that a date of circa 1619–20 for the undated album is supported yet again. Combining this with the evidence presented above, we can conclude that Tung's undated calligraphy after Su and Huang in the National Palace Museum was probably executed between 1620 and 1623.

Two other seals on Tung's album of circa 1619–20 are identical to nos. 96 and 97, which appear on Tung's undated hanging scroll entitled *Reminiscence of Chien River* (vol. 1, pl. 41), discussed in entry XXIII.

The last seal of interest on *Casual Writings by a Window*—no. 119, reading *Tsuan-hsiu liang-ch'ao shih-lu*, "Compiling the Veritable Records of Two Reigns"—was obviously adopted by Tung in consequence of his appointment, on the seventh day of the seventh month, 1622, as Academician Reader-in-waiting in the Han-lin Academy, in order to assist in the compilation of the Veritable Records, those of the Emperors Shen-tsung and Kuang-tsung being then under way (see "Tung Ch'i-ch'ang's Life," part 5 and note 317). I know of only two other impressions of this seal: one, following Tung's short colophon, dated the intercalary tenth month of 1623, on a handscroll in the Freer Gallery illustrating the *Sixteen Lohans* (*Shih-liu ying-shen*), attributed to the twelfth century monk Fan-lung (Thomas Lawton, *Chinese Figure Painting*, 1973, pp. 98–101; Suzuki Kei, *Chugoku kaiga sogo zuroku*, vol. 1, A21–073); the other, following Tung's inscription on an untitled and undated hanging scroll by the painter Sung Hsü (1525– after 1605), in the collection of the Shanghai Museum. In the Shanghai Museum's *Chung-kuo shu-hua-chia yin-chien kuan-shih*, where the seal is published (SM 89), there is no indication of whether or not Tung's inscription on Sung Hsü's painting is dated; but the impression is very like that on the Fan-lung handscroll (both showing per-

ceptible wear, compared with the impression on *Casual Writings* [no. 119]), and owing to the seal's rarity, one suspects that like seal 116/118 it was employed by Tung only for a short period.

The last of Tung's seals on *Casual Writings*, no. 120, I have yet to encounter on another work.

XXXII. The two seals (<129,130>) impressed on Tung's undated *Landscape after Wang Ch'ia and Li Ch'eng* (vol. 1, pl. 58) appear as a pair on three dated works, in each case with the office seal (reading *Tsung-po hsüeh-shih*) appearing first, as was generally Tung's practice (though on his *Landscape after Wang Ch'ia and Li Ch'eng* the usual order is reversed). The earliest dated pair is appended to a colophon by Tung, dated the sixth month of 1630, on a handscroll attributed to the T'ang master Ch'u Sui-liang, *After Wang Hsi-chih's "Chang-feng t'ieh"* (*Mo Wang Hsi-chih Chang-feng t'ieh*), in the collection of the National Palace Museum, Taipei (*Ku-kung li-tai fa-shu ch'üan-chi*, vol. 1, p. 43). The second pair follows Tung's signature on his calligraphy hanging scroll now in The Metropolitan Museum of Art, entitled *Poem Commemorating an Imperially Bestowed Feast* (*Wu-men tz'u mai-ping shih*); Tung records that the "banquet of wheaten cakes"—which the emperor bestowed annually on his ministers at the Meridian Gate (Wumen)—took place in 1632 on the third day of the fourth month, and we may assume that Tung composed and copied out his poem in honor of the occasion soon thereafter (for an illustration of this work, see *Fine Chinese Works of Art*, Sotheby, Parke-Bernet, New York, June 1, 1972, no. 202). The latest pair is to be found on a handscroll by Tung in the Freer Gallery, entitled *After Three Calligraphies by Wang Hsi-chih* (*Lin Yu-chün san-t'ieh*), dated by Tung the ninth day of the second month, 1636 (Nakata Yujiro and Fu Shen, *O-Bei shuzo Chugoku hosho meiseki shu*, 1981–83, *Min Shin hen*, vol. 2, pp. 3–5, pls. 1–3, and pp. 130–31). Comparing the three sets of impressions, it is clear that from 1630 to 1636 there was progressive erosion of the seals' contours, so that by 1636 their edges are markedly uneven, notched and abraded on every side. What strikes the eye immediately is that in the impressions of seal 129 from 1632 and 1636, the upper left-hand corner of the seal has been lost, whereas in the impression dated 1630 the corner is still intact. The immediate corollary is that whenever the seal appears with the corner missing—as it does on Tung's *Landscape after Wang Ch'ia and Li Ch'eng*—the impression must postdate the sixth month of 1630. If we examine the impressions on Tung's *Landscape after Wang Ch'ia and Li Ch'eng* (<129,130>), we find that they more closely resemble those following his colophon of 1636 than they do those on the Metropolitan's calligraphy hanging scroll of 1632. Hence the seals were probably impressed on the painting after 1632, though not, perhaps, as late as 1636, since the 1636 pair shows marginally greater wear.

Either one or both of the same seals follow Tung's inscriptions on two other works of interest: one, the hanging scroll by the Yüan master Sheng Mou entitled *Pleasant Summer in a Mountain Retreat* (*Shan-chü ch'ing-hsia*), in The Nelson-Atkins Museum of Art (on which Tung has impressed only the seal reading *Tung Hsüan-tsai*; see Sherman Lee and Wai-kam Ho, *Chinese Art Under the Mongols*, 1968, cat. no. 230; and Suzuki Kei, *Chugoku kaiga sogo zuroku*, vol. 1, A28–043); the other, a hanging scroll dated 1476 by the early Ming painter Yao

Shou (1423–1495), entitled *Fisherman Recluse on a River in Autumn* (*Ch'iu-chiang yü-yin*), in the Beijing Palace Museum (*Che-chiang ku-tai hua-chia tso-p'in hsüan-chi*, 1958, pl. 49). On both paintings seal 129 lacks its upper left-hand corner; thus, though neither inscription by Tung is dated, both were undoubtedly written by Tung after the sixth month of 1630.

On the basis of its style, Tung's *Landscape after Wang Ch'ia and Li Ch'eng* has been tentatively dated in the present catalogue to the period 1626–30; but though—as James Cahill has pointed out, in his essay in vol. 1 of this catalogue—a painting might well receive a dedicatory inscription sometime after it was originally painted, on its being presented to a recipient, the inscription on Tung's *Landscape after Wang Ch'ia and Li Ch'eng* is so essential and integral a part of the painting that it seems to me unlikely that the two were separated by any substantial stretch of time. I would argue, then, that the painting and seals date from the same period, between 1632 and 1636; and that rather than reject the evidence the seals offer because the painting fails to fit a preconceived notion of what Tung's latest paintings must be like, we should revise our view of the final phase of Tung's artistic career and include this among his latest works.

Were this the only painting of its kind from Tung's final years, we might justifiably feel some hesitation in assigning it so late a date; but there is another work, comparable not only in size but also in its reliance on a wetter brush, that on the basis of its seals can be dated to the same period. This is the largest and among the most magnificent of all Tung's hanging scrolls, the painting he himself entitled *In the Shade of Summer Trees* (*Hsia-mu ch'ui-yin*), one of the masterpieces in the collection of the National Palace Museum, Taipei, though for some reason (not, certainly, on grounds of authenticity), the painting is entirely neglected in recent treatments of Tung's work. The two seals on the painting, reading *Tsung-po hsüeh-shih* (a seal different from no. 130) and *Tung-shih Hsüan-tsai*, appear as well on a calligraphy by Tung copying out the text of a memorial tablet composed by Tung's distant connection Ch'ien Lung-hsi (1579–1645) in honor of a Provincial Administration Right Vice Commissioner of Shantung named Ch'ien Chung-so (*Tung Hsiang-kuang hsing-shu Ch'ien Chung-so shen-tao pei chen-chi*, Shanghai: Yu-cheng shu-chü, n.d.; a copy is kept in the Fung Ping Shan Library at the University of Hong Kong). The calligraphy is undated; but Tung has signed it using the title Grand Guardian of the Heir Apparent (*T'ai-tzu t'ai-pao*), so that clearly the calligraphy postdates the twenty-fifth day of the second

month, 1634, when Tung was awarded the title soon after his retirement (see "Tung Ch'i-ch'ang's Life," part 6 and note 454). The same seals appear also on a calligraphy hanging scroll by Tung in the National Palace Museum, Taipei, copying out the text of the *Hsieh ch'un-i piao* by the T'ang poet and official Liu Yü-hsi (772–842) (*Ku-kung li-tai fa-shu ch'üan-chi*, vol. 30, p. 65). Again, the hanging scroll is undated; but written as it is in regular script on Hsüan-te (1426–35) paper dusted with gold (*chin-ni chien*) and further embellished with a design of cloudlike scrolls shaped like the fungus of immortality (*ling-chih*), we may be sure that it was written during Tung's last period at court from 1632 to 1634, when his fame was at its height and he was in great demand for formal compositions of this kind, of which a considerable number survive (cf. Kohara Hironobu, *To Kisho no shoga*, vol. 2 [*Zuhan hen*], pls. 74, 75; both these calligraphies are undated but can be firmly dated to the same period on the basis of their seals). *In the Shade of Summer Trees*, then, which is over ten feet high—well-fitted to grace the most imposing of mansions—was almost certainly painted in the 1630s, very likely after Tung's return to court early in 1632. No one comparing the lush handling of its foreground trees with those that dominate the lower half of Tung's *Landscape after Wang Ch'ia and Li Ch'eng* can harbor any doubt that the two paintings sprang from Tung's brush at much the same time.

The two seals (131 and 132) impressed on the hanging scroll by Tung entitled *After Tung Yüan's "Shaded Dwellings among Streams and Mountains"* (vol. 1, pl. 57), in The Metropolitan Museum of Art, are so close in design to earlier impressions of seals 129 and 130 (as, for instance, those following his colophon dated 1630 on Ch'u Sui-liang's handscroll *After Wang Hsi-chih's "Chang-feng t'ieh,"* mentioned above) that, seen from a slight distance, they give every appearance of being identical. But on close examination, the differences are readily apparent. The characters are much more crudely cut, so that in magnification the strokes at times have a jagged look: note particularly the horizontal strokes of the character *hsüan* of seal 131. The curved or rounded strokes that relieve the overall squareness of shape in seal 130 appear angular and graceless in seal 132: compare how the two seals differ in their treatment of the radical *jen* in the character *po*, or the radical *tzu* in the character *hsüeh*. Seals 131 and 132 are *sui generis*—neither seal is to be found on any other work by or attributed to Tung—and they are too close in their appearance to seals 129 and 130 to be anything other than deliberate imitations. We can only conclude that they were impressed not by Tung but by a later owner, dexterously supplying what to his eyes was the final legitimizing touch.

Ssu-yin t'ang shih-kao

Figure 1. Tung Ch'i-ch'ang. *Ssu-yin t'ang shih-kao*.
Manuscript of poems.
Thirty leaves from one *ts'e*. Shanghai Museum.

贈眉公

何處江山好卜居 卜澤端揆傍事諸人已藉

滋蘭李濠叟猶傳說餉書

贈澗使李司農

笠有備心諭靜嘿公餘手注五千言曾聞仙李

根鹽長知是玄元實葉孫

又

學以頴食

丸經渾身洞

以走涯移去

參禾疋佢

崔吉航圖晉潘傳春風初返潤茶天勞人水邊

想憶君家笠澤園空江密雪流菰蒲于今身在

寮青日對秦封五大夫家

題送家姪原字巡玄二東

何須置廁字相望第二泉

題畫當張右伴

悵子曰寫

海涵奇靈畫溫骨虞巡滕李肋秦封紫頸白省

家山在不必登嘉堂九峯

為王大司馬題繡佛齋圖

蕭濤吳淞松半江靈山竇元走盧窓繁茹即是

廣長香大辭笠非稍近懺

王遜之畫米家山萬青倪元鎮氣款此山

題云

託興米顛相伯仲古來覺只數倪迂座將甬雅

魚乾筆為寫喬林悵石圖

延津署中佑

樓潤憑欄四望通慢寧雲接玉華峯茫風青

見云畫懷素

煙叢骨李濤仙山在鄒中

送張五鹿松部賒畫

十月江南暄泥泘蒲見沙痕若為剪取

吳江柂著我微花笠澤雲

題畫

青天蜀道不難攀運恩微范香雪閒銷著一筐

楊子宅居姓素甲九州山

天馬山游跳

江南驟作名園記海上河陽高言淯岸書畫廊
故造夢古粉風流恨艷聲老往真將福示同始
紙佃仙伎話新与女先男諸木松令及百年戯
佳名催燕溪忠人官情与名官堂帶歸象賀壽楷書拈
傷色怎咸陵廷僕兀先峯生帝廛白水朱楷柏映中
湘研風池方廣陵天鏡劍羽兔鶯逅向人瓷香涵魚波
兩可神不定水竹榜臺照笠霄栖鷂榜芳橦逐賓
臺百粉杏散欸敔都傷客～松南嵐墨呼源
王和定善青粕杏敔咏妖敔都傷客
龍昨郎 田中堂
渺孅涿雲柁星天縞碨道周達泅室深遊人悵
已庠閛住迷迤討飛琴百尺亘吾虹別与予扉揄松窗名
生却榮荒荛莱不為斳經年陸圓留喜風主人風弓煙
新乃上聽窵賛王李馳駝匋敕鲎又銜新詫不辛様為窵
家山夢夢起不臂為作輖川圖一心披形入玉臺
書繚心沒縈椊罕蕐没倬推寀孤男不見埼
乙羊牲倬畫一圭一蜜逢為爾又不見洪屋仙人
枝定居攜时珠都岩喜紛阳如言蕐儀臺不文

李商隱
書月賦
剔眑濵
烟綾怙
中敔敔
兩玊筆
此余罕悵

耶陵耶侯不偰及吾偰～綵而如此迤邻墨琴
相綾買吾孙是栽生摩大丹年～持介福
書湌中含夫人六十
海上三山春色早西池阿母駝青鳥南峇荐華
初座年霞櫻朱赦光綵綾送～䒳曹亥名家碎
璀之竹河陽花紫薇鳳凋迤三殿彫管䍀章道
清六柶世載金門耤避蠹鵝䒷寿每新途中字越䒷燕雲誦
輞綾匀林下風春兾每新途中字越䒷燕雲誦
畫怳不扨 田中堂

黃庭賛敔来頼紫鏍珤鈷將諸無蒸鏖母能斳
珠絰滕玉絲櫃逆錄衣香榜飯浚孫帷善天花
衰綵佛針㐌凸內知祥㘯貝藏棗真里不圓福
果為雲君龍妖熊衒照委牽詩～鳩嵿牽童范
人同嵐玉迤庭禺九䒷爛㘯元宵疫梅花愴弓
偉墨迤揰簵穿羡八子喜戴摹散浄巾墨浚
拙庵詩為萬俟天作
黃賛壬巳越喜新相扨丕空文黃妈㫈羽旣楷

Ink Rubbings of Tung Ch'i-ch'ang's Calligraphy

因此說偏偏

君少而易之儔

我亦之儔上

WANG QINGZHENG　汪慶正

董其昌法書刻帖簡述

本文將就三個方面叙述董其昌的刻帖。一是董其昌彙刻的歷代名人書法；二是在董其昌生前所刻他的墨蹟；三是董氏死後，後人彙刻的董其昌法書。

一、

叢帖之風盛於宋。明代叢帖的數量明顯減少。以目前傳世能見到的，從永樂十四年（1416）的《東書堂集古法帖》及弘治九年（1496）的《寶賢堂集古法帖》算起，至崇禎十四年（1641）的《快雪堂法書》爲止，總共也不過二十餘種。

董其昌於萬曆三十一年（1603）彙刻的《戲鴻堂法書》在明代的叢帖中具有重要的地位，以董氏書壇宗師之尊，《戲鴻堂帖》問世後，前於董氏的文徵明（1470-1559）的《停雲館帖》和稍後的王肯堂（進士1589）的《鬱岡齋墨妙》等帖，均顯得暗淡無光。到了清代，張照（1691-1747）、王文治（1730-1802）、劉墉（1720-1804）、梁同書（1723-1815）等書家更是推崇備至。然而，明、清兩代也有一些學者對《戲鴻堂帖》評價不高，認爲有較多摹刻失真的地方（明沈德符（1578-1642）《萬曆野獲編》卷26）。

《戲鴻堂帖》計十六卷，共收歷代書家五十餘人的墨蹟。董氏在書學方面的一個重要見解是，認爲學書者一定要從學楷入手，以先定間架，然後縱橫跌宕，唯變所適（《戲鴻堂法書》卷4，董其昌跋文）。基於這一觀點，《戲鴻堂》刻入的楷書在全帖中占了重要的地位，他首次節錄和收錄了《女師箴》和唐歐陽詢（557-641）的《千字文》、《離騷》；宋李公麟（約1049-1106）的《九歌》、《孝經》以至元趙孟頫（1254-1322）的小楷《過秦論》，可說是獨具慧眼。此外，如《黃素黃庭內景經》，杜牧（803-852）《張好好詩》等刻入叢帖，在明代也是值得重視的。歷代叢帖不外以三種方法排列順序：一是按時代序列，從先秦三代，以朝代先後排列；一是以歷代帝王的墨蹟置於卷端，然後才是各代書家；一是以王羲之（303-379）（圖一）、王獻之（344-386）父子的墨蹟爲首。董氏《戲鴻堂法書》繼文氏《停雲館帖》，置晉唐小楷於卷首，以明提倡楷書之旨。

對於《戲鴻堂帖》，決不能以摹刻失真一語來貶低他。此帖大多由吳楨手摹，出於董氏親筆，僅卷六的唐《汝南公主墓誌》一帖，董其昌在臨古人法書時並非刻意摹仿，而是根據自己的筆意來臨習前人的書法，可以說是摹中有創。至於吳楨的摹本也有極佳的，卷十二的蘇軾（1036-1101）《春帖子詞》八首（圖二），清代的《三希堂》（圖三）、《式古堂》和《敬一堂》等名帖都曾摹刻，但以《戲鴻堂》所刻最佳。

在取材方面：例如：元趙孟頫《絕交書》殘本，《戲鴻堂》所收是真蹟，而《三希堂》刻入的則是僞作。唐顏真卿（709-785）《祭姪文稿》文氏《停雲館》所收爲宋米芾（1051-1107）的臨本（圖四），《戲鴻堂》刻入的則是原本（圖五）。董其昌在刊刻《戲鴻堂帖》的過程中，還糾正了多處歷史上的錯案，例如：宋代很多叢帖刻入的狂草《東明帖》，一般都視爲謝靈運（385-433）所書，董其昌收入《戲鴻堂》第七卷，提出這是唐張旭（八世紀）所書的《步虛詞》，並謂四聲定於沈約（441-513），狂草始於伯高（即張旭），都是晚於謝靈運而出現的（《戲鴻堂法書》卷7，董其昌跋文）。此可爲定論。又如，在第三卷中將王獻之"十二月割"帖和"已至"帖合併爲一，從而糾正了宋人把"十二月割"及"已至"視爲二帖之誤。在卷六刻入唐懷仁《聖教序》時，提出了《書苑》所云雜取碑字的說法有誤，應是懷仁習王羲之書，"集"即是"習，"而並非雜取的意見（《戲鴻堂法書》卷6，董其昌跋文）。這些見解都說明了董其昌對書法史研

Figure 2. *Hsi-hung t'ang fa-shu.* Compiled by Tung Ch'i-ch'ang in 1603. Two leaves from *chüan* 3. Shanghai Museum.

Figure 3. *Hsi-hung t'ang fa-shu.* Compiled by Tung Ch'i-ch'ang in 1603.

Four leaves from *chüan* 12. Shanghai Museum.

究的博大精深。此外，值得着重一提的是，《戲鴻堂帖》第十六卷收錄了《澄清堂》帖的部分重要內容。《澄清堂帖》舊傳是南唐祖刻，事實上，也是南宋刻本，但早已無法得見全帙。董其昌得宋拓本一至五卷，現在只存一、三、四共三卷，早已流入日本，有日本博文堂印本傳世。二、五兩卷久佚，《戲鴻堂帖》刻入的一部分內容中，如"苦不得眠、"、"月半、"、"庚丹楊"等三十帖，不見於《淳化閣帖》，很可能是《澄

清堂帖》卷五中的內容，這對於研究宋刻《澄清堂帖》是十分重要的。

《戲鴻堂帖》十六卷，萬曆三十一年（1603）勒成，他的始刻年代當更早。此帖初刻木版，後燬於火，重摹石本。其帖尾年月，初爲真字，後易篆書。後，石歸施叔灝（十六至十七世紀），施自稱"用大齋主人，"即所謂的"用大齋本。"清康熙石歸王鴻緒（1645-1723），其時卷一米芾《西園雅集

Figure 4. *San-hsi t'ang fa-t'ieh.* Compiled by Liang Shih-cheng and others in 1750. Two leaves from *ts'e* 12. Shanghai Museum.

Figure 5. *T'ing-yün kuan t'ieh*. Compiled by Wen Cheng-ming; engraved by Wen P'eng and Wen Chia in 1541. One leaf from *chüan* 4. Shanghai Museum.

Figure 6. *Hsi-hung t'ang fa-shu*. Compiled by Tung Ch'i-ch'ang in 1603. Two leaves from *chüan* 9. Shanghai Museum.

圖記》字有缺損，王仿寫刻入，字體稍大。王鴻緒自號橫雲山人，因有"橫雲山莊本"之稱。刻石幾經輾轉，本世紀四十年代初遭日本飛機轟炸，頗有失散和毀壞，現僅存一三三塊，藏安徽省博物館。

二、

董其昌的書法從萬曆中期起就名重一時，在他生前已刊刻了很多法帖。歷來個人的刻帖，一般都是在書法家身後或隔了多少年代，由後人來彙刻的。雖然明代集錄邢侗（1551–1612）及其妹邢慈靜（生於一五五一年後）書蹟的《之室集帖》是在邢慈靜生前所刻，但只是一種例外，而且僅三卷。董其昌生前刊刻的單刻帖竟達二十餘種，這可以說是空前絕後的。其中有萬曆三十七年（1609）的《寶鼎齋法書》六卷；萬曆四十二年（1614）的《書種堂帖》六卷；萬曆四十五年（1617）的《書種堂續帖》六卷；天啟二年（1622）的《來仲樓法書》十卷；崇禎三年（1630）的《汲古堂帖》六卷，其內容都由董其昌親自選定。至於約在萬曆四十三年（1615）後不久的《鵡鶴館帖》四卷；萬曆四十七年（1619）的《紅綬軒法帖》四卷；天啟四年（1624）的《延清堂帖》六卷和《劍合齋帖》六卷，都是由吳縣陳鉅昌所刻，由於陳鉅昌和董其昌是姻親，其內容也是經過董其昌審定的。此外，尚有《玉煙堂董帖》、《研廬帖》、《銅龍館帖》、《紅鵝館帖》、《海漚堂帖》、《來青閣帖》、《蒹葭堂帖》、《衆香堂帖》、《大來堂帖》、《家藏帖》等等。董氏親自參與將其本人的法書大批刊刻成帖的原因有二：一是當時求索墨蹟的人衆多，窮於應對，刻成集帖後可以省去很多麻煩。其二是董氏在世時已有大量仿董偽蹟出

現，且有集刻成帖的，董氏以真蹟上石，便於人們辨偽。他在萬曆四十三年（1615）跋《書種堂帖》時就提到："閒又有《玉露堂》等贗蹟，紛紛鏤版，且奈之何。"

上述董氏諸帖所收錄墨蹟的書寫時間，一般都在刻帖前不久。只有《玉煙堂董帖》收入的包括了從萬曆十七年（1589）到崇禎三年（1630）先後約四十餘年間的書蹟。在明末，除了董氏的單刻帖外，在一些小叢帖中也收入了董氏的法書，例如天啟四年（1624）的《澂觀堂帖》、崇禎五年（1632）後的《晴山堂帖》和崇禎十年（1637）的《清鑒堂帖》等等。上述各種刻帖，特別是董氏單刻帖，目前能見到的已是十分稀少了。

三、

董其昌卒於明末崇禎九年（1636）。入清以後，由於康熙、雍正、乾隆三朝皇帝的推崇，董氏的書法地位益顯。康熙二十九年（1690）內廷刻的《懋勤殿法帖》，收錄歷代君臣書家法書計二十四卷，內康熙帝自書占二卷多；王羲之書占三卷多；王獻之書僅一卷多；趙孟頫書二卷多；其他歷代書家則沒有一位占有一卷全部的，而董其昌書則占了第二十二、二十三兩卷及第二十一卷的部分，可見康熙帝對董氏重視的程度，更有甚者，康熙三十八年（1699）內廷刻的《懋勤殿法帖》八卷本，屬康熙本人書，其中第六、七、八三卷，全屬康熙臨董其昌的書法（一九九一年三月筆者在旅順博物館發現，該館新徵集到一批康熙墨跡，均屬臨各家書，疑即為該帖的原稿）。乾隆元年（1736）內廷刻的《朗吟閣法帖》十六卷，是專門收錄雍正帝的親筆書，其中有二卷半都是雍正臨董其昌的書法。乾隆十

五年（1750）內廷刻《三希堂石渠寶笈法帖》三十二卷，董書占了四卷。內廷刻帖對董書如此看重，清代其他官、私叢帖中，董書所占的篇幅往往也很大，如康熙五十四年（1715）蔣陳錫（1652–1721）的《敬一堂帖》三十二卷，董書有十三卷，摹刻極精。乾隆中孔繼涑（1727–1791或1726–1790）的《玉虹鑑真帖》十三卷和《玉虹鑑真續帖》十三卷，有董書四卷，該帖有部分偽蹟，但董書的摹刻卻極精。清嘉慶二十五年（1820）斌良（1784–1847）的《裒沖齋石刻》十二卷，董書占了七卷等等。當然，在各種叢帖中所刻入的董書也有一些偽蹟，即使像《三希堂》也收入了"龍神感應記"之類的偽書。清代董其昌法書的單刻帖，如康熙年間的《百石堂藏帖》十卷、《清暉閣藏帖》十卷；乾隆年間的《傳經堂法帖》四卷、《式好堂藏帖》四卷及嘉慶年間的《如蘭館帖》四卷，也都是比較好而稀見的本子。

爲了便於學者們檢閱，特附以按筆劃次序排列的"董其昌法書刻帖所見錄。"

董其昌法書刻帖所見錄

法書品名	收錄帖名

一劃

一夜七律	翰香館法書卷十

二劃

七十二峯山下居七律	延清堂帖卷六
七夕賦	百石堂藏帖卷九
八月梅花大開五排律	研廬帖卷六
八林引並跋	書種堂續帖卷六
八柱帖	裒沖齋石刻卷六
八關齋會記並跋	汲古堂帖卷二
九歌河伯	書種堂帖卷六
九歌並跋	來仲樓法書卷二
九點七律	明賢詩冊卷三
十二月朋友相闇書	銅龍館帖卷一
十二峯七律	激觀堂帖卷二
十六日帖並跋	汲古堂帖卷六
十八侯銘	明世春堂帖卷二
十洲志	延清堂帖卷三
丁巳近作七絕十六首並跋	澹應堂墨刻卷八
又合浦散詩	清暉閣藏帖卷七
又池上篇	敬一堂帖第二十三冊
又臨自叙	裒沖齋石刻卷七
力命表並跋	裒沖齋石刻卷五
刀銘二首	百石堂藏帖卷一
刀銘仿李北海	清暉閣藏帖卷一

三劃

小字古柏行	敬一堂帖第二十四冊
小字仿褚遂良蘭亭叙並跋	書種堂帖卷一
小赤壁詩	銅龍館帖卷四
小赤壁詩並跋	平遠山房法帖卷五
小園賦並跋	壯陶閣帖第二十九冊貞五
大士普門品	明世春堂帖卷三
大字古柏行	敬一堂帖第二十四冊
大江東去等詞二首	延清堂帖卷四
大佛頂首楞嚴經圓通偈	鶺鴒館帖卷二
大觀帖跋	紅綬軒法帖卷二
千字文並跋	延清堂帖卷二
女史箴	太虛齋珍藏法帖羽集
女史箴	明世春堂帖卷五
女史箴	寄暢園法帖卷三
女史箴	裒沖齋石刻卷六
女史箴並跋	南雪齋藏真亥集
女史箴並跋	書種堂續帖卷六
女史箴並跋	墨緣堂藏真卷十
女史箴並跋	懋勤殿法帖卷二十一
女史箴並跋	寶鼎齋法書卷一
乞米帖	清暉閣藏帖卷六
山谷老人題跋十則並跋	清歡閣藏帖卷五
山谷題跋十三則	書種堂續帖卷四
山居賦	書種堂續帖卷三
山夜憂	銅龍館帖卷六
山海經	敬一堂帖第二十三冊

四劃

少曾遠游周覽九土	書種堂帖卷六
心經	玉虹鑑真帖卷十三
心經	明世春堂帖卷三
心經	明世春堂帖卷六
心經	餐霞閣法帖卷五
心經並跋	如蘭館帖卷一
心經並跋	南雪齋藏真亥集
心經並跋	滋蕙堂墨寶卷八
內景黃庭經	銅龍館帖卷二
內景黃庭經並跋	如蘭館帖卷一
內景經跋	太虛齋珍藏法帖羽集
元四大家畫評	書種堂帖卷六
元輔抱齋周老先生三載一品考賀序	清暉閣藏帖卷九
孔稚珪北山移文並跋	傳經堂法帖卷四
木玄虛海賦	玉虹鑑真帖卷十三
日詩月詩	百爵齋藏歷代名人法書卷下
月賦	玉煙堂董帖卷上
月賦	傳經堂法帖卷四
天台賦	玉煙堂董帖卷一
天台賦	海寧陳氏藏真帖卷六
天馬賦並跋	百石堂藏帖卷九
天馬賦並跋	來仲樓法書卷十
天馬賦	明世春堂帖卷四
天賜帖	明世春堂帖卷二
太上感應篇並跋	傳經堂法帖卷三
太史與孝廉徘百書	來仲樓法書卷十
太玄觀	敬一堂帖第三十冊
太尊閣卷帖	式好堂藏帖卷二

太廟薦新麥七律	清暉閣藏帖卷二
太廟薦麥七律並跋	紅綬軒法帖卷四
文王見呂尚	清暉閣藏帖卷一
文債帖	式好堂藏帖卷二
文賦並序	鷦鶴館帖卷三
升天行	延清堂帖卷四
升天行	袁沖齋石刻卷十
王子敬敬祖帖	清暉閣藏帖卷三
王介甫春景詞	百石堂藏帖卷十
王履道評東坡書	來仲樓法書卷十
王右軍官奴帖	清暉閣藏帖卷三
王右軍蘭亭序	清暉閣藏帖卷四
王守仁語錄	書種堂帖卷六
王宰山水歌	清暉閣藏帖卷七
王崇簡、沈荃、虞世璭翰香館帖跋	翰香館法書卷十
王珣伯遠帖	紅綬軒法帖卷三
王虞祥除表	傳經堂法帖卷一
王摩詰五律二十四首	壯陶閣帖第二十九冊貞五
王龍寺觀荷七律	百石堂藏帖卷八
王羲之山陰帖	傳經堂法帖卷一
王羲之中冷帖	傳經堂法帖卷一
王羲之玉潤帖	過雲樓藏帖卷八
王羲之成都帖	百石堂藏帖卷二
王羲之奉橘帖	百石堂藏帖卷二
王羲之奉橘帖	傳經堂法帖卷一
王羲之官奴帖並跋五則	玉煙堂董帖卷四
王羲之清晏帖	百石堂藏帖卷二
王羲之霜寒帖	傳經堂法帖卷一
王羲之瞻近帖	紅綬軒法帖卷三
王羲之蘭亭叙並跋	百石堂藏帖卷二
王獻之洛神賦十三行之半	傳經堂法帖卷一
王獻之鵝群帖	敬和堂藏帖卷五
王獻之辭中令帖並跋	百石堂藏帖卷二
王獻之辭中令帖並跋	清暉閣藏帖卷四

五劃

出師頌並跋	敬一堂帖第二十三冊
丙舍帖	袁沖齋石刻卷五
令祖懿行帖	天香樓藏帖卷四
生綃贈行帖	螢照堂明代法書卷八
术忠書院記	綠谿山莊法帖卷四
左太沖詠史詩並跋	安素軒石刻卷十七
左思詠史詩	百石堂藏帖卷六
右軍官奴帖並跋	寶鼎齋法書卷四
右軍霜寒帖	敬一堂帖第二十冊
北山移文並跋	書種堂續帖卷二
北海嶽麓寺	敬一堂帖第二十冊
北樓西望七律二首	玉虹鑑真帖卷十三
史岑出師頌	延清堂帖卷二
史記評語	平遠山房法帖卷五
司馬公傳帖	式好堂藏帖卷二
司馬記室牋	銅龍館帖卷六
司馬德操與盛孝章二則	劍合齋帖卷六
白羽扇賦並跋	百石堂藏帖卷五
白樂天琵琶行並跋	書種堂帖卷四
白騎帖	袁沖齋石刻卷五
玉河冰泮七律	懋勤殿法帖卷二十三
玉帛徵賢七絕二首	百石堂藏帖卷十
田家雜興	研廬帖卷一
古尺牘十二首	激觀堂帖卷五
古柏詩	倦舫法帖卷四
古詩十九首	書種堂續帖卷四
古劍賦	百石堂藏帖卷十

世說語十六人並跋	來仲樓法書卷七
世說顏訏、陸慧曉二則	百石堂藏帖卷四
世事悠悠四言詩並跋	清暉閣藏帖卷六
世春堂雜書	百石堂藏帖卷七
世春堂雜書	來仲樓法書卷九
世說四則並跋	海山仙館藏真三刻卷一
仙鶴帖	澹慮堂墨刻卷八

六劃

西興秋渡五律	敬一堂帖第二十六冊
西園雅集圖記	玉煙堂董帖卷二
西園雅集記	寶鼎齋法書卷一
西園雅集圖記六種並跋	過雲樓藏帖卷八
西園雅集圖序並跋	紅綬軒法帖卷四
西園雅集圖記並跋	壯陶閣續帖亥冊
早朝詩四首	書種堂續帖卷三
先祖行略、先君行略	如蘭館帖卷二
仲長統四言詩	激觀堂帖卷六
仲長統樂志論	式好堂藏帖卷一
仲長統樂志論並跋	書種堂帖卷一
米元章天馬賦並跋	壯陶閣帖第三十一冊貞七
米元章集英春殿七絕	激觀堂帖卷四
米元章贈王渙之詩	激觀堂帖卷四
米芾千字文並跋	寶鼎齋法書卷三
米芾五色水銘	研廬帖卷一
米芾西園雅集圖序	書種堂續帖卷三
米芾青松五古並跋	傳經堂法帖卷二
米芾揚清歌詩	敬一堂帖第二十一冊
米芾弊居帖	壯陶閣帖第三十一冊貞七
米芾歐怪褚妍不自持七古並跋	劍合齋帖卷三
任丘	清暉閣藏帖卷二
至仁山銘	百石堂藏帖卷一
至仁山銘仿虞永興	清暉閣藏帖卷一
仿王羲之王獻之褚遂良虞世南顏真卿懷素各體書	劍合齋帖卷六
仿柳公權書蘭亭詩並跋	蘭亭八柱帖卷七
仿顏魯公德伴覆載帖	汲古堂帖卷六
仿蘇黃米蔡書	紅綬軒法帖卷二
江上愁心賦並跋	激觀堂帖卷五
江文通別賦並跋	書種堂帖卷四
江淹登廬山香爐峯詩	百石堂藏帖卷九
朱熹梅花賦並跋	百石堂藏帖卷六
老人星賦並跋	百石堂藏帖卷五
老子	銅龍館帖卷三
老杜語可味帖	紅綬軒法帖卷一
合浦散詩	百石堂藏帖卷四
池上篇	延清堂帖卷三
池上篇	銅龍館帖卷五
池上篇	劍合齋帖卷四
池上篇	激觀堂帖卷五
池上篇	懋勤殿法帖卷二十二
池上篇並跋	敬一堂帖第二十三冊
伏審帖	汲古堂帖卷六
呂仙贈沈東老七絕並東坡和作	百石堂藏帖卷七
呂兆熊及妻魏氏趙氏制詞(倣唐中書令褚遂良書文皇冊文)	三朝宸詰卷一
呂兆熊妻魏氏趙氏制詞(倣唐中書令褚遂良聖教序)	三朝宸詰卷二
呂兆熊制詞(倣唐少監虞世南汝南公主誌)	三朝宸詰卷二
呂兆熊及妻魏氏趙氏制詞(倣唐括州刺史李邕雲麾碑)	三朝宸詰卷一
呂居仁記前輩作官	來仲樓法書卷十

呂朝用及妻張氏制詞(倣宋無爲州守米芾　　三朝宸誥卷二
　學記)
呂新芳及妻趙氏制詞　　　　　　　　　三朝宸誥卷二
呂新芳及妻趙氏制詞(倣宋端明殿學士蘇　三朝宸誥卷一
　軾宸奎閣記)
呂新芳及妻趙氏制詞(倣唐魯國公顏真卿　三朝宸誥卷一
　家廟碑)
再跋書種堂帖　　　　　　　　　　　　書種堂帖卷一
冲宇戴公傳　　　　　　　　　　　　　采真館法帖卷三
次韻福唐葉少師七律四首附錄原作　　　蔬香館法書卷四
次韻酬葉少師臺山贈行七律四首　　　　敬和堂藏帖卷五
行穰帖　　　　　　　　　　　　　　　紅綬軒法帖卷三
自論書畫　　　　　　　　　　　　　　劍合齋帖卷二
阮籍詠懷詩四首　　　　　　　　　　　百石堂藏帖卷九
似仲和五律　　　　　　　　　　　　　敬一堂帖第二十六冊
因尋白社詩七律一首　　　　　　　　　澄蘭堂法帖卷七

七劃

沈會宗水閣詞　　　　　　　　　　　　百石堂藏帖卷十
李北海毒熱帖　　　　　　　　　　　　寶鼎齋法書卷四
李北海吏部帖　　　　　　　　　　　　寶鼎齋法書卷四
李北海昨夜帖　　　　　　　　　　　　寶鼎齋法書卷四
李北海荊門行　　　　　　　　　　　　清暉閣藏帖卷三
李北海荊門行　　　　　　　　　　　　清暉閣藏帖卷八
李本寧文跋　　　　　　　　　　　　　延清堂帖卷六
李長吉詩　　　　　　　　　　　　　　銅龍館帖卷四
李白月色不可掃詩二首並跋　　　　　　劍合齋帖卷三
李白好鳥巢珍木五古三首　　　　　　　敬一堂帖第二十五冊
李白詩　　　　　　　　　　　　　　　袞沖齋石刻卷十
李白詩二首　　　　　　　　　　　　　銅龍館帖卷六
李白碧草已滿地詩　　　　　　　　　　蓮池書院法帖卷六
李後主櫻桃落盡詞並跋　　　　　　　　劍合齋帖卷三
李陵蘇武別　　　　　　　　　　　　　清暉閣藏帖卷一
李邕杲日帖　　　　　　　　　　　　　傳經堂法帖卷二
李邕荊門行　　　　　　　　　　　　　百石堂藏帖卷四
李邕娑羅樹碑並跋　　　　　　　　　　汲古堂帖卷五
李願歸盤谷序　　　　　　　　　　　　書種堂續帖卷二
宋人小詞二首　　　　　　　　　　　　百石堂藏帖卷七
宋人小詞五首並跋　　　　　　　　　　研廬帖卷二
宋人秋水無痕詞　　　　　　　　　　　壯陶閣帖第三十一冊貞七
宋人霜天曉角辭　　　　　　　　　　　研廬帖卷二
宋子京春景詞　　　　　　　　　　　　百石堂藏帖卷十
宋之問秋蓮賦　　　　　　　　　　　　百石堂藏帖卷六
宋元諸畫題識　　　　　　　　　　　　壯陶閣帖第三十冊貞六
宋詞十首　　　　　　　　　　　　　　壯陶閣帖第二十九冊貞五
宋詞元曲　　　　　　　　　　　　　　玉虹鑑真帖卷十三
宋廣平神道碑側記並跋　　　　　　　　汲古堂帖卷二
吳筠贈箕山人詩　　　　　　　　　　　墨緣堂藏真卷十
杜甫千秋節五律並跋　　　　　　　　　存介堂集帖卷四
杜甫古柏行　　　　　　　　　　　　　書種堂帖卷六
杜甫韋偃雙松圖歌　　　　　　　　　　玉虹鑑真續帖卷十二
杜甫送孔巢父七古　　　　　　　　　　書種堂帖卷六
杜甫秋興八首　　　　　　　　　　　　如蘭館帖卷二
杜甫秦州雜詩　　　　　　　　　　　　清暉閣藏帖卷十
杜甫寄懷旻公七律　　　　　　　　　　書種堂帖卷六
杜甫謁玄元皇帝廟詩並跋　　　　　　　延清堂帖卷四
杜甫薛少保畫鶴五古　　　　　　　　　書種堂帖卷六
杜牧晚晴賦　　　　　　　　　　　　　紅綬軒法帖卷一
杜樊川晚晴賦　　　　　　　　　　　　劍合齋帖卷六
辛稼軒詞　　　　　　　　　　　　　　研廬帖卷二
汪然明綺集引並跋　　　　　　　　　　延清堂帖卷六
佛印禪師　　　　　　　　　　　　　　來仲樓法書卷十
佛說阿彌陀經並跋　　　　　　　　　　玉煙堂董帖卷一

佛經語錄三則　　　　　　　　　　　　激觀堂帖卷五
初月賦　　　　　　　　　　　　　　　百石堂藏帖卷五
初月賦　　　　　　　　　　　　　　　傳經堂法帖卷三
初祖贊　　　　　　　　　　　　　　　蓮池書院法帖卷五
我本漁樵詞十首　　　　　　　　　　　湖海閣藏帖卷五
君子有所思行　　　　　　　　　　　　銅龍館帖卷五
赤壁賦　　　　　　　　　　　　　　　銅龍館帖卷四
赤壁賦　　　　　　　　　　　　　　　激觀堂帖卷六
赤壁賦　　　　　　　　　　　　　　　蔬香館法書卷四
冷泉亭記　　　　　　　　　　　　　　劍合齋帖卷四
冷齋夜話等六則　　　　　　　　　　　墨緣堂藏真卷十
坐看青苔題畫七絕六首　　　　　　　　太虛齋珍藏法帖羽集
孝經　　　　　　　　　　　　　　　　海山仙館藏真三刻卷一
孝經九章　　　　　　　　　　　　　　春草堂法帖卷四
孝經並跋　　　　　　　　　　　　　　三希堂法帖橅本卷四
孝經並跋　　　　　　　　　　　　　　三希堂石渠寶笈法帖第三十冊
孝經並跋　　　　　　　　　　　　　　敬一堂帖第十九冊明人真蹟
序素雯齋集　　　　　　　　　　　　　延清堂帖卷五
別賦　　　　　　　　　　　　　　　　鶍鶙館帖卷一
步虛詞四首並跋　　　　　　　　　　　壯陶閣帖第二十八冊貞四
步虛詞五律十四首　　　　　　　　　　望雲樓集帖卷九
伯夷傳　　　　　　　　　　　　　　　明世春堂法書卷二
伯夷列傳並跋　　　　　　　　　　　　來仲樓法書卷五
妙法蓮華經　　　　　　　　　　　　　妙法蓮華經石刻本
妙法蓮華經　　　　　　　　　　　　　安素軒石刻卷十六
妙法蓮華經卷四　　　　　　　　　　　海寧陳氏藏真帖卷七
妙法蓮華經卷七　　　　　　　　　　　海寧陳氏藏真帖卷八
近作七律四首　　　　　　　　　　　　三希堂石渠寶笈法帖第三十冊
近作七絕十二首　　　　　　　　　　　百石堂藏帖卷二
阿房宮賦並跋　　　　　　　　　　　　玉虹鑑真續帖卷十
阿房宮賦並跋　　　　　　　　　　　　貞松堂藏歷代名人法書卷中
阿房宮賦並跋　　　　　　　　　　　　蔬香館法書卷四
阿彌陀經　　　　　　　　　　　　　　明世春堂卷六
邵康節無名公傳程子朱子傳贊並跋　　　三希堂石渠寶笈法帖第二十
　　　　　　　　　　　　　　　　　　九冊
花隱披垣五律　　　　　　　　　　　　敬一堂帖第二十六冊

八劃

周挹齋三載一品考賀序　　　　　　　　壯陶閣帖第二十八冊貞四
岳陽樓記　　　　　　　　　　　　　　紅豆山齋法帖卷四
奉命帖　　　　　　　　　　　　　　　傳經堂法帖卷二
雨賦　　　　　　　　　　　　　　　　百石堂藏帖卷五
典論論文　　　　　　　　　　　　　　式好堂藏帖卷三
典論論文並跋　　　　　　　　　　　　宗鑒堂法書卷一
泖湖帖　　　　　　　　　　　　　　　澹慮堂墨刻卷八
彼土奉橘兩帖　　　　　　　　　　　　清暉閣藏帖卷四
征途雜題六絕　　　　　　　　　　　　清暉閣藏帖卷二
孟郊酬友人贈新文詩　　　　　　　　　延清堂帖卷四
虎丘山詩　　　　　　　　　　　　　　明世春堂卷五
垂虹亭詩　　　　　　　　　　　　　　銅龍館帖卷四
杭州營籍帖　　　　　　　　　　　　　銅龍館帖卷四
直東宮答鄭尚書詩　　　　　　　　　　銅龍館帖卷五
舍親陳丈帖　　　　　　　　　　　　　劍合齋帖卷五
明月山銘　　　　　　　　　　　　　　百石堂藏帖卷一
明月山銘仿柳誠懸　　　　　　　　　　清暉閣藏帖卷一
雨過蘇端五古　　　　　　　　　　　　懋勤殿法帖卷二十一
苦雨帖　　　　　　　　　　　　　　　澹慮堂墨刻卷八
兒寬傳贊上　　　　　　　　　　　　　三希堂法帖橅本卷五
兒寬傳贊下並跋　　　　　　　　　　　三希堂法帖橅本卷六
兒寬傳贊上　　　　　　　　　　　　　三希堂石渠寶笈法帖第三十
　　　　　　　　　　　　　　　　　　一冊
兒寬傳贊下並跋　　　　　　　　　　　三希堂石渠寶笈法帖第三十
　　　　　　　　　　　　　　　　　　二冊

Fa-t'ieh
Selected Ink Rubbings of
Tung Ch'i-ch'ang's Calligraphy

Figure 7. *Hsi-hung t'ang fa-shu*. Compiled by Tung Ch'i-ch'ang in 1603. Two leaves from sixteen *chüan*. Shanghai Museum.

Figure 8. *Yü-yen t'ang Tung-t'ieh*. Compiled by Ch'en Hsien in 1612. Two leaves from two *chüan*. Shanghai Museum.

Figure 9. *Ts'ao P'i tzu-hsü*. From *Yü-yen t'ang Tung-t'ieh*. Compiled by Ch'en Hsien.
Two leaves. Shanghai Museum.

Figure 10. *Ch'ing-hui ko t'ieh*. Compiled by Wang Hui. Four leaves from two *han*, ten *chüan*. Beijing Palace Museum.

Figure 11. *Shih-hao t'ang t'ieh*. Engraved by Chang Shih-fan. Two leaves from *ts'e* 1 and 2. Beijing Palace Museum.

Figure 12. *Ch'ing-shan t'ang t'ieh.* Compiled by Hsü Hung-tsu. One leaf from *chüan* 4. Shanghai Museum.

Figure 13. *Mao-ch'in tien fa-t'ieh*. Engraved in 1690. Eight leaves from *ts'e* 21–23. Beijing Palace Museum.

青李
來禽
櫻桃
日給滕
子皆囊盛為佳函封多不生

玄凉清等寒堂文字
生当氣産富完名雲

且山川西势乃东向的
以公進目
観朝雨
朔風吹死雨蕾

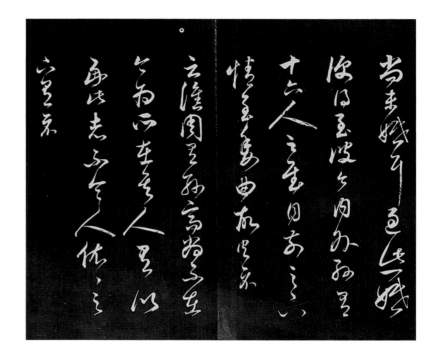

嘗書嫁可觸此減
按日盖淡与肉外孙且
十六人之奎且玄玄意
情筆玄玄曲故思帝

立陰園王孙高雅之玄
气南西在去人呈以
再任去与玄人休之之
六息帝

御詔

平吴日
白太傅至天語
笑其昌

十廊之宅
至麗之園

廿年江海縈紫絲
綵筆度垂釣机
以亥珠毎屠僧
濠上高呈呂鼎莊
呼呈周師

永和九年歲在癸丑暮春之初會于會稽山陰之
蘭亭脩禊事也羣賢畢至少長咸集此地有崇山
峻領茂林脩竹又有清流激湍暎帶左右引以為
流觴曲水列坐其次雖無絲竹管弦之盛一觴一詠
亦足以暢敘幽情是日也天朗氣清惠風和暢仰

御刻三希堂石渠寶笈法帖第三十册

明董其昌書

孝經

仲尼居曾子侍子曰先王
有至德要道以順天下民用
和睦上下無怨汝知之乎曾
子避席曰參不敏何足以知
之子曰夫孝德之本也教之
所由生也復坐吾語汝身體
髮膚受之父母不敢毀傷

孝之始也立身行道揚名於
後世以顯父母孝之終也夫
孝始於事親中於事君終
於立身大雅云無念爾祖
聿脩厥德

天子章

子曰愛親者不敢惡於人敬
親者不敢慢於人愛敬盡於
事親而德教加於百姓刑於
四海蓋天子之孝也甫刑曰
一人有慶兆民賴之

諸侯章

在上不驕高而不危制節
謹度滿而不溢高而不危所
以長守貴也滿而不溢所以
長守富也富貴不離其
身然後能保其社稷而和其
民人蓋諸侯之孝也詩云
戰戰兢兢如臨深淵如履薄冰

卿大夫章

非先王之法服不敢服非先
王之法言不敢道非先王之德
行不敢行是故非法不言非
道不行口無擇言身無擇行

山中人兮帰雲實兮
芳菲菲兮松薺波兮翠
菅靡白鷺魚兮翔兮君
兮思兮寮衣山茶兮一
雲混天地芳不見兮楊臉暖
芳春氣孫不見芳杳冲兮

山西芳夕陽見東皐芳
遠郡芳蓊綠芳千里眇
惆悵芳思夫
村立兮
我本潭推孟法野一兮日
豈照上老作可狂那芳淨

Figure 14. *San-hsi t'ang fa-t'ieh*. Compiled by Liang Shih-cheng and others in 1750. Six leaves from *ts'e* 29–32. Beijing Palace Museum.

Figure 15. *Tzu-hui t'ang fa-t'ieh.* Compiled by Tseng Heng-te in 1768. One leaf from *chüan* 8. Shanghai Museum.

Figure 16. *Tan-lü t'ang mo-k'o.* Compiled by Wang Ming-k'o in 1771. Two leaves from *chüan* 8. Shanghai Museum.

Figure 17. *Ching-ch'uan t'ang fa-shu*. Compiled by Pi Yüan in 1789. Two leaves from *chüan* 12. Shanghai Museum.

Figure 18. *Lan-t'ing pa-chu t'ieh*. Four leaves from the *k'un ts'e*. Beijing Palace Museum.

Figure 19. *Chi-ch'ang yüan fa-t'ieh*. Engraved by Ch'in Chen-chün in 1801. Two leaves from three *chüan*. Shanghai Museum.

Figure 20. *T'ien-hsiang lou ts'ang-t'ieh*. Compiled by Wang Wang-lin in 1804. Two leaves from *chüan* 4. Shanghai Museum.

Figure 21. *Ch'i-lan t'ang fa-t'ieh*. Compiled by Hsieh Hsi-tseng in 1805. One leaf from *chüan* 8. Shanghai Museum.

Figure 22. *Ch'in-yü t'ieh.* Compiled by Ch'ien Yung, engraved in 1815. Two leaves from *chüan* 4. Beijing Palace Museum.

Figure 23. *Shu-hsiang kuan t'ieh*. Compiled by Chin Chih-yüan in 1821. Two leaves from the *li chüan*. Shanghai Museum.

Figure 24. *An-su hsüan shih-k'o.* Compiled by Pao Shu-fang in 1824. One leaf from seventeen *chüan*. Shanghai Museum.

Figure 25. *Hu-hai ko ts'ang-t'ieh*. Compiled by Yeh Yüan-feng in 1835. One leaf from *chüan* 5. Shanghai Museum.

Figure 26. *Keng-hsia-hsi kuan chi-t'ieh*. Engraved by Yeh Ying-yang in 1847. Two leaves from *chüan* 4. Shanghai Museum.

Figure 27. *Nan-hsüeh chai ts'ang-chen t'ieh*. Compiled by Wu Pao-heng in 1852. One leaf from the *hai chi*. Shanghai Museum.

Figure 28. *Hai-shan hsien-kuan ts'ang-chen san-k'o*. Engraved by P'an Shih-ch'eng in 1853. Two leaves from *chüan* 1. Shanghai Museum.

Figure 29. *Yüeh-hsüeh lou t'ieh*. Compiled by K'ung Kuang-t'ao, engraved in 1866–80. Two leaves from *ts'e* 20. Beijing Palace Museum.

Figure 30. *Kuo-yün lou ts'ang t'ieh*. Compiled by Ku Wen-pin in 1883. One leaf from eight *chi*. Shanghai Museum.

Figure 31. *Chuang-t'ao ko t'ieh.* Compiled by P'ei Ching-fu. Two leaves. Shanghai Museum.

Figure 32. *Miao-fa lien-hua ching shih-k'o t'a-pen*. Written by Tung Ch'i-ch'ang in 1617. One leaf from two *ts'è*. Shanghai Museum.

Figure 33. *Yü-hung chien-chen t'ieh*. Compiled by K'ung Chi-su. One leaf. Shanghai Museum.

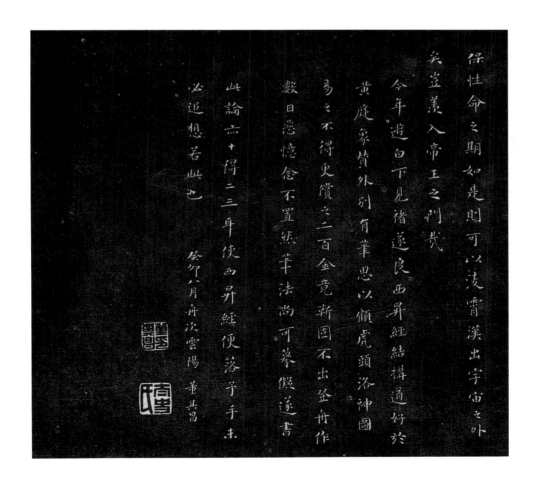

Figure 34. *Hsiao-ch'ang-lu kuan chi-t'ieh.* Two leaves from *ts'e* 7. Beijing Palace Museum.

Figure 35. *Ch'eng-lan t'ang fa-t'ieh*. One leaf. Shanghai Museum.

Figure 36. *Ts'ai-chen kuan t'ieh*. One leaf from *chüan* 3. Shanghai Museum.

善導和尚法語
夫人神好清而心擾之人心好靜
而慾牽之常能遣其欲而心自靜
澄其心而神自清。自然六欲不生三
毒消滅
夫欲修道先舍外事外事都絕
無與忤心然後安坐靜觀心起若
一念起須除滅淨盡惟滅動心不滅
照心但凝空心不凝住心
漸：雞皮鶴髮看：行步龍鍾

Figure 37. *Ch'ien-mo an t'ieh*. One leaf. Shanghai Museum.

Figure 38. *Mo-ling lü-she t'ieh*. Two leaves. Shanghai Museum.

Tung Ch'i-ch'ang's Life

CELIA CARRINGTON RILEY 李慧聞

Tung Ch'i-ch'ang's Life (1555–1636)

I. Family Background

According to family record, Tung Ch'i-ch'ang's early forebears fled south from the Northern Sung capital of K'ai-feng, following its loss in 1126 to the invading Jürched "barbarians" who founded the Chin dynasty in 1115.[1] The family eventually settled at Shanghai, in Sung-chiang prefecture, in what is now the coastal province of Kiangsu; Shanghai, at the time of Tung's birth, was a town still very much subsidiary in importance to the nearby prefectural seat of Hua-t'ing, already a cultural center by the fourteenth century. Tung Ch'i-ch'ang 董其昌 (*tzu* Hsüan-tsai 玄宰, *hao* Hsiang-kuang 香光 or Hsiang-kuang chü-shih 香光居士, Ssu-po 思白, Ssu-weng 思翁[2]) was born on the nineteenth day of the first month (February 10), 1555,[3] to an obscure branch of the family, whose most notable members had for some generations achieved a mild prominence.

Throughout China's later history, the key to advancement in Chinese society lay in a career as an official in government service, for which candidates were in the main recruited on the basis of a series of examinations. These began at the local level and culminated first in a triennial examination conducted in each of the separate provinces, successful candidates being designated *chü-jen* 舉人, or Provincial Graduates; and finally in a nationwide examination held triennially in Peking, successful graduates being designated *chin-shih* 進士, or Metropolitan Graduates.[4] So crucial was the passing of these examinations that the date of a man's *chin-shih* or *chü-jen* degree was recorded even while the dates of his birth and death were often forgotten.

The earliest of the Tung clan to merit a biography in the local gazetteer, the *Shang-hai hsien chih*, was Tung Lun 董綸 (brother or, more probably, cousin of Tung's great-grandfather Tung Hua 董華[5]), who obtained his *chin-shih* degree in 1463 (the first of the family to do so), served initially as a district magistrate, and ended his career as an Investigating Censor in the Nanking Censorate, with a rank of 7a (there being nine ranks, each with two levels—from the lowest, 9b, to the highest, 1a—in the official hierarchy).[6]

Lun had six sons,[7] of whom two, T'ien 恬 (1454–1527) and Ch'en 忱, were awarded the *chin-shih* degree in the same year,

1496, and a third, I 懌, became a *chü-jen* in 1501.[8] A fourth son, Huai 懷 (1465–1542), was known for his filialness and his generosity, and had also a penchant for the arts: he was a devotee of the *ch'in* (the Chinese zither, beloved of the literati) and a collector of calligraphy and painting.[9] The most prominent members of the clan during Tung Ch'i-ch'ang's youth were T'ien's son I-yang 宜陽 (1510–1572) and I's great-grandson Ch'uan-ts'e 傳策 (1530–1579).[10] I-yang failed all attempts to pass the provincial examination, but established nonetheless a considerable local reputation as a learned and cultivated man who devoted his life to reading and writing, poetry and calligraphy, and whose biography describes him as "spending his days sitting in a room revising and collating, breaking off only at midnight."[11] Together he and three others, one of them the Hua-t'ing scholar Ho Liang-chün 何良俊 (1506–1573), achieved local fame as "the four worthies," and in this connection his name appears in Ho's biography in the *Ming-shih*, the dynasty's official history.[12] Tung Ch'uan-ts'e (Tung Ch'i-ch'ang's distant cousin, or "clan nephew" in Chinese parlance) is accorded a biography in the *Ming-shih* in his own right, owing to his denunciation of the notorious Grand Secretary Yen Sung 嚴嵩 (1480–1565).

Ch'uan-ts'e, who gained his *chin-shih* degree in 1550, was the only member of the family in active pursuit of an official career during the years when Tung was growing up; and as such his career would have been a matter of considerable interest (and indeed importance) to the entire clan. In 1558, as a secretary of a bureau in the Ministry of Justice (rank 6a), Ch'uan-ts'e presented a memorial to the throne accusing Yen Sung of six crimes against the state. Two others presented memorials impeaching Yen on the same day; and as the result of Yen's influence, all three were thrown into prison and brutally tortured to elicit the name of their instigator, Yen's suspicions centering on his fellow Grand Secretary Hsü Chieh 徐階 (1503–1583), with whom all three memorialists were allegedly connected (Ch'uan-ts'e as a "fellow native" of Hua-t'ing). Though flogged to the point of death and repeatedly revived, the three admitted nothing; and all were sentenced to exile, Ch'uan-ts'e being banished to Nan-ning, in Kuangsi province, in the far south.

Opposite page: detail of frontispiece, Plate 38. Portrait of Tung Ch'i-ch'ang by Tseng Ching (1564–1647).

On the accession of the Emperor Mu-tsung (r. 1567–72), with the reins of government in the hands of the senior Grand Secretary Hsü Chieh, Ch'uan-ts'e was restored to office as Secretary of the Bureau of Evaluations in the Ministry of Personnel (rank 6a), and rapidly received a series of promotions. In the same year he rose first to Vice Director of the Bureau of Records (5b) and then to Director of the Bureau of Honors (5a) in the same Ministry, and finally to Vice Minister of the Court of Imperial Stud (4a). The following year he was promoted to Chief Minister of the Court of Imperial Stud (3b); but soon after the forced retirement of Hsü Chieh in the seventh month of 1568, he requested permission to resign, initially giving illness as his reason, and then (when his request was disallowed) the need to care for his parents. In 1569 he was appointed Chief Minister of the Court of Imperial Entertainments in Nanking (3b), and in 1570 promoted to Chief Minister of the Court of Judicial Review (3a) in the capital, from which, again on account of his parents, he requested a transfer to Nanking (hence to a position of only nominal power) in 1571. His final appointments were both in Nanking, first as Right Vice Minister of Works in 1572, and then as Right Vice Minister of Rites in 1573 (both 3a). Presumably—if we may so deduce from his resignation in 1568 and request for transfer in 1571—he was little interested in entering the political fray; and indeed his biography in the *Yün-chien chih-lüeh* confirms that his action in 1571 was the result of his determination to distance himself from the party of Hsü Chieh's enemy, the newly reinstated Grand Secretary Kao Kung 高拱 (1512–1578). Toward the end of 1573 he was impeached for accepting a bribe (though it was owing to his repentance that the matter was brought to the attention of the authorities) and dismissed from office. He nevertheless succeeded in having his father and grandfather awarded the prestige title (*san-kuan* 散官) Grand Master for Thorough Counsel (*T'ung-i ta-fu*) and the office of Right Vice Minister of Rites in Nanking, thus raising them posthumously to his own official rank.

Ch'uan-ts'e's end was unexpected: one night while asleep he was murdered by a group of his household slaves, resentful of his harsh discipline.[13] Several short volumes of his writings—three of poetry, one a collection of short travel sketches, and one of his memorials—were republished between 1601 and 1603, the joint effort of a number of his younger relatives and descendants, with Tung Ch'i-ch'ang taking the lead as the compiler.[14] Included were the prefaces that accompanied the volumes on their original appearance, by some of the most notable of Ch'uan-ts'e's contemporaries from Hua-t'ing and Shanghai—among them Lu Shu-sheng and Mo Ju-chung, the latter contributing a preface dated 1571 to one of the volumes of poetry and a commentary to another. Both of these men

were soon to play a role in the opening stages of Tung Ch'i-ch'ang's career.

II. Years of Development (1555–1588)

We can trace the direct line of Tung Ch'i-ch'ang's ancestry through his father Han-ju 漢儒 and grandfather T'i 悌 as far back only as his great-grandfather Tung Hua.[15] Both Hua and Han-ju (though not Tung's grandfather T'i) succeeded in qualifying as *sheng-yüan* 生員 (Government Student; popularly *hsiu-ts'ai* 秀才, or Cultivated Talent), achieved by passing an examination at the prefectural level; but though as holders of the first and lowest of the three civil service degrees they met the minimum standard for gentry status, they were nonetheless ineligible to hold government office. Tung's father, who is described by the *Ming-shih kao* (*Draft History of the Ming*) as a man of "scholarship and upright conduct,"[16] made what was probably a rather meager living by teaching at the local school, and himself began Tung's preparation for a career in government office by giving him a groundwork in the classics and histories, a knowledge of which was essential to achieve success in the examinations. Han-ju was particularly well-versed in the famous Sung historical text, the *Tzu-chih t'ung-chien*, several pages of which he used to recite for Tung to memorize while the two were lying in bed in the evening.[17]

In 1567, when he was thirteen *sui* (twelve years old in Western reckoning), Tung passed the Sung-chiang prefectural examination—winning praise for his performance from the prefect Chung Chen-chi 衷貞吉 (*chin-shih* 1559) and the Education-intendant Censor Keng Ting-hsiang 耿定向 (1524–1596)—and as a *sheng-yüan* was awarded a coveted place in the prefectural school, located in Hua-t'ing.[18] Passing with him was his distant cousin Tung Ch'uan-hsü 董傳緒 (*tzu* Po-ch'ang 伯長; 1556–1576, who, like Tung Ch'uan-ts'e, was actually Tung's clan nephew), and presumably the two entered the prefectural school together. Of Ch'uan-hsü's father, Ch'ien (later Tung) Chih-hsüeh 錢(董)志學 (*tzu* T'ing-p'ing 廷平, *hao* Chien-ch'uan 漸川; *chü-jen* 1540), Tung later wrote:

> In every family there must be an elder who values the Classics and prizes filialness and right conduct, to act as a leader to his kinsmen; so did Chien-ch'uan provide the lofty model for my clan.[19]

一家之中，必有宗老敦詩書，服孝義，爲族人領袖。若漸川先生之於吾宗屹然典型矣。

Ch'uan-hsü (who was to die early, at the age of only twenty-one *sui*) was a year younger than Tung and equally talented; together the two "wore out their brushes," inspiring each other to literary effort, "as mutually dependent as shape and

shadow."[20] The examination, however, left its mark on Tung; as he himself tells the story:

> I began to study calligraphy [formally] when I was seventeen *sui*. Earlier, I and my younger cousin Po-ch'ang, whose *ming* was Ch'uan-hsü, together took the prefectural examination. Because of my clumsy calligraphy, the prefect Chung Hung-hsi [Chung Chen-chi], from Kiangsi, ranked me second [to my cousin]. From then on I began to work hard at practicing my calligraphy.[21]

吾學書在十七歲時。先是吾家仲子伯長，名傳緒，與余同試於郡。郡守江西袁洪溪，以余書拙置第二。自是始發憤臨池矣。

It is generally believed, on the evidence of this passage, that Tung passed the prefectural examination—thereby achieving *sheng-yüan* status—at about the age of seventeen *sui*; that is to say, that his decision at seventeen *sui* to begin a rigorous study of calligraphy followed directly on his failure to outshine his cousin in the prefectural examination.[22] But Tung in his passage has compressed the timing of events for narrative effect; that he was actually only thirteen *sui* at the time of the prefectural examination is recorded by Ch'en Chi-ju 陳繼儒 (1558–1639), Tung's lifelong friend, in his "Life and Conduct of the Grand Guardian of the Heir Apparent and Minister of Rites Tung Ssu-po," composed after Tung's death. Ch'en's accuracy in this respect is confirmed by what we know of the Education-intendant Censor Keng Ting-hsiang, whom Ch'en mentions as complimenting Tung on his examination success; in the fall of 1567—the year that Tung was thirteen *sui*—Keng was promoted to Right Assistant Minister of the Court of Judicial Review in Peking.[23] Had Tung taken the examination at a later date, Keng would not have been present.

It was probably from the age of thirteen *sui* onward that Tung made Hua-t'ing his home, and throughout his life he studiously avoided all reference to Shanghai as his native place, signing himself (on those occasions when he used a place name) "Hua-t'ing Tung Ch'i-ch'ang," as if Hua-t'ing, not Shanghai, were his ancestral home. Even when composing the biography of Ch'uan-hsü's father (included in his collected writings, the *Jung-t'ai chi*), Tung maintained this fiction, writing that according to his clan genealogy, his early forebears moved south in the retinue of the Sung emperor and "settled in Hua-t'ing."[24]

A story much adduced by modern biographers as the probable reason for Tung's determination to leave Shanghai and adopt Hua-t'ing as his home appears as a footnote to Tung's biography in the *Shang-hai hsien chih* of 1871. The gazetteer quotes an anecdote from the *Yün-chien tsa-shih* (*Common Knowledge from Yün-chien*), Yün-chien being a name formerly in use for Hua-t'ing. The author of the *Yün-chien tsa-shih*, a late Ming writer and native of Hua-t'ing by the name of Li Shao-wen 李紹文, recounts the tale that when Tung was a student, he was owner of twenty *mou* (about three acres) of poor arable land, and being subject to corvée (since landholders near the coast were required to provide labor for the erection of defenses against pirates), he abandoned his home and fled, later becoming a member of the Han-lin Academy 翰林院 and establishing residence elsewhere. The story is repeated and slightly embellished by a later contemporary of Li's from Shanghai, Li Yen-hsia 李延昰, in his *Nan-Wu chiu-hua lu* (*Old Tales from Southern Wu*), who adds that Tung's friend Ch'en Chi-ju used to say jokingly to Tung, "Someday people will read the 'Ballad of Tung's Flight,' how only by crossing the border you made your escape!" 後來讀 "董逃行"，惟越境乃免。[25]

On the basis of this story—which because it appears in contemporary sources seems to have such excellent credentials— Tung is presumed to have fled from Shanghai to Hua-t'ing sometime in his teens, and to have passed the prefectural examination shortly afterward, at about seventeen *sui*. But in fact, as we have just seen, Tung passed the prefectural examination and was accepted into the prefectural school in Hua-t'ing, not at seventeen but at thirteen *sui*. From then on he was no longer under threat of corvée, since exemption from corvée was one of the key privileges of *sheng-yüan* status.[26] We can hardly suppose that Tung was forced to flee his home in Shanghai to avoid corvée at the tender age of twelve *sui*, or eleven years old. Li Shao-wen, moreover, begins his tale with the words, "When Ssu-po was a student," the term *chu-sheng* 諸生 (student) being commonly equivalent to *sheng-yüan*; hence, from its very beginning, the story as Li tells it involves an inherent contradiction. Conceivably the story of Tung's "flight" is simply one of a number of unsavory stories that later in Tung's life and after his death were propagated by his enemies, whose number grew in proportion as his wealth and reputation increased. His determination to associate himself with Hua-t'ing can be readily enough explained in terms of his character: throughout his life, he was to exhibit a propensity to seize upon any connection that might work to his advantage, and Hua-t'ing, with a literary and artistic tradition extending back to the Yüan dynasty, must have seemed altogether a more propitious home to one of his ambitions than mercantile Shanghai, which could add little in the way of prestige.[27]

If, as Ch'en Chi-ju implies, it was Tung's exceptional talent that now drew him to the attention of some of the most eminent figures among Hua-t'ing's bureaucratic elite,[28] it was Tung's family connections that paved his way. By 1571 or thereabouts, Tung had been invited to study at the Mo family school,[29] under at least the partial tutelage of Mo Ju-chung 莫

如忠 (1509–1589), who by the end of his career had risen to be Chekiang Provincial Administration Right Commissioner (2b) and had achieved a reputation as a poet and calligrapher (see vol. 1, pl. 75). On the evidence of their writings, both Mo and his son Shih-lung 是龍 (1537–1587) were friendly with all the most prominent members of the Tung clan. Not only did Mo Ju-chung provide the preface dated 1571 and commentary for separate collections of Tung Ch'uan-ts'e's poems that were mentioned above, but he also composed—no doubt on request—a record of the Tung family tombs ("Tung-shih shih-mu chi"); the "Life and Conduct" (*hsing-chuang* 行狀) of Tung Ch'uan-ts'e's father, T'i-jen 體仁; and the epitaph (*mu-chih-ming* 墓誌銘) for Madame Hsü 徐氏, the principal wife of Ch'ien (later Tung) Chih-hsüeh,[30] father of Tung's cousin and boyhood companion Tung Ch'uan-hsü, with whom Tung had passed the prefectural examination.[31] Included in Mo Shih-lung's collected works are both a pair of poems he presented to Tung I-yang when the latter was moving house, and a colophon by I-yang, dated 1571 (the year before he died), appended to a poem written jointly by Mo Shih-lung and several others.[32] With so much proven contact between members of the two families—demonstrably in 1571, the very year Tung probably began to study at the Mo family school—it is hardly surprising that Tung, who with his cousin Ch'uan-hsü represented the Tung clan's best hope of future success in the bureaucratic arena, should be taken under the Mo family's wing.[33]

By 1577, when he was twenty-three *sui*, Tung had been offered a position as tutor to Lu Yen-chang 陸彥章 (d. 1630), the son of Lu Shu-sheng 陸樹聲 (1509–1605), who was Mo Ju-chung's exact contemporary and intimate friend.[34] Lu Shu-sheng was one of the most respected figures in Hua-t'ing; in 1541 he had captured first place in the Metropolitan Examination—a spectacular beginning for anyone intent on launching a political career—but thereafter had spent his life refusing or retiring from a succession of ever higher positions offered him, which culminated finally in the prestigious post of Minister of Rites (2a), from which he had retired, for the final time, at the end of 1573.[35]

Lu was on familiar terms both with Tung Ch'uan-ts'e and with Tung Ch'uan-hsü's father, Chih-hsüeh. Like Mo Ju-chung, Lu had contributed a preface to a collection of Ch'uan-ts'e's poems (completed by 1570, when the blocks for the original edition were engraved), and like Mo, again, had been asked to compose a tribute to Ch'uan-ts'e's father, T'i-jen, in this case the epitaph (*mu-chih-ming*) to be buried in the tomb.[36] Lu's grandniece (or perhaps clan granddaughter) was eventually betrothed to Tung Yü-shu 董玉樹, the eldest son of Ch'uan-ts'e's younger brother Ch'uan-shih 傳史 (who later

took Chin 晉 as his *ming*).[37] Lu Shu-sheng's friendship with Ch'uan-hsü's father, Chih-hsüeh, had begun when they studied together at the prefectural school, and was later solidified when together they passed the provincial examination for the *chü-jen* degree in the same year, 1540[38]—so much so that despite Chih-hsüeh's lackluster career,[39] a marriage was arranged between Lu's daughter and Chih-hsüeh's second son, Ch'uan-hsü's younger brother Chiu-kao 九皋.[40] Like Mo Ju-chung, Lu had every reason to offer Tung a helping hand, particularly after Ch'uan-hsü's premature death in 1576 left Tung as the family's most promising candidate to make his way successfully through the examination process.

Initially, Tung seems to have been less than single-minded in pursuing his examination studies, trying his hand at painting on the side. Ch'en Chi-ju tells the story that once when a guest arrived with a plain paper fan and begged Tung to decorate it, Tung's father Han-ju tore it to pieces, to provoke Tung into concentrating his effort on the examination studies that were essential, "from which point on," Ch'en adds, with the hyperbole incumbent on a friend, "he took first place in every examination."[41] Tung's prowess did little to incline him to modesty, as he himself later confessed:

> In the beginning I had no very deep understanding of my examination studies. In days gone by I used to study at Mo Chung-chiang's [Mo Ju-chung] family school, and time and again he would hold up Pi-ling's prefaces[42] for our instruction, for us to scrutinize through and through. [But] in my youth I had an arrogant turn and could not bear to spend all my time drilling.[43]

僕於舉子業本無深解，徒以曩時讀書於莫中江先生家塾，先生數舉毘陵緒言指示同學，頗有省入。少年盛氣，不耐專習。

Ch'en Chi-ju more than once remarks: "As a student, Tung had a lofty manner and refused to own himself inferior."[44] He records Tung as saying, "'The immortals were able to transport themselves to Heaven; why should I follow in anyone else's footsteps?'"[45]

By the early 1580s, however, Tung had developed an interest in Ch'an Buddhism, and surprisingly, one effect was to reconcile him to the very examination studies whose stylistic exactions he had earlier despised as being "thin and insipid."[46] On a visit to a local abbot, Tung had met the Ch'an master Ta-kuan 達觀 (Chen-k'o 真可, 1543–1603), recently arrived in Hua-t'ing. Three days later Ta-kuan came to see Tung, kowtowed, and paid Tung the highly gratifying compliment (unexpected for one so young) of asking him to compose a preface to the *Ta-ch'eng chih-kuan [fa-men]* (*Method of Concentration and Insight in the Mahayana*) by the monk Hui-ssu 慧思 (514–577, third patriarch of the T'ien-t'ai 天台 School of

Buddhism),[47] observing, "Minister Wang [Wang Shih-chen 王世貞, 1526–1590][48] is marvelous in literary composition; Minister Lu [Lu Shu-sheng] is deep in Ch'an; join them and they become paired perfections; separate them and each is deficient." "From then on," Tung tells us, "I began to immerse myself in the Buddhist scriptures and study [Ch'an's] essential tenets."[49] Ta-kuan's characterization of Lu Shu-sheng as one "deep in Ch'an" is worth remarking: since by the spring of 1577 Tung was tutoring Lu's son, it may have been Lu who first aroused in Tung an interest in Ch'an, so that Ta-kuan's words fell on ground that had already been in part prepared.

In 1585 Tung experienced—in a manner much like that of the Ch'an monks of old—his own moment of enlightenment. He had long been puzzled by the story of the Ch'an monk Shou-shan 首山 (926–992), who holding up his short bamboo staff, asked his disciples what to call it without either asserting it was a staff or negating it as not a staff.[50] One day, traveling by boat, Tung was lying back pondering another Ch'an story of the ninth-century monk Hsiang-yen 香嚴, who, unable to answer the question put to him by the Ch'an master Kuei-shan 溈山, burned his things in despair and went away, but later achieved enlightenment on hearing the sound of a broken tile striking a bamboo stalk.[51] By chance, just at this moment, Tung's hand struck a bamboo pole supporting the boat's sail, and suddenly, like Hsiang-yen, he understood the purpose of the Ch'an master's question.[52] With the monumental self-confidence so characteristic of him, Tung writes as if his sudden moment of illumination was quite the equal of Hsiang-yen's own revelation.

According to Ch'en Chi-ju, it was reading the teachings of the Ch'an Ts'ao-tung 曹洞 School and equally the hundred-chapter *Tsung-ching lu* (*Records of the Source Mirror*) that had the most profound effect on Tung's literary style. Written by the Ch'an monk Yen-shou 延壽 (904–975), who espoused the unity of Ch'an and Pure Land Buddhism, the *Tsung-ching lu* so impressed Tung that he annotated it from start to finish. The result was that he began to compose essays of several dozen words—presumably in the prescribed "eight-legged" examination style—on such diverse subjects as the Five Schools of Ch'an, the *Three Strategies* (*San-lüeh*) of the legendary military tactician Huang-shih kung 黃石公, and the thirteen chapters of the *Art of War* (*Ping-fa*) by Sun Wu 孫武 (6th century B.C.).[53] Tung records that when in 1586 he read the dialogues of the Ch'an masters Tung-shan Liang-chieh 洞山良价 (807–869) and Ts'ao-shan Pen-chi 曹山本寂 (840–901)—the Ts'ao and Tung of the Ts'ao-tung School—which taught the interchangeability or oneness of the Absolute or Universal (*cheng* 正, "erect") and the Relative or Particular (*p'ien* 偏,

"inclined"), he began to appreciate the essayist tradition. He now realized that all he had written hitherto had been simply a waste of time, and that he must bring together everything he had learned, whether from his teachers' discourse or from the writings of earlier generations.[54] Tung's eight-legged examination essays earned him a modicum of fame even before he passed the *chü-jen* and *chin-shih* examinations: his friend T'ao Wang-ling 陶望齡 (1562–1608) later wrote that as a boy he had read Tung's essays thinking he must be someone well-known, and was surprised to find out afterward that the author was still a Government Student.[55]

Interest in Ch'an was widespread among late Ming intellectuals, and Tung and his friends spent long hours in conversation with Ch'an masters. In keeping with the syncretist tendencies of the time, on occasion the topic under debate veered away from one that was strictly Buddhist to one involving the classics of the Confucian school. Tung describes one such session that took place in 1588, when he and six of his friends met with the Ch'an master Han-shan 憨山 (1546–1623) at the Lung-hua Temple in Hua-t'ing, and fell to discussing the purport of a sentence from the Confucian *Doctrine of the Mean*. Tung and his friend Ch'ü Ju-chi 瞿汝稷 (1548–1610) were unable to agree; and when Han-shan refused to side with either, Tung ended by enjoining them all to remember what they had said, so that they could continue the argument another time. Six years later, in Peking, Tung and two of the group—one of them Yüan Tsung-tao 袁宗道 (1560–1600), the eldest of the three brilliant Yüan brothers, who at only twenty-seven *sui* had placed first in the Metropolitan Examination of 1586—met with three other friends for the purpose of discussing Ch'an. Tung, as by now we should expect, brought up their old argument, and records with considerable satisfaction that Yüan, who in 1588 had been new to Ch'an but whose understanding had been deepened by meeting the famous iconoclast Li Chih 李贄 (1527–1602), was at last won over to his point of view.[56] Tung was to meet Li in 1598, and he records that they established an immediate rapport, Li telling him that of all those he had encountered, Tung alone fully grasped the true course.[57] Tung describes himself as abashed by Li's good opinion; if so, it was a sentiment that did not visit him often.

Given Tung's interest in Ch'an, it is hardly surprising that Ch'an recurs as an explanatory metaphor in a number of passages—some of them among the most important in Tung's writings—that seek to convey his theory or experience of calligraphy and painting. In 1571, at the age of seventeen *sui*, as we have seen, he embarked on the serious study of calligraphy; and almost three decades later, he describes his early progress thus:

At first I took as my guide the *To-pao t'a* by Yen P'ing-yüan [Yen Chen-ch'ing, 709–785]; then I changed to studying Yü Yung-hsing [Yü Shih-nan, 558–638]. Realizing that T'ang calligraphy was not the equal of Chin and Wei, I turned to imitating the *Huang-t'ing ching* [by Wang Hsi-chih, 303–379], and also the *Hsüan-shih piao*, *Li-ming piao*, *Huan-shih t'ieh*, and *Ping-she t'ieh* by Chung Yüan-ch'ang [Chung Yu, d. 230]. After three years I considered myself within reach of the ancients, and I no longer deigned even to glance at [the calligraphy of] Wen Cheng-chung and Chu Hsi-che [Wen Cheng-ming, 1470–1559, and Chu Yün-ming, 1461–1527, the two great calligraphers of the middle Ming period].

But actually I had failed to penetrate the divine principles of the [great] calligraphers, and I was only following along in well-worn tracks. When I went to Chia-hsing and saw all of Hsiang Tzu-ching's [Hsiang Yüan-pien, 1525–1590] collection of original works—when, too, I saw General Wang's [Wang Hsi-chih] *Kuan-nu t'ieh* in Chin-ling [Nanking]—then I realized how vain I had been to estimate myself so highly. I felt like the monk Hsiang-yen when he could not answer the question put to him by [the Ch'an master] Tung-shan[58] and so despaired of ever being more than a [worthless] "rice-gruel monk"—just the same way, I wanted to burn my brush and inkstone. From that point on, I gradually made some slight progress. [Yet] now it is almost twenty-seven years later, and I am still an [ordinary] "flow-with-the-tide" calligrapher.[59]

初師顏平原《多寶塔》，又改學虞永興。以爲唐書不如晉、魏，遂倣《黃庭經》，及鍾元常《宣示表》、《力命表》、《還示帖》、《丙舍帖》。凡三年，自謂逼古，不復以文徵仲、祝希喆置之眼角。
乃於書家之神理，實未有入處，徒守格轍耳。比游嘉興，得盡觀項子京家藏真蹟，又見右軍《官奴帖》於金陵，方悟從前妄自標評。譬如香嚴和尚，一經洞山問倒，願一生做粥飯僧，余亦願焚筆研矣。然自此漸有小得。今將二十七年，猶作隨波逐浪書家。

Tung's seeming modesty is belied by his comparison of himself with Hsiang-yen, whose period of despair, we remember, was followed not long afterward by his sudden enlightenment. As Nelson Wu remarks dryly, Tung's "recollection [has] a post-enlightenment character."[60]

It was Mo Ju-chung, whose family school Tung began to attend, probably in 1571 (as we recall), who now became Tung's instructor in calligraphy; and it was Mo, and Mo alone, whom Tung was later in life ever to acknowledge as having been his teacher, in the sense of someone who influenced his artistic development. His admiration for Mo is revealed in his account of how he chanced to discover the source of Mo's style:

The Provincial Administration Commissioner Mo Chung-chiang [Mo Ju-chung] from my district modeled his calligraphy on that of the General [Wang Hsi-chih]. He himself said he had modeled it on the *Sheng-chiao hsü* [by the seventh-century monk

Huai-jen]; yet it differed slightly from the *Sheng-chiao hsü* in style. In profoundly approaching the ancients, none of today's famous masters can precede him. Each time I asked him about the origin [of his style], he modestly declined to answer. Then in 1579, when I was taking the examination [for the *chü-jen* degree] in the Old Capital [Nanking], I saw the original *Kuan-nu t'ieh* by General Wang, which was exactly like [Mo's] calligraphy, and I began to realize how deeply [Mo] was steeped in the two Wangs [Wang Hsi-chih and his son Hsien-chih, 344–388].[61]

吾鄉莫中江方伯書學右軍。自謂得之《聖教序》，然與《聖教序》體小異。其沉着逼古處，當代名公未能或之先也。予每詢其所由，公謙遜不肯應。及余己卯試留都，見王右軍《官奴帖》真蹟，儼然莫公書，始知公深於二王。

By 1579, then, when he saw the *Kuan-nu t'ieh* (cf. vol. 1, fig. 48) in Nanking, Tung was convinced of the need to found his style on the great masters of the past, the necessity of seeking ever earlier models till he arrived at their true stylistic source, and the vital importance of basing his style on original works. All three convictions were to remain important axioms underlying Tung's artistic theory and practice.

As a favorite with Mo Ju-chung, who (as Ch'en Chi-ju records) was "constantly encouraging him to talk about art,"[62] Tung was naturally thrown into contact with Mo's son, Shih-lung, who by many in Hua-t'ing and indeed the entire Chiang-nan region was considered to be the most promising young man of his generation. Writing in 1599, twelve years after Mo Shih-lung's death, on a handscroll by Kuo Hsi 郭熙 (ca. 1020–ca. 1100) now in the Freer Gallery, entitled *Clearing Autumn Skies over Mountains and Valleys* (*Hsi-shan ch'iu-chi t'u*; vol. 1, figs. 3, 4), which had once belonged to Mo Shih-lung himself, Tung makes a point of referring to Mo as "my friend":

My friend Mo T'ing-han [Mo Shih-lung] loved painting, and in his own painting came very close to Tzu-chiu [Huang Kung-wang, 1269–1354]. This scroll was in his collection, and he valued it as being in the highest class. Later it went to [his son-in-law] Minister P'an, and eventually it came into my hands. Each time I unroll it, I am overcome with grief that "the man and his *ch'in* [are both gone]." . . . Last night I dreamed of T'ing-han, and when I awoke I wrote this.[63]

予友莫廷韓嗜畫，畫亦逼真子久。此卷蓋其所藏，以爲珍賞甲科。後歸潘光祿，流傳入余手。每一展之，不勝人琴之歎。…前一宿夢廷韓及曉起題。

But Tung was eighteen years younger than Mo, and whether they were intimate, as Tung means to imply, or whether Tung was simply a young member of Mo's circle is a matter for

debate. Tung's few other references to Mo suggest none of the closeness of association that marked his relationships with Mo Ju-chung and others like Hsiang Yüan-pien and Ku Cheng-i 顧正誼 (fl. 1575–97), older men whose bond with Tung was in each case born of their interest in him as a protégé and pupil, Mo Ju-chung instructing him in calligraphy, Hsiang and Ku in matters of connoisseurship. The two glimpses Tung has left of himself in Mo Shih-lung's company—both occurring in 1579, though he records them only much later[64]—conjure up an image of Tung, not as Mo's intimate friend, but as one of a group, separated at a slight distance from Mo by a disparity both in age and in achievement.

No doubt this very disparity heightened the impression Mo made on Tung. Mo was brilliant enough, and just old enough, to be held by Tung in some awe; and since by the comparatively young age of forty Mo had achieved no small measure of fame as a painter (see vol. 1, pl. 76), he must inevitably have presented to Tung a standard by which to gauge his own progress. It was Mo's early success that impressed Tung and prompted him to draw an analogy between Mo and Southern Ch'an:

> Ku Chung-fang [Ku Cheng-i] and Mo Yün-ch'ing [Mo Shih-lung] of my prefecture [Sung-chiang] both excelled in the painting of landscape. Chung-fang was already famous, and indeed had been so for many years; yet no sooner did Yün-ch'ing appear, than [like] the Southern and Northern [schools of Ch'an]—the one sudden, the other gradual—[the field of painting] divided into two schools. Nevertheless, Yün-ch'ing inscribed a small scene by Chung-fang as being "divine and untrammeled"; and before me Chung-fang always showed the greatest respect for Yün-ch'ing's paintings. It was as if they had taken to writing poems in each other's praise. In the space of a moment, their attitude [toward one another] succeeded in putting the ancients to shame.[65]

> 吾郡顧仲方、莫雲卿二君皆工山水畫。仲方專門名家，蓋已有歲年，雲卿一出，而南北頓漸，遂分二宗。然雲卿題仲方小景，目以"神逸"，乃仲方向余歙袺雲卿畫不置。有如其以詩詞相標譽者。俯仰間，見二君意氣可薄古人耳。

Tung did not really mean to imply that Ku Cheng-i (a staunch follower of Huang Kung-wang) was at all connected with what he came to call, by a corresponding analogy with Northern Ch'an, the Northern School of painting: those who by their professional standing or adherence to technically proficient "professional" models fell outside the social and stylistic bounds set by the literati. What Tung did intend by his comparison was to pay Mo a supreme compliment—for only the genius, whose talent is innate, can achieve his goal without long effort.

Tung was not always to write of Mo Shih-lung in such flattering terms. In 1620 (some thirty years after the deaths of both Mo and his father) Tung composed a preface to the *Ch'ung-lan kuan t'ieh*—woodcut reproductions of the collected calligraphies of both Mos, father and son—in which he contrasts Mo Ju-chung's calligraphy with Shih-lung's, much to Ju-chung's advantage:

> [The first great pair of] father and son calligraphers was Hsi and Hsien [Wang Hsi-chih and Hsien-chih], followed by Ou-yang Hsün [557–641] and Ou-yang T'ung, and Hsü Ch'iao-chih and Hsü Hao [703–782]. This dynasty [can claim] Commissioner Mo and his son T'ing-han from my own prefecture. The Commissioner was my teacher and T'ing-han my friend. . . . I knew at the time that T'ing-han, like Ta-ling [Wang Hsien-chih], aspired to surpass his father. But my teacher grasped the bone [i.e. the essence], whereas T'ing-han grasped [only] the appearance. My teacher was himself able to structure his composition, while the structure of T'ing-han's characters was largely derived from the famous works of former masters. Just as with Hsi and Hsien, [the father was] first and [the son] second.[66]

> 父子書家，自羲、獻後，有歐陽詢、歐陽通，徐嶠之、徐浩。本朝則吾郡莫方伯與其子廷韓耳。余師方伯而友廷韓…故當時知廷韓者，有大令過父之目。然吾師以骨，廷韓以態。吾師自能結構，廷韓結字多出前人名跡。此為甲乙，真如羲、獻耳。

Admittedly, Tung's object in writing the preface was to extol his early teacher Mo Ju-chung; but he could easily have done so without resorting to a tactic so damaging as that of praising the father at the expense of the son—one wonders that he could so forget his own strictures against earlier masters for their willingness to malign one another. Tung's criticism of Mo Shih-lung is all the more remarkable when we remember that he considered himself bound to Shih-lung by ties of friendship; and with Tung, loyalty to his friends (and to his district: note in the passages above the recurring phrases *wu hsiang* 吾鄉, "my district," and *wu chün* 吾郡, "my prefecture") ran deep. But Tung was a born competitor; even at the tender age of twenty *sui* we have seen him scorning the calligraphy of the eminent Ming masters Chu Yün-ming and Wen Cheng-ming. Tung was willing enough to concede Mo's genius as a painter, but he was reluctant that Mo should seem to succeed on all fronts. Tung early on designed for himself a position as the great calligrapher and painter of his age, and he could brook no rival.

It was while residing in the household of Lu Shu-sheng that Tung attempted his first formal painting:

> On the evening of the last day of the third month, 1577, I lit a candle and tried my hand at painting a landscape. I have loved [painting] more and more ever since. In those days I used to visit

393

the home of the Drafter [of the Central Drafting Office] Ku Chung-fang [Ku Cheng-i], and [there] look at paintings by the old masters. The four great masters from the end of the Yüan delighted me most.[67]

余以丁丑年三月晦日之夕，燃燭試作山水畫。自此日復好之。時往顧中舍仲芳家，觀古人畫。若元季四大家，多所賞心。

One can hardly imagine a passage more succinct; yet these few lines, from his inscription of 1624 on a painting in his collection—*Privileged Residents of the Capital* (*Lung-hsiu chiao-min t'u*; vol. 1, fig. 18) attributed to Tung Yüan 董源 (fl. ca. 945–ca. 960)—are the fullest account we have from Tung's own hand of his earliest acquaintance with painting, either as a painter himself or as a viewer of paintings. That Tung had in fact experimented with painting for several years before 1577 is shown by his noting, in another passage, that he and his cousin Ch'uan-hsü studied painting together for four or five years before Ch'uan-hsü's death in 1576.[68]

Ku Cheng-i, whom Tung mentions in the passage quoted above, was a native of Hua-t'ing, a collector on a moderate scale, and a painter of some ability (see vols. 1 and 2, pl. 77). Chiang-nan, the region south of the Yangtze—in particular, southern Kiangsu and Anhui (then combined into Nan Chih-li, the Southern Metropolitan Area) and northern Chekiang—was in late Ming times a stronghold of Yüan painting, and Ku partook of the prevailing taste: he seems to have confined his collection largely to the Yüan masters and to have painted almost exclusively in Yüan styles. In an inscription he wrote on an album by Ku, Tung neatly summarized Ku's tastes, evolution, and achievement:

> [Ku] began by modeling his paintings on Ma Wen-pi [Ma Wan, ca. 1310–1378]; later he turned to Huang Tzu-chiu [Huang Kung-wang], Wang Shu-ming [Wang Meng, 1308–1385], Ni Yüan-chen [Ni Tsan, 1301–1374], and Wu Chung-kuei [Wu Chen, 1280–1354]. He was adept in each of their styles; but people liked best his paintings in the manner of Tzu-chiu.[69]

君畫初學馬文璧，後出入黃子久、王叔明、倪元鎮、吳仲圭。無不肖似，而世尤好其爲子久者。

Ku, in an inscription on one of his own paintings clearly intended for Tung, claims the honor of having been Tung's teacher:

> Day after day I have copied genuine works of the great Sung and Yüan masters, and have in some small part managed to capture their essence. It was I who pointed Ssu-po on the way; but he has already surpassed me.[70]

連日橅宋元諸大家真蹟，頗能得其神髓。思白從余指授，已自出藍。

It was not a debt that Tung ever admitted. No doubt, however, it was Ku, as much as anyone, who created in Tung an abiding love for the paintings of Huang Kung-wang, which were profoundly to influence Tung's own style. Ku owned several of Huang's paintings, which Tung tells us all passed later into his own collection.[71]

The last name to figure at all frequently in Tung's references to this early period in his career is that of Hsiang Yüan-pien, the greatest collector of the day, who ensured his fame for all posterity by peppering the works in his collection with his own seals. With wealth enough from his pawnbroking activities to support even the most ambitious acquisitions, Hsiang included in his collection calligraphies and paintings by, or attributed to, the most famous masters of the T'ang and Sung periods and even earlier, well over a hundred of which are extant and are among the most important works to survive today. Paintings by the Yüan masters nonetheless held an honored place in his collection. Tung wrote: "Of the four great masters from the end of the Yüan, [Hsiang] owned [works] by each; only Ni Yü's [Ni Tsan] paintings were few."[72] It was certainly not by choice that Hsiang owned so few of Ni's paintings, since Hsiang modeled his own landscape paintings on those of Ni and Huang Kung-wang, and according to Tung was fondest of Ni.[73] Hsiang's preference for Huang Kung-wang and Ni Tsan, over Wu Chen and Wang Meng (who with Ni and Huang succumbed to the Chinese predilection for systemization, emerging as the Four Great Yüan Masters), seems to have been general among the connoisseurs and scholar-painters of Sung-chiang, which in the late Ming period succeeded Su-chou as the leading center of painting. Not surprisingly, Tung inherited the prevailing taste for Ni and Huang; and though Tung was occasionally to execute a painting in the manner of Wang Meng or (even more rarely) Wu Chen, very few of his extant works, apart from album leaves painted as part of a set, mention Wang or Wu as a source of inspiration.

Through an acquaintance with Hsiang's eldest son Te-ch'un 德純 (who later adopted Mu 穆 as his *ming*), Tung became friendly with Hsiang himself, and by his own account spent long hours with Hsiang, evaluating the paintings and calligraphies of past ages. "Morning till night, I forgot all fatigue," Tung wrote. "[Hsiang] recognized that we shared the same taste and said that we had met [too] late." 余永日忘疲。即公亦引爲同味，謂相見晚也。[74] Tung relates that while serving as a private tutor in Chia-ho (i.e. Chia-hsing) he was on intimate terms with Hsiang,[75] and it is this passage that may have given currency to the unfounded story that Tung was employed by Hsiang to tutor Te-ch'un.[76] Tung himself neglects to tell us by whom he was employed as a tutor in Chia-hsing; and we have

only the report of a little-known Ch'ing author named Ma Ch'eng-chao 馬承昭 (a native of P'ing-hu, a district in Chia-hsing prefecture) that before Tung passed his examinations (that is to say, while he was a Government Student), he served as a tutor in P'ing-hu for a family named Feng 馮, so poor that Tung was able to clothe himself only in an unlined gown of white cotton cloth.[77]

Whatever his privations, Tung had the consolation of his sessions with Hsiang Yüan-pien, who not only brought out for Tung to study a large number of his most important works (Tung, as we recall, writes that he saw the whole of Hsiang's collection of calligraphy[78]), but even allowed Tung to borrow works to copy. One work Hsiang lent him was the prized *Autobiography* (*Tzu-hsü t'ieh*; vol. 1, fig. 56) by the T'ang monk Huai-su 懷素 (fl. late 8th century),[79] one of the great monuments of the cursive style, whose influence manifests itself in the closing section of Tung's own calligraphy dated 1603 appearing in this exhibition (vol. 2, pl. 5). Hsiang's generosity was a measure of his confidence in Tung's talent: Hsiang had purchased the *Autobiography* for six hundred in gold, and Tung later valued it at a thousand.[80]

By his early to mid-twenties, Tung was a visitor at Hsiang's home in Chia-hsing;[81] and he remained on intimate terms with members of the family for the rest of his life, in particular with Hsiang's fifth son Te-hung 德宏 (*tzu* Hsüan-tu 玄度), whose collection of calligraphy was particularly fine,[82] and with Hsiang's grandson Sheng-mo 聖謨 (1597–1658). Sheng-mo was himself to become a distinguished painter, and it was he who added the landscape to Tung's portrait by Tseng Ching 曾鯨 (1564–1644) that appears as a frontispiece to Tung's album of 1620 entitled *Eight Views of Autumn Moods* (vols. 1 and 2, pl. 38). Appropriately, the portrait also appears as the frontispiece to this biography.

One of the paintings Tung was shown early on by Hsiang Yüan-pien was the famous *Autumn Colors on the Ch'iao and Hua Mountains* (*Ch'iao Hua ch'iu-se*) by the Yüan master Chao Meng-fu 趙孟頫 (1254–1322), a handscroll now in the National Palace Museum, Taipei. Tung's account of how he came to own it himself, in the first of his five colophons on the scroll, is an example of what store the family set on Tung's friendship. In 1602, twenty years after Tung first saw it, Hsiang Yüan-pien's fourth son Te-ming 德明 brought the *Autumn Colors* for Tung to look at again. When Te-ming arrived, he found an equally famous painting, *The Lotus Society Gathering* (*Lien-she t'u*) by the great Sung master Li Kung-lin 李公麟 (1049–1106), already on Tung's table. The two men unrolled the paintings and admired them side by side. When the time came to go, Te-ming left the *Autumn Colors* behind, saying that the two works belonged together and should not be

parted. In 1635, only a year before his death and forty-five years after the death of Hsiang Yüan-pien, Tung copied out, at the prompting of Hsiang's second grandson Miao-mo 廟謨, the epitaph (*mu-chih-ming*) he had composed for Hsiang at the request of Hsiang's second son Te-ch'eng 德成, who had died in 1622. By great good fortune, the epitaph survives, and is included in the present exhibition (vols. 1 and 2, pl. 69).[83]

Twice, in 1579 and 1585, Tung failed to pass the provincial examination for the *chü-jen* degree, which for natives of the Southern Metropolitan Area, in which Hua-t'ing lay, was held triennially in Nanking: it was on his visit to Nanking in 1579 that he chanced to see the celebrated *Kuan-nu t'ieh* by Wang Hsi-chih.[84] Two and a half years after he failed for the second time, having been selected to study at the National University in the capital,[85] Tung traveled north to Peking in the spring of 1588 with the aid of funds supplied by a generous member of the local gentry, a former collegian of the National University named Fan Erh-fu 范爾孚 (whose name recurs later as one of three visitors on the occasion in 1603 when Tung executed a calligraphy that appears in the present exhibition, vol. 2, pl. 5).[86] At long last, in the autumn of 1588, Tung succeeded in capturing third place in the provincial examination for the Northern Metropolitan Area, held in Peking.[87]

The news was sent south by those in the capital with connections in Chiang-nan, and greeted there with considerable interest: Feng Meng-chen 馮夢禎 (1548–1605), an official from Hsiu-shui in Chia-hsing prefecture—later to own one of the most admired scrolls then existing, *Rivers and Mountains after Snow* (*Chiang-shan hsüeh-chi*) attributed to the T'ang master Wang Wei 王維 (701–761)[88]—records in his diary, on the thirteenth day of the ninth month, receiving word that Tung had placed third, in a letter from Hsü Chen-ming 徐貞明 (*chin-shih* 1571), who was serving in Peking as Vice Minister of the Seals Office.[89] As a *chü-jen*, Tung was now eligible to take the *chin-shih* examination to be held the following spring; and though he returned south briefly toward the end of 1588,[90] early in 1589 he set out again to make the long journey of almost 3,000 *li* to Peking.[91]

III. Han-lin Bachelor and Compiler in Peking (1589–1599)

The preliminary examination for the *chin-shih* degree, conducted once every three years, was known as the Metropolitan Examination (*hui-shih* 會試), and consisted of three sessions scheduled according to regulation on the ninth, twelfth, and fifteenth days of the second month. In 1589 there were four thousand four hundred entrants, of whom three hundred and

fifty emerged as *kung-shih* 貢士, or Passed Scholars,[92] the name given those who had passed the *hui-shih* as the initial hurdle, but had yet to achieve full status as *chin-shih*. Ch'en Chi-ju relates that Hsü Kuo 許國 (1527–1596), who had been appointed a chief examiner for the *hui-shih* of 1589,[93] and was one of the four Grand Secretaries then serving at court (Grand Secretaries being a select group who were the emperor's chief advisers and administrators, hence the most powerful officials in the central government), had placed Tung first after reading his examination paper. Ch'en goes on to recount that the Grand Secretary Wang Hsi-chüeh 王錫爵 (1534–1610) wrote to his fellow townsman in the south, the great litterateur Wang Shih-chen, that Tung appeared certain to place first—though it is unclear whether Hsi-chüeh meant in the *hui-shih*, or in the Palace Examination (*t'ing-shih* 廷試 or *tien-shih* 殿試) to follow, in which *chin-shih* candidates received their final ranking.[94] When the results of the *hui-shih* were announced on the twenty-ninth day of the second month,[95] T'ao Wang-ling of Kuei-chi (the same student who had read Tung's model essays as a boy) had placed first, Tung second, and Liu Yüeh-ning 劉日寧 of Nan-ch'ang third, all three (who soon became friends) attributing their success to the Grand Secretary Hsü Kuo.[96] Tung quickly developed for Hsü the strong regard that so often marks his encounters with the teachers and patrons who advanced his interests—though indeed esteem for one's examiner was felt to be almost obligatory. In a poem composed in 1768 for his own examiner, the poet Yüan Mei 袁枚 (1716–1797) wrote:

> Parents, however much they love a child,
> Have not the power to place him among the chosen few.
> Only the examiner can bring the young to notice,
> And out of darkness carry them up to Heaven![97]
> (Translation by Arthur Waley)

That Tung felt keenly his indebtedness to Hsü is demonstrated not only by a long poem written to celebrate Hsü's birthday that is included in his collected writings, the *Jung-t'ai chi*, but by three other compositions found there as well: a biography of Hsü's secondary wife, Madame Wang 汪氏 (in which Tung notes that over twenty years had passed since Hsü's death); an epitaph (*mu-chih-ming*) for the wife of Hsü's eldest son, Madame Pao 鮑氏; and an account commemorating the memorial shrine erected for Hsü at the site of his tomb.[98] So linked were Hsü and Tung in popular memory that Hsü's magnificent four-sided commemorative stone arch, erected in 1584 in Hsü's native She-hsien in honor of his appointment as Junior Guardian and Grand Secretary of the Hall of Military Glory—and today still standing in the town's center—is reputed to display Tung's calligraphy,[99] an obvious

impossibility given Tung's obscurity in 1584, when he had yet to succeed even in obtaining his *chü-jen* degree.

Tung's original calligraphy commemorating Hsü's memorial shrine, written no earlier than 1625, survives and is included in the present exhibition (vols. 1 and 2, pl. 55).[100] Characteristically, Tung begins his account by recalling gratefully that it was Hsü who had ranked the three of them, T'ao, Tung, and Liu, at the head of the *hui-shih* list.

Candidates in the final examination, the *t'ing-shih,* were ostensibly examined by the emperor himself; but in reality the papers were graded by Readers chosen from among the highest ranking officials in the capital. In 1589 there were fourteen Readers, including three Grand Secretaries (one of them Hsü Kuo), the Ministers of Personnel, Revenue, War, Justice, and Works, and the Left (or senior) Censor-in-chief,[101] evidence in itself of the enormous importance attached to the *chin-shih* process. From 1430 onward, the *t'ing-shih* was regularly held on the fifteenth day of the third month, precisely one month after the third of the *hui-shih*'s three sessions.[102]

Having passed the *hui-shih*, one was virtually assured of the *chin-shih* degree; but in 1589 three candidates failed to take the final examination, and when the results were announced three days later, 347 had been awarded the degree: 3 (as prescribed by regulation) in the first class, 67 in the second class, and 277 in the third. Tung had been placed at the head of the second class: fourth overall.[103]

To stand fourth in a class of three hundred and forty-seven was a very considerable achievement; but Tung, buoyed up by having placed second in the *hui-shih,* must have felt a sharp stab of disappointment. In his account of Hsü Kuo's memorial shrine (vol. 2, pl. 55), Tung mentions only his placement in the *hui-shih,* his final ranking conveniently omitted. Ch'en Chi-ju, in his "Life and Conduct" of Tung, composed after Tung's death, follows suit, writing tactfully only that "in 1589 [Tung] placed second."[104]

The difference between second place and fourth was substantial: holders of the top three places were automatically appointed Compilers in the Han-lin Academy, the institution responsible for, among other things, drafting imperial edicts, compiling the official histories of past reigns, and providing from among its members the Readers and Lecturers assigned the task of tutoring the emperor in the classics and histories. Almost all Grand Secretaries rose to their position through its ranks, as did senior officials in the important Ministries of Personnel and Rites. Membership in the Han-lin was virtually a prerequisite for those, like Tung, who aspired to political high office.

Three months were to pass, doubtless a period of some suspense, before Tung learned that he had been selected as a Han-

lin Bachelor (*Han-lin yüan shu-chi-shih* 翰林院庶吉士), together with twenty-one of his fellow *chin-shih*.[105] Bachelors were in effect trainees, who were "sent to the Academy for study."[106] After a period of tutelage that was nominally three years but was often much shorter, they were examined once again, and only those who passed with top honors were retained in the Academy and assigned functional positions as Junior Compilers (7a) or Examining Editors (7b). Surprisingly, those chosen as Bachelors were not always the highest ranking *chin-shih*: in 1589, fully half came from the third (or lowest) class, and one—Feng Ts'ung-wu 馮從吾 (1556–1627), whose name will reappear later as a staunch supporter of the Tung-lin 東林 cause—stood as far down as 296th. Even the holder of fourth place was by no means guaranteed entrance;[107] and in all likelihood it was owing principally to his success in the *hui-shih* that Tung received his appointment to the Han-lin.

In the seventh month of 1589, the former Left Vice Minister of Rites T'ien I-chün 田一儁 (d. 1591) and a second former minister, Shen I-kuan 沈一貫 (1531–1615), were jointly appointed as instructors to the new class of Han-lin Bachelors nominated the month before.[108] T'ien's selection was a natural one: he had spent much of his career in the Han-lin, at one point in charge of the Han-lin Academy in Nanking; he had served as Chancellor of the Directorate of Education; and in the second month of 1589, owing to the illness of the Minister of Rites Chu Keng 朱賡, he had been placed in charge of superintending the *hui-shih*.[109] Possibly as a result of T'ien's ill health, T'ien and Shen were later joined by Han Shih-neng 韓世能 (1528–1598), who in early 1590 was called out of retirement and promoted to Right Vice Minister of Rites, with a concurrent appointment in the Han-lin Academy.[110] On the eighth day of the third month, 1591, T'ien presented a memorial to the throne, seeking to retire on grounds of illness; and ten days later he died, still officially at his post.[111] Tung had requested leave from the Academy, intending to accompany the ailing T'ien home to his native Ta-t'ien in central Fukien—no mean undertaking, since Ta-t'ien was over 7,000 *li* distant.[112] T'ien's death, however, intervened; and Tung made the pilgrimage with T'ien's coffin instead.

It is sometimes suggested that Tung's decision to ask for leave from the Han-lin betokened a diminishing of his interest in an official career, and that having completed his journey to Fukien he returned to Hua-t'ing to devote himself more entirely to artistic pursuits. But there is ample evidence to show that, far from wishing to escape, in Peking Tung discovered an environment that both mentally and artistically he found stimulating and congenial. The Han-lin surrounded him with men whose intellectual caliber matched his own, and several of those who entered with him in 1589 soon became close

friends, in particular, as we know from Ch'en Chi-ju, Chiao Hung 焦竑 (1541–1620, later to become one of the foremost historians of the day) and Feng Ts'ung-wu, with whom Tung used to debate the Confucian classics; and Huang Hui 黃輝 and T'ao Wang-ling, with whom he held absorbing discussions on Ch'an.[113] Huang Hui (who as a child had been something of a prodigy, placing first in the *chü-jen* examination at the astoundingly young age of fifteen *sui*) also shared Tung's interest in calligraphy and became a calligrapher of some note; Tung later wrote in a colophon on one of Huang's works that of all those in the present dynasty who had modeled their calligraphy on the Sung master Su Shih 蘇軾 (1036–1101), only Wu K'uan 吳寬 (1435–1504) and Huang had come close.[114] In his preface of 1618 for Feng Ts'ung-wu's collected works, Tung jokingly refers to himself and his friends as "our clique" (*wu tang* 吾黨).[115]

Nor was Tung's acquaintance limited to his contemporaries in the Academy. One of his examination papers attracted the attention of the Grand Secretary Wang Hsi-chüeh, who paid Tung the compliment of saying that his calligraphy showed a study of the T'ang calligrapher Ou-yang Hsün, and also resembled Liu Kung-ch'üan's 柳公權 (778–865).[116] Wang was a calligrapher himself and evidently a shrewd judge: elsewhere Tung writes that as a Bachelor in the Academy he wrote his examinations taking Liu's calligraphy as a model.[117] Wang had certainly heard of Tung (we remember his letter to Wang Shih-chen), and may even have known him, before Tung entered the Han-lin: Wang's son, Wang Heng 王衡 (1561–1609), had captured first place to Tung's third in the *chü-jen* examination held in Peking in 1588; and Wang Heng was a close friend also of Ch'en Chi-ju, who as a youth had been invited by Hsi-chüeh to study in the Wang household.[118] As with the family of Hsiang Yüan-pien, Tung's friendship with the Wang family was eventually to extend to a third generation, and in Heng's son Shih-min 時敏 (1592–1680), whose *Landscape in the Manner of Huang Kung-wang* appears in the present exhibition (vol. 1, pl. 122; see also vol. 1, pl. 123–1), Tung was to find his favorite pupil and protégé.

Moreover, through the generosity of Han Shih-neng, his Han-lin professor (*kuan-shih* 館師, as Tung always calls him), Tung had an opportunity to see and study paintings and calligraphies that were among the choicest in private hands. Unlike Hsiang Yüan-pien, Han had no penchant for display: his few seals, where they do occur, are discreetly impressed near the edge of a work or on the mounting; but the works he amassed were fully the equal of Hsiang's in rarity and quality, if inevitably they failed to rival Hsiang's in number. Sometime after Han's death, a record of the collection, one hundred and sixty-seven works in all, was compiled at the instance of

Han's son Feng-hsi 逢禧 by the distinguished connoisseur Chang Ch'ou 張丑 (1577–ca. 1643).[119] Though a large proportion of the collection is lost, those few works that survive are today counted among the monuments of Chinese art: calligraphies like Wang Hsi-chih's *Ts'ao O pei*, which Han so venerated that Tung confesses he lacked the courage to borrow it;[120] or the *P'ing-fu t'ieh* by the Western Chin calligrapher Lu Chi 陸機 (261–303), for which Tung was invited by Han—as a mark of high favor—to write a title strip in the spring of 1591;[121] and such paintings as the *Five Planets and Twenty-eight Constellations* (*Wu-hsing erh-shih-pa-hsiu shen-hsing*), usually associated with Chang Seng-yu 張僧繇 (fl. early 6th century), to which Tung appended a colophon in 1636 attributing the work not to Chang but to the legendary figure painter Wu Tao-tzu 吳道子 (fl. ca. 700–ca. 750);[122] or the *Ten Odes of Ch'en* (*Ch'en-feng shih-pien*) by the Sung master Ma Ho-chih 馬和之 (fl. 1140–90), which Tung inscribed "by candlelight" in 1602, noting that before the painting was Han's, it had belonged to the notorious Grand Secretary Yen Sung.[123] Tung's colophon of 1602 is perhaps the earliest of the many he inscribed on works that had been in Han's collection. Precious as they were, Han was more than willing to bring out his works for students as talented as Tung, and even to loan them to copy; but Tung was not yet of a stature for Han to invite him to append opinions of his own. The title strip on the *P'ing-fu t'ieh* was honor enough for a young Han-lin Bachelor.

Of the ninety-five paintings Chang Ch'ou listed as being in Han's collection, only sixteen were Yüan in date, and of these only ten were landscapes, the one subject that for Tung held any real interest. Lacking the Yüan paintings more plentiful in the south, collectors in the capital like Han focused their attention on Sung and pre-Sung works, and Tung was swept by a convert's enthusiasm. From an admirer of Yüan he became an admirer of Sung; and the Yüan masters lay neglected if not forgotten. Two sentences from Tung's long inscription of 1624 on *Privileged Residents of the Capital* (vol. 1, fig. 18) refer to these first two years in Peking:

> After becoming an official [by which Tung means here, after entering the Han-lin], I used to borrow paintings to copy from the connoisseurs of Ch'ang-an [Peking]. Of genuine works by Sung masters, only those by Ma [Yüan, fl. ca. 1190–ca. 1225], Hsia [Kuei, fl. 1220–ca. 1250], and Li T'ang [ca. 1049–ca. 1130] were numerous, whereas Yüan paintings were scarce.[124]

既解褐，於長安好事家借畫臨倣。惟宋人真蹟馬、夏、李唐最多，元畫寥寥也。

But Tung was little attracted by the works of the Southern Sung Academy painters Ma, Hsia, and Li T'ang, whose works had never found much favor with connoisseurs in the south;

he was intent on the more illusive figures of an earlier period. Precisely where Tung's interest lay is revealed in a letter he sent to Ch'en Chi-ju, written in Peking and probably dating from this very period:

> [The painters] I [most] want to study are [the tenth-century masters] Ching [Hao], Kuan [T'ung], Tung [Yüan], Chü [-jan] and Li Ch'eng. But it is precisely these five whose genuine works are particularly scarce. The Sung paintings [preserved] in the south are not even worth examining. Should you be lucky enough to discover any [genuine works], set down a record of your favorite impressions, like the Sung [connoisseurs of old]. When I have finished my own, we can combine them in a single volume; and even if we cannot collect [such works] ourselves, it will serve to give us pleasure. We must not allow Hai-yüeh [Mi Fu, 1051–1107] alone to produce a *History of Painting*.[125]

所欲學者荆、關、董、巨、李成。此五家畫尤少真跡。南方宋畫不堪賞鑒。兄幸爲訪之，作一銘心記，如宋人者。俟弟書成，與合一本。即不能收藏，聊以適意。不令海岳獨行畫史也。

The last sentence issues a challenge across the centuries: already Tung had set himself to equal—in knowledge and in insight, in the antiquity and even sheer number of works viewed—the great connoisseurs of the past, preeminent among them Mi Fu, author of the *Hua-shih* (*History of Painting*). Famous as a painter, calligrapher, connoisseur, theorist, and art historian, hence a pivotal figure in the history of Chinese art, Mi embodied all Tung hoped to achieve. When Tung envisioned his own place in history, it was Mi Fu, along with the calligrapher and painter Chao Meng-fu—the predominant artistic figures in the Sung and Yüan—whose positions he was determined to match, and perhaps surpass.

Tung complains in his letter to Ch'en of the paucity of works by the five great tenth-century painters Ching Hao, Kuan T'ung, Tung Yüan, Chü-jan, and Li Ch'eng; and indeed during his first two years in Peking there is no record that he saw even a single work by these masters, who had dominated Chinese landscape painting in its first great age. The paintings Han Shih-neng showed him, early though they were, were as often as not figure paintings, and for Tung only landscape paintings had an overpowering attraction. One that Han did show him, perhaps at this time, was a short handscroll with a charmingly archaic landscape entitled *Excursion in Spring* (*Yu-ch'un t'u*; vol. 1, fig. 6), attributed to Chan Tzu-ch'ien 展子虔 (fl. late 6th century), now in the Beijing Palace Museum; long afterward Tung inscribed the scroll when he saw it again in 1630 at the home of Han's son Feng-hsi.[126] Another was the exquisite handscroll now in the National Palace Museum, Taipei, entitled *River and Mountains in Miniature* (*Chiang-shan*

hsiao-ching), attributed to the Sung Academy painter Li T'ang.[127] Li T'ang, whose style had led the way to Ma Yüan and Hsia Kuei, was not an artist Tung was wont to admire, but almost in spite of himself he was won by the painting's delicate beauty.

River and Mountains is the only painting we know that Tung borrowed from Han with a view toward copying. In a colophon on the scroll, he tells how he later came to own it himself:

> This handscroll is the *River and Mountains in Miniature*, which my professor [Vice] Minister of Rites Han obtained from the Commissioner-in-chief Chu Hsi-hsiao [1518–1574]. Once, as a Han-lin Bachelor, I borrowed and examined it for two nights, marveling so over its skill that I was powerless to copy it. [Later], when Han's eldest son Chao-yen [Han Feng-hsi] visited Wu-lin [Hang-chou], he fell prey to temptations and [lacking money] pawned the scroll to a dealer. Unable to reclaim it himself, he asked me to redeem it, [preferring that the painting should belong to me]. [Knowing that the painting was worth more], I gave him back the original *Hsing-jang t'ieh* of fifteen characters by the General [Wang Hsi-chih] [that had once been in his father's collection], to cover the rest of what he owed. Thus this painting [remained] in my box; while the golden pavilions in Wu-lin [that Chao-yen lavished on his mistress] had already crumbled into dust. Having remounted [the painting], [I took the occasion] to write this account. Inscribed by Ch'i-ch'ang in the ninth month of 1623.[128]

此卷屬《江山小景》，館師韓宗伯得之朱太尉希孝。予屬庶常，嘗借觀信宿，嘆其精絕不能下手。及韓長公朝延游武林，有所惑溺，質之好事家。力不能復，告予取歸。又以右軍《行穰帖》真跡十五字還長公，足所未盡。畫則在匧也，而武林金屋已成塵矣。因重付裝潢紀之。歲在癸亥九月，其昌識。

Tung was more intent on training his hand by borrowing the calligraphies in Han's collection, in which works from the very earliest period, the Chin, outstripped even those belonging to Hsiang Yüan-pien.[129] One calligraphy that made a particular impression on him was the *Huang-t'ing nei-ching ching* on yellow silk that Han considered to be the work of Wang Hsi-chih, to whom the scroll had been attributed by an early connoisseur. Tung borrowed the work from Han and made a copy of the opening section, which he later included in his *Hsi-hung t'ang fa-shu*, a collection of woodcut reproductions of calligraphies by famous masters that he published in 1603. There, following for once in his life the lead of Chao Meng-fu, he reattributed the calligraphy to the Taoist mystic Yang Hsi 楊羲 (330–387), and placed it out of chronological order at the very head of his collection, as being (he said) the work of a Taoist immortal.[130] Very likely he was also influenced by Han's evident fondness for the work: the Shanghai Museum

preserves a copy of the entire calligraphy by Han, over nine feet long, dated in a colophon by Han's son to 1586, the only full-length calligraphy by Han now known to be in existence.[131]

Another calligraphy Tung later reproduced in the *Hsi-hung t'ang fa-shu* was Wang Hsien-chih's *Lo-shen shih-san-hang* (vol. 1, fig. 50), which he borrowed from Han three days before setting out in the spring of 1591, on the eleventh day of the intercalary third month, to make the long journey south to Fukien. In a passage recorded in the *Jung-t'ai chi*, he writes:

> That day [i.e. the eighth, when Tung borrowed the scroll] a large number of friends brought wine to my inn, and [only] when I had taken care of them in turn by bringing out my *ch'in*, chess set, and so forth, was I at leisure to copy this scroll. When I was finished, I had succeeded entirely in capturing its physical form [lit. flesh], but what I had failed to grasp was its soul—which was not surprising.[132]

是日也，友人攜酒過余旅舍者甚多，余以琴、棋諸品分曹款之，因得閒身倣此帖。既成，具得其肉，所乏神采，亦不足異也。

As a parting gift to his most promising pupil, Han (who earlier in his career had served as an envoy to Korea) presented Tung with a length of yellow Korean paper. By the spring of 1592 Tung had had it mounted; and on the eighteenth day of the fourth month, having free time as he was boating north by way of the Yellow River on a journey back to Peking, he took up his brush and filled it with comments on the theory and practice of calligraphy—comments that were later incorporated in the opening two sections of the *Hua-ch'an shih sui-pi*, a collection of Tung's writings compiled by an obscure landscape painter named Yang Pu 楊補 (1598–1657).[133] Astonishingly, the yellow paper with Tung's observations still exists (vols. 1 and 2, pl. 1), complete with a colophon by Tung dated 1610 recounting its history, a document doubly important as the dated source of eleven passages in the *Hua-ch'an shih sui-pi* not contained in the *Jung-t'ai chi*, and as the earliest handscroll by Tung yet to be discovered.

Tung's return to Peking in the summer of 1592 was not his first trip back to the capital after making the journey south. This we know from a colophon by Han Shih-neng himself, one of only two by Han recorded in the *Shih-ch'ü pao-chi*, the eighteenth-century catalogue of the imperial collection. The colophon is appended to a painting that was in his own collection, *Wen-chi's Return to China* (*Wen-chi kuei Han*), attributed by him to the T'ang painter Yen Li-pen 閻立本 (fl. ca. 626–73) and now in the National Palace Museum, Taipei (where it is attributed to the Sung painter Li T'ang). At the end of his colophon, Han gives us a fascinating glimpse of what may be described as a "seminar" in connoisseurship, attended by

his Han-lin students, whose names are for the most part already familiar to us:

> Whenever I brought [this painting] to the [Academy] offices, and time remained after holding classes, I used to unroll it [for all] to enjoy. Looking on [today] were my students T'ao Wang-ling, Chiao Hung, Wang K'en-t'ang, and Liu Yüeh-ning. Huang Hui ground the ink for me to write, and Tung Ch'i-ch'ang took charge of burning the incense. I myself held the brush. Written by [Vice] Minister of Rites and Academician [Reader-in-waiting] Han Shih-neng, in the Ying-chou Pavilion of the Han-lin Academy, on the fifteenth day of the tenth month of 1591.[134]

> 余每攜至公署，教習督課之餘，常披玩之。時同觀者，門人陶望齡、焦竑、王肯堂、劉日寧。爲余和墨作字者黃輝，焚香從事者董其昌，執筆者世能也。時萬曆辛卯十月十五日，禮卿學士韓世能書於翰林院之瀛洲亭。

The date of Han's colophon proves conclusively that Tung—far from retiring to Hua-t'ing after accomplishing his mission in Ta-t'ien—was back in Peking and at the Han-lin Academy by the middle of the tenth month, seven months at most after setting out.[135]

Why, then, did Tung choose to undertake the journey to Fukien? No doubt his ostensible motive—his respect for T'ien I-chün—was genuinely a factor: T'ien was known for his probity (his short biography in *The Veritable Records of the Ming Dynasty*, the *Ming shih-lu*, makes the point that he died a man of modest means[136]); and one of Tung's more agreeable qualities was his habit of forging close bonds with older men who were his teachers and patrons. That T'ien's death was sincerely mourned by the Han-lin Bachelors who had been in his charge is suggested by a group of twenty-three poems, written by eleven of their number, that are included in an addendum to T'ien's collected writings, under the heading "Poems Lamenting Mr. T'ien Chung-t'ai."[137]

But Tung, never slow to recognize what could work to his advantage, must also have calculated that so filial an act as the transporting of T'ien's coffin might well impress his superiors—in particular, perhaps, Wang Hsi-chüeh, whom T'ien had supported in the struggle against the former Grand Secretary Chang Chü-cheng 張居正 (1525–1582)[138]—and conceivably lead to promotion. Mo Ju-chung, after all, who had died in 1589, was still remembered for having arranged the funeral of the executed (and later exonerated) Grand Secretary Hsia Yen 夏言 (1482–1548).[139] That Tung's action did impress some of those who heard the story is certain: one whose attention it caught was Hsing T'ung 邢侗 (1551–1612), a provincial official who later in life was to gain considerable prestige as a calligrapher. Hsing and Tung had never met; but moved by an account of Tung's trip, Hsing composed a poem in token of his

admiration, to which he appended an explanatory colophon. The poem, of course, led quickly to friendship.[140] The fact that the story of his journey was included in Tung's *Ming-shih* biography is proof of how favorably the deed was viewed.

Equally important to Tung was the chance afforded him to travel through some of the most spectacular mountain scenery in China. Hitherto, aside from journeying by boat, either to Nanking along the lower reaches of the Yangtze, or to Peking along the Yellow River and through the flat countryside bordering the Grand Canal, Tung had lived all his life in the vicinity of Hua-t'ing and the modest hills and lakes within its reach. For one so enamored of landscape painting and the mountains that were its constant theme, the journey to Fukien must have seemed heaven-sent; and Tung took plenty of time to explore the places that attracted him along the way. Boating along the Yellow River, he practiced his calligraphy, modeling his style on the *Huang-t'ing nei-ching ching* on yellow silk that he had seen in Han's collection.[141] By the fifth month he had reached Chen-chiang in present-day Kiangsu, on the Yangtze River, where he made an excursion with friends to see Mount Pei-ku, beloved by Mi Fu, and the Kan-lu Temple at its foot.[142] By autumn he was in Fukien, arriving finally at Ta-t'ien, which he describes as having "seven cliffs close by the water, and at the foot of the mountains everywhere level fields."[143] Near Fukien's border with Kiangsi, he traveled through the Wu-i mountains, named according to one tradition after the Taoist immortal Wu-i chün 武夷君, who lived there in the time of Ch'in Shih Huang-ti (r. 221–209 B.C.). The mountains enthralled him:

> Wu-i's Chieh-sun Peak is astonishing and wonderful, the most beautiful of all mountains under heaven. I could not climb it, but looked up at it as my boat went past, and [felt as if] I were already in another world.[144]

> 武夷接筍峯奇絕，爲天下各山最佳處。余不能登峯，舟行仰視，已在別一世界。

When at last Tung returned to Peking at the end of autumn or beginning of winter, it was to find he had tarried too long. In 1591, the examination marking the end of the Bachelors' course of study—nominally held after three years in the Han-lin but in practice held after little more than two—was scheduled earlier than usual, by the twelfth day of the eighth month.[145] Tung returned to find the examination over and his coterie of particular friends installed in the Han-lin as Compilers (or in the case of Wang K'en-t'ang as an Examining Editor). Of the six who gathered around Han Shih-neng to examine *Wen-chi's Return to China*, only Tung was still a Bachelor, lacking a formal appointment, his immediate

future uncertain. Whether from a want of funds or otherwise, he decided to return to Hua-t'ing, to devote himself to his painting and calligraphy and await the chance of a promotion he no doubt felt he deserved.

Before he left, Tung wrote out the text for a stele to be erected in a temple dedicated to the fabled Han general Kuan Yü 關羽 (or Marquis Kuan, d. 219; deified in 1594 and worshiped as Kuan-ti 關帝 or Wu-ti 武帝, the God of War) located within the confines of the Cheng-yang Gate, the principal gate on the road leading from the Imperial Palace south toward the Temple of Heaven. Tung's original calligraphy is not known to survive;[146] but rubbings made from the stele are preserved in the Peking Library and in the Field Museum of Natural History in Chicago, an example of Tung's calligraphy even earlier than the comments he wrote out on Han's yellow Korean paper on his way north in 1592.[147] The text of the stele, which is dated "a winter's day, 1591," had been composed by "the Senior Compiler Chiao Hung"; the seal-script characters of the heading written by "the Examining Editor Wang K'en-t'ang"; and of the sixteen additional names listed of men who contributed to the stele's erection, nine were Tung's fellow Han-lin Bachelors, their names prefaced with their new titles: Junior Compiler, Examining Editor, or Censor.[148] That Tung was compelled to sign himself simply "[Han-lin] Bachelor Tung Ch'i-ch'ang" was a graphic illustration of how far he had fallen behind the others.

In Hua-t'ing Tung had little to do but pursue his own interests, and his year there seems to have been significant for the development of what was to become known as his theory of the Northern and Southern schools of landscape painting. How he occupied himself we know from two passages, one of which is again his long inscription of 1624 on *Privileged Residents of the Capital*, in which he traces his early progress. A few lines refer to his months spent in Hua-t'ing:

> In 1591 I requested leave [from the Han-lin] and returned home.[149] There I searched everywhere for paintings [lit. splashed-ink works] by the four painters of my district.[150] Eventually I decided that I should trace the source [of their style] and [realized] that I should take only Pei-yüan [Tung Yüan] as my master.[151]

辛卯請告還里。乃大搜吾鄉四家澄墨之作。久之,謂當溯其原委,一以北苑為師。

The other passage, recorded in the *Jung-t'ai chi*, must once have been inscribed on a painting of his own, which is now unfortunately lost. The painting was evidently a copy of one he borrowed, though the original is not mentioned by name; and the passage suggests that part of Tung's early motivation to copy works came from an inability to afford them:

> This work [is one of those I painted] as a Bachelor on leave [from the Han-lin] in 1592 and 1593, when I was living at home with leisure to spare and [used to] borrow paintings to copy from the Drafter [of the Central Drafting Office] Ku [Cheng-i] and the Collegian of the National University Sung [An-chih].[152] I amassed as many as several dozen such copies,[153] but little by little they have scattered and disappeared, till only this one is left. Since then [1593] I have collected quite a number of paintings; but my copies, by contrast, are fewer than before.[154]

此余壬辰癸巳為庶常請告,家居多暇,與顧中舍、宋太學借畫臨倣之筆。所謂粉本,用貯奚囊者,不下數十幅,遺散漸盡,止存此耳。自是蓄畫頗多,臨摹反不及前。

During the two years he spent in the capital, after passing his *chin-shih* degree in the spring of 1589, Tung's primary interest was still calligraphy rather than painting. Certainly none of the paintings he had so far seen had affected him so profoundly as the *Kuan-nu t'ieh* by Wang Hsi-chih. Despite the number of references to these early years in Peking, we know of only two Sung landscapes that he actually saw there—Li T'ang's *River and Mountains in Miniature*, and the *Peach Blossom Spring* (*T'ao-yüan t'u*) in color by Chao Po-chü 趙伯駒 (ca. 1120–ca. 1170)[155]—though he must have seen or read enough to convince him that the tenth-century masters held the key he was after. Yet in 1592, on the evidence of the passage above, Tung began to borrow and copy paintings at an unprecedented rate. One reason, no doubt, was the nature of the collections available to him in Hua-t'ing: neither Ku Cheng-i nor Sung An-chih, for instance, had the wealth to purchase famous calligraphies of the Chin and T'ang periods. Instead they collected paintings—not figure paintings or the Ma-Hsia paintings Tung had seen so much of in Peking, but the Yüan works familiar to Tung from his youth.

Tung, however, was not content to revert in his own paintings to the Yüan styles that had dominated his early efforts. His appetite for Sung painting, whetted during his brief years in the capital, had been far from satiated by the works he found there. A study of the Yüan paintings he saw in Hua-t'ing soon led him back in the direction of Sung—more particularly, in the direction of the tenth-century master Tung Yüan.

How he reached the conclusion that "[he] should take only Pei-yüan as [his] master" is something of a mystery. In 1592 Tung had never, to his knowledge,[156] seen even a single work by Tung Yüan.[157] Chiang-nan had lamentably few such paintings: Tung later wrote of his months in Hua-t'ing, "I sought [everywhere] in Chiang-nan for Tung Pei-yüan's paintings but I couldn't obtain one."[158] Tung, however, was not averse to basing a conclusion on theoretical grounds, rather than on the

pragmatic grounds of visual evidence. Relying, one might say, on intuition tempered by tradition, he projected Tung Yüan as the stylistic progenitor of the great Yüan masters. That Tung Yüan's surname was the same as his own—"Pei-yüan of my family," as Tung so often calls him—was an added inducement and cause for satisfaction.

In 1592, then, Tung's great ambition was to find and buy (if he could) a painting by Tung Yüan. In Chiang-nan he was unsuccessful; so in the spring of 1593, on the advice of Ku Cheng-i, he made a trip to Peking in search of a painting by Tung Yüan owned by a collector in the capital. As luck would have it, on the third day after his arrival, the very painting was brought to him by a wealthy merchant turned collector named Wu T'ing 吳廷 (*tzu* Yung-ch'ing 用卿, *hao* Chiang-ts'un 江邨), from She-hsien in present-day Anhui, with whom he later became friendly; and Tung succeeded in acquiring his first Tung Yüan, and as far as we know only his first or second painting, *Travelers among Streams and Mountains* (*Hsi-shan hsing-lü*).[159] The *Travelers* was reputed to be the only painting by Tung Yüan ever seen by Shen Chou 沈周 (1427–1509) and Wen Cheng-ming, the two great masters of early and middle Ming. Aspiring as he did to surpass Shen and Wen, Tung must have felt his purchase to be a happy augury.

It is tempting to think that it was Tung's acquisition of the *Travelers* that led him to perceive the importance of Tung Yüan's style for Yüan painting—in other words, that Tung's discovery had an empirical basis. But this does not seem to have been the case. His new painting was something of a disappointment: "Having studied the *Travelers*," Tung wrote, "I still could not fully grasp Pei-yüan's style." It was not until 1597, when he acquired *Privileged Residents of the Capital* (vol. 1, fig. 18), and more important, Tung Yüan's *Hsiao and Hsiang Rivers* (*Hsiao-Hsiang t'u*; vol. 1, fig. 2), that Tung could say he had to some extent "satisfied his ambition" to own a real Tung Yüan.[160] That Tung Yüan's style provided the fundamental impetus for Yüan painting was a conclusion Tung had already reached a priori.

Tung's trip in the spring of 1593 was in fact (as the reader may recall) his second return to Peking after leaving his friends in the Han-lin toward the end of 1591. On works that either date to or refer to the spring and early summer of 1592—one of them his *Theories on Calligraphy and Painting* in the exhibition here (vol. 2, pl. 1)—he mentions either "traveling north" or "returning to court,"[161] though he does not tell us why, as he does for his trip in 1593. The *Hua-ch'an shih sui-pi* contains a passage, purportedly dating from the fifth month of 1592, in which Tung writes that he is on his way back from having officiated as the imperial representative at the investiture of the Prince of Ch'u.[162] But the passage is either wrongly

dated or spurious, on a number of grounds: no Prince of Ch'u was invested in 1592;[163] Tung, being only a Bachelor in the Han-lin, was ineligible for such an assignment; and from the spring of 1592 to the eighteenth day of the fourth month we can trace his progress from Wu-hsi to Yang-chou to Ssu-yang in present-day Kiangsu, heading north, far away from the seat of the Prince of Ch'u in Wu-ch'ang, Hu-kuang.[164] On the fourth day of the fourth month, at Lü-liang in what is now northwestern Kiangsu, Tung painted a fan in the manner of Ni Tsan that is preserved in the National Palace Museum, Tai-pei, the earliest dated painting by Tung now known to survive (fig. 39).[165]

That twice in twelve months Tung made the long trip to Peking suggests that in addition to his ostensible motive, his quest for a genuine Tung Yüan, Tung may have felt that promotion was unlikely to be forthcoming if he absented himself for very long from public view. Unfortunately for Tung, both Grand Secretaries who might have furthered his career, Wang Hsi-chüeh and Hsü Kuo, had resigned their positions in 1591, while Tung was traveling to and from Fukien; but in the first month of 1593 Wang Hsi-chüeh returned to court, this time to serve as senior Grand Secretary.[166] Almost certainly Tung had had a chance to meet with Wang while both were in the south: in the second month of 1592 both had inscribed a handscroll belonging to Ch'en Chi-ju that Ch'en (with an optimism that some, including Tung, privately considered unfounded[167]) attributed to the T'ang calligrapher Yen Chen-ch'ing.[168] Possibly it was Wang who was instrumental in obtaining for Tung his long-awaited appointment; in any event, on the twenty-eighth day of the fifth month, 1593, four months after Wang's return to Peking, Tung received promotion at last as a Junior Compiler in the Han-lin (*Han-lin yüan pien-hsiu* 翰林院編修, rank 7a),[169] a post he was to hold for the next six years.

In 1594 the Emperor Shen-tsung (r. 1573–1620), bowing to intense pressure from his ministers, agreed to allow his eldest son Chu Ch'ang-lo 朱常洛 (then thirteen *sui*) to begin the formal education that for an heir apparent generally began at the age of six. Ch'ang-lo had been born in 1582 to a minor lady-in-waiting, née Wang 王, in the entourage of the emperor's mother, the Empress Dowager Tz'u-sheng 慈聖. Reputedly, Shen-tsung's first impulse had been to deny paternity altogether; and he grudgingly acknowledged the boy only after the empress dowager produced the eunuchs' daybook in which his visit to the lady in question was recorded.[170] In 1586 the emperor's favorite concubine, Lady Cheng 鄭貴妃, gave birth to a son (the emperor's third, his second having died in infancy), whom the emperor soon determined to name as his heir. The controversy that arose over the succession—referred

Figure 39. Tung Ch'i-ch'ang. *Landscape after Ni Tsan*, dated 1592. National Palace Museum, Taipei.

to in records as "the contention over the trunk of the state" (*cheng kuo-pen* 爭國本)—involved the emperor in a dispute with his ministers that was to last until his final capitulation in 1601, when at length he agreed to confirm Ch'ang-lo as heir apparent. The bitterness of the struggle was no doubt a contributory factor in precipitating the emperor's almost total withdrawal from the necessary daily affairs, and even ceremonies, of state: from 1590 onward there was almost no contact between the emperor and his chief ministers, the Grand Secretaries, save through the eunuchs who acted as his emissaries.[171]

The date set for the prince to begin his formal studies was the fourth day of the second month, 1594; and nineteen days earlier there was an announcement of the officials who were to serve as Ch'ang-lo's initial group of tutors.[172] Biographers of Tung, basing themselves on his *Ming-shih* biography (whose oversimplification results here in a most misleading compression of events), have hitherto fixed upon 1594 as the date Tung became a tutor: Tung is even considered by some to have been summoned back to Peking (from leave of absence in Hua-t'ing) precisely for this purpose. Nothing could be further from the truth. The only member of Tung's *chin-shih* year to be accounted senior enough to serve as a tutor was Chiao Hung, who had placed first in the *t'ing-shih* of 1589 and had held his position as a Compiler in the Han-lin for four and a half years. Of the others awarded the junior position of Lecturer and Reader (*Chiang-tu kuan*) to the emperor's eldest son, all five had taken their *chin-shih* degrees earlier, either in 1583 or in 1586; and all had served as Compilers (or in one

case as an Examining Editor) for at least five years. Tung, as a Compiler of only nine months' standing, was in no position even to be considered.

Tung, in fact, over the next five and a half years, was allotted a series of different tasks, running almost the full gamut of the duties customarily assigned to Han-lin Compilers and Examining Editors, collectively called *Shih-kuan* 史官 (Historiographers), intended to familiarize him with the duties that were an integral part of the Han-lin's activity. In the first month of 1594 he was ordered, together with several of his former Han-lin Bachelor classmates, to compile memorials presented to the six Ministries, intended for eventual use in writing the Veritable Records of the Emperor Shen-tsung's reign;[173] and a few days later he was appointed one of several Librarian Assistants (*Chan-shu kuan* 展書官),[174] whose duty it was to turn the pages of the books placed in front of the emperor during the Classics Colloquia (*ching-yen* 經筵), the sessions in which the emperor was tutored in the classics and histories by ministers (often from the Ministry of Rites or Directorate of Education) who held concurrent Han-lin appointments. By 1594, however, the duties of Lecturer and Librarian Assistant no longer entailed the necessity of actual performance, Shen-tsung having wearied of his tutoring sessions and abandoned them in 1589.[175]

In the third month of 1594, Tung was one of a group of thirty appointed to compile a Standard History of the dynasty ([*Kuo-ch'ao* 國朝] *cheng-shih* 正史), Tung as one of nineteen Compilers joining eleven high-ranking ministers appointed to

the project as Vice Directors.[176] The aim of the project was to produce a history of the dynasty relying, to a greater extent than ever before, on material drawn from original sources; unfortunately it was brought to an abrupt halt in 1597, when fire destroyed the building in which the office was housed.[177] More than twenty officials were assigned to the compilation, in addition to the original thirty, over the two and a half years it was in progress, of whom the most important (from Tung's standpoint) was Yeh Hsiang-kao 葉向高 (1559–1627), who in the eighth month of 1595 was appointed a Companion in the Right Secretariat of the Heir Apparent (6a) and joined the project as a Compiler.[178] Yeh, though several years younger than Tung, had taken his *chin-shih* degree six years before Tung in 1583, at the enviably early age of twenty-two *sui*; and he was already a seasoned Compiler in the Han-lin when Tung entered as a Bachelor in 1589. Almost certainly the two had met by 1594, when Yeh left the Han-lin to become Director of Studies in the Directorate of Education;[179] but now their joint connection with the *Cheng-shih* compilation presented them with renewed opportunity to forge a friendship. Years later, on the evidence of Ch'en Chi-ju, it was to be Yeh—recalled to the capital as titular Minister of Personnel and senior Grand Secretary—who in 1621 engineered Tung's reappointment to office in Peking, after a hiatus of more than twenty years.[180]

Though Tung was presumably a participator in the *Cheng-shih* project throughout its duration, he was from time to time called upon to perform other tasks commonly assigned to Han-lin members, which for several weeks or even months superseded his duties at the compilation office. The first of these temporary assignments, as an Associate Examiner (*T'ung-k'ao kuan* 同考官) in the *chin-shih* examination of 1595, we know of only from two anecdotal accounts in the *Jung-t'ai chi*, both written more than thirty years later. One appears in a congratulatory essay to mark the fiftieth birthday of the wife of one of the erstwhile candidates; the other in his biography of another candidate, Wu Hua 吳化 (*tzu* Tun-chih 敦之), of which the original calligraphy, dated 1626, survives in the Tokyo National Museum.[181] From the number of lines he devotes to his own part in the examination, it is clear that Tung relished his novel position as examiner rather than examinee.

Tung must have felt he was prospering. He was already owner of a second valuable painting—*River Village on a Cool Summer Day* (*Chiang-hsiang ch'ing-hsia*), now in the Museum of Fine Arts, Boston, by the late eleventh-century master Chao Ling-jang 趙令穰 (d. after 1100)—that he had obtained in Peking; and as an official and collector now himself, he evidently felt warranted in writing to Feng Meng-chen (who late in 1594 had been appointed a Vice Director of the *Cheng-shih*

project but was still in the south[182]) to propose that Feng lend him his newly acquired *Rivers and Mountains after Snow*. The request was a bold one: Feng was considerably his senior in rank; and *Rivers and Mountains*, which had been discovered concealed in a bamboo tube, in the tearing down of an old house in the capital,[183] was attributed to the legendary T'ang master Wang Wei. Tung writes that Feng was loathe to part with a treasure he valued as much as he did his eye or brain, but reluctantly agreed, and sent the painting with a request that Tung compose a colophon for the scroll. (In his diary, on the thirteenth day of the seventh month, 1595, on the other hand, Feng records that he was delighted to get Tung's letter asking to borrow the painting.[184])

It is hardly too strong to say that for Tung the occasion was to prove a watershed: Feng was the first prominent figure to request his colophon on an important work.[185] Tung rose to the occasion by producing the longest colophon he was ever to compose: a lengthy discourse on Wang Wei's style in which, characteristically, he congratulates himself on having deduced the elements of Wang's style even before unrolling the painting. He begins by drawing an equation between Wang Wei as a painter and Wang Hsi-chih as a calligrapher; and indeed *Rivers and Mountains* only confirmed the conclusion he had already reached: that in Wang Wei was to be found the fountainhead from which sprang what he came to call the "Southern School," the *cheng-ch'uan* 正傳 (correct tradition) to which, of course, he himself belonged. It is by no means certain when (and to some scholars, even if) he wrote the famous passage laying down the theory of the Northern and Southern schools: the Northern—like the Northern School of Ch'an dependent on years of arduous training—that had its beginning in the highly colored blue-and-green style of the T'ang painter Li Ssu-hsün 李思訓 (fl. ca. 705–20); the Southern—like the Southern School of Ch'an with its emphasis instead on inborn talent—that began with the graded ink washes of Wang Wei, and extended through Tung Yüan to the Four Yüan Masters.[186] But drawing as it does on Ch'an as an analogy, very likely the passage dates from his years in Peking, when Ch'an was still an engrossing topic of discussion among Tung and his friends, and when he was actively developing the ideas that later were to seem to him axiomatic.[187]

Two other Han-lin assignments, in 1596 and 1597, were to provide an agreeable chance to travel south and west, at government expense, to the two great lakes P'o-yang and Tung-t'ing, and beyond to the reaches of the Hsiao and Hsiang Rivers, so beloved of painters, which had long dwelt in Tung's imagination.

On the first day of the fifth month, 1596, an announcement was made of the emperor's decision to ennoble eleven mem-

bers of the imperial clan and six wives; and Tung, one of four-teen imperial envoys appointed, was dispatched to officiate at the investiture of Ch'ang-wen 常汶 and Ch'ang-fan 常灞, youn-ger sons of the Prince of Chi 吉王, whose seat was in Hu-kuang at Ch'ang-sha, on the banks of the Hsiang River.[188] Tung traveled south from Peking via the Grand Canal, halting frequently en route as he neared its southern end to visit friends and collectors to whom he had received introductions (notably at Wu-hsi and Chia-hsing, as his colophons show), finally reaching Hang-chou toward the end of the seventh month.[189] From Hang-chou he traveled westward to Ch'ang-sha, presumably on a southerly course whose path must have lain at its outset along the Fu-ch'un River—all the more fasci-nating to Tung since he had just acquired Huang Kung-wang's famous *Dwelling in the Fu-ch'un Mountains* (*Fu-ch'un shan-chü*; vol. 1, fig. 17), which may indeed have determined his choice of route.[190] Returning from Ch'ang-sha, he traveled first north along the Hsiang River, which empties into Tung-t'ing Lake, and then eastward at a leisurely pace along the winding course of the Yangtze, stopping here and there to visit, for instance, a protégé serving as District Magistrate of Huang-kang in Hu-kuang (for whom he executed a calligra-phy), and to view the Tung-lin Temple at Chiu-chiang in Kiangsi, where he was delighted to find the white lotuses in full bloom.[191] By the tenth month he had reached the vicinity of his home in Sung-chiang, where he seems to have dallied several months, delaying the journey back to Peking till the weather turned seasonable the following year.

While still in Peking, Tung had acquired a copy of a paint-ing by Kuo Chung-shu (d. 977) after Wang Wei's *Wang-ch'uan Villa* (cf. vol. 1, fig. 36), and had heard that the original hand-scroll by Kuo was preserved in Hang-chou.[192] The trip to Ch'ang-sha provided the opportunity to take Hang-chou in his way, and Tung turned the chance to good account: not only did he see Kuo's *Wang-ch'uan Villa* but he was invited to inscribe it as well, proof that he was beginning to win suffi-cient recognition as a calligrapher and connoisseur to make his inscription welcome, even on a scroll of such antiquity as this. In it he mentions having Wang Wei's *Rivers and Moun-tains after Snow*, which technically of course was true, since he had not yet returned it to Feng Meng-chen; but it is typi-cal of Tung that he should pretend to slightly more than he could actually claim.[193] In his colophon, Tung's admiration is really all for Wang Wei, rather than for the painting itself; his real opinion we learn from a colophon he wrote two days later on *River Village on a Cool Summer Day* that he owned him-self and had taken with him on the trip.

Earlier, passing through Chia-hsing, I saw Chin-ch'ing's [Wang Shen, 1036–after 1099] *Mount Ying* in the collection of the Hsiang

family; and when I arrived in Wu-lin [Hang-chou] I saw Kuo Shu-hsien's [Kuo Chung-shu] *Wang-ch'uan Villa* in the collection of Mr. Kao [Kao Lien[194]]. Both scrolls were reputed to be famous works of the Northern Sung period. But when one sees this scroll [*River Village*], they cannot but yield [by comparison]. The brush-work of *Mount Ying* was exceedingly fine and meticulous, and lacked freedom and naturalness; whereas the *Wang-ch'uan Villa* was for the most part without modeling strokes: it [was executed] merely in outline and color, with the mannerisms of the Southern Sung painters. When I was in the capital, I was constantly think-ing of them, [so much so] that they appeared in my dreams. But now that I have had the chance to look them over carefully, I begin to know what Ying-p'ing [Chao Ch'ung-kuo, 137–52 B.C.] [meant when he] said, "One look is worth a hundred descriptions." How true were the old general's words. Here we apply them to paint-ing—though what indeed do they not apply to? One must oneself develop the "dharma-eye," and not believe everything one hears.[195]

先是，予過嘉興觀項氏所藏晉卿《瀛山圖》，至武林觀高氏所藏郭恕先《輞川圖》。二卷皆天下傳誦北宋名蹟，以視此卷，不無退舍。蓋《瀛山圖》筆極細謹，而無澹蕩之致；《輞川》多不皴，惟有拘染，猶是南宋人手腳。予在京師，往來于懷，至形夢寐。及是，獲披覽再過，始知營平所言：「百聞不如一見」。真老將語也。此聊以論畫耳，類是者更何限？人須自具「法眼」，勿隨人耳食也。

Clearly Tung considered himself as already possessor of the all-penetrating "dharma-eye," though it is hard altogether to ac-quit him here of the collector's natural bias for a work in his own collection. Nonetheless it was this quality in Tung—an unswerving confidence in his own judgment and ability—that allowed him so thoroughly to dominate his contemporaries and to alter the course of Chinese painting in accordance with his own tenets.

Tung was no longer the impoverished student whose trip to Peking in 1588 had required financial assistance. The perqui-sites of official life had brought him money enough to begin to acquire paintings himself, and he set about with characteris-tic determination to form a collection that would rival, in quality if not in extent, the great collections of the past. He was quick to make use of his contacts, both within the Han-lin and with officials from other sectors of the government whom he met in Peking, to acquire works that might other-wise have eluded him at this stage in his career, when he was still in the process of building his reputation, both as a callig-rapher and as a collector and connoisseur.

One measure of how relentlessly he pursued his search is his almost uncanny success in acquiring works by the most celebrated of masters. He returned to Peking with two hand-scrolls that must have seemed even to him—intent only on the renowned and the antique—to represent almost the

pinnacle of a collector's achievement. The first of these was Huang Kung-wang's *Dwelling in the Fu-ch'un Mountains* (vol. 1, fig. 17), which he had earlier seen at the home of a friend in the capital. The sight of it then had ravished him, and no doubt he inwardly resolved to own it one day himself. The chance came sooner than Tung, ever sanguine though he was, might have expected. Through a friend named Hua who had served as a Drafter in the Central Drafting Office—almost certainly Hua Chung-heng 華仲亨 (1539–1599), one of those who had contributed in 1591 to the stele erected at the Cheng-yang Gate—Tung arranged to buy the painting on his way through Ching-li, a village near Wu-hsi, Hua's native place.[196] In his colophon on the scroll, Tung took pleasure in noting that it was better even than paintings by Huang that he had seen belonging to the famous collectors Hsiang Yüan-pien and Wang Shih-chen. The *Fu-ch'un Mountains* was to have a profound effect on Tung's own style; he ends his colophon with the words,

> My master, my master! From smallest hill to the five great mountains, all are contained within this painting.[197]

吾師乎，吾師乎！一丘五岳，都具是矣。

Tung wrote his colophon at Lung-hua p'u, a short distance from Shanghai; and it was thereabouts that he made his other purchase, a long handscroll entitled *River and Mountains for a Thousand Li* (*Ch'ien-li chiang-shan*), now in the National Palace Museum, Taipei. The painting, which had once belonged to the infamous Grand Secretary and noted collector Yen Sung, had been attributed by the great Yüan connoisseur K'o Chiu-ssu 柯九思 (1290–1343) to the Sung master Chiang Shen 江參 (ca. 1090–1138), and Tung congratulated himself that such a painting had "needs chosen [him] as its owner."[198]

In 1597 Tung was appointed one of two Examiners (*K'ao-shih kuan*) assigned to oversee the provincial examination in Kiangsi, to be held in the eighth month.[199] With a distance to travel, Tung left Peking in the sixth or seventh month and traveled south to the provincial capital at Nan-ch'ang, situated on one of the many rivers flowing into P'o-yang Lake. Just before leaving Peking he succeeded in acquiring, through the mediation of his Han-lin classmate Lin Yao-yü 林堯俞,[200] an unnamed painting by Tung Yüan that he christened the *Hsiao and Hsiang Rivers* (vol. 1, fig. 2), at once recognizing (as he claimed) the scenery of his trip the year before.[201]

Unlike Tung's Peking assignments, which were played out amidst a crowd of contemporaries, both this and his commission of the year before gave Tung the chance at last to assume center stage (albeit in the provinces), and he seems to have derived no inconsiderable pleasure from his performance in both

roles. His colophons of the late 1590s are littered with references to 1596 as the year "I was sent to Ch'ang-sha as an imperial envoy," or to 1597 as the year "I received an imperial commission to act as an Examiner."[202] In contrast, two years later, he was studiously to avoid any reference to 1599 as the year he was made Surveillance Vice Commissioner of Hukuang, the appointment that effectually dashed his hopes of rising rapidly to high office. But for the time being, Tung had reason enough to feel that his feet were well planted on the road to success.

Yet once again Tung lingered in the south, much of his time traveling by boat along the Yangtze and the waterways of Chekiang and what is now Kiangsu. In the ninth month of 1597, boating past Lung-yu and Lan-ch'i in Chekiang, en route to Hang-chou and the Ch'ien-t'ang River, he composed colophons for two of the paintings he carried with him on the trip: Chiang Shen's *River and Mountains for a Thousand Li*, acquired the year before; and Hsia Kuei's *Watching the Tidal Bore at Ch'ien-t'ang* (*Ch'ien-t'ang kuan-ch'ao*), which he had brought along, perhaps with a visit to Hang-chou already in mind. The following month he stopped to see Ch'en Chi-ju, who had recently finished building a study he named the "Wan-luan Thatched Hall" on the northern slope of Mount Hsiao-k'un, a few miles northwest of Hua-t'ing. Whether it was on this occasion or some other that Tung inscribed the studio's walls and pillars is uncertain; at any rate, as a parting gift he presented Ch'en with a painting to which he gave the name of Ch'en's studio (vol. 1, pl. 3).[203]

A few weeks later Ch'en brought the painting to Tung's studio for Tung to "put in the color"; but instead the two spent the day admiring two of Tung's newest acquisitions, a painting in blue-and-green style by Li Ch'eng, and Kuo Hsi's *Clearing Autumn Skies over Mountains and Valleys* (vol. 1, figs. 3, 4), now in the Freer Gallery, that had once belonged to Mo Shih-lung.[204] Tung had acquired the Kuo Hsi handscroll from Mo's son-in-law, along with another painting that had belonged to Mo, Tung Yüan's *Privileged Residents of the Capital* (vol. 1, fig. 18). As the owner now of four Tung Yüan paintings, he could say at last that in this respect his ambition had to some extent been satisfied.[205]

Still another painting Tung acquired from Mo's son-in-law in 1597 was a diminutive handscroll entitled *Returning in Evening beneath Winter Trees* (*Han-lin kuei-wan*) by Li Ch'eng, from which (rather unscrupulously) Tung cut off the colophons—famous though the writers were—in order to mount it at the beginning of an album he was assembling of paintings by early masters.[206] By the following year he had added another Li Ch'eng to his collection, a small hanging scroll that had once belonged to Hsiang Yüan-pien,[207] and had seen

(or more likely acquired) a fourth, a painting attributed to Fan K'uan 范寬 (d. after 1023) that on stylistic grounds Tung promptly reattributed to Li.[208] There was a particular gratification in this: the great Sung connoisseur Mi Fu had seen only two genuine works by Li Ch'eng; now Tung had seen four.[209]

The success of his two expeditions south—measured in the growing number of works he was able to view, inscribe, and acquire—doubtless did much to fan the fire of Tung's determination to become the artistic arbiter of his age. Tung was, however, capable of ambition on more than one front, and he had no intention of abandoning a career in office for one wholly in the realm of art. What he intended was that the two should prosper hand in hand.

The year 1598 was for Tung bright with promise. On his return to Peking, there being no longer any need for his services in compiling the *Cheng-shih*, he was given charge of drafting patents for civil officials (*kuan-li wen-kuan kao-ch'ih* 管理文官誥勅), in company with Yeh Hsiang-kao (with whom Tung was thus again brought into contact) and his old friends and fellow Han-lin classmates Feng Yu-ching 馮有經 and Lin Yao-yü.[210] To judge from the seal Tung was presently to adopt,[211] the appointment was a gratifying one: his more passive roles as a transcriber and compiler were now exchanged for the more active and prestigious role of a drafter of documents destined to be issued in the name of the emperor himself. Patents (*kao-ming* 誥命 and *ch'ih-ming* 勅命, collectively *kao-ch'ih*) were a matter that touched every member of the official hierarchy—in the capital or the provinces, civil or military, high-ranking or low—since by meriting a patent one achieved the commendably filial purpose of acquiring honorary titles for one's forebears, extending (if one's rank were high enough) as far back even as great-grandparents. By 1596 Tung had already received a patent of his own, in which honorary titles were bestowed on his father and mother, as well as himself and his wife;[212] and doubtless the compositions he was called upon to draft whetted his appetite for higher honors.

In the second half of 1598, both Yeh Hsiang-kao and Tung were appointed as tutors to the emperor's eldest son, Ch'ang-lo, whom the emperor was still stubbornly refusing to confirm as heir apparent. Yeh, who received his appointment in the seventh month, was designated a Chief Attendant; Tung, appointed on the seventh day of the eighth month, was nominated as a Lecturer (*Chiang-kuan* 講官), a position that was a degree beneath Yeh's in prestige.[213] The entry in the *Ming shih-lu* recording Tung's appointment substantiates the date 1598 cited in connection with this post by Ch'en Chi-ju in his "Life and Conduct" of Tung, hitherto disregarded by biographers in favor of 1594, the date implied rather than actually furnished in Tung's biography in the *Ming-shih*.[214]

Even at so uncertain a juncture, with the emperor still determined to exclude his eldest son from the succession, the appointment was a coveted one, carrying as it did the promise of future benefit should Ch'ang-lo eventually reach the throne. For Tung, who had fallen behind his Han-lin classmates in 1591, it was proof that he had succeeded at last in drawing even. Of the twenty-five men in Tung's *chin-shih* year initially selected to enter the Han-lin, only half now remained, and only five had so far achieved the distinction of having been appointed as tutors to the emperor's eldest son.[215] With a confidence as yet untarnished by experience, Tung little thought that just six months later his friend and former Han-lin classmate Huang Hui would be appointed a Lecturer as his replacement.[216]

In the course of the next few months, during one of his tutoring sessions with Ch'ang-lo, Tung had occasion to ask him the meaning of a passage from the *Confucian Analects*: "[To] choose labors which are proper, and make [the people] labor on them."[217] The prince answered by saying, "It means that one should not recklessly expend the people's resources." News of his response swept through the court and was greeted enthusiastically as auguring well for a future ruler.[218] For Tung, the incident was to prove of fateful consequence. On the eighth day of the second month, 1599—only six months after receiving his appointment as tutor—he was suddenly assigned to a provincial post, as Surveillance Vice Commissioner of Hu-kuang (*Hu-kuang an-ch'a ssu fu-shih* 湖廣按察司副使).[219]

Nominally, Tung's new post, which had a rank of 4a, represented a considerable promotion; but to Tung, who had no doubt envisioned himself progressing step-by-step upward through the Han-lin ranks, his relegation to the provinces dealt a cruel blow to his hopes. He immediately requested permission to retire, venting his disappointment in the only way possible, by asking that he be allowed to retain his Han-lin title of Compiler.[220]

In his "Life and Conduct" of Tung, Ch'en Chi-ju leads up to this critical turning point in Tung's career as follows:

> In 1597 he conducted the [provincial] examination in Kiangsi. At the time, [Tung] used to discuss Confucian teaching with his Han-lin colleagues Chiao Jo-hou [Chiao Hung] and Feng Chung-hao [Feng Ts'ung-wu], and the Indian sutras [i.e. Buddhism] with Huang Chao-su [Huang Hui] and T'ao Chou-wang [T'ao Wang-ling]; and he excelled them all in a talent for profound discourse. Collectors in the capital often sought his appraisal [of works in their collection], and those he inscribed, at once became valuable. But spiteful people grew jealous, and he was [ordered] to fill a provincial post in Ch'u [i.e. Hu-kuang].[221]

丁酉主江西考。時同館焦弱侯、馮仲好談東魯之學，黃昭素、

陶周望談西竺之書，公介季孟間，超超玄著。輦轂收藏家又時時願得公賞鑒，一品題屬重。而側目者妬之，出補楚藩。

That Tung's brilliance in philosophical debate and reputation as a connoisseur were sufficient cause for opponents to seek his removal from court is hardly tenable; and the compilers of the *Ming-shih* offer a different explanation.

According to Tung's biography in the *Ming-shih*, "[After] the emperor's eldest son began formal study, [Tung] served as a Lecturer; and owing to his edifying instruction, the prince always favored him with his attention. Having failed, however, to suit the views of [those] in control of the government, [Tung] was sent to be Surveillance Vice Commissioner of Hu-kuang, but sought permission to resign on account of illness and returned home."[222] The implication here is that Tung aroused the enmity of a powerful figure or figures at court, either opposed to Ch'ang-lo's selection as heir apparent, or jealous, perhaps, of Tung's influence over the young prince, who procured Tung's departure from court by having him appointed to a post in the provinces.

But in fact the majority of the court, including the only two Grand Secretaries serving in late 1598, Chao Chih-kao 趙志臬 and Shen I-kuan, overwhelmingly supported Ch'ang-lo's designation as heir apparent[223]—save for those who for factional reasons, or because they saw a chance to curry favor with the emperor, were ready enough to oppose the general view for private gain. As a mere Junior Compiler in the Han-lin (rank 7a), moreover, Tung was scarcely in a position to arouse the envy of high-ranking ministers able to effect his ouster from court. It seems likely instead that the vague phrase "[those] in control of the government" was employed as a discreet substitution for naming the emperor, who was well known to harbor animosity for anyone who espoused the prince's cause. Among those who urged Ch'ang-lo's designation as heir apparent or protested against the emperor's procrastination, casualties were many, generally in the ranks of minor officials whom the emperor chose as scapegoats for his wrath.[224] Tung, whose instruction of Ch'ang-lo had induced him to respond in a manner that the court interpreted so strongly in the prince's favor, could hardly have escaped the emperor's notice.[225]

That Tung's activities were indeed brought to the emperor's attention we learn from Tung himself, in a long preface he wrote to a poem he inscribed on a painting of wintry mountains after Li Ch'eng, which he executed in a fury of resentment on hearing that he had been impeached. The poem and preface are undated; but on the evidence of a passage dated 1600 in the *Hua-ch'an shih sui-pi* (where Tung repeats the poem and refers to the impeachment as having occurred at

least a year earlier),[226] combined with the fact of his having been relegated to a provincial position in the spring of 1599, we may be virtually certain that it was in 1599 that the poem and preface were written.

In the first half of his preface, Tung declares an aversion to official life (an attitude adopted by most of the literati, whatever real ambition lurked beneath the surface, though often enough, as in the case of Ch'en Chi-ju, the avowed distaste was genuine) and protests at some length that never once has he used his painting as a means of gaining favor:

> Ever since my youth I have loved painting landscapes after the Yüan masters. In the capital, being much at leisure, I used to dream of home, and increasingly I turned to painting. I remember that when Ku I-ch'ing [Ku Yang-ch'ien, 1537–1604] was Grand Coordinator of Liao-yang [i.e. Liao-tung], he brought two fans to ask me to paint them, one for himself and one for the recluse Wang Ch'eng-fu [Wang Shu-ch'eng]. I painted the one for Ch'eng-fu, but returned I-ch'ing's fan with a message saying, "'The Grand Councilor of the Left [Chiang K'o, d. 672] extended sovereignty over the desert [i.e. gained fame in battle], the Grand Councilor of the Right [Yen Li-pen] won renown as a painter.'[227] With us, neither is a matter of first concern. Wait until we retire so that together we can enjoy ourselves." Not once has any "gentleman on horseback with hairpin and robe" [i.e. official] obtained even a single brushstroke of mine. With my mind intent on springs and mountains, disdaining the desire for life as an official, it is the Way of painting that sustains me.

> 余自弱冠好寫元人山水。金門多暇，夢想家山，益習之。憶顧益卿開府遼陽，以兩箑求畫，一爲益卿，一爲山人王承父。余畫承父，而返益卿扇，報章云：'左相宣威沙漠，右相馳譽丹青。'皆非吾輩第一義。俟歸山以相怡悅耳。蓋簪裾馬上君子未嘗得余一筆。而余結念泉石，薄於宦情，則得畫道之助。

Tung's disgust and indignation sound genuine enough, fueled as they are here by disappointed hopes. But he was not forever to remain immune to the charms of office, in the guise of honors and emoluments; nor, as we shall see, was he forever to refuse to accommodate officials with the power either to advance his career or to protect the position he had already won.

What the latter half of the preface makes clear is that Tung's passion for painting had in some way been adduced as an accusation against him:

> In the spring of this year an influential official memorialized the throne [charging that] my skill as a painter [had attracted such undue attention] that word of it had reached the emperor's ear.[228] On hearing this, I immediately ordered my servant to cut me a piece of Kiangsu silk over ten feet long and wide, and having ground enough ink and more, holding a lamp I painted a painting

of Li Ch'eng's wintry mountains. Working through the night I finished it, and inscribed this poem to wash away the vulgarity of present-day men at court. Han Huang [723–787], Yen Su [961–1040], Sung Fu-ku [Sung Ti, fl. late 11th century], and Su Tzu-chan [Su Shih], [all of them officials], were all good at painting. The official [who impeached me], with a mind quite ignorant of history, knows nothing [about them] at all, and simply regards [an official who paints] as a criminal case.[229]

今年春，有朝貴疏余，雅善盤礡，致塵天聽。余聞之，亟令侍者剪吳綃縱廣丈許，磨瀹糜渖，秉燭寫李成寒山圖。經宿而就，遂題此詩以洗本朝士大夫俗。夫韓滉、燕肅、宋復古、蘇子瞻皆善畫。朝貴腹中無古今，固應不知第以爲罪案。

Though the allegation against Tung was not weighty enough to effect his dismissal from office, or even to block his promotion, it presumably provided a convenient pretext to remove him from his position as one of Ch'ang-lo's tutors. That the emperor himself was ultimately responsible for Tung's relegation to the provinces is the conclusion inescapably forced upon us when we consider that—though Tung's friend Yeh Hsiang-kao was to serve as Grand Secretary from 1607 to 1614, and for much of that time was the only Grand Secretary at court—Tung was not to be offered a post in the capital until after Shen-tsung's death more than twenty years later.

IV. *In Retirement in Hua-t'ing (1599–1621)*

With a measure of fame already to his credit, and wealth to match, Tung was now in a position to enjoy the pleasures that life in retirement afforded. Behind him were the examination studies that had engaged him for so long; laid aside—for the moment, as he thought—were the official duties that had occupied much of his time for the last ten years; and he was free to spend his hours as he liked best—whether exercising his brush, or searching out and authenticating works by the ancient masters to augment his collection; whether seeing friends, or traveling by boat to places of scenic beauty in their company. In a lyrical passage that has no date but perfectly conveys the feeling of release he must have experienced at this period, Tung celebrates the joys of boating:

In the eleventh month Chung-ch'un [Ch'en Chi-ju] and I set forth on the Ch'un-shen River [i.e. the Huang-p'u River, flowing past Shanghai]. For ten days we drifted, a hundred *li* from home, following the wind east and west, with the clouds [our companions] from dawn to dusk. We gathered uninvited friends, and rode upon our unmoored boat. With cup and jug we drank together, now and again plying our brushes. In the garden of [the King of] Wu

we poured out a libation on [the beauty] Chen-niang's tomb;[230] in Ching-man we searched for traces of Lan Tsan [Ni Tsan].[231] My vigor [was such] that [I felt] my breast could swallow Chü-ch'ü [i.e. Lake T'ai], and my eyes could see [as far as] the Milky Way. Age comes and then decrepitude; and all we have gained is soon gone. Now that I perceive that life is a dream quickly over, I am no longer impelled to make "outings [by night] with candle in hand."[232]

To live [in one place] is [to see but] one hill and one valley, and [to have] as company only [the recluses] Ch'iu [-chung] and Yang [-chung].[233] To go forth [and travel] is [to see] a thousand peaks and ten thousand valleys, and to have as a companion [the immortal] Han-man.[234] Thus do we two pursue our old passion.[235]

余與仲醇，以建子之月發春申之浦，去家百里，泛宅淹旬，隨風東西，與雲朝暮。集不請之友，乘不繫之舟，壺觴對引，翰墨間作。吳苑酹真娘之墓，荊蠻尋嬾瓚之踪。固已胸吞具區，目瞠雲漢矣。夫老至則衰，倘來若寄，既悟炊粱之夢，可虛秉燭之遊。

居則一丘一壑，惟求羊是群；出則千峯萬壑，與汗漫爲侶。茲余兩人敦此夙好耳。

Reading through the many inscriptions and colophons Tung has left us as a record of his activity, we are struck with how often he is to be found aboard boat, and how often, as he traveled—halting at places along his route, or prevented by wind from proceeding on his way (vol. 1, pl. 52), or visited by friends aboard his boat (vol. 2, pl. 20)—he beguiled the time by taking up his brush. Wherever he went, he carried with him works from his collection, not only for enjoyment but also for inspiration. On one occasion, after making a list of nineteen works he had with him, by such masters as Tung Yüan, Li Ch'eng, Mi Fu, and Huang Kung-wang, he adds:

These are the kindred spirits of my studio, [each serving as] master and friend. Everywhere I go, I take them with me. Thus Mi [Fu's] "Boat of Calligraphies and Paintings" is nothing I need envy.[236]

右俱吾齋神交師友。每有所如，攜以自隨。則米家書畫船，不足羨矣。

Tung's earliest paintings, of which his fan in the manner of Ni Tsan, dated 1592, in the National Palace Museum, Taipei, survives as a late example (fig. 39),[237] had been modeled on the Yüan masters, whose paintings dominated most of the Chiang-nan collections familiar to him in his youth and whose styles were universally favored by Chiang-nan's gentry. But the taste for Sung painting that prevailed in Peking soon awoke in him a corresponding response, and thereafter in his paintings—as he tells us himself—he embraced Sung styles and abandoned the Yüan. On New Year's Eve, in 1591, he had painted on gold paper a landscape in the manner of Huang Kung-wang, one of only five paintings he had done that year. Twelve years

later, in 1603, he inscribed it with two short sentences that are a measure of how profoundly his experience in Peking had changed him:

> I no longer do paintings in the Yüan manner; and were I to do Yüan paintings, they would be entirely different from the ones I did before.[238]

予不復爲元人畫；爲元畫，亦與故吾別一法門。

Hardly more than a handful of paintings are at present known to survive from the decade 1595 to 1605, the period spanning his last few years in Peking and his first years in Hua-t'ing after his return in 1599; but on those paintings where he mentions his model, the model is in every case Sung, or even earlier. His album entitled *Eight Views of Yen and Wu* (vol. 1, pl. 2), dated 1596, he models simply on "the Sung masters" (though one leaf he paints in the manner of the sixth-century master Chang Seng-yu); the handscroll he begins in the 1590s and finishes in 1603 (vol. 1, pl. 4) "copies" a painting by Kuo Chung-shu; and his *Misty River and Piled Peaks* (*Yen-chiang tieh-chang*, ca. 1604–5; vol. 1, fig. 26), in the National Palace Museum, Taipei, takes its inspiration from Wang Shen.[239] In the case of his *Viewing Antiquities at Feng-ching* (*Feng-ching fang-ku*; vol. 1, fig. 29), dated 1602, it is Ch'en Chi-ju, in his inscription on the painting, who supplies the names of Tung's models: Tung Yüan and the T'ang master Wang Wei.[240]

For five and a half years Tung remained in retirement, without even the tender of official employment. Finally, in the ninth month of 1604, he was offered the post of Surveillance Vice Commissioner of Hu-kuang Supervising the Administration of Education (*Hu-kuang [an-ch'a ssu] fu-shih t'i-tu hsüeh-cheng* 湖廣按察司副使提督學政, rank 4a, usually abbreviated *Hu-kuang t'i-hsüeh fu-shih*, Education Intendant of Hu-kuang), a provincial position equal in rank and similar in title to the one he had spurned in 1599, though having different duties.[241] Fearing, perhaps, to lose all opportunity, reluctantly Tung accepted the appointment.[242]

But some eighteen months later, in the spring or early summer of 1606, he was the target of an ugly student riot reportedly instigated by powerful families angry with his refusal to hand out favors (for which in return, of course, Tung would have been well rewarded); and a mob of several hundred students destroyed his official residence. Tung (as he was so often to do in future, when he found himself suddenly under attack) immediately sought permission to retire, a gesture that his contemporaries would have interpreted not (as in the West) as an admission of guilt but as a determination to disassociate himself from the sordid realities attending a life in government office. Though he was officially exonerated and confirmed in his post,[243] the incident served only to heighten

Tung's distaste for provincial assignments, and by autumn he had succeeded in obtaining permission to resign.[244]

Had it not been for the discreditable events of 1616, which we have yet to encounter, there might never have arisen any but the official version of this incident, the account of which, in the *Ming-shih*, is taken almost word for word from that appearing in the *Ming shih-lu*, and is substantiated by Tung himself, who writes in a passage recorded in the *Jung-t'ai chi* that what led to his departure from Hu-kuang was his strict application of regulations to the families of high-ranking officials, who were incensed (so we are meant to understand) by his principled stance.[245] Yet by 1616 Tung's enemies in Hua-t'ing had placed on the incident quite a different construction:

> That brutish official of our prefecture, Tung Ch'i-ch'ang, is reputed to have some small degree of talent [but in truth is a man] of no very great capacity. Early on, he flattered and befriended eunuchs [at court], and was dismissed from the Han-lin; and [later] he treated his students with contempt and conducted himself improperly at schools [in his charge], till like a rat he [was forced to] flee, shielding his head with his hands, and still is a laughingstock in Ch'u [Hu-kuang].[246]

吾郡獸官董其昌，稱小有才，非大受器。諂交奄宦，先見擯於詞林，藐視諸生，復無狀於學校，直至捧頭鼠竄，尚貽笑於楚中。

Later writers embellished the incident further; and Tung, who, if we believe the official account, was not only blameless in the affair but had even acted with commendable integrity, was made the object of increasing ridicule. One writer tells the story that so hurriedly was Tung forced to decamp that he had to climb over the wall of his residence in a state of undress, and "a disgrace to his cap and robe [i.e. to his status as an official], he returned home shielding his head with his hands, his heart unashamed and unrepentant."[247] The early Ch'ing historian Chi Liu-ch'i 計六奇 recounts that according to his late uncle (who had visited Hu-kuang at the time when Tung was Education Intendant), on one occasion Tung greeted the students he was examining with the words, "Confucian Apprentices (*t'ung-sheng* 童生) sit down, Government Students all sit down." When after waiting some time, the students ventured to ask what topic they were to write on, Tung replied that he had already given it to them (that is to say, that the topic was his order telling them to sit down). Another time Tung is said to have posted a notice saying that tomorrow there would be no examination. The next day the students, evidently puzzled, arrived and waited, but the topic was not forthcoming. When finally they asked for it, Tung told them he had posted it already (that is, that the topic was "tomorrow there will be no examination").[248] There is ample

evidence elsewhere, however, to suggest that Tung took official duties seriously; and the absurdity of stories like the two last speaks for itself.

Three years later, in the late autumn or early winter of 1609, Tung ventured once again to accept a provincial position, this time as Surveillance Vice Commissioner of Fukien (*Fu-chien an-ch'a ssu fu-shih* 福建按察司副使, rank 4a). But the long slow path from one provincial assignment to the next, even if at last it led to a post in the capital, held no attraction for Tung, and he resigned after only forty-five days.[249]

The inducement that had led Tung to accept the Fukien appointment was probably twofold: on the one hand, the pleasant memories he entertained of Fukien (where eighteen years before he had traveled through the Wu-i mountains, after escorting the coffin of his former Han-lin professor T'ien I-chün home to T'ien's native Ta-t'ien), and on the other hand—and more important—his friendship with Yeh Hsiang-kao, with whom Tung had served in 1595 as a Compiler on the *Cheng-shih* project, and in 1598 as a tutor to the emperor's eldest son.[250] Though many of Tung's friends had by now fallen by the political wayside, Yeh had reached the apogee of political success.

In 1599, Yeh, like Tung, had been given a nominal promotion outside the capital, as Right Vice Minister of Rites in Nanking. Tung paid him a visit there in the autumn of 1603, when taking his son to Nanking to sit the provincial examination.[251] After languishing seven years in Nanking without promotion, Yeh was suddenly appointed a Grand Secretary in 1607, and remained in this office till 1614. From the end of 1608 till the autumn of 1613 he was, in fact, the only functioning Grand Secretary.[252] Yeh was a native of Fukien; and Tung could not but consider that his appointment to Fukien was made under Yeh's auspices. To reject it might have caused offense; Tung's solution was to accept it, and to resign six weeks later.

In a letter to Tung which begins by mentioning the appointment to Fukien, and which must have been written about this time, Yeh expresses remorse at being powerless to help Tung (presumably by offering Tung a post more to his liking): he bemoans having "to sit by and watch my intimate friend [Tung] suffering from injustice," and calls Tung "a true gentleman" for never holding this "great crime" against him. He goes on to thank Tung for a calligraphy album that Tung had recently sent him, which "dazzled the eyes and gladdened the heart," but adds that he still longs for a painting by Tung in hanging-scroll form, which (he promises) he would hang in his room and burn incense in front of, and bow down to whenever he went in and out.[253] We may be sure this was one request that Tung was happy to fulfill.

By the spring of 1610 Tung was on his way back from Fukien.[254] Though in the ten years that followed he was offered three other posts—in 1613, as Surveillance Vice Commissioner of Shantung (the same position he had held in Fukien), and later as Administration Right Vice Commissioner of the Huai-ch'ing circuit in Honan (rank 3b), and Administration Right Vice Commissioner of the Ju-chou circuit in the same province—all these posts were provincial ones, and he chose to remain in retirement at home.[255] But though refusing all three appointments, he was not averse to prefacing his signature (as it seems to have been within his rights to do) with the title Administration Right Vice Commissioner of Honan, which was higher in rank than any of the posts he had actually held.[256]

Through most of these long years of retirement, stretching (except for the two brief intervals noted above) from 1599 to 1621, one of Tung's closest friends was Wu Cheng-chih 吳正志 (*hao* Ch'e-ju 澈如, d. ca. 1619),[257] a native of I-hsing in present-day Kiangsu, who like Tung had won his *chin-shih* degree in 1589. Tung's relationship with Wu can only be understood by knowing something of Wu's history. Unlike Tung, Wu came from a scholar-official family of long standing: his great-great-uncle Wu Yen 吳儼 (1457–1519) had risen to be Minister of Rites in Nanking; and his father Wu Ta-k'o 吳達可 (1541–1621) spent much of his life in office, retiring finally at the age of seventy-three *sui* while serving in the capital as Commissioner of the Office of Transmission, with a rank of 3a.[258] Wu Cheng-chih's own career, however, was destined to be unhappy.

On obtaining his *chin-shih* degree, Wu had been appointed to the minor post of Secretary of the Shantung Bureau of the Ministry of Justice in Peking, and almost at once he became embroiled in the factionalism that was increasingly to divide Ming officialdom into bitterly antagonistic camps. In the tenth month of 1589, the Vice Director of the Bureau of Appointments in the Ministry of Personnel Chao Nan-hsing 趙南星 (1550–1627), who was later to become a leading exponent of the Tung-lin party, submitted a memorial to the throne condemning what he called the "four great evils" characterizing the behavior of modern-day officials. Chao was immediately impeached by a Supervising Secretary of the Ministry of Personnel named Li Ch'un-k'ai 李春開. Wu Cheng-chih—newly appointed though he was—rose up in Chao's defense and submitted his own memorial impeaching Li and a second Supervising Secretary named Ch'en Yü-chiao 陳與郊 (1544–1610).[259] The emperor was furious, and an order was issued that Wu should be punished by caning at court. For seven days Wu awaited his fate. Urged by his friends to prepare a black sheepskin to save his flesh from putrefying after the caning, he countered by saying that to do so would show a fear of death.

Figure 40. Tung Ch'i-ch'ang. *After Mi Yu-jen's "Wonderful Scenery of the Hsiao and Hsiang Rivers,"* painted for Wu Cheng-chih, undated (ca. 1616). Museum für Ostasiatische

In the end he was rescued through the intercession of the Grand Secretary Shen Shih-hsing 申時行 (1535–1614), but was ignominiously demoted to District Jailor of I-chün hsien in Shensi,[260] an office that failed even to merit civil service ranking. Wu's spirited stand, however, gained him the applause of those who were later to form the Tung-lin party, which would come to signify renewed morality in government.[261]

In 1594 Wu was appointed Prefectural Judge of Jao-chou fu in Kiangsi;[262] and after serving as Secretary of a Bureau in the Ministry of Justice in Nanking, he was reappointed at last to the capital. There, after rising to be Vice Director of a Bureau in the Ministry of Rites, he was promoted to Assistant Minister of the Court of Imperial Entertainments in the seventh month of 1607.[263] Less than three weeks later, however, he was impeached by the Chief Supervising Secretary of the Office of Scrutiny for Personnel Ch'en Chih-tse 陳治則, for allegedly attempting to entrap others into committing criminal offenses. The case dragged on for a year, but the final decision went against Wu: once more he was demoted and transferred to a provincial post,[264] this time as Prefectural Judge of Hu-chou fu in Chekiang.[265] By 1612 he had been reappointed to Nanking, as Director of a Bureau in the Ministry of Justice;[266] but the following year he was again reassigned to a provincial post, as an Assistant Surveillance Commissioner in Kiangsi,[267] a position he accepted reluctantly only after pressure was brought to bear by his father, who had himself served in Kiangsi as Regional Inspector some years before.[268] But though he traveled to Kiangsi to take up his post, Wu apparently resigned almost upon arrival, thoroughly disheartened and disillusioned by what he chose to interpret as yet another setback.[269] Reflecting on Wu's career in 1612, Tung wrote (with

more warmth of feeling than regard for accuracy) that though Wu's fame extended everywhere, he had held office fewer than three hundred days.[270]

Tung and Wu had known one another even before they passed the *chin-shih* examination together in 1589. Wu's impulsive defense of Chao Nan-hsing and subsequent demotion sparked Tung's interest and solidified their friendship.[271] During periods of retirement the two saw each other with some frequency and kept up a running correspondence when apart. In 1600, a year after his own retirement, Tung visited Wu at his home in Ching-hsi, and at Wu's request wrote out an album of Wang Wei's poems that is now in the National Palace Museum, Taipei.[272] Wu had named his studio the Yün-ch'i lou (Pavilion of Rising Clouds), and at some point before 1616 he asked Tung to paint for him three "Yün-ch'i lou paintings" in different formats—a handscroll, hanging scroll, and round fan—to complement his studio, and by their theme, of course, reflect its name.[273] With a proper show of modesty, Tung declared himself dissatisfied with the paintings he produced, and to make up for their deficiencies he presented Wu with a magnificent hanging scroll he attributed to the Sung master Mi Fu. On the *shih-t'ang* at the top he wrote out the title *Yün-ch'i lou t'u*, adding at the side an inscription recording the reason for his gift.[274] The painting, complete with Tung's inscriptions at last remounted in their proper place, is in the collection of the Freer Gallery, a work whose mysterious power and beauty set it apart from all other extant paintings that have been linked with Mi Fu's name.

Whether or not any of the works we have today can be identified with the three that Tung executed for Wu in different formats it is impossible to say with certainty; but two

Kunst, Berlin.

works he painted for Wu survive to show what the others must have been like. Both, as befits paintings intended for a studio named the Pavilion of Rising Clouds, are painted in the Mi style—the style of Mi Fu and his son Mi Yu-jen—whose family name was by now synonymous with scenes of softly modeled conical peaks with undulating bands of cotton-wool clouds hovering about their feet. The first is a handscroll only seven and a half inches high, modeled on Mi Yu-jen's *Wonderful Scenery of the Hsiao and Hsiang Rivers* (*Hsiao-Hsiang ch'i-ching*), that according to Tung's colophon of 1636 he painted twenty years earlier; in his inscription on the painting itself, he presents it to Wu's Yün-ch'i lou, and thus it may indeed be one of the three paintings in different formats that Wu had requested (fig. 40).[275] The other is a hanging scroll, just over two feet high, entitled by Tung *Strange Peaks and White Clouds* (*Ch'i-feng pai-yün*), now in the collection of the National Palace Museum, Taipei (fig. 41). Among Tung's paintings in the Mi style, these two—small in scale and intimate in feeling, painted for a close friend whose studio they were designed to grace—rank, perhaps, as his most successful.

Wu too was a collector, though by no means on a par with Tung, and a number of the works that passed into his hands had as their source Tung's own collection. Among these were Chao Meng-fu's famous *Autumn Colors on the Ch'iao and Hua Mountains*, and, later, one of the paintings Tung treasured most, Huang Kung-wang's *Dwelling in the Fu-ch'un Mountains* (vol. 1, fig. 17).[276]

But while painting and calligraphy provided the everyday fare on which their friendship throve, Tung and Wu were bound together on a deeper level by what they considered their common political fate: their relegation to provincial posts, away from Peking as the center of power, and their consequent decision to resign rather than expend time and talent in lackluster positions that failed to reflect their worth. It was this aspect of their relationship that Wu was to underscore in 1617, when recalling their friendship he quoted the old saying, "those who suffer from the same illness develop a sympathy for each other" (*t'ung-ping hsiang-lien* 同病相憐).[277] Theirs was not the choice of Ch'en Chi-ju, who had happily renounced official life; instead, Tung and Wu felt the decision had been forced upon them by rejection at the hands of those who should have recognized their merits.

Despite all their protestations to the contrary, had either been offered a post that matched his expectations, he would doubtless have accepted. Tung, in fact, later did so in 1622, after he was finally offered a post in Peking. Indeed, the idea of "returning to office" is a recurrent theme in their relationship. Sometime after Wu's demotion in 1608, Tung expressed his intention of presenting Wu with a calligraphy by Chao Meng-fu transcribing the biography of Chi An 汲黯, an official who served under the Han Emperor Wu Ti. Chi An has been described by Giles as "an able minister . . . [who] on several occasions . . . fell into disfavor, but always managed to recover his position."[278] Tung, of course, was paying Wu the compliment of comparing him with Chi An, and hinting that Wu too would soon be recalled to office.[279]

In 1611 Tung painted for Wu a short handscroll, which is included in the present exhibition (vol. 1, pl. 18). At first glance, the painting appears to be simply a landscape like any other; but its title, *Invitation to Reclusion at Ching-hsi*, which Tung has himself inscribed on the painting, endows it at once with a particular significance. The river landscape, with its few

413

spare houses, and its rocky banks and low cliffs sprinkled pleasantly with trees and bordered by distant hills, symbolizes the quiet tenor of Wu's life in retirement at Ching-hsi, far removed from the dangers and frustrations of the political arena, from which Wu and Tung had made the decision to withdraw. Wu, as it transpired, did not remain in retirement for long: by the eighth month of 1612, as we have seen, he had accepted a position as Director of a Bureau in the Ministry of Justice in Nanking.[280]

In 1613 Tung added a colophon to the painting, in which he professes indifference to office himself, but urges Wu to feel free to adopt a different course: "This year I was summoned from the fields, both Ch'e-ju and I being notified alike [i.e. awarded almost identical official posts].[281] I had already sworn on the tomb [of my ancestors] not to go, and Ch'e-ju too wanted to be like the goose that flies off into the blue. [So] taking a poem I once wrote for a friend, I inscribe it on this scroll as follows: 'I am like the clouds that return to the mountains, you are like the rising sun; going or staying, each has its proper place; why need one choose the crane and the gibbon?'"—the crane and gibbon here being symbols of the hermitic life. "'[Though] only those who retire from the world can grow old in [the land of] the Peach Blossom Spring.'"[282]

Again, as we have seen, Wu did accept office, as an Assistant Surveillance Commissioner of Kiangsi, though he undertook it reluctantly at his father's behest.[283] Tung's colophon, which is dated the eighth month of 1613, was of course written in the knowledge that Wu had been offered this post,[284] and clearly encourages Wu to accept it if he will. It is for this reason that Tung inscribes the poem on the painting, intimating that Wu need not choose the hermitic life, and finishes by saying, "Let Ch'e-ju take this [scroll] on his journey to Chiang-men,[285] [so that] whenever he unrolls it, he will know that I do not model my behavior on K'ung Chih-kuei"—a late fifth-century official known for his unconventional behavior, who made a habit of drinking alone and allowed his courtyard to be overrun with weeds, and once spoke smilingly of the frogs' croaking as his "drum and fife music."[286]

In alluding to K'ung, Tung had in mind the story that lay behind K'ung's famous essay entitled "Proclamation on North Mountain" ("Pei-shan i-wen"), with which Wu would certainly have been familiar. K'ung had had a friend by the name of Chou Yung 周顒, and together the two had made up their minds to forsake the world and live in retirement at North Mountain, known also as Mount Chung. Chou then decided to accept a position as District Magistrate of Hai-yen. When Chou afterwards wanted to return to Mount Chung, K'ung, in a bitter humor, sent him a mock proclamation pretending

Figure 41. Tung Ch'i-ch'ang. *Strange Peaks and White Clouds*, painted for Wu Cheng-chih, undated (ca. 1616–17). National Palace Museum, Taipei.

to be the deities inhabiting the mountain, ridiculing Chou for falsely professing a love of seclusion, and forbidding him to return for having forsworn himself out of a craving for position and fame.[287] By insisting that he was not of K'ung's mind, Tung intended to reassure Wu Cheng-chih that even should Wu accept employment, their friendship would remain unbroken.

In 1617, when Wu appended a colophon of his own, he was in no mood to share Tung's optimism. In the midst of retracing their long years of friendship, he recalls with bitterness the unhappy incidents of his political career, ending with his final retirement, and adds, "This painting thus fulfilled its prophecy." The last lines of the colophon are written with a painful intensity that contrasts markedly with the cheerful platitudes that characterize Tung's colophon. Paraphrasing a line from the *Fa yen* by the Han poet and philosopher Yang Hsiung 楊雄 (53 B.C.–A.D. 18), Wu writes, "I vow never again to come within archers' range," and concludes, "Why should I wait to be summoned, [only to be forced] afterwards to retire?"[288] Whereas Tung's retirement had sprung entirely from feelings of wounded pride, Wu had suffered the indignity of demotion and the real fear of corporal punishment. Reading their colophons side by side, we feel that Wu's sentiments stem from conviction, while Tung's are simply expressions of convention.

In mid-1613, as his colophon on *Invitation to Reclusion* confirms, politics were much on Tung's mind. That spring, on the twenty-seventh day of the third month, he had been offered the provincial post of Surveillance Vice Commissioner of Shantung, which he declined; and sometime before the seventh month he was impeached by a newly appointed censor, Wei Yün-chung 魏雲中, who would later become known as a supporter of the Tung-lin cause.[289] The impeachment seems to have come to nothing, though no doubt it caused Tung some anxiety. But Tung now had good friends in high places, foremost among them (as we have seen) Yeh Hsiang-kao, who in mid-1613 was not only the senior Grand Secretary but also the only Grand Secretary in office. Small wonder, then, that the impeachment attempt against Tung failed to achieve its object. Toward the end of the year, in the ninth month, two new Grand Secretaries were appointed, one of them Tung's old Han-lin classmate Wu Tao-nan 吳道南 (1550–1623), who since 1609 had held the prestigious post of Minister of Rites. Yeh and Wu—if unable to overcome imperial opposition and offer Tung a post in the capital—were at any rate able to shield him from the dangers of censorial attack.

The following year Tung celebrated his sixtieth birthday, and Ch'en Chi-ju excelled himself by producing a celebratory essay munificent both in its language and in its length. Tung, he tells us, is a man of marvels, of which few but himself know the full extent; and lest we remain in ignorance he proceeds to lay them all before us. Yet for all his ability and fame, Tung professes to want, like Ch'en, nothing more than the good luck to live a life a little better than the rest; and Ch'en replies, "You [are a man with] three 'withouts': your brush is without hesitation, your eye is without obstruc-tion, and your breast is without rancor; these three are all omens of a long life." Toward the end of his essay, Ch'en congratulates him: "Your lot in life has been an easy one; your health and your reputation both prosper; and the whole world compares the works from your brush with those of Mi Hsiang-yang [Mi Fu] and Su Mei-shan [Su Shih]. Though you never felt that imperial favor came your way, you have [all of] Yüan-chang's [Mi Fu] enjoyment of life and none of the frustrations of Tzu-chan's [Su Shih] [life in exile] in Ling-hai. So as for 'life better than the rest,' you have it in abundance."[290] Ch'en was to be right about Tung's long life; but two years later fortune was to deal a blow to Tung's reputation from which, in one respect, it would never recover.

Though the events to which we now turn were to culminate only in the third month of 1616, the story begins some six months earlier, in the eighth or ninth month of the year before. Tung had seduced, or at any rate become enamored of, a young and beautiful maidservant by the name of Lü-ying 綠英, who had been adopted by the family of one of Tung's servants, though her parents belonged to the household of a neighboring Government Student named Lu Chao-fang 陸兆芳. Hearing that her real mother was sick, Lü-ying had set out to pay her a visit; and when she failed to return, Tung's second son Tsu-ch'ang became suspicious (perhaps suspecting her of trying to escape Tung's clutches) and determined to bring her back by force. Taking with him more than two hundred of the Tung family's slaves, he broke into the Lu household, invading even the sleeping quarters, terrorized the family, ransacked and looted the Lus' possessions, and carried off Lü-ying.[291]

Outraged by this high-handed behavior, which he promptly decried far and wide, Lu was ill-inclined to let the matter drop; and two members of the local gentry—one of them Tung's friend Ho San-wei 何三畏 (1550–1624), who figures in Tung's inscription of 1611 on *Drawing Water in the Morning* (vol. 1, pl. 11), the other named Wu Hsüan-shui 吳玄水—were brought in to mediate in the dispute, and eventually Lu was obliged to yield. So notorious had the affair become, however, that an anonymous wit composed a street ballad entitled "The Tale of the Black and the White" ("Hei-pai chuan") recounting, in language thinly veiled, the rousing story of Tung's passion and the abduction of Lü-ying by night—the "white" in the title an obvious reference to Tung's *hao* Ssu-po, the "black" to Lu Chao-fang, whose dark countenance had earned him the nickname "Black Lu."

Mortified by this scurrilous assault on his dignity, Tung resolved to identify the culprit and punish him, but without success. Then one day one of his servants happened to notice Tung's brother-in-law Fan Ch'ang 范昶 (the husband

of Tung's wife's sister) standing by the roadside and listening furtively as the tale was recited by a Su-chou storyteller named Ch'ien Erh 錢二. When the servant reported to Tung what he had seen, Tung had the storyteller seized and beaten, and accused Fan Ch'ang of being author of the tale. Under duress, Fan was brought to the courtyard of the Tung mansion, and together with Ch'ien Erh, forced by Tung to kneel down and swear before him, Fan presumably attesting either to his contrition or to his innocence (in one version of the story, Fan is forced to swear his innocence before the god of the city in the local temple). Apoplectic with rage, Fan died a few days later, on the second day of the third month, in what was now the spring of 1616.

Determined to protest the cruelty of Tung's conduct, which in their view was directly responsible for Fan's death, Fan's widowed mother Madame Feng 馮氏, who was all of eighty-three *sui*, and his wife Madame Kung 龔氏, taking with them three or four of their maids, arrived at the Tung mansion near the city's south gate, bewailing their misfortune, to tax Tung with the deed. Tsu-ch'ang issued forth to meet them. Shouting for reinforcements, in particular for the family's head servant Ch'en Ming 陳明 (who had already earned for himself an evil reputation in the town) and a clansman by the name of Tung Wen 董文, he ordered the women's sedan chairs thrown in the river and the gate of the mansion closed behind them. The two women were beaten without mercy, the elderly Madame Feng flung into the gutter and her daughter-in-law stripped of her mourning clothes, after which they were dragged out into the street, where bystanders, taking pity on them, supported them into a small temple called the Tso-hua an that stood opposite. The maids fared still worse. Tsu-ch'ang had them lashed to chairs, stripped of their trousers, humiliated in every way possible, and beaten with the legs of tables broken off for the purpose, so hard that bruises appeared even while they were being struck. When the beating was over, the gate was opened and the women thrown outside, Tsu-ch'ang calling out to the assembled crowd that they should take this as a lesson. Carried into the Tso-hua an, they were a pathetic sight: "their faces covered with mud; above, without clothing to cover their bodies; the blood running down to their feet; and below, lacking even cloth enough to conceal their shame." Constables were fetched, but arrived only in time to find Madame Feng and Madame Kung crouching in the temple whimpering in humiliation, their clothes in shreds and their faces battered. Behind the Tungs' teahouse they found one young maidservant still tied up, her trousers missing and her body indecently exposed to view.

The entire town was in an uproar. The Tungs and Fans were related by marriage twice over: not only had Fan Ch'ang married the sister of Tung's wife, but also his son Fan Ch'i-sung 范啓宋 had married a young woman who was herself a Tung. Madame Feng, moreover, as the wife of an official of the fifth rank (her husband having been Fan T'ing-yen 范廷言, *chü-jen* 1579, who had served as Subprefectural Magistrate of Wan-chou in Kuangtung), had been granted the honorific title Lady of Suitability (*i-jen*) by imperial patent; and in addition she was a member of the Feng clan, one of the most distinguished families in Hua-t'ing. Feng En 馮恩 (1491–1571), her clan uncle or perhaps her father, had made a name for himself as a censor, owing to the courage he displayed while imprisoned for having proffered criticism that displeased the emperor, and had amassed a considerable fortune after his retirement; En's son Hsing-k'o 行可 (ca. 1521–1609), cousin (or possibly brother) to Madame Feng, had achieved a measure of fame for his filial piety, having in 1534, at the age of fourteen *sui*, offered his life in exchange for his father's, and later that year written a memorial in his own blood pleading for his father's release; and Hsing-k'o's brother Shih-k'o 時可 (*chin-shih* 1571) had by 1616 been serving as an official for over forty years, though he had reaped only moderate success because of his reformist measures. Feng Shih-k'o, an old friend of Tung's, had moved to Su-chou; but he immediately joined thirty-two other male members of the Feng clan in submitting a protest to the authorities.[292]

A whole litany of Tung's crimes now rose to the lips of those who had suffered at his hands. A group of Government Students, protesting later Tung's accusation of their part in the events that were to follow, listed his transgressions in a damning indictment that ranges from habitual abuses to particular offenses—his debauching, for instance, two girls from a good family, whom he made his concubines ("through [his seduction of] the elder [he succeeded in] seducing the younger [too]"); his swindling of a thousand taels of silver from one man and a hundred taels from another (even the names of his victims recorded); his forced expulsion of those living adjacent to him when he wished to extend his house ("having in the morning extorted the title deeds, in the evening he forced [the residents] to move"); his ten thousand *mou* of rich farmland, on which he paid only one third the proper tax; his hundred boats, with slaves living on more than half of them—the catalogue of his iniquities goes on and on. Equally odious charges they laid to the door of that "wicked demon," his son Tsu-ch'ang.

The Tungs' treatment of the Fan family women was the final straw. So angry were the people that their "hair stood on end" and they "gnashed their teeth" in rage. Crowds began to gather in the streets, and news of the affair spread like wildfire, carried by traveling merchants and even by prosti-

tutes who plied their trade aboard boat. On the tenth, eleventh, and twelfth of the month, placards in large characters, reading "Beast-official Tung Ch'i-ch'ang" and "Owl-demon Tung Tsu-ch'ang" made their appearance on the streets, and the younger members of the populace took up the chant, "If it's firewood and rice you want, first kill Tung Ch'i-ch'ang!" (*Jo yao ch'ai-mi ch'iang, hsien sha Tung Ch'i-ch'ang* 若要柴米強，先殺董其昌。)

It was not until the fifteenth of the month that any official action was taken. On the thirteenth, two key officials, the Vice Prefect Huang and Prefectural Judge Wu, returned to Hua-t'ing, having been absent on official business, to find a situation that was fast growing out of hand, the streets seething with an unruly mob that numbered at least ten thousand, and by one account had risen as high as a million. Both Tung Ch'i-ch'ang and Fan Ch'i-sung had already departed to put their case before the authorities in Su-chou, each to lay charges against the other;²⁹³ but Fan, like Lu Chao-fang, was a Government Student, and the students had championed his cause. On the fourteenth, the Government Students from five different schools banded together to beg for redress at the prefectural offices; and on the morning of the fifteenth they gathered at the Ming-lun Hall in the prefectural school to plead Fan's case once more before the officials Huang and Wu, after the two had finished holding prayers at the local temple. As a result of their entreaties (and because of a letter that the others alleged was composed by a student named Yü Po-shen 郁伯紳, who seems to have been bolder than the rest), an order was issued for the arrest of the head servant Ch'en Ming on twenty-five different counts, for which he was to receive sentence of death (subject, as was always the case, to imperial review). Satisfied, the students dispersed—at least so they afterwards stoutly maintained, in the face of Tung's later accusations against them.

But the matter was not to resolve itself so easily. An enraged populace still thronged the streets, their number swelled by those arriving from neighboring districts and by soldiers from the local garrison. The street before Tung's gate had now become impassable. Several of Tung's clansmen, in a last desperate attempt to stem the tide, distributed handbills in support of Tung's claim that it was really he who was the victim in the case; but they were set upon by the angry crowd, brandishing their fans or plucking up broken tiles as they entered the fray. Fearing the worst, the Tung servants hastily hired thugs (more than a hundred, so the students were to write) to protect the property; and as the fury and daring of the crowd increased, these hirelings began pouring down feces and urine from the roof on the heads of the crowd below. Some of the crowd clambered up onto the roof and started throwing back

broken tiles, aided by others beneath. Soon they had managed to wreck both gate and street. Taking up a cry against Ch'en Ming, the crowd rushed off to demolish his house, which, in testament to his rapaciousness, boasted several dozen luxuriously appointed halls and rooms. In no time at all they reduced it to ruins. Shortly after noon the crowd dispersed somewhat, but within a few hours it collected once again, and this time there were calls to set Tung's house afire. The sudden onset of thunder and rain, however, frustrated their purpose, and for the time being the crowd withdrew. By nightfall report circulated that Madame Feng was dead.

By the next morning the thugs had fled, leaving those still inside the Tung compound to fend for themselves. Putting on a show of strength, the defenders assembled at the gate, to hurl objects at the crowd that once again packed itself into the street. Finally, as day drew to a close, from among the crowd two youths, "nimble as monkeys," climbed up on the roof, each with a reed mat rolled up and soaked in oil, and touched their makeshift torches to the gate. At first the fire burned slowly, spreading only as far as the teahouse; but as the wind quickened, the great reception hall caught fire, and soon the entire compound was engulfed in flame. Members of the crowd, bodies bare, leapt into the fiery blaze to stoke the flames with chairs and tables lest the fire burn out. To the east and west, the neighboring families and monks from the Tso-hua an hastily hung up signs and lanterns to identify their property, and whenever the flames came too close, the crowd rushed to the rescue. Across the river, what remained of Ch'en Ming's house was set alight, his wife dragged to the fire, and her mangled body thrown to the flames. The fires lasted through the night, and Tung's mansion—with its several hundred rooms richly decorated and filled with treasures, with its garden pavilions, its terraces and open halls—burned till there was nothing left.

The wrath of the crowd was not yet spent. Not content with the destruction it had already wrought, on the following day, the seventeenth, it made its way to the elaborate house belonging to Tung's wealthy third son Tsu-yüan, who lived some little distance from his father and brothers near the city's east gate, and soon that too was set ablaze. Tsu-yüan, whose compound boasted over two hundred rooms, with "halls and towers lofty as the clouds," was hated almost as much as his brother Tsu-ch'ang: originally his house had numbered only several dozen rooms, but wanting to enlarge it, he had ruthlessly instructed his servants to tear down any houses rented by the townspeople that were standing in the way, and when some small householders were slow to move, had seen to it personally that the tiles were stripped from their roofs so that they had no protection from the rain. Tsu-yüan, as it

transpired, had little time to enjoy his new mansion: "Not six months after he finished building it, one torch reduced it [all] to ashes, and when the fire burned out, nothing remained, only [what looked like] the ruins of an ancient palace." Tsuch'ang's house suffered the same fate; and only Tung's eldest son Tsu-ho escaped with his house and belongings intact: as the students put it, "Tsu-ho's house lay in between, but because there was no heavy store of anger against him, not the slightest particle of his was touched; who says that the rabble knows no justice!"

The crowd was not always so scrupulous. Coming upon a well-dressed man in his fifties who was holding a fan with Tung's calligraphy to shade himself from the sun, the crowd snatched it from his grasp and tore it to pieces; and when the hapless man protested, he was roundly beaten by forty or fifty of their number, who stopped only when they had pulled off his clothes and ripped them to shreds. A tablet with Tung's calligraphy in the Ming-lun Hall, commemorating those who had placed well in the Metropolitan Examination, was destroyed before dawn one morning by perpetrators unknown; and when another tablet, inscribed by Tung with the name of the main hall of the Tso-hua an, was used by the crowd as a target for broken tiles, the frightened monks hastily climbed up and took it down, whereupon it was scraped bare and hacked to pieces with cries of "Breaking Tung Ch'i-ch'ang to bits!" Nor was the anger of the populace even yet entirely exhausted. On the nineteenth the crowd set fire to a retreat Tung owned beside Pai-lung Pool to the west of the city, and pulling down from over the entrance the tablet on which Tung had inscribed the name "Pavilion of Cherished Pearls" (in poetic description of the purpose to which the retreat was put), the furious townspeople cast it into the pool shouting, "Here goes Tung Ch'i-ch'ang straight to the bottom!"

On the twentieth day of the sixth month, Wang Ying-lin 王應麟 (1545–1620), Right Vice Censor-in-chief and Concurrent Grand Coordinator of Ying-t'ien (i.e. Nanking, seat of the Southern Metropolitan Area, Nan Chih-li), memorialized the throne, reporting two unrelated disturbances that had occurred within his jurisdiction, the one involving Tung, the other involving a certain Chou Hsüan-wei 周玄暐 (*chin-shih* 1586). The decision in these two cases is clear evidence of the influence wielded in Tung's favor by his powerfully placed friends. Tung escaped penalty of any kind, the throne ruling, on the contrary, that the rioters in Hua-t'ing, both the instigators and their followers, should be rigorously sought out and their proper punishment determined; whereas Chou Hsüanwei, whose high-handed practices in K'un-shan had aroused the populace against him, was arrested and later died in prison.[294] Though Yeh Hsiang-kao had by this time retired,

Tung's former Han-lin classmate Wu Tao-nan was now installed as one of the only two Grand Secretaries, and it is easy enough to guess whence Tung's protection came.

The relative scarcity of Tung's paintings from the years immediately preceding 1616 (only two securely dated works from the years 1613 to 1615 are included in the present exhibition), and their profusion immediately afterward, when Tung was obliged to execute paintings as gifts for friends whose hospitality he enjoyed while his house was being rebuilt, may be attributed to this unhappy incident, as may be also Tung's unpopularity in the People's Republic of China, where he is rated a notorious example of the landlord class, and where, until recently, his works have been only rarely exhibited.

Searching through Tung's writings, one finds Tung understandably reticent about the tragedy that must have claimed not only many of his own works but also a considerable portion of his treasured collection. We glimpse it briefly in the present exhibition through the eyes of Ch'en Chi-ju, in a short note he appends to a handscroll of Tung's sketches (vol. 1, pl. 19): "This is a collection [of sketches] that Hsüantsai made of trees and rocks in antique [shapes], which he used to bring out and copy every time he painted a large scroll. After the disaster [in which everything was] burned, I found it by chance at a mounter's shop. [But] I cannot let him see it again, for fear it would rouse in his breast [the memory of] his house in flames."[295]

Yet though loss there was (as much to posterity as to Tung himself), perhaps the remarkable flowering of Tung's genius in 1616 and 1617, resulting in such masterworks as his unpublished *Landscape after a Poem by Wang Wei*, painted in the fifth month of 1616,[296] and his *Lofty Recluse*, *Ch'ing-pien Mountain*, and untitled *Landscape*, painted the following year (vol. 1, pls. 31–33), owes something to the position in which Tung so unexpectedly now found himself—his house and its contents destroyed and his reputation damaged—forced suddenly to exert himself anew.

The catalyst that ripened Tung's style till it emerged fully formed in 1616 was his resurgent interest in the Yüan styles of Huang Kung-wang and Ni Tsan, whose influence (ostensibly, at least) had been eclipsed for so long by the Sung paintings he had seen in Peking. Now once more, in his major works (not simply in an album leaf here and there, as part of a larger group) Tung was openly working in Yüan styles. On the ninth day of the ninth month, 1616, finding himself at leisure aboard his boat, he painted a handscroll after Huang Kung-wang (now in the National Palace Museum, Taipei), inspired by a rare twenty-leaf album by Huang that he owned but had "not yet had time to open up and copy."[297] His *Lofty Recluse* (the title itself an oblique reference to Ni Tsan) was, to

the initiate, so clearly in Ni's style that mentioning Ni's name in the inscription was superfluous. Even in a work like the *Ch'ing-pien Mountain*—which, according to Tung, is modeled on Tung Yüan—its clumps of small boulders or "alum rocks," its rows of tiny trees punctuating the mountain's mass as it builds to greater and greater height, and its wavy "hemp-fiber" texture strokes are manifestly drawn from the vocabulary of Huang Kung-wang, though for the first and last of these Huang would in turn have acknowledged an indebtedness to Tung Yüan.²⁹⁸ On an undated painting (now apparently lost) that Tung inscribes as painted in Huang's style, Ch'en Chi-ju comments revealingly:

> When Hsüan-tsai was in Ch'ang-an [Peking], he took the Sung painters as his masters. Beyond Tung [Yüan] and Chü[-jan], he confined himself to [Chao] Po-chü and [Chao] Ling-jang. [Now], after working in their manner, studying sometimes one, sometimes another, for thirty years, he has returned once again to the Four Yüan Masters.²⁹⁹

玄宰在長安，以宋人為師。董巨之外，惟伯駒、令穰猶在摹擬。轉學三十年，復返元四家。

We may wonder that Ch'en refers so pointedly to the two Chaos; but overall his observation rings true.

The untoward events of 1616 did nothing to alter the position Tung occupied among his friends, who were as ready to enjoy his company and admire his works as they had ever been. According to the early Ch'ing connoisseur Ku Fu 顧復, whose father had been Tung's friend for twenty years (but who told his son that never once did he actually see Tung paint), the first few months after the destruction of his house Tung spent traveling between Ching-k'ou and Wu-hsing—Ching-k'ou (i.e. Tan-t'u) in what is now southern Kiangsu, where the Grand Canal meets the Yangtze, the home of his friend, the collector Chang Chin-ch'en 張覲宸 (*tzu* Hsiu-yü 修羽); and Wu-hsing (i.e. Wu-ch'eng), on a branch of the canal to the south of Lake T'ai, the home of his former Han-lin classmate Chu Kuo-chen 朱國楨 (1558–1632), later to become a Grand Secretary in 1623. The year 1617 saw Tung as active as ever, boating hither and thither on the waterways of Chiang-nan to visit friends in Ching-k'ou and Hang-chou, and at Chia-hsing, Ching-hsi (i.e. I-hsing), and Su-chou in between.³⁰⁰ But Tung's name had been badly tarnished by the 1616 episode, and though his friends politely ignored it, the populace at large was less forgiving. Ironically, it was to be his promotion to high office—which (in concert with so many of the literati) he affected to despise—that was eventually to reestablish Tung in public esteem.

V. In Peking and Nanking (1622–1625): The Interplay of Politics and Art

In 1620 the Emperor Shen-tsung died, after forty-eight years on the throne. He was succeeded by his son Chu Ch'ang-lo (temple name, Kuang-tsung), who assumed the throne on the first day of the eighth month, 1620, and following long-established custom, ordered that a list of his former tutors be referred to the Ministry of Personnel for promotion or reward.³⁰¹ On the list were thirty-six names, Yeh Hsiang-kao's appearing fourth and Tung's appearing as the twenty-first. Tung's biography in the *Ming-shih* contains the charming (and often-quoted) anecdote, "When [the Emperor] Kuang-tsung ascended the throne, he asked, 'Where is my old tutor [lit. Lecturer] Mr. Tung?,' whereupon [Tung] was summoned to court as Vice Minister of the Court of Imperial Sacrifices and Director of Studies of the Directorate of Education."³⁰² But in all likelihood the story is apocryphal: there is no mention of it by Ch'en Chi-ju (who would surely have included it in his "Life and Conduct" of Tung, had it been true), and Tung was not to be summoned to Peking until sixteen months later.

Kuang-tsung reigned only one month before dying in mysterious circumstances. He was succeeded by his eldest son Chu Yu-chiao 朱由校 (temple name, Hsi-tsung; enthroned, ninth month, 1620; reign title in effect 1621–27), an unlettered boy of sixteen *sui* whose main interest was carpentry. In the tenth month of 1620, the Minister of Personnel, acting in accordance with the wishes expressed by the late Emperor Kuang-tsung, submitted a revised list of Kuang-tsung's former tutors to the new emperor for consideration, Tung's name again appearing, fifteenth on the list of nineteen tutors who were found to be still living.³⁰³ One of those figuring prominently on the list was Yeh Hsiang-kao, who had already received a special summons to Peking in the eighth month, while Kuang-tsung was still on the throne, but refused to go. A new summons was issued, which once again Yeh refused to heed. It was not till a year later, in the tenth month of 1621, that Yeh finally arrived in Peking, to assume the position of senior Grand Secretary.³⁰⁴

The friendship between Yeh and Tung had by no means diminished. One evidence of this is provided by a calligraphy whose text, composed by Yeh, records a curious incident that took place on his journey north in 1621 to take up his office in Peking. Traveling from Fukien by boat, Yeh arrived at Huai-yin in present-day Kiangsu on the Grand Canal, only to find the way blocked with mud as the result of a storm a few days before. In some consternation, Yeh found it impossible either to proceed or to turn back. The local inhabitants insisted that he pray for help to the Four Great Gold Dragon Kings (*Chin-*

lung ssu-ta-wang). Yeh was properly skeptical, but did as he was told. Suddenly, to his surprise, two of the townsmen assumed the voices of the Dragon God and a certain "General Chang," who (the God explained) was the tutelary owner of a branch canal that was causing the problem. At the Dragon God's insistence, the General promised that the canal would be passable the following day. Yeh arose the next morning to find that overnight the water had indeed risen by two feet, and his way lay open.

So impressed was Yeh by the whole affair that he was moved to write an account of his experience, to be carved in due course on a stele, and he called upon Tung to execute the calligraphy. Tung, of course, promptly agreed, and took the opportunity to add some comments of his own—laudatory to Yeh—to be carved on the stele's reverse side. Tung's original calligraphy passed eventually into the imperial collection, where it was recorded in the *Shih-ch'ü pao-chi* and chosen for inclusion in the *San-hsi t'ang fa-t'ieh*, a collection of reproductions of famous calligraphies from the imperial collection commissioned by the Ch'ien-lung emperor (r. 1736–95) in 1747.[305]

Yeh, whose sympathies lay wholly on the side of the Tung-lin party, was now the most powerful man in Peking; and he lent his support to the "good elements" who had already begun to filter back into key positions at court. Prominent among these were two men considered to be at the forefront of the Tung-lin cause. One was Chao Nan-hsing, who had many years before been so rashly defended by Tung's old friend Wu Cheng-chih. The other was Kao P'an-lung 高攀龍 (1562–1626), who had taken his *chin-shih* degree together with Tung in 1589, and in 1612 had assumed leadership of the Tung-lin Academy in Wu-hsi.[306]

Yeh Hsiang-kao, intent upon filling appointments in the capital with men of his own choosing, had not forgotten Tung. As Ch'en Chi-ju attests, "When Yeh [Hsiang-kao] of Fu-ch'ing took charge of the country's affairs [in 1621], he recommended [Tung's] promotion to [the post of] Vice Minister of the Court of Imperial Sacrifices (*T'ai-ch'ang ssu shao-ch'ing* 太常寺少卿)."[307] The appointment, which had a rank of 4a (a step below the last of the provincial appointments Tung had chosen to reject), was made on the tenth day of the twelfth month, 1621, just six weeks after Yeh's arrival in Peking.[308]

On his way north in the spring of 1622 to take up office, Tung stopped at Yang-shan-i[309] (where thirty years before, he tells us, he had broken his journey on an earlier trip to Peking) and there painted a landscape—of which photographs exist, though its present whereabouts is unknown (vol. 1, fig. 33)[310]—which he inscribed and presented to Li Yang-cheng 李養正 (*hao* Hsüan-po 玄白, 1559–1630). Li held the imposing title and important position of Right Vice Minister of Reve-

nue, Director-general of Grain Transport (having responsibility for supervising the transport of tax grains from the Yangtze delta to Peking), and Concurrent Grand Coordinator of Feng-yang, the region comprising what is now northern Anhui and northern and central Kiangsu, including a central portion of the Grand Canal.[311] Tung was ever alert to the advantage that might be gained from fostering the goodwill of a man of Li's importance.

Hardly had Tung had time to do more than reach Peking when, on the ninth day of the fourth month, he was ordered to assume charge of the affairs of the Director of Studies of the Directorate of Education (*kuan Kuo-tzu chien ssu-yeh shih* 管國子監司業事)—the Directorate of Education being the government agency that oversaw the National University—at the same time retaining his original post.[312] Six weeks later his eldest son Tsu-ho was granted admission to the National University as a student under the system known as Protection Privilege (*yin* 蔭), whereby the son of an official, in reward for his father's services, was granted a position or post without the necessity of meeting the usual requirements.[313] But a week later, on the twenty-eighth day of the fifth month, Tung came under attack: he was impeached by a Supervising Secretary of the Office of Scrutiny for Justice named Fu K'uei 傅櫆, who accused him of "avarice and self-indulgence while residing in his native place, and reckless and unbecoming conduct while holding office," adding in conclusion that "it was unsuitable that he should occupy a position that furnished a model [for others] to imitate." 居鄉貪縱，居官放誕。…不宜在師表之地。[314] The emperor ruled that since Tung had been tutor to the late emperor his father, who on his deathbed had ordered that Tung be summoned to hold office, there was no need to be unduly strict.[315] The ruling refers simply to the late Emperor Kuang-tsung's direction that all his former tutors (of whom Tung was one) should be rewarded or employed; but it was this, or something like it, that perhaps gave rise to the story of his having asked, "Where is my old tutor Mr. Tung?"

In reality, of course, it was the Grand Secretaries, chief among whom in 1622 was Tung's friend Yeh Hsiang-kao, who were in charge of drafting all decisions for the emperor's approval, and for the moment Tung had little to fear. His immediate reaction, however, as in the past, was to place himself as far as possible out of harm's way; and eight days later he sought permission to resign on the grounds of illness. The request was disallowed.[316]

In Peking, Tung and Yeh Hsiang-kao continued on familiar terms. Both were associated with the compilation of the *Veritable Records of the Emperor Kuang-tsung* (*Kuang-tsung shih-lu*), Yeh as one of the eight Directors and Tung as a Compiler (*Tsuan-hsiu kuan* 纂修官). Tung's appointment was made on

the seventh day of the seventh month, when he was reassigned to serve concurrently as Academician Reader-in-waiting in the Han-lin Academy (*chien Han-lin yüan shih-tu hsüeh-shih* 兼翰林院侍讀學士) to assist in the compilation of the Veritable Records (those of two emperors, Shen-tsung and Kuang-tsung, being both in progress), relinquishing his duties associated with the Directorate of Education but retaining his post as Vice Minister of the Court of Imperial Sacrifices.[317] (The *Ming-shih* records that in 1622 Tung was promoted to the full rank of Minister of the Court of Imperial Sacrifices, but this is an error.[318]) Altogether thirty-one men were officially appointed to the project of compiling the *Kuang-tsung shih-lu*; but the eminent historian T'an Ch'ien 談遷 (1594–1657), whose *Kuo-ch'üeh* (*An Evaluation of [Events in Our] Dynasty*) is a key source for the detailed study of Hsi-tsung's reign, reports that it was Tung who was solely responsible for its execution, and Yeh who gave it the final polish.[319] Through Yeh, as much as anyone, Tung was brought into contact with the circle of officials closely identified with the Tung-lin movement.

In 1622 Tsou Yüan-piao 鄒元標 (1551–1624) and Feng Ts'ung-wu, two staunch supporters of the Tung-lin cause, founded the Shou-shan Academy 首善書院 in Peking, intended to promote philosophical discussion among scholars and intellectuals residing in the capital. Yeh was asked to compose the text for a stele erected to commemorate the Academy's establishment, and Tung was enlisted to execute the calligraphy[320]— either by Yeh himself or by Feng Ts'ung-wu, Tung's old friend and former Han-lin classmate, with whom Tung had maintained a friendly connection, having in 1618 composed a preface for Feng's collected works.[321] The Shou-shan Academy quickly became the object of vicious verbal attack, and survived only a few months. The stele was later destroyed after orders for the destruction of academies nationwide—and of their steles in particular—were issued in 1625 at the urging of those collaborating with the Tung-lin party's arch-enemy, the infamous eunuch Wei Chung-hsien 魏忠賢 (ca. 1568–1627).[322]

Tung's talents as a calligrapher were solicited by at least one other member of the Tung-lin group. For the Censor Chou Tsung-chien 周宗建, who was one of the two lecturers to inaugurate the Shou-shan Academy,[323] and was to die in 1626 as one of the "second group of six" martyred for the Tung-lin cause,[324] Tung made a copy of the imperial patents (*kao-shen* 告身) that had been awarded to Chou in 1621, granting honorary titles to Chou, his wife, and his father and mother.[325] Tung's calligraphy is undated, but antedates the seventh month of 1623, and was probably executed in 1622, shortly before he left the capital to undertake a protracted assignment in Nanking.[326]

On the eighteenth day of the seventh month, just eleven days after his appointment to the *Shih-lu* projects, Tung had requested permission, on his own initiative, to be transferred south to Nanking to collect material for the *Veritable Records of the Emperor Shen-tsung (Shen-tsung shih-lu).*[327] Permission was granted on the fifth day of the eighth month;[328] and a month or so later, after finishing his work on the *Kuang-tsung shih-lu*, Tung started south. On the eve of his departure, his friends gathered to hold a farewell banquet and exchange parting poems: Yeh Hsiang-kao took the lead, composing a poem to which Tung responded with a set of four in the same rhyme scheme.[329] Tung's calligraphy copying out all five poems (together with another poem for Yeh and three more composed for other friends), dated the tenth month of 1622—by which time he had made the journey south—is included in the present exhibition (vols. 1 and 2, pl. 45).[330]

Though on secondment in Nanking, Tung was not content to let his friendship with Yeh fall into abeyance, as a letter written to him by Yeh serves to prove:

> Once again I have received a kind letter from you, and [with it] your handsome gift; [my thanks] for remembering my birthday and giving me this wonderful painting. It will be handed down as a family heirloom, and forever held in honor.
>
> Although the *Veritable Records [of the Emperor Kuang-tsung]* has only a few chapters, everything from start to finish needs exhaustive investigation; I have done my best to settle every particular, and yet I am never wholly satisfied. Such are the difficulties involved in compiling history! As for what form the *Veritable Records of the Emperor Shen-tsung* should take, I do not know; it is really a matter of great anxiety.
>
> Troubles along the border continue to persist, and rifts among palace [personnel] are gradually widening. Both soldiers and food are in short supply, and there is an utter dearth of capable officials. The outer court wants to exercise its official prerogatives to rectify eunuch [excesses]; and eunuchs seize upon [every] fault and flaw to expose [members of] the outer court. Though the emperor himself is sacrosanct, the people who surround him from morning to night are all of the [latter] sort [i.e. the eunuchs]; [we] Grand Secretaries are only members of the outer court [i.e. limited in our access to the emperor], yet people endlessly upbraid us [for our inability to do more]. I cannot go on forever bottling up [my feelings]: if I [simply] bear everything unprotestingly and do not leave, I am bound to come to an unhappy end. I have already reached a decision [to go]; so there is nothing you can do to persuade me otherwise.
>
> If in the Metropolitan Gazette you succeed in hunting out any anecdotes to supplement what we lack in the History Bureau, [remember that what we write] will stand for a thousand years, so pray make every effort. When are you coming north?—perhaps we can shake hands en route.[331]

再承惠書，併損佳貺；且念及賤辰，將之妙染，傳爲世寶，奉以無斁矣。

《實錄》一書，雖卷帙不多，而前後事體儘費討議；生亦悉心詳定而反之，鄙意終未盡愜。修史之難如此。不知《神廟實錄》他日當作何狀，殊可慮也。

封疆之禍未息，宮府之釁漸開。兵食俱詘，任事無人。外廷欲執名義以繩中貴；中貴復搜瑕釁以摘外廷。主上雖神聖，然朝夕左右，皆是若輩；閣臣亦外臣耳，而人責之不已。終難稱塞，隱忍不去，決無好結局。鄙意已決，固非翁丈所能挽也。

《邸報》中若搜得軼事，以補史局之所未備，自足千秋，願勉為之。尊駕何日北來？或可於途次一握手乎？

In the end, Yeh Hsiang-kao remained in Peking; and the two friends met again only after Tung returned to the capital.

On the third day of the fourth month, 1624, some nineteen months after his departure for Nanking, Tung presented to the throne, as the culmination of his efforts, the historical materials he had gathered in three hundred *chüan* (chapters), together with a collection of unpromulgated memorials in forty *chüan*—"concerning," as he tells us, "'the trunk of the state' [the issue that arose over the designation of the heir apparent], the princely establishments, men of talent, local customs, waterways, food and commerce, government administration, and border defense"—each memorial with his own commentary.[332] To his forty-*chüan* compilation, copies of which still exist, Tung gave the title *Shen-miao liu-chung tsou-shu hui-yao* (*A Selection of Retained Memorials [from the Reign] of the Emperor Shen-tsung*), which Wolfgang Franke amplifies as "selected memorials of the Wan-li period which were not presented to the emperor for endorsement but [were] retained in various government offices."[333] As a work recording his own opinions on matters of historical import, Tung was evidently proud of it: shortened versions of the memorials, together with his commentaries in full, were added to the second edition of his collected writings, compiled in 1635.[334]

During these months in the south Tung completed another book, now lost—the *Nan-ching Han-lin chih* (*A Record of the Han-lin Academy in Nanking*), in twelve *chüan*—listed in the *Ming-shih* under the category of Official Administration (*chih-kuan* 職官). Monographs of this kind commonly dealt with an institution's organization and regulations, as well as including at times biographies of its former officials.[335] That the book dates from this period seems certain in the light of an appointment he was apparently offered on a temporary basis during his tour of duty in the south, as Junior Supervisor of the Household Administration of the Heir Apparent in charge of the Han-lin Academy in Nanking (*Chan-shih fu shao-chan-shih chang Nan-ching Han-lin yüan shih* 詹事府少詹事掌南京翰林院事). We know of this appointment not from the *Ming-shih* nor from the *Ming shih-lu*, but from Tung's copy of a pa-

tent (*kao-ming*), now in the collection of the Beijing Palace Museum, which bestowed on him the prestige title Grand Master for Thorough Counsel (*T'ung-i ta-fu* 通議大夫) in 1624, and fortuitously includes a definitive list of the offices he was awarded through 1623.[336]

The vigor of Tung's historiographical efforts was undoubtedly inspired by the prospect of promotion: traditionally it was by performing such tasks of compilation, and thereby familiarizing himself with historical precedents, that an official was considered to prepare himself for the responsibilities of high office. It was, in fact, for his contribution to the *Veritable Records of the Emperor Kuang-tsung* that on the twenty-third day of the seventh month, 1623, while he was still absent in the south, Tung received promotion to Right Vice Minister of Rites (rank 3a), and was appointed to serve concurrently as Academician Reader-in-waiting in the Han-lin Academy assisting in the direction of the Household Administration of the Heir Apparent (*Li-pu yu-shih-lang chien Han-lin yüan shih-tu hsüeh-shih hsieh-li Chan-shih fu shih* 禮部右侍郎兼翰林院侍讀學士協理詹事府事).[337]

It is thus with some surprise that we find that the memorial Tung submitted on the third day of the fourth month, 1624, reporting the completion of his mission in the south, begins with a request to retire, having, as he says, fallen ill midway through his tour of duty in the south.[338] Since the Veritable Records for the year 1624 were later destroyed, we can do little more than guess his reason. Almost certainly his "illness" was only a pretext; more than likely he had been impeached, and reacted, as he made a practice of doing, by requesting to retire. But it is also possible that with the court in Peking ever more divided between the Tung-lin party on the one hand and its enemies on the other, Tung felt that he would be safer in the south, far removed from the eye of the storm.

Nevertheless, when Tung—his request for permission to retire set aside—took up his new appointment in Peking as Right Vice Minister of Rites in the early summer of 1624, his prospects of further promotion must have seemed reasonably assured. Despite setbacks like the forced closure of the Shou-shan Academy, by the summer of 1624 the Tung-lin party seemed all but triumphant, with its adherents installed in many of the most influential positions at court. Of the seven Grand Secretaries currently serving, four could be counted in the Tung-lin camp, and only two were firmly aligned with the eunuch party.[339] Chao Nan-hsing, moreover, held the key post of Minister of Personnel; and in the eighth month of 1624, Kao P'an-lung was promoted to the immensely powerful post of Left Censor-in-chief. Tung was friendly not only with Chao and Kao but with at least three Grand Secretaries: Yeh Hsiang-kao; Chu Kuo-chen, his old Han-lin classmate, with

whom he had stayed for a time after his house was burned down in 1616; and Chu Yen-hsi 朱延禧, owner of *Waiting for the Ferry at the Foot of Summer Mountains* (*Hsia-ching shan-k'ou tai-tu*), one of the three great handscrolls attributed to Tung Yüan existing in the early seventeenth century. Tung was invited by Chu to see the painting in the summer of 1624, writing many years later that "Chu treasured it and did not show it to people lightly."[340]

In the seventh month of 1624, however, the Tung-lin party was dealt a severe blow by the resignation of Yeh Hsiang-kao, angered and humiliated when his house was forcibly searched by a group of eunuchs dispatched by Wei Chung-hsien. Tung composed a set of four poems for Yeh on his departure;[341] and in the same month that saw Yeh's resignation he painted a small but impressive painting, now in the collection of the Guangdong Provincial Museum, for Chao Nan-hsing, who remained as the most influential Tung-lin figure at court (fig. 42).[342] The imposing composition exhibits a complexity unusual in Tung's works of the early 1620s, proof in itself of the effort Tung invested in executing a work intended for so important a figure.

Over the next two months, the Tung-lin party fought a losing battle against the mounting power of Wei Chung-hsien, who by now entirely dominated the young Emperor Hsi-tsung and had cleverly allied himself with officials antagonized by the Tung-lin group. Starting in the tenth month of 1624, there was wholesale ousting of the Tung-lin faction, including its most prominent members, Chao Nan-hsing and Kao P'an-lung. In 1625 the expulsion developed into an all-out purge. Tung-lin partisans were not simply dismissed, but more often than not demoted; exiled; or imprisoned, tortured, and put to death. Chao Nan-hsing was fined 15,000 taels and sent off to Shansi as a common soldier; Kao P'an-lung was stripped of his status as an official and in 1626 drowned himself to escape arrest. In so dangerous a climate, many abruptly changed their allegiance to curry favor with Wei Chung-hsien. Others sought to satisfy their conscience by trying to steer a neutral course.

Tung, who had nothing in him of the martyr's temperament, was quick to foster what relationships he could with those who chose collaboration with Wei Chung-hsien. His calligraphy and painting were the ideal means to this end: apolitical tools that allowed him to forge a bond with men whose friendship could prove politically useful. Tung's opportunism is amply demonstrated by a hitherto little noticed calligraphy in the Shanghai Museum, which taken together with its colophons forms a most remarkable document. The handscroll, entitled *K'ang-i Li hsien-sheng chuan*—the text of which appears in slightly truncated form in the *Jung-t'ai chi* under the title

Figure 42. Tung Ch'i-ch'ang. *Landscape Expressing Wang Wei's Poetic Feeling*, painted for Chao Nan-hsing, dated 1624. Guangdong Provincial Museum.

"Li t'ai-kung chuan"—is the biography of a virtually unknown figure by the name of Li Fan-kuan 李反觀, which Tung composed and copied out in late 1624 or very early 1625.[343] Following Tung's text are six colophons, of which the first four are of particular interest: two by the Grand Secretary Wei Kuang-wei 魏廣微, the second of which is dated the fourth month of 1625; a third colophon, dated the ninth month of 1625, by the Grand Secretary Chu Yen-hsi (who had been forced from office three months earlier, and at whose home in Peking Tung had seen Tung Yüan's *Waiting for the Ferry* in 1624); and a fourth colophon, undated, by the Grand Secretary Feng Ch'üan 馮銓. Such an array of testaments by political figures combined on a single scroll inevitably suggests the existence among them of political ties; and what motivated Wei, Chu, and Feng to inscribe the scroll—and Tung to compose and copy out the text—is revealed when we discover the identity of Fan-kuan's son to be Li Lu-sheng 李魯生, whom the biography and the first four colophons clearly intended to compliment.[344]

Li Lu-sheng, a native of Chan-hua in Shantung, had taken his *chin-shih* degree in 1613, and after serving as magistrate of four successive districts, had been appointed a Supervising Secretary of the Office of Scrutiny for War in the fourth month of 1624.[345] Through Wei Kuang-wei (who had risen to the position of Grand Secretary in 1623 by becoming one of the first officials to ally himself with Wei Chung-hsien), Li gained entrée into the eunuch's circle, and being "base and treacherous" (as the *Ming-shih* describes him), soon made himself a party to its schemes. In mid-1625, when a vacancy occurred in the Grand Secretariat, Li argued that experience need not depend on age, and that ability should be construed as a lofty dedication to serve the state—a veiled reference to the suitability of the eunuch party's candidate Feng Ch'üan, whom the party was determined to install despite Feng's youth and subordinate position as Junior Supervisor of the Household Administration of the Heir Apparent. Feng was appointed a Grand Secretary fifteen days later.[346] Eleven other men Li recommended for office were known members of his own private clique. So influential did Li become, in company with another Supervising Secretary, Li Heng-mao 李恒茂, and the Censor Li Fan 李蕃, that a jingle made the rounds, "If promotion you please, ask the three Lis" (*Kuan yao ch'i, wen san Li* 官要起，問三李).[347] Small wonder, then, that Tung agreed to compose the biography of Li's father Fan-kuan, particularly when it drew him into friendly (and innocent) contact with one of the eunuch's chief confederates, Wei Kuang-wei, who had himself composed Fan-kuan's epitaph (*mu-chih-ming*).[348] Wei, for his part, was effusive in his praise of Tung: Tung's literary style and calligraphy, he wrote in his first colophon on the

scroll, joined with Fan-kuan's high moral conduct, might rightly be called the "three imperishables" (*san pu-hsiu* 三不朽).

When—soon after the demise of Wei Chung-hsien and the disgrace of his followers—Tung's writings were being compiled in 1630, Tung was evidently embarrassed by his biography of Li Fan-kuan, which testified all too clearly to his friendly association with members of the eunuch party. Presumably pleased with the composition, however, Tung allowed his grandson (who was acting as editor) to include it in the *Jung-t'ai chi*, disguising it first by making a number of small changes.[349] Even in the original, Tung had inexplicably written "Chan-i" 霑益 (which occurs as a place name only in Yünnan) instead of Li's native "Chan-hua" 霑化 (in Shantung).[350] Now he altered the surnames of two officials (natives of Chan-hua, and its most prominent figures at the time) mentioned in the original text: "Ting" 丁 to "Chung" 鍾, and "Li" 李 to "Ku" 顧;[351] changed his reference to Wei Kuang-wei from "the Grand Secretary Wei" 大學士魏 to "the Junior Guardian Wei" 少保魏, thus leaving the reader in doubt as to Wei's identity;[352] and while retaining Li Lu-sheng's *tzu* Tsun-ni 尊尼 in the final text,[353] deleted the short sentence in the original that identified Li's father—the subject of the biography—by his given name: "[K'ang-i hsien-sheng's] *ming* was Fan-kuan, his *tzu* was Shou-chan, and his *pieh-hao* was Erh-feng chü-shih" [康義先生] 名反觀，字守詹，別號二峯居士.[354] Posterity, at least, was to be thrown very thoroughly off the track.

Tung's efforts in the final months of 1624 to distance himself from the Tung-lin faction were evidently successful. At the very end of the ninth month or beginning of the tenth (the date is uncertain), he was promoted to Left Vice Minister of Rites and Academician Reader-in-waiting in the Han-lin Academy (*Li-pu tso-shih-lang chien Han-lin yüan shih-tu hsüeh-shih* 禮部左侍郎兼翰林院侍讀學士),[355] and according to Ch'en Chi-ju was offered even more prestigious posts: "The court wished to make him Vice Minister of Personnel, but he declined. The court then wished to make him Minister of Rites, but he declined again. Shortly afterward he requested appointment as Minister of Rites in Nanking [*Nan-ching Li-pu shang-shu* 南京禮部尚書, rank 2a], and [presently] submitted a memorial [seeking permission to retire] on account of old age."[356] The Nanking appointment to which Ch'en refers was made on the twenty-sixth day of the first month, 1625.[357]

In writing this passage, Ch'en's purpose was to portray Tung as determined to escape all association with the eunuch party. But the situation in fact was not as straightforward as Ch'en would have us believe. The office of Minister of Rites in Peking (which according to Ch'en was one of the posts Tung was offered) had been held since 1623 by Tung's former Han-lin classmate Lin Yao-yü, who years before had helped

him obtain Tung Yüan's *Hsiao and Hsiang Rivers*; and Tung could hardly have been expected to express an interest in a post already filled by an old friend. Lin continued to occupy the post until he retired in the eighth month of 1625.[358]

The circumstances preventing Tung's acceptance of a post as Vice Minister of Personnel were more involved but equally compelling. In 1623 the name of Tung's old friend and former Han-lin classmate Feng Ts'ung-wu had been put forward by the Ministry of Personnel as first choice for a vacancy as Right Vice Minister of Personnel; but Feng had been rejected by the throne and the position given instead to Ts'ao Yü-pien 曹于汴 (1558–1634), who had been named as the second choice. Unwilling to accept a post he considered rightfully belonging to Feng, Ts'ao attempted to refuse the post four times, and when his refusals were rejected, retired on grounds of illness at the end of 1623.[359] In the first month of 1624 the post was awarded to Ch'en Yü-t'ing 陳于廷 (*chin-shih* 1601), whom Tung used to meet (as he was later to recall) while the two were waiting to take part in audiences at court, when they would talk over their common ambition to retire.[360] On the twenty-eighth day of the tenth month—soon after Tung's appointment as Left Vice Minister of Rites—Ch'en Yü-t'ing, together with two of the most famous of the Tung-lin partisans, Yang Lien 楊漣 (1571–1625) and Tso Kuang-tou 左光斗 (1575–1625), was summarily dismissed and stripped of his official status.[361] Tung, who whatever his faults was a loyal friend, could not have done otherwise than refuse a post from which his old classmate Feng Ts'ung-wu had been excluded and his colleague Ch'en Yü-t'ing ousted in so humiliating a manner.

On the face of it, the post of Minister of Rites in Nanking seemed an ideal solution to Tung's difficulties. Though with no substantive power attached to it, it was visibly a step upward in rank, and it was far from the turmoil in Peking. Yet Ch'en Chi-ju's testimony that Tung requested the appointment (that is to say, intimated to a friend in the Grand Secretariat, perhaps, that such an appointment would prove welcome) is thrown into question by an entry in the *Ming shih-lu* recording that only four days after the appointment was made Tung submitted a memorial to the throne seeking permission to decline it.[362] We can only speculate on his motive. Conceivably his show of unwillingness to accept the position sprang from a sense of loyalty to his fellow official Li Wei-chen 李維楨 (1547–1626), who had vacated the post only three weeks earlier:[363] in his memorial of early 1624 reporting on the completion of his mission in Nanking, Tung had himself recommended that Li be employed to assist in the compilation of the *Veritable Records of the Emperor Shen-tsung* because of his ability as a historian.[364] As a result, Li had been appointed Left Vice Minister of Rites and then promoted to

Minister of Rites in Nanking. Ostensibly Li had retired on the grounds of age and decrepitude (which indeed had a basis in truth); but he had also proved intensely unpopular with his colleagues in Nanking, who resented his autocratic manner.[365]

What is interesting is that despite a political scene growing daily more dangerous, Tung does not seek to retire; instead, he requests permission to reject the very appointment that would remove him to a position of relative safety. We cannot, then, rule out altogether the possibility that Tung felt himself sufficiently secure for the moment to remain in Peking; he was on friendly terms, after all, with Wei Kuang-wei and Chu Yen-hsi, who at the beginning of 1625 were two of only three Grand Secretaries serving at court. Other friends like Lin Yao-yü still remained in Peking; Lin, in fact, was made Grand Guardian of the Heir Apparent (rank 1b) in the second month of 1625, and on his retirement six months later was awarded, as a mark of imperial favor, permission to make use of government postal relay facilities on his journey home.[366]

Whatever Tung's reason for attempting to decline the Nanking post, his request was refused; and in the second month of 1625 he started south. As we learn from his inscription on a painting now in the Nanjing Museum (vol. 1, fig. 34),[367] Tung spent his last night before leaving Peking in the company of the Censor P'an Yün-i 潘雲翼. P'an today is scarcely remembered, but in 1625 he wielded extensive power in his position as a Regional Inspector of the Metropolitan Area (*Hsün-an chih-li yü-shih*),[368] the most important commission that a censor could hold. In 1624, before the Tung-lin party's downfall, P'an had joined the chorus speaking out against eunuch abuses. But less than a year later he was striving to ingratiate himself with Wei Chung-hsien by contributing 5,000 taels of his own money to one of the eunuch's cherished building projects.[369] P'an was also a collector. One work he owned was a handscroll attributed to the Sung master Yen Wen-kuei 燕文貴 now in the Osaka Municipal Museum of Art, which Tung had borrowed from P'an and examined for ten days in 1624.[370] On their last evening together in Peking, Tung and P'an occupied themselves in examining a scroll by the tenth-century master Kuo Chung-shu in P'an's collection; but Tung had perhaps another motive—the cementing of a friendship that might protect him should impeachment charges against him later arise. The danger was very real: Tung was to be impeached twice that year.

As he traveled south in the second and third months of 1625, Tung painted two paintings, now in the collection of the Shanghai Museum, as parting presents for two younger officials in the eunuch camp with whom he was friendly in Peking (figs. 43, 44). Both men, Feng Ch'üan (whom we met above, at a slightly later point in his career, as the writer of a

Figure 43. Tung Ch'i-ch'ang. *Village in the Mountains on a Clear Day*, painted for Meng Shao-yü, dated 1625. Shanghai Museum.

Figure 44. Tung Ch'i-ch'ang. *Bidding Farewell on the River Lu*, painted for Feng Ch'üan, dated 1625. Shanghai Museum.

colophon on Tung's biography of Li Fan-kuan) and Meng Shao-yü 孟紹虞, held relatively junior positions as Advisers in the Secretariat of the Heir Apparent (*Chʻun-fang yü-te*),[371] a common enough stepping-stone in what was usually a long road leading to high office; but in so volatile a political climate, with the tide turning in favor of Wei Chung-hsien, Tung may easily have marked them out as men soon destined to rise higher. Indeed, Meng Shao-yü had just been appointed a Lecturer to the emperor (*Jih-chiang kuan*).[372] Meng seems to have been a rather colorless figure, who succeeded so well in striking a political balance that in 1627, at the height of Wei's power, he was appointed Vice Minister of Rites, and five months later, despite Wei's final downfall, he was elevated to the full rank of Minister. Soon afterwards, however, he was forced to resign and was subsequently implicated in Wei's crimes.[373]

A very different man was Feng Chʻüan, who was soon to make his mark with a vengeance. Feng's rise was nothing short of meteoric: within six months of Tung's executing his painting, Feng had been appointed first a Junior Supervisor of the Household Administration of the Heir Apparent and then (at the age of only thirty-one *sui*) Right Vice Minister of Rites and Grand Secretary; and he rapidly established himself as one of Wei Chung-hsien's most notorious henchmen. In 1626 he was one of the three men who directed the compilation of the infamous *Canon of the Three Reigns* (*San-chʻao yao-tien*), which in effect became in the hands of its compilers a vicious anti-Tung-lin treatise; and much later, as one of the first Ming officials to take office under the Chʻing, he is thought to have committed the heinous crime of destroying the Veritable Records for 1624 and parts of 1627 because they contained references to his own misdeeds.[374] Feng was also a collector of some pretensions, and was later to publish a collection of calligraphy rubbings entitled the *Kʻuai-hsüeh tʻang fa-shu* after Wang Hsi-chih's *Kʻuai-hsüeh shih-chʻing tʻieh*, the prize piece in his collection.[375] Once again, by trading on a shared interest in art, Tung was able to further a relationship that might possibly prove a political safeguard, without encountering the dangerous accusation of political affiliation.

The friends Tung left behind at court were soon to stand him in good stead. In the sixth month of 1625 Tung and two others, an Assistant Minister of the Seals Office named Sun Shan-chi 孫善繼 and a Bureau Vice Director in the Ministry of Justice named Li Tʻeng-chiao 李騰蛟, were impeached as "avaricious and depraved officials" 斜貪競邪臣 by the Investigating Censor of the Kuangsi Circuit Liang Ping 梁炳. After detailing the iniquities of Sun and Li, Liang continued:

> Yet another is the Minister of Rites in Nanking Tung Chʻi-chʻang, his character that of a man of low sort, and his mind besotted by

calligraphy and painting. When he was [put in charge of] examining scholars, they created a disturbance; and when he was residing in his native town, the town became embroiled in fighting. In wielding the brush, he shows perhaps some trifling skill; but as a holder of office he has long been without a redeeming feature. He indulges and screens his dependents, takes bribes and makes trouble, and relies on power and influence, turning first to one minister, then to another. I do actually appreciate his talent [such as it is]; but really this man is beyond the pale of the law.

如南京禮部尚書董其昌者，匪比小人，情耽書畫。衡士士譁，居鄉鄉閧。載筆或有微長，奉職久無善狀。縱護家人，受賄生事，依傍權勢，旋孤旋卿。臣實惜才，然而其人實不法矣。

The throne ruled that the cases involving Sun and Li, Tung's fellow accused, should be referred to their respective Ministries for deliberation, to be followed by a report to the throne; Tung, however, was exonerated immediately, and in no uncertain terms:

> Tung Chʻi-chʻang, by virtue of his [high] standing and reputation, was selected and promoted [to hold office] in the south; since he has held his new post a short time [only], how dare anyone slander him?[376]

董其昌以凤望簡擢南卿，履任未幾，何得輕詆？

There could be no clearer evidence of the influence wielded in Tung's favor by his friends at court—friends, in this case, almost certainly of the eunuch party.

One of the complaints leveled against Tung here, of being "besotted by calligraphy and painting," illustrates the kind of charge that must have been made against him in 1599, though no official record survives. That Tung was himself reminded of the old charge we discover from his inscription on an album he painted for his young friend and protégé Wang Shih-min, which appears in the present exhibition (vol. 1, pl. 54). On the album's final leaf, which is dated the ninth month of 1625—three months after his impeachment by Liang Pʻing—Tung inscribes the very poem that so long ago he wrote on his painting of Li Chʻeng's wintry mountains, painted in a fit of anger after his first experience of being impeached in 1599.[377] After writing out the poem on his album of 1625, he adds, "This I wrote long ago. Affected by this recent business [i.e. his impeachment by Liang Pʻing], I inscribe it [here] once again." Even after twenty-six years, the bitter memory of 1599 was not entirely erased.

In the seventh month of 1625, six weeks after his impeachment by Liang Pʻing, Tung was impeached a second time, along with several others, by a Supervising Secretary of the Office of Scrutiny for Justice named Tu Chʻi-fang 杜齊芳. The case against Tung was dismissed as having been ruled upon al-

ready;[378] but twenty-one days later, reacting probably to his impeachment earlier by Liang P'ing, Tung requested permission to retire, once more on the grounds of illness.[379] Permission was refused. It was not until the twenty-ninth day of the twelfth month—having again requested permission to retire, this time giving age as his reason—that Tung was finally permitted to relinquish his office and granted the privilege of using government postal relay facilities to return home.[380]

VI. Last Years and Final Honors (1626–1636)

The next six years, spent in retirement, were pleasant ones for Tung. In 1626, on the first day of the tenth month, his wife Madame Kung 龔氏, who was two years younger than Tung, celebrated her seventieth birthday, and Ch'en Chi-ju did the honors by composing an essay to mark the occasion, congratulating Tung on having escaped the "battlefield" at court. Tung's fame had now spread to the very borders of the empire: "Any of the gentry holding a family celebration," Ch'en boasts, "sends a carriage bearing gold and jade several thousand *li*, hoping against hope to beg only a character or two [from Tung's brush], to bring honor to his ancestors and prestige to his descendants."[381] Madame Kung, according to Tung, was a devout Buddhist; and with the idea of pleasing her, on her seventieth birthday Tung started on a copy of the *Diamond Sutra* (*Chin-kang ching*), which he finished on the fifteenth of the month, intended, as he tells us, to promote the happiness of their parents in the life after death.[382]

Of Madame Kung herself we learn most from reading Ch'en Chi-ju's "Life and Conduct" of Tung, where, as one might expect, she is described as the epitome of the frugal and virtuous wife: decorous and reticent, loyal and sincere; who spent her early married years in poverty, embroidering by day and spinning at night, serving meals to Tung's father, secluding herself without complaint in their modest home, and managing all so that Tung was entirely relieved of household cares and at liberty to realize his scholarly ambitions. Even after Tung was a high-ranking official, she persisted in washing the clothes and cooking the meals, as she had done in the needy days when Tung was still a Government Student. Ch'en concludes the catalogue of her good qualities by adding that she was given neither to jealousy nor to dalliance, nor to a fondness for company "beyond the family gate"; that she treated the young women in the household as her daughters and performed the duties of a sharp-eyed inspector and stern schoolmaster to her sons and grandsons; and that within the family walls "the sound of scolding the dogs and chickens and whipping the servants was no longer to be heard."

All this seems on the face of it standard fare; what is of unexpected interest is that Ch'en includes enough clues about her family to enable us to reconstruct her background. Her immediate family seems to have been a more prosperous one than Tung's, though its antecedents were undistinguished. Two of her uncles (or, more accurately, clan uncles, though one may indeed have been her father's elder brother) held official positions, which Ch'en (with a regard for posterity not always shown by Chinese authors) is obliging enough to name. The two can be identified as the cousins Kung Ch'ing 龔情 (*hao* Fang-ch'uan 方川, *chin-shih* 1553) and Kung K'ai 龔愷 (*hao* Ch'üan-shan 全山, *chin-shih* 1547), who were from a Shanghai family.[383] The elder, Kung Ch'ing, took his *chü-jen* degree in 1540 together with Lu Shu-sheng and two members of the Tung clan, one of them Ch'ien (later Tung) Chih-hsüeh, the father of Tung's cousin and boyhood companion Tung Ch'uan-hsü.[384] Kung Ch'ing, after passing his *chin-shih* degree and serving as a Messenger in the Messenger Office attached to the Ministry of Rites, was promoted to a position as a Supervising Secretary of the Office of Scrutiny for Rites, and eventually became the Director of a Bureau in the Ministry of Works in Nanking (rank 5a). The younger and better known of the two, Kung K'ai, began his career as a District Magistrate, and was subsequently appointed a Censor. In 1551 he was sentenced to a flogging of eighty strokes at court for having submitted a memorial impeaching the Minister of War Shih Tao 史道 (d. 1553). He survived (though his fellow memorialist did not) and rose in the end to be a Surveillance Vice Commissioner of Hu-kuang (rank 4a).[385] On Kung Ch'ing's death, it was Lu Shu-sheng who composed his epitaph (*mu-chih-ming*), Lu's friendship with Kung Ch'ing being yet another reason why Lu was well disposed to befriend the young Tung Ch'i-ch'ang.[386]

According to Ch'en Chi-ju, the two Kung cousins had their eye on Tung while he was still in the village school; and convinced that Tung was destined to go far, they resolved to marry him to one of their own daughters. Their wives, however, were of mixed mind; and in the end the cousins arranged to betroth Tung to the daughter of a younger brother, who we may assume was less successful than themselves. Libidinous though Tung may have been—and not a few stories attest to his amorous proclivities or accuse him outright of salaciousness, though in some part they may have been concocted and propagated by his enemies, of whom he had as many as he had friends[387]—Tung seems to have been genuinely fond of Madame Kung, as the sutra he wrote out for her in 1626 bears witness. Ch'en Chi-ju's characterization of her, moreover, by its length and detail, becomes something more than a pro forma description; by the time he finishes, one in-

clines almost to believe it. According to Ch'en, Tung once said, "The wife from [my days of] 'dregs and chaff' [i.e. from my days of poverty] was [Madame Kung]; she it is [I call] my good friend; my friend from poor and humble [days] was Ch'en [Chi-ju]; he it is [I call] my revered friend."[388] It has the ring of truth.

Of Tung's three sons whose existence is well-documented—Tsu-ho 祖和 (*tzu* Meng-lü 孟履), Tsu-ch'ang 祖常 (*tzu* Chung-ch'üan 仲權), and Tsu-yüan 祖源 (*tzu* Chi-yüan 季苑)[389]—Ch'en says not a word (save that Tsu-ho had Tung's collected writings reprinted in Fukien), perhaps because there was little that could be said in their favor. Tsu-ch'ang and Tsu-yüan, at any rate, had earned for themselves an unsavory reputation, even before the burning of the Tung estate in 1616.[390] None of the three inherited his father's scholarly aptitude. We know that at least one attempted to pass the provincial examination, since in Tung's inscription of 1603 on his *Landscape after Kuo Chung-shu* (vol. 1, pl. 4) he mentions accompanying a son to Nanking for this purpose, but none of them succeeded. Both Tsu-ho and Tsu-ch'ang, under the system of Protection Privilege, were eventually appointed to minor government positions, Tsu-ho as Secretary of a Bureau in the Ministry of Works (rank 6a), Tsu-ch'ang to a corresponding post in the Ministry of Justice, but neither progressed further.[391] The third son, Tsu-yüan, seems never to have held an official post. At the time of the 1616 incident, he was reputed to be even wealthier than his father, having married a woman who was the niece of the Grand Secretary Shen Shih-hsing and the great-great granddaughter of the Grand Secretary Hsü Chieh (who during his tenure in office was said to have acquired some forty to sixty-six thousand acres of farmland, the greater part of which he managed to retain, despite the confiscation of more than ten thousand acres by the authorities).[392]

A few of Tung's works are inscribed by him as having been executed as a present for one or another of his sons or grandsons: one such is his *Detailed and Complex Landscape in the Sung Manner* (vol. 1, pl. 70), which he painted for a hitherto unknown son by the name of Tsu-ching 祖京. Several works, moreover (though the number is surprisingly small), bear the seal of his son Tsu-yüan or, in at least one case, the seals of his son Tsu-ho,[393] an example of the former being the magnificent album entitled *Eight Views of Autumn Moods* (vols. 1 and 2, pl. 38), that evidently remained for a time a family treasure. But, curiously, Tung failed to awaken in his sons or grandsons any inclination to follow in his footsteps as a calligrapher or painter, or even to inspire their interest in maintaining or expanding his collection. Not one of the many paintings he acquired is impressed with their seals. One can only presume that by a perverse fate, his sons possessed none

of the ability, application, and tireless ambition that were so much a part of their father's character. His eldest grandson T'ing, it is true, was responsible (at least ostensibly) for compiling the initial edition of Tung's collected writings in 1630, and together with his father Tsu-ho the second edition in 1635. But it is worth remarking that both editions were compiled during Tung's lifetime, as if Tung could not quite bring himself to trust that his sons or grandsons would complete the task after his death. That Tung had a hand in the compilation is clear from the changes he made in his biography of Li Fan-kuan.[394]

If his sons proved a disappointment, his relationship with Wang Shih-min did much to console him. Shih-min, the reader may recall, was the grandson of Wang Hsi-chüeh, the Grand Secretary who so long ago had admired Tung's calligraphy, and the son of Ch'en Chi-ju's great friend Wang Heng, with whom Tung had passed the provincial examination in Peking. Tung had known Shih-min since his boyhood; and when Shih-min exhibited the eager interest in and aptitude for calligraphy and painting that his own sons so conspicuously lacked, there developed between them a bond rendered all the stronger by Shih-min's having lost both his father and grandfather in the space of twenty-four months, before he turned twenty *sui*.[395] It was to Tung that Shih-min naturally turned for direction and encouragement, and Tung was unfailingly generous in his response. The earliest of the works that document their relationship are paintings of Tung's own, like the album of sixteen leaves (twice the usual number) that he painted and presented to Shih-min in 1617 (vol. 1, pl. 30). Later on, the works are Wang Shih-min's, which Tung inscribes with encomiums that are liberal in their praise.

It was in 1627, the second year of Tung's retirement, that the two were most often in each other's company. In spring Tung paid Shih-min a visit of ten days at his home in T'ai-ts'ang, where the two devoted themselves to making a thorough examination of the works in Shih-min's family collection, and spent their spare hours practicing calligraphy, "sometimes [working in] small standard script, sometimes free running script; sometimes copying the ancient masters, sometimes striking out in a direction of our own."[396] In the fourth month Tung was back again, accompanied by Ch'en Chi-ju, and to commemorate the occasion each of the three composed a poem, and Tung wrote the two characters *Hua Yü* 話雨 (Talking over Old Times) on the wall of Shih-min's Hall of Embroidered Snow (Hsiu-hsüeh t'ang), so named because years before Shih-min's grandfather Hsi-chüeh had planted several hundred plum trees in the garden, and in early spring the mingling of the red and white blossoms and green calyxes gave the garden the appearance of an embroidery.[397] A month

later Tung inscribed a hanging scroll that Shih-min had only just painted of Chieh-sun Peak in the Wu-i mountains, which Shih-min had seen the year before on a trip to Fukien, and we can assume that the two of them were together once again.[398] In autumn Tung made Shih-min a present of a painting by the Yüan master Wang Meng that still exists, with Tung's colophon recording the gift, in the National Palace Museum, Taipei. Later it was to be copied into the famous album entitled by Tung *Hsiao-chung hsien-ta* (*The Great Revealed in the Small*), which forms a record, in some part, of the paintings by ancient masters in Wang Shih-min's collection, with Tung's transcription of his own inscriptions on facing leaves. On Wang Meng's painting Tung wrote:

> Hsün-chih [Shih-min] studies Shan-ch'iao [Wang Meng], and is just on the point of surpassing him. He has not yet [quite] exhausted [Shan-ch'iao's] concept, [but when he does] he will pluck up [Shan-ch'iao's] flag![399]

遜之學山樵，幾於過藍。意猶未盡，便欲拔其幟矣。

As long as the eunuch Wei Chung-hsien remained in power, however, retirement was no guarantee of safety; and twice more, at least, Tung executed commissions on behalf of officials who had thrown in their lot with Wei Chung-hsien. Both officials were men with whom Tung had passed the provincial examination for the Northern Metropolitan Area in 1588: the Minister of War Wang Yung-kuang 王永光, a leading figure in the eunuch party, for whom Tung composed a memorial tablet (*shen-tao pei* 神道碑) in honor of his father;[400] and Wang's successor as Minister of War, Feng Chia-hui 馮嘉會, whose epitaph (*mu-piao* 墓表) Tung was invited to write in 1627.[401] That both were fellow *chü-jen* graduates provided Tung with a justification for his compliance.

The Emperor Hsi-tsung's providential death in the autumn of 1627 was all that saved the throne from total usurpation by Wei, whose appetite for wealth, power, and position had swollen to unimaginable bounds. Two and a half months after Hsi-tsung's brother Chu Yu-chien 朱由檢 (temple name Ssu-tsung; reign title in effect 1628–44) ascended the throne in the eighth month of 1627, an order was issued for Wei's arrest, and he committed suicide by hanging. The way was now open for the return to court of those Tung-lin partisans who had survived Wei's purge. But they were never again to form even so coherent a group as in the early 1620s, and there was constant quarreling with their opponents, who, despite the eventual removal of a large number of Wei's most flagrant supporters, managed to maintain a strong foothold at court.

Initially, however, those who espoused the Tung-lin cause seemed to have gained the ascendant. In the last month of

1627, the new emperor appointed six new Grand Secretaries, four with strong Tung-lin connections. One of these was Ch'ien Lung-hsi 錢龍錫 (1579–1645), who came from Hua-t'ing. Ch'ien was remotely connected to Tung, being the son-in-law of Tung's distant cousin Tung Ch'uan-ts'e, who had been murdered in 1579. Both Tung and Ch'ien had been involved in the 1601 edition of Tung Ch'uan-ts'e's travel sketches, the *Ch'i-yu man-chi*, Tung as the compiler and Ch'ien as one of thirteen others acting as editorial assistants, all family members.[402] The two evidently became friends: in 1610 they collaborated on a stele erected to commemorate the achievements of a local official, with Tung as the author of the text and Ch'ien, interestingly enough, as the calligrapher;[403] and recorded in the *Jung-t'ai chi* is a poem Tung composed for Ch'ien sometime between 1612 and 1623, on Ch'ien's return to court while serving as a Companion in the Secretariat of the Heir Apparent.[404] Ch'ien's most important contribution as a Grand Secretary was to be his part in compiling the *Yen-tang ni-an* (*Roster of Traitors [belonging to] the Eunuch Party*), promulgated in the spring of 1629, which listed some two hundred and sixty of Wei Chung-hsien's former supporters and their different degrees of guilt.[405] Among those on the list were Tung's erstwhile friends Feng Ch'üan, Meng Shao-yü, Li Lu-sheng, and Feng Chia-hui; Wang Yung-kuang managed to escape unscathed.[406]

Tung lost no time in reaffirming his ties with the Tung-lin group. In 1628 the people of Su-chou erected a commemorative arch to honor the Tung-lin martyr Chou Tsung-chien, who had been tortured to death in 1626, and Tung executed the words *shou-chung* 首忠, meaning "first in loyalty," to be engraved in large characters on the arch's lintel.[407] In the autumn of 1629 Kao P'an-lung, who had drowned himself in 1626 to escape arrest, was awarded the posthumous name Chung-hsien 忠憲 (loyal and judicial), and a memorial shrine was erected in his native Wu-hsi. Tung, in tribute to his former *chin-shih* classmate, composed and copied out a eulogy (*hsiang-tsan* 像贊), which was engraved on a stone slab and placed in Kao's shrine.[408] It was probably during the same period, the late 1620s, when the government was awarding posthumous honors to the Tung-lin party's fallen heroes, that Tung composed and copied out an undated biography of Tso Kuang-tou. Tso, among the most idealistic and outspoken of the Tung-lin partisans, had been tortured to death in 1625 as one of the "first group of six" martyred in the Tung-lin downfall.[409]

Despite the Tung-lin party's rehabilitation, the new emperor was ill-disposed toward factionalism, whatever the affiliation, and the Tung-lin party was soon to suffer for over-aggressiveness in asserting its claims. Toward the end of 1628,

a dispute arose over the naming of a new Grand Secretary. A list of eleven names was submitted to the emperor, ten of them Tung-lin supporters. Excluded altogether were two men, Chou Yen-ju 周延儒 (1588–1643) and Wen T'i-jen 溫體仁 (d. 1638), who were soon to figure as the Tung-lin party's keenest opponents.[410] The protagonists in the dispute were summoned to appear before the emperor, who decided against the Tung-lin party's leading candidate, Ch'ien Ch'ien-i 錢謙益 (1552–1664). Ch'ien was immediately forced to retire, and a month later his name was erased from the official roll.[411]

Many of Ch'ien's supporters suffered as a consequence. Among them was Ch'ü Shih-ssu 瞿式耜 (1590–1650), the nephew of Tung's old friend Ch'ü Ju-chi, with whom, we may remember, Tung had debated the meaning of a passage in the *Doctrine of the Mean* when he, Ju-chi, and five others had visited the Lung-hua Temple in 1588 for a night's discussion with the Ch'an master Han-shan.[412] Tung was evidently a friend of the family; and when Shih-ssu was summoned to Peking in the spring of 1628 and appointed to serve as a Supervising Secretary in the Office of Scrutiny for Revenue, Tung composed a poem to congratulate him on his recall to office in Peking.[413] Shih-ssu's service in Peking was short-lived: following Ch'ien Ch'ien-i's downfall in late 1628, Shih-ssu was demoted one grade and transferred forthwith to a provincial post.[414]

The following year Tung sent him a painting now preserved in the collection of the Beijing Palace Museum (fig. 45). The landscape bears two inscriptions: the first (written presumably at the time of painting) is a two-line poem reading, "The solitary lotus pierces heaven; The mountains' might crushes all beneath" 芙蓉一朵插天表，勢壓天下群山雄, followed by Tung's signature and two seals; the second, followed by a single seal, records briefly that the scroll had been painted in the autumn of 1626 and was sent to Chia-hsüan 稼軒 (i.e. Shih-ssu) in the autumn of 1629. No doubt it was the poem—with the image it evokes of a solitary upright figure contrasted with the powerful forces of oppression—that inspired Tung to choose this particular painting to send as a sympathetic gift to Shih-ssu, whose fate must have recalled his own suffering on losing his post in the capital thirty years before. The fact that Tung specifically recorded the work as painted in 1626, at the height of Wei Chung-hsien's ruthless regime, was perhaps in itself a subtle suggestion that recent events bore some similarity to those that had taken place three years earlier—a suggestion, then, that Shih-ssu might rightfully claim a place among those who had suffered for the Tung-lin cause.

Two years later, on the seventeenth day of the eighth month, 1631, Tung was recalled to Peking for the third and final time, to serve as Minister of Rites and Concurrent Chancellor of the Han-lin Academy in charge of the Household Administration of the

Figure 45. Tung Ch'i-ch'ang. *Landscape Presented to Ch'ü Shih-ssu*, dated 1626, with a second inscription by Tung dated 1629. Beijing Palace Museum.

Heir Apparent (*Li-pu shang-shu chien Han-lin yüan hsüeh-shih chang Chan-shih fu shih* 禮部尚書兼翰林院學士掌詹事府事).[415] Tung's appointment as Minister of Rites was a nominal one, his real duty being to oversee the Household Administration of the Heir Apparent. Appointed at the same time, as the substantive Minister of Rites, was another former minister,

Huang Ju-liang 黃汝良 (*chin-shih* 1586), against whom Tung was soon to be accused of conspiring. At the time of their appointment, a Censor by the name of Ch'ien Shou-lien 錢守廉 submitted a memorial remonstrating against their age (Tung was now seventy-seven *sui* and Huang three years younger), but he was severely reprimanded by the emperor for his pains.[416] The political climate had by now shifted in favor of those who opposed the Tung-lin faction, and Tung's recall, just at a point when the Tung-lin party no longer found itself in a position of control, is a measure of Tung's success in cultivating men on both sides of the political divide.

We have it on Ch'en Chi-ju's authority that Tung showed no reluctance to accept his new post: "How can [I], an old minister, sit by," Ch'en records him as saying, "when newly commanded [to serve]? I will go to court."[417] Tung, of course, was well aware that at his advanced age he was unlikely to have to serve long, and that ministers of his rank on their final retirement were not uncommonly awarded high-ranking titles to enhance their prestige. He was nevertheless in no hurry to begin the trip north; and it was not until the spring of 1632 that he finally set out, in the company of his eldest son Tsu-ho. When they reached Ch'ing-ho (present-day Huai-yin, in northern Kiangsu), however, Tung ordered his son to return home to look after his mother, entrusting to Tsu-ho's care the copy of the *Diamond Sutra* that he had written out for his wife's birthday in 1626.[418] Tung arrived in Peking to take up his post on the sixteenth day of the third month;[419] Ch'en Chi-ju recounts that when the assembled ministers caught sight of him in his audience with the emperor, they murmured to one another, "Here [comes among us] a 'phoenix and unicorn' from a former reign. [Surely] his appearance heralds [the beginning of a new and] auspicious age."[420] Even as he wrote, Ch'en must have been aware that no such age was in the offing.

Four months after his arrival, on the nineteenth day of the seventh month, Tung was impeached, together with the Vice Minister of Rites Wang Ying-hsiung 王應熊, by a Supervising Secretary of the Office of Scrutiny for Revenue named Feng Yüan-piao 馮元颷. Feng's accusation exhibits all the vituperative acrimony one associates with court politics: "[These two] hate [the Minister of Rites] Huang Ju-liang for refusing to heed their personal behests, and by vilifying him unrestrainedly they [attempt] to entrap him and engineer his downfall. How can [men such as these] set an example for their colleagues to follow?"[421] Tung had already submitted a request to retire on the grounds that the compilation of the *Veritable Records of the Emperor Hsi-tsung*, to which he had been assigned as a Vice Director (*Fu tsung-ts'ai* 副總裁) shortly after his arrival in Peking, was now finished, and that he was both

old and ill. On being impeached, he redoubled his efforts. In what remained of the month, he submitted two further memorials pleading his case, but was unsuccessful.[422]

In the midst of these efforts to retire, Tung submitted yet another memorial, refusing an imperial grant of Protection Privilege, which he had been awarded as far back as 1628, and which in fact he had gone to considerable effort to secure. The story is an interesting one, precisely because Tung's behavior is at every step of the way so thoroughly in character. In the first month of 1625, while Tung was still in Peking—having been serving as Left Vice Minister of Rites—it was announced that work on Ch'ing-ling, the Emperor Kuang-tsung's tomb, had been completed; and in keeping with past practice, rewards were granted to all prominent officials who theoretically had played a part in overseeing its construction. (It is interesting to speculate that it was the imminent completion of Ch'ing-ling, and the knowledge that rewards would follow, that prompted Tung to pay a visit to the imperial tombs in the autumn of 1624. The visit is recorded on his landscape, *Returning Home from an Homage to the Imperial Tombs*, in the present exhibition, vol. 1, pl. 50.) Tung received a grant of silver and almost immediately afterwards departed for Nanking to take up his new post as Minister of Rites.[423]

He then heard that owing to an oversight, neither he nor Wen T'i-jen (the other Vice Minister of Rites serving in 1624) had received rewards comparable to those granted to Chou Tao-teng 周道登 and Cheng I-wei 鄭以偉, both of whom were Vice Ministers of Rites when Ting-ling, the emperor Shen-tsung's tomb, was completed in the previous reign. But being in Nanking, he was unable to learn the full facts of the case (so he says, though the closing years of Hsi-tsung's reign, with the government in the hands of Wei Chung-hsien, were not the time to petition for imperial favors), and he was unable to take the matter further.

In 1628, however, with the accession of the new emperor, Tung formally requested the reward whose presentation, he points out, had been so long delayed. The emperor instructed the Ministry of Rites to look into the matter, with the result that the Minister of Rites Ho Ju-ch'ung 何如寵 gave it as the Ministry's opinion that since Chou and Cheng had been granted the *yin* privilege on the completion of Ting-ling, Tung and Wen merited it as well. The final decision, of course, was left to the emperor. Three days later the verdict was handed down in Tung's favor.

All was to Tung's satisfaction, then, until he was on his way to court in 1632. En route he read in the Metropolitan Gazette that Wen T'i-jen (now a Grand Secretary) and Cheng I-wei had both refused the *yin* privilege on its having been offered to them. Tung was in a quandary: to keep what others

had refused could expose him to charges (for instance, of "coveting office," in this case on behalf of his son) that might at any moment be leveled against him. How could he decline the *yin* privilege and yet explain his earlier persistence in trying to obtain it? In his memorial of 1632 refusing the favor, he excuses himself on the grounds that only in 1632, on reading the Metropolitan Gazette, did he realize that the *yin* privilege was intended for those in the Ministry of Works but not in the Ministry of Rites, and he intimates that perhaps the Ministry of Rites (which in 1628 had delivered its opinion in his favor) had not investigated the matter as carefully as it ought. Perhaps it was this last allusion that brought down on his head the wrath of Feng Yüan-piao, though there is no hint in Tung's memorial that the fault was in any way attributable to the current Minister of Rites Huang Ju-liang.[424]

What Feng's accusation makes clear is that now, as much as ever, Tung stood in need of good friends in high office, if he was not to risk losing everything he had gained. With impeachment an ever-recurring threat—leading often enough to dismissal or demotion; to excision of one's name from the official roll; to confiscation of property; or even to imprisonment and death—it is hardly surprising that throughout his career Tung courted the friendship of influential ministers, in particular those powerful arbiters the Grand Secretaries, whom chance placed in his path. His fame as a painter and calligrapher, the wealth of his collection, and his acknowledged expertise as a connoisseur: all were made to play a role in securing his political survival. Despite Feng's accusation and his own attempts to retire, Tung was ordered to remain in his post, the emperor no doubt acting on the advice of his senior officials. Foremost among them at the time was the senior Grand Secretary Chou Yen-ju, who had good reason to regard Feng Yüan-piao as his enemy, and whose friendship Tung had made a point of cultivating.

In early 1632, when Tung arrived in Peking, the court was dominated by the two Grand Secretaries Chou Yen-ju and Wen T'i-jen, who had joined forces as early as 1628 to discredit their Tung-lin enemy Ch'ien Ch'ien-i. In 1629 the anti-Tung-lin faction to which they belonged had succeeded in ousting Tung's friend and distant connection, the Grand Secretary Ch'ien Lung-hsi, who a few months later was arrested and imprisoned, and narrowly escaping death, in 1631 was sent as a frontier guard to an island off the Chekiang coast, where he was fated to remain twelve years.[425]

Tung nevertheless was eager to pursue an acquaintance with Chou, in which he was abetted by the interest Chou apparently had in collecting: Tung's writings include a colophon he wrote for an album Chou owned of Sung and Yüan paintings.[426] Tung and Chou were otherwise connected through

their common friendship with Feng Ch'üan, who may have been the one who introduced them. Chou and Feng were fellow *chin-shih* graduates in 1613 and became good friends, as the *Ming-shih* makes a point of mentioning, no doubt intending to shed light on Chou's character.[427] Possibly Tung had already made Chou's acquaintance in Nanking, where both were stationed at intervals during the T'ien-ch'i period (1621–27).[428] In 1633 Chou, who had been appointed Grand Guardian of the Heir Apparent (rank 1b) in the second month of 1630, successfully survived his first triennial evaluation or merit rating (*k'ao* 考) as an official of the first rank; and Tung presented him with a congratulatory essay in honor of the occasion.[429]

Unbeknown to Chou (and to Tung), however, Chou's erstwhile friend Wen T'i-jen aspired to fill Chou's place as senior Grand Secretary and was plotting to gather the reins of power entirely into his own hands. From mid-1632 onward Chou came under increasing attack, one of his attackers being Feng Yüan-piao. In the first month of 1633, a Senior Compiler named Ch'en Yü-t'ai 陳于泰, with Chou Yen-ju's backing, submitted a memorial to the throne listing the four abuses besetting government of the present day. A eunuch by the name of Wang K'un 王坤, prompted by Wen T'i-jen, impeached Ch'en and succeeded in implicating Chou in his accusation. The Left Vice Censor-in-chief Wang Chih-tao 王志道 (*chin-shih* 1613), whose inscription appears alongside Ch'en Chi-ju's on the *shih-t'ang* of Tung's *Lofty Recluse* of 1617 in the present exhibition (vol. 1, pl. 31), was one of those who sprang to Chou's defense.[430] Even Tung (convinced, presumably, that Chou would prove victorious in the struggle) was sufficiently moved to present a memorial of his own impeaching Wang K'un and protesting against the prevalence of eunuchs at court—the only audacious act in his otherwise circumspect career.[431] Fortunately Tung escaped retribution; but Wang Chih-tao was so outspoken in his condemnation of eunuchs in general and Wang K'un in particular that he was ordered by the emperor to resubmit his memorial. The new memorial angered the emperor even more than before, and Chou was unable to save him: Wang Chih-tao's name was erased from the official roll.[432] Tung must have shuddered to think how easily he might have suffered the same fate. In the three months that followed he submitted three memorials requesting permission to retire, citing the example of Huang Ju-liang (who though three years younger had already been allowed to retire) and alleging the severity of his ailments, complaining of both asthma and dropsy.[433] Again he was unsuccessful.

In the sixth month of 1633, Chou Yen-ju was forced out of office, falling victim at last to the machinations of Wen T'i-jen. Ostensibly Chou was permitted to retire on account of ill-

ness, and was presented with gifts from the emperor and an escort to accompany him on his way home.[434] Officially, then, Chou was "courageously retiring" from high office of his own accord (*yung-t'ui* 勇退),[435] and Tung was one of those who presented him with a gift to mark his departure. The present he chose was a handsome one: Li T'ang's *River and Mountains in Miniature*, the handscroll he had first seen while a student under Han Shih-neng in the Han-lin Academy over thirty years before, and later rescued when Han's son Feng-hsi pawned it in Hang-chou. In the colophon he now appended to the scroll, Tung wrote that he would like to have painted for Chou the beautiful scenes of Chou's native Ching-hsi, but that such a painting would have taken him too long, and the handscroll must instead suffice. It is interesting to add, as a footnote to Chou's story, that despite his previous antagonism toward the Tung-lin faction, he afterward effected a rapprochement with members of the Tung-lin party desperate to counterbalance the forces ranged against them, and was reinstated as senior Grand Secretary in 1641 with the support of his former Tung-lin enemies. But even this did not serve him with later historians, virtually all of whom inherited a sympathy with the Tung-lin cause: in the *Ming-shih*, Chou's biography is placed under the heading of "Traitorous Ministers."[436]

Chou was not the only powerful figure whose friendship Tung was at pains to secure. On his arrival in Peking in 1632, he had renewed an old acquaintance with Ch'en Yü-t'ing, who had served in Peking in 1624 as Right Vice Minister of Personnel while Tung was Right (and then Left) Vice Minister of Rites, and who had been struck from the official register for his Tung-lin sympathies, in company with the courageous Tung-lin partisans Yang Lien and Tso Kuang-tou.[437] In 1628, under the new Emperor Ssu-tsung, Ch'en was appointed Right Censor-in-chief in Nanking, and in 1631 promoted to Left Censor-in-chief in the capital,[438] a post wielding enormous influence as the senior of the Censorate's two chief executives, hence the highest censorial post in the government. Ch'en was eager for Tung to copy out an imperial patent (*kao-ming*) awarding him the prestige title Grand Master for Assisting toward Good Governance (*Tzu-cheng ta-fu* 資政大夫) in accordance with his new appointment as Junior Guardian of the Heir Apparent,[439] and Tung was happy to oblige, appending a colophon in which he traced the history of their friendship. The calligraphy, dated the seventh month of 1632, is now in the Beijing Palace Museum.[440]

Two months later Ch'en was dismissed, having incurred the emperor's displeasure over a matter involving two provincial Investigating Censors.[441] The following month his post was awarded to Chang Yen-teng 張延登, who earlier had succeeded Ch'en as Right Censor-in-chief in Nanking in 1631.[442]

Tung was as ready to render his services to Chang as to Ch'en; and in the sixth month of 1633 (the very month of Chou Yen-ju's retirement) he inscribed a long colophon on a scroll Chang chanced to acquire, in which he identified the painting as Tung Yüan's *Dwelling in the Mountains (Shan-chü t'u)*, three paintings by Tung Yüan with this title having been recorded in the twelfth-century collection of the Sung Emperor Hui-tsung.[443] Chang was no doubt delighted: his anonymous handscroll was now authenticated as a genuine Tung Yüan. It is worth remembering, however, that in 1635, when Tung was recalling that thrice in his lifetime he had met with Tung Yüan handscrolls in Peking, Chang Yen-teng's handscroll was not among them.[444] The painting, with its colophon by Tung (though no longer known by the title Tung bestowed on it), is now in the collection of the Museum of Fine Arts, Boston.[445]

The writer and connoisseur Chiang Shao-shu 姜紹書, who made a trip to Peking in 1633 and was on friendly enough terms with Tung to pay him a number of visits, describes Tung as being little encumbered by official duties but in constant demand by the notables of Peking for the "products of his brush." For close friends and connoisseurs Tung would execute these requests himself; but otherwise he would turn over the task to a disciple of his, also in Peking, named Wu I 吳易. Wu, owing to his proficiency as a calligrapher, held a minor post as a Drafter in the Central Drafting Office, and when Chiang paid his visits to Tung, was always to be found "sitting in a corner." Tung would himself present the work to the petitioner, who would go away perfectly satisfied.[446] The practice of employing another artist, usually a student or disciple, to execute works in his stead (*tai-pi* 代筆), to which Tung would then add his signature and perhaps a poem, and affix his seals, was one that Tung had long had recourse to, in part from sheer necessity; and by his contemporaries it was considered only to be expected. It had one merit, at least—that a petitioner was never mortified by rejection—though the story is told of at least one would-be collector ruefully discovering that the work in his possession was not, after all, from the master's own hand.[447] Three artists represented in the exhibition here—Chao Tso (vol. 1, pls. 82–84), Shen Shih-ch'ung (vol. 1, pls. 85–87), and Wu Chen (vol. 1, pls. 88, 89)—are recorded in one source or another as having executed paintings for Tung's convenience,[448] though Chao and Shen were talented artists who developed styles of their own quite distinct from Tung's.

A few days before Chou Yen-ju's retirement in the sixth month of 1633, Tung lost a second friend in the Grand Secretariat, Cheng I-wei, who died in office.[449] No longer able to count on either friend's support or protection, Tung was in a

more exposed position. With everything to lose by remaining at court and nothing to gain save the chance of receiving a higher-ranking title on his retirement, he was increasingly anxious to resign his post. In a memorial to the throne presented in the same month, he pleads Cheng's example to urge his case: though Cheng had been thought by everyone to be in good health, suddenly he was dead; should he—Tung—not fear his own demise the more, when he himself had been ill for the past fifty years? Tung's exaggerated claims of illness (an illness of which we hear nothing except in his memorials seeking to retire) were taken for what they were worth, and he was simply ordered to resume his duties.[450] Eleven weeks later he submitted yet another memorial, and was bluntly told that he need not continue to apply.[451]

For the time being, then, he was obliged to desist; and instead he addressed himself to the delicate problem of how to obtain the title he thought was due him as a tutor to the former Emperor Kuang-tsung. No doubt he hoped that a title would be awarded him without his asking; but in the end he was forced to petition the emperor in a memorial, naming three former tutors who had been favored with titles over the decade past, including his so-called enemy Huang Ju-liang.[452] Fortunately for Tung, another friend and a former subordinate, Ho Wu-tsou 何吾騶, was appointed a Grand Secretary in late 1633. The *Jung-t'ai chi* records a long inscription that Tung wrote on a painting he executed for Ho, while Ho was still a Vice Minister of Rites, expatiating on their friendship and on Ho's sympathetic concurrence in his feelings about retirement.[453] Finally, after a renewed appeal by Tung for permission to resign, in a memorial he presented to the throne on New Year's Day, the emperor was persuaded to allow him to retire on his eightieth birthday, the nineteenth day of the first month, 1634, and a month later, on the twenty-fifth day of the second month, granted Tung's earlier request by awarding him the title Grand Guardian of the Heir Apparent (*T'ai-tzu t'ai-pao* 太子太保), with a rank of 1b.[454] In rank, at least, Tung had succeeded at last in outdistancing Chao Meng-fu. Tung was now free to return to Hua-t'ing; and to the usual pleasures of retirement was added the charm of copying out the imperial patents granting him, his father, grandfather, and great-grandfather the prestige title Grand Master for Splendid Happiness (*Kuang-lu ta-fu* 光祿大夫) in accordance with his promotion to the first rank. One such copy, executed in the last year of his life, appears in the exhibition here (vol. 2, pl. 71).[455]

To describe Tung's final years and death we can do no better than turn to Ch'en Chi-ju:

When Tung returned home from the north he was eighty-one.[456] Brilliant and vigorous, with beard and eyebrows flowing in the wind,[457] he had the air of a far-off immortal. With guests he chatted and laughed, forgetting weariness the whole day long, unmindful of advancing age. In 1636, on the ninth day of the second month of winter [i.e. the eleventh month], he suddenly began to cough up phlegm; and not three days later he was dead. The crown of his head was hot, and his limbs were like cotton floss; was he [not] what the Buddhists would call "one without pain and suffering, bound by no evil bonds"?[458]

公北歸時八十有一，精采健旺，鬚眉颯颯，有神仙霞舉意。對客談笑，竟日忘疲，不知其老之將至。丙子仲冬九日，忽痰作，不三日而逝。頂心熱，四肢如兜羅綿，豈佛家所謂無諸痛苦不受惡纏者耶？

Three different death dates are given for Tung, the earliest (recorded in the clan genealogy, the *Tung-shih tsung-p'u*) being the twenty-fourth day of the eighth month, a date we must perforce rule out as too early on the basis of the superb handscroll entitled *Detailed and Complex Landscape in the Sung Manner*, dated to the seventh day of the ninth month, that is included in this exhibition (vol. 1, pl. 70).[459] A second and more plausible date appears in a letter from Ch'en Chi-ju to Wang Shih-min: not only does the text appear in Ch'en's collected writings, but also what may prove to be the original letter is preserved in the Tianjin History Museum, though because it is unpublished in reproduction and thus largely unknown, its authenticity has yet to be generally accepted. In his letter to Shih-min, Ch'en writes that Tung died on the evening of the twenty-eighth day of the ninth month, between the hours of seven and nine, and that he himself attended the body into the coffin, adding that mindful of what was to come, Tung had decided that his body should be clad in Taoist robes, without the jade belt that would mark him as an official of high rank.[460]

The latest of the three dates is that given by Ch'en Chi-ju in the passage quoted above, taken from his "Life and Conduct" of Tung, which like the letter appears in his collected writings. Ch'en's two dates are impossible to reconcile: one, at least, is an error. Without further evidence, one can only note that at the moment we know of no work by Tung, extant or recorded, that dates from the tenth or the eleventh month.

According to the clan genealogy, Tung died not at Hua-t'ing (as we would suppose from Ch'en Chi-ju's accounts) but on a tiny island off the Chekiang coast, on which rose Mount P'u-t'o, one of the four famous Buddhist mountains, and in the seventeenth century a stronghold of the Ch'an sect.[461] Initially he was buried, as was Madame Kung, at the family grave site in Sung-chiang (that is to say in Shanghai, where Tung's grandfather and great-grandfather both were buried).[462] In the sixth month of 1637, the court conferred upon Tung a burial with ceremonial rites and the title Grand Mentor of the

Heir Apparent (*T'ai-tzu t'ai-fu* 太子太傅);[463] and the genealogy records that the emperor ordered the bodies of Tung and his wife to be reinterred at Yü-yang shan, a mountain scarcely more than a hill, one hundred and seventy meters high, that rises from a small peninsula projecting into Lake T'ai, not far from the city of Su-chou.[464] The site was (and reportedly is still) a particularly lovely one, "beautiful as a painting," and Tung had buried his parents there with the idea that one day he would rest there himself. Commemorative tombs, or in some cases "tombs [containing his] cap and robe," were built at Hua-t'ing and Su-chou, Hang-chou, Nanking, and the like; and imperial permission was granted for the erection in Hua-t'ing of a memorial temple and the construction of three commemorative arches (*p'ai-fang* 牌坊) in stone. The temple and arches are all now destroyed; but there still survives the photograph of an arch with a three-tiered roof and a central panel inscribed with the words *Shang-shu fang* 尚書坊 (Arch of the Minister [of Rites]), erected in honor of his appointment as Minister of Rites in Nanking.[465] In the ninth month of 1644, on the eve of the dynasty's collapse, the court took time to award Tung the posthumous name Wen-min 文敏, meaning "literate and perceptive," the very name that some three hundred years earlier had been chosen for Chao Meng-fu.[466]

Thirty years ago two tombs with Tung's name stood at Yü-yang shan: a commemorative tomb, with a double row of stone figures of officials and horses leading up to a stele, erected by imperial command, on which was engraved the epitaph (*mu-chih-ming*); and the real tomb not quite two hundred meters distant, with a tumulus three meters in diameter. In 1967, in the early throes of the Cultural Revolution, the grave was opened and the corpses exposed: the two bodies were by report "so well-preserved they looked alive," Tung clothed in court dress with cap and belt (no sign now of Taoist robes!), his hands holding the long, narrow ivory tablet he would have used in audiences at court; Madame Kung wearing bridal dress. The burial fittings were looted, the coffin smashed, and the bodies tossed back into the burial pit. The stone officials and horses were thrown down and the stele destroyed, its text impossible now to reconstruct. We are thus deprived of Tung's epitaph, of which, by some extraordinary chance, no written record seems to survive. The sole copy of the family genealogy, most of it written in Tung's own hand—detailing twelve generations of the clan, ending with Tung's great-grandsons—was confiscated from the family at the time the tomb was desecrated, and has never been returned.[467]

One would like to think that, could he have known of it, this exhibition and this catalogue, entitled *The Century of Tung Ch'i-ch'ang*, would have gone some way toward consoling him.

* * *

In the art of early seventeenth-century China, Tung Ch'i-ch'ang towers above his contemporaries. He was the preeminent painter, calligrapher, and connoisseur of his day, whose pronouncements on art quickly became the accepted dogma underpinning the development of later Chinese painting, and whose style exerted an influence stretching down to the modern age. So entirely does his fame today rest upon his artistic achievement that his official career has for the most part been discounted as irrelevant, despite the substantial role it played in his life as he was living it.

From biographical accounts that have appeared hitherto, one gains an impression of Tung as a man whose genius established him in early middle age at the center of a network of friends and acquaintances whose interests devolved entirely on the artistic, literary, and philosophical pursuits traditionally associated with those members of the gentry class who had renounced or retired from official life, and had thus divested themselves of the tribulations inevitably associated with a life in politics. We are led to assume that if, from time to time, Tung accepted an official post, he soon found the occupation uncongenial, and before long elected to escape.

And yet a careful scrutiny of Tung's career in conjunction with his writings and works—interpreted against the backdrop of late Ming politics in which he was forced to act out his part—suggests a quite different picture: of Tung as a man intensely ambitious to win for himself official honors, and adept at securing the friendship of those who could advance or safeguard his political fortunes. In an age rife with intrigue, with impeachment an almost daily occurrence among officials serving at court, political survival was at best uncertain. Yet by the end of his life Tung had managed to attain a position that was certainly distinguished if not brilliant, and had so successfully scouted his way through the political maze that unlike many of his contemporaries he was never stripped of the honors he had acquired. If one counts up his periods of active service, all told he had spent some fifteen years in office, during the course of three reigns. Though circumstances had denied him the chance to wield political power, if indeed he ever wished for it, he had nevertheless won the honors that from the beginning it was his ambition to achieve.

In a career that spanned four and a half decades, he was on friendly terms with at least thirteen Grand Secretaries, including three—Wang Hsi-chüeh, Yeh Hsiang-kao, and Chou Yen-ju—who were among the most influential in their respective periods.[468] To these were added an uncountable number of lesser officials, holding offices that ranged the full gamut from District Magistrate to Censor-in-chief and Ministers of Personnel, Rites, and War. It was as much through friends who actively inhabited the political world, as through the scholar-

artists, litterateurs, and merchant-collectors who peopled his world in retirement, that he came to see more works by the ancient masters than any other man of his time; and it was owing in part to his official standing, as well as to his fame as a calligrapher, painter, and connoisseur, that his colophons on these works were so avidly sought. The prestige he commanded as Minister of Rites endowed his critical pronouncements with an aura of authority that perhaps even his prodigious talents could not have secured for him on their own.

Tung's ambition, which has so often been called in doubt, is amply demonstrated by his continued forays into government service whenever a more prestigious position offered. Given his close association with Yeh Hsiang-kao, there is every chance that Tung would have advanced still further, had it not been for the untimely rise to power of the eunuch Wei Chung-hsien. Though one might argue that Tung's political career had little bearing on the quality and style of the artistic works that he produced, there can be no doubt that it formed an integral part of the image he conceived of himself. When his writings were collected in 1630, it was under the title *Jung-t'ai chi* (*The Collected Writings of the Minister of Rites*).[469] Time and again, as he rose to higher and higher office, he copied out the imperial patents that awarded him the prestige title corresponding to his rank and number of merit ratings. Hitherto only rarely had an artist or collector adopted a seal with his office title for private use; Tung adopted seals with no fewer than ten different legends referring to various offices he received as he progressed up the official ladder.[470] At least three times in his career he listed great painters of the past who had succeeded also as high officials.[471] The list was a very small one, all the names drawn from the T'ang, Sung, and Yüan. In the Ming period no artist but himself had risen so far, and he was intensely conscious of the unique position he occupied in his own dynasty. Late in life he wrote:

> The *T'u-hua p'u* records that as for Ministers (*Shang-shu*) who could paint, there was Yen Su in the Sung and Kao K'o-kung in the Yüan. In the present dynasty, I join them to make the tripod's [third] foot. As for Sung Ti and Chao Meng-fu, among great statesmen they have fame and glory.[472]

圖畫譜載，尚書能畫者，宋時有燕肅，元有高克恭。在本朝余與鼎足。若宋迪、趙孟頫，則宰相中烜赫有名者。

Tung had done what he set out to do: he had placed himself on their level.

Tung's reputation as an artist, enormous during his lifetime, waxed even greater after his death. In the hands of such later Chinese painters as the Four Wangs (Wang Shih-min, Wang Chien, Wang Hui, and Wang Yüan-ch'i), Wu Li, and Yün Shou-p'ing, his theories and style became the basis of a new

orthodoxy and exerted a powerful influence on the course of later Chinese painting. Even the great individualist painter Pa-ta shan-jen (1626–1705) drew on Tung's style for inspiration, transforming it into a style that was thoroughly his own, just as Tung had transformed the style of the Yüan master Huang Kung-wang—proof that it was the narrow vision of Tung's followers in the "orthodox" manner, rather than any inherent property of Tung's style itself, that in the end caused his style to have a stultifying effect on their works.

Tung's reputation was further enhanced by the admiration accorded his calligraphy by the two Ch'ing emperors K'ang-hsi (r. 1662–1722) and Ch'ien-lung (r. 1736–95), great patrons of the arts, both of whom frequently copied his works; and, as a consequence, by calligraphers at the Ch'ing court such as Chang Chao 張照 (1691–1745), chief editor of the initial compilation of the imperial catalogue of painting and calligraphy, the *Shih-ch'ü pao-chi*, presented to the throne in 1745. As a collector and connoisseur, recording his views and attributions on a large proportion of the almost innumerable paintings and calligraphies that passed beneath his eye, Tung stamped an impression on the history of Chinese painting and calligraphy so indelible that its effects must still be reckoned with today. More than any other artist he can be said to have changed the face of Chinese painting and its history.

NOTES

This biography relies extensively on material drawn from the *Ming shih-lu*, the *Veritable Records of the Ming Dynasty*—specifically, on the *Shen-tsung shih-lu*, *Kuang-tsung shih-lu*, and *Hsi-tsung shih-lu*, the Veritable Records of the Emperors Shen-tsung (r. 1573–1620), Kuang-tsung (r. 1620), and Hsi-tsung (r. 1621–27).

The 2,913 *chüan* of the *Ming shih-lu* (some 56,000 pages in the Academia Sinica's 1962–68 edition) furnish a day-by-day account of Ming political events and imperial pronouncements infinitely more detailed than any account provided elsewhere. Properly speaking, the Veritable Records are themselves a secondary source; but the primary documentary materials from which they were compiled are for the Ming period largely lost, and hence the Veritable Records remain as the fundamental source for our knowledge of daily administrative activity at court from the beginning of the dynasty through the reign of the Emperor Hsi-tsung. Biographers of Tung have hitherto overlooked the *Ming shih-lu* as a potential repository of information about Tung's tenure in office, perhaps because of the *Shih-lu*'s formidable length: Tung's official career, stretching from 1589 to 1634, spans nearly 18,000 pages of the *Ming shih-lu* and its appendices in the 1962–68 edition, for which at present no index exists.

The only other annalistic record to rival the *Ming shih-lu* to any extent is the *Kuo-ch'üeh* (*An Evaluation of* [*Events in Our*] *Dynasty*) by the historian T'an Ch'ien (1594–1657), who devoted his life to compiling a private history of the Ming that is remarkable for its length and the breadth of its research. The several manuscript copies of T'an's text that survive were collated and published for the first time only in 1958, in a typeset, punctuated edition of some three to three and a half million characters (roughly calculated, about one-fifth of the *Ming shih-lu* in length), in which T'an's account of the Ch'ung-chen period (1628–44), the reign of the last Ming emperor, Ssu-tsung, is proportionately much the lengthiest section of the

book. Owing to the collapse of the dynasty, the Veritable Records for Ssu-tsung's reign were never officially compiled; hence the *Kuo-ch'üeh* remains far and away the most important history of the dynasty's final years.

This is, as far as I know, the first time (except in two earlier papers of my own, cited below) that the *Ming shih-lu* has been explored in an attempt to augment, correct, and clarify Tung's biography; and though Ren Daobin, in his *Tung Ch'i-ch'ang hsi-nien* (and consequently Zheng Wei, whose *Tung Ch'i-ch'ang nien-p'u* culls from Ren's work a few passages from historical texts), does include the *Kuo-ch'üeh* among his sources, he in fact lists only two of fifteen references to Tung that can be found there. Since the *Ming shih-lu* and the *Kuo-ch'üeh* permit the biographer to construct an account of Tung's official career far more detailed and more precise in regard to date than is otherwise possible, I have not thought it necessary, in the notes that follow, to point out in every case where the dates I offer differ from those suggested by other biographers of Tung, who were working without the benefit of this key material.

Many of the revised dates for Tung's official appointments (the most radical revision being the date 1598 for the year in which Tung was appointed a tutor to the emperor's eldest son), as well as the works he executed for political figures that are mentioned in the course of this biography, were earlier presented by me in a paper entitled "Tung Ch'i-ch'ang and the Interplay of Politics and Art," at a symposium in Hong Kong in 1986 on "The Scholarly Tradition in Chinese Art." This paper was expanded for an "Academic Symposium on Dong Qichang," held in Songjiang in 1989, and published (unfortunately, with some errors on the part of the Chinese translator, and with notes omitted for lack of space) under my Chinese name, Li Hui-wen, as "Tung Ch'i-ch'ang cheng-chih chiao-yu yü i-shu huo-tung ti kuan-hsi" (The relation between Tung Ch'i-ch'ang's political association[s] and artistic activities), in *To-yün* 23, no. 4 (1989): 97–108, 133, 153–159. The English version of this paper was accepted for publication by *Artibus Asiae* in 1989; I would like to thank the editor, Dr. Alexander C. Soper, for graciously allowing me to withdraw the paper so that I could incorporate its contents here. I would like to take this opportunity, as well, to express my gratitude to Chang Lin-sheng, Deputy Director of the National Palace Museum, Taipei, a valued friend, whose expertise and insight helped me to reach conclusions on many knotty questions of language.

All dates that appear in this biography signify dates according to the lunar calendar: "day" means "day of the lunar month," and "month" means "month of the lunar year." Since so many dates are to be found in these pages, I have dispensed with the unwieldy and rather pedantic practice of retaining in translation the cyclical characters used to denote the lunar year (as in "the sixth day of the fourth month of the *hsin-mao* year"), and simply translated the cyclical designation (or as the case may dictate, the reign title [*nien-hao*] and year of reign) into the numerical year of the Western calendar that generally corresponds to it (i.e. "the sixth day of the fourth month, 1591"). For any given year, the interested reader can, of course, easily find the corresponding cyclical designation by consulting a table in a variety of modern sources.

In this biography, therefore, "1591" (to give a single example) is to be understood as "the lunar year *hsin-mao*, or nineteenth year of the Wan-li era, corresponding in the main (though not in its entirety) to the year 1591 in the Western calendar."

Abbreviations of sources cited in the notes:

Ch'en Mei-kung ch'üan-chi: Ch'en Chi-ju, *Ch'en Mei-kung hsien-sheng ch'üan-chi*, Ming ed., ca. 1641.

Dictionary of Ming Biography: L. Carrington Goodrich and Chaoying Fang, *Dictionary of Ming Biography*, 1976.

Dictionary of Official Titles: Charles Hucker, *A Dictionary of Official Titles in Imperial China*, 1985.

Hsi-tsung shih-lu: Wen T'i-jen et al., *Ta Ming Hsi-tsung Che-huang-ti shih-lu* (Veritable records of the Emperor Hsi-tsung), probably completed 1637, facsim. of ms. copy, 1966.

Hua-ch'an shih sui-pi: Tung Ch'i-ch'ang, *Hua-ch'an shih sui-pi*, compiled by Yang Pu (1598–1657), orig. ed. 1720; rev. ed. in ISTP, vol. 28, no. 252.

ISTP: *I-shu ts'ung-pien*, *Ti-i-chi*, 1966–68.

Jung-t'ai pieh-chi, 1635: Tung Ch'i-ch'ang, *Jung-t'ai pieh-chi*, 6 *chüan*; facsim. repr. in 1 vol. of 1635 edition, with a preface by Yeh Yu-sheng, n.d., *Ming-tai i-shu-chia chi hui-k'an* series, Taipei: Kuo-li chung-yang t'u-shu-kuan, 1968. (Note: the Kuo-li chung-yang t'u-shu-kuan edition of Tung's collected writings, the *Jung-t'ai chi*, is in fact composed of portions of two different editions: the *wen-chi* and *shih-chi* sections of the original 1630 edition and the *pieh-chi* section of the 1635 edition.)

Jung-t'ai shih-chi, 1630: Tung Ch'i-ch'ang, *Jung-t'ai shih-chi*, 4 *chüan*; together with the *Jung-t'ai wen-chi*, facsim. repr. in 3 vols. of original 1630 edition, *Ming-tai i-shu-chia chi hui-k'an* series, Taipei: Kuo-li chung-yang t'u-shu-kuan, 1968.

Jung-t'ai wen-chi, 1630: Tung Ch'i-ch'ang, *Jung-t'ai wen-chi*, 9 *chüan*; together with the *Jung-t'ai shih-chi*, facsim. repr. in 3 vols. of original 1630 edition, *Ming-tai i-shu-chia chi hui-k'an* series, Taipei: Kuo-li chung-yang t'u-shu-kuan, 1968.

Jung-t'ai wen-chi, 1635: Tung Ch'i-ch'ang, *Jung-t'ai wen-chi*, 10 *chüan*, pref. by Ch'en Chi-ju, dated 1630; by Huang Tao-chou, dated 1635; by Yeh Yu-sheng, n.d.; and by Shen Ting-k'o, n.d.

Ku-kung shu-hua lu: *Ku-kung shu-hua lu*, 1956, rev. ed. 1965.

Kuang-tsung shih-lu: Yeh Hsiang-kao et al., *Ta Ming Kuang-tsung Chen-huang-ti shih-lu* (Veritable Records of the Emperor Kuang-tsung), completed 1623, facsim. of ms. copy, 1966.

Kuo-ch'üeh: T'an Ch'ien, *Kuo-ch'üeh* (An Evaluation of [Events in Our] Dynasty), orig. ed. 1958, facsim. repr. 1978.

Ming-jen chuan-chi: *Ming-jen chuan-chi tzu-liao so-yin*, 1965.

Ming-shih: Chang T'ing-yü et al., *Ming-shih*, completed 1736, orig. ed. 1739, rev. ed. 1974.

Po-shih-ch'iao: Ch'en Chi-ju, *Po-shih-ch'iao chen-kao*, pref. 1636, rev. ed. 1935–36.

Ren Daobin, *Hsi-nien*: Ren Daobin, *Tung Ch'i-ch'ang hsi-nien*, 1988.

Shen-tsung shih-lu: Ku P'ing-ch'ien et al., *Ta Ming Hsien-huang-ti Shen-tsung shih-lu* (Veritable records of the Emperor Shen-tsung), completed 1630, facsim. of ms. copy, 1966.

Shih-ch'ü pao-chi [*ch'u-pien*]: Chang Chao et al., *Shih-ch'ü pao-chi*, completed 1745, facsim. of ms. copy, 1971.

Shih-ch'ü pao-chi hsü-pien: Wang Chieh et al., *Shih-ch'ü pao-chi hsü-pien*, completed 1793, facsim. of ms. copy, 1971.

"Ssu-po Tung kung hsing-chuang": Ch'en Chi-ju, "T'ai-tzu t'ai-pao Li-pu shang-shu Ssu-po Tung kung chi yüan-p'ei kao-feng I-p'in fu-jen Kung-shih ho-tsang hsing-chuang" (Life and Conduct of the Grand Guardian of the Heir Apparent and Minister of Rites Tung Ssu-po and his wife Madame Kung, honored as a Lady of the First Rank, interred in the same tomb), in *Ch'en Mei-kung ch'üan-chi*, ch. 36, pp. 1–6; reproduced in facsimile at the beginning of *Jung-t'ai wen-chi*, 1630, *Ming-tai i-shu-chia chi hui-k'an* series.

Tung Hua-t'ing shu-hua lu: Ch'ing-fu shan-jen (Ch'ing), *Tung Hua-t'ing shu-hua lu*, n.d. (but no earlier than 1800), rev. ed. in ISTP, vol. 25, no. 192.

Zheng Wei, *Nien-p'u*: Zheng Wei, *Tung Ch'i-ch'ang nien-p'u*, 1989.

1. *Jung-t'ai wen-chi*, 1630, *ch.* 6, p. 45; and "Ssu-po Tung kung hsing-chuang," *ch.* 36, p. 1.
2. For the meaning of Tung's names, see Nelson Wu, "Tung Ch'i-ch'ang, the Man, his Time, and his Landscape Painting," 1954, pp. 1–2. Zheng Wei (*Nien-p'u*, p. 10) points out that Tung never signed himself "Ssu-po," and

suggests, therefore, that Ssu-po ought not to be considered a *hao*, being instead—on the evidence of Ch'en Chi-ju, in his "Ssu-po Tung kung hsing-chuang" (*ch.* 36, p. 6)—a name bestowed on Tung by his literary friends. Zheng Wei's point that Tung himself did not use "Ssu-po" is well taken; but there is one instance, at least, where Tung did employ it: he lists himself as "Ssu-po Ch'i-ch'ang" at the beginning of the *Ch'i-yu man-chi*, a collection of travel sketches by his distant cousin Tung Ch'uan-ts'e that Tung, as the principal editor, brought out in a second edition in 1601 (see note 14).

3. See Nelson Wu, "Tung Ch'i-ch'ang, the Man, his Time, and his Landscape Painting," pp. 17–18, n. 5; and Zheng Wei, *Nien-p'u*, p. 1. A source for Tung's birthdate more reliable than any mentioned by Nelson Wu or Zheng Wei is the *Jung-t'ai chi* itself: see the *Jung-t'ai wen-chi*, 1635, *ch.* 5, pp. 83–84.

4. Throughout this essay, official terms and titles will be translated according to Charles Hucker's *Dictionary of Official Titles in Imperial China*.

 Provided a candidate qualified, he could take the examinations as often as he liked until he passed.

5. Tung is mentioned, in his biography in the *Shang-hai hsien chih* (1871, rev. ed. 1872, *ch.* 19, p. 24), as the great-great-nephew (*ts'ung-ts'eng-sun*) of Tung Lun, but the term was often used loosely, and since there is no other evidence that Hua and Lun were brothers, it is generally assumed that the two were only clan members of the same generation. The first Tung to be accorded a biography in the *Shang-hai hsien chih* is a certain Tung Chi, but there is no traceable link between Chi and Lun.

6. *Shang-hai hsien chih*, rev. ed. 1872, *ch.* 18, p. 31. The full title of Lun's final post was Investigating Censor of the Ho-nan Circuit in the Nanking Censorate (*Nan-ching Ho-nan tao chien-ch'a yü-shih*): see the *Shang-hai hsien chih*, *ch.* 17, pp. 8–9.

7. The *Hung-chih chiu-nien chin-shih teng-k'o lu*, Hung-chih (1488–1505) ed., n.d., in Ch'ü Wan-li, *Ming-tai teng-k'o lu hui-pien*, 1969, vol. 4, p. 1901, lists Tung Lun's son, Tung T'ien, as having eleven brothers; whereas Lun's biography in the *Shang-hai hsien chih* (see note 6) records Lun as having only six sons, perhaps because there were only six who reached maturity.

8. *Shang-hai hsien chih*, rev. ed. 1872, *ch.* 18, p. 31.

9. *Ming-jen chuan-chi*, vol. 2, p. 738.

10. Tung Ch'uan-ts'e's dates are not generally known. His death date, however, is recorded in Ho San-wei's *Yün-chien chih-lüeh* (1623, facsim. repr. 1987, *ch.* 14, pp. 4–7, in particular p. 6), which also records that Ch'uan-ts'e was only fifty when he died.

11. Ho San-wei, *Yün-chien chih-lüeh*, facsim. repr. 1987, *ch.* 19, pp. 26–27.

12. *Ming-shih*, *ch.* 287, p. 7364.

13. In addition to the *Yün-chien chih-lüeh* (see note 10), I have based this short biography of Tung Ch'uan-ts'e on two sources: *Kuo-ch'üeh*, pp. 3906, 4041, 4095, 4105, 4138, 4161, 4184, 4221, 4233; and Lei Li et al., *Kuo-ch'ao lieh-ch'ing chi*, Ming ed., n.d. but after 1592, *ch.* 45, p. 3; *ch.* 66, p. 4; *ch.* 91, p. 4; *ch.* 92, p. 4; *ch.* 145, pp. 4, 15; *ch.* 150, pp. 6, 23; *ch.* 153, p. 8.

14. Tung Ch'uan-ts'e, *Ts'ai-wei chi*, pref. 1571, rev. ed. 1602; *Yung-yü kao*, pref. 1571, rev. ed. 1603; *Yu-chen chi*, 1570, rev. ed. 1603; *Ch'i-yu man-chi*, pref. 1564 and 1570, rev. ed. 1601; *Tung Tsung-po tsou-shu chi-lüeh*, 1602.

15. According to the clan genealogy, the *Tung-shih tsung-p'u* (cited by both Tung and Ch'en Chi-ju), Tung, like the rest of his clan, was descended from Tung Kuan-i, the first member of the clan to settle at Shanghai: see "Ssu-po Tung kung hsing-chuang," *ch.* 36, p. 1; and *Jung-t'ai wen-chi*, 1630, *ch.* 6, p. 45. We do not know, however, the names of those linking Kuan-i to Tung's great-grandfather Tung Hua. The family tree constructed by Zheng Wei (*Nien-p'u*, p. 2) is based on the premise that Tung and Ch'ien (later Tung) Chih-hsüeh were first cousins, since Tung speaks of Chih-hsüeh's father (whom we know only as Ching-hsüan) as "my uncle" (*po-fu*): see the *Jung-t'ai wen-chi*, 1630, *ch.* 6, p. 45. But *po-fu* is used here only as a courtesy title. Tung also tells us that several generations earlier Chih-hsüeh's ancestor Mien had adopted his mother's surname, Ch'ien, in place of Tung, Chih-hsüeh being the first of Mien's line to take back the surname Tung (*Jung-t'ai wen-chi*, 1630, *ch.* 6, p. 45). Thus if Tung and Chih-hsüeh were first cousins, Tung's grandfather and great-grandfather would have had the surname Ch'ien. According to the

Shang-hai hsien chih, this was not the case; hence Zheng Wei's premise is mistaken, and Tung and Chih-hsüeh were much more distantly related.

16. Wang Hung-hsü et al., *Ming-shih kao*, completed 1723, Ch'ien-lung (1736–96) ed., n.d., facsim. repr. 1962, vol. 6, *ch.* 269 (*lieh-chuan* 164), p. 6. Biographies of those included in the dynastic histories (and hence the characterizations of those who influenced them in their youth) were, of course, purposely laudatory, except for figures included in special groupings like "Treacherous Ministers."

17. "Ssu-po Tung kung hsing-chuang," *ch.* 36, p. 1.

18. Ibid.

19. *Jung-t'ai wen-chi*, 1630, *ch.* 6, p. 51. For an explanation of Chih-hsüeh's surname, see note 15.

20. *Jung-t'ai wen-chi*, 1630, *ch.* 6, p. 51; and *Jung-t'ai pieh-chi*, 1635, *ch.* 5, p. 47.

21. *Hua-ch'an shih sui-pi*, 1720, *ch.* 1, p. 8; ISTP ed., p. 5. In both these editions, the passage reads "Po-ch'ang *ming* Po-ch'ang," which is clearly an error; in the 1908 edition, the passage is corrected to "Po-ch'ang *ming* Ch'uan-hsü," which is how I have translated it here.

22. Nelson Wu, "Tung Ch'i-ch'ang: Apathy in Government and Fervor in Art," 1962, p. 268; Ren Daobin, *Hsi-nien*, pp. 5–6.

23. Chang Chü-cheng et al., *Ta Ming Mu-tsung Chuang-huang-ti shih-lu*, completed 1574, facsim. of ms. copy, 1965, *ch.* 10, p. 8.

24. *Jung-t'ai wen-chi*, 1630, *ch.* 6, p. 45.

25. *Shang-hai hsien chih*, rev. ed. 1872, *ch.* 19, p. 25; Li Yen-hsia (17th century), *Nan-Wu chiu-hua lu*, pref. 1924, *ch.* 18, p. 13. Li Yen-hsia's dates are not known; he is generally considered to be Ch'ing rather than Ming, but in the *Combined Indices to the Eighty-Nine Collections of Ming Dynasty Biographies* (repr. 1966, vol. 2, p. 228), his name is listed as occurring in a number of biographical sources for Ming figures. I assume, therefore, that he spanned the period from the end of Ming through the beginning of Ch'ing.

 Save for corrections and some additions, the 1871, 1872, and 1882 editions of the *Shang-hai hsien chih* are identical.

26. Ping-ti Ho, *The Ladder of Success in Imperial China*, 1962, repr. 1964, p. 35.

27. There is some evidence that Tung was not in fact the first of his clan to register himself as a native of Hua-t'ing. Tung Ch'uan-ts'e is recorded in the *Ming-shih* as a native of Hua-t'ing (*Ming-shih*, *ch.* 210, p. 5567); and in one of his memorials to the throne Ch'uan-ts'e speaks of himself as "originally registered" (*yüan chi*) as a native of Shanghai, which would seem to imply that he had since moved his family register elsewhere (Tung Ch'uan-ts'e, *Tung Tsung-po tsou-shu chi-lüeh*, p. 53). In a preface to his *Ts'ai-wei chi*, moreover, he is called "Yün-chien Tung Yu-hai," though admittedly the writer of the preface, P'an En (1496–1582), a native of Shanghai, signs himself as "from the same district," and Hua-t'ing notables who contributed prefaces to his other books sign themselves only as "from the same prefecture." It is clear, however, that Ch'uan-ts'e preferred to think of himself as a native of Hua-t'ing.

28. "Ssu-po Tung kung hsing-chuang," *ch.* 36, p. 1.

29. See note 33.

30. For short extracts from these essays in Mo Ju-chung's *Ch'ung-lan kuan chi* (Wan-li [1573–1620] ed.), see Zheng Wei, *Nien-p'u*, pp. 1–8 passim.

 Hsing-chuang, which I have rendered here and elsewhere as "life and conduct," is often translated as "account of conduct" or "curriculum vitae."

31. Chih-hsüeh's two sons, Ch'uan-hsü and Chiu-kao, were his sons by his secondary wife, whose surname was also Hsü (*Jung-t'ai wen-chi*, 1630, *ch.* 6, p. 51).

32. Mo Shih-lung, *Mo T'ing-han i-kao*, *t'i-tz'u* (complimentary remarks) by Ch'en Chi-ju dated 1602, *ch.* 4, p. 50, and *ch.* 6, p. 8.

33. Tung writes that in 1586 it was fifteen years since he was studying in the Mo family school (*Jung-t'ai wen-chi*, 1630, *ch.* 2, p. 11). Since he also says that he began to study calligraphy seriously when he was seventeen *sui* (i.e. in 1571; see note 21), and since we know that Mo Ju-chung was his calligraphy teacher, we can conclude with reasonable certainty that he began studying in the Mo family school in 1571.

34. See *Ming-jen chuan-chi*, vol. 1, p. 615, for four essays (*hsü*, *mu-chih-ming*) by Lu either addressed to or written for Mo Shih-lung.

35. *Ming-shih*, *ch.* 216, pp. 5694–95.

36. Lu's preface was to the *Yu-chen chi* (see note 14). For the *mu-chih-ming*, see *Ming-jen chuan-chi*, vol. 2, p. 737 (where Tung T'i-jen is cited as Tung Kung-chin, Kung-chin being in fact his *tzu*).

37. Zheng Wei, *Nien-p'u*, p. 8.

38. *Sung-chiang fu chih*, 1631, *ch.* 34 (*kuo-ch'ao, hsüan-chü, hsiang-chü*), p. 26.

39. Chih-hsüeh's highest post was that of Left Case Reviewer in the Court of Judicial Review (*Ta-li ssu tso-p'ing-shih*), rank 7a (*Sung-chiang fu chih*, 1631, *ch.* 34 [*kuo-ch'ao, hsüan-chü, hsiang-chü*], p. 26).

40. *Jung-t'ai wen-chi*, 1630, *ch.* 6, p. 51; and Zheng Wei, *Nien-p'u*, pp. 8–9.

41. "Ssu-po Tung kung hsing-chuang," *ch.* 36, pp. 1–2.

42. The "Pi-ling" of "Pi-ling's prefaces" we learn elsewhere from Ch'en Chi-ju was "Mr. T'ang of Pi-ling," Pi-ling being another name for Wu-chin in Kiangsu (*Po-shih-ch'iao*, p. 10). This can only have been T'ang Shun-chih (1507–1560), a native of Wu-chin, whose "ancestors for six generations were all civil service degree holders or recipients of imperial honors," who himself had placed first in the Metropolitan Examination of 1529, and whose "prose style [was] widely praised and admired" (see Ray Huang's biography of T'ang in the *Dictionary of Ming Biography*, vol. 2, pp. 1252–1256; and *Ming-jen chuan-chi*, vol. 1, p. 398).

43. *Jung-t'ai wen-chi*, 1630, *ch.* 2, p. 11.

44. *Po-shih-ch'iao*, p. 12; cf. p. 10.

45. Ibid., p. 12. Tung uses here a shortened form of the expression *pa-chai shang-sheng* "to pluck up one's household and transport it to Heaven," a reference to the immortal Hsü Hsün (240–374), who "at the age of 134 . . . was translated to heaven, together with his whole family, his dogs and cats, and even the denizens of his poultry-yard" (Herbert Giles, *A Chinese Biographical Dictionary*, 1898, pp. 304–5).

46. *Po-shih-ch'iao*, p. 10.

47. See Wm. Theodore de Bary et al., *Sources of Chinese Tradition*, 1960, rev. ed. 1964, vol. 1, pp. 309–11, 314–17.

48. Ta-kuan uses the title *T'ing-wei*, meaning here Chief Minister of the Court of Judicial Review (*Ta-li ssu ch'ing*) (*Dictionary of Official Titles*, nos. 5986, 6767, 6770). Wang Shih-chen was appointed to this post (which, however, he was forced to refuse) in the autumn of 1576 and was appointed Right Vice Minister of War in Nanking in 1588 (see Barbara Yoshida-Krafft's biography of Wang in the *Dictionary of Ming Biography*, vol. 2, pp. 1399–1405, in particular p. 1401). Hence the meeting between Tung and Ta-kuan must have taken place between these two dates.

49. *Jung-t'ai pieh-chi*, 1635, *ch.* 3, p. 13; also *Hua-ch'an shih sui-pi*, 1720, *ch.* 4, p. 20; ISTP ed., p. 82. The two texts differ in a few characters.

The term *tsung-ch'eng*, "'vehicle' of a sect," which Soothill and Hodous explain as a sect's "essential tenets," was appropriated by the Ch'an and Pure Land sects as a reference specifically to their own doctrines (see William Soothill and Lewis Hodous, *A Dictionary of Chinese Buddhist Terms*, 1937, repr. 1972, p. 255; and Ting Fu-pao, *Fo-hsüeh ta tz'u-tien*, 1929, p. 1512).

50. See D. T. Suzuki, *An Introduction to Zen Buddhism*, 1961, rev. ed. 1964, p. 66.

51. See Heinrich Dumoulin, *A History of Zen Buddhism*, 1963, p. 107; and Chang Chung-yuan, *Original Teachings of Ch'an Buddhism*, 1969, repr. 1971, pp. 219–20. For the pronunciation of Kuei-shan, the name of Hsiang-yen's mentor (whom Dumoulin calls Wei-shan), see Chang, *Original Teachings*, p. 224, n. 5.

52. *Jung-t'ai pieh-chi*, 1635, *ch.* 3, pp. 10–11; also *Hua-ch'an shih sui-pi*, 1720, *ch.* 4, pp. 17–18; ISTP ed., pp. 80–81.

53. *Po-shih-ch'iao*, pp. 10, 12.

54. *Jung-t'ai wen-chi*, 1630, *ch.* 2, p. 11.

55. Ren Daobin, *Hsi-nien*, pp. 18–19.

56. *Jung-t'ai pieh-chi*, 1635, *ch.* 3, pp. 11–12; also *Hua-ch'an shih sui-pi*, 1720, *ch.* 4, pp. 18–19; ISTP ed., p. 81.

57. *Jung-t'ai pieh-chi*, 1635, *ch.* 3, p. 12; also *Hua-ch'an shih sui-pi*, 1720, *ch.* 4, p. 19; ISTP ed., p. 81.

58. Tung is mistaken here in remembering Tung-shan as the Ch'an master under whom Hsiang-yen studied. See note 51.

59. *Hua-ch'an shih sui-pi*, 1720, *ch.* 1, pp. 8–9; ISTP ed., p. 5. This passage is a continuation of one translated above (see note 21).

60. Nelson Wu, "Tung Ch'i-ch'ang: Apathy in Government and Fervor in Art," p. 269.

61. *Hua-ch'an shih sui-pi*, 1720, *ch.* 1, p. 9; ISTP ed., pp. 5–6. Wang Hsi-chih's official title was *Yu-chün chiang-chün*, or General of the Right Army. In early periods like the Han, such titles were often honorary and the appointments nothing more than sinecures (see Hans Bielenstein, *The Bureaucracy of Han Times*, 1980, repr. 1981, pp. 116–17, 122–23).

62. *Po-shih-ch'iao*, p. 10.

63. Kao Shih-ch'i, *Chiang-ts'un hsiao-hsia lu*, pref. 1693, 1971 facsim. repr. of 1923 ed., *ch.* 3, p. 20. The expression "the man and his *ch'in* are both gone" (*jen ch'in chü wang*) comes from the story told of Wang Hui-chih, brother of the famous calligrapher Wang Hsien-chih (*tzu* Tzu-ching, 344–388), who when his brother died, took out his brother's *ch'in* and began to play, but finding it already out of tune, threw it on the ground and called out in his grief, "Tzu-ching, Tzu-ching, the man and his *ch'in* are both gone."

That the former owner of *Clearing Autumn Skies over Mountains and Valleys*, "P'an *Kuang-lu*," whom Tung mentions in his colophon, was Mo Shih-lung's son-in-law we know from Tung's colophon dated 1635 on Tung Yüan's *Summer Mountains* (see note 340). The title *Kuang-lu* refers to a post in the Court of Imperial Entertainments (*Kuang-lu ssu*), but does not specify precisely which position P'an held; without knowing P'an's identity, then, it is impossible to translate the title accurately, and I have rendered it here simply as "Minister." P'an has been identified by Zheng Wei (*Nien-p'u*, p. 35) as P'an Yün-tuan, but this seems improbable; P'an Yün-tuan (1526–1601), the son of P'an En (see note 27), was older than Mo (thus was unlikely to have been his son-in-law) and is not recorded as ever having held a post in the Court of Imperial Entertainments.

A more plausible candidate for "P'an *Kuang-lu*" is P'an Yün-k'uei, a grandson of P'an En and P'an Yün-tuan's third son, of whom there is but scant mention, even in the gazetteers of his own district. The epitaph (*mu-chih-ming*) for Yün-k'uei's father P'an Yün-tuan, composed by the Grand Secretary Shen Shih-hsing (1535–1614) and included in Shen's collected writings (*Tz'u-hsien t'ang chi*, pref. 1616, *ch.* 31, pp. 14–19), lists Yün-tuan's five sons by name and records briefly that Yün-k'uei married a woman whose surname was Mo (whereas Yün-tuan himself had married a woman named Ku) and held the post of an Assistant Office Director (*Shu-ch'eng*), though the government agency in which Yün-k'uei served is not mentioned. In the 1750 edition of the *Hua-ting hsien chih* (*ch.* 9, p. 99), however, Yün-k'uei is recorded as having served as an Assistant Director of an Office in the Court of Imperial Entertainments (*Kuang-lu shu-ch'eng*, rank 7b). Yün-k'uei, then, fits the little we know of "P'an *Kuang-lu*": he was from Shanghai, a member of a family more than the equal of Mo Shih-lung's family in prestige; he was of the proper age; his wife's surname was Mo; and he served at some point in the Court of Imperial Entertainments.

64. *Jung-t'ai pieh-chi*, 1635, *ch.* 4, p. 19; and *Hua-ch'an shih sui-pi*, 1720, *ch.* 2, pp. 43–44; ISTP ed., p. 60.

For an additional argument supporting the position that Tung and Mo were never actually close friends, see the final paragraph of note 157.

65. *Hua-ch'an shih sui-pi*, 1720, *ch.* 2, pp. 33–34; ISTP ed., p. 54.

66. *Jung-t'ai wen-chi*, 1630, *ch.* 3, p. 42. See also Jung Keng, *Ts'ung-t'ieh mu*, 1980–86, vol. 3, pp. 1208–1213. In the *Ch'ung-lan kuan t'ieh*, Tung's *t'i-tz'u* (complimentary remarks, usually appearing as an introduction to a book) appears as a colophon at the end of Mo Ju-chung's works, that is to say, at the end of the third *chüan*. See also Nelson Wu, "Tung Ch'i-ch'ang: Apathy in Government and Fervor in Art," p. 26, n. 42; Wu confuses the *Ch'ung-lan kuan chi*, Mo Ju-ch'ung's collected works, with the *Ch'ung-lan kuan t'ieh*; it was for the *Ch'ung-lan kuan chi* that Tung modestly refused to write a preface, on the grounds that he was only a Government Student.

67. *Ku-kung shu-hua lu*, vol. 3, *ch.* 5, p. 20. Nelson Wu suggests that this inscription may be spurious, on the grounds that there are a few textual errors, but concedes that the text itself is genuine ("Tung Ch'i-ch'ang: Apathy in Govern-

ment and Fervor in Art," pp. 20–22, n. 19). To me, however, the calligraphy gives every appearance of being genuine, and it is so taken by the curators of the National Palace Museum in Taipei.

For the passage where Tung mentions that he began to study painting while living as a tutor in the Lu household, see *Jung-t'ai pieh-chi*, 1635, *ch*. 2, p. 20. Here he gives the date as the first day of the fourth month, 1577. This slight discrepancy with the date given in his inscription on the *Lung-hsiu chiao-min* argues in favor of the latter's authenticity rather than the reverse, since a forger would have tended simply to copy the date given in the *Jung-t'ai chi*; clearly Tung began his painting on the last night of the third month and either worked into the small hours of the night or finished it the following day.

In another passage, Tung writes that he started to paint when he was twenty-two *sui*, i.e. in 1576 (*Jung-t'ai pieh-chi*, 1635, *ch*. 4, p. 25); in all likelihood this is simply an error, either on Tung's part or in the printed text.

68. *Jung-t'ai pieh-chi*, 1635, *ch*. 5, p. 47. Since we learn from Tung in this and the preceding passage (*ch*. 5, p. 46) that Ch'uan-hsü was a year younger than Tung and died at the age of twenty-one [*sui*], he must have died in 1576.

69. *Hua-ch'an shih sui-pi*, 1720, *ch*. 2, pp. 39–40; ISTP ed., pp. 57–58.

70. *Ku-kung shu-hua lu*, vol. 3, *ch*. 5, p. 435.

71. *Jung-t'ai pieh-chi*, 1635, *ch*. 6, p. 38; *Ku-kung shu-hua lu*, vol. 4, *ch*. 6, p. 73, leaf 8.

72. *Jung-t'ai pieh-chi*, 1635, *ch*. 6, p. 40.

73. See Tung's *Epitaph* (*mu-chih-ming*) for Hsiang (vol. 2, pl. 69). See also (for the text) the *Jung-t'ai wen-chi*, 1630, *ch*. 8, pp. 30–(*yu*)31, in particular p. 31.

74. See note 73.

75. *Jung-t'ai pieh-chi*, 1635, *ch*. 2, p. 25.

76. That it was this passage that gave rise to the story was a suggestion made to me by Chu Tsing-li.

77. Ren Daobin, *Hsi-nien*, p. 15. This is one of many interesting passages that Ren Daobin has uncovered and included in his book.

78. See note 59.

79. *Jung-t'ai pieh-chi*, 1635, *ch*. 2, p. 25.

80. Ibid., *ch*. 2, p. 25; *ch*. 4, pp. 63–64.

81. Chang Tzu-ning (Joseph Chang), in an interesting article entitled "Tung Ch'i-ch'ang yü 'T'ang Sung Yüan hua-ts'e'" (1990, pp. 71–72), suggests—on the basis of a passage in the *Jung-t'ai wen-chi* (1630, *ch*. 5, p. 31), the content of which parallels in part Tung's well-known passage from the *Hua-ch'an shih sui-pi* translated above in the text (see notes 21 and 59)—that Tung went to Tsui-li (i.e. Chia-hsing) and had his first chance to see Hsiang Yüan-pien's collection of Chin and T'ang calligraphies in about the year 1574, that is to say, when he was about twenty *sui*. The *Jung-t'ai wen-chi* passage reads in part: "I have engaged in this pursuit [i.e. the practice of calligraphy] for more than fifty years. In the beginning I started [by copying the works of the T'ang masters] Yü [Shih-nan] and Yen [Chen-ch'ing]; then I turned to studying [the even earlier masters] General [Wang Hsi-chih] and Grand Mentor Chung [Chung Yu]. Having succeeded in large measure in imitating the appearance of such [masterworks] as [Wang Hsi-chih's] *Lan-t'ing* [*hsü*] and [Chung Yu's] *Ping-she* [*t'ieh*] and *Hsüan-shih* [*piao*], I was pleased with myself, and considered myself superior to the T'ang masters. [But when some] three to five years (*san wu nien-chien*) [later] I went to study at [Tsui]-li and discovered the whole of the Collegian Hsiang Tzu-ching's [Hsiang Yüan-pien] collection of [original] Chin and T'ang calligraphies, then I realized that my earlier hard work had been [nothing more than] a waste of time." Chang interprets the phrase *san wu nien-chien* as meaning here "three to five years [after I first began to study calligraphy]"; and since we know from the passage cited in note 21 that Tung took up the serious study of calligraphy in 1571, Chang arrives at a date of circa 1574 for Tung's first introduction to Hsiang's collection. But in the context here, the phrase might equally well mean "three to five years [after I considered myself superior to the T'ang masters]," which (as we may deduce from the passage cited in note 59) was after Tung had been studying calligraphy for three years, i.e. in about 1574. Thus, if the second interpretation is correct, Tung would have had his first opportunity to see Hsiang's collection only in about 1577. At any rate, it seems un-

wise to construct too exact a chronology on the basis of a passage that is undeniably vague.

We can be virtually certain, however, that Tung had gained access to Hsiang's collection by the late 1570s: included in the *Jung-t'ai pieh-chi* (1635, *ch*. 2, p. 17) is a colophon Tung wrote on a work that he tells us he first saw in 1580 at the Yen-yü lou, a studio usually associated with Hsiang's grandson Sheng-mo, but here clearly belonging to Hsiang Yüan-pien himself.

82. See the colophon by Chin Jung-ching (b. 1856), dated 1928, which follows Tung's *Epitaph of Hsiang Yüan-pien* in the present exhibition (vol. 2, pl. 69). Chin lists the names of Hsiang Yüan-pien's six sons, as well as the names of his grandsons and great-grandsons, with their *tzu* and *hao*, when known, as well as a few details concerning their official careers, taken from the Hsiang family genealogy. Chin records that Te-hung's collection of calligraphy was particularly rich.

83. For Tung's colophon on the *Autumn Colors*, see the *Ku-kung shu-hua lu*, vol. 2, *ch*. 4, p. 106; see also Chu-tsing Li, *The Autumn Colors on the Ch'iao and Hua Mountains*, 1965, p. 29. In his colophon, Tung calls Te-ming (whom Chu-tsing Li does not identify) "Hsiang Hui-po." Te-ming's *tzu* was Hui-fu, and "Hui-po" is probably used by Tung here as a variation, to indicate affectionate respect (*po* having the meaning of "uncle" or "elder brother"). That it was Hui-fu (i.e. Te-ming) who brought the *Autumn Colors* to Tung is shown by Tung's inscription on a painting of his own recorded in the *Hua-ch'an shih sui-pi* (1720 ed., *ch*. 2, pp. 27–28; ISTP ed., p. 50).

For the identification of Hsiang's second grandson as Miao-mo, see note 82. For Hsiang Te-ch'eng's death date, see Wang Shiqing, "Tung Ch'i-ch'ang ti chiao-yu" (Tung Ch'i-chang's circle), in vol. 2 of this catalogue.

84. For the passages in which Tung mentions traveling to Nanking to take the provincial examination, see notes 52 and 61.

85. *Sung-chiang fu chih*, 1663, *ch*. 36, p. 33.

86. "Ssu-po Tung kung hsing-chuang," *ch*. 36, p. 2; and *Po-shih-ch'iao*, p. 10. For Tung's arrival in Peking in the spring of 1588, see Fujiwara Arihito, "To Kisho nenpu," in Kohara Hironobu, *To Kisho no shoga*, 1981, vol. 1 [*Kenkyu hen*], p. 180.

87. It is often assumed that in 1588 (as in 1579 and in 1585, when he failed to pass) Tung took the provincial examination for the *chü-jen* degree in Nanking (see, for instance, Ren Daobin, *Hsi-nien*, p. 18). Clear evidence that Tung passed the provincial examination not in Nanking but in Peking (called, in the examination lists, by another of its names, Shun-t'ien [fu]) is provided in several sources, among them the *Shang-hai hsien chih*, 1588, *ch*. 8, p. 36; the *Sung-chiang fu chih*, 1631, *ch*. 34 (*kuo-ch'ao, hsüan-chü, hsiang-chü*), p. 35; and Feng Meng-chen (1548–1605), *K'uai-hsüeh t'ang chi*, pref. 1615 and 1616, *ch*. 48, p. 29.

88. In his article on this scroll, Wen Fong takes the position that the scroll with this title now in the Ogawa collection in Kyoto (vol. 1, fig. 19) is indeed the scroll Tung saw, but that the colophon, purportedly Tung's, now attached to the scroll is actually a forgery, i.e. a replacement of the original colophon ("Rivers and Mountains after Snow," 1976–77, pp. 10, 18–19). My own view is the opposite: that the scroll in the Ogawa collection is not the scroll Tung actually saw, but that the colophon is genuine and was attached to the scroll at a later date.

89. Feng Meng-chen, *K'uai-hsüeh t'ang chi*, pref. 1615 and 1616, *ch*. 48, p. 29. Hsü was already serving as Vice Minister of the Seals Office (the highest post to which he was appointed) by the spring of 1586: see the *Kuo-ch'üeh*, p. 4530.

90. Tung records that in the winter of 1588 he met with friends at the Lung-hua Temple in Hua-t'ing for an evening of discussion with the Ch'an master Han-shan (see note 56).

91. For a convenient table showing the distances (in *li*) from various cities throughout China to Peking, see J. K. Fairbank and S. Y. Teng, "On the Transmission of Ch'ing Documents," 1960, rev. ed. 1968, pp. 12–17.

92. Chang Ch'ao-jui, *Huang Ming kung-chü k'ao*, Wan-li (1573–1620) ed., n.d., *ch*. 9, p. 40. According to Charles Hucker (*Dictionary of Official Titles*, no. 3474), use of the term *kung-shih* to mean "Passed Scholars" was confined to the Ch'ing period. That the term in this sense was current also in the Ming,

Celia Carrington Riely

however, is shown by two entries in the *Shen-tsung shih-lu* (*ch.* 209, pp. 5, 6).

93. *Shen-tsung shih-lu*, *ch.* 208, p. 2.

94. *Po-shih-ch'iao*, p. 10. Ch'en, for some reason, designates Hsü inaccurately as *Ta-ssu ch'eng* (a literary term for *Kuo-tzu chien chi-chiu*, Chancellor of the Directorate of Education), perhaps intending by the title to signify that Hsü was the chief examiner.

95. *Shen-tsung shih-lu*, *ch.* 208, p. 12.

96. See Tung's *"Record of the Grand Tutor Hsü Kuo's Tomb Shrine"* in the present exhibition (vol. 2, pl. 55); for its text, see also the *Jung-t'ai wen-chi*, 1630, *ch.* 4, pp. 48–49. Confirmation that in 1589 Tung passed the *hui-shih* in second place is provided in the *Sung-chiang fu chih*, 1631, *ch.* 34 (*kuo-ch'ao, hsüan-chü, chin-shih*), p. 23.

97. Arthur Waley, *Yüan Mei*, 1956, p. 24.

98. See the *Jung-t'ai shih-chi*, 1630, *ch.* 1, pp. 13–14; *Jung-t'ai wen-chi*, 1630, *ch.* 6, pp. 52–53, and *ch.* 8, pp. 42–47; and Tung's *"Record of the Grand Tutor Hsü Kuo's Tomb Shrine"* (note 96).

99. *Chung-kuo ming-sheng tz'u-tien*, 1981, rev. ed. 1986, p. 451. The *Chung-kuo ming-sheng tz'u-tien* says that the arch was erected in 1584 in honor of Hsü's appointment as Grand Guardian of the Heir Apparent (*T'ai-tzu t'ai-pao*) and Grand Secretary of the Hall of Military Glory (*Wu-ying tien ta hsüeh-shih*), but this is an error; the arch commemorates Hsü's appointment in the ninth month of 1584 as Junior Guardian [to the Emperor] (*Shao-pao*) and Grand Secretary of the Hall of Military Glory, not his appointment as *T'ai-tzu t'ai-pao*, a title he was awarded in 1583: see the *Kuo-ch'üeh*, pp. 4455, 4488.

100. Though the calligraphy is undated, it is signed by Tung using the title Minister of Rites in Nanking (*Nan-ching Li-pu shang-shu*), an office to which he was appointed in the first month of 1625 (note 357). Thus 1625 is the earliest possible date for the calligraphy. Tung retired from the post late in 1625; but there are a number of works that prove that he continued to use the title on compositions such as this until 1631, when he was appointed Minister of Rites in charge of the Household Administration of the Heir Apparent (note 415). Since, however, the text is included in the original edition of the *Jung-t'ai wen-chi* (note 96), the calligraphy dates no later than 1630.

101. *Shen-tsung shih-lu*, *ch.* 209, p. 5.

102. Chang Ch'ao-jui, *Huang Ming kung-chü k'ao*, Wan-li ed., n.d., *ch.* 1, p. 4.

103. Chu Pao-chiung and Hsieh P'ei-lin, *Ming Ch'ing chin-shih t'i-ming pei-lu so-yin*, 1980, vol. 3, pp. 2570–72.

104. *"Ssu-po Tung kung hsing-chuang,"* *ch.* 36, p. 2.

105. The selection was announced on the eighteenth day of the sixth month: *Shen-tsung shih-lu*, *ch.* 212, p. 7; *Kuo-ch'üeh*, p. 4607.

106. See the wording of the announcement in 1592: *Shen-tsung shih-lu*, *ch.* 249, pp. 6–7.

107. In 1592, for instance, fourth place holder Hung Ch'i-jui was passed over in the selection, and in consequence, perhaps, passed into oblivion.

108. *Shen-tsung shih-lu*, *ch.* 213, p. 6.

109. Ibid., *ch.* 208, p. 2; for a short biography with a summary of T'ien's official career, see *ch.* 234, p. 4.

110. Ibid., *ch.* 221, p. 3. Han is here mistakenly named as Left Vice Minister of Rites; see *ch.* 232, p. 2, for a later entry where his title is correctly given as Right Vice Minister of Rites.

111. Ibid., *ch.* 233, p. 2; *ch.* 234, p. 4.

112. For the distance from Fukien to Peking, see the table cited in note 91. For Tung's decision to accompany T'ien home to Fukien, see Tung's "Hsing Tzu-yüan fa-t'ieh hsü," in the *Jung-t'ai wen-chi*, 1630, *ch.* 1, p. 23. See also Jung Keng, *Ts'ung-t'ieh mu*, vol. 3, p. 1215, where the preface is recorded together with Tung's signature and the date—the fifteenth day of the tenth month, 1621—both omitted when the preface was included in the *Jung-t'ai chi*.

113. *"Ssu-po Tung kung hsing-chuang,"* *ch.* 36, p. 2; *Jung-t'ai wen-chi*, 1630, *ch.* 1, p. 13.

114. *Jung-t'ai pieh-chi*, 1635, *ch.* 2, p. 13. According to the Western calendar, Wu K'uan was born in 1436.

115. *Jung-t'ai wen-chi*, 1630, *ch.* 1, p. 13. Tung's signature and the date 1618,

which appeared at the end of the preface when it was first written, were deleted when the preface was included in the *Jung-t'ai chi*. Both are included, however, at the end of the preface in Feng Ts'ung-wu's collected works, the *Feng Shao-hsü chi* (see note 320).

116. *Jung-t'ai pieh-chi*, 1635, *ch.* 5, p. 26.

117. Ibid., p. 20.

118. *Ming-shih*, *ch.* 298, p. 7631.

119. Chang Ch'ou, *Nan-yang fa-shu piao* and *Nan-yang ming-hua piao*, under the heading *Chang-shih shu-hua ssu-piao*, in Feng Chao-nien (Ch'ing), *Ts'ui-lang-kan kuan ts'ung-shu*, repr. 1916, *ts'e* 42. See also Ting Fu-pao and Chou Yün-ch'ing, eds., *Ssu-pu tsung-lu i-shu-pien*, 1957, vol. 1, pp. 751–52.

120. *Hua-ch'an shih sui-pi*, 1720, *ch.* 1, p. 30; ISTP ed., pp. 17–18. The calligraphy is now in the Liaoning Provincial Museum.

121. See Tung's colophon of 1604 on the *P'ing-fu t'ieh*, in Wu Sheng, *Ta-kuan lu*, pref. 1712, facsim. of ms. copy, 1970, *ch.* 1, p. 10. The calligraphy is now in the Beijing Palace Museum.

122. Suzuki Kei, *Chugoku kaiga sogo zuroku*, 1982–83, vol. 3, p. 132, pl. JM 3–165. The painting is now in the Osaka Municipal Museum of Art.

123. *Shih-ch'ü pao-chi hsü-pien*, vol. 4, pp. 2033–34, in particular p. 2034. The painting is now in the British Museum.

124. *Ku-kung shu-hua lu*, vol. 3, *ch.* 5, p. 20. The expression *chieh-ho*, translated here as "after becoming an official," means literally "to take off rough clothing" in order to put on official dress.

125. *Hua-ch'an shih sui-pi*, 1720, *ch.* 2, p. 13; ISTP ed., p. 42; also Ch'en Chi-ju (1558–1639), *Ni-ku lu*, in Huang Pin-hung and Teng Shih, *Mei-shu ts'ung-shu*, 1911–36, rev. ed. 1975, vol. 5, I/10, p. 300. The text of the letter in the *Hua-ch'an shih sui-pi* differs in one character from that in the *Ni-ku lu*; I have used the latter, which makes better sense.

Hin-cheung Lovell (*An Annotated Bibliography of Chinese Painting Catalogues and Related Texts*, 1973, pp. 31–32, no. 43) suggests that the *Ni-ku lu* was written in or about 1635; but since the dates mentioned in the text all fall to the period 1592–97, it seems more likely that the text was written in the late 1590s, and thus that the letter from Tung to Ch'en translated here falls to the same period. From its contents, it is clear that Tung wrote the letter early in his career.

126. Wu Sheng, *Ta-kuan lu*, facsim. ed. 1970, *ch.* 11, p. 4.

127. *Ku-kung shu-hua lu*, vol. 2, *ch.* 4, pp. 43–45.

128. Ibid., p. 44. Chu Hsi-hsiao's full official title was Commissioner-in-chief of the Left Chief Military Commission (*Tso tu-tu*).

129. For Han's collection, see the *Nan-yang fa-shu piao* (note 119), which lists sixteen calligraphies from the Chin period. There is no complete list of Hsiang's collection, but Cheng Yin-shu has attempted to reconstruct it from extant works and recorded sources in *Hsiang Yüan-pien chih shu-hua shou-ts'ang yü i-shu*, 1984, pp. 96-203, which lists ten calligraphies from the Chin period. While Hsiang may well have owned others, Cheng's list accounts for his famous pieces.

130. See two passages in the *Jung-t'ai pieh-chi* (1635, *ch.* 5, pp. 29–30), of which the first was originally written by Tung for the *Hsi-hung t'ang fa-shu*, where it follows his copy of the *Huang-t'ing nei-ching ching*. For a discussion and translation of this passage, see Lothar Ledderose, "Some Taoist Elements in the Calligraphy of the Six Dynasties," 1984, pp. 262–64. The same passage appears also in the *Hua-ch'an shih sui-pi* (1720, *ch.* 1, pp. 54–55; ISTP ed., p. 32).

131. *Chung-kuo ku-tai shu-hua t'u-mu*, vol. 3, 1990, pp. 238–39, *Hu* 1–1325.

132. *Jung-t'ai pieh-chi*, 1635, *ch.* 4, p. 53; also *Hua-ch'an shih sui-pi*, 1720, *ch.* 1, p. 26; ISTP ed., p. 15. Though no year is given in the text—the date mentioned being simply the eleventh day of the intercalary third month—the year must be either 1591 or 1610, the only years to have an intercalary third month during Tung's lifetime. The overwhelming likelihood is that the year should be understood as 1591, the time when Tung was borrowing and copying calligraphies from Han Shih-neng, and that the boat Tung boards in the passage refers to the beginning of his trip south in the spring of 1591 to accompany the body of T'ien I-chün back to T'ien's native Fukien.

442

133. For the identity and dates of Yang Pu (*tzu* Wu-pu), see Yü Chien-hua et al., *Chung-kuo mei-shu-chia jen-ming tz'u-tien*, 1981, rev. ed. 1987, p. 1195.

134. *Ku-kung shu-hua lu*, vol. 4, *ch.* 6, p. 8.

135. Ren Daobin (*Hsi-nien*, p. 29) is under the impression that by the winter of 1591 Tung had not yet returned to Peking; hence he suggests that a stele of that date (see my notes 147 and 148), for which Tung executed the calligraphy, could not have been written till after Tung's return the following spring. He was evidently unaware of Han's colophon, which proves that Tung did indeed return to Peking in 1591.

136. See note 109.

137. T'ien I-chün, *Chung-t'ai hsien-sheng wen-chi*, 1600, *fu-lu*, pp. 5–10.

138. *Ming-shih*, *ch.* 216, pp. 5697–98.

139. Ibid., *ch.* 288, p. 7397.

140. *Jung-t'ai wen-chi*, 1630, *ch.* 1, p. 23; Jung Keng, *Ts'ung-t'ieh mu*, vol. 3, p. 1215; Ren Daobin, *Hsi-nien*, p. 25; and Fujiwara Arihito, "To Kisho to sono shuhen," in Kohara Hironobu, *To Kisho no shoga*, vol. 1 [*Kenkyu hen*], p. 127.

141. *Jung-t'ai pieh-chi*, 1635, *ch.* 5, p. 18.

142. Ibid., *ch.* 4, pp. 6–7.

143. Ibid., p. 10; also *Hua-ch'an shih sui-pi*, 1720, *ch.* 3, p. 6; ISTP ed., p. 63. For evidence that Tung traveled through the Wu-i mountains in autumn, see the *Jung-t'ai pieh-chi*, 1635, *ch.* 6, p. 46.

144. *Jung-t'ai pieh-chi*, 1635, *ch.* 4, p. 9.

145. *Shen-tsung shih-lu*, *ch.* 239, p. 5. In 1588 the examination for the previous Han-lin class had been held on (or just before) the tenth day of the tenth month (*ch.* 204, p. 4), and in 1585, for the class before that, on or just before the twenty-first day of the intercalary ninth month (*ch.* 166, pp. 3–4). The examination determined which Bachelors would be retained in the Academy (*liu-kuan*) and which, because of a lower mark, would be released from the Academy (*san-kuan*) and appointed to minor positions in the central government or to low-ranking provincial posts.

146. The original calligraphy is recorded in the *Shih-ch'ü pao-chi* [*ch'u-pien*], vol. 2, p. 929.

147. For the rubbing in the Peking Library, see Ren Daobin, *Hsi-nien*, p. 29. Ren's comments on the date of the stele are discussed in note 135.

148. I am indebted to Professor Susan Naquin of the University of Pennsylvania for photographs of the rubbing of this stele, which is catalogued as no. 244305, in the Field Museum of Natural History, Chicago.

149. Tung compresses events here, as he does so often: see, for instance, the passage cited in note 21, which is translated and discussed in the text.

150. "Wu hsiang ssu chia" or "four masters of my district" has been translated elsewhere as "the four [Yüan] masters" (Wen Fong et al., *Images of the Mind*, 1984, p. 166), i.e. Huang Kung-wang, Wu Chen, Ni Tsan, and Wang Meng. But it seems rather unlikely that Tung could have associated all four of the Great Yüan Masters with Hua-t'ing. Elsewhere he writes of the painters of his district as being, in the Yüan, such men as Ts'ao Chih-po, Chang I-wen, and Chang Chang (*Hua-ch'an shih sui-pi*, 1720, *ch.* 2, p. 38; ISTP ed., p. 56), and possibly he had in mind artists like these when he wrote the passage here. In the *Hua-ch'an shih sui-pi* passage, Tung mentions owning a painting by Chang I-wen in the style of Huang Kung-wang, and another by Ts'ao in the manner of Chü-jan. Both Huang and Chü-jan were acknowledged to have modeled their style on Tung Yüan; thus the paintings of Ts'ao Chih-po and Chang I-wen would also have led Tung back in the direction of Tung Yüan.

151. *Ku-kung shu-hua lu*, vol. 3, *ch.* 5, p. 20. I am indebted to Wai-kam Ho for the translation of the last line. For a passage, which I afterward discovered, in which Tung employs the same idiom (*i i . . . wei shih*) to mean "took only . . . as my master," see the *Jung-t'ai pieh-chi*, 1635, *ch.* 5, p. 18.

152. Zheng Wei (*Nien-p'u*, p. 24) identifies "the Collegian of the National University (*T'ai-hsüeh*) Sung" in this passage as the painter Sung Hsü. From what is known of Sung Hsü, however, it is unlikely that he was ever selected to attend the National University; and in his undated (and unsigned) inscription on Ni Tsan's *Empty Grove after Rain* (*Yü-hou k'ung-lin*), Tung speaks of try-

ing to see the painting while (as he thought) it was in the collection of "the Collegian of the National University Sung An-chih" (*Ku-kung shu-hua lu*, vol. 3, *ch.* 5, pp. 215–16). Since the "Sung T'ai-hsüeh" mentioned in the passage translated here is also a collector, the two are almost certainly one and the same. For another passage in which Tung mentions Sung An-chih (An-chih being probably Sung's *tzu*, rather than his *ming*), see the *Jung-t'ai pieh-chi*, 1635, *ch.* 4, p. 19.

153. The term *fen-pen* is usually translated as "sketch," but Tung seems to use it more often in the sense of "copy." Cf. his colophon on *Rivers and Mountains after Snow*, where "Kuo Chung-shu's *Wang-ch'uan fen-pen*," which he has just acquired, means almost certainly a copy (rather than a sketch) of Kuo Chung-shu's *Wang-ch'uan Villa*, of which the original (Tung goes on to say) is reputed to be in Wu-lin (*Jung-t'ai pieh-chi*, 1635, *ch.* 6, p. 27).

154. *Jung-t'ai pieh-chi*, 1635, *ch.* 6, p. 26.

155. For *River and Mountains in Miniature*, see notes 127 and 128, and the translation of Tung's colophon in the text; for the *Peach Blossom Spring*, which Tung records that he saw in Peking in 1590, see the *Jung-t'ai pieh-chi*, 1635, *ch.* 6, p. 34.

156. In fact, as he was later to write, Tung had seen Tung Yüan's *Travelers among Streams and Mountains*, but failed to realize at the time that the painting was by Tung Yüan: see his first colophon on the *Travelers*, written in 1601 (note 158).

157. Junghee Han, in his 1988 dissertation entitled "Tung Yüan's Influence on Tung Ch'i-ch'ang's Paintings," includes a table (p. 72) in which he lists three paintings by Tung Yüan that Tung saw before he acquired the *Travelers* in early 1593. Two of these, one a handscroll with a colophon by Tung, the other a leaf from an album (of which nothing remained but Tung's record) are known only from P'ei Ching-fu's *Chuang-t'ao ko shu-hua lu* (pref. 1924 and 1937, facsim. repr. 1971, vol. 1, *ch.* 2, pp. 103–4, and vol. 4, *ch.* 11, pp. 741–42), a catalogue of works that are in many cases readily identifiable as forgeries (see, for instance, Ren Daobin, *Hsi-nien*, pp. 11–12, 39–42, 115–16; see also my note 429). P'ei records that the colophon by Tung on the Tung Yüan handscroll is followed by two seals, reading *Tung-shih chia-ts'ang* and *Hsüan-shang chai shu-hua yin*; since no such seals follow Tung's signature on any other work, recorded or extant (and since, indeed, they defy his usual practice), the colophon is clearly spurious. Ren Daobin (pp. 39–42) concludes that Tung's calligraphy recording the Tung Yüan album leaf is equally bogus.

 The last painting by Tung Yüan that Han lists in his table as having been seen by Tung before 1593 is *Privileged Residents in the Capital*, since it had been in the collection of Mo Shih-lung, and Han assumes that Tung, as a close friend of Mo, would have had the opportunity to see it while it was in Mo's hands. But though a number of paintings that had once belonged to Mo (including *Privileged Residents*, as well as *Clearing Autumn Skies over Mountains and Valleys* [see notes 63 and 204] and *Returning in Evening beneath Winter Trees* [see note 206]) later found their way into Tung's collection, not once does Tung mention ever having seen them (or any other work) while they were in Mo's possession. Had Tung indeed seen *Privileged Residents* before 1597, when he acquired it, there is little doubt that he would have told us so in one of the many inscriptions and colophons he wrote on Tung Yüan's paintings, among them his long inscription on *Privileged Residents* itself (note 160). Tung's apparent lack of access to the works in Mo's collection in itself lends support to the argument that Tung and Mo were not on such terms of intimacy as art historians have hitherto assumed.

158. See Tung's first colophon, dated 1601, on Tung Yüan's *Travelers among Streams and Mountains* (*Hsi-shan hsing-lü*), in Pien Yung-yü, *Shih-ku t'ang shu-hua hui-k'ao*, pref. 1682, facsim. repr. 1921, facsim. repr. of 1921 ed., 1958, vol. 3, p. 436 (*hua-chüan* 11, p. 49).

159. The only painting, as far as we know, that Tung may have acquired before the *Travelers* was Chao Ling-jang's *River Village on a Cool Summer Day*; though Tung fails to record what year he acquired it, he writes in his colophon of 1595 on *Rivers and Mountains after Snow* (note 185) that he obtained the *River Village* (which he calls by an alternate title, *Lakeside Village on a*

Cool Summer Day [*Hu-chuang ch'ing-hsia*]) "upon arriving in the capital." Presumably he is referring here to his arrival in Peking in 1589, though before 1595 Tung made at least four other trips to Peking, in 1588, 1591, 1592, and 1593.

160. See Tung's inscription on *Privileged Residents of the Capital* (*Ku-kung shu-hua lu*, vol. 3, *ch.* 5, p. 20).

161. See also Tung's *River Landscape* of 1622 (vol. 1, fig. 33) and his inscription on a calligraphy of his own, recorded in the *Hua-ch'an shih sui-pi*, 1720, *ch.* 1, p. 19; ISTP ed., p. 11.

162. *Hua-ch'an shih sui-pi*, 1720, *ch.* 3, p. 3; ISTP ed., p. 62.

163. *Ming-shih*, *ch.* 101, pp. 2607–20.

164. For his trip to the Hui-shan Temple near Wu-hsi in the spring of 1592, see the *Jung-t'ai pieh-chi*, 1635, *ch.* 4, p. 7. For his calligraphy written aboard boat at Kuang-ling (i.e. Yang-chou), see the *Hua-ch'an shih sui-pi*, 1720, *ch.* 1, p. 19; ISTP ed., p. 11. For his *Theories on Calligraphy and Painting*, written at Ts'ui-chen near Ssu-yang on the eighteenth day of the fourth month, see vol. 2, pl. 1.

165. The fan is recorded in the *Shih-ch'ü pao-chi* [*ch'u-pien*], vol. 2, p. 857. A fan with the same seal, from the same period or slightly later, is in the collection of the Honolulu Academy of Arts (see Tseng Yu-ho Ecke, *Poetry on the Wind*, 1981, color pl. 4 and p. 75; and Celia Carrington Riely, "Tung Ch'i-ch'ang's Seals," entry II, in vol. 2 of this catalogue).

166. *Kuo-ch'üeh*, p. 4691; *Ming-shih*, *ch.* 110, p. 3370.

167. Shen Te-fu (1578–1642), *Fei-fu yü-lüeh*, rev. ed. in ISTP, vol. 29, no. 256, pp. 2–3.

168. The *Chu Chü-ch'uan kao-shen* (or *Chu Chü-ch'uan kao*), attributed to Yen Chen-ch'ing, with colophons by Wang and Tung as well as by many others, is recorded in Yü Feng-ch'ing, [*Yü-shih*] *Shu-hua t'i-pa chi*, postscript 1634, woodblock ed. 1911, *ch.* 3, pp. 12–15, in particular pp. 13, 14; facsim. of ms. copy, 1970, pp. 157–64, in particular pp. 160, 162. The scroll is also recorded in Wang K'o-yü, *Shan-hu wang*, pref. 1643, orig. ed. 1916, rev. ed. 1936, repr. 1985, vol. 1 (*shu-lu*), pp. 28–31; and in Pien Yung-yü, *Shih-ku t'ang shu-hua hui-k'ao*, facsim. repr. 1958, vol. 1, pp. 364–66 (*shu-chüan* 8, pp. 4–9).

169. *Shen-tsung shih-lu*, *ch.* 260, p. 8; *Kuo-ch'üeh*, p. 4702. Hitherto there has been little agreement on the date when Tung received his compilership. The correct date (i.e. the fifth month of 1593, though no day is mentioned) is given by Fujiwara Arihito in his "To Kisho nenpu" (see Kohara Hironobu, *To Kisho no shoga*, 1981, vol. 1 [Kenkyu hen], p. 182), but he cites no source for his information. In an earlier (and less complete) *nien-p'u* for Tung, Fujiwara gives Tung's biography in the *Ming-shih* as his source for the date, though in fact no hint of such a date occurs there ("To Kisho to sono jidai," 1972, p. 25). Either on the insufficient evidence of Tung's *Ming-shih* biography, or on the mistaken assumption that Bachelors in the Han-lin were assigned new posts after three years of study (see note 145 and the preceding discussion in the text), other biographers and art historians have arrived at a date of 1590 or 1592 for the date Tung received his compilership (e.g. Wen Fong et al., *Images of the Mind*, p. 166, following Nelson Wu, "Tung Ch'i-ch'ang: Apathy in Government and Fervor in Art," p. 283; Shih Ta, "Tung Ch'i-ch'ang fu-kuan ti nien-fen wen-t'i," 1975, pp. 92–93; and Ren Daobin, *Hsi-nien*, p. 28). The above entry in the *Shen-tsung shih-lu* (as well as the corresponding entry in the *Kuo-ch'üeh*) lays the matter to rest, once and for all.

170. See Chaoying Fang's biography of Lady Cheng (Cheng Kuei-fei) in the *Dictionary of Ming Biography*, vol. 1, p. 209.

171. For the Emperor Shen-tsung's fifteen-year dispute with his ministers over his unwillingness to designate his eldest son as Heir Apparent, see the *Dictionary of Ming Biography*, vol. 1, pp. 209–10, vol. 2, pp. 1377–78. For his withdrawal from the affairs of state, see his biography by Charles Hucker, *Dictionary of Ming Biography*, vol. 1, pp. 326–27. See also Ray Huang, *1587, A Year of No Significance*, 1981, pp. 1–129 passim.

172. *Shen-tsung shih-lu*, *ch.* 269, pp. 1–2; *ch.* 270, p. 1.

173. Ibid., *ch.* 269, p. 5.

174. Ibid., *ch.* 270, p. 1. The title *Chan-shu kuan* does not appear in Charles Hucker's *Dictionary of Official Titles*; in translating it, I have followed Ray Huang (*1587, A Year of No Significance*, p. 43).

175. *Shen-tsung shih-lu*, *ch.* 208, p. 6.

176. Ibid., *ch.* 271, p. 8.

177. *Dictionary of Ming Biography*, vol. 1, p. 191.

178. *Shen-tsung shih-lu*, *ch.* 288, p. 1. Most reference works (e.g. *Ming-jen chuan-chi*, vol. 2, p. 728) record Yeh's birthdate as 1559; but Chou Tao-chi, in his biography of Yeh in the *Dictionary of Ming Biography* (vol. 2, p. 1567), gives his birthdate as 1562.

179. *Shen-tsung shih-lu*, *ch.* 275, p. 1; *Kuo-ch'üeh*, p. 4732. Yeh's biography in the *Ming-shih* (*ch.* 240, p.6231) records that Yeh was appointed Director of Studies at the National University (i.e. Directorate of Education, in Charles Hucker's terminology: see his *Dictionary of Official Titles*, no. 3541) in Nanking rather than in the capital. But since neither the *Shen-tsung shih-lu* nor the *Kuo-ch'üeh* makes any mention of Nanking, one must conclude that this is an error on the part of the *Ming-shih* compilers, and that Yeh was in fact appointed to serve in Peking.

180. "Ssu-po Tung kung hsing-chuang," *ch.* 36, p. 2.

181. *Jung-t'ai wen-chi*, 1630, *ch.* 2, pp. 58–61; *ch.* 6, pp. 4–8. Tung's original calligraphy of the latter, his biography of Wu Hua, is now in the Tokyo National Museum (*Tokyo kokuritsu hakubutsukan zuhan mokuroku: Chugoku shoseki hen*, 1980, p. 71, pl. 104).

182. Feng was appointed Mentor in the Left Secretariat of the Heir Apparent (5a) to serve additionally as a Vice Director of the *Cheng-shih* project and as a Chief Attendant to the Emperor's Eldest Son (*Huang-ch'ang-tzu shih-pan kuan*, see note 213) in the tenth month of 1594 (*Shen-tsung shih-lu*, *ch.* 278, p. 3). The *Kuo-ch'üeh* (p. 4757) records later that Feng's appointment was as Mentor in the Left Secretariat of the Heir Apparent in Nanking; but either this is an error or Feng's appointment was subsequently changed from the Peking to the Nanking Secretariat of the Heir Apparent.

Why Feng remained in the south in unclear; though he was impeached in the twelfth month of 1594, he was immediately exonerated and confirmed in his post (*Shen-tsung shih-lu*, *ch.* 280, p. 3). Tung writes, in his letter to Feng asking to borrow *Rivers and Mountains after Snow*, that since the beginning of spring (i.e. early 1595) he has been awaiting Feng's arrival in the capital. He goes on to say, however, that he has recently heard that Feng will be promoted to the post of Chancellor of the Directorate of Education in Nanking (4b). For a reproduction of Tung's letter, a later portion of which is translated by Wen Fong, see Fong's "Rivers and Mountains after Snow," Appendix II G and p. 14. Tung's letter was received by Feng Meng-chen on the thirteenth day of the seventh month (see Feng's notation at the left-hand edge of Tung's letter, and note 184 below). Feng's appointment as Chancellor is recorded in the *Ming shih-lu* on the ninth day of the eighth month, 1595 (*Shen-tsung shih-lu*, *ch.* 288, p. 3).

183. This account of the scroll's discovery (which according to Tung he had from Feng himself in a letter accompanying the scroll) appears in Tung's colophon on the scroll (see note 185); Feng Meng-chen, however, in the colophon he himself composed for the scroll, tells the story somewhat differently (Feng Meng-chen, *K'uai-hsüeh t'ang chi*, pref. 1615 and 1616, *ch.* 30, pp. 18–19).

184. Feng Meng-chen, *K'uai-hsüeh t'ang chi*, pref. 1615 and 1616, *ch.* 53, p. 26.

185. For Tung's colophon on *Rivers and Mountains after Snow*, see the *Jung-t'ai pieh-chi*, 1635, *ch.* 6, pp. 27–28.

Before the tenth month of 1595, when he wrote his colophon on *Rivers and Mountains after Snow*, Tung appears to have written only one colophon on a work not in his own collection: his short colophon dated 1592 on the *Chu Chü-ch'uan kao-shen* attributed to Yen Chen-ch'ing in the collection of his friend Ch'en Chi-ju (see note 168). Tung's colophon on a handscroll by Chü-jan entitled *Ten Thousand Li along the Yangtze* (*Ch'ang-chiang wan-li*), now in the Freer Gallery, is recorded as having been written in the autumn of 1595 (see Lu Hsin-yüan, *Jang-li kuan kuo-yen lu*, pref. 1892, facsim. repr. 1975, vol. 1, *ch.* 2, p. 5; and Ren Daobin, *Hsi-nien*, p. 37), but in the *Jang-li kuan kuo-yen lu* the actual date, *chi-wei* (i.e. 1619), is wrongly transcribed as

i-wei (i.e. 1595). (For a reproduction of the scroll, see Suzuki Kei, *Chugoku kaiga sogo zuroku*, vol. 1, p. 234, pl. A 21–114.)

186. *Jung-t'ai pieh-chi*, 1635, *ch.* 6, pp. 6–7. For the controversy surrounding the authorship of this passage, see note 187. The phrase *cheng-ch'uan* appears in another passage discussing "literati painting" (*wen-jen chih hua*), in which the lineage of the Southern School is again set forth, though the term "Southern School" is not used (*ch.* 6, p. 4).

187. Debate still rages over whether it was Tung or Mo Shih-lung who composed the famous passage cited in note 186 that first enunciated the theory of the Northern and Southern schools of painting. For a discussion of the theory and the history of its publication, see Susan Bush, *The Chinese Literati on Painting*, 1971, pp. 158–72, and p. 159, n. 13. For an original, well-reasoned, and (in my own view) entirely convincing argument supporting Tung as the author, see Fu Shen, "Hua-shuo tso-che wen-t'i ti yen-chiu" (A Study of the Authorship of the So-called "Hua-shuo"), 1970. Wai-kam Ho takes the same view, though for different reasons ("Tung Ch'i-ch'ang's New Orthodoxy and the Southern School Theory," 1976, pp. 113–14). For an extensive collection of articles by twentieth-century art historians, both on the theory and on its authorship, see Zhang Lian and Kohara Hironobu, *Wen-jen hua yü nan-pei tsung*, 1989.

188. *Shen-tsung shih-lu*, *ch.* 297, p. 1.

189. In his colophon of 1596 on *Dwelling in the Fu-ch'un Mountains* (see note 197), which he wrote after the completion of his mission in Ch'ang-sha, Tung records that he acquired the painting on his outward journey, at Ching-li, Ching-li being a village near Wu-hsi (see note 196). For his colophon on *River Village on a Cool Summer Day*, attributed to Chao Ling-jang, in which Tung mentions stopping at Chia-hsing, see note 195 and the translation of this colophon in the text. For three colophons Tung wrote during the time he was in Hang-chou, see his first colophon, dated the twenty-eighth day of the seventh month, on the *Wang-ch'uan Villa*, attributed to Kuo Chung-shu (note 193), and his first two colophons, dated two days later, on *River Village on a Cool Summer Day* (note 195).

190. See notes 189 and 197.

191. *Jung-t'ai pieh-chi*, 1635, *ch.* 5, p. 4; and *Hua-ch'an shih sui-pi*, 1720, *ch.* 1, p. 20, *ch.* 3, pp. 8–9; ISTP ed., pp. 11–12, 65.

192. *Jung-t'ai pieh-chi*, 1635, *ch.* 6, pp. 27–28, in particular p. 27. For Tung's use of the term *fen-pen*, see note 153.

193. Tung's adoption of the seal *Chih chih-kao jih-chiang kuan* is a case in point: see my discussion of its meaning in the second half of entry III in "Tung Ch'i-ch'ang's Seals," in vol. 2 of this catalogue.

 For Tung's colophon on Kuo's *Wang-ch'uan Villa*, see the *Shih-ch'ü pao-chi* [*ch'u-pien*], vol. 1, p. 554. His colophon of 1596 is followed by a second shorter colophon, written the following year.

194. For a short biography of Kao, see *Ming-jen chuan-chi*, vol. 1, p. 392.

195. Kohara Hironobu, *To Kisho no shoga*, 1981, vol. 1 [*Kenkyu hen*], p. 255, no. 32. See also the *Jung-t'ai pieh-chi*, 1635, *ch.* 6, pp. 33–34.

196. For the identification of Ching-li, see Jao Tsung-i, *Huang Kung-wang chi Fu-ch'un shan-chü t'u lin-pen*, 1975, pp. 16–17; and Heinrich Busch's biography of Ku Hsien-ch'eng in the *Dictionary of Ming Biography*, vol. 1, p. 736. For Hua Chung-heng, see *Ming-jen chuan-chi*, vol. 2, p. 671.

197. *Ku-kung shu-hua lu*, vol. 2, *ch.* 4, p. 134. For a translation of the whole of Tung's colophon on the *Fu-ch'un Mountains*, see Celia Carrington Riely, "Tung Ch'i-ch'ang's Ownership of Huang Kung-wang's 'Dwelling in the Fu-ch'un Mountains,'" 1974–75, p. 58.

198. See Tung's first colophon on the scroll, dated 1597: *Ku-kung shu-hua lu*, vol. 2, *ch.* 4, p. 48.

199. *Shen-tsung shih-lu*, *ch.* 313, p. 2. The provincial examinations consisted of three sessions, held on the ninth, twelfth, and fifteenth days of the eighth month. The title *K'ao-shih kuan* for the Examiners in charge appears in the *Ming-shih* (*ch.* 73, p. 1786). Charles Hucker does not list this title; instead he lists *Chu-kao* [*kuan*], which was evidently an alternate (*Dictionary of Official Titles*, no. 1392).

200. In 1597 Lin was serving in the Han-lin as an Examining Editor (*Chien-t'ao*), to which he had been promoted in 1591 (*Shen-tsung shih-lu*, *ch.* 239, p. 5; that he was appointed an Examining Editor rather than a Junior Compiler is confirmed in a later entry, *ch.* 269, p. 5). A poem Tung composed for Lin while Lin was still an Examining Editor is recorded in the *Jung-t'ai shih-chi* (1630, *ch.* 3, pp. 13–14). Lin later served as Minister of Rites from mid-1623 to early 1625, at the same time that Tung was serving as Right and then Left Vice Minister of Rites.

 Tung mentions his indebtedness to Lin for helping him obtain the *Hsiao Hsiang t'u* (now in the Beijing Palace Museum) in his second colophon on Tung Yüan's *Summer Mountains* (see note 340).

201. Hu Ching et al., *Shih-ch'ü pao-chi san-pien*, completed 1816, facsim. of ms. copy, 1969, vol. 3, pp. 1380–81.

202. See Ren Daobin, *Hsi-nien*, pp. 43–46, 49–51, 53; and Zheng Wei, *Nien-p'u*, pp. 30, 32, 34–35.

203. For Tung's colophon on *River and Mountains for a Thousand Li*, written at Lan-ch'i in 1597, see note 198. For his colophon on *Watching the Tidal Bore*, written at Lung-yu, see Wang K'o-yü, *Shan-hu wang*, repr. 1985, vol. 2 (*hua-lu*), p. 854. For Tung's inscriptions on the walls and pillars of Ch'en's studio, see *Ch'en Mei-kung ch'üan-chi*, *nien-p'u*, p. 11.

204. For his colophon of 1599 on *Clearing Autumn Skies over Mountains and Valleys*, see note 63 and the translation of this colophon in the text.

205. See his colophon on *Privileged Residents in the Capital* (note 160). See also his colophon dated 1635 on Tung Yüan's *Summer Mountains* (note 340), where Tung records that he acquired *Privileged Residents* from Mo's son-in-law and lists three other paintings by Tung Yüan that he had acquired by 1597: *Travelers among Streams and Mountains*; a large untitled hanging scroll; and the *Hsiao and Hsiang Rivers* (vol. 1, fig. 2).

206. An Ch'i, *Mo-yüan hui-kuan lu*, pref. 1742, completed probably in 1744, rev. ed. in ISTP, vol. 17, no. 161, pp. 215–16.

207. Ibid., pp. 188–89. In his colophon, which is dated 1618, Tung mentions that the painting had been in his collection for twenty-one years; hence he must have acquired it in 1597 or 1598 (in counting, Tung sometimes includes the first year in his calculation, sometimes not; for an example of the latter, see the colophon cited in note 238, of which only part has been translated in this essay).

208. *Ku-kung shu-hua lu*, vol. 4, *ch.* 6, p. 72, leaf 1.

209. Tung mentions Mi as having seen only two genuine works by Li Ch'eng in his colophon on Li's small hanging scroll that had once belonged to Hsiang Yüan-pien (note 207).

210. *Shen-tsung shih-lu*, *ch.* 318, p. 9.

211. *Chih chih-kao jih-chiang kuan*: see "Tung Ch'i-ch'ang's Seals," entry III, in vol. 2 of this catalogue.

212. *Shih-ch'ü pao-chi hsü-pien*, vol. 5, pp. 2841–43.

213. *Shen-tsung shih-lu*, *ch.* 324, p. 5, *ch.* 325, p. 3. Yeh was designated *Huang-ch'ang-tzu shih-pan kuan*, a title that does not appear in Charles Hucker's *Dictionary of Official Titles*, or in any other authority, but which may here be translated as "Chief Attendant to the Emperor's Eldest Son." That the title was one of those assigned to members of the court selected as tutors is clear from another passage in the *Shen-tsung shih-lu* (*ch.* 269, pp. 1–2), in which a first group of Supervisors (*T'i-tiao*), Chief Attendants (*Shih-pan kuan*), and Lecturers and Readers (*Chiang-tu kuan*) were chosen when Ch'ang-lo began his formal education in the first month of 1594. The title awarded Tung in 1598 was Lecturer to the Emperor's Eldest Son (*Huang-ch'ang-tzu chiang-kuan*), which the passage just cited establishes as a step below Yeh's in prestige.

214. In every *nien-p'u* or account of Tung's career that has appeared hitherto (except in my own article in *To-yün* in 1989: see the introduction to these notes), Tung is represented as having been appointed a tutor to Chu Ch'ang-lo in 1594, a date based on Tung's biography in the *Ming-shih*, which—in typically elliptical fashion—reads (or seems to read), "[When] the Emperor's eldest son began formal study, [Tung] served as a Lecturer" (*ch.* 288, p. 7395; for what now seems a better reading, see the translation of this pas-

sage in the text [note 222]). Hence Tung's biographers, taking the two events to be simultaneous, arrive at 1594 as the date of Tung's appointment, that year being well known as the year Ch'ang-lo was allowed to commence his formal education.

The entry in the *Shen-tsung shih-lu* (*ch.* 325, p. 3) establishes beyond doubt that Tung was actually appointed four years later, in 1598—only six months before his relegation to a provincial post (note 219). The difference in timing is important, since the shorter time of six months supports the thesis that Tung was relegated to a provincial post precisely because of the attention he attracted in his capacity as tutor. The connection between his tutorship and relegation to the provinces is examined in the remaining portion of part 3 of this biography.

The correct date for Tung's appointment as tutor—1598—is given by Ch'en Chi-ju in his "Ssu-po Tung kung hsing-chuang" (*ch.* 36, p. 4), evidence passed over probably because those biographers aware of the passage assumed that the date applied only to the well-known incident involving the prince and his answer to Tung's question about a passage from the *Analects* (see note 218), rather than to the appointment itself.

215. Besides Tung himself, the other four were Chiao Hung, appointed in 1594 as one of Ch'ang-lo's original group of tutors (see note 172); Wu Tao-nan, appointed in 1597 (*Shen-tsung shih-lu.* *ch.* 315, p. 3); and Liu Yüeh-ning and Feng Yu-ching, appointed respectively in the first and seventh months of 1598 (*ch.* 318, p. 9; and *ch.* 324, p. 5).

216. *Shen-tsung shih-lu*, *ch.* 331, p. 9.

217. Translation adapted from James Legge, *The Chinese Classics*, 1861–72, rev. ed., n.d. but after 1949, facsim. repr. 1969, vol. 1, p. 353.

218. *Kuang-tsung shih-lu*, *ch.* 1, p. 4; "Ssu-po Tung kung hsing-chuang," *ch.* 36, p. 4; and Nelson Wu, "Tung Ch'i-ch'ang: Apathy in Government and Fervor in Art," p. 284. I have quoted the passage from the *Analects* as it appears in the *Kuang-tsung shih-lu*; the quotation as it appears in the "Ssu-po Tung kung hsing-chuang" reflects the sense of the passage but does not mirror it word for word.

219. *Shen-tsung shih-lu*, *ch.* 331, p. 3. The entry abbreviates Tung's new post as *Hu-kuang fu-shih*.

220. In his "Yin-nien ch'i-hsiu shu" (Memorial requesting permission to retire on account of age), Tung writes that he was "promoted to Surveillance Vice Commissioner of Hu-kuang, but [permitted] by order of the emperor [to retire] as Compiler [i.e. in his original office] on grounds of illness" (*Jung-t'ai wen-chi*, 1630, *ch.* 5, pp. 53–54). Ch'en Chi-ju writes rather more explicitly that Tung "was [ordered] to fill a provincial post in Ch'u [i.e. Hu-kuang], whereupon he requested permission to return home retaining his original title as Compiler": "Ssu-po Tung kung hsing-chuang," *ch.* 36, p. 2.

221. "Ssu-po Tung kung hsing-chuang," *ch.* 36, p. 2.

222. *Ming-shih*, *ch.* 288, p. 7395.

223. See note 171. See also Shen I-kuan's biography in the *Dictionary of Ming Biography*, vol. 2, p. 1180; and Chao Chih-kao's biography in the *Ming-shih*, *ch.* 219, pp. 5775–76.

224. See, for instance, the punishment meted out in 1598 to Tai Shih-heng and Fan Yü-heng: *Dictionary of Ming Biography*, vol. 1, p. 210; and *Kuo-ch'üeh*, p. 4814.

225. Tung's fellow *chin-shih* classmate Chiao Hung presents a parallel case. Chiao had placed first in the *chin-shih* examination of 1589, and in consequence had been immediately appointed a Senior Compiler in the Han-lin. He was unquestionably the most promising scholar of his year and was later to establish himself as a first-class historian. In 1594 he was appointed a tutor to Chu Ch'ang-lo (note 215) and compiled for the prince's use a work entitled the *Yang-cheng t'u-chieh*, "an illustrated thesaurus of golden sayings and noble deeds of past heirs apparent drawn from history" (Edward Ch'ien, *Chiao Hung and the Restructuring of Neo-Confucianism in the Late Ming*, 1986, p. 52). Chiao and Tung are the only two of Ch'ang-lo's many tutors (who in the end numbered more than twenty-five, though not all of them served at the same time) to be mentioned in the *Veritable Records of the Emperor Kuang-tsung* in connection with incidents in which Kuang-tsung, as a

youth, astonished and delighted the court by displaying precocity and benevolence in answer to questions put to him on the meaning of passages from the classics (*Kuang-tsung shih-lu*, *ch.* 1, p. 4).

In 1597 Chiao was one of two officials appointed to supervise the provincial examination for the Northern Metropolitan Area and was impeached for passing nine candidates whose papers were considered to exhibit seditious opinions. Though he submitted a memorial to the emperor protesting his innocence (in fact, eight of the nine papers had been graded not by him but by his fellow examiner), he was demoted to a provincial post as a subprefectural Vice Magistrate in far-off Fukien. A little more than a year later he was demoted a second time and resigned, never to hold office again (*Ming-shih*, *ch.* 288, p. 7393; *Shen-tsung shih-lu*, *ch.* 316, pp. 1, 4). Commenting on the examination controversy, Edward Ch'ien writes that Chiao "appealed to the emperor to dismiss the whole matter as a political conspiracy among some of his fellow officials who were trying to oust him from court. The reason for this conspiracy, which he did not specify in this memorial but which he revealed in the privacy of his personal correspondence, was his outspoken support of Ch'ang-lo as the legitimate heir to the throne. This support which, he claimed, aroused the anger of . . . 'many scoundrels,' would certainly also have displeased the emperor. Therefore, it is not surprising that his appeal to the emperor did not result in his exoneration" (*Chiao Hung and the Restructuring of Neo-Confucianism*, p. 59).

Chiao, like Tung, was never offered a post in the capital during the more than twenty years that remained of Shen-tsung's reign.

226. *Hua-ch'an shih sui-pi*, 1720, *ch.* 4, pp. 15–17; ISTP ed., pp. 79–80. For a translation of the poem (differing slightly in a few characters), see vol. 1, pl. 54, leaf 8.

227. For this quotation, see Tsang Li-ho, *Chung-kuo jen-ming ta-tz'u-tien*, 1921, repr. 1966, p. 1623; and Susan Bush and Hsio-yen Shih, *Early Chinese Texts on Painting*, 1985, p. 87.

228. The phrase *pan-p'o* (or in its complete form, *chieh-i pan-p'o*) comes from the *Chuang tzu*, and in the words of Lin Yutang, "has become a common idiom for describing the untrammelled mood of an artist at work" (Lin Yutang, *The Chinese Theory of Art*, 1967, p. 22). See also Yü Chien-hua, *Chung-kuo hua-lun lei-pien*, 1957, rev. ed. 1973, p. 3; and Susan Bush and Hsio-yen Shih, *Early Chinese Texts on Painting*, p. 42. I am indebted to Wai-kam Ho for the identification of this allusion.

229. *Jung-t'ai shih-chi*, 1630, *ch.* 4, pp. 40–42.

230. Chen-niang was a famous courtesan of the T'ang dynasty; her tomb is in Suchou, near Tiger Hill, on the site that in the Spring and Autumn period (722–481 B.C.) once formed the palace and gardens of the King of Wu (*Tz'u-yüan*, 1915, rev. ed. 1979, repr. 1984, vol. 1, p. 488; vol. 3, p. 2210).

231. Ching-man is variously identified, usually as a reference to the ancient state of Ch'u or to a part of its territory in present-day Hunan; but in the National Palace Museum's *Yüan ssu ta-chia* ([*The Four Great Masters of the Yüan*], 1975, English text, p. 75), it is glossed as referring to Kiangsu (or to somewhere in that province).

232. Tung's phrase *ch'ui liang chih meng* refers to the story known as "the dream of the millet" (*huang-liang meng*), which tells of a man who "had a dream wherein he married a handsome wife, gained wealth and high official honours, etc., and died at 80 years of age," only to awake and find that the millet being prepared for his supper was not yet cooked (R. H. Mathews, *Chinese-English Dictionary*, orig. ed. 1931, rev. ed. 1963, p. 340, no. 2297–28, and p. 302, no. 2036–2), the moral of the story being that life and worldly concerns are evanescent.

The significance of the phrase *ping-chu chih yu* (usually *ping-chu yeh-yu* "night outings with candle in hand") is that, life being short, one can seem to prolong it by enjoying the nighttime hours as well as day. By dismissing "night outings," Tung means that he now recognizes the futility of any such attempt: better instead spend the hours that one has doing what one loves best.

233. Ch'iu-chung and Yang-chung were Han dynasty recluses (*Chung-wen ta tz'u-tien*, 1962–68, vol. 18, p. 446; *Tz'u-yüan*, repr. 1984, vol. 3, p. 1719).

234. The phrase *han-man* occurs in the *Huai-nan tzu*, a collection of Taoist writings compiled at the instance of Liu An, Prince of Huai-nan (d. 122 B.C.) (James Hightower, *Topics in Chinese Literature*, 1950, rev. ed. 1953, repr. 1965, p. 8). The phrase was later taken to be the name of a Taoist immortal (*Tz'u-yüan*, repr. 1984, vol. 3, p. 1720).

235. *Jung-t'ai pieh-chi*, 1635, ch. 4, p. 6; also *Hua-ch'an shih sui-pi*, 1720, ch. 3, p. 2, ISTP ed., p. 61.

236. *Hua-ch'an shih sui-pi*, 1720, ch. 2, p. 23; ISTP ed., p. 47. The *Wu-Yüeh so chien shu-hua lu* (pref. 1776) records a calligraphy handscroll entitled *Discoursing on Painting* (*Lun-hua chüan*), dated 1613, with this and eleven other passages, all appearing also in the *Hua-ch'an shih sui-pi* (see Ren Daobin, *Hsi-nien*, p. 129; Zheng Wei, *Nien-p'u*, pp. 88–90); but since the scroll is not known to be extant, its authenticity and hence the date remain open to question. For another passage in which Tung lists the paintings he was carrying with him on his boat, see Ren Daobin, *Hsi-nien*, p. 162.

237. See note 165.

238. Sun Ch'eng-tse, *Keng-tzu hsiao-hsia chi*, composed in 1660, orig. ed. 1761, facsim. repr. 1971, ch. 3, p. 26.

239. In my opinion, the version of *Misty River and Piled Peaks* in the present exhibition (vol. 1, pl. 7) is a copy of the original scroll now in the National Palace Museum, Taipei.

240. Earlier essays in this catalogue discuss two paintings attributed to Tung that appear to refute the view that Tung's paintings from this period are all modeled after Sung masters. The first of these is a handscroll dated 1599, entitled in this catalogue *Landscape in the Manner of Huang Kung-wang* (vol. 1, fig. 27), which in the past has often been considered a genuine work. To a reader closely acquainted with Tung's collected writings, however, the second of its two inscriptions suggests that the work is suspect. The inscription is a pastiche, constructed from bits and pieces of the long passage from the *Jung-t'ai pieh-chi* (note 235) translated at the beginning of this section of the biography, with a few words added to bridge the gaps. The writer of the inscription, moreover, appears not to have understood Tung's allusion to the "dream of the millet" (see note 232) and substituted *wan* (evening) for *meng* (dream) (for a transcription of the two inscriptions on the painting, see Ch'en Ch'uo, *Hsiang-kuan chai yü-shang pien*, pref. 1782, repr. in ISTP, vol. 19, no. 169, p. 424). When we consider, in addition, that stylistically the painting is unlike any other work by Tung from this decade, and indeed exhibits, in fully developed form, motifs that belong to paintings of a later period (e.g. the small gesticulating tree, slightly grotesque in shape, that is silhouetted against the water [cf. vol. 1, pl. 42–2]; and the tiny cone-shaped trees—seen in Tung's early works only in embryonic form—that spring up like mushrooms around the base of much larger trees arranged in groups, each tree clothed in a different foliage), we can conclude that the handscroll is the work of a forger familiar with Tung's later production. In one motif, however—the three tall pines, leaning right and left, with which the painting opens—the forger has betrayed himself: in Tung's own work, their mannered elegance has no counterpart.

The second painting—entitled *Old Hermitage at Mount Heng-yün*, dated 1597 (vol. 1, fig. 28)—draws its inspiration, like the first, from Huang Kung-wang. I have not yet had the opportunity to see this painting; but I am told by Joseph Chang, whose expertise has for several years been devoted to the production of this exhibition and catalogue, that "the silk [of this painting] is coarse and 'fresh,' suggesting a much later date [for the painting], possibly early twentieth century." Having discovered another scroll, dated 1613, with virtually the same inscription, Chang suggests that "both paintings are forged from an original still unknown to us." The three seals on *Old Hermitage* support this conclusion: they appear to be copies of seals Tung used between the years 1607 and 1610 (see "Tung Ch'i-ch'ang's Seals," group VI, in vol. 2 of this catalogue).

241. *Shen-tsung shih-lu*, ch. 400, p. 3. Minor confusion has arisen from a misinterpretation of Tung's biography in the *Ming-shih* (ch. 288, p. 7395), which says that Tung was "elevated to his former office, to supervise the administration of education in Hu-kuang," with the result that it is sometimes suggested that the office Tung accepted in 1604 was identical to the office he rejected in 1599.

What the *Ming-shih* really means is that Tung was appointed to "his former office" (Surveillance Vice Commissioner of Hu-kuang) but with changed responsibility. Thus the office he accepted in 1604 was functionally quite different from the office he refused in 1599. As Surveillance Vice Commissioner of Hu-kuang Supervising the Administration of Education, he was one of two such officials whose jurisdiction was limited to education but whose responsibility extended to the whole province. (Hu-kuang, according to the *Ming-shih*, had two Education Intendants; other provinces had only one.) Had Tung served in 1599 as a Surveillance Vice Commissioner of Hu-kuang (*Hu-kuang an-ch'a ssu fu-shih*), his duties, as one of several such assistants to the Surveillance Commissioner, would have been more varied in scope, but his jurisdiction would have been limited to a single circuit (*tao*), hence to an area much smaller in size. See the *Ming-shih*, ch. 75, pp. 1840–41, 1843.

Curiously, T'an Ch'ien mistakenly records that Tung was appointed Hu-kuang Education Intendant in 1599 (*Kuo-ch'üeh*, p. 4828). That he was not is clear from Tung's copy of an imperial patent granted him in 1624 (see notes 318 and 336), which lists the first of his Hu-kuang offices as *Hu-kuang an-ch'a ssu fu-shih* and the second as *Hu-kuang t'i-hsüeh fu-shih*, thus plainly differentiating the two.

That *Hu-kuang [an-ch'a ssu] fu-shih t'i-tu hsüeh-cheng* is used interchangeably with *Hu-kuang t'i-hsüeh fu-shih* is clear from a later passage in the *Shen-tsung shih-lu* (ch. 420, p. 8) in which Tung requests permission from the throne to resign the post.

242. Tung speaks of his reluctance to accept the post in a passage recorded in the *Jung-t'ai pieh-chi*, 1635, ch. 4, p. 30. As Professor Susan Naquin pointed out to me in 1989, however, when she read my original paper on "Tung Ch'i-ch'ang and the Interplay of Politics and Art," the post of Education Intendant was potentially a lucrative one, which may have been one reason Tung decided to accept it. For this aspect of the post, see Tilemann Grimm, "Ming Education Intendants," 1969, repr. 1975, pp. 140–41.

243. For Tung's memorial seeking permission to resign, and the official account of the incident prompting it, see the *Shen-tsung shih-lu*, ch. 420, p. 8. The entry in the *Shen-tsung shih-lu* is dated the twenty-eighth day of the fourth month; hence the riot must have occurred in spring or early summer.

244. *Jung-t'ai pieh-chi*, 1635, ch. 4, p. 30. In this passage, which treats of his 1604 appointment, Tung writes that he resigned it in "the autumn of this year." Since the riot that precipitated his departure took place in the spring or early summer of 1606 (note 243), we can conclude that he succeeded in retiring in the autumn of 1606. For a closely related passage, see ch. 4, pp. 16–17.

245. *Shen-tsung shih-lu*, ch. 420, p. 8; *Ming-shih*, ch. 288, pp. 7395–96; *Jung-t'ai pieh-chi*, 1635, ch. 4, pp. 16–17.

246. *Min-ch'ao Tung huan shih-shih* (anon., late Ming), p. 4, in Chao I-ch'en, *Yu-man lou ts'ung-shu*, 1920–25. For a brief discussion of this text, see note 291.

247. Ts'ao Chia-chü (17th century), *Shuo-meng*, n.d., ch. 2, p. 2, in Lei Chin, *Ch'ing-jen shuo-hui, ch'u-chi*, 1913. (A second edition of the *Ch'ing-jen shuo-hui*, published in 1917, is identical except for the date.)

248. Chi Liu-ch'i, *Ming-chi pei-lüeh*, pref. 1671, rev. ed. 1984, vol. 1, p. 168.

249. In his "Memorial requesting permission to retire on account of age" (see note 220), Tung writes, "Six years later I was promoted to Hu-kuang Education Intendant, and served [in this office] for a year and six months. . . . Three years later, I was appointed Surveillance Vice Commissioner of Fukien [Tung uses the abbreviated title *Fu-chien fu-shih*], and served [in this office] for forty-five days." Since Tung served as Hu-kuang Education Intendant from 1604 to 1606 (notes 241, 244), he must have received his Fukien appointment in 1608 or 1609 (depending on whether Tung counts "three years" beginning with 1606 or 1607).

This conclusion is supported by combined evidence from the *Fu-chien t'ung-chih* and the *Shen-tsung shih-lu*. The *Fu-chien t'ung-chih*—while it gives no dates of appointment for those assigned to Fukien posts—nevertheless records the names of officeholders in order of appointment. Tung's name is preceded by that of Fang Hsüeh-lung, and followed by the names Kan Yü

447

and Feng T'ing (*Fu-chien t'ung-chih*, completed 1829, orig. ed. 1871; facsim. repr. 1968, *ch.* 96, p. 23). Though the *Shen-tsung shih-lu* fails to record dates of appointment for Tung and Kan (an omission not unusual in the case of minor offices), it does record dates for Fang and Feng: Fang was appointed Surveillance Vice Commissioner of Fukien on the fifth day of the eighth month, 1608, and Feng on the twenty-first day of the eleventh month, 1609 (*Shen-tsung shih-lu*, *ch.* 449, p. 1, *ch.* 464, p. 9). Thus Tung must have been appointed Surveillance Vice Commissioner of Fukien between the eighth month of 1608 and the eleventh month of 1609. Tung tells us that he served only forty-five days. Since he speaks of having just returned from Fukien in a passage written at West Lake in Chekiang in the spring of 1610 (*Jung-t'ai pieh-chi*, 1635, *ch.* 6, pp. 54–55), we can conclude that he was appointed Surveillance Vice Commissioner of Fukien toward the end of 1609.

Ren Daobin (*Hsi-nien*, p. 108) reaches the same conclusion on different grounds.

250. See notes 176, 178, and 213, and the accompanying discussion in the text.

251. *Jung-t'ai pieh-chi*, 1635, *ch.* 1, p. 10. That Tung was in Nanking—having accompanied his son there to take the provincial examination—we know from his second colophon, dated the second day of the ninth month, 1603, on his *Landscape after Kuo Chung-shu* (vols. 1 and 2, pl. 4).

252. See Chou Tao-chi's biography of Yeh in the *Dictionary of Ming Biography*, vol. 2, pp. 1567–68. Chou writes that from the beginning of 1609 (the end of 1608, according to the lunar calendar) Yeh was in reality the only Grand Secretary. See also the *Ming-shih*, *ch.* 110, p. 3374–75.

253. "Ta Tung Ssu-po," in Yeh Hsiang-kao, *Ts'ang-hsia hsü-ts'ao*, late Ming ed., n.d., *ch.* 19, p. 2.

254. *Jung-t'ai pieh-chi*, 1635, *ch.* 6, pp. 54–55; and Ren Daobin, *Hsi-nien*, pp. 109–10.

255. In his "Memorial requesting permission to retire on account of age" (note 220), Tung writes that having relinquished his post as Surveillance Vice Commissioner of Fukien, "from then on [i.e. until 1622] I lived quietly in retirement; and though from time to time I was offered positions as [intendant of] the Teng-Lai circuit in Shantung, the Chang-te circuit in Honan, and the Ju-chou circuit [in Honan], I declined them all, and ate my own bread for more than twenty years" (Tung's "more than twenty years" encompasses, for purposes of effect, the entire period he was excluded from holding office in the capital—from 1599 to 1622—rather than simply the period following his retirement as Surveillance Vice Commissioner of Fukien).

The precise titles of the three posts Tung was offered are recorded in an imperial patent awarded to Tung in 1624 (see notes 318 and 336), in which they are listed as Surveillance Vice Commissioner of Shantung (his appointment recorded in the *Shen-tsung shih-lu* on the twenty-seventh day of the third month: *ch.* 506, p. 5); Administration Right Vice Commissioner of the Huai-ch'ing circuit, Honan; and Administration Right Vice Commissioner of the Ju-chou circuit, Honan. Huai-ch'ing was the seat of the Ho-pei circuit in Honan (*Ming-shih*, *ch.* 75, p. 1842), which was composed of Huai-ch'ing, Wei-hui, and Chang-te prefectures; in his "Memorial," Tung for some reason mentions Chang-te instead of Huai-ch'ing.

256. See, for instance, the titles prefacing his signature at the end of his epitaph (*mu-chih-ming*) for a former Administration Vice Commissioner of Kuangtung, Huang K'o-ch'ien (1572–1618), in *Tung Hua-t'ing shu-hua lu*, pp. 29–32. Though Tung refused the appointment as Administration Vice Commissioner of Honan, the title nevertheless prefaces his name in the Veritable Records, when he was appointed Vice Minister of the Court of Imperial Sacrifices late in 1621 (note 308).

257. For the approximate date of Wu Cheng-chih's death, see the final paragraph of note 276.

258. Wu Ta-k'o was appointed Commissioner in the fourth month of 1612 (*Shen-tsung shih-lu*, *ch.* 494, p. 5) and permitted to retire in the sixth month of 1613 (*ch.* 509, p. 5). For his biography, see the *Ming-shih*, *ch.* 227, pp. 5972–73.

259. *Kuo-ch'üeh*, pp. 4615, 4618; *Shen-tsung shih-lu*, *ch.* 216, p. 6, *ch.* 218, pp. 4–5. According to the Western calendar, Ch'en Yü-chiao died in 1611; for his biography, see the *Dictionary of Ming Biography*, vol. 1, pp. 188–90.

260. Charles Hucker renders the office title *Tien-shih* either as Clerk or as Dis-

trict Jailor, adding that from the Ming period onward it was probably more often used in the latter sense (*Dictionary of Official Titles*, no. 6638). According to the *Ming-shih* (*ch.* 75, p. 1850), the duties of the *Tien-shih* were clerical in nature; but in districts that lacked either a Vice Magistrate or an Assistant Magistrate, the policing duties of that office devolved upon the *Tien-shih*.

261. The account given here of this early episode in Wu's career is based primarily on his biography in the *I-hsing hsien chih*, 1686, *ch.* 8 (*cheng-chih*), pp. 38–39; but it is supplemented and slightly modified by material in the *Kuo-ch'üeh* (pp. 4615, 4618). The *I-hsing hsien chih* says, for instance, that as a result of Wu's memorial "the Grand Secretaries were very angry"; I have followed instead the version of the story in the *Kuo-ch'üeh*, which says that the emperor himself was angry.

262. For Wu's 1594 appointment as Prefectural Judge (*T'ui-kuan*), see the *Jao-chou fu chih*, 1684, *ch.* 14, p. 19.

263. The *I-hsing hsien chih* (note 261), where the account of Wu's career after 1589 is greatly simplified, mentions only that he served as Secretary of a Bureau in the Nanking Ministry of Justice between serving as Prefectural Judge of Jao-chou fu and Assistant Minister of the Court of Imperial Entertainments in Peking. That he served in Peking as Secretary of a Bureau in the Ministry of Rites, and later as Vice Director of a Bureau in the same Ministry, before his appointment to the Court of Imperial Entertainments, is clear from two entries in the *Shen-tsung shih-lu* (*ch.* 382, p. 7, *ch.* 436, p. 7). Though his rank as Assistant Minister of the Court of Imperial Entertainments (6b) was lower than his rank as Vice Director of a Bureau in the Ministry of Rites (5b), the *Shen-tsung shih-lu* speaks of Wu as "promoted."

264. *Shen-tsung shih-lu*, *ch.* 437–450 passim, in particular *ch.* 437, pp. 2, 3–4; *ch.* 443, p. 1; *ch.* 449, pp. 1–2, 3; and *ch.* 450, p. 1. In his colophon on Tung's *Invitation to Reclusion at Ching-hsi* (vol. 2, pl. 18), Wu writes that, owing to the machinations of Ch'en Chih-tse, he was demoted to a provincial post before his new "seat" as Assistant Minister of the Court of Imperial Entertainments "was even warm."

265. Yeh Hsiang-kao, in an epitaph for Wu Cheng-chih's father, Wu Ta-k'o (entitled "Ming T'ung-i ta-fu T'ung-cheng shih ssu t'ung-cheng shih tseng Tu-ch'a-yüan yu tu yü-shih An-chieh Wu kung mu-chih-ming"), records unequivocally that Wu Cheng-chih (whom he calls Ch'ien-hsien chün) was demoted from Assistant Minister of the Court of Imperial Entertainments to Prefectural Judge of Hu-chou fu (*Hu-chou t'ui-kuan*): see Yeh Hsiang-kao, *Ts'ang-hsia yü-ts'ao*, Ming ed., n.d., *ch.* 10, p. 12. Wu Cheng-chih, in his colophon on Tung's *Invitation to Reclusion at Ching-hsi* (vol. 2, pl. 18), employs the more general literary term *Ssu-li* in place of *T'ui-kuan*.

266. *Shen-tsung shih-lu*, *ch.* 498, p. 6.

267. Yeh Hsiang-kao, in his epitaph for Wu Ta-k'o (note 265), writes that Wu Cheng-chih received his posting to "Hsi-chiang" (i.e. Kiangsi) at the same time that Wu Ta-k'o received permission to retire (*Ts'ang-hsia yü-ts'ao*, *ch.* 10, p. 13). Since Wu Ta-k'o was granted permission to retire in mid 1613 (note 258), we may assume that it was in 1613 that Wu Cheng-chih was appointed Assistant Surveillance Commissioner of the Hu-hsi Circuit in Kiangsi (the full title of his post, recorded in the *I-hsing hsien chih*: see note 261). This assumption is borne out by Tung's colophon of 1613 on his *Invitation to Reclusion at Ching-hsi* (vol. 2, pl. 18), in which he says that "this year I was summoned from the fields, both Ch'e-ju and I being notified alike," meaning that both he and Wu had been offered almost identical official posts—Wu as Assistant Surveillance Commisioner of Kiangsi; Tung as Surveillance Vice Commisioner of Shantung. For Tung's appointment, see note 289.

Yeh's use of "Hsi-chiang" to mean Kiangsi, though not found in standard sources, is not unique: a Kiangsi provincial gazetteer in 206 *chüan* completed in 1720 was entitled the *Hsi-chiang chih*.

268. In his epitaph for Wu Ta-k'o (note 265), Yeh Hsiang-kao writes that when Wu Cheng-chih "lingered, unwilling to go, [Ta-k'o] constrained him, saying, 'This was my old territory [i.e. the place where I once held office]'" (*Ts'ang-hsia yü-ts'ao*, *ch.* 10, p. 13).

That Wu Ta-k'o was Regional Inspector of Kiangsi in 1603 is clear from the combined evidence of two passages in the *Ming-shih* (*ch.* 227, p. 5972, and *ch.* 237, p. 6173), which concern an incident involving a Supervisor of Taxes in Kiangsi named P'an Hsiang.

269. Wu himself tells us that he went to Kiangsi: "From P'eng-li [i.e. P'o-yang Lake in Kiangsi], I shook [the dust from] my clothing and returned home [i.e. retired from the official post he was holding in Kiangsi]": see his colophon on Tung's *Invitation to Reclusion at Ching-hsi* (vol. 2, pl. 18). That he may have held the post only a very short time is suggested by the fact that his name does not appear in any of several editions of the *Chiang-hsi t'ung-chih* I have consulted (i.e. those dated 1683, 1720 [entitled *Hsi-chiang chih*], 1732, and 1881) among the names of those who served in Kiangsi as Assistant Surveillance Commissioner during the Ming.

Wu's post as an Assistant Surveillance Commissioner of Kiangsi was equal in rank to his previous post as Director of a Bureau in the Ministry of Justice in Nanking—both had a rank of 5a. Clearly Wu disliked the new post because it was a provincial appointment and represented a move sideways rather than a promotion.

270. See Tung's colophon—written at Wu's studio, the Yün-ch'i lou—on Su Shih's *Yang-hsien t'ieh*, which was in Wu's collection (*Shih-ch'ü pao-chi hsü-pien*, vol. 1, p. 295).

271. See Wu's colophon on Tung's *Invitation to Reclusion at Ching-hsi* (vol. 2, pl. 18). Wu is clearly referring to the events of late 1589 when he writes, "because of my impetuous words I was demoted to the provinces, and it was owing to this [matter] that Hsüan-tsai [i.e. Tung] really came to know me." He adds that not ten years later (i.e. in early 1599, as we know from the *Shen-tsung shih-lu*, *ch.* 331, p. 3), Tung was himself relegated to a provincial post.

272. *Ku-kung shu-hua lu*, vol. 1, *ch.* 3, p. 104.

273. Tung recorded Wu's request in his inscription on the left-hand mounting of the hanging scroll attributed to Mi Fu that he named the *Yün-ch'i lou t'u*, which is discussed below in the text (see also note 274). Evidence that Tung wrote the inscription before 1616 is provided by the two seals, a pair that Tung used with great frequency from 1607 to 1615, but, so far as I know, not thereafter (see "Tung Ch'i-ch'ang's Seals," entry III, in vol. 2 of this catalogue). The two seals, moreover, exhibit markedly less wear than do the impressions of these seals dated 1615.

274. The inscription is on the mounting to the left of the painting. In addition to his inscriptions on the *shih-t'ang* and left-hand mounting, Tung has written another inscription to the right of the painting. Fu Shen suggests that this inscription, which refers to the painting itself, was written slightly earlier, soon after Tung acquired the painting and before, presumably, he decided to present it to Wu (see Nakata Yujiro and Fu Shen, *O-Bei shuzo Chugoku hosho meiseki shu*, 1981–83, *Min Shin hen*, vol. 2, p. 9, pl. 8, and pp. 131–32, where all three of Tung's inscriptions are transcribed).

At some point after the painting entered the Freer Gallery in 1908, the inscriptions were cut off by the curators, who considered their authenticity doubtful, and mounted under glass on the back of the painting. The current curator, Fu Shen, has had them restored to their proper place.

275. The suggestion that Tung's *Wonderful Scenery of the Hsiao and Hsiang Rivers* after Mi Yu-jen was in fact one of the three paintings in different formats Tung painted at Wu's request was made by Fu Shen, in his commentary on Tung's inscriptions on the *Yün-ch'i lou t'u*, in *O-Bei shuzo Chugoku hosho meiseki shu* (see note 274). When Tung writes in 1636 that he painted the handscroll twenty years earlier, "twenty years" must of course be understood simply as a round figure; if *Wonderful Scenery* was indeed one of the three paintings in different formats (as seems entirely likely), it must date from before 1616, for the reason given in note 273.

276. In a colophon dated 1619 on Chao Meng-fu's *Water Village (Shui-ts'un t'u)*, Tung mentions that Chao's *Autumn Colors*, once in his own collection, was now in the hands of "the [Assistant] Minister of the Court of Imperial Entertainments Wu" (i.e. Wu Cheng-chih): see the *Shih-ch'ü pao-chi [ch'u-pien]*, vol. 1, p. 584.

For Tung, and subsequently Wu, as owner of the *Fu-ch'un Mountains*, see my article (cited in note 197). There I argued that Tung owned the *Fu-ch'un Mountains* until at least 1627, and that the scroll passed to Wu Cheng-chih (whose seals appear on the painting) sometime between 1627 and 1634. Despite a long succession of articles that have appeared on the subject of the *Fu-ch'un* scroll, both before my article and since, most of which touch on Wu's ownership of the scroll (e.g. Hin-cheung Lovell, "Wang Hui's 'Dwelling in the Fu-ch'un Mountains,'" 1970; Jao Tsung-i, *Huang Kung-wang chi Fu-ch'un shan-chü t'u lin-pen*, 1975; Fu Shen, "Lüeh-lun 'Chung lun'—*Fu-ch'un* pien chui yü," 1975, which supports a date of about 1630 for Wu's acquisition of the Fu-ch'un scroll; and Weng T'ung-wen, "Wu-ch'uan Ta-ch'ih wei Fu-yang-jen yu-tao Fu-ch'un wei-chi," 1975, which argues for an earlier date)—as well as one article that specifically treats Wu Cheng-chih and the Wu family (Huang Kuan, "Wu Chih-chü yü Yün-ch'i lou," 1975)—Wu Cheng-chih's death date has never been established; hence (though Huang Kuan astutely concludes on the evidence of a passage in the *Jung-t'ai chi* that Wu probably died towards the end of the Wan-li period) it has not been possible to fix with certainty an earlier *terminus ad quem* for the passing of the Fu-ch'un scroll from Tung to Wu.

In the course of writing the paper on which this biography is based, however, it occurred to me that evidence bearing on Wu Cheng-chih himself might be found in the epitaph written by Yeh Hsiang-kao for Wu's father Ta-k'o (note 265). This epitaph, when consulted, proved to be a key source for Wu Cheng-chih's biography as well as for his father's. It establishes beyond question that Wu died before his father (who died in 1621), and in its chronological treatment of events, places Wu Cheng-chih's death before 1620, when his father turned eighty (*sui*). Thus, despite conflicting statements by Tung himself (see my article, p. 63), we must now accept that Tung was owner of the Fu-ch'un scroll no later than 1619.

277. See Wu's colophon on Tung's *Invitation to Reclusion at Ching-hsi* (vol. 2, pl. 18), which is discussed below in the text and in notes 264, 269, 271, and 281.

278. Herbert Giles, *A Chinese Biographical Dictionary*, 1898, p. 117.

279. Tung records his intention of presenting Wu with Chi An's biography in his inscription on the left-hand mounting of the *Yün-ch'i lou t'u* (see notes 273 and 274). That Tung intended to compare Wu with Chi An is suggested by Huang Kuan in his article "Wu Chih-chü yü Yün-ch'i lou" (p. 45), though Huang does not indicate why the comparison was significant, except to say that Tung was intending to express his admiration for Wu.

280. See note 266.

281. A sentence in Wu's colophon of 1617 on the same scroll (vol. 2, pl. 18) refers also to the events of 1613, though Wu makes no mention of the year in his text: "Sometime later each of us was posted to a Provincial Surveillance Commission, [but] those envying Hsüan-tsai prevented him from leaving the mountains [i.e. coming out of retirement]." The term *fan-nieh*—a collective reference to both the Provincial Administration Commission and the Provincial Surveillance Commission—must here be translated as the latter only, in the light of the positions that Tung and Wu were actually offered (see note 267). For Tung's impeachment in 1613 by Wei Yün-chung (the person or one of the persons "envying Hsüan-tsai" to whom Wu refers), see note 289.

282. For the Chinese text of Tung's colophon, see vol. 2, pl. 18. For the phrase *hung ming*, "goose [that flies off into] the blue," see note 288.

283. See notes 267 and 268.

284. Tung says as much when he writes, in his own colophon (translated above in the text), "This year I was summoned from the fields, both Ch'e-ju and I being notified alike [i.e. awarded almost identical official posts]."

285. Chiang-men, which is cited in standard sources as a place name only in Kuangtung and Szechuan, must nevertheless here be construed as a reference in some way to (or to some place in) Kiangsi, since nothing else makes sense.

286. "Drum and fife [music]" (*ku-ch'ui*) means in this case music granted to an important official that was played as a token of his rank.

287. I am indebted to Chiang Chao-shen and Chang Lin-sheng, of the National

Palace Museum, Taipei, for pointing me in the direction of Kung's essay. The essay is translated by my former professor James Hightower in Cyril Birch, *Anthology of Chinese Literature*, 1965, rev. ed. 1967, pp. 169–73.

288. For the pertinent line in Yang Hsiung's original text (and its quotation also in the *Hou Han shu*), see *tai-jen ho ts'uan* in the *Chung-wen ta tz'u-tien*, 1962–68, vol. 12, p. 98. The *P'ei-wen yün-fu* points out that the character *ts'uan*, in this passage traditionally glossed as meaning *ch'ü*, is sometimes mistakenly written *mu* (as indeed it appears in Wu's colophon): see *tai-jen ts'uan* in the *P'ei-wen yün-fu*, rev. ed. 1983, vol. 2, p. 3029.

 What leads Wu to paraphrase Yang's line is that the phrase *hung ming* "goose [that flies off into] the blue," which Tung used in his colophon of 1613, derives also from the same passage: Yang's line in its entirety reads *Hung fei ming-ming, tai-jen ho ts'uan yen.*

289. *Shen-tsung shih-lu*, *ch.* 506, p. 5; *ch.* 510, p. 2.

290. Ren Daobin, *Hsi-nien*, pp. 133–34. "Ling-hai" refers to the two provinces of Kuangtung and Kuangsi, i.e. to the region between the Wu-ling (five mountain ranges on the northern border of Kuangtung and Kuangsi) and Nan-hai, the South China Sea. In 1094 Su Shih was banished to Hui-chou on the Kuangtung coast (see George Hatch's biography of Su in Herbert Franke, *Sung Biographies*, 1976, repr. 1978, vol. 2, p. 965).

291. The principal source for this and all of the story to follow is the *Min-ch'ao Tung huan shih-shih* (see note 246) by an unknown author who, if not an eyewitness to events—though, indeed, in some part he may have been—was close enough in time and place not only to pen a narrative that is astonishing in the degree of its detail but also to amass more than twenty documents connected with the case, whose texts appear with his own. Hence the story is told (in outline, at least) many times over; and though the author's account is by far the most complete, there are particulars to be gleaned from the accompanying documents that here and there add to the story he tells. The most interesting of these documents is the last, in which twelve Government Students from Sung-chiang (including Lu Chao-fang, one of the key actors in the drama) present their grievances against Tung in a formal complaint. (It should be remembered that Government Students could be of any age, the term referring simply to those who continued to pass examinations at the prefectural level, which qualified them to sit the provincial examination and entitled them to a government stipend. Though he was a Government Student, Fan Ch'ang, for instance—whose wife, Madame Kung, was Tung's wife's sister, and whose mother, Madame Feng, was eighty-three *sui*—was clearly more or less the same age as Tung himself.)

 The story as I have told it here is constructed for the most part from the author's narrative (pp. 1–2, 5–9) and the students' account of events (pp. 34–37), supplemented at a few points by the story as it is recounted by Ts'ao Chia-chü in his *Shuo-meng* (*ch.* 2, pp. 7–8; see note 247). Where particulars differ (as very occasionally they do), I have usually chosen to follow whichever account presents the story at that point in greatest detail.

 The *Min-ch'ao Tung huan shih-shih* has sometimes been printed with the initial section missing; in the *Yu-man lou ts'ung-shu*, however, where the version I have used appears, the missing portion of the text has been restored and the text emended slightly in a number of different places, on the basis of two manuscript copies that survived in private hands.

 A few small points are worth mentioning. The students write that Madame Kung, who (as a note in their text explains) was the sister of Tung's wife, was the granddaughter of "the Supervising Secretary (*Chi-chien*) [Kung]," a reference to Kung Ch'ing (*chin-shih* 1553), who served as a Supervising Secretary of the Office of Scrutiny for Rites (see note 383 and part 6 of this biography). But we know from Ch'en Chi-ju that Tung's wife (called also, of course, Madame Kung) was actually Kung Ch'ing's niece or clan-niece; hence her sister must have been the same. The students, then, are here slightly in error.

 One phrase in their text—*t'ou-k'ao*, used to describe those living on Tung's "hundred boats"—is best explained by turning to the *Tz'u-yüan* (repr. 1984, vol. 2, p. 1222), where it is defined as meaning one who "sells himself to a powerful family as a slave."

292. For the location of Tung's house (as being near Hua-t'ing's south gate) and of the house of his son Tzu-yüan, I have relied on a map distributed to participants at the "Academic Symposium on Dong Qichang" held in Songjiang under the auspices of the Shanghai Calligraphy and Painting Publishing House in the autumn of 1989.

 For Fan T'ing-yen, see the *Sung-chiang fu chih*, 1631, *ch.* 34 (*kuo-ch'ao, hsüan-chü, hsiang-chü*), p. 33; and the *Hua-t'ing hsien chih*, 1791, *ch.* 12, p. 25.

 For Feng En and his sons Hsing-k'o and Shih-k'o, see the *Dictionary of Ming Biography*, vol. 1, pp. 445–48, 55–58; and the *Ming-shih*, *ch.* 209, pp. 5518–22. In their biography of Feng En in the *Dictionary of Ming Biography*, Chaoying Fang and L. Carrington Goodrich write that Hsing-k'o was twelve (i.e. thirteen *sui*) when he offered his life to save his father's; but the *Ming-shih* makes it clear that Hsing-k'o made his offer in 1534, i.e. at the age of fourteen *sui* (if indeed, as the *Ming-shih* records, Hsing-k'o was thirteen *sui* in 1533). For evidence of Shih-k'o's friendship with Tung, see "Tung Ch'i-ch'ang ti chiao-yu" in vol. 2 of this catalogue.

293. *Shen-tsung shih-lu*, *ch.* 546, p. 3.

294. Ibid. Chou Hsüan-wei also figures briefly in a memorial submitted by the Education-intendant Censor Wang I-ning (*chin-shih* 1598), the text of which is recorded in the *Min-ch'ao Tung huan shih-shih*, p. 18, in Chao I-ch'en, *Yu-man lou ts'ung-shu*, 1920–25.

 For Wang Ying-lin's appointment and full official title, see the *Kuo-ch'üeh*, p. 5079.

295. A scroll of Tung's sketches, with precisely the same inscription by Ch'en Chi-ju, is recorded in Lu Hsin-yüan, *Jang-li kuan kuo-yen lu*, facsim. repr. 1975, vol. 2, *ch.* 24, pp. 7–8. Since the dimensions of that scroll are similar to the those of the scroll in the present exhibition, it is likely that the two scrolls are one and the same; but it is curious that Lu Hsin-yüan makes no mention of the notations by Tung that appear on the scroll in the exhibition, even though one of these notations is longer than Ch'en's inscription at the end of the scroll, and is, moreover, of some little interest. Nor does Lu record Tung's seal, which, though blurred, is nonetheless legible. We cannot entirely rule out the possibility, then, that the two scrolls are different, and that Ch'en's colophon is a copy, either on one scroll or the other.

 The phrase *huo chai* (burning house), which Ch'en uses at the close of his inscription, is a Buddhist metaphor for this world of troubles and emotional entanglement, from which one must endeavor to escape; Ch'en intends the phrase here both in its literal and in its metaphorical sense.

 For a letter in which Tung does speak of his lost estate (and, presumably in want of funds, offers to sell some Sung calligraphy that escaped the calamity), see Nelson Wu, "Tung Ch'i-ch'ang: Apathy in Government and Fervor in Art," p. 380, n. 114.

296. This painting, which belongs to the Shanghai Museum, is at present on view in the small Exhibition Hall of Historical Objects from Shanghai (Shang-hai-shih li-shih wen-wu ch'en-lieh kuan) on the outskirts of the city.

297. *Ku-kung shu-hua lu*, vol. 2, *ch.* 4, pp. 239–40. The handscroll is illustrated in Ch'en Shun-ch'en, Kohara Hironobu, et al., *Jo I, To Kisho* (*Bunjinga suihen: Chugoku hen*, vol. 5), repr. 1986, pl. 27.

298. James Cahill, in an illuminating discussion of Tung's *Ch'ing-pien Mountain* (*Compelling Image*, 1982, pp. 39–44), demonstrates convincingly that Tung's primary stylistic debt in this painting is to Huang Kung-wang, whose *Stone Cliff at the Pond of Heaven* (of which only copies now exist) makes a telling comparison with Tung's own work, notably in the means used to articulate the mountain's form.

299. Chen Chün, *T'ien-chih ou-wen*, 1907, *ch.* 6, p. 22, rev. ed. 1982, p. 147; Ren Daobin, *Hsi-nien*, p. 200.

300. Ku Fu, *P'ing-sheng chuang-kuan*, pref. 1692, facsim. of ms. copy, 1971, *ch.* 10, pp. 116–17, 119; Ren Daobin, *Hsi-nien*, p. 146.

 For Chu Kuo-chen's biography, see Arthur Hummel, *Eminent Chinese of the Ch'ing Period*, 1943, repr. 1970, pp. 187–88, where Chu's birth date is given as 1557; for the date used here in the text, see "Tung Ch'i-ch'ang ti chiao-yu," in vol. 2 of this catalogue.

301. *Kuang-tsung shih-lu*, *ch.* 8, p. 4.

302. *Ming-shih*, ch. 288, p. 7396.

303. *Hsi-tsung shih-lu*, ch. 2, p. 3.

304. *Ming-shih*, ch. 110, p. 3377. See also Chou Ta-li's biography of Yeh in the *Dictionary of Ming Biography*, vol. 2, p. 1568, where the date of Yeh's arrival in the capital has been translated into its Western equivalent.

305. *Shih-ch'ü pao-chi* [ch'u-pien], vol. 2, pp. 928–29; *San-hsi t'ang fa-t'ieh*, completed 1750, rev. ed. 1984, vol. 2, ts'e 29, pp. 2092–2109.

306. For excellent biographies of Chao Nan-hsing and Kao P'an-lung, on which I have depended for facts relating to their careers, see the *Dictionary of Ming Biography*, vol. 1, pp. 128–32, 701–10.

307. "Ssu-po Tung kung hsing-chuang," ch. 36, p. 2.

308. *Hsi-tsung shih-lu*, ch. 17, p. 9; cf. *Kuo-ch'üeh*, p. 5197. Here, as is often the case, the *Kuo-ch'üeh* differs slightly from the *Shih-lu* as to the exact day.

309. The place Tung calls Yang-shan-i (Yang-shan government post station) seems equivalent to none of the places named Yang-shan to be found in standard sources. Presumably it was a small stopping place at some point along the route of the Grand Canal.

310. The painting is discussed by James Cahill in "Tung Ch'i-ch'ang's Painting Style: Its Sources and Transformations," in vol. 1 of this catalogue.

311. For a short biographical note on Li, see *Ming-jen chuan-chi*, vol. 1, p. 221. For the office he held in the spring of 1622, see Wu T'ing-hsieh, *Ming Tu-fu nien-piao*, 1982, vol. 2, p. 343. Tung addresses Li on the painting as "Hsüan-po Lao kung-tsu," the term *Kung-tsu* (alternatively *Lao kung-tsu*) referring here to Li's position as *Hsün-fu* "Grand Coordinator," thus illustrating the use of *Kung-tsu* as a term of address with a wider application than is recognized by Charles Hucker in his *Dictionary of Official Titles*. See instead the *Chung-wen ta tz'u-tien*, 1962–68, vol. 4, p. 85; and the *Tz'u-yüan*, repr. 1984, vol. 1, p. 312. The poem on the painting is included in the *Jung-t'ai shih-chi*, 1630, ch. 2, p. 20.

 Li may also have been a friend of Ch'en Chi-ju: Ch'en's *Po-shih-ch'iao* (pp. 254–55) records a eulogy (*hsiang-tsan*) written for a Li Hsüan-po, who (since his name is accompanied by no other means of identification) may or may not be Li Yang-cheng. For the term *hsiang-tsan*, see note 408.

312. *Hsi-tsung shih-lu*, ch. 21, p. 7.

313. Ibid., ch. 22, p. 16.

314. Ibid., p. 18.

315. Ibid.

316. Ibid., ch. 23, p. 4.

317. Ibid., ch. 24, p. 10.

318. *Ming-shih*, ch. 288, p. 7396. The patent that includes a definitive list of the offices Tung was awarded from 1593 through 1623 (see note 336) makes it clear that Tung was promoted from his post as Vice Minister of the Court of Imperial Sacrifices to the post of Junior Supervisor of the Household Administration of the Heir Apparent in charge of the Han-lin Academy in Nanking, and then to the post of Right Vice Minister of Rites; there is no mention of an appointment as Chief Minister of the Court of Imperial Sacrifices. The *Hsi-tsung shih-lu*, moreover, records that Tung was still serving as Vice Minister of the Court of Imperial Sacrifices when he applied for permission to be transferred south (note 327).

 See also Tung's colophon on his copy, dated 1636, of the imperial patent awarding him the prestige title *Kuang-lu ta-fu*, included in the present exhibition (vol. 2, pl. 71), where he summarizes his official career: on leaf 12 he mentions appointments as Vice Minister of the Court of Imperial Sacrifices, Junior Supervisor of the Household Administration of the Heir Apparent, Right (and then Left) Vice Minister of Rites, and Minister of Rites in Nanking; significantly, he makes no mention of serving as Chief Minister of the Court of Imperial Sacrifices.

319. *Kuo-ch'üeh*, p. 5224. For the thirty-one officials associated with the project, see the *Kuang-tsung shih-lu*, chin shih-lu piao, p. 3. For the *Kuo-ch'üeh* itself, see the introduction at the beginning of these notes.

320. The text of the stele, entitled "Hsin chien Shou-shan shu-yüan chi"—recording Yeh as the author and Tung as the calligrapher—may be found as an addendum to another entry entitled "Shou-shan shu-yüan Yüan-hsüeh tz'u

321. See notes 115 and 320.

322. See Yü Min-chung, Ying Lien, et al., (Ch'in-ting) *Jih-hsia chiu-wen k'ao*, commissioned by the emperor in 1774, ch. 49, pp. 3–5; Charles Hucker, *The Censorial System of Ming China*, 1966, pp. 214–15; and the *Hsi-tsung shih-lu*, ch. 61, p. 7; ch. 62, pp. 6–7.

323. See the last three lines of the "Hsin chien Shou-shan shu-yüan chi" (note 320).

324. For the two groups of six martyrs (the first group imprisoned and tortured to death in 1625, the second in 1626), see Charles Hucker's biography of Kao P'an-lung in the *Dictionary of Ming Biography* (vol. 1, pp. 701–10). In 1626 there were actually seven men whose arrest was ordered, but Kao P'an-lung drowned himself before he could be seized.

325. *Tung Hua-t'ing shu-hua lu*, pp. 3–4.

326. Tung signs the calligraphy using the title Vice Minister of the Court of Imperial Sacrifices and Academician Reader-in-waiting in the Han-lin Academy, a title he was awarded in the seventh month of 1622 (note 317). A year later, in the seventh month of 1623, he was promoted to Right Vice Minister of Rites (note 337). Hence the calligraphy must have been executed between these dates.

327. *Hsi-tsung shih-lu*, ch. 24, p. 22; *Ming-shih*, ch. 288, p. 7396.

328. *Jung-t'ai wen-chi*, 1630, ch. 5, p. 50.

329. *Jung-t'ai shih-chi*, 1630, ch. 4, pp. 5–6.

330. The four additional poems are also recorded in the *Jung-t'ai shih-chi* (1630, ch. 3, pp. 9–10, 44; ch. 4, p. 6).

331. "Ta Tung Ssu-po," in Yeh Hsiang-kao, *Hou Lun-fei ch'ih-tu*, late Ming ed., n.d., ch. 8, p. 18. Though the letter is undated, the approximate date is easy to deduce from internal evidence: clearly it was written while Tung was on assignment in Nanking gathering material for the *Veritable Records of the Emperor Shen-tsung*, hence between the fall of 1622 and the spring of 1624. Wang Shiqing argues that the letter must have been written in 1624, since Yeh speaks in the letter of his determination to retire (he was to leave Peking in the seventh month of 1624): see "Tung Ch'i-ch'ang ti chiao-yu" in vol. 2 of this catalogue. But Yeh was intent on retiring virtually from the moment he arrived in Peking: his *Hsü Lun-fei tsou-ts'ao* contains sixty-seven memorials, dating from the second month of 1622 to the seventh month of 1624, requesting the emperor's permission to retire.

332. *Jung-t'ai wen-chi*, 1630, ch. 5, p. 51. Tung's description is repeated word for word in his biography in the *Ming-shih* (ch. 288, p. 7394).

333. Wolfgang Franke, *An Introduction to the Sources of Ming History*, 1968, p. 15 and pp. 125–26, no. 5.2.5. A copy of Tung's book is kept in the National Central Library, Taipei. Tung presented it to the throne in a memorial dated the third day of the fourth month, 1624 (see note 338); and it was acknowledged by the throne three days later (*Hsi-tsung shih-lu*, Liang-pen, ch. 41, p. 2; and *Kuo-ch'üeh*, p. 5273).

334. *Jung-t'ai wen-chi*, 1635, ch. 6.

335. *Ming-shih*, ch. 97, p. 2394; Wolfgang Franke, *An Introduction to the Sources of Ming History*, 1968, p. 176.

336. The patent (listed as *Ching* 1–2178 in *Chung-kuo ku-tai shu-hua mu-lu*, vol. 2, 1985, p. 51) is reproduced in *Ku-kung po-wu-yüan ts'ang li-tai fa-shu hsüan-chi*, Ti-san-chi, 1982, no. 17.

337. *Hsi-tsung shih-lu*, ch. 36, p. 16; *Kuo-ch'üeh*, p. 5224.

338. The memorial, entitled in the *Jung-t'ai chi* "Pao-ming shu," is recorded in the *Jung-t'ai wen-chi*, 1630, ch. 5, pp. 50–52; and at the beginning of Tung Ch'i-ch'ang, *Shen-miao liu-chung tsou-shu hui-yao*, completed 1624 (see note 333). The date of its presentation appears only in the latter.

339. The four Grand Secretaries supporting the Tung-lin cause were Yeh Hsiang-kao; Han K'uang; Sun Ch'eng-tsung, who for most of the crucial period from 1622 to 1625 was absent from the capital, conducting the defense of the

northeastern frontier; and Chu Kuo-chen, whose sympathies lay with the Tung-lin party, but who had little appetite for political intrigue. For Yeh and Han, see the *Dictionary of Ming Biography*, vol. 1, pp. 483–85, vol. 2, pp. 1567–70; for Sun and Chu, see Arthur Hummel, *Eminent Chinese of the Ch'ing Period*, repr. 1970, pp. 187–88, 670–71. See Ren Daobin, *Hsi-nien*, p. 58, for an interesting passage from Chu Kuo-chen's *Yung-ch'uang hsiao-p'in* (1622), in which Chu recalls a conversation with Tung ("my friend Tung Hsüan-tsai") in 1598: acknowledging Tung as the best calligrapher and painter of the present generation, Chu asks Tung whether he considers himself to have surpassed Ch'ü Yün-ming and Wen Cheng-ming; when Tung modestly demurs and writes out a few lines in illustration, Chu concludes that—as (he tells us) he has often said before—Wen's calligraphy is indeed superior to Tung's.

Of the other three Grand Secretaries, two—Ku Ping-ch'ien and Wei Kuang-wei—were leading members of the eunuch party (see Chi Liu-ch'i, *Ming-chi pei-lüeh*, rev. ed. 1984, vol. 1, p. 46; and the *Ming-shih*, ch. 306, pp. 7843–46). The remaining Grand Secretary, Chu Yen-hsi, was evidently on friendly terms with several figures in the eunuch camp, as is shown by his colophon on Tung's biography of Li Fan-kuan (see note 343 and the discussion of this biography in the text); but according to Chu's biography in the *Liao-ch'eng hsien chih* (note 340), Chu objected to the naming of Wei Chung-hsien as *Yüan-ch'en*, or "Eminent Minister" (*Tsung-ch'en* in the *Shan-tung t'ung-chih*, 1915, facsim. repr. 1934, vol. 4, p. 4756); and in the sixth month of 1625 he was forced to resign (*Ming-shih*, ch. 110, p. 3380).

340. See Tung's colophon dated 1635 on Tung Yüan's *Summer Mountains* (*Hsia-shan t'u*) (P'ang Yüan-chi, *Hsü-chai ming-hua lu*, pref. 1909, facsim. repr. 1971, vol. 1, pp. 53–56), translated in Richard Barnhart, *Marriage of the Lord of the River*, 1970, pp. 15–16. Barnhart suggests that Chu, who is mentioned twice—first as "Tung-ch'ang *Hsiang* Chu," and later as "Tung-ch'ang Chu *Ko-hsüeh*," both meaning "the Grand Secretary Chu of Tung-ch'ang"—may be Chu Keng (1535–1608); but though Chu Keng had indeed held the office of Grand Secretary, he was a native of Shan-yin in Chekiang rather than Tung-ch'ang in Shantung, and by 1624 he was no longer living.

Chu Yen-hsi, on the other hand, was Grand Secretary from the beginning of 1623 to the sixth month of 1625 (*Ming-shih*, ch. 110, pp. 3379–80), and was a native of Liao-ch'eng hsien, the prefectural seat of Tung-ch'ang fu. A minor figure, his biography appears neither in the *Ming-shih* nor in modern reference works like *Ming-jen chuan-chi tzu-liao so-yin*; his biography may be found in the *Liao-ch'eng hsien chih*, pref. 1885, facsim. repr. of 1910 rev. ed., ch. 8, pp. 15–16.

The wording of Tung's colophon of 1635—where he writes that in 1622 he again came to Peking and there saw *Waiting for the Ferry* at the home of the Grand Secretary Chu of Tung-ch'ang—is misleading, since the passage might be taken as meaning that Tung saw the painting in 1622. The date, however, applies only to the first half of the sentence (i.e. to Tung's arrival in the capital); earlier in the colophon he makes it quite clear that it was in 1624 that he saw the painting. Chu, moreover, as I noted above, became Grand Secretary only in 1623.

Barnhart suggests that the scroll entitled *Waiting for the Ferry at the Foot of Summer Mountains* that is today in the Liaoning Provincial Museum may only be a copy of the one Tung saw in 1624 (*Marriage*, p. 19, n. 29). This view is supported by the crude appearance of Tung's inscription on the *yin-shou*, which from photographs I would judge to be a forgery. The present inscription, however, is in all likelihood a copy of a lost original, so that it is reasonable to suppose that its date—the sixth month of 1624—is the date Tung saw and inscribed the original painting.

341. *Jung-t'ai shih-chi*, 1630, ch. 3, pp. 14–16. The second line of the first poem mentions Yeh as retiring after having served three emperors (i.e. Shen-tsung, Kuang-tsung, and Hsi-tsung); hence, though undated, the poems must have been written when Yeh resigned his post to return to Fukien in 1624.

342. *Kuang-tung-sheng po-wu-kuan ts'ang-hua-chi*, 1986, pl. 79 and p. 8; see also Xu Bangda, *Ku-shu-hua wei-o k'ao-pien*, 1984, *Hsia-chüan: wen-tzu pu-fen*, p. 157.

343. *Jung-t'ai wen-chi*, 1630, ch. 6, pp. 32–34. The original calligraphy (reproduced in *Chung-kuo ku-tai shu-hua t'u-mu*, vol. 3, p. 290, *Hu* 1–1418) is signed by Tung using the title Left Vice Minister of Rites, an office Tung held from late 1624 till the twenty-sixth day of the first month, 1625, when he was promoted to Minister of Rites in Nanking (see notes 355 and 357).

344. Because Tung begins the biography (even in his original calligraphy) with the wrong place name—Chan-i, in Yünnan, instead of Chan-hua, in Shantung, which eventually proved to be correct—the subject of the biography, Li K'ang-i (*ming* Fan-kuan), and his son Li Tsun-ni (whose *ming* was not given) were extremely difficult to identify. Neither name appears in any standard reference work; the only clue was that Li, the son, is called by Tung "the *Chi-chien* Tsun-ni," *Chi-chien* meaning *Chi-shih-chung* or "Supervising Secretary." By tracing in the *Kuo-ch'üeh* and *Hsi-tsung shih-lu* all those named Li who held the post of Supervising Secretary in or about 1624 (of whom I found four), and by turning then to their respective gazetteers, it was possible to identify Li Tsun-ni as Li Lu-sheng. For both father and son, see the *Chan-hua hsien chih*, pref. 1635 and 1636, facsim. repr. 1978, ch. 2, pp. 53–54, 75–76.

345. *Kuo-ch'üeh*, p. 5275.

346. For Li's memorial in covert support of Feng, see his biography in the *Ming-shih* (ch. 306, p. 7866); and the *Kuo-ch'üeh*, p. 5309. For Feng's promotion, see the *Kuo-ch'üeh*, p. 5310.

347. Most of the biographical information about Li Lu-sheng given here comes from his biography in the *Ming-shih* (ch. 306, p. 7866).

348. Wei himself tells us that he composed Li Fan-kuan's *mu-chih-ming*, in his first colophon on Tung's biography of Li. Tung also mentions Wei's epitaph (*mai-chih*) in the body of his biography (*Jung-t'ai wen-chi*, 1630, ch. 6, p. 34).

349. Tung not infrequently made small changes—a slight rearrangement of word order, or substitution of a more felicitous word or phrase—in the texts of his longer compositions (e.g. biographies and *mu-chih-ming*) before including them in the *Jung-t'ai chi*, but his purpose was improvement in style, not intentional obfuscation.

350. The *Chan-hua hsien chih* makes no mention of Chan-i as a name ever having been used for Chan-hua hsien: see the "Yen-ko" section of the *Chan-hua hsien chih*, facsim. repr. 1978, ch. 1, pp. 1–2.

351. The two officials mentioned in the original text as friends of K'ang-i hsien-sheng (i.e. Li Fan-kuan) are "the Vice Minister of Works (*Shao ssu-k'ung*) Ting and Left Provincial Administration Commissioner (*Tso fang-po*) Li." In the printed version these have become "the Vice Minister of Works Chung and the Left Provincial Administration Commissioner Ku" (*Jung-t'ai wen-chi*, 1630, ch. 6, p. 32). The two may be identified as Ting Mao-sun (*chin-shih* 1580), who during the T'ien-ch'i period was appointed Left Vice Minister of Works; and Li Fang (*chin-shih* 1580), who rose to be Left Provincial Administration Commissioner of Szechwan (*Ming-shih*, ch. 233, p. 6076; *Chan-hua hsien chih*, facsim. repr. 1978, ch. 2, pp. 2–3).

352. "The Grand Secretary Wei" could only have meant Wei Kuang-wei, the sole Grand Secretary in Tung's lifetime with the surname Wei; whereas conceivably there might have been several men surnamed Wei who had been awarded the largely honorary title Junior Guardian (*Shao-pao*). At any rate, the surname Wei coupled with the title *Shao-pao* would not have brought Wei Kuang-wei automatically to mind.

353. Li Lu-sheng's *tzu* is not recorded in his *Ming-shih* biography (a common omission in the case of members of the eunuch party), nor does it appear to be coupled with his name anywhere but in his biography in the *Chan-hua hsien chih*. A short biography of Li Fan-kuan—but, significantly, not of his son Lu-sheng—is included in the *Chi-nan fu chih* (1706, ch. 47, p. 21) and in the *Wu-ting fu chih* (1859, ch. 26, [*i-hsing*], p. 6); but neither father nor son is accorded a biography in any edition of the *Shan-tung t'ung-chih* that I have been able to consult.

354. Tung's biographies in the *Jung-t'ai chi* more often than not include this information; cf. *Jung-t'ai wen-chi*, 1630, ch. 6, pp. 5, 9, 18, 20, 23, 28, 29, 44, 72.

355. Presumably Tung was Right Vice Minister of Rites at least until the twenty-

ninth day of the ninth month, 1624, the date of a patent addressing Tung by that title that Tung himself later copied out in his own hand (the date at the end of the patent being, of course, the date that the patent was issued, not the date that Tung made his copy, as is implied by its listing under the date 1624 in the *Chung-kuo ku-tai shu-hua mu-lu*: see note 336).

In a passage in the *Jung-t'ai pieh-chi* (1635, ch. 4, p. 1), Tung records the presentation to the throne of an ancient state seal (discovered during the plowing of a field), and mentions that he was serving at the time as Left Vice Minister of Rites. The seal was presented to the throne on the tenth day of the tenth month (*Kuo-ch'üeh*, p. 5293); and presumably it was sometime between the twenty-ninth day of the ninth month and tenth day of the tenth month that Tung received his promotion. Tung, however, records in the *Jung-t'ai chi* that the seal was presented in the autumn of 1624; either his memory is at fault, or he refers by error to the finding of the seal, which was discovered on the fourth day of the ninth month.

That he retained his position as Academician Reader-in-waiting in the Han-lin is clear from a later entry in the *Hsi-tsung shih-lu* (ch. 55, p. 15).

356. "Ssu-po Tung kung hsing-chuang," *ch.* 36, p. 3.

357. *Hsi-tsung shih-lu*, ch. 55, p. 15; *Kuo-ch'üeh*, p. 5297.

358. *Ming-shih*, ch. 112, pp. 3492–93.

359. *Ming-shih*, ch. 254, p. 6556; *Hsi-tsung shih-lu*, ch. 37, p. 16; ch. 42, p. 13. Cf. *Kuo-ch'üeh*, pp. 5229, 5249. In the first of the two references from the *Hsi-tsung shih-lu* (ch. 37, p. 16), the post awarded to Ts'ao instead of Feng is reportedly that of Left (rather than Right) Vice Minister of Personnel, but this seems to be an error; thereafter Ts'ao is spoken of as Right Vice Minister of Personnel (e.g. ch. 41, p. 26; ch. 42, p. 13). Ts'ao's biography in the *Ming-shih*, cited at the beginning of this note, records that the vacant post was that of Right Vice Minister of Personnel.

360. *Kuo-ch'üeh*, p. 5253; and the colophon Tung appended to his copy of a patent awarding Ch'en the prestige title *Tzu-cheng ta-fu* (see note 440).

361. *Kuo-ch'üeh*, p. 5294.

362. *Hsi-tsung shih-lu*, ch. 55, pp. 24–25.

363. Records replacing the missing chapters of the *Hsi-tsung shih-lu* for the year 1624 record that Li retired on the sixteenth day of the twelfth month (*Hsi-tsung shih-lu*, ch. 49, p. 2). T'an Ch'ien, however, records that Li retired on the eighth day of the first month, 1625 (*Kuo-ch'üeh*, p. 5297), and Li's biography in the *Ming-shih* supports the later date (ch. 288, pp. 7385–86).

364. See *Jung-t'ai wen-chi*, 1630, ch. 5, pp. 51–52; and Li's biography in the *Ming-shih* (note 363).

365. See Li's biography in the *Ming-shih* (note 363).

366. *Hsi-tsung shih-lu*, ch. 56, p. 1; ch. 62, p. 19.

367. The painting is recorded in *Tung Hua-t'ing shu-hua lu*, p. 43 (with minor inaccuracies in the transcription of the inscriptions); and in P'ang Yüan-chi, *Hsü-chai ming-hua hsü-lu*, pref. 1924, facsim. repr. 1971, vol. 1, pp. 293–95.

368. *Kuo-ch'üeh*, pp. 5260, 5290; *Hsi-tsung shih-lu*, ch. 33, p. 1; ch. 60, p. 15.

P'an is a difficult figure to identify. In his inscription on the Nanking painting, Tung calls P'an "the Censor P'an Hsiang-kung of Shan-yu [i.e. Shansi]." Fu Shan (1605–1690), in a colophon on the handscroll attributed to Yen Wen-kuei in the Osaka Municipal Museum of Art (see note 370), calls P'an "Mr. P'an of T'ai-yüan." In the *Combined Indices to the Eighty-Nine Collections of Ming Dynasty Biographies* (repr. 1966, vol. 1, p. 136), Hsiang-kung is identified as P'an Yün-i. P'an Yün-i was a native of Ning-hua so (in Ning-wu fu), Shansi (*Ming Ch'ing chin-shih t'i-ming pei-lu so-yin*, 1980, vol. 2, p. 1090). His short biography in the *Ning-wu fu chih* (1750, facsim. repr. 1968, ch. 7, p. 1) records that he lived in T'ai-yüan (which agrees with Fu Shan), but reports that he rose to be Vice Minister of the Court of the Imperial Stud (which must be an error). The P'an Yün-i recorded in *Ming-jen chuan-chi* (vol. 2, p. 775) must be altogether different.

Kohara Hironobu (in *To Kisho no shoga*, vol. 1 [*Kenkyu hen*], p. 244) identifies "the Censor P'an Hsiang-kung of Shan-yu" in Tung's inscription on the Nanking painting as P'an Chi (*tzu* Tzu-hsiang). But P'an Chi was from Kuei-chi in Chekiang, not from Shansi; nor is he recorded as having held an official post: see his short biography in *Ming-jen chuan-chi*, vol. 2,

p. 779; and a passage in the *Ming-shih* (ch. 276, p. 7060) where he is mentioned among "Government Students and common people" who died as martyrs at the end of the Ming. That P'an Yün-i was a Censor from at least 1623 to 1625 we know from the references in the *Kuo-ch'üeh* and the *Hsi-tsung shih-lu* cited at the beginning of this note.

369. Charles Hucker, *The Censorial System of Ming China*, 1966, pp. 212, 221.

370. From a colophon by Fu Shan on the handscroll attributed to Yen Wen-kuei in the Osaka Municipal Museum of Art, now called *River and Mountains with Pavilions* (*Chiang-shan lou-kuan*), we learn that the painting was once owned by Mr. P'an of T'ai-yüan (i.e. the Censor P'an Yün-i, note 368), from whom Tung borrowed the scroll and then spent seven or eight days copying it. Fu also records that Tung appended a colophon to the scroll that was later removed, and that the Yen Wen-kuei painting Tung mentions in the *Jung-t'ai chi* was this very scroll. In the *Jung-t'ai pieh-chi* (1635, ch. 6, pp. 13–14)—where Tung calls the scroll by another title, *Streams and Mountains with Wind and Rain* (*Hsi-shan feng-yü*)—Tung writes that he saw the painting the year before at the official residence of the Censor P'an Hsiang-kung (i.e. Yün-i), and borrowed and examined it for ten days. The same passage, but dated the sixth month of 1625 at the end (the final date being customarily deleted when a passage was included in the *Jung-t'ai chi*), appears on an album leaf recorded in *Tung Hua-t'ing shu-hua lu*, p. 19. Hence (supposing the leaf to be genuine) we may deduce that Tung borrowed P'an's painting in 1624.

371. In his inscriptions on the two Shanghai paintings, Tung in each case refers to the recipient as *Kung-yü*, which (for want of any identifying source) must be deduced as a literary term meaning [*Ch'un-fang*] *yü-te* (Adviser in the Secretariat of the Heir Apparent), just as *Kung-shu*, *Kung-yün*, and *Kung-tsan* are literary terms meaning [*Ch'un-fang*] *shu-tzu*, *chung-yün*, and *tsan-shan* (Mentor, Companion, and Admonisher in the Secretariat of the Heir Apparent). The term *Kung-yü* is omitted by Charles Hucker in his *Dictionary of Official Titles*; nor does he make it clear that in the Ming period the office of *Yü-te* (rank 5b)—like *Shu-tzu* (5a), *Chung-yün* (6a), and *Tsan-shan* (6b)—falls within the hierarchy of the *Ch'un-fang* (Secretariats of the Heir Apparent), of which there were two, one Left and one Right (see the *Ming-shih*, ch. 73, pp. 1783–85).

372. *Hsi-tsung shih-lu*, ch. 55, p. 10.

373. *Hsi-tsung shih-lu*, ch. 87, p. 27; *Kuo-ch'üeh*, pp. 5406, 5441; *Ming-shih*, ch. 112, pp. 3495–96. The *Ming-shih* records that Meng was dismissed, the *Kuo-ch'üeh* that he retired and was given a present of gold (a sign that ostensibly he was allowed to retire of his own accord, though undoubtedly he was forced to do so). Nine months later, Meng was included in *Yen-tang ni-an* (*Roster of Traitors* [*belonging to*] *the Eunuch Party*) (*Kuo-ch'üeh*, p. 5474).

374. For the *San-ch'ao yao-tien*, see the *Kuo-ch'üeh*, pp. 5319–20; and Charles Hucker, *The Censorial System of Ming China*, 1966, p. 217. For Feng's suspected tampering with the Veritable Records, see Wolfgang Franke, *An Introduction to the Sources of Ming History*, 1968, p. 18.

375. See Jung Keng, *Ts'ung-t'ieh mu*, vol. 1, pp. 348–56.

376. For this and the passage quoted above, see Li Ch'ang-ch'un (late Ming?), *Ming Hsi-tsung ch'i-nien Tu-ch'a-yüan shih-lu*, ms. copy, n.d., facsim. ed. 1967, pp. 545–46. Cf. *Hsi-tsung shih-lu*, ch. 60, p. 16.

377. See the final paragraphs of part 3 of this biography, and notes 226 and 229. For a translation of the poem, see vol. 2, cat. no. 54.

378. *Hsi-tsung shih-lu*, ch. 61, p. 13.

379. Ibid., ch. 62, p. 15. Since Tung was serving in Nanking, there was necessarily a lapse of time before he received notice of his impeachment and before his request to retire could be received in Peking.

380. Ibid., ch. 66, p. 29.

381. "Shou Tung Tsung-po yüan-p'ei Kung fu-jen ch'i-shih hsü," in *Ch'en Mei-kung ch'üan-chi*, ch. 19, pp. 20–21. Parts of this essay are quoted in Ren Daobin, *Hsi-nien*, pp. 239–40.

382. *Shih-ch'ü pao-chi* [*ch'u-pien*], vol. 1, p. 52; Ren Daobin, *Hsi-nien*, p. 274. Tung does not mention, in his colophon on the sutra, that the first day of the tenth month, 1626, when he began his copy, was Madame Kung's seven-

tieth birthday; but surely it was not coincidence that he began his copy on that particular date.

383. Fukumoto Masakazu ("To Kisho den," in Kohara Hironobu, *To Kisho no shoga*, vol. 1 [*Kenkyu hen*], p. 171) correctly identifies Fang-ch'uan as Kung Ch'ing, but thinks that Fang-ch'uan is a mistake for Fang-shan (cf. *Ming-jen chuan-chi*, vol. 2, p. 961, where Kung Ch'ing's *hao* is given as Fang-shan). The *Shang-hai hsien chih*, however, confirms that Kung Ch'ing's *hao* was Fang-ch'uan (see note 385), as it appears in Ch'en Chi-ju's "Ssu-po Tung kung hsing-chuang," *ch.* 36, p. 5.

384. *Shang-hai hsien chih*, rev. ed. 1872, *ch.* 15, pp. 17–18.

385. Ibid., *ch.* 18, pp. 56–57. For Kung Ch'i, see also the *Ming-shih*, *ch.* 209, pp. 5542–43; and the *Kuo-ch'üeh*, p. 3783. In *Ming-jen chuan-chi* (vol. 1, p. 105), Shih Tao's dates are given as 1485–1554; in the *Kuo-ch'üeh* (pp. 162, 3815), he is recorded as having died in the fourth month of 1553.

386. *Shang-hai hsien-chih*, rev. ed. 1872, *ch.* 29, p. 7.

387. See Fukumoto Masakazu, "Geirin hyakusei no shi," in Kohara Hironobu, *To Kisho no shoga*, vol. 1 [*Kenkyu hen*], pp. 153–54; and Ren Daobin, *Hsi-nien*, p. 305.

388. For this passage and Ch'en's description of Madame Kung, see the "Ssu-po Tung kung hsing-chuang," *ch.* 36, p. 5.

389. Zheng Wei (*Nien-p'u*, pp. 2, 6), for reasons that are unclear (since he cites no sources), gives the names of Tung's sons as Lü (Tsu-ho), Ch'üan (Tsu-ch'ang), and Yüan (Tsu-yüan), the names in parentheses being (by analogy with other names in his table) their *tzu*. For evidence that their names are as I give them here, see the *Shang-hai hsien-chih*, rev. ed. 1872, *ch.* 17, pp. 31–32; Ts'ao Chia-chü, *Shuo-meng*, *ch.* 2, p. 7, in Lei Chin, *Ch'ing-jen shuo-hui*, *ch'u-chi*, 1913; and *Min-ch'ao Tung huan shih-shih*, p. 5, in Chao I-ch'en, *Yu-man lou ts'ung-shu*, 1920–25.

390. See the second half of part 4 of this biography.

391. *Shang-hai hsien-chih*, rev. ed. 1872, *ch.* 17, pp. 31–32.

392. *Min-ch'ao Tung huan shih-shih*, p. 8, in Chao I-ch'en, *Yu-man lou ts'ung-shu*, 1920–25. For Hsü Chieh's wealth, see his biography in the *Dictionary of Ming Biography*, vol. 1, pp. 574–75.

393. Tsu-ho's seals, reading *Meng-lü chen-ts'ang* and *Tung-shih chia-ts'ang*, appear on a hanging scroll by Tung painted in the manner of Yen Wen-kuei (*Fang Yen Wen-kuei pi-i*), now in the National Palace Museum, Taipei. The painting is recorded in the *Shih-ch'ü pao-chi* [*ch'u-pien*], vol. 1, p. 662—though no mention is made there of Tsu-ho's seals—and is discussed at some length in entry xxv of "Tung Ch'i-ch'ang's Seals," in vol. 2 of this catalogue.

Three seals belonging to Tsu-ho (different from those impressed on the landscape after Yen Wen-kuei), and also his inscription, appear on the calligraphy handscroll entitled *Running Script in the Manner of the Four Sung Masters* in the present exhibition (vol. 2, pl. 64). This scroll, to my mind, exhibits some anomalies: though Tsu-ho, in his inscription, presents it to a high official (who seems, from Tsu-ho's mode of address, to have held the title of Grand Preceptor, the highest title that could be awarded to a government official), the official is not named in the dedication; the scroll (as we know from Tung's own inscription) had earlier been presented by Tung to his grandson, and thus was a curious choice to present to an official of such high rank; and the seal on the calligraphy purporting to be Tung's (seal 69) is a forgery, a rather crudely executed but unmistakable copy of one of Tung's most frequently seen seals, of which two genuine impressions appear on works in the present exhibition (seals 65 and 68; for all three impressions, see "Tung Ch'i-ch'ang's Seals," group XVI). While these objections do not necessarily preclude the possibility that the calligraphy is genuine, I would prefer to reserve judgment on its authenticity until I have had the chance to examine the work itself, rather than base an opinion on an enlargement of Tung's seal and signature, which was the only photograph available to me.

394. See notes 349–354 and the discussion of Tung's biography of Li Fan-kuan in part 5 of this essay.

395. Wang Heng died on the twenty-ninth day of the first month, 1609; Wang Hsi-chüeh died on the twenty-ninth day of the twelfth month, 1610 (early 1611 according to the Western calendar): Ku Wen-pin, *Kuo-yün lou shu-hua chi*, pref. 1882, orig. ed. 1883, facsim. repr. 1973, *ch.* 6, p. 13. Because 1610 contained an intercalary third month, their deaths were twenty-four months apart.

396. Ren Daobin, *Hsi-nien*, p. 242.

397. Ku Wen-pin, *Kuo-yün lou shu-hua chi*, facsim. repr. 1973, *ch.* 6, pp. 14–15. The text in this edition appears to differ from that in the edition consulted by Ren Daobin (*Hsi-nien*, p. 243).

398. Ren Daobin, *Hsi-nien*, pp. 244–45.

399. For Wang Meng's painting, entitled *Tan-t'ai ch'un-hsiao*, see the *Shih-ch'ü pao-chi* [*ch'u-pien*], vol. 2, p. 802; for the copy in the *Hsiao-chung hsien-ta*, see the *Ku-kung shu-hua lu*, vol. 4, *ch.* 6, p. 75, leaf 19. The transcription of Tung's inscription in the *Ku-kung shu-hua lu* contains slight errors, as does the transcription by Ren Daobin (*Hsi-nien*, p. 246).

400. For the names of Feng Chia-hui and Wang Yung-kuang among those passing the provincial examination for the Northern Metropolitan Area (Pei Chih-li) in 1588, see the *Chi-fu t'ung-chih*, completed 1871, orig. ed. 1884, *ch.* 39, pp. 13, 15. Tung's name does not appear, since he was not a native of Pei Chih-li; it appears instead in gazetteers of his own district and prefecture (see note 87).

For the text of Tung's *shen-tao pei* honoring Wang T'ung, Wang Yung-kuang's father, see the *Jung-t'ai wen-chi*, 1630, *ch.* 9, pp. 39–42. According to the text, Wang Yung-kuang asked Tung to compose the *shen-tao pei* just before starting north to take up his new post as Minister of War in Peking. Wang was appointed Minister of War in the tenth month of 1625 (*Kuo-ch'üeh*, p. 5315).

401. *Jung-t'ai wen-chi*, 1630, *ch.* 9, pp. 20–25. Feng died in office in the fourth month of 1627 and was immediately granted the posthumous name Chung-hsiang (*Kuo-ch'üeh*, p. 5368). Tung writes that the emperor (i.e. Hsi-tsung) was so shaken with grief that he ordered that the business of the court be suspended. Since Tung speaks of the emperor as "the Son of Heaven" (*T'ien-tzu*), it is clear that Hsi-tsung (who died in the eighth month of 1627) was still alive at the time Tung was writing, i.e. that Tung composed the *mu-piao* between the fourth and eighth months of 1627.

In both the *shen-tao pei* (note 400) and the *mu-piao*, Tung makes the excuse that as a fellow graduate he could not but accede to the request made of him (*Jung-t'ai wen-chi*, 1630, *ch.* 9, pp. 39, 20).

402. Tung Ch'uan-ts'e, *Ch'i-yu man-chi*, rev. ed. 1601, *hsing-shih*, p. 1.

403. *Hua-t'ing hsien chih*, 1879, *ch.* 20, p. 32.

404. *Jung-t'ai shih-chi*, 1630, *ch.* 3, p. 5. The title of the poem refers to Ch'ien as *Kung-yün*, a literary term for *Chung-yün* (Companion in the Secretariat of the Heir Apparent, rank 6a; see note 371). Hence the poem must date between the third month of 1612, when Ch'ien was appointed a Junior Compiler in the Han-lin (7a), and the eighth month of 1623, by which time Ch'ien already held the higher-ranking post of Adviser in the Right Secretariat of the Heir Apparent (*Yu yü-te*, 5b) (*Kuo-ch'üeh*, pp. 5043, 5226).

405. *Kuo-ch'üeh*, pp. 5473–76. For Ch'ien's role in the compilation, see the *Dictionary of Ming Biography*, vol. 1, p. 484; and T'an Ch'ien's commentary, *Kuo-ch'üeh*, p. 5476.

406. Wang, though considered one of Wei Chung-hsien's principal henchmen (see Chi Liu-ch'i, *Ming-chi pei-lüeh*, rev. ed. 1984, vol. 1, p. 46), escaped listing in the *Yen-tang ni-an*. Under the new Emperor Ssu-tsung, he was appointed Minister of Revenue in the third month of 1628 and transferred two months later to the post of Minister of Personnel, in which he remained until he was dismissed in the third month of 1631 (*Ming-shih*, *ch.* 112, pp. 3496–97).

407. Zhu Wenjie, "Ming Tung Ch'i-ch'ang chuan shu 'Kao Chung-hsien kung hsiang-tsan' shih-k'o," 1984, p. 36. Zhu, unfortunately, gives no source for his information that Tung was the calligrapher of the characters *shou-chung* engraved on Chou's arch; the arch is briefly recorded in the *Wu-chiang hsien chih* (1747, facsim. repr. 1975, *ch.* 10, p. 41) and in the *Su-chou fu chih* (1883, *ch.* 5, p. 37) as erected in 1628, but with no mention of the calligrapher.

408. The *hsiang-tsan* was a particular type of eulogy (for a person who might be

alive or dead) intended to accompany his portrait—the portrait, of course, executed not by the writer but by an artisan. Kao's portrait has not survived. Tung's *hsiang-tsan* for Kao is unusual in that his signature is followed by a seal reading *Tung Hsüan-tsai yin*, the only example of a seal with this legend that I have so far discovered in the entire body of Tung's work, both recorded and extant. There is, however, nothing inherently wrong with such a legend, and there is no other reason to doubt the authenticity of the piece. The stone (which I have seen) is now kept at the site of the former Tung-lin Academy in Wu-hsi, where there is a small museum dedicated to the memory of the great figures in the Tung-lin movement; only the rubbing is on display, the stone itself occupying an ignominious position beneath one of the display cabinets. The *hsiang-tsan* was published in 1984 by Zhu Wenjie, in a brief but interesting article discussing three stone inscriptions with Tung's calligraphy that attest to his connection with members of the Tung-lin party (see note 407).

409. *Shih-ch'ü pao-chi* [*ch'u-pien*], vol. 2, p. 832. Unfortunately the text is not recorded, though the compilers of the catalogue place the calligraphy in the top class (*shang-teng*). For Tso, see Charles Hucker's excellent biography in the *Dictionary of Ming Biography*, vol. 2, pp. 1305–8.

410. Chou Yen-ju died in 1644 according to the Western calendar. For biographies of Chou and Wen T'i-jen, see the *Dictionary of Ming Biography*, vol. 1, pp. 277–79, vol. 2, pp. 1474–78.

411. *Dictionary of Ming Biography*, vol. 2, pp. 1474–75; and the *Kuo-ch'üch*, pp. 5461, 5464.

412. See note 56. Ch'ü Ju-chi (*hao* Tung-kuan, 1548–1610) was the older brother of Shih-ssu's father, Ch'ü Ju-yüeh (1565–1623). For short biographies of all three, see *Ming-jen chuan-chi*, vol. 2, p. 919. For a longer biography of Shih-ssu (who died in 1651 according to the Western calendar), see Arthur Hummel, *Eminent Chinese of the Ch'ing Period*, repr. 1970, pp. 199–201.

413. *Jung-t'ai shih-chi*, 1630, *ch*. 3, p. 7. The term *Huang-men* in the title of the poem is used here to mean *Chi-shih-chung* (Supervising Secretary). Shih-ssu was appointed a Supervising Secretary of the Office of Scrutiny for Revenue in the fourth month of 1628 (*Kuo-ch'üeh*, p. 5429). Shih-ssu, however, left for Peking in the first month (Qu Guoxing, *Ch'ü Shih-ssu nien-p'u*, 1987, p. 24), having evidently received notice of his appointment, which is why Tung writes in his poem that the plum blossoms will be in bloom at the government post stations when Shih-ssu begins his journey north.

Ren Daobin (*Hsi-nien*, p. 155), for some reason, discounts the office title by which Tung addresses Shih-ssu in the title of the poem, and suggests instead that it was written by Tung in the winter of 1617, when Shih-ssu was appointed District Magistrate of Yung-feng hsien in Kiangsi.

414. Wan Yen et al., *Ch'ung-chen ch'ang-pien*, early Ch'ing ed., n.d., facsim. ed. 1967, *ch*. 15, p. 15. For Wan Yen as the compiler, see Wolfgang Franke, *An Introduction to the Sources of Ming History*, 1968, p. 43, no. 1.4.9; and Arthur Hummel, *Eminent Chinese of the Ch'ing Period*, repr. 1970, p. 804.

415. The precise formulation of Tung's final official post—before he received the higher-ranking title of Grand Guardian of the Heir Apparent on his retirement—is known only from a few of his own calligraphies in which he prefaces his signature with his full official title, e.g. his *Li Yin-ch'üan hsing-chuang* (Life and Conduct of Li Yin-ch'üan), recorded in Lu Hsin-yüan, *Jang-li kuan kuo-yen lu*, facsim. repr. 1975, vol. 2, *ch*. 24, pp. 8–10.

416. Wan Yen et al., *Ch'ung-chen ch'ang-pien*, facsim. ed. 1967, *ch*. 49, p. 14.

417. "Ssu-po Tung kung hsing-chuang," *ch*. 36, p. 3.

418. See note 382.

419. Wan Yen et al., *Ch'ung-chen ch'ang-pien*, facsim. ed. 1967, *ch*. 57, p. 13.

420. "Ssu-po Tung kung hsing-chuang," *ch*. 36, p. 3. The term *feng-lin* (alternatively *lin-feng*), which following Lin Yutang I have translated here as "phoenix and unicorn," connotes, as Lin points out, "auspicious animals, rarely seen" (Lin Yutang, *Chinese-English Dictionary of Modern Usage*, 1972, repr. 1982, p. 913). The imaginary *ch'i-lin*, like the Western unicorn, had a single horn (though only the male [*ch'i*], not the female [*lin*]), but it was otherwise very different in appearance, having the body of a deer, the tail of an ox, the hooves of a horse, and a five-colored skin. It was regarded as "a

happy portent . . . of the advent of good government." Similarly, the phoenix was thought to appear "only when reason prevails in the country" (C. A. S. Williams, *Outlines of Chinese Symbolism and Art Motives*, pref. 1932, facsim. repr. of rev. ed., 1975, pp. 324, 415).

421. *Kuo-ch'üeh*, p. 5594.

422. *Jung-t'ai wen-chi*, 1635, *ch*. 5, pp. 59–60, 64–70. According to Tung's second memorial asking permission to retire, his first memorial was dated the twenty-seventh day of the sixth month (*Jung-t'ai wen-chi*, 1635, *ch*. 5, p. 68); thus he presented it before his impeachment by Feng Yüan-piao. According to his third memorial, the second was presented on the twelfth day of the seventh month (*ch*. 5, p. 69), though it is recorded in the *Ch'ung-chen ch'ang-pien* only on the twenty-fourth day, when the throne handed down its ruling (Wan Yen et al., *Ch'ung-chen ch'ang-pien*, facsim. ed. 1967, *ch*. 61, pp. 29–31). That it was presented in response to Feng Yüan-piao's impeachment (which, though recorded on the nineteenth of the month—the date it was entered into the court records—was probably submitted to the throne a few days earlier) is made clear in the *Kuo-ch'üeh* (p. 5594). His third memorial seeking permission to retire, in the same group, is undated; but in a later memorial, dating from 1633, Tung writes (simplifying slightly for convenience) that he presented three memorials seeking to retire in the seventh month of 1632 (*Jung-t'ai wen-chi*, 1635, *ch*. 5, p. 73).

423. "Ssu-po Tung kung hsing-chuang," *ch*. 36, p. 3a.

424. For Tung's memorial refusing the grant of Protection Privilege, entitled "Tz'u-en shu," from which one can reconstruct the story told here in the text, see the *Jung-t'ai wen-chi*, 1635, *ch*. 5, pp. 61–63. From dates mentioned in the course of the eleven memorials recorded in *chüan* 5, it is clear that they appear in order of date. The "Tz'u-en shu" appears after Tung's first memorial requesting permission to retire (presented on the twenty-seventh day of the sixth month, 1632), but before his second memorial seeking to retire (presented on the twelfth day of the seventh month), submitted in response to Feng Yüan-piao's impeachment (see note 422). Probably (but not certainly), then, Tung submitted his memorial refusing the grant of Protection Privilege before he was impeached by Feng Yüan-piao.

425. *Ming-shih*, *ch*. 251, pp. 6486–87.

426. *Jung-t'ai pieh-chi*, 1635, *ch*. 2, p. 11.

427. *Ming-shih*, *ch*. 308, p. 7926.

428. During the T'ien-ch'i period, Chou served first in Peking as a Companion in the Secretariat of the Heir Apparent, and then as Junior Supervisor of the Household Administration of the Heir Apparent in charge of the Han-lin Academy in Nanking (*Ming-shih*, *ch*. 308, p. 7926). The *Ming-shih* does not give the dates of his postings; but the second post was one that Tung also held in the T'ien-chi period, and it is possible that Chou was Tung's immediate successor. Though Tung was appointed to serve in Peking as Right Vice Minister of Rites in the seventh month of 1623 (note 337), he remained in the south till well into the following spring; thus there was ample time for him and Chou to meet.

It is possible, too, that Tung and Chou were acquainted even before the T'ien-ch'i period, since Chou was a native of I-hsing and Tung was from time to time a visitor there owing to his friendship with Wu Cheng-chih.

429. For Chou's appointment, see the *Ming-shih*, *ch*. 110, p. 3384.

Rubbings of Tung's congratulatory essay, entitled "Yüan-fu I-chai Chou lao-hsien-sheng san-tai i-p'in k'ao ho-hsü" (Essay congratulating the Senior Grand Secretary Chou I-chai on his [successful] triennial evaluation as [an official of] the first rank), appear in the *Ch'ing-hui ko ts'ang-t'ieh*, probably commissioned by Wang Hui (1632–1717), Ch'ing ed., n.d., *ch*. 9; and in P'ei Ching-fu, *Chuang-t'ao ko t'ieh*, completed 1912, *ch*. 28: see Jung Keng, *Ts'ung-t'ieh mu*, vol. 2, p. 876, and vol. 3, p. 1268. The two rubbings are not identical, and almost certainly the rubbing in the *Chuang-t'ao ko t'ieh* was taken from a forgery. The text, however, which is recorded in P'ei's *Chuang-t'ao ko shu-hua lu* (facsim. repr. 1971, vol. 4, *ch*. 12, pp. 47–49), is the same as that in the *Ch'ing-hui ko ts'ang-t'ieh*.

430. *Ming-shih*, *ch*. 256, p. 6613; *ch*. 308, pp. 7927, 7933; *Kuo-ch'üeh*, p. 5612.

431. *Jung-t'ai wen-chi*, 1635, *ch*. 5, pp. 71–72.

432. *Ming-shih*, *ch.* 256, p. 6614; *Kuo-ch'üeh*, pp. 5603–4.

433. *Jung-t'ai wen-chi*, 1635, *ch.* 5, pp. 73–78. Huang Ju-liang retired in the third month of 1633 (*Ming-shih*, *ch.* 112, p. 3498); hence the first of Tung's memorials in this group, which mentions Huang's retirement, can have been written no earlier than the third month. Tung's second memorial seeking to retire (as we know from the third) was submitted on the twenty-second day of the fourth month (*Jung-t'ai wen-chi*, 1635 *ch.* 5, p. 77); and his third memorial (as we know from a fourth) was submitted on the twenty-first day of the fifth month (*Jung-t'ai wen-chi*, 1635, *ch.* 5, p. 78).

434. *Ming-shih*, *ch.* 308, p. 7928.

435. Tung uses the phrase *yung-t'ui* in his second colophon on Li T'ang's *River and Mountains in Miniature*, in which he makes Chou a present of the painting (*Ku-kung shu-hua lu*, vol. 2, *ch.* 4, p. 44).

436. *Ming-shih*, *ch.* 308, pp. 7925–31.

437. *Kuo-ch'üeh*, p. 5294. The *Ming-shih* (*ch.* 254, p. 6561) erroneously records that Ch'en served as Left Vice Minister of Personnel.

438. *Kuo-ch'üeh*, pp. 5459, 5560.

439. Ch'en was appointed Junior Guardian of the Heir Apparent in the third month of 1632 (*Ming-shih*, *ch.* 112, pp. 3497–98).

440. The calligraphy is reproduced in Lo Chen-yü, *Chen-sung t'ang ts'ang li-tai ming-jen fa-shu*, n.d., vol. 2; and facsim. repr. 1976, pp. 145–63. See also Jung Keng, *Ts'ung-t'ieh mu*, vol. 2, p. 891. The calligraphy is listed as *Ching* 1–2191 in *Chung-kuo ku-tai shu-hua mu-lu* (vol. 2, p. 51), under the title *Hsing-shu Ch'en Yü-t'ing kao-ming*, the character *t'ing* being an error.

441. *Ming-shih*, *ch.* 254, p. 6562; *Kuo-ch'üeh*, p. 5597.

442. *Kuo-ch'üeh*, pp. 5563, 5598.

443. *Hsüan-ho hua-p'u*, pref. 1120, rev. ed. in ISTP, vol. 9, no. 65, *ch.* 11, p. 281.

444. See Tung's colophon dated 1635 on Tung Yüan's *Summer Mountains* (note 340). Tung commonly used the name of the old T'ang capital, Ch'ang-an, to mean the current capital, Peking.

445. Jan Fontein and Tung Wu, *Unearthing China's Past*, 1973, pp. 231–34, no. 121 and pl. 121. The painting is now known by the title *A Clear Day* (or *Clear Weather*) *in the Valley* (*P'ing-lin chi-se*). Fontein and Wu appear to have doubts about the authenticity of Tung's colophon ("the first [colophon] is *signed* by Tung Ch'i-ch'ang . . . followed immediately by a colophon *written* by Wang Shih-min," [italics mine]), perhaps because the colophon, minus its date, appears in the *Jung-t'ai pieh-chi* (1635, *ch.* 1, p. 6), and Fontein and Wu feel it might simply have been duplicated by an enterprising forger; but viewed from every standpoint—calligraphy, date, and seals —the colophon is unquestionably genuine.

446. Xu Bangda, *Ku-shu-hua wei-o k'ao-pien, Hsia-chüan: wen-tzu pu-fen*, p. 147; Ren Daobin, *Hsi-nien*, pp. 284–85.

447. Qi Gong, *Ch'i Kung ts'ung-kao*, 1981, p. 159; Fukumoto Masakazu, "Geirin hyakusei no shi," in Kohara Hironobu, *To Kisho no shoga*, vol. 1 [*Kenkyu hen*], pp. 149–50.

448. Qi Gong, *Ch'i Kung ts'ung-kao*, pp. 150–54; Xu Bangda, *Ku-shu-hua wei-o k'ao-pien, Hsia-chüan: wen-tzu pu-fen*, pp. 147–48.

449. *Kuo-ch'üeh*, p. 5612. See the *Jung-t'ai shih-chi*, 1630, *ch.* 3, p. 16, for a poem written by Tung for Cheng I-wei (*hao* Fang-shui) after Cheng had asked permission of the court to return home to reinter a member (or members) of his family. The poem must have been written between 1629, when Cheng became Minister of Rites (*Ta tsung-po*, as he is addressed in the title of the poem), and 1630, when the *Jung-t'ai shih-chi* was published. For Cheng's biography, see the *Ming-shih*, *ch.* 251, pp. 6494–95.

450. *Jung-t'ai wen-chi*, 1635, *ch.* 5, pp. 78–80, in particular p. 79. Included at the end of the memorial is the throne's response, which was handed down on the eighth day of the sixth month. The *Kuo-ch'üeh* records Cheng I-wei's death on the fifteenth of the month (note 449); but though entered in the court records on that date, his death must actually have occurred at the very least a week earlier, since Tung speaks of it in his memorial.

451. *Jung-t'ai wen-chi*, 1635, *ch.* 5, pp. 80–81. The throne's response (which Tung includes at the end of the memorial) was handed down on the thirtieth day of the eighth month.

452. *Jung-t'ai wen-chi*, 1635, *ch.* 5, pp. 81–83. See also the "Ssu-po Tung kung hsing-chuang," *ch.* 36, p. 4.

453. *Jung-t'ai pieh-chi*, 1635, *ch.* 1, pp. 7–8. In 1632, Ho was appointed Right Vice Minister of Rites assisting in the direction of the Household Administration of the Heir Apparent. Tung had been appointed Minister of Rites in charge of the Household Administration of the Heir Apparent in 1631; thus Tung says in his inscription that he and Ho "became good friends while holding the same office" (*t'ung-shu chiao-shan*). The inscription, ending in a poem, appears on a painting (which I have not yet seen) in the Kimbell Art Museum in Fort Worth, Texas, together with a concluding sentence not recorded in the *Jung-t'ai chi*, in which Tung says that he executed the painting and wrote the inscription on the twenty-ninth day of the twelfth month, 1632 (the last day of the year), and added his signature the following day (see Kohara Hironobu, *To Kisho no shoga*, vol. 1 [*Kenkyu hen*], pp. 246–47; and vol. 2 [*Zuhan hen*], pl. 22). For Ho's biography, with a detailed account of his official career, see the *Hsiang-shan hsien chih*, 1750, in Wu Hsiang-hsiang, *Chung-shan wen-hsien*, 1965, vol. 2, pp. 650–60. The *Hsiang-shan hsien chih* gives Ho's *hao* as Hsiang-kang, as it appears in the title of Tung's inscription in the *Jung-t'ai chi*, not as Chia-kang, as it appears in *Ming-jen chuan-chi* (vol. 1, p. 270).

454. See the *Jung-t'ai wen-chi*, 1635, *ch.* 5, pp. 83–84; *Kuo-ch'üeh*, p. 5631; and leaf 13 of Tung's copy, dated 1636, of an imperial patent, included in the present exhibition (vol. 2, pl. 71). When Tung speaks of being eighty, he means, of course, that he was eighty *sui* (seventy-nine by Western count).

455. The album in the exhibition here in fact forms only a portion of the album as it was originally constituted; another portion, mounted differently and separately catalogued, is also in the collection of the Shanghai Museum (*Hu* 1–1415 in *Chung-kuo ku-tai shu-hua t'u-mu*, vol. 3, pp. 285–287). The pages of the album catalogued as *Hu* 1–1415—the beginning of what was the original album—are no longer in correct sequence (the opening leaves of the original album, for instance, were leaves 16 and 15 of *Hu* 1–1415, in that order); and in addition a number of leaves (e.g. the majority of those conferring prestige titles on Tung's grandfather and grandmother) are missing. The album in the present exhibition formed the closing section of the original album, awarding Tung the prestige title *Kuang-lu ta-fu* and his wife Madame Kung the prestige title *I-p'in fu-jen* (Mistress of the First Rank).

456. Ch'en's memory is at fault here; in 1634, when Tung returned home, he was only eighty *sui*.

457. The onomatopoeic phrase *sa sa*, used here to describe Tung's beard and eyebrows, is meant to convey the sound something makes as it blows or rustles in the wind.

458. "Ssu-po Tung kung hsing-chuang," *ch.* 36, p. 5.

459. For the Tung clan genealogy, see note 467. Tung's pupil Mao Hsiang, in his colophon of 1690 on Tung's handscroll of 1635 entitled *Clearing after Snow on Mountain Passes* (vol. 2, pl. 68), also records that Tung died in the eighth month (for the text of Mao's colophon, see the *Shih-ch'ü pao-chi [ch'u-pien]*, vol. 2, pp. 1188–89). See also Tung's *Poem for Mao Hsiang* (vol. 2, pl. 67).

460. *Ch'en Mei-kung ch'üan-chi*, *ch.* 57, p. 16. Part of the letter is quoted in Zheng Wei, *Nien-p'u*, p. 232.

461. For Mount P'u-t'o, see E. T. C. Werner, *A Dictionary of Chinese Mythology*, 1932, repr. 1969, pp. 386–87.

462. For the location of the tomb of Tung's grandfather Tung T'i and great-grandfather Tung Hua, see the *Shang-hai hsien chih*, rev. ed. 1872, *ch.* 29, p. 4.

463. *Kuo-ch'üeh*, p. 5787.

464. *Sung-chiang fu chih*, 1631, *ch.* 48, p. 51; *Sung-chiang fu chih*, 1663, *ch.* 25, p. 25; *Sung-chiang fu chih*, 1819, *ch.* 79, p. 82; *Wu-hsien chih*, 1933, vol. 2, *ch.* 40, p. 24. The 1663 edition of the *Sung-chiang fu chih* (whose information is repeated in the 1819 edition) records Tung's tomb as being at Yang-shan (a mountain northeast of Su-chou), though "now moved and [his body] buried at [the site of] his father's tomb," which in all three editions cited above is given as being at "Yü-yang shan [near] Su-chou." One suspects, however, that the 1663 edition is somehow in error: on the evidence

of the family genealogy (note 467), Tung was buried initially in Sung-chiang and in 1637 reinterred at Yü-yang shan, an altogether more likely story than that Tung was first buried at Yang-shan (with which he had no known connection) and later moved to Yü-yang shan, a comparatively short distance away. At the moment, however, there is nothing to verify either account, and there are those who prefer to accept the evidence of the 1663 *Sung-chiang fu chih* (see Wang Yongshun, "Tung Ch'i-ch'ang i-chi k'ao," 1991, p. 73).

For a visit Tung paid in 1623 to his father's tomb at Yü-yang (the character *yü* written differently, though the place is clearly the same), see Ren Daobin, *Hsi-nien*, pp. 205–6.

465. Though the clan genealogy (note 467) reportedly mentions that permission was granted for the construction of three commemorative arches, the 1631 and 1663 editions of the *Sung-chiang fu chih* record only one arch specifically connected with Tung, erected (since it figures in the 1631 edition) no later than 1631: an arch with the legend *Shang-shu fang*, which must have commemorated either Tung's 1625 appointment as Minister of Rites in Nanking or (though this is less likely, since there was probably insufficient time to construct an arch) his appointment to Peking in 1631 as Minister of Rites in charge of the Household Administration of the Heir Apparent (1631 ed., *ch.* 3, p. 29; 1663 ed., *ch.* 17, p. 10). The 1791 and 1879 editions of the *Hua-t'ing hsien chih* (the earliest editions postdating Tung) record another arch, engraved with the legend *Chi-ch'ou chin-shih fang*, which according to the 1879 edition commemorated eight men from Hua-t'ing and Shanghai (the first of them Tung) who won their *chin-shih* degrees in 1589 (1791 ed., *ch.* 1, p. 18; 1879 ed., *ch.* 21, p. 24).

Wang Yongshun, in "Tung Ch'i-ch'ang i-chi k'ao" (1991, p. 72), writes that there is considerable confusion over the number and location of stone *p'ai-fang* connected with Tung, but cites four deserving particular mention: an arch that supposedly stood in front of Tung's memorial temple (*tz'u-t'ang*), though as yet no record has been found to confirm it definitely existed; the *Chi-ch'ou chin-shih fang* recorded in the *Hua-t'ing hsien chih*; an arch with the legend *Shang-shu fang* that according to the 1819 edition of the *Sung-chiang fu chih* (*ch.* 3, p. 9) stood near Pai-lung Pool (presumably the same arch mentioned in the 1631 and 1663 editions, though with its location, at Pai-lung Pool in Lou-hsien, now recorded); and a second arch with the legend *Shang-shu fang*, which I have described here in the text. This last arch, not mentioned in the gazetteers, was still standing in 1958 (the only one of the four to survive), when it was photographed and a record was made of its inscriptions; since it commemorates Tung's appointment as Minister of Rites in Nanking, it was presumably erected soon after 1625. All but one pillar of the arch has since been destroyed; but a photograph of the arch as it once appeared is reproduced in Wang's article, and displayed as well in the Exhibition Hall of Historical Objects from Shanghai (see note 296).

466. *Kuo-ch'üeh*, p. 6147.

467. For all of the information that appears in this and the preceding paragraph (except for that cited in separate notes), I am indebted to Mr. Dong Zhaochang, Tung Ch'i-ch'ang's direct descendant ("seventeenth generation grandson"), and Mr. Hui Qinqi, the family's representative, who very generously wrote to me several times, enclosing a typeset article they had written in 1989 on the subject of Tung Ch'i-ch'ang's tomb, entitled "Hsien-kung Tung Ch'i-ch'ang mu k'ao," for which they relied in part on their memory of what was recorded in the clan genealogy, confiscated in 1967.

For another account of Tung's two tombs and their destruction during the Cultural Revolution, see Zheng Wei, "Tung Ch'i-ch'ang ti tzu hao, tsu yüeh, mu-ti san k'ao," 1989. Zheng's account is in many respects similar to the one sent me by Mr. Dong and Mr. Hui, though what they describe as the commemorative tomb is described by Zheng as the real tomb, and vice versa.

468. The other ten were Hsü Kuo; Wu Tao-nan; Chu Yen-hsi; Chu Kuo-chen; Wei Kuang-wei; Feng Ch'üan; Ch'ien Lung-hsi; Ch'ien Hsiang-k'un (*hao* Lin-wu, for whom Tung composed a poem on the occasion of Ch'ien's return to his native Kuei-chi: see the *Jung-t'ai shih-chi*, 1630, *ch.* 3, p. 16); Cheng I-wei; and Ho Wu-tsou.

469. *Jung-t'ai* is a literary term used to refer (as it does here) to the Ministry of Rites, or to the Court of Imperial Sacrifices. Ch'en Chi-ju begins his preface to the *Jung-t'ai chi* explaining why the Minister of Rites (*Ta tsung-po*) should be known as *Jung-t'ai* (*Jung-t'ai wen-chi*, 1630, *hsü*, p. 1).

470. A number of these legends are discussed in "Tung Ch'i-ch'ang's Seals," in vol. 2 of this catalogue.

471. For two such passages, see notes 229 and 472, and the translations of these passages in the text of the biography; for the third passage, see the *Hua-ch'an shih sui-pi*, 1720, *ch.* 2, pp. 34–35; ISTP ed., p. 54.

472. *Jung-t'ai pieh-chi*, 1635, *ch.* 6, p. 17. This passage, and the first half of the passage that follows it, appear as the two inscriptions on an album leaf dated 1625 recorded in *Tung Hua-t'ing shu-hua lu*, p. 20. The album to which this leaf belongs is at present not known to be extant, so that there is no way to judge its authenticity; hence this passage cannot be dated 1625 with absolute security. Tung, however, cannot have written the passage before the first month of 1625, since it was only then that he attained the rank of Minister (*Shang-shu*), when he was appointed Minister of Rites in Nanking.

Articles and dissertations cited in the notes:

Chang Tzu-ning (Joseph Chang). "Tung Ch'i-ch'ang yü 'T'ang Sung Yüan hua-ts'e.'" *To-yün* 24 (1990/1): 71–76.

Fairbank, J.K., and Teng, S.Y. "On the Transmission of Ch'ing Documents." In Ssu-yü Teng, ed., *Ch'ing Administration: Three Studies*. Cambridge, Massachusetts: Harvard University Press, 1960; rev. ed., 1968.

Fong, Wen. "*Rivers and Mountains after Snow (Chiang-shan hsüeh-chi)*: Attributed to Wang Wei (A.D. 699–759)." *Archives of Asian Art* 30 (1976–77): 6–33.

Fu Shen. "*Hua-shuo* tso-che wen-t'i ti yen-chiu." Paper presented at the International Symposium on Chinese Painting, National Palace Museum, Taipei, 1970.

Fu Shen. "Lüeh-lun 'Chung lun'—*Fu-ch'un* pien chui yü." *Ming-pao yüeh-k'an* 116 (August 1975): 55–58.

Grimm, Tilemann. "Ming Education Intendants." In Charles O. Hucker, ed., *Chinese Government in Ming Times: Seven Studies*, New York, 1969; repr. ed., Taipei: Hung-ch'iao shu-tien, 1975.

Han, Junghee. "Tung Yüan's Influence on Tung Ch'i-ch'ang's Paintings." Ph.D. dissertation, University of Kansas, 1988.

Ho, Wai-kam. "Tung Ch'i-ch'ang's New Orthodoxy." In Christian F. Murck, ed., *Artists and Traditions*, Princeton: Princeton University Press, 1976.

Huang Kuan. "Wu Chih-chü yü Yün-ch'i lou." *Ming-pao yüeh-k'an* 113 (May 1975): 42–45.

Ledderose, Lothar. "Some Taoist Elements in the Calligraphy of the Six Dynasties." *T'oung Pao* 70 (1984): 246–78.

Lovell, Hin-cheung. "Wang Hui's 'Dwelling in the Fu-ch'un Mountains': A Classical Theme, its Origins and Variations." *Ars Orientalis* 8 (1970): 217–242.

Riely, Celia Carrington (Li Hui-wen). "Tung Ch'i-ch'ang cheng-chih chiao-yu yü i-shu huo-tung ti kuan-hsi." *To-yün* 23 (1989/4): 97–108, 133, 153–159.

Riely, Celia Carrington. "Tung Ch'i-ch'ang's Ownership of Huang Kung-wang's 'Dwelling in the Fu-ch'un Mountains,' with a Revised Dating for Chang Ch'ou's *Ch'ing-ho shu-hua fang*." *Archives of Asian Art* 28 (1974–75): 57–76.

Shih Ta. "Tung Ch'i-ch'ang fu-kuan ti nien-fen wen-t'i." *Ming-pao yüeh-k'an* 109 (January 1975): 92–93.

Wang Yongshun. "Tung Ch'i-ch'ang i-chi k'ao." *To-yün* 30 (1991/3): 70–74.

Weng T'ung-wen. "Wu-ch'uan Ta-ch'ih wei Fu-yang-jen yu-tao Fu-ch'un wei-chi." *Ming-pao yüeh-k'an* 119 (November 1975): 63–68.

Zheng Wei. "Tung Ch'i-ch'ang ti tzu hao, tsu yüeh, mu-ti san k'ao." *Ta kung-pao*, 28 July 1989.

Zhu Wenjie. "Ming Tung Ch'i-ch'ang chuan shu 'Kao Chung-hsien kung hsiang-tsan' shih-k'o." *Shu-fa* 37 (1984/4): 36.

Wu, Nelson I. "Tung Ch'i-ch'ang, the Man, his Time, and his Landscape Painting." Ph.D. dissertation, Yale University, 1954.

Tung Ch'i-ch'ang's Circle

WANG SHIQING 汪世清

董其昌的交游

董其昌的交游

董其昌（1555-1636）是中國美術史上的一位具有劃時代意義
的作家和理論家。他書畫兼擅，且均造極詣，可與宋米芾、元
趙孟頫相媲美。若論在書畫的實踐和理論上用力最勤、鑽研最
深，而對後世的影響又最廣泛而且深遠，則董其昌稱得上是後
來居上，超邁前賢。

他自述："余十七歲學書，二十二歲學畫"（《容臺別
集》卷4）。以此起算到他逝世的六十多年中，他始終孜孜不倦
地筆耕在硯田上。即使在大約二十二年的居官時期，書畫也成
爲他生活的第一需要，不可一日或缺。管楮生涯，耗盡他的畢
生精力。他生平親手創作的書畫作品，即今存於世的也屈指難
以勝數。這是他留給後世的一份極有價值的文化遺產，對進一
步發展中國書畫藝術，毫無疑義具有十分重要的現實意義。

綜觀他的一生，歷時八十二年，足跡幾及半個中國。他北
抵燕山，南臨湘水，登武夷，涉彭蠡，吳山越水更是他來往常
經之地。以此他的交游也遍及全國各地。在宦海浮沉中，他當
然會結識不少達官貴人，其中鄰也不乏具有書畫同好的良師益
友。而在他的交游中，更多的則是書畫創作家、鑑賞家和收藏
家。藝術交往便成爲他師友往還的主要活動，因而敘述他的交
游，難免較多地着眼於他的藝術交往。

第一部分雲間師友

一　二位師長

　　陸樹聲　陸彥章
　　莫如忠　莫是龍　莫是元　莫後昌

二　同社兄弟

　　唐文獻　何三畏　馮大受　陸萬言
　　陸萬里　方應選　楊繼禮　楊繼鵬
　　楊汝成　朱國盛　朱軒

三　齊名二老

　　范允臨　陳繼儒

四　藝苑故交

　　顧正誼　孫克弘　趙左　沈士充

第二部分座師、館師和同年

一　四位座師

　　黃洪憲　盛訥　許國　許立德
　　許立禮　王弘誨

二　三位館師

　　沈一貫　田一儁　韓世能

三　鄉試同年

　　王衡　張文柱

四　鼎甲三儁

　　焦竑　吳道南　陶望齡

五　庶常同館

　　王肯堂　黃輝　朱國楨　馮從吾
　　區大相

六　館外同年

　　王士騏　高攀龍　吳正志　陳所蘊

第三部分鑑藏同好

一　秀水項氏（〈秀水項氏質支世系表〉）

　　項元汴　項穆　項德成　項德新
　　項德明　項德弘　項德達　項聖謨
　　項徽謨　項奎　項夢原　項鼎鉉

二　橋李三友

　　馮夢禎　李日華　汪砢玉

三　新安朋好

　　吳廷　吳國遜　吳一瀋　吳士諤　吳希元　吳家鳳　吳養春
　　吳養都　吳楨　汪宗孝　程季白　程正言　吳懷賢

461

唐文獻（1549-1605）字元徵，號抑所，萬曆乙酉（1585）舉人，丙戌進士，殿試一甲第一名，官至禮部侍郎，卒謚文恪。文獻工詩古文詞，著《占星堂集》十六卷。擅書法，王錫爵評「元徵詩如襄陽、輞川。筆法端楷，即家報皆蠅頭細書，語語可訓」（轉引自《明詩紀事·庚籤》卷15，《唐文獻小傳》）。

在同社兄弟中，陸萬言、馮大受、何三畏相繼於萬曆丙子、己卯、壬午秋試告捷，而唐文獻和董其昌鄰連遭鎩羽。然隨後二人亦先後蟬聯登第。在萬曆戊子（1588）董其昌中舉後的冬天，董其昌與唐文獻等同會高僧憨山德清（1546-1609）於龍華寺，夜談《中庸》「戒懼」和「觀聞」的關係，也是一次互相切磋的集會（《畫禪室隨筆·禪說》）。及後同官史館，寓址相近，更多把臂談心之樂。唐文獻曾爲董其昌的京寓題名曰「舫齋」（上海博物館藏董其昌「燕吳八景冊·舫齋候月」題識）。董其昌有《同唐元徵宮允遊善權洞四首》五律（《容臺詩集》卷2），知二人曾偕遊宜興。又有《送唐元徵太史二首》七絕（《容臺詩集》卷4）。惜均不知寫作的確年了。唐文獻於萬曆「乙巳病卒，年五十七」（《康熙松江府志》卷42，《唐文獻小傳》）。董其昌爲撰《嘉議大夫禮部右侍郎兼翰林院侍讀學士贈尚書抑所唐公行狀》（《容臺文集》卷9），備述生平，頗爲詳盡，亦足見二人的深厚友情。

何三畏（1550-1624）字士抑，號繩武，萬曆壬午（1582）舉人，官紹興府推官。工詩文。富於著述。詩文集有《芝園集》二十五卷（萬曆丙申刊）、《新刻漱六齋全集》四十八卷（萬曆戊申刊）。董其昌曰：「余與士抑皆髫鬌就試童子科。督學使耿恭簡公手其文，竝目爲雙南金」（《陳眉公先生全集》卷52，代董其昌撰《司理繩武何公暨配季孺人墓誌銘》）。二人是總角之交。及何三畏天啓甲子（1624）卒，董其昌年亦七十，也算得上是白首之交。今在二人詩文集中都可以見到交往的資料。何三畏有《遊棲霞寺同董玄宰》五律一首（《芝園集》卷8），知二人曾偕遊南京棲霞山，惜亦未著年月。又有《寄楊彥履因憶馮開之、唐元徵、董玄宰諸同社俱在史館感賦》、《寄董太史玄宰》七律各一首（同上，卷9）和《送董太史玄宰》、《人日同唐元徵、陸君策、董玄宰、郁孟野諸社友餞方衆甫職方北上》七律各一首（同上，卷10）。還有《寒夜同徐孟孺、董玄宰、陳仲醇、家弟士端登城，歸憩馬嵊寺》七絕一首，詩云：「一天暮色度飛鴉，水漫空城月漫花。清露濕衣人未睡，還邀詩伴到僧家」（同上，卷12）。《簡董玄宰》一札有云：「人從北來，輒問諸兄弟起居，知與衆甫、元徵、彥履寓址密邇，時時聚首把臂，樂何如也」（同上，卷22）。董其昌有《送何士抑遊南》七律一首，又《題畫贈何士抑》云：「士抑兄每望余不爲作畫，所得余幅輒贋者。余以行役久廢此道。檢笥中舊時點三尺山，自武夷寄之」（《畫禪室隨筆》，題自畫）。可見當時贋作董畫的很多，甚至拿來愚弄他的好友。

馮大受（生卒待考）字咸甫。祖恩，字子仁，嘉靖丙戌（1526）進士，官至大理寺丞；父行可（1521-1605），字道卿，號勅齋，嘉靖庚子（1540）舉人，官至應天府通判，以孝行稱於時；八叔時可（約生於1552）字敏卿，號元成，隆慶

辛未（1571）進士，官至湖廣參政。大受「少負才名，工書法。」與董其昌同受業於莫如忠，爲同門兄弟。萬曆己卯（1579）舉人，「因公車者三十年，謁選得陽山知縣，遷教諭餘姚，遷慶元知縣。致仕歸，葺竹素園，日吟咏於其中」（《康熙松江府志》卷44，《馮大受小傳》）。著《竹素園集》九卷，收詩起萬曆庚辰訖丁亥，僅爲中舉後八年之作。他的書法手蹟，今可見的僅上海博物館所藏《行書七絕詩軸》。董其昌有《送馮咸甫》七絕一首，詩云：「畫裏扮將楚客詞，登山臨水送新知。蒼蒼葭菼三千里，盡是懷人入夢時」（《容臺詩集》卷4）。

陸萬言（生卒待考）字君策，號咸齋，萬曆丙子（1576）舉人。築「畸墅」於「郡北二十五里，」陳繼儒爲作《陸君策畸墅記》（《陳眉公先生全集》卷22）。董其昌有《陸君策畸墅問水二首》七律（《容臺詩集》卷3），又《題畫贈君策》云：「余既爲君策作畸墅詩，復作此補圖。然畫中殘山剩水，不能畫畸墅之勝，命之曰《廬山讀書圖》云」（《畫禪室隨筆》，自題畫）。萬言亦能書畫，然作品極少見。在他卒後，董其昌有《祭陸君策孝廉文》，首曰：「嗚呼！咸齋兄竟止於斯耶？」「咸齋」之號，僅見於此。以「兄」稱之，他的年齡或稍長於董其昌。又云：「念余與兄，望衡數步，敦契三益，林居以來，匪伊朝夕，無奇不賞，有疑必析，酒壚詩社，花茵月席。」「兄有逸才，厥名允赫，筆花匪夢，腹笥爲癖，百韻瀾汎，千篇膾炙。」「追維疇曩，形影相惜，三月爲睽，千秋永隔。密友不數，贖身難百，談容可想，勝事陳跡」（《容臺文集》卷9）。萬言兄萬里，字君羽，「善書。於時莫雲卿早逝，而董文敏其昌後起，故萬里稱獨步。其昌少貧，作萬里書市之，人以爲贋，弗售也」（《康熙松江府志》卷46）。

方應選（生年待考）字衆甫，號明齋，萬曆癸未（1583）進士，官至福建提學副使。「以勞瘁卒於官」（同上，卷44，《方應選小傳》），當在「督閩學政」任上。馮夢禎《祭方衆甫學使》有句云：「宦轍相左，廿年飛蓬。三佩州符，一贊兵戎。尋擢外臺，視學觀風。」又曰：「最後入閩，甲乙髦士。羨登武夷，兼食荔子。忽聞臥病，奄然不起」（《快雪堂集》卷21）。應選從萬曆癸未登朝到卒於福建任所，歷經三任州官，一任盧龍兵備副使，總共二十年。他當卒於萬曆三十一年癸卯（1602）前後。湯顯祖有《方衆父選徙冀州，自笑今日開籠放白鷳矣，因渠服色嘲之》七律一首，末句云：「同門幾月仍同署，具曉襟情似白鷳」（《湯顯祖詩文集》卷10）。後來他又從冀州調任河南汝州，因有《汝上集》。董其昌序曰：「《汝上集》者，方衆甫守汝時所著詩若古文也」（《容臺文集》卷1）。志稱他有「文集若干卷行於世，」今遍搜已不可得。

楊繼禮（生年待考）字彥履，萬曆壬辰（1592）進士，在京與唐文獻、董其昌同朝爲官，異地故交，更感親切。董其昌於萬曆丙申（1596）作《燕吳八景冊》（今藏上海博物館），就是在「長安墨禪室中」畫贈楊繼禮的，有燕景，也有吳景，客思鄉愁，情牽兩地。這本畫冊凝聚着同社兄弟多麼深摯的交誼。繼禮「甲辰晉宮諭，掌南京翰林院，病卒」（《康熙松江府志》卷42，《楊繼禮小傳》）。他當卒於萬曆三十二年

（1604）。弟繼鵬，字彥冲。董其昌說他是"余友楊彥履宮論之弟，庶常元章之叔。善詩畫，尤好余書。嘗從余爲玄真鈞舫之游，所得余行楷甚真，又時有摹本，且十卷矣。余既入長安，而彥冲盡以入石。念余書多贗本，又懶役手腕，以此爲馬文淵銅馬之式，命之曰《銅龍館帖》云"（《容臺別集》卷3）。後來姜紹書便說他"畫學師資於董思翁，頗能得其心印。思翁晚年應酬之筆，出於彥冲者居多"（《無聲詩史》卷7）。傳世的董其昌書畫贗品，哪些是楊繼鵬的代筆，哪些是他的摹本，恐怕已經辨別不清了。繼禮子汝成，字元章，天啓乙丑（1625）進士，官至禮部侍郎。

朱國盛（生卒待考）字敬韜，號雲來，萬曆庚戌（1610）進士，翌年董其昌爲作《仿古山水册》（今藏北京故宮博物院），末頁款題"玄宰畫爲敬韜社兄。辛亥春禊日。"越十二年，二人相遇於覽社湖（在今江蘇省高郵縣境内），董其昌又於"壬戌二月十九日"爲之重題。國盛工畫山水，法米友仁。董其昌《題朱雲來圖》云："敬韜作米虎兒墨戲，不減高尚書。閱此欲焚吾硯"（《畫禪室隨筆》，評舊畫）。董其昌以"仿倪高士筆"爲作《橫雲秋霽圖》，題識有云："橫雲山吾郡名勝，本陸士龍故居，今敬韜構草舍其下。敬韜韻致，書畫皆類倪高士，故余用倪法作圖贈之"（同上，題自畫）。

朱國盛仲子軒（1620—1690）字韶九，號雪田，書學董其昌，畫學趙左。主張"以書入畫，"故畫亦得董其昌的工力。顧大申有《董尚書畫卷歌贈朱子雪田》七古一首，歷叙自"隆萬之際"以來"東吳繪事推雲間"的作者：顧正誼、莫是龍、孫克弘及"游寓"的宋旭，然後寫到："尚書（董文敏其昌）雅得鍾王真，畫通書理空前人。下筆森瘦秀徹骨，吳振、趙左（振字竹嶼，左字文度，皆同時工畫者）皆逡巡。左之澹逸得天趣，振也瀟灑工枯樹。董公墨妙天下傳，潤飾特資兩君助。"又曰："邇來頗許朱雪田，苦心書畫皆工力。爾家先人慕長年，尚書亦授錢鏗傳。傳心盡合參同契，促膝半寫黃庭篇。以茲密證忘昏曙，好手初呈泥割據。彩筆還同江令留，丹鶏不逐劉安去。誰道生兒翰墨精，臨池走筆多峥嶸。清波門外老屋裏，四壁絢爛藏丹青。韓生（曠字平原）、陸老（灝字平遠）恒携杖，展玩紛然各惆悵。吝惜時虞勢家奪，知我無心屢相餉。況此短卷與衆殊，庚庚瘦削同璠璵。南宮、北苑應避席，始知名下真無虛"（轉引自李濬之《清畫家詩史》甲下）。詩當作於康熙辛亥、甲寅間（以"文敏亡幾四十載"推之），可提供對雲間畫學及董其昌與朱氏父子藝術因緣的瞭解。

齊名二老

在雲間師友中，還有兩位與董其昌齊名於藝苑的好友，二人均小於董其昌三歲，又都年逾八十卒。白首交情，並以書畫而傳名千古。他們是范允臨和陳繼儒。

范允臨（1558—1641）字至之，又字長倩，號石公，父惟丕，嘉靖己未（1559）進士，旋卒。允臨"早孤，贅於吳門徐氏，因家焉"（《康熙松江府志》卷44，《范允臨小傳》）。

故亦作吳縣人。萬曆乙未（1595）進士，官至福建參議。允臨善屬文，工詩畫，尤擅書法。"高懷藻逸，爲海内所重。"朱彝尊稱他的書法"筆精墨妙，揮毫落紙，與董尚書爭工"（《明詩綜》卷58）。著《輸寥館集》八卷（順治丁酉刊）。他中舉早於董其昌三年，而成進士卻晚於董其昌六年。萬曆己丑（1589），二人同上春官，"玄宰則館余冰清君邸舍，與余同硯席"（《輸寥館集》卷4，《貞孝婦屠氏小傳》）。可見二人過從甚密。榜發，董其昌獲捷，殿試又以二甲第一名登第。而允臨仍名落孫山。妻徐氏，名淑，字冰清，工詩翰，晚偕隱於蘇州天平山別業，唱和爲樂。董其昌作《范長倩偕隱天平山居四首》七絕贈之。又有《壬子九月八日同范長倩、朱君采、董退周西湖泛舟，次退周韻》五言排律一首，爲萬曆四十年（1612）重陽前一日同遊杭州西湖之作。在范允臨官雲南僉事期間，董其昌正在湖廣提學副使任上，范允臨有《與董玄宰》一函，中爲友人求助，末云："弟與丈同事，豈敢謬爲曹丘，以開干謁，直以憐才一念，或與丈同，且恃相知意氣，故敢不辭緩頰耳"（同上，卷8）。允臨善畫山水，今極少見。書法手蹟，尚有行書詩詞卷軸扇頁存世。

陳繼儒（1558—1639）字仲醇，號眉公，"少爲高材生，與董玄宰、王辰玉齊名。年未三十，取儒衣冠焚棄之，與徐生益孫結隱於小崑山"（《列朝詩集小傳》丁集下，《陳徵君繼儒》）。徐益孫，字孟陽，華亭人，少有文名，遊南雍，爲祭酒許國、司業張位所知。亦與董其昌爲好友。繼儒"工詩文，雖短翰小詞，皆極風致"（《康熙松江府志》卷45，《陳繼儒小傳》）。著作極富，不易縷述。詩文集有《陳眉公先生全集》六十卷（崇禎末刻）；文集有《白石樵真稿》二十四卷，董其昌爲作叙，末署"丙子暮春禊日，"當爲陳繼儒生前所刻。他與董其昌相交，自少至老數十年，交往之密，切磋之勤，相知之深，已爲藝苑所共知。但從二人的言論來看，會更感真切。陳繼儒《祭董宗伯文》曰："少而執手，長而隨肩；函蓋相合，磁石相連；八十餘歲，毫無間言；山林鐘鼎，並峙人間"（《白石樵真稿》卷8）。董其昌則說："余與眉公少同學。公小余三歲，性敏心通，多聞而博識。余師畏公，不敢稱兄弟行也。余稍長，干祿於時，浮湛五十年，始獲請老。公閒意榮進，買山卜築，比於盧鴻草堂。著書教孫，彌有年載。"而"鐘鼎之業乃在山林，孰謂皋夔稷契賢於箕潁哉？"（同上，卷首載董其昌《叙》）。一以高官告老，一以布衣終身。人生異轍，藝事同心。鐘鼎山林，千秋並峙。真也是可以流傳千古的藝林佳話。但有一椿公案，也值得在此一提。董其昌卒後，《行狀》是陳繼儒所寫，其中記董其昌"至丙子仲冬九日，忽痰作，不三日而逝"（《陳眉公先生全集》卷36，《太子太保禮部尚書思白董公暨元配誥封一品夫人龔氏合葬行狀》）。據此，董其昌卒於崇禎九年丙子十一月十一日。但在他《答王遜之》函中，卻寫的是"痛哉！思翁九月廿八日戌時已遊俗矣"（同上，卷5）。據此，董其昌卒於崇禎九年丙子九月二十八日。何者爲是？急待澄清。幸好這通《答王遜之》書札的手蹟，現在完好地保存在天津市歷史博物館，内容與刻本完全一致。這是及時訃告王時敏，董其昌去世的年月日時，而且是出於陳繼儒親筆所書，又據以刻入《全集》，應該是完全可信

的。從而也就可以確知，董其昌實卒於崇禎九年丙子九月二十八日，以公元紀年，是一六三六年十月二十六日。

藝苑故交

雲間畫學，晚明爲盛。著名畫家除上面已舉出的諸家而外，尚有與董其昌藝苑相知的朋友多人，選他們中的名尤著者略加介紹。

顧正誼（生卒待考）字仲方，號亭林，萬曆中，以國子生授武英殿中書，工畫，與莫是龍齊名。「二人並學黃子久，然惟寫扇頭及小幅七八寸闊、二尺許高，則俊朗翩翩，圓滿無缺，足存也。如幅稍闊而長，便山山形同，樹樹狀似，立見窮窘，不堪爲品騭矣。」「二君則顧差讓莫。莫能矯健，又善用苦綠作大點樹葉，有勝韻。顧不能巨樹，樹千林一律，點染無濃淡」（《詹氏性理小辨》卷42，《畫旨下》）。這是詹景鳳（1528-1602）對莫顧二家畫的比較評論，談得很具體，自是一家之言。董其昌《跋仲方雲卿畫》有云：「吾郡顧仲方、莫雲卿二君，皆工山水畫。仲方專門名家，蓋已有歲年；雲卿一出而南北頓漸，遂分二宗。然雲卿題仲方，目以神逸。乃仲方向余歆衪雲卿畫不置，有如其以詩詞相標譽者。俯仰間見二君意氣，可薄古人耳」（《畫禪室隨筆》，題自畫）。正誼在莫是龍卒後的第十年尚在世（上海博物館藏顧正誼《山水卷》作於萬曆丁酉），他的畫過求「肖似」元四家，「而世尤好其爲子久者」（同上，評舊畫），故以「肖似」黃公望爲尚，子弟及後輩起而學之，便有所謂「華亭派。」

孫克弘（1533-1611）字允執，號雪居，父承恩（1481-1561）字貞父，號毅齋，正德辛未（1511）進士，官至禮部尚書，卒謚文簡。克弘「少敏慧，博涉群籍，氣度蕭遠，有晉人之風」（《康熙松江府志》卷46，《孫克弘小傳》）。工書善畫。「公正書倣宋仲溫，隸篆八分，追踪秦漢。初寫徐熙、趙昌花鳥，晚年畫馬遠水、米南宫父子雲山」（《晚香堂小品》卷17，《孫漢陽傳》）。以蔭官至漢陽府知府，故稱「孫漢陽。」莫是龍《跋孫漢陽梅竹卷》，說他「好游戲於丹青，華鳥生意下輒得其妙。晚好寫梅竹，蓋亦有雅尚云」（《莫廷韓遺稿》卷14）。又有《跋孫漢陽竹譜》和《題孫漢陽畫石譜卷後》兩文。董其昌《題孫漢陽卷》有云：「余又於宋光祿家得米元章所畫研山，雲根雪浪，直鑿混沌。吾鄉雪居先生又圖爲卷，可與元章競爽。余將以米畫贈之，惟欲易東皋草堂前一片烟霞，便意足也」（《畫禪室隨筆》，評舊畫）。「東皋草堂」是克弘家園中一所齋室的名稱。「公聲音洪暢，狀貌疎野，居恒好着民間平頭帽，旁綴小金瓶。又好寫笠屐小像，彷彿皆魏晉遺風，非近代以下人物也。」「公無疾而逝，年七十有九」（《孫漢陽傳》）。他的畫今存於世的以梅竹爲多。署年最早的隆慶二年戊辰（1568）所作的《梅竹圖扇頁》（《中國古代書畫目錄》第三册，第31頁），時年三十六。他長於董其昌二十二歲，而他卒時，董其昌已五十七。二人自然會有直接的交往。

趙左（生卒待考）字文度，與同里宋懋晉俱學畫於游寓松江的宋旭（1525-1604），工山水。懋晉字明之，雲南參政宋

堯武（1532-1596）從子，畫山水「揮灑自得，而左惜墨搆思，不輕涉筆。其畫宗董源，兼有黃公望、倪瓚之意，神韻逸發，故爲士林所珍」（《康熙松江府志》卷46，《趙左小傳》）。從游者學之，於是有所謂「蘇松派。」姜紹書說他「與董思白爲翰墨家，流傳董蹟，頗有出文度手者。兩君頡頏藝苑，政猶魯衞，若董畫而出於文度，縱非林頭捉刀人，亦所謂買王得羊也」（《無聲詩史》卷4，《趙左》）。明遺民顧復也說過：「先君與思翁交游二十年，未嘗見其作畫。案頭絹紙竹簣堆積，則呼趙行之泂、葉君山有年代筆，翁則題詩寫款用圖章，以與求者而已。」「聞翁中歲，四方求者頗多，則令趙文度左代作，文度沒而君山、行之繼之，真贋混行矣」（《平生壯觀·圖繪》卷10）。據此知趙左卒在董其昌逝世之前。趙左畫蹟今存於世的，以作於萬曆己未（1619）的《仿大癡秋山無盡圖卷》爲最晚。他的卒年當在天啓中或崇禎初。

沈士充（生卒待考）字子居，畫「出於宋懋晉之門，亦學趙左，兼得兩家法。時名最盛，郡人能畫者多師之」（《康熙松江府志》卷46，《沈士充小傳》）。他便是「雲間派」的創始人。黃賓虹評沈士充畫「清蔚蒼古，運筆流暢。其後學者，務爲淒迷瑣碎，至以華亭習尚爲世厭薄，不善效法之過也」（《古畫微》第11章，《明畫尚簡之筆》）。士充也往往替董其昌代筆作畫。董其昌有函致友人，謂「久不作畫，時以沈子居筆應求者。倘得子居畫，不佞昌可題款，否則使者行期有誤，奈何奈何！」（此函爲黃賓虹舊藏，轉引自啓功《啓功叢稿》，「董其昌書畫代筆人考」）。士充手蹟今存於世的較宋懋晉、趙左均多。其中明著甲子的，最早爲萬曆乙巳（1605）所作《山居圖軸》（今藏上海博物館），最晚爲崇禎癸酉（1633）所作《秋林書屋圖軸》（今藏上海博物館）和《寒林浮靄圖軸》（今藏北京故宫博物院）。他的生卒還難以準確地推定。

第二部分　座師、館師和同年

董其昌於萬曆戊子、己丑聯捷鄉會兩榜，一躍而青雲直上，進入仕途。自此政治生涯與藝術交往相結合，交游日益廣，眼界日益開，而書畫藝術也日益增進。這是他一生的一個轉折點。他以第三名舉戊子科順天鄉試，是科主考是黃洪憲和盛訥，解元是他的好友王衡，第二名是張文柱，第四名是鄭國望。同科舉人還有茅一桂、潘之恒、任家相、李鼎、張敏塘等。己丑科會試的主考是許國和王弘誨，會元是陶望齡。廷試，賜焦竑、吳道南、陶望齡及第。董其昌是二甲第一名（即傳臚）。是科共取中進士三百四十七名。五月，改進士王肯堂、劉日寧、顧際明、莊天合、董其昌、蔣孟育、區大相、黃輝、馮有經、傅新德、周如砥、朱國楨、喬徹、唐儁純、林堯俞、孫羽侯、徐彥登、包見捷、羅拺、吳鴻功、馮從吾、郭士吉等二十二人爲庶吉士。命沈一貫、田一㒦爲教習。充任教習的還有韓世能。在是科同年中，與董其昌交往較密切的有焦竑、吳道南、陶望齡、王肯堂、黃輝、朱國楨、馮從吾、區大相以及吳正志、陳所蘊、王士騏、高攀龍等。僅就所知，略加介紹。

四位座師

黃洪憲（1541-1600）字懋忠，號葵陽，秀水（今浙江省嘉興市）人，隆慶辛未（1571）進士，官至少詹事兼侍讀學士。工制舉文，亦能詩。著《碧山學士集》二十一卷《別集》四卷（萬曆間刊）。萬曆戊子主順天鄉試，取大學士王錫爵子衡爲榜首，大學士申時行婿李鴻亦中式，以此「爲言者所攻訐，朝令覆試，文皆如格。學士疏十上，乃得歸。後言者猶以爲口實，在籍聽勘」（同上，卷10，《黃洪憲小傳》後陳田按語）。洪憲有《上疏後長安友相訊賦謝》七律一首，詩云：「閶闔天高五鳳樓，覆盆何幸徹宸流。故人霄漢誰青眼，老我江湖已白頭。涉世總知名是累，論交惟有淡相投。山翁到處堪瓢笠，一笑從人呼馬牛」（同上，卷10）。洪憲長子承玄，字履常，號與參，萬曆丙戌（1586）進士，官至福建巡撫。著有《盟鷗堂集》，未見傳本。《送人南歸》云：「落日驪歌酒一觴，大河明月引歸航。離情恰似東流水，一路隨君到故鄉」（《橋李詩繫》卷16）。詩亦風致可誦。家富收藏。董其昌記「米元章天馬賦，有摩窠大字本，禾嘉黃中丞所購，後以歸吳功甫太學。太學物故，爲金壇于氏所收」（《十百齋書畫錄》卯集，《董其昌法書紀略冊》）。知大字本《米元章天馬賦》曾爲黃承玄所藏。

盛訥（生年待考）字敏叔，潼關衛（今陝西潼關縣）人，「父德，世職指揮也，討洛南盜戰死。訥號泣請於當事，水漿不入口者數日，爲發兵討斬之」（《明史》卷243附《孫慎行傳》）。因以孝行稱於時。旋舉隆慶辛未（1571）進士，選庶吉士，與趙用賢、黃洪憲等爲同館。萬曆戊子受命與黃洪憲同主順天鄉試，也是董其昌的座師。官至吏部右侍郎。萬曆乙未（1595）卒，天啓初追諡文定。訥子以弘，字子寬，萬曆戊戌（1598）進士。天啓癸亥（1623）二月受命爲禮部尚書，五月致仕，在任不到四個月。史稱「魏忠賢亂政，落其職。崇禎初，起故官，協理詹事府，卒官」（同上）。他顯然是受閹黨的排擠而去職的，而在復官後，並沒有回任禮部尚書之職（參閱《明史》卷112，《七卿年表二》）。以弘爲官清廉，「取與不苟，卒之日，幾不能具棺歛」。有《紫氣亭集》、《鳳毛館帖》」（《明人傳記資料索引》，第647頁）。

許國（1527-1596）字維楨，號潁陽，歙（今安徽省歙縣）人。嘉靖辛酉（1561）舉鄉試第一，乙丑（1565）進士，官至吏部尚書建極殿大學士。萬曆己丑（1589）二月，受命與王弘誨主會試，「所舉會稽陶望齡、華亭其昌、南昌劉日寧三人，皆以天下士相許，復以生死交相託」（董其昌手蹟《太傅許文穆公墓祠記卷》，今藏北京故宮博物院）。從此，董其昌對這位恩師倍加敬重，執弟子禮甚恭。師生情誼，沒有因許國致仕而稍淡薄，也沒有因許國卒而漸消融。萬曆丙申（1596）六月六日是許國的七十誕辰，董其昌賦《問政山歌爲太傅許老師壽》七古一首以賀之。中有句云：「山中人兮今呂望，全粟前身語非妄，膏澤已編閻浮提，經綸半出光明藏。斗杓調燮政所因，拂衣仍作山中相。歲月赤烏生有涯，道德青牛壽無量。」最後結語是「汾陽二十四考中書令，南華八千餘歲秋復春」（《容臺詩集》卷1）。遺憾的是，許國在渡過七十生日

後，便於當年十月十八日辭世了。董其昌的祈禱熱情歸於幻滅，但惓念師門，却無時或已。「余嘗走新安，弔文穆之墓；文穆諸子皆如寒竣，無厚業，惟清白忠孝之遺獨厚耳」（《容臺文集》卷1，《皇華集序》）。國有四子，伯子立德（1557-1586）字伯上，諸生，「精藝事，楷書似晉人，畫山水有襄陽風，亦工蘭石」（《民國歙縣志》卷8，《孝友·許立德小傳》）。然年僅三十，先其父而卒。仲子立功（生於1559）字仲次，號敦素；叔子立言（生於1585）字叔次，號心穎；生平事蹟不詳。季子立禮（生於1594）字季履，號蓮岫，以蔭歷中書舍人，官至雲南知府。天啓四年甲子（1626），立禮以舍人奉使朝鮮，得「彼邦所鐫《皇華錄》一冊，」是歌頌五十八年前許國出使朝鮮之作，歸以示董其昌而刻爲《皇華集》，董其昌爲之作《皇華集序》。立禮亦「工晉唐法書。」許氏富收藏，董其昌記「王右軍官奴小女玉潤帖真蹟，新安許少師家藏本，得之王元美」（《董其昌法書紀略冊》）。他在《臨官奴帖後》說：「己卯秋余試都門見真蹟，蓋唐冷金箋摹者，爲閣筆不書者三年。此帖復歸婁江王元美。予於己丑詢之王澹生，則已贈新都許少保矣」（《畫禪室隨筆》，跋自書）。又在「戊申十月十有三日，舟行朱涇道中」所題《臨官奴帖真蹟》中，說此帖「已聞爲海上潘方伯所得，又復歸王元美，王以貽余座師新安許文穆公。文穆傳之少子胄君。一武弁借觀，因轉售之。今爲吳太學用卿所藏」（同上）。「少子胄君」就是許立禮。知所謂「官奴帖真蹟」在萬曆三十六年戊申（1608）已在吳廷手中了。

王弘誨（生於1542）字忠銘，一字紹傳，定安（今海南省定安縣）人，嘉靖乙丑（1565）進士，官至南京禮部尚書。能詩，著《天池草》二十六卷。萬曆己丑值會試之年，二月，王弘誨以「詹事府掌府事、太子賓客、吏部左侍郎兼侍讀學士」受命主會試，是年四十八。這年陞南京禮部尚書。萬曆辛卯（1591），王弘誨年屆五十，曾朝節撰《壽大宗伯忠翁先生王公五十序》（《紫園草》卷3）賀之。弘誨調護海瑞，作詩諷張居正，稱得上是一位「介特之士。」宣城吳伯與撰《王大宗伯致仕序》，盛稱王弘誨「於學無所不窺，於才無所不達。」並說他「在事九年，不爲不久」（《素雯齋集·文部》卷24）。他是在任職九年才致仕的，其年當爲萬曆二十五年丁酉（1597），王弘誨已五十六。

三位館師

沈一貫（1531-1615）字肩吾，號龍江，鄞（今浙江省寧波市）人，隆慶戊辰（1568）進士，官至戶部尚書武英殿大學士。卒諡文恭。一貫是布衣詩人沈明臣的從子，少即師事明臣，故詩文均有根柢。著《喙鳴詩集》十八卷、《喙鳴文集》二十一卷（萬曆間刊）。萬曆己丑科庶吉士開館，一貫以吏部左侍郎太子賓客兼侍讀學士受命爲教習，正式成爲董其昌的館師。越六年甲午（1594），十一月一貫以禮部尚書兼東閣大學士入閣，至丙午（1606）七月致仕，在閣十三年，而任首輔者四年。「戊辰史館大拜者七人（即趙志皋、王家屏、陳于陛、張位、于慎行、朱賡、沈一貫），以詞章擅名者，東阿、鄞縣

為最。東阿之學殖，優於鄞縣；鄞縣之才筆，秀於東阿"（《列朝詩集小傳》丁集中，《沈少師一貫》）。東阿指于慎行，鄞縣指沈一貫。史稱"慎行學有原委，貫穿百家"（《明史》卷217，《于慎行傳》）。這就是所謂"學殖。"一貫"家居十年卒，"年八十五。

田一儁（生年待考）字德萬，大田（今福建省大田縣）人，隆慶戊辰（1568）會元，官至禮部左侍郎。著《鍾臺遺稿》十二卷。作無題詩，為張居正奪情而發。詩云："兩朝勳業列旗常，連正台階十五霜。功格皇天誰可比？只應前世有空桑"（《明詩紀事·庚籤》卷9）。萬曆己丑（1589），一儁以禮部左侍郎兼侍讀學士受命為庶常館教習，為董其昌的館師。越三年辛卯（1591），一儁卒於京邸，"其昌請假走數千里，護其喪歸葬"（《明史》卷288，《董其昌傳》）。時人多以此而稱贊董其昌的"古誼兼高尚"（邢侗詩中用語）。董其昌亦因護喪南下，首次入閩，而有武夷之游。

韓世能（1528-1598）字存良，號敬堂，長洲（今江蘇省蘇州市）人，隆慶戊辰（1578）進士，時已五十一歲。"選庶吉士，時同館三十人，世能為之長。館師趙貞吉意不可一世，獨目之曰：韓存良，佛地位中人也"（《民國吳縣志》卷67，據《乾隆志》所寫《韓世能傳》）。官至禮部左侍郎。教習己丑科庶吉士，以此董其昌稱他為"館師"。世能恬於榮利，而好收藏法書名畫。又精賞鑒，故所藏多稀世之寶。他家在蘇州，而為官於京師，所藏名蹟亦分存於兩地。董其昌為庶常時，有機會在他的京邸觀賞所藏《陸機平復帖》、《曹娥碑》、《子敬洛神十三行》以及《楊羲黃素黃庭內景經》、《褚摹褉帖》、《唐拓戎輅表》等。有的還借出來臨摹過。這對促進董其昌書法藝術的進步，顯然具有重要的作用。董其昌在"丁酉三月十五日"曾偕陳繼儒遊蘇州，同訪"韓宗伯家，"世能長子逢禧"攜示余顏書《自身告》、徐季海書《朱巨川告》，即海藏書史所載，皆是雙玉。又趙千里《三生圖》、周文矩《文會圖》、李龍眠《白蓮社圖》。惟顧愷之作《右軍家園景》，直酒肆壁上物耳"（《畫禪室隨筆》，畫源）。世能亦善書，今上海博物館藏有韓世能《楷書臨黃庭內景經卷》（《中國古代書畫目錄》第三冊，第35頁），天津市藝術博物館藏陳栝、韓世能《書畫卷》（同上，第七冊，第38頁）。韓逢禧（1576-1655後）字朝延，號古洲，別號半山老人，以蔭官至雷州府知府。錢謙益稱他為"吾吳之佳公子，""國之老成人，""閱覽博物之君子，""海內收藏賞鑑專門名家"（《牧齋有學集》卷24，《韓古洲太守八十壽序》）。

鄉試同年

王衡（1561-1609）字辰玉，號緱山，太倉州（今江蘇省太倉縣）人。父錫爵（1534-1610）字元馭，號荊石，嘉靖壬戌（1562）榜眼及第，官至吏部尚書建極殿大學士，卒諡文肅。著《王文肅公集》五十五卷（萬曆乙卯刊）。衡登萬曆戊子科順天鄉試第一名，至辛丑（1601）始成進士，殿試一甲第二名。官翰林院編修。吳偉業曰："雲間董宗伯玄宰、陳徵君眉

公，相國之高弟，而編修公執友也，折輩行與游"（《吳梅村全集·文集》卷15，《王奉常煙客七十序》）。董其昌以王錫爵為師，王衡為友，而又以王時敏為弟子，三世交情，極為深摯。王衡又與董其昌鄉試同年，關係更為密切。他"少為詩，落筆數千言，已而多所持擇，每一詩就，輒悄然不自得"（《列朝詩集小傳》丁集下，《王編修衡》）。著《緱山先生集》二十七卷（萬曆丙辰刊）。《秋日玄宰邀飲舟中，同仲醇遊畸墅》五律一首，詩云："得得山情近，深深客意便。高延九峰翠，半渚竹樓烟。種樹書無恙，看花榻尚懸。滄洲吾欲共，未許白鷗尊"（《緱山先生集》卷9）。這是三位好友同在松江泛舟遊賞的一次紀錄。王衡於成進士後僅九年，即先於其父一年而卒，年四十九。

張文柱（生卒待考）字仲立，崑山（今江蘇省崑山縣）人。"萬曆戊子領鄉薦，除臨清州，凡四年，卒於官"（《列朝詩集小傳》丁集上，《張臨清文柱》）。萬曆癸酉（1573），文柱在南京，與吳瑞穀子玉、魏季朗學禮、莫雲卿是龍、邵長孺正魁從青溪社中為詩會，唱和為樂。因與莫是龍同被譽為"青溪社中之白眉。"文柱詩清新俊逸。著《溟池集》十六卷。《夜泊與無美、雲卿同作》云："青袍為客日，艫棹幾江城。天地還吾輩，浮沉亦世情。郭虛村雨暗，沙合水烟生。此夕當杯意，悲歡不為名"（《國雅》卷18）。

鼎甲三儁

焦竑（1540-1620）字弱侯，號澹園，江寧（今江蘇省南京市）人。焦竑生年尚有二說，一為嘉靖十九年庚子（1540），一為二十年辛丑（1541）。吳榮光《歷代名人年譜》主後者，台灣近年出版《明人傳記資料索引》從之。近得數據皆証此說為非。沈德符《萬曆欣賞編》卷五《師弟相得》條有曰："先人少於焦十四年，而早登第。"德符父自邠生於嘉靖三十三年甲寅（1554），若小於焦竑十四歲，則焦竑當生於嘉靖十九年庚子。焦竑為德符祖啟源鄉試門生，未成進士前，每年必來沈家就讀，與沈氏三世交情，故德符所言，自屬可信。沈自邠生卒見馮夢禎《快雪堂集》卷十八，《沈茂仁行狀》。馮與沈自邠（字茂仁）為兒女親家，關係至為密切，所言自邠生卒當無謬誤。又俞安期《焦弱侯太史誕辰詩自序》（《松陵文集三編》卷37），"萬曆己酉十一月廿日為弱侯太史攬揆之辰"（實為七十誕辰），記出生日，可証焦竑萬曆己酉七十，其生亦為嘉靖庚子，而非辛丑。黃宗羲《明儒學案》卷三五《焦竑傳》謂其"泰昌元年卒，年八十一。"亦正合。故焦竑生年，以公元紀年，為一五四〇年十二月二十三日。為諸生，值耿定向提學江南，從之學。"為舉子二十餘年，博極群書，束修講德，巍然負通人之望"（《列朝詩集小傳》丁集下，《焦修撰竑》）。及己丑冠多士，年已五十。官翰林修撰，任東宮講官。丁酉（1597）以科場事謫福寧州同知。自是屏居里中，專事著述，成書數十種，詩文集有《焦氏澹園集》四十九卷（萬曆丙午刊）。"修撰晚擷巍科，仕雖不達，公望歸之。亳州李文友仁卿詩云：'文章南國多門下，翰墨西園集上才。'蓋實錄

也"（《明詩綜》卷55）。竑學問淵博，詩文卓然名家，不愧爲當時"東南儒者之宗。"他雖晚達，而享大年。四方之士凡來金陵的，都要造門相訪，談文論道。"李卓吾、陳季立不遠數千里相就問學"（《列朝詩集小傳》丁集下），便是一例。他所編輯的《國朝獻徵錄》一百二十卷（萬曆丙辰刊），搜羅明人傳記資料，極爲宏富，確是一代的史學巨製。

吳道南（1550-1623）字會甫，號曙谷，崇仁（今江西省崇仁縣）人，己丑廷試第二人及第，授編修，"直講東宮，太子偶傍聽，道南即輟講拱竢，太子爲改容"（《明史》卷217，《吳道南傳》）。官禮部侍郎時，屢上諫疏，均未見成效。萬曆癸丑（1613）九月，道南以禮部尚書兼東閣大學士入閣，首輔葉向高。史稱他"大政不爲詭隨，頗有時望。"以科場事遭彈劾，終於丁巳（1617）七月，以"丁憂"去，在閣還不到四年。天啓癸亥（1623）卒，年七十四。謚文恪。著《吳文恪公文集》三十二卷（崇禎間刊）。他有《送董思白太史》七律一首，詩云："西清幾度擁霜裘，忽漫長歌出帝州。董貫不妨京國去，尊罍暫爲故鄉留。燕雲拂袂青陽候，江月懷人白露秋。自是賜環明主事，雅懷何處不滄洲"（《吳文恪公文集》卷28）。

陶望齡（1562-1609）字周望，號石簣，會稽（今浙江省紹興市）人，萬曆己丑（1589）會元，殿試一甲第三名，官至國子祭酒。卒謚文簡。著《歇菴集》二十卷（萬曆辛亥刊）。他"在詞垣，與同官焦竑、袁宗道、黃輝，講性命之學，精研內典"（《列朝詩集小傳》丁集下，《陶祭酒望齡》）。史稱他"篤嗜王守仁，所宗者周汝登"（《明史》卷216附《唐文獻傳》）。陶望齡所宗的當然就是周氏的"會通儒釋"之學。他工詩，"早年詩格清越，超超似神仙中人。中歲講學逃禪，兼惑公安之論，遂變芸夫蕘豎面目。白沙在泥，與之俱黑，良可惜也"（《明詩綜》卷55）。

陶望齡與董其昌都是許國的得意門生。許國致仕歸里後，陶望齡曾於萬曆癸巳（1593）十月"自越詣新都，恭謁我師於高陽里。"爲作《題許少師冊》五古四首，第四首有句云："我公炳明哲，大方絕藩籬。青冥寥廓中，一任鴞鸞飛。寵辱一以忘，讚譏胡足疑。況公進退間，所得誠不貲。進常班皁夔，退則傲由夷"（《歇菴集》卷1）。翌年甲午，袁宗道入都，與董其昌"復爲禪悅之會。"時陶望齡亦在京，與董其昌及袁氏兄弟"數相過從"（《畫禪室隨筆》，禪說）。董其昌還記云："陶周望甲辰冬請告歸，余遇之金閶舟中，詢其近時所得，曰：亦尋家耳！余曰：兄學道有年，家豈待尋？第如今日次吳，豈不知家在越？所謂到家罷問程，則未耳。"這是二人相遇蘇州，在舟中的一次談話。此後吳越兩地相隔，或亦時有音問。又三年丁未（1607），春陶望齡"兩度作書"與董其昌，約"爲西湖之會。有云：兄勿以此會爲易。暮年兄弟，一失此便不可知。"果然相會難期，"至明年而周望竟千古矣。其書中語遂成讖，良可慨也"（同上）。陶望齡"卒萬曆己酉六月十七日，享年四十有八。通籍者二十一年，三以告歸，里居共十五年，立朝者纔六年耳"（《歇菴集》附錄陶奭齡撰《先兄周望先生行略》）。而里居則以講學爲事，故史稱他"與弟奭齡皆以講學名。"

庶常同館

王肯堂（1549-1613）字宇泰，金壇（今江蘇省金壇縣）人，父樵（1521-1599），字明遠，號方麓，嘉靖丁未（1547）進士，官至右都御史。卒謚恭簡。"樵恬澹誠慤，溫然長者。邃經學，《易》、《書》、《春秋》，皆有纂述"（《明史》卷221，《王樵傳》）。著《方麓居士集》十四卷。肯堂散館後授檢討，官至福建參政。金壇王氏，累世簪纓，家道殷富。肯堂承祖（臬字汝陳，正德丁丑進士，官至山東副使）父之蔭，亦富收藏。米芾所書《天馬賦》，董其昌所見有四本，其"一爲檢討王宇泰藏"（《畫禪室隨筆》，跋自書）。又《題評紙帖爲朱敬韜》中說"米元章評紙，如陸羽品泉，各極其致，而筆法都從顏平原幻出，與吾友王宇泰所藏《天馬賦》同是一種書"（同上，評舊帖）。姜紹書記《黃子久天池石壁圖》，說"其真蹟舊藏金沙王宇泰家。董思翁於萬曆甲辰歲遊茅山，過訪宇泰，披閱此圖，極其欣賞"（《韻石齋筆談》卷下）。史稱"肯堂好讀書，尤精於醫。所著《證治準繩》，該博精粹，世競傳之"（《明史》卷221附《王樵傳》）。尚著有《鬱岡齋筆塵》四卷（萬曆壬寅刊）。卷四曾記他"得觀《澄清堂帖》十餘卷，皆二王書，字畫流動，筆意宛然，乃同年王大行孝物。後余在翰林時，有骨董持一卷視董玄宰。玄宰叫絕，以爲奇特。"肯堂亦善書法。手蹟恐已不易多見。王珣《伯遠帖》後有王肯堂一跋，今存北京故宮博物院。

黃輝（生卒待考）字平倩，一字昭素，南充（今四川省南充市）人，幼穎異，稍長，博極群書。年十五舉鄉試第一，久之始成進士，改庶吉士，散館授編修。官至少詹事兼侍讀學士。輝刻意爲古文，以韓愈、歐陽修爲師，由此館閣文稍變。詩奇而藻，爽雋爲人所稱。著《鐵菴集》八十卷、《平倩逸稿》三十六卷。"己丑同館者，詩文推陶周望，書畫推董玄宰，而平倩之詩與書與之齊名"（《列朝詩集小傳》丁集下，《黃少詹輝》）。後與袁氏兄弟相交，不免爲公安所染，他的詩便"稍稍失其故步。"然其近雅者，如《入峽書懷》云："華髮還來照玉溪，斑衣常是夢中啼。屛陵尺素何時到？家在相如客舍西（《明詩紀事·庚籤》卷16，《黃輝詩》）。筆觸仍不愧爲當時才子。

朱國楨（1558-1632）字文寧，號平涵，別號虯菴居士，烏程（今浙江省湖州市）人，通籍後，初入史館，累官祭酒，謝病歸，久不出。天啓三年癸亥（1623）正月拜禮部尚書兼東閣大學士，翌年十二月以禮部尚書文淵閣大學士致仕。卒謚文肅。國楨"博學多著述，有良史才"（《費恭菴日記》，轉引自謝國楨《增訂晚明史籍考》）。著《朱文肅公詩集》七卷（清初抄本）。國楨在閣整二年，正當魏忠賢柄國，與閹黨顧秉謙、魏廣微同掌政，佐首輔葉向高，多所調護。然終不容於魏忠賢，在六個月內，與葉向高、韓爌相繼罷去。董其昌擢禮部右侍郎及三世誥命，署年均爲"天啓四年九月二十九日"（董其昌《楷書三世誥命卷》今藏北京故宮博物院），正當朱國楨佐韓爌當政之時。朱國楨與焦竑、陶望齡、董其昌誼屬同年，往還甚密。《喜晤陶石簣、董玄宰兩年丈》云："朝發江之皐，暮抵虞山麓。兩賢並而立，一如輈與輻。我今得友之，

先後俱心腹。接君尤灑然，習習清風穆。前歲看竹歸，今各班荊宿」（《朱文肅公詩集》卷1）。三人交誼，可見一斑。

馮從吾（1556-1627）字仲好，長安（今陝西省西安市）人，「生而純慤，長志濂、洛之學，受業許孚遠」（《明史》卷243，《馮從吾傳》）。故從吾學宗良知，得王陽明正傳。著《馮少墟集》二十二卷（萬曆丁巳刊）。從吾在館時，「金陵焦弱侯以理學專門爲領袖。是時同儕多壯年盛氣，不甚省弱侯語。惟會稽陶周望好禪理，長安馮仲好聖學，時與弱侯相激揚」（《容臺文集》卷1，《馮少墟集序》）。散館授御史，旋罷官家居，至天啟初始再登朝，官至工部尚書。尋致仕，以忤閹黨削籍。天啟丁卯（1627）卒，年七十二。崇禎初復官，追謚恭定。學者稱少墟先生。從吾亦能詩。《涇野呂先生》云：「涇野呂夫子，矯矯崇正學。挾冊遊成均，馬崔同切瑳（馬谿田、崔後渠）。射策冠時髦，聲華何卓犖。慷慨批逆鱗，封章凌五嶽。講學重躬行，乾坤在其握。吁嗟橫渠後，關中稱先覺」（《明詩紀事·庚籤》卷16）。這可說是學人之詩。

區大相（生卒待考）字用孺，號海目，高明（今廣東省高明縣）人，己丑選庶吉士，散館授檢討，官至南京太僕寺丞。工詩。著《區太史詩集》二十七卷（崇禎癸未刊）。朱彝尊曰：「海目持律既嚴，鑄詞必錬。其五言近體，上自初唐四傑，下至大曆十子，無所不仿，亦無所不合。」《明詩綜》選區大相詩，《中秋望月簡董玄宰太史》云：「月滿層城上，秋分御苑中。玉樓寒自迴，珠箔照還空。望美今宵隔，含情幾處同。此時折桂客，或在明光宮」（《明詩綜》卷56）。此詩當是董其昌官翰林院編修時，二人同在北京所作。區大相年輩較黎惟敬民表、歐楨伯大任爲晚，然亦及交二人，時有唱和。屈大均曰：「嶺南詩，自張曲江倡正始之音，而區海目繼之。明三百年，嶺南詩之美者，海目爲最，在泰泉、蘭汀、崙山之上。」並舉「其《謁張文獻祠》云：『一代孤忠在，千秋大雅存。詩才推正始，相業憶開元。曝日陳金鑑，蒙塵想劍門。更吟羽扇賦，搖奪不堪論。』即此一篇已工絕」（《廣東新語》卷12，《區海目詩》）。區大相是繼黎民表、歐大任之後，實爲嶺南風雅的領袖。

館外同年

王士騏（生於1554）字冏伯，號澹生，世貞長子，萬曆壬午（1582）舉應天鄉試第一，三上公車始成進士，官至吏部員外郎。「冏伯倜儻軒豁，好結納海內賢士大夫，勇於爲人，不避嫌怨。」或即以此「爲權要所娖，覼髒以死，公議惜之」（《列朝詩集小傳》丁集上，《王尚書世貞》附見《王司勳世騏》）。士騏承家學，亦工詩。著《醉花菴詩》五卷。論詩文與其父異趣，而詩亦「不拾過庭片語。」《送顧太史使朝鮮》：「微天火樹照邊陲，軟伴肩輿坐自移。到日定知春麥秀，請看箕子廟前碑」（《明詩綜》卷56）。董其昌及交王世貞，而與士騏爲同年友。二人自多交往。《右軍官奴帖》由王世貞贈予許國，便是問到王士騏才得知的。

高攀龍（1562-1626）字存之，號景逸，無錫（今江蘇省無錫市）人，登第後，初授行人，旋謫揭陽典史，之官七月歸，遂不出。家居三十年。天啟辛酉（1621）起爲光祿寺少卿，官至右都御史。以忤逆閹削籍被逮，赴水死。謚忠憲。攀龍「少讀書，輒有志程、朱之學。」後與顧憲成同講學東林書院，「以靜爲主。操履篤實，粹然一出於正，爲一時儒者之宗」（《明史》卷243，《高攀龍傳》）。著《高子遺書》十二卷（崇禎壬申刊）。攀龍與董其昌志趣不同，交誼較疏。董其昌撰《明御史大夫忠憲高公像贊》，以「蕩陰裾濊，常山斷裂，三光浴焉，此一點血」起興，盛贊高攀龍爲一血性男子，也寄託了對故人的景仰。

吳正志（生卒待考）原名秉忠，字之矩，號澈如，宜興（今江蘇省宜興縣）人。父達可（1541-1621）字叔行，一字安節，萬曆丁丑（1577）進士，官至通政使。以理學傳家，著《荊南漫稿》等書行世。正志幼承家訓，長工詩文。初登朝，授刑部主事，遷光祿丞，官至南京刑部郎中。邑志父子均有傳。宜興吳氏，家富收藏。正志亦善書法。萬曆庚子（1600）三月，董其昌爲正志書王維輞川詩冊，跋云：「過荊溪訪吳澈如年丈，出素楮屬余書右丞輞川絕句。澈如愛右詩，且學之欲逼人，愧余書不能學右丞也。董其昌識。庚子暮春」（《石渠寶笈初編》卷10，《輞川詩冊》）。志稱吳正志有《雲起樓詩文集》，今無傳本。《初至西村》云：「避世不可得，聊復居西村。西村亦何有，松竹羅故園。況茲春陽暮，卉脫芳蔭繁。雨餘睹秀野，寒風帶隴翻。既隨物候適，亦絕人情援。嘿坐觀無始，散步神理存。喧寂故自如，昏旦安足論。所愧素心人，悠然獨舉樽」（《重刊宜興縣志》卷8）。正志子洪昌，崇禎甲戌（1634）進士；孫貞度，順治乙未（1655）進士；曾孫元臣，康熙壬戌（1682）進士。五世科甲蟬聯，先後百年，人稱極盛。

陳所蘊（1543-1626）字子有，上海（今上海市）人，爲官自南京刑部主事，歷湖廣參議、河南參政、山西按察使，至南京太僕寺少卿。著《竹素堂藏稿》十四卷（《四庫全書存目》）、《竹素堂續稿》二十卷（萬曆乙巳刊）。任河南參政時，有《乞歸未遂》詩：「忽忽吾何意，長歌懷隱淪。出真成小草，積竟是前薪。蘆落悲吾道，支離笑此身。菟裘營已久，生計足垂綸」（《明詩紀事·庚籤》卷16，《陳所蘊詩》）。志言其「爲諸生，孝廉即以名教清議爲己任。」及「請老於家，足跡不入公府，削牘不及一私。地方有大利弊，往往以片言抵定。嚴嚴倚重，幾五十載。卒年八十有四」（轉引自《松風餘韻》卷13，《陳所蘊小傳》）。

第三部分鑑藏同好

董其昌以書畫結交天下士，其中很多是具有書畫同好的鑑賞家和收藏家，而較多地集中在檇李和新安兩郡。檇李是明嘉興府的古稱，附郭爲嘉興和秀水兩縣。其地雖屬浙江，而與松江府相接壤。兩府治相距百里而遙，舟楫往還，朝發夕至，交通甚便。董其昌一生數至其地，因而交友也獨多。首敘秀水項氏。

秀水項氏質支世系表

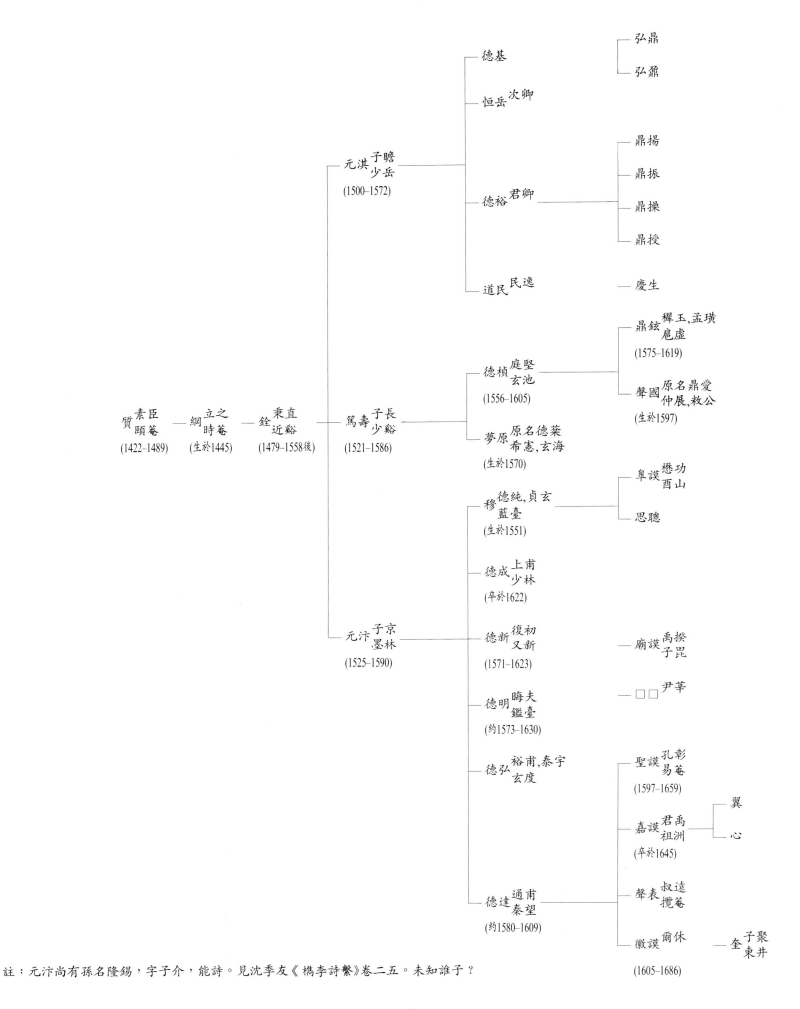

秀水項氏

項元汴（1525-1590）字子京，號墨林，少穎敏，長而「博物嗜古，精繪事，好蓄書畫及鼎彝、尊壺、琴硯、玉器之屬，不惜重賚購取，時人艷稱‘項三麻子’云」（《檇李詩繫》卷13，《項元汴小傳》）。能詩，著《墨林山堂詩集》。家有天籟閣，以藏法書名畫精品著稱於世。董其昌自述與項元汴相交之始，寫道：「憶余為諸生時游檇李，公之長君德純實為夙學，以是日習於公。公每稱舉先輩風流及書法繪品，上下千載，數若列眉。余永日忘疲，即令公亦引為同味，謂相見晚也」（《容臺文集》卷8，《太學項墨林墓誌銘」）。董其昌十七歲學書，凡三年，「比遊嘉興，得盡觀項子京家藏真蹟」（《畫禪室隨筆》，評法書）。據此知董其昌第一次在項元汴家，縱觀所藏晉唐真蹟，當在他年二十歲稍後。他的書法「自此不向碑版上盤桓，直悟入用筆、用墨三昧」了。這是在天籟閣觀摩的結果。而且項元汴的上下千載，娓娓而談，也給他留下了深刻的印象。元汴工書善畫，他給予的評價是，「公畫山水學元季黃公望、倪瓚，尤醉心倪，得其勝趣。每作縑素，自為韻語題之。書法亦出入智永、趙吳興，絕無俗筆」（《容臺文集》卷8，《太學項墨林墓誌銘」）。這也稱得上是知己之言。元汴有六子，大都與董其昌有或淺或深的交往。

項穆（生於1551）原名德純，後以為字，號藍臺，別號貞玄子，元汴長子。國子生，萬曆初以貢官中書。能詩，有《貞玄子詩草》，惜今不可得。《與友人話舊》有句云「半生事業徒殘卷，萬慮消除祇濁醪」（《檇李詩繫》卷15，《項中書穆》詩）。穆書畫有家法，撰《書法雅言》一卷，頗有創見。這書有抄本，比印本多一篇姚思仁（1547-1637）所撰《書法雅言後叙》，有云：「貞元少余四齡，弱冠同業，互相切劇，出入起臥計十載餘，相知之深，莫我二人若也」（《重刻書法雅言》卷後）。又刻有《雙美帖》。他的書法手蹟，今已絕無僅有。姚思仁說「余友貞元妙入其室，縱少復起，何以加焉。」他的書法自然是以王羲之為宗的。

項德成（卒於1622）「字上甫，號少林，元汴次子，官中書，有《靜遠堂詩》」（《檇李詩繫》卷17，《項中書德成》）。能詩。沈季友僅選他的《訪友人》五律一首。「壬戌仲兄少林公歿」（《陳眉公先生全集》卷33，《檇李太學鑑臺項君墓誌銘》），知德成卒於天啓二年（1622）。董其昌是應德成之請，為其父撰墓誌銘，自必在壬戌以前。

項德新（1571-1623）字復初，號又新，元汴三子，受業於馮夢禎之門，工畫山水，著《歷代名家書畫題跋》四卷。汪砢玉說他「博雅好古，翩翩文墨間」（《珊瑚網·名畫題跋》卷18，項德新《墨荷》後題跋）。家有讀易堂，董其昌於萬曆己未（1619）春偕汪砢玉登堂評玩書畫，至《項子京花鳥長春冊》，歎賞久之，遂跋於後，謂寫生「墨林子醞釀甚富，兼以巧思閑情，獨饒宋意」（同上，卷22）。德新收藏宋元畫，陳繼儒於萬曆乙未（1595）六月初四日所見，有顧定之《修篁圖》等九種（《妮古錄》卷3），又董其昌和陳繼儒同觀的趙千里四大幅，「諦視之，乃顏秋月筆」（《畫禪室隨筆》，畫源）。這是在項元汴卒後五年，天籟閣名蹟大概已分為諸子所

藏了。德新山水畫，今尚時可得見。上海博物館藏《絕壑秋林圖軸》署年壬寅（1602），時年三十二；北京故宮博物院藏《桐陰寄傲圖軸》署年丁巳（1617），年已四十七。

項德明（約1573-1630）字晦夫，號鑑臺，元汴四子，諸生。「二十六鼓篋南雍，屢躓不售，患鼻齇，遂絕公車，而好與方衲道者游。屠緯真、王百穀、沈純父、李君實郵筒酒鎗，歲時不絕；而不佞與董玄宰亦時過從，玉蹙金題，未嘗不摩挲竟日也」（《陳眉公先生全集》卷33，《鑑臺項君墓誌銘》）。德明所藏名蹟，今可知者有《盧浩然嵩山十志圖》，萬曆庚戌（1610）十一月二十九日，李日華過其家，曾出相示，記於《味水軒日記》中。越三年壬子（1612）六月四日，李日華將日記出示項鼎鉉，鼎鉉又記於《呼桓日記》中。然此時「此卷歸鎮江張上舍修宇，」不屬德明所有了。德明尚有《山谷老人書廉蘭傳》、《楊弘農書夏熱帖》以及《馬遠單條四幅》（楊妹子題），亦見項鼎鉉《呼桓日記》。德明卒崇禎庚午（1630），年未及六十。

項德弘（生卒待考）字玄度，元汴五子。與兄德明均精鑑賞，富收藏，世其父業。陳繼儒於萬曆乙未（1595）八月二十五日在他家觀賞書畫，記其精品得二十餘件，「皆平生未見之翰墨也。諸蹟中宜以《東坡手柬》六紙為輔，而以懷素《枯笋帖》後有米敷文跋者冠之」（《妮古錄》卷1）。庚戌（1610）十一月二十九日，李日華「過項晦甫、玄度昆季，」「玄度出觀趙吳興《落花游魚圖》，」「又王叔明《花溪漁隱圖》、趙千里《原憲甕牖圖》」（《味水軒日記》，「庚戌十一月二十九日」）。德弘有一次從南京寫信告訴項鼎鉉：「董思白太史於潤州某家得《惠崇卷》、《倪瓚畫》，皆絕佳」（《呼桓日記》卷4，「八月十五日」）。德弘生年當在萬曆元年癸酉（1573）與八年庚辰（1580）之間，崇禎三年庚午（1630）尚在世。

項德達（約1580-1609）字秦望，元汴六子。萬曆三十七年己酉（1609）卒，年約三十。有四子。

項聖謨（1597-1658）字孔彰，號易菴，德達長子，生十三歲而孤。自幼薰習風雅，尤長於畫，後即以畫名。董其昌《評項易菴畫冊》有云：「項孔彰此冊，乃眾美畢臻。樹石、屋宇、花卉、人物，皆與宋人血戰；就中山水，又兼元人氣韻。雖其天骨自合，要亦功力深至。所謂士氣、作家俱備。項子京有此文孫，不負好古鑑賞，百年食報之勝事矣」（《珊瑚網·名畫題跋》卷22）。署年「乙丑，」時聖謨年二十九。此評非但評論了項聖謨的畫，也寄託著對項氏三世的交情。聖謨有張琦合作的《尚友圖軸》（《中國古代書畫目錄》第三冊，第50頁），作於入清後的第八年壬辰（1652）。聖謨題詩並叙，首曰：「項子時年四十，在五老游藝林中，遂相稱許。相師相友，題贈多篇。滄桑之餘，僅存什一。今惟與魯竹史往還，四公皆古人矣。因追憶昔時，乃作《尚友圖》，各肖其神。其晉巾荔服，一手執卷端，一手若指示而凝眸者，為宗伯董玄宰師」（《中國古代書畫圖目》第四冊，第98頁影印項聖謨《尚友圖》）。其餘五人為陳繼儒、李日華、魯得之、釋智舷和項聖謨。叙中稱董其昌為「師，」聖謨當為董氏及門弟子。

項徽謨（1605—1686）字爾休，德達季子，善畫，與兄聖謨齋名，雖獨享大年，而他的畫蹟今已不易得見。子奎，字子聚，號東井，別號牆東居士。“居士不好名，愛讀書，工詩，精繪事”（《己畦集》卷15，《牆東居士生壙誌銘》）。黃傳祖《扶輪廣集》卷十一選項奎《紀秋》七律一首。集刻於順治乙未（1655），項奎已有詩入選，其年必在二十以上，以此推得他的生年當在天啓和崇禎初。至年七十尚在世。《檇李詩繫》卷二十七選項奎詩五首，《畫菊》云：“秋在柴桑舊草堂，不因風雨廢重陽。先生自愛南山好，却借東籬作酒場。”項奎在董其昌卒時年尚幼，以他是項氏書畫的第四代傳人，亦附系於此。

項夢原（生於1570）字希憲，號玄海，元汴仲兄篤壽（1521–1586）季子，萬曆壬子（1612）舉人，己未（1619）進士。繼父兄後，多藏法書名畫。汪砢玉據“陳眉公書畫史諸帙”著錄“項希憲家藏”：《王晉卿瀹山圖》上《小米雲山卷》上《趙千里丹青三昧卷》上《陳居中畫胡笳十八拍卷》上《倪瓚留昌言高尚書堂戲寫此圖并賦贈》上《沈石田水墨三檜卷》上《文徵仲雲山卷》上《仇英傲宋人花鳥山水畫册一百幅》（《珊瑚網·名畫題跋》卷23）。尚有《馬和之邠風一卷》和米芾書《大行皇太后輓詞楷書真蹟》（《妮古錄》卷1和卷4）。

項鼎鉉（1575–1619）初字梓玉，又字孟璜，號凥虛，篤壽孫，德楨長子，萬曆辛丑（1601）進士，選庶吉士，因“中飛語”而去，便不復出仕。居家以“泉石自娛，茗椀盆花，怡心奪目。即狎友滿前，而中心嚴事則皆文人韻士、當世鉅儒也。軒蓋往來，落落寡合，然亦憚公之直口。出入以千帙自隨，編纂十一朝紀事，如高太史《鴻猷錄》上鄭司寇《徵吾錄》”（《學易堂三筆·滴露軒雜著》載《兵部進士從弟凥虛項公行略》）。又著《魏齋佚稿》九卷，《呼桓日記》五卷。鼎鉉好收藏書畫，與董其昌有直接交往。萬曆壬子（1612）六月十九日，董其昌來訪鼎鉉，“急索《萬歲通天真蹟》閱之。”“更出觀《米海岳九帖》上《蔡君謨十幅又四帖》及《海岳雲山卷》。董跋《通天帖》云：‘摹書得在位置，失在神情。此直論下技耳。觀此帖雲花滿眼，奕奕生動，並其用墨之意一一備具。王氏家風，漏洩殆盡。是必薛稷上鍾紹京諸手名雙鉤填廓。豈云下真蹟一等。項庶常藏古人名蹟雖多，知無逾此。又徵仲耄年蠅頭跋，尤可寶也。萬曆壬子董其昌題。’此帖前爲張雨跋，有云：‘雙鉤之法，世久無聞。米南宮謂下真蹟一等。’末小楷跋，則文待詔八十八歲書。故董云然。”“《海岳雲山圖》，董鑒定王晉卿筆，亦未爲確然”（《呼桓日記》卷2，“六月十九日”）。此會董其昌還爲郁伯承嘉慶題所藏《廟堂碑》。又爲鼎鉉作《犀杯銘》，爲書於扇頭。“其書超絕中兼自妍美。”這是項鼎鉉對董其昌書法的贊語。亦可以見他精於書法的鑒賞。

檇李三友

馮夢禎（1548–1605）字開之，號具區，秀水人，萬曆丁丑（1577）會元，殿試二甲第三名，官至南京國子監祭酒，歸田後，“築室孤山之麓，家藏《快雪時晴帖》，名其堂曰‘快雪。’”“爲詩文疏朗通脫，不以刻鏤求工”（《列朝詩集小傳》丁集下，《馮祭酒夢禎》）。著《快雪堂集》六十四卷（萬曆丙辰刊）。夢禎“師事盱江羅近溪，講性命之學。”“紫柏可公以宗乘唱於東南，奉手摳衣，稱幅巾弟子”（《牧齋初學集》卷51，《南京國子監祭酒馮公墓誌銘》）。萬曆初，松江諸子“結爲同社，檇李馮開之每當社期，棹一葉東來，相與授簡分觚，流連文酒，數日夜乃去”（《陳眉公先生全集》卷35，代董其昌撰《繩武何公暨配季孺人墓誌銘》）。原來馮夢禎早就是董其昌的同社兄弟。夢禎雅好法書名畫，精鑒賞，富收藏。《跋王右丞雪霽卷》云：“吳崑麓夫人與余外族有葭莩之親，偶攜此卷見示。述其先得之管後門小火者。火者家有一鐵櫃門閂，或云漆布竹筒，搖之似有聲。一日爲物所觸，遂破，墮三卷，此其一也。余初未深信，翻閱再三，不覺神王。因閉戶焚香，屏絕他事，便覺神峰吐溜，春圖生烟。真若蠶之吐絲，蟲之蝕木。至如粉繢曲折，毫膩淺深，皆有意致。信摩詰精神與水墨相和，蒸成至寶。得此數月以來，每一念及，輒狂走入丈室，飽閱無聲。出戶見俗中紛紜，殊令人捉鼻也。真實居士記於南翰林院之寄樂亭”（《快雪堂集》卷30）。此跋當作癸巳（1593）或甲午（1594），時署南京翰林院。董其昌是乙未（1595）秋“聞金陵有王維江山雪霽一卷，爲馮開之宮庶所收。亟令人走武林索觀，宮庶珍之如頭目腦髓。以余有右丞畫癖，勉應余請。清齋三日，始展閱一過，宛然吳興小幀筆意也”（《容臺別集》）卷4，“畫家右丞如書家右軍”條）。馮夢禎於乙未七月十三日“得董玄宰書，借王維卷閱”（《快雪堂集》卷53，《乙未日記》）。董其昌借得此卷自然在七月十三日以後。馮夢禎有信致董其昌，提到“王右丞雪霽卷久在齋閣，想足下已得其神情，益助出藍之色。乞借重一跋，見返何如？原儀僅如數壁上”（同上，卷64，《與董玄宰太史》）。此信尚未考知何時所寫。董其昌題《王右丞江山雪霽卷》（即“畫家右丞如書家右軍”條），末署“萬曆廿三年歲在乙未十月之望，秉燭書於長安客舍。”此卷何時回到馮夢禎手中，亦無確切年月日的記載，但總是返璧歸趙了。這也是書畫史中的一段佳話，體現了二人的真摯友誼。故爲略記這段書畫因緣的時日。在董其昌任湖廣提學副使期間，馮夢禎又有信致董，前段云：“三楚掄才，想得士爲多。歸途經秣陵，而不得物色一晤，真人紫氣，故不易識也。憶昔追隨湖山浪跡，倏忽五、六年。僕媿如昔，於足下玄詣，當倍倍增進。恨滯留此中，不能從扁舟相邀於吳閶道中，一探秘密藏耳。榮名富貴，轉眼成空。足下超朗，僕所服膺。彼此俱未離障染，須猛著精彩；異時相見，互爲偪拶，共作透網金鱗，豈不快甚！”（同上，卷32，《與董玄宰太史》）。

李日華（1565–1635）字君實，號竹嬾，又號九疑，嘉興人，萬曆壬辰（1592）進士，官至太僕寺少卿。“君實和易安雅，恬於仕進，後先家食二十餘年。能書畫，善賞鑒。一時士大夫風流儒雅、好古博物者，祥符王損仲、雲間董玄宰爲最。君實書畫亞於玄宰，博雅亞於損仲，而微兼二公之長，落落穆穆，韻度顥然，可謂名士矣”（《列朝詩集小傳》丁集下，《李少卿日華》）。“君實著述甚富，工於詩，妙於書，精

於畫"(《無聲詩史》卷4)。著《恬致堂集》四十卷(崇禎丁丑刻本)。日華小於董其昌十歲,而他成進士僅晚於董其昌三年。他同董其昌、陳繼儒的友誼都很深,同秀水項氏不僅同里,且有姻親。"居官日淺,優游田里,以法書名畫自娛"(《明詩綜》卷57)。所以他在詩書畫上都已達到較高的造詣。他爲官也能操守自持,潔身自好。"天啓中,接除書補北膳司,俄晉靈丞,趨命受事,五閱月,璫燄日熾,士大夫懦者染濡,強者摧折,亟竟差以出"(《明詩紀事·庚籤》卷7,《李日華小傳》後陳田按語)。他的《味水軒日記》八卷,"起萬曆己酉正月,終丙辰十二月,凡八年,釐爲八卷。其間所記繙閱書畫,評騭翰墨,十居八九"(《味水軒日記》卷前李肇亨敘言)。所記董其昌的書畫題跋,已有爲人所引用的,尚有題《鼎帖》一跋,爲"甲寅十月二十九日所記。""吳宇賜太學以所藏法帖求跋,松江董太史玄宰已先著語矣。董云:'此爲《鼎帖》至佳本,去《閣帖》不遠。因《裹鮓》、《快雪》二帖,有寶晉曹之格印款,遂强命之《寶晉齋帖》。耳食者類如是。伯樂教子相馬,不相千里馬,但相凡馬。凡馬人易知,而千里馬鮮售耳。余故爲拈出以示鑒者。其昌題'"(同上,卷6)。日華先董其昌一年去世,年七十一。

汪砢玉(生於1587)字樂卿,號玉水,別號龍惕子,又號毗飛居士,歙人,僑居嘉興。父世賢,別號荆筠山人,與項元汴爲友。項元汴爲作《荆筠圖卷》,王穉登於"乙丑秋七月"爲題"荆筠圖"三字,知此卷當作於嘉靖四十四年(1565)以前。家有凝霞閣,貯書畫甚富。砢玉崇禎中官山東鹽運使判官,入清不仕,卒年不詳。他與項氏諸子交好,與項德新尤相契。他小於董其昌三十二歲,及長與董氏相交,以切磋書畫而相知很深。輯所藏所見所聞的法書名畫題跋極爲豐富,編成《珊瑚網古今法書題跋》二十四卷和《珊瑚網古今名畫題跋》二十四卷。二書均自撰叙,前者署"崇禎癸未天中節,"後者署"崇禎癸未嘉平臘,"時距明王朝的覆滅,只有三個多月。他已五十七歲了。董其昌遊嘉興,不止一次造訪汪砢玉。萬曆"丁巳春,董太史玄宰來吾家,鑒賞書畫"(《珊瑚網·名畫題跋》卷18,《項子京荆筠圖卷》諸家題詩後汪砢玉跋)。董其昌也爲他題《荆筠圖卷》七絶一首,詩云:"一派湖州畫裏詩,娟娟風篠兩三枝。今朝汶水帆前雨,正是龍孫長籜時。"越三年,"己未春,董太史過余舍,因觀此卷,著數語後。"這是指董其昌爲題所藏《趙承旨書光福重建塔記真蹟卷》,文曰:"子昂碑版絶似李泰和,余所見無下二十本。此卷筆意虛和,尤可寶也。董其昌題於墨花閣。"而李日華亦有跋,則謂"松雪翁此書,正用薦福道緊之筆,視他本倣泰和者,大不類也"(《珊瑚網·法書題跋》卷8,《趙承旨書光福重建塔記真蹟卷》)。汪砢玉輯錄董其昌的書畫題跋很多,粗略統計,《法書題跋》中董跋三十一則,《名畫題跋》中有九十四則(包括《董玄宰論畫》)。汪砢玉亦能詩。《項氏所藏《管仲姬竹卷》,友人得之,已斷後跋。忽有得其題語者,爲中峰及松雪兩翁手蹟。時反疑爲贗作。爲賦一絶》云:"露葉烟梢幾幅攤,晴窗影落石泓殘。堪嗟書畫金湯失,一樣河山破後看"(《橋李詩繫》卷23,《汪司幕砢玉》)。

新安朋好

新安古郡名,唐爲歙州,宋屬徽州,明爲徽州府,轄歙、休寧、績溪、黟、祁門、婺源等六縣,歙爲附郭縣。府治在問政山與練水之間。新安的經濟和文化,到明萬曆間都已趨於極盛。吳其貞(1607-1677後)曰:"憶昔我徽之盛,莫如休、歙二縣,而雅俗之分在於古玩之有無。故不惜重值爭而收入。時四方貨玩者聞風奔至,行商於外者搜尋而歸。因此所得甚多。其風始開於汪司馬兄弟,行於溪南吳氏、叢睦坊汪氏、榆村程氏所得皆爲海內名器"(《書畫記》卷1)。董其昌爲許國門生,數遊歙休,一登黃山,與新安人士交友獨多。以書畫鑑賞而與董其昌交往者,亦以溪南吳氏、叢睦坊汪氏、榆村程氏爲最著。

歙之西鄉有村名溪南(俗稱西溪南),距縣治三十里,位於發源於黃山的豐樂水之陰,亦稱豐南。吳氏自唐以來即族居於此,子姓蕃衍,爲歙中望族。殷富之家便多風雅之士,而收藏亦最富。董其昌與溪南吳氏交往最密切的,當爲餘清齋主人吳廷。

吳廷(約1555-1626後)譜名國廷,字用卿,號江村,以諸生入贅爲太學生。父尚鈞,字和甫,少孤,以刻意向學,不問生產,家中落。廷"始扶牀"而父卒。其兄國遜字景伯,亦"方齔。"弟國旦字震方,則爲遺腹子。三孤兒全仗母"織紝纂組"以活。及長,"國遜營什一"而家稱"中貲,兩弟始得入泮。"後"用卿則與兄俱之京師,悉出金錢篋笥易書畫鼎彝之屬,鑒裁明審,無能以贗售者。好事家見之,不惜重購,所入視所出什伯千萬"(《大泌山房集》卷102,《吳節母墓誌銘》)。吳氏兄弟便以經營古玩而致富。吳廷與董其昌相交始於萬曆庚寅(1590)。吳廷跋董其昌《瀟湘白雲圖畫卷》有云:"余庚寅之春入都門,得與董玄宰太史周旋往返,乘閒以素綾作橫卷乞畫"(《董華亭書畫錄》著錄《瀟湘白雲圖畫卷》)。翌年秋,吳廷尾董其昌舟南下。在黃河舟中董其昌作《瀟湘白雲圖》以贈。越三年癸巳(1593)董其昌又入京,從吳廷得董源《溪山行旅圖》。吳廷刻《餘清齋帖》始於萬曆丙申(1596),分正篇和續篇,正篇於丙申八月上石,續篇於甲寅(1614)六月上石。董其昌爲作跋十一則,署年最早爲戊戌(1598),最晚爲己酉(1609),所跋當爲正篇諸帖,但亦有刻入續篇的。此帖原石今藏歙縣碑園。丙申以後,吳廷與董其昌或在北京,或在杭州,或在揚州,時相晤面,多有書畫交往。最後一次在天啓丙寅(1626)。董其昌跋《范華原溪橋雪霽軸》云:"泊舟江口,守風八日,吳用卿出城,持此圖見示。"末署"丙寅正月廿七日,其昌識"(《穰梨館過眼錄》卷2,《范華原溪橋雪霽軸》)。董其昌爲吳廷跋《梁摹樂毅論真蹟》,《梁摹》是董所定。吳廷從之,曰"《梁摹樂毅論》爲正書第一。""不知何幸得落余手。王太史宇泰多方欲得之,余實不能割舍。借摹入石,雖曰刻成,與餘清齋石刻差別遠絶。此卷在余所藏三十載,尚未盡知深奧處。偶病閒,細閱數次,神彩煥發,肥瘦相停。余年六十有一,方真知其妙也。"吳廷年六十一,約在萬曆乙卯(1615)。他得此卷約在萬曆丙戌(1586)。又曰:此卷"當同《定武蘭亭》行書第一

並稱。此二卷真是性命可輕，至寶是保。餘清齋有此，藏書之願足矣。子子孫孫宜世守，不負余生平苦心，踪跡海內奇品也"（《珊瑚網·法書題跋》卷1，《梁摹樂毅論真跡》）。董其昌《吳江村像贊》云："圖書彝鼎，琢玉雕金。人食以耳，汝衡以心。璞中剖璧，籫下賞音。苛耶瓚耶，風流可尋。昔人陶隱居云：'不作無益之事，何以悦有涯之生。'庶幾似爾之築，其知爾之深者耶？"（《容臺文集》卷7）。他正是吳廷相知甚深的老友。

吳士諤（生卒待考）字謇叔，一作寒叔，吳廷族弟，父一濬，字惟明，號康虞，父子均與馮夢禎、董其昌爲友。家富收藏。馮夢禎爲《跋孫虔禮千文真蹟》謂係"吳謇叔所藏。首有乾坤圓印，則宋禁中物。"又曰："余素不善草，愧未嘗學。三復此卷，見其筆勢飛動，有遊刃弄丸之妙，不覺心折。《書譜》真蹟尚在天壤間，又不知終能寓目不？謇叔名士諤，余友康虞之子。時萬曆乙巳夏四月上澣日寓溪南吳氏翠帶樓跋"（《快雪堂集》卷31）。董其昌曾記《米元章天馬賦》有四本，並曰："又有中樣一卷，學顏行。余同年王簡討所藏，乃得之吳康虞。康虞即謇叔之父。故寒叔刻此蹟於京師"（《十百齋書畫錄》卯集，《董其昌法書紀略》）。程嘉燧跋《梁摹樂毅論真蹟》，中有云："天啓初，同錢宮諭觀諸河南真蹟於吳寒叔家，以爲妙絕。然字稍大，當知此更逼真矣"（《珊瑚網·法書題跋》卷1，《梁摹樂毅論真蹟》）。知褚遂良臨樂毅論真蹟，天啓初在吳士諤之手。

吳希元（1551-1606）字汝明，號新宇，吳廷族兄。家雄於貲，萬曆中，詣闕獻萬金，授中書舍人。"希元不屑就，退而里居"（《大泌山房集》）卷78，《中書舍人吳君墓誌銘》）。崇禎己卯四月四日，吳其貞觀《楊少師夏熱帖》、《趙千里桃源圖》、《王右軍平安帖》等三種於"溪南吳琛生家。琛生諱家鳳，乃巨富鑑賞吳新宇第五子。弟兄五人，行皆鳳字，時人呼之爲"五鳳，"皆好古玩，各有青綠子父鼎，可見其盛也。琛生善能詩畫"（《書畫記》卷1）。家鳳亦字瑞生，號研舟，工畫山水。北京故宮博物院藏吳家鳳《仿倪瓚耕雲軒圖卷》，題"崇禎乙亥仲夏，擬雲林先生筆意。家鳳。"鈐"瑞生"白文方印與"畫禪"白文長方印。並題七古一首。卷後有謝紹烈、查士標二跋。

吳養春（生卒待考）字百昌，弟養澤，字民望，於吳廷爲族姪。祖守禮，字一達，號石笢，以鹽起家，至養春已雄貲一鄉，有黃山地二千四百畝。以貲爲中書舍人。天啓丙寅（1626），以"黃山大獄"（《民國歙縣志》卷16，《雜記·拾遺》）遭"魏璫之害"慘死獄中，"當日收藏頗多，""皆散去。"但當吳其貞來訪養春長子吳象成時，還出示《李營邱飛雪沽酒圖》、《王叔明竹石圖》、《趙松雪士馬圖》、《李師古高士觀泉圖》和《倪雲林景物清新圖》，吳其貞便買"得其《景物清新》、《飛雪沽酒》二圖"（《書畫記》卷1）。萬曆乙巳（1605）春馮夢禎來歙，三月十二日"到溪南，主江村家園中。""十三，早尚雨，吳氏諸昆季來拜，日宣字季常，府庠生；孝廉士誨、應鴻；中翰二，養春、養都；廷羽，字左干，舊識。"十六日，"江村設讌相款，""諸吳慎卿、寒叔、民望、左干、季常、鄭翰卿俱在座"（《快雪堂集》卷

62，《乙巳日記》）。董其昌數至溪南，與諸吳也都有交往。

距溪南三里許有村名莘墟，在豐樂水北側，亦吳姓族居之地。明正統中，有兵部侍郎吳寧（1399-1482），字永清，佐尚書于謙禦寇保國爲世所稱，即莘墟人。寧的九世孫有吳楨。

吳楨（生卒待考）字周生，幼承家學，好讀書，及長與董其昌、陳繼儒爲友，更喜收藏法書名畫。董其昌在崇禎戊辰（1628）作《墨禪軒說》"寄吳周生，"稱他"坐擁萬卷，博雅好古，尤精八法"（《容臺文集》卷5）。又爲吳楨撰并書《歙西莘墟重修詰贈許氏宜人祖母墓記》（原稿清乾隆中爲金瑗所得，著錄於《十百齋書畫錄》申集，亦收入《容臺文集》卷3），"許氏宜人"即吳寧母。吳楨家藏晉唐法書名蹟甚多，而以王羲之的《澄清堂主帖》上下二巨卷爲最著。康熙中，汪士鈜（1632-1706）有《吳周生家觀右軍澄清堂法帖》七古一首，中有云："華亭尚書極寶惜，石川故物傳太倉，吳君博雅竟購取，更向宿老同平章。宗伯翰墨數稱許，擬之王薛矜弄藏（華亭以王晉卿、薛紹彭爲周生比）。瑯琊橋李與傳桂（周生所居爲傳桂里），風流鼎足堪頡頏"（《粟亭詩集》卷2）。董其昌於崇禎癸酉（1633）《重跋澄清堂帖》謂"澄清堂李後主所刻石"（實爲南宋匯刻），"予己丑獲觀惟此一卷，又四十五年而觀於高司空所"（《容臺別集》卷1）。知此帖崇禎六年尚在北京，而吳楨於崇禎七年甲戌（1634）刻《清鑑堂帖》已將《澄清堂主帖》二卷收入，則此帖爲吳楨所有當在癸酉、甲戌間。《清鑑堂帖》也經董其昌的鑑定，摹刻精致，可與《餘清齋帖》相媲美。現在原石一百零三塊仍完好地保存在歙縣碑園中。

叢睦坊亦簡稱叢睦，位於豐樂水南側，西距溪南約十里，自南宋汪氏族居於此，至萬曆、崇禎間，科第蟬聯，亦臻極盛。

汪宗孝（生卒待考）字景純，"年十六爲邑諸生，以高第受廩。"又"獨好拳捷之戲，緣壁行如平地，躍而騎危瓦無聲，已更自簷下，屹立不知于色。""後謝諸生，籍入太學，徙家廣陵。"於是"用鹽筴起家，不數年金錢繒帛仞積。"更"購名畫法書、先代尊彝鐘鼎，與通人學士，指刺瑕瑜，差別真贋，莫不精審"（《大泌山房集》卷71，《汪景純家傳》）。再徙家金陵，"卜居白門城南，築樓六朝古松下，好蓄古書畫鼎彝之屬。妾孫靈光善鑑別，王伯穀稱之，以爲今之李清照也。"又以"憂時慷慨，期毀家以紓國難。"因稱之爲"江左大俠"（《金陵詩徵》卷40）。董其昌曾記"《虞永興汝南公主誌》，王元美家物，後歸汪景純，今仍在新都"（《十百齋書畫錄》卯集，《董其昌法書紀略冊》）。又今藏北京故宮博物院的唐人國詮《楷書善見律卷》（《中國古代書畫目錄》第二冊，第1頁，董其昌跋曰："余爲史官時，友人以此卷求題，愛其楷法遒媚，與和會不可得。已於黃座師學士碩寬堂再見之，流傳入新安汪宗孝手，三十年始收之篋笥"（《石渠寶笈重編》第一冊，《國詮善見律》一卷）。知此卷在爲董其昌所有之前，曾是汪宗孝藏品。

榆村屬休寧縣，而與歙南西陲相毗隣，兩縣居民交往較爲密切，亦多姻親關係。榆村程氏爲休寧望族。萬曆中，程氏亦有大家巨室，以殷富著稱於休歙，且多博雅好古之士。榆村程氏與同邑商山吳氏均富收藏而著稱。

程季白（名與生年均待考）休寧榆村人，時僑寓嘉興，富收藏，精鑑賞，以書畫與董其昌、陳繼儒、李日華、汪砢玉爲友。萬曆丁巳（1617）二月，董其昌攜《唐宋元寶繪》册至嘉興，項德新、汪砢玉得以在舟中觀賞。此册合計二十板，而以《王維雪谿圖》（第一板）和《李成晴巒蕭寺圖》（第二板）最引人注目。翌年戊午（1618）五月十五日，董其昌跋《晴巒蕭寺圖》，謂"石角有'臣李'等字，余之二十年未曾寓目，茲以湯生重裝潢而得之。本出自文壽承，歸項子京，自余復易於程季白。季白力能守此，爲傳世珍。令營邱不朽，則畫苑中一段奇事"（《珊瑚網·名畫題跋》卷19）。此册歸程季白後，汪砢玉於"己未秋"得"復閱於交遠閣。已去馬文璧一幅、元人著色櫻桃白頭翁鳥一幅，補入王摩詰雪谿圖。用五百金得之青浦曹啓新者，又入王叔明秋林書屋圖。太史因題其籤云，今日始得加一唐字矣。余時錄其題語。未幾，季白遭魏璫毒手，其家裝還歙。壬申冬，聞售於東倉王□□，并叔明青弁圖諸幅，僅償千金，未及原值之半也"（同上，《唐宋元寶繪》後汪砢玉跋）。董其昌有《宋元名家畫册》，計李成小卷、趙大年對幅、荆浩一幅、郭忠恕三幅、趙吳興垂釣圖等。"庚戌十月其昌題"："余最愛吳興公及伯駒小景，皆聞而購之，共得百幅，拔之衆尤，得此廿幅。猶欲去朱銳、曹雲西，未有可易者。二十年結集之勤，亦博得閩中賞玩。人間清曠之樂，消受已多。東坡云：'我薄富貴而厚於畫，豈人情哉？'然授非其人，能不靳固？瑞生有畫才，少年篤嗜，非耳食者，因以歸之"（同上，《宋元名家畫册》）。李日華識云："天啓壬戌元日至十有三日，無日不陰雨冰雪。戚友相過，皆嘘呵瑟縮，無少歡緒。因發猛思，拉徐潤卿、汪玉水，同兒子過程季白齋頭，煮茗團坐，出觀董氏畫册，一一評賞"（同上李日華跋）。這時程季白仍在嘉興。此册已由吳瑞生轉入程季白之手。又董其昌"戊午夏五"跋《宋徽宗雪江歸棹圖》，末云："王元美兄弟藏爲世寶，雖權相跡之不得，季白得之。若遇谿南吳氏，出右丞雪齋長卷相質，便知余言不謬。二卷足稱雌雄雙劍。瑞生莫嗔妒否？"此跋後有汪砢玉記，末云："董跋吳瑞生所有王右丞江山雪齋卷，後竟歸程季白。季白與余善，故獲觀其珍秘"（同上，卷3）。崇禎丁丑（1637）二月十一日，吳其貞同他的從弟亮生來到榆村，在"程正言鼎文室"看到《盧鴻草堂圖》、《洪谷子山水圖》、《郭河陽喬松山水圖》等名畫，附記云："正言諱明詔，季白之子也。季白篤好古玩，辨博高明，識見過人，賞鑑家稱焉。所得物皆選拔名尤。逮居中翰，因吳伯昌遭璫禍，連及喪身七家於天啓六年。子正言遂不守父故物，多售於世。然奢豪與父同，善臨池，摹倪迂咄咄逼真。與予爲莫逆交"（《書畫記》卷1）。程季白與吳養春有戚誼，以黃山一案受牽連，而慘死於天啓丙寅（1626）。他的故物便不時散出。但當吳其貞於戊辰（1628）和己卯（1639）兩次再來時，他的兒子還可以拿出值得吳其貞記下的《趙幹晴冬遊騎圖》、《黃山谷草書古詩》、《蘇子瞻維摩贊魚冠頌》和《柯丹古木竹石圖》等四種。至於那卷《王右丞雪齋圖》，吳其貞也於己卯三月十一日在"榆村程龍生家"看到，"龍生，正言從兄也。數代繁衍，篤好古玩，陳設布置，無不精絕"（同上，卷2）。

再說休寧商山吳氏。商山在休寧縣境的南部，東距屯溪約三十里，居民多吳姓。萬曆、崇禎間經營古玩的骨董商，在《書畫記》中記下的便有三十多人。

吳懷賢（生卒待考）字齊仲，號翼明，吳其貞的族兄。"自少通敏，性慧強項，不肯下人。與兄伯仁、弟復季俱慷慨負俠烈之風，有聲成均。馮司成具區以國士。七困棘闈而著述不少倦"（《陳眉公先生全集》卷43，《特贈工部主事翼明吳公傳》）。天啓初，被薦入史館。助修神、光兩朝實錄，授中書舍人。當逆璫盜竊國柄之時，懷賢髮指眦裂，異常憤慨，長嘆"狐狸滿座，虎豹據闥，惟有涕泗橫流，或歌或嘯而已"（同上）。懷賢亦有收藏，最著的是《周文矩文會圖》大絹畫一幅，是他"以七百緡購於嘉興項氏。其匣蓋上董思白題云：'此畫原陸太宰以千金購之，後爲胡宮保宗憲開府江南，屬項少參籌購此以遺分宜；分宜敗，歸內府；朱太尉希孝復以侯伯俸准得之；太尉沒，項於肆中重價購歸'。此圖在嚴時，湯裱背裝成後，姪日如重裱。見軸桿上題云：'嘉靖庚寅六月望後二日，延陵郡湯曰忠重裝，日如復裱者，朱啓明也'"（《書畫記》卷2）。懷賢的族兄弟中，尚有吳明宸，字中元，號秋蟬，"能臨池，好古玩，家有雷琴曰秋蟬，因號焉。"明本，字師利；明鐸，字元振，萬曆丁酉（1597）舉人；明遠，字伯徵；懷敬，字德聚，由太學入中翰。子姪輩中有吳道榮，字尊生，善詩；道錡，字信叔，嗜古好陳設；道鉉，字聞遠；道昂，字伯昭；祚，字長孺。都是既收藏又做古玩書畫生意的商人。萬曆己酉（1609）二月，董其昌遊黃山，在吳懷賢住了兩個月。題《宋元明集繪一册》，有云："新安吳君翼明，家世好古，收藏唐、宋以來名繪甚富。己酉春仲，予遊黃山，居停君家兩月。以余頗能賞鑑，盡出其所藏相示，且遴其小幅之尤精者匯爲此册，使人惝恍，如遊十洲三島間，洵臥遊之巨觀也哉。雲間董其昌觀并題"（《石渠寶笈續編》第二十二册）。

還要介紹一下其他郡邑的鑑藏同好者。

蘇常二家

王穉登（1535-1614）字百穀，別號玉遮山人。先世晉陵（今江蘇省武進縣）烏氏，後徙蘇州，有贄於王姓者，從其姓，便爲吳人。幼敏慧，十歲屬詩，及長以詩名。與吳江王承父叔承、鄞縣沈嘉則明臣合稱爲萬曆間"三大布衣詩人。"著《王百穀集》四十二卷（萬曆癸卯刊）。又有《南有堂詩集》十卷（崇禎丙子刊）。他"妙於書及篆隸，好交游，善結納"（《列朝詩集小傳》丁集中，《王較書穉登》）。今所見王穉登書法手蹟，大多爲行書，篆隸極少見。家有書齋，顏曰"半偈菴。"文嘉於萬曆癸酉（1573）爲作《半偈菴圖軸》，今藏北京故宮博物院。圖的上部有王穉登書自題詩七律二首。王穉登長於董其昌二十歲，及穉登卒，董其昌年且六十。二人也有較久的友誼。董其昌出任湖廣提學副使，穉登有《送董玄宰督學楚中》七律一首，後四句云："燃藜較藝周南客，負笈傳經魯國儒。宋玉景差才不乏，肯教淪落歎遺珠"（《南有堂詩集》卷10）。臨別贈行，把掄才之望寄於好友，詩就不同於泛

泛的應酬之作。董其昌《鼎帖跋》云："今年春正，在吳閶得王百穀所藏宋搨絳帖，項攜以自隨，疑爲澧州帖。觀其每數十行輒有'武陵'二字，又疑爲鼎帖。及入常武署中，翻閱第一卷，以宋太宗爲弁，跋曰：'太宗皇帝御筆，在絳州摹，爲諸帖之首。'後款曰鼎州提舉，曰沅辰判事。常武爲鼎州，而武陵其附城邑也。乃定爲《鼎帖》。特爲'絳州'二字所誤，而世人只知有絳帖，遂誤名爲絳州帖耳。"末曰："俟他日語百穀，了一公案也。乙巳六月七日，舟次武陵磯，時自常荊校士還武昌書"（《珊瑚網‧法書題跋》卷21）。糧登有四子，幼子無留，亦名留，字亦房，有詩名，年未四十卒。婿文震亨（1585–1645）字啓美，彭孫，"風姿韻秀，詩畫咸有家風"（《列朝詩集小傳》丁集下，《王秀才留》）。

安紹芳（1548–1605）字懋卿，一作茂卿，號研亭，無錫人，國子監生。"所居膠山下西林，山水林樹最美。築館著書其間"（《西林全集》卷前魏禧《西林集叙》）。家道殷富，藏古書畫彝鼎及異書甚多。紹芳工詞翰，善書畫。著《西林全集》二十卷（萬曆己未刻本）。他"繪事傚元鎮、公望、叔明諸家，揮灑盤礡，無一不妙天下"（同上，附錄吳亮撰《太學研亭安公墓誌》）。擅山水，亦工蘭竹。但他傳世的書畫作品，今已不易多見。無錫市博物館藏安紹芳《傚倪瓚疏林遠岫圖軸》（《中國古代書畫目錄》第五冊，第29頁），萬曆己丑（1589）所作；天津市藝術博物館藏安紹芳《蘭竹石軸》（《中國古代書畫目錄》第七冊，第39頁），則爲辛丑（1601）所作。安紹芳長於董其昌七歲，自少年即與董相交。他《與董太史》書，末曰："不佞倦遊，希遁，雌伏衡門，塞兌息交，幾與海鷗爭席矣。何時覓足下於三泖九峰之間，一追夙昔少年豪舉焉。念之神越"（《西林全集》卷17）。

第四部分 同朝、同道和師承

董其昌居官約二十二年，初任翰林院編修，歷六任外放地方官，還朝任太常寺少卿、詹事府少詹事、禮部右侍郎，至南京禮部尚書。上自宰輔，下至主事、縣令，同朝爲官的屈指難以勝數。其中也不乏交往較密、相知較深的好友。有的是東林志士，有的是"禪悅"之友，有的有師承的關係。現在分《同朝知己》、《禪悅之交》和《學術師承》三個子目，擇交往尤密者順次加以簡略介紹。

同朝知己

葉向高（1559–1627）字進卿，號臺山，福清（今福建省福清縣）人，萬曆癸未（1583）進士，官至吏部尚書中極殿大學士。卒謚文忠。著《蒼霞草》十二卷（萬曆丙午刊）、《蒼霞續草》二十二卷（天啓間刊）、《後綸扉尺牘》十卷（天啓間刊）。向高"爲人光明忠厚，有德量，好扶植善類"（《明史》卷240，《葉向高傳》）。兩次入閣，萬曆丁未（1607）十一月以禮部尚書兼東閣大學士入，癸丑爲首輔，甲寅八月致

仕，在閣不到七年。泰昌元年（1620）八月奉召，翌年天啓元年辛酉十月入爲首輔，四年甲子七月致仕，在閣不到三年。再入相，正當魏忠賢擅政，欲興大獄，賴向高與之爭，善類得以保全。但當葉向高、韓爌、朱國楨相繼罷去後，"居政府者皆小人，清流無所依倚。忠賢首誣殺漣，光斗等次等戮辱，貶削朝士之異己者，善類爲一空云"（同上）。

葉向高與董其昌友誼很深。董其昌有《次韻酬葉少師臺山贈行四首》七律，有序云："壬戌秋，奉詔求遺書於陪京，出都門，群公祖餞，各有贈行，少師臺山葉公爲首倡，依韻和之"（《容臺詩集》卷4）。此詩手稿《行書與葉少師唱和詩卷》（《中國古代書畫目錄》第二冊，第51頁），今藏北京故宮博物院。葉向高《答董思白》書，有云："楊公祖來，辱手教，並大書冊葉之惠，輝煌掩映，奪目快心。何意蕭條邸中頓生光怪，真不世之寶也。所稍未饜足而欲爲無已之求者，惟是丹青一幅，懸之室中，使得以一爐香供養，出入頂禮，斯爲滿志耳。極知門下靳此如魏王之符，賓客游說萬端，終不能得，然如姬力能得之。今門下後房佳麗，孰爲如姬，幸以鄙意告之，託爲代請，庶幾可望乎？一笑"（《蒼霞續草》卷19）。如非至交，何能出此方式求畫？在葉向高第二次任首輔期間，他有《答董思白》書，談到修《實錄》問題。很感"修史之難如此，不知神廟實錄他日當作何狀，殊可慮也。"又說"封疆之禍未息，宮府之釁漸開，兵食俱詘，任事無人。外廷欲執名義以繩中貴，中貴復搜瑕釁以摘外廷。主上雖神聖，然朝夕左右皆是若輩。閣臣亦外臣耳。而人責之不已，終難稱塞隱忍，不去決無好結局。鄙意已決，固非翁丈所能挽也。邸報中若搜得軼事以補史局之所未備，自是千秋。願勉爲之。尊駕何時北來，或可於途次一握手乎？"（《後綸扉尺牘》卷8）。這些話只有面對知己，才能如此坦率的傾吐。這時他似乎已經決定要離內閣而去了。因此，這通書札應當寫在天啓四年甲子（1624），已知時事不可爲，便向好友表示了自己的決心。

畢自嚴（1569–1638）字景曾，淄川（今山東省淄博市）人，萬曆壬辰（1592）進士，官至戶部尚書。著《石隱園藏稿》八卷。自嚴年少有才幹，以"經濟兼文章"爲時所稱。工詩文，高珩（1611–1696）兩序《石隱園藏稿》，頗"稱其七言近體分滄溟、華泉之座，""擬其文於韓、蘇，擬其四六於徐、庾"（《四庫總目》卷172，《石隱園藏稿提要》）。畢自嚴少於董其昌十四歲，而登第僅晚於董三年。二人相交，畢自嚴正是青年。到了天啓元年畢自嚴任天津巡撫時，他致書《與董思白》，文曰："目今玉堂金馬之間，雕龍繡虎之彥，指不勝屈；求其胸中磊砢，筆下淋漓，片言而東壁輝騰，隻字而雞林紙貴者，台臺之外，不多見也。比復翔翔留京，提衡國史，擄董狐之直筆，擅班馬之兼長，獨步蓬瀛，永垂琬琰，天下文章，抑孰大於是乎？某以三十年交誼觀茲盛事，抑何幸分華割采而愉快焉。念某猥以駑鈍，承乏津門，昔猶兵餉遞任，今且督撫兩肩，悵無米之難炊，徒循墻而滋懼，鞭策無當，伎倆已窮。冀惟台臺不棄而終誨之，庶幾香屑時垂，迷雲常豁，於以藉手救過萬一乎！"（《石隱園藏稿》卷8）。以"三十年交誼"推之，二人始交正是畢自嚴登朝之日，他初任爲松江推官，也會促使二人更趨接近。

沈思孝（1542-1611）字純父，號繼山，嘉興人，隆慶戊辰（1568）進士，官至右僉都御史。著《沈繼山全集》六卷（清抄本）。史稱"思孝素以直節高天下，然尚氣好勝，動輒多忤"（《明史》卷229，《沈思孝傳》），以故宦途坎坷，晚又以"丁此呂案"而被物議，及"顧憲成、高攀龍力辨其誣，而思孝卒矣"（同上）。引疾歸田後，時與李日華相往還。李於日記中時記其事。萬曆辛亥（1611）五月"六日，澀雨。過沈純父先生，出觀郁彥吉畫《綠蘿莊圖》及雜畫數種。"又"十月朔日，雨。哭沈純父先生。""六日奠沈純父先生。是日先生誕辰"（《味水軒日記》卷3，《辛亥日記》）。據此可知沈思孝的生日和卒年月日。思孝工詩，沈季友稱"其詩格調幽疏，聲文華潔，長於近體"（《檇李詩繫》卷14，《沈思孝小傳》）。董其昌"贈沈繼山司馬"云："一曲鴛湖好，非關請乞來。東山選絲竹，北使問樓臺。鴻向青冥遠，花因白社開。只愁萬目意，黃綺亦難裁"（《容臺詩集》卷2）。

顧憲成（1550-1612）字叔時，別號涇陽，無錫人，萬曆庚辰（1580）進士，官至光祿寺少卿。卒後於崇禎初諡端文。著《顧端文公集》二十卷（崇禎間刊）。憲成姿性絕人，自幼即有志聖學。及罷官家居，偕弟允成（1554-1607）與高攀龍講學於東林書院，海內推爲山斗。而"講習之餘，往往諷議朝政，裁量人物。朝士慕其風者，多遙相應和。由是東林名大著，而忌者亦多"（《明史》卷231，《顧憲成傳》）。天啓中，東林與閹黨相抗爭，便釀成一場延續二十餘年的朋黨之禍。

董其昌與顧憲成的交往，今可從顧憲成致董其昌兩札中見之。兩札都以"學憲"稱董其昌，當作於董其昌萬曆乙巳（1605）至丙午秋任湖廣提學副使期間。《復董玄宰學憲》云："承示方正學先生《求忠書院記》，時且欲就寢，復燒燭讀之，至孔朱忠臣二語，不覺爲之且驚且喜，且喜且驚，遂不覺遙爲之下拜也。曰：有是乎？舉我太祖紀綱一世之精神，及吾夫子紀綱萬世精神，等閒收攝盡矣。此所謂有關係文字也。不肖方當揭諸日月，與天下共之，其何敢私，又何敢謝？謹復。"《與董思白學憲》一札，首曰："向聞楚中督學之命，竊爲楚賀得丈；楚實材藪也，又爲丈賀得楚。"而此札的中心內容，則是爲他的同科進士鄒觀光（字孚如，湖廣雲夢人）請從祀於尚行書院的事。"鄒太僕孚如先生，丈所知也。""其山居之日，特建尚行精舍，與多士相切磋，尤其精神所注。竊以爲宜并祀孚如於此中。非謂孚如藉此爲重，表往者乃以勵來者，俾其邑人士自今以後，世世有所觀感而興起，以不負孚如一片心，實主張世教第一事也。丈以爲何如？久欲相聞，未得良便。適從馮元敏詢有鴻鯉，輒爾投寄。懸知丈有同心，千里一堂，不俟辭之畢也。囑望，囑望"（《顧端文公集》卷4）。

馮時可（約生於1552）字敏卿，號元成，隆慶辛未（1571）進士，官至湖廣參政。他年長於董其昌約三歲，而"弱冠登朝"却早於董十八年。一生仕途所經，"縣薊門歷河洛荊蜀，入夜郎，去國天末，作《西征集》。自粵入楚入浙，往來萬里，歷臬藩三遷，作《超然樓集》。里居吳閶，文譽四馳，又作《天池》、《石湖》、《皆可》、《繡裳》、《北征》諸集。晚年出山西，陟羅浮，南踰金齒，中航彭蠡、洞

庭，作《後北征》、《燕喜》、《溟南》、《武夷》諸集（《康熙松江府志》卷44，《馮時可小傳》）。他的一生踪跡和著作，於此可以概見。後又輯成《馮元成選集》八十三卷。王重民"按是集博大鴻深，爲明代一大家，惜流傳未廣"（《中國善本書提要》，第642頁）。集中收入與董其昌贈答詩多首。《過虎丘與董玄宰編修送元徵庶子北上漫賦却寄》云："開樽懷昔日，與客送行舟。翠鳳翔三閣，玄猿怨一丘。雲天初送月，烟樹又迎秋。曾否江南望，青山好夢遊。"《月夜邀玄宰不至》云："月到幽林景倍妍，期君不至欲淒然。花前短燭無雙影，松際清風有獨絃。殘夢頻搖驚怨鶴，孤吟屢斷咽寒蟬。闌干北斗宵將半，還敞雙扉候馬鞿"（《馮元成選集》卷7）。又有書札四通。《與董太史思白》是在任廣西參政時所寫，叙到"處桂林一歲，處昭州十旬，窮荒岑寂，四顧無徒。然雄長蠻夷，上無相與角，而署齋在屋瀛間，山奇水清，松密竹深，雖簪紱儼然，自有濯纓挂笏意，則亦何所不愜志。"顧見曠達胸懷。《與董思白太史》一札是在湖廣參政任內所寫，首叙"奴自燕歸，過諸鄂城之南。其時楚之侯吏紛紛郊迎，征塵撲面，流汗沾衣，令人肺腸盡俗。及取門下八行讀之，頓如酌金莖之露而坐摩訶池畔也。至於推腹置心，扶顛持隕，即古人所稱石交金契，何殊哉！"中叙"入襄""入郢"的觀感，接著寫道："然漢江之流，注於城隅者，則又直若絃，平若鏡，當夏雨溢而秋水至，混混滔滔，不減揚子津頭，惟此可稱會心處。惜無門下鉅筆以丹青其巖，而藻繡其壑耳"（同上，卷33）。董其昌有《馮元成第觀牡丹》七律一首，小序云："參知元成治第，東有繡佛，西置萬卷。今年牡丹盛開，東西第皆命觴焉"（《容臺詩集》卷3）。惜何時所賦，尚未考知。

邢侗（1551-1612）字子愿，臨清（今山東省臨清市）人，萬曆甲戌（1574）進士，官至陝西行太僕卿。著《來禽館集》二十八卷（崇禎間刊）。邢侗"先世席資鉅萬，美田宅，甲沛水上。子愿築來禽館，在古犛丘上，讀書識字，焚香掃地，不問家人生產。四方賓客造門，户屨恒滿。減產奉客，酒鐺簪珥，時時在質庫中。晚年書名益重，購請填咽，碑版照四裔"（《列朝詩集小傳》丁集下，《邢少卿侗》）。書名齊董其昌、米萬鍾、張瑞圖，時號"邢張米董。""同里王尚書洽，集子愿書，刻《來禽館帖》。濟南風流文采，幾與江左文、董先後照映"（同上）。邢侗亦能詩，但詩名爲書法所掩。陳田評其詩"神清體弱，能張書苑，不足以踞騷壇，以較玄宰諸詩，羞甚過之"（《明詩紀事·庚籤》卷7）。萬曆辛卯（1591），田一儁卒於京，董其昌護柩南下，邢侗有《松江董吉士玄宰以座師田宗伯喪南歸，慨然移疾護行，都不問解館期，壯而賦之》七律一首，末句云："多君古誼兼高尚，碩謝銅龍緩佩魚"（《來禽館集》卷20）。又《題董太史字卷》云："僕生平見玄宰真蹟幾百種。此卷大有李邕、徐浩風，雖小下晉人一等，總之名世業也。是日廣川刺史北卿先生饟至彩筆，遂濡墨爲題此。此時波撼河樓，不減岳陽，惜筆勢不堪作敲"（同上，卷23）。

錢謙益（1582-1664）字受之，號牧齋，晚號蒙叟，又號東澗遺老，常熟（今江蘇省常熟市）人，萬曆庚戌（1610）會

試中式，殿試一甲第三名，崇禎間官至禮部侍郎。南都立，起禮部尚書。弘光乙酉（1645），清兵南下，靦顏迎降，翌年正月，清王朝授秘書院學士兼禮部侍郎，明史副總裁，六月以疾歸。《清史列傳》入《貳臣傳》。著《牧齋初學集》一百卷（崇禎末刊）、《牧齋有學集》五十卷（康熙初刊）。

錢謙益小於董其昌二十八歲，及天啓中，二人同朝爲官，時有往還。錢謙益《李君實〈恬致堂集〉序》首曰："天啓中，余再入長安，海內風流儒雅之士，爲忘年折節之交者，則華亭董玄宰、祥符王損仲、嘉興李君實三君子爲最。玄宰詞林宿素，以書畫擅名一代。其爲人蕭疎散朗，見其眉宇者，以爲晉、宋間人也"（《牧齋初學集》卷31）。《跋董玄宰與馮開之尺牘》云："馮祭酒開之先生，得王右丞《江山齋雪圖》，藏弄快雪堂，爲生平鑒賞之冠，董玄宰在史館，詒書借閱。祭酒於三千里外緘寄，經年而後歸。祭酒之孫研祥以玄宰借畫手書裝潢成冊，而屬余志之。神宗時，海內承平，士大夫廻翔館閣，以文章翰墨相娛樂。牙籤玉軸希有難得之物，一夫懷挾提挈，負之而趨，往復四千里，如堂過庭。九州道路無豺虎，遠行不勞吉日出。嗚呼！此豈獨詞林之嘉話，藝苑之美譚哉！祭酒歿，此卷爲新安富人購去，烟雲筆墨，墮落銅山錢庫中三十餘年。余游黃山，始贖而出之。如豐城神物，一旦出於獄底。二公有靈，當爲此卷一鼓掌也"（同上，卷85）。今所見《初學集》各本均作"江山齋雪，"與《快雪堂日記》、《妮古錄》和《珊瑚網古今名畫題跋》所記爲"雪齋"或"江山雪齋"有所不同。錢謙益游黃山在崇禎辛巳（1641）三月，得《江山齋雪圖》在出山後，而"三月廿四日"已過釣臺東下。此跋當作於東返以後。董其昌"借畫手書"未收入《容臺文集》，今得見於日本小川氏所藏《王右丞江山齋雪圖》卷後附錄董其昌致馮夢禎的三通書札。每通書札後均有馮夢禎手記收到時的年月日。如第一通後記爲"乙未七月十三日，"與《快雪堂日記》所記接到董札的日期正合。札中說到"朱雪蕉來，爲言門下新得王右丞《雪山圖》一卷，大佳。""今欲亟得門下卷一觀。"第二通投到馮夢禎手中時是"丙申二月初十日，"中有云："秋間得遠寄雪圖，快心洞目，深感閣下割愛相成。所恨古意難復，時流易逝，未能得右丞筆法，須少寬之，或稍具優孟衣冠，以不負雅意，更當作一幀，都門面請教也。"這是要求放寬借閱的時間。第三通末署"四月晦日，其昌。"馮夢禎所記收到日期是"甲辰八月初一日。"札中提到"《雪江圖》如武陵漁父，悵望桃源，閣下亦念之乎？"末曰："秋清奉覩，不盡觀縷。"甲辰爲萬曆三十二年（1604），八月董其昌果然來到杭州，二十日在昭慶寺重見此卷，並重題一短跋於前跋之後。所謂"如漁父再入桃源，阿閦一見再見也。"表現了他的滿意心情。日本所藏《王右丞江山齋雪圖》及附錄董其昌書札三通的影印本，見美國亞洲學會出版《亞洲藝術檔案》第三十期（1976-77）所載方聞教授《江山雪齋圖》的長篇論文。錢謙益尚有《跋董玄宰書少陵詩卷》，文曰："陶仲璞守寶慶，強項執法，獲罪岷藩，罷官還滇南，舟中無長物，惟董宗伯所書少陵詩一卷，是其生平所寶愛者，藏弄篋衍，出入懷袖。鬱林太守以廉石壓載，以此方之，彼爲笨伯矣。宋人有渡江遇風者，悉索舟中寶玩畀之，風益急，最後以黃魯直書扇投之，立

止。江神故具眼如此。其視此卷，安知不寶重於南金大貝乎？仲璞其善藏之"（《牧齋初學集》卷85）。

禪悅之交

德清（1545-1623）字澄印，號憨山，全椒（今安徽省全椒縣）人，族姓蔡氏。"年十二，辭親入報恩寺，與雪浪恩公並事無極法師。"相與"留心詞翰，"兼通內外黃老之學。萬曆中，與達觀真可、蓮池袾宏、雪浪洪恩稱"四大高僧。"萬曆戊子（1588）冬，董其昌"與唐元徵、袁伯修、瞿洞觀、吳觀我、吳本如、蕭玄圃，同會於龍華寺，憨山禪師夜談"（《畫禪室隨筆》，禪說）。這是一次"禪悅之會。"董其昌請釋《中庸》"戒慎乎其所不覩，恐懼乎其所不聞"之義。"又徵'鼓中無鐘聲，鐘中無鼓聲。鐘鼓不可參，句句無前後'偈。"對此，"憨山禪師亦兩存之，不能商量究竟"（同上）。諸子與會者，除唐元徵已作介紹外：

袁宗道（1560-1600）字伯修，公安（今湖北省公安縣）人，萬曆丙戌（1586）會元，殿試二甲第一名，官至右庶子。與弟宏道（1568-1610）字中郎、中道字小修，均以詩文名於世，號"公安三袁。"宗道幼承母教，篤信佛法，長更深入禪理。及甲午入都，與董其昌談《中庸》"戒懼"與"覩聞"之關係，他"竟猶洣涬"董其昌之說。

瞿汝稷（1548-1610）字元立，號洞觀，常熟（今江蘇省常熟市）人，以蔭官至太僕寺少卿。汝稷"博學無所不窺，尤邃於內典，一時推爲總持"（《列朝詩集小傳》丁集下，《瞿少卿汝稷》）。

吳應賓（1564-1634）字尚之，號觀我，別號三一老人，桐城（今安徽省桐城縣）人，萬曆丙戌（1568）進士，官翰林院編修，與錢謙益同受法於憨山德清，爲幅巾弟子，是一位主張三教合一的學者。

吳用先（生卒待考）字本如，桐城人，萬曆壬辰（1592）進士，曾任臨川知縣，與湯顯祖爲友。湯顯祖有《與吳本如岳伯》書，有云："惟清惟惠，可以富民；能富其民，乃以見思，則門下之謂矣"（《湯顯祖詩文集》卷47）。

真可（1543-1603）字達觀，號紫柏，吳江（今江蘇省吳江縣）人，族姓沈氏，年十七至蘇州，投虎丘僧舍，設齋剃髮。二十從講師受具戒。後游五臺，至京師，參徧融、笑巖諸老。嗣復由吳至燕，西游峨眉，下至廬山，所至護持正法，人以爲"人天師。"萬曆庚子（1600）再入都門。"及妖書獄起，逮師入詔獄，""師既被笞，血肉狼藉，笑曰：'世事如此，久住何爲？'索浴說偈，堅坐而逝。癸卯之十二月也"（《列朝詩集小傳》閏集，《紫柏大師可公》）。董其昌記初謁達觀真可，曰："達觀禪師，初至雲間，余時爲諸生，與會於積慶方丈。越三日，觀師過訪，稽首請余爲思大禪師大乘止觀序。曰：'王廷尉妙於文章，陸宗伯深於禪理，合之雙美，離之兩傷，道人於子，有厚望耳。'余自此始沉酣內典，參究宗乘；復得密藏激揚，稍有所契"（《畫禪室隨筆》，禪說）。董其昌的"通禪理"蓋始於此。"後觀師留長安，余以書招之，曰：'馬上君子無佛性，不如雲水東南，接引初機利

根，紹隆大法。'自是不復相聞。癸卯冬，大獄波及，觀師搜其書。此書不知何在。余謂此足以報觀師矣"（同上）。"師化後，暴露待命六日，自春及秋，霖雨漂浸"（《列朝詩集小傳》）。這項冤獄對於這位高僧是十分慘酷的。

李贄（1527-1602）字宏甫，號卓吾，別號溫陵居士，晉江（今福建省晉江縣）人，嘉靖壬子（1552）舉人，官至姚安知府。"與黃安耿子庸善，罷郡遂客黃安。子庸死，遂至麻城龍潭湖上，閉門下楗，日以讀書爲事。"後爲"馬御史經綸，迎之於通州，尋以妖人逮下詔獄。獄詞上議，勒還原籍。卓吾曰：'我年七十有六，死耳，何以歸爲？'遂尋薙髮刀自剄，兩日而死"（《列朝詩集小傳》閏集，"異人三人"《卓吾先生李贄》）。錢謙益以"卓老風骨稜稜，中燠外冷，氽求理乘，別膚見骨，迥絕理路，出語皆刀劍上事，獅子送乳，香象絕流，真可與紫柏老人相上下"（同上）。董其昌與李贄有過直接的交往。"李卓吾與余以戊戌春初，一見於都門外蘭若中。略披數語，即評可莫逆。以爲眼前諸子，惟君爲正。知見某某，皆不爾也。余至今愧其意云"（《畫禪室隨筆》，禪說）。

湯顯祖（1550-1616）字義仍，號若士，一稱海若，臨川人，萬曆癸未（1583）進士，官終遂昌（今浙江省遂昌縣）知縣。"生而穎異不群。體玉立，眉目朗秀。""於書無所不讀，而尤攻漢魏《文選》一書，至掩卷而誦，不訛隻字。於詩若文無所不比擬，而尤精西京、六朝、青蓮、少陵氏。""又以其餘緒爲傳奇，若《紫簫》、二《夢》、《還魂》諸劇，實駕元人而上"（沈際飛輯《玉茗堂選集》卷首載郁迪光撰《臨川湯先生傳》，亦見《湯顯祖詩文集》下冊，《附錄·傳》）。"義仍志意激昂，風骨遒勁，扼腕希風，視天下事數看可了。""晚事師盱江而友紫柏，翛然有度世之志。胸中魁壘，陶寫未盡，則發而爲詞曲。四夢之書，雖復留連風懷，感激物態，要於洗蕩情塵，銷歸空有，則義仍之所存略可見矣"（《列朝詩集小傳》丁集中，《湯遂昌顯祖》）。著《玉茗堂文集》十卷、《詩集》十八卷。徐方朔輯爲《湯顯祖詩文集》五十卷。

湯顯祖與董其昌相交不知始於何時。萬曆乙未（1595）二月，湯顯祖以遂昌知縣赴京上計歸，作《乙未計遽，二月六日同吳令袁中郎出關，懷王衷白、石浦、董思白》七絕一首，詩云："四愁無路向中郎，江楚秦吳在帝鄉。不信關南有千里，君看流涕若爲長"（《湯顯祖詩文集》卷12）。又在《重得亡蘧訃二十二絕》中第七首云："乙未拋辭再不同，丁春重見亦匆匆。淞嘉大有相援意，不敢題書報董公。"詩後注云："先是華亭董玄宰語嘉興弟子許生應培，教遊太學許爲地道意，追念之"（同上，卷14）。蘧即顯祖長子士蘧，卒年二十三。詩作於萬曆庚子（1600），蘧當生於萬曆六年戊寅（1578）。湯顯祖尚有《寄董思白》二札，其一云："卓、達二老，乃至難中解去。開之、長卿、石浦、子聲，轉眼而盡。董先生閱此，能不傷心？莽莽楚風，難當雲間隻眼。披裂唐突，亦何與於董先生哉。形家饒生上謁，十年通此一字。生願而爽，要離塚傍，亦可用也"（同上，卷47）。此札雖未署年，然必作於萬曆乙巳（1605）十月以後。札中已故六人，去世最後的是馮夢

禎，他卒於乙巳十月二十二日。其餘五人，卒年順次爲王子聲一鳴，萬曆丙申（1596）；袁石浦宗道，萬曆庚子（1600）；李卓吾贄，萬曆壬寅（1602）；真可，萬曆癸卯（1603）；屠長卿隆，萬曆甲辰（1604）。

學術師承

董其昌的書畫藝術淵源是頗爲深遠的。他自言："余十七歲時學書，初學顏魯公《多寶塔》，稍去而之鍾王，得其皮耳。更二十年學宋人，乃得其解處"（《畫禪室隨筆》，論用筆）。他於宋人書，似更傾向於米芾。畫則以北宋人董源爲宗，上溯於唐，尊王維爲文人畫之祖。下於元四家，則"少學子久山水，""今閱一做子久，亦差近之"（同上，畫源）。這是就師古人而言的。至於親承其教的師門，其著者有陸樹聲、莫如忠和王錫爵，前均有所論述。現僅就所知，一述他的門生或藝術傳人。在他的門生中，有張清臣者，在他的書畫題跋裏常可見到這個名字，《書自敘帖題後》云："米元章書多從褚登善悟入。登善深於蘭亭，爲唐賢秀穎第一。此本蓋其衣鉢也。摹授清臣。清臣其寶之"（同上，跋自書）。又《題張清臣集扇面冊》云："余所畫扇頭小景，無慮百數。皆一時應酬之筆。趙子昂亦有做爲之者，往往亂真。清臣此冊，結集多種，皆出余手。且或有善者，足供吟賞。人人如此具眼，余可不辨矣"（同上，題自畫）。張清臣正是一位能辨別董畫真僞的具眼人。何三畏在《簡董玄宰太史》書中提到"高足張清臣歸，知起居之詳"（《芝園集》卷22）。但張清臣的名爲何，里居何地，何時從業於董其昌，都尚未考知。只能在此略一提及其人而已。下面所述，則是確曾得董的指授，或受其直接影響較大的。

程嘉燧（1565-1644）字孟孺，號偶菴，晚號松圓老人，歙之長翰山人（長翰山地近休寧縣境，從錢謙益起，許多載籍都誤作休寧人），僑居嘉定（今上海市嘉定縣），老歸故里。工詩。著《松圓浪淘集》十八卷、《偶菴集》二卷、《耦耕堂集》五卷，清康熙間，王士禛選《程孟陽集》四卷，與吳兆《吳非熊集》合刻爲《新安二布衣詩》八卷（康熙甲申刊）。他是"畫中九友"之一，"善畫山水，兼工寫生"（《列朝詩集小傳》丁集下，《松圓詩老程嘉燧》）。山水畫取法倪瓚，以簡淡爲宗。影響新安畫家，明末清初便有所謂"天都派"，他就是這一派的開創人之一。他藏倪瓚"霜林遠岫圖"，有詩云："蕭疎遠岫雲林畫，映帶清流內史書。"夾注曰："余攜倪迂《霜林遠岫》及《定武帖》，皆師所賞愛"（《新安二布衣詩》卷7，《三月三日泊虞山尋等慈師不遇》）。他《題董宗伯畫冊後》謂董其昌"又曾過余家索觀倪雲林《霜林遠岫》"（《偶菴集》卷2）。

李流芳（1575-1629）字長蘅，號檀園，歙之西溪南人，僑居嘉定。萬曆丙午（1606）舉人。"長蘅爲人，孝友誠信，和樂易直，外通而中介，少怪而寡可，與人交，落落穆穆，不爲翕翕熱。""長蘅書法規橅東坡，畫出入元人，尤好吳仲圭。其於詩，信筆書寫，天真爛然，其持擇在斜川、香山之

間；而所心師者，孟陽一人而已"（《列朝詩集小傳》丁集下，《李先輩流芳》）。著《檀園集》十五卷。流芳與程嘉燧爲中表兄弟，而小於程十歲，故於詩畫均心折於程。每語錢謙益："精舍輕舟，晴窗淨几，看孟陽吟詩作畫，此吾生平第一快事"（《牧齋初學集》卷85，《題長蘅畫》）。

李流芳小於董其昌二十歲，二人爲忘年交。董其昌稱"長蘅以山水擅長，其寫生又有別趣，出入宋元，逸氣飛動"（轉引自《明詩紀事·庚籤》卷4，《李流芳小傳》後輯各家評論）。錢謙益《題武林鄒孟陽所藏李長蘅卧游畫册》有句云："山堂懷人更感舊，摩挲畫册流涕淺，山中宿昔共游燕，酒痕墨瀋猶班班。""石田詩句拂雲浪，大癡粉本留屏顏。漳收漁莊淥照水，霜酣寶霰紅滿灣。海山雲氣互吞吐，羽人仙客時往還。石田大癡尚未死，共捉麈尾戴白綸"（《牧齋初學集》卷16）。詩作於崇禎庚辰（1640）春，時距李流芳下世已十二年了。及至順治壬辰（1652），吳偉業作《畫中九友歌》，在寫到李流芳時，曰："檀園著述誇前修，丹青餘事追營邱。平生書畫置兩舟，湖山勝處供淹留"（《吳梅村全集》卷11，《詩後集三》）。末句當指李流芳"性好佳山水，中歲於西湖尤數"（《牧齋初學集》卷54，《李長蘅墓誌銘》）。流芳多材多藝，"萬曆間，雪漁何震以印章著稱。長蘅戲爲之，遂與方駕，真敏而多能者也"（《無聲詩史》卷4）。何震（1535-1604）字主臣，號雪漁，婺源（今江西省婺源縣）人，工篆刻，與文彭（1498-1573）齊名，世稱文何。

王時敏（1592-1680）字遜之，號煙客，自號歸村老農，又號西廬老人，學者稱西田先生，太倉人，衡子。年十八與十九，父與祖先後卒，時敏以蔭官至太常寺少卿。崇禎庚辰（1640）因病歸。入清高尚不仕，而以畫獨享盛名，居"四王"之首。時敏能詩文，"於尺牘師蘇子瞻、黃山谷，於詩倣白香山、陸渭南"（《吳梅村全集·文集》卷15，《王奉常煙客七十序》）。著《王煙客集》十卷。書工八分。"玄宰署書爲古今第一，顧以八分推許奉常，語陳徵君曰：'此君何所不作，吾當避舍'"（同上）。畫則獨擅山水。"自髫時便游娛繪事。乃祖文肅公屬董文敏隨意作樹石，以爲臨摹粉本。南宮、華原、營邱，樹法石骨，皴擦鈎染，皆有一二語拈提，根極理要"（《明詩紀事·辛籤》卷27上，《王時敏小傳》後引自《甌香館集》）。其後一意臨摹家藏宋、元名蹟，獨宗黃公望，得董其昌的真傳。吳偉業《畫中九友歌》就是以董其昌爲首，而王時敏次之。"董宗伯每見公作，必讚歎題識，有'蒼秀高華，奪幟古人'之稱"（王寶仁《王煙客年譜》後跋）。時敏平生之作，倣古爲多。然亦有他獨到的見解。如在《爲子顓菴仿古册》的跋中便寫道："諸幀雖借古人之名，漫爲題仿，實未能少窺其藩；然坡公有言：'論畫以形似，見與兒童鄰。'則臨摹古蹟，尺尺寸寸而求其肖者，要非得畫之真。山谷詩云：'文章最忌隨人後，自成一家始逼真。'正當與坡語並參也"（《過雲樓書畫記》卷10，畫類6，《西廬老人爲子顓菴仿古册》）。

王時敏小於董其昌三十七歲，及董卒年已四十五。從游時間在二十年以上。且有一段時間同朝爲官。世誼師門，往還當很密切。天啓丁卯（1627）四月七日，董其昌偕陳繼儒同至太

倉，過王氏南園繡雪堂，話雨留宿。董題"話雨"二字於壁。王時敏有"思翁、眉公過繡雪堂，話雨留宿"詩紀其事，詩云："滿徑綠陰靜，清和景最佳。微風歸宿燕，細雨落輕花。老友不期至，清言何以加？酒酣餘逸興，粉壁走龍蛇"（轉引自《清畫家詩史》甲上）。末句當指董其昌題壁"話雨"一事。時董年七十三，陳年七十，時敏也已三十六了。這是董、陳晚年來訪王時敏，留宿王氏南園的一次紀錄。到了董其昌病逝之後，陳繼儒便很快把這一噩耗通知王時敏，這份書札的手蹟至今還完好地保存在人間，可以確證董其昌去世的年月日。董其昌與太倉太原王氏的三世交情，更可藉此而永垂千古。

楊文驄（1597-1646）字龍友，號山子，貴州衛（今貴州省貴陽市）人，家秣陵，天啓辛酉（1621）舉人。崇禎間，官華亭教諭，改青田、永嘉、江寧知縣；弘光時，由兵部主事，歷員外、郎中，遷兵備副使，擢右僉都御史，巡撫常、鎮；隆武時，拜兵部侍郎，進浙、閩總督。以抗清兵敗，被執，不屈死。文驄工詩，著《山水移》、《洵美堂集》。周亮工曰：《龍友工畫，善用墨，初爲華亭學博，從董文敏精畫理。然負質頗異，不規規雲間蹊徑也"（《讀畫錄》卷3，《楊龍友》）。文驄官華亭教諭在崇禎甲戌、丁丑間，時正董其昌致仕家居，得以親承董其昌的指授。他在"乙亥春日"所作贈"潭公"的《山水卷》，董其昌於三月跋曰："點綴九峰佳境，直將以家山私之，又懼不克任受也。謂與屏風九叠爭秀，因而盧阜之"（過雲樓續書畫記》卷5，《楊龍友山水卷》）。這卷畫的是雲間山水，所以董其昌"賞愛之深，何等切至"（顧麟士語）。文驄在"崇禎丙子元旦畫於雲間竹居"的《台蕩圖》軸，董其昌跋謂"龍友所作《台蕩圖》，出入惠崇、巨然之間。"並題詩於其上："別一山川眼更明，幽居端的稱高情。從來老筆荊關意，施粉施朱笑後生"（《過雲樓書畫記》卷9，《楊龍友山水軸》）。這時楊文驄年近四十，畫藝已相當成熟。所謂"從董文敏精畫理，"主要是在理論上的請益。他《與董玄宰先生論筆墨》云："惜墨不在墨，要知先惜水。苦心不問手，對鏡豈謀紙。君潑墨時，濃淡皆有理。毫端噓董巨，硯池活范李。滴滴生氣飛，尺幅幾千里"（轉引自《明詩紀事·辛籤》卷6上，《楊文驄詩》）。宋祖謙《與盛丹》書有云："董宗伯常有言：作畫不惟惜墨，亦當惜水"（《尺牘新鈔》卷1，《宋祖謙尺牘》）。文驄詩的前二句正是用的董其昌的這句話。而且有些畫理，他是通過親自觀察董其昌作畫而得到體會的。他有《題畫》詩云："一抹山林水一灣，幽人情性頗相關。胸中自寫塊礧氣，筆底何妨斧鑿斑。生卷老雲皴白石，不將媚骨點青山。便如個裏幽棲客，更要何人相往還"（《明詩紀事·辛籤》卷6上）。董其昌稱讚他的畫"有宋人之骨力，去其結；有元人之風韻，去其佻"（《容臺別集》卷4）。這是符合實際的。他最早的畫是"丙辰二月爲無功社兄畫"的《山水卷》（《過雲樓書畫記》卷9，《楊吉州贈無功山水卷》），是年二十。今存於世的，最晚是作於崇禎壬午（1642）的《仙人村塢圖軸》，北京故宮博物院所藏（見《中國古代書畫目錄》第二册，第70頁）。《畫中九友歌》云："阿龍北固持長矛，披圖赤壁思曹劉。酒醉灑墨橫江樓，蒜山月落空悠悠。"文驄開府常、鎮，駐兵京口，在弘光乙酉

春，時邢昉、萬壽祺、程邃、方文等都來相聚，戎馬倥傯，臨江灑酒，兕觥高歌，諸家均有詩紀其事。

王鑑（1598-1677）字玄照，一作圓照，號湘碧，太倉人，王世貞曾孫，由恩蔭歷部曹，出知廉州府，世稱「王廉州。」入清不仕，以畫與王時敏齊名。「誰其匹者王廉州，神姿玉樹三山頭。擺落萬象烟霞收。尊彝斑駁探商周。得意換卻千金裘。」《畫中九友歌》正是在緊接王時敏之後就寫到他。他的同里友人王弘導贈他的詩，有句云：「畫推北苑仍宗伯，家寄東林是故侯」（《婁東耆舊傳》，轉引自《吳梅村先生詩集》卷7，《送王元照還山》第二首詩末箋）。前一句是說，他的畫雖然可以遠溯到北宋人董源，實際卻仍然是從董其昌脫胎而來。他以世家晚輩而及見董其昌，董的畫學理論和實踐自然都會對他有一定的影響。順治甲午（1654），王鑑「偶來京師，」吳偉業有《送王玄照還山》七絕八首，其五云：「布衣懶自入侯門，手跡留傳姓氏存。聞道相公談翰墨，向人欲訪趙王孫。」其六云：「朔風歸思滿蕭關，筆墨荒寒點染間。何似大癡三丈卷，萬松殘雪富春山。」又有《再送王玄照》云：「行止頻難定，裝輕忽戒途。望人離樹立，征棹入雲呼。野色平沙雁，朝光斷岸蘆。此中蕭瑟意，非爾不能圖」（《吳梅村先生詩集》卷7）。在吳偉業看來，王鑑是能夠用自己的筆寫出見景生情的胸中「蕭瑟」之感的。當然也不妨以做古的形式來描述出來。一般地說，王鑑畫確有很多是做古的。例如，北京故宮博物院藏王鑑畫三十八件中，有二十件便在標題上明著做古字樣（《中國古代書畫目錄》第一冊，第83-84頁）。上海博物館藏王鑑畫六十七件中，有三十四件便在標題上明著做古字樣（《中國古代書畫目錄》）第三冊，第58-60頁）但他在繪畫上所下的功夫是深厚的。王翬（1632-1717）跋他的畫云：「吾師廉州王公筆墨妙天下，此做趙文敏《九夏松風圖》，設色幽秀，神韻超逸，兼得北宋高賢三昧。」（《過雲樓書畫記》）卷10，畫類6，《王圓照仿趙文敏九夏松風圖軸》）。黃賓虹曰：王鑑「精通畫理，摹古尤長。凡唐宋元明四朝名繪，見之輒為臨摹，務肖其神而止。故其蒼筆破墨，時無敵手。丰韻沉厚，直追古哲。於董北苑、僧巨然兩家，尤為深造」（《古畫微》第13節，《清初四王吳惲之復古》）。王鑑走的正是董其昌所指出「從北苑築基」的路子。

鄭元勳（1598-1645）字超宗，號惠東，歙之長齡橋人，家江都，占籍儀徵，崇禎癸未（1643）進士，乙酉（1645）卒後三日始有兵部職方之命。元勳與叔弟元化字贊可、季弟俠如字士介均饒於貲，各有家園，以為親朋吟咏遊賞之地。元勳有影園，元化有嘉樹園，俠如有休園，兄弟便以園林相競，盛極一時。元勳工詩文，著《影園詩稿》二卷，輯《影園瑤華集》三卷（乾隆癸未刊），所輯《媚幽閣文娛》，選載董其昌的《閒窗論畫》十一則，編在「雜文」一類之中。鄭元勳跋其後云：「國朝畫以沈石田、董思白為正派，可以上接宋、元。觀其立論，故自尚友千古，不墮甜邪坑塹也。」他自己作畫，自然要奉「正派」為圭臬；在畫理上，他自然也會傾心於董其昌的「立論。」在《文娛自序》中，他寫道：「戊辰冬，過雲間，私視眉公先生，若有甚獲其心者，愛而欲傳，援牘為序。」戊辰為崇禎元年（1628），冬他來到松江，請陳繼儒為

《文娛》作序；並且去到董家看過畫，卻沒有見到董其昌。後董在《跋鄭超宗畫卷》中提到：「超宗遊雲間，欲觀吾家所收諸畫。會余滯留吳門，且迫歲除，不能多待。家有裝池未竟二、三卷，就裱工閱之。如子猷看竹，不問主人也。茲余赴闕，過廣陵，超宗出示此卷。筆法出入子昂、子久、叔明、元鎮間。又如江淹夢中見景純索錦，恨其裁割都盡。海內畫苑添此國能士氣作家，當入鄧氏《畫繼》（六卷本《容臺別集》卷2）。董其昌應召「赴闕」在崇禎四年辛未（1631），北上途中到揚州是十一月。此跋當是應鄭元勳之請而作的，對鄭元勳的畫以其「筆法出入子昂、子久、叔明、元鎮間」而稱許為「國能士氣作家。」足見董其昌對這位後輩在畫學造詣上的另眼相看。鄭元勳畫今已不多見。蘇州博物館藏有兩件，一為《臨石田山水軸》，作於崇禎辛未（1631），時年三十四；一為《為鏡月作山水扇頁》，作於辛巳（1641），時年四十四（見《中國古代書畫目錄》第五冊，第7頁）。南京博物院藏鄭元勳《紀遊山水圖冊》八開，作於甲戌（1634）；年三十七（同上，第98頁）。北京故宮博物院藏鄭元勳《山水扇頁》，作於壬午。時年四十五（同上，第一冊，第75頁）。

程正揆（1604-1676）本名正葵，字端伯，號鞠陵，又號青溪道人，孝感（今湖北省孝感市）人，崇禎辛未（1631）進士，歷官尚寶寺卿。入清更今名。官至工部侍郎。工詩文，著《青溪遺稿》二十八卷（康熙乙未刊）。「書法師李北海，而丰韻蕭然，不為所縛」（《讀畫錄》卷2，《程正揆》）。工畫山水。他有《題畫》詩云：「高士聞風三百年，今從清閟得神傳。偶拈枯管學迂法，只恐青山笑未然」（《青溪遺稿》卷14，《題畫九首》之一）。這也是說，他學倪而又不為倪所縛。他的最有名的畫是《江山臥遊圖》。「嘗欲作《臥遊圖》五百卷，十年前，余已見其三百幅矣。或數丈許，或數尺許，繁簡濃淡，各極其致」（《讀畫錄》卷2）。今存世的，北京故宮博物院尚有十卷，最早作於順治辛卯（1651），最晚作於康熙丙辰（1676）（《中國古代書畫目錄》第二冊，第87頁）。前後二十七年，同一題材，而創作出近五百卷的畫圖，這也是亙古所未有的。張庚（1685-1760）說他「喜山水，初師董華亭，得其指授，後則自出機杼，多禿筆，枯勁簡老，設色濃湛」（《國朝畫徵錄》卷上，《程正揆》）。姜紹書說得更具體：「是時，董宗伯思白為風雅儒師，先生折節事之，虛心請益。董公益雅愛先生，凡書訣畫理，傾心指授，若傳衣鉢焉」（《無聲詩史》卷4）。他在《書王摩詰江干雪霽圖卷後》中寫道：「崇禎壬申年，先生以宗伯應召，攜此圖入都，好事每求一見，弗得；惟余往，先生必出圖相示，展玩必竟日，且為指授筆墨三昧處，謂荊、關、董、巨皆從此出，若繪事不見摩詰真面目，猶北行不見斗也」（《青溪遺稿》卷23）。程正揆小於董其昌四十九歲，而當他成進士時，年已二十八，詩、書、畫都有較好的根柢。翌年壬申（1632），董其昌在北京時，他便有機會親承董氏之教。這無疑對他的書法和繪畫都會有所影響。但他並沒有完全按照董其昌的路子走下去。他的畫風從清潤明秀走向石濤（1642-1707）所稱的「高古。」

吳偉業（1609-1672）字駿公，號梅村，太倉人，崇禎辛未（1631）進士，殿試一甲第二名。入清，官至國子監祭酒。

與錢謙益、龔鼎孳合稱江左三大詩人。著《梅村集》四十卷（康熙庚戌刊）縱觀諸家爲他所撰的傳記，無不暢論他的詩，偶有言及他"雅善書，尺牘便面，人爭藏弄以爲榮"（《吳梅村全集》卷後《附錄一》，顧湄《吳梅村先生行狀》）。却沒有提到他亦善於畫的。只有周亮工（1612-1672）說到他"不多爲畫，然能萃諸家之長，而運以己意，故落筆無不可傳者"（《讀畫錄》卷1，《吳梅村》）。實際上，他生平作畫恐怕也不少。今存於世的，北京故宮博物院有八件，上海博物館有四件。以這十二件而論，署年最早的是上海所藏作於壬辰（1652）的《南湖春雨圖軸》（《中國古代書畫目錄》第三冊，第62頁），光緒間爲蘇州顧文彬所有，著錄於《過雲樓書畫記》卷九，畫類五，圖上方自書《鴛湖曲》一詩，爲重游嘉興，有感而作。稱得上是一幅書畫合璧傑作。署年最晚的是北京所藏作於丁未（1667）的《爲舜工作山水軸》（《中國古代書畫目錄》第二冊，第89頁）。

吳偉業小於董其昌五十四歲。他自言："董爲江南望族，余猶及見大宗伯文敏公，館閣老成，文章書畫妙天下"（《吳梅村全集》卷30，《董蒼水詩序》）。他寫的《畫中九友歌》，以董其昌爲開篇："華亭尚書天人流，墨花五色風雲浮。至尊含笑黃金投，殘膏剩馥雞林求"（同上，卷11）。他還有《題思翁倣趙承旨筆》七絶一首，詩云：佘山雲接弁山遙，苕雲扁舟景色饒。美殺當時兩文敏，一般殘墨畫金焦"（同上，卷20）。

綜合全篇所述董其昌的交游，從出生於一五〇九年的陸樹聲到出生於一六〇九年的吳偉業，整整一個世紀，共得九十九人。至此本文該可結束了。但還有一位不能列入本文框架，而確實稱得上是董其昌最爲密切的好友，他就是著作等身的江陰學者夏樹芳。而如果遺漏了他，那對敘述董其昌的交游，便是一大憾事。特將介紹如下：

夏樹芳（1551或1556-1635）字茂卿，號習池，江陰（今江蘇省江陰市）人，萬曆乙酉（1585）舉人。以母老不赴公車，隱居崑山，以教授生徒爲生。工詩文，勤著述。著《消暍集》二十卷（崇禎間刊）、《詞林海錯》十二卷（萬曆戊午刊）、《茶董》二卷、《酒顛》二卷，董其昌均爲他分別作序或引。董其昌稱夏樹芳爲"今之柴桑翁，"並且認爲他和陶潛"兩君子出處之際，一如閒雲，一如介石，一如連林之獨樹，一如在谷之幽蘭，而間有小異，不害爲善學者"（《容臺文集》卷1，《消暍集序》）。對夏樹芳的爲人和爲學，真可謂推崇備至了。在《消暍集》中，與董其昌有關的詩文有詩十五首，詞二闋，序跋二篇，書札二十四通，可見二人交往之密切。《鳳凰臺上憶吹簫·遲董太史到山莊不至》云："春去秋來，幾翻芳訊，携書擬過山頭。看雲間紫氣，欲墮還浮。試仰古今豪傑，如公輩，風雅誰疇？茸城下，當朝元老，天誕星球。 油油，殢人處也。千百幅鍾王，夷夏爭求。更雲山烟樹，畫絶千秋。傲殺羽儀命世，尚書履，急櫂扁舟。瞻山斗，何時命駕，方慰綢繆"（《消暍集》卷2）。《董宗伯予告馳節還鄉贈言六首》之一云："元老開嵩獻，鴻名動八州。四朝貽典則，百代振風流。憺蕩功名薄，迂疎氣節遒。逍遙五茸下，不戀九花虬"（同上，卷3）。《奉懷董思白宗伯四首》之四

云："祥雲五色墮長庚，手擘紅霞散玉京。一幅青山堪照乘，數行殘墨重連城。殼音學語慚新韻，鴻筆題詞感舊盟。惆悵蛾眉照顏色，幾人曾說項斯名"（同上，卷4）。董其昌七十歲時，他有《贈少宗伯董思翁七十幃詞》調寄《萬年歡》一闋；董其昌登八十時，他有《玄宰歌，爲董尚書八十壽賦》古風一首。壽詩有句云："鴻堂昨夜蒼鬼泣，鐵限磨穿索書急。顛書旭草數十張，獅吼龍吟百靈集。翻思輞川繪事工，天機跳躍光熊熊。雲林石屋快真賞，時參北苑步南宮。法書名畫世稀有，無翼而飛不脛走。生來天縱又多能，神漢玄瑛自非偶。風流浪藉幾多春，金蓮再召寧容後。千秋著述在鴻梁，一代才名高北斗。三朝典要藉纂修，狐史森嚴別蕪垢。猿獴覥魄忠良扶，春秋筆削伊誰首"（同上，卷6）。這樣的祝壽詞，生動地歌頌了董其昌在藝術和史學上的成就。他《題董玄宰赤壁賦後》云："玄宰書法，流佚寰中海外者，不知其幾千萬億。五茸城內，摩勒焚然。余每過戲鴻堂，縱意落筆，輒有靈氣。蓋㭊頭捉刀人能具英雄本色者，一盼得之。即此赤壁一書，芝英靈氣，勃窣照人，便足爲贗本奪魄矣"（同上，卷14）。這裏明言董其昌的書法有代筆人，但用董的手蹟《赤壁》一對照，便立見其爲贗作。夏樹芳還有二十四通致董其昌的書札，涉及方面很廣，僅摘錄有關書畫方面的一段："往從海上購戲鴻法書，與海內同志之士相聚讚歎，得未曾有。已又竊見董先生真蹟，羊裙鵝帖，散落人間，欷若驚沙坐飛，迴翔萬狀。至山水圖畫，淋漓潑墨，莽蕩無涯。令觀者神明頓易，沈寥千古。若夫文字制作，與金石爭雄，則先生在石渠虎觀，業已私淑有年，無容喙矣"（同上，卷19）。他對董其昌的書畫文章也可以說是推崇備至了。董其昌除爲《消暍集》作序外，還爲他寫了《詞林海錯引》（《容臺文集》卷4），又爲他的《茶董二卷酒顛二卷》作了序。董其昌曾爲夏樹芳作《崑山讀書圖》，題詩云："崑山把酒和陶詩，千載柴桑是爾師。敢道柴桑輸一著，出山何似在山時"（《容臺詩集》卷4，《崑山讀書圖爲夏茂卿題》）。這從側面歌頌了夏樹芳的隱居不仕。

參考文獻

（以文中出現的先後爲次）

董其昌。《容臺別集》四卷。崇禎庚午刻本。
何良俊。《四友齋叢說》三十八卷。萬曆己卯刻本。
郭廷弼、周建鼎。《松江府志》五十四卷。康熙癸卯刻本。
董其昌。《容臺詩集》四卷。崇禎庚午刻本。
陳繼儒。《陳眉公先生全集》六十卷。崇禎末刻本。
陳田。《明詩紀事》八籤共一百八十七卷。一九三六年上海商務印書館排印本。
錢謙益。《列朝詩集小傳》十集。一九五九年上海中華書局排印本。
莫秉清。《傍秋菴文集》二卷。康熙刻本。

董其昌。《容臺文集》九卷。崇禎庚午刻本。

董其昌。《畫禪室隨筆》不分卷。楊補輯，一九八三年北京市中國書店《藝林名著叢刊》排印本。

何三畏。《芝園集》二十五卷。萬曆丙申刻本。

莫是龍。《小雅堂集》八卷。崇禎癸酉刻本。

馮夢禎。《快雪堂集》六十四卷。萬曆丙辰刻本。

湯顯祖。《湯顯祖詩文集》五十卷。徐朔方箋校，一九八二年上海古籍出版社排印本。

姜紹書。《無聲詩史》七卷。康熙庚子刊本。

李濬之。《清畫家詩史》二十二編。一九九○年北京中國書店排印本。

朱彝尊。《明詩綜》一百卷。康熙間刻本。

范允臨。《輸寥館集》八卷。順治甲午刻本。

陳繼儒。《白石樵真稿》二十四卷（《中國文學珍本叢書》第一輯第十二種）。一九三五年上海雜誌公司排印本。

詹景鳳。《詹氏性理小辨》六十四卷。萬曆丙申刻本。

陳繼儒。《晚香堂小品》二十四卷。崇禎末湯大節簡緣居刻本。

莫是龍。《莫廷韓遺稿》十六卷。沈及之輯，萬曆壬寅刻本。

中國古代書畫鑑定組。《中國古代書畫目錄》及《中國古代書畫圖目》（前書已出第一、二、三、五、七冊，後書已出第一、二、三、四、六、七、八冊）。一九八四至一九九○年北京文物出版社排印本。

顧復。《平生壯觀》十卷。成書於康熙辛未，道光間蔣氏精抄本。

黃賓虹。《古畫微》不分卷。一九六一年商務印書館香港分館排印本。

啓功。《啓功叢稿》不分卷。一九八一年北京中華書局排印本。

沈季友。《檇李詩繫》四十二卷。康熙丁丑刻本。

金瑗。《十百齋書畫錄》二十二卷。成書約在乾隆乙巳，約一九四二年馮氏實萍盦抄本。

張廷玉等。《明史》三百三十二卷。一九七四年北京中華書局點校排印本。

台灣中央圖書館。《明人傳記資料索引》不分卷。一九八七年北京中華書局復印本。

許承堯等。《歙縣志》十六卷。一九三七年旅滬同鄉會印本。

曾朝節。《紫園草》二十二卷。萬曆丁酉刻本。

吳伯與。《素雯齋集》三十八卷。天啓甲子刻本。

吳秀之、曹允源。《吳縣志》八十卷。一九三三年刻本。

錢謙益。《牧齋有學集》五十卷。康熙間刻本。

吳偉業。《吳梅村全集》六十四卷。李學穎集評標校，一九九○年上海古籍出版社排印本。

王衡。《緱山先生集》二十七卷。萬曆丙辰刻本。

顧起綸。《國雅》二十卷。萬曆癸酉刻本。

陳去病。《松陵文集三編》五十五卷。民國丁巳至壬戌《百尺樓叢書》排印本。

黃宗羲。《明儒學案》六十二卷。乾隆己未慈谿鄭氏二老閣刻本。

吳道南。《吳文恪公文集》三十二卷。崇禎間刻本。

陶望齡。《歇菴集》二十卷。萬曆辛亥刻本。

姜紹書。《韻石齋筆談》二卷。一九一一年上海神州國光社《美術叢書》排印本。

朱國楨。《朱文肅公詩集》七卷。清初抄本。

屈大均。《廣東新語》二十八卷。康熙庚辰刻本。

張照等。《石渠寶笈初編》四十四卷。一九一八年上海商務印書館印本。

唐仲冕等。《重刊宜興縣舊志》十卷。光緒壬午刻本。

姚弘緒。《松風餘韻》五十卷。乾隆癸亥刻本。

項穆。《重刊書法雅言》不分卷。萬曆間刻本。

汪砢玉。《汪氏珊瑚網古今名畫題跋》二十四卷。成書於崇禎癸未，清抄本。

陳繼儒。《妮古錄》四卷（收在《尚白齋秘笈‧眉公雜著》）。萬曆間刻本。

李日華。《味水軒日記》八卷。一九二三年吳興劉氏嘉業堂刻本。

項鼎鉉。《呼桓日記》五卷。清抄本。

葉燮。《己畦集》二十二卷。乾隆間刻本。

項皋謨。《學易堂三筆‧滴露軒雜著》不分卷。萬曆末刻本。

汪砢玉。《汪氏珊瑚網古今法書題跋》二十四卷。成書於崇禎癸未，清抄本。

錢謙益。《牧齋初學集》一百十卷。崇禎癸未刻本。

吳其貞。《書畫記》六卷。成書於康熙丁巳，一九五六年商務印書館影印本。

李維楨。《大泌山房集》一百三十四卷。萬曆辛亥刻本。

青浮山人。《董華亭書畫錄》不分卷。元和江氏靈鶼閣叢書本，光緒丙申據舊藏滕逸湖抄本刻。

陸心源。《穰梨館過眼錄》四十卷。光緒辛卯刻本。

汪士鈜。《栗亭詩集》六卷。康熙間刻本。

朱緒曾。《金陵詩徵》四十一卷。光緒壬辰刻本。

王穉登。《南有堂詩集》十卷。崇禎間刻本。

安紹芳。《西林全集》二十卷。明刻清印本（原本刻於萬曆己未）。

葉向高。《蒼霞續草》二十二卷。天啓間刻本。

葉向高。《後綸扉尺牘》十卷。天啓、崇禎間刻本。

紀昀等。《四庫全書總目》一百九十八卷。乾隆。

畢自嚴。《石隱園藏稿》八卷。四庫全書本。

顧憲成。《顧端文公集》二十二卷。崇禎間刻本。

王重民。《中國善本書提要》不分卷。一九八三年上海古籍出版社排印。

張照等。《石渠寶笈重編》（卷數未詳）。乾隆辛亥刻本。

馮時可。《馮元成選集》八十三卷。萬曆間刻本。

邢侗。《來禽館集》二十八卷。崇禎間刻本。

王士禛選。《新安二布衣詩》八卷。康熙甲申刻本。卷一至卷四為吳兆《吳非熊集》，卷五至卷八為程嘉燧《程孟陽集》。

程嘉燧。《松圓偈菴集》二卷。崇禎間刻本。

惲格。《甌香館集》十二卷。道光丙午刻本。

王寶仁。《王煙客年譜》四卷。道光間刻本。

顧文彬。《過雲樓書畫記》十卷。光緒壬午刻本。

周亮工。《讀畫錄》四卷。康熙癸丑刻本。

周亮工。《尺牘新鈔》十二卷。康熙壬寅刻本。

程穆衡箋。《吳梅村先生詩集》十二卷。一九八三年上海古籍出版社據清保蘊樓鈔本影印本。

程正揆。《青溪遺稿》二十八卷。康熙乙未刻本。

張庚。《國朝畫徵錄》三卷。乾隆己未刻本。

夏樹芳。《消暍集》二十卷。崇禎間刻本。

Chronology of Tung Ch'i-ch'ang's
Works and Inscriptions

董其昌書畫鑑藏題跋年表（無紀年部分附後）

凡例

一　本表所載,中外圖書凡言及董其昌之書畫鑑藏題跋一概收入。若文獻資料有所牴觸,則附按語釋疑;若筆墨之真偽,尚待讀者自辨。

二　本表紀年部分所載月日屬陰曆。每月內以有日期者居先,僅有月份或季節者次之,有年份而無月日者殿後。參見部分所列日期以"月/日/年"之形式排列。

三　表中年份有推算所得者,如董其昌一六一四年十二月自題《煙江疊嶂圖卷》云畫於十年前秋日,則定此作紀年爲一六〇五年。照中式算法,首尾二年皆包括在內。

四　本表無紀年部分分書、畫、書畫合璧及鑑藏題跋四段。書與畫又各分"做作"與"自作"二部分。"做作"照所做對象之姓名筆劃順序排列,"自作"以卷、軸、冊、扇及型式不詳之順序排列。"書畫合璧"按卷、軸、冊、扇排列,"鑑藏題跋"則按所題作品之作者姓名筆劃順序排列。書、畫及書畫合璧三部分亦載董其昌之官銜印如"知制誥日講官""太史氏"或"宗伯學士"等,雖不可據以斷定創作之年代,亦聊備參考價值。

五　表內所稱"董"悉指董其昌。

六　書畫作品現藏中外各大博物館者,請自行參考各博物館之出版物。《故宮書畫集》或《東京國立博物館圖版目錄》等書將不列於表內。

七　表內所引圖書之書名多爲縮寫,謹將書之全名、作者、版本等資料詳列於下:

《十百》
十百齋主人(金瑗)。《十百齋書畫錄》二十二卷。金匱室手抄本。

《三希》
《三希堂法帖》,即《御刻三希堂石渠寶笈法帖》八冊。一九八四年北京日報出版社排印本。

《三松》
潘奕雋。《潘氏三松堂書畫記》。一九四三年合衆圖書館叢書第三種。

《三秋》
關冕鈞。《三秋閣書畫錄》二卷。一九二八年關氏刊本。

《大觀》
吳升。《大觀錄》二十卷。庚申九月武進李氏刊本。

《文人畫》,v.2
《文人畫粹編》中國篇2,《董源·巨然》。一九八五年東京中央公論社。

《文人畫》,v.5
《文人畫粹編》中國篇5,《徐渭·董其昌》。一九八六年東京中央公論社。

《支那名畫寶鑑》
原田謹次郎編。一九三六年東京大塚巧藝社。

《天瓶》
張照。《天瓶齋書畫題跋》二卷。丙子叢編本。

《天補》
張照。《天瓶齋書畫題跋補輯》。同上。

《天際》
翁方綱。《天際烏雲帖攷》二卷。美術叢書本。

《天隱》
《天隱堂名畫選》。一九六三年東京天隱堂。

《中國目錄》
中國古代書畫鑑定組編。《中國古代書畫目錄》第一、二、三、五、七冊。一九八四至一九九〇年北京文物出版社。

《中國圖目》
中國古代書畫鑑定組編。《中國古代書畫圖目》第一、二、三、四、六、七、八冊。一九八六至一九九〇年北京文物出版社。

《中國名畫集》
田中乾郎編。共八冊。一九四五年東京龍文書局。

《玉几》
陳撰。《玉几山房畫外錄》二卷。美術叢書本。

《玉雨》
韓泰華。《玉雨堂書畫記》四卷。美術叢書本。

《平生》
顧復。《平生壯觀》十卷。一九六二年上海人民美術出版社排印本。

《石初》
《石渠寶笈初編》四十四卷。戊午涵芬樓排印本。

《石續》
《石渠寶笈續編》。一九七一年台北國立故宮博物院排印本。

《石三》
《石渠寶笈三編》。一九六九年台北國立故宮博物院排印本。

《石隨》
阮元。《石渠隨筆》八卷。百部叢書本。

《古芬》
杜瑞聯。《古芬閣書畫記》十八卷。光緒七年太谷杜氏藏版刊本。

《古物》
《內務部古物陳列所書畫目錄》十四卷。一九二五年北京京華印書局代印本。

《古附》
《內務部古物陳列所書畫目錄附卷》二卷。同上。

《古補》
《內務部古物陳列所書畫目錄補遺》二卷。同上。

《古緣》
邵松年。《古緣萃錄》十八卷。光緒甲辰上海鴻文書局石印本。

《白雲》
《白雲堂藏畫》二集。一九八一年台北國泰美術館。

《式古》
卞永譽。《式古堂書畫彙考》書畫各三十卷。一九五八年台北正中書局據鑑古書社影印吳興蔣氏密均樓藏本。

《好古》
姚際恆。《好古堂家藏書畫記》二卷。美術叢書本。

《好續》
姚際恆。《好古堂續收書畫奇物記》。同上。

《江村》
高士奇。《江村銷夏錄》三卷。寶芸堂藏板刊本。

《自怡》
張大鏞。《自怡悅齋書畫錄》三十卷。金匱室刊本。

《朱臥》
朱之赤。《朱臥庵藏書畫目》。美術叢書本。

《西清》
胡敬。《西清箚記》四卷。胡氏三種本。

《吉雲》
陳驥德。《吉雲居書畫錄》二卷。一九四二年合衆圖書館叢書第二種。

《年譜》
鄭威。《董其昌年譜》。一九八九年上海書畫出版社。

《別下》
蔣光煦。《別下齋書畫錄》七卷。江氏叢刻文學山房本。

《辛丑》
吳榮光。《辛丑銷夏記》五卷。叢書集成續編本。

《系年》
任道斌。《董其昌系年》。一九八八年北京文物出版社。

《快雨》
王文治。《快雨堂題跋》八卷。上海廣智書局校印本。

《我書》
作者不詳。《我川書畫記》。美術叢書本。

《我寓》
作者不詳。《我川寓賞編》。美術叢書本。

《壯陶》
裴景福。《壯陶閣書畫錄》二十二卷。一九三七年上海中華書局排印本。

《吳越》
陸時化。《吳越所見書畫錄》六卷。懷烟閣本。

《庚子》
孫承澤。《庚子銷夏記》八卷。一九八七年上海古籍出版社影印文淵閣四庫全書本(以下簡稱"四庫全書本")。

《味水》
李日華。《味水軒日記》八卷。吳興劉氏嘉業堂刊本。

《妮古》
陳繼儒。《妮古錄》四卷。美術叢書本。

《松江府志》
宋如林、孫星衍編。一九七〇年台北成文出版社《中國方志叢書》影印嘉慶二十二年刊本。

《享金簿》
孔尚任。美術叢書本。

《念聖》
丁念先。《念聖樓讀畫小記》。一九六一年台北文星雜誌社。

《金匱》
陳仁濤編。《金匱藏畫集》二冊。一九五六年香港統營公司。

《神州》
《神州國光集》二十一冊。一九〇八至一九一二年上海神州國光社。

《紅豆》
陶樑。《紅豆樹館書畫記》八卷。光緒八年吳趙潘氏靜園雕版本。

《貞松》
羅振玉。《貞松堂藏歷代名人法書》三卷。原刊本。

《柳南續筆》
王應奎。《柳南隨筆·附續筆》,前六卷,後四卷。百部叢書本。

《重修華亭縣志》
楊開第、姚光發編。一九七〇年台北成文出版社《中國方志叢書》影印光緒四年刊本。

《故宮》
國立故宮博物院編。《故宮書畫錄》八卷,增訂本。一九六五年台北中華叢書委員會。

《故週》
故宮博物院編。《故宮週刊》五一〇期。一九二九至一九三六年北京故宮博物院。

《南畫》
《支那南畫大成》十六卷,續集六卷。一九三五至一九三七年東京興文社。

《南畫集成》
田口米舫編。《支那南畫集成》三十六冊。一九三四年東京晚翠軒。

《郁題》
郁逢慶。《書畫題跋記》十二卷。四庫全書本。

《郁續》
郁逢慶。《續書畫題跋記》十二卷。同上。

《珊瑚》·書
汪砢玉。《珊瑚網法書題跋》二十四卷。叢書集成續編本。

《珊瑚》·畫
汪砢玉。《珊瑚網名畫題跋》二十四卷。同上。

《容文》
董其昌。《容臺文集》九卷,收於《容臺集》。一九六八年台北國立中央圖書館編印《明代藝術家集彙刊》據崇禎三年原刻本。

《容詩》
董其昌。《容臺詩集》四卷,收於《容臺集》。同上。

《容別》
董其昌。《容臺別集》六卷,收於《容臺集》。一九六八年台北國立中央圖書館編印《明代藝術家集彙刊》據明末閔刊本。

《海王》
李葆恂。《海王村所見書畫錄》。丙辰刻本。

《真初》
張丑。《真蹟日錄初集》。戊午姚江馮恩崑刻本。

《真二》
張丑。《真蹟日錄二集》。同上。

《真三》
張丑。《真蹟日錄三集》。同上。

《秘初》
《秘殿珠林初編》二十四卷。版本不詳。

《秘續》
《秘殿珠林續編》。一九七一年台北國立故宮博物院排印本。

《秘三》
《秘殿珠林三編》。一九六九年台北國立故宮博物院排印本。

《退菴》
梁章鉅。《退菴金石書畫跋》二十卷。一九七二年台北漢華文化事業股份有限公司影印國立台灣大學藏清道光二十五年刊本。

《書畫》
吳其貞。《書畫記》六卷。一九六二年上海人民美術出版社影印北京故宮博物院所藏四庫全書鈔本。

《書畫史》
陳繼儒。美術叢書本。

《書道藝術》
中田勇次郎編。二十四卷。一九七〇至一九七三年東京中央公論社。

《書跡名品叢刊》
二百餘冊。一九五八年起東京二玄社刊。

《眼初》
楊恩壽。《眼福編初集》十四卷。坦園叢稿本。

《眼二》
楊恩壽。《眼福編二集》十五卷。同上。

《眼三》
楊恩壽。《眼福編三集》七卷。同上。

《清河》
張丑。《清河書畫舫》十二卷。四庫全書本。

《清儀》
張廷濟。《清儀閣題跋》四卷。光緒十七年錢塘丁氏刊本。

《雪堂》
羅振玉。《雪堂書畫跋尾》。一九二〇年天津刊本。

《爽籟》,v.1
阿部房次郎編。《爽籟館欣賞》第一輯。一九三〇年大阪博文堂。

《爽籟》,v.2
阿部孝次郎編。《爽籟館欣賞》第二輯。一九三九年大阪博文堂。

《虛舟》
王澍。《虛舟題跋》十卷。叢書集成續編本。

《虛齋》
龐元濟。《虛齋名畫錄》十六卷。宣統己酉烏程龐氏刊於申江。

《虛續》
龐元濟。《虛齋名畫續錄》四卷。甲子吳興龐氏刊於申江。

《盛京》
金梁輯。《盛京故宮書畫錄》七冊。藝術叢編本。

《畫集》
車鵬飛、江宏編。《董其昌畫集》。一九八九年上海書畫出版社。

《寓意》
繆曰藻。《寓意錄》四卷。春暉堂叢書本。

《湘管》
陳焯。《湘管齋寓賞編》六卷。藝術叢編本。

《畫禪》
董其昌。《畫禪室隨筆》四卷。四庫全書本。

《筆嘯》
胡積堂。《筆嘯軒書畫錄》二卷。道光十九年安徽胡氏刊本。

《愛日》
葛金烺。《愛日吟廬書畫錄》四卷。宣統二年當湖葛氏刻本。

《愛續》
葛金烺。《愛日吟廬書畫續錄》八卷。同上。

《愛別》
葛金烺。《愛日吟廬書畫別錄》四卷。同上。

《董其昌》
古原宏伸編。《董其昌の書畫》二冊。一九八一年東京二玄社。

《董華亭》
青浮山人編。《董華亭書畫錄》。藝術叢編本。

《董盦》
齋藤悅藏編。《董盦藏書畫譜》。一九二八年大阪博文堂。

《過雲》
顧文彬。《過雲樓書畫記》十卷。光緒八年蘇州顧氏刊本。

《過續》
顧麟士。《過雲樓續書畫記》。版本不詳。

《萱暉》
程琦。《萱暉堂書畫錄》二冊。一九七二年香港萱暉堂。

《槐安》
高島菊次郎纂。《槐安居樂事》。一九六四年東京求龍堂。

《圖畫精意識》
張庚。美術叢書本。

《夢園》
方濬頤。《夢園書畫錄》二十五卷。光緒三年定遠方氏刊本。

《歐米收藏法書》
中田勇次郎、傅申編。《歐米收藏中國法書名蹟集》四冊。一九八一至一九八三年東京中央公論社。

《編年表》
徐邦達。《歷代流傳書畫作品編年表》。一九六三年上海人民美術出版社。

《劍花》
李鴻球編。《劍花樓書畫錄》二卷。一九七一年台北大中書局。

《墨緣》
安岐。《墨緣彙觀》六卷。光緒庚子刊本。

《澄懷》
山本悌二郎。《澄懷堂書畫目錄》。昭和六年澄懷堂。

《選學》
崇彝。《選學齋書畫寓目記》三卷。美術叢書本。

《選續》
崇彝。《選學齋書畫寓目記續編》三卷。同上。

《總合圖錄》
鈴木敬編。《中國繪畫總合圖錄》五冊。一九八二至一九八三年東京大學出版會。

《嶽雪》
孔廣陶。《嶽雪樓書畫錄》五卷。光緒己丑三十有三萬卷堂刊本。

《歸石》
楊翰。《歸石軒畫談》十卷,收於《息柯先生全集》。同治十年刊本。

《叢帖目》
容庚。一九八〇年香港中華書局。

《藤花》
梁廷枏。《藤花亭書畫跋》四卷。順德龍氏刊本。

《寶迂》
陳夔麟。《寶迂閣書畫錄》四卷。原刻本。

《曝畫紀餘》
秦潛。一九二九年梁溪秦氏刊本。

《繪畫史圖錄》
徐邦達編。《中國繪畫史圖錄》二冊。一九八一至一九八四年上海人民美術出版社。

《穰梨》
陸心源。《穰梨館過眼錄》四十卷。光緒十七年吳興陸氏刻本。

《穰續》
陸心源。《穰梨館過眼續錄》十六卷。同上。

《鑑影》
李佐賢。《書畫鑑影》二十四卷。同治辛未利津李氏藏板印本。

《聽颿》
潘正煒。《聽颿樓書畫記》五卷。美術叢書本。

《聽續》
潘正煒。《聽颿樓續刻書畫記》二卷。同上。

《鷗陂》
葉廷琯。《鷗陂漁話》六卷。筆記小說大觀續編本。

1571　隆慶五年,辛未,十七歲

無月日

發憤學書,初師顏真卿《多寶塔》,又改學虞世南(《畫禪》卷1, 7;又參見《容別》卷4, 25b及28b)。

1572　隆慶六年,壬申,十八歲

無月日

學晉人書,仿《黃庭經》及鍾繇《宣示表》、《立命表》、《還示帖》、《丙舍帖》,得其形模(《畫禪》卷1, 7;《三希》,第三十冊, 2192–93, "跋趙吳興書";《故宮法書》冊28, 104)。董跋趙孟頫書之墨蹟現藏台北國立故宮博物院。

1573　萬曆元年,癸酉,十九歲

二月一日

始作行楷《金剛經冊》[見董自題此冊]。

參見:4/8/1580

按:此冊疑偽,見7/1582。

1577　萬曆五年,丁丑,二十三歲

三月晦日

燃燭試作山水畫,自此日復好之,時往顧正誼家觀古人畫,若元季四大家多所賞心[見董題自藏董源《龍宿郊民圖軸》]。

參見:九月晦/1624(2)

四月一日

始學畫,館於陸樹聲家[見董自題《山水書畫冊》之末幅]

參見:11/10/1633

[又見董自題《倣古山水畫冊》八幅]。

參見:9/9/1630

無月日

臨顏真卿《普門品》,學《麻姑仙壇記》[見張照跋董《詩帖真蹟卷》]。

參見:8/1/1630

1578　萬曆六年,戊寅,二十四歲

無月日

觀吳松戴氏所藏趙孟頫書《跋定武蘭亭卷》[見董一六一七年跋此作]。

參見:9/5/1617

1579　萬曆七年,己卯,二十五歲

五月

自題墨筆《倣北苑山水軸》,絹本(《蘇雪》卷4,52b–53a;《編年表》,94)。

六月十五日

友人持虞世南書《破邪論》相示,董爲楷書《臨破邪論冊》并自題,高麗箋本(《石續》,淳化軒,3310–12;《編年表》,94)。

秋

(1)

舉試留都,見唐摹王羲之《官奴帖》真蹟,冷金箋本[見董《背臨官奴帖》後自題](《畫禪》卷1,8及13;《容別》卷4,50b)。

(2)

觀莫是龍爲宋光祿作畫卷[見董一五九八年題此作]。

參見:1598(2)

1580　萬曆八年,庚辰,二十六歲

四月八日

書竟行楷《金剛經冊》,烏絲闌絹本(《湘管》卷4,272–73;《編年表》,94)。

參見:2/1/1573; 7/1582

按:此冊疑僞,見7/1582。

十月一日

爲顧正誼鑒定并題米芾絹本書《天馬賦》[《唐曹霸畫馬·宋米元章書天馬賦合卷》之書幅](《壯陶》卷2,13b–14a)。

按:董此時尚未出仕,書畫皆未成名,顧正誼請其鑒定題跋,似不可能,此跋疑僞。參照《系年》,11–12。

無月日

於嘉禾烟雨樓觀古帖[見董跋此帖](《容別》卷2,17a)。

參見:1589(4)

1582　萬曆十年,壬午,二十八歲

七月

將舊作行楷《金剛經》裝成冊并再題。

參見:2/1/1573; 4/8/1580

按:董於此題中言及王時敏,但王時敏一五九二年生,故此題爲僞,此冊亦疑僞。參照《系年》,12。

1583　萬曆十一年,癸未,二十九歲

二月一日

倣楊凝式行書王粲《登樓賦》,鏡光紙本[《楷書四種冊》之四](《寓意》卷4,28b–29a;《編年表》,94)。

參見:3/16/1621

無月日

於嘉興項元汴處初見趙孟頫《鵲華秋色圖卷》[見董初跋《鵲華秋色圖卷》]。

參見:長至日/1602(1); 12/30/1602; 1605(1); 2/1612(2); 約八月/1629; 5/13/1630(1)

1585　萬曆十三年,乙酉,三十一歲

五月

舟過嘉興武塘,忽悟禪宗"竹篦子話"[見《禪語隨筆冊》]。[又見《禪悅》](《畫禪》卷4,15–16;《容別》卷3,10b)。

參見:11/15/1614

九月晦日

跋米芾草書《九帖卷》於西湖舫齋,紙本(《真蹟》,初集,72b;《珊瑚》·書,卷6,6;《式古》,v.1,書卷11,532;《大觀》卷6,29a–b)。

參見:九月晦/1609(1)

按:《郁題》亦載米芾此卷,所記題跋皆同,惟缺米友仁之題,且載董跋紀年爲"己酉(一六〇九年)"九月晦。按董乙酉年僅三十一歲,尚未及第,較不可能爲人題跋書畫,又西湖(在北京西山道中)舫齋乃董出仕後旅京所居,而董此時尚未中舉,因疑《真蹟》、《珊瑚》、《式古》及《大觀》誤記"己酉"爲"乙酉。"

又:《大觀》載此作爲冊,或爲重新裱裝之故。

秋

自金陵下第歸[見《禪語隨筆冊》]。[又見《禪悅》](《畫禪》卷4,15–16;《容別》卷3,10b–11a)。

參見:11/15/1614

1586　萬曆十四年,丙戌,三十二歲

無月日

讀《曹洞語錄》偏正賓主互換傷觸之旨,遂稍悟文章宗趣[見《戲鴻堂稿自序》(即《復趙公益書》)](《容文》卷2,11a)。

1587　萬曆十五年,丁亥,三十三歲

八月廿二日

爲陳繼儒作淺設色《山居圖軸》,紙本(《寓意》卷4,32a–b;《編年表》,94)。

無月日

爲平湖馮季山作《塵隱居士像贊》(《容文》卷7,60a–b)。

1588　萬曆十六年,戊子,三十四歲

三月三日

於官署中草書李白七言古詩二首一卷,紙本(《古芬》卷7,15a–b)。

按:董此時尚未出仕,無官署可居,此作疑僞。參照杜瑞聯之論述語。

閏四月十二日

自題行書書評四則[《雜書卷》四段之四]。

按:此卷實爲戊午(一六一八)年之作,見閏4/12/1618。

五月八日

以《聖教序》筆意行草書唐高宗《菩薩藏經後序冊》,麗紙本(《大觀》卷9,41a–b;《編年表》,94)。

按:《秘續》與《故宮》亦載此作,董之識語同,但紀年爲戊午(一六一八)而非戊子(一五八八),且後有何焯跋。見5/8/1618。

八月

爲陳繼儒作墨筆《山居圖卷》并題"渭北春天樹"五言詩一聯,紙本。是秋又於東佘之頑仙盧重題云此卷乃合自藏之董源《瀟湘圖》與米友仁《瀟湘白雲圖》所作(《鑑影》卷8,2b–4a)。

按:《選續》亦載董其昌《山居圖卷》,尺幅稍異(或爲裝裱之故),題跋全同,唯紀年爲戊午(一六一八)。按董得董源《瀟湘圖卷》在一五九七年六月,疑《鑑影》誤認"戊午"作"戊子"(一五八八)而失記,見8/1618(1)。

又:《編年表》於一五八八年與一六一八年處皆載此作,見第九十四及九十八頁。

冬

與唐文獻、袁宗道、瞿汝稷、吳應賓、吳用先、蕭玄圃同會於松江龍華寺,與憨山禪師夜談[見《禪語隨筆冊》]。[又見《禪悅》](《畫禪》卷4,16;《容別》卷3,11a–b)。

參見:11/15/1614

無月日

(1)

在京觀仇英《明皇幸蜀圖卷》[見董一六三六年題

此卷]。

參見:3/1636

(2)

在京邂逅陶望齡,相得甚歡[見陶望齡《董玄宰制義序》]《歇庵集》卷3,引自《系年》,18–19)。

1589 萬曆十七年,己丑,三十五歲

四月一日

偶得高麗精繭紙,因行楷書背臨在京所見米芾《題李伯時西園雅集圖記》一冊(《壯陶》卷12,53a)。

四月二日

背臨米芾小楷《題李伯時西園雅集圖記》(《湘管》卷4,284–85;《編年表》,94)。

四月十八日

自臨《臨米南宮小楷千文》,紙本,米芾真蹟借自唐完初(《真蹟》,初集,18b–19b)。題語又見《容別》卷5,7b–8b;《畫禪》卷1,30–31)。

參見:4/3/1598

無月日

(1)

觀晉陵唐完初家藏宋《秘閣本》王獻之《十三行洛神賦》[見董題宋搨王獻之《十三行洛神賦》]。

參見:1612(1); 3/2/1618; 3/1/1625

按:據《快雨》載,唐氏所藏《十三行洛神賦》後有董跋及續書九行,惜未紀年,附於此。見卷2,7。

(2)

從館師韓世能借褚遂良摹《蘭亭序》,縮臨爲蠅頭體(《容別》卷4,48b;《畫禪》卷1,50)。

參見:3/3/1621(1)

(3)

獲觀賀知章所摹,李後主所刻之《澄清堂帖》[見董再跋此帖]。

參見:約三月/1633

(4)

客攜一五八〇年所觀古帖至京,留案頭閱月。

參見:1580

(5)

觀宜興吳正志所藏米芾行書"有美一人"四言詩及杜甫"寺下春江深不流"與"城上春雲覆苑墻"七言律詩二首一卷,紙本[見董跋《米元章·朱晦翁詩札合卷》]《壯陶》卷4,49b–50a)。

1590 萬曆十八年,庚寅,三十六歲

八月十五日

撰并行楷書《萬壽無疆頌冊》,綾本(《壯陶》卷12,

14b–16a)。

按:此作並未紀年,但文中云:"恭惟我皇上握金鏡,調玉燭…宣九聖之重光,襲百靈之奧祉,十八載於茲矣。時惟仲秋節…"故此文應作於萬曆十八年八月十五日。但款識云:"賜進士出身資政大夫禮部尚書兼翰林院學士掌詹事府事實錄副總裁華亭董其昌撰并書,"董時爲庶吉士,尚無這些官銜,此作疑僞。參照《系年》,23。

無月日

(1)

於中丞黃承玄所,見米芾擘窠大字書《天馬賦卷》[見董自題《臨天馬賦卷》]《石初》卷5,32a–33a;《我川》,217–18)。

參見:1/27/1619; 1/27/1620

(2)

臨米芾書《破羌帖》及跋語,後又臨米詩并劉涇詩一卷,鏡光高麗紙烏絲闌本(《華亭》,37–38)。

(3)

見趙伯駒設色《桃源圖卷》於京[見董跋仇英臨本]《容別》卷6,34b)。

按:董跋云趙伯駒卷後爲吳廷所購。

1591 萬曆十九年,辛卯,三十七歲

三月

作《雜體書冊》,絹本[見張廷濟記《歇硯背董思翁書》]《清儀》,113a)。

按:山西省博物館藏有董一五九一年所作絹本行書《臨各家書冊》十三開,未知是否即此作,見《中國圖目》,v.8,晉1–022。

閏三月八日

在京借臨韓世能家藏之王獻之《洛神賦十三行》并自跋(《容別》卷4,53b;《畫禪》卷1,22–23)。

按:此作未紀年,但董跋云:"…予以閏三月十一日登舟,以初八日借臨…"董氏一生僅此年與一六一〇年閏三月,而一六一〇年春董在江南。且此春董以座師田一儁卒,告假護柩南行,故跋語云以十一日登舟,友人送行甚衆。參見《系年》,24–26。

春

得觀韓世能所藏陸機《平復帖》,并爲題簽[見董題此帖]。

參見:12/1/1604(1)

四月

舟泊徐州黃河岸,跋自藏《潁上禊帖》(《容別》卷5,30b–31a;《畫禪》卷1,38;《清儀》,74b)。

五月四日

與陳從訓、李將軍游眺京口北固山與甘露寺(《容別》卷4,6b–7a)。

秋

(1)

遊武夷,作"武夷陳司馬雲窩"七言律詩二首[見董題王時敏《武夷山接笋峰圖軸》](詩見《容詩》卷3,42a–b)。

參見:5/1627(1)

(2)

以庶常請告南歸,爲吳廷摹米氏父子筆作《瀟湘白雲圖卷》,綾本,舟至黃河乃竟(《華亭》,7–8)。

按:董請告南歸時在暮春,秋遊武夷後返江南,至次年春始北返,自識云"秋日泊舟黃河"似不可能,此卷疑僞。參照《系年》,27。

十月十五日

於翰林院之瀛洲亭觀韓世能所携李唐畫、宋高宗書設色《文姬歸漢圖冊》十八對幅,絹本。同觀者陶望齡、焦竑、王肯堂、劉日寧、黃輝[見韓世能跋語,韓誤認此冊爲閻立本畫、虞世南書](《石三》,延春閣十三,1475;《西清》卷1,10b–12a;《故宮》卷6,8)。台北國立故宮博物院藏。

按:董此時似仍在江南,韓跋疑僞。

十二月三十日

倣元人畫作《山水》一幀,金箋本(《庚子》卷3,26b)。

參見:1/1/1603

冬

自題《臨宣示表》(《容別》卷4,45a–b)。

參見:冬/1601(1)

按:《畫禪》、《石續》及《石隨》亦載此作,董之題語全同,但紀年爲辛丑(一六〇一年)冬,而非辛卯(一五九一年)冬,疑《容別》誤記。

約四月

以庶常請告歸,泊舟黃河,以黃素《黃庭經》爲師,書《寶鏡三昧》,爲《禪德偈頌》之一[見董自題此作]。

參見:1622(1)

約秋

(1)

自題舊作山水,自武夷寄贈何三畏(《畫禪》卷2,33)。

(2)

請告還里,大搜鄉邑元四家潑墨之作[見董題自藏董源《龍宿郊民圖軸》]。

參見:約十月/1597;九月晦/1624(2)

1592 萬曆二十年,壬辰,三十八歲

二月

題陳繼儒所藏顏真卿楷書《朱巨川告身真蹟卷》(《郁題》卷3, 14a-b;《珊瑚》書2, 4;《式古》, v.I, 書卷8, 366;《平生》卷I, 95-96;《大觀》卷2, 27b-28a)。

按:此卷《郁題》與《平生》作絹本,《大觀》作白麻紙本,待考。

春

(1)

楷書《金剛經》荐資父母冥福,藏於雲栖蓮池大師禪院[見董自跋一六二六年作所《金剛經冊》]。

參見:IO/I-I5/1626; 2/I/1632; 1634(2)

按:《雲栖志》載董此年(正月?)初八日書《金剛般若波羅蜜經》,或即此作。見《年譜》, 24。

(2)

與范爾孚、戴振之、范爾正、姪原道同遊無錫惠山,觀太湖(《容別》卷4, 7a)。

(3)

送館師田一儁之喪後還朝,舟中以韓世能所贈高麗黃箋行書論書畫法,後折作橫卷[《論書卷》二幅之二]。

參見:9/7/1610; 4/18/1592

(4)

北行次羊山驛,作"宿羊山驛"五言律詩一首[見董一六二二年春題《羊山小景圖軸》]。

參見:春/1622(I)

(5)

行書焦竑撰《漢前將軍關侯正陽門廟碑》(《系年》, 29), 拓片現存北京圖書館。

按:此碑款識云"明萬曆辛卯冬日焦竑撰,董其昌行書,王肯堂篆額,"但董是年冬仍在江南,當屬次年(一五九二)春返京後始書。參照《系年》, 29。

(6)

行書"會心處不必在遠"等二句於智果禪房,灑金箋本扇頁(*Christie's*, Nov. 1988, no. 182)。

四月四日

呂梁道中,作著色《倣懶瓚筆意圖》,金箋本。後又為孟博題"雲開見山高"五言絕句及"青山一抹簷外"六言絕句[《便面畫冊》山水十幅之首](《石初》卷4I, 35b-36a;《南畫》卷8, 102;《畫集》, no. 153)。此冊現藏台北國立故宮博物院。

參見:I/1602(I); 4/7/1625; 5/1633(I); 9/1635(I)

四月十八日

阻風黃河崔鎮,行書論書語,素箋本[《論書卷》二幅之首](《石續》, 乾清宮, 439-4I;《中國目錄》, v.2, 50, 京I-2145)。北京故宮博物院藏。

參見:春/1592(3); 9/7/1610

八月

書蔡汝賢所撰《重修松江府儒學碑》文(《松江》卷73, 2I)。

九月

與陳繼儒過嘉禾,觀諸遂良《摹蘭亭序》、徐浩《少林詩》、顏真卿《祭濠州伯父文稿》、趙孟頫小楷《道德經》。陳借得王逸季所藏虞世南《汝南公主志》,董手摹之(《書畫史》, II6-I7;《容別》卷4, 58b;《清河》引《妮古》卷三下, 2I)。

約四月

北上返京時在廣陵舟中作書卷(《畫禪》卷I, I6)。

參見:I2/30/1596

1593　萬曆二十一年, 癸巳, 三十九歲

春

在京得董源《谿山行旅圖軸》[一名《江南山色圖軸》]半幅於吳廷, 乃沈周舊藏[見董題此軸]。

參見:5/26/1601

[又見董題董源《夏山圖卷》]。

參見:8/15/1635

按:董藏有此軸又見《清河》卷六下, 2I;《式古》引《清河》, v.3, 畫卷II, 433;《雪堂》, 28b-30b。

四月

待閘清河口, 作淺設色《畫法祕訣圖卷》, 間書畫論, 紙本(《總合圖錄》, v.2, EI5-256)。The British Museum.

五月

初題自藏《唐拓懷仁集字本蘭亭袖珍冊》(《壯陶》卷2I, 44b)。

按:董題此冊凡五次, 惟初題紀年。

無月日

(I)

倣黃公望筆作水墨《山水卷》未竟, 紙本[見董一六三三年題此卷](《虛舟》卷IO, 5; *Christie's*, June 1986, no. 34)。香港北山堂藏。

參見:1623(I); 1633(I)

按:此卷作於"癸巳"(1593)年, 至"癸亥"(1623)年復為補筆, 又十年"癸酉"(1633)乃題, 故名為《三癸圖卷》。

(2)

入京途中值俞汝為解組歸, 晤於淮北[見董《僉憲俞毅夫傳》](《容文》卷6, I3b)。

(3)

倣黃公望筆意作墨筆《山水軸》, 紙本(《年譜》引《左庵一得初錄》, 25)。

1594　萬曆二十二年, 甲午, 四十歲

無月日

入都, 為禪悅之會, 與袁氏兄弟、蕭玄圃、王衷白、陶望齡數相過從[見《禪語隨筆冊》]。[又見《禪悅》](《畫禪》卷4, I6;《容別》卷3, IIb-I2a)。

參見:II/I5/1614

1595　萬曆二十三年, 乙未, 四十一歲

七月十三日

武林馮夢禎獲董自京來函, 求借觀馮新購之王維墨筆《江山雪霽圖卷》, 絹本(《快雪堂集》卷53;《雪堂》, 26b-27a;《董其昌》, no. 29)。該函與畫現歸日本小川家藏。

參見:IO/I5/I595; 2/IO/1596; 四月晦/1604; 8/I/I604; 8/I5/I604; 8/20/I604; 5/I6I8(I)

八月二十日

題巨然《長江萬里圖卷》。

參見:8/20/I6I9

秋

借觀顏真卿《祭姪季明文》兩閱月[見董《仿古書冊》五段之二:臨顏書《祭姪文》之自題]。

參見:8/II/I629

十月十五日

在京客舍初跋武林馮夢禎所藏王維《江山雪霽圖卷》(《珊瑚》·畫, 卷I, 5-6;《式古》, v.3, 畫卷9; 382-83;《董其昌》, no. 30。跋語又見《容別》卷6, 27a-28b, 文字略有出入)。

參見:7/I3/I595; 2/IO/1596; 四月晦/1604; 8/I/I604; 8/I5/I604; 8/20/I604; 5/I6I8(I)

十一月

書唐文獻所撰《重修神霄雷壇碑》文(《松江》卷73, 2I)。

無月日

在京見《陽關詩卷》, 定為米芾筆[見董跋此卷]。

參見:春/I6I7(3); I62I(3)

1596　萬曆二十四年, 丙申, 四十二歲

二月十日

武林馮夢禎再接獲董自京來函, 謝馮出借王維《江山雪霽圖卷》, 並要求寬限時日容後歸還(《雪堂》, 26b-27a;《董其昌》, no. 3I)。

參見:7/I3/I595; IO/I5/I595; 四月晦/1604; 8/I/I604; 8/I5/I604; 8/20/I604; 5/I6I8(I)

二月十七日

二月往虎林謁具區還, 下榻項氏天籟閣品檢書畫, 殆百十餘件。十七日小行書《天籟閣觀畫記》, 紙本(《壯陶》卷II, 5Ia-54a)。

按:董此時似仍在京,此作疑僞。

四月

(1)

西蜀陳文憲公求董作《四代誥命》,以所藏李成《寒林大軸》作潤筆[見董重題此圖]。

參見:10/1627

(2)

在京倣宋人筆意作設色《燕吳八景圖冊》並題贈楊繼禮,團扇式,絹本。八幅分別爲《倣張僧繇西山雪霽》、《西湖蓮社》、《舫齋候月》、《西山暮靄》、《城南舊社》、《西山秋色》、《九峰招隱》及《赤壁雲帆》。後在京墨禪室中再題於冊末,款後鈐有"太史氏"印(《中國圖目》,v.3,滬1-1338)。上海博物館藏。

七月廿八日

奉旨持節封吉藩道出武林,觀高濂所藏郭忠恕著色《摹右丞輞川圖卷》,素絹本,並初跋之(《石初》卷14,27b-28a;《味水》卷4,9a)。

參見:十月晦/1597

七月三十日

奉旨持節封吉府,渡錢塘,次馬(馮?)氏樓,出自藏趙令穰絹本設色《江鄉清夏圖卷》臨寫并題之(《容別》卷6,33a-34a;《平生》卷7,70;《石初》卷34,6a;《董其昌》,no.32)。Museum of Fine Arts, Boston.

參見:7/3/1601;4/1615(1);8/15/1629(1)

閏八月廿日

過蘄州泊江上,題王蒙在京師龍何方丈所作紙本《山水軸》(《別下》卷3,5a-b)。

閏八月廿四日及廿八日

楷書自書父母及本身妻室《封勅稿本》二幅一卷,高麗牋本(《石續》,寧壽宮十四,2841-43)。

閏八月

(1)

舟行池州道中,得朝鮮鼠筆,行書《問政山歌卷》,素絹本,書"問政山錯出黃山白嶽間"七言歌行(《盛京》,第三冊,25a-26a;《古物》卷2,13a-b。詩見《容詩》卷1,13b-14b,"問政山歌爲太傅許老師壽")。

(2)

舟行池州江中,題陳繼儒《小崑山舟中讀書圖》(《容詩》卷1,14b)。

秋

(1)

奉使長沙,至東林寺,時白蓮盛開,作"廬山東林夜宿"五言律詩以記(《畫禪》卷3,7。詩見《容詩》卷2,19b)。

(2)

作《仿北苑沒骨山水軸》,絹本(《鑑影》卷22,2b;《編年表》,94)。

(3)

奉使長沙浮江歸,道出齊安,時門下士徐暘華爲黃岡令,請董大書蘇軾"大江東詞,"董乘利風解纜後作《小赤壁詩》[見董自書"大江東詞"題尾](《容別》卷5,4b;《畫禪》卷1,17)。

十月七日

初秋奉使三湘時,取道涇里,自友人華中翰獲購黃公望墨筆《富春山居圖卷》(無用師本),紙本。此日於龍華浦舟中跋之(《式古》,v.4,畫卷18,209;《書畫》卷3,255;《平生》卷9,30;《江村》卷1,55a-b;《大觀》卷17,1b-2a;《墨緣》,名畫續錄卷下,4a-b;《石三》,乾清宮十,518-19;《西清》卷4,37a-b;《夢圖》卷6,19a-b;《南畫》續集5,53;《故宮》卷4,134;《董其昌》,no.33)。台北國立故宮博物院藏。

十二月三十日

張清臣持董一五九二年所作書卷至齋中,董因題之(《畫禪》卷1,16)。

參見:約四月/1592

冬

得江參《千里江山圖卷》於海上,購自嚴世藩家[見董初跋此卷]。

參見:9/22/1597;4/20/1598;1598(1)

約七月

於武林得趙孟頫《挾彈走馬圖卷》與《支遁洗馬圖》[見董題《挾彈走馬圖卷》]。

參見:1608(2)

約秋

持節長沙,作"題畫贈眉公"五言絕句一首寄陳繼儒(《容別》卷4,16b。詩見《容詩》卷2,31a)。

約秋末

(1)

頃過齊安,至赤壁,作《小赤壁圖》·(《畫禪》卷2,26)。

(2)

持節封吉藩,浮江東歸,阻風石鍾山下,謁侍御張達泉[見董《賀侍御達泉張公八十序》]。

參見:春/1605(1)

約冬

重仿巨然筆意,爲陳繼儒作《崑山讀書小景圖》(《畫禪》卷2,22-23)。

1597 萬曆二十五年,丁酉,四十三歲

二月十五日

與陳繼儒及悟軒泛泖,過黃公望昔居之橫雲山,歸舟後倣其筆法作設色《橫雲舊隱圖軸》,絹本。上海博物館藏。

參見:2/1613(2)

三月十五日

與陳繼儒在吳門韓世能家,韓逢禧携示顏真卿《自身告》、徐浩書《朱巨川告》、趙伯駒《三生圖》、周文矩《文會圖》、李公麟《白蓮社圖》、惟顧愷之《右軍家圖景》劣(《容別》卷6,5a-b;《畫禪》卷2,10-11;《妮古》所記文字略有出入,見卷3,281)。

三月十六日

以《三藏聖教序》筆意,爲邵適安(邵雍二十二世孫)行書邵雍《無名公傳》及《程朱夫子傳贊》一冊,朝鮮牋烏絲闌本(《石初》28,26a-27a;《三希》,第二十九冊,2050-81;《編年表》,94)。

六月

在京得董源《瀟湘圖卷》於李納言[見董初跋此卷]。

參見:4/3/1599(1);八月晦/1605;4/17/1613[又見董跋董源《夏山圖卷》]。

參見:8/15/1635

九月廿一日

(1)

典試江右歸,次蘭谿,舟中對題自藏之李成淡色《寒林歸晚圖斗方》,絹本[名畫大觀]第二冊二十五對幅之四(《式古》,v.3,畫卷3,220-21);[五代宋元集冊]十二幅之二(《墨緣》,名畫卷下,1b-2b)。

參見:2/10/1622;5/1624(1)

按:董題云此圖本潘允端家藏,前後有名人題跋,本作一卷,董得之遂割去題跋,裝爲冊頁。

又:《墨緣》謂此幅爲絹本水墨。

(2)

龍游舟中,題夏珪《錢塘觀潮圖冊頁》(《珊瑚》·畫,卷6,7;《平生》卷8,60)。[又見《董氏集古畫冊》十四幅之七](《珊瑚》·畫,卷19,8-9)。

九月廿二日

奉命校士畢,還自江右,於蘭谿舟中展觀自藏之江參墨筆《千里江山圖卷》,素牋本,并初跋之(《墨緣》,名畫續錄卷下,3b;《石初》卷42,45a-47b;《故宮》卷4,48-49;《故週》,v.353,3)。台北國立故宮博物院藏。

參見:冬/1596;4/20/1598;1598(1)

九月

從江右試士歸宿高濂齋中,跋隋開皇刻王羲之《蘭亭詩序卷》(《石續》,養心殿十四,1126;《快雨》卷1,7)。

參見:5/1615

十月晦日

校士江右歸,訪高濂,宿魚磐軒,再跋郭忠恕《摹右丞輞川圖卷》。

參見:7/28/1596

十月

自江右還,訪陳繼儒於崑山讀書臺,作墨筆《婉孌草堂圖軸》爲別,鏡面箋本(《平生》卷10,115;《墨緣》,名畫卷上明,30a-b;《石三》,延春閣廿六,2067-69;《西清》卷1,8b;《編年表》,94;《董其昌》,no.1;《文人畫》,v.5,no.37;《畫集》,no.66)。台灣私人收藏。

參見:冬至日/1597

冬至日

陳繼儒攜董《婉孌草堂圖軸》過齋頭設色,適得李成青綠《烟巒蕭寺圖》及郭熙《溪山秋霽卷》,以觀李郭畫,不暇設色,僅再題之。

參見:10/1597

十一月

倣米芾墨戲作《楚山清曉圖卷》(《好續》,130;《編年表》,94。題語又見《容別》卷6,15b)。

冬

燕山道上,悟霜景與煙景之辨,作七言絕句一首題於驛樓(《容詩》卷4,34a)。

約秋

典試江右,同年黃輝初爲分考,談及王羲之《療疾帖》,恨不得寓目[見董日後題米芾行書《臨王羲之療疾帖卷》,綠麻紙本](《石續》,寧壽宮,2701)。

參見:1/1599(2)

約十月

典試江右歸,得董源《龍宿郊民圖軸》於上海潘允端[見董題此軸]。

參見:九月晦/1624(2)

無月日

(1)

於真州吳治處觀所藏虞世南《臨蘭亭帖卷》[見董一六〇四年正月十五日題此卷]。

參見:12/30/1598;1/15/1604(1);1/1618(1);1/22/1618(1)

(2)

遊九華山,有題額三大字於寺[見《夜臺禪師像贊》](《容文》卷7,56b-57b)。

參見:1604(1);1607(2);1610(1)

1598　萬曆二十六年,戊戌,四十四歲

正月一日

於都門外蘭若中見李贄[見《禪語隨筆冊》]。[又見《禪悅》](《畫禪》卷4,17;《容別》卷3,12a)。

參見:11/15/1614

四月三日

重題一五八九年所作《臨米南宮小楷千文》。

參見:4/18/1589

四月二十日

四跋自藏之江參《千里江山圖卷》(《故週》,v.355,3)。

參見:冬/1596;9/22/1597;1598(1)

六月廿三日

題傳范寬所作淺設色山水,改定爲李成筆[見傳董《倣宋元人縮本畫跋冊》(即《小中現大冊》)二十二對幅之首](《盛京》,第六編,19a-23a;《古物》卷4,7b-11b;《南畫》卷14,56-77及續集5,128-43;《故宮》卷6,71-75)。《倣宋元人縮本畫跋冊》現藏台北國立故宮博物院。

參見:16/1600;1607(1);2/1614(1);5/1620;5/1625(1);秋/1626(1);11/19/1627(1)

秋

小楷書《法華經》,書第一卷[見董自跋《彌陀經卷》](《容別》卷2,31a)。[又見董跋徐道寅書《法華經冊》]。

參見:1608(4);1610(2)

十一月九日

行書《評書帖》[《臨古卷》九段之六]。

參見:冬/1598

冬至日

在京跋王珣行草書《伯遠帖卷》五行,素箋本(《石初》卷19,11b;《墨緣》,法書卷上東晉,5b-6a;《三希》,第二冊,133-34;《董其昌》,no.34)。北京故宮博物院藏。

十二月三十日

在京楊明時寓舍,吳廷從董索歸虞世南《臨蘭亭帖卷》,同觀者吳治、吳國遜、吳廷及楊明時[見楊明時跋此卷](《石初》卷42,3b)。

參見:1597(1);1/15/1604(1);1/1618(1);1/22/1618(1)

冬

在京作《臨古卷》九段,朝鮮鏡光箋本。第一、二段行書《雪賦》,又稍以褚遂良《家姪帖》之運筆,書《月賦》及《登樓賦》。第三、四段俱行楷書,前仿王羲之,後仿《家姪帖》。第五段楷書,臨王僧虔。第六段行書《評書帖》。第七、八段楷書《溫泉賦》及《竹扇賦》。第九段行書《九日送菊帖》。其中第二、四、六段後有自識語。日後於來仲樓總跋於卷末(《石初》卷30,48b-49a;《故宮》卷1,136-37;《編年表》,94。《平生》所錄無第六段《評書帖》,總段略長,云此卷書於戊戌(一五九八年),見卷5,54-55。跋語又見《畫禪》卷1,20-21,文字略有出入)。台北國立故宮博物院藏。

參見:11/9/1598

按:此卷九段中惟第六段《評書帖》紀年,且內容之性質與其餘八段皆異,因疑此作原八段,《評書帖》爲《平生》成書後另加入。

至前五日

題唐摹王獻之草書《元度遲來帖卷》,麻紙本(《石續》,御書房一,1903)。

長至日

(1)

借觀并題虞世南行草書《積時帖卷》,素箋本(《餘清齋帖》,第三冊;《石續》,寧壽宮九,2617)。

(2)

題王羲之《霜寒帖》(《餘清齋帖》,第二冊)。

無月日

(1)

錄吳寬跋江參《江山長圖》語於四跋自藏江參《千里江山圖卷》之後(《故週》,v.356,3)。

參見:冬/1596;9/22/1597;4/20/1598

(2)

題莫是龍爲宋光祿所作畫卷(《畫禪》卷2,38-39)。

參見:秋/1579(2)

(3)

在京邸舍與楊明時賞玩古畫[見董題楊《秋山亭子圖軸》]。

參見:1/1616

(4)

分獻文廟,齋宿,與朱國楨論書(《涌幢》卷22,18,"好譚")。

1599　萬曆二十七年,己亥,四十五歲

正月

(1)

作墨筆《溪山秋霽圖卷》於苑西墨禪室,白宣德紙本[即《山水袖卷》](《選續》卷上,194-95;《董其昌》,no.2;《文人畫》,v.5,no.36;《畫集》,no.4;《中國圖目》,v.7,蘇24-0178)。南京博物院藏。

參見:1/13/1604

(2)

黃輝初函囑爲王羲之《療疾帖》作跋,乃唐人雙鈎

填廓者,董爲黃道破,不復作跋[見董日後題米芾《臨王羲之療疾帖卷》]。

參見:約秋/1597

(3)

兼趙孟頫與米家筆意作《山水卷》[見董一六一四年補題此作]。

參見:2/1614(2)

三月

(1)

爲姪孫董鎬作墨筆《郊居山水小軸》,紙本(《壯陶》卷12,8a-b)。

參見:1600(2)

(2)

作《論書畫卷》,白綾本(《十百》,子卷,17b-23a;《編年表》,94。論述語散見《容別》卷4,29b-30a;卷6,2b-4a,5b-7a,8a-12a;《畫禪》卷1,4,7;卷2,4-7,13-15,17-20,文字略有出入)。

四月三日

(1)

跋自藏之董源淺設色《瀟湘圖卷》,絹本(《式古》,v.3,畫卷11,434;《好古》卷上,28-29;《大觀》卷12,15b-16a;《寓意》卷1,5a-6a;《墨緣》,名畫卷上五代,3b-4b;《石三》,延春閣十,1380-81;《眼二》卷13,5b-6a;《中國歷代繪畫》,v.1,附錄17;《中國目錄》,v.2,2,京1-235。跋語又見《容別》卷6,31a-b)。北京故宮博物院藏。

參見:6/1597;八月晦/1605;4/17/1613

(2)

題自藏郭熙墨筆《溪山秋霽圖卷》,絹本。乃莫是龍故物(《清河》卷七上,37;《式古》,v.3,畫卷11,465;《書畫》卷5,517;《平生》卷7,43;《江村》卷3,20b;《大觀》卷13,29a;《董其昌》,no.35;《總合圖錄》,v.1,A21-059)。Freer Gallery of Art。

七月廿七日

泊舟徐門,題陳繼儒所藏倪瓚墨筆《漁莊秋霽圖軸》,紙本(《鑑影》卷20,8a-b;《夢園》卷7,11a-b;《中國圖目》,v.2,滬1-0230)。上海博物館藏。

秋

作設色《水閣圖扇頁》,紙本(《自怡》卷22,3b;《中國圖目》,v.3,滬1-1339)。上海博物館藏。

十一月

與陳繼儒泛舟春申江浦,爲作墨筆《己亥子月山水卷》,紙本,并題"罔嵐屈曲徑交加"七言絶句一首(《湘管》卷6,424-25;《編年表》,94;《董其昌》,no.3;《文人畫》,v.5,no.22;《畫集》,no.125。詩見《容詩》卷4,33b,"題畫贈眉公"二首之二。識語又見《容別》卷4,6a-b;《畫禪》卷3,1-2,文字時有出入)。美國翁萬戈藏。

長至日

楷書《金剛經塔》刻石(《中國仏教の旅》,v.1,50;《系年》,61)。北京廣濟寺及北京圖書館均藏有拓片。

無月日

(1)

得李成《晴巒蕭寺圖》,爲項元汴舊藏[見董題此圖]。

參見:5/15/1618

(2)

北歸過汶上,跋于文定公所示東平李道坤《山水花卉册》(《容別》卷6,52b-53b)。

(3)

行書《達觀説書李柏偈》,刻於北京圓通寺(《系年》,59)。拓片現藏北京圖書館。

1600 萬曆二十八年,庚子,四十六歲

二月晦日

題趙孟頫小楷《過秦論》,絹本(《辛丑》卷3,8;《清鑑堂帖》卷7,見《叢帖目》,第一册,340)。

按:董於款識自稱"文華濫直,"但此時尚未出任文華殿學士,此題存疑。參見《系年》,63。

三月

過荆谿訪吳正志,爲行書王維"輞川"絶句[即《輞川詩册》],宣德鏡光箋本(《石初》卷10,53b-54a;《故宮》卷3,104;《董其昌》,no.36)。台北國立故宮博物院藏。

按:是册今附《董其昌小像》。

四月十五日

題倪瓚宋箋本墨筆《林石小景圖軸》於戲鴻堂(《石初》卷8,18b)。

七月七日

艤棹姑蘇,觀同年王文考家藏之趙孟頫《溪山仙館圖》及倪瓚、黃公望畫[見董自題《仿趙文敏溪山仙館圖軸》]。

參見:4/19/1623

九月

作墨筆《溪回路轉圖軸》,鏡光宣紙本,并題"溪回路轉自轉"五言絶句一首(《華亭》,17-18)。

參見:4/17/1621

秋

作設色《仿叔明筆意圖卷》,絹本(《畫集》,no.5)。上海朶雲軒藏。

十二月八日

題黃公望《浮嵐暖翠圖軸》於石湖山莊,絹本(《壯陶》卷7,11b-12a)。

十六日

重觀并題自藏之墨筆山水,云去年十六日易自曹任之[見傳董《倣宋元人縮本畫跋册》](即《小中現大册》)二十二對幅之十六]。

參見:6/23/1598;1607(1);2/1614(1);5/1620;5/1625(1);秋/1626(1);11/19/1627(1)

無月日

(1)

爲太常作墨筆《仿馬文璧山水卷》,紙本(《古緣》卷5,29a-b)。

參見:冬/1619(1)

(2)

題一五九九年所作《郊居山水小軸》。

參見:3/1599(1)

(3)

臨《閣帖》五卷,後分贈門人魏澹明、東昌許維新、俞廷諤及友人(《容別》卷4,43a-b)。

(4)

行書一卷,絹本(《中國圖目》,v.1,京9-026)。北京中國文物商店總店藏。

1601 萬曆二十九年,辛丑,四十七歲

二月

作墨筆《鶴林春社圖軸》,紙本,并題"便欲冲霄去"五言律詩一首贈唐之屏(《虛齋》卷8,46a-47a;《編年表》,94;《畫集》,no.67。題語又見《畫禪》卷2,25;《容詩》卷2,15b-16a)。上海博物館藏。

三月三日

跋海上潘允端所藏趙孟頫爲甥張景亮所作草書《千字文卷》,烏絲闌紙本(《式古》,v.2,書卷16,121;《江村》卷1,47b;《大觀》卷8,33b-34a;《過雲》書卷2,3a-b;《中國圖目》,v.2,滬1-0148)。上海博物館藏。

三月十五日

過西湖,仲茅攜董舊作《西湖八景圖册》至行舫,因題於册末(《年譜》,42)。

春

虎邱山居,作設色《倣黃公望山水卷》,金箋本(《石三》,延春閣廿六,2065;《編年表》,94)。

五月廿六日

題自藏董源墨筆《谿山行旅圖軸》,黃絹本大幅雙軸,只存半幅(《式古》,v.3,畫卷11,435-36;《平生》卷6,77;《江村》卷1,8;《大觀》卷12,18a-b;《寓意》卷1,4b-5a;《鑑影》卷19,6b-7a;《南宗衣鉢》,v.1;《支那名畫寶鑑》,45;《中國書畫》,v.1,7)。日本小川氏藏。

参見:春/1593

七月三日

於湖莊再跋自藏之趙令穰《江鄉清夏圖卷》(《董其昌》, no. 37)。

参見:7/30/1596; 4/1615(1); 8/15/1629(1)

七夕後

於湖莊作書論,論米芾書(《容別》卷4, 68b)。

秋

爲陳繼儒所藏吳鎮紙本濃墨《溪山深秀圖卷》行書橫額(《古芬》卷13, 15a–b)。

按:董日後於畫禪室題此卷,時已歸王思任所藏。

冬

(1)

楷書《臨宣示表》[高麗箋本《臨古帖三種冊》之三](《石續》,淳化軒,3307–3308;《石隨》卷6, 5a–b;《編年表》,94。自跋語又見《畫禪》卷1, 33)。

参見:3/3/1634(1); 冬/1591

(2)

爲長子祖和書《雪賦》,又爲次子祖常小楷書謝莊《月賦卷》,麗箋本(《大觀》卷9, 39a–b)。北京故宮博物院藏。

無月日

(1)

於靈巖村觀并題黃承玄所藏蘇軾楷書《前赤壁賦卷》,素箋本(《石初》卷29, 71a–b;《故宮》卷1, 50;《故週》,v.233, 2)。台北國立故宮博物院藏。

(2)

書唐人詩八幅,一六〇六年孫克弘爲補圖乃成冊[見翁方綱跋《孫雪居·董香光書畫合冊》](《復初齋文集》卷34,引自《年譜》,44)。中國私人收藏。

1602 萬曆三十年,壬寅,四十八歲

正月一日

自亡父璵洋墓裹事歸,始書《盂蘭盆經卷》[見董自跋此卷]。

参見:12/1602

正月

(1)

爲復陽作墨筆《山水便面》,金箋本[《便面畫冊》十幅之九](《石初》卷41, 36b;《南畫》卷8, 103;《畫集》, no. 154)。

参見:4/4/1592; 4/7/1625; 5/1633(1); 9/1635(1)

(2)

同顧侍御自橋李歸,阻雨葑涇,檢古人名跡,作墨筆《葑涇訪古圖軸》,高麗賤本(《式古》,v.3,畫卷7, 325;《明法書名畫合璧高冊》第一冊廿七幅之十五;《大觀》卷19, 31b;《墨緣》,名畫卷下·宋元明大觀高冊》二十幅之末幅, 10a–b;《石續》,寧壽宮十四,2850;《選續》卷下, 275–76;《故宮》卷5, 458–59;《編年表》,94;《董其昌》, no. 4;《文人畫》,v.5, no. 29;《畫集》, no. 68)。台北國立故宮博物院藏。

寒食

從高仲舉見妻水王奉常家藏之趙孟頫楷書《千文》,把玩移日,漫臨一冊,紙本(《三秋》卷上, 61b–62a;《編年表》,94)。

按:王奉常通常指王時敏,然此時年僅十一歲,因疑此指王世懋(1536–1588),嘗任太常少卿(奉常),有《奉常集》。

四月十五日

倣自藏之趙孟頫《鵲華秋色圖卷》作設色山水,絹本[《倣六家冊》六幅之六](《華亭》, 28–29)。

参見:7/12/1621

按:董得趙孟頫《鵲華秋色圖卷》在此年長至日,此時尚未收藏,此作存疑。參照《系年》,70。

四月

訪于比部中甫於金沙,觀其所藏唐摹索靖草書《月儀帖》,因臨一卷,紙本(《石三》,御書房二,3137–38;《故宮》卷1, 133–35;《編年表》,94;《董其昌》, no. 38)。台北國立故宮博物院藏。

参見:7/1619

五月一日

臨唐玄宗《鶺鴒頌》,并自題行書仲長統《樂志論卷》,灑金箋本(*Christie's*, June 1984, no. 745)。

五月

雨中過陸萬言所,有張子淵在座,爲陸作設色《赤壁招隱圖軸》,絹本,并小楷書昔爲沈微士《小赤壁圖》所賦"吾松山有九"五言古詩一首(《容詩》卷1, 3b–5a;《吳越》卷5, 46a–47a;《湘管》卷6, 431–33;《編年表》,94)。

六月七日

作《倣趙令穰村居圖》,寫嘉興江中所見(《畫禪》卷2, 32)。

六月

(1)

應項元汴之請,題舊作五言古詩"小赤壁詩"於趙孟頫小楷書《赤壁賦》并墨筆《蘇文忠小像》合冊,絹本(《古芬》卷12, 28b–29b。詩見《容詩》卷1, 3b–5a)。

按:項元汴卒於一五九〇年,故此題爲僞。

(2)

觀項氏所藏米友仁《瀟湘白雲圖》,憶自藏高克恭《雲林秋霽》大幅,擬作《山水扇頁》(《年譜》,47)。上海博物館藏。

七月十五日

爲項德弘跋傳張旭草書《古詩四帖卷》,紙本,并摹刻於《戲鴻堂帖》(《董其昌》, no. 39)。遼寧省博物館藏。

七月

倣文徵明作《神樓圖軸》,絹本(《別下》卷3, 14a–b;《編年表》,94)。

参見:1603(1); 4/19/1634

八月晦日

行書論書畫於金沙小清涼館,紙本[《金沙帖卷》十段之三](《中國圖目》,v.1,京5–227)。北京首都博物館藏。

参見:1633(4)

九月十一日

題倪瓚墨筆《六君子圖軸》,紙本(《虛齋》卷7, 50a;《味水》卷1, 54a–b;《平生》卷9, 92;《中國圖目》,v.2,滬1–0229)。上海博物館藏。

十二月八日

題舊藏之李公麟墨筆《蜀川圖卷》,素箋本。此卷已轉歸信陽王思延(《石初》卷44, 33a;《西清》卷3, 23b–24a;《南畫》續集5, 11–12;《總合圖錄》,v.1, A21–088;《文人畫》,v.2, nos. 60 & 69)。Freer Gallery of Art。

按:董得此卷於海上顧從義家。

又:董未紀年之初跋見《董其昌》, no. 80。

十二月廿九日

(1)

題韓世能家藏之宋高宗楷書、馬和之設色畫《陳風圖卷》,絹本(《石續》,御書房,2034;《總合圖錄》,v.2, E15–258;《文人畫》,v.2, no. 77)。The British Museum。

参見:12/29/1602(2)

(2)

夕臨《衡門篇》,復展爲長軸,用董源意作遠山[見董題宋高宗書、馬和之畫《陳風圖卷》]。

参見:12/29/1602(1)

十二月三十日

初跋自藏之趙孟頫著色《鵲華秋色圖卷》,宋箋本(《書畫》卷5, 473;《平生》卷9, 15;《石初》卷33, 2a–b;《南畫》續集5, 32;《故宮》卷4, 106;《董其昌》, no. 40。跋語又見《容別》卷6, 37a)。台北國立故宮博物院藏。

参見:1583; 長至日/1602(1); 1605(1); 2/1612(2); 約八月/1629; 5/13/1630(1)

長至日

(1)

項德明携趙孟頫《鵲華秋色圖卷》訪董,囑藏之戲鴻閣,以副李公麟《蓮社圖》[見董初跋《鵲華秋色圖卷》]。

參見:1583; 12/30/1602; 1605(1); 2/1612(2);約八月/1629; 5/13/1630(1)

(2)

行書"許周翰郡侯捐俸助刻《戲鴻堂帖》占謝"五言古詩一卷,紙本(《中國圖目》,v.3,滬1-1340。詩見《容詩》卷1, 5b-6a)。上海博物館藏。

(3)

初跋米友仁墨筆《瀟湘奇觀圖卷》,繭紙本(《味水》卷8, 24b-25a;《郁題》卷4, 5a;《珊瑚》·畫,卷4, 5-6;《式古》,v.4,畫卷13, 13-14;《大觀》卷14, 30a-b;《眼二》卷13, 28a-29a)。

參見:5/19/1605

按:此為《眼二》所載董之再跋,其初跋與他書所載之再跋亦異,應為後人移跋裝裱之故。

長至後五日

過朱國盛,跋所藏《趙孟頫·鮮于樞合册》,宋牋本,并借歸摹之《戲鴻堂帖》中(《石初》卷10, 38b;《故宮》卷3, 230。跋語又見《畫禪》卷1, 42)。台北國立故宮博物院藏。

按:此册為趙孟頫論虞世南及裝行儉書法,與鮮于樞尺牘論古人畫跡,鮮于樞論張旭、懷素、高閑草書。

十二月

掃亡母墓,宿戴振之山莊,書竟楷書《盂蘭盆經卷》,朝鮮牋本(《秘初》卷6, 22a-b;《好古》卷上,27;《編年表》,94)。

參見:1/1/1602

無月日

兼自藏之趙伯駒《春山讀書圖》、趙令穰《江鄉清夏圖》、趙孟頫《鵲華秋色圖卷》筆意,作《仿三趙筆意圖》(《畫禪》卷2, 24)。

1603 萬曆三十一年,癸卯,四十九歲

正月一日

重題一五九一年所作《山水》。

參見:12/30/1591

正月七日

《戲鴻堂法書》十六卷模勒上石畢(《善本碑帖錄》卷4,宋元明刻叢帖·明《戲鴻堂帖》;《叢帖目》,第一册,262-72)。上海博物館藏有全帖十六卷。

按:《戲鴻堂法書》殘餘石刻現存合肥安徽博物館,參見《系年》,75-76。

二月十六日

舟次葽水,於鶴來堂自識大行書《臨穎上蘭亭序十二軸》,絹本(《藤花》卷4, 45a-46b)。

三月

在蘇州雲隱山房,范爾孚、王伯明、趙滿生同過訪,行草書一卷,紙本。書《羅漢贊》二首、《初祖贊》、"送僧遊五台"五言律詩、"送僧之牛山雞足"五言古詩、文語五則及書論(《槐安》,no. 171;《書道藝術》卷8, 103-11;《書跡名品》,董其昌《行草詩卷》;《董其昌》,no. 41)。東京國立博物館藏。

按:《平生》載董紙本行書《雜言卷》似即此作,見卷5, 56。

春

自題昔日在京苑西草堂所作墨筆《臨郭忠恕山水卷》之粉本,絹本(《總合圖錄》,v.2, E20-074;《文人畫》,v.5, no. 19;《董其昌》,no. 5;《畫集》,no. 126)。Östasiatiska Museet, Stockholm。

參見:9/2/1603

六月晦前三日

臨王獻之《洛神賦》[《臨書册》三段之首](《書苑》,4-6)。

參見:立秋/1603; 7/4/1603

立秋

臨米芾《西山院記》[《臨書册》三段之二]。

參見:六月晦前三日/1603; 7/4/1603

七月四日

臨張旭書[《臨書册》三段之末]。

參見:六月晦前三日/1603; 立秋/1603

七月

作墨筆《仿北苑夏山欲雨圖軸》,紙本(《爽籟》,第一輯, no. 35;《總合圖錄》, v.3, JM3-053)。大阪市立美術館藏。

八月

(1)

舟次雲陽,擬遊白下時所見褚遂良《西昇經》,小楷書《樂志論卷》,紙本(《過續》卷2, 5a-b;《編年表》,94;《中國圖目》,v.6;蘇1-124)。蘇州博物館藏。

(2)

遊白門,跋李公麟白描《山莊圖卷》,澄心堂紙本(《石續》,寧壽宮,2686)。

九月二日

携子以試事至白門,於大江舟中完成舊作《臨郭忠恕山水卷》并重題。

參見:春/1603

九月十六日

俞廷諤以吳綃索書,董為書《梅花賦》並識書法之要一卷於畫禪室(《壯陶》卷12, 21b-22a)。

秋

(1)

許維新與陸辰陽泛海賦詩,索董為和,董因作"秋日泛泖"七言律詩四首[見董自題《泛海游詩卷》]。

參見:1/1608

(2)

於汪砢玉家觀汪父新購之李成《山水寒林圖》[見汪砢玉題此圖](《珊瑚》·畫,卷2, 1)。

(3)

偕吳彬遊攝山,觀其所作《五百應真》若干軸於棲霞寺,為書《棲霞寺五百阿羅漢記册》於乳泉亭(《十百》,甲卷, 25a-27b;《編年表》,95)。

(4)

為俞汝為作墨筆《山莊秋景圖扇》,金牋本(《中國圖目》,v.3,滬1-1341)。上海博物館藏。

十月晦日

題蘇軾《祭黃幾道文卷》於曹周翰所,同觀者陳繼儒、周仲曹、季良兄弟(《書跡名品》,蘇軾《黃州寒食詩卷·他二種》)。上海博物館藏。

十月

(1)

夜宿周季良清鑒閣,題倪瓚墨筆《秋林山色圖軸》,宋牋本(《大觀》卷17, 48b;《墨緣》,名畫卷上元,19a-b;《石續》,淳化軒,3242)。

(2)

過婁江,跋蘇軾行書《種橘帖卷》,紙本(《石三》,敬勝齋,966)。

十一月

行書《孔德璋北山移文卷》,高麗紙本(《華亭》,4)。

十二月

觀并題宋旭《松窗讀易圖軸》(《享金簿》,219)。

冬

憨山德清發配嶺南,董為作七言絶句"畫扇贈別憨師成嶺表"(《容詩》卷4, 34a)。

長至日

作行楷各體《臨鍾王帖卷》,宣德鏡光牋本,臨《力命》、《季直》、《戎輅》、《丙舍》及《蘭亭》五帖(《石初》卷5, 30a-b;《天瓶》卷下, 5a-b;《編年表》,94)。

無月日

(1)

以自藏之文徵明《神樓圖》贈許維新[見董再題一

497

六〇二年所作《神樓圖軸》]。

參見:7/1602; 4/19/1634

(2)

行書《輞川詩卷》,灑金箋本(《中國目錄》,v.2, 50,京1-2146)。北京故宮博物院藏。

1604 萬曆三十二年,甲辰,五十歲

正月十三日

遇戴長明,重題一五九九年所作《溪山秋霽圖卷》。

參見:1/1599(1)

正月十五日

(1)

吳廷攜天曆本《臨蘭亭帖卷》至畫禪室,白麻紙本, 董爲跋之(《大觀》卷1,32b;《墨緣》,法書卷上唐, 1a-b;《石初》卷42, 2b-3a;《石隨》卷1, 7a;《書跡名 品》,王羲之《蘭亭序六種》)。

參見:1597(1); 12/30/1598; 1/1618(1); 1/22/1618(1)

按:此卷無款,董定爲虞世南書,爲《蘭亭八柱帖》 八卷之首。

(2)

作《陳懿卜古印選引》於戲鴻堂(《歷代印學論文 選》,530。文見《容文》卷4, 70a-b)。

二月

行書《精書冊》,紙本(《劍花》,上卷,28-29)。

1604

三月三日

泊舟滸墅,擬虞世南、歐陽詢行楷書《禮觀音文 卷》,絹本(《萱暉》,書158a-160a。自跋語又見《容 別》卷5, 17b-18a;《畫禪》卷4, 2)。程琦舊藏。

四月十七日

作墨筆《谿山雨意圖軸》,紙本。上海博物館藏。

四月廿三日

題趙孟頫楷書《妙法蓮華經冊》,烏絲格宋紙本 (《壯陶》卷5, 65a)。

四月晦日

三度致函武林馮夢禎,言思王維《江山雪霽圖卷》, 欲再觀之於武林(《董其昌》,no. 43)。

參見:7/13/1595; 10/15/1595; 2/10/1596; 8/1/1604; 8/15/1604; 8/20/1604; 5/1618(1)

五月一日

自題小行楷書《禮觀音文》,絹本[《孫雪居白描大

士像·董文敏小行楷禮觀音文卷》之書幅](《吳 越》卷2, 78b-79b。題語又見《容別》卷5, 17b- 18a,《畫禪》卷4, 2)。

五月

(1)

吳廷攜米芾行書《蜀素帖卷》至西湖,董以諸名蹟 易之[見董初跋此卷](《式古》,v.1,書卷11, 545- 46;《書畫》卷5, 503;《江村》卷1, 13-17;《大觀》卷 6, 22a;《石續》,重華宮,1521;《石隨》卷2, 12a-b; 《故宮》卷1, 57-58;《書跡名品》,米芾《真迹五種》; 《董其昌》,no. 84)。台北國立故宮博物院藏。

參見:11/1633(1)

(2)

從項德弘借觀黃公望《浮嵐暖翠圖軸》閱半歲將 還,作淺設色《臨黃公望浮嵐暖翠圖軸》,絹本(《石 續》,淳化軒,3320;《編年表》,95)。

按:據陳繼儒題董之臨本,董以百金得黃公望此軸 於項德弘,項不忍釋,因復返去。

(3)

婁江舟次,觀并題郭熙微著色《雪景山水軸》,絹本 (《鑑影》卷19, 16a)。

六月三日

過南湖,觀并題吳功甫所藏巨然墨筆《山寺圖卷》, 絹本[一名《治平寺圖》](《珊瑚》·畫,卷2, 2;《式 古》,v.4,畫卷13, 32;《壯陶》卷2, 41b-42a)。

六月

(1)

得高克恭《山水巨軸》於吳門[見董自題《容安草 堂圖軸》]。

參見:10/1604

按:吳湖帆謂高克恭此作即《秋樹煙嵐圖軸》,待 考。見吳湖帆自題《傲秋樹煙嵐圖軸》,*Sotheby's*, 5/18/1989, no. 158。

(2)

觀王獻之行草書《中秋帖》於西湖僧舍,硬黃紙本, 乃項氏藏本,前後遺失,董以《閣帖》補書之,並題 於卷末(《式古》,v.1,書卷6, 308;《平生》卷1, 24- 25;《大觀》卷1, 31a-b;《石初》卷29, 7a-b;《三希》, 第二冊,103-104;《董其昌》,no. 42)。

(3)

於西湖畫舫觀并題宋高宗行楷書杜甫七言律詩 "暮春,"趙孟頫補圖,絹本[《宋元寶翰冊》二十二 幅之首,畫已逸去](《石初》卷21, 5b;《故宮》卷3, 222)。台北國立故宮博物院藏。

(4)

題趙孟頫《臨王大令四帖卷》於西湖舟中,素箋本 (《盛京》,第三冊,8b;《古物》卷2, 11a)。

(5)

題吳廷所藏蘇軾行書《後赤壁賦卷》於西湖,紙本 (《式古》,v.1,書卷10, 505;《江村》卷2, 12a)。

八月一日

武林馮夢禎獲董三度來函,欲再觀所藏王維《江山 雪霽圖卷》於武林(《雪堂》,26b-27a)。

參見:7/13/1595; 10/15/1595; 2/10/1596; 四月晦/ 1604; 8/15/1604; 8/20/1604; 5/1618(1)

八月十五日

告馮夢禎甫至武林,下榻於西湖昭慶禪寺(《快雪 堂集》卷61, 11)。

參見:7/13/1595; 10/15/1595; 2/10/1596; 四月晦/ 1604; 8/1/1604; 8/20/1604; 5/1618(1)

八月二十日

(1)

於西湖昭慶禪寺觀馮夢禎遣示之王維《江山雪霽 圖卷》、蘇漢臣《宋高宗瑞應圖卷》及米友仁《山水 卷》(《快雪堂集》卷61, 11),並重題王維《江山雪 霽圖卷》(《珊瑚》·畫,卷1, 6;《式古》,v.3,畫卷9, 383)。

參見:7/13/1595; 10/15/1595; 2/10/1596; 四月晦/ 1604; 8/1/1604; 8/15/1604; 5/1618(1)

按:米友仁《山水卷》或即美國Freer Gallery of Art所藏米友仁《楚山秋霽圖卷》,見下條。

(2)

題米友仁墨筆《楚山秋霽圖卷》於西湖之昭慶禪 房,紙本(《退菴》卷12, 1b-2a;《虛齋》卷1, 34a-b; 《總合圖錄》,v.1, A21-087)。Freer Gallery of Art。

參見:8/20/1604(1)

九月

(1)

書《千文》[見董一六二七年題此作]。

參見:10/1627(2)

(2)

撰并書《重建雲棲禪院碑記》(《雲棲志》;《名山勝 概志》卷15。引自《年譜》,58)。

秋

(1)

作墨筆《仿梅道人山水圖軸》,絹本(《畫集》, no. 7)。浙江省博物館藏。

參見:10/1/1607

(2)

得寶鼎於西湖,因以名藏書之室[見董自題《寶鼎 齋法帖》]。

參見:10/1/1609

十月廿三日

跋王羲之草書《行穰帖真蹟卷》於戲鴻堂,黃麻 紙本(《石續》,寧壽宮,2599-2600;《墨緣》,法書卷 上東晉,3b-4b;《三希》,第一冊,50;《歐米收藏法

書》卷1, nos. 3-6）。The Art Museum, Princeton University。

參見:6/26/1609

十月

因與徐道寅爲別,訪之容安草堂,爲倣高克恭法作墨筆《容安草堂圖軸》,絹本(《畫集》,no.69;《中國圖目》,v.3,滬1-1342)。上海博物館藏。

參見:6/1604(1)

十二月一日

(1)

題韓世能家藏之陸機草書《平復帖》,紙本(《清河》卷一下,31-32;《真蹟》,二集,54a-b;《墨緣》,法書卷上西晉,1a-b;《大觀》卷1,10a-b)。

參見:春/1591

按:《書畫》、《平生》及《眼二》亦載董題陸機《平復帖》九行,紙本,但題語全異,且未紀年,置此待考。見後文未紀年部份"鑑藏題跋"之"陸機"條。

又:北京故宮博物院藏有陸機草書《平復帖卷》,紙本,不知爲何本,待考。見《中國目錄》,v.2,1,京1-172。

(2)

題孫克弘淡著色《十峰圖卷》,絹本(《澄懷》卷3,124-25)。

十二月四日

行書《禮樂亭記冊》,紙本(Sotheby's, 12/5/1984, no.10 及 11/30/1988, no.29)。

十二月

題徐浩楷書《朱巨川告身卷》,白麻紙本(《平生》卷1,91;《大觀》卷2,41b;《石續》,重華宮,1492;《石隨》卷1,13b;《故宮》卷1,27)。台北國立故宮博物院藏。

冬

(1)

陶望齡請告歸,董遇之金閶舟中[見《禪語隨筆冊》]。[又見《禪悅》](《畫禪》卷4,17;《容別》卷3,12b)。

參見:11/15/1614

(2)

有楚中之命而不欲出,爲鍾黃初作畫,並系"微書雖不到門"五言絕句一首(《容別》卷4,16b-17a及30a;《容詩》卷2,28a-b)。

無月日

(1)

於杭州南屏山,應夜臺禪師之請,爲五臺、峨嵋、普陀三山書牓[見《夜臺禪師像贊》]。

參見:1597(2);1607(2);1610(1)

(2)

遊茅山,訪金沙王肯堂,觀所藏黃公望《天池石壁圖》(《韻石》卷下,215-16)。

1605 萬曆三十三年,乙巳,五十一歲

正月十九日

臨顏真卿、虞世南、楊凝式等書古詩數首一卷(《畫禪》卷1,25)。

正月

(1)

得王穉登所藏宋搨《鼎帖》於吳閶[見董題此帖]。

參見:6/7/1605

(2)

取道橋李赴楚,遊南湖,大書"魚樂國"三字[見車大任《魚樂國記》](嘉慶刻本《嘉興縣志》卷七·名勝。引自《系年》,86-87)。

春

(1)

作《賀侍御達泉張公八十序》(《容文》卷2,26a-28b)。

(2)

倣自藏之郭忠恕《谿山行旅圖》作山水小幅(《容別》卷6,13a)。

五月十九日

舟行洞庭湖中,再題自藏米友仁《瀟湘奇觀圖卷》。

參見:長至日/1602(3)

六月七日

自常荆校士還武昌,舟次城陵磯,跋自藏之宋搨《鼎帖》(《郁題》卷10,11b;《珊瑚》·書,卷21,20-21;《容別》卷5,23b-24b)。

參見:1/1605(1)

六月

舟次城陵磯,作畫并題(《珊瑚》·畫,卷18,22-23;《式古》,v.4,畫卷30,532;《編年表》,95)。

八月晦日

校士湖南,於湘江舟中再跋自藏之董源《瀟湘圖卷》。

參見:6/1597;4/3/1599(1);4/17/1613

秋望

於武昌署中行書《禊序卷》,烏絲藏經紙本(《式古》,v.1,書卷5,241;《編年表》,95)。

秋

想像王詵筆意,作墨筆《烟江疊嶂圖》,又行書蘇軾

"王定國所藏烟江疊嶂圖詩"一卷,絹本[見董重題此卷]。

參見:12/1614

無月日

(1)

曬畫武昌公廨,再跋自藏之趙孟頫《鵲華秋色圖卷》(《容別》卷6,37a-b;《式古》,v.4,畫卷16,134;《大觀》卷16,10b;《石初》卷33,4a;《故宮》卷4,107;《董其昌》,no.44)。

參見:1583;長至日/1602(1);12/30/1602;2/1612(2);約八月/1629;5/13/1630(1)

(2)

校士衡陽,行書《大唐中興頌卷》,紙本。時永州守以拓本至,念不能往讀碑,而篋中有趙孟頫《山谷浯溪讀碑圖》,因作歌屬永州守錦之,書於《頌》後並自題(《虛白》,no.110;《藝苑掇英》,v.31,44)。香港劉作籌藏。

(3)

以校士至鼎州[見董《馬憲副崇祀錄序》](《容文》卷2,16a)。

1606 萬曆三十四年,丙午,五十二歲

春

過湖口,遊石鐘山,書蘇軾《石鐘山記卷》,紙本(《壯陶》卷12,28a-b)。

四月

行書論書語數則,灑金箋本[《法書名畫冊》之前段](《式古》,v.2,書卷28,497;《編年表》,95)。

夏午

作墨筆《仿梅道人圖軸》,楚紙本(《大觀》卷19,34b;《編年表》,95)。

參見:5/1626(1)

按:《華亭》亦載董墨筆《擬梅花道人筆意軸》,宣德紙本,題語與此作僅數字之差,惟紀年爲"丙寅夏五"(一六二六年)而非"丙午夏午"(一六〇六年),待考。見《華亭》,13及42-43。

六月八日

避暑蘄州公署,楷書鮑照《舞鶴賦》一冊,綾本(《鑑影》卷14,16a-b;《編年表》,95。識語又見《容別》卷4,41b;《畫禪》卷1,33-34)。

按:《壯陶》載董《戲鴻堂小楷冊》之末段亦爲《舞鶴賦》識語僅數字之差,但董款印及鑑藏印不同,附此待考。見7/4/1607;長至前二日/1631。

又:《式古》與Christie's亦載董書《舞鶴賦》,自識語全同,但年款及印鑑有異,待考。見6/16/1609(1);3/9/1618。

六月十五日

作大字行草書,臨自藏米芾《蜀素帖》末段七古"集

英詩",綾素十幅,後汪砢玉裝屏張於其墨花閣(《珊瑚》·書,卷6,8)。

參見:5/1604(I)

按:米芾此卷書於元祐"戊辰"九月二十三日,董之臨本作"戊申",或爲筆誤。

六月

避暑蘄州,擬柳公權楷法書張雨題黃公望畫語於舊作重設色《良常山館圖軸》,絹本(《寓意》卷4,33a–b;《編年表》,95)。

八月十五日

大行書節臨顏真卿《送明遠帖》及《送劉太冲叙》一卷,粉箋本(《筆亭》,10)。

八月廿六日

舟泊龍江關,吳廷出示米芾畫,因作墨筆《倣米山水圖軸》,紙本(《總合圖錄》,v.2, S12–005)。香港徐伯郊藏。

八月

南陵舟次,作墨筆《秋山圖軸》,絹本(《藝苑掇英》,v.14, 29;《畫集》,no.8)。廣東省博物館藏。

參見:9/1606

九月

自楚歸,與陳繼儒同遊泖湖,出示月前所作《秋山圖軸》[見陳繼儒題此作]。

參見:8/1606

秋

在武昌,思歸甚,因作《山水軸》寫王維"田園樂"詩意[見董題此作](《編年表》,95)。

參見:7/3/1610

十月三日

草書張栻《遊衡嶽記卷》,絹本(《石三》,寧壽宮一,3328–29)。

十二月八日

以米芾《天馬賦》筆意行書蘇軾"赤壁懷古詞"一卷,絹本(《穰續》卷9, 8b–9a;《編年表》,95)。

十二月廿九日

楷書《臨畫贊大字卷》,鏡面紙本,臨顏真卿《東方朔畫贊》(《壯陶》卷12, 31a–b;《中國目錄》,v.2, 50,京I–2147)。北京故宮博物院藏。

無月日

(I)

自楚歸,居郡西龍潭抱珠樓,擬米家父子《袖珍著色卷》及《五洲圖》作《書畫冊》十二對幅,末副葉自

題二幅。各葉分題,分倣董源、王蒙《高逸圖》、倪瓚、韓文仁、方從義爲允中所作畫、黃公望《天池石壁圖》、馬琬、倪瓚,後四葉有題無畫,一題"喬木生畫陰"五言絕句,一題"錫山無錫是無兵"七言絕句,一書庚信《枯樹賦》"顧庭槐"一段,一書蘇軾"掃地焚香"七言絕句(《玉雨》卷3, 95–98)。詩見《容詩》卷2, 35b及卷4, 42a–b)。

參見:I/1633

(2)

行楷書《千文冊》未竟[見董書竟此冊時自識語]。

參見:12/19/1609(I)

1607 萬曆三十五年,丁未,五十三歲

二月晦日

倣李邕筆意爲杜日章行書《大學冊》,泥金紙本,書《大學》一章(《古芬》卷7, 29a–31a;《眼初》卷5, 12a)。

三月七日

行書王維"登樓歌"一冊,粉箋本(《筆亭》,23;《眼初》卷5, 4a–b)。

三月

作設色《倣趙文敏谿山紅樹扇頁》於細林山下,灑金箋本[《畫中九友山水扇面集》九幅之首](《畫集》,no.16;《中國圖目》,v.7,蘇24–0179)。南京博物院藏。

春

陶望齡兩度作書邀董爲西湖之會[見《禪語隨筆冊》]。[又見《禪悅》](《畫禪》卷4, 17;《容別》卷3, 12b–13a)。

參見:11/15/1614

六月八日

行書《臨蘇黃米蔡帖卷》,絹本。節臨蘇軾書嵇康《養生論》,黃庭堅"九陌黃塵烏帽底""桃李無言一弄風"七言絕句二首及尺牘一通、米芾書帖"揚帆載月遠相過""山清氣爽九秋天"七言律詩二首、蔡襄尺牘一通,各段分題(《中國目錄》,v.2, 50,京I–2149)。北京故宮博物院藏。

七月四日

見王羲之《快雪時晴帖》於館師韓世能家,因借歸摹之,并錄趙孟頫、劉慶跋語[見董《戲鴻堂小楷冊》](《壯陶》卷11, 45a–46a)。

參見:6/8/1606;長至前二日/1631

按:韓世能卒於一五九八年,《快雪時晴帖》是否借自其子逢禧,待考。

七月五日

作《青綠山水軸》,絹本(《編年表》,95;《中國目錄》,v.2, 50,京I–2151;《畫集》,no.10)。北京故宮

博物院藏。

參見:I/2/1611

七夕後

過青溪別館,作《山水冊》十幅,每幅有陳繼儒對題七言絕句一首(《穰續》卷9, 14b–17a;《編年表》,95)。

九月

題仲幹所藏丁雲鵬墨筆《仿米氏雲山圖軸》,紙本(《虛齋》卷8, 50b;《中國圖目》,v.8,津I–04)。天津市文化局文物處藏。

秋

倣董源筆,作設色《倣北苑山水圖軸》,絹本,并題"山居幽賞入秋多"七言絕句一首(《畫集》,no.9。詩見《容詩》卷4, 43b,"題紅樹秋色")。廣州美術館藏。

十月一日

李康出示所藏董一六〇四年所作《仿梅道人山水圖軸》,董爲補筆并再題。同觀者吳充符、汪履康及履泰。

參見:秋/1604(I)

十月廿六日

臨懷素《千字文》一卷。石拓本現藏松江圖書館。

十月

泊舟鴛湖,行書《杜詩·臨顏帖卷》,綾本。前倣王羲之帖書杜甫"觀少保薛稷書畫壁""題韋偃畫馬"古詩二首,後節臨顏真卿《爭坐位帖》(《夢園》卷13, 5a–6a;《編年表》,95)。

十一月十二日

陳繼儒、林符卿同至青溪,董草書王維"觀獵"五言律詩一卷,紙本(《古芬》卷7, 10a–11a)。

十二月七日

檢班書《安世房中歌》十七章及《郊祀歌》,書"練時日"、"帝臨"、"青陽"、"朱明"、"西顥"及"元冥"六篇,又臨《閣帖》王羲之《通慧塔院碑》及鍾繇、王廙、皇象、郗愔書數種,合爲《澄懷游古卷》,高麗紙本(《筆亭》,34–37)。

無月日

(I)

禮白岳還,購趙孟頫學董源淺設色畫於休寧洪氏并題之[見傳董《倣宋元人縮本畫跋冊》](即《小中現大冊》)二十二對幅之四]。

參見:6/23/1598; 16/1600; 2/1614(I); 5/1620; 5/1625(I);秋/1626(I); 11/19/1627(I)

(2)

應夜臺禪師之請,爲九華山書牓[見《夜臺禪師像

贊》]。

參見:1597(2);1604(1);1610(1)

(3)

行書《別賦卷》,紙本(《中國圖目》,v.1,京8–013)。北京中央工藝美術學院藏。

(4)

行書《宋人詞卷》,綾本(《中國目錄》,v.2,50,京1–2148)。北京故宮博物院藏。

(5)

撰并書《青浦縣儒學新建尊經閣碑記》(《松江》卷73,22)。

1608 萬曆三十六年,戊申,五十四歲

正月四日

臨自藏之褚遂良《摹蘭亭叙》一册於瑞環樓,宣德鏡光箋本(《石初》卷3,22b–23b;《編年表》,95)。

參見:8/15/1609

按:董藏褚遂良《臨褉帖墨跡卷》爲白麻紙本,曾入元文宗御府,董得之吳廷。

正月

齋中行書一六〇三年和許維新、陸辰陽所作七律"泛海游詩"一卷,金箋本(《華亭》,5。詩見《容詩》卷3,40a–b,"秋日泛泖四首"之四)。

參見:秋/1603(1)

二月二日

爲成夫作《山靜日長書畫卷》,絹本。畫幅設色,寫《鶴林玉露》山居詩意,書幅行書羅大經《鶴林玉露》論唐庚詩"山靜似太古,日長如小年"一段(*Christie's*,11/28/1990,no. 20)。

二月

客出示趙孟頫書《雪賦》,董因大行書《雪賦卷》,紙本烏絲格(《壯陶》卷12,24a–b。題語又見《容別》卷5,11b–12a;《畫禪》卷1,20)。

寒食後七日

掃亡父墓於震澤璵洋山,憩靈巖村居,行楷書《臨鍾王帖册》,高麗牋本。首書"刻鵠不成"四字,節臨鍾繇《力命》、《墓田丙舍》、《戎路》三帖,王羲之《曹娥碑》及王獻之《洛神賦》十三行,間有自識語(《石續》,養心殿,1070–71;《故宮》卷3,97–99;《編年表》,95;《董其昌》,no. 45。册末總跋又見《容別》卷4,52a–b)。台北國立故宮博物院藏。

按:據陳繼儒跋,董此册乃爲項于蕃作。

四月八日

以陝本《聖教序》後集王羲之書縮成小行體作《心經册》,泥金書,磁青箋本(《秘初》卷3,13b–14a)。

四月

爲陸萬言作墨筆《山郭幽居圖軸》,絹本,并題"山

郭幽居正向陽"七言絶句一首(《夢園》卷13,42a;《編年表》,95)。

參見:10/1/1608

六月十五日

作墨筆《嘉樹垂陰圖軸》,絹本,并題"嘉樹森梢一百章"七言絶句一首。後又重題贈楊玄蔭(詩見《容詩》卷4,35a–b,"題畫贈楊玄蔭大參")。上海博物館藏。

七月十七日

書《赤壁賦册》於澱湖,紙本(《穰續》卷8,14b;《編年表》,95)。

八月一日

重題楷書《雪賦卷》,紙本。初題云此作以虞世南書意入智永(《中國圖目》,v.8,津2–030)。天津市歷史博物館藏。

八月廿三日

與陳繼儒同觀趙孟頫《小像立軸》,宋紙本,并題之於寶鼎齋(《吳越》卷2,9b–10a)。北京故宮博物院藏。

八月

兼法王維與巨然,爲欽仲作《秋林晚翠圖軸》於西郊草堂,絹本(《穰梨》卷24,8a)。

參見:10/15/1628(1)

秋九日

草書臨王羲之《十七帖》并小行楷釋文,白鏡面箋本[《晉唐諸帖卷》三段之三](《墨緣》,法書卷下明,13b;《編年表》,95)。

十月一日

再題《山郭幽居圖軸》。

參見:4/1608

十月十一日

在鳳麓家觀宋搨顏真卿《麻姑仙壇記》,因作小楷臨意一卷[此作後與董《臨女史箴》合爲一卷](《辛丑》卷5,45–47;《三秋》卷上,62a–64a;《編年表》,95)。

參見:1619(1);7/11/1630

按:據《辛丑》,董自題云"今來鳳麓楊年兄家,"但《三秋》無"楊"字,待考。

又:《辛丑》載《臨麻姑仙壇記》爲紙本,《臨女史箴》爲絹本,《三秋》則錄全卷爲藏經紙本,董之四印中亦有一不同,未知是否爲同一作,待考。

十月十三日

舟行朱涇道中,行楷書臨吳廷所藏王羲之《官奴（玉潤）帖》,白宋紙本[《倣洞庭、力命、玉潤三

帖册》之末段](《吳越》卷5,39a–b;《編年表》,95。《容別》所錄自識語謂當日并以《官奴帖》筆意書《褉帖》,見卷4,49a–50a;《畫禪》同,見卷1,36–37)。

十月

作墨筆《山水扇頁》,金箋本,并題"海外九州浪語"六言絶句一首(《中國圖目》,v.3,滬1–1343)。上海博物館藏。

十一月七日

於吳門觀趙孟頫臨王羲之《十七帖》,遂效之作《臨十七帖卷》,高麗紙本(《吉續》卷下,16a–17a)。

十二月一日

倣米芾、黃庭堅二家,行草書杜甫詩二首一卷,綾本(*Christie's*,6/4/1986,no. 35)。

無月日

(1)

續書《法華經》至四卷有奇[見董跋徐道寅書《法華經册》]。

參見:秋/1598;1610(2)

(2)

重題舊藏之趙孟頫《挾彈走馬圖卷》於雪浪軒,時已易去(《珊瑚》·畫,卷8,11;《式古》,v.4,畫卷16,131)。

參見:1596

(3)

作設色《北固山圖卷》,絹本(《中國圖目》,v.1,京2–09)。北京中國歷史博物館藏。

(4)

跋徐道寅書《法華經册》(《容別》卷5,14b–15a)。

1609 萬曆三十七年,己酉,五十五歲

正月

撰并行書《嵩山少林寺玉紫住持曹洞正宗第二十六代禪師道公碑銘》并篆額(《系年》,105)。拓片現藏北京圖書館。

花朝

作墨筆《山水册》八幅,紙本,其中三幅分倣荊浩、米友仁及董源(《白雲堂藏畫》,上集,no. 27)。台灣黃君璧藏。

二月

遊黃山,居新安吳懷賢家二月,擇其所藏小幅之精者黃十二幅,彙爲《宋元明集繪册》,并題於册末。十二幅一爲黃居寀設色《萱花蛺蝶》,絹本;二爲董源墨筆《叠嶂飛泉》,絹本;三爲文同墨筆《琅玕挺秀》,藍箋本;四爲許道寧墨筆《翠巘精藍》,絹本;五爲趙孟頫淺設色《松泉淪茗》,絹本;六爲黃公望淺

設色《野酌吟筇》，宋箋本;七爲吳鎮墨筆《叢薄幽居》，絹本;八爲倪瓚墨筆《喬柯新粉》，宋箋本;九爲李衎墨筆《秋圃霜菘》，宋箋本;十爲王紱墨筆《古木疎筠》，素箋本;十一爲徐賁墨筆《雲壑探幽》，素箋本;十二爲唐寅澄墨《牡丹》，粉箋本(《石續》，御書房，2061)。

三月廿一日

四跋自藏李公麟墨筆《孝經圖并書經文卷》，絹本，以易新都劉幼真所藏趙孟頫《秋林撫琴圖》，又售以蘇軾書《金剛經》石搨(《文人畫》，v.2, nos. 67及68;《歐米收藏法書》卷1, nos. 77–79)。《孝經圖并書經文卷》現藏The Art Museum, Princeton University。

四月八日

楷書《心經軸》，宣德泥金黃表箋本(《秘初》卷7, 3b;《編年表》，95)。

四月十九日

作墨筆《小崑石壁圖軸》於寶鼎齋，絹本(《畫集》，no. 14)。中國陸平恕藏。

四月

書陳繼儒壽藍瑛父芝厓六十所作書(《鳴野山房書畫記》卷4，引自《年譜》，72)。

五月廿三日

作設色《摩詰詩意圖軸》，絹本，并書王維"悦石上兮流泉"辭(《畫集》，no. 15)。中國程十髮藏。

六月十六日

(1)
行書鮑照《舞鶴賦》一卷，綾本(Christie's, 11/28/1990, no. 113。題語又見《容別》卷4, 41b;《畫禪》卷1, 33–34)。

參見:6/8/1606; 3/9/1618

(2)
作淡彩《平遠山水軸》[一名《峰巒渾厚圖軸》]，絹本(《東洋美術大觀》，v.11)。日本西松喬舊藏。

六月廿六日

與陳繼儒、吳廷同觀王義之《行穰帖真蹟卷》，并重題之。

參見:10/23/1604

六月

韓晶宇以生絹索書，董爲行書舊作七言律詩五首及五言古詩一首一卷(《石初》卷31, 26a;《編年表》，95)。

八月七日

楷書顏真卿《贈懷素草書序》，又行書顏《借米帖》及《鹿脯帖》，紙本[《行楷書詩卷》之前段](《中國圖目》，v.3, 滬1–1344)。上海博物館藏。

八月十五日

重題一六〇八年所作《臨褚遂良摹蘭亭叙冊》(題語又見《畫禪》卷1, 35–36;《容別》所錄缺末尾數語，見卷4, 45b–46a)。

參見:1/4/1608

九月九日

(1)
題趙孟頫墨筆《古木竹石圖軸》於墨禪軒，絹本(《鑑影》卷20, 3a)。

(2)
爲曙海行書"九點芙蓉墮淼茫"及"白芷青蘭宿有盟"七言律詩二首一卷，絹本(Sotheby's, 11/26/1990, no. 35。詩見《容詩》卷3, 39b–40a, "秋日泛泖四首"之二及三)。

九月晦日

(1)
題米芾草書《九帖真蹟卷》於西湖舫齋，紙本(《郁題》卷4, 14b)。

參見:九月晦/1585

按:西湖(在北京西山道中)舫齋乃董旅京所居，而董此時應在江南，故此題存疑。

(2)
題趙孟頫著色《謝幼輿丘壑圖卷》，絹本(《郁題》卷6, 19b;《珊瑚》·畫，卷8, 6;《式古》，v.4, 畫卷16, 119;《古緣》卷2, 4b;《總合圖錄》，v.1, A17–056;《歐米收藏法書》卷3, no. 54)。E. Elliott Family Collection, on loan to The Art Museum, Princeton University。

九月

中楷書臨虞世南《微臣屬書帖》一冊(《華亭》，25)。

秋

追想吳正志所藏黃公望《富春山居圖》作設色《山水卷》，絹本。The Nelson-Atkins Museum of Art。

十月一日

題子所輯舊臨古帖真行各體書所刻《寶鼎齋法帖》(《味水》卷2, 66b–67a)。

參見:秋/1604(2)

十二月十九日

(1)
書竟歷四載而成之行楷《千文冊》於延津，紙本(《石三》，延春齋廿六，2042;《故宮》卷3, 102;《編年表》，95;《故週》，復刊vols.11及12)。台北國立故宮博物院藏。

參見:1606(2)

(2)
跋鮮于樞草書杜甫《茅屋爲秋風所破歌卷》於延津公署，白宋紙本(《墨緣》，法書卷下元，16a–b)。

無月日

(1)
行書《岳陽樓記卷》，絹本(《中國目錄》，v.2, 50, 京1–2152)。北京故宮博物院藏。

(2)
作設色《長干舍利閣圖軸》，絹本(《中國目錄》，v.2, 50, 京1–2150)。北京故宮博物院藏。

1610　萬曆三十八年,庚戌,五十六歲

穀日

三山道中，夢書韓愈《送李愿歸盤谷序》并自題[見董題《枕漱閒勳》六圖]。

參見:4/15/1610

春

(1)
自閩中歸，舟行湘江道中，兼董源、巨然筆作《烟雲圖卷》，并書蘇軾《烟江疊嶂歌》[見董題《烟雲圖》後](《四印堂詩稿》，引自《年譜》，75)。

(2)
自閩中歸，阻雨湖上，寓於吳德清之來青樓，收西湖之勝，作《山水長卷》(《容別》卷6, 54b–55a)。

四月十五日

題《枕漱閒勳》六圖(《畫禪》卷4, 13–15)。

參見:穀日/1610

五月上澣

爲梅谷行書《帝京篇冊》，紙本(《劍花》，上卷，27–28)。

五月

題文徵明《墨竹卷》，紙本(《壯陶》卷9, 62a)。

七月三日

倣自藏之北宋人《晴嵐蕭寺圖》，爲一六〇六年所作絹本《山水軸》設色并題[即《晴嵐蕭寺圖軸》](《大觀》卷19, 33a)。

參見:秋/1606

七月十八日

展觀江參《江居圖》與趙令穰《湖莊圖》，動興遂作《書畫圖扇冊》十對幅。畫幅墨筆，金箋本，爲《江郎山圖》、《潤松圖》、《延津烟雨》、《鯢山亭子》、《古木高士》、《懸厓絕壑》、一倣王蒙筆意、一題"山下孤烟遠村"、一題"天邊獨樹高原。"書幅紙本，行書題詩或論畫。香港劉作籌藏。

七月

撰《邑司訓望治洪公去思碑》(《松江》卷73, 22-23)。

八月七日

臨項氏家藏懷素《自叙帖》真蹟,草書《臨自叙帖卷》,絹本(《寶迂》卷1, 34b-35b;《編年表》,95)。

八月廿一日

作《小楷袖珍卷》,宣德鏡光牋本,述宋書家軼事(《湘管》卷4, 275-77,《編年表》,95)。

九月七日

新安江舟次,自跋一五九二年所作《論書畫卷》[《論書卷》二幅之二]。

參見:春/1592(3); 4/18/1592

九月十一日

作《仿各家書古詩十九首冊》,紙本。每首各仿一家書,分別爲皇象、鍾繇《還示帖》、王羲之《褉帖》與《十七帖》、王獻之《鵝群帖》、智永、歐陽詢《化度寺碑》、虞世南《汝南誌》與《夫子廟堂碑》、褚遂良《哀冊》、薛稷《杳冥碑》、李邕、陸柬之、懷素《聖母帖》、顏真卿《多寶塔碑》與《乞米帖》、柳公權《褉詩卷》、蘇軾、黃庭堅及米芾,冊末并自跋,後附再跋與三跋(《董其昌》, no. 46)。

參見:10/15/1610; 5/15/1619

按:上海博物館藏有董行書《仿各家書古詩十九首卷》,非冊,且爲絹本。內容與冊相同,惟第十三首仿懷仁《聖教序》筆意而非仿陸柬之,且題語有脫漏,其後無董印鑑與再跋及三跋,而有周亮工跋語,著錄於《愛日》卷2, 8b-9b;《編年表》95;《中國圖目》,v.3,滬1-1345。置此待考。

十月十五日

訪方季康於岩之期麓,觀方所臨《聖教序》,因再題舊作《仿各家書古詩十九首冊》以贈。

參見:9/11/1610; 5/15/1619

十月

題自藏之《宋元名家畫冊》[即《董氏小冊》]以贈吳瑞生。冊中李成小卷得之潘雲鳳,趙令穰對幅得之劉禧,荊浩一幅得之靖江朱在明,郭忠恕二幅得之顧正誼,趙孟頫《垂釣圖》得之朱大韶,另有趙伯駒《花谿漁隱》、王詵《梧庭霜樾》、朱銳《雪中鱸綱》、及黃公望、曹知白、王蒙、倪瓚畫幅(《珊瑚》‧畫,卷19, 7-8;《式古》,v.3,畫卷4, 260。又參見《紫桃》卷1, 17b-18b)。

十一月十五日

吳廷攜黃公望畫至,鑑賞彌日,作《仿大癡青綠山水軸》寫其意於寶鼎齋(《神州》,v.21)。

無月日

(1)

作《夜臺禪師像贊》[見李日華一六一一年四月二日記](《味水》卷3, 7b。文見《容文》卷7, 56b-57b)。

參見:1597(2); 1604(1); 1607(2)

按:此作未紀年,但夜臺禪師卒於一六一〇年十月,故估計應作於此年年底或一六一一年初。

(2)

書竟一五九八年始書之小楷《法華經》七卷[見董自跋《彌陀經卷》]。

參見:秋/1598; 1608(4)

(3)

書"聚沙功德"四字存興聖塔院(《重修華亭縣志》卷20, 32b)。

1611 萬曆三十九年,辛亥,五十七歲

正月二日

重題一六〇七年所作《青綠山水軸》贈何三畏。

參見:7/5/1607

正月七日

爲吳正志作墨筆《荊谿招隱圖卷》於寶鼎齋,宣德紙本(《平生》卷10, 113;《金匱藏畫集》,v.2, no. 22;《董其昌》, no. 7;《總合圖錄》,v.1, A13-055;《文人畫》,v.5, no. 18;《畫集》, no. 128)。The Metropolitan Museum of Art.

參見:8/18/1613

正月十五日

(1)

爲王思任書"三槐堂"[見董自題《大書陶詩卷》]。

參見:3/1612

(2)

作《倣黃子久山水軸》(《神州》,v.14)。中國潘佩裳舊藏。

正月

作著色《山水卷》於寶鼎齋,素絹本(《石初》卷6, 70a-71a。自題語又見《畫眼》,40)。

二月

(1)

作墨筆《倣董北苑夏山圖軸》,絹本(《神州》,v.16;《南畫》卷9, 170;《畫集》, no.100)。中國風雨樓舊藏。

(2)

許玄祐訪董及陳繼儒於浦上,董因作《江渚垂綸圖軸》,絹本,并題"無心事軒冕"五言詩一聯以贈

(《愛日》卷2, 9b-10a)。

寒食次日

臨自藏之吳琚五色倭箋本書《歸去來辭真蹟》一卷,麗牒本(《大觀》卷9, 37b;《編年表》,96)。

三月三日

爲朱國盛作墨筆《山水冊》八幅,絹本,其中三幅分倣米友仁、黃公望及王蒙(《中國目錄》,v.2, 50,京1-2153)。北京故宮博物院藏。

參見:2/19/1622

按:故宮所藏此冊僅七幅,或其中一幅迭去.

春

小楷書《宋人詞冊》,絹本,書詞九闋(《壯陶》卷11, 47b-49b)。

四月廿六日

吳琚書詩刻石沒於焦山江中,潤州守霍氏爲拓墨本,董因臨之,素牋本[行書《雜書冊》四段之首](《石初》卷43, 1a-2b;《故宮》卷3, 120-21,《編年表》,96。自跋語又見《畫禪》卷1, 48)。台北國立故宮博物院藏。

五月十五日

作《臨各帖字卷》於寶鼎齋,綾本。分臨王珣《伯遠帖》、新安溪南吳氏所藏謝萬《鯁恨帖》、新安許國家藏王羲之《官奴帖》、項氏所藏楊凝式《韭花帖》、《鼎帖》所刻顏真卿《乞米帖》、《鹿脯帖》、《鄱游帖》(《聽颿》卷2, 159-62;《編年表》,96)。

五月

題蘇軾《偃松圖贊卷》於寶鼎齋,紙本(《聽續》卷上,505)。

六月

將爲松江書院書《求忠書院記》,先以玉枕《蘭亭》法縮臨徐浩書《唐大興寺故大德大辨正廣智三藏和尚碑銘并序》一冊,紙本(《別下》卷7, 8b-9a;《編年表》,96。自題語又見《容別》卷4, 59b-60a,文字略有出入)。

參見:8/1/1611; 8/1611

按:此作之董題《容別》作辛亥(一六一一年)六月,《別下》作辛亥八月。據《重修華亭縣志》,董書《求忠書院記》於此年八月一日,則此臨徐浩冊應書於八月一日之前,疑《別下》誤記。

七月三日

擬米家山,復雜元人法,作設色《蘇軾詩意卷》,金箋本,并題"行人稍度喬木外"七言詩一聯(《石三》,乾清宮十一,575;《藝林月刊》,v.64, 5;《編年表》,95)。

七月

擬蘇軾臨王詵畫,作墨筆《石壁飛泉圖卷》,絹本,

并題"兩岸蒼蒼暗石壁"七言絕句一首(《畫集》,no. 19)。中國程十髮藏。

八月一日

行楷書《松江府建求忠書院記》碑文一册,琅玕箋本(《十百》,午卷,33b−36b;《重修華亭縣志》卷20,32b。文見《容文》卷4, 8a−10b)。此碑現存上海博物館。

按:《玉雨》亦載董同日行楷書《求忠書院記卷》,非册,且爲繭紙本,待考。見卷3, 89−92。

八月十五日

(1)

楷書《千文》一册,宣德箋鳥絲闌本(《石初》卷10,55b−56a;《故宮》卷3, 101−102;《編年表》,96)。台北國立故宮博物院藏。

(2)

臨顏真卿《乞米帖》,并書論書語數段(《味水》卷4, 21b−23a)。

八月廿八日

行書《古詩册》,鳥絲闌紙本,書左思"詠史"三首、"桃源行"一首及"寒食城東"三首(《劍花》,上卷,28)。

八月

將書《求忠書院記》,先縮臨徐浩書《唐大興寺故大德大辨正廣智三藏和尚碑銘并序》一册,紙本。

參見:6/1611; 8/1/1611

九月九日

大楷書《燕然山銘卷》,素絹本(《石初》卷31, 25b;《中國圖目》,v.1,京5−228;《編年表》,96)。北京首都博物館藏。

秋

(1)

行書"訪隱到江潭"、"松菊陶公徑"、"買山何足問"、"石徑幽無際"、"不盡尊中興"等五言律詩六首一卷,紙本(*Christie's*, 5/29/1991, no. 34。詩見《容詩》卷2, 8a, 16b−17a, 23a−b, 26a−b)。

(2)

重題丁雲鵬《達摩東渡圖軸》於靜香閣。歐洲私人收藏。

(3)

倣董源筆作山水於潰川山莊寄邢侗,并題"吳綃圖就枕烟庭"七言絕句一首(《容詩》卷4, 34b)。

十月廿七日

書竟《倣古十種二册》,素絹本。首册倣鍾繇楷書、王羲之楷書、懷仁《聖教序》、歐陽詢楷書、虞世南楷書、褚遂良行楷書《枯木賦》;次册倣顏真卿楷書、李邕行楷書、蘇軾行楷書、米芾行書(《石初》卷10, 52a−53b);《三希》第二十九册載董倣懷仁、

蘇軾、米芾三種書,2081−93;《編年表》,96)。

十二月

吳正志寄褚遂良書《千文》示董,披賞數日,書竟行書《別賦·舞鶴賦卷》,金粟箋本(《石續》,淳化軒,3312−15; *Sotheby's*, 12/5/1985, no. 90。自跋語又見《別卷》卷5, 37a)。

參見:4/1625

按:董自云此作爲卷,但《石續》及*Sotheby's*皆以册載,待考。

冬

學李成寒林法作《寒林山水軸》,并題"歸鴻別鶴夜鐘殘"七言絕句一首(《宋元明清名畫大觀》,165。詩見《容詩》卷4, 37a,"題畫送人歸江西")。日本速水一孔舊藏。

無月日

(1)

行書《詩卷》,紙本(《中國目錄》,v.2, 51,京1−2157)。北京故宮博物院藏。

(2)

楷書《臨不空和尚碑册》,紙本(《中國目錄》,v.2, 51,京1−2156)。北京故宮博物院藏。

(3)

行書《樂志論册》,綾本(《中國目錄》,v.2, 51,京1−2155)。北京故宮博物院藏。

(4)

作墨筆《雲起樓圖卷》,紙本(《中國目錄》,v.2, 51,京1−2154)。北京故宮博物院藏。

1612 萬曆四十年,壬子,五十八歲

正月四日

小楷書《信心銘册》,絹本(《鑑影》卷14, 14b−15b;《編年表》,96)。

二月十三日

兼楊凝式《韭花帖》與陶弘景《華陽帖》筆意,行楷書王粲《登樓賦》一卷,紙本(《古緣》卷5, 26a−b;《編年表》,96)。

二月

(1)

題吳正志所藏蘇軾行書《陽羨帖卷》於雲起樓,素箋本(《石續》,乾清宮,295)。

(2)

書張雨"《鵲華秋色圖》詩"於舊作《追摹趙孟頫鵲華秋色圖》并自題。時趙之原作已歸吳正志(《大觀》卷19, 35b;《編年表》,96)。

按:吳升以此畫"多作家習氣"疑系代筆。

三月三日

楷行書嵇康《養生論》一卷,鳥絲闌高麗繭紙本(《壯陶》卷12, 28b−29b)。

三月

爲王思任大字書《陶詩卷》,紙本,書陶潛"玉臺凌霞秀"及"迢遞槐江嶺"五言古詩二首(《華亭》,39)。

參見:1/15/1611(1)

春

舟泊黃河岸口,小行書白居易《長恨歌》一册,紙本(《石三》,延春閣廿六,2043; *Sotheby's*, 12/5/1985, no. 14; *Christie's*, 12/4/1989, no. 142)。

四月晦日

作《疎林茅屋圖軸》,絹本,并題"疎林茅屋水雲邊"七言絕句一首(《夢園》卷13, 41a;《編年表》,96)。

四月

行書"循彼南陔"四言詩於寶鼎齋,絹本[《書畫合璧卷》之書幅](*Sotheby's*, 6/2/1987, no. 30及4/11&12/1990, no. 5)。

按:此卷畫幅爲設色《倣黃子久筆意圖》。

夏

避暑山莊,作《倣宋元諸家山水册》十幅,絹本。分倣董源、方從義、范寬、郭熙、馬和之、吳鎮、王蒙筆意(《愛日》卷2, 10b−11b;《編年表》,96)。

七月九日

題黃公望墨筆小橫幅《芝蘭室圖并銘》,宋箋本[《唐宋元寶繪》二十幅之十七](《珊瑚》·畫,卷19, 1−6;《式古》,v.3,畫卷3, 211−15)。[《唐宋元寶繪高橫册》十二幅之九](《墨緣》,名畫卷下歷代畫册,1a−11a);即[《唐宋元名畫大觀》十二幅之九](《石初》卷42, 5b−14b)。(《南畫》卷14, 37)。

參見:1599(1); 2/1617(1); 5/15/1618; 秋/1619(1); 8/13/1621; 1621(1);及後文未紀年部份"鑑藏題跋"之"諸家"條

按:《珊瑚》與《式古》載董題紀年爲"壬子九日,"《墨緣》始正之。

八月一日

崑山道中,陳廉以所撰《承天誌》見示,因作墨筆《楚天清曉圖軸》報謝,紙本,并題"綵筆朱幡照郢都"七言絕句一首(《編年表》,96;《董其昌》, no. 8;《文人畫》,v.5, no. 28;《畫集》, no. 70)。台北國立故宮博物院藏。

參見:8/1625(1)

八月十四日

自題《書畫卷》於嘉禾道中,宣德奏本紙。行書《楚

辭》之《九歌》四章、《桃源行》一首、七言絕句十首、五言古詩一首;畫作墨筆山水十一方,分倣荊浩、關仝、倪瓚、二米等(《吳越》卷5,67a-69b;《編年表》,96)。

九月

觀褚遂良行書《千文》於荊溪,用其筆意大行書班固《封燕然山銘》十二條屏,絹本(《鑑影》卷22,2a-b)。

九月八日

同范允臨、朱君采、董斯張泛舟西湖,次董斯張韻行書"花源神界敞"五言排律一軸,宣紙本(《吳越》卷5,47b-48a。詩見《容詩》卷1,28b-29a)。

按:《吳越》載此軸作於"九月八日,"但未紀年,《容詩》則云"壬子(1612)九月八日。"

九月廿三日

(1)

小行楷書仲長統《樂志論》一冊於石湖舟中,烏絲闌素箋本[《蘭亭序·樂志論冊》之後段](《盛京》,第六冊,16a-b;《古物》卷1,16b-17a)。

參見:3/3/1621(1)

(2)

舟行蔣門城下,大行書臨米芾《天馬賦》一卷,絹本。維揚高仲舉、華亭張仲文、青浦雷宸甫及姪孫董鎬同觀(《中國圖目》,v.3,滬1-1346)。上海博物館藏。

秋

作設色《秋山紅樹圖》小頁,絹本(《古書畫偽訛考辨》,圖版下,no. 33-3)。常熟縣文物管理委員會藏。

十月六日

爲夏有之自書《詩卷》於崑山道中,同觀者王修微道人(《天補》,10b-11a)。

十月十六日

題王維著色《江干雪霽圖卷》,絹本(《古芬》卷9,45b-46b;《眼初》卷7,17b-18a)。

十月廿二日

兼高克明《雪漁卷》與趙孟頫《水村圖》筆意,作《倣趙集賢水村圖》於錫山道中[諸家橫幅《雜書畫冊》三十五幀之一](《好古》卷下,96)。

參見:閏11/27/1612(2)

按:董自題云張平仲攜高克明《雪漁卷》至官舍,與陳繼儒賞歎永日,又憶昔於婁水王氏見趙孟頫《水村圖》,遂合二家筆意作此。

十月廿四日

作墨筆《仿黃子久山水軸》,絹本,并題沈周"詩在大癡畫前"六言絕句(《畫禪》卷2,33;Christie's,11/30/1988,no. 32)。

十月晦日

(1)

舟中仿倪瓚作墨筆《九峰秋色圖軸》,宣德紙本,并題"十月江南野色分"七言絕句一首(《華亭》,15。詩見《容詩》卷4,36b,"題畫贈張平仲水部")。

按:董日後重題此軸以寄贈汪宗魯。

(2)

行書《臨楊凝式詩帖冊》於泖湖舟中,金粟箋本(《石續》,淳化軒,3294-95;《三秋》卷上,61a-b;《編年表》,96;Sotheby's,12/8/1987,no. 43。自題詩又見《容別》卷5,42a)。

十月

行書臨蘇軾尺牘六段一冊,金粟箋本(《石續》,淳化軒,3305-3306;《石隨》卷6,2b-4a;《編年表》,96)。

按:《華亭》亦載董行書《臨東坡九札》"卷,"宣德紙本。其中六札及跋語與《石續》所載同,但印鑑全異,待考。見《華亭》,8-9。

閏十一月廿七日

(1)

金閶門舟次,題丁雲鵬所藏宋拓《心太平本黃庭經卷》(《壯陶》卷21,59b)。

參見:閏11/28/1612;閏11/27/1612(2)

(2)

訪崑山張孝廉於奇樹齋,觀所藏宋人《鍾離村田圖》,賞閱彌日,歸舟後作圖倣之[諸家橫幅《雜書畫冊》三十五幀之一](《好古》卷下,96)。

參見:10/22/1612;閏11/27/1612(1)

按:據《壯陶》載,董此日又在蘇州題宋拓《心太平本黃庭經卷》。以當時交通條件,不可能一日同在兩地,因疑此二題有一屬偽。參見《系年》,126-27。

閏十一月廿八日

臨并再題宋拓《心太平本黃庭經卷》。

參見:閏11/27/1612(1)

十二月八日

行草書《雜詩卷》,書"高臺多悲風""西北有織婦""南國有佳人""僕夫早嚴駕""飛觀百餘尺""志士惜日短"及"晷度隨天運"五言古詩七首(《華亭》,33-34)。

按:《華亭》載此卷爲鏡面宣德箋本,董自識云爲高麗鏡光紙本。

十二月廿五日

行書杜甫"秋興八首"一冊,藏經紙本(《華亭》,24)。

十二月廿九日

行書《雲笈卷》,素絹本,以爲獻歲發願學道之契(《石初》卷31,23a;《編年表》,96)。

十二月

作設色山樹,并題"開此鴻濛荒"五言絕句一首[絹本《書畫合璧卷》之畫幅](《石三》,御書房,3139-40。詩見《容詩》卷2,33b)。

晦日

小行楷書王羲之《辭世帖》并臨《霜寒帖》一冊,紙本烏絲闌(《壯陶》卷11,46b-47b)。

無月日

(1)

購得宋搨王獻之《十三行洛神賦》[見董題此作]。

參見:1589(1);3/2/1618;3/1/1625

(2)

倣張僧繇沒骨山,作設色《蘆鄉秋霽圖》,紙本[《八家山水卷》之首段](《中國圖目》,v.1,京5-229)。北京中國歷史博物館藏。

(3)

跋項氏家藏唐人雙鈎摹王方慶萬歲通天所進法帖一卷,素箋本(《珊瑚》·書,卷1,23;《式古》,v.1,書卷6,312;《石初》卷5,40b-41a;《三希》,第五冊,362-63)。

(4)

行書《擬古十九首卷》,紙本(《中國目錄》,v.2,51,京1-2158)。北京故宮博物院藏。

(5)

潤州僧永琳行遊至浙江桐鄉縣青鎮密印寺,發願重鑄鐘,先走雲間乞董書"功成鐘鼎"字於冊端,持歸,後鐘成(《烏青鎮志》卷6,引自《系年》,144)。

1613　萬曆四十一年,癸丑,五十九歲

二月

(1)

爲汪履康作墨筆《岩居圖卷》,紙本(《石初》卷34,33b-34a;《編年表》,96;《中國圖目》,v.6,蘇6-048;《畫集》,no. 63)。無錫市博物館藏。

(2)

與陳繼儒泛泖,過黃公望昔居之橫雲山,作墨筆《倣黃子久山水軸》,絹本(Christie's,5/31/1990,no. 27)。

按:此軸董之自題與上海博物館所藏董《橫雲舊隱圖軸》僅有數字異,待考。見2/15/1597。

(3)

作設色《溪山秋霽圖卷》於虎丘僧舍,絹本(《十百》,戊卷,17a-b;《辛丑》卷5,51)。

按:此卷有王穉登行書額并題七言絕句一首,但王卒於一六一二年,因疑此題及此卷屬偽。參見《系年》,128-29。

三月上旬

爲陳瓛《玉烟堂帖》作序并書(《叢帖目》,第一冊,309-10)。

三月廿二日

作墨筆《倣李成寒林圖卷》,絹本(《十百》,辛卷,30a;《編年表》,97)。

三月

(1)

作《仿古山水書畫冊》十對幅,紙本。右墨筆山水,左行書畫記或七言絕句(《中國圖目》,v.1,京1-032;《畫集》,no.146)。北京故宮博物院藏。

(2)

書《論畫卷》,綾本(《吳越》卷5,71a-75a;《編年表》,96。論述語又散見《容別》卷4,29b-30a;卷6,3b-4a,5b-12a;《畫禪》卷1,7;卷2,4-7,13-15,17-20,文字略有出入)。

四月十七日

三跋董源《瀟湘圖卷》於射陽湖舟中。

參見:6/1597;4/3/1599(1);八月晦/1605

四月廿八日

行書《論書冊》,高麗牋本(《石續》,寧壽宮,2834-36;《故宮》卷3,121-23;《編年表》,96)。台北國立故宮博物院藏。

正午前一日

行書《文賦冊》,紙本(《退菴》卷8,29a-b)。

七月

作《倣梅道人圖軸》,絹本(《藤花》卷4,44a)。

八月四月

泊舟江陰,行書蘇軾《後赤壁賦》一冊,高麗牋本,雷宸甫、夏有之同觀(《石續》,淳化軒,3301,《編年表》,96)。

參見:12/1613

八月十五日

(1)

秋至京口,送別武陵楊鶴,居張氏園中,中秋日新安黃賓王以惠崇《春江圖卷》見示,董亦攜自藏之王蒙《青弁隱居圖軸》,因共易一觀[見董自題《仿惠崇冊》]。

參見:9/1613(1);9/1614;立秋/1615;2/1622(1)

(2)

行楷書《大佛頂首楞嚴經冊》,素牋本烏絲闌(《盛京》,第七冊,3a-b;《古物》卷1,15b)。

八月十八日

吳昌舟次,再跋一六一一年所作《荊谿招隱圖卷》(《董其昌》,no.47)。

參見:1/7/1611

九月廿四日

舟泊昇山湖中,吳性中以顏真卿真蹟相示,爲臨二紙,因作淡墨《山水軸》,紙本,并系“柁樓徹夜雨催詩”七言絕句一首(《十百》,辛卷,14a-b。詩見《容詩》卷4,31a,“題顏魯公《裴將軍詩》真蹟,”下聯不同)。

參見:10/1614(1);9/25/1613

按:此作與董次日所作《昇山圖卷》題跋同。

九月廿五日

舟泊昇山湖中,吳性中以顏真卿真蹟見示,爲臨二本,因作墨筆《昇山圖卷》[一名《倣米南宮山水卷》],紙本,并系“柁樓徹夜雨催詩”七言絕句一首(《虛齋》卷4,38a-42a;《夢園》卷13,32a-36b;《退菴》卷17,2a-b;《編年表》,96;《畫集》,no.20;《中國圖目》,v.7,蘇24-0180。詩見《容詩》卷4,31a,“題顏魯公《裴將軍詩》真蹟,”下聯不同)。南京博物院藏。

參見:9/24/1613

按:《退菴》載此作年款爲“癸丑九月二十日,”或爲失記,待考。

九月

(1)

在京口臨黃賓王所藏惠崇《春江圖卷》,作《倣惠崇冊》七幀,麗牋紙本,其中第一、二、三、五幀著色,第四、六、七幀墨筆。畫未就,適朱國盛亦至,奪董所臨冊[見董總跋此冊]。

參見:立秋/1615;8/15/1613(1);9/1614;2/1622(1)

(2)

登南徐甘露寺,望西江,憶王詵《烟江疊嶂圖卷》,乃臨一幅於僧舍,絹本(《古芬》卷16,35a-36b;《眼二》卷15,29a)。

(3)

跋項元汴所藏李昭道界畫《洛陽樓圖軸》,絹本(《石續》,寧壽宮,2622;《故宮》卷5,4-5)。台北國立故宮博物院藏。

按:項元汴卒於一五九〇年,而董跋有“墨林其寶諸”語,故應爲僞跋。參見《系年》,131-32。

秋

(1)

放棹虞山,作著色《虞山雨霽圖軸》,素絹本(《石初》卷17,56b-57a;《故宮書畫集》,v.40;《編年表》,96)。台北國立故宮博物院藏。

(2)

從項德弘借觀黃公望《浮嵐暖翠圖》閱半歲將還,因作墨筆《倣子久浮嵐暖翠圖軸》,紙本(《壯陶》卷7,13a-b)。

十二月

過青溪,潘宷開出示董八月四日所書《後赤壁賦冊》,董再跋之。

參見:8/4/1613

無月日

行書臨陳瓛刻《玉烟堂帖》一卷,紙本(《中國圖目》,v.1,京5-230)。北京首都博物館藏。

1614　萬曆四十二年,甲寅,六十歲

正月

吳閶舟次,作墨筆山水寫倪瓚意,絹本[《山水集屏》四幅之四](《鑑影》卷22,6b;《編年表》,97)。

二月廿二日

以黃公望法作墨筆《林和靖詩意圖軸》[一名《三竺溪流圖軸》],紙本,并題其“山水未深魚鳥少”七言絕句(《湘管》卷6,425;《編年表》,97;《畫集》,no.71;《中國目錄》,v.2,51,京1-2159)。北京故宮博物院藏。

參見:3/1621(1)

二月

(1)

題黃公望墨筆《山水軸》[見傳董《倣宋元人縮本畫跋冊》](即《小中現大冊》二十二對幅之十八]。

參見:3/1614(1)

(2)

自題一五九九年所作《山水卷》,絹本(《瀟灑書齋書畫述》卷2,引自《年譜》,95)。

參見:1/1599(3)

(3)

作以禪論書語(《畫禪》卷1,11;又見《容別》所錄題《蒹葭帖》,但未紀年,且無末尾識語,見卷4,44b-45a)。

三月寒食前一日

行書王安石“金陵懷古詞”[《仿米虎兒楚山清曉圖卷》後段]。

參見:3/1614(4)

寒食

小楷書曹丕《自敍》一冊,烏絲闌絹本(《華亭》,24-25。自題語又見《容別》卷4,35a)。

參見:8/15/1614(1)

寒食後二日

舟渡斜塘,作《盧山圖軸》,絹本(《湘管》卷6,427;《編年表》,97)。

按:董自識云曾爲陸萬言作《盧山圖》,寫九峰盧山之景。

三月六日

重摹米友仁《米海嶽像贊》石刻(《吹網錄》卷3,16)。

三月

（1）

題黃公望墨筆《山水軸》（《珊瑚》·畫，卷9，17；《式古》，v.4，畫卷18，208）。

按：此軸似即傳董《倣宋元人縮本畫跋冊》[即《小中現大冊》]二十二對幅之十八所倣之原本，惟對題紀年爲"甲寅春二月"，此爲臨倣誤書，或《珊瑚》與《式古》誤錄，待考。

又：《倣宋元人縮本畫跋冊》現藏台北國立故宮博物院。見後文未紀年部分"書畫合璧"之"冊"段。

（2）

跋宋刊本《首楞嚴經》十冊，傳爲中峰明本持誦本（*Chinese Rare Books in American Collection*, no. 5）。美國翁萬戈藏。

（3）

草書《梅花詠卷》於吳門舟次，紙本，書七言絶句五首（《古芬》卷7，21a–b）。

（4）

偶閲自藏之米友仁《楚山清曉圖》，作墨筆《倣米虎兒楚山清曉圖卷》，絹本（《鑑影》卷8，5a–6a；《編年表》，97）。

參見：三月寒食前一日/1614

四月八日

行書《舞鶴賦卷》於泖湖舟中，紙本（《年譜》，97）。上海博物館藏。

四月

行書《舞鶴賦卷》於泖湖舟中，紙本（《董盒》，v.3，no. 8）。日本齋藤氏舊藏。

五月

撰《大中丞徐公分置華亭縣學田碑》文（《重修華亭縣志》卷20，32b）。

夏

（1）

爲侍御徐十洲大行楷書莊子《逍遙遊》一冊，金箋本（《石初》卷28，42a–b，《編年表》，97）。

（2）

作《仿倪迂山水》，并題"剩水殘山且卜居"七言絶句一首（《味水》卷7，43a–b。詩見《容詩》卷4，42a）。

七月十五日

舟行崑山道中，作設色《秋林晚景圖卷》，絹本，并書論趙令穰（《畫集》，no. 25。題語又見《容別》卷6，7b–8a及3b–4a，文字略異）。松江縣博物館藏。

八月十五日

（1）

書魏文帝《自叙》一冊，紙本（《筆嘯》卷下，3a–b；《編年表》，97。自題語又見《容別》卷4，35a）。

參見：寒食/1614

按：《華亭》載此年寒食日董所書曹丕《自叙冊》自題語與此冊全同。

（2）

由董鎬摹勒，刻成《書種堂帖》正帖三十一種，專刻董書（《中國書法大辭典》，1749）。

參見：1617(2)

九月廿一日

題周祖行書《金剛經冊》，烏絲闌高麗紙本（《退菴》卷8，35a；《夢園》卷14，3a–b）。

九月

黃賓王以惠崇《春江圖卷》易董所藏王蒙《青弁隱居圖軸》[見董三跋自藏趙令穰《江鄉清夏圖卷》]。

參見：4/1615(1)

[又見董自題《仿惠崇冊》]。

參見：8/15/1613(1)；9/1613(1)；立秋/1615；2/1622(1)；8/15/1620(2)

秋

與趙左同遊洞庭歸，以董源筆意合作設色《同遊洞庭圖卷》，絹本（*Chinese Painting*, v.7, 159；*Sotheby's*, 5/30/1990, no. 38）。香港張碧寒舊藏。

十月

（1）

重書"題顏魯公《裴將軍詩》真蹟"於一六一三年所作《山水軸》（詩見《容詩》卷4，31a）。

參見：9/24/1613

（2）

吳閶舟次，題吳性中所藏蘇軾行書《與廷評郭君札》、《與忠玉提刑札》、《又與忠玉提刑札》、《記蘇秀才遺歜硯》及《獻蠔帖》，并蘇過書"題郭熙平遠"六言絶句三首[即《眉山六帖合冊》]，紙本（《味水》卷7，57a；《大觀》卷5，39b–40a；《過雲》書卷4，13a–b）。

（3）

作《閒窗興致詩畫冊》十對幅於京口舟次。畫幅絹本墨筆，一倣元人筆法，二倣王洽潑墨，三倣董源《溪山亭子》，五倣董源法作《江郎山圖》，六題"龍潭草閣墨戲"，七倣董源樹法，八倣黃公望《�🔲山秋霽圖》，九題"畫閣凝青畫"五言詩一聯。書幅冷金箋本，各幅行書五言或七言詩一首（《鑑影》卷14，21b–24b；《萱暉》，畫96b–99a；*Sotheby's*, 11/30/1988, no. 28）。程琦舊藏。

十一月十五日

行書《禪語隨筆冊》，松江竹紙本（《壯陶》卷12，55a–58a。冊中語又散見《容別》卷3，9b–14b；《畫禪》卷4，15–19）。

參見：5/1585；秋/1585；冬/1588；1594；1/1/1598；冬/1604(1)；春/1607

十一月廿二日

作墨筆《寫和靖詩意圖軸》，紙本（《中國目錄》，v.2，51，京I–2159）。北京故宮博物院藏。

十二月廿三日

題吳彬爲米萬鐘藏奇石所繪《靈壁石圖卷》（《年譜》，99–100）。上海博物館藏。

十二月廿九日

作《參同契叙篇》[見《董文敏曹娥碑》]（《年譜》，100）。

十二月

重題一六〇五年所作《烟江疊嶂圖》并書蘇軾"王定國所藏烟江疊嶂圖詩"一卷（《石續》，重華宮，1641；《故宮》卷4，237–38；《編年表》，95；《董其昌》，no. 6；《文人畫》，v.5，no. 21；《畫集》，no. 127；《中國圖目》，v.3，滬I–1347）。

參見：秋/1605

按：台北國立故宮博物院與上海博物館均藏有此卷，董之題跋亦同，惟尺寸稍異，且跋語位置不同，疑其一爲僞。

二月

草書《臨三家古帖卷》，綾本。末段臨高閒上人，首二段不詳（*Christie's*, 11/25/1991, no. 105）。

無月日

楷書《千文冊》未竟[見董書竟此冊時自識語]。

參見：3/3/1620

1615 萬曆四十三年，乙卯，六十一歲

三月三日

作墨筆《春山欲雨圖卷》，絹本，并題"七十二高峰"五言絶句一首（《啓功叢稿》，306）。

春

（1）

自京口陳永年收購惠崇《江南春卷》[見董再跋與三跋趙令穰《江鄉清夏圖卷》]。

參見：7/3/1601；4/1615(1)

（2）

作著色《倣楊昇沒骨山水軸》，絹本（《虛齋》卷8，48b–49a；《澄懷》卷4，12–15；《南畫》卷9，171；《編年表》，97；《董其昌》，no. 9；《總合圖錄》，v.1，A28–054；《文人畫》，v.5，no. 24；《畫集》，no. 72）。The Nelson-Atkins Museum of Art.

按：《澄懷》載此軸爲紙本，待考。

（3）

憶巴陵舟中望洞庭空闊之景，作墨筆《倣小米瀟湘

奇境圖卷》寄彭嵩螺[一名《倣米芾洞庭空闊圖卷》],宣德牋本(《石初》卷34, 34a–b;《編年表》,97;《中國目錄》,v.2, 52,京I–2214;《畫集》,no. 18)。北京故宮博物院藏。

(4)

舟次崑山道中,行草書《王述帖卷》,紙本(《書道藝術》卷8, 114–21;《董其昌》,no. 48)。日本澄懷堂文庫藏。

四月二日

作墨筆《倣米芾雲山圖卷》[一名《倣王洽澄墨山水卷》],絹本,自識云畫在澄墨王洽,意在韓愈《盤谷序》之境(《石三》,延春閣廿六, 2064;《寶迂》卷I, 36b–37a;《編年表》,97)。

四月五日

爲姪孫舜甫學徐浩與蔡襄筆法作《臨諸體書冊》,麗光牋本,書杜甫《與諸公登慈恩寺塔》"玄都壇歌寄元逸人""今夕行""夜歸""閿水歌""憶昔行""縛雞行""哀王孫""漢陂行""茅屋爲秋風所破歌"詩十首(《大觀》卷9, 34a–b;《編年表》,97)。

四月八日

行楷書蘇軾"題王定國所藏王晉卿畫《煙江疊嶂圖》詩"一卷於京口舟中,絹本。書前用米家法作墨筆《煙江疊嶂圖》(《總合圖錄》,v.3, JM19–094)。日本黑川古文化研究所藏。

四月十九日

作墨筆《鍾貴山陰望平原邨景圖卷》,紙本,自題云出入惠崇、巨然兩家。Léo & Charlotte Rosshandler Collection。

按:北京故宮博物院亦藏有此卷,識語全同,但爲捶金牋本,且無年款,有"太史氏"印,待考。見後文未紀年部分"畫·倣作"之"倣巨然"條。

四月

(I)

三跋自藏之趙令穰《江鄉清夏圖卷》(《董其昌》,no. 49)。

參見:7/30/1596; 7/3/1601; 8/15/1629(I)

(2)

草書《唐人絕句卷》於西郊草堂,絹本,書絕句八首(《古芬》卷7, 19a–b)。

五月二十日

爲雲棲袾宏楷書《阿彌陀經冊》以刻石流布,鏡面麗牋烏絲闌本(《大觀》卷9, 37a;《墨緣》,法書卷下明, 12a–b;《編年表》,97。自題語又見《容別》卷5, 16a–b)。

按:安歧於冊末題云:"向見一倚本,於淨面高麗紙上對此臨模者,後有吳錫秦氏一題,幾爲亂真...。"似即《秘初》所載董朝鮮牋本行楷書《阿彌陀經冊》,惟紀年爲此年五月二十一日。見卷3, 14b–15a;《編年表》,97。

五月

再題隋開皇刻王羲之《蘭亭詩序卷》於畫禪室。

參見:9/1597

六月十八日

倣吳士諤出示之米友仁《五洲山圖》,作墨筆《倣米五洲山圖卷》,紙本(《畫集》,no. 130;《中國圖目》,v.3,滬I–1348)。上海博物館藏。

六月

(I)

閱友人所示宋搨王獻之《洛神賦》十三行,小楷書潘岳《秋興賦》一冊,宣德牋烏絲闌本(《華亭》,24)。

(2)

西郊避暑,雷宸甫見訪,作墨筆《雲山圖軸》贈之,紙本(《金石書畫旬刊》,v.12; *Christie's*, 12/4/1989, no. 39)。

夏

倣趙伯駒筆意作青綠《秋山圖軸》於玄賞齋,絹本[見董一六三〇年題此圖]。

參見:8/15/1630(I)

七月一日

以王維"萬樹江邊杏"詩題唐寅《觀杏圖軸》以贈汝文南遊(《過雲》畫類4, 18a–b)。蘇州博物館藏。

立秋

爲一六一三年臨惠崇《春江圖卷》所作《倣惠崇冊》補第八幀,是時真卷已失(《平生》卷10, 121–22;《大觀》卷19, 28a–29a)。

參見:8/15/1613(I); 9/1613(I); 9/1614; 2/1622(I)

立秋後三日

蔣道樞見訪,留西樓十餘日,董爲作墨筆《山居圖軸》[一名《荊扉圖》],紙本,并題唐人"雖有柴門長不關"七言絕句一首以贈(《大觀》卷19, 32b;《墨緣》,名畫卷上明, 31b–32a;《編年表》,97)。

參見:5/18/1623

九月三日

作墨筆《右丞詩意圖卷》,并題"人家在仙掌"五言詩一聯[見王鑑《臨董香光卷》](《穰續》卷14, 9a–b)。

參見:春/1624(I); 8/15/1625

九月十五日

作墨筆《長松夏寒圖軸》於荊溪道中贈時來,灑金牋本(*Christie's*, 12/3/1985, no. 33)。

九月

(I)

作墨筆《倣北苑山水卷》,絹本(《澄懷》卷4, 20–21)。

參見:12/1615

(2)

爲存憶行書《詩帖冊》,朝鮮牋本,書自作七言律詩十首及七言古詩一首(《石初》卷28, 41b;《編年表》,97;《中國目錄》,v.2, 51,京I–2162)。北京故宮博物院藏。

秋

作《山水扇頁》寫王維詩意寄焦竑[《山水扇冊》十二幅之三](《聽颿》卷3, 278)。

十月一日

倣褚遂良《哀冊》,行書《古詩十九首卷》,金粟牋本(《石三》,御書房二, 3133)。

十月

(I)

題自藏王廙墨筆《一葉吟秋圖卷》,絹本,云得自吳廷(《歸石》卷I, 5a–b)。

參見:6/1624(2)

(2)

作設色《湖山秋色圖卷》,絹本(《藝苑掇英》,v.23, 23;《畫集》,no. 129)。無錫市博物館藏。

十二月

展觀九月所作《倣北苑山水卷》,草書舊作七言律詩三首於卷末并重題(所題三詩之一爲"題紫陽庵",載於《容詩》卷3, 38b)。

參見:9/1615(I)

無月日

(I)

作墨筆《仿古山水冊》十開,紙本(《中國目錄》,v.2, 51,京I–2160)。北京故宮博物院藏。

(2)

行書《刻八林引卷》,綾本(《中國目錄》,v.2, 51,京I–2161)。北京故宮博物院藏。

1616 萬曆四十四年,丙辰,六十二歲

正月十五日

爲浙江桐鄉縣青鎮密印寺撰并書《高峰妙禪師香火碑》文(《烏青鎮志》卷12,引自《系年》,144)。

正月

題楊明時一五九三年冬所作墨筆《秋山亭子圖軸》,紙本(《虛續》卷2, 50a;《穰梨》卷26, 9a)。

參見:1598(3)

二月十五日

(1)

偶讀黃庭堅題跋因書數則（《容別》卷4，35b–36a）。

參見:8/20/1616

(2)

行楷書《字卷》，綾本，論柳公權、黃庭堅及唐人書（《十百》，卯卷，28a–29a。論述語散見於《容別》卷4，46a–b，35b–36a，23a–b）。

按:此卷末董所云"偶筆書此一似詩識，"如《容別》所錄，應專指論黃庭堅一段而言，此卷插入論柳公權與唐人書二段，殊不類，疑爲後人拼湊，見《容別》卷4，35b–36a。

二月

行草書"蒼玉與朱旆"及"星郎拜慶日"五言律詩二首，絹本[《書畫合璧卷》之書幅]（《總合圖錄》，v.2，E18–037。詩見《容詩》卷2，6a–b及12b，"贈曹嗣山總河三首"之二及"壽蕭封翁八十，"後首漏末聯）。Museum für Ostasiatische Kunst, Berlin。

三月

(1)

民抄董宦事發後，避地往來於京口、吳興間，觀張觀宸、朱國楨所藏書畫[見"京口張氏所藏畫冊"與"吳興朱氏所藏畫冊"]（《平生》卷10，116–17）。

(2)

督學楚後歸荆山，王穉登携示李邕書法，遂摹李邕筆意，行書《千字文卷》以贈，紙本（《華亭》，25）。

按:王穉登卒於一六一二年，此作爲僞。參見《系年》，145。

又:此卷後改裝冊。

春

行書《賀丁雲鵬七十大壽詩軸》，紙本（《中國圖目》，v.1，京12–042）。北京市文物商店藏。

五月

作墨筆《王維詩意圖軸》，紙本，並題王"人家在仙掌"五言詩一聯（《年譜》，108）。上海博物館藏。

六月

作墨筆《倣黃子久筆意圖軸》，紙本。Léo & Charlotte Rosshandler Collection。

參見:9/1630

夏

重觀并題李公麟鐵線描《維摩說不二法圖》於蘇門舟次[又名《昆邪問疾圖》、《維摩經相圖》、《文殊問維摩圖》]，澄心堂紙本（《清河》卷八下，35；《珊瑚》·畫卷2，11；《式古》，v.3，畫卷12，477–78；《平生》卷7，61）。

按:《清河》載董書云三十餘年前曾見此圖於項氏，《珊瑚》及《式古》則云二十餘年前。

又:《平生》又載董曾二跋李公麟紙本白描《維摩說不二法門圖卷》，應是另一作。見卷7，61。

七月

作《書畫合璧卷》於毗陵道中，絹本（《瀟灑書齋書畫述》卷2，引自《年譜》，108。自跋語又見《容別》卷6，2b）。

八月二十日

重題二月十五日所書黃庭堅題跋數則。

參見:2/15/1616(1)

八月

(1)

行書《論畫冊》，繭紙本（《石三》，延春閣廿六，2043–46；《故宮》卷3，123–26；《編年表》，97）。台北國立故宮博物院藏。

參見:3/1627(2)

(2)

作墨筆《山水軸》，紙本，并題"隤糜磨一石"五言絕句（《董盦》，v.4，no.30；《唐宋元明名畫大觀》，359。詩見《容詩》卷2，34a）。日本齋藤氏舊藏。

參見:1619(2)

九月六日

舟行晉陵道中，作《神怡寫興書畫冊》八對幅。其中三畫幅分仿黃公望、趙伯駒及李成，一作《山居圖》，書幅各行草書倪瓚七言絕句一首。Princeton University.照片檔案。

按:董之總跋又見《容別》卷6，26b，惟冊中云作八景，《容別》則云十景，待考。

九月九日

昆山道中，仿自藏之黃公望贈陳彥廉畫二十幅，作墨筆《仿黃公望山水卷》，素箋本，并題"大癡筆法超凡俗"七言絕句一首（《石初》卷6，73a–b；《編年表》，97；《故宮》卷4，239–40；《文人畫》，v.5，no.27）。台北國立故宮博物院藏。

秋

(1)

作墨筆《石磴盤紆圖軸》於海上，紙本[見董一六二六年題此作]。

參見:5/1626(3)

(2)

崑山道中，望九峰作墨筆《九峰寒翠圖軸》，絹本（《中國圖目》，v.8，津2–031）。天津市歷史博物館藏。

(3)

作墨筆《倣倪迂謹細筆圖》（《郁題》卷10，11a；《珊瑚》·畫，卷18，23；《式古》，v.4，畫卷30，532；《編年表》，97）。

(4)

書大字臨顏真卿《蔡明遠序》及《贈裴將軍詩》一卷，綾本（《壯陶》卷12，44a–46a）。

十月晦日

作墨筆《昆山道中圖扇頁》，金箋本（《中國圖目》，v.3，滬1–1349）。上海博物館藏。

十月

爲金玉檢作設色《秋山圖軸》，絹本（《虛續》卷2，52b–53a；《編年表》，97）。

參見:4/15/1625

十一月

行書《重修新橋募緣疏卷》於青溪舟次，紙本（《吳越》卷5，78a；《編年表》，97。文見《容文》卷7，39a）。

十二月

書《蘇詩冊》於青溪舟次，金箋本，書蘇軾"王定國所藏烟江疊嶂圖詩"（《鑑影》卷14，16b）。

無月日

(1)

始作《山水書畫冊》十對幅[見董自題末幅]。

參見:秋/1618(1)

(2)

作墨筆《仿黃公望山水卷》，紙本（《中國目錄》，v.2，51，京1–2163）。北京故宮博物院藏。

1617 萬曆四十五年，丁巳，六十三歲

正月三日

葉有年見訪海上，董作墨筆《裴晉公詩意圖軸》，紙本，并題"門逕俯清谿"五言絕句一首以贈（《總合圖錄》，v.1，A21–195；《編年表》，97）。Freer Gallery of Art。

花朝

過汪砢玉之墨花閣，題所藏貫休設色《應真高僧像卷》，絹本[見汪砢玉跋此卷]（《珊瑚》·畫，卷1，19；《式古》，v.3，畫卷10，409；《秘續》，65）。

二月十五日

行書《檇李徐翼所公家訓碑》（《系年》，151；《年譜》，111）。拓片現藏北京圖書館。

二月十九日

舟宿鳳凰山麓，偶有《萬竹山房帖》，因行書《臨宋四家書卷》，絹本（《寶迂》卷1，34a–b；《編年表》，97；《中國圖目》，v.3，滬1–1351）。上海博物館藏。

二月

(1)

携《唐宋元寶繪冊》至嘉興，汪砢玉同項德新、項聖

謨過舟中得閲。望日挈雷仁甫、沈商丞至汪家,更携黄公望畫二十幅與汪父觀,越宿始返之[見汪砢玉記此册](《珊瑚》·畫,卷19,6–7;《式古》,v.3,畫卷3,214–15)。

參見:1599(1);7/9/1612;5/15/1618;秋/1619(1);8/13/1621;1621(1);及後文未紀年部分"鑑藏題跋"之"諸家"條

(2)

作墨筆《倣古山水册》十六幅,紙本,并題贈王時敏。其中第二幅爲《溪山亭子》,四爲《補白香山詩意》,九爲《巖居高士》,十爲《倣倪高士》,十二爲《蔡天啓詩意》,十五爲《倣雲林筆意》,餘俱題詩(《輞輝》,94–95;《中國圖目》,v.3,滬1–1350)。上海博物館藏。

三月十五日

訪天平范允臨偕隱山房,作設色《天平山圖軸》,絹本,并賦"百疊松篁繞畫楹"七言絶句一首(《華亭》,17。詩見《容詩》卷4,25a–b,"范長倩偕隱天平山居四首"之一)。

三月十九日

題張覯宸所藏沈周爲吳寬所作設色《東莊圖册》,紙本,原二十四對幅,僅存二十一幅(《虛齋》卷11,43a–b;《快雨》卷7,8;《中國圖目》,v.7,蘇24–0028)。南京博物院藏。

參見:8/1621(2)

三月

(1)

過京口訪張覯宸,出所藏楊凝式真蹟,賞玩彌日,登舟擬行書《樂志論册》,紙本(《石三》,延春閣廿六,2047–48。自題語又見《容別》卷5,2b)。

(2)

與蔣道樞同泛荆溪,舟中作墨筆《高逸圖軸》,紙本,並題"同嵐屈曲徑交加"七言絶句一首以贈(《繪畫史圖錄》,下册,no.405;《編年表》,97;《中國目錄》,v.2,51,京1–2164;《畫集》,no.74。詩見《容詩》卷4,33b,"題畫贈眉公"二首之二)。北京故宮博物院藏。

春

(1)

於汪砢玉處觀高克恭《烟嶺雲林圖軸》、趙孟頫《杏花書屋》、倪瓚《翠竹喬柯》、王蒙《鐵網珊瑚》及王冕《墨梅》[見汪砢玉題高克恭《烟嶺雲林圖軸》](《珊瑚》·畫,卷8,2;《式古》,v.4,畫卷17,177)。

(2)

鑑賞書畫於汪砢玉家,題項元汴《荆筠圖卷》(《珊瑚》·畫,卷18,17;《式古》,v.4,畫卷29,521)。

(3)

門下士穆東明携所藏《陽關詩卷》求董跋,董定爲米芾筆[見董跋此卷]。

參見:1595;1621(3)

(4)

作《書畫合璧册》五對幅,紙本。右作水墨山水,其中二幅分仿關仝及王蒙;左行草書詩或論畫(《總合圖錄》,v.1,A18–062)。Private collection on loan to the Art Museum, Princeton University。

(5)

作墨筆《臨趙(令穰)倪(瓚)筆意書畫卷》,絹本(《中國圖目》,v.8,津6–017。自題語又見《容別》卷6,7b–8a;《畫禪》卷2,18及7)。天津市文物公司藏。

五月二日

行書《司馬將軍歌卷》,綾本(*Christie's*,5/31/1990,no.150)。

五月晦日

仿董源筆作墨筆《青弁山圖軸》寄張慎其,紙本(《董其昌》,nos.10&50;《總合圖錄》,v.1,A13–029;《文人畫》,v.5,nos.38–39;《畫集》,no.75)。The Cleveland Museum of Art。

夏

(1)

休夏吳門,小楷書謝莊《月賦》一卷,鏡面箋烏絲闌本(《華亭》,1–2。自跋語又見《容別》卷4,40a–b)。

(2)

作設色《仿趙大年畫卷》,絹本(《華亭》,2)。

九月五日

於會稽山陰朱明臣之息柯軒,重觀并題趙孟頫行楷書《跋定武蘭亭卷》,宋箋本(《石初》卷13,51b)。

參見:1578

按:趙孟頫此卷書其《蘭亭十三跋》中之十一跋,缺第一及第六跋。

九月九日

題趙令穰絹本《山水卷》於武林舟次,云"用金碧筆意"(《退菴》卷11,31a)。

九月十五日

爲楊玄蔭作墨筆《丁巳九月山水軸》於武林樂志園,紙本(《古緣》卷5,39a–b;《編年表》,97;《董其昌》,no.11;《文人畫》,v.5,no.31;《畫集》,no.76)。The National Gallery of Victoria, Melbourne。

九月

行書《杭州孤山關帝廟特建關帝君殿募緣疏》(《系年》,154;《年譜》,114)。拓片現藏浙江圖書館。

秋

行書仲長統《樂志論》一卷,鏡面箋本(《華亭》,4)。

十一月十八日

行書《法華經序品卷》,勒石上海大士殿壁,爲亡母薦資冥福(《年譜》,114)。石刻本現藏上海博物館。

無月日

(1)

吳廷易去董所藏《澄清堂帖》王羲之書五卷[見董題此作於吳楨所刻《清鑑堂帖》](《叢帖目》,第一册,336)。

參見:2/1631(1)

(2)

由董鎬摹勒,刻成《書種堂帖》續帖,專刻董書共二十六種(《中國書法大辭典》,1749)。

參見:8/15/1614(2)

1618 萬曆四十六年,戊午,六十四歲

正月一日

邀陳繼儒過看自藏之董源畫軸[見陳跋董《仿黄公望浮嵐暖翠圖卷》]。

參見:獻歲/1622

按:據陳繼儒跋,董於數年前購莫是龍家黄公望畫一軸,是日拂拭忽見"董源"二字在樹石間,因邀陳共賞。

正月廿二日

(1)

吳廷、京山王制、楊鼎熙、王應侯同觀虞世南《臨蘭亭帖卷》於董之世春堂[見此卷吳廷之記](《石初》卷42,4a)。

參見:1597(1);12/30/1598;1/15/1604(1);1/1618(1)

(2)

茅元儀過墨禪軒論書,因臨柳公權書《蘭亭詩》一卷,宋箋本[《蘭亭八柱帖卷》之七](《石續》,重華宮,1664–65;《石隨》卷1,8a;《編年表》,98)。

按:北京故宮博物院藏有董行書《臨柳公權蘭亭詩卷》,紙本,或即此作。見《中國目錄》,v.2,51,京1–2166)。

正月

(1)

跋虞世南《臨蘭亭帖卷》,該卷久藏董之齋中,時已歸茅元儀所有。北京故宮博物院藏。

參見:1597(1);12/30/1598;1/15/1604(1);1/22/1618(1)

(2)

題《蘇詞黄詩卷》(《容別》卷5,2b–3a)。

二月四日

行書題《旌陽仙籍書卷》寄晉陵唐獻可,并以志喜,

宣德紙本(《華亭》,2-3)。

二月二十日

作《臨褚遂良摹蘭亭叙冊》,宣德鏡光牋本(《石初》卷21,31b-32a;《故宮》卷3,100-101;《編年表》,98)。台北國立故宮博物院藏。

參見:8/1635(2)

二月

跋吳廷所藏《淳化閣帖》無銀錠本十卷(《珊瑚》·書,卷21,29)。

三月二日

題自藏宋搨王獻之《十三行洛神賦》於婁江道中(《寓意》卷2,8a-9b)。

參見:1589(1);1612(1);3/1/1625

按:董題云此作購自楚劉金吾。

三月九日

行書鮑照《舞鶴賦》,絹本(《式古》,v.2,書卷28,498;《編年表》,97。題語又見《容別》卷4,41b;《畫禪》卷1,33-34)。

參見:6/8/1606;6/16/1609(1)

三月十五日

行書《後赤壁賦卷》(《西泠印叢》,v.15)。

三月十八日

(1)

楷書仲長統《樂志論》於吳門舟次,烏絲闌紙本[《楷書六種冊》之首](《穰續》卷9,12b-14a)。

參見:9/7/1620(2)

按:此冊似即上海博物館所藏董小楷《五經一論冊》,紙本。見《中國圖目》,v.3,滬1-1352。

(2)

倣虞世南楷書《千文冊》,宣德牋本(《石初》卷3,35a;《編年表》,98)。

三月晦日

臨《禊帖》於南湖舟次,紙本[《臨禊帖並修禊四言詩卷》前段](《古緣》卷5,18b-20a)。

參見:4/1/1618

三月

以虞世南法,楷書皮日休《桃花賦》於崑山道中[見《雜書冊》前段董之自跋]。

參見:8/1621(1);10/8/1621

春

小行書中唐七言絕句八首,宋人趙令時、蘇軾、秦觀、黃庭堅詞六首,玉雪牋本[《畫江南秋並小行書唐詩宋詞卷》之書幅](《壯陶》卷12,38b-40b)。

四月一日

臨柳公權書《山陰修禊四言詩并序》[《臨禊帖並修禊四言詩卷》之後段](《天瓶》卷上,8b;《古緣》卷5,19a-20a)。

參見:三月晦/1618

四月八日

(1)

泥金書《金剛經冊》,磁青牋本(《秘初》卷3,11b)。

(2)

泥金書《金剛經》上下二冊,磁青牋本(《秘初》卷3,13a)。

四月

作紙本墨筆《書畫冊》八開之畫幅,其中第三幅倣倪瓚,第七幅倣趙伯駒(《畫集》,no.138;《中國圖目》,v.3,滬1-1353)。上海博物館藏。

參見:2/15/1619

閏四月十二日

行書書評四則,朝鮮牋本[《雜書卷》四段之四](《石初》卷31,23a-b;《故宮》卷1,139-40;《董其昌》,no.51)。台北國立故宮博物院藏。

按:《石初》與《故宮》均載紀年屬戊子(一五八八),但查原件應爲戊午(一六一八)年無疑,且戊子年閏六月,不閏四月,戊午年則閏四月。誤"午"爲"子",亦參見《董其昌》,no.51。

五月八日

以《聖教序》筆意行書唐高宗《菩薩藏經後序》一冊,高麗牋本(《秘續》,169-70;《故宮》卷3,114-15;《編年表》,98;《董其昌》,no.52)。台北國立故宮博物院藏。

參見:5/8/1588

五月十五日

題舊藏之李成重青綠小條幅《晴巒蕭寺圖》,素絹本,時爲程季白所藏[《唐宋元寶冊》二十幅之二]。[《唐宋元寶繪高橫冊》十二幅之二],[即《唐宋元名畫大觀冊》十二幅之二]。

參見:1599(1);7/9/1612;2/1617(1);秋/1619(1);8/13/1621;1621(1);及後文未紀年部分"鑑藏題跋"之"諸家"條

五月

(1)

跋程季白所藏宋徽宗設色《雪江歸棹圖卷》,絹本,比諸吳瑞生所藏王維《江山雪霽圖卷》(《郁題》卷8,2b;《真蹟》,三集,3a;《珊瑚》·畫,卷3,2;《式古》,v.3,畫卷11,413;《書畫》卷4,364-65;《平生》卷7,1-2;《大觀》卷12,2b-3a;《石續》,重華宮五,1505;《虛齋》卷1,19a-b;《文人畫》,v.2,no.35;《中國歷代繪畫》,v.2,附錄13;《中國目錄》,v.2,4,京1-304)。北京故宮博物院藏。

參見:10/15/1595

按:《書畫》載董跋年款屬"戊子(一五八八年)夏,"應爲誤記之故。

(2)

題程季白所藏倪瓚墨筆《優鉢曇花圖軸》,紙本(《書畫》卷2,105及卷4,377;《平生》卷9,91-92;《大觀》卷17,56b;《辛丑》卷4,23;《墨緣》,名畫卷上元,23a及名畫續錄卷下,5b;《蘇雪》卷3,31b)。

六月一日

行書《陶潛·謝靈運詩冊》,金粟牋本,書陶潛"始作鎮軍參軍·經曲阿作"、"辛丑歲七月赴假還江陵·夜行途口作"二詩及謝靈運"永初三年七月十六日之郡初發時"、"過始寧墅"二詩(《石續》,淳化軒,3300)。

七月廿五日

舟中望三塔灣,携趙伯駒《春陰圖》、趙孟頫《谿山清隱圖》、王蒙《青弁圖》、倪瓚《春靄圖》、《南渚圖》、黃公望二幅、馬琬《鳳山圖》共十幅,皆奇絕,因作小景(《郁題》卷10,11a;《珊瑚》·畫,卷18,23;《式古》,v.4,畫卷30,533;《編年表》,97)。

七月

(1)

作重青綠《沈會宗詞意圖軸》,絹本,并書其詞(《大觀》卷19,34a;《編年表》,98)。

(2)

題趙伯駒青綠《山水卷》,絹本(《古芬》卷10,102a-b)。

八月十一日

作墨筆《夜村圖軸》於崑山道中,宣德紙本(《華亭》,13-14;《故宮博物院院刊》,1981,v.2,封2;《古書畫僞訛考辨》,nos.33-8及33-9)。

按:此作有真僞二本,皆藏北京故宮博物院。

八月十五日

張覲宸購董所藏王蒙墨筆《雲林小隱圖卷》,紙本[見張覲宸題此卷](《穰續》卷3,28b-29a)。

八月十六日

純仁持趙左爲其所作紙本墨筆《山水卷》索題,董因題之(《夢園》卷14,12a-b;《藝苑掇英》,v.31,13)。香港劉作籌藏。

八月

(1)

合自藏之董源《瀟湘圖》與米友仁《瀟湘白雲圖》,作墨筆《山居圖卷》寄陳繼儒,白宣德紙本,并題"渭北春天樹"五言詩一聯。是秋又於東佘之頑仙廬再題之(《選續》卷上,193-94)。

參見:8/1588

(2)

作墨筆《夕陽秋影圖扇頁》於武林香月堂,金牋本,

并題"雲開見山高"五言絕句一首(《三松》,21b;《中國圖目》,v.3,滬1-1354)。上海博物館藏。

秋

(1)

續成《山水書畫册》十對幅,紙本,今佚其二。畫幅一設色仿李唐《曲江覽勝》,二墨筆仿米芾《烟雨樓臺》,三設色仿黃公望《瀑簾瑤屑》,四墨筆仿荆浩《晴山聳翠》,五墨筆仿吳鎮《雨欄獨眺》,六設色仿王蒙《春嵐吐瑞》,七設色仿王維《雲山競秀》,八設色仿巨然《秋林倚杖》。書幅各行草書詩一首(《藝苑遺珍》,名畫第三輯, no. 39)。

參見:1616(1)

(2)

觀倪瓚畫并錄其自題詩[見董自題一六二六年所作《仿倪黃山水軸》]。

參見:5/1626(2)

(3)

小楷書葛長庚《湧翠亭記》并《懶翁齋記》一册,紙本(《壯陶》卷12, 34a-37b)。

十二月一日

(1)

作墨筆《仿倪雲林山水圖卷》於鳳山村舟次,紙本(《畫集》, no. 26)。上海文物商店藏。

(2)

行書《白衣大慈陀羅尼經册》,朝鮮鏡光箋本(《秘初》卷2, 13a;《編年表》,98)。

冬

作墨筆《倣黃子久江山晚興圖卷》,宣德紙本(《華亭》,40)。

無月日

(1)

作《畫禪室小景圖册》四對幅,紙本,右墨筆山水,左行書題詩(《中國圖目》,v.3,滬1-1355)。上海博物館藏。

(2)

作《子久筆意圖軸》(《畫集》, no. 77)。

(3)

作墨筆《仿古山水册》八開,紙本(《中國目錄》,v.2, 51,京1-2165)。北京故宮博物院藏。

(4)

見黃庭堅《梵志詩》學懷素,復倣之大草書杜甫《醉歌行》(《平生》卷5, 58)。

(5)

作墨筆《小景册》十開(《編年表》,98)。

(6)

作《林居息影圖軸》(《編年表》,98)。

(7)

作《書畫合璧册》四開(《編年表》,98)。

1619　萬曆四十七年,己未,六十五歲

正月一日

(1)

楷書《心經册》,高麗紙本[見董補題此作]。

參見:1/1/1620

(2)

書李白《大鵬賦》一卷未竟[見董書竟時自題]。

參見:2/12/1620

正月廿七日

行楷書臨米芾擘窠大字《天馬賦》於龍華道中[絹本《詩卷》三段之二](《我川》,217-22)。

參見:1590(1); 1/27/1620; 7/8/1620

按:《石初》亦載董《臨天馬賦卷》,自題同此作,惟紀年爲"庚申"(一六二○年)正月二十七日,印鑑亦異,待考。

二月十五日

補一六一八年所作《書畫册》之書幅於崑山道中,各幅行書倪瓚七言絕句一首。

參見:4/1618

三月八日

書《漢書銘贊册》於龍華舟次,絹本(《藤花》卷3, 23b-24a)。

三月

(1)

跋沈周設色《無聲之詩書畫册》十二開,絹本(《中國圖目》,v.2,滬1-0367)。上海博物館藏。

(2)

題米芾大行書"攢石當軒倚"及"玉環騰遠劍"五言詩二首一卷[即《唐詩卷》],紙本(《鑑影》卷2, 20b)。

春

(1)

過長水訪汪砢玉,適潤州繆杞亭持二畫來,即汪舊藏之陸廣《谿山清眺圖》及其另半幅,董以二軸復合,題之以記[見汪砢玉記此圖](《珊瑚》·畫,卷9, 18-19;《式古》,v.4,畫卷22, 308)。

按:《石初》與《故宮》載陸廣著色《仙山樓觀圖軸》,素絹本。其上董其昌和李日華之跋與《谿山清眺圖軸》之跋僅數字之差,疑《仙山樓觀》即《谿山清眺》之另半幅(則其上陸廣之款識爲後人所加),汪砢玉並未將二軸裱爲一作,故董跋與李跋仍在《仙山樓觀》。見《石初》卷26, 13a-14a;《南畫》卷9, 67;《故週》,v.118, 4;《故宮》卷5, 237。《仙山樓觀圖軸》現藏台北國立故宮博物院。

(2)

於汪砢玉之墨花閣題汪家藏之趙孟頫行書《光福重建塔記真蹟卷》,紙本[見汪砢玉記此卷](《珊瑚》·書,卷8, 19-20;《式古》,v.2,書卷16, 87;《中國圖目》,v.2,滬1-0155)。上海博物館藏。

按:《珊瑚》與《式古》載董"題於墨花閣,"爲上海博物館所藏卷所無,待考。

(3)

於項德新之讀易堂會汪砢玉并評賞書畫,題項元汴《花鳥長春圖册》二十四幅(《郁題》卷10, 12a;《珊瑚》·畫,卷22, 10;《式古》,v.3,畫卷5, 286)。

按:董此題未紀年,年月見汪砢玉記此册。

(4)

行書《參同契卷》於吳門舟次,絹本(《古芬》卷7, 26a-b;《眼初》卷5, 11a)。

四月

舟次邗溝,題吳廷所藏趙孟頫《道經生神章卷》,素箋本,并以自藏之趙孟頫爲大長公主所作《倣閻立本三清瑞像》歸吳廷(《盛京》,第三册,3a;《古物》卷2, 9a)。

五月十五日

舟次京口,與方季康縱談書道,并三跋舊作《仿各家書古詩十九首册》(《董其昌》, no. 53)。

參見:9/11/1610; 10/15/1610

五月

過廬陵,觀褚遂良《蘭亭真蹟》,并題《復州裂本蘭亭》[卷首有錢選《賺蘭亭圖》本](《郁題》卷1, 13a)。

六月

草書白居易及蘇軾詩於杭州孤山(《系年》,167)。拓片現存浙江圖書館。

夏

(1)

爲劉延伯作《牛山讀書圖軸》,絹本,并題"青藜山館瞰澄江"及"千峰選勝著西清"七言律詩二首(《華亭》,16-17。詩見《容詩》卷3, 37a-b,"題劉金吾牛山讀書圖二首")。

(2)

作《閒窗逸筆書畫卷》於婁水道中,絹本。畫幅設色,倣米芾《煙江疊嶂圖》筆意,并題"喬木生畫陰"五言絕句。書幅行書"山出雲時雲出山"及"地僻林深無過客"七言絕句二首(*Sotheby's*, 6/15/1983, no. 7。詩見《容詩》卷2, 35b及卷4, 36a)。

七月十七日

爲陳繼儒行書七言律詩四首一卷,宣德鏡光紙本,書"贈陳仲醇微君東佘山居詩三十首"之二十一、二十九、二十七及二十五(《吳越》卷5, 34b-35a;《玉雨》卷3, 93-94;《編年表》,98;《中國圖目》,v.3,滬1-1356。詩見《容詩》卷3, 31a-33a)。上海博物館藏。

七月

再題舊作《臨唐摹月儀帖卷》(《董其昌》, no. 54)。

參見:4/1602

八月二十日

跋巨然墨筆《長江萬里圖卷》, 絹本(《珊瑚》·畫, 卷6.6;《式古》, v.4, 畫卷14, 66;《穰梨》卷2, 5a;《總合圖錄》, v.1, A21–114;《歐米收藏法書》·明清篇, 卷1, no. 82)。Freer Gallery of Art。

按:《珊瑚》及《式古》載此卷爲夏珪筆, 又記董跋爲"己未秋後五日。"《穰梨》作巨然筆, 但記董跋爲"乙未中秋後五日。"今從《總合圖錄》及《歐米收藏法書》所刊是卷, 應爲"己未中秋後五日。"

九月晦日

題溪上吳嘉賓家藏之絹本《名畫集册》十幅, 三幅方式, 七幅宮扇式;四幅墨筆, 六幅著色, 均無款識。其中三幅有舊籤題爲趙幹《春山曉泛》、李成《寒林遠岫》、趙伯駒《武林先春》(《鑑影》卷10, 10b–11a)。

九月

(1)

題項氏家藏宋高宗楷書、馬和之設色畫《豳風圖卷》中《破斧》一篇, 絹本, 以爲圖爲趙孟頫筆[即《式古》及《大觀》所載馬和之《二人圖卷》](《式古》, v.4, 畫卷14, 55;《大觀》卷14, 17b;《石續》, 御書房, 2035;《雪堂》, 50b)。

參見:2/1628

(2)

跋舊藏趙孟頫墨筆《水村圖卷》, 宋箋本, 時已轉歸程季白(《石初》卷14, 103a–b)。北京故宮博物院藏。

秋

(1)

汪砢玉閱董舊藏之《唐宋元寶繪册》於新主程季白之交遠閣, 時已去馬琬一幅, 元人著色櫻桃白頭翁鳥一幅, 補入王維《雪溪圖》(得之青浦曹啓新)及王蒙《秋林書屋圖》[見汪砢玉記此册](《珊瑚》·畫, 卷19, 6–7;《式古》, v.3, 畫卷3, 214–15)。

參見:1621(1); 1599(1); 7/9/1612; 2/1617(1); 5/15/1618; 8/13/1621;及後文未紀年部分"鑑藏題跋"之"諸家"條

(2)

作墨筆《夏木垂陰圖軸》, 紙本(《鑑影》卷22, 3b–4a;《虛續》卷2, 53a–b;《編年表》, 98;《中國目錄》, v.2, 51, 京1–2167)。北京故宮博物院藏。

參見:秋/1626(3)

(3)

再題自藏之黃公望紙本淡設色《山水軸》以歸榆溪程季白(《寓意》卷2, 29b;《過雲》, 畫類2, 1b)。

按:《過雲》稱此作爲《浮嵐暖翠圖軸》。

十二月三日

書竟爲公垂所作《臨古十二種册》, 紙本。分臨鍾繇

《戒路》、《還示》二帖、王羲之《蘭亭》、《官奴》二帖、王獻之《辭中令》一段、楊凝式《韭花帖》、《前赤壁賦》一段、《露筋祠碑》一段、"揚清歌"七言歌行及謝安七言詩一首(《壯陶》卷12, 20a–b)。

十二月十五日

謁元元皇帝廟, 觀廟中吳道子畫《五聖圖》, 并臨徐浩行楷書杜甫《謁元元皇帝廟詩》, 素箋本[《書畫合璧卷》之書幅](《石續》, 乾清宮, 441;《編年表》, 98)。遼寧省博物館藏。

參見:3/1627(1)

十二月十六日

作墨筆《仿董源山水軸》, 紙本(《畫集》, no. 78;《中國圖目》, v.3, 滬1–1357)。上海博物館藏。

十二月

行書近作七言律詩五首一册於海上世春堂, 朝鮮箋本(《石初》卷28, 41b;《編年表》, 98;《中國圖目》, v.1, 京12–043)。北京市文物商店藏。

冬

(1)

爲吳廷題一六〇〇年所作《仿馬文璧山水卷》。

參見:1600(1)

(2)

青溪道中臨自藏蘇軾、米芾行書數種一卷, 紙本(《石三》, 靜寄山莊一, 4136–37)。

無月日

(1)

行楷書《女史箴》"茫茫造化"至"神聽"一段, 烏絲闌絹本[見董書竟此作時自識語]。

參見:7/11/1630; 10/11/1608

(2)

爲一六一六年所作《山水軸》補筆并再題。

參見:8/1616(2)

1620 萬曆四十八年, 庚申, 六十六歲

正月一日

重觀一六一九年所作《心經册》并題, 此日并書《圓通偈》(《夢園》卷13, 14a–16a)。

參見:1/1/1619(1)

按:董日後重題時稱此作爲"卷, "或爲重裱之故, 時爲比丘成果所藏。

正月廿七日

小行書臨米芾大字《天馬賦》一卷於龍華道中, 宣德鏡光箋本(《石初》卷5, 32a–33a;《編年表》, 98)。

參見:1590/(1); 1/27/1619

二月一日

行書《天馬賦卷》於玄賞齋, 灑金箋本(*Christie's*, 12/4/1989, no. 163)。

二月十二日

書竟《大鵬賦卷》, 鏡面麗箋本(《大觀》卷九下, 37b;《編年表》, 98)。

參見:1/1/1619(2)

二月十六日

行書《臨淳化閣帖册》, 素箋本[十册之首](《盛京》, 第六册, 12a–14a;《古物》卷1, 18a–19a)。蘇州市文物商店藏。

參見:3/3/1621(2); 3/1622; 7/8/1626; 4/6/1627; 立春/1628; 7/6/1631; 7/9/1631; 8/17/1631; 9/9/1631

三月二日

(1)

行書臨石本《聖教序》一册, 宋賤本(《石續》, 淳化軒, 3296;《編年表》, 98)。

參見:1627(2)

(2)

作《臨聖教序册》, 朝鮮箋本(《石初》卷11, 6b–7a;《編年表》, 98)。

(3)

書《蘭亭序册》, 麗賤本(《大觀》卷九下, 42a;《編年表》, 98)。

三月三日

書竟楷書《千文册》, 素箋烏絲闌本(《石初》卷28, 23a–b;《故宮》卷3, 101)。台北國立故宮博物院藏。

參見:1614

三月廿一日

舟行海上, 爲滿百朋行書《樂壽圖叙書屏》十二幅於秋水亭, 紙本(《古芬》卷7, 41a–b;《眼初》卷8, 28a)。

三月

明州朱定國携楊昇沒骨《峒關蒲雪圖》至松江, 董借作《臨峒關蒲雪圖軸》, 絹本(《穰梨》卷24, 6b–7a;《選續》卷下, 274–75;《湖社》, v.40, 封面)。

春

作《書畫合璧册》十對幅, 右行草雜書舊句, 宋箋本;左作墨筆山水, 宣德箋本。二對幅已佚去(《石初》卷12, 50a;《故宮》卷6, 68;《編年表》, 98)。台北國立故宮博物院藏。

四月廿二日

作墨筆《烟江疊嶂圖》, 後行書蘇軾"烟江疊嶂圖

詩"及杜甫"題王宰畫山水圖歌"七言古詩二首一卷,紙本(《畫集》,no. 131)。天津市藝術博物館藏。

正午

作墨筆山水於金閶舟中,紙本,并題"石徑盤紆山木稠"七言絕句一首[《仿十六家巨冊》之九](《華亭》,19-21)。

參見:9/1621(1)(2); 2/1/1625; 6/1625(1)(2); 9/27/1625; 10/9/1625;春/1626; 2/2/1626; 4/24/1626; 3/15/1627(1); 6/1628

五月

在吳門購顧正誼舊藏之黃公望紙本墨筆《陡壑密林圖軸》并題(《平生》卷9, 35;《穰梨》卷9, 12b;《藝苑掇英》,v.38; *Sotheby's*, 10/12&13/1984, no. 44。題語又見《容別》卷6, 38b)。美國王季遷藏。

按:董之臨本見《倣宋元人縮本畫跋冊》[即《小中現大冊》]二十二對幅之八,紙本墨筆(《盛京》,第六冊,20b;《古物》卷4, 8b-9a;《故宮》卷6, 73)。台北國立故宮博物院藏。

夏

作《書畫合璧冊》八對幅,白鏡面箋本。右作墨筆山水,其中第二幅自題倣王蒙,左幅各行書前人五言絕句一首(《墨緣》,名畫卷上明, 36b;《石續》,淳化軒,3317-19;《編年表》,98)。

七月七日

舟濟黃龍浦,重題舊作設色《林和靖詩意圖軸》,絹本,舊題有林逋"山水未深魚鳥少"七言絕句一首(《中國美術全集》,繪畫編8, no. 9;《中國目錄》,v.2, 51,京1-2168;《畫集》, no. 79)。北京故宮博物院藏。

七月八日

行楷書舊作"題《東佘山居圖》寄陳徵君仲醇三十首"中十八首[《詩卷》三段之三](詩見《容詩》卷3, 26a-31b)。

參見:1/27/1619

七月九日

為甥復之作墨筆《助喜圖軸》(《大觀》卷19, 34a-b;《華亭》,43;《編年表》,98)。

按:此軸《華亭》作宣紙本,《大觀》作白麗箋本。

七月十五日

為甥復之小楷書臨王羲之《樂毅論》一卷,宣德箋本(《石續》,寧壽宮,2844-45;《編年表》,98)。

七月晦日

(1)

倣趙孟頫筆意作淺絳山水小景,紙本[《秋興八景冊》八幅之首](《華亭》,44-46;《辛丑》卷5, 70-73;《聽颿》卷2, 162-68;《蘇雪》卷4, 47a-51b;

《虛續》卷2, 62a-71a;《編年表》,98;《中國美術全集》,繪畫編8, no. 10;《畫集》, no. 27;《中國圖目》,v.3,滬1-1358)。上海博物館藏。

參見:8/15/1620(1); 8/25/1620; 8/1620(1); 9/1/1620; 9/5/1620; 9/7/1620(1); 9/8/1620

(2)

有吳門之行,因行草書顧野王《登虎丘山序》一冊,絹本(《董其昌》, no. 55)。

八月一日

得宋搨徐浩書《洛州府君碑》,以其意書《畫錦堂記卷》,絹本(《藤花》卷2, 25b-26a)。

八月八日

為莫後昌作《崇蘭帖題詞》(《容文》卷3, 42a-b)。

八月十四日

跋張慎其所藏趙孟頫小楷書《千字文冊》,宋箋本(《石續》,養心殿,979)。

八月十五日

(1)

作淺絳兼淡青綠山水小景於吳門舟中,并題"溪雲過雨添山翠"及"平波不盡兼葭遠"詩詞各一首[《秋興八景冊》八幅之二]。

參見:七月晦/1620(1); 8/25/1620; 8/1620(1); 9/1/1620; 9/5/1620; 9/7/1620(1); 9/8/1620

(2)

題王蒙墨筆《青弁隱居圖軸》於金閶門程季白舟中,紙本(《平生》卷9, 107-108;《大觀》卷17, 15a-b;《墨緣》,名畫卷上元, 25a;《中國圖目》,v.2,滬1-0245)。上海博物館藏。

參見:9/1614

(3)

為徐肇惠作墨筆《仿倪雲林風亭秋影圖軸》(《編年表》,98;《藝苑掇英》,v.24, 1)。香港唐雲藏。

(4)

為程季白題吳鎮淡設色《臨巨然山陰賺蘭亭圖軸》,絹本(《寓意》卷2, 36b-37a)。

八月十六日

作墨筆《山水扇頁》,金箋本[《明人畫扇》第四冊二十幅之七](《石初》卷4, 14a-b)。

八月廿五日

舟行瓜步大江中,作淡青綠山水小景,并題白樸"黃蘆岸白蘋渡口"曲一首[《秋興八景冊》八幅之三]。

參見:七月晦/1620(1); 8/1620(1); 8/15/1620(1); 9/1/1620; 9/5/1620; 9/7/1620(1); 9/8/1620

八月晦日

作墨筆《山水軸》於吳門道中,綾本(《總合圖錄》,

v.4, JP12-166)。日本私人收藏。

八月

(1)

舟行瓜步江中,作淺絳山水小景,并題秦觀"秋光老盡芙容院"《玉樓春》詞[《秋興八景冊》八幅之五]。

參見:七月晦/1620(1); 8/15/1620; 8/25/1620; 9/1/1620; 9/5/1620; 9/7/1620(1); 9/8/1620

(2)

鑑定并題王蒙著色《多寶塔院圖卷》,宋箋本(《石初》卷6, 95b-96a)。

(3)

作墨筆《山水軸》,紙本(《十百》,未卷, 11a;《編年表》,99)。

九月一日

作設色山水小景於京口舟中,并題"短長亭,古今情"《長相思》詞[《秋興八景冊》八幅之六]。

參見:七月晦/1620(1); 8/1620(1); 8/15/1620(1); 8/25/1620; 9/5/1620; 9/7/1620(1); 9/8/1620

九月五日

作設色山水小景,并題"霽霞散曉月猶明"《少年游》詞一首[《秋興八景冊》八幅之四]。

參見:七月晦/1620(1); 8/1620(1); 8/15/1620(1); 8/25/1620; 9/1/1620; 9/7/1620(1); 9/8/1620

九月七日

(1)

作設色山水小景,臨吳門友人出示之米芾《楚山清曉圖》[《秋興八景冊》八幅之七]。

參見:七月晦/1620(1); 8/1620(1); 8/15/1620(1); 8/25/1620; 9/1/1620; 9/5/1620; 9/8/1620

(2)

楷書《陰符經》、《西昇經》、《度人經》、《內景經》、《清靜經》[《楷書六種冊》之二、三、四、五、六]。

參見:3/18/1618(1)

九月八日

作綫絳山水小景,并題"今古幾齊州"《浪淘沙》詞[《秋興八景冊》八幅之末]。

參見:七月晦/1620(1); 8/1620(1); 8/15/1620(1); 8/25/1620; 9/1/1620; 9/5/1620; 9/7/1620(1)

九月廿一日

跋畢懋康所藏張即之楷書《金剛般若波羅蜜經冊》於金閶舟次,白麻紙本(《歐米收藏法書》卷2, nos. 97-99)。The Art Museum, Princeton University。

秋

(1)

行書李嶠"奉和韋嗣立山莊侍宴應制"詩一卷

（《書道藝術》卷8,插圖9)。日本澄懷堂文庫藏。

(2)

作《書畫冊》八對幅,畫幅鏡面箋本,分仿董源、巨然《江山蕭寺》、黃公望、倪瓚、米芾、高克恭等筆意,對幅自題爲藏經紙本(《華亭》,40-42)。

(3)

爲徐肇惠作《仿高房山山水軸》於海上世春堂,紙本(《寓意》卷4,32a;《編年表》,98)。

十月

作《倣古山水冊》八幅中之一幅,未竟。

參見:9/1625(2)

十一月

題王蒙淺設色《松窗高士圖軸》,紙本(《石三》,延春閣十六,1630;《西清》卷1,6b)。

十二月三十日

行書《答徐孝穆書卷》,朝鮮鏡光箋本(《石初》卷30,49a-b;《編年表》,98)。

冬

作墨筆《米家山水扇頁》,金箋本(《中國圖目》,v.3,滬I-1360)。上海博物館藏。

無月日

小楷書《千字文卷》未竟[見董自題此作]。

參見:2/12/1622

1621 天啓元年,辛酉,六十七歲

正月二日

臨顏眞卿《送明遠序》一卷,鏡光紙本(《寓意》卷4,31b;《編年表》,99)。

二月七日

作《江上蕭寺圖軸》,生紙本,并題"蕭寺曾同一鶴棲"七言絕句一首(《大觀》卷19,35a;《編年表》,99)。

參見:12/1626

二月

行書趙孟頫"鷗波亭詩"五言絕句十首一卷,紙本(《古芬》卷7,22a-23a)。

三月三日

(1)

從韓世能借臨《禊帖》,縮爲蠅頭小楷書,素箋本[《蘭亭叙·樂志論册》之前段]。

參見:9/23/1612;1589

按:董之自題語與《容別》及《畫禪》所載題跋幾乎

全同,惟二書載董《臨禊帖》於"己丑"(一五八九年),爲此合冊之自題所無,見《容別》卷4,48b;《畫禪》卷1,50。按韓世能卒於一五九八年,董不可能於一六二一年向其借《禊帖》,因疑此合冊之《蘭亭叙》一段爲僞。

(2)

行書《臨淳化閣帖》,書竟十册中之第三册。

參見:2/16/1620;3/1622;7/8/1626;4/6/1627;立春/1628;7/6/1631;7/9/1631;8/17/1631;9/9/1631

(3)

題于里甫所藏米芾書《天馬賦》(《四印堂詩稿》,引自《年譜》,134)。

三月十五日

過西湖,仲茅攜董舊作《山水書畫冊》八對幅至行舫,紙本,董爲重題。此册畫幅六墨筆,二設色;書幅一題七言詩一聯,餘幅各行書七言絕句一首,此重題爲第九幅(《墨迹大成》卷6;《中國名畫集》,外册第一;*Sotheby's*,5/30/1990,no. 33)。

按:此冊印鑑各幅不一,書幅一鈐有"知制誥日講官"印,餘鈐有"太史氏"印,或諸幅非作於一時,或後人拼湊成冊,待考。

三月十六日

偶得唐搨善本鍾繇《宣示帖》,楷書臨之,并自題云乃王義之書,非鍾繇[《楷書四種册》之首]。

參見:2/1/1583

三月

(1)

重題一六一四年所作《林和靖詩意圖軸》。

參見:2/22/1614

按:《湘管》載此重題年款爲"辛酉二月,"查原畫實爲"三月。"

(2)

作墨筆《烟樹茆堂圖軸》於西湖蘭若,宣德鏡光箋本,并題"岡嵐屈曲樹交加"七言絕句一首(《石初》卷17,45a-b;《編年表》,99)。詩見《容詩》卷4,33b,"題畫贈眉公"二首之二)。

(3)

客靜道人出示吳彬設色《二十五圓通册》,絹本,董題於西湖舟中(《吳越》卷4,103b;《故宮》卷8,141;《故週》,v.75,3)。台北國立故宮博物院藏。

春

作《臨蘭亭小字册》,紙本(《華亭》,22)。

四月八日

臨文徵明筆,泥金小楷書《金剛經册》,磁青箋本(《秘初》卷3,13a-b)。

四月十七日

點綴舊作《溪回路轉圖軸》并再題之。

參見:9/1600

四月

作墨筆《深谷幽獨圖扇頁》於天馬山舟中,金箋本,并題"閒雲無四時"五言絕句一首(《中國圖目》,v.3,滬I-1361)。上海博物館藏。

五月正午

書蘇軾《外紀》及《東坡遺事》一册(《四印堂詩稿》,引自《年譜》,135)。

五月十三日

爲亡母沈孺人忌日楷書七《佛偈》,每則下并自注[宣德鏡光箋本《倣古三種册》之第一種](《石初》卷10,56a-57a;《故宮》卷3,126-27;《編年表》,99)。台北國立故宮博物院藏。

五月

作墨筆《雲山圖卷》於世春堂,素箋本,本擬董源,復似巨然筆意,後又書杜甫五言詩一章(《石初》卷6,78b-79a)。

六月八日

擬舊藏之王蒙《雲山小隱圖卷》作墨筆《山水卷》,紙本(《聽颿》卷下,605;《三秋》卷上,58a-59a;《編年表》,99;《繪畫史圖錄》,下册,no. 6;《畫集》,no. 132)。

參見:5/1635(1)

按:據董一六三五年再跋,董得王蒙原作於王世貞冢孫慶常,但尋與張覲宸易《倪迂王蒙合作山水》,因念此圖,而作此卷。

夏

作絹本設色《山水卷》,并題"閒花滿巖谷"五言絕句一首(《古緣》卷5,30b-31a;《編年表》,99)。

七月一日

舟過澱河,寫王蒙筆意作設色畫[紙本《倣宋元山水册》十幅之十](《寓意》卷4,31b;《編年表》,99)。

參見:7/7/1621(1)

七月七日

(1)

倣趙伯駒作設色畫於青龍江舟中,并題"遍地皆黃葉"五言詩一聯[《倣宋元山水册》十幅之六]。

參見:7/1/1621

(2)

行書《酒德頌書屏》八條於世春堂,絹本(《劍花》,上卷,33)。

七月十二日

作墨筆山水并題"衆山遙對酒"五言詩一聯,絹本

[《做六家冊》六幅之二]。

參見:4/15/1602

七月十五日

行書《論書軸》,冷金箋本(《鑑影》卷22,1a–b;《編年表》,99)。

八月十三日

題衛九鼎小橫幅墨筆《溪山蘭若圖》,宋箋本[《唐宋元寶繪高橫冊》十二幅之十一],即[《唐宋元名畫大觀冊》十二幅之十一]。

參見:1599(1);7/9/1612;2/1617(1);5/15/1618;秋/1619(1);1621(1);及後文未紀年部分"鑑藏題跋"之"諸家"條

八月十五日

(1)

題唐摹王羲之《瞻近帖》八行於張觀宸畫舫,硬黃紙本(《寓意》卷1,2a;《三希》,第一冊,65–66)。

按:《石續》載有王羲之行書《瞻近帖卷》,內容及題跋與《寓意》所載同,尺幅略大,惟為冷金箋本,且董跋紀年為辛酉"仲秋,"待考。見《石續》,乾清宮五,279。《書畫》及《石隨》亦載董跋此卷,見《書畫》卷5,478–79及《石隨》卷1,4b。

(2)

作《山水》於靈巖村(《支那畫家落款印譜》,下,17b)。

八月

(1)

從京口張觀宸觀虞世南書《廟堂碑真蹟》[見《雜書冊》前段董之自跋]。

參見:3/1618;10/8/1621

(2)

再題張觀宸所藏沈周《東莊圖冊》於京口。

參見:3/19/1617

(3)

行書白居易《琵琶行》一卷於吳門舟次,紙本[《文嘉畫白居易琵琶行·董其昌書合璧卷》之書幅](《石三》,乾清宮十三,658)。

九月九日

與雷宸甫遊西山,行書《東坡詞軸》,紙本(《中國圖目》,v.3,滬1–1362)。上海博物館藏。

九月十一日

行書七言律詩十四首一冊付子祖常,朝鮮箋本(《石初》卷28,28b–29a;《故宮》卷3,127;《編年表》,99)。台北國立故宮博物院藏。

九月十六日

作設色《山水軸》,紙本,并題"霽霞散曉月猶明"詞

一首(《總合圖錄》,v.3,JM11–006)。京都國立博物館藏。

九月

(1)

作墨筆山水,紙本,做自藏之董源《關山行旅圖》[《仿十六家巨冊》之三]。

參見:正午/1620;9/1621(2);2/1/1625;6/1625(1)(2);9/27/1625;10/9/1625;春/1626;2/2/1626;4/24/1626;3/15/1627(1);6/1628

(2)

舟行玉峰道中,作墨筆山水,紙本,并題李煜"一重山"詞一首[《仿十六家巨冊》之十三]。

參見:正午/1620;9/1621(1);2/1/1625;6/1625(1)(2);9/27/1625;10/9/1625;春/1626;2/2/1626;4/24/1626;3/15/1627(1);6/1628

按:《澄懷》載董《秋山萬疊圖卷》,題跋款識與此冊頁全同,置此待考。見9/1621(4)。

(3)

作重設色《杜陵詩意圖》寫惠山道中所見,并題杜甫"石壁過雲開錦繡"七言詩一聯,白紙本[《山水高冊》十幅之八](《墨緣》,名畫上明,33a–35a;《壯陶》卷12,16a–17b;《虛續》卷2,55a–58a;《南畫》9,172–80,183,及續集一,10–19;《董其昌》,no.17;《文人畫》,v.5,nos.44–47;《畫集》,no.139)。The Nelson-Atkins Museum of Art。

參見:4/1623;7/22/1623;7/29/1624;8/13/1624;9/12/1624;九月晦/1624(1)

(4)

舟行玉峰道中,作設色《秋山萬疊圖卷》,紙本,并題李煜"一重山"詞一首[《文董二家山水雙卷》之後段](《澄懷》卷4,28–29)。

參見:9/1621(2)

(5)

行草書"邠風圖"七言古詩一卷,紙本(《董其昌》,no.56。詩見《容詩》卷1,9a–b)。日本神奈川私人收藏。

秋

(1)

作墨筆《山水冊》七幅,素箋本,其中一幅自題"畫米家山"(《盛京》,第六冊,23a–24a;《古物》卷4,7a–b;《編年表》,99;《中國目錄》,v.2,51,京1–2170;《明代繪畫》,no.60;《畫集》,no.33)。北京故宮博物院藏。

參見:閏10/22/1623

(2)

作《仿米元暉墨戲畫卷》,絹本(《華亭》,4)。

(3)

將之京江舟次,作《山水扇頁》(《年譜》,137)。上海博物館藏。

(4)

同趙希遠至京口訪張觀宸,見其所藏黃公望《浮嵐暖翠圖》(《畫史會要》卷5,39)。

十月六日

作《書畫合冊》,鏡面箋本。書幅十,書馮延巳、林逋、周邦彥、蘇軾二首、韋莊、溫庭筠、歐陽修、辛棄疾、賀鑄詞,末并自識。畫幅十,一墨筆做董源,一設色做黃公望,一墨筆做范寬,一設色做王蒙,一墨筆《松林秋霽》,一設色《巖居高士圖》,一設色《秋林書屋》,一墨筆做米友仁(《華亭》,23)。

十月八日

以智永《千文》意作虞世南書,楷書重錄皮日休《桃花賦》[白鏡面箋烏絲闌本《雜書冊》之前段](《墨緣》,法書卷下明,13b–14b;《石續》,淳化軒,3297–98;《石隨》卷6,5b–6b;《壯陶》卷12,23a–b;《編年表》,99)。

參見:3/1618;8/1621(1);10/17/1621

按:《壯陶》以董書《桃花賦》自成一冊。

十月十七日

行書臨吳廷家藏之徐浩書杜甫《謁元元皇帝廟詩》[《雜書冊》後段](自題語又見《容別》卷4,59a–b)。

參見:10/8/1621

十月

作墨筆《做倪元鎮松亭秋色圖軸》,紙本,并題"松溪水色綠於松"及"危根瘦蓋聳孤峰"七言絕句二首(《董其昌》,no.12;《總合圖錄》,v.1,A13–019;《文人畫》,v.5,no.40;《畫集》,no.80)。美國翁萬戈藏。

十二月三日

題周祖書《洛神賦冊》,絹本(《穰續》卷8,11a–b)。

十二月十五日

行楷書《龍神感應記卷》并篆額,宣德鏡光箋烏絲闌本(《石初》卷30,50b;《三希》,第二十九冊,2094–111;《編年表》,99)。

冬

仿米芾筆意作《雲山圖軸》,紙本,(《自怡》卷2,22b–23a;《編年表》,99)。

按:《自怡》載此圖有項元汴三印,但項早卒於一五九〇年,因疑此作為偽。參見《系年》,189。

無月日

(1)

程季白重攜《唐宋元寶繪冊》至董齋中,適楚中王幼度、松江陳繼儒、吳君傑、楊繼鵬、張世卿、姑蘇楊仲修同集,縱觀永日。董再題首幅王維墨筆《雪溪圖》長方冊,素絹本[《唐宋元寶繪高橫冊》十二幅之首],即[《唐宋元名畫大觀冊》十二幅之首](*Early Chinese Painting*, no.58)。

參見:秋/1619(1);1599(1);7/9/1612;2/1617(1);5/15/1618;8/13/1621;及後文未紀年部分"鑑藏題跋"之"諸家"條

按:董爲程季白跋王維《雪谿圖》又見《平生》卷6, 39。

(2)

作墨筆《王維詩意圖軸》,紙本(《董其昌》,no. 13;《文人畫》,v.5, no. 20;《畫集》,no. 81)。美國王季遷藏。

參見:1/16/1622

(3)

重觀并跋傳米芾書《陽關詩卷》於新城王長公所(《容別》卷4, 66a)。

參見:1595; 春/1617(3)

(4)

行書《臨帖冊》六開,紙本(《中國目錄》,v.2, 51,京1-2171)。北京故宮博物院藏。

(5)

作設色《仿古山水冊》八開,紙本(《編年表》,99;《中國目錄》,v.2, 51,京1-2169)。北京故宮博物院藏。

(6)

游武林,作《書畫合璧冊》八開(《郭表》,205;《編年表》,99)。故宮博物院藏。

(7)

書《西倉橋記》(《松江》卷73, 24)。

1622　天啓二年,壬戌,六十八歲

獻歲

爲陳繼儒擬黃公望筆意作《浮嵐暖翠圖卷》,綾本[見陳繼儒題此卷](《自怡》卷8, 40b-41a)。

參見:1/1/1618

正月十六日

題王維"積雨空林煙火遲"七言律詩於一六二一年所作《王維詩意圖軸》。

參見:1621(2)

正月晦日

行書《龍井記》(《系年》,191)。拓片現藏浙江圖書館。

二月三日

行書杭州《永福寺石壁法華經記》(《系年》,193)。拓片現藏北京圖書館。

二月十日

晉陵舟次,與米萬鍾同觀程季白所藏李成《寒林歸晚圖》并再題之。

參見:9/21/1597(1); 5/1624(1)

二月十二日

爲婿復之自題小楷《千字文卷》,鏡面麗箋本烏絲

闌(《大觀》卷9, 42b;《編年表》,99)。

參見:1620

二月十八日

舟次高郵覽社湖,倣吳門石刻米芾書《天馬賦》小行書《天馬賦卷》,紙本(Christie's, 11/30/1988, no. 55)。

二月十九日

朱國盛出示董一六一一年所作《山水冊》八幅,董爲重題於覽社湖分司署中。

參見:3/3/1611

二月

(1)

重覽昔臨惠崇《春江圖卷》所作《仿惠崇冊》,并再題於射陽湖朱國盛公署。

參見:8/15/1613(1); 9/1613(1); 9/1614; 立秋/1615

(2)

楷書《陰符經》半卷一冊,宣紙本(《石續》,重華宮,1635;《編年表》,99)。

參見:10/15/1622

(3)

與米萬鍾同觀程季白所藏仇英《臨宋人山水界畫人物畫冊》十幅并題之,絹本(《墨緣》,名畫卷上明,23a-b)。

三月

行書《臨淳化閣帖冊》[十冊之四]。

參見:2/16/1620; 3/3/1621(2); 7/8/1626; 4/6/1627; 立春/1628; 7/6/1631; 7/9/1631; 8/17/1631; 9/9/1631

春

(1)

北行復宿羊山驛,作《羊山小景圖軸》,十六日題一五九二年春所作"宿羊山驛"五言律詩於畫上并題贈李養正(Chinese Painting, v.6, 261A;《畫集》,no. 82。詩見《容詩》卷2, 20a)。

參見:春/1592(4)

(2)

奉召北上,化育衲子操舟送別索書,爲作《化育衲子狀卷》,紙本(《吳越》卷5, 75a-76a;《編年表》,99)。

(3)

董鎬勒成《來仲樓法帖》八卷(《善本碑帖錄》卷4,引自《系年》,195)。

四月八日

行楷書《金剛經冊》未竟,素箋本[見董自跋此冊]。

參見:10/3/1634

四月十七日

行書蘇軾《十八大阿羅漢頌》一卷,宣德箋本(《秘續》,170-71;《編年表》,99)。

四月

(1)

馮詮觀董藏智永紙本《真草千文卷》,特深賞識[見董自題所書蘇軾《評唐六家書》,引自郭尚先題智永紙本《真草千文卷》](《鑑影》卷1, 10b-12a)。

參見:10/21/1624

(2)

作墨筆《仿倪高士山水軸》,絹本(《古緣》卷5, 39b;《編年表》,99)。

(3)

爲李伯襄作墨筆《寶研齋圖軸》并系五言律詩二首於范西畫禪室,紙本,酬其贈二端硯(《年譜》,145。詩見《容詩》卷2, 14b-15a)。上海博物館藏。

六月一日

重題庶常時行楷書焦竑所撰《正陽門關侯廟碑》一卷於范西畫禪室,宋箋本(《石初》卷30, 50b-51b)。

六月

重題王羲之草書《氣力帖》於范西,硬黃紙本(《大觀》卷1, 28a)。

參見:3/2/1634

八月

作設色《倣黃子久層巒暖翠圖軸》,紙本(《畫集》,no. 44)。上海博物館藏。

九月

奉使往南京搜輯遺書,過湯陰,撰《湯陰縣重修宋忠武岳鄂王精忠祠記》[見董自跋此冊]。

參見:夏/1624; 3/15/1625(1)

秋

(1)

奉詔求遺書於南京,出都門,友人祖餞,各有贈什,葉向高爲首倡,董依韻和之,行草書七言律詩"次韻誚葉少師臺山贈行四首"一冊(詩見《容詩》卷4, 5a-6a)。香港北山堂藏。

按:董於一六二二至一六二三年間數書此四詩,紀年均異。見10/1622; 12/30/1623。

(2)

行書張九齡《白羽扇賦》一卷,灑金箋本(《石三》,延春閣二十六,2061;《故宮》卷1, 137)。台北國立故宮博物院藏。

十月十四日

作《古松圖軸》於崑山道舟中,白楮紙本(《大觀》卷19, 31b;《編年表》,99)。

十月十五日

書竟《陰符經冊》。

參見:2/1622(2)

十月

行書《與葉少師唱和詩卷》,紙本。書七言律詩"福唐葉少師有贈行之什,次韻誦四首"、葉向高原作,"葉君錫茂才以詩贈行,復次前韻誦之"、"送侯六真侍御按黔,時黔有兵事,侍御兼視師之命二首"及"贈張蓬玄中丞,張自吏部郎出撫上谷"(《朱卧》,24;《中國目錄》,v.2,51,京I-2173。詩見《容詩》卷4,5a-6b;卷3,9b-10b及44b)。北京故宮博物院藏。

參見:秋/1622(I)

按:《十百》載董《詩冊》,內容與此卷全同,或為另一作,或誤記為冊,待考。見酉卷,21b-23a;《編年表》,99。

冬

觀郭金吾家藏燕文貴畫卷於京,因作設色《倣燕文貴筆意軸》,宣德箋本(《石初》卷17,56a-b;《編年表》,99)。

無月日

(I)

自題一五九一年所書《寶鏡三昧》[《禪德偈頌》之一]。

參見:約四月/1591

(2)

觀郭金吾家藏之燕文貴、趙源畫卷於京,因倣其意作《山水小軸》,紙本(《筆嘯》卷上,4a;《編年表》,99)。

(3)

行書《題畫七絕詩軸》,綾本(《中國目錄》,v.2,51,京I-2172)。北京故宮博物院藏。

1623 天啓三年,癸亥,六十九歲

正月晦日

(I)

自識《仿倪雲林山水軸》於大江舟中(《編年表》,100;《畫集》,no.86)。虛靜齋藏。

參見:11/16/1623

(2)

作歐陽詢書(《容別》卷5,36b)。

二月

作設色《延陵村圖軸》於丹陽舟中,絹本(《中國目錄》,v.2,51,京I-2175;《畫集》,no.54。題語又見《容別》卷6,21b-22a,文字略有出入,"丹陽"作"朱楊")。北京故宮博物院藏。

參見:3/1623

三月廿一日

作墨筆《墨卷傳衣圖軸》,白楚紙本,以換回一五八九年應試時對策卷,付孫董庭收之(《大觀》卷19,35a;《編年表》,100;《中國目錄》,v.2,51,京I-2176)。北京故宮博物院藏。

三月廿二日

行書《閑窗漫筆冊》,紙本(《中國目錄》,v.2,51,京I-2177)。北京故宮博物院藏。

三月

作墨筆《延陵村圖軸》於丹陽舟中,絹本(《華亭》,18)。

參見:2/1623

按:北京故宮博物院藏有董《延陵村圖軸》,亦絹本,自題語與《華亭》所載全同,惟紀年為"癸亥二月,"且屬設色,待考。

四月一日

自題青綠《秋山圖軸》於崑山舟中,紙本(《華亭》,13及44)。

四月八日

作墨筆《倣倪黃合作圖軸》於虎邱舟次,紙本(《石三》,延春閣廿六,2072;《編年表》,100)。

四月十一日

晉陵唐獻可持贈王蒙墨筆《谷口春耕圖軸》[一名《黃鶴草堂圖軸》],素箋本。十三日題之於吳江道中(《大觀》卷17,14b;《石初》卷26,8b-9a;《故宮》卷5,204)。台北國立故宮博物院藏。

參見:7/7/1600

四月

倣王蒙筆意作設色山水[《山水高冊》十幅之三]。

參見:9/1621(3);7/22/1623;7/29/1624;8/13/1624;9/12/1624;九月晦/1624(I)

五月十八日

再題一六一五年所作《山居圖軸》。

參見:立秋後三日/1615

五月

重題舊作楷書陳繼儒所撰《陸處士傳》,烏絲闌冊改裝橫卷(《式古》,v.2,書卷28,493-95;《編年表》,99)。

六月晦日

作《杜少陵詩意圖軸》,紙本,并題杜甫"荒村建子月"五言詩一聯(《寓意》卷4,33b-34a;《編年表》,100)。

參見:8/17/1623;1/1624;1625(I)

七月七日

行書《東佘山居詩卷》於百花里,高麗紙本,書"贈陳仲醇徵君東佘山居詩三十首"中之十八首(《石三》,御書房二,3134-36。詩見《容詩》卷3,25b-33b)。

七月十一日

書竟《女史箴圖》(《歷代名人年譜》·明·五,引自《年譜》,149)。

七月廿二日

倣倪瓚筆作墨筆山水,并書倪"江渚暮潮初落"六言絕句一首[《山水高冊》十幅之四]。

參見:9/1621(3);4/1623;7/29/1624;8/13/1624;9/12/1624;九月晦/1624(I)

七月廿五日

以王羲之集書《陰符經帖》書《誥敕卷》,紙本,書《陝西道監察御史沈猶龍父母敕命》及《陝西道監察御史沈猶龍并妻敕命》二道(《穰梨》卷24,14a-16b)。

八月九日

客持吳鎮畫見示,因作《仿梅花道人筆意軸》,絹本(《華亭》,17)。

參見:9/9/1629

八月十七日

為六月晦所作《杜少陵詩意圖軸》設色并重題。

參見:六月晦/1623;1/1624;1625(I)

九月十日

行書《五律詩卷》於寶鼎齋,紙本,書"晚市人煙合"、"江城連日雪"、"公子青驄馬"、"山上新亭好"、"高險有深意"及"樓閣籠雲氣"六首(《壯陶》卷12,53b-54b)。

九月

重裝自藏之李唐設色《江山小景圖卷》,絹本,因題之(《石續》,畫禪室,3622-23;《故宮》卷4,44)。台北國立故宮博物院藏。

參見:6/26/1633

按:《平生》載此卷為陳居中所作,見卷8,27。

秋

(I)

作著色《仿黃公望山水卷》,素綾本,并錄張雨題

黃公望畫語。後別幅附宋詞二闋（《石初》卷6，72a–73a;《編年表》，100）。

(2)
作《仿古書畫冊》八對幅。畫幅爲絹本，一作墨筆《溪山清樾》，二作設色畫倣黃公望筆意，三作墨筆《大姚村圖》，四作設色《澗松圖》，五作墨筆《谿山亭子》，六作設色畫倣高克恭筆意，七、八皆爲墨筆，各幅分識。書幅爲金箋本，各幅書七言絕句一首（《自怡》卷12，4b–7a;《中國目錄》，v.2，51，京1–2174）。北京故宮博物院藏。

(3)
楷書《後赤壁賦》并行書《陶隱居與梁武帝論書啓》一卷，紙本（Christie's，11/25/1991，no. 8）。

按：此作現與文徵明辛亥秋日所作《赤壁圖卷》裱爲一卷。

十月十三日

跋文天祥行草書《遺像家書卷》，紙本（《石三》，延春閣十四，1514–16;《西清》卷4，24a–26b）。

十月十五日

作墨筆山水一幅[《書畫合璧冊》六對幅之二]。

參見：10/1623(1)

十月

(1)
作《書畫合璧冊》六對幅於寶華山莊，紙本。右作墨筆《山莊紀興六景》，其中一倣王蒙，四畫李白"平林漠漠煙如織"詞意。左行書詩、詞或曲一首（《大觀》卷19，30a–31a;《墨緣》，名畫卷上明，35b–36a;《石三》，寧壽宮一，3326–28;《故宮》卷6，69–71;《董其昌》，no. 14;《文人畫》，v.5，nos. 50–55;《畫集》，no. 140）。台北國立故宮博物院藏。

(2)
掃先人墓於嶼洋，憩寶華山莊，作墨筆《寶華山莊圖軸》，宣紙本，并題"積鐵千尋屆紫虛"七言絕句一首（《吳越》卷5，62a–b;《歸石》卷4，16a–b;《編年表》，100。詩見《容詩》卷4，43a–b，"題《倣黃子久畫》"）。

(3)
行書七言絕句五首於東光道中，碧色箋本[《書畫合璧卷》之後幅]（《石初》卷36，39a–b;《編年表》，100; Sotheby's，12/5/1985，no. 13）。

(4)
觀并題仇英著色《十美圖卷》，絹本（《十百》，卯卷，8b–10a）。

閏十月一日

題梵隆白描《十六應真圖卷》於武丘舟次，宋紙本（《吳越》卷1，27a;《總合圖錄》，v.1，A21–073）。Freer Gallery of Art.

閏十月廿二日

重題一六二一年所作《山水冊》，時爲晉陵聖萊所藏。

參見：秋/1621(1)

十一月十六日

重題正月所作《仿倪雲林山水軸》。

參見：正月晦/1623(1)

十二月三十日

爲道實行楷書《和葉臺山詩卷》，綾本，書七言律詩"次韻誚葉少師臺山贈行四首"（《十百》，丁卷，26b–27a;《編年表》，100。詩見《容詩》卷4，5a–6a）。

參見：秋/1622(1)

長至次日

跋蘇軾小楷書方干詩六十三首一卷，紙本（《珊瑚》·書，卷4，29;《式古》，v.1，書卷10，481;《萱暉》，書28a）。程琦舊藏。

無月日

(1)
補畫一五九三年所作《三癸圖卷》於容臺署中，爲子祖常索去[見董一六三三年題此卷]。

參見：1593(1); 1633(1)

(2)
作墨筆《倣倪雲林山水軸》[一名《楓林霜葉圖軸》]，紙本，并臨倪書"江渚暮潮初落"六言絕句一首及識語（《過續》，畫類3，3b–4a;《編年表》，100;《畫集》，no. 84;《中國圖目》，v.3，滬1–1363）。上海博物館藏。

參見：5/1625(2)

按：《過續》載此作款後鈐有"宮詹"印，且有乙丑（一六二五年）五月重題。上海博物館所藏軸鈐"昌"字印，且無重題，應爲另一作。

(3)
以米芾行楷書詩詞十九首一冊，宣德箋烏絲闌本[即《詩詞手稿冊》]（《石初》卷28，28b;《故宮》卷3，115;《編年表》，100）。台北國立故宮博物院藏。

(4)
續成舊作《臨李晞古畫卷》，宣德紙本（《華亭》，2）。

按：此卷乃昔臨潯關張平仲所攜李唐畫卷所作粉本。

1624　天啓四年，甲子，七十歲

正月一日

(1)
作《倣倪高士山水》[《山水書畫冊》十對幅之七]。

參見：11/10/1633

(2)
書竟倣前代名家歷三載而成之行楷《金剛經冊》，

素箋本，自跋於寶鼎齋（《秘初》卷3，12b–13a;《編年表》，100）。

正月

三題一六二三年所作《杜少陵詩意圖軸》，時爲青谿雷大綸所藏，董爲題贈趙正宇。

參見：六月晦/1623; 8/17/1623; 1625(1)

二月

(1)
訪櫟社老人擁翠山房，出示國詮書《善見律卷》[見櫟社老人跋此卷]。

參見：1628; 1634(1)

(2)
行書《內景黃庭經卷》於德州公署，紙本（《石三》，延春閣廿六，2061）。

春

(1)
見董源《夏口待渡圖卷》於京[見王肇《臨董香光卷》中董之重題]。

參見：9/3/1615; 8/15/1625

(2)
夢張旭於金陵，曉起以草書入畫，作墨筆《幽壑圖》，紙本（《系年》，209;《年譜》，154）。中國私人收藏。

(3)
過問政山房，擬倪瓚筆作《山水軸》，絹本（《筆嘯》卷上，13a;《編年表》，100）。

四月廿五日

跋《定武五字損本蘭亭卷》，黃紙本[即趙孟頫十三跋之"獨孤本定武蘭亭"]（《墨緣》，法書墨搨卷下，7a–b;《大觀》卷1，60b;《槐安》，no. 295）。東京國立博物館藏。

按：此卷乾隆時毀於火，殘片重裝成冊，但董跋已佚。

四月

(1)
因觀顏真卿《多寶塔碑》，楷書《陰符經》，又臨徐浩楷書《府君碑》合爲一卷，紙本，并自跋於苑西行館（《玉雨》卷3，93;《編年表》，100;《中國圖目》，v.3，滬1–1365）。上海博物館藏。

(2)
仿自藏之董源畫，作《仿北苑山水軸》（《瀟灑書齋書畫述》卷2，引自《年譜》，156）。

五月廿四日

行書《解學龍父母告身卷》，蠟箋本（《中國圖目》，v.6，蘇20–018）。南京市博物館藏。

五月

(1)
對題自藏之關仝淡色《秋峰聳秀圖》小長幅，絹本

[《名畫大觀》第二冊二十五對幅之二];[《五代宋元集冊》十二幅之首]。

參見:9/21/1597(1); 2/10/1622

按:《墨緣》謂董題不真刪去。

(2)

在京吳廷寓,同王時敏觀董源《夏口待渡圖卷》[見王自題《倣董北苑夏口待渡圖卷》](《吳越》卷6,76a;《歸石》卷5,4b)。

參見:6/1624(1)

按:董一六三五年跋董源《夏山圖卷》云一六二四年在京時,亦曾見《夏口待渡圖卷》於東昌朱閣學所。見8/15/1635。

(3)

書《心經》於丁雲鵬設色《觀自在菩薩像軸》并跋之,絹本(《秘續》,166–67)。

六月

(1)

跋董源著色《夏景山口待渡圖卷》於京,黃絹本(《大觀》卷12, 14a;《石初》卷25 3b)。遼寧省博物館藏,但董跋已佚。

參見:5/1624(2)

六月

(2)

重裝王廙《一葉吟秋圖卷》并記。

參見:10/1615(1)

(3)

旅泊內史過訪董及陳繼儒,董因贈墨筆《倣黃公望筆意圖軸》,素箋本,并書倪瓚題黃公望畫"大癡畫格超凡俗"七言絶句一首(《石初》卷8, 39a–b)。

按:此時董在京,而陳繼儒隱於佘山,此作存疑。參見《系年》,212。

(4)

重裝方從義著色《雲林鍾秀圖卷》并題之,絹本(《巚雪》卷3, 43a;《壯陶》卷7, 62b)。

夏

在京始書《湯陰縣重修宋忠武岳鄂王精忠祠記冊》未竟[見董自跋此冊]。

參見:9/1622; 3/15/1625(1)

七月六日

許立禮出使朝鮮,攜《皇華集》歸,董爲作序,此日書《皇華集記卷》,紙本(《藤花》卷2, 24a–b。文見《容文》卷1, 15a–16b)。

七月廿九日

倣偏頭關萬邦孚家藏之李成平遠小絹幅作墨筆《巖居高士圖》[《山水高冊》十幅之五]。

參見:9/1621(3); 4/1623; 7/22/1623; 8/13/1624; 9/12/1624; 九月晦/1624(1)

七月

(1)

爲趙南星作設色《王右丞詩意圖軸》,絹本,并題"人家在仙掌"五言詩一聯(《過續》,畫類3, 2b–3a;《畫集》, no. 43)。廣東省博物館藏。

(2)

題沈度墨筆《山意衝寒欲放梅圖軸》,宋紙本(《石續》,淳化軒,3260)。

八月二日

題倪瓚墨筆《小山竹樹圖軸》,紙本(《鑑影》卷20, 10a–b。題語又見《容別》卷6, 20a)。

八月十三日

作墨筆山水寫白居易"聞道移居村塢間"七言絶句詩意,并書其詩畫上[《山水高冊》十幅之七]。

參見:9/1621(3); 4/1623; 7/22/1623; 7/29/1624; 9/12/1624; 九月晦/1624(1)

九月十二日

自上陵回,作墨筆山水[《山水高冊》十幅之九]。

參見:9/1621(3); 4/1623; 7/22/1623; 7/29/1624; 8/13/1624; 九月晦/1624(1)

九月晦日

(1)

倣舊藏之趙孟頫《水村圖》作墨筆山水[《山水高冊》十幅之末幅]。

參見:9/1621(3); 4/1623; 7/22/1623; 7/29/1624; 8/13/1624; 9/12/1624

(2)

題自藏之董源設色《龍宿郊民圖軸》,絹本(《石續》,寧壽宮,2650;《大觀》卷12, 19a–b;《故宮》卷5, 19)。台北國立故宮博物院藏。

參見:1597

按:《大觀》所載董跋缺紀年與款識。

(3)

跋陸繼善雙鉤填墨《摹禊帖冊》於苑西,宋箋本(《石初》卷10, 42b;《故宮》卷3, 49)。台北國立故宮博物院藏。

九月

自上陵還,作墨筆《上陵所見圖軸》,紙本,爲繪北贈行(《虛續》卷2, 52a;《編年表》,100;《董其昌》, no. 16;《總合圖錄》,v.2, E7–024;《文人畫》,v.5, no. 32;《畫集》, no. 85)。Museum Rietberg, Zürich, The C.A. Drenowatz Collection。

秋

(1)

觀董源《夏口待渡圖》於京[見董自題《仿十六家巨冊》之十四](《華亭》,21)。

參見:春/1626

(2)

觀吳興姚太學所藏黃公望《溪山讀書圖》[見董自題仿其筆意所作設色《山水軸》,紙本,現藏上海博物館](《年譜》,159)。

(3)

作墨筆《倣董北苑畫卷》於京公署,雲母箋本(《華亭》,4)。

十月一日

皇極殿頒曆,陪祀太廟回邸第,望西山,作墨筆《西山墨戲圖軸》,紙本(《虛續》卷2, 53b–54a;《編年表》,100;《中國目錄》,v.2, 51,京1–2179)。北京故宮博物院藏。

十月九日

楷書《陰符經冊》,朝鮮鏡光箋本(《秘初》卷15, 6b–7a;《編年表》,100)。

十月十五日

行書《禪悅》六則一卷,宣德鏡光箋烏絲闌本(《石初》卷31, 25a–b;《編年表》,100)。

十月廿一日

題自藏智永紙本《真草千文卷》於苑西行館,以贈馮詮收藏(《鑑影》卷1, 10b–11a)。蘇州博物館藏。

參見:4/1622(1)

冬至前一日

爲北京明因寺僧永舜行書王勃撰《釋迦如來成道記》(《書道藝術》卷8, 154)。拓片十二張現藏北京圖書館,拓本殘片現藏京都大谷大學圖書館。

十一月十五日

爲朱萬年楷書《三元妙經冊》,朝鮮鏡光箋本(《秘初》卷15, 7b;《編年表》,100)。

十一月晦日

行書唐人"贈張旭"及"題盧道士房"五言古詩二首一卷於苑西邸舍,紙本(《中國圖目》,v.1,京4–09)。北京市文物局藏。

無月日

(1)

見燕文貴《溪山風雨圖》於潘翔公所[見董自題《仿十六家巨冊》之首幅]。

參見:6/1625(1)

(2)

行書《臨韭花帖卷》,綾本(《中國圖目》,v.6,蘇6–049)。無錫市博物館藏。

(3)

楷書《三世誥命卷》,紙本(《中國目錄》,v.2, 51,京1–2178)。北京故宮博物院藏。

(4)

作設色《秋山紅樹圖軸》(《好續》,131;《編年表》,100)。

(5)

陳鉅昌刻成《延清堂帖》三十六種,俱屬董書之精者(《中國書法大辭典》,1749)。

1625 天啓五年,乙丑,七十一歲

正月一日

行書《般若波羅密心經冊》,素箋本烏絲闌(《盛京》,第七冊,2b;《古物》卷1,15b—16a)。

穀日

臨顏真卿《爭坐位帖》一卷,鏡面高麗紙本(《華亭》,38)。

正月十五日

作墨筆《倣雲林山水圖軸》,白紙本(《墨緣》,名畫卷上明,30b—31b;《編年表》,101)。

二月一日

擬自藏之《倪元鎮、黃子久合作設色山》作重設色山水,紙本[《仿十六家巨冊》之十]。

參見:正午/1620;9/1621(1)(2);6/1625(1)(2);9/27/1625;10/9/1625;春/1626;2/2/1626;4/24/1626;3/15/1627(1);6/1628

二月十九日

爲孟紹虞預題《山水軸》,三月始補畫。

參見:3/13/1625

二月穀雨日

行書節書《竹樓記》一卷,綾本(《愛續》卷2,13b;《編年表》,101)。

二月

爲馮詮作《潞水贈別圖軸》於潞水舟次,并題"青林鬱蒼茸"五言絕句一首(《畫集》,no.87。詩見《容詩》卷2,28b,"贈蔣山人")。上海博物館藏。

三月一日

天津舟次,再題自藏之宋搨王獻之《十三行洛神賦》以贈馮詮。

參見:1589(1);1612(1);3/2/1618

三月八日

舟行東光道中,倣出關前一夕潘翔公出示之郭忠恕《王子喬吹笙圖》,作墨筆《松溪幽勝圖軸》[一名《倣郭恕先筆意軸》],紙本(《華亭》,43;《虛續》卷2,54a—55a;《編年表》,101;《董其昌》,no.19;《中國美術全集》,繪畫編8,no.13;《畫集》,no.55;《中國圖目》,v.7,蘇1—0181)。南京博物院藏。

參見:4/3/1625

三月初旬

舟行平原道中,倣楊凝式筆意書宋詞二闋[《倣黃公望山水卷》之後段別幅]。

參見:秋/1623(1)

三月十三日

舟行清源道中,作紙本墨筆《山水軸》寫所見,并重題之寄孟紹虞(《畫集》,no.89)。上海博物館藏。

參見:2/19/1625

三月十五日

(1)

過清源,撿顏真卿《爭坐位帖》,覺有所會,遂書竟一六二四年始作之《湯陰縣重修宋忠武岳鄂王精忠祠記冊》,白宋紙烏絲闌本(《吳越》卷5,35a—37a;《編年表》,101)。

參見:9/1622;夏/1624

(2)

作《臨顏真卿爭座位帖卷》,黃蠟箋本(《石續》,寧壽宮,2846—48;《編年表》,101)。

三月十七日

清源舟中,友人談范寬畫,因作《山水扇頁》擬之(《年譜》,164)。上海博物館藏。

春

(1)

題潘翔公所藏郭忠恕設色《縱嶺飛仙圖軸》,絹本(《大觀》卷13,1b)。

(2)

行書《詩冊》,紙本。前段書詩四首,後段一首(*Christie's*,5/31/1990,no.121)。

四月三日

阻風崔鎮,重題月前所作《松溪幽勝圖軸》。

參見:3/8/1625

四月七日

作墨筆《山水便面》於寶應舟次,素箋本[《便面畫冊》十幅之二](《南畫》卷8,104;《畫集》,no.156)。

參見:4/4/1592;1/1602(1);5/1633(1);9/1635(1)

四月十五日

重題一六一六年所作《秋山圖軸》,時歸聖棐相國所藏。

參見:10/1616

四月廿二日

阻風平望,倣近於朱國盛官舫所觀之董源畫,作

墨筆《山水軸》,紙本,并題"青林鬱蒼茸"五言絕句(《總合圖錄》,v.2,E7—025;《董其昌》,no.18;《文人畫》,v.5,no.33;《畫集》,no.88。詩見《容詩》卷2,28b,"贈蔣山人")。Museum Rietberg,Zürich。

四月

自京師還,於王右史舟中復見一六一一年所書《別賦・舞鶴賦冊》,爲聖斐重題之。

參見:12/1611

按:董之重題云此冊乃擬虞世南《汝南公主志》及《齋僧帖》,與初跋不符,又此頁獨爲宣德箋本。或如乾隆識云裝潢家因重題中有"辛亥書此"句,遂并此題於冊末。

五月十五日

行書《飲中八仙歌軸》,灑金箋本(《石初》卷7,3a—b;《編年表》,101)。

五月

(1)

題自藏之王蒙淺著色畫,云得之鄒之郛之容[見傳董《倣宋元人縮本畫跋冊》(即《小中現大冊》)二十二對幅之十四]。

參見:6/23/1598;16/1600;1607(1);2/1614(1);5/1620;秋/1626(1);11/19/1627(1)

(2)

返京甫十日,重題一六二三年所作《倣倪雲林山水軸》。

參見:1623(2)

六月廿四日

行書江陰夏孝廉所輯《栖真志》數則一卷,宣德箋本(《石初》卷5,33a;《故宮》卷1,135—36;《編年表》,101)。台北國立故宮博物院藏。

六月

(1)

借觀潘翔公所藏燕文貴《溪山風雨圖》旬日,作墨筆山水擬之,紙本[《仿十六家巨冊》之首幅]。

參見:1624(1);正午/1620;9/1621(1)(2);2/1/1625;6/1625(2);9/27/1625;10/9/1625;春/1626;2/2/1626;4/24/1626;3/15/1627(1);6/1628

(2)

作設色畫,紙本,爲許宣平"題壁酬李太白詩"補圖,并書其詩畫上[《仿十六家巨冊》之六]。

參見:正午/1620;9/1621(1)(2);2/1/1625;6/1625(1);9/27/1625;10/9/1625;春/1626;2/2/1626;4/24/1626;3/15/1627(1);6/1628

七月一日

爲朱國盛行書臨古搨唐碑《般若波羅蜜多心經》一卷,紙本(*Christie's*,12/11/1987,no.42)。

參見:1626(2)

七月十五日

題范寬《寒江釣雪圖卷》,連州白玉箋本,及黃庭堅行楷書"題范寬雪圖"七言古詩卷,紙本(《蘇雪》卷2,3b)。

八月十五日

再題一六一五年所作《右丞詩意圖卷》,云頗覺與董源《夏口待渡圖卷》有合處[見王鑑《臨董香光卷》]。

參見:9/3/1615;春/1624(1)。

八月

(1)

重題一六一二年所作《楚天清曉圖軸》,時歸王時敏所藏。

參見:8/1/1612

(2)

小楷書《洛神賦冊》於書種堂,紙本(《古緣》卷5,31a-b;《編年表》,101)。

九月一日

行楷書白居易八《漸偈》於采芹堂,金粟箋本[《白居易諸偈冊》之前段](《秘初》卷2,14a-b;《編年表》,101)。

參見:9/20/1625(1)。

九月十五日

楷書杜甫"華清宮"五言古詩於扈波塘舟中,素箋本[《便面書冊》十幅之六](《石初》卷28,42b-43b)。

參見:9/1625(1);5/1633(2)

九月二十日

(1)

值孫董庭生日,行楷續書白居易六《詩偈》以付[《白居易諸偈冊》之後段]。

參見:9/1/1625

(2)

應道友朱丈教,行書《圓悟禪師法語冊》,高麗紙本(《夢園》卷13,21a-23a;《編年表》,100)。

按:董款識云"乙丑九月二十日...時年八十一歲,"然董此年僅七十一歲,因疑此作爲僞,或《夢園》誤記。

九月廿七日

詣竹岡先塋,宣三品贈誥,念曾祖母爲高克恭之雲孫女,歸舟因作設色《仿高房山山水小景》,紙本,付孫董庭收貯[《仿十六家巨冊》之八]。

參見:正午/1620;9/1621(1)(2);2/1/1625;6/1625(1)(2);10/9/1625;春/1626;2/2/1626;4/24/1626;3/15/1627(1);6/1628

九月

(1)

爲孟博楷書《道德經》六則,全箋本[《便面書冊》十幅之二]。

參見:9/15/1625;5/1633(2)

(2)

自寶華山莊還,舟中作紙本《倣古山水冊》八幅贈王時敏,六幅墨筆,兩幅青綠,間有自題,其一爲《松亭秋色》,三倣燕文貴筆,五爲《秋山黃葉》(《虛齋》卷13,1a-3b;《編年表》,101;《中國美術全集》,繪畫編8,no.12;《畫集》,no.38;《中國圖目》,v.3,滬1-1359)。上海博物館藏。

參見:10/1620

秋

(1)

草書陸游"龍門洞"、"登太平塔"、"雙清堂"及"睡起作帖"四詩一冊,紙本(《古芬》卷7,35a-36a)。

按:此冊似即《眼初》所載宣德紙本《陸詩冊》,見卷5,15a。

(2)

題項聖謨《畫聖冊》二十六幅,墨筆設色兼有,山水、樹石、屋宇、花卉、人物俱備(《珊瑚》·畫,卷22,13;《式古》,v.3,畫卷5,289。題語又見《容別》卷6,50b-51a)。

十月九日

擬自藏之趙伯驌橫卷小景作重設色沒骨山水,紙本[《仿十六家巨冊》之四]。

參見:正午/1620;9/1621(1)(2);2/1/1625;6/1625(1)(2);9/27/1625;春/1626;2/2/1626;4/24/1626;3/15/1627(1);6/1628

十月

會項聖謨於吳江,詢其所作《招隱圖詠卷》[見項聖謨一六二六年六月十六日自題此卷]。

參見:1626(1)

十一月一日

楷書王維五言詩二十四首一冊於寶顏堂,紙本(《壯陶》卷12,41b-43b)。

無月日

(1)

四題一六二三年所作《杜少陵詩意圖軸》於金津舟次,時歸彥采所藏。

參見:六月晦/1623;8/17/1623;1/1624

(2)

行書《梁武帝諸人書評冊》,紙本(《中國目錄》,v.2,51,京1-2180)。北京故宮博物院藏。

(3)

跋《快雪堂法書》所刻蘇軾《天際烏雲帖》[見翁方綱記此帖](《天際》一,26)。

(4)

行書《乙丑七札卷》,紙本,七札長短寬狹不一,裱爲一卷(《十百》,壬卷,22a-23b)。

按:此七札均未紀年,《十百》定爲"乙丑,"或根據書札之內容,或另有所據,待考。

(5)

書《家告》數通[見陳繼儒跋此作](《晚香堂小品》卷22,引自《年譜》,169)。

1626 天啓六年,丙寅,七十二歲

正月一日

行草書《日月詩卷》,紙本,書李益"登天壇夜見海日"七言古詩及李白"月下獨酌"五言古詩(《天瓶》卷上,11a;《書道藝術》卷8,122-33;《書道全集》,v.21,nos.16-21;《董其昌》,no.57)。

正月十五日

重裝并自題行書《臨褚遂良蘭亭序冊》,紙本(《董其昌》,no.73)。台北國立故宮博物院藏。

按:董題云"天聖丙寅年正月十五日重裝,"疑"天聖"乃"天啓"之誤,因置此。

正月廿七日

(1)

泊舟江口,守風八日,吳廷出城出示范寬《溪橋雪霽圖軸》,絹本,董爲題之(《穰梨》卷2,15b)。

參見:1/27/1626(2)

(2)

泊舟江口,守風八日,吳廷出城出示董源絹本墨筆《山水軸》,董爲題之(《十百》,壬卷,9a)。

參見:1/27/1626(1)

按:《穰梨》載董題范寬《溪橋雪霽圖軸》,除"吾家北苑"作"范華原"外,題語與此全同,待考。

正月晦日

作《臨古樹賦卷》,灑金箋本(《石初》卷30,47b-48a;《編年表》,101)。

正月

阻風龍江關,倣李邕筆意爲吳光龍行書《吳敦之傳卷》,紙本,以副其孝情,且以留別(《槐安》,no.176;《東京國博》,書,no.104)。東京國立博物館藏。

二月二日

倣偏頭關萬邦孚家藏之李成畫,作墨筆山水於真州舟中,紙本[《仿十六家巨冊》之五]。

參見:正午/1620;9/1621(1)(2);2/1/1625;6/1625(1)(2);9/27/1625;10/9/1625;春/1626;4/24/1626;3/15/1627(1);6/1628

二月十五日

(1)

題王蒙墨筆《破窠風雨圖卷》於金閶官舫,紙本(《珊瑚》·畫,卷11,31;《式古》,v.4,畫卷21,303;《石續》作"元人《破窠風雨書畫合璧卷》,"淳化軒,3332)。

按:此卷如畫者自題,先有陸居仁、楊維楨、錢惟善等人作記賦詩成卷,後屬補題,裱於卷首。董題云"'跋者'十餘人皆名士,"非是。以董之精鑑,似不應率略至此,待考。

又:《式古》另載有王立中《破窠風雨圖并題卷》,畫者自題七言絕句、識語及紀年與王蒙卷全同,惟款署"遼寧人王立中彥強,"且無董題,見v.4,畫卷19,236–42。卷後附元明人書《破窠風雨》記及詩凡四十一則,其中八則見於王蒙卷,另十七則見於趙雍素牋本墨筆《破窗風雨圖卷》(《石初》卷6,21a–27a)。其中"劉郎讀書如學仙"一詩,王立中卷及趙雍卷皆作韓元靚,王蒙卷作宇文公諒,此外王蒙卷與趙雍卷所載詩文全異。因疑後人裁一卷為數段,以王立中之畫記名王蒙,偏加董跋,另數段又與趙雍畫拼湊成另一卷,待考。

(2)

再題李公麟《維摩演教圖卷》於吳門官舫,紙本(《式古》,v.3,畫卷12,505;《江邨》卷3,22b)。北京故宮博物院藏。

按:董題云"舊觀於長安苑西邸中…二紀餘矣,"但董二十餘年前出仕北京時不住苑西,或為偽跋,待考。參照《系年》,229。

又:此卷似即《平生》所載李公麟白描《維摩説不二法門圖卷》,紙本。見卷7,61。

二月十九日

得高麗牋於武林僧舍,因行楷書《心經》裝為一冊(《秘初》卷3,14a–b;《編年表》,101)。

二月

行書陳希夷《謝表》二十六句一軸,灑金牋本(《古緣》卷5,38b;《編年表》,101)。

春

作墨筆《仿董源夏口待渡圖》,紙本[《仿十六家巨冊》之十四]。

參見:秋/1624(1);正午/1620;9/1621(1)(2);2/1/1625;6/1625(1)(2);9/27/1625;10/9/1625;2/2/1626;4/24/1626;3/15/1627(1);6/1628

按:《編年表》錄此作為"小軸,"見頁101。

四月十四日

舟行龍華道中,作墨筆《佘山游境圖軸》,紙本。先一日宿陳繼儒之頑仙廬(《編年表》,101;《中國目錄》,v.2,51,京1–2181;《明代繪畫》,no.61;《畫集》,no.59)。北京故宮博物院藏。

按:《年譜》載上海博物館亦藏董《佘山圖軸》,紙本,自識語與此全同,尺寸稍異,見頁171及《海天鴻藻》,v.1,2,待考。

四月廿四日

作重設色《仿關仝山水》,紙本[《仿十六家巨冊》之

十二]。

參見:正午/1620;9/1621(1)(2);2/1/1625;6/1625(1)(2);9/27/1625;10/9/1625;春/1626;2/2/1626;3/15/1627(1);6/1628

四月晦日

作著色《仿大癡山水軸》,鏡面牋,自題云初做吳鎮,後類黃公望(《三秋》卷上,60b;《中國名畫》,v.21)。

參見:7/7/1634

四月

仿《聖教序》行書杜甫"幽人"、"宿鑿石浦"及"津口"五言古詩三首一卷,鏡面宣德牋本(《石續》,養心殿,1076;《劍花》,上卷,21–22;《編年表》,101)。

五月一日

小楷書《陰符經冊》,鏡面牋烏絲闌本,自題云因觀顏真卿《八關齋會帖》,書此經有分隸法(《華亭》,22及39–40)。

正午

擬柳公權小楷書《道德經》一幀,鏡面牋烏絲闌本(《華亭》,22)。

五月

(1)

作墨筆《擬梅花道人筆意軸》,宣德紙本(《華亭》,13及42–43;Sotheby's,6/1/1988,no.32)。

參見:夏午/1606

按:《華亭》與Sotheby's所載董之印鑑有異,或非一作。

(2)

作墨筆《仿倪黃山水軸》,紙本,云畫用黃公望筆意,所題為一六一八年所錄倪瓚自題畫詩(《名筆集勝》,v.2,引自《年譜》,172)。

參見:秋/1618(2)

(3)

題"石磴盤紆山木稠"七言絕句一首於一六一六年所作《石磴盤紆圖軸》(《虛齋》卷8,47a–b;《畫集》,no.73)。上海博物館藏。

參見:秋/1616(1)

(4)

跋吳鎮墨筆《清溪垂釣圖卷》,宋牋本(《石初》卷24,23b–24a)。

(5)

題吳爾成為紫巘所作紙本墨筆《山水軸》(《中國圖目》,v.3,滬1–1276)。上海博物館藏。

(6)

紫巘訪董來仲軒,大出所藏縱觀竟日,就中最賞董源及吳鎮二幅,因用其意作《倣董北苑山水軸》以贈,紙本(《年譜》,172)。上海博物館藏。

六月十五日

作《草書卷》,綾本(《筆嘯》卷下,63a)。

六月十八日

行楷書《陰符經》,宣德牋烏絲闌本[《臨晉唐法書冊》七段之首](《墨緣》,法書卷下明,12b–13a;《編年表》,101);[《雜書冊》六段之首](《石續》,寧壽宮,2836–37;《故宮》卷3,115–17)。台北國立故宮博物院藏。

六月

(1)

作墨筆《棲霞寺詩意圖軸》於蕭閒館,紙本[見董一六二七年題此圖]。

參見:5/15/1627

(2)

作墨筆《王維詩意圖軸》,素牋本,并題"閉戶著書經歲月"七言詩一聯(《石初》卷39,17a–b;《編年表》,101)。

閏六月一日

為孫婿潘堯年作墨筆《輞川詩意圖軸》,紙本,并題"人家在仙掌"五言詩一聯(《虛齋》卷8,47a;《編年表》,101)。

夏

作墨筆《山水》二幅,紙本,其中一幅題"大癡未是癡"五言詩一聯[《山水冊》十二幅之五及六](《石三》,延春閣廿六,2060;《故宮》卷6,67;《編年表》,101)。台北國立故宮博物院藏。

七月七日

作《書畫雙璧小冊》八對幅,紙本。畫皆墨筆,首二幅各題七言詩一聯,三倣自疏之黃公望《姚江曉色圖》筆意,寫林逋詩意,四倣米芾,五倣倪瓚,六作煙雲景,七用米芾法,追倣太末道中所見山景,八倣董源小景。書幅第二題七言絕句一首,餘皆作論畫語(《文人畫》,v.5,nos.89–90)。

七月八日

行書臨《淳化閣帖》宋儋及智果書一冊[十冊之五]。

參見:2/16/1620;3/3/1621(2);3/1622;4/6/1627;立春/1628;7/6/1631;7/9/1631;8/17/1631;9/9/1631

七月

自題《山水小軸》,絹本(《藤花》卷4,44b)。

八月十五日

(1)

作墨筆《山水軸》,紙本,并題"芙蓉一朵插天表"七言詩一聯[一名《贈稼軒山水軸》](《中國古代繪畫選集》,85;《中國目錄》,v.2,51,京1–2182;《畫

集》，no. 91）。北京故宮博物院藏。

參見：秋/1629

(2)
書孫虔禮《書譜》一卷，麗光箋本（《大觀》卷九下，42a；《編年表》，101）。

參見：8/15/1626(3)

(3)
興化李組修出示王維《雪圖》［見董自跋《書譜卷》］。

參見：8/15/1626(2)

(4)
題李昇設色《高賢圖卷》，絹本（《大觀》卷11，44b）。

(5)
題項氏所藏定武本《蘭亭序》（《容別》卷4，46b）。

九月一日

偶得朱熹詩稿，因作《寫朱晦翁詩意山水軸》於玉峰道舟中，紙本，并題其"梯雲石磴羊腸繞"七言絕句（《中國名畫集》，v.3；《明清山水名畫選》，24）。

九月十五日

題沈周淺設色《摹子久富春山圖卷》於惠山，紙本（《大觀》卷20，12b）。

九月廿日

(1)
題王齊翰青綠設色《江山隱居圖卷》，絹本（《石續》，寧壽宮九，2643）。

(2)
題周文矩《唐十八學士圖卷》（《真蹟》，初集，38a）。

按：張丑云此卷實乃宋徽宗筆，見初集，39b。

九月廿一日

題丁雲鵬設色畫《五像觀音》于若瀜小楷書《楞嚴經》合璧一卷於王廷珸舟中，素箋本（《秘續》，264；《總合圖錄》，v.1，A28-001）。The Nelson-Atkins Museum of Art。

九月廿三日

因觀顏真卿《田神功八關齋會記》，擬其筆意楷書《心經冊》於青浦舟中，紙本烏絲闌。同觀者俞廷諤、陳子龍、許令則（《蘇雪》卷4，45b-47a；《編年表》，101）。

九月

(1)
題沈周澹色《自壽圖軸》，絹本（《大觀》卷20，4b）。

(2)
行書《唐人詩卷》於戲鴻堂，綾本，書張謂"湖中對酒作"（《華亭》，8）。

秋

(1)
自梁溪吳千之得王蒙墨筆《山水軸》［見傳董《倣宋元人縮本畫跋冊》（即《小中現大冊》）二十二對幅之十九］。

參見：秋/1627；6/23/1598；16/1600；1607(1)；2/1614(1)；5/1620；5/1625(1)；11/19/1627(1)

(2)
從惠山吳千之得倪瓚《小景》題"垂垂烟柳籠南岸"者［見董自題《丁卯小景冊》八幅之首］。

參見：1627(1)；春/1627(1)

(3)
題一六一九年所作《夏木垂陰圖軸》。

參見：秋/1619(2)

(4)
得沈周《倣黃公望富春山圖卷》［見董自題《倣黃公望富春山圖卷》］（董之倣作屬紙本墨筆，見《總合圖錄》，v.1，A13-012；《文人畫》，v.5，no. 26。美國翁萬戈藏）。

十月一日至十五日

楷書《金剛經》上下二冊，薦資父母冥福［見董自跋此冊］。

參見：春/1592(1)；2/1/1632

十月十五日

作《秋林石壁圖軸》，紙本（《泰山殘石樓藏畫集錦》，第四集十冊；《編年表》，101）。

十二月八日

(1)
青龍江舟中書舊詩二首於墨筆《疎林遠山圖卷》拖尾，素箋本（《石初》卷44，10a-11a；《編年表》，101）。

(2)
行書《宋人詞卷》，綾本，書"戀別山登憶水登"、"元宵"、"霜天曉角"及"玉樓春"四首（《愛續》卷2，13b-14a；《編年表》，101）。

十二月十三日

作墨筆《贈珂雪山水卷》，絹本，并題"隨雁過衡岳"及"開此鴻蒙荒"五言絕句二首（《畫集》，no. 62；《中國圖目》，v.3，滬1-1368。詩見《容詩》卷2，31a，"題畫贈眉公"二首之一，及33b，"題畫"）。上海博物館藏。

按：珂雪應指李肇亨。

十二月廿七日

師顏真卿法，書竟《彌陀經卷》。後過廣陵，自跋贈駐舫吳鶴澤屬別（《容別》卷2，31a-b）。

十二月

(1)
婁江阻風，重題一六二一年所作《江上蕭寺圖軸》。

參見：2/7/1621

(2)
行書《題焦竑稿卷》，金箋本（《中國圖目》，v.6，蘇22-01）。江蘇省文物商店藏。

約七月

作設色水山，并於次幅行書"朱旆行部帶明霞"七言絕句一首，以壽李約菴六十初度［絹本《壽李約菴書畫合璧冊》十六幅之三及四］（《中國圖目》，v.8，津6-019。詩見《容詩》卷4，36a-b，"題畫貽毘陵張夢澤（舊武陵守）"）。天津市文物公司藏。

按：董此作並未紀年，但冊中其他作者或署"丙寅長夏"、"丙寅又六月"、"丙寅新秋"或"丙寅秋日，"故約略置於七月。

廿日

得劉松年設色界畫《十八學士圖卷》，絹本，因題之於京邸（《石三》，御書房一，3078；《故宮》卷4，55）。台北國立故宮博物院藏。

按：董此年在江南，似未北上，此題存疑。

無月日

(1)
題項聖謨此年六月十六日所成墨筆《招隱圖詠卷》，紙本（《項聖謨》，pls. 14-17。題語又見《容別》卷6，49a-b）。Los Angeles County Museum of Art。

參見：10/1625

(2)
游梁溪，略倣米芾《寶章待訪錄》列親見與所聞者，作《法書紀略冊》十六幅共二十三條，紙本［見董一六三二年題此冊］。

參見：1/17/1632

(3)
重題一六二五年所作《臨般若波羅蜜多心經卷》。

參見：7/1/1625

(4)
行書《孟東野詩扇頁》，金箋本（《中國目錄》，v.2，51，京1-2183）。北京故宮博物院藏。

(5)
行書宋人"霜天曉角"詞一軸，紙本（《中國圖目》，v.3，滬1-1366）。上海博物館藏。

(6)
楷書《金剛般若波羅密經（持志堂帖）》，刻石於北京陶然亭龍泉寺（《系年》，238及240）。拓片現藏北京圖書館。

1627　天啓七年，丁卯，七十三歲

正月一日

以歐陽詢、顏真卿屬法，楷書《心經冊》，朝鮮鏡光箋本（《秘初》卷2，13b-14a；《編年表》，102）。

正月二日

小楷書臨楊羲《內景黃庭經》三幀,鏡面箋烏絲闌本(《華亭》,22–23。自跋語又見《容別》卷5,30a–b)。

參見:8/12/1630(1)

按:《秘初》亦載董楷書《臨楊羲黃庭內景經冊》,題語與此冊全同,惟紀年為"庚午八月十二日"於百花里之保和堂,待考。

三月三日

細楷書《心經》三幅,紙本朱絲闌[附於陳繼儒書《金剛經冊》之後](《吳越》卷5,81b–82a;《編年表》,102)。

三月十五日

(1)

王廷琚携李昇畫卷見示,因作墨筆山水臨之,紙本[《仿十六家巨冊》之七]。

參見:正午/1620;9/1621(1)(2);2/1/1625;6/1625(1)(2);9/27/1625;10/9/1625;春/1626;2/2/1626;4/24/1626;6/1628

(2)

作墨筆《為錢胤作山水扇頁》,金箋本(《中國圖目》,v.3,滬1–1369)。上海博物館藏。

(3)

虞山錢微君以倪瓚《山水軸》見示,董重題之(《神州》,v.7)。沈辛伯舊藏。

按:查是圖未見董之初題,不知何故曰"重題,"或於裝裱時佚去。

(4)

觀并題宋刻《華嚴經冊》於海虞錢宮詹齋中(《秘初》卷14,3b–4a)。

按:董題紀年為"明天啟元年丁卯歲三月望日,"查丁卯非天啟元年,而為天啟七年,疑《秘初》編者誤將"七"作"元。"

三月廿二日

題李公麟墨筆《幽風圖卷》,素箋本(《石初》卷32,35a–b;《總合圖錄》,v.1,A15–023)。The Metropolitan Museum of Art。

三月

(1)

作墨筆《倣米家山圖》,素箋本[《書畫合璧卷》之畫幅](《石續》,乾清宮,441;《編年表》,102;《中國美術全集》,繪畫編8,no.16;《畫集》,no.64)。遼寧省博物館藏。

參見:12/15/1619

(2)

過虞山,訪瞿式耜於耕石齋賞鑑書畫,自題一六一六年所作《論畫冊》。

參見:8/1616(1)

春

(1)

於惠山易得倪瓚畫題"雲影山光翠蕩磨"七言絕句者[見董自題《仿十六家巨冊》之十一](《華亭》,21)。

參見:6/1628

按:董自題《丁卯小景冊》之首幅云得倪瓚此作於丙寅(一六二六年)秋,未知孰是,待考。見秋/1626(2);1627(1)

(2)

過王時敏鶴來堂賞鑑書畫,暇時或臨摹或自書小楷真行各體,王一六四三年裝成十二冊[見王時敏癸卯中秋後三日跋於《名人書畫集錦冊》十對幅之六](《曝畫紀餘》卷3,5b–6a)。

四月一日

題唐寅墨筆《夢筠圖卷》於玉峰道中,紙本,并系以"一派湖州畫裡詩"七言絕句(《大觀》卷20,26a;《澄懷》卷3,48;《槐安》,8–3。詩見《容詩》卷4,38b,"廣陵舟次題房侍御畫竹")。東京國立博物館藏。

四月六日

過白門阻風采石,舟中行書《臨淳化閣帖》,書竟十冊中之第七冊(《盛京》,第六冊,12b–13a;《古物》卷1,19a)。

參見:2/16/1620;3/3/1621(2);1/1622;7/8/1626;立春/1628;7/6/1631;7/9/1631;8/17/1631;9/9/1631

按:此冊未紀年,惟有月日,但第六冊書於丙寅(一六二六年)新秋八日,第八冊書於戊辰(一六二八年)立春日,故是冊應書於丁卯(一六二七年)。

四月七日

與陳繼儒訪王時敏於南園繡雪堂,題"話雨"二字於壁(《過雲》引王時敏年譜,畫類6,14b。又見《過續》記黃公望《秋山圖卷》,畫類1,5a–b)。

四月十五日

題新都汪宗孝所藏虞世南《汝南公主誌》(《真蹟》,二集,22b)。

四月

為致虛行書舊作七言律詩五首一卷,金箋本(《石初》卷31,24a–b;《編年表》,101)。

五月十三日

題自藏之范寬《谿山行旅圖軸》(《中國名畫》,v.29)。

五月十五日

題權德輿七言絕句"棲霞寺壁詩"於一六二六年所作《棲霞寺詩意圖軸》(《畫集》,no.90;《中國圖目》,v.3,滬1–1367)。上海博物館藏。

參見:6/1626(1)

夏五日

與李流芳同賞王時敏《倣黃子久富春大嶺圖卷》并題之(《容別》卷6,47a)。

五月

(1)

題王時敏墨筆《武夷山接筍峰圖軸》,宣紙本,憶一五九一年秋武夷之遊(《吳越》卷6,70a–b。自題語又見《容別》卷6,46b)。

參見:秋/1591(1)

(2)

楷書《琵琶行冊》於蔞江道中,素箋烏絲闌本(《石初》卷3,36a–b;《編年表》,102)。

六月一日

楷書《心經冊》,朝鮮箋本(《秘初》卷2,13b;《編年表》,102)。

六月

(1)

題夏珪墨筆《山水十二景圖卷》,絹本(《式古》,v.4,畫卷14,67;《平生》卷8,59–60;《江村》卷1,30;《大觀》卷15,2b;《墨緣》,名畫續錄卷下,3b;《總合圖錄》,v.1,A28–002。題語又見《容別》卷6,32b)。The Nelson-Atkins Museum of Art藏有末四景。

(2)

作墨筆《夜山圖扇頁》,紙本(《中國圖目》,v.3,滬1–1370)。上海博物館藏。

(3)

為魯士行書米芾《天馬賦》一卷,金箋本(Sotheby's,6/13/1984,no.13)。

七月十五日

(1)

行書《馮嘉會并妻黃氏及祖馮大寧并妻郭氏誥身冊》,紙本(Sotheby's,12/6/1989,no.44;及5/29/1991,no.12)。

(2)

作《臨黃大癡山水軸》於青溪舟次,紙本(《聽颿》卷2,157–58;《編年表》,102)。

七月

(1)

書舊作"贈宗侯"與"題劉金吾《牛山讀書圖》之一"七言律詩二首於湖莊[金箋本《書畫扇面冊》十二幅之九](《石三》,延春閣十六,2059–60)。

參見:2/16/1628;7/1630(1);5/1632

(2)

行書《唐人詩卷》於吳門道中,綾本(《華亭》,8)。

八月十五日

舟泊金閶門,唐獻可携倪瓚畫至,王時敏為雷宸甫

作《倣迂翁山水軸》,紙本,董因題之(《別下》卷3,11b)。

按:《別下》所載董題似有脫誤,揣測其意,約略如此。

秋

以自藏之王蒙墨筆《山水軸》歸王時敏[見傳董《倣宋元人縮本畫跋冊》(即《小中現大冊》)二十二對幅之十九]。

參見:秋/1626(1)

十月十日

以楊凝式筆意書李白、孟浩然、王維、韋應物詩數首一冊,紙本(《穰梨》卷24,18b-19b)。

十月

(1)

重題自藏之李成《寒林大軸》,絹本(《平生》卷7,25;《玉几》卷上,112)。

參見:4/1596(1)

(2)

題一六〇四年所書《千文》付孫董庭(《四印堂詩稿》,引自《年譜》,58)。

參見:9/1604(1)

十一月十九日

(1)

題王蒙《倣董源谿山行旅圖軸》(《大觀》卷17,17b)。

按:此圖及題又見傳董《倣宋元人縮本畫跋冊》[即《小中現大冊》]二十二對幅之十,惟題作"仿董源"秋"山行旅圖軸",所錄題語亦有二字異。參見後文末紀年部分"書畫合璧"之"冊"段。

(2)

訪華文伯於東皋亭,觀所藏倪瓚墨筆《鶴林圖卷》,紙本,咄咄歎賞,華因以見歸,董之以記(《中國圖目》,v.1,京3-003)。題語又見《容別》卷6,40a-b)。北京中國美術館藏。

十一月

(1)

作《雜書冊》於錫山道中,宣德箋烏絲闌本,臨顏真卿《多寶塔碑》,行書"小赤壁詩",楷書"前後赤壁詞"(《石初》卷11,8a;《故宮》卷3,119-20;《編年表》,102)。台北國立故宮博物院藏。

(2)

作設色《倣黃公望富春大嶺圖卷》,紙本,黃之原作仍屬董藏(《石三》,延春閣廿六,2064;《編年表》,102;《總合圖錄》,v.2,S15-007)。香港趙從衍藏。

長至日

(1)

與唐獻可同賞高克恭長方紙本墨筆山水并題之

[《歷代名畫大觀高冊》二十九幅之十九](《式古》,v.3,畫卷4,243-45)。

參見:4/15/1632;2/16/1634

(2)

於唐雲客齋中與賀函伯同觀唐氏所藏任詢草書韓愈"秋懷詩"一卷,絹本,并題之(《辛丑》卷2,52)。

(3)

訪唐獻可,爲作《山水扇頁》,金箋本(《扇面大觀》,v.1;《名人書畫扇集》,v.11;《明清便面集錦》)。

長至後二日

題唐獻可家藏之李成淡青綠《雪村歸棹圖軸》,絹本(《吳越》卷2,2b-3a)。

無月日

(1)

舟泊南徐,作墨筆《丁卯小景圖冊》書畫八對幅,金箋本,於歸途終之。一倣自藏之倪瓚《小景》所題"垂垂煙柳籠南岸"者,二以荊、關筆作石壁,三倣高克恭寫米家山,四寫虞山拂水亭臺,五倣王蒙《松岫圖》,六倣黃公望《九峰雪圖》,七倣自藏之巨然《江山蕭寺圖》,八作《谿閣秋晴圖》并總跋(《編年表》,102;《中國圖目》,v.3,滬1-1371)。上海博物館藏。

參見:秋/1626(2)

按:《三秋》亦載董紙本《丁卯小景》,然僅四幅,爲上海博物館所藏之一、三、五及八幅,置此待考。見卷上,60b-61a。

(2)

過金壇,爲伯涵辨所藏董書真僞,并重題一六二〇年所作《臨懷仁聖教序冊》。

參見:3/2/1620(1)

按:董之重題並未紀年,但冊末有于馮宰題云"乃丁卯後過金壇重跋者,"因置此。

(3)

作墨筆《仿巨然小景軸》,紙本(《編年表》,102;《中國目錄》,v.2,51,京1-2184)。北京故宮博物院藏。

(4)

行書《臨閣帖卷》,紙本(《中國目錄》,v.2,51,京1-2185)。北京故宮博物院藏。

(5)

書《張元弼語》,雲龍黃蠟箋本(《雪堂》,16a)。

(6)

爲范允臨作七言律詩"壽范長倩學憲七十"(《容詩》卷4,13b-14a)。

1628 崇禎元年,戊辰,七十四歲

立春日

行書《臨淳化閣帖冊》[十冊之八]。

參見:2/16/1620;3/3/1621(2);1/1622;7/8/1626;4/6/1627;7/6/1631;7/9/1631;8/17/1631;9/9/1631

按:此冊似即《古芬》所載董《臨閣帖墨蹟冊》,紙本,但頁數與印鑑有異,待考。見卷7,37a-38a。

正月廿六日

行書《書旨帖卷》,宣德箋本,評晉唐諸家書凡十則(《石初》卷13,64a;《編年表》,102)。

花朝

觀巨然《秋山蕭寺圖》,因作《山水扇頁》(《年譜》,184)。上海博物館藏。

二月十五日

臨二王小楷書《孝女曹娥碑》及《洛神賦十三行補》,素牋本[《臨王帖三種卷》之首二種](《石續》,重華宮六,1636-38;《三希》,第二十九冊,2112-23)。

參見:2/25/1628;清明/1628

二月十六日

書李白《春夜宴桃李園序》於寶鼎齋[《書畫扇面冊》十二幅之首]。

參見:7/1627(1);7/1630(1);5/1632

二月廿二日

楷書《脊令頌》,朝鮮鏡光箋烏絲闌本[《雜書冊》三段之二](《石初》卷3,34a-b;《編年表》,102)。

二月廿五日

三題十五日所臨《孝女曹娥碑》及《洛神賦十三行補》。

參見:2/15/1628;清明/1628

二月

於陳繼儒之頑仙廬,再題宋高宗書馬和之畫《豳風圖卷》中《破斧》一章。

參見:9/1619(1)

清明

邀陳繼儒於北門別宅論書[見陳繼儒題董二月十五日所臨《孝女曹娥碑》及《洛神賦十三行補》]。

參見:2/15/1628;2/25/1628

三月三日

閱宋懋晉《阿房宮圖》於西湖舟次,因楷書《阿房宮賦冊》,紙本(《貞松》卷中;《澄懷》卷4,23-24)。

三月十五日

行書《舞鶴賦卷》,紙本(《中國圖目》,v.6,蘇1-125)。蘇州博物館藏。

三月

作《書畫袖珍冊》十二幅於木瀆村居,書論畫六則,附山水六幅(《過雲》,畫類5,11a-b;《編年表》,102)。

按:據《過雲》,木瀆村即《容詩》所謂瀆川山莊。見秋/1611。

春

楷書《倣歐陽詢千字文冊》未竟[見董一六三四年自跋此冊]。

參見:夏/1634(1); 閏8/12/1634

四月晦日

臨自藏之宋搨歐陽詢草書《千文》一冊,金粟箋本(《石初》卷28,25a;《故宮》卷3,102-103;《編年表》,102;《董其昌》,no.60)。台北國立故宮博物院藏。

四月

(1)

跋宋人《睢陽五老圖冊》(《中國圖目》,v.2,滬1-0040)。上海博物館藏。

(2)

與王時敏泊舟崑山塔下[見董與王時敏尺牘,紙本](《別下》卷6,12b-13a)。

五月一日

楷書《松江府城隍廟神制告卷》,花蠟箋本(《中國圖目》,v.7,蘇24-0182)。南京博物院藏。

五月

作《倣唐人書冊》,素箋烏絲闌本,分倣虞世南、楊凝式及顏真卿書(《石初》卷3,34b-35a;《編年表》,102)。

六月

仿自藏之倪瓚畫題"雲影山光翠蕩磨"七言絕句者,作紙本墨筆山水并書此詩[《仿十六家巨冊》之十一]。

參見:春/1627(1); 正午/1620; 9/1621(1)(2); 2/1/1625; 6/1625(1)(2); 9/27/1625; 10/9/1625; 春/1626; 2/2/1626; 4/24/1626; 3/15/1627(1)

七月七日

行書"春日行"七言詩一軸,宣德箋烏絲闌本(《石初》卷37,8a;《故宮》卷2,18;《編年表》,102)。台北國立故宮博物院藏。

七月十日

作著色《仿張僧繇白雲紅樹圖卷》於湖莊,絹本(《故宮》卷4,239;《文人畫》,v.5,no.42)。台北國立故宮博物院藏。

八月十五日

(1)

追想梁溪吳黃門舊藏之沈周《嵐容川色圖》,作墨筆《嵐容川色圖軸》,紙本(《過雲》,畫類5,13a-b;《編年表》,102;《中國目錄》,v.2,51,京1-2186;*Treasures of the Forbidden City*, no.107)。北京故宮博物院藏。

參見:2/1629(1)

(2)

爲鴻雪堂主人書《池上篇卷》,絹本,復作《仿趙承旨林塘晚歸圖軸》并錄趙自題七言絕句以贈長卿(Princeton University照片檔案)。

(3)

作《行書軸》寄贈吳楨,紙本(《年譜》,187)。上海博物館藏。

(4)

書陳繼儒所撰《重修泖橋澄鑒寺碑》(《重修松江府志》卷73,24-25)。

中秋後

題沈周淡設色《雨夜止宿圖軸》,紙本(《大觀》卷20,2a;《寓意》卷3,22a-b)。

八月晦日

行書東方朔《答客難》,又以朱國盛園中八月梅花盛開,繼書"大遠江南信"五言排律合爲一卷,宣德箋本(《石續》,御書房,2015-17;《編年表》,102。詩見《容詩》卷1,28a-b)。遼寧省博物館藏。

八月

爲壽卿作墨筆《吳淞江水圖軸》[一名《倪元鎮詩意圖軸》],紙本,并書倪瓚"吳淞江水春"五言詩一首(《中國圖目》,v.3,滬1-1372)。上海博物館藏。

參見:11/15/1631

九月十日

行書《墨禪軒說卷》寄吳楨,奏本紙(《大觀》卷9,43a-44a;《編年表》,102。文見《容文》卷5,31a-32b)。

九秋

作絹本《山水卷》(《退菴》卷17,5a)。

秋

(1)

作《山水扇頁》(《年譜》,187)。上海博物館藏。

(2)

作《江口萬木圖軸》,紙本,并題"古木萬餘株"五言絕句一首(《晉唐五代宋元明清名人書畫集》,189)。

十月十五日

(1)

再題一六〇八年所作《秋林晚翠圖軸》於塵隱居。

參見:8/1608

(2)

書竟《宋人詞冊》,紙本,書王安石詞十一首(《穰續》卷9,9a;《編年表》,102;《書法》,一九八四年第四期。自題語又見《容別》卷4,19a)。

十月

重題舊作《倣歐陽詢楷書千字文冊》,朝鮮鏡光箋烏絲闌本(《石初》卷28,25b-26a;《故宮》卷3,103-104;《編年表》,102;《董其昌》,no.61)。台北國立故宮博物院藏。

參見:1629(1)

按:此冊董未紀年之初跋與《快雨》所載董《臨歐陽詢千文》之跋語同,但《快雨》未提董一六二八、一六二九年之二跋,或爲另一作,附此。見卷5,16。

十一月

大行書臨吳琚《倣米元章書詩帖》於蓮花莊,書"橋畔垂楊下碧溪"七言絕句一軸,綾本(《華亭》,16)。

十二月三日

啜閔汶水所蓄佳茗,作淡設色《梧陰試茗圖卷》,紙本(《古緣》卷5,28b-29a;《編年表》,102;*Christie's*, 11/30/1988, no.66)。

冬

(1)

作絹本《書畫冊》八對幅於畫禪室。畫爲墨筆,各幅分識,一擬金沙于氏所藏曹知白畫,二倣倪瓚《古木幽亭》,三倣王蒙法,四倣董源筆,五倣巨然小景,六題"千山萬疊雲無盡"七言詩一聯,七倣自藏之趙令穰《秋江歸棹圖》。行楷對題各幅書七言絕句一首(《十百》,丑卷,7b-9a;《編年表》,102)。

(2)

作《山水冊》十幅,分倣王洽、倪瓚、黃公望、米家山及高克恭《廬山高》等(《南畫》,續集1,28-37)。

無月日

以國詮書《善見律卷》易櫟社老人所藏《靈飛經》[見櫟社老人跋此冊]。

參見:2/1624(1); 1634(1)

1629 崇禎二年,己巳,七十五歲

二月三日

再題蕭照絹本著色《瑞應圖卷》於西湖陳生甫之聽驪樓,同觀者陳梁、孫仲魯、馮雲將、雷宸甫、楊繼鵬、王彥可及王玉烟,爲主人陳階平收藏(《式古》,v.4,畫卷14,41;《大觀》卷14,22a-b;《石續》,重華宮三,1530)。

二月

(1)

重題一六二八年所作《嵐容川色圖軸》贈汪元霖。

參見:8/15/1628(1)

(2)

為當湖劉亮采作《學竇大楷書卷》於孤山,綾本(《萱暉》,書157a–b)。程琦舊藏。

(3)

與陳甫伸論書於昭慶禪林,出示趙孟頫小楷《黃庭內景經》[見陳甫伸跋此作於《渤海藏真帖》卷六](《叢帖目》,第一冊,321–22)。

三月一日

行草書"祝融南來鞭火龍"七言古詩一首於婁江道中,紙本[《明人翰墨集冊》,第一冊詩翰三十開之十七及十八](《鑑影》卷14,27b–28a)。

三月十五日

為生甫臨米芾書《天馬賦》一冊,朝鮮鏡光牋本(《石初》卷11,7b–8a;《故宮》卷3,96–97;《編年表》,102)。台北國立故宮博物院藏。

三月

(1)

自西湖歸,作墨筆山水一開,宣紙本[《畫禪室寫意冊》八對幅之首](《大觀》卷19,26a–b;《歸石》卷4,9a–10a;《澄懷》卷4,21–23;《槐安》,no. 19;《編年表》,102;《董其昌》,no. 20;《文人畫》,v.5,nos. 48–49;《畫集》,no. 151)。東京國立博物館藏。

參見:8/15/1629(3)

按:《大觀》載此冊畫幅八,書幅四,至楊翰跋時僅存畫幅七,書幅一,見《歸石》。今東京國立博物館所藏冊有畫幅七,書幅四,反較《歸石》所載多三書幅,待考。

(2)

行書白居易《池上篇》一卷於岳陽樓之東舍,絹本(《古芬》卷7,17a–18a;《眼初》卷5,8a)。

按:董此時在江南,未至湖廣,此作存疑。參見杜瑞聯及楊恩壽之論述語。

春

應孫道生之請,為友人譚獻卿之祖母壽登八十作《鍊石補天圖卷》,紙本(《愛續》卷2,15a–16b;《編年表》,102)。

按:《愛續》以"畫不甚精,而本紙題及另紙跋皆其親筆,且前後紙色一律,疑此畫系代筆而自屬題記。

四月一日

題郁孟陽所藏李流芳《花卉竹石冊》十八幅,淡金牋本(《十百》,丙卷,15a–b)。題語又見《容別》卷6,47a–48a)。

四月

作紙本墨筆《山水軸》并題"怪石與枯槎"五言絕句一首,贈得岸上人六十壽(《吳越》卷5,80b–81a;《歸石》卷4,17a;《編年表》,103。詩見《容詩》卷2,33a–b,"贈煎茶僧")。

閏四月廿一日

為王時敏作墨筆《山水軸》於青龍江舟次,宣德紙本(《吳越》卷5,49a–b;《編年表》,103)。

五月五日

於武陵官署出米芾書《擬古詩》及米友仁畫《瀟湘白雲圖卷》與辰州郡守瞿汝稷及同年辛司理同賞,復作墨筆《楚山清霽圖軸》寫德山景,絹本(《大觀》卷19,32a;《編年表》,102)。

參見:5/7/1629;7/14/1629

按:瞿汝稷卒於一六一〇年,此作疑偽。然董乙巳(一六〇五)年在楚,或《大觀》誤將"乙巳"作"己巳,"參照《系年》,87–88。

五月七日

再題午日所作《楚山清霽圖軸》。

參見:5/5/1629;7/14/1629

六月廿二日

避暑湖莊,久旱初雨,書《喜雨亭記卷》,紙本。次日陳繼儒見訪,董出示此卷并再題之以贈(《壯陶》卷12,53a–b)。

六月

作墨筆《臨倪瓚東岡草堂圖軸》,宣德牋本,并存張雨詩識(《石續》,寧壽宮,2850;《故宮》卷5,462–63;《南畫》卷11,39)。台北國立故宮博物院藏。

夏

(1)

倣董源筆作墨筆《夏木垂陰圖軸》,紙本(《華亭》,43–44)。

參見:11/1635(1)

(2)

作《臨蘭亭叙冊》,紙本(《古緣》卷5,31a;《編年表》,102)。

七月一日

撰并楷書《沈夫人壽言立軸》,綾本,書"虹渚流輝日"五言古詩(《吳越》卷5,70b–71a;《編年表》,103)。

按:此作紀年為"萬曆己巳七月吉旦,"查己巳屬崇禎二年(一六二九),已非萬曆,此作疑偽。

七月十四日

為午日所作《楚山清霽圖軸》設色并三題之。

參見:5/5/1629;5/7/1629

八月十一日

行書《仿古書冊》五段於金閶門舟次,藏經紙本。一臨顏真卿《爭坐位帖》,二背臨顏真卿《祭姪文稿》,三臨顏真卿《送蔡明遠序》,四背臨《潭帖》所刻"拙於生事"至"仍恕千煩也"一段,五書"揚清歌,發皓

齒"七言歌行一首,各段分識(《鑑影》卷14,17a–18a)。

參見:秋/1595

八月十五日

(1)

四跋自藏之趙令穰《江鄉清夏圖卷》,云以此卷易趙孟頫書《六體千字文》(《董其昌》,no. 62)。

參見:7/30/1596;7/3/1601;4/1615(1)

(2)

題于嘉所藏惠崇著色《谿山春曉圖卷》,素絹本(《盛京》,第二冊,45b及46b;《古物》卷5,21b–22a;《中國歷代繪畫》,v.2,附錄4。題語又見《容別》卷6,30b–31a)。北京故宮博物院藏。

參見:5/1630(1)

(3)

作墨筆山水[《畫禪室寫意冊》八對幅之六]。

參見:3/1629(1)

(4)

王廷珺以倪瓚設色畫易董藏之趙孟頫墨筆《長林絕壑圖軸》,絹本[見董重題此軸](《大觀》卷16,5b)。

(5)

題錢選設色《維摩像卷》於閶門舟次,素牋本(《秘績》,84)。

九月九日

重題一六二三年所作《仿梅花道人筆意軸》,時為俞廷諤所藏。

參見:8/9/1623

九月

草書唐詩一卷,綾本(*Christie's*, 6/4/1986, no. 39)。

秋

再題一六二六年所作《山水軸》寄瞿式耜。

參見:8/15/1626(1)

十月四日

於昭彥舟中再觀所藏蘇軾書《淨因院畫記卷》,素牋本烏絲闌,并重題之(《盛京》,第二冊,4a;《古物》卷2,5b)。

十一月十九日

以李邕《岳麓寺碑》筆意行楷書《艮卦冊》,金粟牋本(《石初》卷28,24a–b;《編年表》,102)。

約八月

于嘉攜趙孟頫《鵲華秋色圖卷》至金閶舟中,董三跋之(《石初》卷33,4a–b;《南畫》,續集5,34;《故宮》卷4,107;《董其昌》,no. 44)。

參見:1583; 長至/1602(1); 12/30/1602; 1605(1); 2/1612(2); 5/13/1630(1)

無月日

(1)

三題舊作《倣歐陽詢楷書千字文冊》,時藏於武林郁孟陽南浮閣。

參見:10/1628(1)

(2)

行書《般若波羅密多心經冊》,紙本(《中國目錄》,v.2, 51,京1-2187)。北京故宮博物院藏。

(3)

武林郁孟陽見訪,觀董舊臨《蕭閒堂帖》米芾書一卷(《容別》卷4, 43b-44a)。

(4)

題馮起震畫竹(《容別》卷1, 4a)。

1630　崇禎三年,庚午,七十六歲

三月三日

楷書《千字文卷》未竟。

參見:11/1631。

春

學楊凝式《韭花帖》筆意書唐人"應制詩"三首一卷,紙本(《夢園》卷13, 10a;《編年表》,103)。

五月十三日

(1)

應于嘉囑,錄張雨"鵲華秋色圖詩"於趙孟頫《鵲華秋色圖卷》後并四跋之(《石初》卷33, 5a-b;《南畫》,續集5, 36-38;《故宮》卷4, 107;《董其昌》, no. 64)。

參見:1583; 長至/1602(1); 12/30/1602; 1605(1); 2/1612(2); 約八月/1629

(2)

再題于嘉鑑藏之趙孟頫行書《與中峰十一札帖冊》,宋牋本[後附管道昇行書《與中峰帖》](《式古》,v.2,書卷16, 118;《平生》卷4, 10-11;《大觀》卷8, 51b;《墨緣》,法書卷下元,13a-b;《三希》,第二十二冊,1611-12)。

按:《石續》及《故宮》又附趙雍行書中峰明本"懷淨土詩"七言絕句六首於冊後,合屬一門法書冊。見《石續》,乾清宮,486;《故宮》卷3, 239。此冊現藏台北國立故宮博物院。

又,趙雍書又見《式古》,v.2,書卷16, 123;《墨緣》,法書卷下元,14a-b;《三希》,第二十三冊,1683-87。

五月十六日

於金沙于嘉之惲齋,跋蘇軾《制草卷》,紙本(《石續》,養心殿,939)。

五月

(1)

再跋惠崇《谿山春曉圖卷》於于嘉高齋。

參見:8/15/1629(2)

(2)

題于鏘所藏沈周《九段錦畫冊》,紙本,水墨設色兼有(《式古》,v.3,畫卷5, 280;《平生》卷10, 66;《江村》卷1, 77b-78a;《夢園》卷9, 32b-33a)。

(3)

為葉有年倣懷素書詩一冊於明月橋,絹本(《藤花》卷3, 21b)。

六月十日

題劉松年設色《香山九老圖卷》,絹本(《穰續》卷2, 8b)。

六月

(1)

倣倪瓚筆作墨筆山水二幅於姑蘇[《倣古山水畫冊》八幅之首二幅]。

參見:9/9/1630

(2)

作青綠《倣高彥敬青山白雲圖軸》,絹本(《寶迂》卷1, 37b-38a;《編年表》,103)。

七月一日

陳繼儒為董《容臺集》作序(《容臺集》,1-31)。

七月六日

行書杜甫"秦州雜詩"之四一卷,絹本(《古芬》卷7, 13a-b)。

七月十一日

書竟一六一九年始書之《女史箴卷》("無響"至"敢告庶姬"一段)[此作後與董《臨麻姑仙壇記》合屬一卷]。

參見:1619(1); 10/11/1608

七月

(1)

書唐人"雨過一蟬噪"及"野人間種樹"五言律詩二首,金牋本[《書畫扇面冊》十二幅之七]。

參見:7/1627(1); 2/16/1628; 5/1632

(2)

作《書扇》[《明人書扇冊》十八開之一](《年譜》,198)。上海朵雲軒藏。

(3)

行書《詩扇》於夷山蘭若,書"山涼微見月"五言律詩(《中國書法》,一九八六年第一期)。

八月一日

行書《詩帖真蹟卷》,素牋本,書"還山貽陳仲醇微君二首"、"楊淇園侍御巡方事竣仍視學南畿,詩以為贈二首"、"贈吳彥倫五十時寓居吳門"、"送穆仲裕中舍還東明"及"龍潭正午觀水嬉"五言律詩七首(《石續》,重華宮,1640;《編年表》,103)。詩見《容詩》卷2, 5b-6a, 9a-b, 13a, 5a, 25b)。

參見:1577

八月十二日

(1)

楷書《臨楊羲黃庭內景經冊》於百花里之保和堂,素牋本(《秘初》卷15, 12b-13a;《編年表》,103。自題語又見《容別》卷5, 30a-b)。

參見:1/2/1627

(2)

楷書臨韓世能所藏顏真卿《告身》一冊,高麗牋本(《石初》卷43, 19a-b;《編年表》,103)。

按:韓世能卒於一五九八年,此作疑僞。或僅謂韓氏家藏,為其後人所有,待考。

八月十五日

(1)

重觀一六一五年所作《秋山圖軸》,并題"遠近秋山千萬重"七言絕句一首(《墨緣》,名畫卷上明,29b-30a)。

參見:夏/1615

(2)

大行書《臨顏真卿裴將軍詩卷》,綾本(《中國圖目》,v.3,滬1-1373)。上海博物館藏。

九月九日

作墨筆《倣古山水畫冊》八幅,紙本。其中首二幅倣倪瓚,第四幅倣巨然《江山蕭寺》,第五幅《巖居高士圖》,第七幅題"炊煙連宿靄"五言絕句一首(《董其昌》, no. 21;《總合圖錄》,v.1, A17-115;《文人畫》,v.5, nos. 65-72;《畫集》, no. 142。詩見《容詩》卷2, 31b,"題畫贈張山人二首"之一)。The Metropolitan Museum of Art.

參見:6/1630(1)

九月十五日

行書《禪悅》數則一冊於姑蘇保和堂,紙本(*Christie's,* 5/29/1991, no. 31)。

九月

重題一六一六年所作《仿黃子久筆意圖軸》。

參見:6/1616

十月

(1)

行書《畫旨帖冊》於丹陽城下畫舫中,素牋本(《石初》卷3, 24a-b;《三希》,第三十冊,2168-80;《編年表》,103)。

(2)

題趙孟頫楷書《法華經冊》,麻紙本(《秘續》,105)。

十二月

作《春山暖翠圖軸》。The Metropolitan Museum of Art。

無月日

(1)

題展子虔設色《遊春圖卷》於韓逢禧之虎邱山樓，絹本(《清河》卷三上,17;《式古》,v.3,畫卷8,355;《平生》卷6,11;《大觀》卷11,4a;《墨緣》,名畫卷上隋,1b;《石續》,寧壽宮,2613;《中國歷代繪畫》,v.1,附錄5;《中國目錄》,v.2,1,京1-184)。北京故宮博物院藏。

(2)

黃庭所輯《汲古堂帖》鑴成,專刻董書共二十三種(《中國書法大辭典》,1750)。

1631 崇禎四年,辛未,七十七歲

正月一至三日

始書《孝經冊》。

參見:長至日/1631

二月

(1)

題吳楨寄觀之《澄清堂帖》王羲之書五卷[見吳楨所刻《清鑑堂帖》]。

參見:1617(1)

(2)

臨王世貞家藏之董源《谿山清樾圖軸》[見金城臨此作](《湖社月刊》,v.52,9)。

三月

(1)

題金陵于中丞所藏李嵩、蕭照合作設色《宋高宗瑞應圖卷》,絹本(《聽續》卷上,520;《夢園》卷4,22b-23a)。

(2)

爲念翀作墨筆《臨高尚書老樹圖軸》,紙本,并書趙孟頫題高克恭畫"金風帶商威"五言絕句(《董盦》,v.4,no.31)。日本齋藤氏舊藏。

春

行書蘇軾"花褪殘紅青杏小"詞一軸,宣紙本(《墨緣》,法書卷下明,17a-b;《編年表》,103)。

四月下浣

楷書《太上感應篇卷》,絹本(《秘初》卷17,3a;《編年表》,103)。

四月

(1)

作墨筆《山水軸》於臨平道中,絹本,并題"三竺溪流獨木橋"七言絕句一首(《穰梨》卷24,7b;《南畫集成》,第二期,第十二輯,2。詩見《容詩》卷4,34b-35a,"題《西溪圖》贈虞德園吏部")。

參見:11/1631(2)

(2)

行書《道釋語冊》,紙本(《秘三》,延春閣,122-23;《中國目錄》,v.2,51,京1-2188)。北京故宮博物院藏。

六月十五日

草書李商隱七言律詩二首一卷,紙本(《古芬》卷7,16a-b)。

夏

維舟荊溪,爲吳正志作《山水卷》,高麗紙本(《吉雲》卷上,6a)。

七月三日

行書《雜詩冊》,朝鮮鏡光箋烏絲闌本,書晉唐諸家詩(《石初》卷3,25b)。

七月六日

行書《臨淳化閣帖》,臨畢十冊中之末冊并自跋。

參見:7/9/1631; 2/16/1620; 3/3/1621(2); 1/1622;7/8/1626; 4/6/1627; 立春/1628; 8/17/1631;9/9/1631

七月九日

再跋《臨淳化閣帖》十冊之末冊。

參見:7/6/1631

七月十五日

行書杜甫"醉歌行"一卷,紙本(《書法》,一九八四年第四期,2)。

七月

行書七言律詩四首一卷於韻樓,紙本(Sotheby's,12/5/1985, no. 12)。

八月十五日

(1)

始作鏡面紙本《山水冊》八幅,其中五幅分倣元人、巨然、李唐、王蒙、吳鎮(《平生》卷10,118;《編年表》,103)。

參見:6/1/1632(1)

按:此冊似即《大觀》所載董鏡面麗箋本《山水冊》,唯中少倣元人及李唐二條,見卷19,29b。《墨緣》亦載董白鏡面箋本墨《山水方冊》,尺寸及題識大致相同,但僅六幅,無倣巨然頁,見名畫卷上明,35a-b。併置此待考。

(2)

行書"金榜重樓開夜扉"等七言絕句十二首一卷,紙本[《元明書翰》七十六冊之五十六(即辛二冊)](《石三》,延春閣三十八,2624-25;《故宮》卷3,349-50;《董其昌》,no. 65)。台北國立故宮博物院藏。

(3)

時有金陵之行,舟中與沈猶龍爲別,爲行書李白"把酒問月"七言古詩及"山池"五言古詩一冊,紙本(《石三》,乾清宮十一,574;《編年表》,103)。

八月十七日

三跋《臨淳化閣帖》十冊。

參見:7/6/1631

九月九日

四跋《臨淳化閣帖》十冊。

參見:7/6/1631

九秋

爲君平行書《臨宋四家書卷》於吳門之清嘉室,紙本,臨蘇軾、黃庭堅、米芾及蔡襄七言絕句各一首(《中國圖目》,v.3,滬1-1374)。上海博物館藏。

九月

題于鑠所藏趙孟頫《臨黃庭經冊》於其寓,紙本(《辛丑》卷3,14)。

十月二日

行書"輞川詩"二十首一卷,灑金箋本[與仇英設色《倣摩詰輞川圖卷》合裱,絹本](《劍花》,下卷,112;*Christie's*, 6/3/1987, no. 65)。

十一月十五日

爲一六二八年所作《吳淞江水圖軸》補筆并再題。

參見:8/1628

十一月廿九日

書《李司勳告身冊》,紙本朱絲闌(《穰續》卷8,12a-14b;《編年表》,103)。

十一月

(1)

應掌詹之召,舟次維揚,得夔龍漢硯,遂書竟昨年始書之楷書《千字文卷》,紙本(《吳越》卷5,63a-b;《編年表》,103)。

參見:3/3/1630

按:此卷後改裝冊。

又:董北上途中十一月已至揚州,閏十一月反在蘇州,十二月方至晉陵,似不合理,待考。見閏11/26/1631; 12/8/1631。

(2)

姻家喬明懷微董作以貽瞻屺,董因再題四月所作《山水軸》以贈。

參見:4/1631(1)

(3)

赴詹事之召舟次廣陵,倣顏真卿筆意,爲真吾書溫庭筠"蘭塘詞"一軸,紙本烏絲闌(《華亭》,16)。

閏十一月廿六日

將有都門之行,泊舟金閶門,於吳與京舟中觀沈周墨筆《萬壽吳江圖卷》,紙本,并初跋之(《澄懷》卷2,108–109;《總合圖錄》,v.3,JM1–247)。東京國立博物館藏。

參見:5/1634;11/1631(1)

按:董跋此卷共三次,初跋後不久陳繼儒至,同觀於吳與京舟中,董再跋之。

十二月八日

題明人設色《雲間高會圖卷》於晉陵舟次,絹本(《石三》,延春閣卷十七,2120–21;《西清》卷4,4b–5a;《雪堂》,73a–b)。

參見:11/1631(1)

冬

吳震元纂成《宋相眼》二百餘卷,募友人共貲摹刻,董助刻六卷,惜終未刻成,今已泯滅(《吳越》卷4,65b–75a)。

長至前二日

書《樂志論》及《舞鶴賦》[見《戲鴻堂小楷冊》]。

參見:6/8/1606;7/4/1607

長至日

書竟并自跋楷書《孝經冊》,金粟箋本(《大觀》卷九下,40a;《石初》卷3,21a–22a;《三希》第三十冊,2128–62;《編年表》,103)。

參見:1/1–3/1631;9/1635(2)

按:《石初》另載董楷書《孝經冊》,款識字句皆同此冊,但二冊頁數、尺寸及印鑑不同。《石初》編纂者云二冊俱真,乃重書。見卷3,25b–26b。

又:北京市文物商店藏有董此年"行書"《孝經冊》,未知是否即此作,見《中國圖目》,v.1,京12–044。

無月日

(1)

行書《爭座位帖冊》,紙本(《中國目錄》,v.2,51,京1–2189)。北京故宮博物院藏。

(2)

行書詩二首一卷,絹本(《中國圖目》,v.1,京9–027)。北京中國文物商店總店藏。

(3)

吳泰摹勒《研廬帖》鐫成,專刻董書共三十七種(《中國書法大辭典》,1750)。

(4)

撰書《石碑》,擬題《熊明遇德政碑》(《年譜》,205)。碑在浙江長興發現。

(5)

應召赴闕過廣陵,鄭元勳出示所作畫卷,董因跋之(《容別》卷2,2a–b)。

按:此跋未紀年,但董赴闕北上過廣陵在一六三一年底至一六三二年初,因置此。見11/1631(1)(3)及1/17/1632;1/19/1632(1)(2);2/1/1632。

1632 崇禎五年,壬申,七十八歲

正月十六日

行書《臨淳化閣帖冊》[《臨淳化閣帖》十冊之首,皆素箋本](《盛京》,第六冊,14a–16a;《古物》卷1,17a–18a)。

參見:1/24/1632;2/19/1632

按:此十冊爲董北行途中所書:第二冊識云"泊舟清江浦臨,"第三冊見1/24/1632,第四冊云"舟次古城,"第五冊云"舟行蘇門道中,"第六冊云"舟行清源驛,"第七冊云"臨於桃花口,"第八冊云"舟次楊村守風,"第九冊云"舟次和合驛,"第十冊見2/19/1632。

正月十七日

題一六二六年所作《法書紀略冊》於寶應舟次(《十百》,卯卷,14b–19b;《編年表》,103)。

參見:1626(1)

正月十九日

(1)

初度七十八之辰,時應宮詹大宗伯之召,舟次寶應,作墨筆《仿高尚書雲山圖軸》,紙本(《畫集》,no.92)。上海博物館藏。

(2)

觀董源《夏山圖》於寶應舟次,因作墨筆《倣董北苑筆意圖軸》,高麗紙本(《華亭》,17)。

正月廿四日

行書《臨淳化閣帖冊》於新莊舟次[《臨淳化閣帖》十冊之三]。

參見:1/16/1632;2/19/1632

二月一日

應宮詹宗伯之召,道出淮陽至清河,題一六二六年楷書《金剛經冊》付子祖和,宣德鏡光箋本(《秘初》卷2,12a–13a。題語又見《容別》卷2,30b–31a)。

參見:10/1–15/1626

二月十九日

楷書《心經》數行,復行書臨《淳化閣帖》末卷王獻之書[《臨淳化閣帖》十冊之十]。

參見:1/16/1632;1/24/1632

二月

舟泊金山下,爲友人行書"魏國山河險"、"鳴鑾初

幸岱"及"軒轅應順動"五言排律三首一卷[即《公字卷》],紙本(《紅豆》卷3,8a–b;《編年表》,103;Christie's,5/29/1991,no.37)。

按:董正月間已北行至揚州、寶應等地,此卷自題云舟泊金山,或爲僞作。參見《系年》,275。

三月

爲大都華氏行書"城南本是征南裔"七言絕句一軸,綾本(《中國圖目》,v.8,津2–032)。天津市歷史博物館藏。

四月三日

仿黃庭堅筆楷書"勒賜百官午門麥餅宴恭紀"七言律詩一軸。The Metropolitan Museum of Art.

四月十日

題文徵明青綠《仙山圖卷》於京兆署中,絹本(《式古》,v.4,畫卷28,493;《江村》卷1,78b–79a;《大觀》卷20,34b–35a)。

四月十五日

對題王維著色《雪堂幽賞圖》,長方絹本[《歷代名畫大觀高冊》二十九幅之首]。

參見:長至/1627(1);2/16/1634

五月十五日

楷書周邦彥"夏景隔蒲蓮"詞一軸,宣德箋烏絲闌本(《石初》卷7,4a;《編年表》,103)。

五月

行書《詩扇》,金箋本,書"賜百官麥餅宴"七言律詩一首[《書畫扇面冊》十二幅之五]。

參見:7/1627(1);2/16/1628;7/1630(1)

按:《董其昌》亦載董行書《賜百官麥餅宴詩扇》,識語亦同,但爲紙本,見no.66。

六月一日

(1)

倣吳鎮作《山水冊》八幅之末幅,付第七孫廣收藏。

參見:8/15/1631(1)

按:據《大觀》,董此幅作於壬申"六月,"見卷19,29b。

(2)

背臨《黃庭外景經》於苑西邸舍,紙本[《節臨黃庭經各種冊》十二段之首二段](《古緣》卷5,21b–22b;《編年表》,103。自題語又見《容別》卷4,21b–22a)。

按:此冊後改裝卷。

七月十日

行書《太子少保都察院左都御史陳于廷并妻誥命冊》,紙本(《貞松》卷中;《中國目錄》,v.2,51,京1–2191)。北京故宮博物院藏。

七月

題虞山孫氏所藏陸治著色《玉田圖卷》,紙本(《總合圖錄》,v.1, A28–029)。The Nelson-Atkins Museum of Art。

八月廿六日

楷書《白衣大慈陀羅尼經冊》,宋箋本(《祕初》卷2, 13a–b;《編年表》, 103)。

八月廿九日

爲聖枼行書《雜書卷》,高麗表文箋本,書"題《武夷山圖》贈林納言·次史少傅原韻"七言古詩,臨米帖數十行,又書"勅賜百官午門麥餅宴恭紀"七言律詩二首(《石續》,御書房, 2014–15;《編年表》, 103;《中國圖目》, v.6,蘇6–050。"題武夷山圖詩"又見《容詩》卷1, 17b–18b)。無錫市博物館藏。

九月

臨婁江王世貞家藏之顏真卿《贈裴將軍詩帖》(《四印堂詩稿》,引自《年譜》, 209)。

秋

(1)

爲君常作墨筆《泉光雲影圖軸》,紙本,并題四言詩一首(《南畫》卷9, 181;《名畫寶鑑》, 662;《故宮》卷5, 459–60;《畫集》, no. 93)。台北國立故宮博物院藏。

(2)

行書張九齡《白羽扇賦》一軸,綾本(《故週》, v.73, 3;《故宮》卷2, 17–18)。台北國立故宮博物院藏。

(3)

行書"開有風輪持世界"及"野人何以傲游子"題畫七言絕句二首以遺友人,素箋本[《書畫合璧卷》之書幅](《石三》,乾清宮十一, 575。詩見《容詩》卷4, 44a–b)。

(4)

行書臨蘇軾《二守同訪新居詩帖》,素牋本[《臨蘇軾三帖冊》之首帖](《石續》,淳化軒, 3302)。

十月十六日

行書嵇康《養生論》一卷,高麗精箋本(《壯陶》卷12, 29b–31a)。

十二月廿七日

題鄭僖畫(《容別》卷1, 3a–b)。

十二月廿九日

在京爲何吾騶作墨筆《壬申嘉平月山水軸》以留別,紙本,并系以"泰交恢帝紘"五言古詩(《聽颿》卷2, 168–69;《過雲》,畫類5, 12b–13a;《編年表》, 103;《董其昌》, no. 22;《畫集》, no. 94。自題及詩又見《容別》卷1, 7b–8a)。The Kimbell Art Museum, Fort Worth, Texas。

約正月

作《仿董北苑圖》於廣陵舟中,并題"綠溪青嶂是秦餘"七言絕句一首(《庚子》卷3, 27a。詩見《容詩》卷4, 36b,"題畫爲楊弱水侍御")。

約三月

遇李伯襄於入都德州道中,觀所藏宋搨《聖教序》[見董題高弘圖所藏宋搨《聖教序》]。

參見:3/1633

無月日

(1)

經萬邦孚得收董源《夏山圖卷》於京[見董跋此卷]。

參見:8/15/1635; 6/27/1636(2)

(2)

見宋刻《英光樓帖》數本於京,得王獻之二卷以歸刻石[見董一六三五年自題臨本]。

參見:8/1635(1); 12/15/1635

(3)

與王志道、冷賀中、劉退齋翰撰結社於京[見董對題《山水書畫冊》十對幅之末幅]。

參見:11/10/1633; 1635(1)

(4)

行書《東里公志冊》,紙本(《中國目錄》, v.2, 51,京1–2190)。北京故宮博物院藏。

按:東里公指王志道。

(5)

行書《臨顏真卿爭坐位帖冊》,紙本烏絲闌(《故宮》卷3, 100;《董其昌》, no. 67)。台北國立故宮博物院藏。

(6)

見倪元璐及馮可賓畫於京[見董對題馮可賓墨筆《畫石冊》八開之三,紙本](《總合圖錄》, v.4, JP6–048)。日本柳孝氏藏。

(7)

觀李公麟《西園雅集圖》於京,有米芾蠅頭小字題後,又從馮詮借觀《千文》,遂楷書《臨千文冊》,黃箋烏絲闌本(《石初》卷28, 40b–41a;《編年表》, 103)。

(8)

爲張文學書《張廷尉誥命》(《容別》卷2, 25b–26a)。

1633 崇禎六年,癸酉,七十九歲

正月

邱純仁出示董一六○六年所作《書畫冊》,董再題之於京。

參見:1606(1)

按:此題據《美術叢書》本書於正月,據《叢書集成續編》本書於五月,待考。

三月

爲高弘圖題其所藏宋搨《聖教序》(《寓意》卷2, 7a–b。題語又見《容別》卷2, 12a–b)。

參見:約三月/1632

四月一日

(1)

行草書臨《淳化閣帖》五則一卷,素箋本(《石初》卷28, 24b–25a;《三希》,第三十冊, 2162–68;《編年表》, 104)。

(2)

將南行,題劉光暘所藏《淳熙秘閣續帖》二卷,有鍾繇、王羲之、王獻之、王珣、王珉、王洽、郗鑑等人書[見《翰香館法書》十卷之一及二](《叢帖目》,第一冊, 374及134)。

四月八日

跋張延登楷書《白兔公記卷》[此作并董跋現附於崔子忠《長白仙踪圖卷》之後](《中國圖目》, v.4,滬1–1891。跋語又見《容別》卷2, 11a–b)。上海博物館藏。

四月十六日

過吳門彭氏,題其家藏之趙孟頫行書《高松賦卷》,紙本(《古芬》卷5, 6a;《眼二》卷7, 1b–2a)。

四月

撰《五學顓憲彙碑顨廡記》(《松江》卷73, 25)。

五月

(1)

參合宋元人筆作墨筆山水,素箋本[《便面畫冊》十幅之四](《南畫》卷8, 105;《畫集》, no. 157)。

參見:4/4/1592; 1/1602(1); 4/7/1625; 9/1635(1)

(2)

行書倣虞世南《汝南誌》,素箋本[《便面書冊》十幅之首]。

參見:9/1625(1); 9/15/1625

(3)

參合董源與范寬筆法作墨筆《山水軸》,紙本(《編年表》, 103;《畫集》, no. 65)。北京故宮博物院藏。

六月八日

行書臨褚遂良書庚信《枯樹賦》一卷於范西邸舍,素箋本(《石續》,御書房, 2012;《編年表》, 104)。

六月十八日

跋張延登所藏董源淺設色《山居圖卷》[一名《平林霽色圖卷》],紙本(《文人畫》, v.2, no. 6。跋語又見《容別》卷1, 6a–b)。Museum of Fine Arts, Boston。

六月廿六日

周延儒退隱將歸荊溪,董以所藏李唐《江山小景圖卷》贈別,并重題之。

參見:9/1623

十月一日

得王獻之自刻《保母帖》於菜市口秦人[見董題此帖]。

參見:9/17/1634

十月十五日

袁樞將歸省父袁可立,董作墨筆《山水軸》以贈,紙本,并題"挂冠神武覿庭闈"七言絕句一首(《圖畫精意識》,88–89;《畫集》,no. 95)。天津市藝術博物館藏。

十一月十日

自題《書畫冊》十對幅於京,紙本。右作設色山水,分倣荊浩、董源兼范寬、夏珪、趙孟頫、黃公望、倪瓚、王蒙及自藏之高克恭《大姚村圖》等,第九幅寫杜甫"柴門草閣"詩意,末幅畫報國寺古松。左幅行書論畫,題詩或紀事(《過續》,畫類3, 1a–2b;《鷗陂》卷6, 3–4;《畫集》,no. 141;《中國圖目》,v.3,滬1–1364。題語又見《容別》卷2, 20b)。上海博物館藏。

參見:4/1/1577; 1/1/1624(1); 1632(3); 1635(1)

按:此冊第五幅董對題有"是日詣竹岡先塋,宣三品贈誥"等語。據《明史》本傳,董於一六二二年擢太常寺少卿兼侍讀學士,一六二三年秋擢禮部右侍郎,皆屬三品,故此幅應作於此二年間。

又:此冊已見三本,一為上海博物館所藏,一為美國私人收藏,一見《畫集》,no. 141。三作極類似,惟印鑑不同。其中惟上海博物館所藏冊於十對幅外,又有第十一幅總跋,書於一六三三年十一月十日。按此冊末幅(第十)之對題書於一六三五年,書總跋於一六三三年似不可能。《鷗陂》載此總跋為此冊之首幅,亦非尋常慣例。且總跋云"今在燕臺中,多北宋人筆,復舍所學而為之…"但冊中倣趙孟頫、高克恭、黃公望、倪瓚、王蒙等,皆非宋人,故疑總跋屬為董書真蹟,應自他冊移來,非上海博物館所藏冊之原本。又所見三冊中,以美國私人所藏者筆墨最勝,疑上海博物館所藏與《畫集》所載二冊為後人臨本,待考。

十一月

(1)

再跋米芾書《蜀素帖卷》於京。

參見:5/1604(1)

(2)

作《臨帖卷》,綾本(《年譜》,214)。上海朵雲軒藏。

(3)

為張灝《學山堂印譜》撰序於京邸(《歷代印學論文選》,第二編,601)。

十二月十日

行書臨蘇軾雜帖三種一卷於京,宣紙本(《石續》,重華宮,1639;《編年表》,104;《中國目錄》,v.2, 51,京1–2192)。北京故宮博物院藏。

十二月三十日

為張延登仿顏真卿大楷書謝朓七言古詩一卷,紙本(《澄懷》卷4, 24–25)。

十二月

題黃庭堅楷書《觀音贊·燒香贊卷》,澄心堂紙本(《壯陶》卷4, 21b)。

約三月

再跋賀知章所摹,李後主所刻《澄清堂帖》於高弘圖所(《容別》卷2, 12a)。

參見:1589(3)

無月日

(1)

歸里舟次韓莊閘,孫董廷出董一五九三年所作《三癸圖卷》求跋,董因跋之。

參見:1593(1); 1623(1)

(2)

得收董源《秋江行旅圖軸》、《群峰霽雪圖卷》及巨然小幅山水[見董跋董源《群峰霽雪圖卷》]。

參見:6/27/1636(1)(2)

按:此跋與《虛齋》所載董源《夏山圖卷》之董再跋相同,見卷1, 12b–13a。若此,則董此年所收之三幅為董源《秋江行旅圖軸》、《夏山圖卷》及巨然小幅山水。然董於《夏山圖卷》之初跋云收此卷於壬申(一六三二年),故此再跋存疑。見1632(1)。

(3)

觀沈周八十一歲所作《倣梅花道人卷》[見董自題一六三六年所作《細瑣宋法山水卷》]。

參見:9/7/1636(1)

(4)

重題舊作小行楷《臨米芾書道德經與破羌帖詩跋》[見《金沙帖卷》十段之八及九]。

參見:八月晦/1602

(5)

臨蘇軾《廣平碑側記》[見張照自跋《臨董仿東坡帖》](《天補》,7a–b)。

(6)

楷書《趙應禎父子誥勅袖珍冊》,硬黃紙本(《吳越》卷5, 43a–46a;《編年表》,104)。

(7)

書《得岸僧壽序冊》,紙本烏絲闌(《吳越》卷5, 79b–80b;《編年表》,104)。

(8)

作《溪山仙館圖軸》(《編年表》,103)。

1634 崇禎七年,甲戌,八十歲

二月十五日

作墨筆《擬倪雲林山水軸》,紙本,并題"錫山無錫是無兵"七言絕句(《藝苑遺珍》,名畫第三輯,no. 37;《總合圖錄》,v.1, A18–005。詩見《容詩》卷4, 42a–b,"題倪迂畫二首"之二)。美國方聞夫婦藏。

二月十六日

對題米友仁墨筆《雲山墨戲圖》,長紙本[《歷代名畫大觀高冊》二十九幅之十三]。

參見:長至/1627(1); 4/15/1632

二月

行書《畫旨》三則一卷,綾本(Christie's, 11/30/1984, no. 685)。

三月二日

錢去非携王羲之草書《氣力帖》至董苑西邸舍,董三跋之。

參見:6/1622。

三月三日

(1)

行楷書臨歐陽詢《醴泉銘》"冠山抗殿"起至"不能尚也"及米芾詩帖"揚帆載月"一首[《臨古帖三種冊》之首二種]。

參見:冬/1601(1)

(2)

重觀并題項氏所藏米芾行草書《易義卷》[一名《易説卷》]於苑西邸舍,素箋本(《平生》卷2, 67;《江村》卷2, 19;《大觀》卷6, 26a;《石初》卷29, 86b;《壯陶》卷4, 45b)。

按:《大觀》載此作為黃麻紙本。

又:《珊瑚》與《式古》亦載董題項氏所藏米芾行草書《易説卷》,紙本,米書與其後周伯溫跋相同。然第二跋此二書作洪恕,《石初》等書作鄭元祐。第三跋雖皆作董,但跋語全異,且未紀年,待考。見《珊瑚》·畫,卷6, 2;《式古》,v.1,書卷10, 528。

三月

用鍾繇筆法行書米芾"竹西桑柘暮鴉盤"七言絕句一幅於京,高麗長紙本[《明法書名畫合璧高冊》第一冊二十七幅之十五,畫幅為《苕溪訪古圖》](《式古》,v.3,畫卷7, 325)。

參見:1/1602(2)

春

仿自藏黃公望畫冊二十幅作墨筆山水(《真蹟》,三集,18a–b)。

四月十九日

過東昌,許維新之長公出示董一六〇二年所作《神樓圖軸》,董重題之於官舫中。

參見:7/1602; 1603(1)

四月晦日

陳貞慧攜示所藏董舊作墨筆《倣米敷文瀟湘奇境圖卷》,鏡面箋本,董爲重題(《華亭》,1)。

參見:5/1634(1); 5/1636(1)

按:此卷乃十幾二十年前爲吳正志倣自藏之米友仁《瀟湘奇境圖》,董自題云倣黃公望《富春山居圖卷》筆意,兼帶趙孟頫《水村圖》。

五月

(1)

南歸舟次維揚,繆先葦以高克恭《溪山圖長卷》見示[見董三題舊作《仿米敷文瀟湘奇境圖卷》]。

參見:四月晦/1634; 5/1636(1)

(2)

歸自都中,吳興京以所藏沈周《萬壽吳江圖卷》歸董,董三跋之。

參見:閏11/26/1631

(3)

楷書皮日休五言古詩四首一冊,紙本(《石三》,御書房二,3130-31;《故宮》卷3,110-12;《編年表》,104)。台北國立故宮博物院藏。

六月

(1)

舟次武塘,行書《古法書雜記冊》,紙本(《中國圖目》,v.1,京5-232)。北京首都博物館藏。

(2)

避暑山房,試新都汪氏墨寶,作《倣北苑雲山圖軸》(《南畫》,續集4,28左;《神州大觀》·續編,第五集)。

(3)

避暑東佘山莊,觀王氏所藏書畫,倣其筆意行草書七言律詩一冊,素箋本(《石初》卷3,35b-36a;《編年表》,104)。

(4)

作《臨米帖冊》,紙本,臨米芾《蜀素帖》中"揚帆載月遠相過"七言律詩與"泛泛五湖霜氣清"七言絕句(《十百》,辰卷,20b-21a;《編年表》,104)。

夏

(1)

書竟《倣歐陽詢千字文冊》[見董此年閏八月自跋]。

參見:春/1628; 閏8/12/1634

(2)

爲北京昌平城內呂祖祠撰并行書《呂祖祠記》(《系年》,287)。此碑拓片現藏北京圖書館。

七月七日

再題一六二六年所作《倣大癡山水軸》。

參見:四月晦/1626

七月晦日

行書臨顏真卿書《送蔡明遠序》一冊,紙本(《石三》,延春閣廿六,2046;《故宮》卷3,99-100;《編年表》,104)。台北國立故宮博物院藏。

七月

作《倣子久溪山亭子圖》[金箋本墨筆《仿宋元山水冊》八開之三](《畫集》,no. 143;《中國圖目》,v.3,滬1-1375)。上海博物館藏。

參見:夏/1635; 秋/1635(1)

按:此冊未紀年之五幅中,一爲《松窗讀易圖》,四倣倪瓚筆意,五倣吳鎮,六臨董源《夏山圖》,七擬自藏之巨然《春雲欲雨圖》。

八月一日

行書《護身真言》及《六字大明真言》,紙本[《准提菩薩真言冊》之首段](《中國圖目》,v.1,京5-231)。北京首都博物館藏。

參見:8/15/1634(1); 9/1/1634; 3/1635(1)

八月十五日

(1)

行書《准提菩薩真言冊》二開。

參見:8/1/1634; 9/1/1635; 3/1635(1)

(2)

跋趙孟頫大楷書松江《普照寺藏殿記卷》,素箋朱絲闌本(《石初》卷5,17a)。

按:此作又著錄於《石三》,尺寸略同,題跋僅一字之差,但印鑑異,待考。見乾清宮十,514。

(3)

題"僻學屠龍似"及"平子思元賦"五言絕句二首於小像并識[見王文治題汪恭《摹董文敏石刻小像》](《筆嘯》卷上,64a-b)。

八月

作《倣梅花道人筆意圖扇頁》[一名《山居小景圖扇頁》],紙本(《畫集》,no. 155)。

閏八月十二日

自跋一六二八年春至一六三四年夏所作《倣歐陽詢楷書千字文冊》,宣紙本(《吳越》卷5,63b-64a)。

參見:春/1628; 夏/1634(1)

閏八月十五日

於頑仙盧與陳繼儒子孫同觀松江本一禪院(即北禪院)僧偶萍上人出示該院所藏趙孟頫墨筆《祖燈圖像卷》,宋安南箋本,因題之(《秘初》卷9,29b)。

按:董跋與其後陳繼儒跋抵觸,此卷或向爲陳繼儒所藏,此日歸之偶萍上人。參照《秘初》編者按語於

卷9,30b-31a。

閏中

作《行書卷》,紙本(《年譜》,220)。上海朵雲軒藏。

九月一日

行書《陀羅尼真言》[《准提菩薩真言冊》之第二段]。

參見:8/1/1634; 8/15/1634(1); 3/1635(1)

九月十一日

舟過毘陵道中,行書蘇軾《後赤壁賦》十屏,綾本(*Sotheby's*, 6/3/1986, no. 31)。

九月十六日

試朝鮮鼠鬚筆,行楷書唐人五言排律四首及五言律詩七首一冊,紙本(《古緣》卷5,31b;《編年表》,104)。

九月十七日

跋自藏王獻之《保母帖》(《三希》,第二冊,121-22;《董其昌》,no. 68;《歐米收藏法書》卷1,no. 11)。Freer Gallery of Art.

參見:10/1/1633

九月

與陳繼儒訪王時敏西盧齋中,王出示近得之董源《溪山圖》及李公麟《赭白馬圖》,復出素綾索畫,董因作墨筆《倣北苑溪山半幅圖卷》并書杜甫"曹霸畫馬詩"以贈(《劍花》,下卷,117-18)。

秋

楷書"春至鶺鴒鳴"五言古詩一軸,紙本(《中國圖目》,v.8,津2-033)。天津市歷史博物館藏。

十月三日

書竟一六二二年始書之《金剛經冊》,自跋云出入鍾繇、王羲之、王獻之、顏真卿、楊凝式、米芾諸家(《秘初》卷3,11b-12b;《編年表》,104)。

參見:4/8/1622

十月四日

行書《臨各家詩卷》,紙本(《中國圖目》,v.3,滬1-1376)。上海博物館藏。

十月

題王時敏墨筆《仿倪春林山影圖軸》,紙本(《鑑影》卷23,1a-b;《中國圖目》,v.4,滬1-2207)。上海博物館藏。

十一月一日

行書《禪悅》四則一卷,金粟箋本(《秘三》,養性齋,148-49。語見《容別》卷3,10b-11a, 13a-14a;《畫

禪》卷4, 15–16, 18）。

十一月八日

行書《楊道甫墓誌》（《系年》,290）。此碑拓片現藏
浙江圖書館。

無月日

（1）

跋國詮楷書《善見律卷》,麻紙本（《秘續》,56）。

參見:2/1624(1); 1628

（2）

題一五九二年春楷書《金剛經》所刻石本（《容別》
卷1, 13a）。

參見:春/1592(1)

（3）

行書《詩翰冊》,紙本（《中國目錄》,v.2, 51,京I–
2193）。北京故宮博物院藏。

（4）

楷書米芾詩一軸,紙本（《中國圖目》,v.6,蘇I–
126）。蘇州博物館藏。

（5）

行楷書《臨顏真卿書冊》,素箋本（《石初》卷3, 25a;
《編年表》,104）。

（6）

對題韓希孟繡《宋元名蹟冊》八幅,綾本,各幅題四
言詩一首（《三秋》卷上,71b–74a）。

（7）

楷書《千文冊》,紙本（《退菴》卷8, 28a–b）。

（8）

爲崑山士紳書《吳民九歌》頌劉知縣（《崑山現存
石刻錄》卷3,引自《年譜》,222）。

（9）

跋吳楨《清鑑堂帖》所刻虞世南書《汝南公主
墓誌》（《平生》卷1, 64;《叢帖目》,第一冊,327及
337）。

（10）

題柯九思《墨竹冊》,紙本（《眼二》卷14, 10a）。

按:董此題自署年款爲"天啓甲戌,"但甲戌（一六
三四年）非天啓,此題存疑。

1635　崇禎八年,乙亥,八十一歲

正月廿九日

節臨宋拓李邕《小雲麾李秀碑》一卷,紙本（《古緣》
卷5, 21a–b;《編年表》,104）。

二月一日

書《金剛經冊》[見董自跋此冊]。

參見:7/1/1635

三月

（1）

見秦居士《顯密圓通呪》刻本,因行書禪語[《准提
菩薩真言冊》之後段]。

參見:8/1/1634; 8/15/1634(1); 9/1/1634

（2）

題楊文驄爲潭吉道人還蘇州玄墓山所作設色《山
水卷》,紙本（《嶽雪》卷5, 14b–15a;《湖中》,175–76;
《過續》,畫類3, 6b–7a;《中國目錄》,v.2, 70,京I–
2962）。北京故宮博物院藏。

春

過掃花庵,題王時敏所藏《宋人畫冊》十九幅,絹本
[即《宋元董跋畫冊》,一名《宋畫典型冊》]（《聽
續》卷上,526;《嶽雪》卷2, 55a）。

按:《聽續》載此冊僅一幅有"毛益"款,《嶽雪》則載
毛益之外,另二幅有"馬遠"款,待考。

五月

（1）

再題一六二一年所作《倣黃鶴山樵雲山小隱圖
卷》。

參見:6/8/1621

（2）

以自藏關仝《關山雪霽圖》中諸景改爲小卷,作墨
筆《關山雪霽圖卷》,素箋本（《墨緣》,名畫卷上明,
29a–b;《石初》卷44, 6b–10a;《編年表》,104;《繪畫
史圖錄》,下冊, no. 407;《中國目錄》,v.2, 51,京I–
2194;《畫集》, no. 61）。北京故宮博物院藏。

（3）

書薛言所撰《祈子靈應碑》（《松江》卷73, 25）。

六月十五日

行書《臨李邕荆門行冊》,宣德箋本（《石續》,淳化
軒,3304;《天瓶》卷上,7a–8a;《編年表》,104）。

六月

（1）

題陳繼儒家藏之曹善楷書《山海經》四冊,宋箋本
（《石初》卷10, 45b;《故週》,v.435, 4;《故宮》卷3,
54）。台北國立故宮博物院藏。

（2）

重觀并題舊作行楷《樂毅論冊》,金箋本（《石三》,
長春園思永齋,3908）。

（3）

撰并行書《兵部左侍郎節寰袁公行狀》四冊,宣德
高麗紙本（《吳越》卷5, 49b–60a;《編年表》,104）。

（4）

重裝瞿院深淡設色《夏山圖軸》,絹本,因題之於玄
賞齋（《嶽雪》卷2, 18a）。

夏

臨高克恭設色雲山[《倣宋元山水冊》八開之末]。

參見:7/1634; 秋/1635(1)

七月一日

玄黙上人索書《金剛經》,董因題二月朔所書一本
以歸（《四印堂詩稿》,引自《年譜》,222）。

參見:2/1/1635

七月

（1）

以李邕筆法行書黃庭堅"重陽詞"一軸,紙本
（*Sotheby's*, 6/3/1985, no. 25）。

（2）

三峰法藏和尚圓寂,董爲撰塔銘（《宗統編年》卷
31,引自《年譜》,224）。

八月十五日

跋自藏之董源淡設色《夏山圖卷》,絹本（《壯陶》卷
2, 38b–39a;《虛齋》卷1, 11a–13a;《中國圖目》,v.2,
滬I–0021）。上海博物館藏。

參見:1632(1); 6/27/1636(1)(2)

按:此長跋與其後之再跋即《大觀》所載董大行楷
書《論畫卷》,光麗箋本,或爲董日後重書舊跋,或
後人僞作,待考。見《大觀》卷九下,35a–36a。

八月廿四日

訪同籍李原中於其鄉居,觀所藏王獻之行草書帖,
乃虞、褚所臨本,歸舟後臨其"鬱鬱澗底松"一詩,
宣德鏡光箋烏絲闌本[《臨閣帖冊》之前段]（《石
初》卷10, 54a–55b;《編年表》,104;《中國圖目》,
v.3, 滬I–1378）。上海博物館藏。

參見:12/1/1635

八月

（1）

至嘉興梅里訪道者李氏,李出王獻之之書《選》詩求
鑑,乃唐時硬黃,虞、褚倣書[見董一六三五年自題
《臨英光樓帖卷》]。

參見:1632(2); 12/15/1635

按:李氏疑即李原中,參見8/24/1635。

（2）

再題一六一八年所作《臨褚遂良摹蘭亭叙冊》。

參見:2/20/1618

（3）

作墨筆《仙巖圖》,金箋本[《書畫合璧冊》十八對幅
之五]（《石初》卷41, 59b）。

九月十五日

臨金沙于比部肇家藏之米芾學案大字書《天馬賦》
一卷,紙本（《古芬》卷7, 1a–2a）。

九月

（1）

得趙孟頫《盤谷圖》於海上,學米芾筆法爲光四丈

臨之,素箋本[《便面畫册》十幅之五]。

參見:4/4/1592;1/1602;4/7/1625;5/1633(1)

(2)

楷書《孝經册》,紙本(《古芬》卷7,32a–33b;《眼二》卷8,27a–b)。

按:董此作後自附長跋,與一六三一年所書《孝經册》之跋語全同,見長至/1631。

秋

(1)

倣黃公望《秋林讀書小景》兼董源筆意作墨筆山水[《倣宋元山水册》八開之二]。

參見:7/1634;夏/1635

(2)

題嘉善縣竹林鄉《唐子畏像》刻石(《竹林八圩志》卷5,引自《系年》,297)。

十月四日

跋卞氏《二隱居詩真蹟卷》(《瀟灑書齋書畫述》卷1,引自《年譜》,226)。

十月十七日

行書謝莊《月賦》數行一卷,綾本(《古芬》卷7,8a–9a;《眼二》卷8,26a–b)。

十月

行書唐人七言絕句五首及七言律詩三首一卷,鏡面箋烏絲闌本(《華亭》,11)。

十一月

(1)

再題一六二九年所作《夏木垂陰圖軸》。

參見:夏/1629(1)

(2)

項元汴次孫相訪,請書其祖墓誌銘以鐫石,董因行楷書《明故墨林項公墓誌銘卷》,宣紙本(《吳越》卷5,40a–43a;《清儀》,128b;《穰續》卷8,14b–19a;《槐安》,no.169;《書道藝術》卷8,140–43;《編年表》,104;《書跡名品叢刊》,《董其昌集2》,《董其昌》,no.69,銘文又見《容文》卷8,30a–又31a)。東京國立博物館藏。

按:據《吳越》,此作原為卷,後拆成册,但餘書皆以卷錄,現東京國立博物館所藏亦為卷,待考。

又:董之銘文乃應項元汴次子項德成之請所撰,據汪世清先生考訂,項德成卒於一六二二年,故此文應撰於一六二二年之前。

(3)

題唐寅設色《楊柳陰濃圖軸》於期仙廬,絹本(《十百》,戊卷,14a–b)。

十二月一日

行草書臨王獻之《鄱陽》、《散情》、《極熱》及《冠軍》四帖[《臨閣帖册》之後段]。

參見:8/24/1635

十二月十五日

行書《臨英光帖卷》,素箋本烏絲闌,臨自藏之宋刻《英光樓帖》王獻之書《選》詩(《盛京》,第三册,26a–b;《古物》卷2,14a–b)。

參見:1632(2);8/1635(1)

冬

(1)

題楊文驄《湖山圖軸》(《年譜》,227)。上海博物館藏。

(2)

書《臨古卷》於戲鴻堂,絹本,臨王羲之《奉橘帖》、《療疾帖》、《思想帖》、顏真卿《鹿脯帖》及蘇軾《黃州詩帖》(《壯陶》卷12,26b–28a)。

無月日

(1)

自題《山水書畫册》十對幅之末幅,述與王志道等人交游。

參見:1632(3);11/10/1633

(2)

行書《騷經卷》,紙本(《中國目錄》,v.2,51,京1–2195)。北京故宮博物院藏。

(3)

行書《圓悟禪師法語册》,紙本(《中國圖目》,v.3,滬1–1377)。上海博物館藏。

(4)

冒襄輯董其昌書,刻為《寒碧樓帖》(《同人集》卷3,引自《年譜》,228)。

1636 崇禎九年,丙子,八十二歲

正月五日

題楊文驄丙子元日所作紙本墨筆《山水軸》(《鑑影》卷22,14a;《過雲》,畫類5,15a–b;《中國圖目》,v.4,滬1–1979)。上海博物館藏。

二月九日

作《臨右軍三帖卷》,紙本,書《官奴玉潤帖》,臨《墓田丙舍帖》,又倣《絳帖》所刻《洽頭眩帖》。繼書李白五言《古風》"詠魯連"一首(《歐米收藏法書》,明清篇第二卷,nos.1–3)。Freer Gallery of Art。

二月

(1)

訪陳繼儒山齋,偶觀黃公望畫,因作潑墨《倣子久圖軸》,金箋本,自題云并用荊、關遺意(《玉雨》卷3,99;《編年表》,104)。

(2)

小楷書七言律詩"贈陳仲醇徵君東佘山居詩三十首"一册,白宋紙本(《吳越》卷5,30a–34b)。詩見《容詩》卷3,25b–33b)。

三月一日

學《黃庭》、《樂毅》筆意,楷書王羲之《佛遺教經》一册,絹本(《壯陶》卷12,40b–41b)。

三月三日

為陳繼儒作《白石樵真稿序》(《系年》,301–302)。

三月十五日

(1)

楷書自書《勅誥册》,紙本(《中國圖目》,v.3,滬1–1379)。上海博物館藏。

(2)

行書"紫茄詩"四首一卷,紙本(*Christie's*,11/25/1991,no.86。詩見《容詩》卷2,24a–25b)。

三月

(1)

跋韓希孟顧繡《花鳥册》(《上海博物館藏寶錄》,221)。上海博物館藏。

(2)

題仇英青綠鈎金《明皇幸蜀圖卷》,絹本(《吳越》卷4,29a)。

參見:1588(1)

四月一日

伏生過訪,作墨筆《山水扇頁》以贈,金箋本(《自怡》卷22,2b;《中國圖目》,v.3,滬1–1380)。上海博物館藏。

五月

(1)

三題舊作《倣米敷文瀟湘奇境圖卷》,仍為陳貞慧所藏。

參見:四月晦/1634;5/1634(1)

(2)

草書《書論册》,紙本(《槐安》,no.175;《東京國博》,書,no.108)。東京國立博物館藏。

六月三日

題米友仁墨筆《雲山墨戲圖卷》,澄心堂紙本(《墨緣》,名畫卷上南宋,3a–4a;《石續》,養心殿,949)。

六月廿七日

(1)

跋自藏董源淡設色《群峰霽雪圖卷》,絹本(《退菴》卷11,12a–13a;《夢園》卷2,9b–10b;《雪堂》,31a;《董盦》,v.2,no.4;《總合圖錄》,v.3,JM25–002)。日本大原美術館藏。

參見:1633(2)

按:此作似即《鑑影》所載董源《群峰雪霽圖卷》,絹本,見卷2,1a–2a。但董所題前額略異,且爲墨筆,紀年爲丙子六月"七日",或因失記。

又:此跋與《虛齋》所載董再跋董源《夏山圖卷》同,見卷1,12b–13a。疑此再跋本爲《群峰霽雪圖卷》之跋,今大原美術館所藏卷之董跋乃後人臨仿,見6/27/1636(2)。

(2)

再跋自藏之董源《夏山圖卷》。

參見:1632(1); 8/15/1635

按:此跋與初跋所載不符,初跋云得《夏山圖卷》於壬申(一六三二年),此跋則云癸酉(一六三三年),因疑此跋原非爲《夏山圖卷》,而爲董源《群峰霽雪圖卷》之跋,見6/27/1636(1)。

六月

(1)

草書杜甫七言律詩二首於楷書《清淨經册》之後,朝鮮箋本(《秘初》卷15,8a)。

(2)

效蘇體行楷書《謙父詞軸》,宣德紙本,書"壺山居士未老心先懶"詞一首(《吳越》卷5,48a–b)。

夏

行楷自書詩帖一卷,朝鮮箋烏絲闌本(《石初》卷30,50a–b;《編年表》,104;《中國目錄》,v.2,51,京1–2196)。北京故宮博物院藏。

八月十五日

(1)

跋嘉禾戴康侯所藏吳道子設色《五星二十八宿真形圖卷》,絹本(《平生》卷6,9–10;《大觀》卷11,24b;《墨緣》名畫續錄卷下,1a;《爽籟》,v.2, no. 1;《董其昌》, no. 70;《總合圖錄》,v.3, JM3–165)。大阪市立美術館藏。

按:據《平生》與《大觀》,此卷首有八分書署梁令瓚,但董定爲吳道子筆,陳繼儒復定爲閻立本,《大觀》從董。《平生》作張僧繇畫。

(2)

同陳繼儒於天馬山熏塔,作《雪詩軸》,絹本,書"嚴更餘朔雪"五言律詩一首(《夢園》卷13,24a;《編年表》,104。詩見《容詩》卷2,17b–18a,"賦得亂山殘雪後")。

八月

(1)

行書《臨宋四家書卷》,素箋本,臨蔡襄、蘇軾、黃庭堅及米芾四家帖(《盛京》,第三册,26b–28b;《古物》卷2,14a;《編年表》,104)。

(2)

背臨《蘭亭序》一卷,紙本烏絲闌(《念聖》, no. 45)。

九月七日

(1)

作墨筆《細瑣宋法山水卷》,紙本,付子祖京收藏

(《中國圖目》,v.3,滬1–1381)。上海博物館藏。

參見:1633(3)

(2)

憶劉尚書大司空所藏范寬圖軸之筆法,作墨筆《仿范華原山水軸》,鏡面箋本(《大觀》卷19,33b;《編年表》,104)。

九月

題楊文驄賀陳白庵五十壽所作綾本墨筆《山水卷》(《虛齋》卷4,51b–52a;《中國圖目》,v.4,滬1–1978)。上海博物館藏。

按:陳白庵生辰在九月十日,是日吳兆瑩、李瑞和及楊文驄皆賦詩書於畫後,董跋附於卷末。

無月日

(1)

行書《雜詩册》,紙本(《中國圖目》,v.3,滬1–1382)。上海博物館藏。

(2)

背臨鍾繇《還示帖》及《宣示帖》一册,紙本。上海博物館藏。

按:此作與尺牘四通合裝一册。

(3)

題楊文驄《山水册》八對幅(《年譜》,232)。上海博物館藏。

(4)

大行草書題鄭約《倣古山水大册》十二幅,設色墨筆兼有,紙本(《澄懷》卷4,38–39)。

(5)

王鑑訪董於雲間,觀所藏趙孟頫《鵲華秋色圖卷》[見王鑑自跋《倣松雪圖卷》](《退菴》卷18,4a)。

(6)

作墨筆《山水軸》,紙本,(《虛齋》卷8,48b;《編年表》,104)。

董其昌無紀年書畫鑑藏題跋

書

書:倣作

倣王羲之

吳廷贈以館本《十七帖》并索書,爲草書《臨十七帖卷》,綾本,鈐有"太史氏"印(《石續》,養心殿,1072–74;《故宮》卷1, 130–33;《董其昌》, no. 72)。台北國立故宮博物院藏。

過崑山,作"送曹中丞"詩四首,并效王羲之《黃庭經》、《樂毅論》筆意,楷書仲長統《樂志論》,又小楷

書記南都所見諸遂良《老子西昇經》真蹟,又小行書蘇軾題王獻之《鴨頭丸帖》"家鷄野鶩齋登俎"七言絕句,又臨王羲之《行穰帖》,鈐有"太史氏"印。此卷爲宣德鏡光箋烏絲闌本,引首有"山陽真逸"四字,款下亦鈐"太史氏"印(《平生》卷5,54;《石初》卷5,30b–32a。書《樂志論》之自識語又見《容別》卷4,51b)。

按:《穰梨》載董小楷書卷,內容與此全同,但爲絹本,首無"山陽真逸"四字,亦無"太史氏"印,見卷24,10a–11b,待考。

草書臨"得表二口書","敬和在彼","近日東陽絕無書問","陽安送口書","瞻近無緣","夫人遂善平康也","中郎女頗有所向","便大熱","二月廿一日","舊者道意甚慇至","筍侯佳不"及"日月如馳"十二帖一卷,綾本,鈐有"太史氏"印(《鑑影》卷8,1a–2a)。

行書臨"想諸舍悉佳","謝生佳頃大潤","足下各可","又脚舊小服"及"得書知足下"五帖一卷,絹本,鈐有"太史氏"印(《石三》,御書房二,3132–33)。

臨《絕交書》一卷,絹本,鈐有"大宗伯章"印(《愛日》卷2,5a–7b)。

臨帖一卷,綾本(《中國圖目》,v.6,蘇4–009)。常熟市文物管理委員會藏。

行書《蘭亭序》[《臨王帖三種卷》之第三種]。

參見:2/15/1628; 2/25/1628

行書《臨蘭亭軸》,綾本,鈐有"宗伯學士"印(《鑑影》卷22, 1a)。

臨自藏天曆本唐摹《禊帖》一册,絹本,鈐有"知制誥日講官"印(《夢園》卷13,13a–b)。

行書《臨蘭亭序册》,紙本(*Christie's*, 6/1/1989, no. 41)。

大行書臨自藏唐摹《禊帖》一册,紙本(《華亭》, 22)。

學《黃庭》、《樂毅》筆意楷書沈約《高松賦》及梁簡文帝《列燈賦》,後論詩書畫數則,合爲一册,素箋烏絲闌本(《盛京》,第六册,17a–18b。自題語又見《容別》卷4,51b)。

臨吳楨所藏梁摹《樂毅論》一册,高麗箋烏絲闌本(《過雲》,書卷4,12b–13a)。

臨《官奴玉潤帖》,白鏡面紙本(《平生》卷5, 53)。

臨《王略帖》,鏡面紙本(《平生》卷5, 53)。

倣王獻之

閱友人所示宋搨《洛神賦》十三行,遂小行楷書潘岳《秋興賦》一卷,紙本,鈐有"宗伯學士"印(《式古》,v.2,書卷28, 495)。

爲悟軒草書《臨送梨帖》,附書蘇軾所題"家鷄野鶩

Shi-yee Liu Fiedler

同登俎"七言絕句一首[此作附於王獻之《送梨帖真蹟卷》之後]（《墨緣》，法書卷上東晉，4b–5a；《石續》，寧壽宮，2607；《壯陶》卷1，15b）。

倣米芾

爲丕丞大行書臨宋堯武家藏之《天馬賦》一卷，綾本，鈐有"知制誥日講官"印（Christie's, 11/30/1988, no. 75）。

行書臨帖一卷，紙本，鈐有"太史氏"印（Sotheby's, 12/8/1987, no. 72; 11/30/1988, no. 31; 11/26/1990, no. 34）。

背臨《天馬賦》一卷，紙本，鈐有"太史氏"印（《藤花》卷2，24b–25a）。

觀并臨《金山詩帖》一卷，金箋本，鈐有"大宗伯印"（《東京國博》，書，no. 109）。東京國立博物館藏。

行書臨金沙于氏所藏擘窠大字《天馬賦》一卷，紙本，鈐有"大宗伯印"（《古芬》卷7，3a–5a；《眼二》卷8，25a–b）。

行書《西園雅集記長卷》，紙本，鈐有"宗伯學士"印（《夢園》卷13，11a）。

行書《臨天馬賦卷》，紙本，鈐有"宗伯之章"印（《古芬》卷7，6a–7a）。

書大字《天馬賦卷》，紙本（《平生》卷5，56–57）。

背臨擘窠大字《天馬賦》一卷（《壯陶》卷12，10a–11a）。

擬自藏小楷題《破羌》、《謝公》、《蘭亭》三帖詩及書《老子》、竇憲《燕山銘》，行楷書《六朝賦卷》，高麗鏡面箋本，節書"氣霽地表""白羽雖白"及"建章二月火"三賦（《華亭》，5–7）。

臨《破羌帖》并米芾及劉涇詩一卷，鏡光高麗紙本烏絲闌（《華亭》，37–38）。

爲周斗垣臨《龍井記》一卷（《十百》，子卷，3a–b）。

觀唐獻可所藏米書《陰符經》，因臨一卷以贈[見下第七條董自跋《臨米芾向太后挽詞冊》]。

行草書臨《僕射相公帖》一軸，綾本（《澄懷》卷4，15–17）。

行草書臨"蒙書爲慰"帖一冊，紙本，鈐有"知制誥日講官"印（《紅豆》卷6，43a–b）。

汪宗魯出示米芾所臨《爭坐位帖》，因臨一冊，粉箋烏絲闌本，鈐有"宗伯學士"印（《石初》卷11，6b；《故宮》卷3，100。自跋語又見《容別》卷4，62b–63a，文字略有出入）。台北國立故宮博物院藏。

行楷書《孝經冊》，金粟箋烏絲闌本，鈐有"宗伯學士"印（《石初》卷28，23b–24a）。

行書《臨天馬賦冊》，粉箋本，鈐有"宗伯學士"印（《華亭》，25）。

行書臨帖一冊，素箋本，鈐有"大宗伯章"印（《盛京》，第六冊，11b；《古物》卷1，18a）。

唐雲客出示米芾小楷書《向太后挽詞卷》，白鏡面宋紙本，因臨一冊以贈，高麗箋本（《選學》卷中，91–92；《故宮博物院藏歷代法書選集》之十一）。米書與董書今合裝一冊爲北京故宮博物院所藏。

行書臨帖一冊，紙本（《中國目錄》，v.2, 52, 京1–2205）。北京故宮博物院藏。

臨《天馬賦》，紙本[《明賢翰墨冊》十五幅之二至十三]（《故宮》卷3，421）。台北國立故宮博物院藏。

行書米芾題畫詩一冊，灑金箋本（《中國目錄》，v.2, 52, 京1–2204）。北京故宮博物院藏。

行書《琵琶行冊》，繭紙本朱絲闌（《西清》卷1，18b–19a；《盛京》，第六冊，16b–17a）。

行書臨帖[《雜書冊》三段之末]。

參見：2/22/1628

背臨《天馬賦》（《容別》卷5，6a–b；《畫禪》卷1，15）。

以褚遂良法楷書臨米芾書《燕然山銘》（《平生》卷5，59）。

書杜甫"驄馬行"及"醉歌行"二詩（《朱臥》，115）。

倣宋高宗

臨大字"挂鏡臺西挂玉籠"七言絕句，縮爲小字（《好古》卷上，21–22）。

倣柳公綽

楷書臨裴度文一軸，赤箋本（《大觀》卷9，38b）。

大楷書《武侯廟碑》[見張照自跋臨董此作]（《天瓶》卷下，5b；《天補》，8b）。

倣李邕

臨《大照禪師塔銘》一卷，白鏡面箋本，鈐有"太史氏"印（《墨緣》，法書卷下明，15b–16a）。

按：《石隨》亦載董《臨李北海大照禪師塔銘卷》，未知是否爲一作，見卷6，2a–b。

以李邕、徐浩筆法行書《嚴君平傳卷》，繭紙本，鈐有"太史氏"印（《式古》，v.2, 書卷28, 493）。

書杜甫"飲中八仙歌"一卷（《朱臥》，109）。

行書宋詞三闋一冊，朝鮮牋本（《石初》卷11，7a–b）。

按：此作似即《吳越》所載《倣李北海體書洞庭、西湖、春景詞卷》，惟爲宣紙本，且非冊，待考。見卷5，66a–67a。

行書節臨《大智禪師碑》，紙本扇頁（《中國圖目》，

v.1, 京12–048）。北京市文物商店藏。

倣《大照禪師碑》書《燕然山銘》（《好古》卷上，27）。

倣徐浩

楷書臨《淳熙秘閣續法帖》所刻《張九齡告身》一卷，絖本，鈐有"知制誥日講官"印（《槐安》，no. 170；《書道藝術》卷8，144–51；《東京國博》，書，no. 106；《董其昌》，no. 76）。東京國立博物館藏。

以李邕、徐浩筆法行書《嚴君平傳卷》，繭紙本，鈐有"太史氏"印（《式古》，v.2, 書卷28, 493）。

爲禹修楷書《詩經》"斯干之什"一軸，紙本，鈐有"宗伯學士"印（《石三》，延春閣廿六，2067；《故宮》卷2，18）。台北國立故宮博物院藏。

楷書杜甫"謁玄元皇帝廟"五言古詩一軸，屑金紙本（《石三》，乾清宮十一，576；《故宮》卷2，15–16）。台北國立故宮博物院藏。

以徐浩《道德經》筆意，兼用顏真卿法，楷書儲光義"田家雜興"五言古詩一軸，宣德箋本（《石初》卷37，11b–12a）。

倣索靖

臨項元汴所藏草書《出師頌》一卷，綾本，鈐有"知制誥日講官"印（《石三》，延春閣廿六，2063）。

按：董曾題項元汴所藏索靖章草《出師頌》，題語與此作自題全同，或臨後昔日題語亦重書一過，見《式古》，v.1, 書卷6, 285。

倣張旭

參合懷素與張旭筆勢，草書懷素《自敘帖》一卷，綾本，鈐有"太史氏"印（《夢園》卷13，12a）。

草書《臨郎官壁記卷》（《石續》，養心殿，1075；《歐米收藏法書》，明清篇第二卷，nos. 4–7；《董其昌》，no. 93）。Detroit Institute of Arts。

按：此卷《石續》作綾本，《歐米收藏法書》作紙本，《董其昌》作絖本，待考。

楷書《臨郎官壁記軸》，紙本，鈐有"宗伯之印"（《石續》，乾清宮，442；《故宮》卷2，13；《董其昌》，no. 74）。台北國立故宮博物院藏。

楷書《臨郎官壁記軸》，鈐有"宗伯學士"印（《貞松》卷中）。中國羅振玉舊藏。

倣黃庭堅

臨尺牘一通[見張照自題臨董此書]（《天補》，10a）。

倣《黃庭經》

參合《內景》筆法，楷書《黃庭經卷》，宣德黃表箋本

538

《大觀》卷9,40b;《秘初》卷16,28b–29a)。

書《黃庭內景經卷》(《眼初》卷5,14a)。

行書《黃庭內景經冊》,紙本烏絲闌,鈐有"知制誥日講官"印(《古芬》卷7,34a–b)。

背臨《黃庭外景經》一冊,朝鮮鏡光箋本(《秘初》卷15,6a–b)。

書《臨黃庭內景經冊》(《虛舟》卷8,18)。

按:此冊後失五頁,由韓逢禧補書。

書《黃庭內景經冊》,鏡面箋本(《平生》卷5,52–53)。

摹韓世能所藏楊羲黃素《黃庭經》(《清河》卷一下,7–8)。

倣楊凝式

行書杜甫"高都護驄馬行"及"送孔巢父"二詩一卷,絹本,鈐有"知制誥日講官"印(《古芬》卷7,14a–b)。

行書《倣步虛詞卷》,綾本(《中國圖目》,v.6,蘇8–022)。南通博物苑藏。

臨《大仙帖》一卷(《天瓶》卷上,9a–b)。

臨《楊風帖》[見張照跋此作](《天瓶》卷上,9a)。

倣虞世南

行書節書仲長統《樂志論》"蹲蹰畦苑"至"出乎宇宙之外"一段,綾本手卷,鈐有"知制誥日講官"印(《鑑影》卷8,2b)。

參合虞世南與褚遂良筆法,楷書《千字文冊》,金箋本(《中國圖目》,v.8,晉I–023)。山西省博物館藏。

臨《汝南公主墓誌銘》,并論虞世南《夫子廟堂碑》及褚遂良書一冊,鏡面紙本(《平生》卷5,53–54)。

楷書儲光羲"梧桐蔭我門"五言古詩一冊,紙本[附於董《樂志論冊》之後]。

參見:3/1617(1)

倣趙孟頫

蠅頭小楷書《舞鶴賦》等二篇一卷,紙本(*Sotheby's*, 6/2/1987, no. 29)。

倣褚遂良

臨《枯樹賦》一卷,綾本,鈐有"宗伯學士"印(《筆嘯》卷下,62b)。

臨《枯樹賦》一卷[見張照跋此卷](《天瓶》卷上,6b–7a。又見《天補》,6a–b)。

小楷書《臨黃庭經卷》(《過雲》書卷4,12a–b)。

按:此卷後有陳繼儒跋云董爲項子蕃臨。

臨自藏《摹蘭亭序》一冊,紙本,鈐有"太史氏"印(《古芬》卷7,39a–40a;《眼初》卷5,17a–b)。

臨《摹蘭亭詩叙》及其後米芾跋語一冊,高麗牋本。後重題寄贈汪宗魯,鈐有"太史氏"印(《石續》,寧壽宮,2839–40)。

觀《枯木賦》,取其筆意行書王粲《登樓賦》一冊,紙本,鈐有"宗伯學士"印(《劍花》,上卷,30;*Christie's*, 6/1/1989, no. 42)。

臨《唐賜本蘭亭序》一冊,紙本,鈐有"宗伯學士"印(《藤花》卷3,21b–22a)。

參合虞世南與褚遂良筆法,楷書《千字文冊》,金箋本(《中國圖目》,v.8,晉I–023)。山西省博物館藏。

以褚遂良法臨米芾楷書《燕然山銘》(《平生》卷5,59)。

倣鍾繇

小楷書臨《洞庭》及《力命》二帖[《倣洞庭、力命、玉潤三帖冊》之前二段]。

參見:10/13/1608

臨《宣示表》一冊,鏡面光紙本(《壯陶》卷12,14a–b)。

倣顏真卿

行書節臨《送劉太沖序》并蘇軾跋語一卷,紙本,鈐有"大宗伯印"[行楷書《詩卷》之後段]。

參見:8/7/1609

爲白陽楷行書臨王世懋家藏《贈裴旻將軍詩真蹟》一卷,綾本,鈐有"宗伯學士"印(《澄懷》卷4,27–28)。

以《送劉太沖序》及《贈裴將軍詩》筆意書《爭坐位帖卷》,素絹本,鈐有"宗伯學士"印(《華亭》,38–39)。

行書《臨爭座位帖卷》,綾本(《中國圖目》,v.1,京I–034)。北京故宮博物院藏。

大楷書《倪寬傳贊卷》,素絹本(《石初》卷30,49b–50a;《三希》,第三十一及三十二冊,2206–2401;《董其昌》,no. 91)。

行楷書背臨《鼎帖》所刻"昔在平原"至"蔡明遠"一段一卷,黃蠟箋本(《十百》,卯卷,24b–25a)。

臨《爭坐位帖》及《送劉太沖序》一卷贈茂芝孫婿,鏡面箋本(《朱臥》,116)。

臨《送蔡明遠序》一卷[見張照跋此卷](《天瓶》卷上,8a)。

行書陳子昂"奉和皇帝圜丘禮撫事述懷應制"五言古詩一軸,素箋本,鈐有"太史氏"印(《大觀》卷9,39b;《石三》,延春閣廿六,2066;《故宮》卷2,13–14)。台北國立故宮博物院藏。

節書《郎官壁記》一軸,黃箋本,鈐有"宗伯之章"印(《石初》卷37,8a;《故宮》卷2,14–15)。台北國立故宮博物院藏。

楷書鮑照五古"盧山詩"一軸,宣紙本,鈐有"宗伯之章"印(《石三》,靜宜園,4092)。

節臨《送劉太沖序》六句一軸,素箋本,鈐有"宗伯學士"印(《石初》卷7,3b)。

楷書《臨告身帖軸》,黃描金箋本,鈐有"青宮太保"印(《石初》卷37,7b;《故宮》卷2,15;《董其昌》,no. 75)。台北國立故宮博物院藏。

行書節臨《送劉太沖序》一軸,黃箋烏絲闌本,鈐有"青宮太保"印(《石初》卷37,11b;《故週》,v.72,1)。故宮博物院藏。

行書班固"寶鼎歌"一軸,綾本(《中國圖目》,v.3,滬1–1430)。上海博物館藏。

楷書蕭嵩"奉和聖製送張説上集賢學士賜宴"五言排律一軸,素絹本(《石初》卷37,11a–b)。

臨《自書告身》一軸,高麗鏡面牋本(《石續》,淳化軒,3319)。

以徐浩《道德經》筆意,兼用顏真卿法,楷書儲光羲"田家雜興"五言古詩一軸,宣德箋本(《石初》卷37,11b–12a)。

楷書《臨八關齋會記冊》,宣德鏡光箋烏絲闌本,鈐有"青宮太保"印(《石初》卷3,24b–25a)。

行書《臨送劉太沖序》[《元明書翰》七十六冊之五十五(即辛一冊)後四對幅,蠒紙本](《石三》,延春閣四十,2624;《故宮》卷3,348)。台北國立故宮博物院藏。

按:此冊前四對幅爲行書"秋日泛泖"七言律詩,紙本。詳見《容詩》卷3,39b。

楷書《詩扇》,書杜甫"飲中八仙歌"七言古詩一首[《集明人小楷扇冊》十二幅之九](《聽颺》卷4,301)。

書《高皇帝瑞光塔贊》,璽紙本(《朱臥》,116)。

倣懷仁

臨《聖教序》一卷,白鏡面箋本(《墨緣》,法書卷下明,15b)。

行楷書《臨聖教序冊》,素箋本,鈐有"宗伯學士"印(《石初》卷3,24a)。

爲陳增城行書《臨聖教序扇》,紙本(*Christie's*, 11/30/1988, no. 208)。

539

倣懷素

草書《聖母帖》并旁釋小楷一卷,素箋本,鈐有"知制誥日講官"印(《秘初》卷16,29a–b)。

觀《自敘帖》,狂草書倣六句一卷,絹本,鈐有"太史氏"印(《槐安》,no. 172;《書跡名品叢刊》之《董其昌集2》;《董其昌》,no. 95)。東京國立博物館藏。

參合懷素與張旭筆勢,草書《自敘帖卷》,綾本,鈐有"太史氏"印(《夢園》卷13,12a)。

行草書《臨聖母帖卷》,紙本,鈐有"太史氏"印(*Christie's,* 12/4/1989, no. 186 及 5/29/1991, no. 45)。

草書《臨自敘帖卷》,綾本,鈐有"宗伯學士"印(*Hanart Gallery Exh.,* no. 18)。

草書節臨《自敘帖》一卷,綾本,鈐有"宗伯學士"印(《石三》,延春閣廿六,2063)。

行草書宋之問五言律詩二首一卷,金箋本(《中國圖目》,v.1,京5–236)。北京首都博物館藏。

按:此卷前有行草書杜甫"同諸公登慈恩寺塔"及高適二詩,合稱《唐詩卷》。

草書"放歌行"及"野田黃雀行"二詩一卷,絹本(《中國圖目》,v.3,滬1–1420)。上海博物館藏。

草書《臨自敘帖卷》,綾本(《中國圖目》,v.3,滬1–1427)。上海博物館藏。

崑山道中舟次,草書白居易"琵琶行"一卷,紙本。同觀者陳繼儒、夏文學、莊山人及孫太學(《董其昌》,no. 92)。

草書五言古詩三首一卷,素絹本(《石初》卷31,22b–23a)。

草書節臨《自敘帖》一冊,綾本,鈐有"宗伯學士"印(《澄懷》卷4,25–26)。

行書釋《聖母碑》一冊,宣德牋本(《石續》,淳化軒,3309–10)。

行書《自敘帖扇頁》,金箋本(《中國目錄》,v.2,52,京1–2235)。北京故宮博物院藏。

書古詩"詠貧士"一卷(《朱臥》,116)。

書"醉翁操"(《朱臥》,116)。

書"牡丹"諸詩一卷,綾本(《朱臥》,116)。

臨《聖母帖》并旁釋文[石刻本附於宋元祐戊辰刻懷素《聖母帖》之後](《清儀》,88b–89a)。

倣蘇軾

行楷書《臨養生論卷》,綾本,鈐有"知制誥日講官"印(《吳越》卷5,70a–b)。

行書節書孫虔禮《書譜》一卷於寶鼎齋,鈐有"太史

氏"印[此書附於董《倣郭忠恕山水卷》後]。

參見:春/1603

行草書臨《跋黃泥坂詞》及蘇庠詩并跋一卷,素絹朱絲闌本,鈐有"太史氏"印(《石初》卷5,30b)。

書"深秋詩"一卷(《朱臥》,116)。

行書杜甫"飲中八仙歌"一卷,鏡光紙本(《寓意》卷4,33b)。

行書"可使食無肉"五言古詩一軸,綾本,鈐有"知制誥日講官"印(《故週》,v.502,3)。故宮博物院藏。

行書臨《承天寺夜游帖》及《懷賢閣詩帖》,素箋本,鈐有"宗伯學士"印[《臨蘇軾三帖冊》之二及三]。

參見:秋/1632(4)

臨札一冊,紙本烏絲闌,鈐有"宗伯學士"印(《古緣》卷5,32a)。

按:據《古緣》,此冊首有小楷書"臨蘇黃米蔡帖"六字,乃臨宋四家書,僅存此冊臨蘇軾。

吳門吳性中出示蘇氏父子六帖,因行書《臨蘇氏六帖冊》,紙本,臨蘇軾《與米玉提刑札》、《又與忠玉提刑札》、《與廷平郭君札》、《記蘇秀才遺蘉硯》與《獻蠔帖》,及蘇過"題郭熙平遠"六言絕句三首(《石三》,延春閣廿六,2055–56;《故宮》卷3,109–10;《董其昌》,no. 77)。台北國立故宮博物院藏。

按:此作未紀年,但董一六一四年十月曾題吳性中所藏此冊,或書於此前後。見10/1614(2)。

又:《過雲》亦載董《臨東坡叔黨父子帖冊》,缺其中《與廷評郭君札》及《獻蠔帖》,待考。見書卷4,13a–b。

從邢侗得觀"遊仙"、"招隱"諸詩墨蹟,行書背臨一冊,紙本烏絲闌(《壯陶》卷12,44a)。

按:邢侗卒於一六一二年,故應書於此年之前。

臨自藏"爲呂夢得作五言偈""論張旭與王羲之書"及七言古詩"真一歌"三帖,鏡面箋本[見張照《臨董其昌臨蘇軾雜帖卷》](《石續》,寧壽宮十五,2921)。

倣諸家

臨懷仁《聖教序》、顏真卿《爭坐位帖》及懷素《自敘帖》一卷,綾本,鈐有"知制誥日講官"印(《夢園》卷13,9a–b)。

行書《倣宋四大家書卷》,紙本。倣蘇軾文、黃庭堅七言絕句、米芾五言律詩及七言絕句各一首、蔡襄七言絕句,鈐有"大宗伯章"印(*Christie's,* 6/24/1983, no. 673; *Images of the Mind,* no. 26)。John B. Elliott Collection。

行楷書《臨宋四大家書卷》,朝鮮牋本。臨蘇軾書三則、黃庭堅、米芾、蔡襄各一則,鈐有"宗伯學士"印(《石初》卷13,63a–b)。

楷書《臨唐人四家書卷》,後行書蘇詩,白鏡面箋烏

絲闌本。一臨徐浩至德、廣德間《恩制》一段,二節臨褚遂良《唐文皇哀冊》,三臨薛稷《杳冥君之銘》中"悠悠洛邑"四言詩,四節臨歐陽詢《九成宮醴泉銘》。後行書蘇軾"和子由論書"五言古詩,紙本(《墨緣》,法書卷下明,14b–15b及16b;《玉雨》卷3,92;《壯陶》卷12,24b–26a;《中國圖目》,v.1,京12–047)。北京市文物商店藏。

按:此卷如《墨緣》所載,原屬二作,後合併爲一。

行書臨蘇軾書五則及黃庭堅書三則一卷,宣德鏡光牋本(《石初》卷24,6a–b;《故宮》卷1,135)。台北國立故宮博物院藏。

爲高懸圃作《臨古帖卷》,宣德箋本。臨鍾繇《還示帖》、王羲之《禊帖》、《奉橘》等數帖,褚遂良《枯木賦》、歐陽詢、李邕行書、顏真卿《爭座位帖》、《送劉太沖序》及尺牘,楊凝式行草《神仙起居法》(并行書釋文)、蘇軾、米芾行書(《三松》,37a–38a;《中國圖目》,v.6,蘇1–131)。蘇州博物館藏。

作《雜書卷》,金箋本。楷書節臨《孝女曹娥碑》,行書顏真卿祭文,蘇軾"天際烏雲含雨重"及"瘦骨何堪玉帶圍"七言絕句二首,又爲君一行書雜記八則(《中國圖目》,v.1,京5–237)。北京首都博物館藏。

爲孫董廣行書《臨蘇黃米蔡帖卷》,綾本,書七言絕句十首(《中國目錄》,v.2,52,京1–2227)。北京故宮博物院藏。

行書《臨古帖卷》,紙本。臨顏真卿《爭坐位帖》、李邕《大照禪師碑》與《荆門行》、羊欣《移居帖》(*Sotheby's,* 6/3/1985, no. 24)。

作《晉唐諸家卷》,白鏡面箋本。楷書《洛神賦》與《景福殿賦》,又草書《臨王羲之十七帖》并小行楷釋文(《墨緣》,法書卷下明,13b)。

參見:秋九日/1608

行楷書背臨《黃庭外景經》、顏真卿《爭坐位帖》及李邕書"仲夏萌生早"詩,紙本[《臨黃庭經各種冊》十二段之首、九及末段](《古緣》卷5,21b–24b)。

按:此作惟首二段紀年,見6/1/1632(2)

又:此作原屬冊,後改裝卷。

臨懷素"寄邊衣詩"及張旭不全《千文》一卷(《好古》卷上,27)。

爲悟軒行書記前人真蹟墨刻二十餘種,并臨王獻之《送梨帖》及蘇軾詩一卷,紙本(《平生》卷5,56)。

作《倣唐宋諸家法書真蹟卷》,綾本。臨蘇軾《記遊》與"題塵隱居"五言律詩三首、懷素《自敘帖》、蔡襄并黃庭堅詩帖,及蔡襄尺牘(《夢園》卷13,1a–4b)。

小楷行書《臨古帖卷》,紙本。臨《黃庭經》、王羲之《玉潤帖》、虞世南《汝南誌》、褚遂良《枯樹賦》及顏真卿《爭坐位帖》(《壯陶》卷12,33b–34a)。

楷書臨歐陽詢《實際禪師碑》及謝安《告淵朗帖》,紙本,鈐有"大宗伯印"[《元明書翰》七十六冊之二

十六(即丁三冊)〕(《石三》,延春閣三十九,2595;《故宮》卷3,309)。台北國立故宮博物院藏。

廣陵舟次,客出示《寶賢堂帖》,爲行楷書《臨諸家帖冊》,朝鮮箋烏絲闌本。臨顏真卿書四則、蔡襄二則、蘇軾、黃庭堅及米芾各一則,鈐有"宗伯學士"印(《石初》卷10,57a–58b;《選學》卷中,95;*Sotheby's*, 12/8/1987, no. 6 及 5/30/1990, no. 36)。

楷書臨吳正志所藏柳公權小楷《清靜經》并書顏真卿《宋廣平神道碑側記》一冊,朝鮮箋本,鈐有"宗伯學士"印(《秘初》卷15,8a–b)。

臨《還示帖》、《蘭亭叙》、《十七帖》、《辭中書令》及《歸田賦》五則一冊,紙本,鈐有"宗伯學士"印(《劍花》,上卷,32)。

作《雜書冊》〔一名《臨晉唐法書冊》〕六段,宣德牋烏絲闌本。一行楷書《陰符經》,二臨自藏宋搨不全本《黃庭經》,三臨王羲之書《樂毅論》,四臨顏真卿《乞米帖》及楊凝式《韭花帖》,五臨顏真卿《爭座位帖》,六臨懷素《律公》、《脚氣》二帖并周越跋(《墨緣》,法書卷下明,12b–13a;《石續》,寧壽宮,2836–39;《故宮》卷3,115–19;《編年表》,101;《董其昌》,nos. 58 及 59)。台北國立故宮博物院藏。

按:此冊僅第一段紀年,見6/18/1626

行書《雜書冊》四段,素箋本。一臨吳琚,二書《蜀四賢詠》,三及四擬李邕"洞庭詞"及"春景詞"(《石初》卷43,1a–2b;《故宮》卷3,120–21;《編年表》,96)。台北國立故宮博物院藏。

按:此冊首段臨吳琚書紀年爲"辛亥四月廿六日",第二段則署"季秋朔日書,"未知是否作於同一年。見4/26/1611。

作《刻鵠不成小冊》二本,鏡面紙本。前本做鍾繇、王羲之、王獻之小楷,後本倣唐人楷書及宋人小行書(《平生》卷5,53)。

按:此冊前本似即台北國立故宮博物院所藏《臨鍾王帖冊》。見寒食後七日/1608。

避暑李氏山房,行楷書《臨晉唐諸帖冊》,分臨鍾繇、王羲之、王獻之、嵇康、褚遂良、顏真卿及楊凝式書。香港北山堂藏。

作《雜書冊》。前臨顏真卿《大唐中興頌》、鍾紹京《遁甲神經》及吳正志所藏宋搨柳公權小楷《清靜經》,高麗箋本。後四幅行書《戲鴻堂帖》跋尾草稿四段,論新都汪宗孝家藏謝莊書,文嘉所摹索靖《出師頌》、鍾繇及索靖書、唐摹王羲之之真迹,素箋本(《石續》,乾清宮,434–37。臨鍾及柳之自跋又見《容別》卷5,20b–21b)。

按:此冊前段似即《天瓶》所載《臨唐人書四種》,見卷上,9a及《天補》,13b–14a。

作《便面書冊》十幅,第一及六幅素箋本,餘俱金箋本。一行書臨虞世南《汝南誌》,二爲孟博楷書《道德經》六則,三行楷書杜甫七言律詩一首,四行楷書五言律詩一首,五行草書《說部》一則,六楷書杜甫"華清宮"五言古詩於虎波塘舟中,七行書五言律詩一首,八做楊凝式行書五言古詩一首,九遊善權,爲復陽行草書五言律詩一首,十行草書七言律詩一首(《石初》卷28,42b–43b)。

按:此冊僅第一、二及六幅紀年,見5/1633(2);9/1625(1);9/15/1625

作《楷書四種冊》,鏡光紙本。書鍾繇《宣示帖》、褚遂良《家姪至帖》、陸機《文賦》,又做楊凝式行書《登樓賦》(《寓意》卷4,28b–29a)。

參見:2/1/1583;3/16/1621

臨懷仁《聖教序》及韓世能所藏徐浩真蹟一冊,素箋本(《石初》卷3,35b)。

臨虞世南、褚遂良、張旭、顏真卿、懷素、蘇軾、黃庭堅、米芾、蔡襄、王羲之、王獻之、索靖《出師頌》、懷仁《聖教序》及李邕書一冊,紙本(《石三》,延春閣廿六,2050–55)。

作《臨蔡蘇黃米帖冊》,宣紙本。臨蔡襄尺牘一則、中州俞中舍家藏蘇軾書《養生論》真蹟、黃庭堅"贈東坡"五言古詩,米芾"揚清歌,發皓齒"歌行及"絃歌興罷拂衣還"七言絕句(《吳越》卷5,64b–66a)。

臨王獻之五帖及王羲之一帖一冊,金箋本(《玉雨》卷3,95)。

行書臨蘇軾及米芾書一冊,紙本(《穰梨》卷24,11b–13a)。

行書杜甫五言律詩八首,白綾本,做蘇軾、黃庭堅、米芾、蔡京四家書各二首(《平生》卷5,55–56)。

各做本家筆,書黃庭堅寄蘇軾詩二首及蘇軾次韻答二首〔見張照自題臨董書此作〕(《天補》,1b–2a)。

做古帖

行書臨《潭帖》六則一卷,素絹本,鈐有"太史氏"印(《盛京,第三冊》,28b–29a;《古物》卷2,13b–14a)。

按:此作似即《天瓶》所載董《臨潭帖》,見卷上,9b。

臨《潭帖》一卷,每段并小楷釋文(《好古》卷上,27)。

行書節臨吳瑞生所藏晉帖呈嘉賓,宣德鏡光箋本〔做古三種冊〕之第二種(《石初》卷10,56a–b;《故宮》卷3,126–27)。台北國立故宮博物院藏。

補書《大觀帖》首卷〔見董題陳鉅昌刻《大觀帖》〕(《容別》卷5,21b–22a;《好古》卷上,15;《叢帖目》,第一冊,78)。

書:自作

卷

試高麗筆,書唐人"萬壑樹參天"五言詩一卷,紙本,鈐有"知制誥日講官"印(《虛續》卷2,72a–b)。

按:董書後有趙左一六一一年秋爲補圖,故應書於此前。

楷書《太學澹菴吳君墓表卷》,鏡面紙本,後衘"編修日講官"(《平生》卷5,60。文見《容文》卷9,26a–28a)。

大行書《呂祖詩卷》,綾本。書"西鄰已富憂不足"七言絕句,鈐有"知制誥日講官"印(《華亭》,9–10)。

雜書《禪偈歌詩卷》,紙本,鈐有"知制誥日講官"印(《吳越》卷5,76a–77a)。

草書杜甫"不見旻公三十年""劍外忽傳收薊北"及"宓子彈琴邑宰日"七言律詩三首一卷,綾本,鈐有"知制誥日講官"印(《石三》,延春閣廿六,2062)。

行書《論書卷》,絹本,鈐有"知制誥日講官"印(《辛丑》卷5,48–51)。

行書《詩卷》於佘山,綾本。書"窪盈軒畫爲重拈"七言古詩,鈐有"知制誥日講官"印(《聽續》卷下,608–609)。

草書杜甫"送孔巢父""題畫鶴""寄懷旻公"及"春宿左省"四詩一卷,綾本,鈐有"知制誥日講官"印(《古芬》卷7,12a–b)。

行書《詩卷》於青溪道中,綾本。書唐人"慈恩塔"五言古詩又五言絕句一首,鈐有"知制誥日講官"印(《夢園》卷13,8a)。

草書蘇軾"大江東詞"一卷,綾本,鈐有"知制誥日講官"印(《古緣》卷5,27a)。

大行書《昆吾洲記卷》,綾本,鈐有"知制誥日講官"印(《古緣》卷5,26b–27a)。

書《詩卷》二段,綾本。前草書唐人"掛席幾千里"及"屋上春鳩鳴"五言古詩二首,後行草書"題東佘山居圖"七言律詩三首,鈐有"知制誥日講官"印(《古緣》卷5,27a–28a)。

書《容齋隨筆卷》,絹本,鈐有"知制誥日講官"印(《藤花》卷2,26b)。

行書書法故事五則一卷,綾本,鈐有"知制誥日講官"印(《劍花》,上卷,25)。

草書杜甫"高都護驄馬行"古詩一卷,素絹本,鈐有"太史氏"印(《石初》卷31,24b;《故宮》卷1,137–38)。台北國立故宮博物院藏。

行書道家故事二則一卷,綾本,鈐有"太史氏"印(《劍花》,上卷,23;*Christie's*, 12/1/1986, no. 45)。

草書《畫馬篇》一卷,絹本,鈐有"太史氏"印(*Christie's*, 6/5/1985, no. 28)。

行草書"魏將軍歌"七言古詩一卷,綾本,鈐有"太史氏"印(*Christie's*, 5/31/1990, no. 95)。

行書《蘭花詩卷》,紙本,鈐有"太史氏"印(*Sotheby's*, 5/30/1990, no. 37)。

行楷節書孫虔禮《書譜》并論蘇軾書一卷於寶鼎齋，鈐有"太史氏"印[此作附於《倣郭忠恕山水卷》後，合裱爲一卷]。

參見：春/1603

行書白居易樂府一卷，朝鮮鏡光箋烏絲闌本，鈐有"太史氏"印（《石初》卷30，48a-b）。

行書陶潛"弱齡寄事外""行行循歸路"及"在昔聞南畝"五言古詩三首一卷，綾本，鈐有"太史氏"印（《十百》，丁卷，15b-16a）。

行楷書《論書卷》，魚子箋本，鈐有"太史氏"印（《十百》，辰卷，8b-9a）。

行書"唐人有詩云"至"故自佳"一卷，絹本，鈐有"太史氏"印（《十百》，巳卷，9b-10a）。

行書王安石"金陵懷古詞"一卷，絹本，鈐有"太史氏"印（《辛丑》卷5，47-48）。

行書《贈陳仲醇徵君東佘山居詩卷》，綾本。書"歸然耆舊表江南""名僧會裏事瞿曇""無限離離壓杞楠"及"元味曾同草木參"七言律詩四首，鈐有"太史氏"印（《鑑影》卷8，9b-10a。詩見《容詩》卷3，25b-27a，"贈陳仲醇徵君東佘山居詩三十首"之一、四、五及六首）。

行書"後赤壁詞"一卷於青溪道中，絹本，鈐有"太史氏"印（《古芬》卷7，27a-28a）。

草書"蘭花詩"二首一卷，綾本，鈐有"太史氏"印（《古芬》卷7，20a-b）。

行書黃庭堅《論文》一則，紙本，鈐有"太史氏"印[《明仇十洲畫魚·董文敏公書合卷》之後段]（《古芬》卷15，87a-b）。

小楷書杜甫"秋興八首"七言律詩一卷，綾本，鈐有"太史氏"印（《愛續》卷2，13a）。

行書杜甫"立春日曉望三秦雲""秋日""南至日太史登書臺書雲物"及"蚤登太行山中言志"四詩一卷，紙本，鈐有"太史氏"印（《劍花》，上卷，22-23）。

行草書蘇軾和友人七言古詩一卷，絹本，鈐有"侍讀學士"印（《東京國博》，書，no.110）。東京國立博物館藏。

行書《太傅許文穆公墓祠記卷》，紙本，鈐有"宗伯學士"印（《中國目錄》，v.2，52，京I-2224。文見《容文》卷4，48a-49b）。北京故宮博物院藏。

楷書"早朝詩"二首一卷，宣德鏡光箋本，鈐有"宗伯學士"印（《石初》卷13，63b-64a；《故宮》卷1，138）。台北國立故宮博物院藏。

行書《佛語卷》，綾本。書"南無多寶如來妙法蓮華經院，"鈐有"大宗伯印"（《故宮》卷1，139）。台北國立故宮博物院藏。

按：此作無款。

行書《李康義傳卷》，紙本，鈐有"宗伯學士"印（《中國圖目》，v.3，滬I-1418）。上海博物館藏。

行書節書孫虔禮《書譜》一卷，紙本，鈐有"宗伯學士"印（《中國圖目》，v.3，滬I-1421）。上海博物館藏。

行草書李白"日照錦城頭"及"蜀國多仙山"五言古詩二首一卷，綾本，鈐有"宗伯學士"印（《鑑影》卷8，2a-b；《書道藝術》卷8，134-39）。東京都書道博物館藏。

行書蘇軾"畫王定國所藏煙江疊嶂圖"七言古詩一卷，鈐有"宗伯學士"印（《總合圖錄》，v.2，S8-025）。香港至樂樓藏。

按：此作現與吳彬絹本著色《煙江疊嶂圖》裱爲一卷。

行草書李白《採蓮曲》及《烏夜啼》樂府二首一卷，綾本，鈐有"宗伯學士"印（*Christie's*，12/1/1986，no.46）。Freer Gallery of Art。

行楷書白居易"琵琶行"一卷，高麗賤本，鈐有"宗伯學士"印（《董其昌》，no.78）。

行書詩五首一卷，綾本，鈐有"宗伯學士"印（*Christie's*，5/31/1990，no.59）。

行草書"滄池漭沆帝城邊"等詩數首一卷於青溪道中，紙本，鈐有"宗伯之章"印（*Christie's*，5/29/1991，no.40）。

三月九日見桃花，因行書唐人"廣陵三月花正開"等絕句數首一卷，綾本，鈐有"宗伯學士"印（*Sotheby's*，11/25/1991，no.22）。

行書《明故光祿寺署丞隱泉李君行狀卷》，綾本，鈐有"宗伯學士"印（《穰梨》卷24，8a-10a；《萱暉》，書157b-158a）。程琦舊藏。

撰并行楷書《吳氏修墓記卷》，宣紙朱絲闌本，書《誥贈許氏宜人祖母墓誌》，鈐有"宗伯學士"印（《十百》，申卷，17a-19a）。

按：此作款識有"翰林院侍讀學士詹事府少詹事"等官銜，應書於一六三一年之後。

行書《世説新語》三則、張九齡《白羽扇賦》、唐明皇批荅一卷，宣德泥金箋本，鈐有"宗伯學士"印（《石初》卷13，62b-63a）。

行書"半月臺"及"登太白峰"五言古詩二首一卷，綾本，鈐有"宗伯學士"印（《石三》，御書房二，3136）。

行書杜甫"醉歌行"一卷，綾本，鈐有"宗伯學士"印（《石三》，養性齋，3258）。

書"次韻葉少師父子贈行詩"五首一卷，綾本，鈐有"大宗伯章"印（《筆嘯》卷下，62b）。

書《唐人早朝二詩卷》，綾本。書"絳幘鷄人報曉籌"及"銀燭朝天紫陌長"七言律詩二首，鈐有"宗伯學士"印（《壯陶》卷12，20b-21b）。

行書《雜言卷》，綾本，鈐有"宗伯學士"印（《壯陶》卷11，49b-51a）。

行楷書《王公弼誥卷》，素箋本（《石初》卷31，24b-25a）。

按：此作款識有"禮部尚書"官銜，應書於一六二五年後。

行書"題武夷山圖詩"等一卷，紙本（《石隨》卷6，1a-2a）。

按：此作所用朝鮮進表鏡面紙上有"天啓六年閏六月十五日朝鮮國王李倧所進表"文，故應作於一六二六年閏六月十五日之後。

行楷書《淮安府潘路馬湖記卷》，朝鮮鏡光賤烏絲闌本（《墨緣》，法書卷下明，16b-17a；《石初》卷24，4b-5a；《中國目錄》，v.2，52，京I-2219）。北京故宮博物院藏。

行書尺牘，紙本（《中國圖目》，v.1，京I-061-11）。北京故宮博物院藏。

楷書《朱泗夫婦墓誌銘卷》，紙本（《中國目錄》，v.2，52，京I-2218）。北京故宮博物院藏。

楷書謝莊《月賦》一卷，紙本（《中國目錄》，v.2，52，京I-2220）。北京故宮博物院藏。

行書《倪寬傳贊卷》，絹本（《中國目錄》，v.2，52，京I-2223）。北京故宮博物院藏。

行書《瓠子歌卷》，紙本（《中國目錄》，v.2，52，京I-2225）北京故宮博物院藏。

行楷書《金陵懷古詩卷》，絹本（《中國目錄》，v.2，52，京I-2221）。北京故宮博物院藏。

行書《馮青方先生八十壽卷》，紙本（《中國目錄》，v.2，52，京I-2226）。北京故宮博物院藏。

行書《麻姑仙壇記》，紙本[董其昌·陳繼儒《書畫合璧卷》之書幅]（《中國圖目》，v.3，滬I-1390）。上海博物館藏。

行書《呂巖詩卷》，紙本（《中國圖目》，v.3，滬I-1419）。上海博物館藏。

行書《燕然山銘卷》，綾本（《中國圖目》，v.3，滬I-1426）。上海博物館藏。

行書《黃庭內景經卷》，紙本（《中國圖目》，v.3，滬I-1422）。上海博物館藏。

小楷書《洛神賦》、李白"羅幃風舉"四言詩、岑參"秋色從西來"及"秋風一夜至"五言絕句二首，仲長統《樂志論》、范成大文，"報國寺古松同社中諸公詠"七言律詩，紙本[《金沙帖》十段之一、二、三、五、六及十]（《中國圖目》，v.1，京5-227）。北京首都博物館藏。

參見：八月晦/1602；1633(4)

行書《題浯溪讀碑圖卷》，紙本（《中國圖目》，v.1，京5-015）。北京首都博物館藏。

爲蔣道樞行書《少曾遠遊卷》，紙本（《中國圖目》，v.1，京5-234）。北京首都博物館藏。

行書馬援《銅馬式卷》,灑金箋本(《中國圖目》,v.1,京5-235)。北京首都博物館藏。

行書《裴將軍歌卷》,綾本(《中國圖目》,v.1,京9-028)。北京中國文物商店總店藏。

與黃道周合作行書《詩札卷》,紙本(《中國圖目》,v.1,京12-045)。北京市文物商店藏。

行書《輪合行卷》,綾本(《中國圖目》,v.6,蘇1-132)。蘇州博物館藏。

行書《解學龍告身卷》,蠟箋本(《中國圖目》,v.6,蘇20-019)。南京市博物館藏。

行書《重修董公堤記卷》,絹本(《中國圖目》,v.7,蘇24-0186)。南京博物院藏。

行書自題《小像卷》,金箋本(《中國圖目》,v.8,津2-039)。天津市歷史博物館藏。

行書《吾衍子室中修行法卷》,綾本(《中國圖目》,v.8,豫1-03)。河南省博物館藏。

行書《呂仙詩卷》,灑金箋本,書"西鄰已富憂不足"七言詩(《石三》,延春閣廿六,2062;《故宮》卷1,138-39)。台北國立故宮博物院藏。

大楷書額"九如樓"三字一卷,朱牋本(《石初》卷31,24a;《故宮》卷1,140)。台北國立故宮博物院藏。

草書節書張衡《歸田賦》一卷,紙本(《總合圖錄》,v.1,A17-101)。E. Elliott Family Collection on loan to The Art Museum, Princeton University。

行書《草稿卷》,紙本(《總合圖錄》,v.1,A17-102)。E. Elliott Family Collection on loan to The Art Museum, Princeton University。

楷書《演連珠卷》(《西泠印叢》,v.15,14)。

行書《寶鼎歌·連環歌卷》(《西泠印叢》,v.15)。

書雜言一卷,論蘇軾、李邕、杜甫、李白等(《郁續》卷12,20)。

爲汪世賢書"鷗友鱸鄉兩不猜"及"池邊荷葉衣無盡"七言絕句二首[《國朝名公詩翰後卷》](《珊瑚》·書,卷18,9-10;《式古》,v.2,書卷30,563。第一首見《容詩》卷4,26a,"寄葉臺山宗伯留都,"第二句異)。

書"真心無散亂"五言絕句於墨禪齋[《國朝名公詩翰後卷》](《珊瑚》·書,卷18,9;《式古》,v.2,書卷30,563)。

行書盧崇道"新都南亭別郭元振,"蘇味道"單于川對雨"及宋之問"初到陸渾山莊"一卷,鏡面箋本(《華亭》,2)。

楷書《周宗建告身四通》一卷,鏡面箋鳥絲闌本(《華亭》,3-4)。

草書偈四首一卷,白鏡面麗箋本(《大觀》卷9,38a)。

行書蘇軾"書王定國所藏煙江疊嶂圖歌"一卷,白鏡面箋鳥絲闌本(《墨緣》,法書卷下明,16a-b)。

行楷書杜光庭《毛仙翁傳》并毛仙翁"贈行詩"一卷,素絹本(《石初》卷31,23b-24a)。

小楷書《牡丹賦卷》,宣德鏡光箋鳥絲闌本(《石初》卷5,33b-34a)。

行書《禮觀音文卷》,素絹本(《秘初》卷6,21b-22a)。

行楷書《唐詩宋詞合璧卷》,藏經紙本,書詞及詩各二首(《天瓶》卷上,11a-12a;《我書》,附,239-41)。

書《編修告身卷》[見張照自跋臨董此作](《天補》,10a-b)。

書《吳懷野墓誌銘卷》(《快雨》卷5,12)。

書《浯溪讀碑圖詩卷》(《快雨》卷5,13-14)。

書《疏解老子卷》(《快雨》卷5,14)。

行書《閒窗論畫卷》,素綾本(《石三》,御書房二,3138-39。論畫語又見《容別》卷6,9a-10a及12a;《畫禪》卷2,5-7)。

書《姜寶誥命卷》二幅。一爲姜紹書書《姜寶誥命》,綠粉箋本;二書姜寶妻《劉氏、賀氏誥命》(《石隨》卷6,2b)。

按:此卷前幅或即《天瓶》所載《金沙姜鳳阿尚書官銀臺告身卷》,見卷上,13a-b。紹書乃姜寶孫。

行楷書江淹《論隱書》一卷,綾本(《玉雨》卷3,92)。

行楷書《演連珠長卷》(《玉雨》卷3,88-89)。

書《佛印壽禪師事卷》,綾本(《藤花》卷2,26a-b)。

行書《心經》,紙本[元夏子言白描觀音·明董文敏公心經合卷》之後段](《古芬》卷13,63a-64a)。

草書曹丕《典論論文》一則,綾本手卷(《古芬》卷7,24a-25b)。

書《摸魚兒》詞一卷,絹本(《夢園》卷13,7a-b)。

書《贈陳眉公東佘山居詩卷》,紙本,書七言律詩二十三首(《穰續》卷8,19a-23a。詩見《容詩》卷3,25b-33b,原作共三十首)。

行楷書《論畫書四則卷》,絹本(《古緣》卷5,24b-26a。論述語散見《容別》卷5,23b-24a;卷6,6a及10b-11a;《畫禪》卷1,7及卷2,4;《畫眼》,40及26-27)。

大行書王安石"金陵懷古詞"一卷,綾本(《古緣》卷5,20a-21a)。

行書蘇軾"大江東去詞"一卷於當塗舟次,綾本

草書偈四首一卷,白鏡面麗箋本(《劍花》,上卷,25-26)。

行草書尺牘數通裝爲一卷,紙本(Christie's,5/31/1990, no. 129)。

書尺牘七通裝爲一卷,紙本(《別下》卷6,11a-13b)。

參見:4/1628(2)

書尺牘九通裝爲一卷,紙本(《十百》,乙卷,19b-22a)。

行書尺牘一通,紙本[《五代宋元明書畫合璧卷》八幅之三](《古芬》卷4,39b)。

行書尺牘四通裝爲一卷,素箋本(《盛京》,第三冊,29a-b;《古物》卷2,13b)。

書尺牘一通[收於《明人叢簡卷》](《壯陶》卷11,13b)。

書尺牘十通裝爲一卷,松江箋本(《壯陶》卷12,1a-4a)。

軸

爲德蓮上人行書"名門利路杳何憑"七言絕句一軸,絹本,鈐有"太史氏"印(《中國圖目》,v.3,滬1-1429)。上海博物館藏。

行書"題大宮保霖翁李老先生平播詩"七言律詩一軸贈李霖寰,綾本,鈐有"太史氏"印(《中國圖目》,v.6,蘇1-137。詩見《容詩》卷3,36a)。蘇州博物館藏。

行書"桃蹊柳陌轉山椒"七言絕句一軸,絹本,鈐有"太史氏"印(《石三》,御書房二,3141;《故宮》卷2,19;《故週》,v.509,3。詩見《容詩》卷4,44b)。台北國立故宮博物院藏。

行書"輕陰閣小雨"五言絕句一軸,絹本,鈐有"太史氏"印(《槐安》, no. 173;《書道藝術》卷8,152;《董其昌》, no. 90)。東京國立博物館藏。

行書"山出雲時雲出山"七言絕句一軸,紙本,鈐有"太史氏"印(《槐安》, no. 174。詩見《容詩》卷4,36a,"題畫贈周奉常")。東京國立博物館藏。

行書"風軒水檻壓春流"七言絕句一軸,鈐有"太史氏"印(詩見《容詩》卷4,45a)。The Metropolitan Museum of Art。

行草書"獨坐幽篁裡"五言絕句一軸,鈐有"太史氏"印(《西泠印叢》,v.15)。

爲一泉行書"渭北春天樹"五言絕句一軸,紙本,鈐有"太史氏"印(Christie's, 12/11/1987, no. 61)。

行書"寶鏡頌神節"五言律詩一軸,絹本,鈐有"太史氏"印(Sotheby's, 12/5/1985, no. 91)。

爲李養正行書"柳外青帘颺晚風"七言絕句一軸,綾本,鈐有"太史氏"印(Sotheby's, 11/30/1988,

no. 32。詩見《容詩》卷4, 32a,"房村夜宿劉莊談河事")。

草書陸暢"怪得北風急"五言絕句一軸,綾本,鈐有"太史氏"印(《石三》,御書房二,3141)。

書"綠水明秋月"五言絕句一軸,紙本,鈐有"太史氏"印(《自怡》卷2, 24a–b)。

行書"桂樹生南海"五言絕句一軸,絹本,鈐有"太史氏"印(《紅豆》卷8, 50a–b)。

書"亂飄僧舍茶烟濕"七言絕句一軸,綾本,鈐有"太史氏"印(《筆嘯》卷上,16a)。

行書"蓋張樂於洞庭之野"至"則常無所結滯矣"一軸於達甫之素園,金箋本,鈐有"太史氏"印(《鑑影》卷22, 1b–2a)。

行書"冷泉亭"五言古詩一屏,綾本,鈐有"太史氏"印[《明人書集屏》四幅之首](《鑑影》卷22, 22b)。

行書"曾遊方外見麻姑"七言絕句一軸,絹本,鈐有"太史氏"印(《劍花》,上卷, 32)。

草書"通神筆法得玄門"七言絕句一軸,綾本,鈐有"太史氏"印(《澄懷》卷4, 17–18)。

行書"文杏裁爲梁"五言絕句一軸,綾本,鈐有"侍讀學士"印(《自怡》卷2, 24a)。

草書"君自故鄉來"五言絕句一軸,綾本,鈐有"大宗伯印"(《中國圖目》卷7,蘇24–0189)。南京博物院藏。

行書"朱旆行部帶明霞"七言絕句一軸,綾本,鈐有"宗伯之章"印(《中國圖目》,v.3,滬1–1428。詩見《容詩》卷4, 36a–b,"題畫貽毘陵張夢澤舊武陵守")。上海博物館藏。

行書崔顥"晴川歷歷漢陽樹"七言詩一聯,紙本立軸,鈐有"宗伯之章"印(《中國書法》,v.1)。天津市藝術博物館藏。

楷書晁迴語一軸,紙本,鈐有"宗伯學士"印(《中國圖目》,v.6,蘇1–138)。蘇州博物館藏。

楷書劉禹錫《謝春衣表》一軸,宣德泥金箋本,鈐有"宗伯學士"印(《石初》卷17, 1a–b;《故宮》卷2, 16–17)。台北國立故宮博物院藏。

行書"麥餅宴恭紀"五言律詩一軸,絹本,鈐有"宗伯之章"印(《故宮》卷2, 19)。台北國立故宮博物院藏。

行書岑參《叢竹歌》一軸,宣德箋本,鈐有"宗伯學士"印(《石初》卷37, 8b;《故週》,v.181, 3;《故宮》卷2, 17)。台北國立故宮博物院藏。

行書"金粟如來丈室中"七言絕句一軸,鈐有"宗伯學士"印(《故週》,v.271, 2。詩見《容詩》卷4, 30a–b,"廷評潘同江尊閫顧夫人六十,余既爲長歌祝觴,內子復請此圖壽之并題一絕")。故宮博物院藏。

行書"溫洛嵩高天地中"七言律詩一軸,綾本,鈐有"宗伯學士"印(《盛京》,第五冊,12b–13a;《故宮》

卷2, 19–20。詩見《容詩》卷3, 2b,"中州鳳凰見爲大中丞馮禮亭年丈贈")。台北國立故宮博物院藏。

爲冒襄行書"直從藝苑割鴻溝"七言律詩一軸,灑金箋本,鈐有"宗伯學士"印(《總合圖錄》,v.1, A18–049)。美國方聞夫婦藏。

草書王維"山中相送罷"五言絕句一軸,紙本,鈐有"宗伯之章"印(《董其昌》, no. 94)。The Metropolitan Museum of Art.

行書"桂樹生南浦"五言絕句一軸,鈐有"宗伯之章"印(《中國明代書畫陶瓷展覽》, no. 140)。

行書"綠葉迎春綠"五言絕句一軸,絹本,鈐有"大宗伯印"(《神州》,v.8)。鄧氏風雨樓舊藏。

爲李天植行草書《留別侯司徒詩軸》,綾本。書"劍履瞻民部"五言律詩,鈐有"宗伯學士"印(《萱暉》,書156b; Christie's, 12/3/1985, no. 32)。程琦舊藏。

行書"嘉樹森梢一百章"七言絕句一軸,紙本,鈐有"宗伯之章"印(Christie's, 6/1/1989, no. 107)。

朱國盛園中梅花以中秋發,爲行書"大遠江南信"五言排律一軸以紀瑞,紙本,鈐有"宗伯學士"印(Sotheby's, 12/6/1989, no. 46。詩見《容詩》卷1, 28a–b,此軸爲節錄)。

按:此作似即《聽颿》所載董行書《詩軸》,見卷下,605–606。

行書"肘佩黃金印"五言絕句一軸以壽鳳台初度,綾本,鈐有"大宗伯印"(Sotheby's, 12/5/1984, no. 9。詩見《容詩》卷2, 30b,"右投轄館")。

行書"林中觀易罷"五言絕句一軸,綾本,鈐有"大宗伯印"(Sotheby's, 6/3/1986, no. 32)。

行書"君自故鄉來"五言絕句一軸,絹本,鈐有"大宗伯印"(Christie's, 6/24/1983, no. 674)。

大行書"花開攜酒詩"七言絕句一軸,紙本,鈐有"大宗伯印"(《式古》,v.2,書卷28, 495–96)。

爲彥采楷書節書《月賦》四句一軸,素箋本,鈐有"大宗伯印"(《石初》卷7, 3b–4a)。

行書七佛偈一軸,金箋本,鈐有"宗伯學士"印(《秘初》卷7, 3a–b)。

行書"山光凝翠,山容如畫"詞一軸,宣紙本,鈐有"宗伯學士"印(《吳越》卷5, 47a)。

爲曼修行書《二十八宿寶硯詩軸》,綾本,鈐有"宗伯學士"印(《吳越》卷5, 69b–70a)。

爲王時敏行書"遨遊出西城"五言古詩一軸,紙本,鈐有"宗伯之章"印(《吳越》卷5, 81a)。

楷書《曹溪偈》一軸,宣德紙本,鈐有"宗伯學士"印(《吳越》卷5, 77a–b)。

小行書王安石"金陵懷古詞"一軸,宣紙本,鈐有"宗伯學士"印(《吳越》卷5, 77b–78a)。

行書"神功開混沌"與"西風撥雲盡"五言律詩二首一軸,粉箋本,鈐有"宗伯學士"印(《十百》,癸卷,14b–15a。詩見《容詩》卷2, 22b–23a,"同唐元徵宮允游善權洞四首"之一及二)。

行書"雷聲忽散千峰雨"七言詩一聯,紙本立軸,鈐有"大宗伯印"(《自怡》卷2, 23b–24a)。

書"安得舍塵緣"五言絕句一軸,綾本,鈐有"宗伯之章"印(《筆嘯》卷上,6a)。

爲瞻月行書《燕然山銘掛屏》,綾本,鈐有"大宗伯印"(《聽颿》卷下,606–607)。

行書崔子玉《座右銘》中"無道人之短"一章,紙本立軸,鈐有"大宗伯印"(《聽颿》卷下,607–608)。

行書"雲館接天居"五言律詩一屏,綾本,鈐有"宗伯之章"印[《明人詩翰集屏》四幅之首](《鑑影》卷22, 21b)。

作《天香書屋小軸》贈項嘉謨,紙本,鈐有"大宗伯章"印(《壯陶》卷12, 26a–b)。

行書"閒雲無四時"五言絕句一軸,紙本,鈐有"青宮太保"印(《中國圖目》,v.6,蘇1–136)。蘇州博物館藏。

行書"天門新闢日瞳朧"七言律詩一軸送張吏部,綾本,鈐有"青宮太保"印(Christie's, 6/5/1985, no. 30。詩見《容詩》卷3, 6b,"送張符禺吏部自常熟令內召")。

楷書《恭讀宣宗皇帝御製翰林院箴軸》,硬黃紙本。書"崢嶸木天署"五言古詩,鈐有"青宮太保"印(《吳越》卷5, 62b。詩見《容詩》卷1, 1a–b)。

行書朱熹遊山事一軸,絹本(《中國圖目》,v.6,蘇3–006)。蘇州市文物商店藏。

行書《泛泖詩軸》,紙本(《中國圖目》,v.6,蘇8–023)。南通博物苑藏。

大楷節書周子通書一軸,素箋本(《石初》卷37, 7a;《故宮》卷2, 17)。台北國立故宮博物院藏。

書"嘉樹森梢一百章"七言絕句一軸,宋箋本(《華亭》,14。詩見《容詩》卷4, 35a–b,"題畫贈楊玄蔭大參")。

行書崔子玉《座右銘》一軸,宣德鏡光箋本(《石初》卷37, 7a–b)。

大行書《清靜經》二句一軸,素箋本(《秘初》卷17, 5a)。

草書唐人"躍龍門外主家親"七言律詩一軸,紙本(《朱卧》,83)。

冊

作《起草冊》[見李日華一六一二年九月三日記此作](《味水》卷4, 58a–b)。

行書《明故翰林院提督四夷館太常寺少卿陳

公神道碑册》,紙本,鈐有"知制誥日講官"印(*Sotheby's*, 11/26/1990, no. 33)。

按:陳公指陳與郊,卒於一六一〇年。

行書《明故廣東參政瀍河黃公墓誌銘册》,高麗紙本,鈐有"知制誥日講官"印(《華亭》,29–32)。

按:黃克謙(號瀍河)卒於一六一八年閏四月三日。

行書《明故勅贈承德郎戶部主事崑泉米公小傳册》,綾本,鈐有"太史氏"印(*Sotheby's*, 12/6/1989, no. 45)。

按:米崑泉乃米玉(1527–97),米萬鍾父。

行書《陳心抑尚書神道碑墨蹟册》,紙本烏絲闌,鈐有"宗伯學士"印(《嶽雪》卷4, 53a–57a;*Christie's*, 11/30/1984, no. 684)。

按:陳心抑指陳禹謨(1548–1618),此作款識有"禮部右侍郎"官銜,應書於一六二三年後。

小楷書《道德經册》,鏡光箋烏絲闌本(《華亭》,18)。

按:此作款識有"禮部尚書"官銜,應書於一六二五年後。

楷書《金剛經册》,金粟箋本(《秘初》卷2, 10b–11b)。

按:此作款識有"禮部尚書"官銜。

楷書《金剛經》四册,朝鮮鏡光箋本。每册前有《如來像》,後有《韋馱像》,俱磁青箋本泥金畫(《秘初》卷2, 11b–12a)。

按:此作款識有"禮部尚書"官銜。

小楷書《金丹四百字册》(《過續》,書類2, 8a–b)。

按:此作款識有"禮部尚書"官銜。

大楷書《賀曹大中丞召對敘册》,綾本(《壯陶》卷12, 11a–13b)。

按:此作乃卷改裝册,款識有"禮部尚書"官銜。

大行楷書《周挹齋三載一品考序册》,越箋烏絲闌本(《壯陶》卷12, 47a–49b)。

按:周挹齋指周延儒。此作款識有"禮部尚書"官銜。

楷書《先世誥身册》,紙本(《中國圖目》,v.3,滬1–1415)。上海博物館藏。

按:此作款識有"掌詹事府事"官銜,應書於一六三一年後。

又:此作似即《過續》所載楷書《誥身合册》,見卷2, 5b–7a。

行草書《檃括前赤壁賦册》,綾本,鈐有"知制誥日講官"印(《中國目錄》,v.2, 52,京1–2206)。北京故宮博物院藏。

行書《方眴谷行狀册》,金箋本,鈐有"知制誥日講官"印(《中國圖目》,v.6,蘇1–130)。蘇州博物館藏。

行書王維"桃源行"七言古詩一册,絹本,鈐有"知制誥日講官"印(*Sotheby's*, 11/25/1991, no. 23)。

行書《墨苑序册》,絹本烏絲闌,鈐有"知制誥日講官"印(《湘管》卷4, 277–80)。

楷書《御書樓記册》,鈐有"知制誥日講官"印(《湘管》卷4, 280–84。文見《容文》卷4, 1a–3b)。

書《晝錦堂記册》,綾本,鈐有"知制誥日講官"印(《藤花》卷3, 22a–b)。

草書《杜詩册》,絹本。書杜甫"巢父掉頭不肯住"七言古詩及"不見旻公三十年"七言律詩,鈐有"知制誥日講官"印(《鑑影》卷14, 15b–16a)。

按:《鑑影》云此作乃卷改裝册。

行書杜甫"苑外江頭坐不歸""蓬萊宮闕對南山"及"聞道長安似奕棋"七言律詩三首一册,紙本,鈐有"太史氏"印(《石三》,御書房二,3129;《故宮》卷3, 107)。台北國立故宮博物院藏。

行書秦觀"山抹微雲"詞一册,鈐有"太史氏"印(《貞松》卷中)。中國羅振玉舊藏。

行書《畸墅詩册》,玉版箋本,鈐有"太史氏"印(《萱暉》,書162b–64a)。程琦舊藏。

行書《長恨歌册》,紙本,鈐有"太史氏"印(*Christie's*, 12/4/1989, no. 142)。

草書杜甫"古柏行"一册,朝鮮箋本,鈐有"太史氏"印(《石初》卷3, 22a–b)。

行書《西都賦墨蹟册》,綾本,鈐有"太史氏"印(《夢園》卷13, 17a–20a)。

按:據《夢園》,此作乃卷改裝册。

行書《詩册》,紙本烏絲闌。書"勅賜百官午門麥餅宴恭紀"四首、"肅宗皇帝聖雲孫九日涼糕宴恭紀""聖主考文天雨粟故拈糕字慰三農""報國寺觀古松""慈慧寺訪僧""任丘道中""茂州道中""昭君村""涿鹿道中""督亢村""天雄道中""壽萬同吾金吾六十""萬郡尉移居賜第""陳參政碉雲七十""廣陵元日酬李宮允太虛"及"大司寇胡公考績"諸詩,鈐有"太史氏"印(《穰續》卷9, 9a–12a)。

書《琵琶行》、《桃源行》及《池上篇》一册,紙本,《琵琶行》款後鈐有"太史氏"印(《古緣》卷5, 32a–b)。

書《正草千字文册》,紙本,鈐有"宗伯學士"印(《中國圖目》,v.7,蘇24–0185)。南京博物院藏。

行楷書杜甫七言律詩"秋興八首"之五一册,素箋本,鈐有"宗伯學士"印(《石初》卷43, 14a–b;《故宮》卷3, 106–107)。台北國立故宮博物院藏。

行書蘇軾《前後赤壁賦》一册,朝鮮箋烏絲闌本,鈐有"宗伯學士"印(《石初》卷28, 27a–b;《故宮》卷3, 108)。台北國立故宮博物院藏。

行書張鍊師《乞梅竹疏》,宣德鏡光箋本,鈐有"宗伯學士"印[《倣古三種册》之第三種](《石初》卷10, 56a–57a;《故宮》卷3, 126–27)。台北國立故宮博物院藏。

爲質公書"九日敕賜百官午門花糕宴"七言律詩二首一册,紙本,鈐有"宗伯學士"印(《古物》卷1, 15a;《故宮》卷3, 113)。台北國立故宮博物院藏。

行書《大中丞少司馬曹公生祠碑册》,金箋本,鈐有"大宗伯章"印(《式古》,v.2,書卷28, 496–97;*Sotheby's*, 5/18/1989, no. 38)。

值潘百朋壽誕,爲行書《樂壽堂圖歌册》,紙本,鈐有"宗伯學士"印(《劍花》,上卷,26–27;*Christie's*, 6/3/1987, no. 64)。

草書"頌酒深衷豈放憨"七言律詩一册,紙本,鈐有"宗伯學士"印(*Christie's*, 5/31/1990, no. 110。詩見《容詩》卷3, 29a–b,"贈陳仲醇微君東佘山居詩三十首"之十五)。

行書李白"少年上人稱懷素"七言詩一册,綾本,鈐有"宗伯學士"印(*Christie's*, 11/28/1990, no. 109)。

行書杜牧"千里楓林烟雨深,""烏紗頭上是青天""十二晴峰倚碧天"及"南陵水面漫悠悠"七言絕句四首一册,紙本,鈐有"宗伯學士"印(《華亭》,26–28)。

撰并行楷書《左光斗傳册》,灑金箋本,鈐有"宗伯學士"印(《石初》卷28, 28a)。

行書《初月賦》、《答處士書》、《送張處士》及《揚州看競渡序》一册,宣德高麗紙本,鈐有"宗伯學士"印(《吳越》卷5, 60b–62a)。

按:據王澍跋,此作乃以卷改裝。

行書《陋室銘册》,紙本,鈐有"宗伯學士"印(《石三》,御書房二,3132)。

行書《秋夜讀書詩册》,紙本。書"良宵迎爽至"五言古詩,鈐有"宗伯學士"印(《石三》,御書房四,3238)。

書曹丕《典論論文》一册,絹本,鈐有"宗伯學士"印(《自怡》卷13, 17b–18a)。

行書《墨禪軒說册》寄吳楨,紙本,鈐有"宗伯學士"印(《穰梨》卷24, 16b–18a。文見《容文》卷5, 31a–32b)。

爲質公行書《花糕宴詩册》,素箋本。書"霜降應省百工勞"及"建章月曉聽霜鐘"七言律詩二首,鈐有"宗伯學士"印(《盛京》,第六冊,18b–19a)。

行楷書《知長興縣事熊侯生祠碑記册》,絹本烏絲格,鈐有"宗伯之章"印(《壯陶》卷12, 17b–20a)。

行草書《小赤壁詩册》,紙本,鈐有"青宮太保"印(*Christie's*, 6/4/1986, no. 36。詩見《容詩》卷1, 3b–5a)。

行書《偶然欲書册》,紙本。書"三竺溪流獨木橋"及"傑閣憑欄四望通"七言絕句二首,鈐有"青宮太保"印(《華亭》,28。詩見《容詩》卷4, 34b–35a,"題

西溪圖贈虞德園吏部"及32b,"題延津署閣")。

行書白居易《池上篇》一册,宣紙本,鈐有"青宮太保"印(《吳越》卷5,49a)。

楷書《心經册》,紙本,鈐有"青宮太保"印(《筆嘯》卷下,2b)。

行書《世說新語》數則一册,紙本,鈐有"青宮太保"印(《退菴》卷8,30a–b)。

楷書《樂毅論册》,紙本(《中國目錄》,v.2,52,京I–2203)。北京故宮博物院藏。

行書《琵琶行册》,紙本(《中國目錄》,v.2,52,京I–2207)。北京故宮博物院藏。

行書《常清靜經册》,紙本,(《中國目錄》,v.2,52,京I–2208)。北京故宮博物院藏。

行書《聖教序册》,紙本(《中國目錄》,v.2,52,京I–2209)。北京故宮博物院藏。

行書《贈王大中丞詩册》,雲母箋本(《中國圖目》,v.3,滬I–1412)。上海博物館藏。

楷書《汪虹山墓誌銘册》,綾本(《中國圖目》,v.3,滬I–1416)。上海博物館藏。

行書《秋雨嘆册》,綾本(《中國圖目》,v.6,蘇19–06)。江蘇省美術館藏。

行書《琵琶行册》,金箋本(《中國圖目》,v.8,津2–036)。天津市歷史博物館藏。

行書白居易"琵琶行"一册,紙本(《石三》,延春閣廿六,2048–49;《古物》卷I,15b;《故宮》卷3,104–106)。台北國立故宮博物院藏。

行書高啓"梅花詩"九首與王冷然《初月賦》一册,紙本(《故宮》卷3,113)。台北國立故宮博物院藏。

行書沈約《七賢論》,紙本[《元明書翰》七十六册之二十五(即丁二册)](《石三》,延春閣三十九,2594–95;《故宮》卷3,307–308)。台北國立故宮博物院藏。

行書跋畫二則,素箋本。第二則爲信儒題[《明人翰墨册》二十一幅之十二、十三及十四](《石初》卷21,25a–b;《故宮》卷3,413)。台北國立故宮博物院藏。

行書尺牘致仲淳,紙本[《明賢翰墨册》十五幅之末](《故宮》卷3,422)。台北國立故宮博物院藏。

行書"邠風圖""問政山歌"七言古詩二首、"秋夜讀書"五言排律及"送黃待御歸江西"五言古詩一册(詩見《容詩》卷I,9a–b,13b–14b,23a及6b)。香港北山堂藏。

行書《游記隨筆册》(文散見《容別》卷4及《畫禪》卷3)。香港北山堂藏。

作《行書册》二十五幅,紙本(*Christie's*,6/1/1989,no. 109)。

楷書《金剛經册》(《平生》卷5,57)。

行書王勃《如來成道記》一册,高麗紙本(《平生》卷5,57)。

行楷書《四十二章經册》,白紙本(《平生》卷5,58)。

楷書"茶山詩"三十三首一册,鏡面烏絲闌本(《平生》卷5,59)。

小行楷書《管城子誥》,又中行書雜言數則一册,鏡面紙本(《平生》卷5,59–60)。

行書《戲鴻堂帖》題跋稿一册,宣紙本(《平生》卷5,60)。

行草書唐人"主人不相識"五言絕句,長紙本[《明法書名畫合璧高册》第一册二十七對幅之五](《式古》,v.3,畫7,322–23)。

行書宋人"買陂塘旋栽楊柳"及"青烟羃處,碧海飛金鏡"詞二闋一册,粉箋本(《華亭》,23–24)。

小楷書曹丕《自叙》"余年五歲"至"無不畢覽"一册,紙本(《華亭》,25)。

楷書《心經册》,宣紙烏絲闌本(《墨緣》,法書卷下明,17a)。

楷書《金剛經摺册》,白鏡面箋本(《墨緣》,法書續錄卷下,2b–3a)。

行書崔子玉《座右銘》一册,朝鮮鏡光箋本(《石初》卷11,7a)。

書《阿彌陀佛經册》,素箋本(《秘初》卷3,14b)。

行書《煉陽訣册》,素箋本(《秘初》卷15,7a–b)。

楷書《玉皇經册》,宣德箋本(《秘初》卷15,13a)。

書《宗門茶話》,又曾作《宗門茶話册》贈南沙,亦黃宋箋本[見張照跋此作](《天瓶》卷上,14b)。

小行書《檗梔前後赤壁賦詞册》(《湘管》卷4,273–75)。

書《遺教經》前半部一册(《快雨》卷5,10–11)。

撰并行書《翰林院成樂軒記册》,紙本(《石三》,綺春園問月樓,3984–85。文見《容文》卷4,6a–7b)。

爲姪輝章行楷書孫虔禮《續書譜》一册,絹本(《自怡》卷13,18a–19b)。

書"奉敕賜百官午門麥餅宴恭紀"七言律詩四首一册,紙本(《退菴》卷8,33a–b)。

書《明故中憲大夫憲副中涵吳公墓表册》,繭紙本(《藤花》卷3,20b–21a)。

楷書《韓氏三十乘藏書樓記册》,文乃陳繼儒爲韓雨公撰(《過續》,書類2,7a–8a)。

書《明故文學虹山汪先生墓誌銘册》,綾本(《穰續》卷9,5a–8b)。

小行書節書《陳言時政疏》奏稿二頁[《明人各家詩札册》二十幅之十六及十七](《古緣》卷6,16a–b。文見《容文》卷5,43a–44a)。

比丘成果出素牋索書《金剛經》,因行書《金剛經册》(《盛京》,第七册,2b–3a;《古物》卷I,16a–b)。

按:此册前有丁雲鵬白描佛像。

楷書《金剛經册》,紙本烏絲闌(《壯陶》卷12,8b–9a)。

行書《滕王閣叙册》,棉紗紙本(《壯陶》卷12,9a–b)。

行書《蘭亭叙》并行草書白居易《池上篇》一册,紙本(《劍花》,上卷,30–31)。

行書《寶鼎歌》、《刀銘》、《世說》及《江上愁心賦》四則一册,紙本(《劍花》,上卷,31)。

行書尺牘四通,楷書《東方朔像贊》,紙本[《元明書翰》七十六册之七十二(即癸四册)](《石三》,延春閣四十,2648–49;《故宮》卷3,380–82)。台北國立故宮博物院藏。

行書尺牘五通,紙本[《元明書翰》七十六册之七十三(即癸五册)](《石三》,延春閣四十,2650–51;《故宮》卷3,382–85)。台北國立故宮博物院藏。

書尺牘二十三通,紙本[《明人尺牘上册》](《故宮》卷3,409–10)。台北國立故宮博物院藏。

行書天牘十二通一册,紙本(《槐安》,no. 177;《書道藝術》卷8,153;《東京國博》,書,no. 107)。東京國立博物館藏。

行書《尺牘册》,紙本(*Christie's*,11/30/1988,no. 24)。

行書尺牘十通裝爲一册,紙本(*Christie's*,11/28/1990,no. 117)。

行書尺牘五通裝爲一册,紙本朱絲闌(《萱暉》,書160a–162b)。程琦舊藏。

書尺牘八通集爲一册(《十百》,巳卷,14b–19b)。

書尺牘集爲二册,紙本(《自怡》卷12,7a–26b;卷13,12a–17a)。

書尺牘一通,紙本[見《明人書啓册》](《自怡》卷14,4a)。

書尺牘一通,紙本[《集明人十六札册》之六](《聽颿》卷2,183–84)。

書尺牘二十通裝爲一册,紙本(《別下》卷6,5a–10a)。

書尺牘三通裝爲一册,紙本(《退菴》卷8,31a–b)。

書尺牘五通致陳繼儒裝爲一册,紙本(《退菴》卷8,32a–b)。

書尺牘八通裝爲一册,高麗紙本烏絲闌;又十三通一册,宣紙本(《藤花》卷3,22b–23b)。

書《札稿册》,紙本(《穰續》卷9,1a–5a)。

書尺牘九通裝爲一册,紙本(《古緣》卷5,32b–33b)。

草書尺牘一通,粟色牋本[收於《三吳書翰册》](《我書》,235)。

扇

爲中湛行書《麥餅宴詩扇》,金箋本(《中國圖目》,v.1,京2–182)。北京中國歷史博物館藏。

行書《偃松亭詩扇》,金箋本(《中國圖目》,v.6,蘇14–02)。鎮江市文物商店藏。

爲德芬行書"野涉得同人"五言律詩,金箋本扇頁(《中國圖目》,v.7,蘇24–0191。詩見《容詩》卷2,23b–24a,"泖湖春泛")。南京博物院藏。

行草書"晚年唯好靜"五言律詩,泥金紙本扇頁(《故宮旬刊》,v.20,80)。故宮博物院藏。

行書《詩扇》,書"何年顧虎頭"五言律詩(《故週》,v.15,3)。故宮博物院藏。

行草書《詩扇》,書"西鄰已富憂不足"七言絕句(《故週》,v.21,3)。故宮博物院藏。

行書"三竺溪流獨木橋"七言絕句,金箋本扇頁(《虛白》,no.109。詩見《容詩》卷4,34b–35a,"題《西溪圖》贈虞德園吏部")。香港劉作籌藏。

九日爲尤年行草書"今日爲重九"五言律詩於白門,金箋本扇頁[《明清書畫便面册》(甲)三十幅之九](《總合圖錄》,v.3,JM24–011–9)。日本岡山美術館藏。

行書"朝飲花上露"五言絕句,金箋本扇頁[《書畫禪扇面册》(一)四十五幅之二十八](《總合圖錄》,v.4,JT178–10–28)。日本萬福寺藏。

行書《詩扇》於范允臨山房,紙本,書"百疊松篁繞畫楹"七言絕句(《董畫》,v.3,no.9。詩見《容詩》卷4,25a–b,"范長倩偕隱天平山居四首"之一)。日本齋藤氏舊藏。

行草書王維"積雨空林烟火遲"七言律詩,紙本扇頁(《董其昌》,no.81)。The Art Institute of Chicago。

行草書"難把長繩繫日烏"七言絕句,紙本扇頁(《董其昌》,no.82)。The Art Institute of Chicago。

行書節書陶潛《歸去來辭》,泥金紙本扇頁(《董其昌》,no.83)。The Metropolitan Museum of Art。

行草書《詩扇》,書"翦得吳淞水半江"七言絕句(詩見《容詩》卷4,38b,"題王齋宇繡佛齋圖二首"之

一)。The Metropolitan Museum of Art。

行草書"松子落何年"五言律詩,灑金箋本扇頁(*Christie's*, 12/1/1986, no.47)。

爲肇紀行書"仲舉無心除一室"七言絕句,灑金箋本扇頁(*Christie's*, 6/4/1986, no.38。詩見《容詩》卷4,38a–b,"爲眉公作苕帚庵圖并題")。

行書"舞劍助書顛"五言律詩,金箋本扇頁(*Christie's*, 6/24/1983, no.675。詩見《容詩》卷2,15a–b,"訓項文學")。

行草書"樹密口山徑"五言律詩,金箋本扇頁(*Christie's*, 6/24/1983, no.676)。

行草書"清川帶長薄"五言律詩,灑金箋本扇頁[《扇册》七幅之一](*Christie's*, 12/4/1989, no.97)。

作金箋本《詩扇》五幅。一爲伸之草書五言律詩,二爲仲瞻行草書五言律詩,三爲知忍行書"遊善權"五言律詩,四爲廷吹行書"送王純白山人歸清源"七言律詩,五爲張延登行書"平播詩"七言律詩[《明人書扇》第八册二十幅之七至十一](《石初》卷3,47a–b)。

書《詩扇》六幅,首四幅冷金面,末二幅礬面。一爲廟園行書"酬李伯裹太史贈端研"五言律詩,二行書"題偃松亭圖"七言律詩,三草書"六嫏生繡畫建溪"七言絕句,四爲廣霞草書"金閣妝仙杏"五言律詩,五行書"芙蓉闕下會千官"七言律詩,六行書"白門朱户總悠悠"七言律詩[《扇册》第九册二十四幅之十九至末幅](《自怡》卷23,17b–19a。首二詩見《容詩》卷2,14b及卷3,39a,"題秦中李箕谷黃門偃松圖")。

草書"細管雜青絲"五言律詩,冷金面扇頁[《扇册》第十三册二十四幅之七](《自怡》卷24,19b)。

爲項嘉謨行楷書"人天皈佛日"五言律詩,礬紙本扇頁[《明人書畫扇面》第三册二十幅之十三](《紅豆》卷6,74b。詩見《容詩》卷2,18b,"高梁即事")。

爲草若行書"朱旂行部擁明霞"七言絕句,泥金面扇頁[《明人書畫扇面》第三册二十幅之五](《紅豆》卷6,71b。詩見《容詩》卷4,36a–b,"題畫貽毘陵張夢澤舊武陵守")。

草書"水北原南野草春"七言絕句,泥金面扇頁[《明人書畫扇面》第一册二十幅之三](《紅豆》卷6,55a)。

行草書《扇册》十二幅。一書"請告嚴程日"五言律詩;二爲袁樞書"石室奎章待訪編"五言絕句;三書"澤國驅朝節"五言律詩;四書"武陵川路狹"五言律詩;五書"郭天谷入關"七言律詩;六游善權洞,撰并書"山齋氣初澄"五言律詩;七書"珍木文禽玉珮瑜"五言律詩;八爲聖功書"家臨長信往來道"七言律詩;九書"邊城多遠別"五言律詩;十書"建鄴高秋夜"五言律詩;十一失記,十二書白居易《池上篇》(《聽颿》卷3,269–74)。

鄭崟陽太史過訪贈詩,依韻行書"猶有英僚訪病

翁"七言律詩[《集明人行草扇册》二十八幅之二十一](《聽颿》卷4,314。詩見《容詩》卷3,16b,"送鄭庶常崟陽")。

爲夷父書"春朝澹容與"五言詩[《集明人書畫扇册》二十四幅之十七](《聽颿》卷4,324)。

書《詩扇》七幅,金箋本。一爲管洛行草書"乍把瓊枝宛舊游"七言律詩,二爲岱松行書"李白乘舟將欲行"七言詩,三行草書王維"晴川帶長薄"五言詩,四爲我真行草書"清秋望不極"五言律詩,五行書"瑞氣凌青閣"五言律詩,六爲君承草書"積鐵千尋屆紫虛"七言絕句,七爲乾伯行書"烟景駐征騎"五言律詩[《明人書畫扇面集册》第二册二十對幅之十二及十一、第三册二十對幅之末、第四册二十對幅之十一、十二、九及十](《鑑影》卷15,14a,13b,24a,27b–28b。第一首及末二首詩見《容詩》卷4,4b,"酬劉燕及明府二首"之一;卷4,43a–b,"題倣黃子久畫"及卷2,22a–b,"惠山黃園")。

書金箋本《詩扇》二幅。一草書王維"不知香積寺"五言律詩,一行楷書"十二城樓閬苑西"七言律詩[《明人書畫扇面册》十三幅之五及七](《古緣》卷6,5b–6a)。

行楷書陶潛《歸去來辭》"乃瞻衡宇"至"門雖設而常關"一段,碎金面扇頁[《明人各家書扇面册》十二幅之七](《古緣》卷6,9a)。

書扇頁四幅,泥金面。一小楷書《初潭集》所載王維與裴迪事,二行書"淮南安好道術"事,三行書"朝發羊腸暮鹿頭""灘聲嘈嘈雜水聲"及"燒燈過了客思家"七言絕句三首,四行書元人《水調歌頭》詞"江湖渺何許"一首(《壯陶》卷20,6b–7b)。

草書前人題梅"處士橋邊古岸限"七言絕句,金箋本扇頁[《明十名家書畫便面册》十八面之十三](《澄懷》卷11,10)。

草書"栖栖游子若飄蓬"七言絕句[《明十四名家書畫便面册》十四面之三](《澄懷》卷11,34)。

爲瑟予行書"泖湖春泛"五言律詩,金箋本扇頁(《劍花》,上卷,33。詩見《容詩》卷2,23b–24a)。

形式不詳

行書《王文恪公集序》(*The Gest Library Journal*, v.2, no.2, 113a–b)。刻本現藏 Gest Oriental Library, Princeton University。

按:王鏊文集約刻於一五九九年,董書應在此前。

楷書《金剛經》,鏡面紙本(《平生》卷5,57)。

按:此作款識有"禮部尚書"官銜,應書於一六二五年後。

撰并書《高忠憲公像贊》(《書法》,一九八四年第四期,36)。無錫東林書院藏。

按:高忠憲公即高攀龍(1562–1626)。

爲達吾書"雨過松陰翠欲流"七言絕句於金箋面《十八應真》之背,鈐有"太史氏"印[《三公名蹟》

之中段]（《十百》,亥卷,20a–b）。

草書嵇康《絕交書》自"吾嘗讀尚子平"至"其可得乎"一段,紙本,鈐有"宗伯學士"印（《華亭》,25）。

書舊作評畫語,評米友仁、元季諸家、趙孟頫及趙令穰（《真蹟》,初集,34b–35b）。

楷書節書李白《春夜宴桃李園序》（《式古》,v.2,書卷28,498–99）。

行書李白"齊有倜儻生"五言古風,高麗紙本（《平生》卷5,58）。

行楷書《千字文》,白鏡面箋本（《墨緣》,法書續錄卷下,3a）。

書倪元璐撰《少保陳于廷誥命》[見張照跋此作]（《天瓶》卷上,13b–14a）。

撰并書《太僕弘齋林公傳》[見張照跋此作]（《天瓶》卷上,14a–b。文見《容文》卷6,39a–44b）。

按:林太僕指林景暘。

小楷書陶潛《閒情賦》（《湘管》卷4,285–86）。

爲民忱行草書"朝發羊腸暮鹿頭"七言絕句,金箋本（《十百》,亥卷,4b）。

爲張延登書《免柴記》（《快雨》卷5,12–13。文見《容文》卷4,16a–17a）。

書論書語三千八百餘言示子董苑（《鷗陂》卷1,4;《過雲》畫類5,12a。二書俱引張翀《淞南識小錄》）。

行書尺牘數通（*The Gest Library Journal*, v.2, no. 2, 111）。The Art Museum, Princeton University。

行書天牘二通（《藝林月刊》,no. 18,9）。

行草書尺牘二通,紙本（《萱暉》,書104b–105a）。程琦舊藏。

行書尺牘一通致錢龍錫,紙本（《萱暉》,書121a–b）。程琦舊藏。

書尺牘一通（《珊瑚》·書,卷18,11）。

行書尺牘一通致玄翁,朱行素牋紙本（《蘇雪》卷5,28a–b）。

行書尺牘一通（《我寓》,153）。

書尺牘一通（《壯陶》卷12,32b–33b）。

畫

畫:倣作

倣王蒙

秋得《丹臺春曉圖》於惠山吳氏,因擬作一軸,紙本墨筆,鈐有"宗伯學士"印（《別下》卷3,10b）。

作設色《倚松閣圖軸》,紙本（《中國圖目》,v.8,津6–018）。天津市文物公司藏。

作設色《臨一梧軒圖》[見孫承澤記董《夏木垂陰圖》]（《庚子》卷3,29a–b）。

用王蒙、倪瓚二家意作青綠《綠天庵圖軸》贈陳淳,絹本（《選學》卷下,140–41）。

作墨筆《青弁圖扇》,金箋本（*The Single Brush-stroke*, no. 46）。美國景元齋藏。

倣巨然

作墨筆《鍾賈山陰望平原邨景圖卷》,搥金箋本,自題云出入惠崇、巨然二家,鈐有"太史氏"印（《石續》,御書房,2019;《中國目錄》,v.2,52,京1–2216）。北京故宮博物院藏。

按:Léo & Charlotte Rosshandler Collection 亦有此卷,識語全同,但爲紙本,且有年款,待考。見4/19/1615。

作墨筆《倣雲山煙樹圖軸》,絹本,鈐有"宗伯學士"印（《畫集》,no. 42）。廣州美術館藏。

觀京口陳氏所藏倪瓚《山陰丘壑圖》,未及摹成粉本,聊以巨然《關山雪霽圖》筆意倣作一軸,素箋本墨筆,鈐有"宗伯學士"印（《石初》卷26,23b–24a;《故宮》卷5,462;《畫集》,no.121）。台北國立故宮博物院藏。

作墨筆《山水軸》,絹本,鈐有"宗伯學士"印（*Sotheby's*, 12/6/1989, no. 47）。

作墨筆《倣出雲降雨圖軸》,絹本,鈐有"宗伯學士"印（《自怡》卷2,22a–b）。

作《倣山色圖軸》,金箋本（《自怡》卷2,23a–b）。

作《倣山雨欲來圖軸》,絹本（《筆嘯》卷上,10b）。

作山水一幀[《明人小高幅雜畫冊》十五幀之一]（《好古》卷下,94）。

背臨雲間顧中翰所藏《夏山欲雨》作紙本小幀（《壯陶》卷12,54b–55a）。

倣司馬槐

倣自藏畫卷作墨筆《山水扇》,礬紙本[《扇冊》第二冊二十四幅之十五]（《自怡》卷22,7b）。

倣米芾·米友仁

作《倣米海嶽山水卷》,并題"喬木生畫陰"五言絕句,鈐有"太史氏"印（《宋元明清名畫大觀》,v.1,166）。中國梁鴻志舊藏。

作墨筆《九峰春霽圖卷》,絹本,鈐有"太史氏"印（《啟功叢稿》,306; *Christie's*, 11/28/1990, no. 119）。

作墨筆《雲山圖卷》,紙本（《中國目錄》,v.2, 52,京1–2213）。北京故宮博物院藏。

倣米芾作墨筆《煙樹雲山圖卷》,高麗紙本,并題"米顛純師董巨"六言絕句（《華亭》,2）。

宿陳繼儒頑仙廬曉起,作《倣米襄陽山水卷》,并書張雨題米芾畫"十日雨,五日風"語（《湘管》卷6,425–26）。

作墨筆《臨米友仁雲山圖卷》,紙本,鈐有"太史氏"印（《石三》,靜寄山莊一,4137）。

作《山水卷》,高麗紙本（《別下》卷5,10b–11a）。

作墨筆《雲山卷》,絹本,并書米自題"山中宰相有仙骨"七言絕句（《古緣》卷5,28a–b）。

作澄墨《倣米元暉瀟湘圖軸》,并書米自題"山中宰相有仙骨"七言絕句,宣紙本,鈐有"太史氏"印（《寓意》卷4,32b–33a;《吳越》卷5,47b; *Chinese Painting in Hawaii*, v.1, no. 6）。The Honolulu Academy of Art。

作設色《倣米海岳雲山圖軸》,絹本,鈐有"太史氏"印（*Christie's*, 6/1/1989, no. 58）。

作墨筆《湖山雲起圖軸》,絹本,并題"七十二高峰"五言絕句,鈐有"太史氏"印（*Christie's*, 11/30/1984, no. 688）。

作《煙江疊嶂圖軸》寫楚山,絹本,鈐有"太史氏"印（《十百》,乙卷,18a–b。自題語又見《容別》卷6,15b）。

作墨筆《山水軸》,紙本,鈐有"宗伯學士"印（《總合圖錄》,v.3, JM11–027）。京都國立博物院藏。

按:中國程十髮亦藏董紙本墨筆《倣米家山水軸》,幾與此作全同,疑其中一圖爲僞。見《畫集》,no. 41。

爲肖荄作墨筆《倣米元章雲山圖軸》於虎丘舟次,紙本,鈐有"宗伯學士"印（*Sotheby's*, 12/8/1987, no. 19 及 5/30/1990, no. 34）。

倣自藏米芾《瀟湘白雲圖》作一軸,素絹本墨筆（《石初》卷17, 56b）。

作墨筆《倣小米雲山圖軸》,絹本（《壯陶》卷12,6a–b）。

作墨筆《倣米元章雲山圖軸》,灑金箋本（《劍花》,下卷,116）。

作淺色《倣老米雲山圖》,小方絹本[《明君臣山水

人物方册》二十二幅之十三]（《式古》,v.3,畫卷7,333-34）。

擬張覲宸所藏米友仁《五洲圖》作墨筆《山水册》八幅,素箋本（《石初》卷4,18a）。

作墨筆《山水扇》,金箋本[《明人扇頭畫册》十二幅之九]（《石初》卷12,28b）。

作泥金面《山水扇》[《明人書畫扇面》第三册二十幅之六]（《紅豆》卷6,71b-72a）。

倣李公麟

作《倣盧鴻草堂圖軸》（《藝林月刊》,v.95,6）。黃賓虹舊藏。

倣李成

錢受之出示《寒林落日圖》,因倣作設色《寒林圖》小幅寄贈王時敏,絹本（《壯陶》卷12,54b）。

作《寒林圖扇》（《南畫》卷8,95）。

倣沈周

作《谿亭秋霽圖軸》,絹本。上海博物館藏。

按:此軸有陳繼儒題,云董擬其自藏沈周《谿亭秋霽圖》。

倣吳道子

作淡著色《觀音像軸》,宣德箋本,鈐有"太史氏"印（《秘初》卷12,9b）。

倣吳鎮

遊雲陽居委宛堂,爲主人倣昔見陳繼儒家藏吳鎮畫作《山水卷》,紙本（《湘管》卷6,430）。

婁江道中,憶去冬所觀吳鎮諸畫作墨筆《山水册》八幅,紙本,鈐有"宗伯學士"印。分倣《溪山仙館》、《江阜雨渡》、《江村書屋》、《雨霽秋林》、《晴嵐松色》、《秋山烟雨》諸圖（《總合圖錄》,v.1,A13-050;《文人畫》,v.5,nos.81-84）。美國翁萬戈藏。

作墨筆《山水扇》,金箋本（《中國圖目》,v.3,滬1-1408）。上海博物館藏。

倣范寬

作墨筆《山水軸》,白鏡面箋本（《平生》卷10,114）。

倣倪瓚

作墨筆《小景圖卷》,紙本,後書倪自題畫"夕陽渡口見青山"及"戲寫江南雨後山"七言絕句二首,鈐有"宮詹學士"印（《虛齋》卷4,42a-b）。

作設色《秋山高士圖軸》,絹本,鈐有"太史氏"印。後又爲虎聖題"剩水殘山好卜居"七言絕句一首於畫上（《畫集》,no.29;《中國圖目》,v.3,滬1-1396。詩見《容詩》卷4,42a,"題倪迂畫二首"之一）。上海博物館藏。

按:此作有陳繼儒一六二○年九月題。

作《山水軸》,鈐有"太史氏"印（《唐宋元明名畫大觀》,360）。日本藤井善助舊藏。

作墨筆《山水軸》,絹本,鈐有"太史氏"印（*Christie's*,5/31/1990,no.26）。

作墨筆《溪山圖軸》,絹本,鈐有"太史氏"印（《鑑影》卷22,3a-b）。

作《喬林峭壁圖軸》,絹本,并題"能與米顛相伯仲"七言絕句,鈐有"太史氏"印（《愛日》卷2,10a-b）。

觀京口陳氏所藏倪瓚《山陰丘壑圖》,未及摹成粉本,聊以巨然《關山雪霽圖》筆意倣作一軸,素賤本墨筆,鈐有"宗伯學士"印（《石初》卷26,23b-24a;《故宮》卷5,462;《畫集》,no.121）。台北國立故宮博物院藏。

爲龍生作墨筆《山郭幽居圖軸》寫倪瓚詩意,并書倪"山郭幽居正向陽"七言絕句,宣德紙本,鈐有"宗伯學士"印（《華亭》,15）。

作墨筆《山水軸》,宣紙本,并題"寒山轉蒼翠"五言詩一聯,鈐有"宗伯學士"印（《華亭》,15-16）。

作墨筆《山水軸》,紙本,鈐有"宮詹學士"印（《玉雨》卷3,98-99;《總合圖錄》,v.1,A15-062）。The John M. Crawford,Jr. Collection。

王廷珸出示倪瓚真蹟,因倣一軸,高麗紙本墨筆,并題"聽松菴裡試茶還"七言絕句,鈐有"青宮太保"印（《華亭》,14）。

作墨筆《山陰丘壑圖軸》,紙本（《中國目錄》,v.2,52,京1-2230）。北京故宮博物院藏。

作墨筆《疏林遠山圖軸》,絹本,并書倪"灘聲嘈嘈雜雨聲"七言絕句（《畫苑掇英》,v.1,no.44;《畫集》,no.13）。上海博物館藏。

作墨筆《山水軸》,灑金紙本（《十百》,丙卷,6a;《畫集》,no.34）。廣州美術館藏。

作墨筆《山水軸》,紙本（《總合圖錄》,v.2,S8-021）。香港至樂樓藏。

作墨筆《山水軸》,紙本（《總合圖錄》,v.4,JP6-042）。日本柳孝氏藏。

作《山水軸》（《畫集》,no.103）。

作墨筆《山水軸》,金箋本,并題"相逢之處花茸茸"七言絕句（《藝苑遺珍》,名畫第三輯,no.38）。

作設色《林亭秋色圖軸》,宣德紙本,并書倪"性癖居幽每起遲"七言絕句（《華亭》,15）。

於吳門王承天守家見倪瓚山水,書宋僧絕句四首

於上,已忘其一,因倣作一軸,素箋本墨筆,并臨原詩絕句三首（《石初》卷26,24a-b）。

作墨筆《平林遠岫圖軸》,高麗紙本（《湘管》卷6,426）。

作《山水軸》,紙本,并書倪"夕陽渡口見青山"七言絕句（《湘管》卷6,429）。

作《松亭秋色筆意圖軸》,紙本（《湘管》卷6,430-31）。

用倪瓚、王蒙二家意作青綠《綠天庵圖軸》贈陳淳,絹本（《選學》卷下,140-41）。

作墨筆《山水扇》,金箋本（《中國目錄》,v.2,52,京1-2229）。北京故宮博物院藏。

作墨筆《山水扇》,金箋本（《中國目錄》,v.2,52,京1-2234）。北京故宮博物院藏。

爲宏任(?)作《山水扇》（《南畫》卷8,97;《畫集》,no.184）。

作《山水圖》,并題"三年不見雲林面"七言絕句（《好古》卷下,73）。

作《錫山圖》[見汪承誼記王文治題此圖]（《快雨》卷7,13）。

爲陳繼儒倣作《山景圖》（《妮古》卷4,295;《歸石》卷4,25b）。

倣馬和之

作《山水扇》,紙本,并小行書"青山白雲父"絕句於左[《二扇立軸》之一]（《平生》卷10,115-16）。

倣高克恭

作著色《山川出雲圖卷》,素絹本,再跋後鈐有"太史氏"印（《石初》卷6,71a-72a。自跋語又見《容別》卷6,10a-b）。

憶昔在京苑西草堂所見高克恭畫卷,倣作設色《山水卷》,紙本（《古緣》卷5,29b-30b）。

作青綠《山川出雲圖軸》,絹本,鈐有"宗伯學士"印（《寶迂》卷1,37a-b;《古書畫僞訛考辨》,圖版下,no.33-7）。上海博物館藏。

作墨筆《雲山圖軸》,紙本（*Christie's*,12/11/1987,no.105）。

作墨筆《山水扇》,紙本（《中國圖目》,v.3,滬1-1407）。上海博物館藏。

作《山水扇》（《南畫》卷8,92）。

作墨筆《山水扇》,金箋本,并題"嚴壑雲初起"五言詩一聯[《明人書畫扇面集册》第二册二十對幅之十一]（《鑑影》卷15,13b）。

作《山水小幅》，并題"白雲無四時"五言絕句一首（《圖畫精意識》，85及89）。

倣張僧繇

憶庶常時在京所見《翠岫丹楓圖》，爲陳繼儒倣作一軸，紙本青綠橫幅（《虛齋》卷8，47b–48b；《畫集》，no. 11）。吉林省博物館藏。

按：董自題此軸云作於庶常時二十餘年後，則應爲一六一五年左右。

作青綠《沒骨山水軸》，鈐有"太史氏"印（《支那名畫寶鑑》，664；《宋元明清名畫大觀》，v.1，164）。中國葉範園舊藏。

作著色《沒骨山圖軸》，綾本，鈐有"大宗伯章"印（《辛丑》卷5，51）。

作金箋本《畫册》十幅寄陳繼儒，內有《倣西嶽降靈筆意圖》，自云學張僧繇（《書畫史》，122）。

作設色《雪山圖扇》，泥金紙本（《故宮旬刊》，v.1，4）。故宮博物院藏。

倣曹知白

作墨筆《秋林書屋圖軸》，宣德鏡光箋本（《石初》卷17，45b；《南畫》卷11，40；《故宮》卷5，461；《畫集》，no. 123）。台北國立故宮博物院藏。

作《山水扇》（《南畫》卷8，94）。

倣黃公望

作墨筆《山水卷》，絹本，後書畫論，鈐有"知制誥日講官"印（《石三》，養性齋，3259–60）。

作墨筆《谿山秋霽圖卷》，紙本，鈐有"太史氏"印（《畫集》，no. 32）。南京博物院藏。

擬三十年前所見文徵明《谿山秋霽》作一卷，絹本淺著色，鈐有"太史氏"印（《十百》，辰卷，15a–b及申卷，2b–3a；《總合圖錄》，v.2，S13–035）。香港黃仲方藏。

臨自藏《富春大嶺圖》一卷，紙本墨筆，鈐有"太史氏"印（《華亭》，5）。

爲許翰公作墨筆《山水卷》，紙本（《藝苑掇英》，v.31，9；《虛白》，no. 20）。香港劉作籌藏。

作墨筆《江山秋霽圖卷》，高麗表牋本（《石續》，御書房，2018–19；《董其昌》，no. 24；《總合圖錄》，v.1，A22–079；《文人畫》，v.5，no. 23；《畫集》，no. 135）。The Cleveland Museum of Art。

青溪道中，臨自藏《富春大嶺圖卷》及沈周《倣癡翁富春卷》作一卷，紙本墨筆，并題"山出雲時雲出山"七言絕句（《總合圖錄》，v.1，A13–012；《文人畫》，v.5，no. 26。詩見《容詩》卷4，36a，"題畫贈周奉常"）。美國翁萬戈藏。

作墨筆《山水卷》，絹本（《華亭》，11）。

作《山水卷》，并題"大癡畫法超凡俗"七言絕句（《好古》卷下，74）。

作《山水卷》於茆湖舟次，紙本（《退菴》卷17，4a）。

以董源法作墨筆《倣黃大癡湖莊圖卷》，絹本（《古芬》卷16，42a–b；《眼初》卷12，11a）。

作墨筆《山水卷》，絹本，并題"歸鴻別鶴夜鐘殘"七言絕句（《鑑影》卷8，8a–b。詩見《容詩》卷4，37a，"題畫送人歸江西"）。

作設色《夏木垂陰圖軸》，絹本，鈐有"太史氏"印（《穰梨》卷24，20a；《畫集》，no. 3）。廣東省博物館藏。

作墨筆《山水軸》，寫張雨題黃公望"渡水傍山尋絕壁"七言絕句詩意，并書其詩，鈐有"太史氏"印（*Christie's*，12/4/1989，no. 152）。

作設色《山水軸》，絹本，并題"幽人茶竈煙"五言絕句，鈐有"太史氏"印（《華亭》，16。詩見《容詩》卷2，34b）。

倣沈能甫所藏畫册十二幅作一軸，紙本墨筆，鈐有"纂修兩朝實錄"印（《穰梨》卷24，7a）。

作墨筆《山水軸》，紙本，并書"大癡畫法超凡俗"七言絕句，鈐有"宗伯學士"印（《董其昌》，no. 25；《文人畫》，v.5，no. 34；《畫集》，no. 115）。美國王季遷藏。

作潑墨《山水軸》，宣德紙本，鈐有"宗伯學士"印（《吳越》卷5，48b–49a）。

作墨筆《山水軸》，絹本（《畫集》，no. 102）。上海博物館藏。

作設色《溪山讀書圖軸》，紙本（《中國圖目》，v.3，滬1–1392）。上海博物館藏。

作墨筆《山水軸》，絹本（《總合圖錄》，v.2，S13–038；《畫集》，no. 96）。香港黃仲方藏。

作淺設色《山水軸》，絹本，并書"大癡畫法超凡俗"七言絕句（《總合圖錄》，v.1，A1–054；《畫集》，no. 105）。The Metropolitan Museum of Art。

舟次湖上，作《山水軸》寫馬鞍山色（《南畫》卷9，182；《畫集》，no. 99）。

作《石田詩意圖軸》，并題沈周"詩在大癡畫前"六言絕句（《中國名畫》，v.29；《畫集》，no. 111）。

作《富春大嶺圖軸》（《畫集》，no. 113）。

作墨筆《山水軸》，金箋本（*Sotheby's*，12/5/1985，no. 11）。

作設色《浮嵐暖翠圖軸》，鏡面箋本（《華亭》，14）。

倣自藏畫二十幅作一軸，宣德紙本墨筆（《吳越》卷5，48a）。

往梁谿，友人攜示黃公望畫，因倣作一軸，紙本墨筆（《石三》，延春閣廿六，2072）。

作墨筆《陡壑密林圖軸》，紙本（《別下》卷6，15a）。

按：董自題云曾藏黃公望《陡壑密林圖》三十年，後爲王尚寶所易。

倣作《山水軸》（《歸石》卷4，15b–16a）。

作《山水軸》，紙本（《愛日》卷2，10b）。

作《山水軸》，綾本（《愛續》卷2，14b）。

作《山水圖册》四幅，紙本。一爲墨筆倣黃公望，二爲設色，題"林紅欲變秋"，三爲設色，倣黃公望《秋山圖》，四爲墨筆，題"日色冷青松"（《畫集》，no. 28）。吉林省博物館藏。

作著色《野色遙岑圖》，方紙本，并題"野色散遙岑"五言絕句[《明君臣山水人物方册》二十二幅之十一]（《式古》，v.3，畫卷7，333；《墨緣》，名畫卷下·《明賢集册》十四幅之十，7a）；又見[《明人名筆集勝册》十二幅之八]（《虛齋》卷11，35b）。（詩見《容詩》卷2，33a，"題倣黃子久畫"）。

作《仙山讀書圖》，并題"練谿青嶂是秦餘"七言絕句[《墨花閣鑑藏另册》二十二幅之十四]（《式古》，v.3，畫卷7，341–42。詩見《容詩》卷4，36b，"題畫爲楊弱水侍御"）。

作設色《雙峽迴溪圖》，金箋本[《明人畫扇册》八幅之首]（《石續》，淳化軒，3333；《石隨》卷5，18b）。

作墨筆《山水扇》三幅，金箋本（《中國圖目》，v.3，滬1–1401，1402及1403）。上海博物館藏。

作墨筆《富春圖便面》，金箋本[《便面畫册》十幅之八]（《石初》卷41，36b；《故週》，v.259，2；《南畫》卷8，101；《畫集》，no. 180）。台北國立故宮博物院藏。

參見：4/4/1592

作《丹臺春曉圖扇》（《南畫》卷8，93）。

倣自藏《良常館圖》，并書黃自題"邈矣盧鴻乙"五言絕句（《好續》，131）。

作墨筆《山水扇》，金箋本[《明十名家書畫便面册》金扇十八面之十四]（《澄懷》卷11，11）。

倣郭熙

常荆校士歸，作《山水》（《珊瑚》·畫·卷18，22；《式古》，v.4，畫卷30，533）。

按：《珊瑚》載董自云"時愛荆（汪砢玉父）拔士歸，爲寫此并題，"《式古》作"時常荆校士歸…，"未知孰是。

倣惠崇

作《鍾賈山陰望平原郊景圖卷》，自題云出入惠崇、巨然二家。

參見:本節"倣巨然"此條。

倣董源

作墨筆《秋林晚翠圖卷》，絹本，并行書七言詩，鈐有"宗伯學士"印(《故宮》卷4, 238–39)。台北國立故宮博物院藏。

作著色《山水卷》於寶鼎齋，絹本，後并行書"題紫陽庵"七言律詩(《總合圖錄》, v.2, E17–034;《畫集》, no. 137. 詩見《容詩》卷3, 38b)。Museum für Ostasiatische Kunst, Köln。

作《几上烟雲畫卷》(《快雨》卷7, 14)。

觀董源畫於龍潭抱珠樓，遂倣作《烟江叠嶂圖卷》，絹本(《退菴》卷17, 3a–b)。

作墨筆《山水卷》，絹本，後并行草書王維"中歲頗好道"五言律詩(《鑑影》卷8, 4a–b)。

作墨筆《倣黃大癡湖莊圖卷》，絹本(《古芬》卷16, 42a–b;《眼初》卷12, 11a)。

作墨筆《疏樹遙岑圖軸》，金箋本，鈐有"太史氏"印(《中國圖目》, v.3, 滬1–1397)。上海博物館藏。

作墨筆《山水軸》，絹本，鈐有"太史氏"印(《畫集》, no. 30)。南京博物院藏。

作設色《春山雨霽圖軸》，絹本，鈐有"太史氏"印(《天隱堂名畫選》, v.1, no. 34)。

作墨筆《山水軸》，絹本，鈐有"太史氏"印(Sotheby's, 11/21/1984, no. 12)。

作墨筆《湖山雲起圖軸》，絹本，并題"七十二高峰"五言絕句，鈐有"太史氏"印(Christie's, 11/30/1984, no. 688)。

倣自藏《谿山行旅圖軸》作《山水軸》，紙本，鈐有"太史氏"印(《十百》, 甲卷, 20b)。

作墨筆《山水軸》，絹本，鈐有"太史氏"印(《鑑影》卷22, 2b–3a)。

作墨筆《山水軸》，絹本，鈐有"太史氏"印(《寶迂》卷1, 38a)。

觀《夏木垂陰圖》於京吳太學所，因倣作一軸，紙本墨筆，鈐有"宗伯學士"印(《石三》, 延春閣廿六, 2071;《故宮》卷5, 460–61;《畫集》, no. 112)。台北國立故宮博物院藏。

按:《十百》亦載董紙本墨筆《山水軸》，自識語與故宮所藏此軸僅二字異，但無"宗伯學士"印，置此待考，見庚卷, 17b–18a。

作設色《山市晴嵐圖軸》，絹本，鈐有"宗伯學士"印(《畫苑掇英》, v.1, no. 43;《畫集》, no. 50)。上海博物館藏。

觀《溪山樾館圖》於北扉朱黃門所，後倣作一軸，紙本墨筆，鈐有"宗伯學士"印(《蘇雪》卷4, 59b; Whitfield, *In Pursuit of Antiquity*, no. 9)。The Metropolitan Museum of Art。

作墨筆《溪山圖軸》，紙本，鈐有"宗伯之章"印(《神州》, v.9)。中國風雨樓舊藏。

作墨筆《山水軸》，紙本，并題"青林何茸茸"五言絕句，鈐有"宗伯學士"印(《華亭》, 14. 詩見《容詩》卷2, 28b, "贈蔣山人")。

作墨筆《山水軸》於荊溪，絹本(《神州》, v.8;《南畫》卷9, 184;《畫集》, no. 98)。中國陶蘭石舊藏。

作《山水軸》(《南畫》卷9, 187;《畫集》, no. 97)。

作墨筆《山水軸》，紙本(Christie's, 6/3/1987, no. 74)。

作墨筆《山水軸》，絹本(Sotheby's, 11/26/1990, no. 36)。

作《山水軸》，紙本，并題"翠嵐迎步興何長"七言絕句(《庚子》卷3, 26b–27a)。

作墨筆《九夏松風圖軸》，宣德紙本(《華亭》, 15)。

作《夏口待渡圖軸》，白宋紙本(《吳越》卷5, 63a;《歸石》卷4, 16b)。

作《山水軸》，絹本，并題"飛帆歸遠洲"五言絕句(《古芬》卷16, 46a–b)。

作墨筆《山水扇》，金箋本(《總合圖錄》, v.4, JP30–245)。日本橋本大乙藏。

作墨筆《山水扇》，金箋本(《董盦》, v.4, no. 28)。日本齋藤氏舊藏。

為漢翀作《山水扇》(《畫集》, no. 160)。

作著色《秋林遠岫圖》，金箋本[《明人扇頭畫冊》十二幅之八](《石初》卷12, 28b)。

作《山水圖》(《中國名畫集》, v.3)。

作設色《夏木垂陰圖》(《庚子》卷3, 29a–b)。

倣楊昇

作青綠《沒骨山水軸》，絹本，鈐有"太史氏"印(《式古》, v.4, 畫卷30, 533;《墨緣》, 名畫卷上明, 32b–33a)。

觀《峒關蒲雪圖》，因倣作一軸，絹本大青綠，鈐有"太史氏"印(《十百》, 庚卷, 15a及辰卷, 23a–b)。

按:此圖有陳繼儒題云楊昇《峒關蒲雪圖》為甬東朱定國所藏。

作著色《峒關蒲雪圖軸》，絹本(《總合圖錄》, v.4, JT118–016;《畫集》, no. 106)。日本慈照院藏。

作著色《峒關蒲雪圖軸》，絹本(《總合圖錄》, v.4, JP8–024)。日本阿形邦三藏。

作《峒關蒲雪圖扇》(《南畫》卷8, 91;《畫集》, no. 170)。

倣趙伯駒

作青綠《山水小幅》，絹本(《平生》卷10, 115)。

倣趙伯驌

作青綠《松陂平遠圖軸》，絹本，并小行楷書詩跋二百餘字(《平生》卷10, 114)。

擬《萬松金闕圖》作《臥遊五岳書畫冊》，絹本。畫幅著色，其中一題"天降時雨，山川出雲，"一作《巖居圖》。書幅各行書五言律詩一首，另幅自跋，鈐有"太史氏"印(《總合圖錄》, v.3, JM1–109;《文人畫》, v.5, nos. 73–76)。東京國立博物館藏。

倣趙孟頫

作墨筆《水村圖卷》於香雪齋，絹本，鈐有"太史氏"印(《古芬》卷16, 43a–b;《眼初》卷12, 12a)。

背臨沈氏所藏山水一軸，絹本淡彩，鈐有"太史氏"印(《董盦》, v.4, no. 29)。日本齋藤氏舊藏。

將自藏巨軸山水中諸景收為小幀，作設色《秋山圖軸》，紙本，并題"積鐵千尋屆紫虛"七言絕句，鈐有"宗伯學士"印(《古緣》卷5, 38b–39a;《畫集》, no. 48. 詩見《容詩》卷4, 43a–b, "題倣黃子久畫")。上海博物館藏。

作設色《秋江圖軸》，絹本(《中國目錄》, v.2, 52, 京1–2231)。北京故宮博物院藏。

為陳繼儒作《桃花綠山冊》(《妮古》卷3, 270)。

作重絳色《臨溪書屋圖》小幅，絹本(《平生》卷10, 114)。

倣趙幹

擬自藏《烟靄秋涉圖》作一軸，絹本(《筆嘯》卷上, 13b)。

倣關全

作墨筆《山水軸》，紙本，鈐有"宗伯學士"印(《式古》, v.4, 畫卷30, 533)。

作墨筆《山水扇》，金箋本(《中國圖目》, v.3, 滬1–1411)。上海博物館藏。

倣諸家

觀燕文貴、王維、巨然、李成及趙源倣卷於京郭金吾家，因倣其意作墨畫一卷，素箋本(《石初》卷6, 70a)。

作《倣諸名家山石皴法長卷》(《快雨》卷7, 15)。

按:此作似即《眼初》所載《摹各家山水卷》,見卷12, 10a。

作《摹各家山水卷》六幅,紙本。一題"谿迴路自轉"五言絕句,二倣自藏米友仁《雲山烟樹圖》,三倣荆關意,并題七言詩一聯,四倣倪瓚《江亭秋色》,五倣自藏高克恭《雲林秋霽圖》,六倣昔於吳廷家所見郭熙小景(《古芬》卷16, 39a–40b;《眼二》卷15, 30a–31a)。

作《山水集屏》四幅,絹本。一參合董源、趙令穰筆意作淡著色山水;二墨筆倣黃公望;三作淡著色山水,并題"樹樹皆秋色"五言詩一聯;四墨筆倣倪瓚,有年款。第二、三幅款後鈐有"太史氏"印(《鑑影》卷22, 5b–6b)。

參見:1/1614

作《臨各家山水冊》十幅,絹本。一倣趙令穰《柳塘垂釣圖》,二倣黃公望作青綠山水,三倣巨然,四倣荆浩,五倣董源,六倣米友仁《雲山圖》作潑墨山水,七倣吳鎮,八倣李成,九倣柯九思《古木竹石》,十倣倪瓚《□士溪山圖》。冊中鈐有"知制誥日講官"印(《古芬》卷16, 44a–45b)。

觀董源、黃公望、倪瓚畫於婁江舟中,因作設色《山水冊》八幅,金箋本,其中三倣黃公望作《長松草堂圖》,五倣吳鎮作《奇峰拔雲圖》,八倣董源《溪山暮靄圖》(《中國圖目》,v.3,滬1–1384)。上海博物館藏。

作《倣古山水冊》八幅,金箋本,第三及八幅設色,餘皆墨筆。其中第二幅倣董源作《湖橋秋色》,三作《林塘進艇》,四倣夏珪作《山居圖》,五作《夏木垂陰》,六倣高克恭,七於婁江舟次,寫虞山所見之景,八倣倪瓚(《畫集》,no. 22;《中國圖目》,v.3,滬1–1387)。上海博物館藏。

作設色《山水圖冊》六幅,灑金紙本。其中一倣黃公望,二作《秋山圖》,六倣關全(《畫集》,no. 35)。天津市藝術博物館藏。

作淺設色《倣古山水冊》八幅,絹本,分倣李成《寒林圖》、倪瓚、董源、倪瓚《谿亭亭子》、黃公望等(《總合圖錄》,v.2, S7–044;《畫集》,no. 148)。香港北山堂藏。

作《山水高冊》十幅,白紙本,其中七幅紀年,第一、二及六幅未紀年。一墨筆倣張覲宸家藏李公麟《臨盧鴻草堂圖》中之《雲錦淙》;二墨筆擬燕文貴;六作著色山水,并題楊慎"雨中遣懷曲。"The Nelson-Atkins Museum of Art。

參見:9/1621(3); 4/1623; 7/22/1623; 7/29/1624; 8/13/1624; 9/12/1624;九日晴/1624(1)

作墨筆《倣宋元山水冊》四幅,紙本,倣米友仁、黃公望等(《文人畫》,v.5, nos. 77–80)。美國王季遷藏。

作墨筆《倣古山水冊》五開,紙本,分倣黃公望、荆關、趙令穰《柳溪歸棹圖》、松江朱大韶家藏吳鎮《雪谿圖》及董源(《總合圖錄》,v.2, E20–080)。Ostasiatiska Museet, Stockholm。

作《倣古山水冊》八幅,其中三幅分倣黃公望、倪瓚及米家山(《中國名畫集》,v.3)。

作墨筆《山水冊》七幅,紙本。其中二幅仿董源,一仿黃公望《山庄圖》,一仿倪瓚(*Christie's*, 11/25/1991, no. 99)。

作《倣十六家巨冊》,其中十三幅紀年。未紀年者爲第二幅設色寫顏真卿與耿偉水亭聯句"度琴方解慍臨水已迎秋"詩意,紙本;第十五幅墨筆倣自藏關仝《關山雪霽圖》,并題"泉聲咽危石"五言詩一聯,紙本;第十六幅墨筆臨趙孟頫《贈鮮于太常委順卷圖》,絹本。

參見:正午/1620; 9/1621(1)(2); 2/1/1625; 6/1625(1)(2); 9/27/1625; 10/9/1625;春/1626; 2/2/1626; 4/24/1626; 3/15/1627(1); 6/1628

作《倣宋元山水冊》十幅,紙本。一設色,書倪瓚題王蒙畫"澄懷觀道宗少文"七言絕句;二墨筆,擬自藏宋搨徐浩《洺州府君碑》楷書鮑照"廬山詩";三設色倣董源《龍宿郊民圖》筆意,題李白"元丹丘,愛神仙"歌行;四設色,題"大癡畫格超凡俗"七言絕句;五墨筆,題"春山無伴獨相求"七言律詩;六設色倣趙伯駒,題"遍地皆黃葉"五言詩一聯;七墨筆,題李白"白雲歌";八設色倣郭熙,題"奇峰出奇雲"五言古詩;九墨筆倣倪瓚《師子林圖》,題"日照錦城頭"五言古詩;十設色寫王蒙筆意(《寓意》卷4, 29b–31b)。

參見:7/1/1621; 7/7/1621(1)

作《倣六家冊》,絹本,其中二幅紀年。未紀年者一設色倣趙孟頫,并題"人家在仙掌"五言詩一聯;二設色臨趙孟頫,并題"六月杖藜來石路"七言詩一聯;三墨筆倣趙令穰,并題"帆檣柳外出"五言詩一聯;四墨筆,將偶得范寬巨軸收爲小幅(《華亭》,28–29)。

參見:7/12/1621; 4/15/1602

作《山水小景并題冊》九段,分擬米氏父子、倪瓚、黃公望等,各段分題(《郁續》卷12, 21;《式古》,v.3,畫卷5, 288–89)。

作墨筆《倣十二家冊》,絹本。一倣燕文貴,二倣王詵,三倣米芾,四倣米友仁雲山,五題"煙耶雲耶遠莫知"七言詩一聯,六倣許道寧,七倣高克恭,八倣倪瓚《平林遠岫》,九題"山水未深魚鳥少"七言詩一聯,十倣王蒙,十一倣黃公望,十二題"空山無人,水流花開"(《華亭》,28)。

用米氏父子法,兼董源與趙令穰筆意,作墨筆《夏雲奇峰圖冊》八幅於泖湖塔院,宣德高麗紙本。其中三爲《煙江疊嶂》,四爲米家山,七爲雨中山,八爲《洞庭秋霽》(《吳越》卷5, 60a–b)。

作《山水冊》八幅,紙本。一題"香中別有韻"五言詩一聯,二擬米友仁《雲山圖》,三倣楊補之,四倣李昭道,六寫杜甫詩意,題"暫時花戴雪"五言詩一聯,七倣倪瓚,八倣荆關作疊雪皴(《紅豆》卷6, 43b–44b)。

作《倣古山水冊》十二幅,絹本,分倣郭熙、趙令穰、董源《夏山圖》、巨然小景、趙幹、荆關、黃公望、李昇、曹知白、畢宏《秋山靜靄》、盛懋及范寬《雪景》(《退菴》卷17, 1a–b)。

舟行平湖道中,作《倣古畫冊》十二幅,紙本,分倣董源、江參、張僧繇沒骨山、范寬、李成、黃公望、米芾《雲山圖》、倪瓚、吳鎮、王蒙、巨然及曹知白(《藤花》卷3, 24a–25a)。

作墨筆《山水冊》八幅於白門舟次,紙本,其中三幅分倣倪瓚、黃公望及王蒙(《藏雪》卷4, 51b–52b)。

作《倣古山水冊》十幅,絹本。一墨筆倣巨然,并題"山水未深魚鳥少"七言詩一聯;二墨筆倣董源;三墨筆寫米家山於臨平道上;四設色倣黃公望;五墨筆倣倪瓚,并題"雨洗秋山淨"五言詩一聯;六墨筆倣吳鎮;七設色倣趙雍;八墨筆倣燕文貴,并題"連潭萬木影"五言詩一聯;九設色倣馬琬,并題"樹密多因雨"五言詩一聯;十墨筆倣李成《寒巖積雪》(《古緣》卷5, 35b–36b)。

作《倣古山水冊》七幅,粉箋紙本。一倣梁谿華學士家藏黃公望《山水巨軸》,二倣董源,三倣董源《溪山行旅圖軸》,四題"海風吹不斷"五言詩一聯,五題"氣霽地表"四言詩,六題"南陵水面漫悠悠"七言絕句,七題"集賢仙客問生涯"七言絕句(《三秋》卷上, 59a–60a)。

作墨筆《山水冊》八幅,白鏡面光紙本,分倣倪瓚、米友仁、吳鎮、關仝、董源、巨然、黃公望及荆浩(《壯陶》卷12, 46a–b)。

作著色《蟾蜍水戲山水冊》八幅,紙本。一題"平地風煙橫百鳥"七言詩一聯,三倣米友仁筆,六爲《谿亭秋霽》,八爲《寒林圖》(《壯陶》卷12, 37b–38a)。

作淺設色《山水扇面冊》十二幅,金箋本,分倣倪瓚《六君子圖》、巨然、吳鎮、董源二幅、倪瓚及元人筆意(《總合圖錄》,v.2, S8–080;《畫集》, nos. 158, 161, 162, 163, 164, 165, 166, 173, 174, 175, 178, 183)。香港至樂樓藏。

按:至樂樓所藏此冊與下條《聽颿》所載有諸多符合,但不全同,或爲原冊拆散後與他作合併,待考。

作《山水扇冊》十二幅。一倣倪瓚,二爲宏任擬倪瓚,三有年款,四倣元人筆意,并題"山木半葉落"五言絕句,五題"煙暝雲迷渡"五言詩一聯,七倣巨然,八擬倪瓚《六君子圖》,十倣董源,十一倣米家山(《聽颿》卷3, 277–81)。

參見:秋/1615

畫:自作

卷

爲陳繼儒作《東佘山居圖卷》四幅,紙本,各題"獨往山家歇還涉","烏絲白練是生涯,""山郭幽居正向陽"及"石磴盤紆山木稠"七言絕句一首,鈐有"知制誥日講官"印(《穰續》卷8, 23a–24b)。

作墨筆《雲多地僻圖卷》,紙本,并題"雲多不計山

深淺"七言絕句,鈐有"太史氏"印。後又題"老大閑身得自由"七言絕句(《十百》,卯卷,7b-8a。第二首詩見《容詩》卷4,39b-40a,"題王幼度畫")。

作設色《采菊望山圖卷》,絹本,并行書陶潛"結廬在人境"五言古詩,鈐有"太史氏"印(《石續》,寧壽宮,2849)。

作墨筆《春山晴霽圖卷》,絹本,鈐有"太史氏"印(《夢園》卷13,37a-b)。

按:此作無款。

作淺設色《秋山圖卷》,絹本,并題"崑山殊宛孌"五言絕句,鈐有"太史氏"印(《古芬》卷16,34a-b。詩見《容詩》卷2,32a,"自畫吾松小崑山二首"之一)。

作墨筆《山水卷》,紙本,鈐有"宗伯學士"印[董其昌·吳偉業《書畫合璧卷》之畫幅](《畫集》,no.134;《中國圖目》,v.3,滬1-1389)。上海博物館藏。

作墨筆《山水卷》,素箋本,并題王維"行到水窮處"詩四句,鈐有"宗伯學士"印(《石初》卷6,71a)。

作《山雨欲來圖卷》,絹本,并題"無限青山散不收"七言絕句,鈐有"宗伯學士"印(《聽颿》卷2,158)。

作墨筆《集古樹石畫稿卷》,絹本(《中國目錄》,v.2,52,京1-2215)。北京故宮博物院藏。

作墨筆《山水卷》,紙本,并題去秋於惠山所見倪瓚題畫"嵐影川光翠蕩磨"七言絕句[董其昌·陳繼儒《書畫合璧卷》之畫幅](《中國圖目》,v.3,滬1-1391)。上海博物館藏。

作設色《山水卷》,絹本,并題"連峰數十里"五言絕句(《畫集》,no.45)。吉林省博物館藏。

作淺絳《山水卷》,絹本,并題"聞有風輪持世界"七言絕句(《總合圖錄》,v.2,S8-024;《畫集》,no.136。詩見《容詩》卷4,44a-b)。香港至樂樓藏。

作墨筆《山水短卷》,綃本,并題"天降時雨,山川出雲"(《總合圖錄》,v.3,JM11-044)。京都國立博物館藏。

作《山水卷》,并題"山出雲時雲出山"七言絕句(《唐宋元明名畫大觀》,358)。日本藤村義朗舊藏。

作墨筆《右丞詩意圖卷》,綾本,并題王維"山下孤煙遠村"六言詩一聯(Christie's,6/1/1989,no.63)。

為潘仲美作《山水卷》,并題"平疇花侵岸"五言詩一聯(《庚子》卷3,27a-b)。

作《畫稿卷》,絹本,并行楷書分題(《平生》卷10,114)。

作墨筆《疎林遠山圖卷》,素箋本(《石初》卷44,10a-b。自題語又見《容別》卷6,11b)。

作《山川出雲圖短卷》,紙本,并題"天降時雨,山川出雲"(《十百》,丙卷,5a)。

作墨筆《山水卷》,紙本,并題"岡嵐屈曲徑交加"七言絕句(《石三》,延春閣廿六,2065。詩見《容詩》卷4,33b,"題畫贈眉公"二首之二)。

作淺絳《秋山圖卷》,題詩有"故作廬峰勢,青天瀑布流"句(《眼初》卷12,6a)。

作《樹石山水畫稿卷》,絹本(《穰梨》卷24,7b-8a)。

作墨筆《長江萬里圖卷》,紙本(《念堂》,no.44)。

按:此卷拖尾有周壽昌跋,云為董持節楚藩時作,待考。

軸

作著色《谷口泊舟圖軸》,灑金箋本,鈐有"太史氏"印(Christie's,12/4/1989,no.52)。

按:此軸有吳養春一六一七年題,云觀董作此圖。

作墨筆《瑞芝圖軸》為澹園賀壽,絹本(《中國圖目》,v.7,蘇24-0183)。南京博物院藏。

按:澹園疑即焦竑,卒於一六二〇年,則此圖應作於一六二〇年之前。

作墨筆《自在觀音像軸》,素箋本,并題"一根真實海空漚"七言偈,鈐有"知制誥日講官"印(《秘初》卷12,9a-b)。

作《秋山書屋圖軸》,宣紙本,鈐有"知制誥日講官"印(《吳越》卷5,64a-b)。

作設色《水鄉山色圖軸》,絹本,鈐有"太史氏"印(《中國圖目》,v.3,滬1-1393)。上海博物館藏。

作墨筆《雲山圖軸》,絹本,并題"雲多不計山深淺"七言絕句,鈐有"太史氏"印(《畫集》,no.23)。上海文物商店藏。

作墨筆《茂樹村居圖軸》,絹本,并題"時倚籬間樹"五言詩一聯,鈐有"太史氏"印(《畫集》,no.24)。上海文物商店藏。

作設色《青山白雲圖軸》,絹本,并題"來雁霜寒楚客歸"七言絕句,鈐有"太史氏"印(《畫集》,no.2。詩見《容詩》卷4,25a,"送張了心歸楚二首"之二)。廣東省博物館藏。

作墨筆《雨淋牆頭皴圖軸》,紙本,鈐有"太史氏"印(《畫集》,no.12)。吉林省博物館藏。

按:《華亭》亦載董鏡面箋本墨筆《雨淋牆頭法圖軸》,題語款識同,印鑑異,置此待考。見頁14及17。

作設色《霜林秋思圖軸》,絹本,并題劉禹錫《秋詞》"山明水淨夜來霜"一首,鈐有"太史氏"印(《石三》,延春閣廿六,2071;《故宮》卷5,461-62)。台北國立故宮博物院藏。

作設色《秋景山水軸》,絹本,并題"商氣蕭森落木時"七言絕句,鈐有"太史氏"印(《故宮旬刊》,v.15)。故宮博物院藏。

作墨筆《雲藏雨散圖軸》,絹本,并題"雲藏神女觀"五言詩一聯,鈐有"太史氏"印(《藝苑掇英》,v.31,10;《畫集》,no.6;《虛白》,no.21)。香港劉作籌藏。

作《山水軸》,并題"江流天地外"五言詩一聯,鈐有"太史氏"印(《唐宋元明名畫大觀》,357)。日本加藤正治舊藏。

作墨筆《喬木畫陰圖軸》,宣德鏡光賤本,并題"喬木生畫陰"五言絕句,鈐有"太史氏"印(《石初》卷38,75b;《澄懷》卷4,11-12;《董其昌》,no.28;《畫集》,no.117。詩見《容詩》卷2,35b)。The Museum of Fine Arts, Boston。

作著色《建溪山水圖軸》於頑仙廬,紙本,并題"六幅生綃畫建溪"七言絕句,鈐有"太史氏"印(《董其昌》,no.26;《文人畫》,v.5,no.41;《畫集》,no.114)。Yale University Art Gallery。

為徐肇惠作墨筆《王維詩意圖軸》,紙本,并題"泉聲咽危石"五言詩一聯,鈐有"太史氏"印(《南畫》卷9,185;《總合圖錄》,v.2,E15-147;《畫集》,no.118)。The British Museum。

作墨筆《山水軸》,灑金箋本,并題"烟渚輕鷗外"五言絕句,鈐有"太史氏"印(Christie's,6/5/1985,no.29。詩見《容詩》卷2,31b,"題畫贈張山人二首"之二)。

作《山水軸》,紙本,并題"無數歸鴻落照邊"七言絕句,鈐有"太史氏"印(《十百》,甲卷,20a-b;《聽颿》卷2,158-59)。

按:二書所載此軸尺寸不同,或屬二作。

作墨筆《山水軸》,綾本,并題"煙霧初含色"五言詩一聯,鈐有"太史氏"印(《十百》,辛卷,13a)。

作設色《倚樹看村圖軸》,絹本,并題"時倚籬前樹"五言詩一聯,鈐有"太史氏"印(《自怡》卷2,23b)。

作設色《山水軸》,絹本,并題"開此洪濛荒"五言絕句,鈐有"太史氏"印(《筆嘯》卷上,11b。詩見《容詩》卷2,33b)。

作墨筆《嶺上白雲圖軸》,絹本,并題"山中何所有"五言詩一聯,鈐有"太史氏"印(《蘇雪》卷4,53a)。

作設色《秋山圖軸》,絹本,鈐有"太史氏"印(《鑑影》卷22,4a-b)。

作墨筆《孟襄陽詩意山水軸》,絹本,寫孟浩然"水亭涼氣多"詩意,鈐有"太史氏"印(《鑑影》卷22,5a-b)。

作《山居幽賞圖直幅》,絹本,并題"山居幽賞入秋多"七言絕句,鈐有"太史氏"印(《夢園》卷13,39a。詩見《容詩》卷4,43b,"題紅樹秋山")。

作墨筆《林杪水步圖軸》,紙本,并題"林杪不可分"五言詩一聯,鈐有"宗伯學士"印(《中國目錄》,v.2,52,京1-2228;《畫集》,no.52)。北京故宮博物院藏。

作墨筆《山水軸》,紙本,并題"王洽潑墨,李成惜墨"等語,鈐有"宗伯學士"印(《畫集》,no.47)。上

海博物館藏。

作墨筆《卧遊圖軸》,絹本,并題"隨雁過衡嶽"五言絕句,鈐有"宗伯學士"印(《畫集》,no. 40。詩見《容詩》卷2, 31a,"題畫贈眉公"二首之一)。上海中國畫院藏。

作墨筆《剪江草堂圖軸》,高麗鏡面箋本,并題"雪浪雲堆勢可呼"七言絕句,鈐有"宗伯學士"印(《中國美術全集》,繪畫編8, no. 14;《畫集》, no. 57。詩見《容詩》卷4, 43a,"題做水墨大癡畫")。廣州美術館藏。

作墨筆《青林長松圖軸》,紙本,并題"青林何茸茸"五言絕句,鈐有"宗伯學士"印(《中國圖目》,v.1,京11-020;《畫集》, no. 51。詩見《容詩》卷2, 28b,"贈蔣山人")。北京榮寶齋藏。

作墨筆《霜樹圖軸》,灑金紙本,并題"樹下孤石坐"五言絕句,鈐有"宗伯學士"印(《畫集》, no. 53)。上海文物商店藏。

作墨筆《山寺晴嵐圖軸》,絹本,并題"茅屋八九家"五言絕句,鈐有"宗伯學士"印(《畫集》, no. 58)。中國糜耕雲藏。

作墨筆《夏木晴巒圖軸》,紙本,并題"烟渚輕鷗外"五言絕句,鈐有"宗伯學士"印(《中國名畫》,v.3;《總合圖錄》,v.1, A1-042;《畫集》, no. 104。詩見《容詩》卷2, 31b,"題畫贈張山人二首"之二)。The Metropolitan Museum of Art。

作著色《青林長松圖軸》,絹本,并題"青林何茸茸"五言絕句,鈐有"宗伯學士"印(《總合圖錄》,v.1, A35-022;《文人畫》,v.5, no. 35;《畫集》, no. 107。詩見《容詩》卷2, 28b,"贈蔣山人")。The Asian Art Museum of San Francisco。

作墨筆《山水軸》,紙本,并題"雲開見山高"五言絕句,鈐有"宗伯之章"印(《總合圖錄》,v.1, A15-014)。The John M. Crawford, Jr. Collection。

摹之將歸常白山房,作《常白山房讀書圖軸》贈別,鈐有"宗伯學士"印(《畫集》, no. 109)。

作《山出雲圖軸》,并題"山出雲時雲出山"七言絕句,鈐有"宗伯學士"印(《畫集》, no. 122。詩見《容詩》卷4, 36a,"題畫贈周柔常")。

作墨筆《溪山煙樹圖軸》,絹本,鈐有"大宗伯印"(《藝林月刊》,v.56, 2)。

作墨筆《山水軸》,絹本,并題"老我閒身得自由"七言絕句,鈐有"宗伯學士"印(Sotheby's, 6/13/1984, no. 15)。

作墨筆《橫雲嶺樹圖軸》,紙本,并題"橫雲嶺外千重樹"七言詩一聯,鈐有"宗伯學士"印(《愛續》卷2, 14a-b)。

作墨筆《倣古山水軸》於東佘舟次,絹本,鈐有"宗伯學士"印(《古緣》卷5, 39b-40a)。

作墨筆《林巒幽秀圖軸》,紙本,并題"林杪不可分"五言詩一聯,鈐有"宗伯學士"印(《虛續》卷2, 52b)。

作墨筆《石泉松柏圖軸》,紙本,并題"山中人分芳杜若"辭一聯,鈐有"宮詹學士"印(《畫集》, no. 49)。上海文物商店藏。

作墨筆《北山荷鋤圖軸》,綾本,并題"夕陽渡口見青山"七言絕句(《三松》,4b;《中國圖目》,v.3,滬1-1394)。上海博物館藏。

作墨筆《春山茂樹圖軸》[一名《獨樹孤烟圖軸》],紙本,并題"山下孤烟遠村"六言詩一聯(《畫集》, no. 116;《中國圖目》,v.3,滬1-1395)。上海博物館藏。

作墨筆《溪山圖軸》贈若水,綾本(《中國圖目》,v.3,滬1-1398)。上海博物館藏。

作《山水軸》,并題"楚岸帆開雲樹映"七言詩一聯(《董其昌》,插圖32)。上海博物館藏。

作設色《山水軸》,灑金箋本,并題"閉户著書多歲月"七言詩一聯,後又重題。上海博物館藏。

按:此作極似《我寫》所載冷金箋本《摩詰詩意圖軸》,惟印鑑不同,重題之行數亦異,置此待考,見頁182-83。

作設色《雲山墨戲圖軸》,紙本,并題"陳道復草書作畫有米元暉意"等語(《南畫集成》,第一集,第十二輯)。上海博物館藏。

作墨筆《南湖書屋圖軸》,紙本,并題"雲間東嶺千重出"七言詩一聯(《中國圖目》,v.6,蘇6-052)。無錫市博物館藏。

作墨筆《平林秋色圖軸》,絹本,并題"只應三竺溪流上"七言詩一聯(《中國圖目》,v.6,蘇6-051;《畫集》, no. 108)。無錫市博物館藏。

作墨筆《山水軸》,紙本(《畫集》, no. 56)。松江縣博物館藏。

作墨筆《秋雨圖軸》,絹本,并題"颯颯秋雨中"五言絕句(《畫集》, no. 1)。上海文物商店藏。

作墨筆《秋山蕭寺圖軸》,灑金紙本(《畫集》, no. 36)。上海文物商店藏。

作墨筆《山水軸》,紙本,并題"荒率用墨以代米氏雲山之戲"等語(《畫集》, no. 60)。中國俞子才藏。

作墨筆《秋山平遠圖軸》於讀書臺,灑金紙本,(《畫集》, no. 37)。中國應野平藏。

作《山水軸》,并題"曉來嵐氣滿茆舍"七言詩一聯(《南畫》卷9, 186;《神州》,v.13)。中國風雨樓舊藏。

作墨筆《青山倚艇圖軸》,紙本,并題"青山入簾翠滴滴"七言詩一聯(《石三》,延春閣廿六,2070;《西清》卷1, 6a;《故宮》卷5, 459)。台北國立故宮博物院藏。

為吳正志題"悠悠白雲裡"五言絕句於舊作墨筆《奇峰白雲圖軸》,宣德鏡光箋本[《式古》,v.3,畫卷7, 325-26;《明法書名畫合璧高冊》第一冊二十七幅之十六;《石初》卷17, 46a;《故宮》卷5, 460;

《董其昌》, no. 27;《文人畫》,v.5, no. 30;《畫集》, no. 120)。台北國立故宮博物院藏。

作著色《蔡文姬小像軸》,絹本,并題杜甫"千載琵琶作胡語"七言詩一聯(《總合圖錄》,v.3, JM11-028)。京都國立博物館藏。

作墨筆《(米法)山水軸》,絹本,(《總合圖錄》,v.3, JM19-079)。日本黑川古文化研究所藏。

作淡色《山水軸》,絹本,并題"遠近青山千萬重"七言絕句(《總合圖錄》,v.4, JP12-168)。日本私人收藏。

作墨筆《山水圖》與《陽明洞天圖》,紙本,二幅合裝一軸(《總合圖錄》,v.4, JP14-054)。日本江田勇二藏。

作墨筆《山水軸》,絹本,并題"渡水傍山尋絕壁"七言絕句(《總合圖錄》,v.4, JP26-028)。日本藺山龍泉堂藏。

作墨筆《竹石圖軸》,紙本,并題"露下秋水清"五言詩一聯(《總合圖錄》,v.4, JP64-092)。日本中埜又左衛門藏。

作《橫雲流水圖軸》[一名《雲煙圖軸》],并題"橫雲嶺外千重樹"七言詩一聯(《東洋美術大觀》,v.11;《畫集》, no. 110)。日本永井喜炳舊藏。

作《山水軸》,并題"水迴青峰空"五言詩一聯(《藝林月刊》,v.23, 4)。

作《西山欲雨圖軸》(《畫集》, no. 101)。

作墨筆《群峰聳翠圖軸》,紙本,并題"只謂一峰翠"五言絕句(Sotheby's, 12/8/1987, no. 71)。

舟過澱湖,作墨筆《山水軸》寫所見,紙本(Christie's, 12/2/1982, no. 647)。

作《山居圖軸》,并題"饑食松花渴飲泉"七言絕句(《珊瑚》·畫,卷18, 23;《式古》,v.4,畫卷30, 532)。

作淡色《風軒水檻圖軸》[一名《平岡圖軸》],絹本,并題"風軒水檻壓春流"七言絕句(《式古》,v.4,畫卷30, 533;《大觀》卷19, 29a。詩見《容詩》卷4, 45a)。

作墨筆《山水軸》,高麗繭紙本,并題"聞西夏蕩平,吾輩得優悠筆墨之樂"等語(《平生》卷10, 116)。

作墨筆《巫山雨意圖軸》,宋箋本,并題"雲藏神女館"五言詩一聯(《石初》卷8, 38b)。

作墨筆《雲岫圖軸》,素賤本,并題"山矗天中半天上"七言詩一聯(《石初》卷8, 39b-40a)。

作著色《秋山圖軸》,素絹本,并題"紅樹秋山飛亂雲"七言絕句(《石初》卷8, 51a-b)。

作著色《春景山水圖軸》,素絹本,并題"渡水傍山尋絕壁"七言絕句(《石初》卷8, 51b)。

作墨筆《秋山書屋圖軸》,素賤本,并題"雲開見山

高"五言絕句(《石初》卷8, 51b)。

作墨筆《春湖烟樹圖軸》,素絹本,并題"幽人茶竈烟"五言絕句(《石初》卷17, 57a。詩見《容詩》卷2, 34b)。

作墨筆《山市晴嵐圖軸》,絹本(《吳越》卷5, 69b)。

作墨筆《山水軸》,紙本,并題"不雨山常潤"五言詩一聯,又於詩塘題"水榭花繁處"五言絕句(《十百》,丁卷, 15b)。

作淺著色《山水軸》,絹本,并題"老我閒身得自由"七言絕句(《十百》,未卷, 8b。詩見《容詩》卷4, 39b–40a,"題王幼度畫")。

作重著色《鳴琴秋籟圖軸》,絹本,并題"山色無定姿"五言絕句(《十百》,酉卷, 10a)。

作《山水軸》,紙本,并題"泉流香澗落"五言詩一聯(《紅豆》卷8, 32a–b)。

作淡著色《春山欲雨圖軸》,絹本(《筆嘯》卷上, 6b–7a)。

作著色沒骨《紅樹秋山圖軸》,絹本,寫唐寅"紅樹秋山飛亂雲"詩意(《鑑影》卷22, 4b–5a)。

作《山水軸》,紙本,并題"畫家當以古人為師"等論畫語(《夢園》卷13, 40a–b)。

作《秋山書屋圖軸》,有陳繼儒題"架上多異書"五言絕句(《歸石》卷4, 16b)。

作墨筆《秋山蕭寺圖軸》,冷金箋本,(《愛續》卷2, 15a)。

作墨筆《山水軸》,絹本,并題"只謂一峰秀"五言絕句(《劍花》,下卷, 117)。

冊

持節楚藩歸,作《赤壁圖冊》贈陳繼儒,寫三國周瑜赤壁景(《妮古》卷1, 223)。

按:董持節楚藩在一五九六年初秋。

作墨筆《山松小景圖》,小長方紙本,并對題"縱心空洞津"五言詩一聯,鈐有"太史氏"印[《明君臣山水人物方冊》二十二幅之十二](《式古》,v.3,畫卷7, 333)。

作設色《山水冊》九幅,紙本(《過雲》,畫類5, 11b–12a;《中國目錄》,v.2, 52,京1–2199)。北京故宮博物院藏。

按:此冊無款。據高士奇跋,乃董為其子所作。

作墨筆《山水圖冊》四幅,紙本。一作《谿山圖》,二題"飛水千尋瀑"五言詩一聯,三題"古樹連雲密"五言詩一聯(《畫集》,no. 21)。上海文物商店藏。

作《疎林秋汎圖》斗方(《神州》,v.4)。中國四明童氏舊藏。

作墨筆《畫稿冊》二十幅,紙本(《董其昌》,no. 23;

《文人畫》,v.5, nos. 56–64,《畫集》, no. 145)。The Museum of Fine Arts, Boston。

作墨筆《華亭畫冊》十幅於毘陵舟次,紙本(《文人畫》,v.5, nos. 85–88)。美國翁萬戈藏。

作墨筆山水一幀,金箋本(《神州》,v.21)。

作《千秋釣舸邀明月圖》[《藝苑閒情冊》二十四幅之十四](《式古》,v.3,畫卷7, 340)。

作設色《南陵水面詩意圖冊頁》,有紅衣女子一人(《平生》卷10, 117–18;《墨緣》,名畫卷上明, 35a)。

作《山水》并題貢性之"樓倚溪頭水,"五言絕句[《明人高幅雜畫冊》四十五幀之一](《好古》卷下, 92)。

作墨筆《溪山高隱圖》方幅,白鏡面箋本(《墨緣》,名畫卷下·《明賢集冊》十四幅之九, 6a–b)。

作墨筆《縮本山水袖珍冊》八幅,宣德紙本,有王時敏、笪重光跋(《吳越》卷5, 37a–b)。

作墨筆《倣古山水冊》十幅,金箋本,各幅自題五言絕句一首(《古緣》卷5, 34a–35b)。

扇

作墨筆《山居圖扇》,金箋本(《中國圖目》,v.3,滬1–1400)。上海博物館藏。

按:此作有程嘉燧題云作於一五八二至八三年間,待考。

作墨筆《山川出雲圖扇》,金箋本(《中國圖目》,v.3,滬1–1399)。上海博物館藏。

作墨筆《水繞山回圖扇》,金箋本(《中國圖目》,v.3,滬1–1404)。上海博物館藏。

作墨筆《茂林幽靜圖扇》,金箋本(《中國圖目》,v.3,滬1–1405)。上海博物館藏。

作墨筆《秋樹山村圖扇》,金箋本(《中國圖目》,v.3,滬1–1406)。上海博物館藏。

作設色《湖莊清夏圖扇》,金箋本(《中國圖目》,v.3,滬1–1409)。上海博物館藏。

作設色《秋山積翠圖扇》,金箋本(《中國圖目》,v.3,滬1–1410)。上海博物館藏。

為德芬作設色《秋景山水扇》,金箋本(《畫集》,no. 17;《中國圖目》,v.7,蘇24–0184)。南京博物院藏。

作《山水扇》,并題"樓倚城陰九點烟"七言絕句(《南畫》卷8, 99;《故週》,v.241, 1;《畫集》,no. 176。詩見《容詩》卷4, 34a–b,"題畫贈許繩齋郡伯時濬河成")。故宮博物院藏。

作墨筆《山水扇》,金箋本,并題"巇峍蓮為峰"五言絕句[《書畫扇面冊》十二幅之四](《石三》,延春閣廿六, 2059;《南畫》卷8, 98;《故週》,v.247, 4;《畫集》,no. 177。詩見《容詩》卷2, 35a)。故宮博物院藏。

作墨筆《煙樹圖》,素箋本,并題"遠樹暖芊芊"五言絕句[《便面畫冊》十幅之三](《石初》卷41, 36a;《南畫》卷8, 96;《畫集》,no. 182)。台北國立故宮博物院藏。

參見:4/4/1592

作墨筆《山水便面》,金箋本[《便面畫冊》十幅之七](《石初》卷41, 36b;《南畫》卷8, 100;《畫集》,no. 171)。台北國立故宮博物院藏。

參見:4/4/1592

作墨筆《雲近蓬萊圖》,金箋本[《明清書畫便面冊》(甲)三十幅之十](《總合圖錄》,v.3, JM24–011–10)。日本岡山美術館藏。

作墨筆《水邨圖》,紙本[《名人便面集珍冊》二十四幅之十六](《總合圖錄》,v.4, JP14–187–16)。日本江田勇二藏。

作墨筆《山水扇》,金箋本(《總合圖錄》,v.2, S6–010–2)。The E. Lu Collection, Singapore。

作淡色《(米法)山水扇》,金箋本(《總合圖錄》,v.1, A38–023)。The Honolulu Academy of Arts。

作淺設色《山水扇》,金箋本(*Honolulu Academy of Arts Journal*, v.2, no. 9)。The Honolulu Academy of Arts。

作墨筆《秋山高遠圖扇》,金箋本(《總合圖錄》,v.2, E17–059;《畫集》,no. 159)。Museum für Ostasiatische Kunst, Köln。

作《山居圖扇》(《畫集》,no. 168)。

作《山水扇》(《畫集》,no. 169)。

作墨筆《秋山書屋圖》,素牋本[《明人扇頭畫冊》十二幅之七](《石初》卷12, 28b)。

作墨筆《秋林策杖圖》,金箋本[《明人扇頭畫冊》十二幅之十](《石初》卷12, 28b)。

作著色《秋山圖》,金箋本[《明人畫扇集冊》下冊十二幅之七](《石初》卷22, 15a)。

作設色《春巖花樹圖》,金箋本[《明人畫扇冊》二十二幅之十七](《石三》,乾清宮十二, 608)。

作《山水扇》,并題"朝來小雨作輕寒"七言絕句[《集明人書畫扇冊》二十四幅之十八](《聽颿》卷4, 324–25)。

形式不詳

作山水一幀,并題"拈筆經營輞口居"七言絕句[見李日華一六〇九年五月二十二日記此作](《味水》卷1, 15b)。

作墨筆山水,紙本,并題"只謂一峰翠"五言絕句,鈐有"宗伯學士"印(《十百》,甲卷, 18b)。

作墨筆《松風流水圖小幅》,紙本,并題"萬壑響松

風”五言詩一聯(《庚子》卷3, 26a)。

作《苕帚菴圖》(《平生》卷10, 115)。

作《柳陰釣艇圖》,并題“有綠陰處不受署”七言絕句(《好古》卷下, 74)。

作墨筆《山水小幅》,絹本,并題“時倚簷前樹”五言詩一聯(《十百》,乙卷, 6a–b)。

書畫合璧

卷

作設色《秋山圖卷》,絹本,後行書論畫,鈐有“知制誥日講官”印(《畫集》, no. 31。論畫語見《容別》卷6, 8a及10b–11b;《畫眼》, 40)。上海文物商店藏。

作《書畫卷》,紙本。右設色山水,左行書記修道亭與嚴州府,鈐有“知制誥日講官”印(《中國文物集珍》, no. 34)。香港黃仲方藏。

作《書畫卷》,絹本。前用米家法作墨筆《煙江叠嶂圖》,後行草書王維贈張諲“不逐城東遊俠兒”七言古詩,鈐有“知制誥日講官”印(《總合圖錄》, v.3, JM19–094)。日本黑川古文化研究所藏。

參見: 4/8/1615

作墨筆《倣宋元各家山水卷》四段,絹本,一倣米友仁,二倣倪瓚,三倣董源,四倣黃公望,各段畫後行草書七言絕句一首,鈐有“知制誥日講官”印(《鑑影》卷8, 6a–8a)。

作《書畫卷》,絹本。前墨繪山水倣米家山,後書“田家無四鄰”五言律詩,鈐有“知制誥日講官”印(《夢園》卷13, 25a)。

作《王右丞詩并圖卷》,絹本。前墨繪山水,後大行書王維“中歲頗好道”五言律詩,鈐有“知制誥日講官”印(《愛日》卷2, 7b–8b)。

作《書畫卷》,絹本。前作墨筆山水,後行書“惟將野服問仙槎”及“霏霏煙雨送征蓬”七言律詩二首,鈐有“太史氏”印(《湘管》卷2, 131;《中國圖目》, v.6, 蘇1–128。詩見《容詩》卷3, 4b–5a,“送李易齋還朝,”及17a,“送李太守思弦二首”之一)。蘇州博物館藏。

作《畫錦堂書畫卷》,素絹本。前以董源、黃公望法作著色《畫錦堂圖》,後以米芾筆行書歐陽修《畫錦堂記》於寶鼎齋,鈐有“太史氏”印(《石初》卷36, 34a–35a;《藝苑掇英》, v.6, 24–25;《中國美術全集》,繪畫編8, no. 15;《畫集》, no. 46)。吉林省博物館藏。

作《盤谷序書畫卷》,絹本。前摹趙孟頫作淺設色山水,後行書韓愈《送李愿歸盤谷序》,鈐有“太史氏”

印(《穰梨》卷24, 13a–14a;《澄懷》卷4, 18–19;《爽籟》, v.2, no. 60;《董其昌》, no. 86;《總合圖錄》, v.3, JM3–171;《文人畫》, v.5, no. 43。題畫語又見《容別》卷6, 24b)。大阪市立美術館藏。

作墨筆山水,高麗賤本,并題“喬木生畫陰”五言絕句,鈐有“太史氏”印[《書畫合璧卷》之畫幅](《石三》,乾清宮十一, 575。詩見《容詩》卷2, 35b)。

參見: 秋/1632(3)

作《書畫卷》於楓涇舟次,綾本。前作墨筆山水,後書蘇軾“書王定國所藏煙江叠嶂圖”七言古詩,鈐有“太史氏”印(《紅豆》卷3, 9a–10b)。

作墨筆《山水卷》,絹本,并題“鐵壁千尋劈巨靈”七言絕句。後又大行書王維“青谿諸山詩”二首,鈐有“太史氏”印(《鑑影》卷8, 9a–b)。

作《池上篇書畫卷》,絹本。前作墨筆山水,後草書白居易《池上篇》,鈐有“太史氏”印(《古芬》卷16, 41a–b)。

作墨筆《琵琶行圖卷》,後行書白居易“琵琶行”,紙本,鈐有“宗伯學士”印(《中國圖目》, v.1,京5–014;《畫集》, no. 133)。北京首都博物館藏。

作《書畫卷》。畫幅絹本,作著色山水,鈐有“宗伯學士”印。書幅紙本,行草書唐詩二首(Christie's, 6/2/1988, no. 65)。

作《書畫卷》,灑金箋本。前墨繪《倣巨然夏山欲雨圖》,後書白居易“連山斷處大江流”七言律詩,鈐有“宗伯學士”印(《盛京》,第三冊, 29b–30a;《古物》卷8, 4a–b)。

作《書畫卷》,高麗紙本。前墨繪山水,書倪瓚題巨然畫卷“嵐影川光翠蕩磨”七言絕句;後書“春臺望”五言古詩,鈐有“宗伯學士”印(《虛續》卷2, 51a–52a)。

作《書畫卷》,素絹本,書畫相間各八幅,先畫後書。一墨筆倣倪瓚,二著色倣黃公望,三墨筆倣董源,四著色山水,五墨繪《山居圖》,六著色《倣吾松小崑山赤壁圖》,七著色倣米芾,八墨筆倣趙孟頫。書幅各行書七言絕句一首(《盛京》,第三冊, 31a–32b;《古物》卷8, 3a–4a;《南畫》續集1, 20–27及續集5, 119–26)。

按:此卷書畫各幅皆鈐“董其昌印”一印,惟卷末書幅第八鈐“董氏元宰”及“宗伯學士”二印,待考。

作《綠谿青嶂書畫卷》,綾本,前墨繪山水於青溪舟次,後行書“綠谿青嶂自秦餘”七言絕句(《中國圖目》, v.6, 蘇1–129。詩見《容詩》卷4, 36b,“題畫爲楊弱水侍御”)。蘇州博物館藏。

作《書畫卷》,絹本。前作設色畫,後行書臨海上顧氏所示米芾書《壯觀楚辭》(《石三》,御書房二, 3139–40)。

參見: 12/1612

作《書畫卷》,素箋本。前以《黃庭經》筆法小楷書《瘞鶴銘》,後墨繪蕉山景。

參見: 10/1623(3)

作墨筆《雲山矮袖卷》,鏡面紙本,後行書“山水歌”(《平生》卷10, 113)。

作《倣北苑谿山行旅圖》,後題《滿庭芳》詞,又大字書白樸“黃蘆岸白蘋渡口”曲(《好古》卷下, 75)。

張清臣攜示倪瓚小景,因作墨筆《倣倪雲林山水》,并書仲長統《樂志論》一卷,宣德紙本(《吳越》卷5, 66a;《歸石》卷4, 16b–17a)。

作《唐人詩意圖卷》,絹本。畫分五段,一倣黃公望,二倣巨然,四倣董源《秋山圖》。每段畫後大行書七言詩一聯(《湘管》卷6, 427–29)。

作《書畫卷》,絹本。前行書孟浩然、王昌齡、杜甫、劉長卿、王維等五言律詩六首,中爲周季良墨繪山坡林屋,後行書論書語(《石續》,養心殿, 1077–78)。

作書畫十幅,紙本,書畫相間。書幅各書五言絕句一首(《自怡》卷8, 3a–5a)。

按:此作裱爲一卷,附於米友仁紹興三年七月所作紙本畫卷之後,稱《米董合璧卷》。

吳槙以素絹索書畫,因作墨筆山水,書論畫二則一卷[即《倣董米山水卷》](《澄懷》卷4, 19–21。論畫語又見《容別》卷6, 2b–3b;《畫禪》卷2, 1及7)。

軸

作墨筆《書畫冊頁合裝軸》,灑金箋本(《中國圖目》, v.8,冀1–021)。河北省博物館藏。

冊

作《書畫冊》八對幅,左書右畫。畫幅第三倣黃公望,四倣自藏米友仁《瀟湘圖》,七寫米家山,七寫元人筆意,八倣高克恭。書幅第四行書五言絕句,餘幅各行書七言絕句一首(《南畫》續集1, 38–45)。

按:董得米友仁《瀟湘圖卷》在一六〇二至一六〇五年間,故此冊應作於一六〇二年之後。見後文“鑑藏題跋”之“米友仁”條。

作《書畫冊》八幅,絹本,書畫各半。畫幅墨筆,二書幅各行書五言絕句一首,餘二幅不詳(Sotheby's, 5/30/1990, no. 35; 5/29/1991, no. 11)。

按:據 Sotheby's,此冊後附有 Wang Ch'i-mao(未詳何人)一六二八年跋,故應作於此年之前。

作《書畫冊》十二幅,灑金箋本,書畫相間。畫幅墨筆,一擬荊浩、關仝,三倣江參,五倣倪瓚《平林遠岫》,七倣米友仁《雲山袖卷》,九倣燕肅,十一倣自藏李成小景。書幅各行書絕句或律詩一首,其中第六幅鈐有“知制誥日講官”印(《畫集》, no. 147;《中國圖目》, v.3,滬1–1388)。上海博物館藏。

作《書畫冊》八對幅,紙本。右墨繪山水,一倣黃公望,四倣米家山,六倣倪瓚。左行草書論畫,鈐有“太史氏”印(《中國圖目》, v.3,滬1–1386)。上海博物館藏。

作《書畫冊》六對幅,紙本,左書右畫。畫幅設色,一做董源,二擬張僧繇沒骨山,四作《山川出雲圖》。書幅行楷書題詩或論畫,其中第四幅做顏真卿筆書倪瓚六言絕句(《古緣》卷5,36b–38b;《畫集》,no. 149;《中國圖目》,v.3,滬1–1385)。上海博物館藏。

按:R. Edwards亦藏董《書畫冊》六對幅,內容與此冊全同,惟屬絹本,且書幅款後鈐有"太史氏"印。待考。見《總合圖錄》,v.1,A6–005。

作《書畫冊》十對幅,紙本[《法書名畫冊》之後段]。畫幅墨筆,一擬楊瑄《崆關蒲雪圖》,二做關仝,三做巨然,四做米芾雲山,五做趙孟頫《鵲華秋色》,六做王時敏家藏趙孟頫《水村圖》,七及八做王蒙,九做黃公望,十作《松亭圖》。書幅行草書題畫,鈐有"太史氏"印(《式古》,v.2,書卷28,497–98)。

作《書畫冊》八對幅,左書右畫。畫幅墨筆,分做黃公望樹法及《富春大嶺圖》、李成寒林、米家山、王蒙《青弁山圖》、倪瓚等。書幅行書題畫,鈐有"太史氏"印(《石續》,淳化軒,3315–17;《石隨》卷6,4a–5a;《虛續》卷2,58a–62a)。

按:此冊《石續》及《石隨》載畫幅宣德箋本,書幅宋箋本,《虛續》載畫幅高麗紙本,書幅藏經紙本,未知是否屬一作。

作《雨窗筆嘯書畫冊》六對幅,絹本,左書右畫。畫幅前三為墨筆,二作《寒林圖》,三做米芾;後三為著色,四做黃公望,六作《谿山秋霽》。對題各幅書詩一首,冊末并自識,鈐有"太史氏"印(《筆嘯》卷下,1a–2b)。

作《書畫冊》八對幅,畫幅冷金箋本墨筆,其七自題"天降時雨,山川出雲,"末幅做倪瓚,書幅白綾本,行書題詩或論畫,鈐有"太史氏"印(《巘雪》卷4,57a–59b)。

作《書畫冊》八對幅,紙本,左書右畫。畫幅墨筆,其中第二幅做倪瓚。書幅各行書五言絕句一首或七言詩一聯,鈐有"宗伯學士"印(《中國圖目》,v.8,津2–034)。天津市歷史博物館藏。

作《書畫冊》八對幅,左畫右書。畫幅冷金箋本,一墨筆做黃公望,二墨筆做吳鎮,三作設色《青山圖》,四墨畫隔岸山亭,五設色做米家山,六墨筆丹磴幽林,七墨畫《岩居圖》,八作設色《鵲華秋色》。書幅綾本,各行書七言詩一聯,鈐有"宗伯學士"印(《石三》,延春閣廿六,2057;《故宮》卷6,68–69)。台北國立故宮博物院藏。

作《千巖萬壑書畫冊》六對幅,紙本,左畫右書。畫幅墨筆,做董源《溪山亭子》、倪瓚及荊、關等,一作《天池石壁圖》。書幅各題五言或七言絕句一首,鈐有"宗伯學士"印(《故宮》卷6,66–67)。台北國立故宮博物院藏。

作《倣宋元人縮本畫跋冊》[即《小中現大冊》]二十二對幅,左山水,右題跋。題跋第十三、二十及二十二幅為羅紋箋本,餘皆素箋本。畫幅一至四為素絹本淺著色。一臨傳范寬山水,題云實為李成筆;二臨范寬《谿山行旅圖》;三臨董源,鈐有"青宮太保"印;四臨趙孟頫學董源;五臨巨然《雪圖》,素絹本墨筆;六作青綠山水,素絹本;七臨高克恭,素絹

本著色;八臨黃公望《陸翠密林圖軸》,素箋本墨筆,鈐有"宗伯學士"印;九臨黃公望《臨董源夏山圖》,素絹本著色;十臨王蒙《做董源秋山行旅圖》,素絹本墨筆,鈐有"大宗伯印";十一臨吳鎮,素絹本淺著色,鈐有"宗伯學士"印;十二臨黃公望,素絹本墨筆,鈐有"大宗伯印";十三墨繪山水,素絹本;十四臨王蒙,素箋本淺著色;十五做吳鎮《關山秋霽圖》,素絹本墨筆,鈐有"大宗伯印";十六墨繪山水,素絹本,鈐有"大宗伯印";十七臨吳鎮仿王詵所作絹本《煙江疊嶂圖》,素絹本墨筆,鈐有"宗伯學士"印;十八至二十二為素墨畫;十八臨黃公望;十九臨王蒙,鈐有"宗伯學士"印;二十及二十二作山水;二十一臨王時敏所藏倪瓚畫,鈐有"大宗伯印"。(《盛京》,第六冊,19a–23a;《古物》卷4,7b–11b;《南畫》卷14,56–77及續集5,128–43;《故宮》卷6,71–75)。台北國立故宮博物院藏。

參見:6/23/1598;16/1600;1607(1);2/1614(1);5/1620;5/1625(1);秋/1626(1);11/19/1627(1)

按:此冊引首有董書"小中現大"四字,款下鈐有"青宮太保"印。冊中對幅題跋,乃董昔日題畫語,故紀年為題畫當時,而非作此臨本之日。

又:此冊畫者諸說不一,或云董自作,或云王時敏,或云陳廉,待考。

作《書畫冊》十六幅,書畫相間。畫幅紙本,三幅設色,五幅墨筆,分做董源、王蒙、趙幹《水村圖》、黃公望、倪瓚《寒山荒翠圖》、郭熙《平岡晚霽》及方從義《雲山》等。書幅絹本,各行草書五言絕句一首,鈐有"宗伯學士"印(《總合圖錄》,v.1,A13–051;《中國美術全集》,繪畫編8,no. 11;《畫集》,no. 144)。The Metropolitan Museum of Art.

作《書畫冊》八對幅,金箋本,左書右畫。畫幅淺設色,分做黃公望《溪山清樾圖》、巨然《秋雲出岫》、董源、趙孟頫《春山暖翠圖》、趙令穰《江山亭子圖》,又作《松溪圖》。書幅各行草書五言絕句一首,鈐有"宗伯學士"印(《總合圖錄》,v.2,S13–034;畫幅又見《畫集》,no. 150)。The Papp Collection.

作《書畫冊》八對幅,左書右畫。畫幅一做王維,四做高克恭,六做趙伯駒《江亭遠眺圖》,七做米友仁,八做黃公望。書幅行書題詩句,鈐有"宗伯學士"印(《南畫》續集1,46–53)。

作《書畫冊》六對幅,紙本。畫幅墨筆山水,一題"山川出雲,"餘不詳。書幅之一行書"閑雲無四時"五言絕句,餘不詳,鈐有"宗伯學士"印(Christie's,12/4/1989,no. 79)。

作《書畫冊》八對幅於青溪道中。畫幅金箋本,一墨繪《做梅花菴主山居圖》;二著色《松溪秋色》;三墨繪山水,并題"寒山轉蒼翠"五言詩一聯;四墨筆做巨然;五墨繪《溪山亭子》;六著色《做黃鶴山樵筆意圖》;七墨筆擬董源;八墨繪山水。書幅紙本,各行書七言絕句一首,末幅鈐有"宗伯學士"印(《十百》,丁卷,20b–21b)。

作《書畫冊》八對幅,左書右畫。畫幅冷金箋本,一墨筆寫虞山拂水所見,二墨畫《嵐翠山居》,三墨筆做黃公望《石徑秋嵐》,四墨筆做商琦,五淺設色擬方從義,六墨筆做董源《夏木垂陰》,七做趙孟頫作設色《秋江夕照》,八墨畫《雪霽林塘》。書幅絹本,各行草書五言絕句一首,鈐有"宗伯學士"印(《石三》,延春閣廿六,2058)。

妻江舟中觀董源、黃公望及倪瓚畫,因作《書畫冊》八對幅。畫幅冷金箋本墨筆,一題"溪橋分埜色"五言詩一聯,二做黃公望作《長松草堂圖》,三作《做北苑溪山暮靄圖》,四做吳鎮作《奇峰拔雲圖》,五題"悅石上今流泉"六言詩一聯,六寫"半嶺通佳氣,中峰繞瑞煙"詩意,七題"平墅花侵石"五言詩一聯,八寫秋山雨意。書幅綾本,各書五言絕句一首,鈐有"宗伯學士"印(《夢園》卷13,26a–28b)。

作《書畫冊》十二對幅。畫幅灑金箋本,一做黃公望作《林塘春色圖》,二作《碧浪蒼松》,三題"喜無多屋宇"五言詩一聯,四題"一瓢供渭水"五言詩一聯,五作《溪山清樾》,六做吳鎮,七做董源,八作《石梁溪聲》,九做董源,十作《荒松石壁》,十一作《山川出雲》。書幅絹本,各題五言絕句一首,前八幅款後鈐有"宗伯學士"印(《穰梨》卷24,3b–6b)。

按:此冊前八幅尺寸及印款為一式,後四幅尺寸及印款為另一式,疑屬二冊合併。

作《書畫冊》八對幅。畫幅金箋本,二臨倪瓚《鶴林圖》,三擬黃公望,四題"人家在仙掌"五言詩一聯,六做倪瓚,七作《秋山落照》,八做趙令穰平遠小景。書幅鏡面箋本,各題五言絕句一首,鈐有"宗伯學士"印(《壯陶》卷12,4a–5a)。

作《書畫冊》八對幅。畫幅泥金本,一題"柳塘春水漫,"二做倪瓚作著色山水,三作《巖居圖》,四題"時倚簷前樹"五言詩一聯,五作著色山水,六作著色《瀟湘秋色》,七作《奇樹圖》,八作絳《秋林雨霽》。書幅絹本,各題七言詩一聯,鈐有"大宗伯章"印(《壯陶》卷12,5a–6a)。

作《書畫冊》八對幅,僅存其六。畫幅泥金箋本,墨筆間著淡色,二做巨然,三題"寒山轉蒼翠"五言詩一聯,四作《水邨秋色》,五題"泉聲咽危石"五言詩一聯,六題"十月江南岸。"書幅白綾本,各題五言或七言絕句一首,鈐有"宗伯學士"印(《壯陶》卷12,6b–8a)。

作《書畫冊》六對幅,紙本。畫幅墨筆,一做董源,二摹燕文貴《夏山欲雨》,三做李成《寒林圖》,四做米友仁《雲山圖》,五做趙令穰《柳溪平遠》,六做倪瓚《溪山亭子》。書幅題詩,鈐有"宗伯學士"印(《壯陶》卷12,46b–47a)。

作《書畫冊》五對幅,紙本,左書右畫。畫幅墨筆,其中第三幅做李成寒林;書幅行草書詩(《中國圖目》,v.3,滬1–1383)。上海博物館藏。

作《書畫冊》八對幅,紙本。右墨繪山水,做倪瓚及王蒙《石梁秋瀑》等,左行書論畫,或錄前人題跋,或書詩,又小行楷節臨褚遂良《枯樹賦》(《中國圖目》,v.6,蘇1–127)。蘇州博物館藏。

作《書畫冊》八對幅,紈本,左畫右書。畫幅淺設色,分做吳鎮、盧鴻《草堂圖》、黃公望《富春大嶺圖》、倪瓚,又作《綠天庵》及《孤邨釣叟》。書幅各行草書七言絕句一首(《總合圖錄》,v.4,JP34–078)。日本山口良夫藏。

作《書畫冊》八開,紙本,書畫相間。畫幅墨筆,其中第一及三幅分做倪瓚、董源,第七幅作《溪山圖》。書幅各行書七言絕句一首(《總合圖錄》,v.1,A13–049;畫幅又見《畫集》,no. 152)。美國翁萬戈藏。

作《書畫冊》八對幅。畫幅分做楊昇、王蒙、倪瓚、米友仁、吳鎮、盧鴻《草堂圖》、惠崇、李公麟《山莊圖》,書幅不詳(《中國名畫集》,v.3)。

作《書畫冊》八對幅。畫幅之四分做董源、米友仁、倪瓚、及得自梁溪華氏之巨然小軸,書幅不詳(《中國名畫集》,v.3)。

作《書畫冊》八對幅。畫幅金箋本墨筆,一做吳鎮,一做黃公望,一題“鶴巢松樹遍”五言詩一聯,餘未詳。書幅紙本,其一行書“文杏裁爲梁”五言絕句,餘未詳(Sotheby's, 5/18/1989, no. 37)。

作《畫中禪書畫冊》十八對幅,素箋、金箋、絹本、綾本夾雜,水墨、設色兼備。畫做黃公望《溪山書屋》及《秋山圖》、王蒙、倪瓚、方從義、李成、米芾、趙令穰、惠崇、吳鎮等,又寫陶潛詩意及晉陵秋色。書幅行書前人詩詞(《石初》卷41, 59a–61a)。

按:此冊僅第五幅《仙巖圖》紀年,見8/1635(3)

作《做八家書畫冊》八對幅。畫幅絹本,墨筆設色各半。第二幅擬楊瑄《峒關蒲雪圖》,三作雲山,四做黃公望,五臨吳中王年先家藏倪瓚畫,六做明洲文仲連所示黃公望畫,七做黃公望,八擬自藏黃公望贈陳彥廉畫二十幅。書幅紙本,行書題畫(《華亭》,26)。

用米氏父子法,兼用董源與趙令穰筆意,作《夏雲奇峰圖》八對幅於泖湖塔院,麗箋本[一名《做董米法八冊》]。其中第二幅作《煙江疊嶂》,三作《雨中山景》,八作《洞庭秋霽》。書幅各題五言絕句一首(《大觀》卷19, 27a–b;《歸石》卷4, 16a)。

作《書畫冊》八對幅,左書右畫。畫幅素綾本墨筆,分做董源、倪瓚、黃公望、高克恭,又作《寒林圖》及《松亭圖》;書幅金箋本,各行書五言絕句一首(《石初》卷4, 44a–b)。

作《書畫冊》十二幅,宣德鏡光箋本。右墨繪山水;左以米芾筆意行書,首幅書畫記一則,餘各書七言絕句一首(《石初》卷4, 42b–44a)。

作《書畫冊》八對幅。畫幅金箋本墨筆,首及末幅做黃公望,三做倪瓚,五做董源,七作《溪山秋霽》。書幅絹本,各行書七言詩一聯(《十百》,丁卷, 19b–20b)。

作《書畫冊》八對幅,宣德箋本。畫幅墨筆作《山居圖》、《水邨圖》、《小米雲山》、《夜山圖》、《石壁圖》、《松巖圖》、《西巖圖》、《湖天空闊》。書幅行書題畫意詩(《石續》,寧壽宮, 2840–41)。

作《閒窗遺筆詩畫冊》十對幅。畫幅絹本,一淡著色做王蒙《山房讀書圖》,二墨筆擬自藏米芾《瀟湘白雲圖》,三著色做黃公望,四墨筆做董源,五青綠設色山水,六墨筆做米友仁《欲雨圖》,七著色山水,八墨繪《懸流石壁圖》,九著色做自藏黃公望《吳山蕭寺圖》,十墨筆做倪瓚。書幅冷金箋本,各行書詩一首(《鑑影》卷14, 18a–21a)。

作《書畫冊》八對幅,紙本。一做荊關,二做巨然,三做曹知白,四做米芾,五做米友仁,六做倪瓚,七做王蒙,八做黃公望。書幅各書七言絕句一首(《夢園》卷13, 29a–31b)。

作《書畫冊》十二對幅。畫幅不詳,書幅分題吳道玄寫嘉陵山水事,陸瑾寫杜牧詩,米芾自題畫,蔡天熙題李公麟畫,張雨題黃公望畫,自題畫寄林之中吳黃門,李衍題米友仁畫,張雨題倪瓚畫,倪瓚自題畫(二幅),倪瓚錄宋僧詩、林逋詩。除首幅外,餘皆七言絕句[見乾隆《臨董文敏書畫合璧冊》](《三秋》卷下, 31a–33b)。

閱宋元人畫冊於玉峰道中,作《書畫冊》六對幅。畫幅絹本墨筆,一作《長松遠岫》,二做吳鎮,三做米友仁《夏山煙雨》,四做趙令穰《水村圖》,五做王蒙。書幅紙本,各行書七言詩一聯(《劍花》,下卷, 116–17)。

扇

作《書畫團扇條屏》二幅,金箋本墨筆。一做倪瓚《谿山亭子》,行書張雨論黃公望畫語;二做董源《谿山行旅》,行書論自藏董源《谿山行旅圖》。書扇鈐有“太史氏”印(《中國圖目》,v.8,津2–035)。天津市歷史博物館藏。

作《書畫扇面冊》,金箋本,推篷裝十二幅,書畫相間。畫幅墨筆,其中四幅分做黃公望《丹臺春曉》、高克恭雲山、李成《寒林圖》及曹知白。書幅一書李白《春夜宴桃李園序》,三節書蘇軾“煙江疊嶂歌”,五書“賜百官麥餅宴詩”,七書唐詩二首,九書詩二首,十一節臨《聖教序》。鈐有“太史氏”印(《石三》,延春閣廿六, 2059–60。畫扇又見《畫集》, nos. 167, 172, 179及181)。

按:此冊第一、五、七及九幅有年款,見2/16/1628; 5/1632; 7/1630(1); 7/1627(1)

作《書畫扇頁》三幅一軸,金箋本,畫一書二。一書“四月橫塘路”五言律詩,一臨古帖(《筆嘯》卷上, 15a)。

作《書畫扇冊》十幅。一爲梧賓行書“皎潔明星高”五言律詩;三爲爾韜草書“老樹成雙便作扉”七言絕句;四爲婿復之作山水,并題“炊煙連宿霧”五言絕句;五爲畝仲行書“登廬山”五言律詩;七爲吳楨草書“秋風起兮白雲飛”辭;八爲石齋(黃道周?)做米芾山水;九爲孟開草書“家住趙邯鄲”五言律詩;十做董源山水(《聽颿》卷3, 274–77)。

作《書畫便面冊》八幅,書畫相間。一草行書“奉詔向軍前”五言律詩,二墨繪山水,三爲篁圃草行書“忽聞齊語變吳歈”七言律詩,四墨筆做米友仁,五草書王維“清川帶長薄”五言律詩,六做董源墨繪山水於西邨草堂,七草行書“綠葉迎新綠”及“日飲金屑泉”五言絕句二首,八墨繪山水(《澄懷》卷11, 44–47。第三幅又見《容詩》卷3, 19b,“送王純伯鄉丈”)。

按:第四幅有王時敏一六一四年四月題跋。

鑑藏題跋

丁雲鵬

跋丁丑(一五七七年)戊寅(一五七八年)寓松江馬耆禪院時所作著色《羅漢圖卷》,宣德箋本(《秘初》卷9, 36a–b)。

題一六〇〇年五月所作《白描羅漢渡海圖卷》,紙本(《古芬》卷16, 7a–b)。

題一六〇三年四月八日所作淺設色《羅漢圖軸》,紙本(Christie's, 12/11/1987, no. 6)。

以慧能“心迷法華轉”五言偈題墨筆《六祖像圖軸》,紙本(《中國美術全集》,繪畫編8, no. 81;《中國圖目》,v.1,京11–018)。北京榮寶齋藏。

題吳康寧所作墨筆《大士像軸》,紙本(《三秋》卷上,64b;《總合圖錄》,v.2, S12–009)。香港徐伯郊藏。

按:據董題,丁雲鵬爲吳所作《大士像》原爲十二幅。

題王世貞舊藏丙子(一五七六年)丁丑(一五七七年)遊雲間時所作《白描羅漢圖》(《容別》卷6, 45b)。

同丁雲鵬、陳繼儒、張仲文、莊平叔舟行崑山道中,將至張慎其家,觀宋人畫《鍾離解甲受道圖》,雨中丁雲鵬作《吉雲居硯山圖》,紙本,董爲作跋(《快雨》卷7, 15–16)。

小行書《心經》一篇於絹本著色《達摩像》上方(《湖中》,155)。

丁謂

與黃琬琰同觀墨筆《山水卷》於畫禪室中,紙本[見黃琬琰跋此卷](《古芬》卷10, 23b–24a)。

元文宗

題臨唐太宗《晉祠銘》所書“永懷”二字刻石墨帖(《湘管》卷1, 53–54;《穰梨》卷6, 2a)。

尤求

題《臨睢陽五老圖冊》,絹本(《穰梨》卷23, 23a)。

按:董題書於魏浣初一六二三年十二月題識與朱之蕃一六二四年七月六日題識之間,或題於一六二四年春夏之際。

文伯仁

題墨筆《萬頃晴波》、《萬竿烟雨》、《萬壑松風》、《萬山飛雪》四屏軸,紙本[即《四萬圖屏軸》](《澄懷》卷3, 90–92;《南畫》卷9, 154–55)。

文從簡

張丑得米芾《寶章待訪錄》真蹟,董爲大行書"米菴"二字,附於文從簡墨筆《米菴圖卷》之前,紙本(《真蹟》,二集,48a-b;《中國圖目》,v.6,蘇1-170)。蘇州博物館藏。

文徵明

徐階之孫晨茂出示文徵明壽徐階所作設色《永錫難老圖并詩卷》,絹本,董爲題之(《吳越》卷1,67b-68b;《石三》,延春閣廿一,1894-95;《中國圖目》,v.1,京1-020)。北京故宮博物院藏。

題墨筆《山水卷》,絹本(《總合圖錄》,v.4,JP30-275;《董其昌》,no.88)。日本橋本大乙藏。

重觀并題舊藏墨筆《關山積雪圖卷》於京邸,絹本,云昔得之吳門張山人,後爲項氏易去(《平生》卷10,83;《壯陶》卷10,1b)。

題《墨蘭卷》,紙本(《紅豆》卷2,16b)。

題設色《倣鵲華秋色圖卷》,絹本,(《辛丑》卷5,44-45)。

題《落花詩卷》(《過雲》,書卷4,9a)。

題墨筆《倣王蒙山水軸》,宣紙本(《石續》,乾清宮,417;《故宮》卷5,386)。台北國立故宮博物院藏。

題《贈參孫畫并題軸》(《珊瑚》·畫,卷15,13;《式古》,v.4,畫卷28,483。題語又見《容別》卷6,55a)。

按:《式古》載此軸乃贈"泰"孫。

題《山水書畫冊》六對幅(《過雲》,畫類4,27a-b)。

題著色《山水扇》,金箋本[《明人書畫扇面集冊》第一冊二十對幅之八](《鑑影》卷15,4a)。

題《後赤壁圖并行書賦》(《平生》卷10,82-83)。

小楷書蓮池大師法語跋楷書《金剛經》(《好古》卷上,26)。

觀《谿山秋霽圖》[見董自題《谿山秋霽圖卷》](《十百》,辰集,15a-b及申卷,2b-3a;《總合圖錄》,v.2,S13-035)。董現藏香港黃仲方處。

觀《摹趙孟頫南陵水面詩意圖》(《畫禪》卷2,38)。

藏《臨趙孟頫水村圖》[見董自題《倣趙集賢水村圖》於《山水高冊》十幅之末]。

參見:九月晦/1624(1)

仇英

題重設色《倣蕭照高宗瑞應圖卷》六段,絹本(《寓意》卷4,21a-b)。

題重設色《後赤壁圖卷》,絹本(《寓意》卷4,24a)。

題《東坡行吟圖短卷》,紙本,并書蘇軾自贊小像"心是已灰之木"六言絕句(《十百》,丙卷,4a-b)。

題《陶靖節圖卷》,紙本(《別下》卷5,12a)。

題設色《秋堂課子圖卷》,紙本(《選學》卷上,66-67)。

題墨筆《畫錦堂圖卷》,紙本(《虛齋》卷3,1b)。

按:此卷仇英畫後有文嘉小楷書歐陽修《畫錦堂記》。

題爲項元淇所作設色《桃村草堂圖軸》,絹本(《中國目錄》,v.1,37,京1-1596;*Masterworks of Ming and Qing Painting*, no.17)。北京故宮博物院藏。

題設色《西園雅集圖軸》,絹本(《石三》,避暑山莊六,4410;《古物》卷6,16b-17a;《故宮》卷5,363)。台北國立故宮博物院藏。

題《蓬萊仙弈圖軸》(《珊瑚》·畫,卷17,6;《式古》,v.4,畫卷27,468)。

題《小冊》二十四幅。人物山水十二作一本,董對題其中《倣李昭道海岸圖》及《倣趙伯駒江帆圖》。另有《倣蘇漢臣村學圖》二頁、《倣李嵩觀潮圖》、《倣胡瓌獵歸圖》,餘倣馬遠、夏珪。花菓翎毛十二作一本,畫荔枝、楊梅、石榴、梨花之類。董爲題簽并跋(《平生》卷10,101-102)。

題著色《聽箜篌圖小幅》,絹本(《平生》卷10,100;《選學》卷下,138)。

題設色《抱琴圖扇》背面於世恩堂,泥金紙本(《故週》,v.501,4)。故宮博物院藏。

題設色《花鳥扇》背面,金紙本(*Sotheby's*, 5/30/1990, no.28)。

題《漢筠圖》,絹本(《平生》卷10,94)。

王時敏

題一六二九年六月一日所作墨筆《倣董北苑山水軸》,紙本(《中國圖目》,v.4,滬1-2203;《王時敏畫集》,no.3)。上海博物館藏。

題一六二五年五月所作《仿董北苑山水軸》(《王時敏畫集》,no.2)。

題一六二七年八月所作著色《層巒秋霽圖軸》,素箋本(《石初》卷8,41a)。

題一六二七年二月所作墨筆《倣雲林筆意圖軸》,紙本(《虛齋》卷9,1a)。

友人出示《山水冊》八幅,素箋本墨筆,爲行書對題七言絕句各幅一首(《石初》卷12,50b-51a)。

王珣

題吳廷所藏真蹟(《畫禪》卷1,40)。

王紱

題自藏墨筆《萬竹秋深圖卷》,素箋本(《式古》,v.4,畫卷26,437;《江村》卷1,74b-75a;《大觀》卷19,14a;《石初》卷33,55a;《總合圖錄》,v.1,A21-051)。Freer Gallery of Art.

按:董題云此卷得之玄池。

題《耕隱圖軸》(《珊瑚》·畫,卷12,13;《式古》,v.4,畫卷26,430)。

題爲芝林所作墨筆《山水軸》,紙本(《穰梨》卷13,17b)。

王詵

觀項氏所藏設色《瀛山圖》[見董初跋趙令穰《江鄉清夏圖卷》及自題《烟江疊嶂圖卷》]。

參見:7/30/1596; 秋/1605; 12/1614

跋著色《瀛山圖卷》,素絹本(《書畫》卷6,725;《墨緣》,名畫卷上北宋,8b-10a;《石初》卷43,21b;《西清》卷3,6b-8a;《故宮》卷4,29-31)。台北國立故宮博物院藏。

按:此卷董題及《石初》著錄作《瀛海圖》,但宋元人題跋及其他著錄皆作《瀛山圖》。

又:董一六〇五年秋自跋《烟江疊嶂圖卷》云昔所見項氏藏王詵設色《瀛山圖》已燬於火,安岐與乾隆俱云乃傳聞不真,以董與項氏相交之深,似不應有誤。吳其貞亦云此圖乃錢選筆,非王詵原作。因疑故宮所藏此卷爲僞,董跋待考。

題大著色《西塞漁社圖卷》,絹本(《真蹟》,二集,44b-45a;《大風堂名蹟》,v.4,10;《文人畫》,v.2,no.42)。The Metropolitan Museum of Art.

觀王世貞家藏《煙江疊嶂圖卷》,謂不真[見董自題《煙江疊嶂圖卷》]。

參見:12/1614

藏《仙山圖》[見董題王齊翰《勘書挑耳圖卷》]。

王舜國

題一六一六年夏所作墨筆《羅漢圖卷》,紙本(《中國圖目》,v.8,津2-026)。天津市歷史博物館藏。

王維

題設色《山陰圖卷》,絹本(《書畫》卷5,496;《平生》卷6,38;《石三》,延春閣十,1358;《西清》卷4,2b-3b;《故宮》卷4,10-11)。台北國立故宮博物院藏。

題著色《江干雪意圖卷》於海虞嚴文靖家,素絹本(《容別》卷6,29a-30a;《式古》,v.3,畫卷9,385;《大觀》卷11,33a-34a;《石初》卷34,1b-2a;《故宮》卷4,12)。台北國立故宮博物院藏。

按:此卷原標籤及《石初》著錄均作王維《溪山雪渡圖》。《故宮》編者稱跋真,畫疑僞。

觀項元汴家藏《江干雪意圖卷》及杭州高濂家之宋摹《輞川圖》,絹本[見董初致馮夢禎書]。

參見:7/13/1595

題《江干雪霽圖卷》[見楊恩壽記此作](《眼初》卷7,17b-18a)。

按:楊恩壽謂此卷即嚴嵩舊藏之王維《雪溪圖》,或即董自藏《唐宋元寶繪高橫冊》十二幅之首,見下文"諸家"部分。

藏《江干雪霽圖》[見孫承澤記王蒙《惠麓小隱圖》](《庚子》卷8,22b)。

題《雪霽圖卷》,絹本(《書畫》卷2,117)。

題《山居圖》小幅,絹本(《平生》卷6,41)。

觀京師楊太和大夫家藏《山居圖》[見董自題《書畫合璧冊》八對幅之末幅];[又見《書畫史》,126-27;《妮古》卷4,297]。

按:董《書畫合璧冊》現藏蘇州博物館,見《中國圖目》,v.6,蘇1-127。

得青綠設色《山居圖》小幅於京楊高郵所(《畫眼》,30-31;《妮古》,256;《清河》卷六下,13)。

題吳楨所藏《奕棋圖》,云或為後人擬作(《容別》卷6,56a-b;《式古》引《容臺集》,v.3,畫卷9,382)。

王蒙

題墨筆《雲林小隱圖卷》,紙本(《墨緣》,名畫卷上元,25b-26b;《穰續》卷3,28b)。

參見:8/15/1618

題墨筆《芝蘭室圖卷》於陳繼儒所,宋箋本(《石續》,乾清宮,362)。

藏《樂志論圖卷》及《陶詩采菊圖卷》,後以易江參《江居圖》[見董自題《采菊望山圖卷》](《石續》,寧壽宮,2849)。

夏日吳廷攜紙本設色《具區林屋圖軸》至齋中,與陸萬言、陳繼儒、諸德祖、朱本洽同觀并題(《石三》,御書房一,3088;《故宮》卷5,210)。台北國立故宮博物院藏。

題淺絳《南村草堂圖軸》,宋箋本(《郁題》卷9,9a;《平生》卷9,112)。

與陳繼儒同觀王穉登家藏《喬松絕壑圖軸》并題(《珊瑚》·畫,卷11,4;《式古》,v.4,畫卷21,273)。

題《倣巨然山水軸》(《珊瑚》·畫,卷11,4-5;《式古》,v.4,畫卷21,274)。

藏《青卞圖軸》[見董題自藏之王蒙《秋林書屋圖》,《唐宋元寶繪冊》二十幅之八](《珊瑚》·畫,卷19,3);[又見董自題《倣王蒙山水》,《法書名畫冊》十對幅之七](《式古》,v.2,書卷28,498)。

題設色《松山書屋圖軸》,紙本(《庚子》卷2,11b;

《辛丑》卷4,13;《聽颿》卷1,78;《蘇雪》卷3,39a-b;《過雲》,畫類2,5b)。

跋《寒林鍾馗圖軸》,紙本(《書畫》卷2,116)。

題墨筆《丹臺春曉圖軸》,素箋本(《石初》卷26,26a-b)。

題墨筆《滌硯圖軸》,宋紙本(《石續》,淳化軒,3245)。

題《松下停琴圖軸》(《過續》,畫類1,7b-8a)。

題墨筆《山水冊》推蓬式十幅,紙本(《夢園》卷6,28b-29a)。

對墨筆《雨後嵐新圖圓扇》[《名畫大觀》第一冊二十五對幅之末](《式古》,v.3,畫卷3,220);[又見《墨緣》,名畫卷下·《五代宋元集冊》十二幅之九,5a-b)。

按:《墨緣》謂董題不真刪去。

得孫朝讓家舊藏《花谿漁隱圖》[見孫朝讓題王時敏《倣王蒙山水軸》](《石續》,重華宮九,1721;《故宮》卷5,441-42)。《倣王蒙山水軸》現藏台北國立故宮博物院。

按:董藏王蒙《華溪漁隱圖》又見《清河》卷六下,13;《妮古》卷3,270。

藏《秋山讀書圖》[見董自題《書畫圓扇冊》十對幅]。

參見:7/18/1610

題《山水小景》[見李日華一六○九年十二月十八日記此作](《味水》卷1,54b)。

藏《秋山圖》(《式古》,v.3,畫卷2,190)。

題《松林讀易圖》小幅,紙本(《平生》卷9,111)。

王齊翰

題著色《勘書挑耳圖卷》(屏風三疊),絹本(《平生》卷7,12;《鑑影》卷1,26b)。

王羲之

跋唐人臨《東方朔像贊》一卷,素絹本(《真蹟》,二集,58b-59a;《石初》卷31,28a;《故宮》卷1,36-37)。台北國立故宮博物院藏。

託門人嘉興令顏氏致絹本《絕交書卷》(安福本)賞鑑,閩人林海壇復出示有豐坊補書之冷金箋本《絕交書》,董以後者非真[見李日華一六○九年十一月十日記此作](《味水》卷1,41b-43a)。

跋雨恭所藏《蘭亭序》(《容別》卷2,5b-6a)。

跋《禊帖》(《畫禪》卷1,37,38及40)。

題宋搨《定武蘭亭序》(《辛丑》卷1,10-11)。

題宋拓蠟本《定武蘭亭冊》,宋紙本(《壯陶》卷21,46b)。

藏唐摹《禊帖》,白麻紙本,後歸茅元儀[見董自題《臨蘭亭大字冊》](《華亭》,22);[又見董《法書紀略冊》],見1626(2);1/17/1632。

藏隋開皇本《蘭亭序》石刻[見董《法書紀略冊》]。

參見:1626(2);1/17/1632

題華學士家藏草書《雨後帖》真蹟,素箋本[王、謝《雨後·中郎二帖冊》之前段](《石初》卷10,6b);[又見顧復記此帖](《平生》卷1,17)。

藏《行穰帖》[見董題自書蘇軾"題大令鴨頭九帖詩"](《石初》卷5,31b-32a)。

以所藏《行穰帖真蹟》歸贈韓逢禧[見董題自藏李唐《江山小景圖卷》]。

參見:9/1623

題吳楨所藏《樂毅論》真蹟,定爲梁摹本。又曾見《樂毅論》宋搨本及唐貞觀摹真蹟二本(《珊瑚》·書,卷1,9;《式古》,v.1,書卷6,317;《過雲》,書卷4,12b-13a)。

題《氣力帖》八行,硬黃紙本(《平生》卷1,15-16)。

按:董題云"學書四十年,三見右軍真蹟,"則應在一六一○年前後。

跋唐人廓填《瞻近帖卷》,冷金箋本(《書畫》卷5,479;《石隨》卷1,4b)。

王錫爵

題行楷書詞三十二闋一冊,宣紙本(《石三》,御書房二,3128;《故宮》卷3,92)。台北國立故宮博物院藏。

王鏊

題行書《洞庭兩山賦》及《性善對》一卷,紙本,書後附唐寅補作《洞庭兩山圖卷》,絹本(《紅豆》卷2,9b-10b)。

王獻之

題《洛神賦》、《達遠帖》及《辭中令帖》等(《畫禪》卷1,38-39)。

題項元汴家藏楷書《洛神賦》十三行,硬黃紙本(《清河》引《戲鴻堂帖》卷二下,11-12;《畫禪》卷1,46;《式古》,v.1,書卷6,306;《平生》卷1,26。又參見《虛舟》卷1,12-13)。

觀《東山松帖》及《送梨帖》[見董《法書紀略冊》]。

參見:1626(2);1/17/1632

與魏實秀同觀《東山帖》於京[見董題魏實秀《詩卷》]。

得宋搨《閣帖》第九及十卷於京,乃王獻之真蹟摹刻[見董三題臨王獻之"鬱鬱澗底松"一詩]。

參見:8/24/1635

王獻圖

跋《千文》(《容別》卷2, 3b)。

跋《臨徐浩書道經》(《容別》卷2, 5b)。

王鐸

跋畫一幅(《容別》卷2, 3a–b)。

司馬槐

觀《山水》於廣陵(《容別》卷6, 32a–b)。

按:《書畫史》載董所見為司馬端明(司馬光)所作《山水》,見117–18。

巨然

得《山水卷》於惠山,上有倪瓚題"嵐影川光翠蕩磨"七言絕句[見董自題《書畫合璧卷》](《虛續》卷2, 51a–b)。

題自藏墨筆《秋山圖軸》,素絹本(《石初》卷17, 47b;《故宮》卷5, 23)。台北國立故宮博物院藏。

題墨筆《層巖叢樹圖軸》,素絹本(《石初》卷17, 6a;《故宮》卷5, 27;《文人畫》, v.2, no. 9)。台北國立故宮博物院藏。

題墨筆《雪圖軸》,絹本(《平生》卷7, 24;《墨緣》,名畫卷上北宋, 11b–12a;《石續》,寧壽宮, 2653;《南畫》卷9, 17;《故宮》卷5, 22–23)。台北國立故宮博物院藏。

按:此軸《平生》作李成《奇峰積雪圖》。

題淺絳《蕭翼賺蘭亭圖軸》,絹本[見吳升記此軸](《大觀》卷13, 42a)。

題墨筆《山水軸》,絹本(《選學》卷下, 126)。

以自藏姚綬《臨巨然秋山圖軸》,易雲川朱侍御之弟所藏巨然《關山小景》[見董題巨然《秋山圖軸》]。

對題淡色《烟江晚渡圖團扇》,絹本[《名畫大觀》,第二冊二十五對幅之十五](《式古》,v.3,畫卷3, 222);[《墨緣》,名畫卷下·《唐五代北南宋集冊》二十幅之九, 5b];[《宋元名人山水冊》八對幅之三](《鑑影》卷11, 18b;《海王》, 10b)。

按:《鑑影》載巨然此幅為墨筆。

米友仁

題墨筆《雲山得意圖卷》,縣紙本(《書畫》卷1, 52–53;《平生》卷8, 12;《江村》卷1, 19;《大觀》卷14, 34a;《墨緣》,名畫續錄卷下, 3b;《石續》,乾清宮,

304;《石隨》卷3, 10a–b;《辛丑》卷2, 11;《嶽雪》卷2, 29a;《壯陶》卷5, 2a;《選續》卷上, 181;《故宮》卷4, 33)。台北國立故宮博物院藏。

題墨筆《五洲烟雨圖卷》,紙本(《式古》, v.4,畫卷13, 27;《平生》卷8, 12–13;《江村》卷1, 23;《大觀》卷14, 35b;《總合圖錄》, v.1, A13–008)。美國翁萬戈藏。

題墨筆《雲山圖卷》,絹本[見李日華一六一六年二月二十一日記此作](《味水》卷8, 10a。又見《江村》卷3, 12a)。

按:此卷董跋前有文嘉和文肇祉跋,皆云米芾畫,董卻逕謂米友仁,未加任何解釋,或非原跋,待考。

題墨筆《雲山圖卷》,紙本(《郁題》卷4, 13a;《珊瑚》·畫,卷4, 19–20;《式古》, v.4,畫卷13, 21)。

題《雲山短卷》(《珊瑚》·畫,卷4, 20)。

按:董此題言及自藏之米友仁《瀟湘白雲圖》,董藏《瀟湘白雲圖》在一六〇二至一六〇五年之間,故題《雲山短卷》應在此之後。見下條。

題自藏墨筆《瀟湘圖卷》,素箋本(《平生》卷8, 11;《墨緣》,名畫卷上南宋, 1b–3a;《石初》卷42, 24b–25a及39b–40a)。

按:此即《瀟湘白雲圖卷》,後有沈周長跋。董曾二跋米友仁《瀟湘奇觀圖卷》,一六〇二年初跋云曾見《瀟湘白雲圖》,一六〇五年再跋則云已歸己有,故董得此卷應在此二年之間。見長至日/1602(3);5/19/1605。

又:董購《瀟湘白雲圖卷》於項德明[見董自題巴陵舟次所作畫](《郁題》卷10, 11b–12a;《珊瑚》·畫,卷18, 22;《式古》, v.4,畫卷30, 532–33)。

跋《海嶽菴圖卷》,紙本(《平生》卷8, 11–12)。

題《大小米畫合卷》,紙本(《藤花》卷1, 23a)。

按:梁廷枏謂此卷數跋乃後人拼湊。

題《山水軸》,絹本(《藤花》卷4, 14b–15a)。

藏《大姚村圖》[見董題董源畫](《畫禪》卷2, 23);[又見董題米友仁《雲山卷》](《味水》卷8, 10a, "萬曆四十四年二月二十一日"條)。

藏《海嶽菴圖》及《白雲圖》[見董自題《書畫合璧冊》八對幅之四](《石續》,淳化軒, 3315;《石隨》卷6, 4a–5a)。

米芾

跋吳廷所藏行書《十紙説卷》,絹本(*Christie's*, 12/3/1985, no. 3。跋語又見《畫禪》卷1, 41)。

按:董跋云曾臨寫此卷。聞山西運城地區一小型博物館藏有董書《十紙説》,未見真偽。

題項氏所藏行草書《易説卷》,紙本,云五十年前曾借觀(《珊瑚》·書,卷6, 2;《式古》, v.1,書卷10, 528)。

參見:3/3/1634(2)

黃鄰初擢守福州,寄示米芾行書《臨王羲之療疾帖卷》,綠麻紙本,董爲題之(《石續》,寧壽宮, 2701)。

參見:約秋/1597; 1/1599(2)

題韓世能家藏《韓魏公像卷》,以爲像後祭文乃蘇軾撰,米芾書。時韓已卒(《真蹟》,初集, 21a)。

按:張丑云此卷書畫俱託名米芾,實則像係北宋院畫名手,祭文係宋高宗之筆。見《真蹟》,初集, 17b–18a。

跋《顏魯公碑陰卷》,紙本(《寓意》卷1, 20b)。

題行草書《樂兄帖卷》,宋箋本(《墨緣》,法書續錄卷下, 2a;《壯陶》卷4, 40a;《澄懷》卷1, 49)。

題《山林圖卷》(《清河》卷九下, 20;《式古》, v.4,畫卷13, 9)。

按:《式古》云此卷米友仁所題三詩爲其自題《大姚村圖》,置此稱謂不合,年月雷同,疑畫與跋皆僞,則董跋亦僞。

吳正志屬作《雲起樓圖》卷、軸、圓扇共三幀,董尚未愜意,題所藏米芾墨筆《雲起樓圖軸》以贈,絹本(《鑑影》卷19, 14a–b;《文人畫》, v.2, no. 57;《總合圖錄》, v.1, A21–007;《歐米收藏法書》明清篇第二卷, no. 8;《董其昌》, no. 89)。Freer Gallery of Art。

題宜興吳鳴虞所藏行書《離騷經冊》(《容別》卷5, 49b–50a;《石隨》卷2, 11a);[又見董《法書紀略冊》],見1626(2);1/17/1632。

按:此冊疑即台北國立故宮博物院所藏米芾行書《離騷經冊》,宋箋本,其後于敏中、董誥等人合跋。《石續》,乾清宮五, 300–302;《故宮》卷3, 20–21。

題行書七言絕句二首、五言絕句二首、五言律詩一首及尺牘三通一冊,素箋本[即《詩牘冊》](《石續》,養心殿, 948)。

對題淡色《雲山圖團扇》,絹本[《名畫大觀》第一冊二十五對幅之十三](《式古》, v.3,畫卷3, 218);[又見《墨緣》,名畫卷下·《五代宋元集冊》十二幅之四, 3b]。

題小楷書《九歌》,白紙本(《平生》卷2, 67)。

題爲周仁行書《樂章》二首,白紙本(《平生》卷2, 68)。

題草書《九帖》,第一帖爲白紙本,餘皆黃鬆紙本(《平生》卷2, 69–70)。

題草書《寒光二帖》,淡黃紙本(《墨緣》,法書卷上北宋, 32b–33a)。

題《臨晉王羲之禊序》,白楮紙本(《墨緣》,法書續錄卷下, 2a)。

觀《天馬賦》計四本,一爲擘窠大字,在嘉禾黃承玄家,一倣顏真卿《爭座位帖》,在王肯堂家,一在華亭宋堯武家,一在新都吳廷家,後有黃公望及諸元

人跋［見董自題《背臨天馬賦》］（《容別》卷5，6a–b；《畫禪》卷1，15）；［又見董自題大行書《天馬賦卷》，綾本］（*Christie's*，11/30/1988，no. 75）。

觀《竹溪峻嶺圖》［見董自題《倣米老雲山》於《法書名畫冊》十對幅之四］（《式古》，v.2，書卷28，497）。

藏《雲山圖》（《畫禪》卷2，20；《式古》，v.3，畫卷2，190）。

得《研山圖》於宋光祿家［見董題孫克弘《仿米芾研山圖卷》］。

藏小楷書《破羌》、《謝公》、《蘭亭》三帖詩及書《老子》與竇憲《燕山銘》［見董自題《六朝賦卷》］（《華亭》，5–7）。

江參

題自藏墨筆《江山無盡高頭長卷》，絹本，云購自龔氏（《平生》卷8，31。又參見《清河》卷十下，1；《妮古》卷1，222；《式古》，v.4，畫卷14，43）。

跋《萬壑千巖圖卷》，絹本（《書畫》卷4，371）。

以所藏王詵《樂志論圖卷》及《陶詩采菊圖卷》易得江參《江居圖》［見董自題《采菊望山圖卷》］（《石續》，寧壽宮，2849。又參見《畫禪》卷2，20；《式古》，v.3，畫卷2，190）。

藏《江山圖》，乃盱眙陳明之舊藏［見董題劉敞書《南華秋水篇》］。

任詢

跋楷書韓愈"秋懷詩"十一首（《書畫》卷5，494；《平生》卷3，63）。

按：此作《書畫》載爲紙本手卷，有任詢自識；《平生》載爲絹本冊頁，有印無款，但其後諸跋皆同，待考。

朱國盛

題《仿米友仁墨戲》（《畫禪》卷2，39）。

朱銳

題淡色《雪莊行騎圖團扇》，絹本，有楊后對題七言絕句絹本團扇［《名畫大觀》第一冊二十五對幅之十六］（《式古》，v.1，畫卷3，219）；［又見《墨緣》，名畫卷下·《唐五代北南宋集冊》二十幅之十六，9a–b］。

按：《墨緣》謂此幅爲絹本墨筆。

對題淡色《訪戴圖團扇》，絹本［《名畫大觀》，第二冊二十五對幅之十七］（《式古》，v.3，畫卷3，222–23）；［又見《墨緣》，名畫卷下·《唐五代北南宋集冊》二十幅之十七，9b–10a］。

按：《墨緣》謂此幅爲絹本墨筆。

朱德潤

題墨筆《煙嵐秋澗圖軸》，絹本（《故宮》卷5，179–80）。台北國立故宮博物院藏。

沈士充

題一六一〇年十月爲喬拱璧所作設色《桃源圖卷》，絹本（《石續》，寧壽宮，2828；《中國目錄》，v.2，56，京1–2390；《明代繪畫》，no. 70）。北京故宮博物院藏。

題一六二八年六月所作設色《山水長卷》，紙本（《吳越》卷5，84a–b）。

按：此卷應即上海博物館所藏沈士充《長江萬里圖卷》，見《鑑影》卷8，17b及《中國圖目》，v.3，滬1–1560。但其後董跋及陳繼儒跋之內容全異，且董跋云沈士充此卷"乃贈其高足蔣志和"，而沈之自跋并未言及，因疑上海博物館所藏沈士充卷之董跋與陳跋乃自他處移來，成書早於《鑑影》約一世紀的《吳越》所載之董跋與陳跋已佚。

題一六一〇年十一月爲喬拱璧所作設色《倣宋元十四家筆意卷》，絹本（《石續》，寧壽宮，2832）。

作《董沈書畫冊》八對幅之書幅，絹本，各行草書七言詩一聯，鈐有"宗伯學士"印。右沈士充作淺設色山水（《總合圖錄》，v.3，JM1–032）。東京國立博物館藏。

沈周

藏《春山欲雨圖卷》（《清河》卷十二上，14；《妮古》卷2，236；《式古》引《清河》，v.4，畫卷25，418）。

題八十一歲所作《山水卷》（《容別》卷1，2a–b）。

跋鄭元勳持至京之《山水卷》（《容別》卷2，26a–b）。

跋《寫花卷》（《容別》卷2，27a）。

題淺絳《富春圖卷》，紙本（《平生》卷10，58）。

題墨筆《寫生花鳥卷》十三則，素箋本（《石初》卷24，28a–b）。

題淺著色《罨畫溪圖卷》，紙本（《吳越》卷1，85a–b；《寶迂》卷1，11a–b）。

題弘治甲子仲秋七日所作絹本設色《山水大卷》（《夢園》卷9，3b–4a）。

題沈周墨筆《倣梅道人山水圖》，紙本，小橫幅裱爲軸（《總合圖錄》，v.2，E13–003）。Musée Guimet, Paris.

觀汪砢玉家藏《陽岡圖軸》，欲以黃公望《山水》相易未果［見汪砢玉記此圖］（《珊瑚》·畫，卷14，9；《式古》引《珊瑚》，v.4，畫卷25，409）。

題《支硎山圖軸》（《湘管》卷6，365–67）。

題《雨夜止宿圖軸》，紙本（《平生》卷10，62）。

題大著色《自壽圖軸》，絹本（《平生》卷10，65；《過續》引《大觀》，畫類2，6b）。

題《倣王叔明山水軸》，紙本（《寓意》卷3，27b–28a）。

題淺設色《菊花鶺翎圖軸》，紙本（《蘇雪》卷4，4a）。

題淺絳《湖天過雨圖軸》，紙本（《壯陶》卷9，30a）。

題馮侍御家藏墨筆《倣倪瓚筆意冊》八幅，素箋本（《石初》卷41，12a–13a；《故宮》卷6，35）。台北國立故宮博物院藏。

題《寫生冊》（《畫禪》卷2，34）。

觀《吳中八景冊》、《澹圖九段錦冊》及《義興吳氏盧墓十景冊》［見董題沈周《無聲之詩書畫冊》］。

參見：3/1619（1）

題倣馬、夏畫（《容別》卷1，9b–10a）。

題臨倪瓚畫（《畫禪》卷2，34）。

藏《谿亭秋霽圖》［見陳繼儒題董《谿亭秋霽圖軸》］。董作現藏上海博物館。

觀《東湖圖》（《朱卧》，113）。

沈度

題楷書《菊花百詠卷》，紙本，後有唐寅畫《淵明像》及文徵明補圖《採菊東籬》（《十百》，己卷，5a–15b）。

李公麟

題墨筆《山莊圖卷》，紙本（《真蹟》，初集，47a–48a；《平生》卷7，62；《古物》卷5，7a；《故宮》卷4，22–23）。台北國立故宮博物院藏。

按：此卷乾隆題云系後人臨摹，董跋亦僞。

又：乾隆題云復得《山莊圖》真蹟一卷，筆墨更勝，圖後亦有董跋。

題陳所蘊家藏墨筆《瀟湘卧遊圖卷》，素箋本（《平生》卷7，62；《大觀》卷12，39a–b；《墨緣》，名畫續錄卷下，3a；《石初》卷44，43b–44a；《西清》卷3，24a；《董其昌》，no. 79；《文人畫》，v.2，nos. 64及70）。東京國立博物館藏。

按：此卷爲舒城李氏所作，誤傳爲李公麟。

又：據陳所蘊一六〇八年十二月題李公麟《蜀川圖卷》，《瀟湘卧遊圖卷》時已轉歸吳廷，則董此題應書於一六〇八年十二月之前。見12/8/1602。

題淺設色《淵明歸隱圖卷》，絹本（《總合圖錄》，v.1，A21–062）。Freer Gallery of Art.

跋墨筆《醉僧圖卷》於惠山舟次，紙本［此卷先有蘇

沟草書懷素"醉僧詩,"李爲補圖]（《郁題》卷4,21b;《珊瑚》·畫,卷2,17;《式古》,v.3,畫卷12,482）。
按:此卷又見《虛齋》卷1,29a,龐元濟云董跋已佚。

題項氏所藏白描《唐明皇擊球圖卷》於南湖,素箋本。云藏有李公麟《白蓮社圖》及《理帛圖》,又曾見韓世能家之《郭汾陽單騎見虜圖》（《書畫》卷1,56;《石初》卷14,49b）。

題白描《龍宮赴齋圖卷》,素箋本（《秘初》卷9,15b）。

題白描《列仙圖傳卷》,素箋本（《秘續》,226）。

題自藏著色《十六羅漢圖卷》,絹本（《鑑影》卷2,23b-24b）。

按:據董題,此卷原爲韓世能所藏,董以宋元畫一冊易之。此卷後歸王士禎父,董爲題前額。

題著色《孝經圖冊》十八幅,絹本（《眼二》卷13,22a-23a）。

得《西園雅集圖團扇》於京,有米芾細楷書詩（《容別》卷6,34a-b;《清河》卷六下,13;《妮古》卷1,210）;[又見董題自藏《集古畫冊》卷19,9;《式古》,v.3,畫卷3,216);[又見張丑一六一三年三伏日題李公麟《九歌圖卷》]（《式古》,v.3,畫卷12,487）。

觀京口張觀宸家藏《臨盧鴻草堂圖》[見董自題《做李公麟雲錦淙圖》於《山水高冊》十幅之首]。

參見:9/1621(3)

觀《長江圖》於陳所蘊家[見董題巨然《長江萬里圖卷》]。

參見:8/20/1619

藏《九歌圖》[見董題李公麟《瀟湘臥遊圖卷》]。

藏《龍眠山莊圖》與《蓮社圖》[見董題張宏《蘭亭雅集圖卷》]。

題設色《山莊圖》九段,絹本（《平生》卷7,64）。

觀設色《山莊圖》[見董題李公麟《醉僧圖卷》]。

李日華

題《山水扇》[見李日華一六一二年正月八日記此作]（《味水》卷4,1b）。

李成

題《烟波漁艇圖軸》（《真蹟》,初集,28a）。

題《雪景圖軸》,絹本（《平生》卷7,23）。

題《雪霽歸舟圖軸》,絹本（《平生》卷7,23-24）。

觀《山水寒林圖軸》於一六〇三年秋後[見汪砢玉識此圖]（《珊瑚》·畫,卷2,1;《式古》,v.3,畫卷11,422）。

題墨筆《瑤峰琪樹圖》,絹本[《歷朝畫幅集冊》六對幅之首]（《石續》,重華宮,1684;《故宮》卷6,194）。台北國立故宮博物院藏。

對題《積雪圖》,絹本冊頁（《書畫》卷4,452）。

題《青嶺暮靄圖冊頁》,絹本（《平生》卷7,23 & 25-26）。

對題墨筆《雪圖團扇》,絹本[《名畫大觀》,第一冊二十五對幅之五]（《式古》,v.3,畫卷3,217）。

藏《著色山圖》（《畫禪》卷2,20;《式古》,v.3,畫卷2,190）。

李昇

藏《雪圖軸》[見董題李昇《高賢圖卷》]。

參見:8/15/1626(4)

李迪

題設色《秋卉草蟲》方幅,絹本[《宋元集繪冊》二十六幅之十四]（《石續》,乾清宮九,514;《故宮》卷6,213）。台北國立故宮博物院藏。

對題淺色《鷹熊圖》方幅,絹本[《名畫大觀》,第四冊二十五對幅之二十]（《式古》,v.3,畫卷3,228）。

李思訓

藏《秋江待渡圖》（《畫禪》卷2,20;《式古》,v.3,畫卷2,190）。

藏李將軍《蜀江圖》（《畫禪》卷2,20;《式古》,v.3,畫卷2,190）。

李唐

爲庶常時嘗借觀韓世能所藏李唐《江山小景圖卷》,其子韓逢禧後售之武林,繼轉歸董藏,董又以王羲之《行穰帖真蹟》十五字還韓逢禧,足所未盡[見董題《江山小景圖卷》]。

參見:9/1623

題著色《風雨歸舟圖卷》,素絹本（《盛京》,第二冊,18b;《古物》卷5,14b）。

題墨筆《雪江圖軸》,絹本（《石續》,御書房,1927;《故宮》卷5,75）。台北國立故宮博物院藏。

題淡著色《水莊琴棋圖軸》,絹本（《澄懷》卷1,92）。

題設色《四時山水冊》四對幅,絹本（《石三》,延春閣十三,1476;《西清》卷1,4b-5a;《故宮》卷6,9-10）。台北國立故宮博物院藏。

對題《雪山圖》,絹本冊頁（《書畫》卷4,452-53）。

藏《桃源圖》,乃盱眙陳明之舊藏[見董題劉敞書《南華秋水篇》]。

李邕

題《縉雲三帖》（《清河》引《戲鴻堂帖》卷四下,37;《珊瑚》·書,卷2,1;《畫禪》卷1,48-49）。

題《雲麾將軍碑》拓本（《畫禪》卷1,38）。

跋《娑羅樹碑》（《畫禪》卷1,37）。

題《大照禪師碑》,硬黃紙本（《平生》卷1,77）。

宋旭

題七言"華嚴偈"一首於一五九八年所作設色《雲山訪道圖卷》,紙本,以壽瀛洲上人（《中國圖目》,v.7,蘇24-131）。南京博物院藏。

題一六〇四年冬所作《玉湖漁隱圖卷》,絹本（《郁續》卷12,23）。

題一五九六年五月十六日所作墨筆《山水軸》,紙本（《穰梨》卷25,13b-14a）。

題一五九九年所作設色《輞川圖冊》二十幅,絹本（Sotheby's, 12/5/1985, no. 89）。

宋迪

跋《瀟湘八景圖卷》（《書畫》卷5,468）。

宋徽宗

題著色《摹衛協高士圖卷》（《真蹟》,三集,2b-3a;《珊瑚》·畫,卷3,3;《式古》,v.3,畫卷11,413;《平生》卷7,2）。

杜牧

題《張好好詩并序卷》,硬牙色闊紋紙（《珊瑚》·書,卷2,9;《式古》,v.1,書卷8,379;《大觀》卷2,43;《吳越》卷2,1a-2b;《叢帖目》,第一冊,266）。

杜董

題韓元介所藏設色《祭月圖軸》,絹本（《中國圖目》,v.1,京3-009）。北京中國美術館藏。

杜瓊

題楊文聰所藏設色《南邨別墅十景冊》,紙本（《過雲》,畫類3,4a-b;《中國圖目》,v.2,滬1-0307）。上海博物館藏。

按:此冊有李日華及陳繼儒一六二九年八月及九月八日二跋,董跋或書於此前後。

周文矩

題淺設色《唐宮春曉圖卷》,絹本(《總合圖錄》,v.2,E5–001)。Villa I Tatti, the Harvard University Center for Italian Renaissance Studies。

跋項氏所藏《文會圖軸》,絹本(《書畫》卷2, 108)。

周之冕

題著色《花竹鵪鶉圖軸》,素絹本(《石初》卷39, 16b;《故宮》卷5, 441)。台北國立故宮博物院藏。

題著色《翠竹秋葵圖軸》,絹本(《十百》,戌卷, 6b–7b)。

明仁宗

題《諭蔣太醫御札冊》[見王文治題此冊](《快雨》卷5, 1)。

吳琚

題吳正志所藏《臨右軍三帖卷》,藏經紙本(《吳越》卷1, 13a–14a)。

觀榜書"天下第一江山"於京口北固山及七言絕句一幅於京,并藏傳朱熹書《歸去來辭》,改定爲吳琚筆[見董自題《臨吳琚書》於《雜書冊》四段之首]。

參見:4/26/1611

吳道子

題《鍾馗元夜出游圖卷》(《珊瑚》·畫,卷1, 3;《式古》,v.3,畫卷8, 369)。

藏《三十二相觀音》[見陳繼儒題董《觀音像軸》](《秘初》卷12, 9b)。

吳隆徹

跋行書《演連珠卷》(《容別》卷2, 2b–3a)。

吳鎮

題墨筆《臨荊浩漁父圖卷》,紙本(《清河》卷七下, 10;《珊瑚》·畫,卷9, 4;《式古》,v.4,畫卷19, 215–16;《平生》卷9, 61;《大觀》卷17, 73a)。

按:此卷似即Freer Gallery of Art所藏吳鎮《漁父圖卷》,但董跋已佚。見《總合圖錄》,v.1, A21–042;《歐米收藏法書》卷4, nos. 25–29。

題自藏墨筆《清江春曉圖軸》,絹本(《故宮》卷5, 200)。台北國立故宮博物院藏。

題《山水軸》(《平生》卷9, 66–67;《大觀》卷17, 78a;《三秋》卷上, 27b)。

按:此軸似即傳董《倣宋元人縮本畫跋冊》[即《小中現大冊》]二十二對幅之十一《倣吳鎮山水》之所本,見《盛京》,第六冊, 21a–b;《古物》卷4, 9b;《故宮》卷6, 73。《倣宋元人縮本畫跋冊》現藏台北國立故宮博物院。

又:此軸《平生》作墨筆無款,惟二印。《大觀》作《關山秋霽圖軸》,絹本雙幅,有"梅花道人"款。《三秋》作紙本,尺寸約爲《大觀》所載之半,有吳鎮自題七言絕句一首,并紀年落款。併置此待考。

題墨筆《關山秋霽圖軸》,絹本雙幀(《平生》卷9, 66)。

題《頭白開卷圖軸》,絹本(《自怡》卷1, 8b–9a)。

七夕泊舟吳閶,購《仿巨然山水大軸》於張慕江(《畫禪》卷2, 38)。

題《漁父圖冊》(《郁題》卷8, 8b;《珊瑚》·畫,卷20, 4;《式古》,v.3,畫卷5, 268)。

對題墨筆《雙松圖團扇》,絹本[《名畫大觀》,第二冊二十五對幅之二十四](《式古》,v.3,畫卷3, 223)。

題《竹居圖小幅》(《平生》卷9, 69)。

宗測

題著色《東林高會圖卷》,紙本(《壯陶》卷1, 23a)。

宗開先

跋《山水冊》(《容別》卷2, 1b–2a)。

邵彌

題著色《山水冊》七幅,紙本(《三秋》卷上, 70b)。

林藻

題草書冊,紙本(《退菴》卷6,又5a)。

柯九思

對題墨筆《古木寒梢圖》,紙本[《歷代名畫大觀大推篷冊》九幅之六](《式古》,v.3,畫卷4, 249)。

題《竹譜冊》三十六幅,宋紙本,遺失二幅,夏昶補畫(《書畫》卷2, 103;《平生》卷9, 48)。

按:《石初》亦載董跋柯九思墨筆《竹譜冊》二十幅,素箋本,似即此冊,然僅二十幅,且前後次序有異,見卷41, 23a。

柳公權

題韓世能所藏小楷《臨王獻之洛神賦十三行》真蹟(《湖社月刊》,v.46, 2)。

題《謝人惠筆帖》(《珊瑚》·書,卷20, 22)。

題海上潘氏所藏宋搨《清淨經》(《清河》引《戲鴻堂帖》卷五下, 15;《叢帖目》,第一冊, 263)。

觀小楷《度人經》[見董題柳公權《清淨經》](《清河》引《戲鴻堂帖》卷五下, 15;《畫禪》卷1, 49)。

姚允在

汪宗魯持示姚允在一六二八年冬所作設色《倣宋元六家山水卷》,素箋本,董屬題之(《石續》,寧壽宮十五, 2851–52)。

姚綬

題設色《秋江漁隱圖軸》,紙本(《虛齋》卷8, 10b–11a)。

藏《臨巨然秋山圖軸》,後爲雪川朱侍御之弟以巨然《關山小景》易去[見董題巨然《秋山圖軸》]。

祝允明

題楷書《臨黃庭經卷》,藏經紙本(《澄懷》卷3, 2;《書道藝術》卷8,插圖11)。日本澄懷堂文庫藏。

題行書《詩詞墨蹟卷》,紙本(《十百》,寅卷, 6a–9b)。

題倣歐陽詢、虞世南、黃庭堅、米芾諸體書近作詩一卷(《朱臥》,108)。

范牧之

題范象先所藏《禊帖卷》(《畫禪》卷1, 41–42)。

范仲淹

題行書尺牘二通一卷,素紙本(《石續》,乾清宮, 293)。

范寬

題淺設色《長江萬里圖卷》,白麻紙本(《真蹟》,初集, 24a;《珊瑚》·畫,卷2,《式古》,v.3,畫卷11, 427;《壯陶》卷2, 50a;《萱暉》,畫7b)。程琦舊藏。

題墨筆《谿山行旅圖軸》,素絹本(《石初》卷26, 25a–b;《南畫》卷9, 14;《故宮》卷5, 41)。台北國立故宮博物院藏。

題墨筆《谿山行旅圖軸》,紙本(《聽颿》卷1, 49;《總

合圖錄》,v.1,A35–032)。The Asian Art Museum of San Francisco。

題王時敏所藏大軸二幅(《墨緣》,名畫卷上北宋,2b)。

題《晚景圖軸》,絹本(《愛日》卷1,1a–b)。

對題淡色《雪景寒林圖團扇》,絹本[《名畫大觀》,第二冊二十五對幅之六](《式古》,v.3,畫卷3,221);[又見《墨緣》,名畫卷下·《唐五代北南宋集冊》二十幅之七,4b–5a]。

按:《墨緣》謂董題不真刪去。

題《踏雪圖》小幅,絹本(《平生》卷6,70)。

藏《雪山圖》及《輞川山居圖》(《畫禪》卷2,20;《式古》,v.3,畫卷2,190)。

俞和

題小楷《臨黃庭經卷》,紙本烏絲闌(《真蹟》,二集,7a;《戲雪》卷3,58b;《壯陶》卷8,35b)。

姜貞吉

題一六一六年五月所作設色《山靜日長圖卷》,紙本(《中國圖目》,v.4,滬1–1883)。上海博物館藏。

侯懋功

題淡著色《倣元人筆意圖軸》,素箋本(《石初》卷38,75a–b;《南畫》卷9,202左;《故宮》卷5,452)。台北國立故宮博物院藏。

胡翼

對題著色《水閣晴樓圖團扇》,絹本[《名畫大觀》,第二冊二十五對幅之三](《式古》,v.3,畫卷3,221);[又見《墨緣》,名畫卷下·《唐五代北南宋集冊》二十幅之五,4a]。

按:《墨緣》謂董題不真刪去。

胡瓌

題設色《番馬圖卷》,絹本(《石三》,御書房一,3069)。

孫兆麟

爲一六三二年夏所作設色《水齋禪師像軸》題贊,絹本(《藝林旬刊》,v.19,7。題贊又見《容別》卷1,3a)。天津市藝術博物館藏。

孫克弘

題畫梅并書孫太白與林逋爭孤山五絶句一卷[見

李日華一六一〇年十一月十日記此作](《味水》卷2,73b)。

題畫石一卷及一冊(《容別》卷6,44a–45a)。

題《畫石卷》(《畫禪》卷2,34–35)。

題《倣米芾研山圖卷》(《畫禪》卷2,37)。

題《達摩面壁圖軸》,紙本(《穰梨》卷26,1b)。

孫知微

跋著色《十一曜圖卷》,素箋本(《清河》卷六下,31;《式古》,v.3,畫卷11,445;《秘初》卷18,14b–15a)。

觀《松圖》[見董題郭忠恕《縱嶺飛仙圖軸》]。

參見:春/1625

孫虔禮

跋草書《千文卷》,疑爲懷素筆(《式古》,v.1,書卷7,347;《平生》卷1,74–75;《大觀》卷2,14b;《石續》,寧壽宮,2621)。

按:《式古》與《大觀》記此作爲硬黃紙本朱絲闌,《石續》記爲白麻紙本,待考。

又:董跋後有馮夢禎一六〇五年四月跋。

藏行書《孝經卷》真蹟(《真蹟》,初集,19b–20a)。

跋草書《孝經冊》,宋箋本(《石初》卷11,1a–b;《故宮》卷3,5)。台北國立故宮博物院藏。

按:《故宮》編者以書中避宋太祖諱,而不避孝宗,定爲北宋人書。

跋楷書《千文》真蹟(《畫禪》卷1,41)。

高克明

與陳繼儒同觀張平仲携至官舍之《雪漁卷》[見董自題《倣趙集賢水村圖》]。

參見:10/22/1612。

高克恭

題設色《雲山圖卷》(《雪堂》,54a–b)。

題《山水》[《宋元名畫冊》二十幅之七](《珊瑚》·畫,卷20,10;《式古》,v.3,畫卷4,258)。

七夕泊舟吳閶,購《雲山秋霽圖》於張慕江(《畫禪》卷2,38)。

高閑上人

題大字行草書《千字文卷》,牙色闊紋紙本(《大觀》卷2,54a–b)。

馬和之

題馬和之畫、宋高宗書《陳風十篇圖卷》,云所見馬和之畫《詩經圖》計十六卷(《平生》卷8,5)。

對題淡色《伐木圖斗方》,絹本[《名畫大觀》,第一冊二十五對幅之十八](《式古》,v.3,畫卷3,219)。

藏《范蠡五湖圖小冊》(《清河》卷六下,13)。

跋《王右軍小像》,絹本小幅(《書畫》卷4,443)。

對題淺設色《瀑邊遊鹿圖團扇》,絹本[《名賢寶繪冊》十五幅之八](《總合圖錄》,v.3,JM3–200–8)。大阪市立美術館藏。

對題淡色《柳堤待渡圖團扇》,絹本[《名畫大觀》,第二冊二十五對幅之十八](《式古》,v.3,畫卷3,223);[《墨緣》,名畫卷下·《唐五代北南宋集冊》二十幅之十三,7a];[《宋元名人山水冊》八對幅之五](《鑑影》卷11,19a;《海王》,11a–b)。

對題墨筆《山水宮扇》,絹本[《名賢寶繪集冊》十二幅之六](《鑑影》卷12,21a)。

馬琬

題淺設色《秋山行旅圖軸》,宋箋本(《石續》,養心殿三,1017;《故宮》卷5,247)。台北國立故宮博物院藏。

題墨筆《澄溪靜樾圖軸》,紙本(《總合圖錄》,v.1,A24–010)。Cincinnati Art Museum。

馬遠

題《瀟湘八景圖卷》(《玉几》卷上,112)。

觀《松泉圖卷》[見張丑記此圖](《清河》卷十下,7;《式古》引《清河》,v.4,畫卷14,63)。

題《吟松圖冊頁》(《平生》卷8,56)。

對題淡色《觀泉圖團扇》,絹本[《名畫大觀》,第一冊二十五對幅之十九](《式古》,v.3,畫卷3,219)。

對題淡色《夜山圖團扇》,絹本[《名畫大觀》,第二冊二十五對幅之十九](《式古》,v.3,畫卷3,223);[《墨緣》,名畫卷下·《唐五代北南宋集冊》二十幅之十九,10b–11a];[《宋元名人山水冊》八對幅之六](《鑑影》卷11,19b)。

題《落照圖》(《好古》卷上,33)。

跋畫四幀(《容別》卷2,26b)。

徐浩

題無錫華學士家藏《道經》上卷,黃花素本(《清河》卷一下,9)。

藏小楷《道德經》,黃素真蹟本,乃華學士家舊藏

(《真蹟》,初集,26b)。

得《洺州府君碑》宋拓本[見董自題《傲宋元山水冊》十幅之二](《寓意》卷4,29b-30a)。

徐崇嗣

題《荷花雙鶼軸》,絹本(《平生》卷7,37)。

徐道寅

跋《千佛名經》(《畫禪》卷1,42-43)。

徐賁

題墨筆《澄江春泛圖短卷》,紙本(《平生》卷10,11)。

荆浩

藏《峻峰圖短卷》(《清河》卷六下,13)。

題設色《鍾離訪道圖軸》,絹本(《鑑影》卷19,1b)。

對題淡色《臂鷹人物圖斗方》,絹本[《名畫大觀》,第一冊二十五對幅之三](《式古》,v.3,畫卷3,217)。

題《雲生列岫冊頁》(《平生》卷6,51)。

夏珪

題淡色《夜潮風景圖團扇》,絹本[《名畫大觀》,第一冊二十五對幅之二十](《式古》,v.3,畫卷3,219-20)。

唐寅

觀《野望憫言圖卷》及紙本墨筆《越城泛月圖》(《清河》卷十二下,7;《式古》引《清河》,v.4,畫卷27,460)。

題墨筆《松坡高士圖卷》,白紙本(《墨緣》,名畫卷上明,11a-b)。

題墨筆《夢筠圖卷》,紙本(《墨緣》,名畫續錄卷下,6a)。

題《溪山亭子圖卷》,紙本(《聽颿》卷下,565)。

跋著色《江南烟景圖卷》,絹本(《壯陶》卷10,28a)。

題墨筆《高泉古樹圖軸》,白紙本(《墨緣》,名畫卷上明,12b-13a)。

觀墨筆《挂瓢圖軸》,紙本[見陳繼儒題此軸](《鑑影》卷21,16a-b)。

跋《山水冊》(《容別》卷2,6b-7a)。

題重設色《絕代名姝冊》十幅,絹本(《寓意》卷4,14b)。

題《醉舞狂歌五十年圖》(《珊瑚》·畫,卷16,6;《式古》,v.4,畫卷27,454)。

桓溫

題《燥早帖》[見王澍題米芾《雜帖》](《虛舟》卷8,8)。

按:王澍謂此帖乃米芾臨本。

索靖

題項元汴家藏章草書《出師頌》(《清河》引《戲鴻堂帖》卷一下,12;《畫禪》卷1,49;《式古》,v.1,書卷6,285)。

倪元璐

題《山水》(《容別》卷1,10a)。

倪瓚

題自藏《鶴林圖卷》(《清河》卷十一下,1-2;《式古》引《清河》,v.4,畫卷20,261)。

按:張丑一六二八年三月三日識此卷在董家,乃嗣四十二代天師無爲爲周元真(別號鶴林)所作。高巽志作傳倪瓚寫圖,系以《靈鶴辭》跋。見《真蹟》,二集,40a-b。

題《韋應物詩意圖卷》,絹本(《藤花》卷1,51b)。

題自藏淺設色《水竹居圖軸》,宋箋本,云得之吳治(《平生》卷9,86;《石續》,寧壽宮,2777;《中國圖目》,v.1,京2-01)。北京中國歷史博物館藏。

題墨筆《松林亭子圖軸》,素絹本(《平生》卷9,92-93;《石初》卷38,22b-23a;《南畫》卷9,63;《故宮》卷5,221)。台北國立故宮博物院藏。

題汪宗孝所藏淺設色《雨後空林圖軸》,宋箋本(《平生》卷9,87;《墨緣》,名畫卷上元,21a-22a;《石續》,獅子林二/長春園二,4030;《故宮》卷5,215-16)。台北國立故宮博物院藏。

按:此題無款。

題《松坡平遠圖軸》,紙本(《郁題》卷6,2a;《珊瑚》·畫,卷10,7;《式古》,v.4,畫卷20,246;《平生》卷9,87-88;[又見李日華一六一○年正月十三日記此作](《味水》卷2,2b)。

題《雙松圖軸》(《郁題》卷9,3a;《珊瑚》·畫,卷10,20;《式古》,v.4,畫卷20,255)。

題《傲李成筆意圖軸》(《珊瑚》·畫,卷10,29,《式古》,v.4,畫卷20,260)。

題紙本《山水小軸》,有倪自題"張君狂嗜古"詩(《平生》卷9,103)。

按:此圖《平生》作張中畫。

過程嘉燧家,題所藏《霜林遠岫圖軸》(《好古》引程嘉燧《耦耕堂集》"題董畫冊後,"卷上,41)。

題《西園圖軸》於充符齋,紙本(《寓意》卷2,34a)。

題青綠《山陰丘壑圖短幅》,絹本(《墨緣》,名畫續錄卷下,5b)。

題自藏墨筆《溪山圖軸》,宋箋本(《石初》卷17,15b)。

題墨筆《葉湖別墅圖軸》,白麻紙本(《石續》,淳化軒,3240;《石隨》卷8,13b)。

題自藏《竹石小軸》以貽伯襄司成[見王文治題此軸](《快雨》卷7,5)。

題至正甲辰十月二十八日爲約齋所作紙本《山水軸》(《聽颿》卷上,553)。

題《竹樹秋風小軸》,紙本(《壯陶》卷7,40b)。

題墨筆《吳淞春水圖軸》,紙本(《虛齋》卷7,56a)。

題墨筆《畫譜冊》十對幅,宋箋本,畫樹石竹譜九段(《石續》,重華宮,1588;《故宮》卷6,22)。台北國立故宮博物院藏。

題《清秘閣圖》[見王翬臨此作](《歸石》卷5,18b)。

觀京口陳從訓所藏《山陰丘壑圖》[見董題倪瓚《優鉢曇花圖軸》]。

參見:5/1618

[又見董題倪瓚《秋林山色圖軸》]。

參見:10/1603(1)

觀吳門老僧及松江宋光祿所藏設色山水二、三幅[見董自題《傲倪迂逕細筆圖》]。

參見:秋/1616(3)

藏《喬林古木圖》(即《荆蠻民》)[見董題自藏倪瓚《六君子圖》於《唐宋元寶繪畫》二十幅之七](《珊瑚》·畫,卷19,3);[又見董一六○三年十月題倪瓚《秋林山色圖軸》]。

藏至正四年十二月望日爲袁子方所作絹本《山水小幀》(《真蹟》,初集,4a及42b)。

藏《秋林圖》[見董題倪瓚畫](《畫禪》卷2,39)。

黃公望

題《困學齋圖短卷》,白紙本(《平生》卷9,102)。

按:此圖《平生》作張中畫。

觀項氏家藏《沙磧圖卷》及婁江王氏所藏《江山萬

里圖長卷》,云後者不似真蹟[見董跋自藏黃公望《富春山居圖卷》(無用師本)]。

參見:10/7/1596

藏《絕壑奔流圖長卷》[見董題王蒙《芝蘭室圖卷》]。

按:此圖原爲梁溪談志伊所藏,董得之梁溪周臺幕,後歸吳正志。

題《騎馬看山圖軸》(《珊瑚》·畫,卷9,16;《式古》,v.4,畫卷18,207)。

題《秋山林木圖軸》於東雅堂(《珊瑚》·畫,卷9,17;《式古》,v.4,畫卷18,208)。

題至正九年四月一日所作淺絳《天池石壁圖軸》(《珊瑚》·畫,卷9,17;《式古》,v.4,畫卷18,208;《大觀》卷17,7a;畫語又見《容別》卷6,38b–39a)。

題元統乙亥六月爲文敏所作淺絳《天池石壁圖軸》,絹本(《平生》卷9,38)。

於晚香堂與陳繼儒同觀并題王廷珸所藏七十三歲爲文敏所作設色《天池石壁圖軸》,闊連粗紋元紙本(《大觀》卷17,6b–7a)。

題自藏淡色《擬北苑夏山圖軸》,絹本,云"易之曹任之"(《墨緣》,名畫續錄卷下,5b)。

按:《真蹟》載董藏黃公望淺絳《臨董北苑夏山圖軸》,絹本(見初集,3b–4a),《平生》載董藏題黃公望《夏山圖軸》,絹本(見卷9,115),未知是否相關,併置此。

題八十歲時爲東泉學士所作《山水軸》,絹本(《湘管》卷5,331–32)。

題爲次方所作設色《良常山館圖軸》,絹本(《自怡》卷1,5b;《古緣》卷2,27a)。

按:董題云三十餘年前曾向睢陽袁環中借臨此軸。

跋王氏所藏七十九歲所作《天池石壁圖軸》(《歸石》卷2,7a–b)。

觀張覲宸所藏青綠設色《秋山圖軸》(《歸石》卷2,5b–7a)。

藏《萬壑松風圖軸》及《晴巒晚色圖軸》(《清河》卷十一上,13–14;《式古》引《清河》,v.4,畫卷18,211)。

跋自藏《畫冊》二十四幅,紙本(《書畫》卷2,170及卷4,362)。

藏贈陳彥廉《畫冊》二十幅[見董自題《倣八家冊》八對幅之末](《華亭》,26);[又見董一六三四年春自題《倣黃公望山水》]。

觀《鐵崖圖》[見董題黃公望《騎馬看山圖軸》]。

藏爲張雨所作《良常館圖》[見董自題《倣黃子久良常館圖》](《好續》,131)。

藏《秋山讀書圖》[見董自題《倣北范九夏松風圖

軸》](《華亭》,15)。

藏《溪山小隱圖》[見劉曙題藍瑛《臨大癡山水卷》](《古芬》卷16,70a;《眼二》卷15,38a)。

藏設色《晴山晚色圖》[見董題黃公望七十三歲時所作《天池石壁圖軸》]。

黃存吾

題設色《青林高會圖卷》,紙本(《柳南續筆》卷1,16b–17a; *Christie's*, 6/3/1987, no. 7)。The Paul Moss Collection.

黃筌

題淺設色《勘書圖軸》,絹本(《故宮》卷5,30)。台北國立故宮博物院藏。

題《班彪訓女圖軸》,絹本(《平生》卷6,73)。

題著色《梨花山雀圖軸》,素箋本(《石初》卷17,4a)。

藏《勘書圖》與《金盤鵓鴿圖》[見董題沈周《寫生冊》]。

黃庭堅

題行書《梵志詩卷》,青閣箋本(《平生》卷2,56;《江村》卷2,17b;《吳越》卷3,5a;《過雲》,書卷1,10b)。

崇禎冬至日於戲鴻堂與陳繼儒及董祖和觀行書《王史二公墓誌銘稿卷》,紙本,因題之(《書畫》卷4,408;《夢園》卷3,25b;《壯陶》卷4,18a;《書蹟名品叢刊》之《黃山谷集》3)。

跋《參悟詩卷》,花箋本(《書畫》卷4,461)。

題楷書《蓮經》於一六二三年秋之前[見汪砢玉記黃庭堅《法語真迹卷》](《珊瑚》·書,卷5,3;《式古》,v.1,書卷10,511–12)。

題《戎州帖》,綠閣紙本(《平生》卷2,60)。

題陳繼儒所藏草書二帖(《平生》卷2,61)。

觀書范寬《釣雪圖歌》、松江蔡太學所藏狂草《琵琶行》、梁溪華氏所藏《李太白詩》[見董《法書紀略冊》及題黃庭堅《觀音贊·燒香贊卷》]。

參見:1626(2); 12/1633

藏書李白"秋浦歌"(《真蹟》,初集,26b)。

《黃庭經》

跋沈問卿所藏宋拓《黃庭經冊》(《壯陶》卷21,54a)。

按:董跋後有陳繼儒一六二九年十月二十二日跋,

云此冊已由沈問卿轉歸陳孫繩所藏,則董題應在此之前。

題韓世能家藏楊義小楷《黃庭內景經卷》,黃素烏絲闌本(《平生》卷1,29–30;《叢帖目》,第一冊,262)。

題唐臨楷書《黃庭經卷》,金粟牋本,云或爲鍾紹京書(《墨緣》,法書卷上唐,10b–11a;《石三》,乾清宮九,473)。

按:《墨緣》謂此卷爲硬黃紙本。

題丁雲鵬所藏宋搨《黃庭經卷》[見梁章鉅記此作](《退菴》卷3,14a)。

跋《內景黃庭經》(《容別》卷2,3b–4b)。

跋《黃庭經》(《畫禪》卷1,37,38,39及47)。

觀楊義《黃素黃庭經》真蹟於韓世能所[見董自跋《內景黃庭經冊》]

參見:1/2/1627; 8/12/1630(1)

黃輝

跋張延登所示書幅(《容別》卷2,13a–b)。

張以文

得《山水》於京[見董題曹知白《仿巨然山水》]。

張旭

題草書軸,絹本(《古物》卷3,2a)。

題項德弘所藏書庚信《步虛詞》二首,紙本(《畫禪》卷1,43;《清河》引《戲鴻堂帖》卷四下,30;《平生》卷1,81)。

題王世懋所藏楷書《郎官壁記》(《畫禪》卷1,50;《清河》引《戲鴻堂帖》卷四下,33;《叢帖目》,第一冊,265)。

題今草《秋深帖》(《清河》卷四上,34;《真蹟》,二集,54b–55a;《式古》引《清河》,v.1,書卷7,356)。

觀韓世能所藏《宛陵帖》[見董《法書紀略冊》]。

參見:1626(2); 1/17/1632

張即之

題大字《古柏行卷》,紙本(《退菴》卷7,11a)。

按:此作本爲大卷,梁章鉅改裝爲大冊。

跋楷書《金剛經》二本,紙本(《書畫》卷5,570)。

張宏

題一六一六年三月四日所作設色《蘭亭雅集圖卷》,絹本(《中國圖目》,v.1,京5-022)。北京首都博物館藏。

對題一六三二年冬所作設色《吳中勝覽圖冊》十幅之第三幅,絹本(《中國圖目》,v.1,京12-063)。北京市文物商店藏。

張復(元春)

舟泊桃源,題一五九六年所作設色《蓬池春曉圖卷》,紙本(《中國圖目》,v.8,津6-009)。天津市文物公司藏。

張復(復陽)

觀汪砢玉家藏《山水》二軸[見汪砢玉記此圖](《珊瑚》·畫,卷14,19;《式古》引《珊瑚》,v.4,畫卷30,540;《眼初》引《珊瑚》卷12,15a)。

張璟

藏《松石圖小幅》(《清河》卷六下,13)。

陸治

題《杏花鸂鶒圖》中幅,絹本(《平生》卷10,105)。

觀《臨王履華山圖冊》四十幅(《書畫史》,126;《妮古》卷4,296)。

按:上海博物館藏陸治設色《華山圖冊》四十幅,絹本,未知是否即此作。見《中國圖目》,v.3,滬1-0892。

陸東之

題《臨王羲之蘭亭詩五首》(《清河》引《戲鴻堂帖》卷三下,27;《平生》卷1,71;《叢帖目》,第一冊,265)。

陸深

題書四札[見王文治題此作](《快雨》卷5,4-5)。

題《雜札卷》六幅,紙本[見梁章鉅記此作](《退菴》卷8,20a-b)。

陸探微

題著色《佛母圖卷》,素絹本(《秘初》卷9,1a-b)。

陸應陽

跋書幅[《明賢翰墨冊》十五幅之十四](《故宮》卷3,421-22)。台北國立故宮博物院藏。

陸廣

跋著色《仙山樓觀圖軸》,絹本。

參見:春/1619(1)

跋《丹臺春賞圖軸》(《南畫》卷14,44)。

跋《洞天春曉圖軸》,紙本(《書畫》卷1,76)。

按:此作無款無印,舊傳黃公望筆,吳其貞改定爲陸廣,董跋內容不詳。

陸機

跋草書《平復帖》,紙本(《書畫》卷4,430;《平生》卷1,7-8;《眼二》卷2,19a-b)。

按:董跋此帖各書所載不一,應非一本,待考。見12/1/1604(1)。

曹知白

題爲王蒙所作《重巒暮靄圖軸》,紙本(《珊瑚》·畫,卷9,14;《式古》,v.4,畫卷22,305;《大觀》卷18,37b)。

題畫冊(《郁題》卷11,25)。

題《烟巒晚景册頁》(《平生》卷9,56)。

題《吳淞山色》小幅,紙本(《平生》卷9,56)。

題自藏《仿巨然山水》(《畫禪》卷2,33-34)。

郭畀

題金沙于太學所藏墨筆《雪竹卷》,紙本(《石三》,延春閣十六,1607;《西清》卷1,25b-26a;《故宮》卷4,124)。台北國立故宮博物院藏。

郭思

對題著色《散牧圖團扇》,絹本[《名畫大觀》第二冊二十五對幅之十三](《式古》,v.3,畫卷3,222)。

郭忠恕

跋《摹王維輞川圖長卷》(《平生》卷7,28)。

題《青綠山水雙軿大軸》(《平生》卷7,27)。

對題淡色《車棧橋閣圖團扇》,絹本[《名畫大觀》,第一冊二十五對幅之九](《式古》,v.3,畫卷3,217);[《墨緣》,名畫卷下·《唐五代北南宋集冊》二十幅之八,5a-b];[《宋元名人山水冊》八對幅之二](《鑑影》卷11,18a;《海王》,10b)。

藏《避暑宮殿圖卷》及《雪景大軸》[見董題郭忠恕《緱嶺飛仙圖軸》]。

參見:春/1625

藏《越王宮殿圖》(《清河》卷六上,14;《式古》引《清河》,v.3,畫卷11,440;《妮古》卷4,284);[又見董一五九六年七月廿八日跋郭忠恕《摹右丞輞川圖卷》]。

藏《輞川招隱圖》(《畫禪》卷2,20;《式古》,v.3,畫卷2,190)。

郭熙

自楚中校士歸,舟次采石,題淺設色《關山行旅圖卷》,絹本(《石續》,養心殿,932)。

跋《喬松山水圖軸》雙拼大幅,絹本(《書畫》卷1,78)。

跋《春曉圖軸》,絹本(《書畫》卷6,708)。

題《重巒雪積圖》大幅,絹本(《平生》卷7,45-46)。

對題墨筆《烟景圖團扇》,絹本[《名畫大觀》,第一冊二十五對幅之十](《式古》,v.3,畫卷3,218);[又見《墨緣》,名畫卷下·《唐五代北南宋集冊》二十幅之十一,6a-b]。

梁武帝

將韓世能所藏《異趣帖》摹刻入《戲鴻堂帖》(《清河》卷五上,41;《叢帖目》,第一冊,263)。

陳居中

跋《番騎圖卷》(《容別》卷2,9b)。

陳淳

題淺設色《倣米友仁雲山圖卷》,紙本(《平生》卷10,91;《總合圖錄》,v.1,A21-068)。Freer Gallery of Art.

跋墨筆《仿米氏山水卷》,紙本(《眼二》卷15,34b-35a)。

題《墨花圖卷》,紙本(《十百》,寅卷,22a-23a)。

陳廉

題一六三四年八月所作墨筆《蘆汀飛瀑圖軸》,紙本(《中國圖目》,v.4,滬1-1905)。上海博物館藏。

陳裸

題一六二七年正月爲陳繼儒七十壽所作設色《苕帚盦種芝圖軸》,紙本(《萱暉》,畫99b;Christie's,11/30/1988,no.76)。程琦舊藏。

陳嘉選

題一六三〇年十二月所作設色《花卉軸》,絹本(《中國圖目》,v.4,滬1-1906)。上海博物館藏。

陳蓮

題《梅軸》,紙本(《穰梨》卷27, 12b)。

陳繼儒

為栖雲上人題一六一九年行書《華嚴菴記冊》,紙本(Li and Watt, *Chinese Scholar's Stadio*, no. 12B–E)。上海博物館藏。

題一六二〇年秋所作著色《江南秋圖卷》,絹本(《澄懷》卷4, 34–35;《總合圖錄》,v.3, JM1–232)。東京國立博物館藏。

莫是龍

題一五七六年夏所作淺絳《山靜似太古圖軸》,紙本(*Christie's*, 11/25/1991, no. 107)。

題絹本墨筆《仿諸家山水冊》八幅中仿柯九思之一幅(*Sotheby's*, 11/25/1991, no. 18)。

盛琳

對題墨筆《山水冊》八幅之三并題額,紙本(《中國圖目》,v.4,滬1–2066)。上海博物館藏。

按:此冊末幅紀年為"丁丑(一六三七)除夕,"但有楊文驄一六三六年十月二十五日對題,且董亦卒於一六三六年,或此冊歷數年始成,待考。

盛懋

題淺設色《山居納凉圖軸》,絹本(《鑑影》卷20, 18a;《總合圖錄》,v.1, A28–043)。The Nelson-Atkins Museum of Art。

許道寧

題著色《雲出山腰圖卷》,絹本(《總合圖錄》,v.1, A21–057)。Freer Gallery of Art。

題墨筆《嵐鎮秋峰圖軸》,絹本(《墨緣》,名畫卷上北宋,3a–b)。

題《雪山行旅圖軸》,絹本(《穰梨》卷2, 11a)。

莊麟

題墨筆《倣巨然蓮社圖》,素箋本[《元人集錦卷》八幅之末](《平生》卷10, 16;《大觀》卷18, 29b;《墨緣》,名畫卷下·《元人八圖合卷》之末幅, 4b–5a;《石續》,乾清宮, 519–20;《石隨》卷4, 14b–15a;《故宮》卷4, 303–304)。台北國立故宮博物院藏。

按:《平生》載此作為淺絳,待考。

又:《大觀》及《墨緣》稱此作為《翠雨軒圖》。

項元汴

題《小山叢竹圖》(《郁續》卷11, 17)。

項惟寅

題《臨鍾王法楷卷》,紙本[臨《薦季直表》、《宣示表》、《黃庭經》、《樂毅論》、《曹娥碑》等](《穰梨》卷26, 19a–b)。

項聖謨

題淡著色《天香書屋圖軸》,白鏡面箋本(《墨緣》,名畫卷下·《宋元明大觀高冊》二十幅之十八, 9a–b;《選學》卷下, 133–34)。

題墨筆《王維詩意圖冊》十二幅之首幅,紙本(《中國圖目》,v.4,滬1–1973)。上海博物館藏。

智永

跋自藏《真草千文卷》[見顏文彬記此作](《過雲》,書卷1, 1a–2a)。

題宋搨《真草千文》(《寓意》卷2, 11a)。

跋《千文》(《容別》卷2, 15b–16a及17b–18a)。

跋《倣鍾繇宣示表》(《畫禪》卷1, 42)。

馮可賓

對題墨筆《畫石冊》八開,紙本(《總合圖錄》,v.4, JP6–048)。日本柳孝氏藏。

參見:1632(7)

跋《石圖》(《容別》卷1, 4a–b;卷2, 9b–10a, 13a及14b–15a)。

惠崇

題《江南春袖卷》,絹本(《平生》卷6, 81)。

觀京口陳氏所藏《江南春卷》及真州吳治所贈《早春圖巨軸》[見董自題《書畫合璧冊》十八對幅之十二](《石初》卷41, 60a)。

觀王氏所藏《江南春圖小袖卷》,紙本(《真蹟》,初集,59a)。

程正揆

跋《九歌卷》(《容別》卷2, 14a)。

跋書卷(《容別》卷2, 27b–28a)。

程嘉燧

題一六三五年八月所作《倣雲林山水軸》,紙本(《吳越》卷4, 107a)。

彭譲木

跋《岸圖圍圖卷》(《容別》卷2, 10a–11a)。

溫庭筠

題《湖陰曲》(《畫禪》卷1, 48)。

楊士賢

對題淡色《遙岑烟霭圖團扇》,絹本[《名畫大觀》第二冊二十五對幅之十六](《式古》,v.3,畫卷3, 222)。

楊文驄

題一六三四年冬所作墨筆《倣元人山水軸》,紙本(《藝林月刊》,v.10, 1;《中國文物集珍》,no. 49)。香港北山堂藏。

題《祓園圖冊》(《容別》卷2, 1a–b)。

題《山水圖》(《平生》卷10, 120)。

楊凝式

題楷書《韭花帖》真蹟,紙本(《珊瑚》·書,卷2, 13;《式古》,v.1,書卷8, 400;《平生》卷1, 119)。

按:董題後有陳繼儒一六三七年題,云曾與董同觀此帖於項德明齋中。無錫市博物館所藏《韭花帖卷》似即此作,但董跋已佚,見《中國圖目》,v.6,蘇6–001。

又:《真蹟》引《戲鴻堂帖》,載董有二題,併置此待考。見《真蹟》,二集,62a–b。

藏《步虛辭》及《合浦》、《乞花》諸詩帖[見董自題《杜詩卷》](《古芬》卷7, 14a–b)。

郟之麟

題《山水軸》,紙本,(《退菴》卷17, 31a)。

葉有年

題設色《花苑春雲圖軸》,絹本(《藝林月刊》,v.87, 7;《中國目錄》,v.2, 58,京1–2493)。北京故宮博物院藏。

董源

題淺絳《清谿春泛高頭長卷》,絹本(《平生》卷7,17)。

按:此卷《平生》作巨然筆。

題自藏墨筆《山水長卷》,絹本,將重裝付子祖常(《壯陶》卷2,35b)。

藏《秋山圖短卷》(《清河》卷六下,13)。

題設色《秋山行旅圖軸》,絹本(《金匱》,v.1,no.2)。香港陳仁濤藏。

按:董曾藏此軸,見董一六二七年題王蒙《倣董源谿山行旅圖》及台北故宮所藏《倣宋元人縮本畫跋冊》二十二對幅之十,時此軸已易手,見11/19/1627(1)。

題淺設色《寒林重汀圖軸》,絹本(《鑑影》卷19,7b;《海王》,7b;《總合圖錄》,v.3,JM19–058)。日本黑川古文化研究所藏。

吳闐泊舟,再題《秋山行旅圖軸》,淡黃絹本(《郁題》卷10,14b;《珊瑚》·畫,卷1,27;《式古》,v.3,畫卷11,432;《大觀》卷12,17a–b)。

題《溽暑山行圖軸》(《平生》卷7,14;《墨緣》,名畫卷上元,29a)。

按:此圖《平生》與《墨緣》作巨然。

題設色《茆堂消夏圖軸》[一名《茆屋清夏圖軸》]於京,絹本(《聽續》卷上,511;《巖雪》卷1,45a;《壯陶》卷2,35a)。

題墨筆《雲壑松風圖軸》,絹本雙幀大幅(《雪堂》,32a;《澄懷》卷1,24–25;《爽籟》,v.2,no.6)。

按:此題無款,羅振玉定爲董晚年書。

對題自藏著色《採芝圖斗方》,絹本[《名畫大觀》第二冊二十五對幅之八](《式古》,v.3,畫卷3,221);[又見《墨緣》,名畫卷下·《唐五代北南宋集冊》二十幅之十五,8a–b]。

按:《墨緣》謂此幅爲趙伯駒筆,且董題不真刪去。

對題自藏著色《萬木奇峰圖團扇》,絹本[《名畫大觀》第一冊二十五對幅之八](《式古》,v.3,畫卷3,217);[又見《墨緣》,名畫卷下·《唐五代北南宋集冊》二十幅之六,4a–b]。

按:《墨緣》謂董題不真刪去。

藏《溪山圖》(《容別》卷6,13a)。

藏《蜀江圖》及《瀟湘圖》(《畫禪》卷2,8)。

藏《瀟湘圖》、《征商圖》、《雲山圖》及《秋山行旅圖》(《畫禪》卷2,20;《式古》,v.3,畫卷2,190)。

虞世南

跋《積時帖卷》(《畫禪》卷1,40–41)。

跋楷書《夫子廟堂碑冊》,紙本(《書畫》卷5,478)。

題楷書《東觀帖》(《珊瑚》·書,卷1,16;《式古》,v.1,書卷7,332)。

趙令穰

題淺設色《春江烟雨圖卷》,絹本(《雪堂》,41a;《澄懷》卷1,58;《總合圖錄》,v.4,JP8–042)。日本阿形邦三藏。

題設色《賓菊圖短卷》[一名《柴桑賞菊圖卷》],絹本(《平生》卷8,22–24;《穰續》卷1,16b;《有鄰大觀》,宇集)。日本藤井善助舊藏。

按:此圖《平生》作趙伯驌畫。

題《江干雪霽圖卷》(《珊瑚》·畫,卷3,12;《式古》,v.4,畫卷13,2)。

題淺設色《江邨秋曉圖卷》,絹本(《大觀》卷13,36a)。

對題淡色《秋塘群鳧圖斗方》,絹本[《名畫大觀》第二冊二十五幅之十二](《式古》,v.3,畫卷3,222);[又見《墨緣》,名畫卷下·《唐五代北南宋集冊》二十幅之十二,6b]。

按:《墨緣》謂董題不真刪去。

題自藏《荷香清夜圖》[見杜瑞聯論王肇《擬趙大年荷香清夜圖軸》](《古芬》卷17,34b)。

藏《夏山圖》(《畫禪》卷2,20;《式古》,v.3,畫卷2,190)。

趙左

題一六一九年六月所作設色《秋山無盡圖卷》,鏡面箋本(Li and Watt, *Chinese Scholar's Studio*, no.14)。上海博物館藏。

題一六一一年九月二十日所作設色《摹松雪翁高山流水圖軸》,絹本(《紅豆》卷8,50a;《鑑影》卷22,9b;《中國圖目》,v.4,滬1–1588)。上海博物館藏。

題一六一一年九月所作著色《倣楊昇秋山紅樹圖軸》,素絹本(《石初》卷39,16a;《故週》,v.216,2;《故宮》卷5,438)。台北國立故宮博物院藏。

題一六一七年四月二十日所作《煮茶圖軸》,紙本(《別下》卷2,19b)。

題一六一四年九月所作設色《四時山水屏》,絹本,一爲《武陵春色圖》,二爲《竹樓清夏圖》,三爲《黃鶴樓圖》,四爲《梁園飛雪圖》(《鑑影》卷22,10a–11a)。

題設色《秋林小坐圖扇》,泥金紙本(《故週》,v.509,4)。故宮博物院藏。

趙伯駒

藏《後赤壁賦圖卷》[見董題沈士充《桃源圖卷》];[又見董題文徵明《仙山圖卷》]。

參見:4/10/1632

題著色《漢宮圖團扇》,絹本(《石續》,寧壽宮,2704;《故宮》卷5,70)。台北國立故宮博物院藏。

按:此扇現裱爲軸。

對題著色《倣鄭虔山居説聽圖斗方》,絹本[《名畫大觀》第一冊二十五對幅之十七](《式古》,v.3,畫卷3,219)。

對題臨王維畫所作設色《姮娥奔月圖宮扇》,絹本[《歷朝寶繪集冊》十對幅之七](《鑑影》卷10,24b);[《歷代名筆集勝冊》十二對幅之首](《虛齋》卷11,25a)。

曾見《桃源圖》、《赤壁圖》及《補杜詩絕句圖》[見董題郭忠恕《緱嶺飛仙圖軸》]。

參見:春/1625

觀溪南吳氏所藏《桃源圖》[見董跋沈士充《桃源圖卷》]。

得《杜甫詩意圖》於京[見董題自藏《集古畫冊》](《珊瑚》·畫,卷19,9)。

趙孟頫

跋行書《光福寺重建塔記》,紙本(《中國圖目》,v.2,滬1–0155)。上海博物館藏。

按:董跋後有李日華一六二八年三月跋。

題《真草千字文卷》,紙本(《中國圖目》,v.2,滬1–0165)。上海博物館藏。

跋爲月林上人行書蘇軾"次韻潛師古詩"一卷,素箋本(《石初》卷30,14b–15a;《故宮》卷1,81)。台北國立故宮博物院藏。

按:董跋云此卷乃趙爲中峰明本所作,且誤以蘇詩爲趙自作。以董之精鑑,不應率略至此,董跋既僞,則趙書亦可疑。參見《故宮》編者按語。

題楷書《玄妙觀重修三門記卷》,紙本(《真蹟》,初集,61a;《選學》卷上,52;《書跡名品叢刊》;《董其昌》,no.85)。東京國立博物館藏。

跋行書《千文卷》,素箋烏絲闌本(《石初》卷31,6a)。

過廣陵,吳嬰能以張端衡畫卷易董所藏趙孟頫行書《頭陀寺碑卷》,藏經紙本,董董之以歸(《式古》,v.2,書卷16,106;《大觀》卷8,11b;《辛丑》卷3,30–31)。

按:此卷有王穉登一五九九年十二月十九日跋,云"此卷乃董太史物,吳君嬰能以一宋人畫易之,"但董此時尚未爲太史,王跋疑僞,董跋待考。

又:《平生》載董題趙孟頫小行書《頭陀寺碑》,爲黃蠟箋烏絲闌本,未知是否即此作。見卷4,13。

題行書《與甥張景亮書卷》(《平生》卷4, 6)。

按:此作似即趙草書《千字文卷》。見3/3/1601。

題項氏所藏楷書《陰符經卷》,高麗箋本(《墨緣》,法書卷下元,1b–2a;《秘績》,239)。

按:《墨緣》謂此卷爲白宋紙本,董跋雖真非原題。

題陳繼儒出示之行書《雨詩六札卷》,宋紙本(《吳越》卷2, 12a;《石三》,延春閣十五,1565)。

題行書中峰明本"懷淨土詩"一卷,素箋本(《石續》,御書房,1959)。

題大行書《太湖石贊》、《蕭子中真贊》、"題董源溪岸圖詩"及"題洗馬圖詩"一卷,藏經紙本(《辛丑》卷3, 22;《過續》卷1, 6a–b)。

題小楷書《金丹四百字卷》,烏絲闌本[見林吉人題此卷](《過續》卷1, 3a)。

題鐘鼎、小篆、八分、行、真、草《六體千文卷》,素箋烏絲闌本(《盛京》,第三冊,4b–5a;《古物》卷2, 10a)。

題楷書《墨琴兩譜卷》於天津舟次,絹本(《壯陶》卷6, 36a)。

跋《臨褚河南禊帖卷》,白麻紙本(《萱暉》,書43a)。程琦舊藏。

題設色《摹盧愣伽羅漢像卷》[一名《紅衣羅漢樹石卷》],宋箋本(《式古》,v.4,畫卷16, 137;《大觀》卷16, 47a–b;《秘續》,108;《愛日》卷1, 5b)。遼寧省博物館藏。

題白描《洗馬圖卷》,紙本[見李日華一六〇九年八月十六日與一六一一年十一月十一日記此作](《味水》卷1, 27a–b及卷3, 39a。又參見《大觀》卷16, 44b)。

題著色《謝幼輿丘壑圖卷》,紙本(《眼二》卷14, 2a–b)。

題青綠設色《淵明歸田圖卷》,絹本(《郁題》卷7, 9b;《珊瑚》·畫,卷8, 7;《式古》,v.4,畫卷16, 121)。

題《雙馬圖卷》(《珊瑚》·畫,卷8, 16;《式古》,v.4,畫卷16, 132)。

題畫卷(《畫禪》卷2, 36)。

題無款《百駿圖卷》,絹本[見梁章鉅記此作](《退菴》卷13, 4a)。

藏墨筆《水村圖卷》,紙本[見張丑記此卷](《清河》卷十下,19;《式古》引《清河》,v.4,畫卷16, 130);[又見董自題《倣倪雲林山水圖卷》]。

參見:12/1/1618(1)

[又見董自題《倣趙集賢水村圖》於《山水高冊》十幅之末]。

參見:九月晦/1624(1)

按:董於一六一二年作《倣趙集賢水村圖》時,尚

未收藏趙之原作,於一六一九年跋趙卷云舊藏此卷,已轉歸程季白。故董藏趙《水村圖卷》應介於一六一二至一六一九年間。見10/22/1612; 9/1619(2)。

跋自藏青綠《鶴林春社圖》小直幅,絹本(《古緣》卷2, 5a)。

按:董此跋云藏有趙孟頫《水村圖卷》。董藏此卷於一六一二至一六一九年間,故此跋亦應書於此二年之間,見上條。

又:此圖有楊慶麟一八七八年七月七日題,云改裝爲卷時,書於邊幅之董跋殘破故裁之。

藏《鵲華秋色圖卷》、《水村圖卷》、《洞庭東西山》二軸、《萬壑響松風·百灘渡秋水》巨幅、及設色《高山流水圖》,皆爲友人易去,僅存《學巨然九夏松風巨軸》[見董自題《秋興八景冊》八幅之首]。

參見:七月晦/1620(1)

題墨筆《臨黃筌蓮塘圖軸》,宋箋本(《石續》,寧壽宮十二,2751–52;《故宮》卷5, 147–48)。台北國立故宮博物院藏。

題著色《中峰像并行書題贊》,紙本闊條幅(《平生》卷9, 22;《大觀》卷16, 48b;《穰績》卷2, 19a)。

按:《玉雨》亦載趙紙本《中峰禪師像并贊》,邊幅亦有董跋。趙之自識語全同,但畫爲白描,置此待考。見卷1, 62。

題設色《高山流水圖軸》,絹本(《萱暉》,畫22b)。程琦舊藏。

觀新都汪氏所藏《臨黃筌勘書圖軸》[見董題黃筌《勘書圖軸》]。

與汪砢玉過項德新家,觀重著色《覿花仕女圖軸》於讀易堂之松軒,絹本[見汪砢玉題此圖](《珊瑚》·畫,卷8, 9–10;《式古》,v.4,畫卷16, 122)。

藏《高山流水圖》[見董題趙左《摹松雪翁高山流水圖軸》]。

跋《法書名畫冊》,紙本,行書十八段,墨畫七段(《式古》,v.2,書卷16, 113)。

按:董跋前有王穉登一六〇三年三月三日跋。

跋小楷《麻姑仙壇記冊》,宋箋本(《石初》卷3, 14a)。

跋草書《臨王羲之帖》四十二段一冊,宋箋本(《石續》,淳化軒,3210)。

按:張照云董跋系市賈僞作。

題松江朱大韶家藏《臨陸瑾山水小景》[《唐宋元人畫冊》十四幅之十二](《珊瑚》·畫,卷19, 10;《式古》,v.3,畫卷3, 229)。

按:《珊瑚》及《式古》另載《元零冊》有趙孟頫《山陰高會圖》,董題與此圖僅一字之差,見《珊瑚》·畫,卷20, 3;《式古》,v.3,畫卷5, 267,待考。

對題王世貞家藏著色《採蓮圖》,長絹本[《歷代名

畫大觀高冊》二十九幅之十五](《式古》,v.3,畫卷4, 245)。

題設色《花溪漁隱圖冊頁》,絹本(《平生》卷9, 24)。

對題墨筆《夏木垂陰圖團扇》,絹本[《名畫大觀》第一冊二十五對幅之二十二](《式古》,v.3,畫卷3, 220;《平生》卷9, 24;《墨緣》,名畫卷下·《五代宋元集冊》十二幅之五,4a)。

按:《墨緣》謂董題不真刪去。

題《臨黃素黃庭內景經》,有俞和補書一百九十字(《容別》卷1, 1b)。

題爲石民瞻小楷書《過秦論》三篇,黃絹本(《畫禪》卷1, 43;《平生》卷4, 3)。

按:此題款云"文華濫直,"即任文華殿大學士時,故應書於一六二二至一六二五年間。

題楷書《汲黯傳》(《平生》卷4, 5)。

題《松江普照寺藏殿記》,朱闌紙本(《平生》卷4, 7–8)。

題臨《閣帖》第六卷王羲之之書,白紙本(《平生》卷4, 9;《寓意》卷2, 24b)。

觀小楷《臨內景黃庭經》,絹本[見董重題趙孟頫《臨黃庭經冊》]。

參見:9/1631

觀項氏所藏《臨張旭秋深帖》[見董題張旭《秋深帖》]。

藏小楷《內景黃庭經》、《過秦論》三篇,又曾見王時敏家藏小楷《法華經》及項元汴家之《汲大夫傳》[見董題趙孟頫《麻姑仙壇記冊》]。

題重著色《少陵詩意圖》,絹本,有宋高宗書"暮春三月巫峽長"詩於斜紋綾(《平生》卷9, 17)。

題《嘯傲煙霞圖》(《平生》卷9, 24)。

觀京師楊高郵所藏《雪圖》小幅[見董初跋王維《江山雪霽圖卷》]。

參見:10/15/1595

觀松江北禪寺所藏《歷代祖師像》,梵漢相雜,都不設色[見董題趙孟頫《摹盧愣伽羅漢像卷》]。

觀《秋林散步圖》并小楷書陶潛"嬴氏亂天紀"詩[見陳繼儒題此作](《庚子》卷2, 4b)。

藏重著色《捕魚圖》小本,絹本,傳爲趙孟頫筆(《真蹟》卷1, 4)。

趙昌

跋著色《蛺蝶圖卷》,素箋本(《石初》卷32, 26b;《中國歷代繪畫》,v.2,附錄3)。北京故宮博物院藏。

題自藏著色《四喜圖軸》，素絹本（《石初》卷17，48a；《故宮》卷5，50）。台北國立故宮博物院藏。

按：《故宮》編者疑董跋僞。

對題著色《紅薇圖方幅》，絹本（《墨緣》，名畫卷下·《清賞花鳥集冊》十二幅之七，3a-b）。

趙雍

題設色《江山放艇圖軸》，絹本（《故宮》卷5，164）。台北國立故宮博物院藏。

題著色《春郊遊騎圖軸》，素絹本（《石初》卷17，49a；《故宮》卷5，165）。台北國立故宮博物院藏。

題設色《春山遊騎圖軸》，淡黃絹本（《大觀》卷16，53a）。

趙幹

題橋李項于蕃出示《秋涉圖軸》，紙本（《退菴》卷11，9a）。

褚遂良

跋草書《摹王羲之長風帖卷》，素箋本（《石初》卷31，2a；《故宮》卷1，9）。台北國立故宮博物院藏。

按：據《故宮》編者，此卷爲唐人雙鉤本，非褚遂良所摹。

題上海顧從義家傳《臨王羲之蘭亭詩序卷》，絹本，爲諸摹第十九本賜高士廉者（《石續》，乾清宮，282）。

題楷書《摹王羲之樂毅論》（《清河》引《戲鴻堂帖》卷二上，43）。

觀《臨蘭亭序》二本。一在海寧陳家，乃澄心堂紙本，後有米芾跋，缺末三行。一乃王世貞家藏，後歸汪宗孝至廣陵，絹本，後有米芾小行楷跋（《容別》卷4，70a；《眼初》卷5，17a-b）。

觀韓世能家藏《倪寬傳贊》真蹟（《容別》卷4，58b）。

觀小楷書《西昇經》於南京[見董自題《樂志論卷》]（《石初》卷5，31a-32a。又參見《容別》卷4，27a-b；《平生》卷1，67）。

管道昇

題墨筆《竹石軸》，素箋本（《石初》卷38，7a-b；《故宮》卷5，164）。台北國立故宮博物院藏。

題《墨竹》六段并書楊萬里《此君賦》一卷，絹本（《式古》，v.4，畫卷16，147）。

劉松年

跋《七賢圖卷》，絹本（《書畫》卷6，664-65）。

題《海天旭日圖軸》，絹本（《玉雨》卷1，54）。

題《耕織圖》[《宋元名畫冊》二十幅之六]（《珊瑚》·畫，卷20，10；《式古》，v.3，畫卷4，258）。

對題淡色《風雨歸莊圖團扇》，絹本[《名畫大觀》第一冊二十五對幅之二十一]（《式古》，v.3，畫卷3，220）；[又見山本悌二郎論許道寧《雪山樓觀圖軸》]（《澄懷》卷1，66）。

對題墨筆《田園樂圖團扇》，絹本[《歷朝寶繪集冊》十對幅之二]（《鑑影》卷10，21b）；[《歷代名筆集勝冊》十二對幅之六]（《虛齋》卷11，26b）。

按：《虛齋》載此作爲設色，待考。

劉敞

題《南華秋水篇》（《清河》卷七上，5；《式古》，v.1，書卷9，445-46；《大觀》卷3，57b）。

歐陽詢

袁樞所藏宋搨《醴泉銘冊》失首帙十行，董用高麗箋臨補之并跋（《石續》，懋勤殿三/宮內五，3574）。

題宋搨《九成宮醴泉銘》於汪氏墨華閣（《珊瑚》·書，卷20，11）。

按：董題後有李日華一六二八年二月題。

跋《九成宮帖》（《容別》卷2，16a）。

題楷書《千文》（《清河》引《戲鴻堂帖》卷三上，27；《式古》，v.1，書卷7，327。題語又見《容別》卷5，35b-36a）。

觀小楷書《九歌》於朱御醫家[見孫承澤記此作]（《庚子》卷6，10b）。

得楷書《千文》搨本於金陵[見董自題《臨歐陽詢草書千文冊》]。

參見：四月晦/1628

蔡襄

爲昭彥題行書《尺牘卷》，紙本（《石三》，延春閣十一，1412；《故宮》卷1，44-45）。台北國立故宮博物院藏。

與陳繼儒觀《十帖卷》，定第九帖紙本楷書《山堂書詩帖》七言絕句二首爲雙鉤廓填[見汪砢玉一六三一年三月二十四日識此卷]（《珊瑚》·書，卷3，11；《式古》，v.1，書卷9，455；《墨緣》，法書卷上北宋，6b）。

劉松年

題楷書《謝賜御詩表卷》，澄心堂紙本（《大觀》卷6，39a；《墨緣》，法書卷上北宋，5a-b；《鑑影》卷2，14a-b）。

題行書白居易《動靜交相養賦》一卷，素絹本（《盛京》，第二冊，10a；《古物》卷2，3a）。

觀常熟趙叔度所藏《謝宸翰表》[見董《法書紀略冊》]。

參見：1626(1)；1/17/1632

跋五言古詩一首七十字，粉箋本（《書畫》卷5，594）。

燕文貴

題設色《青谿釣翁圖卷》，牙色紙本（《大觀》卷13，24b）。

題著色《柳莊觀荷圖》，宋高宗對題七言絕句，皆方絹本[《名畫大觀》第二冊二十五對幅之十]（《式古》，v.3，畫卷3，222）。

諸念修

題設色《倣宋元山水冊》十六幅，紙本（《中國圖目》，v.8，冀2-03）。河北省石家莊文物管理所藏。

錢選

題設色《蘭亭觀鵝圖卷》，紙本（《書畫》卷1，55；《故宮》卷4，73-74）。台北國立故宮博物院藏。

題墨筆《臨顧愷之列女圖卷》，素箋本（《石續》，養心殿，963）。

題重著色《青山白雲圖卷》[一名《南山幽棲圖卷》]，紙本（《平生》卷9，7-8；《穰梨》卷5，15a；《壯陶》卷7，31b）。

題著色《山居圖卷》（《過雲》，畫卷1，9a）。

題畫贈慎游（《容別》卷1，8a-b）。

鮮于樞

跋草書卷（《容別》卷2，7a-b）。

謝莊

跋自藏詩帖摹本，云得自汪宗孝（《畫禪》卷1，50）。

薛稷

題《四言詩帖》（《珊瑚》·書，卷1，23；《式古》，v.1，書卷7，353）。

薛素素

題《水仙圖》及《蘭石圖》,皆金箋橫披[《藝苑閒情冊》二十四幅之十九及二十]《式古》,v.3,畫卷7,340);[又見山本悌二郎論薛素素《倣子昂蘭花卷》](《澄懷》卷4,50-51)。

小楷書《心經》於墨筆《大士圖》并題[見張燕昌跋薛素素《蘭竹長卷》](《壯陶》卷11,39b)。

按:朱彝尊亦載董爲薛素素楷書《心經》,未知是否即此,見《曝書》,181-82。

鍾紹京

跋楷書《靈飛六甲經》三十幅,麻紙本(《平生》卷1,85;《虛舟》卷5,4-5)。

藏《道經》[見董題唐臨楷書《黃庭經卷》]。

藏小楷《靈飛六甲經》楮紙真蹟與《準提經咒》(《清河》引《嚴氏書畫記》卷一下,8;《式古》引《嚴氏書畫記》,v.1,書卷7,354)。

謝伯誠

七夕泊舟吳閶,購《廬山觀瀑圖》於張慕江(《畫禪》卷2,38)。

戴進

題著色《靈谷春雲圖卷》,絹本(《鑑影》卷6,6b-7a;《古緣》卷3,4b;《董其昌》,no.87;《總合圖錄》,v.2,E18-032)。Museum für Ostasiatische Kunst, Berlin。

題墨筆《倣燕文貴山水軸》,紙本(《中國圖目》,v.2,滬1-303)。上海博物館藏。

顏真卿

題鄒之麟所藏楷書《送裴將軍北伐詩真蹟卷》,紙本(《眼二》卷4,23b-24a);[又見美國翁萬戈所藏鄒之麟《山水冊》後翁同龢跋]《總合圖錄》,v.1,A13-001-7/7)。

按:董題言及鄒之麟於庚戌(一六一〇年)中進士,則應書於一六一〇年之後。

題韓世能家藏楷書《自書告身卷》,白麻紙本(《清河》卷五上,3;《式古》,v.1,書卷8,363;《書畫》卷4,440;《平生》卷1,95;《大觀》卷2,24b;《寓意》卷1,2b-3a;《墨緣》,法書卷上唐,6a;《石續》,淳化軒,3158-59;《三希》,第三冊,210-11;《石隨》卷8,1a;《湖社月刊》,v.40,1;《叢帖目》,第一冊,266)。

按:董題此卷兩次,一在刻入《戲鴻堂帖》上石時,未書卷中,一在刻後補題卷上。見《石續》編者按語。

題韓世能家藏楷書《摩利支天經卷》,唐箋本(《秘初》卷6,1b-2a)。

題唐搨《麻姑仙壇記卷》(《石續》,重華宮,1705)。

題《送劉太冲叙真蹟卷》,紙本(《壯陶》卷1,65b-66a。題語又見《容別》卷5,39a-b;《畫禪》卷1,45-46)。

題行書《與劉中使帖》,青紙本(《郁題》卷1,4b;《珊瑚》·書,卷20,21;《書畫》卷1,58)。

題楷書《鹿脯帖》真蹟,白紙本(《畫禪》卷1,46-47;《真蹟》,初集,45a-b;《式古》,v.1,書卷8,369;《平生》卷1,96)。

題《與兄帖》真蹟(《真蹟》,初集,67a)。

題《與華中甫札》(《平生》卷1,94)。

題宋搨《爭座位帖》(《寓意》卷2,11b-12a;《退菴》卷4,37a-b)。

題自藏宋搨《爭坐位帖》[見梁章鉅記此作](《退菴》卷4,34a)。

觀《祭姪文稿》真蹟,後有文徵明跋[見張丑記此作](《真蹟》,三集,6a-b)。

藏宋搨《送明遠序》[見董自題《臨顏魯公送明遠序卷》]。

參見:1/2/1621

藏《祭姪季明文稿》,後有鮮于樞跋[見董跋顏真卿《劉中使帖》真蹟]。

顏暉

與陳繼儒觀項德新家藏趙伯駒四大幅,定爲顏暉筆(《妮古》卷4,283)。

魏實秀

題一六一二年春行草書《詩卷》,紙本(《中國圖目》,v.4,滬1-1594)。上海博物館藏。

蕭照

題《清溪晚照小冊》(《平生》卷8,41)。

觀《高宗瑞應圖》於馮夢禎家,後歸武林陳生甫藏[見董題仇英《倣蕭照高宗瑞應圖卷》];[又見董一六三一年三月題李嵩、蕭照合作《宋高宗瑞應圖卷》]。

懷仁

題《聖教序真蹟卷》,黃絹本(《真蹟》,初集,45b-46a;《容別》卷4,57a-b)。

題宋搨《聖教序冊》(《石續》,懋勤殿三/宮內五,3569)。

跋《聖教序》(《容別》卷2,15a-b及27a-b;《畫禪》卷1,45)。

題《聖教序》(《珊瑚》·書,卷2,9;《式古》,v.1,書卷8,387)。

藏唐臨《聖教序》真蹟,絹本[見董自題《臨聖教序冊》](《石初》卷3,24a);[又見陳繼儒題《聖教序冊》](《退菴》卷3,29a);[又見董一六三三年三月題宋搨《聖教序》]。

按:董一六二〇年自題《臨聖教序冊》云藏《聖教序》真蹟一紀餘,則董得此絹本真蹟應在一六〇五年左右。見3/2/1620(1)。

懷素

題草書《嵇叔夜詠懷詩卷》,紙本(《古芬》卷2,46b-47a)。

跋草書律詩卷(《容別》卷2,20a)。

關仝

跋《關山積雪圖》小幅,澄心堂紙本(《書畫》卷1,88)。

按:吳其貞謂此作乃范寬筆。

題《山水軸》,絹本(《古芬》卷9,74a-b)。

藏《雪霽圖》[見董自題《倣雲林山水圖軸》]。

參見:1/15/1625

藏《秋林暮靄圖》,絹本[見冒襄題董《關山雪霽圖卷》]。

參見:5/1635(2)

蘇軾

題草書《贈黎侯千文卷》,紙本(《式古》,v.1,卷10,500-501)。

跋《禱雨帖卷》,蠟箋本(《書畫》卷2,109;《平生》卷2,44)。

跋楷書《赤壁賦卷》,紙本,前段殘,有文徵明補書(《書畫》卷4,408)。

按:此卷或即李日華一六一〇年三月二十日所記蘇書《前赤壁賦》,見《味水》卷2,21b。

題行書"黃州"及"寒食"五言古詩二首一卷,素箋本(《平生》卷2,41;《墨緣》,法書卷上北宋,14a-b;《石續》,寧壽宮,2677;《三希》,第十一冊,745;《壯陶》卷3,61a;《書蹟名品叢刊》,蘇軾《黃州寒食詩卷及他二種》)。

題行楷書"煎茶""聽賢師定慧琴""過南華寺""妙高臺"四詩一卷,白闊紋紙本(《平生》卷2,43-44)。

題《臨懷素千字文并雜書二則卷》，黃紋牙花紙本（《平生》卷2, 48;《大觀》卷5, 17b）。

題行書《尺牘卷》，素箋本（《石初》卷13, 42a）。

題楷書《祈雨篇卷》，紙本（《秘三》, 115）。

題《與謝民師札卷》（《過雲》, 書卷1, 10a）。

跋行書《中山松醪賦卷》（《盛京》，第二冊, 1b;《古物》卷2, 6a）。

按:此卷有文徵明跋"秋日偶遊華亭，過董庶常家，出此見賞"等語。文徵明卒時，董年僅五歲，此跋當是偽作。董跋待考。

又:此卷《盛京》作藏經箋本，《古物》作金粟箋本。

題《墨竹卷》，絹本（《壯陶》卷3, 43a）。

題行書《營籍周韶落籍詩軸》，絹本烏絲闌（《壯陶》卷4, 1a）。

跋《天際烏雲帖冊》（《天際》一, 14）。

按:此作乃卷改裝冊。董跋應書於一六二五年之後，見翁方綱記此帖於《天際》一, 26。又見1625(3)。

跋王履善所藏《赤壁賦》（《畫禪》卷1, 45）。

題《養生論》（《式古》, v.1, 書卷10, 492）。

題《楚頌》，白紙本（《平生》卷2, 47）。

題行書《新歲展慶》及《人來得書》二帖，白紙本（《墨緣》，法書卷上北宋, 13b–14a）。

題《嵩陽帖》（《天際》一, 10）。

觀《赤壁賦》三本。一在嘉禾黃又元家，一在江西廬陵楊少師家，一在楚中何仁仲家[見董題蘇軾《後赤壁賦卷》]。

參見:6/1604(5)

觀妻江王氏所藏題王詵《烟江疊嶂圖》真蹟[見董自題《烟江疊嶂圖歌卷》]（《墨緣》，法書卷下明, 16a–b）。

藏《養生論》及《三馬圖贊》，但疑非真蹟[見董初跋蘇軾《淨因院畫記卷》]。

參見:10/4/1629

顧正誼

題一五九七年夏所作墨筆《山水卷》，紙本（《穰梨》卷26, 5b;《中國圖目》, v.3, 滬1–1326）。上海博物館藏。

題《秋林歸櫂圖卷》，紙本，爲李日華將歸武林贈別（《穰梨》卷26, 6b）。

按:此卷有莫是龍、吳治、孫枝等多人題跋，皆未紀年，卷末有孫枝一五七八年重題云"戊寅孫枝爲素

行徵君重題，"但此時李日華僅十四歲，殊不可能，此作疑偽，則跋亦偽。

題墨筆《雲林樹石圖軸》於玄賞齋，紙本（《故宮》卷5, 434）。台北國立故宮博物院藏。

題《山水冊》（《畫禪》卷2, 35）。

顧愷之

跋著色《洛神圖卷》，絹本（《海王》, 2b;《總合圖錄》, v.1, A21–027）。Freer Gallery of Art.

跋設色《女史箴圖卷》，絹本（《清河》卷一下, 22–23;《式古》引《戲鴻堂法書》, v.3, 畫卷8, 349–50;《平生》卷6, 1;《叢帖目》，第一冊, 262）。

藏《洛神圖》[見董自題《樂志論卷》]

參見:8/1603(1)

顧懿德

題一六一二年十月所作設色《秋林落照圖軸》，絹本（《中國圖目》, v.1, 京13–04）。北京徐悲鴻紀念館藏。

題一六二〇年冬所作設色《春綺圖軸》，紙本（《石三》，延春閣廿七, 2080;《南畫》卷9, 189;《故宮》卷5, 464）。台北國立故宮博物院藏。

題淺設色《倣王蒙溪橋翫月圖軸》，紙本（《總合圖錄》, v.1, A12–019）。The Metropolitan Museum of Art.

題《倣李思訓山水扇》[《集明人山水扇冊》二十幅之二]（《聽颿》卷4, 332）。

諸家

題趙伯驌畫《雪圖》宋高宗書《雪賦》一卷[見李日華一六一〇年三月四日記此作]（《味水》卷2, 14b）。

按:此圖傳爲宋徽宗筆，董以印款有"晞遠"二字改定爲趙伯驌。

題米芾節書《九歌》及李公麟作畫合卷（《清河》引《戲鴻堂帖》卷八上, 14;《畫禪》卷1, 49）。

題自藏李公麟白描《三馬圖》及蘇軾行書《三馬圖贊》一卷，澄心堂紙本（《清河》卷八下, 5–6;《式古》, v.3, 畫卷12, 502;《平生》卷7, 63;《大觀》卷12, 30b;《石續》，乾清宮, 299;《石隨》卷2, 12b–13a）。

按:此卷有張丑一六〇九年春跋云爲董所藏，則董得之於一六〇九年之前。見《清河》卷八下, 1–2。

題司馬槐、米友仁合作墨筆《少陵詩意圖卷》，紙本。畫分二段，前題"瀼瀼石間溜，"後題"山稠隘石泉，"每段各系五言絕句一首，或謂米友仁筆。董以畫者爲司馬光之孫，題字者吳說（《式古》, v.4, 畫

卷15, 111;《平生》卷8, 15–16;《江村》卷1, 21–22）。

跋倪瓚、趙原合作《師子林圖卷》，紙本（《清河》卷十一下, 2,《式古》引《清河》, v.4, 畫卷20, 261;《書畫》卷3, 271）。

按:吳其貞謂此卷乃趙原畫，倪瓚題，非合作。

題復州裂本《蘭亭序》，後附錢選《蕭翼賺蘭亭圖卷》（《過續》，畫類1, 2a–3a）。

按:《過續》云此卷時已分爲二作，《蘭亭》搨本與董跋俱佚。

題宋高宗書馬和之畫《陳風圖卷》（《雪堂》, 50a）。

題自藏倪瓚、王蒙合作墨筆《山水軸》，宋箋本（《石續》，御書房, 2067;《故宮》卷5, 581）。台北國立故宮博物院藏。

按:董題云所藏倪王合作尚有《良常館圖》。

題自藏《唐宋元寶繪冊》二十幅，爲王維《雪谿圖》、李成《晴巒蕭寺圖》小幅、趙孟頫絹本設色《東西洞庭》小對幅、關仝《雪圖小冊》、米芾《雲山圖》小幅、倪瓚設色山水及《六君子圖》、王蒙《秋林書屋圖》、曹知白《吳淞山色圖》、王履白紙本《蒼崖古樹圖》小幅、趙元《山水圖》、商琦畫、陸廣紙本《丹臺春賞圖》、巨然《江山晚興圖短卷》、范寬絹本《江山蕭寺圖短卷》、郭忠恕《摹王右丞蜀山圖短卷》、黃公望《芝蘭室圖并銘短卷》及《姚江圖團扇》、高克恭《山水圖》、吳鎮畫（《清河》卷六下, 13;《珊瑚》·畫卷19, 1–7;《式古》, v.3, 畫卷3, 211–15。冊末總題跋又見《容別》卷1, 7a–b及8b–9b）。

參見: 1599(1); 7/9/1612; 2/1617(1); 5/15/1618; 秋/1619(1); 1621(1)

按:董藏巨然《江山晚興圖》又見《清河》卷七下, 5;《式古》引《清河》, v.4, 畫卷13, 33。董題王維《雪谿圖》又見《容別》卷1, 13b;題趙孟頫《東西洞庭》又見《容別》卷1, 13b–14a及《平生》卷9, 24;題王履《蒼崖古樹圖》又見《容別》卷1, 14a及《平生》卷10, 17;題陸廣《丹臺春賞圖》又見《平生》卷9, 74;題范寬《江山蕭寺圖》又見《平生》卷7, 33–34;題郭忠恕《摹王右丞蜀山圖》又見《平生》卷7, 28。

又:據《清河》，此二十幅中高克恭爲《溪山返照團扇》、吳鎮爲《竹居圖短卷》、倪瓚爲《喬林澗石》小幅、黃公望除《姚江曉色團扇》及《芝蘭室圖并銘短卷》外，另有《層巒疊嶂圖短卷》。

題自藏《唐宋元寶繪高橫卷》[即《唐宋元名畫大觀冊》]十二幅。前六幅長條式，爲王維素絹本墨筆《雪溪圖》、李成素絹本青綠《晴巒蕭寺圖》、趙孟頫素絹本淡著色《東西洞庭》二圖、王蒙素絹本淡著色《松路仙巖圖》、陸廣宋箋本墨筆《丹臺春賞圖》。後六幅推篷式小橫幅，爲巨然素絹本墨筆《江山晚興圖》、范寬素絹本淡著色《江山蕭寺圖》、黃公望宋箋本墨筆《芝蘭室圖并銘》、倪瓚宋箋本墨筆《春山圖》、衛九鼎宋箋本墨筆《溪山蘭若圖》、方從義宋箋本墨筆《雲山圖》（《墨緣》，名畫卷下歷代冊, 1a–11a;《石初》卷42, 5b–24a）。

按:此冊之董題僅四幅紀年，見7/9/1612; 5/15/1618; 8/13/1621; 1621(1)

又:此冊本二十幅[即《唐宋元寶繪冊》二十幅]，爲

董氏四十餘年先後結集所成,後歸程季白,復爲增汰,又轉歸王時敏,擇存十二幅,董爲王時敏題"唐宋元畫冊"籤。見2/1617(1);秋/1619(1)。十二幅中僅趙孟頫《洞庭東山圖》現藏上海博物館,餘皆失傳。王維《雪谿圖》、陸廣《丹臺春賞》、黃公望《芝蘭室圖并銘》、倪瓚《春山圖》、衛九鼎《溪山蘭若》及方從義《雲山圖》尚有影本流傳,見Cahill, *Index*。

靖江朱在明得王世懋家藏畫冊九十二幅,董購之,擇其精者十四幅彙爲《董氏集古畫冊》并題。有周文矩、趙伯駒、趙伯驌各二幅、劉松年三幅、顧閎中、趙令穰、馬麟各一幅、馬遠《列子御風圖》及夏珪《錢塘觀潮圖》,并高宗、楊妹子等御題(《珊瑚》·畫,卷19, 8-9;《式古》,v.3,畫卷3, 215-16)。

參見:9/21/1597(2)

題《元季十二名家冊》二十幅,爲趙孟頫《高松幽人》,管道昇《長明庵圖》,趙雍著色《山水》及澄墨《澗樹圖》,王蒙寫王維詩意,倪瓚《楓林亭子》,黃公望《重山疊嶂》、著色《山水》、淺色《山水》、《雪景》及設色《山水》,吳鎮《林巒古刹》及《竹下泊舟圖》,曹知白著色《山水》,柯九思《山水》及《秋林曉色》,馬琬設色《倣馬和之新柳釣船圖》及著色《山水》,方從義《倣小米雲山圖》,盛懋著色《山水》(《珊瑚》·畫,卷20, 18-19;《式古》,v.3,畫卷4, 263-64)。

分識《宋元明名畫冊》六幅,其中第五幅宋箋本,餘俱絹本。一爲宋徽宗設色《蠣房文蛤》,二爲劉松年設色《捕魚圖》,三爲屬歸真墨筆《牧牛圖》,四爲馬遠墨筆《柳塘清夏》,五爲王淵設色《菊花竹石》,六爲商喜設色《山水》(《石續》,懋勤殿四/畫禪室/宮內六, 3630)。

題吳正志所藏宋搨《晉唐小楷冊》十一帖,爲王義之書《樂毅論》、《黃庭經》、《曹娥碑》、《曼倩帖》,王獻之書《洛神》十三行,歐陽詢書《心經》、《護命經》,虞世南書《破邪論》,褚遂良書《度人經》、《陰符經》,顏真卿書《仙壇記》(《石三》,延春閣四十四, 2796)。

題吳寬舊藏《宋元名畫冊》十四幅,絹本。其中宋徽宗四幅,趙孟頫二幅,李唐、李嵩、陳居中、閻次平、馬麟、劉松年、梁楷等各一幅(《退菴》卷12, 24a-b;《夢園》卷4, 49a-b)。

題《唐宋元明女子書冊》,紙本,有武則天、吳彩鸞、朱淑真、呂良子、管道昇、高妙瑩、曹妙清、沈瓊蓮諸家書(《壯陶》卷2, 59b-62b)。

鑑定《唐宋元人畫冊》十四幅,爲戴嵩《驅牛圖》、李贊華《人馬衝雪圖》、徐熙《文禽戲水圖》、巨然絹本《平湖舟泊圖》、宋徽宗《荔枝》對幀、李公麟《毛女》對幀、趙伯駒絹本《臥雪圖》、劉松年《田園樂》二幀、馬麟《弈碁圖》、馬遠《觀瀑圖》、朱大詔家藏趙孟頫《山水圖》、盛懋《谿山曳杖圖》及《停舟觀雁圖》(《珊瑚》·畫,卷19, 10)。

藏《歷朝寶繪冊》二十四幅,有楊妹子《春柳垂金圖》宋高宗題,《葵花圖》孝宗題,及趙昌、於青年、馬遠、馬遠諸畫[見黃易題宋孝宗"春雲初起拂青林"七言絕句詩翰](《湘管》卷1, 28-29)。

跋吳説楷書、馬和之畫《九歌圖》(《畫禪》卷1, 44)。

古帖

題《鼎帖》,云傳稱《寶晉齋帖》非是[見李日華一六一四年十月二十九日記此作](《味水》卷6, 62b)。

得《大觀帖》六卷於王世貞家孫,旋爲馮銓易去[見董題《大觀帖》](《容別》卷1, 12b-13a;《叢帖目》,第一冊, 77-78)。

跋張弼刻《慶雲堂帖》(《容別》卷2, 4b-5b)。

題陳鉅昌所刻《大觀帖》十卷(《容別》卷5, 21b-22a;《叢帖目》,第一冊, 78)。

跋宋搨《絳帖》一卷(《畫禪》卷1, 37)。

題《群玉堂帖》(《畫禪》卷1, 39)。

觀項氏所藏《淳化閣帖》,乃周密舊藏(《郁題》卷10, 10a-b;《珊瑚》·書,卷21, 16-17)。

題《泉州閣帖》(《郁題》卷10, 10a-b;《珊瑚》·書,卷21, 16-17)。

題王廷珸所藏宋搨《泉州閣帖》(《郁續》卷12, 21)。

題宋搨《武岡帖》對幅裝十冊(《石三》,延春閣四十四, 2781-82)。

題周祖所藏《淳化閣帖》[見張廷濟題《集翠帖》](《清儀》,v.4, 95a)。

無款

爲《陳元璞畫像》題贊,紙本(《中國圖目》,v.1,京10-017; *Sotheby's*, 5/18/1989, no. 43)。北京市工藝品進出口公司舊藏。

按:此作畫像已不存,其後諸家題贊裱爲一卷,董題未紀年,但前有楊文驄一六三五年五月題贊,或書於此後。

題設色《旌陽移居圖卷》(《容別》卷1, 4b-5a)。

跋明人《濟川圖卷》(《畫禪》卷2, 37)。

題明人設色《瑠湖六逸圖卷》,紙本,云畫中六人除己外爲陳繼儒、張所望、朱國盛、秦昌遇、麻衣和尚(《雪堂》, 72a-73b)。

書《寶積經》系於五代人設色《揭盃圖卷》後并題,絹本(《壯陶》卷2, 65b-66a)。

題明人設色《范景文小像軸》,紙本(《中國圖目》,v.8,冀1-036)。河北省博物館藏。

題唐摹六朝人重著色《觀鵝圖軸》,絹本(《墨緣》,名畫卷上唐, 2a-b)。

題《杜九如畫像》贊(《容別》卷1, 1a-b)。

題《汪希伯小像》(《容別》卷1, 2b-3a)。

題秦光四刻父鳳章七十《庭訓》(《容別》卷1, 3b-4a)。

題《大士像》(《容別》卷1, 5a-b)。

題熊氏所藏《羅漢圖》(《容別》卷2, 13b-14a)。

Index of Chinese Names

References to plates are in italics. All dates are A.D. unless otherwise indicated.

589

Selected Bibliography

This selected bibliography includes the sources cited in the essays in Volume I of this publication, the full references for sources cited in the catalogue entries in Volume II, and other frequently used sources related to the study of late Ming and early Ch'ing painting.

Akiyama Terukazu, Nagahiro Minuyu, Suzuki Kei, et al., eds. *Chugoku bijutsu* (Chinese art in Western collections). 5 vols. Tokyo: Kodansha, 1973.

An Ch'i. *Mo yüan hui kuan*. Preface dated 1742. Repr. 1900.

——. Repr. 1909. 4 *ch*.

——. Repr. 1962. *I-shu ts'ung-pien* edition, vol. 17. Taipei: Shih-chieh shu-chü.

Ancient Chinese Painting. Miami: Lowe Art Museum, University of Miami, 1973.

Anhui ming-jen hua-hsüan. Hofei, Anhui: Anhui Provincial Museum, 1961.

Anhui t'ung-chih (Gazetter of Anhui province). 1877. Repr. 1967. Taipei.

Arts Council of Great Britain. *Chinese Painting and Calligraphy in the Collection of John M. Crawford, Jr.* London: Victoria and Albert Museum, 1965.

Asiatic Art in the Seattle Art Museum. Seattle, 1973.

Barnhart, Richard M. *Marriage of the Lord of the River: A Lost Landscape by Tung Yüan*. Artibus Asiae Supplementum 28. Ascona, Switzerland, 1970.

——. *Wintry Forests, Old Trees: Some Landscape Themes in Chinese Painting*. New York: China Institute in America, 1972.

Baudelaire, Charles. "The Painter of Modern Life." In *The Painter of Modern Life and Other Essays*, edited and translated by Jonathan Mayne. London: Phaidon Press Ltd., 1964.

Bush, Susan. *The Chinese Literati on Painting: Su Shih (1037–1101) to Tung Ch'i-ch'ang (1555–1636)*. Harvard-Yenching Institute Studies 27. Cambridge, Mass.: Harvard University Press, 1971.

Bush, Susan, and Hsio-yen Shih. *Early Texts on Painting*. Cambridge, Mass.: Harvard University Press, 1985.

Cahill, James. "Chugoku kaiga ni okeru kiso to genso" (Fantastics and eccentrics in Chinese painting, pt. 1). *Kokka* 978 (1975): 9–20.

——. *The Compelling Image: Nature and Style in Seventeenth-Century Chinese Painting*. Cambridge, Mass., and London: Harvard University Press, 1982.

——. *The Distant Mountains: Chinese Painting of the Late Ming Dynasty, 1570–1644*. New York and Tokyo: John Weatherhill, Inc., 1982.

——. *Fantastics and Eccentrics in Chinese Painting*. New York: The Asia Society, Inc., 1967.

——. *Hills Beyond a River: Chinese Painting of the Yüan Dynasty, 1279–1368*. Tokyo and New York: John Weatherhill, Inc., 1976.

——. "K'un-ts'an and His Inscriptions." In *Words and Images: Chinese Poetry, Calligraphy, and Painting*, edited by Alfreda Murck and Wen C. Fong, 513–34. New York: The Metropolitan Museum of Art and Princeton University Press, 1991.

——. "Lun Hung-jen *Huang-shan t'u ts'e* ti kuei-shu" (A discussion of the attribution of the *Album of Huang-shan* attributed to Hung-jen). *To-yün* 9 (December 1985): 108–24.

——. Manuscript on seventeenth-century Chinese painting. 1986.

——. *Parting at the Shore: Chinese Painting of the Early and Middle Ming Dynasty, 1368–1580*. New York and Tokyo: John Weatherhill, Inc., 1978.

——. "Tang Yin and Wen Zhengming as Artist Types: A Reconsideration." Paper for the Symposium on Wu School Painting, Beijing Palace Museum, October 1990.

——. *Three Alternative Histories of Chinese Painting*. Lawrence, Kans.: Spencer Museum of Art, 1988.

——. "Tung Ch'i-ch'ang's Southern and Northern Schools in the History and Theory of Painting: A Reconsideration." In *Sudden and Gradual: Approaches to Enlightenment in Chinese Thought*, edited by Peter N. Gregory, 429–46. Honolulu: University of Hawaii Press, 1987.

——. "Wu Pin and His Landscape Paintings." In *Proceedings of the International Symposium on Chinese Painting*, 637–85. Taipei: National Palace Museum, 1972.

——. "Yüan Chiang and His School." Parts 1 and 2. *Ars Orientalis* 5 (1963): 259–72; 6 (1966): 191–212.

Cahill, James, ed. *The Restless Landscape: Chinese Painting of the Late Ming Period*. Berkeley: University Art Museum, 1971.

——. *Shadows of Mount Huang: Chinese Painting and Printing of the Anhui School*. Berkeley: University Art Museum, 1981.

Capon, Edmund. *Chinese Painting*. New York and Oxford: Phaidon, 1979.

Capon, Edmund, and Mae Anna Pang. *Chinese Paintings of the Ming and Qing Dynasties, XIV–XXth Centuries*. Melbourne: International Cultural Corporation of Australia, 1981.

Ch'ai Te-keng. "Ming-chi liu-tu fang-luan chu-jen shih-chi k'ao." In *Shih-hsüeh ts'ung-kao*, 1–49. Peking: Chung-hua shu-chü, 1982.

Chang Ch'ou. *Ch'ing-ho shu-hua-fang*. 1822 edition. 12 vols.

Chang, Joseph (Chang Tzu-ning). "K'un-ts'an te Huang-shan chih lü" (K'un-ts'an's travels to Mount Huang). In *Lun Huang-shan chu hua-p'ai wen-chi* (Essays on the Huang-shan schools of painting), 359–71. Shanghai: Jen-min mei-shu ch'u-pan-she, 1987.

——. "Kung Hsien yü K'un-ts'an." *Study of the Arts (I-shu hsüeh)* 4, no. 3 (1990): 223–41.

——. "Pa-ta shan-jen chih shan-shui-hua ch'u-t'an" (Preliminary study of Pa-ta shan-jen's paintings). *To-yün* 15 (1987): 143–49.

Chang Keng. *Kuo-ch'ao hua cheng lu* (A record of painters of the reigning dynasty). Preface dated 1739. Repr. 1963. In *Hua-shih ts'ung-shu*, edited by Yü An-lan. Shanghai: Jen-min mei-shu ch'u-pan-she.

Chang Kuang-pin. *Yüan ssu-ta-chia* (The four great masters of the Yüan). Taipei: National Palace Museum, 1975.

Chang Ta-ch'ien. *Ta-feng t'ang ming-chi* (*Taifudo meiseiki*; Masterpieces of Chinese painting selected from the Great Wind Hall of the Chang family). 4 vols. Kyoto: Benrido, 1955–56.

Chang T'ai-chieh. *Pao-hui lu*. 1633. In *Chih-pu-tsu chai ts'ung-shu*, compiled by Pao T'ing-po, 1782, *ch*. 6. Repr. 1912. Shanghai: Shanghai ku-shu liu-t'ung-ch'u.

Chang Wanli and Hu Jen-mou, eds. *Pa-ta shan-jen shu-hua chi* (Selected calligraphy and paintings of *Pa-ta shan-jen*). 2 vols. Hong Kong, 1969.

———. *Shih-t'ao hua-chi* (*The selected paintings and calligraphy of Shih-t'ao*). Hong Kong: Cafa, 1969.

———. *Shih-hsi hua-chi* (Selected paintings of K'un-ts'an). Hong Kong: Cafa, 1969.

Chang Wei-hua. "Nan-ching chiao-an shih-mo." In *Wan-hsüeh chai lun-wen chi*, 493–519. Chi-nan: Ch'i-lu shu-she, 1986.

Chang Yu-mo. *Ching-ch'uan chai pi-chi*. Preface dated 1764. Repr. *Ming-chi shih-liao ts'ung-shu* edition.

Chao Meng-fu. *Sung-hsüeh chai chi*. Repr. *Ssu-pu ts'ung-k'an* edition, *ch*. 10. Shanghai: Shang-wu yin-shu-kuan.

Ch'en Chi-ju. *Ch'en Mei-kung ch'üan-chi. Chung-cheng* edition.

———. *Hsiao-hsia pu*. In *Pao-yen t'ang pi-chi*, edited by Ch'en Chi-ju. Repr. 1922. Shanghai: Wen-ming shu-chü.

———. *Ni-ku lu*. Repr. *Ts'ung-shu chi-ch'eng* edition, *ch*. 12.

———. *Pi-chi*. In *Pao-yen t'ang pi-chi*, edited by Ch'en Chi-ju. Repr. 1922. Shanghai: Wen-ming shu-chü.

———. "Shou Ssu-weng Tung-kung liu-shih hsü." In *Wan-hsiang t'ang chi*, *ch*. 7.

———. *Shu-hua shih*. In *Pao-yen t'ang pi-chi*, edited by Ch'en Chi-ju. Repr. 1922. Shanghai: Wen-ming shu-chü.

———. *T'ai-p'ing Ch'ing-hua*. In *Pao-yen t'ang pi-chi*, edited by Ch'en Chi-ju. Repr. 1922. Shanghai: Wen-ming shu-chü.

———. *Yen-p'u t'an-yü. Pao-yen t'ang pi-chi*, edited by Ch'en Chi-ju. Repr. 1922. Shanghai: Wen-ming shu-chü.

Ch'en Cho. *Hsiang-kuan chai yü-shang pien* (Notes on art from the Hsiang-kuan Studio). Preface dated 1782. Repr. 1962. *I-shu ts'ung-pien* edition. Taipei: Shih-chieh shu-chü.

———. Repr. 1963. *Mei-shu ts'ung-shu* edition, edited by Huang Pin-hung and Teng Shih, vol. 38. Taipei: Kuang-wen shu-chü.

Chen Chuanxi, "Yu-kuan Hsiao Yün-ts'ung chi 'T'ai-p'ing shan-shui shih-hua' chu wen-t'i." *To-yün* 25 (1990): 86–92.

Ch'en Jen-t'ao. *Chin-kuei ts'ang-hua chi* (Chinese paintings from the King Kwei collection). 2 vols. Kyoto: T'ung-ying kung-ssu, 1956.

———. *Chin-kuei ts'ang-hua p'ing-shih* (Notes and comments on paintings in the King Kwei collection). 2 vols. Hong Kong: T'ung-ying kung-ssu, 1956.

———. *Ku-kung i-i shu-hua mu chiao-chu* (An annotated list of lost calligraphy and painting from the [Ch'ing] Palace Collection). Hong Kong: T'ung-ying kung-ssu, 1956.

Ch'en Wei-sung. *Ch'en Chia-ling wen-chi*. Repr. *Ssu-pu ts'ung-k'an* edition, *ch*. 9. Shanghai: Shang-wu yin-shu-kuan.

Ch'en Yu-ch'in, comp. *Pai Chü-i tzu-liao hui-pien*. Peking: Chung-hua, 1962.

Ch'en Yüan. "Wu Yü-shan: In Commemoration of the 250th Anniversary of His Ordination to the Priesthood in the Society of Jesus." Translated by Eugene Feifel. *Monumenta Serica* 3 (1938): 130–70.

———. "Wu Yü-shan sheng-p'ing." In *Ch'en Yüan shih-hsüeh lun-chu hsüan*, 395–420. Shanghai: Jen-min ch'u-pan-she, 1981.

Cheng Chen-to. *Wei-ta ti i-shu ch'uan-t'ung* (The great heritage of Chinese art). Peking: Wen-wu ch'u-pan-she, 1951–54.

Cheng Chen-to, ed. *Yün-hui chai ts'ang T'ang Sung i-lai ming-hua chi* (Famous paintings since the T'ang and Sung dynasties in the collection of the Yün-hui chai). Shanghai: Shanghai ch'u-pan kung-ssu, 1948.

Ch'eng Ch'i. *Hsüan-hui t'ang shu-hua lu* (Record of calligraphy and painting from the Hsüan-hui Hall). 2 vols. Hong Kong: Hsüan-hui t'ang, 1972.

Cheng Hsi-chen. *Hung-jen, K'un-ts'an. Chung-kuo hua-chia ts'ung-shu* series. Shanghai: Jen-min mei-shu ch'u-pan-she, 1979.

Cheng Ming-shih. *Yün Shou-p'ing shu-hua chi*. Peking: Wen-wu ch'u-pan-she, 1987.

Cheng Yüan-hsün. *Mei-yu ko wen-yü*. Ming edition. Repr. 1935. *Chung-kuo wen-hsüeh chen-pen ts'ung-shu*, first series, no. 25, *ch* 1. Shanghai: Pei-yeh shan-fang.

Chi Yün, ed. *Ssu-k'u ch'üan-shu tsung-mu t'i-yao*. Repr. 1933. Shanghai: Shang-wu yin-shu-kuan.

Chiang Chao-shen. *Wu-p'ai hua chiu-shih nien chan* (Ninety years of Wu School painting). Taipei: National Palace Museum, 1975.

Chiang P'ing-chieh. *Tung-lin shih-mo. Hsüeh-hai lei-pien* edition.

Chiang Shao-shu. *Wu-sheng-shih shih* (A history of soundless poetry). Postface dated 1720. Repr. 1963. In *Hua-shih ts'ung-shu*, edited by Yü An-lan. Shanghai: Jen-min mei-shu ch'u-pan-she.

———. *Yün-shih chai pi-t'an*. Repr. 1962. *I-shu ts'ung-pien* edition, vol. 29. Taipei: Shih-chieh shu-chü.

Chiao-yü pu ti-erh tz'u ch'üan-kuo mei-shu chan-lan hui chuan-chi ti-i chung: Chin T'ang Wu-tai Sung Yüan Ming Ch'ing ming-chia shu-hua chi (The famous Chinese painting and calligraphy of Chin, T'ang, Five Dynasties, Sung, Yüan, Ming, and Ch'ing dynasties: A special collection of the second national exhibition of Chinese art under the auspices of the Ministry of Education, part 1). Preface 1937. Nanking: Shang-wu yin-shu-kuan, 1943.

Ch'ien Ch'ien-i. *Lieh-ch'ao shih-chi hsiao-chuan*. Shanghai: Ku-tien wen-hsüeh, 1957.

———. *Mu-chai yu-hsüeh chi*. Repr. *Ssu-pu ts'ung-k'an* edition, *ch*. 46. Shanghai: Shang-wu yin-shu-kuan.

———. *Mu-chai ch'u-hsüeh chi* (Collected writings of Ch'ien Ch'ien-i). 1643. Repr. 1929. *Ssu-pu ts'ung-k'an chi-pu* edition, *ch*. 85. Shanghai: Shang-wu yin-shu-kuan.

Ch'ien Chung-shu. *Chiu-wen ssu-p'ien*. Shanghai: Ku-chi ch'u-pan-she, 1979.

Ch'ien Ta-hsin. *Shih-chia chai yang-hsin lu*. 1805. Repr. 1983. Shanghai: Shanghai shu-tien.

Chin Liang. *Sheng-ching ku-kung shu-hua lu* (Catalogue of calligraphy and painting in the Palace Museum, Shen-yang). 1913. Repr 1962. *I-shu ts'ung-pien* edition. Taipei: Shih-chieh shu-chü.

Chin Sandi. "Xiao Yuncong." In *Shadows of Mt. Huang: Chinese Painting and Printing of the Anhui School*, edited by James Cahill, 67–73. Berkeley: University Art Museum, 1981.

Chin Shishin. *Chugoku gajin ten*. Kyoto, 1984.

Chinese Art Treasures. Taichung: National Palace Museum, 1961.

Chinese Art Treasures, A Selected Group of Objects from the Chinese National Palace Museum and the Chinese National Central Museum, Taichung, Taiwan, exhibited in the United States by the Government of the Republic of China, 1961–1962. Geneva: Skira, 1961.

Ch'ing hua-chia shih-shih. Facsim. repr. 1983. Peking: Chung-kuo shu-chü.

Chou Ju-hsi. "From Mao Hsiang's Oberlin Scroll to his Relationship with Tung Ch'i-ch'ang." *Bulletin of the Allen Memorial Art Museum*, Oberlin College, 36, no. 2 (1978–79).

Chou Liang-kung. *Tu-hua lu* (Record of critiques on painting). Postface dated 1673. Repr. 1963. *Hua-shih ts'ung-shu* edition, edited by Yü An-lan. Shanghai: Jen-min mei-shu ch'u-pan-she.

———. *Yin-shu wu shu-ying*. Repr. 1981. Shanghai.

Chou Liang-kung, ed. *Ch'ih-tu hsin-ch'ao*. Repr. *Ts'ung-shu chi-ch'eng* edition, *ch*. 2.

Chou Mi. *Yün-yen kuo-yen lu*, *ch. hsia*. Repr. 1963. *Mei-shu ts'ung-shu* edition, edited by Huang Pin-hung and Teng Shih, *ch*. 12. Taipei: Kuang-wen shu-chü.

Chou Tao-chi. "Yeh Hsiang-kao." In *Dictionary of Ming Biography, 1368–1644*, edited by L. Carrington Goodrich and Fang Chaoying, 1567–70. New York and London: Columbia University Press, 1976.

Chou Yü-te. "Lin-ch'uan ssu-meng ho Ming-tai she-hui." In *T'ang Hsien-tsu yen-chiu lun-wen chi*. Peking: Hsin-hua shu-tien, 1984.

Chu, Christina. "Li Liu-fang and the Pure Land Faith in Late Ming." Unpublished paper presented at the Symposium on Painting of the Ming Dynasty, Hong Kong, November 30–December 2, 1988.

Chu, Hui-liang J. *Chao Tso yen-chiu* (A study of Chao Tso). Taipei: National Palace Museum, 1979.

Chu Kuo-chen. *Yung-t'ung hsiao-p'in*. Repr. 1960. *Pi-chi hsiao-shuo ta-kuan* edition, no. 22, vol. 7. Taipei: Hsin-hsing ch'u-pan-she.

Chugoku meigashu (Collection of famous Chinese paintings). Compiled by Tanaka Kenro. 8 vols. Tokyo: Ryubun Shokyoku, 1945.

Chugoku no hakubutsukan (Museums of China). No. 6, *Tenjin-shi geijutsu hakubutsukan* (Tianjin Municipal Art Museum). Tokyo: Kodansha, 1982.

Chung-kuo ku-tai shu-hua mu-lu (Catalogue of authenticated works of ancient Chinese painting and calligraphy). Compiled by the Group for the Authentification of Ancient Works of Chinese Painting and Calligraphy. Vol. 2. Peking: Wen-wu ch'u-pan-she, 1985.

——. Vol. 3. Peking: Wen-wu ch'u-pan-she, 1987.

——. Vol. 7. Peking: Wen-wu ch'u-pan-she, 1990.

Chung-kuo ku-tai shu-hua t'u-mu (Illustrated catalogue of selected works of ancient Chinese painting and calligraphy). Compiled by the Group for the Authentification of Ancient Works of Chinese Painting and Calligraphy. Vols. 3 and 4. Peking: Wen-wu ch'u-pan-she, 1990.

Chung-kuo li-tai hui-hua: Ku-kung po-wu-yüan ts'ang-hua chi. Vol. 4. Peking: Jen-min mei-shu ch'u-pan-she, 1983.

Chung-kuo mei-shu-chia jen-ming tz'u-tien. Taipei: Wen-shih-che ch'u-pan-she, 1982.

Chung-kuo mei-shu ch'üan-chi. Painting vols. 8 and 9. Shanghai: Jen-min mei-shu ch'u-pan-she, 1988.

——. Painting vol. 10. Shanghai: Jen-min mei-shu ch'u-pan-she, 1989.

Contag, Victoria. *Zwei Meister Chinesischer Landschaftsmalerei*. Baden-Baden: 1955.

——. *Chinese Masters of the 17th Century*. Translated by Michael Bullock. Rutland, Vermont, and Tokyo: Charles E. Tuttle Co., Inc., 1969.

Contag, Victoria, and Wang Chi-ch'ien. *Maler- und Sammler-Stempel aus der Ming und Ch'ing Zeit*. Shanghai: Shang-wu yin-shu-kuan, 1940.

d'Argence, René-Yvon Lefebvre, ed. *Treasures from the Shanghai Museum: 6,000 Years of Chinese Art*. San Francisco: Asian Art Museum, 1983.

de Bary, W. Theodore. "Individualism and Humanitarianism in Late Ming Thought." In *Self and Society in Ming Thought*, edited by W. Theodore de Bary et al., 188–225. New York: Columbia University Press, 1970.

DeBevoise, Jane and Scarlett Jang. "Topography and the Anhui School." In *Shadows of Mt. Huang: Chinese Painting and Printing of the Anhui School*, edited by James Cahill, 43–50. Berkeley: University Art Museum, 1981.

Delbanco, Dawn Ho. "Nanking and the Mustard Seed Garden Painting Manual." Ph.D. diss., Harvard University, 1981.

Dix siècles de peinture chinoise: peintures et calligraphies de la collection de M. John M. Crawford, Jr. Paris: Musée Cernuschi, 1966.

Ecke, Tseng Yu-ho. *Chinese Calligraphy*. Philadelphia: Philadelphia Museum of Art, 1971.

Edwards, Richard. *The World around the Chinese Artist: Aspects of Realism in Chinese Painting*. Ann Arbor: The University of Michigan, 1987.

Edwards, Richard, ed. *The Painting of Tao-chi*. Ann Arbor: University of Michigan, 1967.

Elvin, Mark. *The Pattern of the Chinese Past*. Stanford: Stanford University Press, 1973.

Feng T'ien-yü. "Li Ma-tou teng Yeh-su-hui-shih ti tsai Hua hsüeh-shu huo-tung." In *Ming-Ch'ing wen-hua-shih san-lun*, 143–61. Wu-ch'ang: Hua-chung kung-hsüeh yüan, 1984.

Feng Ts'ung-wu. *Feng Shao-hsü chi*. 1617 edition.

Fiedler, Shi-yee Liu. "Tung Ch'i-ch'ang te shu-hua-lun yü Ming-chi shih-wen-p'ing" (Tung Ch'i-ch'ang's art theory and literary criticism of The Ming). *The Journal of the Institute of Chinese Studies of the Chinese University of Hong Kong* 22 (1991): 291–322.

Fong, Wen C. "Ch'i-yün sheng-tung: Vitality, Harmonious Manner and Aliveness." *Oriental Art* 12, no. 3 (Autumn 1966): 1–6.

——. "The Lohans and a Bridge to Heaven." *Freer Gallery of Art Occasional Papers* 3, no. 1 (1958).

——. "Modern Art Criticism and Chinese Painting History." In *Tradition and Creativity: Essays on Asian Civilization*, edited by Ching-i Tu, 98–108. Rutgers, NJ: The State University of New Jersey, 1987.

——. "The Orthodox Master." *Art News Annual* 33 (1967): 33–39.

——. Review of *The Compelling Image*, by James Cahill. *The Art Bulletin* 68, no. 3 (September 1986): 506.

——. "Rivers and Mountains after Snow (Chiang-shan hsüeh-chi), attributed to Wang Wei (A.D. 699–759)." *Archives of Asian Art* 30 (1976–77).

——. "Stages in the Life and Art of Chu Ta (1626–1705)." *Archives of Asian Art* 40 (1978): 7–23.

——. "Towards a Structural Analysis of Chinese Landscape Painting." In *Symposium in Honor of Dr. Chiang Fu-ts'ung on His 70th Birthday*, 1–12. *National Palace Museum Quarterly*, Special Issue no. 1. Taipei, 1969.

——. "Tung Ch'i-ch'ang yü cheng-tsung-p'ai hui-hua li-lun" (Tung Ch'i-ch'ang and the orthodox theory of painting). *National Palace Museum Quarterly* 2, no. 3 (January 1968): 1–26.

——. "Wang Hui chih chi ta-ch'eng" (Wang Hui: The great synthesis). *National Palace Museum Quarterly* 3, no. 2 (October 1968): 5–10.

——. "Wang Hui, Wang Yüan-ch'i and Wu Li." In *In Pursuit of Antiquity: Chinese Paintings of the Ming and Ch'ing Dynasties from the Collection of Mr. and Mrs. Earl Morse*, by Roderick Whitfield, 175–94. Rutland, Vermont, and Tokyo: The Art Museum, Princeton University and Charles E. Tuttle Co., 1969.

Fong, Wen C., and Alfreda Murck, Shou-chien Shih, Pao-chen Ch'en, and Jan Stuart. *Images of the Mind: Selections from the Edward L. Elliott Family and John B. Elliott Collections of Chinese Calligraphy and Painting at The Art Museum, Princeton University*. Princeton: The Art Museum, Princeton University, 1984.

Fong, Wen C., and Marilyn Fu. *Sung and Yüan Paintings*. New York: The Metropolitan Museum of Art, 1973.

Fong, Wen C., and Maxwell K. Hearn. "Silent Poetry: Chinese Paintings in the Douglas Dillon Galleries." Reprinted from *The Metropolitan Museum of Art Bulletin* (Winter 1981–82).

Fu, Shen C. Y. "Ming Ch'ing chih chi te k'e-pi kou-le feng-shang yü Shih-t'ao te tsao-ch'i tso-p'in" (An aspect of mid-seventeenth century Chinese painting: the "dry linear" style and the early work of Shih-t'ao). *The Journal of the Institute of Chinese Studies of the Chinese University of Hong Kong* 8, no. 2 (1976): 579–615.

——. "Shan-kao shui-ch'ang: Lun Shih-hsi tsai Huang-shan hua-p'ai chung te ying-yü ti-wei" (The place of K'un-ts'an in the Mount Huang School of painting). *Hsiung-shih mei-shu* 201 (November 1987): 62–69.

——. "A Study of the Authorship of the 'Hua-shuo': A Summary." In *Proceedings of the International Symposium on Chinese Painting*, 85–140. Taipei: National Palace Museum, 1972.

Fu, Shen C. Y., and Marilyn Fu. *Studies in Connoisseurship: Chinese Paintings from the Arthur M. Sackler Collection in New York and Princeton*. Princeton: The Art Museum, Princeton University, 1973.

Fu, Shen C. Y., and Marilyn Fu, Mary Gardner Neill, and Mary Jane

Clark. *Traces of the Brush: Studies in Chinese Calligraphy*. New Haven: Yale University Art Gallery, 1977.

Fu, Shen C. Y., Glenn D. Lowry, and Ann Yonemura. *From Concept to Context: Approaches to Asian and Islamic Calligraphy*. Washington, D.C.: Freer Gallery of Art, Smithsonian Institution, 1986.

Fu, Shen C. Y., Miyazaki Ichisada, and Nakata Yūjiro, eds. *Sekito* (Shih-t'ao). Vol. 8 of *Bunjinga suihen*. Tokyo: Chuokoron-sha, 1976.

Fu Yün-tzu. "Tu Hsi-shan p'in." In *Pai-ch'uan chi*.

Giacalone, Vito. *Chu Ta: Selected Paintings and Calligraphy*. Poughkeepsie, NY, 1972.

Gleysteen, Marilyn Wong. "Calligraphy and Painting: Some Sung and Post-Sung Parallels in North and South—A Reassessment of the Chiang-nan Tradition." In *Words and Images: Chinese Poetry, Calligraphy, and Painting*, edited by Alfreda Murck and Wen C. Fong, 141–72. New York: The Metropolitan Museum of Art and Princeton University Press, 1991.

———. "Hsien-yü Shu's Calligraphy and His 'Admonitions' Scroll of 1299." 3 vols. Ph.D. diss., Princeton University, 1983.

Goepper, Roger. *Chinesische Malerei: Die Jüngere Tradition*. Bern, 1967.

———. *The Essence of Chinese Painting*. London, 1963.

Goodrich, L. Carrington, and Fang Chaoying, eds. *Dictionary of Ming Biography, 1368–1644*. 2 vols. New York and London: Columbia University Press, 1976.

Graham, A. C. *Poems of the Late T'ang*. Baltimore: Penguin Books, 1965.

Greenberg, Clement. "Modernist Painting." *Art and Literature* 4 (Spring 1965).

Greenblatt, Kristin Yu. "Chu-hung ho wan-Ming chü-shih fo-chiao." Translated by Wang Shih-an. *Shih-chieh tsung-chiao yen chiu* 2 (1982): 24–44.

Guo Weiqu. *Sung Yüan Ming Ch'ing shu-hua-chia nien-piao* (Choronology of calligraphers and painters of the Sung, Yüan, Ming, and Ch'ing dynasties). Peking: Jen-min mei-shu ch'u-pan-she, 1962.

Hachidai sanjin, see Wu T'ung and Kohara Hironobu.

Hai-wai i-chen (Masterpieces in overseas collections). Painting vol. 2. Taipei: National Palace Museum, 1988.

———. Painting vol. 3. Taipei: National Palace Museum, 1990.

Han Cho. *Shan-shui ch'un-ch'üan chi*. Repr. 1963. *Mei-shu ts'ung-shu* edition, edited by Huang Pin-hung and Teng Shih, pt. 2, no. 8. Taipei: Kuang-wen shu-chü.

Han T'ai-hua. *Yü-yü t'ang shu-hua chi* (Notes on calligraphy and painting from the Yü-yü Hall). 1851. Repr. 1963. *Mei-shu ts'ung-shu* edition, edited by Huang Pin-hung and Teng Shih, vol. 13. Taipei: Kuang-wen shu-chü.

Hartman, Charles. *Han Yü and the T'ang Search for Unity*. Princeton: Princeton University Press, 1986.

Hawkes, David. *Ch'u Tz'u: The Songs of the South*. Boston: Beacon Press, 1962.

Hay, John. "Arterial Art." *Stone Lion Review* 1 (1983).

———. "The Human Body as a Microcosmic Source of Macrocosmic Values in Calligraphy." In *Theories of the Arts in China*, edited by Susan Bush and Christian Murck, 74–102. Princeton: Princeton University Press, 1983.

———. "Values and History in Chinese Painting, II: The Hierarchic Evolution of Structure." In *RES* 7–8 (Spring-Autumn 1984): 105–8.

Hay, Jonathan Scott. "Shitao's Late Work (1697–1707): A Thematic Map." Ph.D. diss., Yale University, 1989.

Hearn, Maxwell K. *Ancient Chinese Art: The Ernest Erickson Collection in The Metropolitan Museum of Art*. New York: The Metropolitan Museum of Art, 1987.

Hightower, James Robert. *The Poetry of T'ao Ch'ien*. Oxford: Clarendon Press, 1970.

Ho Ch'uan-hsing. "Ming Ch'ing chih chi te Nan-ching hua-t'an." *Tung-wu ta-hsüeh Chung-kuo i-shu chi-k'an* 15 (February 1987): 343–74.

———. "Pi-mo chih chi: Ch'eng Cheng-k'uei yü Shih-hsi." *Ku-kung wen-wu yüeh-k'an* 33 (December 1985): 57–62.

Ho, Wai-kam. "K'un-ts'an's Secret Associations and Secret Activities in Nanking during the Early Years of the Ch'ing Dynasty." Paper presented at the Symposium on the Four Monk Painters, Shanghai Museum, 1989.

———. "Late Ming Literati: Their Social and Cultural Ambience." In *The Chinese Scholar's Studio: Artistic Life in the Late Ming Period*, edited by Chu-tsing Li and James C. Y. Watt, 23–36. New York: Asia Society Galleries and Thames and Hudson, 1987.

———. "Li Ch'eng lüeh-chuan" (A biographical study on Li Ch'eng). *Ku-kung chi-k'an* 5, no. 3 (Spring 1971): 33–62.

———. "The Literary Concepts of 'Picture-like' (*Ju-hua*) and 'Picture-idea' (*Hua-i*) in the Relationship between Poetry and Painting." In *Words and Images: Chinese Poetry, Calligraphy, and Painting*, edited by Alfreda Murck and Wen C. Fong, 359–404. New York : The Metropolitan Museum of Art and Princeton University Press, 1991.

———. "Ming Loyalist Painters' Activities in Partisan Politics and Buddhist Sectarian Disputes in the Su-chou Area during the Late Ming-Early Ch'ing Period." Paper presented at the Symposium on the Ming Wu School of Painting, Beijing Palace Museum, 1985.

———. "Nan-Ch'en Pei-Ts'ui; Ch'en of the South and Ts'ui of the North." *Cleveland Museum of Art Bulletin* 49 (1962): 1–11.

———. "Tung Ch'i-ch'ang's New Orthodoxy and the Southern School Theory." In *Artists and Traditions: Uses of the Past in Chinese Culture*, edited by Christion F. Murck, 113–29. Princeton: The Art Museum, Princeton University, 1976.

———. "Wei: The First Guiding Principle for Compositional Structure in Early Chinese Painting, and a Restoration of Hsieh Ho's Fifth Law." In *Beyond Brush and Ink*, edited by Wai-kam Ho. In press.

———. "*Ya* and *Su*: The Convergence of Scholarly Taste and Popular Taste in Late Ming Literature and Art." Paper presented at the Symposium on Painting of the Ming dynasty, The Chinese University of Hong Kong, 1988.

———. "Yüan-tai wen-jen-hua hsü-shuo" (An introductory essay on literati painting of the Yüan dynasty). *Hsin-ya hsüeh-shu chi-k'an* 4 (1983): 243–57.

Ho, Wai-kam, and Sherman E. Lee. *Chinese Art under the Mongols: The Yüan Dynasty (1279–1368)*. Cleveland: The Cleveland Museum of Art, 1968.

Ho, Wai-kam, Sherman E. Lee, Laurence Sickman, and Marc F. Wilson, eds. *Eight Dynasties of Chinese Painting: The Collections of the Nelson Gallery-Atkins Museum, Kansas City, and The Cleveland Museum of Art*. Cleveland: The Cleveland Museum of Art and Indiana University Press, 1980.

Hsiang-kuan chai yü-shang pien, see Ch'en cho.

Hsin-an ming-hua chi-chin ts'e. Shanghai: Shen-chou kuo-kuang-she, 1920.

Hsiao Yen-i. "Cha Shih-piao chi ch'i hui-hua i-shu." In *Lun Huang-shan chu hua-p'ai wen-hsüan*, 250–62. Shanghai: Jen-min mei-shu ch'u-pan-she, 1987.

Hsieh Kuo-chen. *Tseng-ting wan-Ming shih-chi k'ao*. Shanghai, 1981.

Hsü Ch'in. *Ming hua lu*. Repr. *Hua-shih ts'ung-shu* edition.

Hsü Shuo-fang. "T'ang Hsien-tsu ho *Chin-p'ing mei*." In *Lun T'ang Hsien-tsu chi ch'i-t'a*. Shanghai: Shanghai ku-chi, 1983.

———. "T'ang Hsien-tsu yü Li Ma-tou" (T'ang Hsien-tsu and Matteo Ricci). *Wen-shih* 12 (1981): 273–81.

Hsü, Sung-peng. *A Buddhist Leader in Ming China: The Life and Thought of Han-shan Te-ch'ing.* Pennsylvania State University Press, 1979.

Hsü T'ing-pi and Chou Chien-ting, comps. *Sung-chiang fu chih* (Gazetter of Sung-chiang). 1663.

Hsüan-ho shu-p'u. Repr. 1962. *I-shu ts'ung-pien* edition, vol. 2, *ch.* 12. Taipei: Shih-chieh shu-chü.

Hsüan-yeh. "Sheng-tsu yü-chih-wen." Repr. *Ssu-k'u ch'üan-shu* edition.

Hsüeh-chuang. *Huang-shan t'u* (Landscapes of Mount Huang). Set of woodblock prints. Preface dated 1698.

Hu Chen-heng. *T'ang-shih t'an-ts'ung.* Repr. *Hsüeh-hai lei-pien* edition, *ch.* 1.

Hu Ching. *Hsi-ch'ing cha-chi* (Notes on painting and calligraphy examined by the author). Preface dated 1816. *Hu-shih shu-hua-k'ao san-chung* edition.

Hu Shih. "Ch'an (Zen) Buddhism in China: Its History and Method." *Philosophy East and West: A Journal of Oriental and Comparative Thought* 3, no. 1 (April 1953).

Hu Yi. "K'un-ts'an nien-p'u." *To-yün* 16 (1988): 98–109.

Hua-yüan to-ying (Gems of Chinese painting, a selection of paintings from the Shanghai and Nanking Museums). 3 vols. Shanghai: Jen-min mei-shu ch'u-pan-she, 1955.

Huang Ch'ang. "Hsi-nan fang-shu chi." In *Yin-yü chi,* 198–200. Peking: San-lien shu-tien, 1985.

———. "Yüan-hu ch'ü chien-cheng." In *Yin-yü chi,* 76–132. Peking: San-lien shu-tien, 1985.

———. "Wan-Ming ti pan-hua." In *Yü-hsia shuo-shu,* 158–92. Peking: San-lien shu-tien, 1982.

Huang Ch'un-yao. *T'ao-an chi.* Repr. 1989. *Ts'ung-shu chi-ch'eng hsü-pien* edition, edited by Wang Te-i, vol. 148. Taipei: Hsin-wen-feng ch'u-pan kung-ssu.

Huang Kung-wang yen-chiu wen-chi. Repr. 1987. *Ch'ang-shu-shih wen-lien* edition. Kiangsu: Kiangsu mei-shu ch'u-pan-she.

Huang Pin-hung. "Kou Tao-jen Shih-shih." In *Kou Tao-jen chi.* Repr. 1963. *Mei-shu ts'ung-shu* edition, edited by Huang Pin-hung and Teng Shih, series 5, no. 8. Taipei: Kuang-wen shu-chü.

Huang, Ray. *1587, A Year of No Significance: The Ming Dynasty in Decline.* New Haven: Yale University Press, 1981.

———. *China: A Macro History.* Rev. ed. Armonk, NY: M. E. Sharpe, 1990.

Huang Tsung-hsi. *Ming-ju hsüeh-an.* Repr. *Ts'ung-shu chi-ch'eng* edition, *ch.* 58.

Huang-weng. "K'un-ts'an ch'uan-shih tso-p'in t'i-shih hui-pien" (K'un-ts'an's inscriptions on his extant works). *To-yün* 16 (1988): 110–18.

Huang Yung-ch'üan. *Ch'en Hung-shou nien-p'u* (A chronological biography of Ch'en Hung-shou). Peking: Jen-min mei-shu ch'u-pan-she, 1960.

Hucker, Charles. "The Tung-lin Movement of the Late Ming Period." In *Chinese Thought and Institutions,* edited by John K. Fairbank. Chicago: University of Chicago Press, 1957.

Hui-hung. *Leng-chai yeh-hua.* Repr. *Ts'ung-shu chi-ch'eng* edition, *ch.* 5.

Hummel, Arthur W., ed. *Eminent Chinese of the Ch'ing Period (1644–1912).* 2 vols. Washington, D.C.: United States Government Printing Office, 1943.

Illustrated Catalogues of the Tokyo National Museum: Chinese Paintings (*Tokyo kokuritsu hakubutsukan zuhan mokuroku: Chugoku kaiga hen*). Tokyo: Tokyo National Museum, 1979.

Illustrated Catalogues of the Tokyo National Museum: Chinese Calligraphies (*Tokyo kokuritsu hakubutsukan zuhan mokuroku: Chugoku shodo hen*). Tokyo: Tokyo National Museum, 1980.

The Individualists: Chinese Painting and Calligraphy of the 17th century from the Collection of John M. Crawford, Jr. Providence: Bell Gallery, List Art Center, Brown University, 1980.

Jao Tsung-i. "Chang Ta-feng chi ch'i chia-shih" (Chang Feng and his family background). *Journal of the Institute of Chinese Studies of the Chinese University of Hong Kong* 8, no. 1 (1976): 51–69.

———. "Wan-Ming hua-chia yü hua-lun (i)." *Journal of the Institute of Chinese Studies* (The Chinese University of Hong Kong) 9, no. 1 (1978): 39–65.

Juan Yüan. *Shih-ch'ü sui-pi* (Notes on calligraphy and painting in the imperial collection). Repr. 1854. *Pai-pu ts'ung-shu chi ch'eng* edition, *Wen-hsüan lou* series, *han* 16. Taipei: I-wen yin-shu-kuan.

Jung Keng. *Ts'ung-t'ieh mu.* Vol. 1. Hong Kong, 1980.

Kanda Kiichiro. *Gazenshitsu zuihitsu kogi* (Lecture on *Casual Jottings from the Painting Meditation Room*). Tokyo: Dohosha, 1980.

Kao Mayching. "Sung Mao-chin hua-i ch'u-t'an" (The art of Sung Mao-chin). Unpublished paper presented at the Symposium on Painting of the Ming Dynasty, The Chinese University of Hong Kong, 1988.

Kao Mayching, ed. *Ming-tai hui-hua, Ku-kung Po-wu-yüan ts'ang* (Paintings of the Ming dynasty from the Palace Museum). Hong Kong: Art Gallery, Institute of Chinese Studies, Chinese University of Hong Kong, 1988.

Kao P'an-lung. *Kao-tzu yü-lu. Tzu-ch'iang pu-hsi chai* edition, *ch.* 1.

Kao Shih-ch'i. *Chiang-ts'un hsiao-hsia lu.* Preface dated 1693. Repr.

———. *Chiang-ts'un shu-hua mu.* N.d. (17th-18th century). Repr. 1924, Shanghai; repr. of MS copy, 1968, Hong Kong.

Kao T'ing-chien. *Tung-lin shu-yüan chih.* Yung-cheng edition. Repr. 1881.

Katz, Mrs. Gilbert (Lois). *Selections of Chinese Art.* New York: China Institute in America, 1966.

Kawakami Kei. "Min Shin ga no shiryo: Kenkyu to kanzo no ichi sokumen" (Study and appraisal of Ming and Ch'ing paintings). *Museum* 150 (September 1963): 31–34.

———. "To Kisho hitsu 'Ho Yo' Sho bokkotsu sansui zu" (A *mo-ku* landscape in the style of Yang Sheng by Tung Ch'i-ch'ang). *Bijutsu kenkyu* 180 (March 1955): 36–38.

Kennedy, George. "Wei Chung-hsien." In *Eminent Chinese of the Ch'ing Period (1644–1912),* edited by Arthur W. Hummel, 846–47. Washington, D.C.: United States Government Printing Office, 1943.

Kim, Hongnam. "The Dream Journey in Chinese Landscape Art: Zong Bing to Cheng Zhengkuei." *Asian Art* 3, no. 4 (Fall 1990): 11–29.

Kohara Hironobu. "Banmin gahyo" (Painting criticism of the late Ming). In *Yamane Yukio sensei taikyu kinen: Mindai-shi ronso.* Tokyo: Kyuko shoin, 1990.

———. "Gazenshitsu zuihitsu sakki" (Notes on the *Hua-ch'an shih sui-pi*). Part 1. *Nara Daigaku kiyo* 15 (1986): 110–12.

———. "An Introductory Study of Chen Hongshou, Part I." Translated by Anne Burkus. *Oriental Art* 32, no. 4 (1986–87): 398–410.

———. "Wan-Ming ti hua-p'ing" (Painting criticism of the late Ming). *To-yün* 4 (1989): 127–33.

Kohara Hironobu, ed. *O I* (Wang Wei). *Bunjinga suihen,* China vol. 1. Tokyo: Chuokoron-sha, 1985.

———. *To Kisho no shoga* (Tung Ch'i-ch'ang: the man and his work). 2 vols. Tokyo: Nigensha Publishing Co., Ltd., 1981.

Kohara Hironobu, Nelson I. Wu, Ch'en Shun-ch'en, Nakada Yujiro, and Iriya Yoshitaka, eds. *Jo I, To Kisho* (Hsü Wei, Tung Ch'i-ch'ang). *Bunjinga suihen,* China vol. 5. Tokyo: Chuokoron-sha, 1978.

Kong Chen. "Kung Hsien ho t'a-te tso-p'in" (Kung Hsien and his works). *Chung-kuo hua* (1984).

Ku Fu. *P'ing-sheng chuang-kuan* (The great sights in my life: a record of paintings and collections). Preface dated 1692. Repr. 1962. Shanghai: Jen-min mei-shu ch'u-pan-she.

Ku Hsien-ch'eng. *Ku Tuan-wen-kung chi.*

Ku-kung fa-shu. Taipei: National Palace Museum, 1965.

Ku-kung ming-hua san-pai chung (Three hundred masterpieces of Chinese painting in the Palace Museum). Taichung: National Palace Museum and National Central Museum, 1959.

Ku-kung shu-hua lu (Catalogue of calligraphy and painting in the National Palace Museum). 3 vols. Taipei: National Palace Museum, 1956.

——. 4 vols. 2nd ed. rev. 1965. Taipei: National Palace Museum.

Ku Wen-pin. *Kuo-yün lou shu-hua chi.* Preface dated 1882 (1883 edition). Facsim. repr. 1970. *I-shu shang-chien hsüan-chen* series. Taipei: Han-hua wen-hua shih-yeh ku-feng kung-ssu.

Ku Yen-wu, *Jih-chih lu chi-shih.* Repr. 1834. Shanghai.

Kuan Mien-chün. *San-ch'iu ko shu-hua lu* (Record of calligraphy and painting from the San-ch'iu Pavilion). 2 *ch.* 1928.

K'ung Kuang-t'ao. *Yüeh-hsüeh lou shu-hua lu.* 1861.

K'ung Shang-jen. *Hsiang-chin pu.* Late 17th century. Repr. 1958. Peking: K'o-hsüeh ch'u-pan-she.

——. *Hu-huai-chi.* Repr. 1957. Shanghai: Ku-tien wen-hsüeh ch'u-pan-she.

——. *The Peach Blossom Fan* (*T'ao-hua-shan*). Translated by Chen Shih-hsiang and Harold Acton. Berkeley: University of California Press, 1976.

Kuo Hsi. *Lin-ch'üan kao-chih.* In *Ying-hsüeh hsüan lun-hua ts'ung-shu*, *ch.* 1.

Kuo, Jason C. (Kuo Chi-sheng). *The Austere Landscape: The Paintings of Hung-jen.* Taipei and New York: SMC Publishing Inc. and University of Washington Press, Seattle and London, 1990.

——. "The Paintings of Hung-jen." Ph.D. diss., University of Michigan, 1980.

——. *Wang Yüan-ch'i te shan-shui-hua i-shu* (Wang Yüan-ch'i's landscape art). Taipei: National Palace Museum, 1981.

Kuo P'eng. "Lüeh-lun Te-ch'ing." *Shih-chieh tsung-chiao yen-chiu* 3 (1982): 1–23.

Kuo P'eng. *Ming-Ch'ing Fo-chiao.* Fukien: Jen-min ch'u-pan-she, 1982.

Kuo Shao-yü. *Chung-kuo wen-hsüeh p'i-p'ing shih* (History of Chinese literary criticism). Shanghai: Chung-hua shu-chü, 1961.

Kuo Wei-ch'ü. *Sung, Yüan, Ming, Ch'ing shu-hua-chia nien-piao.* Peking: Jen-min mei-shu ch'u-pan-she, 1962.

Kyohakusai zoshoga sen (Chinese painting and calligraphy in the Hsü-po Studio). Tokyo: Nigensha Publishing Company, 1983.

Laing, Ellen Johnston. "*Riverside* by Liu Yüan-ch'i and the *Waterfall on Mt. K'uang-lu* by Shao Mi." *The University of Michigan Museum of Art Bulletin* 5 (1970–71): 1–6.

——. "Shao Mi." In *Dictionary of Ming Biography*, edited by L. Carrington Goodrich and Chaoying Fang, 1166–68. New York: Columbia University Press, 1976.

Ledderose, Lothar. *Mi Fu and the Classical Tradition of Chinese Calligraphy.* Princeton: Princeton University Press, 1979.

Ledderose, Lothar, ed. *Im Schatten hoher Baüme Malerei der Ming- und Qing-Dynastien (1368–1911) aus der Volksrepublik China.* Baden-Baden: Staatliche Kunsthalle, 1985.

Lee, Sherman E. *Chinese Landscape Painting.* Cleveland: The Cleveland Museum of Art, 1954; 2d rev. ed., 1962.

——. *The Colors of Ink: Chinese Paintings and Related Ceramics from The Cleveland Museum of Art.* New York: The Asia Society, Inc., 1974.

——. *A History of Far Eastern Art.* 2d ed., rev. New York: Harry N. Abrams, 1973.

——. "The Water and the Moon in Chinese and Modern Painting." *Art International* 14, no. 1 (January 1970): 47–59.

Levenson, Joseph R. "The Amateur Ideal in Ming and Early Ch'ing Society: Evidence from Painting." In *Chinese Thought and Institutions*, edited by John K. Fairbank, 320–41. Chicago: The University of Chicago Press, 1957.

——. *Modern China and Its Confucian Past.* New York, 1964.

Levy, Dore J. Book review. *Chinese Literature: Essays, Articles, Reviews* 11 (December 1989): 149–53.

Li Cheuk-yin. "Lun Tung-lin tang-cheng yü wan-Ming cheng-chih." In *Ming-shih san-lun*, 169–91. Taipei, 1987.

Li, Chu-tsing. *The Autumn Colors on the Ch'iao and Hua Mountains: A Landscape by Chao Meng-fu.* Artibus Asiae Supplementum 21. Ascona, Switzerland, 1965.

——. "Hsiang Sheng-mo chih chao-yin shih hua" (Hsiang Sheng-mo's poetry and painting on eremitism). *Journal of the Institute of Chinese Studies of the Chinese University of Hong Kong* 8, no. 2 (1976): 531–59.

——. "Orientalia Helvetica: Chinese Paintings in the Charles A. Drenowatz Collection." *Asiatische Studien* 21 (1967).

——. "Shih-t'ao te *K'u-kua miao-ti ts'e*" (Shih-t'ao's album *Wonderful Conceptions of the Bitter Melon*). *To-yün* 16 (1988): 91–97.

——. *A Thousand Peaks and Myriad Ravines: Chinese Paintings in the Charles A. Drenowatz Collection.* 2 vols. Ascona, Switzerland: Artibus Asiae Publishers, 1974.

Li, Chu-tsing, and James C. Y. Watt, eds. *The Chinese Scholar's Studio: Artistic Life in the Late Ming Period.* New York: Asia Society Galleries and Thames and Hudson, 1987.

Li Jih-hua. *Liu-yen chai erh-pi.* Mid-17th century.

——. *T'ien-chih t'ang chi.* 1637. In *Ming-tai i-shu-chia chi hui-k'an hsü-chi.* Late Ming edition. Facsim. repr. 1971. Taipei: Kuo-li chung-yang t'u-shu-kuan.

——. *Wei-hsüeh hsüan jih-chi.* 1606–16. Repr. 1918. Edited by Liu Ch'eng-kan.

Li Jingyan. "Tung Ch'i-ch'ang *Ch'iu-hsing pa-ching* t'u-ts'e" (Tung Ch'i-ch'ang's album *Eight Views of Autumn Moods*). *Shanghai po-wu-kuan chi-k'an* 2 (1982).

Li K'ai-hsien. *Chung-lu hua-p'in.* Repr. 1963. *Mei-shu ts'ung-shu* edition, edited by Huang Pin-hung and Teng Shih, part 2, no. 10. Taipei: Kuang-wen shu-chü.

Li Pao-hsün. *Wu-i-yu-i chai lun-hua shih.* 2 ch. 1909.

——. *Wu-i-yu-i chai lun-hua shih.* 2 ch. 1916.

Li Tiangang. "Hsü Kuang-ch'i yü Ming-tai t'ien-chu-chiao" (Hsü Kuang-ch'i and the Roman Catholic Church in the Ming period). *Shih-lin* 2 (1988): 48–56.

Li Tso-hsien. *Shu-hua chien-ying* (Notes on calligraphy and painting). 1871.

Li Yü-fen. *Ou-po-lo shih shu-hua kuo-mu k'ao.* Preface dated 1894.

——. *Yen-k'o t'i-pa* (Collection of Wang Shih-min's inscriptions and colophons on calligraphy and painting). 1909. Repr. 1986. Shanghai: Shanghai jen-min ch'u-pan-she.

Li Zhongyuan, ed. *Shen-yang Ku-kung po-wu-yüan ts'ang Ming Ch'ing hui-hua hsüan-chi* (Selected Paintings of Ming and Ching Dynasties: Collection of Palace Museum in Shenyang). Shen-yang: Liaoning mei-shu ch'u-pan-she, 1989.

Liang T'ung-shu. *P'in-lo an lun-shu.* Repr. 1962. *I-shu ts'ung-pien* edition, vol. 4. Taipei: Shih-chieh shu-chü.

Lin Chien-an. *Ho-ch'a ts'ung-t'an.* Preface 1631. In *Shih-liao ts'ung-k'an*, edited by Chung-shan University, Institute of Historiography.

Lippe, Aschwin. "Kung Hsien and the Nanking School, II." *Oriental Art* 4, no. 4 (Winter 1958): 159–70.

Liu Gangji. *Kung Hsien.* Chung-kuo hua-chia ts'ung-shu series. Shanghai: Jen-min mei-shu ch'u-pan-she, 1981.

Loehr, Max. *The Great Painters of China.* New York: Harper and Row, 1980.

——. "Phases and Content in Chinese Painting." In *Proceedings of the*

International Symposium on Chinese Painting, 285–311. Taipei: National Palace Museum, 1972.

Los Angeles County Museum of Art. *Handbook*. Los Angeles, 1977.

Lu Ch'in-li, comp. *Hsien-Ch'in Han Wei Chin Nan-pei-ch'ao shih*. Vol. 2. Peking.

Lu Hsin-yüan. *Jang-li kuan kuo-yen lu*. 1892. 40 *ch*. Repr. 1975. Taipei: Hsüeh-hai ch'u-pan-she.

Lu Hung. *Pei-cheng chi*. Repr. 1989. *Ts'ung-shu chi-ch'eng hsü-pien* edition, edited by Wang Te-i, vol. 148. Taipei: Hsin-wen-feng ch'u-pan kung-ssu.

Lu Shih-hua. *Wu-yüeh so-chien shu-hua lu* (Record of calligraphy and painting seen in the Wu and Yüeh regions). Preface dated 1776. Repr. 1879.

Lun Huang-shan chu hua-p'ai wen-chi. Shanghai: Jen-min mei-shu ch'u-pan-she, 1987.

Lynn, Richard J. "Ming and Ch'ing Views of Yüan Poetry." In *Chinese Poetry and Poetics*, edited by Ronald C. Miao. San Francisco, 1978.

——. "The Sudden and the Gradual in Chinese Poetry Criticism: An Examination of the Ch'an-Poetry Analogy." In *Sudden and Gradual: Approaches to Enlightenment in Chinese Thought*, edited by Peter N. Gregory, 381–428. Honolulu: University of Hawaii Press, 1987.

Mao Xinlong. "K'un-ts'an sheng-p'ing lüeh-k'ao." *To-yün* 15 (1987): 120–25.

Matsui N. *Min To Kisho: Gyoso shikan. Shoseki meihin sokan* series, vol. 77. Tokyo, 1962.

McCrae, John R. "Shen-hui and the Teaching of Sudden Enlightenment." In *Sudden and Gradual: Approaches to Enlightenment in Chinese Thought*, edited by Peter N. Gregory, 227–78. Honolulu: University of Hawaii Press, 1987.

Mei-chan t'e-k'an (Catalogue of the national exhibition of fine arts). 2 vols. 1929.

Mei, Diana Yu-shih Chen. *Han Yü as a Ku-wen Stylist*. Ph.D. diss., Yale University, 1967. Ann Arbor, Michigan: University Microfilms, Inc.

The Metropolitan Museum of Art: Asia. New York: The Metropolitan Museum of Art, 1987.

Mi Fu. *Hai yüeh ming-yen*. Repr. 1962. *I-shu ts'ung-pien* edition, vol. 2. Taipei: Shih-chieh shu-chü.

——. *Hua-shih*. Repr. 1963. *Mei-shu ts'ung-shu* edition, edited by Huang Pin-hung and Teng Shih, part 2, no. 9. Taipei: Kuang-wen shu-chü.

——. *Pao-chang tai-fang-lu*. Repr. 1962. *I-shu ts'ung-pien* edition, vol. 28. Taipei: Shih-chieh shu-chü.

Miao Yüeh-tsao. *Yü-i lu*. Preface dated 1733. Repr. 1973. Taipei: I-wen yin-shu-kuan.

——. Repr. 1989. *Ts'ung-shu chi-ch'eng hsü-pien* edition, edited by Wang Te-i, *ch*. 1. Taipei: Hsin-wen-feng ch'u-pan kung-ssu.

Min Shin no kaiga (Paintings of the Ming and Ch'ing dynasties). Edited by Tokyo National Museum. Tokyo: Benrido, 1964.

Ming Ch'ing chih chi ming-hua t'e-chan. Taipei: National Palace Museum, 1970.

Ming-tai Wu-men hua-p'ai (The Wu School paintings of the Ming dynasty). Compiled by the Palace Museum. Hong Kong and Peking: The Commercial Press and The Forbidden City Publishing House of the Palace Museum, 1990.

Miyagawa Torao. *A History of the Art of China: Chinese Painting*. Translated by Alfred Birnbaum. New York: John Weatherhill, Inc. 1983.

Moskowitz, Ira, ed. *Great Drawings of All Time*, vol. 4. 1962.

Mu Hsiao-t'ien. *Mei Ch'ing. Chung-kuo hua-chia ts'ung-shu* series. Shanghai: Jen-min mei-shu ch'u-pan-she, 1986.

Munakata, Kiyohiko. "Concepts of *Lei* and *Kan-lei* in Early Chinese Art Theory." In *Theories of the Arts in China*, edited by Susan Bush and Christian Murck, 105–131. Princeton: Princeton University Press, 1983.

——. *Sacred Mountains in Chinese Art*. Urbana: University of Illinois Press, 1990.

Murck, Alfreda, and Wen C. Fong. "A Chinese Garden Court: The Astor Court at The Metropolitan Museum of Art." *The Metropolitan Museum of Art Bulletin* (Winter 1980–81).

—— eds. *Words and Images: Chinese Poetry, Calligraphy, and Painting*. New York: The Metropolitan Museum of Art and Princeton University Press, 1991.

Murray, Julia K., "Chang Feng's 1644 Album of Landscapes," 1976. Unpublished Princeton University seminar paper.

Nakata Yujiro. *Bei Futsu*. 2 vols. Tokyo, 1982.

Nakata Yujiro et al. *Shodo geijutsu*, vol. 6. Tokyo, 1975.

Nei-wu-pu ku-wu ch'en-lieh-so shu-hua mu-lu (Catalogue of the calligraphy and painting in the Antique Department of the Ministry of Interior Affairs). 5 vols. Peking: Ku-wu ch'en-lieh-so, 1925.

Neill, Mary Gardner. "The Integration of Color and Ink: A Landscape Painting by Tung Ch'i-ch'ang (1555–1636)." *Yale University Art Gallery Bulletin* 40 (Spring 1987): 40–46.

Nelson Gallery of Art and Atkins Museum: Handbook of the Collections. Vol. 2: Art of the Orient. Edited by Ross E. Taggart, George L. McKenna, and Marc F. Wilson. Kansas City, Mo., 1973.

Nienhauser, William H., Jr. et al. *Liu Tsung-yüan*. New York: Twayne Publishers, Inc. 1974.

Ning K'ai et al. *I-hsing hsien-chih*. Kuang-hsü edition. Repr. Taipei: Hsin-hsing shu-chü.

Ning-kuo fu chih (Gazetteer of Ning-kuo prefecture). 1919.

Nishigami Minoru. "Tai Banko ni tsuite" (On Tai Pen-hsiao). In *Suzuki Kei sensei kanreki kinen kai Chugoku kaiga shi ronshu*, 291–340. Tokyo, 1981.

——. "Tai Pen-hsiao yen-chiu" (A Study of Tai Pen-hsiao). In *Lun Huang-shan chu hua-p'ai wen-chi*, 118–78. Shanghai: Jen-min mei-shu ch'u-pan-she, 1987.

Oertling, Sewall Jerome. *Ting Yün-p'eng: A Chinese Artist in the Late Ming Dynasty*. Ph.D. diss., University of Michigan, 1980.

Osaka Exchange Exhibition: Paintings from the Abe Collection and Other Masterpieces of Chinese Art. San Francisco: San Francisco Center of Asian Art and Culture, 1970.

Osaka Municipal Museum of Fine Art, ed. *Chinese Paintings in The Osaka Municipal Museum of Fine Art*. 2 vols. Tokyo: Asahi Shimbunsha, 1975.

Ostasiatische Kunst. Berlin: Staatliche Museum Preussischer Kulturbesitz, 1970.

Owen, Stephen. *The Great Age of Chinese Poetry*. 1980.

Paintings and Calligraphy by Ming I-min from the Chih-lo Lou Collection. Hong Kong: Art Gallery, Institute of Chinese Studies, Chinese University of Hong Kong, 1975.

The Paintings and Calligraphy of Pa-ta and Shih-t'ao. Taipei: National Museum of History, 1984.

P'an Cheng-wei. *T'ing-fan lou shu-hua chi*. Preface dated 1843. Repr. 1963. *Mei-shu ts'ung-shu* edition, edited by Huang Pin-hung and Teng Shih, vol. 37. Taipei: Kuang-wen shu-chü.

——. *T'ing-fan lou shu-hua chi hsü-pien*. 1849. Repr. 1963. *Mei-shu ts'ung-shu* edition, edited by Huang Pin-hung and Teng Shih, *ch. shang*. Taipei: Kuang-wen shu-chü.

Pan I-chün. *P'an-shih San-sung t'ang shu-hua chi*. Repr. 1942.

Pang, Mae Anna Quan. *An Album of Chinese Art from the National Gallery of Victoria*. Melbourne, 1983.

——. "A Landscape Quartet by Zhu Da." *Orientations* 17, no. 10 (1986): 24–31.

——. "The Sung-chiang (Hua-t'ing) Painters, II: Tung Ch'i-ch'ang and

His Circle." In *The Restless Landscape: Chinese Painting of the Late Ming Period*, edited by James Cahill, 90–94. Berkeley: University Art Museum, 1971.

——. "Wang Yüan-ch'i (1642–1715) and Formal Construction in Chinese Landscape Painting." Ph.D. diss., University of California, Berkeley, 1976.

——. *Zhu Da, The Mad Monk Painter*. Melbourne: National Gallery of Victoria, 1985.

P'ang Yüan-chi. *Hsü-chai ming-hua lu*. Shanghai, 1909.

——. *Hsü-chai ming-hua hsü-lu*. Shanghai, 1924; addendum, 1925.

Payne, Robert. *The White Pony*. New York: Mentor Books, 1960.

Pien Yung-yü. *Shih-ku t'ang shu-hua hui-k'ao*. 1682. Repr. 1958. Taipei: Cheng-chung shu-chü.

Plaks, Andrew H. *The Four Masterworks of the Ming Novel*. Princeton: Princeton University Press, 1987.

P'u Chi. *Wu-teng hui-yüan*. Repr. 1989. Peking: Chung-hua shu-chü.

Qi Gong. "Tung Ch'i-ch'ang shu-hua tai-pi-jen k'ao" (Investigation into the calligraphers and painters who worked for Tung Ch'i-ch'ang). In *Qi Gong ts'ung-kao*, 149–64. Peking: Chung-hua shu-chü, 1981.

Ren Daobin. *Tung Ch'i-ch'ang hsi-nien* (Chronology of Tung Ch'i-ch'ang). Peking: Wen-wu ch'u-pan-she, 1988.

Riely, Celia Carrington (Li Hui-wen). "Tung Ch'i-ch'ang cheng-chih chiao-yu yü i-shu huo-tung ti kuan-hsi" (The relation between Tung Ch'i-ch'ang's political association(s) and artistic activities). *To-yün* 23, no. 4 (1989): 97–108, 133.

——. "Tung Ch'i-ch'ang's Ownership of Huang Kung-wang's *Dwelling in the Fu-ch'un Mountains*." *Archives of Asian Art* 28 (1974–75): 57–76.

Robinson, G. W. *Wang Wei: Poems*. Penguin Books, 1973.

Rogers, Howard, and Sherman E. Lee. *Masterworks of Ming and Qing Painting from the Forbidden City*. Landsdale, Pennsylvania: International Arts Council, 1988.

Schapiro, Meyer. *Modern Art: 19th and 20th Centuries*. New York: George Braziller, Inc., 1979.

Sekai bijutsu zenshu. Series B, vol. 20. Tokyo: Heibonsha, 1953.

Semmen taikan. Kyoto, 1915.

Sensabaugh, David A. "The Recluse Dwells Deep Within A Thatched Hut." In *Chao Yüan and Late Yüan-Early Ming Painting*, 169–218. Ph.D. diss., Princeton University, 1990.

Shan Guolin. "Chien-chiang tsao-nien hsing-i chi ch'i feng-t'an." *To-yün* 15 (1987): 115–19.

Shao Lo-yang. *Wu Li*. Chung-kuo hua-chia ts'ung-shu series. Shanghai: Jen-min mei-shu ch'u-pan-she, 1962.

Shao Seng-mi shan-shui ts'e (A landscape album by Shao Mi). Shanghai: Shang-wu yin-shu-kuan, 1939.

Shen Kua. *Meng-ch'i pi-t'an chiao-cheng*. Annotation by Hu Tao-ching. Shanghai: Shanghai ku-chi, 1985.

Shi Gufeng. "Kuan-yü Chien-chiang *Huang-shan t'u ts'e* chih wo chien" (My views concerning the *Album of Huang-shan* attributed to Hung-jen). *To-yün* 9 (December 1985): 130–136.

Shih-ch'ü pao-chi (Catalogue of painting and calligraphy in the imperial collection, part 1). Compiled by Chang Chao et al. Completed 1745; repr. 1918. Shanghai: Han fen lou.

Shih-ch'ü pao-chi hsü-pien (Catalogue of painting and calligraphy in the imperial collection, part 2). Compiled by Wang Chieh et al. Completed 1793; repr. 1948. Shanghai: T'an-shih Ou-chai.

——. Facsim. of MS copy, 1971. Taipei: National Palace Museum.

Shih-ch'ü pao-chi san-pien (Catalogue of painting and calligraphy in the imperial collection, part 3). Compiled by Hu Ching et al. Completed 1816, facsim. repr. 1969. Taipei: National Palace Museum.

Shih Chün et al. *Chung-kuo Fo-chiao ssu-hsiang tzu-liao hsüan-pien*. Peking: Chung-hua shu-chü, 1983.

Shih Shou-ch'ien, Maxwell K. Hearn, and Alfreda Murck. *The John M. Crawford, Jr., Collection of Chinese Calligraphy and Painting in The Metropolitan Museum of Art: Checklist*. New York: The Metropolitan Museum of Art, 1984.

Shina nanga shusei (Collected Chinese paintings of the Southern School). Tokyo, 1917–19. Series 2, no. 12.

Shina nanga taisei (Conspectus of Chinese paintings of the Southern School). Vols. 9, 13. Tokyo: Kabunsha, 1935–37.

Shodo zenshu (A collection of calligraphic works). 25 vols. Tokyo: Heibonsha, 1954–68.

Sickman, Laurence, ed. *Chinese Calligraphy and Painting in the Collection of John M. Crawford, Jr.* New York: Pierpont Morgan Library, 1962.

Sickman, Laurence, and Alexander Soper. *The Art and Architecture of China*. Penguin Books, 1956; 3rd edition, 1968.

Silbergeld, Jerome. *Chinese Painting Style: Media, Methods, and Principles of Form*. Seattle and London: University of Washington Press, 1982.

——. "Political Symbolism in the Landscape Painting and Poetry of Kung Hsien." Ph.D. diss., Stanford University, 1974.

Sirén, Osvald. *The Chinese on the Art of Painting*. New York: Schocken Books, Inc., 1963.

——. *Chinese Painting: Leading Masters and Principles*. 7 vols. New York: Ronald Press, 1956–58.

——. *A History of Later Chinese Painting*. 2 vols. 1938. Repr. 1978. New York: Hacker Art Books.

So-Gen irai mei-ga sho-shu. Tokyo, 1947.

So-Gen-Min-Shin meiga taikan (Catalogue of famous paintings of the Sung, Yüan, Ming, and Ch'ing dynasties). Tokyo: Ohtsuka Kogeisha, 1931.

Soraikan kinsho. Parts 1, 2. Osaka: Hakubundo, 1930–39.

Speed, Bonnie. "Tu Ling's Poetic Feeling: An Album Leaf in *Landscapes after Old Masters* by Tung Ch'i-ch'ang." Unpublished paper, 1989.

Ssu-kao-seng hua-chi (The Four Monk Painters: paintings from the Shanghai Museum collection). Edited by Xie Zhiliu. Hong Kong and Shanghai: Tai Yip Co. and Shanghai jen-min mei-shu ch'u-pan-she, 1990.

Su Tsung-jen, comp. *Huang-shan ts'ung-k'an*. Vol. 2. Peking: Pai-i-yen chai, 1937.

Sullivan, Michael. *Symbols of Eternity: The Art of Landscape Painting in China*. Stanford: Stanford University Press, 1979.

——. *The Three Perfections: Chinese Painting, Poetry, and Calligraphy*. London, 1974.

Sun Ch'eng-tse. *Keng-tzu hsiao-hsia chi*. 1765. Repr. *Chih-pu-tsu chai* edition.

Sun K'ai-ti. *Yeh-shih yüan ku-chin tsa-chü k'ao*.

Sung Ch'i-feng. "Pai-shuo." *Wan-Ming tzu-liao ts'ung-k'an* 2 (1982): 77–78.

Suzuki Kei. *Chugoku kaigashi*. 2 vols. Tokyo: Yoshikawa Kabunkan, 1981.

Suzuki Kei, ed. *Chinese Art in Western Collections*. Vol. 2 of *Chugoku bijutsu* (Chinese art). 5 vols. Tokyo: Kodansha, 1973.

Suzuki Kei, comp. *Chugoku kaiga sogo zuroku* (Comprehensive illustrated catalogue of Chinese paintings). 5 vols. Tokyo: University of Tokyo Press, 1982–83.

Takashima Kikujiro, comp. *Kaiankyo rakuji* (Chinese painting and calligraphy of the Sung, Yüan, Ming, and Ch'ing periods, collection of Kikujiro Takashima). Tokyo: Kyuryudo, 1964.

Tam, Laurence C. S. *Six Masters of Early Ch'ing and Wu Li*. Hong Kong: Hong Kong Museum of Art, 1986.

T'ang Shun-chih. *T'ang Ching-ch'uan hsien-sheng chi*. Repr. 1989. *Ts'ung-shu chi-ch'eng hsü-pien* edition, edited by Wang Te-i, vol. 144. Taipei: Hsin-wen-feng ch'u-pan kung-ssu.

T'ao Liang. *Hung-tou-shu kuan shu-hua chi*. 1882.

T'ao Ts'ung-i. *Nan-ts'un ch'o-keng lu.* In *Yüan-Ming shih-liao pi-chi ts'ung-k'an,* ch. 8. Repr. 1959. Peking: Chung-hua shu-chü.

Tausend Jahre Chinesiche Malerei (1000 years of Chinese painting). Munich: Haus der Kunst, 1959.

Teng Chih-ch'eng. "Yu Ch'eng *Chiang-shan hsüeh-chi* chüan." (Wang Wei's *Rivers and Mountains after Snow*). In *Ku-tung suo-chi,* ch. 1. Peking: San-lien shu-tien, 1955.

Three Hundred Masterpieces, see *Ku-kung ming-hua san-pai chung.*

T'ien-hui ko hua-ts'ui (Masterpieces of the T'ien-hui Studio). Vol. 1. Shanghai, 1930.

To-So-Gen-Min meiga taikan (Conspectus of famous paintings of the T'ang, Sung, Yüan, and Ming dynasties). Tokyo: Tokyo Imperial Museum, 1930.

Tokiwa Daijo and Sekino Tadashi. *Shina bunka shiseki.* 12 vols. Tokyo, 1939.

Tomita Kojiro and Tseng Hsien-chi. *Portfolio of Chinese Paintings in the Museum: Yüan to Ch'ing Periods.* Boston: Museum of Fine Arts, Boston, 1961.

Tong, Ginger. "Yün Shou-p'ing and His Landscape Art." Ph.D. diss., Stanford University, 1983.

Toyo bijutsu, kaiga (Far Eastern fine arts: painting, vol. 2). Tokyo: Asahi Shimbunsha, 1968.

Ts'ao Chia-chü. *Shuo-meng.* Ch'ing-jen shuo-hui edition, chs. 1 and 2. Ca. 1638.

Tsao, Hsing yuan. "Art as a Means of Self-cultivation and Social Intercourse: On the Social Function of Dong Qichang's Art." Master's thesis, University of California, Berkeley, 1991.

Tseng Tsao. *Lei-shuo.* Repr. *Ts'ung-shu chi-ch'eng* edition, ch. 49.

Tung Ch'i-ch'ang. *Hua-ch'an shih sui-pi* (Miscellaneous notes of the Hua-ch'an Studio). 4 *ch.* Compiled by Yang Wu-pu. 1720. Repr. 1960. *Pi-chi hsiao-shuo ta-kuan* edition, vol. 7. Taipei: Hsin-hsing shu-chü.

——. Repr. 1962. *I-shu ts'ung-pien* edition, vol. 29. Taipei: Shih-chieh shu-chü.

——. Repr. 1987. *Ssu-k'u ch'üan-shu* edition, ch. 2. Shanghai: Shanghai ku-chi ch'u-pan-she.

——. *Hua-shuo* (The exposition of painting). Repr. 1962. *I-shu ts'ung-pien* edition, first series, vol. 12. Taipei: Shih-chieh shu-chü.

——. *Hua-yen* (The eye of painting). Repr. 1962. *I-shu ts'ung-pien* edition, first series, vol. 12. Taipei: Shih-chieh shu-chü.

——. *Jung-t'ai chi.* Preface by Ch'en Chi-ju dated 1630. Repr. 1968. Taipei: Kuo-li chung-yang t'u-shu-kuan.

——. *Jung-t'ai pieh-chi.* Preface by Ch'en Chi-ju dated 1630. Repr. 1968. Taipei: Kuo-li chung-yang t'u-shu-kuan.

——. *Jung-t'ai shih-chi.* Preface by Ch'en Chi-ju dated 1630. Repr. 1968. Taipei: Kuo-li chung-yang t'u-shu-kuan.

——. *Jung-t'ai wen-chi.* Preface by Ch'en Chi-ju dated 1630. Repr. 1968. Taipei: Kuo-li chung-yang t'u-shu-kuan.

Tung Ch'i-ch'ang hua-chi (Selected paintings of Tung Ch'i-ch'ang). Edited by Che Pengfei and Jiang Hong. Shanghai: Shanghai shu-hua ch'u-pan-she, 1989.

Tung Hsiang-kuang shan-shui ts'e (A landscape album by Tung Hsiang-kuang [Tung Ch'i-ch'ang]). Shanghai: Chung-hua shu-chü, 1922 and 1936.

Tung Hua-t'ing shu-hua lu (Calligraphy and painting of Tung Ch'i-ch'ang). Ch'ing-fu shan-jen edition. Repr. 1962. *I-shu ts'ung-pien* edition. Taipei: Shih-chieh shu-chü.

Tung Ssu-chang. *Ching-hsiao chai ts'un-ts'ao.*

Wang Chung-wen-kung chi. Repr. *Ts'ung-shu chi-ch'eng* edition.

Wang Fangyu and Richard M. Barnhart. *Master of the Lotus Garden: The Life and Art of Bada Shanren (1626–1705).* Edited by Judith G. Smith. New Haven: Yale University Art Gallery and Yale University Press, 1990.

Wang Hui. *Ch'ing-hui hua-pa* (Wang Hui's colophons on paintings). In *Hua-hsüeh hsin-yin* (Insights from painting studies), compiled by Ch'in Tsu-yung, ch. 4. Preface dated 1856. 1878.

Wang K'o-yü. *Shan-hu wang.* Repr. *Ts'ung-shu chi-ch'eng* edition, ch. 21.

——. *Wang-shih shan-hu-wang ming-hua t'i-pa.* 1643. Repr. 1914–16. *Shih-yüan ts'ung-shu,* compiled by Chang Chün-heng, ch. 19.

Wang Mien. "Yüan Chung-lang ti tsai-p'ing-chia." *Chung-hua wen-shih lun-ts'ung* 2, no. 3 (1987).

Wang Seng-ch'ien. *Lun shu* (Discourse on calligraphy). In *Fa-shu yao-lu.* Repr. 1962. *I-shu ts'ung-pien* edition, ch. 1. Taipei: Shih-chieh shu-chü.

Wang Shicheng. *Hsiao Yün-ts'ung.* Chung-kuo hua-chia ts'ung-shu series. Shanghai: Jen-min mei-shu ch'u-pan-she, 1979.

Wang Shih-chieh, Na Chih-liang, and Chang Wan-li, eds. *I-yüan i-chen* (A Garland of Chinese Paintings). Vol. 3. Hong Kong: Cafa, 1967.

Wang Shiqing. "Ch'ing-ch'u ssu ta hua-seng ho-k'ao" (A combined study on the four great monk painters in the early Ch'ing dynasty). *Journal of the Institute of Chinese Studies of the Chinese University of Hong Kong* 15 (1984): 183–215.

——. "*Ch'iu-feng wen-chi* chung yu kuan Shih-t'ao ti shih-wen." *Wen-wu* 12 (1979): 43–48.

——. "Hsüeh-chuang te *Huang-hai yün-fang* t'u" (Hsüeh-chuang's painting *Cloudy Boat in the Yellow Ocean*). *Ta-kung pao* (March 30, 1987).

——. "*Hua-shuo* chiu wei shei chu?" (Who is the author of the *Hua-shuo*?). Unpublished paper.

Wang Shiqing and Wang Cong. *Chien-chiang tzu-liao chi* (Collected research materials on Chien-chiang). Hofei: Anhui jen-min ch'u-pan-she, 1984.

Wang Tzu-tou (Wang Zidou). *Pa-ta shan-jen shu-hua chi* (Calligraphy and painting of Pa-ta shan-jen). Shanghai: Jen-min mei-shu ch'u-pan-she, 1983.

Wang Wen-tsai. *Yüan-ch'ü chih-shih.* Peking: Jen-min wen-hsüeh, 1985.

Wang Yüan-han. *Ch'üan-chi.* Repr. 1989. *Ts'ung-shu chi-ch'eng hsü-pien* edition, edited by Wang Te-i, vol. 147. Taipei: Hsin-wen-feng ch'u-pan kung-ssu.

Weber, Max. *The Religion of China.* Translated and edited by Hans H. Gerth. New York: The Free Press, 1951.

Wei Chin Nan-pei-ch'ao wen-hsüeh-shih ts'an-kao tzu-liao. Annotated by the Teaching and Research Room for History of Chinese Literature, Beijing University. Peking, 1961.

Wei Hsü, comp. *Mo-sou.* Repr. 1987. *Ssu-k'u ch'üan-shu* edition, vol. 812. Shanghai: Shanghai ku-chi ch'u-pan-she.

Weidener, Marsha, et al. *Latter Days of the Law: Images of Chinese Buddhism (850–1850).* Raleigh: North Carolina Museum of Art, 1992.

Weidener, Marsha, Ellen Johnston Laing, Irving Yucheng Lo, Christina Chu, and James Robinson. *Views from Jade Terrace: Chinese Women Artists, 1300–1912.* Indianapolis and New York: Indianapolis Museum of Art and Rizzoli, 1988.

Weltkunst aus Privatbesitz. Kunsthalle, Köln, 1968.

Wen Chia. *Ch'ien-shan t'ang shu-hua chi.* Repr. 1962. *I-shu ts'ung-pien* edition, vol. 17. Taipei: Shih-chieh shu-chü.

Weng, Wan-go. *Chinese Painting and Calligraphy, A Pictorial Survey: 69 Fine Examples from the John M. Crawford, Jr. Collection.* New York: Dover Publications, 1978.

——. *Gardens in Chinese Art.* New York: China Institute in America, 1968.

Weng, Wan-go, and Yang Boda. *The Palace Museum: Peking—Treasures of the Forbidden City.* New York: Harry N. Abrams, Inc., 1982.

Whitbeck, Judith. "Calligrapher-Painter-Bureaucrats in the Late Ming." In *The Restless Landscape: Chinese Painting of the Late Ming Period,* edited by James Cahill, 115–22. Berkeley: University Art Museum, 1971.

Whitfield, Roderick. *In Pursuit of Antiquity: Chinese Paintings of the Ming and Ch'ing Dynasties from the Collection of Mr. and Mrs. Earl Morse.* Rutland, Vermont, and Tokyo: The Art Museum, Princeton University and Charles E. Tuttle Co., 1969.

Wicks, Ann Barrett. "Wang Shih-min (1592–1680) and the Orthodox Theory of Art: The Six Famous Practitioners." Ph.D. diss., Cornell University, 1982.

——. "Wang Shimin's Orthodoxy: Theory and Practice in Early Qing Painting." *Oriental Art* 29, no. 3 (1983).

Wilson, Marc F. "The Chinese Painter and His Vision." *Apollo* 47 (March 1973): 226–39.

——. "Kung Hsien: Theorist and Technician in Painting." *The Nelson Gallery and Atkins Museum Bulletin* 4, no. 9 (May-July 1969).

Wollheim, Richard. *Painting as an Art.* Washington, D.C.: National Gallery of Art, 1987.

Worringer, Wilhelm. *Abstraction and Empathy.* Translated by M. Bullock. New York: Routledge and Kegan Paul, 1953.

Wu Jung-kuang. *Hsin-ch'ou hsiao-hsia chi.* 1841. Repr. 1989. *Ts'ung-shu chi-ch'eng hsü-pien* edition, edited by Wang Te-i, vol. 95. Taipei: Hsin-wen-feng ch'u-pan kung-ssu.

Wu, Nelson I. "The Evolution of Tung Ch'i-ch'ang's Landscape Style as Revealed by His Works in the National Palace Museum." In *Proceedings of the International Symposium on Chinese Painting*, 1–82. Taipei: National Palace Museum, 1972.

——. "Tung Ch'i-ch'ang (1555–1636): Apathy in Government and Fervor in Art." In *Confucian Personalities*, edited by A. F. Wright and D. C. Twitchett, 260–93. Stanford: Stanford University Press, 1962.

—— (Wu Na-sun). "Tung Ch'i-ch'ang yü Ming-mo Ch'ing-ch'u chih shan-shui-hua" (Tung Ch'i-ch'ang and landscape painting of the late Ming and early Ch'ing). *To-yün* 24 (1990): 21–30.

Wu-p'ai hua chiu-shih nien chan (Ninety years of Wu School painting). Taipei: National Palace Museum, 1975.

Wu Sheng. *Ta-kuan-lu.* Preface dated 1713. *I-shu shang-chien hsüan-chen.* 20 *ch.* Repr. 1970. Taipei: Kuo-li chung-yang t'u-shu kuan.

Wu T'ung and Kohara Hironobu. *Hachidai Sanjin* (Pa-ta shan-jen). Vol. 6 of *Bunjinga suihen* (Selected masterpieces of literati painting). Tokyo: Chuokoronsha, 1977.

Wu, William D. Y. "Kung Hsien (ca. 1619–1689)." Ph.D. diss., Princeton University, 1979.

Wu Yin-ming. "Tung Ch'i-ch'ang yen-chiu" (A study of Tung Ch'i-ch'ang). *Hsin-ya shu-yüan hsüeh-shu nien-k'an* 1 (1959): 332–71.

Wu Ying-chi. *Lou-shan t'ang chi.* Repr. *Ts'ung-shu chi-ch'eng* edition, *ch.* 7.

Xiao Ping and Liu Yujia. *Kung Hsien yen-chiu chi* (Studies on Kung Hsien). Vol. 2. Nanking: Chiang-su mei-shu ch'u-pan-she, 1989.

Xu Bangda. *Chung-kuo hui-hua-shih t'u-lu* (Illustrated catalogue of the history of Chinese painting). 2 vols. Shanghai: Shanghai jen-min mei-shu ch'u-pan-she, 1984.

——. "Huang Kung-wang ti liang-fu hsüeh-ching shan-shui-hua." *Chung-kuo hua* (1981).

——. "Huang-shan t'u ts'e tso-che k'ao-pien" (A determination of the author of *Album of Huang-shan*). *To-yün* 9 (December 1985): 125–129.

——. *Ku shu-hua chien-ting kai-lun.* Peking: Wen-wu ch'u-pan-she, 1981.

——. *Ku shu-hua wei-o k'ao-pien* (Research and correction of forged and misattributed ancient calligraphy and painting). 4 vols. Nanking: Chiang-su ku-chi ch'u-pan-she, 1984.

——. *Li-tai liu-ch'uan shu-hua tso-p'in pien-nien-piao* (Chronological table of recorded and dated Chinese calligraphy and painting). Shanghai: Jen-min mei-shu ch'u-pan-she, 1963.

——. *Li-tai shu-hua-chia chuan-chi k'ao-pien.* Shanghai: Jen-min mei-shu ch'u-pan-she, 1983.

——. "Ku-hua pien-wei shih-chen, part 3: Tung Ch'i-ch'ang, Wang Shih-min, Wang Chien tso-p'in chen-wei k'ao." *To-yün* 6 (1984).

Yamamoto, Taijiro. *Chokaido shoga mokuroku.* Tokyo, 1932.

Yang Chenbin. "Mei Ch'ing sheng-p'ing chi ch'i hui-hua i-shu" (Mei Ch'ing's life and art). *Ku-kung po-wu-yüan yüan-k'an* 4 (1985): 49–57.

——. "Mei Ch'ing sheng-p'ing chi ch'i hui-hua i-shu" (Mei Ch'ing's life and art). In *Lun Huang-shan chu hua-p'ai wen-chi*, edited by Shen Baofa, 206–38. Shanghai: Jen-min mei-shu ch'u-pan-she, 1987.

Yang Chia-yu. "San-mao chui-feng ho Feng-mao hua-chüan." *Shang-hai po-wu-kuan chi-k'an* 3 (1986): 99–101.

Yang Hsiung. *Fa-yen.* *Ssu-pu ts'ung-k'an* edition, *ch.* 6. Shanghai: Shang-wu yin-shu-kuan.

Yang, Lucy Lo-hwa. "The Wu School in Late Ming, II: Innovative Masters." In *The Restless Landscape: Chinese Painting of the Late Ming Period*, edited by James Cahill, 57–76. Berkeley: University Art Museum, 1971.

Yang Lung-yu chi-nien wen-chi (Collected essays in memory of Yang Lung-yu). Kuei-chou: Jen-min ch'u-pan-she, 1988.

Yang Xin. *Ch'eng Cheng-k'uei.* Chung-kuo hua-chia ts'ung-shu series. Shanghai: Jen-min mei-shu ch'u-pan-she, 1982.

——. "Ch'eng Cheng-k'uei chi ch'i *Chiang shan wo-yu t'u*" (Ch'eng Cheng-k'uei and his *Dream Journey among Streams and Mountains*). *Wen-wu* 10 (1981): 77–81.

——. *Hsiang Sheng-mo.* Chung-kuo hua-chia ts'ung-shu series. Shanghai: Jen-min mei-shu ch'u-pan-she, 1982.

——. "Lüeh-lun Shih-hsi te i-shu" (A brief note on the art of K'un-ts'an). *Chung-kuo hua* 28, no. 2 (1983): 44.

——. "Shih-hsi tsu-nien tsai-k'ao" (Another study of the year of K'un-ts'an's death). *Ku-kung po-wu-yüan yüan-k'an* 3 (1988): 36–41.

Yang Yeh-chin. "Ming-tai ching-yen chih-tu yü nei-ko." *Ku-kung po-wu-yüan yüan-k'an* 2 (1990): 79–87.

Yao Chi-heng. *Hsü-shou shu-hua ch'i-wu chi.* In *Mei-shu ts'ung-shu*, edited by Teng Shih and Huang Pin-hung. 1912–36. Repr. of the 1947 enlarged edition. Taipei: I-wen yin-shu-kuan.

Yao Kung-shou hsin-shang shan-shui ts'e (Yao Kung-shou's landscape album *Hearty Appreciation*). Shanghai: Wen-ming shu-chü, 1924.

Yen-chou shan-jen ssu-pu kao. Repr. 1987. *Ssu-k'u ch'üan-shu* edition, *ch.* 138. Shanghai: Shanghai ku-chi ch'u-pan-she.

Yen Yü. *Ts'ang-lang shih-hua chiao-shih.* Collated and annotated by Kuo Shao-yü. Peking: Jen-min wen-hsüeh ch'u-pan-she, 1962.

Yonezawa Yoshiho. *Painting in the Ming Dynasty.* Tokyo: Mayuyama & Co., 1956.

Yu Anlan, comp. *Hua-lun ts'ung-k'an.* Peking: Jen-min mei-shu ch'u-pan-she, 1983.

Yu Jianhua, comp. *Chung-kuo hua-lun lei-pien.* Peking: Jen-min mei-shu ch'u-pan-she, 1957.

Yü Yung-lin. *Pei-ch'uang so-yü.* Repr. *Ts'ung-shu chi-ch'eng* edition.

Yüan Ming Ch'ing ch'ü hsüan. 1952.

Yüan Tsung-tao. *Pai-Su chai lei-chi.* 1615 edition. Repr. 1989. Shanghai: Shanghai ku-chi.

Yuhas, Louise. "Imaginary Journeys: Seventeenth century Chinese Paintings in the Los Angeles County Museum of Art." *Orientations* 20, no. 11 (November 1989): 77–86.

Zhang Lian and Zheng Wei. "Mo Shih-lung nien-p'u." *To-yün* 26 (1990): 90–107.

Zheng Wei. "Ch'eng Chia-sui nien-piao." *To-yün* 10 (1986): 131–35.

——. *Tung Ch'i-ch'ang nien-p'u* (A chronological biography of Tung Ch'i-ch'ang). Shanghai: Shanghai shu-hua ch'u-pan-she, 1989.

——. "Wang Chien nien-p'u" (Chronology of Wang Chien). *To-yün* 22 (1989): 92–115.

Zheng Wei, ed. *Shih-t'ao.* Shanghai: Jen-min mei-shu ch'u-pan-she, 1990.

Zheng Xizhen. *Hung-jen; K'un-ts'an. Chung-kuo hua-chia ts'ung-shu* series. Shanghai: Jen-min mei-shu ch'u-pan-she, 1979.

Zhong Yinlan. "Hung-jen *Shu-ch'üan hsi-yen t'u chüan*" (Hung-jen's *Washing the Inkstone in a Shallow Stream*). *Shang-hai po-wu-kuan chi-k'an* (1982).

——. "Tung Ch'i-ch'ang te shui-mo ch'ing-lü shan-shui-hua" (Tung Ch'i-ch'ang's landscape painting in ink and blue and green). *Wen-wu* 12 (1962): 8, 56.

Zhu Jiajin. *Kuo-pao* (Treasures of China). Hong Kong: The Commercial Press, 1983.

Zhu Yunhui. "Hsüeh-chuang te *Huang-hai yün-fang* t'u" (Hsüeh-chuang's *Cloudy Boat in the Yellow Ocean*). *Wen-wu* 12 (1980).